The Prestel Dictionary of
Art and Artists in the 20th Century

THE PRESTEL DICTIONARY OF

Art and Artists
in the 20th Century

Prestel

Munich · London · NewYork

Foreword

In the last few years public interest in contemporary art has increased steadily. This is clearly reflected in the visitor numbers to exhibitions on twentieth-century art. If, twenty years ago, the Old Masters were still the public's favorites, their place has now been taken by classical modern artists with a discernible tendency also towards contemporary art. Parallel to this the demand for easily available, reliable information on art has grown too. This Dictionary is intended to take account of these developments. It presents the great, established names of art history from the turn of the nineteenth century to the 1990s, and looks forward into the artistic future of the twenty-first century.

We are aware that there are no absolute binding rules for the choice of artists whose main works were produced in the last twenty years, and that exhaustiveness is not possible. We have therefore tried to include those artists who have made a particular impact and brought innovation to their field. In this our main focus has been Western Europe and the USA, although we have also taken into account the most important developments in Eastern Europe, Latin America, and Japan.

Each entry lists the artist's biographical data, their main exhibitions, and describes characteristics of their work. Artistic groups and movements cover the extraordinary wealth of contemporary art which is also illustrated through numerous color reproductions. Concepts are included when they are exclusively and immediately connected to twentieth-century art. Cross-references are indicated only when there is a pertinent connection to the particular artist's work, although many non-cross-referenced concepts, and events such as the biennales and Documenta—in which many artists exhibit—will also be useful for the reader to browse. Titles of works have been translated where a standard translation exists or where the title is purely descriptive. Where any ambiguities or wordplay is evident in the title, the original has been retained. Similarly the original names of schools and institutions have been preserved. Short bibliographical references are given at the end of each entry and refer to the list of over 3,000 full references at the end of the book, which give suggestions for further reading in this area.

The difficult and often controversial process of selecting the entries was helped by the supportive advice of Professor Dr. Wieland Schmied of Munich, Dr. Frank Whitford of London, and Professor Dr Frank Zöllner of Leipzig. We are very grateful to them and to the authors for their participation.

The Publishers

Abakanowicz, Magdalena. *1930 Falenty near Warsaw. Polish sculptor. She studied at the Academy of Fine Art in Warsaw from 1950 to 1954; later becoming professor at the National College of Fine Art in Posnań (1965–90). She developed an

individual sculptural vocabulary using monumental soft, woven shapes, a technique related to traditional Polish weaving with its tendency toward non-figurative ornamentation.

After working in conventional paint and sculpture media, in the 1960s Abakanowicz began to create textile objects (*Abakans*) and structures, which she assembled into → environ-

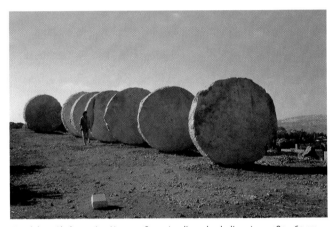

Magdalena Abakanowicz, *Negev*, 1987, 7 standing wheels, limestone, 280 x 60 cm each, installation 500 x 3500 cm, Israel Museum, Sculpture Park, Jerusalem

ments. These are characterized by their → Minimalist alignment of similar shapes, and their diversity of interrelated elements. The transformation of metaphorical shapes is the theme of the *Incarnations* project (begun 1986), where human and animal faces are formed in bronze or jute. From the mid-1980s she created installations in public spaces using bronze, stone, and wood (*Catharsis*, 1985; *Negev*, 1987; *Space of Dragon*, 1988). K.S.-D.

Bibl.: Abakanowicz, New York, 1982 · Abakanowicz, Düsseldorf, 1993

Abbott, Berenice. *1898 Springfield, Ohio, †1991 Monson, Maine. American photographer. Initially she studied sculpture (1918–21 in New York and 1921–29 in Paris with → Bourdelle and → Brancusi), and in 1923 worked with → Man Ray. From 1926 to 1929 she ran her own portrait studio in Paris and in 1927 became executor of → Atget's estate. In 1929 she returned to New York where she began work on a comprehensive documentation of the city, producing not only a factual photographic record but also an extraordinarily compact interpretation of a large city

Gerhard Altenbourg, *masure in Masuren*, 1958, Chinese ink, black printer's ink, chalk, watercolor, 75 x 60.3 cm, Museum Ostdeutsche Galerie, Regensburg (see p. 15)

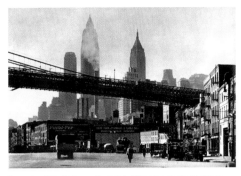

Berenice Abbott, *Lower East Side, Waterfront, South Street*, 1935, Gelatin silver print

(published as *Changing New York*). From 1934 to 1958 she taught at the New School for Social Research in New York. S.P.

Bibl.: Abbott/McCausland, New York, 1939 · Vestal, Abbott, 1970

Abramovíc, Marina. *1946 Belgrade. Serbian-born performance artist, living in Amsterdam and Paris since 1975. She studied at the Academy of Fine Art in Belgrade (1965–70), and became an exponent of → Body art and → Performance art in the 1960s and 1970s. In experiments taken to the point of self-renunciation and transgressing many boundaries (including the use of drugs, and pain in the tradition of medieval flagellation) she concerned herself with the theme of extreme situations of stress and exhaustion. In 1971 she met Ulay, with whom she worked from 1976 to 1988. Performances from 1976 to 1980 dealt with the subject of dual relationship.

Abramovíc radically rejects any form of art that does not respond to the needs of society. Her performance *Balkan Baroque* (see following page) at the 1997 Venice Biennale made a characteristically aggressive yet poetic pronouncement on social reality. Abramovíc's work engages in an intense dialogue with the phenomenon of emptiness, through which humankind becomes regenerated and achieves a new autonomy. S.P.

Bibl.: Abramovíc, Eindhoven, 1985 · Abramovíc, Amsterdam, 1989 · Abramovíc, Paris, 1990

abstract art. General term for non-representational art; also for art forms that reject the portrayal of the contemporary world in a realistic way, in contrast to the classical concept of art as mimesis (imitation of natural reality). The completely abstract work of art, however, is realized only through → Concrete art, where the colors and shapes of the picture refer only to themselves. By "purification" of the creative media (by using "pure" color and form) the pioneers of abstract painting – such as → Kandinsky, → Delaunay, and → Mondrian – wanted to draw attention to invisible forces, spiritual energies, and cosmic laws of nature which were not reproducible by realistic methods of representation.

After an initial "classical" phase (1912–32), abstract art after 1945 enjoyed a major fillip (→ Art informel, → Abstract Expressionism, → lyrical abstraction), but was often discredited in the course of its social and artistic development. Subsequently it re-invented itself as a possible artistic way of perceiving the world through

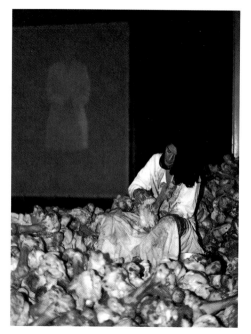

Marina Abramovíc, *Balkan Baroque*, 1997, Performance, Venice Biennale

new movements such as → Op art and → Minimal art. H.D.

Bibl.: Osborne, Abstraction, 1979

Abstract Expressionism. Art trend initiated by → Pollock in New York where the painting process, as a direct expression of spontaneous emotions and spiritual or physical energies, was the reason for and the objective of painting. The art critic Harold Rosenberg called this art, in which new painting methods such as → drip painting were employed, → Action Painting because the act of painting, its sequence of movements, became the theme of the picture. Subsequently the term was also applied to other painters of the → New York School such as de → Kooning, → Kline, → Motherwell, and → Still, whose works are characterized by an expressive, gestural brush even though they pursued totally different artistic concepts. The term is also used as a common definition of free, gestural painting in the context of developments in European art after 1945 (→ Art Informel and → Tachisme). H.D.

Bibl.: Sandler, Abstract Expressionism, 1970 · Everitt, Abstract Expressionism, 1975 · Smith, Art as Politic, 1978

Abstract Impressionism. Eliane de Kooning initially coined this term in 1951 to describe recent paintings that involved the optical concerns of late Monet (→ precursors) but incorporated semi- or non-representational imagery, often on → all-over canvases. The crucial distinctions are with the extravagance or virulence of → Action Painting (especially relevant in the US where → Abstract Expressionism was dominated by large-scale, energetic works) and to a lesser extent the inwardness of → Art Informel, where gesture and image are vehicled by (mainly graphic) → Automatism. International examples (some of whom passed through other phases and were on occasion associated in Europe with Informel exhibitions) include → Guston, de → Staël, → Francis,

→ Heron, → Mitchell, → Riopelle, Tal Coat (1905–85), and → Bazaine. D.R.

Abstract Sublime. The term Abstract Sublime was initially used by American critics in the early 1960s to describe paintings by → Pollock, → Newman (who had referred to the sublime in an article of 1948), → Rothko, and → Still. The distinction between the evenness and proportionality of beauty and the sublime (with its characteristics of power, infinity, untameability, and obscurity) was first analyzed by Edmund Burke and Immanuel Kant in the 18th century. Building on this, the critic Lawrence Alloway attempted to forge a link between the new American painting of inner and outer space to a grand Romantic tradition that European artists had abandoned. The expression used by Alloway in a 1963 article was "American Sublime." D.R.

Abstraction-Création. French association of artists founded in Paris in 1931 by → Vantongerloo and → Herbin and which existed until 1936. The aspiration of its 400 or so members, some of whom were already congregating in the group → Cercle et Carré, was to establish a forum of non-representational art through joint exhibitions and other activities (readings, discussions, an annual publication, public works). Among the group's most prestigious artists were → Arp, → Baumeister, → Bill, Robert → Delaunay, van → Doesburg, L. → Fontana, → Gabo, → Gorky, → Kandinsky, → Lissitzky, → Mondrian, and → Vordemberge-Gildewart. H.D.

Bibl.: Abstraction-Création, Paris, 1978

académie. The Greek term equivalent to the English "Academy" was used originally for an advanced "college." In the modern period, it covers any organized or State-run art or architectural school, or arbiter of language. The reputation of the Parisian art *académies* reached its height in the mid-19th century. By the 20th, the prestigious State-run École des Beaux-Arts had somewhat fossilized and the title *académie* was increasingly used for private schools under the control of a master. The Académie Julian (founded 1860), though originally a forcing-ground for candidates to the École, counted among its students → Nabis such as (from 1887) → Denis and → Vuillard, (from 1888) Paul Ranson (1864–1909) and → Sérusier; alongside → Arp (1908), → Bonnard (1888), André Dunoyer de Segonzac ([1884–1974] 1903), M. → Duchamp (1904), → Derain (1904), → Dubuffet (1918), the Finn Aksel Gallén-Kallela (1865–1931), → Léger (1904), → Lipchitz (1910s), Le Fresnaye (1903), → Matisse (1891–92), → Roy (1904), and → Vallotton. → The Nabis, Sérusier, → Roussel, and Denis taught at the Académie Ranson (founded in 1908), as did Robert Bissière (1888–1964) from 1925 to 1938; students included → Gromaire. Other notable institutions were the Académie Suisse, the Académie de Palette (→ Grant, → Le Fauconnier, → Charchoune) and the Académie de la Grande Chaumière (where → Bourdelle taught, and which was attended by Hans Aeschbacher [1906–], → Giacometti, → Poliakoff and Paul Rebeyrolle [1926–]), the

Académie Carrière (founded by the painter Eugène Carrière [1849–1906]), and the Académie Carmen (founded by James McNeill Whistler [1834–1903]). D.R.

Accardi, Carla. *1924 Trapani, Sicily. Italian painter and object artist, living in Rome. She studied at the Accademia di Belle Arti in Palermo and Florence, moving to Rome in 1946 and Paris the following year. Together with → Dorazio, Mino Guerrini, and Achille Perilli (1927–) she co-founded the formalist, Marxist artists' association → Forma. Toward the end of the 1940s Accardi was still greatly influenced by → Cubism; she then confined herself to working in black and white. Subsequently she experimented with new techniques (also playing optical games) and materials, and from the late 1950s incorporated color more emphatically in her compositions. From the mid-1960s she endeavored to break away from traditional canvas painting by using a diversity of materials. Her installations were influential on the painters of the → Arte Povera generation. S.F.

Bibl.: Accardi, Milan, 1983 · Accardi, Madrid, 1985

Acconci, Vito. *1940 New York . American advocate of → Performance and → Body art, living in New York. He studied literature at Holy Cross College (1964–68) and taught at the School of Visual Arts in New York (1968–71). His actions focus on his own bodily experience of sensory perception – e.g. by plucking his body hair or by rubbing his skin for long periods – and at times have extended to the infliction of painful injuries. These injuries are recorded by photography and video. An important theme since 1974 has been the specific cultural preconditions of the exhibition space (*Cultural Space Pieces*). He exhibited a cube construction (*Abstract House*) at the 1982 Documenta. H.D.

Bibl.: Linker, Acconci, 1994

accumulation. Term referring to the assemblage of many similar or different (mostly everyday) objects into arrangements or → assemblages, often mounted in display cabinets or on panels. The term was formulated by the French artist → Arman who began experimenting with its artistic possibilities in 1959. Detached from their functional environment, these objects display their individual color and power of expression to create an entirely new entity. In its elimination of the distinction between artistic and everyday reality and its mockery and criticism of consumer culture, accumulation approaches → Pop art. H.D.

Bibl.: Rotzler, Objektkunst, 1981

Ackermann, Max. *1887 Berlin, †1975 Bad Liebenzell. German abstract painter and graphic artist. He was the master pupil of van de → Velde in Weimar (1906–07), then studied at the Munich Akademie der Bildenden Künste (1909–10) with von Stuck, and from 1921 at the Stuttgart Kunstakademie with → Hölzel. He moved to Lake Constance in 1936 after being prohibited from teaching. In 1937 his graphic works were confiscated, together with the picture *Resting*. His studio was destroyed in 1943. After the war Ackermann received numerous honors and tribute was paid to his role as a forerunner of abstract art (he had produced his first non-representational works, under Hölzel's influence, in 1918). From 1950 he created lyrical, abstract pictures, in a predominant blue with strong multicolored accents which act as "sound symbols." Ackermann was particularly concerned with the analogy between color and music, and endeavored to conceive abstract picture compositions according to musical laws of counterpoint (*Entschwebende Klänge*, 1954). H.D.

Bibl.: Langenfeld, Ackermann, 1972

Ackling, Roger. *1947 Isleworth, London. British Conceptual artist. Ackling's works originate in the world of nature rather than in the studio. Using a magnifying glass he burns rows of parallel dots into driftwood collected from the shoreline, the rows ultimately converging into dark horizontal bands. Their geometric structure contrasts with the natural grain of the wood, thus forming a new and intense aesthetic uniformity. Ackling's creative process combines → Minimalist techniques with processes also found in → Land art. Since 1976 his work has featured in numerous one-man shows and group exhibitions in Europe, the US, and Japan. H.D.

Bibl.: Ackling, Warwick, 1997

Action Painting. Term for an abstract form of painting where the painting process – the gestural act – determines the picture's form and content. The term was coined in 1950 by the American art critic Harold Rosenberg and initially only described the work of → Pollock and his → Drip painting technique (see also → Abstract Expressionism). It has also been applied to the French artist → Mathieu, who from 1947 (independently from Pollock) painted abstract, lyrical pictures in a very rapid painting style with open-ended compositions reminiscent of calligraphy. Pictures by → Sonderborg and → Götz (→ Art informel) show a more definite structure where an exceedingly fast and gesturally spontaneous application of paint is directed towards undermining the traditional relational composition. H.D.

Bibl.: Seitz, Abstract, 1983 · Auping, Abstract, 1987 · Ross, Abstract, 1990

Activists. In historical usage, a Hungarian artistic, literary, and Socialist movement (Aktivizmus), essentially indebted to → Cubism and → Constructivism, which in 1914 combated the → Post-Impressionist apolitical position of The → Eight (i. e. *Nyolcak*, 1909–12). Aktivizmus was to center around → Kassák's (often censored) journals *A Tett* ("The Deed," 1915–16) and the "Aktivista Folyóirat" *MA* ("TODAY," monthly, 1916–19 and 1920–25). Activists included → Bortnyik, János Máttis Teutsch (1884–1960; infl. by German → Expressionism), → Moholy-Nagy, Jószef Nemes Lamperth (1891–1924; whose monumentality and impasto attracted Kassák), Lajos Tihanyi (1885–1938; fine portraitist, formerly of The Eight), and Béla Uitz (1887–1971; more faithful

to Cubism). Attracted by the → Sturm exhibitions in Budapest (1913) of → Kokoschka and → Jawlensky as well as by the → Futurism of → Boccioni, the Activists combined Socialist Utopianism with dynamism and Expressionism. They produced posters and pedagogic curricula for the 1919 regime of Béla Kun, but eventually abandoned planning a mass culture when *MA* was banned by the Communists, and withdrew to Vienna. The members of Aktivizmus then turned increasingly to Soviet Constructivism; it gave rise to the KURI splinter group at the → Bauhaus and was paralleled by Devětsil in Czechoslovakia. (The term is also used to define *engagé* art of the 1980s–90s: Aids activism, feminist activism, etc.) D.R.

Bibl.: Activism, London, 1980

Adam, Henri-Georges. *1904 Paris, †1967 La Clarté, Brittany. French sculptor and graphic artist. He studied engraving and chasing (1918) and in 1927 worked in → Bourdelle's studio. From 1933 he worked as a stage designer, etcher, and engraver, and in 1942 began to make sculptures. He became Professor of Graphic Art and Monumental Sculpture at the École Nationale Supérieure des Beaux-Arts, Paris, in 1959. Stimulated by his contact with → Surrealism, Adam initially executed drawings with socio-critical content; in 1936 he produced a cycle on the Spanish Civil War. In 1947 he adopted an abstract, almost organic language of form. From 1948 he worked exclusively as a sculptor and created monumental open-air sculptures and memorials (monument for the Auschwitz concentration camp, 1957–58). H.D.

Bibl.: Adam, Amsterdam, 1955

Adami, Valerio. *1935 Bologna. Italian painter, living in New York and Paris. He attended the Accademia di Brera, Milan (1951–54). Early on he developed an individual, narrative and figurative style – based on → Bacon and → Pop art – with cartoon-like, boldly drawn lines and strong color accents. Motifs are taken from the environment of the city-dweller: everyday scenes, hotel rooms, waiting rooms, airports, stations, etc. In the 1970s he produced portraits of famous personalities (Joyce, Freud, Benjamin) with blanked-out, darkened faces, alongside landscapes and pictures of historic events. Here, fragmentation is the principal formal element. Although his work never approaches the direct realism of Pop art, its figurative forms – outlined by firm, even black lines within areas of unrestricted color – are well suited to the representation of communications media such as film, comics, etc. K.S.-D.

Bibl.: Derrida, Adami, 1978 · Adami, 1988 · Adami, 1996

Adams, Ansel. *1902 San Francisco, †1984 Monterey, California. American photographer. He took his first landscape photographs at age 14. In 1923–25 he traveled across the US; 1927 saw the first publication of his landscape photographs. Adams initially trained as a pianist, turning to professional photography in 1930. Supported by → Stieglitz and influenced by → Strand, he soon became one of the leading landscape photographers of the US. He was a co-founder of the F/64 group of photographers in 1932 and held several teaching assignments: at the Art Center School in Los Angeles (1941), for the Office of War Information (1942), and at the Museum of Modern Art in New York (1944–45), where he was co-founder of the photography department; he also co-founded the photography department at the California School of Fine Arts, San Francisco. From 1955 he held summer schools in the Yosemite Valley. His nature and still-life photography demonstrated his overriding interest in the landscape and the people in it. S.P.

Bibl.: Callahan, Adams, 1993 · Adams, 1997

Adams, Robert. *1917 Northampton, †1984 London. British sculptor, graphic artist, and draftsman. He studied sculpture and painting at the Northampton School of Art (until 1942), and taught at the Central School of Art in London from 1949. Influenced by → Moore and → Hepworth, his first work was mainly figurative, but during the course of the 1950s he progressed towards

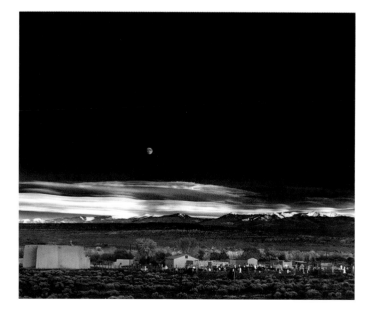

Ansel Adams, *Moon Rising over Hernandez, New Mexico*, c. 1941, Gelatin silver print, 40.6 x 50.8 cm, Artist's Collection

abstract, constructivist sculpture made from geometric elements in bronze, iron, steel, and concrete. His bronze or concrete works are cubic and massive; their freestanding construction, however – from geometric, smooth, thin iron and steel elements (circles, rectangles, segments, rods) – possesses a scaffolding-like lightness; the result is a harmonious construction from static and dynamic forces. Adams participated in the 1952 and 1962 Venice Biennale and at the 1957 Bienal in São Paulo. I.H.

Bibl.: Adams, Northampton, 1971

Adler, Jankel. *1895 Tuszyn near Lódź, †1949 Aldbourne, England. Polish painter and graphic artist. Moving to Germany he attended the Kunstgewerbeschule, Wuppertal, in 1913–14 and in 1922 settled in Düsseldorf, where he had close contact with various artists' groups. The rise of Nazism forced him to leave Germany in 1933 (some of his works were shown at the "Degenerate Art" exhibition); thereafter he traveled widely, settling in England in 1941. Although his early output shows the strong influence of → Chagall, his main work from the mid-1920s onwards is indebted to → Picasso (*No Man's Land*, 1943). In his abstract-cum-figurative individual portraits, figure compositions (*A Family*, 1925), and still lifes, he experiments with various painting techniques (roughing up the paint, mixing with sand, etc.). His late work is characterized by a return to religious and cultural themes within the context of a universal and humanist message. S.P.

Bibl.: Hayter, Adler, 1948 · Adler, Düsseldorf, 1985

Aeropittura (Italian = "air painting"). Italian movement, an offshoot of → Futurism; the term was coined by → Marinetti in a manifesto published in 1929. Inspired by the recent conquest of the skies, which enabled man to view the world from a new perspective, Aeropittura artists aimed to replicate the sensation of flight; they combined this with nationalism and an admira-

Afro, *Viale delle acacie*, 1959, 80.6 x 120 cm, James Johnson Sweeney, Rome

tion of technology. Among the group's members were → Balla, → Depero, and Gerardo Dottori (1884–1977) whose *Air Battle over Naples* (1942) is typical. Also of influence was Enrico Prampolini (1894–1956), who called for "cosmic idealism" as a new world view. The death of Marinetti in 1944

and the turn of the war in Italy marked the end of Aeropittura. H.D.

Bibl.: Aeropittura, Milan, 1977

Affichistes. Group of French artists which counted among its members → Dufrêne, Raymond Hains (1926–), → Rotella, and Jacques de la Villeglé (1926–). By modifying and destroying posters (Fr. *affiches*) – by tearing strips off them, burning, and overpainting them – the intention was to convey a socio-critical message. The objective was to question the consumer-orientated content of the poster by appropriating their original function as advertisements and publicity slogans. H.D.

Bibl.: Wescher, Collage, 1968

Africano, Nicholas. → New Image Painting

AFRICOBRA (African Commune of Bad Relevant Artists). Visual artists who split off from the Coalition of Black Revolutionary Artists (Cobra), founded by Jeff Donaldson, Barbara J. Jones-Hogu, and others in 1968, which initially included musicians, poets, and writers. In the spirit of civil rights and the Black power movement during which it was created, these artists sought to create a uniquely "Black aesthetic." Another aim was to integrate the arts into community life. They drew their inspiration and materials from community life, producing posters, textiles, and paintings that were easily accessible by the community: "black art for every black home in America." In the mural *Wall of Respect* (1967) on the South Side of Chicago, a precursor of the mural art movement of the 1970s and graffiti art, Black nationalism and liberation is expressed. Their work is characterized by bright colors and by harmonious, rhythmic patterns, and compositions. J.F.

Bibl.: Kai, AFRICOBRA, 1990

Afro (Afro Basaldella). *1912 Udine, †1976 Zürich. Italian painter and stage designer. He studied at art schools in Florence and Venice, and moved to Rome in 1938. He held several teaching posts: Accademia, Venice, 1941–44; Mills College, Oakland, US, 1958; and Accademia, Florence, 1968–71. In 1950 he first visited the US where, inspired by the art of → Gorky, he developed an individual style. In 1952, together with → Vedova and others, he founded the Grupo degli Otti Pittori Italiani, which proclaimed a non-representational art form. From 1957 he produced stage designs for opera houses in Cologne, Palermo, and Ljubljana.

Whilst Afro's early output looks back to the 19th century, his works of the 1940s show → Cubist influence. His mature style (from around 1954) is characterized by harmoniously composed, abstract, poetic pictures, in which light and color play a fundamental role. In his late work, compositions are consolidated into isolated, individually unstructured color areas. This reduction of means to a few severe, individual forms is linked to his intense involvement in print graphics from the 1970s onwards. Afro also

produced designs for costumes, jewelry, and carpets. S.P.

Bibl.: Crispolti, Afro, 1987 · Afro, Opere, 1989

Agam, Yaacov (Jacob Gipstein). *1928 Rishon Le-Zion, Israel. Israeli sculptor and advocate of → Kinetic art, living in Paris. He studied in 1946 at the Bezalel School in Jerusalem with Mordecai Ardon (1896–1992), and in 1949 at the Kunstgewerbeschule in Zürich with → Itten. Inspired by → Bill, he concerned himself with color theory and the principles of → Constructivism. The phenomenon of the irreversibility of time forms the basis of Agam's optical and kinetic art. In pictures and reliefs, whose elements derive from → Op art forms, the viewer can arrange the individual elements to their liking (such works are termed "transformable" and "accessible"). From 1953 Agam produced his first "polyphone" and "metapolyphone" pictures, in which optical distortions are caused by changing the viewing angle. In the 1960s he created tone and touch pictures which react when handled. In 1967 his investigative works into light had a first public showing in Paris. I.H.

Bibl.: Agam, Amsterdam, 1973 · Popper, Agam, 1990

Agar, Eileen. *1904 Buenos Aires, †1991 London. British painter. Agar studied at the Slade and then traveled to Paris. She was associated with Paul → Nash, → Jennings, Roland Penrose (1900–84), → Moore, and the → Surrealists, the poet Paul Eluard in particular. The sole British woman to be selected by Penrose and Herbert Read for the London Surrealism show in 1936, Agar also participated in the International Surrealist Exhibitions in New York (1936) and Paris (1938), while her 1930s studio in Bramham Gardens was famous for its Surrealist décor. After work in collage and cut-outs, Agar's output during this phase included an oil *Autobiography of an Embryo* (1933–34), a four-panel account of prenatal and post-parturient life whose Surrealist credentials are somewhat tendentious. Both *Quadriga* (1935) and *Marine Collage* (1939) repeat its compartmentalized structure, which recalls → Cornell or → Brauner. With an ongoing interest in photography and accessory design (*Hat for Eating Bouillabaisse,* c. 1936), Agar also produced enigmatic objects made of beads and silk fabric before returning to collages over which she now applied a paint and plaster mix. Her later → Tachiste and constructed abstract styles (*October,* 1963) were less individual. Her autobiography *A Look at My Life* (London, 1988) provides insight into her approach. D.R.

Agitprop. Term referring to Soviet agitation and propaganda art, employed (mainly mid-1920s – early 1933) as a means of political and ideological mass manipulation. Following the 1917 Revolution, art was seen principally as a weapon in the struggle for a new social order, a stance initially supported by almost all Russian avant-garde artists. The stylistic elements of → Cubo-Futurism and → Constructivism were employed for political purposes to publicize the latest political and economic successes of Soviet politics. After 1930 agitation art gradually degenerated into an aggressive smear campaign and conformed to the canon of Stalinist stylistic features. H.D.

Bibl.: Strigaljow, Agitprop, 1996

Aillaud, Gilles. *1928 Paris. French painter, graphic artist, and poet, living in Paris. He taught himself painting (after initially studying philosophy), and received the Prix Fénéon in 1959. From that year he participated in the Paris Salon de la Jeune Peinture where, like → Arroyo and Antonio Recalcati (1938–), he was one of a number of followers of a new trend toward realistic painting. In the programmatic exhibition "La figuration narrative" (1965, Galerie Creuze, Paris) he exhibited a series of eight pictures in collaboration with Arroyo and Recalcati (*Vivre ou laisser mourir ou la fin tragique de Marcel Duchamp*). Aillaud's most important motif is the caged animal in a zoo, which serves as a metaphor for man's alienation from nature. He also produced stage and costume designs (*Hamlet* at the Schaubühne, Berlin, 1982). H.D.

Bibl.: Aillaud, 1991

AKhRR/AKhR. Association of Artists of Revolutionary Russia. Soviet artists' association founded in 1922 and renamed Association of Artists of the Revolution (AKhR) in 1928; it was dissolved by Stalin in 1932 and incorporated into the Central Association of Artists. The AKhRR was formed in defence against abstract ("formalistic") art after a meeting of the Wanderers group. Although thematically of a propagandistic nature, artistically it was orientated towards the realist painting of the 19th century. Members of this group visited factories and *kolkhozes* (collective farms) to find themes for their painting in everyday Soviet life. H.D.

Alberola, Jean-Michel. *1953 Saida, Algeria. Algerian-born painter and sculptor. He has lived in France since 1962, and studied art in Marseille. Alberola polemicizes against "all that is visible" and concerns himself with the visualization of the invisible. In his pictures, which are linked to the realm of metaphors and symbols, he denies the viewer's expectations with curtains, drapes, screens, etc., and by signing his works anonymously ("Acteon fecit"). In a provocative and aggressive manner he criticizes the perversion of art into merchandise, of religion into politics, and of the ritual object into a souvenir. Alberola places himself outside any classification system, symbolic order or aesthetic category, and beyond questions of period, style, and form. S.P.

Bibl.: Alberola, Paris, 1985 · Alberola, Nîmes, 1990

Albers, Anni. *1899 Berlin, †1994 Orange, Connecticut. German-born textile artist. She studied at the Weimar and Dessau → Bauhaus (1922–30) with → Klee and → Muche, and became head of weaving at the Bauhaus in 1931. In 1933 (together with her husband, Josef → Albers) she emigrated to the US, where she taught at → Black Mountain College until 1949. She was also a visiting lecturer and the recipient of numerous honors. Anni Albers produced both individual creative

art work and industrially manufactured fabrics. The vertical and horizontal structure that results from the weaving process, coupled with a restrained and subtle coloring, constitutes her artistic trademark. H.D.

Bibl.: Schell, Albers, 1989

Josef Albers, *Bundled*, c. 1926, Opaque sandblasted glass, 28.5 x 30.1 cm, Hirshhorn Museum and Sculpture Garden, Smithsonian Institution, Washington D.C.

Albers, Josef. *1888 Bottrop, †1976 New Haven, Connecticut. German-born painter. He initially attended teacher-training college in Büren (1905–08), then worked as a primary school teacher. In 1913–15 he studied at the Königlichen Kunstschule in Berlin under Philipp Franck, and in 1916–19 attended the Kunstgewerbeschule in Essen and worked as a teacher in Bottrop. In 1919–20 he studied at the Königlich-Bayerische Akademie der Bildenden Kunst in Munich, with Franz von Stuck (1863–1928). He then studied at the → Bauhaus in Weimar (1923–23) where, after following the introductory course, he produced independent work in glass painting. He became head of the glass studio in 1922 and master (fully qualified head) at the Dessau Bauhaus in 1925, creating sandblasted glass pictures in geometric compositions at this time. In 1928 he was appointed head of department, responsible for overseeing the introductory course, and in 1928–30 was head of the furniture studio. In 1933 he emigrated to the US (together with his wife Anni → Albers), and taught at → Black Mountain College (until 1949). In 1950 he became head of design at Yale University (until 1960). Albers held numerous visiting professorships and undertook lecture tours throughout America.

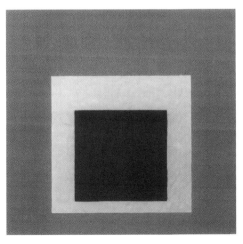

Josef Albers, *Homage to the Square: Festive*, 1951, Oil on hardboard, 61 x 61 cm, Yale University Art Gallery, New Haven

Albers' central concern was color: he discussed its laws vividly in his courses as well as in his book *Interaction of Color* (1963), a standard work on the subject. In the series *Homage to the Square*, produced from 1949 onwards, he demonstrates the subtleness and flexibility of color perception by means of a simple composition of three or four squares on a vertical symmetrical axis. His work combines versatility with "economy of means," as is especially evident in his glass wall-constructions, e.g. the wall-mounted glass picture *Manhattan* (1966) for the Pan-Am building in New York, the overdoors of the Westfälischen Landesmuseums in Münster (1972), or *Stanford Wall* (designed 1973, installed posthumously 1980) at Stanford University. The Josef Albers Museum in Bottrop, containing numerous works and writings on his life and career, was opened in 1983. H.D.

Bibl.: Albers, 1977 · Weber, Albers, 1984 · Waldman, Albers, 1988 · Albers, London, 1989

Ivan Le Lorraine Albright, The Picture of Dorian Gray, 1943–44, Oil on canvas, 271.1 x 106.7 cm, The Art Institute of Chicago

Albright, Ivan Le Lorraine. *1897 Warrenville, Illinois, †1983. American painter. Initially he studied architecture, before serving on the French front during World War I (1918). After the war he began to study painting, attending the Art Institute of Chicago (1920–23); Pennsylvania Academy of Fine Arts, Philadelphia (1923); and the National Academy of Design, New York (1924). He also worked in advertising and in film studios. In 1931 he received the Gold Medal of the Artists of Chicago for the painting *Into the World There Came a Soul Called Ida*; he was appointed Chair at the Art Institute of Chicago in 1938. Around 1930 he began to establish his meticulously realist style, in which the modeling of each detail is given great prominence (*Head of Adam Emory Albright*, 1935). From the 1940s his pictures began to adopt a → hyperrealistic materiality; minute details and subtle, morbid coloring, coupled with their macabre themes, make these pictures a ghostly vision of transitoriness. H.D.

Bibl.: Miller, American Realists, 1969 · Croydon, Albright, 1978

Alcopley (Alfred L. Copley). *1910 Dresden. German-born painter, living in New York. Largely self-taught as an artist, he also studied medicine

and biology in Freiburg im Breisgau, Heidelberg, and Königsberg, receiving a doctorate in medicine. In 1937 he emigrated to the US, where he acquired citizenship. In 1949 he was a co-founder of "The Club," a New York venue for abstract artists. He spent the years 1952–59 in Paris; he also worked in London as a medical doctor and hematologist in the 1950s, and moved to New York in 1960. Alcopley paints in the tradition of → Abstract Expressionism, but has also been inspired by Far Eastern calligraphy.

While abstract, expressive elements are prominent in his oils and acrylics, Alcopley's graphic work is marked by its sparse, meditative quality. In his watercolors muted blue-gray shades are dominant, while the delicate structures of his small-format drawings are reminiscent of → Klee. He also created illustrations (e. g. for Herman Cherry, "Poems of Pain and Other Matters," 1962). H.D.

Bibl.: Alcopley, Amsterdam, 1962

Alechinsky, Pierre. *1927 Brussels. Belgian painter, draftsman, and graphic artist; has lived in Bougival, near Paris, since 1963. He attended the École Nationale Supérieure d'Architecture et

Pierre Alechinsky, *Central Park*, 1965, Acrylic on paper with marginal drawings, 162 x 193 cm, Private Collection

des Arts Décoratifs in Brussels (1944–48), and turned to painting in 1946. He joined the group Jeune Peinture Belge in 1947 and → Cobra in 1949. He maintained a joint studio in Brussels with the sculptors Olivier Strebelle (1927–) and Reinhoud (1928–), the architect André Jacqmain, and the graphic artist Michel Olyff (1927–). In 1951 he organized the last Cobra exhibition, in Liège, then moved to Paris to study printmaking with a French government scholarship. A retrospective was held in 1969 at the Palais des Beaux-Arts in Brussels. In 1976 he created a mural for the Brussels metro, in collaboration with → Dotremont. He was appointed professor and head of a painting class at the École Nationale Supérieure, Paris, in 1983. In 1992 he produced four stamp designs for the 200th anniversary of the French Republic.

Alechinsky fuses inspirations from → Klee, → Miró, → Dubuffet, and → Tachisme into a gesturally spontaneous and strongly colored pictorial language where people, animals, and mythical creatures are interwoven. Influences from Japanese calligraphy led in 1955 to a more abstract, ornamentally enmeshed linear style, partially

Pierre Alechinsky, *Peignoir*, 1972, Acrylic on paper mounted on canvas, Peggy Guggenheim Collection, Venice

executed on old printed papers. In 1965 he changed his medium to acrylic on paper mounted on canvas. Since then his style has been defined by fields of bright colors and quiet forms and lines. Alechinsky often complements his main motif with small marginal drawings, arranged as in comics, which execute variations on the central motif (*Central Park*, 1965). His extensive oeuvre also includes numerous book illustrations, e. g. for *Le Bleu des Fonds* by Surrealist Joyce Mansour (1968). S.P.

Bibl.: Alechinsky, 1973 · Alechinsky, New York, 1987

Alfelt, Else. *1910 Copenhagen, †1976 Copenhagen. Danish painter. Studied at the Technische Højskole in Copenhagen; self-taught as an artist. She traveled widely through Europe, Egypt, Japan, and the US. Between 1949 and 1955 both she and her husband Carl-Henning Pedersen (1913–) belonged to → Cobra. After a phase of representational work she began (from 1927) to paint in an abstract style and in bright colors with thematic motifs. Later she incorporated calligraphic elements into her "Dream Pictures" in green and blue shades. She also executed mural projects, especially mosaics. H.D.

Bibl.: Poulsen, Danish Painting, 1976

all-over painting. Term applied to an evenly covered picture surface which does not exhibit any hierarchic composition (top/bottom, right/left, center/margin). It was first used in connection with the pictures of → Pollock (→ drip painting), and later also applied to other → Abstract Expressionist and Informel artists (→ Art Informel) to describe a diffuse, un-centered composition. H.D.

Allied Artists' Association (A.A.A.). Organization established in London in 1908 by artists around → Sickert, and inspired by the French example of the Salon des Indépendants. The art critic Frank Rutter (1876–1937) arranged national subscription exhibitions without jury (inc. six extensive ones at the Royal Albert Hall) which were meant to serve as a foil both to the Royal Academy and to the New English Art Club. Sickert's typically sarcastic view was that any art, good or bad, should be exhibited by fee-payers, since they were all "shareholders." In such a context quality naturally varied, but the A.A.A. provided an early

platform for Russian crafts and art, and for → Kandinsky's abstract work (1909) to be shown for the first time in Britain, as well as works by → Brancusi (1913) and → Zadkine (1913). The members of the → Camden Town Group were mainly taken from the ranks of the A.A.A. D.R.

Bibl.: Rutter, 1927

Gerhard Altenbourg, *masure in Masuren*, 1958, Chinese ink, black printer's ink, chalk, watercolor, 75 x 60.3 cm, Museum Ostdeutsche Galerie, Regensburg

Altenbourg, Gerhard (Gerhard Ströch). *1926 Rödichen-Schnepfenthal, Thuringia, †1989 Altenburg, Thuringia. German painter, graphic artist, sculptor, and poet. He studied under Erich Dietz in Altenburg (1946–48) and Hans Hoffmann-Lederer in Weimar (1948–50). Despite harrassment by the East German state (he was sent down from his studies in Weimar, and until the early 1980s was prohibited from exhibiting in the GDR) he pursued, with inner detachment, an independent, imaginative, and realistic style marked by Surreal forms and narrative content. At times he adopted various pseudonyms ("Ismael Lysa," "Stephan Kambienna," and from 1955 "Altenbourg"). Until his death he led a reclusive life in Altenburg.

Influenced by war experiences, Altenbourg's themes revolved initially around destruction, injury, death, grieving, becoming, and passing away; in the course of time he adopted a more contemplative attitude (*The Water Corpse*, *The Dead Warrior*, and the cycle around *Ecce Homo*). In his late work, multi-layered strata are supplanted by more relaxed and free dynamic structures. Graphics occupy a significant place in his oeuvre. S.P.

Bibl.: Altenbourg, Arbeiten, 1988 · Schmidt, Ausgebürgert,1990

Gerhard Altenbourg, *It Happened on a Blue Monday*, 1960, Mixed technique, 63.5 x 45 cm, Private Collection

Amado, Jean. *1922 Aix-en-Provence. French sculptor, living in Provence. After studying painting and graphic art Amado worked in a ceramics studio in Aix-en-Provence (from 1947). Subsequently he devoted himself exclusively to monumental sculptures, which from 1956 were integral to their buildings. These sculptures are usually made of enameled concrete, often dyed reddish brown or fired with visible craquelure; occasionally he uses metal and wood. Amado's works are reminiscent of primeval cave landscapes, fantastical monsters, or land formations (*Quesqu'il Traîne*, 1969). H.D.

Bibl.: Amado, 1997

Amaral, Tarsila do. *1886 Capivari, São Paulo, †1973 São Paulo. Brazilian painter who studied in São Paulo with Pedro Alexandrino and J. Fischer Epons in 1916. In 1920 she first visited Paris, studying in 1923 at the Académie Julian. Her "Pau-Brasil" paintings of 1924–27 show rural motifs of intense, tropical colors in a style inspired by → Léger. In 1926 she had her one-woman show of "Pau-Brasil" paintings at the Percier Gallery. In 1927 she founded the Antropofagia movement for the dissemination of new Brazilian aesthetics (*Abaporu*, 1928). In 1929 she had prestigious one-woman shows in São Paulo and Rio de Janeiro. Following a visit to Russia in 1931, elements of → social realism were reflected in her many works of the 1930s and 1940s. In the 1950s and 1960s she returned to her earlier artistic themes. E.Ba.

Bibl.: Amaral, Tarsila, 1971 · Tarsila, 1982 · Marcondes, Tarsila, 1986

American Abstract Artists. Artists' association founded in 1936 by the painters J. → Albers and → Bolotovsky together with the sculptor Ibrahim Lassaw (1913–). Other AAA members included the forerunners of → geometric abstraction who were living in the US, among them the sculptor David → Smith. Through various activities and publications they aimed to contribute to the understanding of abstract art in America. H.D.

Bibl.: American Abstract Artists, 1957 · Geometric Abstraction, New York, 1962

American Craft Movement. A broad movement in postwar American art aimed at recovering the craft tradition and questioning the distinction between fine art and craft. The postwar expansion of the university system permitted the founding of new university art programs (many of the teachers were → Bauhaus-trained artists) within an interdisciplinary, academic environment that encouraged technical innovation and a renewed appreciation for handcrafted work. By the 1950s and 1960s, craft-artists were producing objects that challenged traditional notions of craft versus art, such as vessels, jewelry, and furniture. Many developments in postwar American art (Abstract Expressionism, Minimalism, Pop art, Conceptual art, modern design principles) provided thematic inspiration and helped to blur the boundaries of fine and applied art. The movement reached its zenith in the 1970s and 1980s, these ideas appearing in the work of many ceramists (Peter Voulkos, Ruth Duckworth, Kenneth Price), fiber artists (Sheila Hicks, Lenore Tawney, Ed Rossbach), studio glass artists (Harvey Littleton, → Chihuly, Ginny Ruffner), metalsmiths (→ Paley, Jonathan Bonner), jewelry artists (William Harper, Arlene Fisch), and furnituremakers (Wharton Esherick, Sam Maloof, Wendell Castle). Some of these artists emphasize functionality in their work, while others negate

it, relying more on the expressive qualities of the craft material.　J.C.M.

Bibl.: Smith, Craft, 1986

American Scene Painting. A trend in realist American painting of the 1920s and 1930s. Developing out of American naturalism of the prewar era and the → Ashcan School, it formed a countermovement to abstract painting. The objective was to portray American life and landscape in its truest detail. Among its most illustrious members were Thomas Hart → Benton, → Hopper, and Grant → Wood. These painters had a predilection for motifs from American everyday life, which they portrayed in harsh colors and in a cold light. The term also embraces the Regionalists (→ Regionalism), who depicted specific details of the rural regions in which they lived.　H.D.

Bibl.: Baigell, American Scene, 1974 · Heller/Williams, Regionalists, 1976

Cuno Amiet, *Obsternte*, 1912,
Öl auf Leinwand, 126 x 121 cm, Privatsammlung

Amiet, Cuno. *1868 Solothurn, †1961 Oschwand near Berne. Swiss painter and sculptor. He was a painting student of Frank Buchser (1828–90) in 1884–86 and from 1886 studied at the Munich Kunstakademie. In 1888 he moved to Paris where he shared an apartment with Giovanni Giacometti (1868–1933) and studied at the Académie Julian (1888–91) alongside the → Nabis → Bonnard, → Vuillard, → Denis, and → Sérusier. In 1892 he traveled to Pont-Aven, where his style underwent a transformation in the direction of pure color and two-dimensionality. He became a member of the artistes indépendants group in 1893. In 1906 he joined Die → Brücke and participated in their first exhibition in Dresden. In 1912 he became a member of the artists' group Moderner Bund, and in 1919 received an honorary doctorate from the University of Berne.

Amiet combined the colorfulness of the Nabis with elements of German → Expressionism. Particularly impressive are his portraits which, despite their austerity of form, possess subtle color differentiations. 50 of his (mainly early) portraits were destroyed in the fire at Munich's Glaspalast in 1931.　H.D.

Bibl.: Amiet, Kunst, 1948 · Sandoz-Keller, Amiet, 1988 · Amiet, Philadelphia, 1991

Analytical Cubism. → Cubism

Analytical painting. Style of painting which emerged in the 1970s and took painting materials – i.e. not just the paint and its application but also the support (e.g. canvas) and the picture plane – as a reason for, and theme of, analysis. The reduction of painting to elementary modes of action (→ Elementarism), such as the planned placing of brushstrokes (often referred to as Planned Painting), took place within a context of uncertainty arising from the new media debate. An overloading with theoretical new beginnings and new linguistic definitions, however, very soon led Analytical painting to become submerged by sectarianism (see also → Support-Surface).　H.D.

Bibl.: Honeff/Millet, Analytische Malerei, 1975

Anderson, Laurie. *1947 Chicago. American performance/multi-media artist and musician, living in New York. She studied violin and sculpture at Columbia University, New York, until 1963. Between 1970 and 1974 she taught history of art at City College, New York, and Pace University, and worked as an art critic for *Art News*, *Artforum*, and *Arts in America*. Subsequently she became director at the Whitney Museum of American Art, Arts Resource Center (1974–75) then worked as a freelance artist. From 1972 Anderson concentrated on performances (*Automotive*, 1972), and in 1974 began working with what was to become her trademark combination of gesture, language, and music (violin, audio tape, and record, partly contained in one set). At the same time she also created slide and film projections using light effects, dissolving techniques, and text pictures. Her performances, which are internationally known and presented, often treat a varying theme in several parts (*For Instants – Part 4* at Documenta 6, 1977).

The starting points for her "stories" are emotional, memories of everyday events which are imaginatively expanded upon and realized. Anderson also works as a composer (recordings, e.g. "New Music for Electronic and Recorded Media," 1978) and as a choreographer.　H.D.

Bibl.: Kardon, Anderson, 1983

Andre, Carl. *1935 Quincy, Massachusetts. American sculptor, living in New York. He studied at the Phillips Academy in Andover from 1951 to 1953, and over the next decade took up a variety of jobs (e.g. at the Boston Gear Works, Quincy; in the US army; as an editorial assistant at a New York publishers; and as a brake operator on the Pennsylvania Railroad, New Jersey). After meeting Frank → Stella (introduced by poet Hollis Frampton) he began working in Stella's studio on large wooden blocks into which he made deep incisions (*Last Ladder*, 1959). His early sculptures included *Timber Piece* in 28 parts (destroyed in 1964 and reconstructed in 1970); he also produced paintings and collages. The use of similar ready-made parts as components of a unified whole became the basis of his work at this time. In 1964 he participated in the 8 Young Americans exhibition at the Hudson River Museum in

Carl Andre, *32 Bar Figures on Ancient Metals*, 1988, Steel, copper, lead, zinc,
60 x 240 x 59.7 cm, Anthony d'Offay Gallery, London

Yonkers, and in 1965 held his first one-man show at the Tibor de Nagy Gallery in New York. He subsequently developed the "Element Series," which included pieces such as 64 *Steel Squares* (1967) – a flat sculpture of 64 square metal plates which aims to make space "perceptible" and to express Andre's artistic maxim, "From form to structure – from structure to place." A leading figure of → Minimal art, Andre has participated in important international exhibitions, e.g. Minimal Art (Hague Gemeentemuseum, 1968), and When Attitudes Become Form (Berne, Krefeld, London, 1969). In 1982 he participated in Documenta 7, and in 1984 he was awarded a scholarship by the DAAD artistic program in Berlin. S.P.

Bibl.: Bourdon, Andre, 1978 · Serota, Andre, 1978 · Andre/Frampton, 1981 · Andre, Hague/Eindhorn, 1987

Andrews, Michael. *1928 Norwich, †1995 English painter. He studied part-time at Norwich School of Art between 1940 and 1947. He produced his first watercolors while posted in Egypt during national service (1946–49). In 1949–53 he studied at the Slade School of Art in London, winning a scholarship to Rome to 1953. He held teaching posts at Norwich School of Art (1959), Chelsea School of Art (1962–64), and the Slade (1963–66). He was a member of the → School of London. He lived in London until 1977, then returned to Norfolk.

Andrews' stringent adherence to figurative art and his predilection for ambitious group compositions (especially in his work of the 1960s) make him an outsider among contemporary artists. His portraits show figures, mostly friends and relatives, in everyday situations. M.B.-D.

Bibl.: Andrews, London, 1978 · Andrews, London, 1980 · Andrews, London, 1986

Angrand, Charles. *1854 Criquetot-sur-Ouville, Normandy, †1926 Rouen. French painter. After a short career as a teacher Angrand moved in 1882 to Paris, where he stayed until 1896. He was a founder member of the Societé des Artistes Indépendants in 1884, and became friendly with Georges Seurat (→ Neo-Impressionism). He became well versed in the Pointilliste technique (see → divisionism) and, until 1890, painted mostly landscapes and scenes of everyday life in this style (*La Seine à la Grande Jatte*, 1888). During his Paris years Angrand was closely associated with contemporary artistic and literary movements and was on friendly terms with Paul Signac (1863–1935). In the 1890s he mainly produced large charcoal drawings (*Maternité*, 1895–1900). After World War I he reverted to more traditional Impressionist themes and techniques. K.S-D.

Bibl.: Lespinasse, Angrand, 1982 · Halperin, Aesthete and Anarchist, 1988

Angry Penguins. Australian art movement. An important focus for radical arts thinking in Australia, the journal *Angry Penguins* (1941–46) was edited by a mentor of Melbourne Expressionism, John Reed, together with Max Harris. The group that coalesced around the magazine included A. → Tucker, → Boyd, John Perceval (1923–), the photographer Max Dupain (1911–92), and Yosl Bergner (1920–) from Poland. The publication promoted a variant of → Surrealism combined with social themes strongly motivated by the Pacific War. D.R.

Anguiano, Raúl. *1915 Guadalajara. Mexican painter, living in Mexico City. He studied at the Escuela Libre de Pintura in Guadalajara (1930–34) and moved to Mexico City in 1934. He was a founder member in 1936 of the politically orientated printing press Taller de Gráfica Popular. He taught at the "Esmeralda" (Escuela Nacional de Pintura, Escultura y Grabado) in Mexico City from 1935 to 1967. Anguiano's dominant theme has been the life of the Mexican people, expressed in the indigenous figurative tradition; from 1937 he began incorporating ideas from Western modernism (e.g. → Surrealism and → Cubism). Until the mid-1950s he produced large-figured, monumentally conceived realist paintings in strong colors, as well as numerous portraits. These were followed by expressive and cubistically abstract works. Anguiano has also produced graphic work and several murals. J.R.W.

Bibl.: Anguiano, Mexico City, 1985 · Luna Arroyo et al., Anguiano, 1990

Annigoni, Pietro. *1910 Milan, †1988 Florence. Italian painter, draftsman, and engraver Annigoni met with worldwide success during his lifetime. A student at the Florence Academy, at his first exhibition in 1932 at Galleria Bellini he encountered de → Chirico and was well reviewed by Ugo Ojetti, the most influential Italian critic of the time. Inspired by the meticulous attention to naturalistic details of northern Renaissance masters, such as Dürer, Rembrandt's interpretation of the human spirit, and Goya's obsession with the dark side of life, Annigoni painted landscapes and scenes from the everyday. He was most celebrated for almost photographic portraits commissioned by important figures such as the Shah of Persia Reza Pahlevi, Queen Elizabeth II (twice, 1954–55 and 1969), Paul Getty, and US Presidents

John F. Kennedy, Lyndon B. Johnson, and others. His autobiography, *An Artist's Life* (tr. 1977), charts his career. S.G.

Bibl.: Longo, Annigoni, 1968

Anselmo, Giovanni. *1934 Borgofranco d'Ivrea. Italian exponent of → Arte Povera and → Conceptual art, living in Turin. Initially he painted in oils. After having been inspired by a sunrise on Stromboli that made his body appear to have no shadow, Anselmo refocused on the visual representation of the laws of nature (from 1965 onwards), finally arriving at a poetically coded material art. He concentrates mainly on problem areas between perception and reflection, such as the infinity of the world in time and space, the workings of invisible energies, the immutability of matter, and the relationship between organic, transitory, and durable materials. After 1969 Anselmo widened his use of media (which until then had comprized mainly installations with sculptural objects) to include light and photography, in order to show graphically the infinite and the invisible. During the 1970s Anselmo assembled entire spaces (e.g. *Particolare*, 1974, with 20 projectors; *Direzione*, 1978, with 14 drawings of a compass shown from various directions and mounted onto the walls of the room). In the 1980s he returned to materiality: e.g. by using granite slabs, either lying on the ground or mounted onto a wall, he demonstrated variability in gravity. I.H.

Bibl.: Anselmo, 1972 · Anselmo, Lyon, 1989 · Anselmo, Modena, 1989

Antes, Horst. *1936 Heppenheim. German painter, graphic artist, and sculptor, living in Berlin, Karlsruhe, and Florence. He studied from 1957 to 1959 at the Staatlichen Akademie der Bildenden Künste in Karlsruhe with H. A. P. Grieshaber (1909–87); he later taught there (1965–73) and received a professorship in 1984. From early on he rebelled against → Art Informel, reviving color and expressiveness in figurative painting and making the human figure the principal motif of his art. In 1961–62 he created the "Kopffüßler" ("Headopede" or "Headfooter"), a gnome-like, grossly deformed figure. He found inspiration for this figure in the art of de → Kooning, in → Art Brut, and in

Horst Antes, *Head with 12 Eyes*, 1975–76, Corten and Corten nickel steel 168 x 191 x 52 cm, Universität Fridericianum

→ primitivism; for this reason he is seen as the forerunner of → Pop art in Germany. From 1963 this figure, as bearer of coded personal symbols, became the main motif of Antes' pictures, sculptures, and prints. In 1965 he introduced variations on the figure through duplication and triplication (*Family Picture*, 1960–65) and groups (*232 Figures*, 1981–82), and at the same time began his series of "Head" sculptures. Following close study of Native American art (Pueblo and Hopi). Antes from 1970 gave the figure an almost human, idol-like form and cultic character. In the 1980s the "Kopffüßler" was replaced by a stenciled figure that increasingly dematerializes into mere outline; the pictorial motif is reduced to an image of color, and the figure becomes a silhouette (*Kneeling Figure and House*, 1987). In a new picture series from 1987 he confined himself to elementary motifs: house, window, figure. The theme of Antes' late work is the existentially tortured human being: a figure reduced to an existence without profile – having lost its proportional balance between body and spirit – and which is trying to regain its identity. S.P.

Bibl.: Antes, Hanover, 1983 · Brusberg, Antes, 1983

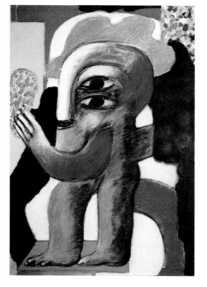

Horst Antes, *Green Figure*, 1963, Egg-yolk tempera on canvas, 130 x 90 cm, Sprengel Museum, Hanover

Antonakos, Stephen. *1926 St Nicolas, Gythioin, Greece. Greek-born sculptor and Light artist, living in New York. He began his career producing → collages and → assemblages from canvas and wood; these were followed by free-standing sculptures that often incorporated pieces of furniture. In the mid-1960s his main medium became neon sculptures with flickering light effects (*Incomplete Neon Square*, Documenta 6, 1977). H.D.

Bibl.: Popper, Kinetic, 1975

Anuskiewicz, Richard. *1930 Erie, Pennsylvania. American painter, living in Englewood, New Jersey. He studied at Cleveland Institute of Art (1948–53), Yale University (1953–55, with Josef → Albers), and Kent State University (1955–56). Anuskiewicz is a leading American exponent of → Op art and a successor to Albers: from the 1960s his artistic experiments have centered on the interplay between color attraction and optical

Giovanni Anselmo, *Towards Overseas (Verso oltremare)*, 1984, Granite, steel cable and paint, 320 x 136 x 3 cm, Galleria Christian Stein, Milan and Turin

perception. Through their intense complementary contrasts, his geometrically structured pictures, painted in oils or acrylics, are infused with a strong optical vibration; this is further enhanced by the lines drawn into them. Anuskiewicz has also created silk-screen prints featuring stereometric forms which, through alternating positive and negative structures, give an illusion of depth. H.D.

Bibl.: Lunde, Anuszkiewicz, 1977

Anzinger, Siegfried. *1953 Weyer, Upper Austria. Austrian painter, draftsman, and graphic artist, living in Cologne, Vienna, and Lucca. He studied at the Akademie der Bildenden Künste in Vienna (1971–77) and moved to Cologne in 1982. He participated in Documenta 7 and the 1988 Venice Biennale. In the 1970s Anzinger became one of the most prominent representatives of → Neo-Expressionism in Austria. He tackles fundamental existential problems (love, pain, fear, death) by means of a sensually direct, expressive style which is inspired by various sources (→ Kokoschka, → Dubuffet, → Picasso, → Cobra, → Arte Cifra). The dominant color in his pictures is a

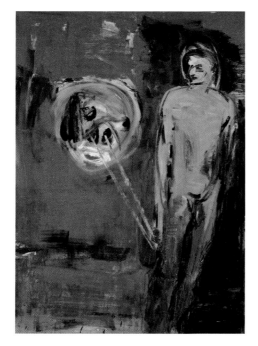

Siegfried Anzinger, *Red Painting*, 1982, Acrylic on canvas, 150 x 100 cm, Essl Collection, Vienna

blue which characterizes the isolation of the figures and imbues them with a pervasive melancholic mood (*Under the Stone*, 1982). His work from the 1980s is marked by multiple overpainting (up to 200 paint layers): for Anzinger this is a cleansing process borne of a mistrust of perfection and completeness (*Hole in Horse and Man*, 1986). The artist's drawings, however, are of a subtly balanced nature. Here, too, the dominant theme is the search for a relationship between body, space, and movement (*The Brothers from Rome*, 1985/86). In 1986 Anzinger published a book, *Laocoon Exercises*. S.P.

Appel, Karel. *1921 Amsterdam. Dutch painter and sculptor, living in New York. He studied at the Rijksakademie in Amsterdam (1942–44) and

Karel Appel, *Children Asking Questions*, 1949, Oil on wood relief, 100 x 60 cm, Stedelijk Museum, Amsterdam

in 1948 founded the Groupe Experimental Hollandais together with → Corneille and → Constant; the → Cobra group emerged from it in November of the same year. He moved to Paris in 1950. In 1964 he created large polychrome reliefs and free-standing figures from wood and polyester. He took part in musical recordings with Merrill Sanders, Chet Baker, etc., in San Francisco in 1970. In 1991 he collaborated with Allen Ginsberg and Gregory Corso on the *Poetry Painting Series*, and in 1995 produced designs for Mozart's *Magic Flute* at De Nederlandse Opera.

Following their experience of war and its aftermath, Appel and his associates developed a skepticism toward traditional artistic practices, especially the abstract ideology of → Mondrian and De → Stijl in Holland. Appel directed his endeavors toward finding a direct method of converting his emotions and expressions, unimpeded by intellectual influences and cultural traditions. Despite showing parallels to → Action Painting, his gestural, expressive style frequently incorporates representational and figurative elements. These are inspired by children's drawings and by the art of the mentally ill and so-called primitives (see → Outsider art). S.P.

Bibl.: Claus, Appel, 1963 · Appel, 1991 · Kuspit, Appel, 1994 · Lyotard, Apple, 1994

Applebroog, Ida. *1929 Bronx, New York. American painter, living in New York; studied at the New York State Institute of Applied Arts and Science (1947–50) and the Art Institute of Chicago (1966–68). She worked as a freelance sculptor from 1969 to 1973 and in 1974 took up a teaching post at the University of California, San Diego. In her paintings Applebroog expresses aspects of human existence that are marked by fragility and contradiction; the gestures of the people portrayed are often ambivalent. Scenes are often condensed into "snapshots" and assembled collage-like to form a single compositional entity. The picture series created in this way (*Variations on Emetic Fields*, 1985–90) portray people simultaneously as victims and perpetrators, experiencing violence, love, destruction, loneliness, and togetherness (*Sacrifice/Paradise*, 1990). Applebroog also makes references to the role of the media intent on the global communication of pictures of catastrophes, violence, love, and passion as an objective reality. Her own pared-down portrayals

Ida Applebroog, *Pull down the Shade*, 1985, Oil on canvas, 218.5 x 152.5 cm, Bavarian National Picture Collections, Munich

are without reference to time or place, lending them a high degree of abstraction. S.P.

Bibl.: Schor, Medusa Redux, 1990 · Phillips, Reviews, 1993

appropriation. Appropriation (from Late Latin: appropriare = to make one's own) as a collective term describes artistic processes, especially of the 1980s, whereby already existing pictures are taken out of diverse contexts (history of art, mass media, advertising) and re-coded, i.e. given a new meaning. Similar to the terms → collage or the → ready-made the term "appropriation" describes a process of appropriating in the sense of creating pastiches, citations, and repetition. Unlike M. → Duchamp's → objets trouvés the visual models which are "appropriated" are not incorporated into another context as found objects but are mostly re-drawn, re-painted or re-photographed – pictorial strategies which are taken to an extreme in → Levine's photographs of → Weston's photography or in E. Sturtevant's painted replicas of works by famous artists. The term appro-

priation art crystallized towards the end of the 1970s and beginning of the 1980s in the New York magazine *October*: in 1977 the art critic Douglas Crimp in his exhibition Pictures assembled various artistic techniques, the concept of which he defined as a critically reflected access to the (mass) media; he described this as "postmodern" (→ Postmodernism). Appropriating pictures from other sources therefore challenged the modernist concepts of originality, autonomy, and authorship in the works of Levine, → Longo and P. Smith, and also of → Lawler, → Prince, → Kruger, → Anderson, or → Sherman. Through this almost matter-of-fact and conscious access to images from the mass media the boundaries between art and popular culture as well as the relationship between producers and receivers were questioned, and creative processes for reflecting the structures of representation and the production of meaning were opened up.

Initially employed as a critical and strategic tool, especially by women artists who by appropriating works by male colleagues, aimed to thematize their own position within the patriarchical art world, the term, during the 1980s, was extended to cover all those artistic approaches where artists worked with already existing image worlds and ultimately embraced oeuvres as diverse as those of G. → Richter, → Salle, and → Koons. A.W.

Arakawa, Shusaku. *1936 Tokyo. Japanese-born painter and → Conceptual artist, living in New York. Initially she studied medicine and mathematics (1954–58), and moved to New York in 1961. In 1972 she received a DAAD scholarship to Berlin, where she studied the work of Marcel → Duchamp and Ludwig Wittgenstein. In 1986 she was made Chevalier des Arts et des Lettres, and was a member of the John Simon Guggenheim Fellowship in 1987–88. From the 1960s onwards Arawaka aimed to translate language structures into pictures, based upon her experiences of Conceptual art and the → ready-made. The geometric precision of her paintings, their sparingly applied color accents, and the graphical and language elements scattered into them

Shusaku Arakawa, *Untitled*, 1964–65, Indian ink, tempera, pencil and fluorescent paint on canvas, 245 x 320 cm, Museum Ludwig, Cologne

result in a cool and, on the surface, highly polished aesthetic. In the cycle *Mechanism of Meaning* (1968–69) Arakawa seeks to portray the meaning of concepts and formulations by revealing different layers of understanding. Elements referring to the psychology of perception and epistemology (in pictorial and syntactical form) are combined with various techniques and materials to stimulate thought processes and establish cross-references. H.D.

Bibl.: Arakawa , Munich, 1981 · Arakawa, Berlin, 1990

Arbus, Diane. *1923 New York City, †1971 New York City. American photographer. She trained as a fashion photographer and in 1959 studied photography with Lisette → Model. In 1967 she participated in the New Documents exhibition at the Museum of Modern Art, New York. She taught at the Rhode Island School of Design in 1970–71. After a successful career as a fashion photographer she retired from the world of fashion. Her photographs of social outsiders combine often gloomy, disturbed themes with a quiet, factual attention, allowing the viewer to maintain a certain distance from the image. Arbus made a point of getting to know her models, and with their permission photographed them in various poses. Her intention was not to make philosophical statements but to record a multi-faceted world. However, her work is not a pure photographic documentary in the tradition of → Sander but depicts psychological contexts, focusing on the private rather than on social reality. Already during her lifetime her work made a significant mark on American photography and beyond. Arbus committed suicide in 1971. S.P.

Bibl.: Arbus, Arbus, 1973 · Arbus/Como, Untitled, 1995

Arcangelo, Allan d'. *1930 Buffalo, New York. American painter and graphic artist, living in Kenozo Lake, New York. After studying at the University of Buffalo he began to paint, moving to Mexico to continue his research at the University of Mexico City. On his return to the US he took up a teaching post at the School of Visual Arts in New York (1959). Arcangelo combines themes associated with → Pop art (traffic signs and signals) with features from → Hard-Edge Painting (clearly defined, geometric forms, brilliantly colored surfaces). His use of imaginary vanishing points gives the viewer the sensation of experiencing movement. In the 1960s Arcangelo incorporated into his pictures actual objects from the street (fences or barriers); since the 1980s he has turned to depicting oil tanks and jets. H.D.

Bibl.: Calas, Art, 1968 · Barnicoat, Posters, 1986

Archipenko, Alexander. *1887 Kiev, †1964 New York. Russian-born sculptor. He studied (initially painting, then sculpture) at the Art School in Kiev from 1902 to 1905. In 1906 he moved to Moscow and two years later to Paris, where he took art studies at the Louvre. From 1910 he exhibited at the → Salon des Indépendants, and held his first one-man show at the → Salon d'Automne in 1911. In 1912 he opened his own art school in Paris and was co-founder of → Section d'Or, which counted among its members → Picasso,

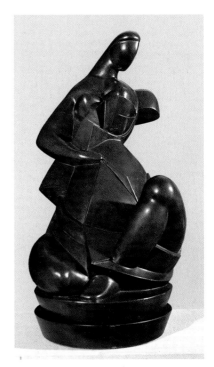

Alexander Archipenko, *Seated Woman*, 1911, Bronze, 59.5 x 29.5 x 29.6 cm, Wilhelm Lehmbruck Museum, Duisburg

→ Braque, → Gris, → Léger, → Delaunay, de → La Fresnaye, → Villon, → Picabia, and Marcel → Duchamp. He spent the war years in Cimiez, near Nice. During 1919–21 he undertook extensive travel through Europe, staging numerous exhibitions, and in 1921 moved to Berlin where he opened his own art school. He emigrated to the US in 1923, and attended the New Bauhaus School of Industrial Arts, Chicago; in 1939 he set up his own school of sculpture in New York. The influence of → Cubism manifests itself in his early sculptures in the form of block-like figures (*Seated Woman*, 1911); in subsequent works empty spaces (or negative forms) are incorporated into

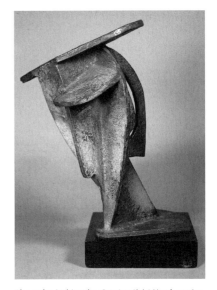

Alexander Archipenko, *Constructivist Head*, 1913/57, Bronze, 38 x 20.5 x 31.5 cm, Saarland Museum, Saarbrücken

the composition (*Femme marchant*, 1912). His most creative years, prior to World War I, were marked by numerous novel ideas for form. In 1912 he produced his first three-dimensional constructions by using new materials ("Sculptopainting," reliefs of painted and hollowed-out plaster). The plaster sculpture *Carrousel Pierrot* (1913) is highly innovative: in it the human figure is "mechanized" by way of abstract, stereometric elements, while the sculpture is opened up through the interplay of positive and negative form and especially by being painted in highly contrasting colors. In 1924 Archipenko developed a motor-driven, mobile picture system, the "*peinture changeante*" which he named "Archipentura." In his late works, of the 1950s and 1960s, he reverted to geometric, stylized forms and created various monumental works of almost abstract appearance, such as *Cleopatra* (1957). S.P.

Bibl.: Archipenko, Fifty Years, 1960 · Archipenko, Los Angeles, 1986 · Michaelsen, Archipenko

Ardon, Mordecai. *1896 Tuchow, Poland, †1992 Jerusalem. Polish-born Israeli painter. He studied at the → Bauhaus in Weimar (1920–25) and the Kunstkademie in Munich (1926), and moved to Jerusalem in 1933. He held teaching posts at the Itten Art School in Berlin (1929) and the Bezalel Art School in Jerusalem (1935; director 1940–52), and in 1952 became artistic advisor to the Ministry of Culture and Education. Ardon's style of painting is strongly influenced by the Bauhaus, especially by → Klee. Besides landscapes and portraits he also executed abstract paintings which, inspired by the myths and legends of Jewish as well as Christian culture, revolve around the events of birth and death, peril and fear, *joie de vivre* and growth (*For Those Killed in Action*, 1984). S.P.

Bibl.: Ardon, Berlin, 1978 · Ardon, 1995

Arikha, Avigdor. *1929 Radautz, Romania. Romanian-born Israeli painter, draftsman, and printmaker. After being held in a concentration camp as a child, Arikha emigrated to Israel. He studied at the Bezalel School of Art with → Ardon (1946–49), and then at the École des Beaux-Arts, Paris (1949–51), at the same time studying philosophy and history of art at the Sorbonne. In 1971 he took drawing courses at the Cabinet des Dessins du Louvre, and in 1972 drew up proposals for reforming the École des Beaux-Arts (*Pédadogie d'Art*). From 1957 to 1965 he produced abstract expressive painting (*Composition*, 1964); he then abandoned painting in favor of figurative drawings and illustrations, and from 1970 etchings. He illustrated texts by Gogol and Samuel Beckett. Around 1973 he took up painting again, especially still lifes, portraits, and landscapes, based on direct observation of nature. S.P.

Bibl.: Arikha , London, 1988 · Beckett, Arikha, 1995

Arman (Pierre Fernandez Arman). *1928 Nice. French-born sculptor living in New York. He studied at the École National d'Art Décoratif in Nice (1946) and in 1947 met Yves → Klein. He attended the École du Louvre, studying archeology and oriental art. He undertook military service in 1952

and in 1955 produced *cachets* (imprints). In 1957 he traveled through Persia, Turkey, and Afghanistan. In Milan in 1960 he co-founded the Nouveaux Réalistes group (→ Nouveau Réalisme) together with → César, → Dufrêne, Raymond Hains (1926–), Klein, Martial Raysse (1936–), → Rotella, → Spoerri, → Tinguely, and Jacques de la Villeglé (1926–). In 1959 he produced his first → accumulations, → assemblages of man-made objects of a similar nature mostly arranged in plexiglas cases; concentrated in heaps and detached from all practical function, they offer a new kind of critique on consumerism. His "coupes" and "colères" followed in 1961: these are cut up objects (e.g. musical instruments) whose individual parts appear in new arrangements or are set in plexiglas. From 1963 he used explosives to destroy objects, exhibiting their fragments in "combustions." The following year he began casting objects in polyester ("inclusions"), and from 1970 in concrete ("invisibles"). I.H.

Bibl.: Martin/Restany, Arman, 1974 · Durand-Ruel, Arman, 1991

Armando. *1929 Amsterdam. Dutch painter, sculptor, and writer, living in Berlin. From 1934 to 1939 he lived near Amersfoort where in 1938 the German occupation established the police transit camp and subsequent concentration camp. Marked by this experience Armando's

Arman, *Chopin's Waterloo*, 1962, Fragments of a piano glued onto a wooden board, 186 x 300 x 48 cm, Musée National d'Art Moderne, Centre Georges Pompidou, Paris

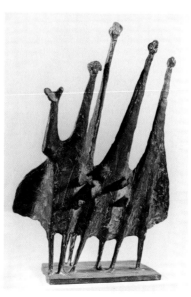

Kenneth Armitage, *People in the Wind*, 1950, Bronze, 65 x 40 x 35 cm, Kunsthalle Mannheim

works embody a dialogue with violence and power, with victim and oppressor.

Armando studied history of art in Amsterdam (1949–54) and taught himself to paint. Under the influence of the → Cobra and → Nul groups he developed series of variations of symbolic forms and purist monochrome painting. He ceased artistic activity between 1964 and 1967. In the 1970s and 1980s he produced landscape drawings and paintings dominated by black. In 1980 Armado began to execute large-format oil paintings, reduced to black and white but nonetheless expressive (*Flags*). Since 1988 he has also made figurative sculptures in bronze (*The Ladder*, 1990; *The Animal*, 1991). K.S.-D.

Bibl.: Armando, The Hague, 1989

Armitage, Kenneth. *1916 Leeds. British sculptor, living in London and Corsham, Wiltshire. He studied at Leeds College of Art (1934–37) and the Slade School, London (1937–39). He was head of the department of sculpture at Bath Academy of Art, Corsham Court (1946–56); and also acted as visiting professor, University of Boston (1970) and Royal College of Art, London (1974). In 1969 he was awarded the CBE. Armitage's early stone sculpture is inspired by Egyptian and Cycladic art. His postwar work comprises three-dimensional groups of individual figures consisting of flat plates with insect-like, protruding limbs. The deformed bodies are testimony to the vulnerability of man; other portrayals have a playful and humorous effect. From the late 1950s Armitage tended to make larger, more monumental, and less frontal sculptures, often of individual figures. From 1960 to 1963 he worked on the façade of the Mouton Rothschild Château near Bordeaux. During this time he also experimented with color and new materials (fiberglass and aluminum) and with combining plaster figures and drawings (he reverted to bronze in the 1970s). In the late 1960s his works became humorous and playful. In his Richmond Oaks series of 1977–78 he used non-anthropomorphic forms for the first time. The essential image of man is portrayed not as a concrete and individual entity but in a more generalized manner, through the expressive power of the media used. I.H.

Bibl.: Armitage, London, 1959 · Armitage, London, 1972–73

Armleder, John M. *1948 Geneva. Swiss experimental artist, living in Geneva. He was co-founder in 1969 of Groupe Écart, which organized → happenings and maintained lively contact with → Fluxus artists. The programmatic rejection of a personal style is reflected in → objets trouvés, pseudo-constructionist painting, and collective messages and expositions. In the 1960s Armleder turned to → Mail art, → assemblages, geometric picture objects, → Installations, and → environments using pieces of furniture. Relics of everyday life such as worn-out chairs, sofas, and chests of drawers are invested with a sculptural meaning. Armleder questions avant-garde viewpoints – from → Suprematism to the → Conceptual art of the 1970s – and deconstructs them in an ironic fashion. S.P.

Bibl.: Armleder, Sculpture, 1990 · Armleder, Vienna, 1993

Armory Show. The first exhibition of modern art in the US (modeled on the concept of the 1912 Sonderbund exhibition in Cologne), held in New York, February 17–March 15, 1913 in the armory of a former barracks (and later in Chicago and Boston). The exhibits comprised European paintings of the 19th and 20th centuries by e. g. Ingres, Delacroix, Courbet, Cézanne, Van Gogh, Gauguin, Seurat (→ precursors, → Neo-Impressionism), → Picasso, → Matisse, → Rousseau, → Léger, → Kandinsky, and → Picabia. Marcel → Duchamp's *Nude Descending a Staircase* (1912) caused a scandal in the art world. The exhibition and related activities represented the breakthrough of modernism onto the American art scene, which had until then been rather provincial. H.D.

Arneson, Robert. *1930 Benicia, California. American sculptor, ceramicist, draftsman, and graphic artist. Studied at the College of Marin, Kentfield, California (1949–52); California College of Arts and Crafts, Oakland; and Mills College, Oakland. He was appointed professor at the University of California, Davis, in 1962. In the 1950s Arneson was influenced by → Abstract Expressionism as well as by → Pop art. His humorous, polychrome ceramic works representing objects of everyday life (telephones, typewriters, miniature toilets, flower vases) made Arneson a leading figure of → Funk art in the 1960s. His drawings, with their careful shading, also demonstrate his command of color. More recently he has produced self-portraits as well as large glazed and richly colored busts. H.D.

Bibl.: Albright, San Francisco Bay Area, 1985

Arp, Jean (Hans). *1887 Strasbourg, †1966 Basel. French painter, sculptor, and poet. He studied at the Akademie in Weimar (1904–07) and the Académie Julian in Paris (1908). In 1911 he joined the group of painters Der Berner Bund (The Berne Association), and the following year met → Kandinsky and had contact with the → Blaue Reiter. In 1913 he worked at Der → Sturm. He was one of the founders of the → Dada movement in Zürich in 1916, and in 1918 authored the Dada Manifesto in Berlin. He organized the Congress of

Jean (Hans) Arp, *First Dada Relief*, 1916, Painted and sprayed wood, 24 x 18.5 cm, Kunstmuseum Basel

Jean (Hans) Arp, *From the Realm of the Gnomes*,
1949, Marble, 20 x 20.5 x 10 cm, Private Collection

Constructivists in 1922. In 1925 Arp settled in Paris, where he had contact with the → Surrealists. In 1930 he became a member of De → Stijl and → Cercle et Carré, and was a founder memebr of → Abstraction-Création in 1931. During the war he fled initially to the South of France (1940) and then to Switzerland (1942), returning to Paris in 1946.

During the Dada years Arp produced mainly paper collages, ink drawings, and woodcuts for Dada publications (in collaboration with his wife, Sophie → Taeuber-Arp). The abstract wood reliefs from 1916, with their constructively balanced, free, fluid forms, contain Arp's essential artistic elements. Following an almost exclusive occupation with reliefs and collages, from 1930 he created freestanding sculptural works (*Human Concretion*, 1930) in smoothly polished, fluid elemental forms (recalling e.g. eggs, wheels, torsos, clouds). Their open, biomorphous nature leaves them open to interpretation, while suggesting plant growth or merging anthropomorphic shapes. In the 1950s Arp received major public commissions: a wall relief at Harvard University (1950), monumental sculpture for the University of Caracas (1953), and monumental relief for the Unesco building in Paris (1957). Arp was awarded the Grand Prize for Sculpture at the 1954 Venice Biennale. His poems, based on the principle of arranging and concatenating a basic corpus of words, bear a close resemblance to his artistic work. S.P.

Bibl.: Arp, 1967 · Read, Arp, 1968 · Faucherau, Arp, 1988

Arroyo, Eduardo. *1937 Madrid. Spanish painter, sculptor, graphic artist, and stage and costume designer; since 1985 he has lived mainly in Madrid. Arroyo was mainly self-taught as an artist. His work generally takes a socio-critical, moral stance; opposed to the Franco regime, he has been an exponent of politically engaged realism. He lived in Paris between 1958 and 1968 then moved to Milan, returning to Paris four years later. From 1969 onwards he produced numerous stage designs for prestigious European productions. Using bold figuration – based upon an → Expressionist style of painting – he denounces deplorable social conditions in an ironic twist. Photographs or pictures serve as models to be transformed into graphic statements (e.g. picture series on the sport of boxing and Winston Churchill). In the 1970s Arroyo turned to portrait painting. S.P.

Bibl.: Arroyo, Paris, 1982

Art & Language. A loose grouping of British and American artists who radically questioned the traditional concept of art. The group's original members were Terry Atkinson (1939–), → Baldwin, David Bainbridge (1941–), and Harold Hurrell (1940–), who together brought out the first issue of their journal *Art-Language* in 1968. → Kosuth became the journal's editor in 1969. Ian Burn (1939–) and Mel Ramsden (1944–) joined the group in 1971, but by the late 1970s it had all but disintegrated in the face of the growing complexity of their problematic framework. Based on Marxist and linguistic analyses, their view was opposed to the notions of art for art's sake and individualistic interpretation; instead, the art object was to be replaced by linguistic concepts (→ Conceptual art). H.D.

Bibl.: Art & Language, Oxford, 1975 · Harrison/Orton, Art & Language, 1982 · Art & Language, London, 1986

Art Autre. Term coined by the French art critic Michel Tapié in 1952 in his book *Un Art autre* to describe a turbulent, gestural form of art which emerged in postwar France in opposition to the established → École de Paris. The term is sometimes used synonymously for → Art Informel, a term which was also coined by Tapié. It applies not only to the → Tachiste art of → Mathieu and → Wols but also to the figurative-cum-abstract forms in work by → Dubuffet and → Matta. H.D.

Art Brut (French = raw art). Term introduced in 1945 by → Dubuffet to describe works by social "outsiders" – those who stand independent of culture, civilization, and artistic training. For Dubuffet the roots of Art Brut are to be found in the myths, legends, and dreams of an "unreal" world which exists, on equal terms, alongside the "real" one. He collected pictures by the mentally disturbed, by children, and by so-called primitives (members of non-European cultural communities), creating in November 1947 the Foyer de l'Art brut; this formed the basis of the Compagnie de l'Art brut (formed with → Breton and Michel Tapié among others). In fall 1949 an Art Brut exhibition was held at the Galerie René Drouin, Paris, featuring more than 200 works by 63 artists. The exhibition catalog carried a text by Dubuffet entitled "L'Art Brut préféré aux arts culturels," which is considered to be the Art Brut manifesto. The collection was in due course handed over to the town of Lausanne which had undertaken to establish a museum (inaugurated in 1976). S.P.

Bibl.: Thevoz, Dubuffet, 1986 · Navratil, Bilder, 1993 · Peiry, Art brut, 1997

Art Concret. → Concrete art

Art Informel (Informalism), Emilio Vedova, *Tondo 85-2*, 1985, Various materials, paint, canvas, diam. 280 cm, Artist's collection

Art Informel (Informalism), Emil Schumacher, *Deli*, 1975, Oil on canvas, 170 x 130 cm, Ludwig Museum, Cologne

Art Deco (sometimes **Art Déco**). General term for a style of design and decoration fashionable in the 1920s and 1930s; it takes its name from the 1925 Exposition Internationale des Arts Décoratifs et Industriels Modernes in Paris, although the term itself was not coined until the 1960s. It is characterized by rectilinear, stylized forms (a reaction to the curvaceous shapes of → Art Nouveau), rich materials, and bright colors. In this it combines elements from → Jugendstil, the → Wiener Werkstätte, De → Stijl, the → Bauhaus, → Cubism, and → Futurism; it also made use of Far Eastern and even Ancient Egyptian stylistic elements. Art Deco manifested itself mainly in the sphere of applied art, but is also encountered in architecture, sculpture, poster art, photography, and stage design (e.g. Diaghilev's Ballets Russes). H.D.

Bibl.: Frantz, Art Deco, 1986 · Lucie-Smith, Art Deco, 1990

Art Informel (Informalism). A broad term coined in 1950 by the French critic Michel Tapié (see *Un art autre*, Paris, 1952) to cover the unstructured, aesthetic inward "psychic improvisations" of e.g. → Wols; it was later to embrace → Tachisme (including Jean Degottex [1918-88], and Simon Hantaï [1922-]). It was mainly applied to European painting (rough American equivalents were → Lyrical Abstraction and → Abstract Impressionism); the work of → Kandinsky, → Klee, and especially the (anti-) cultural concerns of → Dubuffet were paramount influences. Tapié himself initially confined it mainly to the work of → Fautrier, → Wols, and → Hartung. The definition was later extended to cover artists such as → Atlan, → Bazaine, Roger Bissière (1886-1964), Camille Bryen (1907-77), Georges Mathieu (1921-), → Michaux, → Poliakoff, → Soulages, and others. The graphic automatism of Art Informel was concerned with spontaneous, rapid, and often iterative execution; Surrealist violence and analysis of the resulting subconscious were minimalized. Its central confrontation was with the rigor of → Constructivism and → Neo-Plasticism. Tapié organized several Art informel exhibitions, notably "Un Art autre" (1952), while the philosopher Jean Paulhan (referring to → Miró, → Pollock, → Mathieu, and → Tobey) provided the phenomenological grounding.

Art Informel also made inroads outside Paris. The more culturally involved and discordant → COBRA (after a Paris exhibition by Michel Ragon) was influenced by the concept, as were artists such as Modest Cuixart (1925-), → Saura in Spain, A. → Burri, and → Vedova in Italy, and members of Quadriga (Otto Greis [1913-] and → Schultze), the → ZEN 49 group, and Gruppe 53, with K. O. → Götz, Karl Fred Dahmen (1917-), and → Schumacher in Germany. In America, → Pollock, Eliane de Kooning, Willem de → Kooning, → Francis, and the Canadian → Riopelle were all associated with Informalism. By the mid-1960s, → Nouveau Réalisme, → Warhol, and → Pop art had established an art – social context in which Art Informel appeared "personal" and "closed." D.R.

Art Nouveau. The term for the florid, organic, and composite decorative style of c.1900, equivalent to → Jugendstil in Germanic areas. It is the preferred term in both French- and English-speaking lands and is equivalent to the Italian Stile Liberty or Stile Floreale (architect G. Samaruga [1857-1932]) and Modern Style (term used occasionally in England; in Catalonia the form is Modernista). The name was taken from Siegfried Bing's L'Art Nouveau gallery, Paris (1895). The style adopted ideas from the fine arts (→ Symbolism, → Post-Impressionism, and → Japonisme), though it manifested itself mainly in architecture, furniture (van de → Velde's kidney-shaped desk, 1899), applied arts (René Lalique [1860-1946], William de Morgan [1839-1917], C. F. A. Voysey [1857-1941]), decorative arts (with connections to Willam Morris's Arts and Crafts movement), and graphic art (Alphonse Mucha [1860-1939], A. H. Mackmurdo (1851-1942]). It was popularized by e.g. the Esposizione Internazionale d'Arte Decorative (Turin 1902; e.g. by Raimondo D'Aronco's pavilion) as well as by journals (*The Studio*). Cities such as Barcelona (Antoni Gaudí [1852-1926] and Domènech i Montaner [1850-1923]), Glasgow (→ Mackintosh), Nancy (glassware by Émile Gallé [1846-1904]), and Prague gained in importance to join historical centers such as Brussels (e.g. Victor Horta [1861-1947]; houses, 1893-98) and Paris (inc. the Métro entrances [c. 1900] of Hector Guimard [1867-1942], and work by Anatole de Baudot [1834-1915]). In America the applied art of Louis Comfort Tiffany (1848-1933) and the interiors of Louis Sullivan (1865-1924) were crucial.

Thick-outlined "cloisonné" forms were employed by Gauguin, → Denis, Jan → Toorop, Georges de Feure (1869-1928), Augusto Giacometti (1877-1947), Jan Thorn Prikker (1868-1932), Jan Preisler (1872-1918), Louis Anquetin (1861-1932), and → Bernard; the sinuous line influenced → Fauvism, Jean Delville (1867-1953), Armand Point (1860-1932), Eugène Grasset (1841-1917), Carlos Schwabe (1866-1926), Giovanni Segantini (1858-99), Edward Burne-Jones (1833-98), Aubrey Beardsley (1872-98), Walter Crane (1845-1915), and Charles Ricketts (1866-1931), and, in Eastern Europe, Vojtěch Hynais (1854-1925), and Vojtěch Preissig (1873-1955). D.R.

Art Students League of New York. The first independent American art school, established in New

York in 1875 and still in existence today. Founded in protest against the rigid academic traditions of New York's National Academy of Design, the school boasted a totally innovative system of administration and education. Students were able to choose their own courses and to complete their studies in the main independently. The objective was to promote freedom of thought and independence of creative work; consequently all styles and ideas were permitted. The school became the focus of modern artistic aspirations in America and produced a multitude of famous artists. Its most famous teachers were Walter Shirlaw (1838–1919) and William Merritt Chase (1849–1916). H.D.

Arte Cifra. Contemporary Italian art trend that developed from 1977 as a counter movement to → Conceptual art and → Arte Povera. Its main protagonists, → Chia, → Clemente, → Cucchi, Nicola de Maria (1954–), and → Paladino, reveal a wide variation in style. In contrast to the intellectualized concept of Conceptual art these artists emphasize an individual, symbolic language and, by incorporating the subconscious, create expressive pictures in code ("*cifra*"). Arte Cifra forms an integral part of the return to painting in the 1980s. H.D.

Arte Madí. The Madí Movement (purportedly, an abbreviation of *Madrid!*) was a 1940s, South American, essentially → Kinetic art grouping founded by the self-taught Czechoslovak-born Argentine → Kosiče and based in Buenos Aires. Other figures included Uruguayan artists Carmelo Arden Quin (1913–) and Rhod Rothfuss (1920–), the main publicists being Kosiče and the poet Edgar Bayley (1919–). Articles by Arden Quin and Kosiče emphasized imagery free from naturalistic or symbolic concerns and advocated shaped canvases, new technologies and materials – including water jets and neon tubing (Kosiče, *MADI Neon No. 3*, [1946]), or *Gesamtkunstwerk* , such as proposed in Kosiče's *Manifesto Madí* (1947), as well as kinetic forms. Events christened "Madí" or "Arte Madí" took place in 1946 at Buenos Aires and in 1948 in Paris ("Salon des Realités Nouvelles") while a related journal, *Arte Madí Universal*, appeared 1947–54. D.R.

Arte Povera. "Impoverished" or "poor" art: term coined in 1967 by the Italian art critic Germano Celant, initially used to refer to a core group of Italian artists – Mario → Merz, → Kounellis, Giuseppe Penone (1947–), → Paolini, → Pistoletto, and → Fabro – but soon widened to include other European and North American artists such as → Beuys, Reiner Ruthenbeck (1937–), → Kosuth, Douglas Hueber (1936–), → Weiner, and → Serra. It stemmed from an art trend that had emerged in Italy in the mid-1960s and which was opposed to the aestheticizing and commercialization of art. Arte Povera artists combined art and social criticism with a sensivity to hitherto "unartistic" materials such as felt, sand, stone, lead, iron, etc.; these were used to explore new ways of expressing form and content, while classical techniques of art and sculpture were rejected. Few works

survive from the revolutionary mood of those years. Today the term Arte Povera may still be linked to the work of Merz and Kounellis. H.D.

Bibl.: Celant, Arte Povera, 1969 · Szeemann, Attitudes, 1969

Arte Programmata. An early 1960s Italian (particularly Milanese) → Op or → Kinetic tendency. Based on often formalistic, sometimes serial, variations on a congruent or mathematically similar shape or multiples, *Arte Programmata* ("programmed art") is represented by those who followed in the wake of the Milanese-born designer, film maker, and artist, Bruno Munari (1907–), whose multiple *Flexy* (1968) and early sequential work (*Useless Machines*) were forerunners of the aesthetic. Main figures included members of Gruppo T, such as Giovanni Anceschi (1939–), Davide Boriani (1936–), Gabriele De Vecchi (1938–), Grazia Varisco (1937–), and Gianni Colombo (1937–), all of whom were born in Milan, as well as Alberto Biasi (Padua, 1937–) and, at one remove, Enzo Mari (Novara, 1932–). All were concerned with light, with the relation between ground and image, with repetitive and variable structures, and with the interface between (industrial) design and art. One aspect of → Arte Povera is its ongoing reaction to Arte Programmata's "purist" and formalistic concerns. D.R.

Bibl.: Arte Italiana, London, 1982–83 · Tanchis, Munari, 1987

artists' books. Autonomous works created by artists who, in engaging themselves with the book itself as a medium, have used a variety of means (script, drawing, painting, collage, frottage, printing and cutting techniques, photography, and photocopy). Artists' books usually appear in the conventional codex form (verso and recto between 2 book covers), but can also adopt a special form in their cover design, editing, paper type, and size. Artists' books make visible the contexts of perception: these objects, although still similar to the book form, can also be made from unexpected materials (for example, metal, corrugated cardboard, sheet metal, wood, or organic material, e. g. → Roth's *Literaturwürste*). At the beginning of the 20th century, Russian and Italian Futurists in particular analysed the medium of the book. → Marinetti proclaimed the new "futuristic book" which has "a visual, typographical design" on each printed page. The *First Simultaneous Book* by Sonia → Delaunay-Terk is pathbreaking in its artistic arrangement. In the early 1930s the Surrealist artist and bookbinder Georges Hugnet introduced the term "livre-objet" (book object) (creating a book whose cover was made from bark in 1937). In the 1950s the followers of Concrete poetry developed the ideas of the Symbolist poet Mallarmé (*Un coup de dès*, 1897) and of the Futurists further, initially for the dissemination of literature. In the 1960s the medium of the book as an independent form of design gained more ground. The *Methods Books* by → Walther (1963–69) contain instructions for their use, alteration, and appreciation. In 1977 Documenta 6 included a general exhibition on the theme Metamorphoses of the Book.

Bibl.: Deinert, Künstlerbücher, 1995 · Moldehn, Künstlerbücher, 1996

Artschwager, Richard. *1924 Washington, D.C.. American painter and sculptor, living in Rhinebeck, New York, and Brooklyn. He studied natural sciences at Cornell University (1941–48) and subsequently moved to New York where he was a student of → Ozenfant (1950–51). From 1960 he worked as a freelance artist while also teaching at various American universities. In 1953 he began to make his carefully finished "pseudo-furniture;" his preferred materials are fiberboard and synthetics such as Celotex and Formica which, with their woodgrain finish, display an obvious artificiality (*Table with Pink Tablecloth*,1964). His highly simplified and monumentalized everyday objects question habitual visual experience through an ironic mix of form and iconography. By combining furniture, sculpture, and painting (often monochrome), and creating complex installations, Artschwager experiments with the concept of art and with traditional genres, while also questioning the usefulness of art and its place within American culture. I.H

Bibl.: Artschwager, Buffalo, 1979 · Artschwager, Basel, 1985 · Armstrong, Artschwager, 1988 · Artschwager, Paris, 1989

Ashcan School. Ironic term for a group of American artists, active in the 1930s, which emerged from The → Eight. Besides the painters of The Eight its members included → Bellows, Glenn Coleman (1887–1932), Eugene Higgins (1874–1958), Jerome Myers (1867–1940), and → Hopper. The artists aligned themselves in theme and style to the European painting of Courbet and Manet. On account of their realistic, undecorative manner of painting they were also referred to as the "Apostles of Ugliness" and were suspected of having revolutionary tendencies. The Ashcan School marked the beginning of an independent development of painting in America. H.D.

Bibl.: Braider, Ashcan, 1971

Asmus, Dieter. *1939 Hamburg. German painter and graphic artist, living in Hamburg. He studied painting at the Hamburg Hochschule (1960–67) with Paul Wunderlich (1927–) and → Lindner. In 1965, together with Peter Nagel (1941–), Nikolaus Störtenbecker (1940), and Dietmar Ullrich (1940), he co-founded the → Zebra group, which objected to the dominance of informal painting. He qualified as a teacher in 1965, and went on to receive numerous scholarships and awards. In his work, which comprises oil paintings, etchings, and silkscreen prints, figures and objects are presented in a factual, austere style; isolated moments of action are plucked out of a situation and frozen. The extreme light/dark modeling of the figures imbues them with the synthetic hardness and plasticity of a photograph. H.D.

Bibl.: Schreiber/Asmus, 1972 · Schmied, Deutsche Kunst, 1975

assemblage. Term for a relief-like construction resulting from assembling various objects on to a flat surface. Since the 1960s the term has also been used to describe other three-dimensional works of art where real objects (often everyday waste or → objets trouvés) are combined, often with provocative intent as a challenge to everyday realities; a precursor of this was the 1918 assemblage with wastepipe entitled *God*, by → Schamberg. The → combine paintings by → Rauschenberg represent another variation: here the artist combines three-dimensional objects (e. g. pieces of furniture and stuffed animals) with painting. H.D.

Bibl.: Waldman, Assemblage, 1992

Atget, (Jean) Eugène. *1857 Libourne near Bordeaux, †1927 Paris. French photographer. He studied music and theater at the Paris conservatory (1877–80) and from 1885 to 1898 worked as an actor with a touring company. In 1898 he began to take photographs. His pictures, often of

Paris street scenes, served as valuable reference and inspiration for artists such as → Utrillo, → Vlaminck, → Kisling, → Foujita, → Braque, and → Man Ray. In 1899 he began a systematic program of photographing the streets, houses, shops, and courtyards of old Parisian *quartiers*. His photographs, which were first widely published in 1930 after the rediscovery of his work by → Abbott, can be seen as forerunners of social documentary photography. Taking everyday events and suppressed emotions as a theme, Atget rejected the pervasive belief in – and enthusiasm for – progress that was prevalent at the end of the 19th century. H.D.

Bibl.: Abbott, Atget, 1965 · Leroy, Atget, 1976 · Lemagny, Atget, 2000

Atlan, Jean-Michel. *1913 Constantine, Algeria, †1960 Paris. Algerian-born French painter and graphic artist. He moved to Paris in 1930, where he studied philosophy. Self-taught as an artist, he began to paint in 1941. He was imprisoned between 1942 and 1944 for participating in the French Resistance. Strongly influenced by the primitivism of the → Cobra group, and taking part in their exhibitions, he produced from 1945 abstract-cum-figurative, fantastical animal forms. By the mid-1950s he had consolidated his style, where strong, black, meandering lines enclose pastel-colored fields that recall organic and plant life (*Assur*, 1958). Because of Atlan's agnostic and biologistic world view, his works often focus on the theme of fight (e. g. fight for love) and the dreamlike. He was a follower of the new → École de Paris. K.S.-D.

Bibl.: Dorival, Atlan, 1962 · Polieri, Atlan, 1989 · Ragon, Atlan, 1989

Attersee, Christian Ludwig. *1949 Bratislava. Czech-born painter and graphic, object, and action artist, living in Vienna and St. Martin, Burgenland. He studied stage design and painting at the Hochschule für angewandte Kunst in Vienna (1957–63); since 1992 he has held a professorship there. In the early 1960s, operating within the sphere of → Vienna action art, Attersee began to develop his own multimedia world of grotesquely fantastic images. Initially his work was dominated by pencil drawings in which he mixed people, animals, objects, and mythical creatures in a collage-like manner (*Speisekugel und Speisewürfel*, 1965); this was followed by aggressively parodic metamorphoses, as in → Pop art, as well as collages, photographic series, and film. In the 1970s his expressive drawing style intensified, preparing the way for a new phase (from 1980) of acrylic, varnish, and mixed-technique painting, related to the → Neue Wilde (*Nocturnal Fish*, 1986). Attersee also worked as a stage designer (Hamburg Playhouse, Vienna Operetta Theater), organizer of musical events, writer, film producer, and actor ("Greetings Attersee" for Bavarian television). K.S.-D.

Bibl.: Attersee, Vienna, 1990

Atzwanger, Peter Paul. *1888 Feldkirch, Vorarlberg, †1974 Innsbruck. Austrian painter, graphic artist, author, and photographer. He moved to Brixen, South Tyrol, in 1900 and from 1904 to 1908 was a student at the technical college for stoneworking in Laas, Vintschgau. He subsequently attended the Akademie der Bildenden Künste in Vienna (1908–09) and the Heinrich Kühn photography school in Innsbruck (1913). He undertook military service and was imprisoned in 1914–19. His first exhibition of portraits took place in 1920. In 1928 he became a member of the Photographic Society of Vienna and exhibited a series of lithographic prints (bromoil process). 1929 saw his participation in the first international exhibition of photographic art in Vienna. Later in his career he moved from a Stegemann plate camera (9 x 12 cm) to compact print photography (35 mm Leica). In 1941 he became a member of the technical board of photography and print technique. He retired from public life in 1947. S.P.

Bibl.: Hochreiter, Atzwanger, 1981

Auberjonois, René Victor. *1872 Lausanne, †1957 Lausanne. Swiss portrait and landscape painter. He was a student at the Dresden Polytechnic (1895) then studied painting in London and Paris. In 1899 he traveled to Florence, where he copied Old Masters. He participated in the → Salon des Indépendants in 1903, and produced numerous

Christian Ludwig Attersee, Tierlicht, 1989, Oil on canvas, 150 x 200 cm, Essl Collection, Klosternenburg, Vienna

Frank Auerbach, *Camden Theatre in the Rain*, 1977, Oil on wood, 121.9 x 137.1 cm, Private Collection

stage and costume designs. His initial pointillist painting style was consolidated into simple sculptural form and dark colors under the influence of → Modigliani and his elementary Cubist formal language (*Hommage à Madame Pitoeff*, 1920). Besides graphics and oil painting (often portraits and landscapes) Auberjonois also executed book illustrations and glass painting. At the beginning of the 1940s he produced chiaroscuro paintings in expressionist distortion which, after c. 1948, gave way to smaller compositions (*Still Life with Pears*, 1953). S.P.

Bibl.: Auberjonois, Paris, 1977 · Auberjonois, Lausanne, 1994

Auerbach, Ellen. *1906 Karlsruhe. German photographer. In her early career she studied sculpture in Karlsruhe and Stuttgart, taking private tuition from Walter Peterhans (1897–1960) in 1929. Together with student colleague Grete Stern she founded the photographic studio ringl + pit in Berlin which specialized in advertising and portrait photography. The poetic nature of her advertising photographs is due to the influence of her Bauhaus tutor, Peterhans. She was awarded first prize for her publicity photograph *Komol* at the Deuxiéme Exposition Internationale de la Photographie et du Cinéma in Brussels. She emigrated in 1933, first to Tel Aviv (founding the Ishon studio for the photography of children), then to London and in 1937 to the US. She received assignments from Time, Columbia Masterworks, and Columbia Records, among others. She traveled widely, including in 1955–56 to Mexico where, together with Eliot → Porter, she produced a documentary series on churches: *Mexican Churches* (1987) and *Mexican Celebration* (1990). In 1965–84 she worked as an educational therapist for children with learning difficulties at the Educational Institute for Learning and Research in New York. Auerbach has also shot several 16-mm short films whose subjects ranged from Bertolt Brecht to the behavior of new-born babies. P.S.

Bibl.: Eskildsen, Auerbach, 1998

Auerbach, Frank. *1931 Berlin. German-born painter and graphic artist, living in Primrose Hill, London since 1954. He arrived in England in 1939 and in 1947 adopted British citizenship. He studied at St Martin's School of Art (1948–52) and the Royal College of Art, London (1952– 55), and was a member of the → School of London. He held teaching posts at the Slade and elsewhere. An Arts Council retrospective was held in 1978, and in 1986 he represented Britain at the Venice Biennale. Auerbach's subject-matter is largely confined to London parks and cityscapes, and portraits of close friends. His work is characterized by impasto application – with brush, spatula, or by hand – whereby numerous layers of paint give the picture a relief-like character. His late paintings revolve around a ceaseless construction and deconstruction of the subject, which is "un-painted" to the point of being virtually unrecognizable (*Primrose Hill*, 1985). In this way the process of execution, rather than the subject, becomes the theme of Auerbach's art. M.B.-D.

Bibl.: Auerbach, London, 1978 · Auerbach, Venice, 1986 · Auerbach, London, 1987

Auto-destructive art. Auto-destructive art is concerned with the annihilation of the object and has been an integral part of the later modern aesthetic – from M. → Duchamp's *Tu m'* (1918–19), → Fontana's slashed canvases, and the overdrawings of → Rainer, to the more thorough destruction of → Rauschenberg's *Erased De Kooning Drawing* (1953) or → Latham's detonating *Skoob* towers. The *Colères* of → Arman and the harrowing body art of → Pane and Wiener Aktionismus (→ Vienna action art) also form part of destructive art. The German-born (active in England) artist Gustav Metzger (1926–) has theorized extensively on the subject, which for him conflates the artistic and the social. Tracing his roots back to → Dada, he sees art as an irrelevance in a nuclear age. In 1961, at London's South Bank, he poured hydrochloric acid onto nylon cloth in an → Action Painting parody. In 1965, his (published) lecture *Auto-destructive Art*, given to the Architectural Association in London, encouraged the use of technology in an attempt to draw the process of creation/destruction beyond the tame confines of the gallery. Metzger thus concentrates less on the destruction of the artist and more on the dissolution of the perfection of geometrical and artistic space by processes of an industrialized or mechanized origin, as described in *damaged nature, auto-destructive art* (1996). Some of his process "destructions" were imagined to take a decade or more and not necessarily witnessed (*Drop on Hot Plate*, 1969–). D.R.

Bibl.: Metzger, Documents, 1992

automatism. Term introduced by the → Surrealists to describe a technique of spontaneous painting and writing whereby the conscious thought processes are suppressed in order to allow the subconscious to be expressed, without control by the rational mind. In the 1920s → Breton was a practitioner of automatist working methods in literature. The techniques manifest themselves strongly in the works of → Ernst and → Masson and were carried on in → Abstract Expressionism, → Action Painting, and → Art Informel. In

Canada during the years 1948–51 Abstract Expressionist tendencies could be found in the work of "Les Automatistes," a group which counted → Riopelle among its members. H.D.

avant-garde (French = vanguard). Initially a military term, avant-garde has been used since the middle of the 19th century to describe militant political and social art trends. A split between political objectives and artistic ideals, however, occurred after the suppression of the Commune in 1871. Towards the end of the century the term acquired its present-day accepted meaning of artistic innovation, of "progression" from one artistic idea to the next. This spiral of innovation remained unchallenged as an artistic paradigm until the 1960s when, pressured by a growing pluralism of style and, not least, by social considerations, the emphasis on competitive artistic ideas – and with it the almost inflationary use of the term "avant-garde" – began to wane. Peter Bürger sees the "historic avant-garde movements" (→ Futurism, → Dada, and → Surrealism) as a (failed) attempt to break down the bourgeois status of art (as an autonomous term) and to let art and life suffuse one another. Achille Bonito Oliva, by establishing the notion of a → Transavantgarde, has tried to subsume all those artistic endeavors which were trying to make subjective, often interdisciplinary inroads into artistic creativity "beyond" rigidly laid-down doctrine. H.D.

Bibl.: Poggioli, Avant-Garde, 1968 · Bürger, Theory of the Avant-garde, 1974 · Oliva, Transavantgarde, 1982

Avedon, Richard. *1923 New York. American photographer, living in New York. He worked for *Harper's Bazaar* from 1945 to 1964, and for *Vogue* from 1966. In 1974 the Museum of Modern Art, New York, held an exhibition of Avedon's portraits of his father, and two years later a special issue of *Rolling Stone* featured his 73 portraits of America's elite. A retrospective was held in 1980 at the University Art Museum, Berkeley, California. From c. 1980 he undertook journeys through the American West, photographing sick Native Americans, mine workers, racists, and psychiatric patients; the result, showing the influence of → Rodchenko, is a photographic social documentary of great psychological insight (*In the American West*, 1985). The austere style and the seemingly bleached-out portraits which Avedon took for *Harper's Bazaar* had an impact on an entire generation of portrait photographers (*Gloria Vanderbilt, Leslie Caron*, 1954). S.P.

Bibl.: Shanahan, Evidence, 1994

Avery, Milton. *1893 Altmar, New York, †1965 New York City. (Some recent authorities give Avery's birthdate as 1885.) American landscape painter. He took drawing lessons at the → Art Students League from 1913, and taught himself to paint. His first New York exhibition was held in 1928. Inspired by the work of → Matisse, in the 1920s Avery arrived at a style of intense chromatics and two-dimensional simplification, where details give way to large flat color zones. Avery painted largely abstract beach scenes (*In Green Sea*, 1954) and landscapes. The clarity of his composition and brilliant coloring influenced → Gottlieb and → Rothko. H.D.

Bibl.: Kramer, Avery, 1962

Avramidis, Joannis. *1922 Batumi, Georgia. Georgian sculptor, painter, and draftsman; has lived in Vienna since 1943. He studied at the National Art School in Batumi (1937–39) and moved to Athens in 1939. In 1943 he emigrated to Vienna where he studied painting from 1945 to 1949. He was awarded the National Prize of the Akademie der Bildenden Künste in Vienna in 1956, and in 1966–67 was visiting professor at the Hochschule für Bildende Künste in Hamburg. In 1968 he became professor at the Vienna Academy and a member of the Secession. · Avramidis' dominant themes are the head, the human figure, and the group: man as an individual and as a social creature. His works chiefly comprise an upright figure rendered in a seemingly archetypal, stele-like fashion, representing the epitome of a human being. Of particular significance are the artist's drawings, which serve as a tool for natural observation; they are used to devise the anatomy for his three-dimensional work and to precisely plan the figure. These developmental design and thought process are encapsulated in the sculpture, where longitudinal and cross sections are cut out from aluminum and assembled; the structure is then filled with resin, plaster, wood, aluminum, and copper. S.P.

Bibl.: Avramidis, Nuremberg, 1980 · Avramidis, Stuttgart, 1986

Aycock, Alice. *1946 Harrisburg, Pennsylvania. American sculptor and advocate of → Conceptual art, living in New York. She studied at Douglas College, New Brunswick (1964–68) and Hunter College, New York (1968–71) with → Morris, holding teaching posts at the latter in 1972–73 and 1982–85. Her work is concerned with the mechanisms of the universe, with mysterious powers, magical events, ancient cultures, and emotionally charged memories. Thought processes, rather than historical or scientific context, are the central theme of her art. Aycock's style is marked by growth and continuous change: for her, a sculpture is merely the optimum that is achievable at the point of completion, since the ongoing thought process is not conclusively attainable in a single work (*Explanation, An, Of Spring and the Weight of Air*, 1979). S.P.

Bibl.: Labyrinth, Massachusetts, 1975 · Aycock, London, 1985

Ayres, Gillian. *1930 London. British painter, living in Wales. She studied at Camberwell School of Art (1946–50) and St Martin's School of Art (1966–78), and from 1978 to 1981 was head of the Department of Painting at Winchester School of Arts. She was elected a member of the Royal Academy in 1982. She moved to Wales in the early 1980s in order to devote herself entirely to painting. Ayres's pictures are closely related to European postwar abstraction as well as to American → Abstract Expressionism. In 1960 she participated in the Situation exhibition at the Royal Society of British Artists, submitting large-format, informal, spatially arranged color compositions on a neutral background (*Break-off*, 1961).

After 1978 she changed from acrylic to oil paint and from a → Tachiste concept of painting to plant-like ornamentation reminiscent of → Art Nouveau. H.D.

Bibl.: Ayres, Oxford, 1981 · Ayres, London, 1983

Azaceta, Luis (Cruz). *1942 Havana. Cuban-born painter and draftsman, living in Ridgewood, New York. He moved to New York in 1960 and studied at the School of Visual Arts (1966–69) with → Golub. The central motif of his oeuvre is urban violence, which he expressed initially in an abstract style with hard contours; this was modified in 1979 following the influence of → Bacon. From 1980, after contact with Latin American and European art (→ Grosz), he turned to depicting fear as experienced in a large city, through the use of garish colors, energy-charged forms, and grotesque, tortured figures, often self-portraits. More recent works deal with social themes, e.g. AIDS. S.P.

Bibl.: Torruella Leval et al., Azaceta, 1991 · Azaceta, New York, 1993

Azari, Fedele. *1895 Pallanza, Novara, †1930 Milan. Italian → Futurist and → Aeropittura artist also known as "Dinamo." In 1916 he became friends with → Boccioni and met → Marinetti in Milan. He was a reconnaissance pilot in World War I and joined the Futurists after the Armistice, subsequently publishing a manifesto, *Il teatro aereo-futurista*. Taught painting by → Depero, he used elements from his aerial photographs (e.g. *Prospettive di volo*, 1924–26). He later abandoned visual art for writing: his books include *Carlinga armoniosa* and *Il primo dizionario aereo italiano* (1929; with Marinetti), the latter a proposed "expansion" of the Italian language intended to evoke the modern sensations that flight was offering human experience. A drug addict, he suffered nervous breakdowns and underwent a course of detoxification during which he died. In Futurist circles a myth grew up that he had died heroically in an airplane accident. D.R.

Bibl.: Passoni, Aeropittura futurista, 1970

Baader, Johannes. *1875 Stuttgart, †1955 Adeldorf, Lower Bavaria. German architect, collage artist, and painter. He studied in Stuttgart at the Baugewerkschule (1892–95) and at the Technische Hochschule (1898–99). Between 1899 and

1902 he did architecture-related work in Dresden and Magdeburg. In 1905 he settled in Berlin, where he joined up with → Hausmann, who reinforced Baader's crude mixture of religious ideas of salvation and anti-bourgeois sentiments. From 1925 on (after 1945 in Bavaria), he worked as a journalist and architect. About 1920 he became an active member ("Ober-Dada," or "Head Dada") of the → Dada movement. He organized spectacular public scandals, contributed to the magazine *Der Dada* (1919–20) and the *Dada Almanac* (1920), and took part in the Dada Fair (1920). Influenced by Hausmann, he created large-scale collages, photomontages (*Dada Milky Way*, 1918–20), and assemblages. He was an advocate of noise-based sound poetry and the use of new materials in painting. K.S.-D.

Bibl.: Berguis, Baader, 1977

◄ Louise Bourgeois, *Cell, Three White Marble Spheres*, 1993, Glass, metal, marble and mirror, 213 x 213 x 213 cm, Saint Louis Art Museum, Missouri (see p. 57)

Baargeld, Johannes Theodor (Alfred Gruenwald). *1892 Szczecin, Poland, †1927 Mont Blanc area (climbing accident). German draftsman, collage artist, photographer, and poet. A self-taught artist, he was active between 1919 and 1921. Sometimes calling himself "Zentrodada," he was part of the → Dada movement in Cologne with → Ernst and → Arp. Protesting against traditional easel painting, he created collages (*Typische Vertikalklitterung als Darstellung des Dada Baargeld*, 1920), combinations of objects out of everyday materials and junk (*Antropofiler Bandwurm*, 1920), photomontages, assemblages, and typescripts. With his automatic drawings, he was a precursor of → Surrealism and → Tachisme. Largely lost, his work was only rediscovered in the 1970s. K.S.-D.

Bibl.: Vitt, Zentrodada, 1985

Francis Bacon, *Three Studies for Figures at the Base of a Crucifixion*, 1944, Oil and pastel on hardboard, each panel 94 x 74 cm, Tate Gallery, London

Bacon, Francis. *1909 Dublin, †1992 Madrid. British painter. After moving to London in 1925,

Francis Bacon, *Two Studies for a Portrait of George Dyer*, 1968, Oil on canvas, 198 x 147.5 cm, Sara Hildén Art Museum, Tampere, Finland

Bacon worked for a while as an interior designer. He then went to live in Paris and Berlin, returning in 1929 to settle permanently in London, where he continued interior decoration work until 1931. With no formal training, he then took up painting. Inspired by → Cubism and → Surrealism, he produced his first oil paintings, among them a series of crucifixions (*Crucifixion*, 1934). Dissatisfied with the results, Bacon abandoned painting, only returning to it in 1944. His triptych *Three Studies for Figures at the Base of a Crucifixion* (1944), images redolent of angst and war atrocities, caused considerable controversy when it was exhibited in the Lefevre Gallery in 1945. His *Painting* (1946) combines the central themes of his work: distorted bodies, screaming mouths, and the Cross – not as a symbol of redemption, but as a sign of martyrdom; it shows man at the fulcrum of violence and despair, aggression and pain. The portrait series begun by Bacon in the 1950s (notably the screaming pope paintings after Velázquez, 1951–65) are vivid studies of socially produced deformations of the individual. The distinctively colored portraits of his friends are characterized by the gestural brushworks smearing the heads beyond recognition (portraits of George Dyer and Isabel Hawthorne, 1966–67). Between 1972 and 1974 came the *Black Triptych* series, prompted by the death of Dyer. Bacon placed his figures in a complicated spatial structuring, with surreal proplike furniture and cagelike bars. After 1970 his pictures were more clearly defined and the pictorial framework was calmer. The colors were generally brighter, with radiant oranges and reds predominant. These later works, however, retained the intense expressive power of his earlier paintings.

Bacon's paintings show both man's vulnerability and his innate cruelty. His choice of the triptych lends additional emotional power to his highly expressive scenes. Bacon drew inspiration not just from the history of art (Rembrandt, Grünewald, El Greco, → Picasso, and van Gogh),

but also from the cinema and photography (Muybridge). Numerous retrospectives were devoted to him during his lifetime (Solomon R. Guggenheim Museum, New York, 1963–64; Grand Palais, Paris and Städtische Kunsthalle, Düsseldorf, both 1972; Tate Gallery, London, 1962 and 1985; Nationalgalerie, Berlin, 1985). H.D.

Bibl.: Rothenstein, Bacon, 1964 · Sylvester, Bacon, 1982 · Davies, Bacon, 1986 · Schmied, Bacon, 1996

Baj, Enrico. *1924 Milan. Italian painter, collage artist, and journalist living in Vergiate, Varese, Italy. He was a member of Movimento Nucleare, and editor of the *Manifesto della pittura nucleare* (1952), the manifesto *Contro lo Stile* (1957), and (with → Jorn) of the magazine *Il Gesto* (1955–58). He began in the early 1950s with "nuclear" paintings, in which he combined techniques of → Art Informel with a dynamic sign language symbolizing the forces of the atomic world. Then he focused on collages (oil painting with fabric, cotton wool, haberdashery, and colored glass), works in wax crayon (*Montagne*) and pictures made with shards of broken mirror (*Specchi*). Influenced by Nordic → Expressionism, the → Cobra group, and the themes of the → Dadaists and → Surrealists, his output has ranged from caricatures in a naive style to works commenting on contemporary issues. Baj is concerned with power and violence (*Apocalisse*, 1978–83) as well as the myths and fantasies of our age (*Metamorfosi e metafore* series, 1988). K.S.-D.

Bibl.: Baudrillant, Baj, 1980 · Mussini, Baj, 1990

Bakst, Léon (Rosenberg, Lev Samoylovich). *1866 Grodno, Belarus, †1924 Paris. Russian set designer and painter. After studying at the Academy of Arts in St. Petersburg (1883–87), he began illustrating (influenced by Vrubel) in 1888, signing himself "Bakst" from 1889. He met Albert Benois in 1890 and joined Mir Iskusstva (→ World of Art) with Sergei Diaghilev in 1898. Early set designs were for the Aleksandrinsky (*Hippolytus* [1902/4], *Oedipus Rex* [1904]) and Maryinsky Theaters in St. Petersburg, where he met the writers Gorky, Andreyev, and Biely, of whom he sculpted a bust. In 1907, he began collaborating with choreographer Michel Fokine on ballet costumes and sets

(*Cléopâtre*, 1909). He assisted Diaghilev with the Ballets Russes (1909); his costumes for Nijinksy influenced Paul Poiret. Collaborations with Diaghilev included designs for Rimsky-Korsakov's Orientalist *Schéhérazade* and Stravinsky's daring *L'oiseau de feu* ("Firebird"), both premiered in 1910, and *L'après-midi d'un faune* (Debussy, based on Mallarmé) two years later. A Jewish exile, Bakst settled in Paris permanently in 1912. No modernist, his uninhibited, sensual designs possess a rococo intricacy of line. As well as his designs for the theater he also produced some evocatively chic portraits, a number of which have a humorous streak (*Supper*, 1902–a female in a low-cut dress and outlandish hat). D.R.

Bibl.: Levinson, Bakst, 1924 · Pruzhan, Bakst, 1987

Baldessari, John . *1931 National City, California. American Conceptual artist living in Santa Monica. He studied at San Diego State College (1949–53, 1955–57), the University of California, Berkeley (1954–56), and at the Otis Art Institute and Chouinard Art Institute in Los Angeles (1957–59). In 1970 he moved to Santa Monica in California and began teaching at the California Institute of the Arts, Los Angeles. Influenced by Marcel → Duchamp, Baldessari began in the early 1960s with experimental works, in which he sought to overcome the traditional boundaries of the artistic genres. After overpainting posters and photos, he created photo-stories with textual commentaries, revolving thematically around art and the artist. In the 1970s he produced series of photos, short feature films, and videos dealing with the intentions of contemporary artists such as → Cage, → Beuys and → Paik. Since the 1980s he has been working on film images with psychologically oriented themes (*Virtues and Vices*). H.D.

Bibl.: Van Bruggen, Baldessari, 1990

Baldwin, Michael. *1945 Chipping Norton, Oxfordshire, England. British Conceptual artist and sculptor living in Hortley, Northamptonshire. He studied at Coventry College of Art (1964–67) and lectured at Lanchester Polytechnic and Leamington School of Art (1969–71). He was a co-founder with Terry Atkinson, David

Stephan Balkenhol, *Large Head (Man)*, 1991, Some polychrome, height 103 cm, plinth 52 x 66 x 100 cm, Städtische Galerie im Lenbachhaus, Munich

Stephan Balkenhol, *Large Head (Woman)*, 1991, Some polychrome, height 103 cm, plinth 52 x 66 x 100 cm, Städtische Galerie im Lenbachhaus, Munich

Bainbridge, and Harold Hurell of the group → Art & Language. H.D.

Bibl.: Compton, British Art, 1987

Balkenhol, Stephan. *1957 Fritzlar, Hesse, Germany. German sculptor living in Hamburg and Edelbach, Spessart. He studied at the Hochschule für Bildende Künste in Hamburg under Ulrich Rückriem (1976–82). Since 1991 he has been teaching at the Akademie in Karlsruhe. Balkenhol's work centers on the depiction of people. In 1982 he started producing heads which are smaller or larger than life-size. These conjure up the archetypal human in a peaceful state, without narrative intention, balancing individualization and stylization. He has also produced animal pieces and still lifes. He works chiefly in wood, stone, and cement. Surfaces are treated in an expressive manner, accentuated by the use of color, that both emphasizes the materials and leaves visible traces of the sculptural process. Since 1990 he has also produced Conceptual works and sculptural installations, which he attempts to integrate into public spaces by installing them at significant sites. K.S.-D.

Bibl.: Brenken, Balkenhol, 1989

Ball, Hugo. *1886 Pirmasens, Germany, †1927 Sant'Abbondio near Lugano, Switzerland. German writer and dramatist. He promoted Expressionist theater and co-founded the → Cabaret Voltaire, thereby helping to pave the way for the → Dada movement, of which he was a member until 1917. Along with the other members of his circle, which included → Arp and → Tzara, Ball was intent on creating a new artistic movement free from the 19th century's cult of the genius, and hostile to petty bourgeois ideology and academic dogma. K.S.-D.

Bibl.: Ball, Munich, 1986

Balla, Giacomo. *1871 Turin, †1958 Rome. Italian painter, one of the leading → Futurist artists. Self-taught, in 1893 he embraced → divisionism. During a visit to Paris in 1900, he became acquainted with French → Neo-Impressionism. On his return to Rome, Balla shared a studio with → Boccioni and → Severini, instructing them in

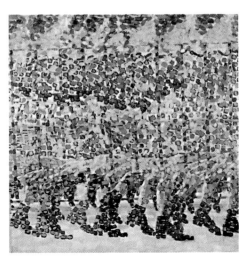

Giacomo Balla, *Walking Girl on a Balcony*, 1912, Oil on canvas, 125 x 125 cm, Civica Galleria d'Arte Moderna, Milan

Giacomo Balla, *Mercury Passing Before the Sun*, 1914, Oil on paper, 61 x 50.5 cm, Musée National d'Art Moderne, Centre Georges Pompidou, Paris

Divisionist technique. He was a co-signatory of the first *Futurist Manifesto*, published by → Marinetti in 1909. A year later he co-authored with Boccioni, → Carrà, Severini, and → Russolo the *Manifesto tecnico della pittura futurista*, which laid the foundations of Futurism. In 1915 Balla supported Italy's entry into the war, painting patriotic pictures. In 1926 he participated in the Venice → Biennale, which had a separate Futurist section, and in 1929, together with Depero and Prampolini, he drew up the *Manifesto dell'aeropittura*. Subsequently Balla turned away from the Futurists, breaking with them altogether in 1937. Following a Neo-Impressionist phase, from 1909 he devoted himself to Futurist experiments concerned with speed and motion, which found clear expression in three works of 1912 (*Dynamism of a Dog on a Leash*; *Little Girl Running on a Balcony*; *The Violinist's Hand*), pictures evincing a direct link with the chronophotographs of Marey and Muybridge. His studies of motion developed toward abstract pictures representing penetrating rays of light (*Compenetrazioni iridescenti*). The motion of an automobile is broken down into geometrical dynamic elements (*Velocità Automobile-luci-rumori*, 1913). Balla also took an interest in the plastic and applied arts. His *Complessi plastici*, objects made of cardboard, fabric, silver foil, wire, mirrors, and colored glass, anticipate → Dada montages and → Constructivist ideas. Later on, he created works characterized by a synthesis of kinetic sequences and abstract designs based on mystical ideas (*Mercury Passing across the Sun*, 1914). This metaphysical orientation is also evident in his postwar works, such as *Lines of Force and Landscape* (1918). In his late work Balla returned to conventional figurative painting. H.D.

Bibl.: Martin, Futurist Art, 1968 · Lista, Balla, 1982 · Balla, Con Balla, 1984–86

Balthus (pseudonym of Balthazar Klossowski de Rola). *1908 Paris. French painter and graphic artist living in Rome and in Rossinière in the

Balthus, *The Street*, 1933, Oil on canvas, 195 x 240 cm, The Museum of Modern Art, New York

Balthus, *The Three Sisters I*, 1960–65, Oil on canvas, 130 x 195 cm, Private collection, Paris

Gruyère Valley, Switzerland. He spent his childhood in the milieu of Gide, → Bonnard, and Rilke, the latter encouraging his artistic talent and later helping to fund him. He went to Paris in 1923 to become a painter, producing drawings after the old masters and copying Poussin's *Echo and Narcissus*. The following year he traveled to Italy, where he studied the works of Masaccio and Piero della Francesca in Florence, Arezzo, and Siena. He did military service in Morocco (1929–33), after which he lived first in Switzerland and then, following the end of World War II, in Paris, where he befriended Camus and Malraux. From 1954 to 1961 Balthus lived as a recluse in Château de Chassy near Paris, then becoming director of the Académie de France in Rome (1961–76). In his early work Balthus assimilated influences from the Impressionists and the → Nabis (Bonnard). In the 1930s he was in contact with artists and writers, and made illustrations for Emily Brontë's *Wuthering Heights* (1935). He first gained recognition with the picture *The Street* (1933). In 1938 Balthus had his first exhibition in the US (Pierre Matisse Gallery, New York), which established his reputation as a painter of classically balanced but erotically charged paintings with Surrealist overtones.

His pictures predominantly present adolescent girls either lost in thought or engrossed in some Muse-like occupation. Through their exquisite colors, lighting reminiscent of Renaissance models, and the artificiality of the poses, these profane scenes take on a dreamy, unreal atmosphere that makes Balthus' painting a unique phenomenon in 20th-century figurative art (*The Three Sisters I*, 1960–65). Rooted in the classical tradition, his pictures are extraordinarily austerely structured, but show, in the unclear arrangement of their pensive isolated figures, a Surreal tendency that suggests the influence of his brother, the writer Pierre Klossowski, as well as of other Surrealist literary figures. Balthus also designed stage sets and costumes for theater and opera productions, including Shakespeare's *As You Like It*, Antonin Artaud's *Les Cenci*, Mozart's *Così fan tutte*, and Albert Camus's *L'État de siège*. H.D.

Bibl.: Leymarie, Balthus, 1982 · Balthus, Paris, 1983 · Rewald, Balthus, 1984 · Balthus, Lausanne, 1993

Barker, Clive. *1940 Luton, England. British sculptor and graphic artist living in London. He studied at the Luton College of Technology and Art (1957–59). Barker creates precisely replicated everyday objects, such as balls of wool, in chromium-plated bronze, as well as models from the pictures of well-known artists, such as → Picasso's *Wine Bottle or Antlers* or van Gogh's *Chair*. The ironic, cryptic quality involved in this links Barker's work with → Neo-Dada and → Pop art. The artist also makes silkscreen prints (*Homage to Magritte*). I.H.

Bibl.: Spalding, Barker, 1982

Barlach, Ernst. *1870 Wedel/Holstein, Germany, †1938 Rostock. German sculptor, graphic artist, and writer. He studied at the Hamburg Kunstgewerbeschule (1888–91), the Dresden Akademie (1891–95), and the Académie Julian in Paris (1895–96). Between 1891 and 1908 he did drawings for the magazines *Jugend* and *Simplicissimus*, and produced his first experiments in monumental sculpture in a style approximating to → Jugendstil and → Symbolism. After living in Altona and Hamburg (1898–99), he settled in Berlin, where he became a member of the → Secession and of the Preussischen Akademie (1919–37). He taught at the Fachschule für Keramik in Höhr, Westerwald (1904–05). In 1906 he visited Russia, and in 1909 went to Florence (Villa Romana scholarship). After his 1906 trip to Russia, he developed his own formal and thematic language, influenced by Russian folk art, → Expressionism, and medieval mysticism (Barlach saw himself as spiritually related to medieval woodcarvers). In 1910 he settled in Güstrow. Denounced by the Nazis as "degenerate," 381 of

Ernst Barlach, *Güstrow Memorial*, 1927/42, Bronze, 71 x 74.5 x 217 cm, Schleswig-Holstein Landesmuseum, Schloß Gottorf, Schleswig

Ernst Barlach, *Sorrowful Woman*, 1910, Oak, height: 66 cm, Ernst Barlach Haus, Hamburg

his works were seized in 1937. In his wood and bronze sculptures, the human body became the medium of a symbolically exaggerated representation of existential, often woeful feelings and situations (hunger, misery, sorrow, despair). Sustained by a deeply religious commitment, Barlach saw in the wretched and rejected "simultaneously the adverse, the comic, … and the divine." His heavy, massive, blocklike figures are characterized by simplification (absence of detailing even on the faces), stylization, monumental form, and a closed linear outline (*Sorrowful Woman*, 1910; cycle of wooden sculptures on the theme of the berserker [mythological Norse warrior], 1910–16; *The Fugitive*, 1920; *Old Woman Crouching*, 1933). After 1926, he turned increasingly to architecture-related sculpture, producing among other things the Güstrow Memorial, (1927); figures for the unfinished facade of the church of St. Katharinen in Lübeck (1930–32); and *Warrior of the Spirit* (1938). The fundamental spiritual polarities of life are also the principal themes of his visionary Expressionistic Symbolist writing (e. g. *Der Tote Tag*, 1912; *Der blaue Boll*, 1926), which he often illustrated with his own woodcuts and lithographs. Barlach's symbolic, expressive realism pointed the way for the woodcarving of → Kollwitz and → Marcks (see → Baskin). K.S.-D.

Bibl.: Schult, Barlach, 1958–71 · Werner, Barlach, 1966 · Jackson-Groves, Barlach, 1972

Barney, Matthew. *1967 San Francisco, California. American painter Barney's work is a fusion of sculpture, performance art, and video, incorporating objects cast in Vaseline, acts of sheer athleticism, and video stills presented in "self-lubricating frames." His first New York solo exhibition was held at the Barbara Gladstone Gallery in 1991. Physical eccentricity and self-imposed restraint are key to Barney's work and can be linked, in part, to his preoccupation with two anomalies: Jim Otto, the former Oakland Raiders football star who played with two prosthetic knees, and Victorian-era escape artist Harry Houdini. Since 1988 Barney has used an "0" bisected by a horizontal line to represent these concepts, an emblem that appears, in varies guises, throughout his 42-minute video *Cremaster 4* (1995) – the first in a five-part epic dealing with physical and sexual potentiality. At the relatively young age of 29, Barney was the subject of a traveling retrospective. His work has been featured in Documenta 9 and the 1993 Venice Biennale. C.S.

Bibl.: Barney, Hamburg, 1996

Barry, Robert. *1936 New York. American Conceptual artist living in Teaneck, N.J. He studied at Hunter College in New York (1957–63), where he also taught (1964–77). Up to 1967 he produced serial pictures in a Minimalist style. In 1968 he turned to Conceptual works with nylon thread and invisible materials (such as glass, radio waves, noble gases), in which his aim was to create a nonmaterial reality (*Inert Gas Series*, 1969). These works became purely intellectual processes which could often only be communicated through words. Eluding attempts to take possession of them directly, they occupy the intermediate zone between idea and pure visualization,

emerging from the thematization of word and text. From 1977, Barry focused almost exclusively on text-based works (for example, tautologies), often in the form of slide projections, which in the 1980s he combined with visual signals (color, geometrical signs, and photos). K.S.-D.

Bibl.: Morgan, Barry, 1986

Bartlett, Jennifer. *1941 Long Beach, California. American painter and sculptor. Bartlett studied at the School of Visual Art, New York (1972–77), and her early painting betrayed a tendency toward neo-Post-Impressionism. She subsequently moved toward → Conceptual concerns, working in enamel steel plates, and then adopted a more painterly approach in the mid-1980s. Now working out of New York, she combines elements from these two phases. Her installations integrate painting and colored sculpture in a dialogue between two and three dimensions: themes include ethnological references (e. g. unseaworthy indigenous seacraft), domestic or vernacular architecture, and dreams of escape. In 1995 Bartlett exhibited figures in reinterpreted folk dress. More recently she was involved in an ambitious project to transform a railway warehouse in Greenwich Village, New York (1997). D.R.

Bibl.: Bartlett, Milwaukee, 1988

Baselitz, Georg. *1938 Deutschbaselitz, Saxony, Germany. Original name Georg Kern. German painter and sculptor living in Derneburg near Hildesheim and in Imperia, Liguria. After he was forced to break off his studies at Weissensee Kunsthochschule in East Berlin, owing to "sociopolitical immaturity," he moved in 1957 to West Berlin and studied at the Hochschule für bildende Künste under Hann Trier. During the 1960s, he wrote (in collaboration with → Schönebeck) his two programmatic texts the *Pandemonic Manifestos*, stayed at the Villa Romana, and had his first exhibitions at the Werner und Katz gallery in Berlin (1963), during which his *Great Piss-up* (or *Big Night Down the Drain*) and *Naked Man* were seized by the public prosecutor's office on the grounds of pornography. He also married and became the father of two sons, moving in 1966 to Osthofen, near Worms. In 1971 he relocated his studio to Forst an der Weinstrasse, then in 1975 to Derneburg. After teaching at Karlsruhe Art Academy from 1977–83, he was a professor at the Berlin College of Art until 1988.

A loner from the outset, Baselitz went against the prevailing abstract art of the time and devoted himself to figurative painting. What interested him above all, however, was purely painterly exploration and pictorial invention. He defamiliarized the subject first through segmentation and then by disturbingly turning his motifs upside down, thereby creating an idiosyncratic pictorial freedom (1969). This "aggressive disharmony" was intended to disturb the depiction of a reality that had become questionable. Drawing on themes alluding to Germany's past and using figures of massive corporeality (for example *Great Friends* and *The Rebel*, both 1965), he turned to everyday subjects such as heads, nudes, flowers, and still lifes, often in series. In his complex, formally restrained, radiantly colored compositions,

Georg Baselitz, *The Rebel*, 1965, Oil on canvas, 162 x 130 cm, Tate Gallery, London

Georg Baselitz, *The Orange Eaters IV*, 1981, Oil and tempera on canvas, 146 x 114 cm, Staatsgalerie Moderner Kunst, Munich, loan by Prince Franz of Bavaria

he achieves a monumentality of often visionary vividness, an → Expressionism *sui generis*. Most recently, abstract tendencies have predominated. No less original is his output of outsize, sparingly painted, crudely carved wood sculptures as well as drawings and graphic works. L.Sch.

Bibl.: Baselitz, London, 1983 · Franzke, Baselitz, 1988 · Waldemar, Baselitz, 1995

Baskin, Leonard. *1922 New Brunswick, N.J.. American sculptor, graphic artist, draftsman living in England. He studied under Maurice Glickman (1937–39), then at New York University (1939–41), Yale School of Fine Arts, New Haven (1941–43), New School of Social Research, New York (1949), Académie de la Grande Chaumière, Paris (1951), and the Accademia in Florence (1951). In 1952 he founded the Gehenna Press in Northampton, Mass. Baskin's work consists of sculptures (mostly in wood and bronze) and prints (woodcuts, etchings, lithographs, and linocuts). He has stated that "man and his condition have been the totality of my concern," and his work endlessly explores the themes of human cruelty, misery, death, and the loss of spiritual values (*Dead Man*, 1961). In parallel Baskin has created portraits dedicated to the artists he admires (*Ernst Barlach*, woodcarving, 1959). He has also illustrated poems by William Blake and Ted Hughes. H.D.

Bibl.: Jaffe, Baskin, 1980

Basquiat, Jean-Michel. *1960 Brooklyn, †1988 New York City. American graffiti artist, painter and draftsman. The son of a Haitian father and Puerto Rican mother, he enjoyed a meteoric rise to fame. While still a minor he left his broken home and school, becoming a part of the New York underground. Progressing rapidly from occasional pub-club musician and graffiti painter in Soho and the Bowery (signing himself as SAMO) he took courses and taught himself to paint. He became friends with → Warhol and → Clemente, collaborating several times with them. He exhibited at Documenta 7 in Kassel and in prestigious galleries in the US and Europe, and was the subject of a special feature in *The New York Times*. He died at the age of 27 from a drugs overdose, leaving behind more than 100 paintings and objects as well as 2,000 drawings.

His oeuvre is characterized by a combination of the magic of black African traditions, to which he referred persistently, and the modern repertoire of motifs from the feverish metropolis. Graffiti gesticulations, children's drawings, comic-book figures, obscene wall scrawlings, pictograms, advertising slogans, and details from town plans are mixed with African masks, totemic figures, visionaries, crocodiles, and elephants. They form an amalgam of symbolic pictures and pictorial and script-based signs in intense colors, often on a black ground. The spectrum of his techniques ranges from painted and sprayed assemblages made out of junk through murals and panels to oil paintings and graphic art. L.Sch.

Bibl.: Basquiat, New York, 1990 · Gruen, Basquiat, 1991 · Marshall, Basquiat, 1992

Bateau-Lavoir (French = wash-boat). A complex of artists' studios in Montmartre, Paris (now destroyed). It was the poet Max Jacob who gave it the name "Bateau-Lavoir" when he compared the dilapidated premises on what is now Place Émile-Goudeau with the laundry boats on the Seine. In 1904 → Picasso took a studio in the building, where he painted *Les Demoiselles d'Avignon*, the fountainhead of → Cubism. Poets such as Pierre Reverdy and Guillaume Apollinaire met up with painters there, developing a theory of Cubism.

Jean-Michel Basquiat, *K*, 1982, Acrylic on canvas, 183 x 102 cm, Galerie Bruno Bischofberger, Zürich

The Dutchman van → Dongen came in 1905, and in 1906 → Gris. In 1908 the Bateau-Lavoir was the venue of the celebrated banquet in honor of the customs official and Sunday painter → Rousseau. Until 1920 a steady stream of artists and writers passed through the studios, among them → Utrillo, → Vlaminck, → Derain, → Modigliani, → Dufy, → Laurencin, Leo and Gertrude Stein, and → Cocteau. However, the Bateau-Lavoir had already lost its attraction by 1912, when Picasso abandoned his studio there. When in 1970 it was scheduled to be turned into a museum, a fire broke out, destroying the building before restoration work could begin. H.D.

Bibl.: Warnod, Bateau-Lavoir, 1976

Bauhaus. New type of art college founded in 1919 by the architect → Gropius in Weimar. The idea behind the institution was to reunify the fine and applied arts to permit cooperative, quality-conscious work appropriate to the times (see → Deutscher Werkbund). Primacy was to be given to architecture, into which the other artistic genres were to be reintegrated. At the Bauhaus (German = "house of building"), in the space of just 14 years (1919–33), ideas were pioneered that were subsequently to have a profound and lasting influence on developments in architecture, the visual arts, and design. The school developed an architectural doctrine whose basic principles remain valid today; aesthetic norms were established for domestic industrial products (today subsumed under "design"); and completely new concepts in the teaching of art were elaborated and taught by important painters from the circle of → Der Sturm and the → Blaue Reiter, such as → Klee, → Kandinsky, L. → Feininger, → Itten, → Muche, and → Schlemmer. Gropius had formulated his objectives, which envisaged the bringing together of art and technology as a guideline for functional construction, as early as 1910. He had the opportunity to realize them when he succeeded van de → Velde at the Weimar Kunstgewerbeschule, founded in 1906. In 1919 the school was merged with the former Weimar Kunstakademie to create the Staatliche Bauhaus Weimar. The inaugural phase (1919–24) in Weimar was characterized by a rapturous, late-Expressionist spirit (foundation manifesto with title woodcut by Feininger, *Cathedrals of Socialism*, 1919). Each workshop was headed jointly by an artist and a craftsman, the stabilizing element being Itten's preliminary course, which laid solid foundations for subsequent study. In 1923, as a result of differences, Itten was replaced by → Moholy-Nagy, who supported the embracing of Constructivist tendencies at the Bauhaus. The new motto in this so-called consolidation phase (1923–28) was "Art and technology – a new unity," implying greater cooperation with industry, and changes in the way the workshops functioned. When funds were cut by right-wing parties, the Weimar Bauhaus was obliged to close, but backing was soon found for the school to reopen in Dessau in a new building. Designed by Gropius, this building houses today the Stiftung Bauhaus (Bauhaus Foundation), which looks after the school's historical legacy and organizes research projects and seminars. The change of location was accompanied by an increase in teaching and production. With Hannes Meyer succeeding Gropius (who left the Bauhaus in the spring of 1928 under pressure from conservative right-wing groups), but also as a result of internal wrangling, the third phase began (1928–33), also known as the "disintegration" phase. Meyer, who was hostile to any "Bauhaus aesthetic," shifted the focus to mass-produced goods, while the combination of the fine and applied arts took a back seat. With the involvement of the Bauhaus workshops, the Gewerkschaftsschule came into being in Bernau near Berlin, which produced affordable "people's furniture." J. → Albers, responsible for the foundation course from 1928, transformed the rounded integrated elementary training into economically oriented materials testing. When ideological tensions threatened to trigger an internal

Bauhaus, *Poster by Joost Schmidt for the Bauhaus exhibition in Weimar*, 1923, Bauhaus Archive (BHA Inv. 748)

crisis in the Bauhaus, Meyer was dismissed. At Gropius's suggestion, the architect Mies van der Rohe was appointed director in the summer of 1930, and as a result The Bauhaus became a purely architectural school. In the summer of 1932, closure of the Bauhaus was approved by Dessau town council. Mies van der Rohe re-opened the school as a private enterprise in a disused Berlin telephone factory. In April 1933 the school was investigated by the Gestapo and temporarily closed. It closed down for good on July 19. Through the emigration of many of its lecturers, the ideas and teaching methods of the Bauhaus continued to spread, especially to the US (Albers at → Black Mountain College; Moholy-Nagy at the New Bauhaus in Chicago; Gropius at Harvard University). After the war, former Bauhaus staff also took up important positions in Europe as architects and designers in art colleges and practices. H.D.

Bibl.: Wingler, Bauhaus, 1962 · Whitford, Bauhaus, 1984 · Dearstyne, Bauhaus, 1986 · Droste, Bauhaus, 1990

Baumeister, Willi. *1889 Stuttgart, †1955 Stuttgart. German painter. He studied at the Akademie in Stuttgart (1905–1922). He was influenced by Neo-Plasticism and Purism, and in 1924 got to know → Le Corbusier and → Léger. From 1928 he taught at the Kunstgewerbeschule Frankfurt am Main, in 1930 he became a member of → Cercle et Carré in Paris, and in 1931 he joined → Abstraction-Création. In 1933, relieved of his teaching post, he returned to Stuttgart. In 1941 he was prohibited from exhibiting, and in 1943 he moved to Urach. He was appointed professor at the Akademie in Stuttgart in 1946, and deputy director in 1951. Baumeister, one of Germany's most distinguished abstract painters, adopted an abstract idiom early on. In 1914 he received a commission, together with → Schlemmer, for a frieze at the Cologne Werkbund (crafts association) exhibition. In 1919 he created his "wall pictures," clearly structured works with colored relief-like surfaces which contain a figure reduced to basic geometrical forms. The pictorial ground is textured by the addition of sand and gravel. His interest in texture and the treatment of surface is evident in subsequent works, notably the abstract compositions done in 1930 on a sand ground, in which the figural is still evident (*Stehende Figur mit blauer Fläche*, 1933). In his "ideograms" series of 1938, Baumeister depicted originally organic shapes reduced to ciphers. From 1938 to 1940 he created his "Eidos" images,

Willi Baumeister, *Montaru 7b*, 1953, Oil on cardboard, 130 x 100 cm, Baumeister Archive, Stuttgart

at the "Darmstädter Gesprächen" (Darmstadt Discussions), he vigorously opposed the "denigration" of modern art (Sedlmayr). W.G.*

Bibl.: Baumeister, 1960 · Grohmann, Baumeister, 1963 · Haftmann, Baumeister, 1976 · Bott, Baumeister, 1990

Baumgarten, Lothar. *1944 Rheinsberg, Germany. German multimedia artist living in Düsseldorf. He studied at the Karlsruhe Kunstakademie (1968) and the Düsseldorf Kunstakademie under → Beuys (1969–71). He taught at Münster Kunstakademie (1975–76) and the Hochschule für Bildende Künste, Hamburg (1983–84). Since 1970 he has made regular working trips to North and South America. Baumgarten's art grows out of his interest in ethnology. On visits to native tribes in the Amazon area, he studies their customs and practices, languages and myths, using this material for his photographic books, films, objects, → environments, and → installations. Different materials are combined and linked with texts (*Land of the Spotted Eagle*, 1983). Since 1986 Baumgarten has turned to his own cultural milieu. Frequently his works result from a dialogue with the site of their creation or relate to past events there (*Drei Irrlichter*, 1987, installation in the Anabaptist cages of the Lamberti-Kirche in Münster). H.D.

Bibl.: Baumgarten, Mönchengladbach, 1983

Willi Baumeister, *Afrikanisch-Afrikanische Erzählungen*, 1950, Silkscreen print, 55 x 62.5 cm, Staatsgalerie Stuttgart

in which soft vegetable forms and organic as well as anthropomorphic elements replace the earlier geometrical abstractions (*Eidos V*, 1939). From 1940 his interest in prehistoric painting led him to produce works composed of ethnological scripts and symbolic forms in dark colors on a pale ground (*Abu Sin*, 1940; *Illustrations for the Gilgamesh Epic*, 1943). After the war, his palette lightened, and a playful element entered the colors and shapes of his metaphysical landscapes. Baumeister again broke new ground with his series *Montaru, Montari and Aru* (1953–55), in which black or white forms fill the picture, while smaller colorful accents play around or permeate them. Thanks to his book *Das Unbekannte in der Kunst* (The Unknown in Art), which was published in 1947 and advocates an ethically motivated, nonrepresentational art, Baumeister ranks alongside → Klee and → Kandinsky as one of Germany's most important artist – theorists. In 1950,

Bay Area Figuration. A term applied to a group of painters from the San Francisco area, whose work was characterized in the 1950s by → Abstract Expressionism. Among its most important members were Elmer Bischoff (1916–91), → Diebenkorn, and David Park (1911–60), who all studied at the California School of Fine Arts. H.D.

Bayer, Herbert. *1900 Haag, Upper Austria, †1985 Santa Barbara, California. Austrian-born painter, photographer, graphic designer, typographer, and architect. In 1919–20 he worked in the office

of the Linz architect Georg Schmidthammer, then as assistant to the architect Josef Emanuel Margold in the Darmstadt artists' colony. Between 1921 and 1923 he studied at the Weimar Bauhaus and in 1925 became head of the printing and advertising workshop at the Dessau Bauhaus. He left the Bauhaus in 1928 to devote himself to his own work. Bayer moved to Berlin, where he worked as an advertising artist and was art director of the Dorland advertising agency. In 1938 he emigrated to the US, moving in 1946 from New York to Aspen, Colorado. He won numerous prizes and awards including the Austrian Cross of Honor for Science and Art, 1978. In addition to his typographic work at the Bauhaus, he also produced advertising posters of the 1930s; he was the first to combine graphic, photography, and typography. After emigrating to the US, he designed major shows, such as the Bauhaus exhibition in the Museum of Modern Art, New York. His paintings and photomontages of the 1920s and 1930s show the influence of Surrealism, although subsequently geometrical structures predominated (*four striped squares*, 1973). H.D.

Bibl.: Bayer, Berlin, 1982 · Cohen, Bayer, 1984

Bazaine, Jean. *1904 Paris. French painter, art theorist, and designer. From 1922 in Paris he studied sculpture at the École des Beaux-Arts, and then literature, art history and philosophy at the Académie Julian. In the 1950s he became a leading representative of the → École de Paris. His abstract paintings are based on dynamic color structures, and incorporate mimetic elements (deriving from natural impressions). At the same time they eschew geometric construction, stressing the importance of color, for example in the subject of the four elements water, earth, air, and fire (*Entre la pierre et l'éau*, 1964). Starting from the idea of a structural unity of man and nature, Bazaine creates an "abstract humanism" reminiscent of Monet's (see → precursors) late work (*Waterlilies*). The dynamization and breaking up of the traditional pictorial space, and progressive fragmentation and dissolution of form, culminate in architecture-related spatial designs (stained-glass windows, mosaics, wall hangings), some of which were public commissions. After 1968 Bazaine simplified his color range, returning to more monumental forms and more dramatic compositions. K.S.-D.

Bibl.: Cabanne, Bazaine, 1990

Baziotes, William. *1912 Pittsburgh, Pennsylvania, †1963 New York. American painter. He studied at the National Academy of Design, New York (1933–36), then worked for the Federal Art Project as teacher and artist (1936–41). In 1948 he co-founded with → Hare, → Motherwell, → Newman, → Rothko, and → Still the Subjects of the Artist School, the cradle of → Abstract Expressionism in America. From 1949 he taught at various New York art schools. Initially painting in a naturalistic manner, from 1941 Baziotes began to paint abstracts, influenced by the works of → Miró and → Masson. Between 1946 and 1948 he produced landscapes peopled by exotic beings from an imaginary submarine world. From the

1950s his painting was characterized by relatively large shapes and biomorphic figures (*Red Landscape*, 1957). H.D.

Bibl.: Baziotes, New York, 1965

Bearden, Romare. *1912 Charlotte, North Carolina, †1988 New York City. American painter and collage artist. Bearden studied under → Grosz at the → Art Students League (1937–38) and later became a university lecturer in Afro-Caribbean art. These two influences are paramount in work that delineates the social culture of Black American populations. Turning away from an initial abstract phase, he produced highly charged → Cubist- or → École de Paris-like paintings incorporating Black figures. His move to collage combined with paint, from 1961, extended his range. Becoming a member of the artistic collective the Harlem 306 Group, his themes included historical elements from his culture (voodoo, jazz, folk music). Less inclined to comment acerbically on oppression than to refer ironically to a quotidian if dream-like existence (*Madame's White Bird*, 1975), Bearden's art provides a glimmer of paradise in the street. His late work also employed watercolor. D.R.

Bibl.: Conwill et al., Bearden, 1991

Beaton, Cecil. *1904 London, †1980 Broadchalke near Salisbury, England. British photographer. He studied history and architecture at St John's College, Cambridge (1922–25). Between 1926 and 1930 he worked as a freelance portrait and fashion photographer. From 1938 he was court photographer to the British royal family. Beaton was one of the most successful of British portrait and fashion photographers. Characteristically his images have elaborately constructed decors and backgrounds, often with reflective materials, in which the model is only a part of the overall scene. Between 1939 and 1944 he documented the effects of World War II in London, North Africa, China, and India. After 1945 he also worked as a successful set and costume designer in the cinema and theater, winning three Oscars for *Gigi* (1959) and *My Fair Lady* (1965). H.D.

Bibl.: Beaton, 1986

Beaudin, André. *1895 Mennecy, France, †1979 Paris. French painter, graphic artist, and sculptor. He studied at the École Nationale des Arts Décoratifs in Paris (1911–13). In his busts and profiles produced after 1930 (*Paul Éluard*) as well as in his painting (everyday subjects, nudes, landscapes, horse, and bicycle motifs), he combined abstract Cubist forms with influences from → Lipchitz, → Picasso and above all → Gris, often working in series (*Horses*; *Rivers*; *Villas*; *Bicycles*; *Birds*). Initially he used Fauvist colors, but shifted toward a cooler, more limited color range. After 1932 he also turned to graphics, at first etchings and then, from 1952, color lithographs. U.D.

Bibl.: Taillandier, Beaudin, 1965

Becher, Bernd and Hilla. *1931 Siegen and *1934 Potsdam, Germany. German photographers living in Munich. Hilla Becher studied at the

Bernd and Hilla Becher, *Water Towers*, 1972, 9-part typology, each 24 x 18 cm, DG-Bank Collection, Frankfurt

Düsseldorf Kunstakademie (1959–61). She started work as an advertising and aerial photographer in Hamburg. In 1961 she married Bernd Becher, who studied at the Stuttgart Kunstakademie and, from 1976, taught photography at the Düsseldorf Kunstakademie. Working in collaboration and adopting an approach influenced by → Sander and → Blossfeldt, they developed a form of "industrial archeology." Through photographs, they undertook a systematic documentation of industrial structures (industrial areas in the Ruhr and Holland) reminiscent of → Conceptual art. Their photographs are conceived in series based on building types (water towers, cooling towers, silos, blast furnaces). They consciously avoid picturesque or dramatic views, producing shots that are free from distortion and as objective as possible. Devoid of shadows and people, the pictures are taken under an overcast sky from an elevated angle, and frequently from all four sides of the building. The photographs present these industrial monuments as anonymous sculptures, "self-portraits of our society." The Bechers see their photos as ersatz objects and look on their work as archival documentation and cultural anthropology. Their approach has given rise to a school → Höfer, → Ruff, and → Struth. K.S.-D.

Bibl.: Ehmer, Visuelle Kommunikation, 1971 · Becher, Stuttgart, 1977

Beckmann, Max. *1884 Leipzig, †1950 New York. German painter, graphic artist, sculptor, and poet. He studied at the Weimar Kunstschule (1900–03) and lived in Paris (1903–04), after which he moved to Berlin. In 1906 he married the painter and future opera singer, Minna Tube, and took up a scholarship at the Villa Romana in Florence. Back in Berlin, Beckmann joined the Berlin → Secession, in 1910, becoming its youngest committee member. During World War I he served as a volunteer medical orderly. Exposure to the horrors of war on the Belgian front in 1915 led to a nervous breakdown. He was discharged and settled in Frankfurt. In 1925 he divorced Minna Tube, married Mathilde "Quappi" von Kaulbach, and was appointed professor at the Städelschule in Frankfurt. That year heralded a period of success and recognition, leading to retrospectives in Mannheim, Basel, Zurich, and Paris. In 1932 a large Beckmann room was opened in the Neue Nationalgalerie in Berlin. Between 1930 and 1932 he had a studio in Paris, but his attempt to make inroads into the Paris art market failed. When Hitler came to power, Beckmann was denounced as a "degenerate artist." In April 1933 he was forced to resign from his teaching post and from 1934 he was prohibited from exhibiting. He moved to Berlin, then went into exile in Amsterdam (1937–47). Finally, in 1947 he went to the US, where he became a professor in St. Louis and New York.

Beckmann's early work is stylistically indebted to German Impressionism, while thematically there is a predominance of landscapes and above all dramatic subjects from the Bible, history, and the present (*Resurrection*, 1908; *Battle of the Amazons*, 1909; *Destruction of Messina*, 1912; *Sinking of the Titanic*, 1912). World War I brought about a radical change of direction in his art. Angular, expressive draftsmanship, reminiscent of late-medieval German painting, and a deconstruction of space inspired by → Cubism proved more appropriate stylistically for tackling the themes of suffering and violence, in which the experiences of the war and the postwar period are reflected. They culminated in Beckmann's principal work of this phase *Night* (1918–19). In the early 1920s Beckmann retreated from harsh and bitter indictments and his work became close stylistically to the → Neue Sachlichkeit. In the second half of the 1920s he progressively liberated himself from a realistic representational idiom, without ever abandoning figuration. His nonmimetic compositional approach extended not only to spatial construction and figural depiction, but also to the linking of different levels of time and reality, which were structurally linked to mythic tales. From the beginning of the 1930s, mythological subject matter – partly drawn from literary tradition (Orphism, late antiquity gnosis, cabbala) and partly of his own invention – also increasingly found its way into his work. Violence and lack of freedom in relationships between men and women, and in society as a whole, dependency on the capriciousness of the gods, the concepts of role playing and

Max Beckmann, *Night*, 1918–19, Oil on canvas, 133 x 154 cm, Kunstsammlung Nordrhein-Westfalen, Düsseldorf

masquerade, which are connected to the idea of a world theater, form the central themes of his work. They condense into full-fledged world views in the ten triptychs (of which one was unfinished), which run like a leitmotif through his late work (1932–50), forming one of the high points of classic modernist painting. R.S.

Bibl.: Fischer, Beckmann, 1972 · Göpel, Beckmann, 1976 · Beckmann, Munich, 1984 · Hofmaier, Beckmann, 1990 · Beckmann, Self-portrait, 1997 ·

Bell, Graham. *1910 Transvaal, South Africa, †1943 killed in action. South-African-born British painter. He studied at the Durban Art School and in 1931 moved to England. He was a pupil of → Grant, who exerted an early influence. Until 1934 he painted in a geometric abstract idiom. In 1937, following a three-year period as a journalist and art critic, he started to paint naturalistic cityscapes, still lifes, portraits, and interiors in a style related to the → Euston Road School (*Dover Front*, 1938). He condemned purely decorative painting and called for an unemphatic naturalism (see → precursors). K.S.-D.

Bibl.: Laughton, Euston Road School, 1986

Bell, Larry. *1939 Chicago. American painter and sculptor, exponent of → Minimal art living in Santa Fe. He studied in Los Angeles at the Choinard Art Institute (1957–59) under → Irwin, Richards Ruben, Robert Cluey, and Emerson Woelfer. Since 1969 he has held numerous teaching posts. His early work consisted of small boxes made out of wood and broken glass. In 1962 he started to make glass cubes with stainless steel frames and plastic cubes. Using a process taken from aeronautical technology, the latter were vacuum-coated with metallic compounds, resulting in colorfully shimmering, semi-transparent, reflective surfaces. The effects of transparency, interference, and reflection produce a visual confusion at odds with the precision of the designs. The works are presented on plexiglass bases, fur-

ther reinforcing the suggestion of a far-reaching dematerialization. From 1969 he experimented with walk-in glass cubes and black, completely darkened rooms. I.T.

Bibl.: Bell, Lyon, 1989

Bell, Vanessa. *1879 London, †1961 Charleston, Sussex. British painter and designer, sister of the writer Virginia Woolf. She studied at the Royal Academy in London under John Singer Sargent (1901–04). She was a founder member of the → Bloomsbury Group (1904). In 1913 she collaborated with the Omega Workshops, producing designs for furniture, textiles, pottery, and book bindings in a geometrical style. From 1919 she was a member of the → London Group. Influenced by French artists, in particular → Bonnard Cézanne, and → Matisse, she experimented with → Post-Impressionist styles (1912–18), although after 1915 she briefly produced abstract Cubist works. The subjects of her representational works and murals were generally taken from her immediate surroundings. K.S.-D.

Bibl.: James, Bell, 1985 · Chadwick, Woman, 1990

Belli, Domenico. *1909 Rome, †1983 Lavinio. Italian painter, graphic artist, and set designer. He studied under → Balla through whom he became an active member of → Futurism in 1929. In 1931 he co-founded the Blocco dei Futurisimultanisti and in 1932 worked for the periodical *Futurismo*. Together with → Prampolini, he designed stage sets for the Teatro delle Arti (1934–42). Belli has much in common with → Aeropittura and shows influences from Prampolini and →Depero. K.S.-D.

Bibl.: Fanelli/Godoli, Futurismo, 1988

Belling, Rudolf. *1886 Berlin, †1972 Krailling near Munich. German sculptor. He studied at the Berlin Kunstakademie under Peter Breuer (1911–22). In 1918 he was a founding member of the → Novembergruppe and a member of the

Rudolf Belling, *Dreiklang*,
1919/1950, Mahogany,
90 x 85 x 77 cm, Wilhelm-
Lembruck Museum, Duisburg

Hans Bellmer, *For Sade I
(Underground Vault)*, 1946,
Pencil drawing, heightened
with white

Arbeitsrat für Kunst, which strove for a synthesis of art. He held teaching posts in New York (1935) and Istanbul (1936). In 1937 he was denounced as a "degenerate" artist and he went into exile in Istanbul, where he taught at the Art Academy and Institute of Technology until 1965.

Belling's early works are in a Cubist – Expressionist style with a dynamic sense of movement. In *Dreiklang* (1919), which is a symbolic synthesis of painting, sculpture, and architecture, influenced by the notion of the → Gesamtkunstwerk, the interpenetration of hollow space and sculptural substance recalls → Archipenko. In the 1920s his formal vocabulary changed under the influence of → Futurism and Russian → Constructivism; he used new materials and adopted as his preferred theme the interrelation between man, technology, and machine. An example of Belling's figurative Constructivism is the head *Sculpture 23* (1923), which is based on wire parts with basic geometrical forms. In the 1920s, working with architects (notably Bruno Taut), Belling was able to put into practice his theories on the integration of sculpture and architecture, designing a number of fountains and functionally related abstract works. After 1925 he also did portraits and busts in a style reminiscent of → Art Deco. After 1937 in parallel with his abstract creations, he returned to works in a style that was markedly naturalistic and classical. I.H.

Bibl.: Nerdinger, Belling, 1981 · Schmoll-Eisenwerth, Belling, 1985

Bellmer, Hans. *1902 Katowice, Poland, †1975 Paris. Polish-born graphic artist, painter, sculptor, and photographer. A self-taught artist, from 1933 he started to make erotic figures of girls. He took a series of photographs of his first creation, published as *Die Puppe* (The Doll, 1934). He sent samples of these pictures to → Breton in Paris, where they were enthusiastically received by the → Surrealists. Bellmer's work, like that of the Surrealists, represented a break with society, rationality, and contemporary morality (stemming in part from his his hatred of his father, his Eros complex, and his fetishistic childhood memories). For Bellmer, his life-size nude dolls gave anatomically concrete form to erotic fantasies, lust, prohibition, and suppression. A system of joints enabled the doll's body to be taken to pieces and reassembled in every conceivable disjointed permutation. The accompanying photo

series (*La Poupée*, 1936, and *Die Puppe*, 1976) show among other things mutilated fragmentary versions of the doll with wigs, clothes, and glass eyes. Bellmer's sculptural work ended in 1938, after which he turned to drawings, graphics, collages, and above all photographs, in which his obsessive erotic themes, the intimate, taboo zone of the sexual, remained paramount. K.S.-D.

Bibl.: Alexandrian, Bellmer, 1972 · Bellmer, Paris, 1983 · Webb/Short, Bellmer, 1985 · Lust, Bellmer, 1990

Bellows, George Wesley. *1882 Columbus, Ohio, †1925 New York City. American painter and lithographer. Bellows was a prize pupil of Robert → Henri, stating in retrospect of their meeting: "My life begins at this point." For a time he was allied to the → Ashcan School and The → Eight, though he was never a member of the latter. His most famous image is *Stag at Sharkey's*, a portrayal of an illicit bare-knuckle ring-fight (1909). Hailed as a "landmark of realism," it is in truth more a dramatic surge of power and savagery than a naturalistic work. Bellows was himself an athlete and knew well the context of compositions that anticipate 1930s' realism: the back-street streams of *River Rats* (1906), and the run-down neighborhoods of *Tenement Block* (1909) and *Cliff Dwellers*. The lithograph *Dempsey and Firpo* (1924) shows a (legal) prize-fight, the defeated being hurled through the ropes towards the spectator; the new objectivized feel was probably influenced by Bellows's experience at the → Armory Show. Later works include luminous almost neon-lit seascapes and somewhat eerie portraits (especially in the 1920s) oddly redolent of → Scuola Romana. D.R.

Bibl.: Bellows, Los Angeles, 1992

Bengston, Billy Al. *1934 Dodge City, Kansas. American painter, graphic artist, and ceramicist living in Venice, California. He studied at the Los Angeles Art School and taught at various higher educational institutions, including the UCLA, Irvine. Initially Bengston produced ceramics and graphics, but since 1969 he has done paintings in the tradition of → Pop art, taking as subjects emblems in garish colors, badges and insignia from uniforms, and motorbike parts. In 1962 he started using metallic and acrylic paints sprayed onto aluminum panels. H.D.

Bibl.: Monte, Bengston, 1968

Benois, Alexandre (Aleksandr Nikolaevich Benua). *1870 St. Petersburg, †1960 Paris. Russian art director, self-taught painter, choreographer, publicist, and art historian, who, with → Bakst and Sergei Diaghilev, co-founded (1898) *Mir Iskusstva* (→ World of Art) and was head of its second incarnation (1910–24). He began his career at the Mariinsky Theater, St. Petersburg, and is best known for his collaboration with e. g. Michel Fokine at Diaghilev's Ballets Russes (e. g. Stravinsky's *Petrushka*, 1911) in influential designs that combined → Symbolism and a curvilinear → Art Nouveau with elements from French Rococo ornament and Russian folk art. He later worked at Stanislavky's Moscow Arts Theater and made designs for La Scala (with Nicola Benois [1901–88]), for Ida Rubinstein's company (*La Valse*, 1929), and for the London Festival Ballet (1957). From 1918 to 1925 he was curator at the Hermitage and left writings such as *Reminiscences of the Ballet Russes* (tr. 1941) and *Memoirs* (tr. 1960). D.R.

Bibl.: Bowlt, Silver Age, 1979

Benton, Fletcher. *1931 Jackson, Ohio. American sculptor, painter, and draftsman living in San Francisco. From 1952 to 1956 he studied at Miami University and in Oxford, Ohio, and after 1956 in San Francisco. From 1959 he taught at the California College of Arts and Crafts in Oakland, and between 1967 and 1987 was professor at San José State University, California. After starting out as a painter, in the 1960s, Benton turned to → Kinetic art, experimenting with electrically driven three-dimensional objects (*Circus Dancers*, 1961). Since 1974, however, he has produced only static objects developed out of the overlapping of basic geometrical forms (*Folded Circles*). In the 1980s he produced bronze sculptures and watercolors, in which he attempted to create a harmonious balance of geometrical elements. H.D.

Bibl.: Lucie-Smith, Benton, 1990

Benton, Thomas Hart. *1889 Neosha, Missouri, †1975 Kansas City, Missouri. American painter, graphic artist, and illustrator. He studied at the Art Institute of Chicago (1907–08) and then went to Paris, where he studied at the Académie Julian (1908–11) making the acquaintance of → Macdonald-Wright. On his return to the US he continued to paint in the style of → Synchromism. From 1920 he turned to figurative painting, becoming one of the leading exponents of → Regionalism. This movement included artists such as Grant → Wood and → Curry, who advocated turning away from the themes and idiom of European modernism back to rural America and a folksy, naturalistic style. In the 1920s Benton evolved his characteristic style, with sinuous long-limbed figures in brilliant colors. Besides watercolors and oil paintings, he also created murals and illustrated books. In 1942 he executed a series of war pictures for propaganda purposes. Despite his openly conservative and patriotic stance, Benton was a teacher of → Pollock during the 1930s at the → Art Students' League in New York. H.D.

Bibl.: Burroughs, Benton, 1981

Berés, Jerzy. *1930 Nowy Sącz. Polish sculptor and performance artist. Resident in Kraków, Berés studied at the Academy there (1950–56), becoming associated with the Kraków Group in the mid-1960s. After landscape-inspired → assemblages invested with a sense of tradition or even folklore (untreated wood is a preferred material), Berés came under the sway of avant-garde tendencies with grotesque forms and ironic titles. His performance work in the late 1960s placed the body in relation to e. g. semi-Constructivist objects. His later works (1980s) return to more reflective and formal concerns where the relation between title, performance, and context is paramount. D.R.

Bibl.: Dialog, 1981 · Art at the Edge, 1983 · Pologne contemporaine, Paris, 1983

Berghe, Frits van der. *1883 Ghent, Belgium, †1939 Ghent, Belgium. Belgian painter, draftsman, graphic artist, and illustrator. He studied at the Hoger Institut voor Beeldende Kunsten, Ghent (1897–1904). After 1906 he exhibited regularly at the triennial Ghent salon. He taught at the Ghent Academy (1907–11). During the war he stayed in the Netherlands, returning to Ghent in 1925. In 1927 he had a contract with the Galerie Le Centaure in Brussels. Following Impressionist beginnings, Berghe developed into an outstanding exponent of Flemish → Expressionism. Through his contact with Expressionist, Cubist and Fauvist tendencies, he evolved an original pictorial language with greatly simplified figures and objects, multilayered compositions, and contrast-rich coloration (*De sterrevisser*, 1920). In the 1920s he turned to → Surrealism with visionary themes and fantastic shapes and figures (*Vallende figuren*, 1928). Besides painting, he produced an extensive body of graphic work. H.D.

Bibl.: Langui, van der Berghe, 1966

Bernard, Émile. *1868 Lille, †1941 Paris. French painter. After flirting briefly with → divisionism (1886) he rejected it as formally muddled. He visited Normandy and Brittany in 1887–88 with his friend Louis Anquentin (1861–1932). Here he devised cloisonnism (a term coined by Symbolist novelist Edouard Dujardin), where planes of color are confined within bold outlines (*Buckwheat Harvest*, 1888). His precocious woodcuts (*Rêverie*, 1886; then illustrations for Moréas, Rémy de Gourmont, Baudelaire, etc.) were particularly successful, their style – derived from Japanese models and stained glass – influencing Gauguin at Pont-Aven. A firm ally of van Gogh (see e. g. *Still Life with Coffee-Pot*, 1888), → Redon, and Cézanne (see → precursors), he treated religious themes after 1889 and joined the → Nabis, exhibiting at the Le Barc de Boutteville (1891–92) and Sâr Péladan's mystical Rose+Croix (e. g. 1892). In *Harvest by the Sea* (1891), figures and sheaves are modernistically abbreviated in form. Later works "reduce [the] palette to two colors" (E. B.). He spent the years 1893–1903 in Egypt and subsequently founded a classicizing journal, *La Rénovation Esthétique* (1905–10): "Painting, being decorative, should *above all*, please the eye" (E. B.). He lived in Venice from 1921 to 1928, and his monumental *Cycle Humain* (1922–) may have influenced

the "return to order." Nudes dominate the 1930s, followed by Impressionist Breton scenes. D.R.

Bernhard, Franz. *1934 Neuhäuser, Bohemia. German sculptor living in Jockgrim, the Palatinate. He studied at the Karlsruhe Kunstakademie under Fritz Klemm and Wilhelm Loth, his initial influences. Bernhard makes monochrome, sometimes multipart sculptures of wood or iron (since the late 1960s in combination), which either rest on the ground or lean against a wall. He always takes the human form as his starting point, creating abstract forms from postures to produce anthropomorphic signs (*Large Reclining Figure*, 1973). In parallel, since 1978 he has produced a series of large-format drawings. I.H.

Bibl.: Bernhard, Karlsruhe, 1990

Bertrand, Jean-Pierre. *1937 Paris. French sculptor, painter, and film-maker living in Paris. He started in film, branching out during the 1960s into installations, painting, video, and photography. His austere compositions (photos, drawings, paper impregnated with substances) are based on the unspoken laws of seeing, tackling themes such as the interplay between inner and outer, visible and invisible. Through his use of unstable organic and inorganic substances, such as salt, honey, and lemon (*Mixed Mediums*, 1987), he explores aspects of human perception and the conformity and simultaneity of reality and fiction. K.S.-D.

Bibl.: Bertrand, 1992

Beuys, Joseph. *1921 Krefeld, Germany, †1986 Düsseldorf. German sculptor and draftsman. He studied at the Kunstakademie in Düsseldorf (1947–51), where he later lectured, from 1961 to 1972. After early sculptural works (*Fountain*, 1952) emulating → Mataré, Beuys underwent a

Joseph Beuys, *Maenad*, undated, Pencil and stain on squared paper, 20.8 x 15.9 cm, Schloß Moyland Museum, van der Grinten collection, Joseph Beuys Archive of the state of North Rhine-Westphalia

profound inner crisis (1955–56) that interrupted his artistic work for a while. At the farmhouse of the van der Grinten family in Kranenburg, he developed a theory of the "extended concept of art" in which the artwork is seen as a "social sculpture," an autonomous creative enterprise, transcending mimetic pretensions, its effects radiating out into all spheres of life. From 1961 Beuys began to put his ideas into practice in a range of contexts. Drawing on Romantic thinkers such as Novalis and on Rudolf Steiner's "anthroposophy," he sought to re-establish the lost unity of nature and mind. He opposed expedient thinking with a holistic understanding involving the archetypal, mythical, and magico-religious. Using a diversity of materials (such as fat, honey, and felt), he created dialectically linked "counter-images" intended to illustrate life's multilayered complexity. A member of → Fluxus, between 1963 and 1974 he gave a series of performances, culminating in *Coyote* (1974), in which he shut himself away for a week with a coyote. Relics from these actions, as well as drawings and installations (*Zeige Deine Wunde*, 1976), document the materialization of his ideas. Convinced that artistic creativity was accessible to all people, Beuys also became involved during the 1970s and 1980s in political and ecological projects (foundation of the Free College of Creativity and Interdisciplinary Research, Documenta 6, 1977; *7000 Oaks*, Documenta 7, 1982). H.D.

Bibl.: Tisdall, Beuys, 1976 · Adriani/Konnertz/Thomas, Beuys, 1979 · Beuys, Multiples, 1980 · Szeemann, Beuys, 1993

Bevan, Tony. *1951 Bradford, England. British painter living in London. He studied at the Bradford College of Art (1968–71), Goldsmiths' College (1971–74), and the Slade School of Fine Art (1974–76). Bevan uses an unusual technique in his pictures: applying coarsely ground color pigments with his brush or fingers onto the canvas, and fixing them with acrylic varnish. This results in intensely vivid coloration and a rough surface (which he calls "scab") suggestive of vulnerability and injury both spiritual and physical. The heads and bodies, often under extreme psychological strain, are rendered in powerful black and red lines. With its use of cinematic techniques (long shot, zoom, close-up), Bevan's art goes far beyond the purely figurative. Indeed, his rear-view images with doors (*Double Portrait Back*, 1990) verge on abstraction. In a recent major work, the polyptych *The Meeting* (1992), for which he made numerous preliminary graphic studies, Bevan is concerned with the power of the group and its relation to the individual. H.D.

Bibl.: Schulz-Hoffmann, Bevan, 1993 · Wollen, Meeting, 1993

Bickerton, Ashley. *1959 Barbados. Barbadian painter and sculptor. Bickerton's work initially incorporated aggressively technological imagery and synthetic materials in conjunction with naturally occurring substances such as coral and seaweed (*Stratified Landscapes*, 1990). Mechanisms with more than a hint of the medical are affixed to the wall and inscribed with commercial trademarks, barren technospeak or instructions-cum-specifications. Bickerton lived in Indonesia from 1993, exhibiting a group of singularly

Franz Bernhard, *B-2–86*, 1986, Pen, brush and Indian ink, grey wash, opaque white, glue-mounted paper, 63 x 45 cm, Museum Ostdeutsche Galerie, Regensburg

Joseph Beuys, *Zeige Deine Wunde*, 1974–75, Installation, assembled 1980 by the artist: 5 pairs of objects: biers, tools, pitchforks, newspapers, blackboards, Städtische Galerie im Lenbachhaus, Munich

dysfunctional castaways at Sonnabend (New York). He has since also worked out of Borneo and has a concern for the negative effects of tourism (scuba-diving, for example) on, for the West, "faraway" places. In an exhibition at London's White Cube (1997) that included paintings on plywood, he explored Christian imagery in an often disrespectful manner. D.R.

biennale. International exhibition of contemporary art that takes place every two years (Italian: "biennale"). The first, and most famous, is the Venice Biennale, founded in the city's Giardini Pubblici in 1895 and held there regularly since that time. The idea for it derived from the World's Fairs organized since the mid-19th century (the first was in London's Crystal Palace in 1851). These were showcases for technological and scientific progress and, with each country allocated a pavilion of its own, reflected the political development of nation-states in the 19th century. Similarly, the Biennale provided a forum in which nations could give an account of themselves within the sphere of the fine arts. Each country selects its own artists, whose works are exhibited in permanent pavilions. In addition there is an international hall with special exhibitions. Although initially a conservative-academic salon event, the Biennale evolved after World War II into an important forum for new and avant-garde art, linked since 1932 to the Venice Film Festival. The Biennale Prize is one of the most prestigious and valuable art prizes. After World War II the model of the Venice Biennale was taken up by other cities, including São Paulo and Tokyo (since 1949), Paris (1959–82), Sydney (since 1974), Havana (since 1984), Lyon (since 1991), Johannesburg (since 1995), and Berlin (since 1998). Although the notion of presenting art nationally in an age of international modernism has come to seem problematic since the 1960s, and although the biennale has been faced with a non-national rival since 1955 in the form of the Kassel Documenta, nevertheless the biennales of Venice and São Paulo in particular remain two of the most important international exhibitions of contemporary art in the world. R.S.

Bibl.: Di Martino, Biennale 1982 · Biennale, Venice, 1996

Bijl, Guillaume. *1946 Antwerp. Belgian installation artist working in Antwerp. He teaches at the Jan van Eyck Academy in Maastricht. Since 1979 Bijl has been transforming the spaces where art is shown – galleries, museums, and art associations – by placing everyday objects in new settings. By redefining the meaning and function of such spaces, he is adopting M. → Duchamp's principle of the → ready-made and applying it on a monumental scale. Eliminating the distance between reality and depiction, Bijl's work is an examination of the relationship between art and consumerism. H.D.

Bibl.: Faust, Bijl, 1991

Bill, Max. *1908 Winterthur, Switzerland, †1994 Berlin. Swiss painter, sculptor, architect, graphic artist, designer, and art theorist. He studied at the Zürich Kunstgewerbeschule (1924–27) and at the Dessau → Bauhaus (1927–29) under → Klee, → Kandinsky, J. → Albers, → Schlemmer, and → Moholy-Nagy. From 1929 he lived in Zurich, becoming a member of → Abstraction-Création (1932–35). Refining ideas published by van → Doesburg in the magazine *L'Art concret* (1930), Bill formulated in the catalog for the exhibition *Contemporary Problems in Swiss Painting and Sculpture* (Kunsthaus Zürich, 1936) the principles of concrete art: "By concrete art we mean those artworks that have been created on the basis of their inherent means and laws – with no external reference to natural phenomena or their transformation, hence not through abstraction." A good example of Bill's approach can be seen in his series *Fifteen Variations on a Theme* (1935–38). Starting from a basic motif, Bill develops a multiplicity of formal and chromatic variants on the basis of a repeatedly applied aesthetic rule. It is this continually reapplied possibility of development, involving above all the investigation of color systems (checkerboard pictures), that gives Bill's formally austere painting its tension and variety. Bill's sculptures were formal transpositions of mathematical concepts. In his monoplanar sculptures, he took as his starting point the Möbius strip, which eternally comes back into itself (*Unending Loop*, 1935). In his colored objects, Bill sought to break down the genre boundaries between painting and sculpture (*2 Pictorial Columns*, Bauhaus Archive, Berlin, 1985). Working within the → Constructivist tradition, Bill was also intensively involved with environmental design. As an architect, his work included the planning and execution of the Ulm Hochschule

Max Bill, *Unity from Light and Dark Color Group*, 1975–76, Oil on canvas, 120 x 120 cm, Max Bill estate

für Gestaltung (1953–55), where he was first director until 1957. After 1945 Bill was also a prominent designer of interiors, exhibitions, and stage sets among other things. He published Kandinsky's writings (from 1946) as well as accounts of his own theories. H.D.

Bibl.: Bill, Buffalo, 1974 · Bill, 1987 · Frei, Bill, 1991 · Thomas, Bill, 1993

Bing, Ilse. *1899 Frankfurt am Main, †1998 New York. German photographer, writer, and painter living in New York. She studied mathematics and art history at the universities of Frankfurt and Vienna. Self-taught, she worked as a freelance photographer first in Frankfurt (1929–30), for among others the architect Mart Stam, and then in Paris (1930–39). After being held in Gurs internment camp (1940–41), she emigrated to the US. She worked as a freelance photographer in New York, taking portraits of children among other things. In 1959 she abandoned photography for poetry, painting, and collage.

Bing was one of the emancipated women photographers of the Weimar Republic who for the first time could explore the possibilities of freelancing. Linked stylistically with the New Vision and → Neue Sachlichkeit, she worked successfully as a magazine photographer in a wide range of fields. One of her best-known pictures is *Self-Portrait with Leica* (1931), which shows her looking through the viewfinder of her camera simultaneously in profile and front on. It was not until the 1970s that her work started to gain greater recognition. H.D.

Bibl.: Rosenblum, Photography, 1984 · Bing, New Orleans, 1985

Bischof, Werner. *1916 Zürich, †1954 near Trujillo, Peru. Swiss photographer and draftsman. He studied drawing and sport at a teacher training college in Schiers in the Grisons, and photography at the Zürich Kunstgewerbeschule (1932–36). From 1939 he worked as a self-employed designer. After a brief stay in Paris, he returned to Switzerland to do his military service. From 1942 he took photographs for magazines and photo journals, and in 1949 he joined the Magnum photo agency. After landscape, animal, and still-life work Bishof turned, under the impact of the

war, to his principal theme of man and the devastation that befalls people physically (ruins, refugee camps) and psychologically (suffering, sorrow, despair). Bischof took numerous pictures of war-torn and postwar Europe as well as of the Korean war, refugee camps in Hong Kong, and famine in India (1951). From about 1951 he abandoned the theme of war and in tranquil compositions portrayed everyday life in East Asia and South America. H.D.

Bibl.: Bischof/Schifferli, Bischof, 1961 · Bischof, Bischof, 1990

Bishop, Isabel. *1902 Cincinnat, Ohio, †1988 New York City. American painter. Raised in Detroit, Bishop studied at the New York School of Applied Design (1918–20) and the → Art Students League of New York (from 1920), teaching there from 1937. She forged a friendship with → Marsh and came under the influence of Old Masters specializing in everyday life (e. g. Adriaen Brouwer), and Rubens's oil-wash techniques. From the early 1930s she adopted a Realist style close to the early → Ashcan School (*On the Street*, series of etchings, 1934) whose themes were centered on working-class figures (especially women) from the streets of Manhattan (*Encounter*). Bishop's work is often categorized as → social realism, though in some ways this is deceptive: her concerns are more anecdotal than political, and her snapshots of collective life (*Hearn Department Store*, 1927), rather than depicting grinding poverty, are closer in spirit to → American Scene Painting. Her oil and tempera on gesso panel figures are vaguely 18th-century in appearance (*Girl Reading a Newspaper*, 1946). Later works include a fine series of *Five Women Walking* (1967). Her meticulous technique meant that she produced fewer than 200 paintings over nearly 60 years. D.R.

Bibl.: Lunde, Bishop, 1975 · Yglesias, Bishop, 1988

Bissier, Julius. *1893 Freiburg im Breisgau, Germany, †1965 Ascona. German painter. He studied art history at the University of Freiburg (1913–14)

Werner Bischof, *On the Way to Cuzco*, Peru, 1954, Gelatin silver print (vintage), 39.8 x 30.1 cm, Museum Ludwig, Cologne

Julius Bissier, *24.III.53 IV*, 1953, Ink on paper, 47.7 x 62.7 cm, Lisbeth Bissier, Ascona

Peter Blake, *Bo Diddley*, 1963–64, Acrylic on hardboard, 122.4 x 78.3 cm, Museum Ludwig, Cologne

and then attended the Karlsruhe Akademie. He did his military service in Freibung (1915–18), where he became a pupil of Hans Adolf Bühler, producing melancholy pictures reminiscent of German Renaissance painting. Through his acquaintanceship with the sinologist Ernst Grosse, Bissier discovered East Asian calligraphy, which had a major impact on his subsequent output. Between 1923 and 1929 he did paintings in the style of → Neue Sachlichkeit and in 1925 he began painting landscape sketches using East Asian brush-and-ink techniques. Through his friendship with → Baumeister, from 1929 Bissier started to abandon his Neue Sachlichkeit idiom for an abstract style. Two years later he produced his first abstract paintings with Indian ink. These depict symbolic forms – "symbols of bipolar life" – with a minimum of gestural strokes and a reduced coloration. Initial landscape motifs are condensed into hieroglyphic abbreviations (→ Art Informel). These were followed by large-format pictures in egg tempera (1929–33 burnt). During the Nazi regime, Bissier was unable to exhibit. After 1947 he turned to monotype, his works teeming with organic shapes in a light palette, and between 1948 and 1952 to woodcut, featuring more austere overlapping geometrical forms. In 1955–56 he started a series of miniatures in egg tempera. Their floating transparency expresses a cheerful spirituality. Parallel to these, Bissier produced watercolors, which likewise testify to a search for "essence" in the Zen Buddhist sense. H.D.

Bibl.: Schmalenbach, Bissier, 1987 · Bissier, Mendrisio, 1989 · Essers, Bissier, 1993 · Schmalenbach, Bissier, 1993

Black Mountain College. American college at Black Mountain, North Carolina. It was founded in 1933 by a group of progressive college lecturers, among them John Andrew Rice, and closed in 1957 owing to financial difficulties. Administered solely by the teaching staff, this small institution (50 students per year) was free of any kind of state control. As at the → Bauhaus, a broad range of artistic subjects was taught and an interdisciplinary approach encouraged. The most outstanding teacher in the field of the decorative arts was Josef → Albers, who had taught at the Bauhaus. Albers, along with his wife Anni, joined the school as soon as it opened and stayed until 1949. Through Albers, substantial elements of Bauhaus were incorporated into the Black Mountain College curriculum. Other famous teachers

were → Motherwell and → Cage, who in 1952 produced his first → happening there. Famous former students of the college include → Chamberlain, K. → Noland, and → Rauschenberg. H. D.

Bibl.: Harris, Black Mountain College, 1988

Blake, Peter. *1932 Dartford, Kent. British painter, and graphic artist living in London. He studied at the Royal College of Art, London (1953–56), from which the second wave of English → Pop art emanated. From 1959 Blake, with his expressively painted scenes of pop singers and filmstars, became the central figure of the Pop movement in England. He combined oil painting, graphic elements, and collage into eye-catching → assemblages. Two of his major works are *Babe Rainbow*, a silkscreen print on metal, and the record cover for the Beatles' *Sergeant Pepper's Lonely Hearts Club Band* album (1967). In 1975, after he had moved to Wellow (near Bath), Blake founded the Brotherhood of Ruralists, a group of seven painters who drew their inspiration from English rural life. Following his return to London in 1979, Blake continued to paint in the style of Fantastic Realism. Between 1994 and 1996 he was Associate Artist at the National Gallery, London. H.D.

Bibl.: Blake, London, 1983

Blaue Reiter, Der. Der Blaue Reiter (The Blue Rider). A group of → Expressionist artists founded in Munich in 1911 by → Kandinsky and → Marc. The name was taken from a picture by Kandinsky (1903), and also reflects their predilection for the mystical color blue. The group's first exhibition bore the same name, as did its *Almanac*, published in 1912 by the Piper publishing house. The founder members were joined by → Kubin, → Münter, → Macke, and, in 1912 → Klee. Besides the inaugural exhibition, which was shown in Cologne, Berlin, Bremen, Hagen, and Frankfurt, the Blaue Reiter mounted an exhibition of watercolors, drawings, and prints in Munich in 1912, as well as a smaller overview in Berlin's → Sturm Gallery with works by Kandinsky, → Jawlensky, A. → Bloch, Marc, Münter and → Werefkin. The group was also represented in the Erster Deutsche Herbstsalon (Berlin 1913), which toured Scandinavia. The core group was joined at these exhibitions by the brothers Vladimir and David → Burliuk, → Delaunay, → Campendonk, J. B. Niestlé, E. Kahler, and the composer → Schoenberg. The gathering together of such disparate artists shows that the group's concern was not to demonstrate any unified style, but to represent the tendency discernible "in all areas of art to expand the boundaries of artistic expression" and to grasp "the spiritual in art," to use a phrase that was part of the title of one of Kandinsky's best-known texts (1912). The Blaue Reiter painters produced a wide variety of work, but unlike the → Brücke group they were intent on the overall spiritual tone of a composition. Kandinsky is generally considered the first to have ventured the step into abstract composition (1912–13). The early death of Marc (1916) prevented the logical progression on his part into abstraction. Further activities of the group were frustrated by World War I. Kandinsky and Klee were later appointed to positions at the

→ Bauhaus, where they further developed important Blaue Reiter ideas.　H.D.

Bibl.: Kandinsky/Marc, Almanach, 1912 (1979) · Vogt, Blue Rider, 1980 · Hüneke, Blauer Reiter, 1989 · Zweite, Blauer Reiter, 1991 · Friedel/Hoberg, Blauer Reiter, 1999

Blaue Vier, Die. A group of four artists – L. → Feininger, → Jawlensky, → Kandinsky, and → Klee – founded in 1924 in Weimar at the instigation of Galka (Emmy) Scheyer (1864–1954). In May 1924, Scheyer emigrated to the US, where she was active for 20 years as a dealer in European art, organizing exhibitions of the four artists' work and giving lectures. She succeeded in winning over a number of important private collectors, especially in the western states, notably Louise and Walter Arensberg. Nevertheless, Die Blaue Vier were unable to gain a foothold in the US. Only Feininger managed the transition, visiting Scheyer in 1936 in her Hollywood home, which she had had specially built for her collection of works by Die Blaue Vier. The following year Feininger moved from Germany to the US.　H.D.

Bibl.: Barnett, Blue Four, 1997

Bleckner, Ross. *1949 New York City. American painter. Bleckner grew up on Long Island, but has worked out of New York since 1973. After an → Op Art period in the 1960s, his emergence coincided with the reassessment of painting in the late 1970s. Following some geometric, tile-like architectural abstracts in the early 1980s, he further explored the relations between interior and exterior in a series of vividly beautiful "bubble chambers," strangely bedecked with chandeliers and other domestic furniture (*Chamber*, 1985). Subsequently (1987–89) there appeared all-over stripe paintings infused with a painterly glow (*Unknown Quantities of Light*). More recently (from 1994) this concern with light has extended into a narrative component with natural allusions (*Falling Birds*, 1994; cells in *Microscopic Life*, 1996). For Bleckner, "the great artistic battles are always those waged with the self." He is acutely concerned with the AIDS epidemic. A mid-career retrospective was held at the Guggenheim Museum, New York in 1995.　D.R.

Bibl.: Bleckner, New York, 1995

Bloch, Albert. *1882 St. Louis, Missouri, †1961 Lawrence, Kansas. American painter, draftsman, illustrator, and writer. His parents emigrated in 1869 from Bohemia to St. Louis, US, where Bloch attended the St. Louis School of Fine Arts, working on the side as a newspaper illustrator. He produced around 200 portrait caricatures for *The Mirror* in a style derived from → Jugendstil. In 1908 he settled in Munich, where he joined the artistic circle revolving around → Kandinsky and → Marc (Der → Blaue Reiter). Through his contact with Der → Sturm, his work was widely exhibited in Europe. Bloch painted landscapes, city views, portraits, occasional still lifes, night scenes, and subjects from the realm of the circus and *commedia dell'arte* (*Harlequin with Three Pierrots*, 1913–14) in a style based on Orphic Cubism. He also translated works by the Viennese satirist Karl Kraus into

English. In 1921 Bloch returned to the US, taking up a professorship at the University of Kansas in Lawrence. He increasingly distanced himself from art, although he never gave up painting completely.　H.D.

Bibl.: Schuchter, Bloch, 1991 · Hoberg, Bloch, 1997

Bloch, Martin. *1883 Neisse, Silesia (Nysa, Poland), †1954 London. A self-taught painter who spent a short time training under → Corinth. Moving to Paris Bloch was struck by the work of the Matisse-dominated artists of the Café du Dôme. Acquainted with → Pascin, Sonia → Delaunay-Terk, Robert → Delaunay, and → Laurencin, and influenced by Die → Brücke (he worked with → Schmidt-Rottluff), → Derain, and → Munch, Bloch was an established artist by the time the Nazis declared his work "degenerate" in 1933. Fleeing to England (naturalized 1947), he struggled to assert himself, though in later years he acquired a post at Camberwell School of Art. Bright landscapes (*Laburnum and May Trees*, 1941) that unite Germanic → Expressionism with → Fauvist delight in pure color, allusive natural imagery (*The Grip of the Branches*, 1945), and still lifes were his main contribution.　D.R.

Blok. Progressive Polish artists' group that came together in 1924 with its first exhibition in Warsaw's Polonia Hotel. A magazine of the same name was published from 1924 for a few issues. Of the eight founder members, the most important were Witold Kayruksztis, the sculptor Katarzyna Kobro, Henryk Stazewski (1894–1988), → Strzemiński and for a while Henryk Berlewi (1894–1967). The group took its lead from Russian → Constructivism and → Suprematism, but it was also influenced by → Bauhaus ideas. Its work ranged from typographic experiments, abstract images, and colored sculptures to architecture and landscape planning. Blok was superseded in 1926 by the group, Praesens.　H.D.

Bibl.: Blok, 1973

Bloom, Barbara. *1951 Los Angeles. American mixed-media installation artist. After studying at the California Institute of the Arts, Los Angeles, with → Baldessari and → Byars (whose work hers resembles), in the 1970s Bloom worked in both New York and Europe. Her installations, incorporating manipulated yet ostensibly "realistic" photographs, refer in their mysterious, often "psychic" basis to Freud's theory of the uncanny. The Reign of Narcissism (1989), for example, displaces a nondescript interior into a melancholic twilight realm approaching the kitsch with vitrines, cameos, and busts of her own image: a shrine to feminine self-regard at a distance from feminist approaches. An installation *Revised Evidence* (1999) centered on reworking Nabakov's library and his famous index-cards.　D.R.

Bibl.: Bloom, Berlin, 1988 · Bloom, Columbus, 1998

Bloomsbury Group. Loose grouping of writers, artists, and intellectuals who left their mark on the cultural life of England in the early 1920s. Leading members were E. M. Forster, Lytton

Strachey, Virginia Woolf, Clive Bell, Vanessa → Bell, → Carrington, Roger Fry, → Grant, Henry Lamb, and the economist John Maynard Keynes, who was also the group's patron. Meeting informally in London's Bloomsbury district either at Woolf's house or that of Clive and Vanessa Bell, the members represented no definite ideology or theory of art, but were united in their struggle against prudish and conservative Victorian cultural life, advocating revolt against social constraints. Schooled by the art critic Roger Fry, they were inclined artistically above all to the art of → Post-Impressionism (Omega Workshops, 1913). After painting purely abstract pictures, Bell and Grant created the colorful figurative idiom typical of the "Bloomsbury style." By the early 1930s the Bloomsbury Group's ideals had become outmoded, and with the death of some of its leading lights (Lytton Strachey, 1932, Virgina Woolf, 1941) the group disbanded. H.D.

Bibl.: Lumsden, Bloomsbury, 1976 · Shone, Bloomsbury, 1996

Blossfeldt, Karl. *1865 Schielo (Harz Mountains), Germany, †1932 Berlin. German photographer. He studied painting at the college of Berlin's Kunstgewerbemuseum, teaching himself photography (1884–91). Between 1891 and 1896 he made a series of trips to Italy, Greece, North Africa, and Egypt, taking pictures of the local flora. From 1896 he taught at the Kunstgewerbemuseum college in Berlin, becoming lecturer in botanical drawing and modeling in 1899. In 1921 he took up a professorship at the Berlin Kunstakadamie. In 1928 he published *Urformen der Kunst*, a book which, following in the footsteps of Ernst Haeckel's *Kunstformen der Natur* (1899–1900), made him famous overnight. Blossfeldt's images present highly magnified plant details and organic forms that show clear parallels to the decorative elements and ornamental shapes of art history. He became a leading exponent of the photography of → Neue Sachlichkeit, influencing Albert Renger-Patzsch (1897–1966) and Finsler. H.D.

Bibl.: Mattenklott, Blossfeldt, 1981 · Mattenklott, Blossfeldt, 1998

Blue Rose, (Russian = "Golubaya Roza"). Group of avant-garde Russian artists formed in 1907 in reaction to the ossified art of the → World of Art movement. Their original works, characterized by forceful colors and stylized figures, were influenced by European painting, notably Symbolism, as well as Mikhail Vrubel (1856–1910), Vladimir Serov (1910–68), and Victor Borisov-Musatov (1870–1905). The most prominent members included Pavel Kuznetzsov (1878–1968) and Martiros Saryan (1880–1972). The group published a journal, *The Golden Fleece*, and from 1908 organized important exhibitions that showed, in addition to Russian artists, works by Impressionists, → Post-Impressionists (van Gogh, Cézanne, and Gauguin → precursors), and → Fauvists (→ Matisse and → Derain). H.D.

Bibl.: Gray, Experiment, 1962

Karl Blossfeldt, *Adiantum pedatum*, Maidenhair Fern, 1920–30, Gelatin silver print, 30 x 24 cm

Blum, Heiner. *1959 Stuttgart. German photographer, painter, and Installation and graphic artist living in Kassel. He started out as photography assistant before becoming a photographer with the German newspaper *Der Frankfurter Rundschau*. In 1981 he won the Otto Steinert Prize of the German Society of Photography. He studied at the Kassel Gesamthochschule until 1983 and then set up his own photo studio. He also took up painting at this time. Blum's photographs present everyday objects and scenes from an unusual angle. His graphic work shows a concern with language and signs. He has also created numerous installations. H.D.

Bibl.: Blum, Essen, 1983

Blume, Anna and Bernhard Johannes. *1937 Bork, Germany (Anna Blume), *1937 Dortmund, Germany (B. J. Blume). German photographers living in Cologne. After variously completing a craft apprenticeship and training to become interior painters and graphic artists, both studied at the Düsseldorf Kunstakademie (1960–65). From 1964 Anna worked as an art teacher at a grammar school, while Bernhard, following philosophy studies, taught in Cologne. They married in 1966.

Anna and Bernhard Johannes Blume, *Küchenkoller*, 1985, 10-part photo sequence, 130 x 91 cm and 200 x 130 cm

After working separately in the 1980s they began working as a team, creating large-format photo sequences. In photo-performances such as *Wahnzimmer* (1984) or *Küchenkoller* (1985), the Blumes address their themes in hypothetical constructed events in which the individual enters into conflict with social mores by jettisoning the accepted rules of behavior. In this calculatedly ecstatic tumult (e. g. when a housewife throws off her social role), the world of everyday objects is animated by seemingly telekinetic forces. Everyday objects take on an intimidating and magical life of their own through a process of animistic "inspiration" that the artists call "ideo-sculpture." Later works, such as *Transcendental Constructivism* (1994), also simulate the menacing of the subject by the object. This demonic supernatural impression of the "rebellion of things" is achieved by the blurring of motion and gyrating the camera during long exposures, by shooting out of focus and by distorting perspective. In parallel with the photo series, the pieces of furniture used to create the sequences are exhibited as objects. P.L.

Bibl.: Wieland, Anna & Bernhard Blume, 1992 · Honnef, Anna and Bernhard Blume, 1992–95 · Honnef, Transzendentaler Konstruktivismus, 1995

Blume, Peter. *1906 Smorgon, Belarus, †1992 New Milford, Connecticut. American painter. Blume's parents settled in Brooklyn in the early 1910s and he became a student at the → Art Students League of New York. After a slightly naive → American Scene period, his interest in technique drew him into contact with → Neue Sachlichkeit and → Valori plastici on one side and American → Precisionism on the other. His illustrative oils occasionally ventured as far as an ironic → Surrealism (*South of Scraton*, 1930–31) and political satire (*The Eternal City*, 1934–37–where Mussolini appears as a garish jack-in-a-box at the Forum). Barely influenced by later modernism, Blume's postwar projects included a series of the *Seasons* and "Manneristic" Venus bronzes morphologically close to → Maillol (from 1970). D.R.

Bibl.: Trapp, Blume, New York, 1987

Blumenfeld, Erwin. *1897 Berlin, †1969 Rome. German photographer. In 1918, after deserting from the army, Blumenfeld fled to Amsterdam. Between 1918 and 1923 he was in contact with members of the Berlin → Dada movement, → Grosz, → Citroën, and author Walter Mehring. Under the pseudonym Jan Bloomfield, he produced → collages and experimental photographs. In 1936 he went to live in Paris, devoting himself chiefly to photography. From 1938 he worked as a fashion photographer for *Vogue* and *Harper's Bazaar*. In 1941 he emigrated to the US, opening his own studio in New York. One of the most innovative photographers of the international fashion press, Blumenfeld took numerous portraits and female nudes, which were published in the journals *Verve* and *Minotaure*. Influences on him included → Man Ray and → Kertész. He experimented with alienating techniques (reflections, use of shadows, shots through glass and other materials), and a variety of darkroom manipulations (solarization, multiple exposure, and color experiments). H.D.

Bibl.: Rosenblum, Photography, 1984

Boccioni, Umberto. *1882 Reggio di Calabria, Italy, †1916 near Verona. Italian painter, graphic artist, and sculptor, a leading exponent of → Futurism. He studied at the Accademia in Rome (1898–1902), where he met among others → Severini and → Balla, who introduced him to the → divisionist technique. He made trips to Padua, Paris, and Venice (1906–08), before settling in Milan, where he worked as an advertising draftsman and illustrator. Following the publication in 1909 of the first *Futurist Manifesto*, he came to know its author, → Marinetti, after which, in 1910, he co-signed the *Manifesto of Futurist Painters* with → Carrà, Balla and → Russolo. In July of the same year he had his first one-man exhibition in Venice. Boccioni's painting of this period combined Neo-Impressionist, Symbolist and Futurist elements. At the first Futurist exhibition in Paris in 1912, Boccioni showed *Street Noises Invade the House*, *The Laugh*, *The City Rises*, *The Strengths of a Street*, and *Modern Idol*. Unlike other Futurist painters, Boccioni represents time and motion – the principal concerns of Futurist theory – in the Bergsonian sense of lines of force through which objects react with their environment. Familiar with the Paris avant-garde, Boccioni used the techniques of inlet-penetration, transparency, and simultaneity, combining them with a divisionist color scheme. Blurred multiple contours reinforced the impression of movement (*Elasticity*, 1912). After 1912 Boccioni also created Futurist sculptures, which are considered some of his best and most innovative works (*Unique Forms of Continuity in Space*, 1913). In 1913 Boccioni's first exhibition with sculptures took place in the Parisian gallery La Boétie, and in 1914 he signed the manifesto *Futurist Synthesis of War*, taking part in pro-war rallies. From July to December 1915 he was a member of the Volunteer Cyclist Battalion at the front, after which he returned to Milan. Following publication of his book *Pittura scultura futuriste*, which summarized his Futurist views and output, Boccioni underwent a crisis, which led him back to a figurative style of painting (*Portrait of Busoni*, 1916). H.D.

Bibl.: Boccioni, Milan, 1982 · Calvesi, Boccioni, 1983 · Coen, Boccioni, 1988 · Schneede, Boccioni, 1994

Umberto Boccioni, *Street Noises Invade the House*, 1911, Oil on canvas, 100 × 100 cm, Sprengel Museum, Hanover

Bochner, Mel. *1940 Pittsburgh, Pennsylvania. American Conceptual artist, painter, graphic artist, and writer who has lived in New York since 1964. He studied at the Carnegie Institute of Technology, Pittsburgh, and in 1965 took up a teaching post at the School of Visual Arts, New York. Under the sway of → Minimal art, Bochner started out making abstract installations that exploited demonstrations of the laws of gravity. His work of the 1960s and 1970s, inspired by → LeWitt, is characterized by a fascination with mathematics, arithmetic, and epistemology, which found expression in cycles of drawings with strictly geometrical forms. In the 1970s Bochner's Conceptual approach waned in favor of an interest in Abstract Expressionist painting – a kind of "pure painting" based on a system of linguistic signs (*Phalanx*, 1985). H.D.

Bibl.: Bochner, Lucerne, 1985

Bodmer, Walter. *1903 Basel, Switzerland, †1973 Basel, Switzerland. Swiss painter and sculptor. He studied at the Kunstgewerbeschule, Basel (1919–23), then earned his living as a jazz musician. In 1933 he co-founded the antifascist 33 Group in Basel with Otto Abt and Walter K. Wiemken, and in 1937 the Allianz group. Between 1939 and 1968 he lectured on drawing and sculptural anatomy at the Basel Kunstgewerbeschule. In 1956 he won a prize from the Guggenheim Foundation, New York. After painting in a Fauvist and Expressionist style (principally landscapes), after 1935 Bodmer turned to sculpture. Assimilating → Cubism and → Constructivism, he detached his compositions from the two-dimensional surface, first producing wire reliefs which later culminated in suspended wire sculptures (*Drahtbild*, 1937), often deploying color to make them more dynamic. He also produced stained glass and incorporated glass into his late work. H.D.

Bibl.: Bodmer, Basel, 1978

Body art. Variant of → Process art and → Action Painting (see also → Conceptual art). The aim is to create model processes or give visible expression to conceptions that are recorded on video or film. Body-related actions or interventions on the artist's own body are performed in order to reveal the conditions underlying existence and behavior, but also to unmask conflicting urges and desires in society. Body art can be choreographed, as in the performances of → Gilbert and George. Since 1965 → Nauman has been concerned with minimal body actions (*Making Faces*, 1968). Another form of Body art involves wounds and lacerations to the artist's own body, revealing a traumatic narcissism. In 1971 → Pane injured herself with razor blades in the performance *Nourriture*; in *Rubbing Piece* (1970), lasting several hours, → Acconci rubbed his forearm until it was raw; and in his *Self-Burial Piece* of 1969 Keith Arnett had himself buried alive. In the same vein are the body actions of Greek artist Stelarc, who, alluding to an old Indian ritual, had himself hung up on hooks passed through his skin (Munich, 1977). Then there are the spectacular, often highly dangerous happenings of → Burden, → Brisley, and Wolfgang Flatz (1952–),

which take into account the viewer's own aggressive impulses. Even the self-destructive actions of → Schwarzkogler (→ Vienna action art) may be considered Body art, although of a particularly masochistic nature (self-mutilation). The exhibiting of one's own vulnerability may contain a critical potential (→ Export), yet such self-displays are most closely connected with certain areas of youth culture, which seeks self-expression in ornamental body jewelry and design (fashion, tattooing, piercing, bodybuilding). H.D.

Bibl.: Jappe, Performance, 1993

Alighiero Boetti, *Nature, a Dull Matter*, 1981, Collage, spray, acrylic on canvas, 150 x 100 cm, Documenta 7, Kassel

Boetti, Alighiero. *1940 Turin, †1994 Rome. Italian painter, Performance and Conceptual artist. He was self-taught. Following in the footsteps of M. → Duchamp, he has been active since 1966 as a Conceptual artist. In his early works he assembled various objects from consumer culture (electrical fittings, rolls of cardboard, painted metal panels, filled plastic containers) to form → accumulations. In 1967 Boetti was one of the cofounders with → Pistoletto, and → Paolini of → Arte Povera. In 1970 he produced *Dossier postale*, consisting of 28 registered letters to the non-existent addresses of personalities in the art world. From 1973 he traveled through Afghanistan and India, requesting local people to weave textiles following the artist's instructions. The giant wall hanging *I mille fumi più lunghi del mondo* (1977), listing the names of rivers, was woven by Afghan women. Boetti's concept of "il doppio" (doubling), also shaped by Conceptual art, is designed to demonstrate the ambiguity and playful element of the aesthetic process (as in the duplication of his signature in "Alighiero & Boetti"). Recent works by the artist display increasing stylization. H.D.

Bibl.: Pohlen, Alighiero & Boetti, 1992

Bolotovsky, Ilya. *1907 Petrograd (St. Petersburg), †1981 New York City. Russian-born American painter. Bolotovsky moved to the United States in 1923 and entered the National Academy of Design, New York. After an early stage of semiabstract and figurative work between 1923 and 1934, he gradually became more concerned with pure form. During the Depression he was called upon to produce large-scale murals (e.g. at the Williamsburg Housing Project, 1936). At Black

Christian Boltanski, *Monument*,
1986, Installation

Mountain College in the late 1940s a less rigorous version of → Neo-Plasticism emerged, with rectangular canvases being often replaced by hatchment diamonds and circles (*Large Tondo*, 1965). His treatment of color tends to expand → Mondrian's spatial division of planes and thin strips into areas of broader bands. Around 1961 Bolotovsky started producing three-dimensional columns of a closely allied aesthetic. He was also a bilingual lexicographer in the domains of art and architecture and military science. D.R.

Boltanski, Christian. *1944 Paris. French Conceptual artist and photographer living in Paris. He was self-taught. Between 1958 and 1967 he produced numerous, large-format compositions depicting narratives and dramatic events. In 1968 he started working with film and photography, *The Fantastic Life of Christian Boltanski*, reconstructs his childhood using fictional and real-life records and documents. In the 1970s Boltanski drew on archival documentation, producing photo collections with pictorial material from friends and favorite photos of a school class (*Les Habits de François C.*, 1972). In 1974 he produced photo sequences and video tapes, in which, comically dressed, he played out sketches, as well as series of color drawings (*One-Act Plays*). His works made increasing use of space, accentuated by lighting effects. His installations, which date back to 1980, refer to particular exhibition venues (*Monuments: Les Enfants de Dijon*, installation in the Chapelle de la Salpêtrière, Paris, 1986). In 1988 a large retrospective of his works toured six major museums in the US and Canada. At each venue Boltanski designed a new work (*Resérve: Canada,* Toronto, 1986). The photographs and clothes used in these installations appear as (present) objects and memories of (absent) subjects. In the late 1980s Boltanski explored the vanitas idea in installations with cast-off clothes, over which the viewer had to climb to look at the installation (*Resérves. La Fête du Pourim*, Basel, 1989). Boltanski's works always deal with the recollection of past life, death, the passing of time, and the relation of the individual to the masses. H.D.

Bibl.: Boltanski, Paris, 1978 · Boltanski, Paris, 1984 · Semin, Boltanski, 1988 · Gumpert, Boltanski, 1994 · Theewen, Boltanski, 1996 · Semin, Boltanski, 1997

Bomberg, David. *1890 Birmingham, England, †1957 London. British painter and graphic artist. The son of Polish – Jewish immigrants, Bomberg trained in London as a lithographer, book designer, and painter. In his geometric and dynamic early work, he took his cue from → Vorticism, although he was not a member of the movement, which was founded 1913–14 and advocated radical abstraction. He lived in Palestine (1923–27) and visited Spain, Morocco, and Greece (until 1935), painting landscapes in an initially impressionistic idiom. He gradually adopted a freer, more expressive style, giving his works a visionary, melancholic quality. From 1945 to 1953 he taught at Borough Polytechnic in Dagenham, co-founding in 1947 with his students the Borough Group and then the Borough Bottega. Disappointed by the lack of recognition for his work, he moved to Spain in 1954, returning to London shortly before his death. L.Sch.

Bibl.: Sylvester, Bomberg, 1973 · Oxlade, Bomberg 1977

Christian Boltanski, *Portraits d'Enfants*, 1975, 10 color photos, each 40 x 30 cm, Sonnabend Collection, New York

Pierre Bonnard, *Nude in a Mirror*, 1910, Oil on canvas, 124 x 48 cm, Wallraf-Richartz Museum, Cologne

Bonnard, Pierre. *1867 Fontenay-aux-Roses, France, †1947 Le Cannet (near Cannes). French lithographer and designer. He studied at the Académie Julian in Paris, where he met → Sérusier, → Denis, Gabriel Ibels and Paul Ranson. He was member of the → Nabis (founded in 1888). In 1889 he started working as a lawyer, but abandoned law after doing military service in Bourgoin (1890). With his poster design *France – Champagne*, he scored such a success that he decided to devote himself entirely to an artistic career. Between 1899 and 1902 he produced some 250 lithographs for posters, wall decorations, stage sets, and illustrations, and this experience in commercial and applied graphics influenced the style of his painting. Besides a deliberate economy of color, line is given a special dynamism, conveying movement and spiritual expression (*Women in the Garden*, 1890–91). About 1900 Bonnard began to free himself of elements of Art Nouveau and Symbolism, experimenting with a new pictorial structure much influenced by Japanese art. His earlier, rather gloomy urban views are superseded by idyllic pastoral scenes in bright colors (*La Famille Terrasse au Grand Lemps*, 1900). A visit to → Matisse in 1909 reinforced Bonnard's view that color and line were equally important. That visit was followed in the summer of the same year by a longer stay in the South of France that was to be the first of many (*View of Saint-Tropez*, 1909). In the 1920s, leaving the label of → Post-Impressionism far behind, Bonnard developed his mature artistic style, characterized by complex compostion, subtle use of perspective and reflection, and sophisticated color schemes (*Terrace at Vernon*, c. 1928). His life became more settled. In 1925 he married his long-standing companion and model Marthe, and in 1926 moved into a house he called Le Bosquet in Le Cannet near Cannes, where he lived until his death. Major exhibitions followed in 1932 in the Kunsthaus, Zürich, and in 1934 in the Wildenstein Gallery in New York. H.D.

Bibl.: Bouvet, Bonnard, 1981 · Terrasse, Bonnard, 1989 · Cogniat, Bonnard, 1991 · Bonnard, London, 1997 ·

Bontecou, Lee. *1931 Providence, Rhode Island. American sculptor. Bontecou's early works, following study in New York and Rome, were figurative sculptures often on avian themes. She soon turned to more allusive → assemblages, especially of stretched canvas cloth and steel. Soft or aggressively toothed ovoid forms predominated as the objects moved away from the flat and into three dimensions (*Untitled*, 1962, Moderna-Museet, Stockholm): a constant theme is the manner in which lip or edge can render distinctions between plenum and void irrelevant. Before turning increasingly to printmaking in the late 1960s, she embarked on a series of large-scale sculptures in plastic that evinced a magical or sexualized component; she also branched out into a type of serenely composed → Junk art. D.R.

Bibl.: Munro, Originals, 1979

Borduas, Paul-Émile. *1905 Saint Hilaire, Quebec, †1960 Paris. Canadian painter. After art training at the Ecole in Montreal, Borduas studied in Paris with → Denis, and taught at the Ecole du Meuble from 1937. His early painting focused on the sacred and on landscape (*Synthesis of a Landscape of Saint Hilaire*, 1932) but he evolved into abstract → Surrealism around 1940, initial sorties being automatic paintings and gouaches somewhat akin to → Masson in structure. The group of young painters around him having formed into the → Automatistes, in 1948 he wrote an anarchic essay, *Refus Global*, which led to his dismissal from the School. Following a period producing delicate watercolors (some close to Bram Van Velde [1895–1981]) and wood sculpture, he repaired to the US in 1953. There he fell under the spell of → Abstract Expressionism (e. g., → Gorky) and proceeded to experiment with techniques inherited from both → Pollock and → Kline (*Untitled*, 1958, Mus. of Contemporary Art, Montreal). His later watercolors are dynamic and in general vertically structured. In Paris by 1955, he enjoyed little recognition and his last works are of a measured harmony. He is accepted as the founder (with → Riopelle) of modernist Canadian art. D.R.

Bibl.: Borduas, 1976

Borès, Francisco. *1898 Madrid, †1972 Paris. Spanish painter and graphic artist. He was a member of the group the Ultraists (1922–23). In 1925 he moved to Paris, where he met → Gris and → Picasso, and developed a dynamic post-Cubist style influenced by → Fauvism (color) and → Surrealism (spatial conception). During the 1920s, in paintings verging on the abstract, he came close to → Art Informel, although his essentially intuitive way of working involved proceeding from the non representational to the representational. In his works, which he subdivided into a number of phrases, he used a single color in varying hues, against which he set figures and objects (still lifes or everyday artefacts). K.S.-D.

Bibl.: Borès, Paris, 1982

Borofsky, Jonathan. *1942 Boston, Mass.. American sculptor, graphic artist, and painter living in Ogur Guit, Maine. He gained a B.F.A. at Carnegie Mellon University, Pittsburgh (1964) and then studied at the École de Fontainebleau and Yale University, graduating with an M.F.A. (1966). Completely committed in his early work to → Conceptual art, Borofsky developed a computerized counting system; he then began to note down a continuous numerical sequence by hand (*Counting*, from 1969; after 1974 counting backward), with which he could document the passage of time. Parallel to this, he combined works from childhood with new pieces to form object and picture sequences (*Continuous Paintings*). Since that time all his works have been designated with a number. In his drawings Borofsky treats dream images: these are also a central theme in his paintings where they are treated in a consciously childlike manner, to express his idea of achieving a higher level of consciousness through art. Inspired by → LeWitt, he enlarged the dream world of his drawings into wall paintings and large-scale sculptures (*Hammering Man*, 1981). Right up to the present day, tentative ideas and dream images jotted down on scraps of paper are the source of his room-filling installations, which

are conceived in different phases. With his city sculptures (*Ballerina*, Metropolis, Berlin, 1991; *Walking Man*, Documenta 1992; and Bayerische Rückversicherung, Munich, 1996), the often nightmarish character of his works has given way to a more playfully cheerful mood. H.D.

Bibl.: Borofsky, Basel, 1981 · Rosenthal/Marshall, Borofsky, 1984 · Borofsky, Frankfurt am Main, 1991 · Cuno, Borofsky, 1992 · Kittelmann, Borofsky, 1993

Bortnyik, Sándor. *1893 Marosvásárhely (Tîrgu Mure, Romania), †1976 Budapest. Hungarian painter, who began his career as a poster designer. Early drawings and linocuts in → Kassák's Activist journal *MA* in 1919 (*Red Star*) show the influence of German → Expressionism and → Futurism impregnated with Formalist concerns. (Non-Objective art was known in Hungary from photos of Uitz and Kemmeny's 1919 trip to Russia.) Other works of the time (*Red Locomotive*) are more → Futurist in spirit. Like Fred Forbát (1897–1972) and László Peri (1899–1967), Bortnyik (especially in his Weimar period, 1922) essayed a synthesis of El → Lissitzky's formalism with → Neo-Plasticism (a wood and cardboard relief *Composition*, 1924, recalls → Moholy-Nagy). After a portrait of Kassák as prophet (1922), he produced two sardonic works (*New Adam* and *New Eve*, 1924) that futuristically enshrine our forebears as smart, mechanized dolls against a Proun backdrop. This ironic vision was to invest all his subsequent work, from *Korszelüsített Klasszikusok* ("Updated Classics" that present Old Masters in a new guise), to the almost postmodern *Pygmalion* (1961) in which the artist is accosted by the "New Eve" of 35 years before. D.R.

Bibl.: Bortnyik, Budapest, 1978

Botero, Fernando. *1932 Medellin, Colombia. Colombian painter and sculptor living in Paris. At the age of 20, after graduating from a Jesuit college (and a matador school), Botero went first to Bogotá, and then to Madrid and Italy to study art (paid for by money already earned through his pictures),. He was equally interested in pre-Colombian, classical European, and avant-garde art. Botero has traveled extensively, staying in Mexico (1956–57), Bogotá (where he taught painting, 1958), and New York (1960), and then in Paris, Germany, Italy, and Spain, for longer stays and exhibitions. He settled in Paris, although he has continued to travel.

Jonathan Borofsky, *Hammering Man*, 1981, Installation, Frankfurt Fair

Molded by his Latin American origins as much as by the cosmopolitan avant-garde, Botero has devoted himself to figure work. In vibrant, abundant, baroque scenes, he paints musicians, politicians, bishops, lovers, and family scenes, as well as parodies of Old Masters such as Cranach, Mantegna, and Velázquez. What has been misinterpreted as caricature or naive folklore in his work, is in fact purely an interaction with painting and the history of painting: artistic transformation through deformation as is the case with → Picasso, → Giacometti, → Bacon and others. His painting is characterized by technical bravura, sumptuous colors, and a baroque, ironic, scintillating delight in narration. Since the 1970s he has also produced a substantial corpus of sculptures in materials ranging from polyester to bronze. L.Sch.

Bibl.: Spies, Botero, 1986 · Sgarbi, Botero, 1991

Boubat, Édouard. *1923 Paris, †1999 Paris. French photographer, who had no formal training. From 1953 to 1967 he was a photojournalist with the magazine *Réalités*, working in, among other places, the Near East and Asia, where he took a series of pictures showing living conditions in rural India. From 1967 he worked as a freelance photojournalist and portrait photographer, producing sensitive, socially committed human interest series on writers and young people in Hyde Park, London, and everyday scenes in Paris and rural France (books: *Femmes*, 1972; *Miroirs: Autoportaits*, 1973; *Le Boubat de Boubat*, 1989). K.S.-D.

Fernando Botero, *The Letter*, 1976, Oil on canvas, 149 x 194 cm

Bibl.: Boubat, Paris, 1990

Bourdelle, Émile-Antoine. *1861 Montauban, Tarn-et-Garonne, †1929 Le Vésinet, Yvelines. French sculptor. Bourdelle was a pupil of J. A. J. Falguière and Jean Lalou at the École des Beaux-Arts, where he was particularly receptive to the latter's modeling. He became an assistant (*praticien*) to → Rodin in 1893, and conserved a fervent admiration for his friend and colleague throughout his life (as demonstrated by his memoir, *La Sculpture et Rodin*). *Hercules, the Archer* (1919), with its extraordinary balance and lithe strength, represents his breakthrough to a more classicizing style. A major official commission came with the façade of the Théâtre des Champs-Elysées (1910–12; with architect Auguste Perret): Tragedy, Comedy, Music, the Muses, etc. (*in situ*). A series dedicated to the genius of Beethoven, begun in the 1880s, was continued until the last year of his life, while his busts – *Rodin* (1910) and *Auguste Perret* (1923) – and works such as *Carpeaux au travail* (1910) often refer to the act of sculpting. Bourdelle's art demonstrates a shift from Rodinesque power to an almost Expressionistic schematicism. His residence in Impasse du Maine, Paris, is now the Musée Bourdelle and houses a vast collection of his work: stone sculpture, bronzes, studies, paintings (inc. self-portraits), etc. His pupils at the → Académie de la Grande Chaumière included → Richier and → Giacometti. D.R.

Bibl.: Dufet/Jianou, Bourdelle, 1984

Louise Bourgeois, *Cell, Three White Marble Spheres*, 1993, Glass, metal, marble and mirror, 213 x 213 x 213 cm, Saint Louis Art Museum, Missouri

Bourgeois, Louise. *1911 Paris. French-born American sculptor and painter. Has lived since 1938 in New York. She studied in Paris at the Sorbonne, the École du Louvre and the Académie des Beaux-Arts, and was a pupil of Roger Bissière (1886–1964) (Académie Ranson) and → Léger. Her first paintings were abstract with Surrealist influences. In 1938, in a move that had a big impact on her life and work, she went to live in New York, where she married the art historian Robert Goldwater. She was a pupil at the → Art Students League of New York and after 1938 began to create sculptures that she soon expanded into installations in the form of large → environments. She values the anonymity of the city, preferring to work in isolation and seclusion. In the 1950s she produced abstract, geometrically simple works, such as totemlike wooden steles painted black or white (*Spiral Women*, 1950), which she arranged in groups and which alluded symbolically to the anonymous and alienating world of metropolitan man. Her early work had a certain fragility, but during the 1960s her sculptures gained in strength. In addition to wood, she used stone, metal, latex (and other synthetic materials), papier-mâché, and plaster. Bourgeois does not seek to develop a unified artistic vocabulary of form, but attempts to fuse elements of geometric abstraction and figuration, endowing them with naturalistic power. Thus her abstract works, reduced to the essential, frequently delineate the human figure, in part with expressly sexual allusions (different versions of "bodyscapes," such as *End of Softness*, 1967). In this respect, her themes are largely defined by personal considerations (traumatic childhood memories of her father and governess). Accordingly Bourgeois sees her sculptures, monuments to the "devastating effect of emotions that one must get through," as "emotional abstractions" in which unprocessed emotional states (relations to other people) emerge. Sexuality, as seen from a female perspective, is a central theme in her works (*Cell, Three White Marble Spheres*, 1993). These have been one-sidedly linked with feminist ideologies. Bourgeois, who represented the US at the Venice Biennale in 1993, is seen as an outstanding figure with whom numerous American artists identify. K.S.-D.

Bibl.: Bourgeois, New York, 1982 · Bourgeois, Destruction, 1998

Louise Bourgeois, *Female Portrait*, 1982, Marble, 55.6 x 43.2 x 29.2 cm, New Orleans Museum of Art, New Orleans

Bourke-White, Margaret. *1904 New York, †1971 Stamford, Conn. American photographer. She studied at the Clarence H. White School of Photography in New York (1920–22), and in several other places (until 1927) before taking her first photos, which were of American university campus life. Moving to Cleveland, she became a professional photographer in 1927, specializing in architecture, industry, and design. She provided photo reportages on Germany (shots of the Krupp iron works, 1929) and the USSR (1930–32), and worked for the magazines *Life* (1936–45) and *PM* (from 1940). The subjects of her essays (photos and text) included war and catastrophe (Buchenwald concentration camp, Korea, India, South Africa), as well as social and cultural topics. Her career was curtailed when she was stricken with Parkinson's disease in 1957. Her most memorable books include *Eyes on Russia* (1931) and *U.S.S.R. Photographs* (1934). In her unsentimentally direct photographs, she was intent on combining visual fact and aesthetic effect. Bourke-White was adept at highlighting telling details and objects in her pictures. Her portrait series of the Amerian populace, influenced by Yousuf Karsh, are as remakable as her photo reportages. Bourke-White was one of the 20th century's groundbreaking photographers. K.S.-D.

Bibl.: Daffron, Bourke-White, 1988

Boyd, Arthur. *1920 Murrumbeena (Melbourne), †1991 Melbourne. Australian painter, graphic

artist, sculptor, and ceramicist, largely self-taught. He is the best-known member of an artistic dynasty. Inspired by European art and mythology as well as by a deep knowledge of the Bible (Old Testament themes), Boyd elevates motifs from his Australian homeland to a universal level. After 1936 he produced landscapes and portraits, and in the 1940s Melbourne street scenes, alluding metaphorically to the destructive forces of war and the spiritual impoverishment of man. Up until the late 1950s he also produced ceramics, influenced by → Picasso, as well as sculptures, drawings, and prints. In his series *Love, Marriage and Death of a Half-Caste* (1957–59), which is indebted to → Expressionism and → Surrealism, Boyd took as his theme the fate of uprooted, dispossessed people, referring to the Aboriginals. His series of pictures filmed in 1960 under the title *The Black Man and his Bride* made him internationally famous. After the mid-1970s, he concentrated on landscape subjects (*Riversdale and Bundanon in Shoalhaven*). K.S.-D.

Bibl.: Pearce, Boyd, 1993

Boyle, Mark and Joan Hills. *1934 Glasgow. Scottish sculptor, painter, Performance artist, and Light artist. After briefly studying law, Boyle lived as a poet (with casual jobs) in London (1955–58). He met the painter Joan Hills in 1958 and turned to the fine arts. Since then they have lived and worked together, joined in the 1980s by their children Georgia (*1962) and Sebastian (*1964) as the Boyle Family. Their → assemblages of junk and found objects, started in 1958, were followed in the 1960s by performances and → Conceptual events (*Theatre*, 1964). In 1966 they founded The Sense Laboratory Ltd, which was concerned with investigating physical and organic processes. These were incorporated into → happenings and → performances, such as light shows (*son et lumière* programs) for rock musicians (Jimi Hendrix and Soft Machine), as well as "body-work" and "taste-and-smell" events. In 1968 they began their project *Journey to the Surface of the Earth*, in which, in the tradition of the → objet trouvé, randomly selected areas of the earth's surface are removed and transferred onto a picture support (Earthprobes). These works, which are conceived in series and executed in mixed media, are a way of fixing fragments of reality and challenging sensory perception (training the eye for all kinds of natural and everyday phenomena). For this comprehensive life work, for which they travel the world accompanied by their children, exact scientific and sociological studies are done for each geographical point (about 2 x 2 meters) randomly chosen by friends throwing a dart at a map of the world, the studies are then publicly set out in a "multisensual presentation." K.S.-D.

Bibl.: Locher, Boyle, 1978 · Boyle, Auckland, 1990

Bragaglia, Anton Giulio. *1890 Rome, †1960 Rome. Italian photographer and stage designer. Bragaglia initially worked as a cinematographer in a pre-Expressionist mode. Together with his brother Arturo (1893–1962) he was inspired by → Futurism at the time of the early manifestos (1909–10), and by Bergson's theories on *durée*, to found *Fotodinamismo futurista* (manifesto, 1913). This aimed

to capture via photography the motion sublimated in the "pictorial dynamism" of → Severini, → Boccioni, → Balla, and → Russolo. Depicting the "vital force" of everyday actions (typing, greeting, smoking), their dynamism depends on smooth superposition (as in some Etienne-Jules Marey [1830–1904] and in Marcel → Duchamp's famous *Nude Descending a Staircase* [1911/1912]), rather than compartmentalized succession. Long-exposure shots highlight change by "out-of-focus" technique. The fluidity of such prints was not in accord with Futurism, and the Bragaglias were excluded in 1913. They founded the Casa d'arte Bragaglia in Rome in 1918. Anton Bragaglia thereafter concentrated on stage sets, but Arturo returned to photography in the late 1920s. Similar photographic work was to be carried out by → Schlemmer and Lux Feininger (1916–). D.R.

Brancusi, Constantin. *1876 Hobitza, Romania, †1957 Paris. Romanian sculptor. He attended the Craiova School of Arts and Crafts (1895–98), and then the Bucharest Academy of Art, graduating in 1902 with a diploma. After completing his military service, Brancusi slowly made his way to Paris, where he began studying at the Académie des Beaux-Arts with the help of a grant. In 1907 he showed his first sculptures at the Société Nationale des Beaux-Arts, earning praise from → Rodin. To distance himself from Rodin, Brancusi started to work directly from the stone (*Head of a Girl*, 1907). With *The Kiss* (1908), he broke definitively with naturalism to create a spiritualized form out of matter. His meditative absorption into an elementary vocabulary of forms led to ever smaller scale. Sensitive to the qualities of his chosen material (marble, stone, and wood),

Constantin Brancusi, *Endless Column*, 1937–38, Steel, height c. 30 m, Ensemble Tirgu Jiu, Romania

Constantin Brancusi, *Bird in Space*, 1940, Polished bronze, height 53 cm, Peggy Guggenheim Collection, Venice

Brancusi painstakingly honed his forms to the utmost simplicity, to an elemental expressiveness. The enormous spiritual concentration in such work did not permit a wide range of themes – there are 14 versions of *The Kiss* alone, the largest of which is in Montparnasse cemetery. The motif of the *Sleeping Muse* was repeatedly taken up by Brancusi between 1906 and 1926, being refined to a highly polished egg shape, symbol of spiritual immersion. Brancusi himself designed the bases for his statues, ensuring the greatest possible demarcation from the environment. The pinnacle of his output is the Tirgu Jiu ensemble (1935–38), which unites several large works: *The Table of Silence*, *The Gate of the Kiss*, and *The Endless Column*, a steel sculpture 30 meters high. The latter, which is made out of separate elements and was originally gilded, is intended to symbolize spiritual elevation. The ensemble, inspired by various sources (Romanian folk art, → primitivism, → Cubism), stands as a memorial to a humanist and pacifist philosophy of life, and also as a vehicle of purification and redemption. Supported by friends, Brancusi spent the war years in Paris in difficult circumstances. In 1952 he acquired French nationality, and in 1955 his career was honored with a major retrospective in New York's Guggenheim Museum. A year before his death Brancusi bequeathed his studio complete with its contents to the French state, which reconstructed the workshop in front of the Pompidou Centre, opening it to the public. H.D.

Bibl.: Geist, Brancusi, 1969 · Geist, Brancusi, 1987 · Bach, Brancusi, 1995 · Brancusi, Paris, 1995

Brandt, Bill. *1904 Hamburg, †1983 London. German-born British photographer, self-taught, who became interested in photography in 1925. Went to Paris in 1929, where he became an assistant to → Man Ray. He was exposed to → Surrealism, and was friends with → Breton, M. → Duchamp, and → Brassaï, who influenced him for a while. In 1931 he moved to England. In the 1930s he produced committed social reportages documenting contrasts among the classes (*The English at Home*, 1936). He worked for the magazines *Verve*, *Picture Post*, and *Lilliput*, as well as for the Home Office (1940–45), documenting air-raid shelters during the London Blitz. After 1943 Brandt concentrated on landscape photography, portraits, and (after 1946) nudes (*Perspective of Nudes*, 1961). In a manner reminiscent of Surrealism and → Symbolism, he produced free portraits of writers and artists, surreal city views, and droll nude and landscape combinations (mostly in contrasting black and white, with striking cropping and considerable emphasis on symbolic elements). K.S.-D.

Bibl.: Brandt, London, 1993

Brangwyn, (Sir) Frank. *1867 Bruges, †1956 Ditchling, Sussex. Belgian-born British painter. Essentially self-taught, this prolific artist – who came to England in 1875–was an associate of the Arts and Crafts movement (1882–84) before being commissioned to decorate the façade of Siegfried Bing's Maison de l'Art Nouveau in Paris (1895). Brangwyn produced high-keyed canvases closer to Continental than British models, and some near-monochrome landscapes of somber power (mid-1890s). His commission to provide panels for the House of Lords' Royal Gallery illustrating scenes from the British Empire was not wholly successful: his designs were rejected in 1930. They now hang in the Brangwyn Hall (Guildhall), Swansea. He was knighted in 1941. Popular for much of his lifetime, Brangwyn's work lies outside the modernist school. The Brangwyn-museum, Bruges, is dedicated to his work. D.R.

Bibl.: Brangwyn, Walthamstow, 1974

Braque, Georges. *1882 Argenteuil-sur-Seine, France, †1963 Paris. French painter and graphic artist. Braque received his first lessons from his father, who owned a house-painting business that was moved in 1890 to Le Havre. Here, from 1899, the young Braque attended evening classes at the Le Havre École Municipale des Beaux-Arts and did an apprenticeship in interior decoration. In 1900 he went to Paris to continue his studies. After military service (1901–02), he went to the private Académie Humbert and in 1903 briefly to the École des Beaux-Arts. In 1906 he showed Impressionist-style pictures at the → Salon des Indépendants, and the following year embraced → Fauvism in L'Estaque (near Marseille). Through Apollinaire, he met → Picasso. A nude painted in December 1907 shows him turning away from Fauvism: impressionistic dots are replaced by sharp-edged shapes and gradated tone values. These experiments were continued in 1908 in L'Estaque, and the showing of these pictures the same year at Kahnweiler's gallery in Paris marked the birth of → Cubism. Braque and Picasso worked closely together until 1914, producing in their respective "analytic phases" paintings that were similar in both composition and color. The motif is disassembled into facets and depicted from a multiplicity of viewpoints (*Composition with Ace of Clubs*, 1911). Braque began to insert lettering, painted labels, price tags, newspaper titles, and other *trompe-l'oeil* effects into his hermetic images to create a link with visual reality.

Georges Braque, *Still Life with Fruit Dish, Bottle and Mandolin*, 1930, Oil on canvas, 116 x 81 cm, Galerie Beyeler, Basel

After 1912 he and Picasso developed the → collage, ushering in "synthetic Cubism." The large forms, stenciled lettering, and strong colors resulted in pictures, which, rather than being illusionistic representations, had an autonomous pictorial reality (*The Guitar*, 1912). During the war Braque suffered a serious head wound, and did not resume painting until 1920. His Cubist austerity relaxed, his draftsmanship softened and loosened, the interlocking of planes became freer, and the intense colors were replaced by an earthy palette. This subtle, attenuated Cubism scarcely changed until 1939. Braque had major retrospectives in Basel, New York, London, Paris, and Brussels. In 1937 his *The Yellow Tablecloth* won the Carnegie Prize awarded by the Carnegie Foundation in Pittsburgh. From 1939, in addition to painting Braque took an intense interest in sculpture, ceramics, and lithography. With his *Atelier* series of studio paintings (1949–56), he again reached new levels of concentration and compression. H.D.

Bibl.: Hofmann, Braque, 1962 · Braque, Bordeaux, 1982 · Rubin, Cubism, 1993 · Braque, Saint-Paul de Vence, 1994

Brassaï, *Phénomène de l'extase*, 1932, Gelatin silver print, Gilberte Brassaï, Paris

Brassaï (Gyula Halász). *1899 Brasov, Romania (formerly Transylvania), †1984 Beaulieu-sur-Mer, Alpes-Maritimes, France. Photographer, draftsman, and sculptor of Hungarian origins (he took French nationality 1948). He studied art in Budapest (1918–19) and Berlin (1921–22). From 1924 he worked as a journalist in Paris, where he settled for good in 1935. He was a member of the Paris group of Surrealists, and was friends with numerous artists of the French and international avant-garde, with some of whom he collaborated (→ Man Ray, → Breton). Inspired by → Atget, whose work became a constant model for him, and → Kertész, he took up photography in 1926, devoting himself to photojournalism. From 1929 he took gloomy melancholic shots of Paris nightlife given precision and amazing depth of field through multiple exposure. The publication of these pictures in the volume (*Paris de Nuit*, 1933) brought him international renown. After 1932 he operated under the pseudonym Brassaï. Between 1932 and 1938 he produced shots of graffiti in Paris (published in 1960) and from 1934 did poet portraits (Paul Eluard, → Dalí, and → Braque). In 1939 he created the photo series *Nus à l'atelier* for → Matisse and *Picasso à l'atelier* for *Life* magazine. Between 1940 and 1942 he took part in the meetings of the literary *bande à Prévert* in the Café de Flore in Paris. He used his photos, enlarged, to create decorative backdrops for the theater (Jacques

Prévert, Raymond Queneau, Elsa Triolet) and ballet (→ Cocteau and Georges Auric). After 1945 Brassaï turned increasingly to commercial photography, documentary shots for *Harper's Bazaar* (1949–60). His repertoire also included films (*Tant qu'il y aura des Bêtes*, 1955) and sculptures (from 1968). He is considered a master of both unposed and available-light photography. K.S.-D.

Bibl.: Brassaï, Artists, 1982 · Krauss, Brassaï, 1985 · Brassai, Paris, 1988 · Grenier, Brassaï, 1990

Brauner, Victor. *1903 Piatra Neamț, Romania, †1966 Paris. Romanian painter, draftsman, and graphic artist. As an art student in Bucharest, he became involved in avant-garde initiatives. In 1930 he moved to Paris and immediately joined the Surrealists. At risk on account of his Jewish background, he went underground in the South of France during the war, after which he remained a restless individual, even if always oriented toward Paris. Although he broke with → Surrealism in 1948, the quality of his varied pictorial language remained visibly inspired by it. His works have esoteric and enigmatic traits derived fromelements of magic and the cabala, Mayan art, and other exotic archetypal forms. Brauner's graphic work also shows a fascination with the combination of typography and painting. L.Sch.

Bibl.: Brauner, Paris, 1972 · Jouffroy, Brauner, 1996

Brecht, George. *1925 Halfway, Oregon. American Performance, Installation, and Conceptual artist who has lived in Cologne since 1972. He worked as a chemist (1950–65) and studied experimental music with → Cage at the New York School of Social Research, (1958–59). He became a member of the New York → Fluxus group (Fluxus International Festival, New York, 1962–63). Between 1965 and 1968 he collaborated on a "center of permanent creation" at Villefranche-sur-Mer with Robert Filliou (1926–87) and then taught at Leeds College of Art (1968–1969). Since the end of the 1950s, he has made objects (→ ready-mades and crystal cultures) and "multimedia events" (including language games) resembling happenings. Experimentation, coincidence, and paradox characterize his chaotically amorphous, indeterminate art, which is open to intervention on the part of the viewer. His work explores existiential feelings of emptiness, open-endedness, and absurdity. In *The Book of the Tumbler on Fire* (1964), Brecht organized all his works into "volumes," "chapters," "pages," and "footnotes." I.T.

Bibl.: Martin, Brecht, 1978

Georges Braque, *Man with Guitar*, 1914, Oil and sand on canvas, 130 x 72.5 cm, Musée National d'Art Moderne, Centre Georges Pompidou, Paris

Brassaï, Graffiti *The Sun King*, from the series IX: Primitive Pictures, 1945–50, Gelatin silver print mounted on wood, 139.8 x 105 x 2 cm, Musée National d'Art Moderne, Centre Georges Pompidou, Paris

George Brecht, *Venus Paradise*, *Exhibit 25, The Book of the Tumbler on Fire, vol. 1, chapter 1, page 25*, 1964, Mixed media on cotton wool in a box, 31 x 34 cm, Städtisches Museum Abteilberg, Mönchengladbach

Breker, Arno. → National Socialist art

Brendel, Walter. *1923 Ludwigshafen, Germany. German painter, draftsman, and collage artist living in Salzburg (since 1974 with a studio in the Künstlerhaus) and Feldwies-Übersee on the Chiemsee. Studied at the Munich Academy under Karl Caspar (1946–48). His first works were expressively realistic landscapes and figural paintings, but in 1948 he turned to abstraction, and for a while → Lyrical Abstraction (Klangbilder or "sound paintings" consisting of rhythmical color compositions). In the 1950s he began developing "scriptural" pictorial structures. These were initially based on organically self-evolving signs, but gradually incorporated visible brushwork, a painterly impasto and a monochrome ground. In 1963 out of his scriptural painting he developed a personal form of collage ("scriptural sectionism"), which combined cut-up works of his own, mixed-media materials such as cardboard, coins, image fragments, paint crust, and found studio objects. Between 1964 and 1978 he combined objects, mostly machine parts, to form figural sculptures which are at once magical and grotesque. Since 1978 he has returned to dynamic linear pictorial composition, into which he inserts associative texts (since 1987). K.S.-D.

Bibl.: Brendel, Cologne, 1989

Breton, André. *1896 Tinchebray, Orne, France, †1966 Paris. French art theorist, writer, poet, and philosopher. Breton has come to enjoy legendary posthumous fame as an initiator, theorist, and central figure of → Surrealism, a renown that somewhat eclipses his reputation as a major figure in French literature (*Nadja*, 1928, *L'amour fou*, 1934, and several volumes of lyric poetry). In 1919, while still a medical student, he founded the magazine *Littérature*, subsequently gathering around himself a group of avant-garde writers and painters of the caliber of Éluard, Reverdy, Aragon, → Ernst, → Dalí, → Tanguy, Buñuel, and → Magritte. In 1924 he published the first *Manifeste du Surréalisme*, which gave the group a programme, at the same time renaming his magazine *La Révolution surréaliste*. The programme, which was influenced by Romanticism, Hegel and psychoanalysis, sought to "resolve the hitherto contradictory conditions of dream and reality into an absolute reality, into a super-reality." This provocation – which also possessed a political dimension – led to constant scandals, as well as to rifts within the group, and caused a furore through exhibitions and further manifestos. In 1940 Breton emigrated to America, where he continued to propagate his ideas. He returned to Paris in 1946, pursuing his artistic and political agitation, with undiminished energy (for example against → Socialist Realism and the war in Algeria). Although he was widely attacked for this, glamorous international exhibitions of Surrealist art constantly confirmed the success of his life's work. L.Sch.

Bibl.: Breton, Surrealism, 1969

Brisley, Stuart. *1933 Haslemere, Surrey. British Performance artist who has been based in Lon-

don since 1963. He studied at the Guildford School of Art (1949–54), the Royal College of Art in London (1956–59), the Munich Kunstakademie (1959–60), and Florida State University (1960–62). In 1968 he took up → Performance art. His performances always start from a political position and explore themes of consumerism, power, authority, brutality, isolation, and repression, and their effects on the body. They often involve self-inflicted pain. In 1973 at Christmas he staged a protest in Berlin with his performance *Ten Days*. He subsequently collaborated with Leslie Hasam on such important perfomances as *Moments of*

André Breton, *Pan hoplie*, 1953, Mixed media, 20 x 12 x 5 cm, Elisa Breton Collection, Paris

Decision/Indecision (Warsaw, 1975) and *Homage to the Commune* (Milan, 1976). His protest against the waste of raw materials and funds on the occasion of Documenta 6 gave rise in 1977 to *Surviving in Alien Circumstances*, in which Brisley and Christoph Gericke dug a hole in the ground with their bare hands and spent two weeks in it. More recent events, which once again involve three-dimensional objects, include *Normal Activities May be Resumed: an Obstruction/Instruction Guide*, a sound installation on the theme of nuclear war (1985). K.S.-D.

Bibl.: Brisley, Glasgow, 1986

Broodthaers, Marcel. *1924 Brussels, †1976 Cologne. Belgian writer, poet, and multimedia artist. From 1945 he published poems and articles in the tradition of French Symbolism and → Surrealism. In 1957 his volume of poems *Mon livre d'Ogre* was published and his first film *La Clef de l'Horloge* was shown at the Knokke film festival. He was briefly a member of the Belgian Communist

Party. In 1964 he emerged for the first time as a visual artist when he put in plaster the remaindered stock of his book of poems *Pense-Bête*. Through shows in the Wide White Space Gallery in Antwerp, he got to know the → Fluxus artists around → Beuys, with whom he built up a critical relationship. In his first museum exhibition, "Court Circuit," which took place in 1967 in the Palais des Beaux-Arts, Brussels, Broodthaers showed earlier objects printed on photo canvas. Taking → Magritte's epistemological perspective as his starting point, Broodthaers concerned himself with the discrepancy between word and image, concept and view, but added a sociological dimension by querying the function of the artist in modern society. He produced → assemblages, → accumulations and → collages, but also films, photo works, texts, and → artists' books, which evolved increasingly into a kind of → Gesamtkunstwerk.The growing criticism (from 1968) of the institution of the museum and of the strategies of the art market led Broodthaers to found his own (fictitious) museum: the *Musée d'Art Moderne, Département des Aigles, Section XIXe*. Using his apartment as the nucleus of this "imaginary

Marcel Broodthaers, *Mussels in White Sauce*, 1967, Mixed media, 50 x 36 x 36 cm, Private Collection, courtesy Galerie Christine and Isy Brachot, Brussels

museum," he sent out open letters and pamphlets, and made preparations for increasingly complex exhibitions. Thus the legendary "Adler" (Eagle) exhibition in Düsseldorf (1972), where the artist had been living since 1970, grew into an open discussion about "dismantling the noble conception of art" (Jürgen Harten). Following the closure of the *Musée d'Art Ancien, Galerie du XXe siècle* at Documenta 5 in Kassel (1972), Broodthaers started on a new group of nine-part-poem-objects, *Peinture Littéraire* (Literary Painting). Between 1974 and 1976 he had six major museum exhibitions in Brussels, Basel, Berlin, Oxford, London, and Paris (film *The Battle of Waterloo*, 1975). Broodthaers' oeuvre paved the way for the → Conceptual art of the 1980s and 1990s. H.D.

Bibl.: Broodthaers, London, 1980 · Broodthaers, Cologne, 1982 · Goldwater, Broodthaers, 1989 · Buchloh, Broodthaers, 1995

Brown, Roger. *1941 Hamilton, Alabama, †1998American painter and printmaker, Brown

Marcel Broodthaers, *Papa*, 1966, Various objects, chair: 89.5 x 42 x 34.5 cm, mirror: 49 cm diameter, Galerie Hauser & Wirth, Zürich

was associated with the Chicago Imagists, a group of artists principally trained at the School of the Art Institute of Chicago who developed a highly expressive and frequently vulgar response to → Pop art during the tumultuous late 1960s. This group included → Paschke, → Nutt, Gladys Nilsson, and Karl Wirsum, among others. Brown's initial training was in commercial art at the American Academy of Art, Chicago in the early 1960s, when he briefly studied at the Art Institute of Chicago. In 1964, he returned to the Art Institute and studied painting with Ray Yoshida, receiving his B.F.A. in 1968 and his M.F.A. in 1970. While a student, Brown was encouraged to explore the collections of the Field Museum and the Art Institute of Chicago, which had a lasting impression. Throughout his career, Brown would borrow freely from such diverse sources as Persian, Japanese, Chinese, and Indian art, early Renaissance painting, Surrealism, and outsider art, especially by Joseph Yoakum. He would also draw from his extensive collection of "trash treasures" culled from flea markets, and from his experiences traveling cross-country absorbing the local color of different regions.

Brown's early paintings of the late 1960s, diminutive theater scenes, evolved by the early 1970s into larger, complex figurative scenes with Magritte-like silhouetted cartoon figures in the Miesian architecture of Chicago. An observer of popular culture and media spectacle, Brown would paint parodies of press coverage of natural and human disasters such as the uprising at Attica or the assassination of Aldo Moro by the Red Brigade. By the late 1970s, Brown achieved national recognition for his life-sized silhouetted figures in simplified, fantasy settings, frequently framed in his characteristic quilt-like patterned sky. Employing an archaic form of flat, isometric perspective, Brown's emblematic images had the instant readability of Pop art. Brown was the subject of a Hirschhorn Museum retrospective in 1987. B.R.

Bibl.: Adrian, Sight, 1985 · Lawrence, Brown, 1987 · Adrian, Chicago Imagism, 1994

62 Brown

Bruch, Klaus vom. *1952 Cologne. German video and installation artist living in Cologne. Studied at the California Institute of the Arts, Valencia, California (1975–76) and at the University of Cologne (1976–79). In the mid-1970s he collaborated with Ulrike Rosenbach and Marcel Odenbach in the production company Alternativ TV. Since 1992 he has been a professor of media art at the Hochschule für Gestaltung, Karlsruhe.

Up to 1986 vom Bruch created some 20 committed videos dealing critically with the electronic media (*Attack and Defence*, 1986). Parallel to this, he also produced videos of a strongly autobiographical nature (*Das Softieband*, 1980). From 1983 he began to assemble video installations out of multipart transmitter and receiver elements (*Coventry War Requiem*, 1987, Documenta 7). In more recent works he has replaced video cameras with sensors, monitors and computers, using them to display measurements in the exhibition room (*Surface to Surface*, 1989). I.T.

Bibl.: vom Bruch, Düsseldorf, 1994

Brücke, Die. (German = The Bridge). Group of German → Expressionist artists founded in Dresden on June 7, 1905 by the architecture students → Kirchner, → Heckel, → Schmidt-Rottluff and Fritz Bleyl (until 1907). In 1906 the group was joined by → Nolde (until 1907) and → Pechstein, and in 1910 by → Mueller. It had international links with among others → Amiet (Switzerland), L. Zyl and van → Dongen (the Netherlands). Attempts in 1909 to get → Matisse and → Munch to join were in vain. Kirchner in 1906 wrote the group's manifesto, which addressed the "creators" and the "enjoyers" (collectors), and challenged young people to "win elbow-room and freedom to act and to live by taking our stand against all that is old and well-established." It culminated in the appeal: "Everyone belongs to us who depicts in a direct and unadulterated way that which urges him to create." The painters of Die Brücke decisively turned away from the art ideal of the 19th century, seeking new possibilities of expression in among other things African and Polynesian art. Other important sources of inspiration for these self-taught painters were French Impressionism, the artists' colonies in Dachau and Worpswede, and the painting of van Gogh, Munch and Gauguin (see → precursors). They sought an emotionally expressive style, characterized by simplified forms, strong colors, and bold, angular outlines. This new visionary pictorial language would replace outmoded traditional art forms with a new personal mode of seeing. More important than the subject was personal feeling and mode of expression, which also included distortion and caricature. The first Die Brücke exhibition in 1905 went unnoticed, but the second in 1906 caused a scandal. Kirchner's pictures especially, with their aggressive, nervous brushwork and explicit eroticism attracted criticism. In 1906 the group's inner circle was reinforced with associate members, (68 by 1910) including associate annual collectors and art historians such as Rosa Schapire. In the early years the group produced portfolios of graphics, which showed the most important innovations and stylistic means in concentrated form (woodcuts, etchings, lithographs). Seeking better working conditions, the Brücke painters moved from Dresden to Berlin, where they began to develop more marked personal styles, undermining the unity of the group. The final break-up came with Kirchner's "Chronicle" of the group's activities (1913), which was rejected by the other members as too subjective. But by this time German Expressionism had already peaked, even if its repercussions continue to be felt today. G.P.

Bibl.: Jähner, Brücke, 1986 · Griesbach, Aufbruch, 1991 · Gerlinger, Brücke, 1995

Brus, Günter. *1938 Ardning, Austria. German Performance artist, painter, poet, writer, and musician living in Graz and on the island of Gomera (Canary Islands). He studied applied arts in Graz (1953–57) and Vienna (1957–60). A cofounder, along with Nitsch, Muehl and Roth, of → Vienna action art in 1964, an immoderate agitator in postwar art. In his public performances (*Self-Painting and Self-Mutilation*, 1964–65, *Art and Revolution*, 1969, *Zerreißprobe*, 1970) and in his monumental action paintings, the scenario has been provided by his own body, by the ecstatic presence of the naked. Thus as "priest and sacrificial animal" (Hofmannsthal) the artist should overcome the gulf between art and life. Charges relating to pornography, blasphemy, and causing a public nuisance were not long in coming, inducing Brus to live in Berlin for a while (1969–79). In the 1970s he produced about 150 picture-poems, which fuse text and image in the spirit of Blake. These are characterized by a specifically Austrian ambivalence, psychological demonic power, and morbidity. The mystery of metamorphosis also plays a fundamental role in his drawings and graphic works. In collaboration with Muehl, → Nitsch, → Roth and Rühm, he has written several concertos (e. g. *Munich Concerto*, 1974, *String Quartet*, 1975). Brus has also penned a wealth of poetic works and publications, notably his novel *Die Geheimnisträger* (1984) and the magazine *Schastrommel – Organ der österreichischen Exilregierung* (from 1969). L.Sch.

Bibl.: Amanshaus/Ronte, Brus, 1986 · Breicha/Klocker, Gemeinschaftsarbeit, 1992

Buchheister, Carl. *1890 Hanover, †1964 Hanover. German painter and graphic artist. After a commercial apprenticeship, he studied at the Kunstgewerbeschule first in Bremen and then in Berlin. But his "real" training was with friends such as → Schwitters, → Arp, and Josef → Albers. During stays in Paris, he became acquainted with European abstraction. From 1927 to 1933 he was president of Die Abstrakten Hannover, and in 1954 he took up a professorship at Hanover Meisterschule. Buchheister painted austere Constructivist paintings, experimenting also with → shaped canvas, → multiples, and mixed-media works. He was exhibited at Berlin's Der → Sturm gallery. During World War II he was prohibited from painting and exhibiting. Following a foray into the representational, he returned to abstraction, achieving a synthesis of → Constructivism and → Art Informel. He also produced perforated and mixed-media reliefs. L.Sch.

Bibl.: Buchheister/Kemp, Buchheister, 1984 · Buchheister/Kemp, Buchheister, 1986

Günter Brus, *Selbstumkehrung*, 1988, Pastel on cardboard, 99.5 × 70.5 cm, Essl Collection, Klosterneuburg, Vienna

Buckley, Stephen. *1944 Leicester. British painter, graphic artist, and sculptor living in London. In 1962–67 he studied at the University of Newcastle; and from 1967 to 1969 at the University of Reading. He taught at Canterbury College of Art; Chelsea School of Art; King's College, Cambridge. In his abstract, symbolic painting Buckley combines a multitude of materials and techniques from which he makes unusual → assemblages and sculptures. *La Manche* (1974) is made of three canvases sewn together and alludes to the air battle over the English Channel during World War I. The various levels of meaning of the picture titles correspond to the different crafts (sewing, patching, sanding, folding, nailing, plaiting) and the materials used (canvas, cardboard, wood, plexiglas, frames, pieces of clothing) and paints (oil, acrylic, enamel, and lino paint). Buckley's work also involves experiments with printing and murals. H.D.

Bibl.: Livingstone, Buckley, 1985

Budd, David. *1926 St. Petersburg, Florida. American painter and sculptor who studied architecture at the University of Florida. He moved to New York in 1954, then to Paris in 1960, later returning to New York. Following early monochrome works, he became an exponent of → Color Field paintings in which areas of color are separated by thickening at the edges. Since 1967 he has produced mono- and duochrome paintings built up with the palette knife in short horizontal strokes, creating an effect reminiscent of shimmering expanses of water. H.D.

Bibl.: Burkhart, Budd, 1979

Buffet, Bernard. *1928 Paris. French painter, etcher, and lithographer living in La Baume, Var (South of France). He studied at the École Nationale des Beaux-Arts in Paris (1943–45). In 1948 he won the Prix de la Critique, launching his artistic rise. In his representational paintings (portraits, self-portraits, landscapes, still lifes, desolate places) Buffet uses muted colors, sometimes verging on monochrome gray values, crisscrossed by a structured network of black lines. His principal themes – sorrow, poverty, fear, death, and loneliness – are derived in part from his experience of World War II and are frequently expressed in a provocative way (*The Horror of War*, 1956). Buffet is thus closely linked with existentialism. With his visionary yet realistic approach, he is an important figure in postwar figurative painting. K.S.-D.

Bibl.: Le Pichon, Buffet, 1989

Burchfield, Charles Ephraim. *1893 Ashtabula Harbor, Ohio, †1967 West Seneca, New York. American watercolorist. After initial study at the Cleveland Museum School of Art (1912–16), Burchfield returned to his childhood home of Salem, Ohio. The move back proved traumatic, and he conjured up a set of scenes (figures are rare) in watercolor to account for the obsessions aroused (*Noontide in Late May*, 1917). During his → American Scene period in the 1920s–30s, themes included small-town architecture, backyards, and isolated figures. A few highly patterned semi-abstract works also survive from this time. Forms gradually became flatter, almost planar, in the 1920s, and vaguely reminiscent of → Sironi or → Hopper, but in the 1930s turned more energetic and highly colored. The 1940s saw an almost pantheistic sensitivity to nature. Burchfield's journals and scrapbooks (partially published as *Nurturing his Muse*, 1997) and the Charles Ephraim Burchfield Archives are a storehouse of information about his work and life. Major retrospectives were held at the Whitney in 1956, and more recently at the Colombus Museum of Art, Ohio (1997). D.R.

Bibl.: Maciejunes, Burchfield, 1997

Burden, Chris. *1946 Boston, Mass.. American sculptor and Conceptual, Performance, and Body artist living in New York. He studied at Pomona College, Claremont in California (1965–69), and at the University of California, Irvine (1969–71). He has taught at, among other places, the University of California, Los Angeles. He started by executing usable objects, before exposing himself after 1971 to sometimes highly dangerous extreme situations between → Body art and staged self-presentation (*Shoot*, 1971; *Transfixed*, 1974). From 1979 he produced installations dealing with political themes. *The Reason for the Neutron Bomb* (1979) deals with the arms race, using Russian coins to represent 50,000 Soviet tanks, while → installations made out of war toys illustrate the perversion of technology to military ends (*All the Submarines of the United States*, 1987). More recent installations explore more abstract energy-related processes. *The Fist of Light* (1992/93), using a powerful but concealed light source, symbolizes nuclear fusion. H.D.

Bibl.: Sayre, Performance, 1989 · · Noever, Burden, 1996

Daniel Buren, *Work in situ, Autour du retour d'un détour*, 1988, Installation in a shop, Centre National d'Art Contemporain de Grenoble

Buren, Daniel. *1938 Boulogne-sur-Seine, France. French Conceptual and Installation artist living in Paris. He studied at the École Nationale Supérieure des Métiers d'Art, Paris until 1960. Between 1965 and 1970 he exhibited with other members of the BMPT group (Olivier Mosset, Michel Parmentier, and Niele Toroni [1937–]). Buren's starting point is a radical questioning of the bourgeois notion of art. He subjects to particular critical scrutiny the museum as a place of "initiation" of the artwork, but at the same time "subversively" uses all the possibilities of the exhibition business. Since 1965 Buren has been painting, parallel, vertical stripes alternating white with a single color, and with a constant width (8.7 cm, the standard pattern for awning material). These stripe patterns can be located in

a variety of places both inside the museum and outside on posters, in trams, on banners, steps, and plinths. To distinguish the stripes from the → ready-made (Duchamp), Buren paints the white ones with white paint. With these interventions, Buren seeks less to reflect the structures of painting than to highlight the situation and cultural status of painting and art in general. Recently he has executed designs for public squares (*Les Deux Plateaux*, at the Palais Royal, Paris, 1985–86) and in-situ constructions, using mirrors, in which he questions the "objectiveness" of his own work. H.D.

Bibl.: Buchloh, Buren, 1981 · Francblin, Buren, 1987 · · Buren, Œuvres, 1991 ·

Burgin, Victor. *1941 Sheffield. British conceptual artist and writer. After studying painting at the Royal College of Art from 1962 to 1965, Burgin exhibited with → Art & Language. His → Conceptual approach has combined photographic images (photo-essays), silhouettes, and printed texts (initially instructions or sentences, later single words) to examine systems of meaning (e. g. *The Bridge*, on cinema), social interplay, sexuality (prostitution as abuse), and power (*Two Essays on Art, Photography and Semiotics*, 1976). His stated aim is to "underline the contingency of the physical object and the primacy of the observer's *act of* observation." Burgin's range of reference is vast, ranging from Copenhagen linguists to French Post-Structuralism. His "Post-Modernist" series *Object Relations* (1989) investigated the connections between language, human activity, and Western material culture. (No. 5, *Gone,* shows a woman's stereotypical outline juxtaposed with the word "Go|ne," which is split by her standing leg as she grasps her other heel – the inference being, Has it "gone"? Is that all?) D.R.

Bibl.: Burgin, 1973 · Burgin, Eindhoven, 1977 · Burgin, 1986

Burliuk, David (Davidovich). *1882 Riabuski, Kharkov, Ukraine, †1967 Southampton, New York. Russian painter. He studied at the Odessa Academy of Art (1899–1902), the Munich Akademie der Bildenden Künste (1902–03), and in Paris (1904). He was a pupil of Cormon. His work was first exhibited in Moscow in 1907 alongside that of → Larionov, → Goncharova and the → Blue Rose group. After 1909 he became a pioneer of Russian → Futurism. In Munich, he took part in the second exhibition of the → Neue Künstlervereinigung München (1910), and the first exhibition of the → Blaue Reiter (1912), and in Berlin he participated in the Erster Deutscher Herbstsalon. He was a member of various Russian artists' groups (→ Jack of Diamonds) and a signatory to the Futurist pamphlet *A Slap in the Face for Public Taste*. In 1922 he participated in the Erste Russische Kunstausstellung in the Van Diemen gallery in Berlin. In the same year he moved to New York, where he continued to work as a painter and art publicist. He became a US citizen in 1930. Between 1930 and 1966 he edited the periodical *Color and Rhyme*, New York. He made several trips to Russia (1956, 1965).

His early work (from 1900) was in an Impressionist vein, but in 1910 he turned to → Fauvism (Flowers, 1910) and then, influenced by Larionov and → Chagall, to Neo-primitivism. Influenced by the Blaue Reiter circle, he also used complementary colors in combination with black outlines. In the US he executed mainly Symbolist paintings (*The Advent of Mechanical Man*, 1920s), as well as some 700 replicas of paintings left behind in Russia. In his late work he returned to naturalistic landscapes and portraits. H.D.

Bibl.: Burljuk, Cologne, 1966 · Passuth, Burlyuk, 1979

Burliuk, Vladimir (Davidovich). *1866 Kherson, Ukraine, †1917 killed in action near Salonica. Russian painter. Like his brother David → Burliuk, he was a champion of the avant-garde, also promulgating theses on Russian → Futurism. He met → Marinetti during the latter's trip to Russia. In 1910 he joined the → Jack of Diamonds group and also the Union of Youth. In 1912 he became a member of the → Neue Künstlervereinigung München and of Blaue Reiter. In 1914 he participated in the Salon des Indépendants in Paris, and in the exhibition "Parole in libertà" in Rome. Between 1913 and 1915, before going off to fight in the war, he co-designed numerous Futurist books.

In his early works Burliuk incorporated elements of Art Nouveau, while he later executed Cubo-Futurist paintings with primitivist elements (*Woman with Mandolin*, 1912–13). Some of his pictures verge on abstraction. H.D.

Bibl.: Dreier, Burljuk, 1944 · Avantgarde & Ukraine, 1993

Burra, Edward (John). *1905 London, †1976 Hastings, Sussex. British painter and printmaker. After studying at the Royal College of Art (1923–25), Burra spent time in France in the later 1920s. The sordidness of urban life especially intrigued him: cafés, bars, cinemas (in Toulon, Marseille, and later Harlem) were treated in a scabrously acerbic manner close to → Grosz (*The Snack Bar*, 1930), though in keeping with traditional British caricature. After a trip to Spain in 1933 his work shifted (around 1934) to a more → Surrealistic vein, moving away from → social realism in favor of the uncanny (*Beelzebub*, 1937–38; *The Torturers*, 1935–both oddly redolent of → Savinio). He became a member of the English Surrealist group but persisted in a less committed strain (*Dublin Street Scene,* c. 1948). Landscape painting became important during World War II when travel was impossible, though he returned to bar scenes at Boston in the 1950s. His final watercolor landscapes (*Dartmoor*, 1974) invest the shadowy terrain with grandeur. D.R.

Bibl.: Aiken et al., Burra, 1992 · Burra, 1994

Burri, Alberto. *1915 Città di Castello, Umbria, Italy, †1995 Nice, France. Italian painter and object artist. After medical studies in Perugia, he served as a doctor in the Italian army until 1943, and in 1944 was interned in a prisoner-of-war camp in Hereford, Texas, where he began to paint. Back in Italy, he continued his art studies in 1946, having his first one-man exhibition in 1947 in Rome. Subsequently Burri turned away from representational painting to experiment with an abstract pictorial language inspired by → Klee and

David (Davidovich) Burliuk, *Dancer*, c. 1910, Oil on canvas, 100 x 61 cm, Städtische Galerie im Lenbachhaus, Munich

Alberto Burri, *Sack*, 1952, Sacking, cloth and acrylic on canvas, 97.5 x 87.5 cm, Albizzini Palace Foundation, Burri Collection, Città di Castello

→ Miró. In 1951 he co-founded with Giuseppe Capogrossi (1899–1972), Mario Ballocco (1913–) and Colla the group Origine, whose ideas were to prove important for Burri's future development: reduction of color to expressive function, rejection of any suggestion of a third dimension, and a return to elementary pictoriality. Burri rapidly ran through various phases of materials-related or painterly work, culminating in monochrome black easel panels. From 1955 he worked with fire → fumage on materials such as wood, iron, and plastic (*Combustoni*). The various materials determined the character of the composition, which was meant to achieve a new materiality and expressiveness through being treated with an oxy-acetylene cutting torch. In the group of works *Cretti* (1971–81), the artist deliberately created cracks, fissures, and crevices. The broken monochrome surfaces sometimes assumed a monumental character (landscape sculpture *Cretto Gibellina*, Sicily, 1981). In the mid-1970s he produced a series of Cellotex pictures, large works on painted chipboard. Besides these meditative sequences, between 1973 and 1976, Burri also created a series of tempera and fumage and color silkscreen prints that show a shimmering chromaticism derived from tiny cell-like forms. In his more recent works of the 1980s and 1990s, he returned to the easel picture with more conventional compositions using color shapes and structural surfaces, taking as his themes pictorial spatiality and temporality. Through numerous exhibitions in Europe and the US, Burri became Italy's best-known artist of the postwar period. Above all his new aesthetic based on the use of artistically unorthodox media, including waste materials, was a stimulus to → Arte Povera, as well as the → combine paintings of → Rauschenberg. H.D.

Bibl.: Calvesi, Burri, 1971 · Nordland, Burri, 1977 · Steingräber, Burri, 1980 · Pirovano, Burri, 1985

Burri, René. *1933 Zürich. Swiss photographer and film maker living in Zürich. He studied at Zürich Kunstgewerbeschule (1949–53). He was awarded a scholarship for a film on the school (1953–54). In 1953 he was camera assistant to Ernst A. Heiniger and did his first photoreportage. In 1954 he set up his own studio with Walter Binder. Since 1955 he has done freelance work, making numerous trips to places such as Czechoslovakia (1955), France (1957), South America (1958, 1960), Germany (1960), Japan (1961), and China (1965).

Burri photographs daily life. He prefers to portray the contexts, causes, and effects of historical events rather than report on them in a sensationalist way. His portraits attempt to capture the subjects' characteristics (*Che Guevara*, 1963). He sometimes takes people in extreme close up so that they are out of focus, or crops them. Besides tackling social and historical subjects, he has also produced graphic landscapes verging on the abstract, as well as images with defamiliarizing effects (*Fort Lauderdale*, 1966). After 1976 Burri also began photographing in color. Parallel to his photo work, he shoots documentary, advertising, and industrial films. Since the 1970s he has produced → collages out of found images and printed publicity material. H.D.

Bibl.: Loetscher, Photographie, 1991

Burton, Scott. *1939 Greensboro, Alabama. Early on in his career, American sculptor Burton discovered modern design, which meant for him liberation from tradition, and the breaking of any idea of the distinction between fine and applied arts. From the very beginning, furniture was crucial in his work: in *Iowa Furniture Landscape* (1970) he photographed store-bought furniture in landscape sites; *Behavior Tableaux*, from the same period, were performances in which actors interacted with furniture. Influenced by the purity of form and by the concern for the needs of the public representatives of neoclassical and functionalist 20th-century architecture, Burton moves toward the realization of actual furniture/sculpture pieces (*Single Block Granite Benches*, 1985) and the design of public spaces in collaboration with landscape architects. S.G.

Bibl.: Sculpture, New York, 1986

Bury, Pol. *1922 Haine-Saint-Pierre, France. Belgian sculptor and Kinetic and graphic artist living in Paris. He studied at the Académie des Beaux-Arts, Mons (1938). Between 1966 and 1968 he made several trips to New York. In 1970 he taught at UCLA, Berkeley and in 1973 was awarded an honorary doctorate at the Minneapolis College of

Alberto Burri, *Red Plastic Piece*, 1964, Plastic and acrylic, 133 x 118 cm, Albizzini Palace Foundation, Burri Collection, Città di Castello

James Lee Byars, *Untitled (Perfect Painting)*, 1962–63, Indian ink on folded paper, 30 x 300 x 30 cm, Private Collection

James Lee Byars, *The Book of the One Hundred Perfects*, 1985, 4 chaises longues, book (velvet, handmade paper), chaise longue 66.5 x 182 x 75 cm, book 35 x 35 x 35 cm, Michael Werner Gallery, Cologne and New York

Art and Design. In 1983 he taught at the École Nationale Supérieure des Beaux-Arts in Paris. Bury was influenced by the Belgian → Surrealists (→ Magritte, → Ubac). He was founder member of the → Cobra group (1949–51) and the group Art Abstrait, but in 1953 he abandoned painting for → Kinetic art, in which he became a leading expert. He made objects that executed extremely slow movements, taxing the viewer's powers of perception. At first these were reliefs (Édition MAT) with moving serial elements (discs, mobile columns), but Bury's interest in kinetic energies then led to monumental sculptures (1973) and fountains (after 1976) that relied on basic forms (spheres, cones, cylinders, and cubes). He has also explored the problem of movement in graphic works with rotating circular parts (*Cinétisations*, from 1964). He has also made films (1968–76, with among others Clovis Prevost). H.D.

Bibl.: Ionesco/Balthazar, Bury, 1976 · Pahlke, Bury, 1988

Bush, Jack. *1909 Toronto, †1977 Toronto. Canadian painter. After studying in Montreal and Toronto, Bush worked as a commercial artist. He was initially influenced by the landscapes of the → Group of Seven; this period was followed by the thinly applied, expressionistic/mystical watercolors of the 1940s. After the formation of Painters Eleven (1953) – and under the sway of → Macdonald's automatism – Bush's canvases could be compared to abstracts by → Olitski and other protégés of the critic Clement Greenberg. *Culmination* (1955) is based on the theme of color relations (the larger areas of pigment are kept apart by dissolving borders); such preoccupations resulted in → Motherwell-like oval swathes of color. The band or stripe paintings of the 1960s (*Color Column on Suede*, 1965) revert to purer colors and clear – but not hard-edged – borders. By the 1970s, Bush was also producing uneven strips of pastel color resembling → Matisse cut-outs on a grainy ground. Musical imagery (*Le Sacre du Printemps No. 1*, 1975) became important in the mid-1970s: synesthetic works aspired to capture the trombone-playing of Jack Teagarden or the fragrance of a flower. D.R.

Bibl.: Bush, Toronto, 1976 · Bush, Edinburgh, 1980

Butler. *1913 Buntingford, Hertfordshire , †1981 Berkhampstead, Hertfordshire. British sculptor. A practising architect in the 1930s, Butler began to sculpt in the mid-1940s. His early work in metal was motivated by a period spent as a blacksmith during World War II, with the forms ini-

tially echoing → Calder. He grew to prominence in the early 1950s when (with Lynn → Chadwick and → Armitage), he was hailed as a major British talent, winning a competition for a monument to the Unknown Political Prisoner. He is best known for free-standing bronzes of full-bodied, nude women and → Constructivist-style anthropomorphic "blocks," often pierced. His later cast work emphasized the sensuousness of the female body. A major retrospective was held at the Tate Gallery, London, in 1983. D.R.

Bibl.: Butler, London, 1983

Byars, James Lee. *1932 Detroit, Michigan, †1997 Cairo. American Performance and Conceptual artist. He studied art and philosophy at Wayne State University, Detroit. Between 1958 and 1969 he lived for periods in Japan, where he learned about aspects of the country's traditional culture, including ceramics, paper-making, Noh theater, and Buddhist philosophy. In 1969 he traveled in Europe. He became friendly with → Beuys, whom he met in Düsseldorf, and in 1974 was awarded a one-year DAAD scholarship within the Berlin Artists' Program. He was represented in 1977, 1982, and 1987 at → Documenta 6, 7, and 8. Byars' → performances, → installations and objects are characterized by metaphysical aspirations and are not easy to classify in the usual stylistic categories. At the heart of his oeuvre lies a quest for perfection and the relationship between the material and the nonmaterial. His work was influenced by philosophical ideas, especially those derived from aspects of Japanese culture, such as Zen Buddhism, Shinto ritual, and Noh. In the 1960s he produced large-format works out of paper, which were "unfolded" in performances (*The Giant Soluble Man*, 1967). Byars saw man as an "ephemeral sculpture," to which he gave expression in various performances. From the mid-1970s he produced subtly presented objects using marble, gold, glass, granite, velvet, and silk. In these works, purity was important to Byars, as the abstract qualities of geometrical shapes (sphere, pyramid, disc, column, cube), and their form and surface treatment were meant to express the idea of perfection. H.D.

Bibl.: Harten, Byars, 1986 · Elliott, Byars, 1990 · Byars, Paris, 1995

Cabaret Voltaire. Meeting place of the Zurich Dadaists and title of the journal published there. Founded by the German poet → Ball, who emigrated to Switzerland in 1914, the Cabaret Voltaire was located in the small back room (30

sq m) of a restaurant at No. 1 Spiegelgasse. Between 1916 and 1919, a number of → Dada events were organized there by Ball and his friends, who included Marcel Janko, → Tzara, → Arp, and Richard Huelsenbeck. Their activities, which took place on a tiny stage, included poetry readings and musical performances. The room was named the "Cabaret Voltaire" in "honor of the man who had spent his life fighting to release creative forces from the oppression of so-called moralist apostles" (Huelsenbeck). The word "dada" appeared for the first time in the journal *Cabaret Voltaire* (of which there was only one issue), subsequently becoming the name of the movement. H.D.

◁ Eduardo Chillida, *Wind Comb*, 1977, Steel, On the coast of San Sebastián

Cadavre exquis (French = the exquisite corpse). Game, also known as "consequences," in which several people put together a sentence or a drawing on a piece of paper. The piece of paper is folded so that each player's contribution is concealed and at the end is unfolded to reveal the final product. The game was used as a creative tool by → Breton and the Surrealists, for whom it provided a way of accessing the unconscious and exploiting the element of chance. The name "cadavre exquis" was taken from the first sentence produced by the Surrealists using the method in 1925: "The exquisite corpse will drink the new wine." H.D.

Cage, John. *1912 Los Angeles, †1992 New York City. American composer, Conceptual artist, and painter. He began studying composition in 1931. From 1934 to 1936 he trained under → Schoenberg, of whom he was the most influential pupil. He composed his first work for prepared piano in 1938 and his first piece of electronic music the

John Cage, *Aria for Voice (Any Range)*, 1960, 20 pages, 17.5 x 26 cm, Edition Peters, New York (see p. 78)

following year. In 1942 he moved to New York, subsequently studying philosophy, Indian music, and Zen Buddhism (under Suzuki). He taught at Black Mountain College (1948–52) and the New School of Social Research, New York (from 1956), which soon became a focus for new artistic movements (a performance featuring pieces by Cage, → Cunningham, → Rauschenberg, and others is widely held to have been the first → happening). Through his use of unusual sound sources and unorthodox compositional techniques, Cage paved the way for inter-media art in the 20th century. With its use of chance, its experimental approach, and its breaking down of traditional barriers between music, dance, theater (readings), and art, his work paralleled developments

John Cage, *Not wanting to say anything about Marcel*, 1971, Plexigramm III of VIII, 8 dark panes of plexiglass, colored print, in a wooden stand, 28.3 x 62.3 x 5.5 cm, Edition Peters, New York

in the visual arts (comparable with Marcel → Duchamp). He questioned the conventional understanding of music, making use of "prepared" instruments, new media (tape recorders, computers, video, etc.), acoustic experiences from everyday life, indirect audience participation (incidental sounds), and (after 1950) the principle of chance (influenced by elements of Confucian and Buddhist philosophy, notably the "I Ching"). Inspired by Rauschenberg's monochrome works in white, for example, he created pieces based on emptiness and duration (*4' 3"*, 1952, in which "no sounds are intentionally produced"). Cage developed new forms of graphic notation based on sequence, chance, and literary texts, resulting in original drawings and graphics (printmaking from 1978). These formed the basis for other compositions (*Mesosticha*). Cage, who worked closely with visual artists (→ Tobey, Rauschenberg, George → Segal, → Johns, and → Beuys), was a pioneer of happenings and provided inspiration for → Paik and the → Fluxus movement (1960s). K.S.-D.

Bibl.: Revill, Cage, 1992 · Lazar, Cage, 1993 · Pritchett, Cage, 1993 · Kostelanetz, Cage, 1994

Cahun, Claude (real name Lucy Schwob). *1894 Nantes, †1954 St Hélier, Jersey. French photographer, and writer. Her main work consisted of photographic self-portraits (from 1912), in which the self-taught artist uses masks and role play to conceal her true sexual identity. In 1917 she assumed the sexually ambivalent name of "Claude Cahun," and worked in Paris from 1920. In her most important book, *Aveux non avenus* (1930), she combines autobiographical fragments

of text with photo montages created with her life partner, S. Malherbe alias Moore. *Le cœur de pic* by L. Deharme appeared in 1937, and Cahun illustrated the text with tableau-like photographs of still lifes. In the 1930s Cahun appeared in public as a political activist. She joined the AEAR (1932) and the group Contre-attaque (1935), which linked her, albeit loosely, with the Surrealists around → Breton. Cahun moved to Jersey in 1940, where she was arrested by the Gestapo in 1944, sentenced to death, and later reprieved. This prominent figure of the Parisian avant-garde slid into obscurity, and was not re-discovered until the mid-1980s. E.R.

Bibl.: Leperlier, Cahun, 1992 · Cahun, Paris, 1995 · Cahun, Munich, 1997

Calder, Alexander. *1898 Lawton, Pennsylvania, †1976 New York City. American sculptor and artist. He studied engineering in Hoboken, N.J. (1915–19). Between 1919 and 1925 he worked at various jobs and made his first attempts at painting. From 1923 to 1926 he studied at the → Art Students League of New York and wrote and illustrated reports on sports events and circus life for the *National Police Gazette*. His first book of sketches, *Animal Sketching*, was published in 1925–26. In 1926 he moved to Paris, where he attended the Académie de la Grande Chaumière.

Alexander Calder, *Le Bougnat (The Coalman)*, 1959, Iron stabile, 205 x 170 cm, Coll. M. and Mme. Adrien Maeght, Paris

He first showed his wire constructions of circus life before an invited audience in 1927. In 1930 he met Mondrian, who persuaded him to try abstract designs. He had a one-man exhibition of movable wire sculptures at the Galerie Percier in Paris in 1931. In about 1934 he created the first mobiles (*Steel Fish*, 1934). Made from wire and rods, these lacked the elegance of his later constructions. In 1939 he began connecting the different elements by means of steel rods suspended from loops, giving an appearance of organic

Alexander Calder, *All Red*, 1955, Painted metal mobile, 140 x 145 cm, The Pace Gallery, New York

unity. Initially the shapes were biomorphic and could be reminiscent, for example, of leaves, but they later became totally abstract. Painted in primary colors, or two contrasting colors such as black and red, his works have a striking visual impact even from a distance and are consequently well suited to public spaces (*Le Guichet*, 1963, Lincoln Center, New York). In contrast to Constructivist attempts at the representation of motion (→ Pevsner and → Gabo), Calder did not set out to illustrate a specific sequence of movements, but rather the multidimensional, simultaneous movements of life itself and the way they interpenetrate and interlock. His so-called → stabiles – static constructions made from sheet steel (*Morning Star*, 1934) – were created at the same time as the → mobiles and can be seen in numerous public spaces all over the world, as can the intermediate works such as the mobile-stabiles (*Grand Crinkly*, 1971). In 1953 Calder moved into a new studio in Saché near Tours, where he created house-sized constructions such as *Teodelapio* (freeway near Spoleto) and the 24-meter-high *Red Sun* (Olympic Stadium, Mexico City). Calder also designed stage sets and produced book illustrations (*Fables of Aesop*, 1931), colored graphics, and gouaches. H.D.

Bibl.: Arnason, Calder, 1971 · Calder, New York, 1976/77 · Marter, Calder, 1991 · Abadie/Hulten, Calder, 1993 · Calder, Paris, 1996 · Baal-Teshuva, Calder, 1998

Callahan, Harry. *1912 Detroit. American photographer. Callahan began photography with his friend Todd Webb in the 1930s, initially without training. He later taught at Black Mountain College (1951) and was Chairman of the Department of Photography at Rhode Island School of Design until 1973. His photographic range includes figure studies, primarily in black and white (often taken on his travels – e.g. to Rome in the 1960s), and urban scenes. He was particularly successful on the theme of the sea and breaking waves. He produced photocollages of faces (mid-1950s) and some abstract-leaning work (*Chicago*, c. 1949, depicting a center-line in the roadway; or *Telephone Wires*, from 1945, where nothing gives a hint as to subject or scale) and highly allusive views of female anatomy. He was a close colleague of the architect Mies van der Rohe, whom he photographed. D.R.

Bibl.: Szarkowski (ed.), Callahan, 1976

Camden Town Group. School of British painters that met in → Sickert's studio in Camden Town between 1911 and 1913. Founder members included Sickert, → Gore, Lucien Pissarro, and Harold Gilman. Members favored depiction of urban life in a Post-Impressionist style. In 1913 they merged with other artists to form the → London Group. H.D.

Bibl.: Camden Town Group, London, 1951

Camoin, Charles. *1879 Marseille, †1965 Paris. French painter. In 1896 he moved to Paris, where he studied under Gustave Moreau at the École des Beaux-Arts (1898). He met Paul Cézanne (1902) and Claude Monet (1903, → precursors), whose Impressionism and naturalistic perception of light he tried to combine with → Fauvism and a desire for constructed form. In 1905 he took part in the first Fauvist exhibition, together with → Marquet, → Derain, Louis Valtat, and → Manguin among others, and for many years he was one of the guiding representatives of the movement. He initially favored landscapes, but later painted portraits and nudes. After World War I he was impressed by the work of Renoir, with whom, like → Signac, he later became friends during his summer stays on the Côte d'Azur (Saint-Tropez). K.S.-D.

Bibl.: Camoin, St-Tropez, 1991

Campendonk, Heinrich. *1889 Krefeld, Germany, †1957 Amsterdam. German artist and designer. He studied at the Kunstgewerbeschule in Krefeld under Thorn Prikker (1905–09), who introduced him to the works of van Gogh and Cézanne. He was introduced to the → Neue Künstlervereinigung by → Macke. In October 1911 he moved to Sindelsdorf in Upper Bavaria on the advice of → Kandinsky. From 1912 he participated in all the major exhibitions of the → Blaue Reiter group. In 1916 he moved to Seeshaupt on the Starnberger See and two years later joined the → Novembergruppe. In 1920 he traveled to northern Italy and in 1923 returned to Krefeld, becoming a lecturer at the Kunstgewerbeschule in Essen. In 1926 he became professor of mural and glass painting and Gobelin weaving at the Akademie in Düsseldorf. He was forced to retire in 1934 because he was deemed a "degenerate" artist. In 1935 he became professor of monumental and decorative art at the Rijksakademie Amsterdam, where he continued to lecture after the war. He received a large number of commissions for stained-glass windows in religious and secular locations.

Campendonk's work was influenced variously by the Blaue Reiter, → Fauvism, and → Cubism, and later by → Orphism and → Futurism. Up to 1916, his central theme was the harmony between man and beast in the Creation, and the circle of becoming and passing, which he interpreted in pictures with intense colors and geometric shapes. The second phase of his work (1912–21) was characterized by softer, more flowing shapes, large, calm areas of intense luminosity, and lyrical, fairy-tale overtones. From 1921 his figures began to assume a distinctive, masklike rigidity, dominated by sad Pierrots in clear, realistic settings. He favored restrained,

dark hues combined with red, white, or green highlights. His murals and stained-glass windows are severe and simple, using a limited range of earth colors. In addition to his public commissions, he produced a number of drawings and watercolors, which are distinguished by their tenderness and subtle coloring. H.D.

Bibl.: Firmenich, Campendonk, 1989 · Engels/Söhn, Campendonk, 1996

Campigli, Massimo. *1895 Berlin, †1971 Saint-Tropez. Italian painter. Campigli (born Max Ihlenfeld) became interested in → Futurist poetry around 1910 in Milan. He began to paint in Paris shortly after World War II in a style close to → Purism and → Léger. The Etruscan collections at the Museo Villa Giulia in Rome induced him in 1928 to begin working in a monumentally archaic (rather than Neo-Classical) style that was close to Margherita Sarfatti's → Novecento aesthetics. Campigli's slightly oppressive female figures, and his use of hieratic yet asymmetric disposition and multi-level or compartmentalized compositions (*L'emporio*, 1929; *The Winding Staircase*, 1940) depict an ideal of Italy that transcends nationalism. Ironic detachment is not wanting: in *Mercato delle donne e delle anfore* (1929), some of the ostensibly rustic women wear corsets to enhance their resemblance to the waisted amphorae. In 1933 he signed → Sironi's *Manifesto della pittura murale,* and during the 1930s interpreted the grand style in large-scale projects: *The Constructors* for the League of Nations, Geneva (1937), and works for the Palazzo di Giustizia, Milan (1938). He produced serene seaside scenes (*The Beach*, 1937) and, in the 1940s, illustrations to works by Paul Verlaine and André Gide. After World War II he turned to structures inspired by tribal art and Georges Seurat, to allusive abstracts (*Shields*, 1960s), and to theatrical compositions (*Red Theater*, 1960; *Two Actresses*, 1946). D.R.

Bibl.: Bortolan, Campigli, 1992

Heinrich Campendonk, *Pierrot with Mask*, c. 1916, Pastel on paper, 46 x 41 cm, Private Collection

Campus, Peter. *1937 New York. American photographer and video artist living in New York. He studied experimental psychology at Ohio State University (1955–60), then attended the City College Film Institute, New York (1961–62). He started working with video in 1970. He produced "closed circuit systems" that usually include the viewer (*Interface*, 1972). Typically his works contain alienating effects which prompt self-reflection, such as mirror-image pictures taken in blacked-out rooms with infrared cameras (Documenta 6, 1977). Since 1979, Campus has worked with photographs of faces, shells, and stones, which he processes digitally, distorting them in photo environments and slide projections and combining them to create complex spatial metaphors. H.D.

Bibl.: Campus, Mönchengladbach, 1990

Cane, Louis. *1943 Beaulieu-sur-Mer, Alpes-Maritimes. French artist and sculptor living in Paris. He studied at the École des Arts Décoratifs in Nice (1961–64) and in Paris. He was a founder member of → Support-Surface and publisher of the group's journal *Peinture, Cahiers théoriques*, but found himself in conflict with their Marxist stance. Cane experimented with unstretched canvases which he painted in monochromes and hung directly on the wall or spread on the floor. He sometimes removed the center of the canvas to include the wall or floor in the picture. From 1972 Cane produced a series of oil paintings featuring strong colors applied with bold sweeping gestures, the resulting multilayered color structures symbolizing a network of artistic and social experiences (*N.G.C. 5350*, 1979). Since the early 1980s Cane has returned to representational painting, using the history of art to question the creative process (*Nymphéas*). H.D.

Bibl.: Cane, Saint-Paul-de-Vence, 1983 · Sollers, Cane, 1986 · Sobelmann, Cane, 1990

Capa, Robert (real name André Friedmann). *1913 Budapest, †1954 Thai-Binh, Vietnam. Hungarian-born American photographer. After being expelled from Hungary in 1931, he became a photo assistant at the Deutscher Photodienst agency in Berlin. He studied journalism at the Hochschule für Politik, before fleeing to Paris in 1933, where he met → Kertész and → Cartier-Bresson, among others. He assumed the name Robert Capa in 1936. He covered the Spanish Civil War as a freelance photojournalist, taking his most famous shot (*Death of a Loyalist Soldier*, 1936). In 1938 he worked with Joris Ivens on a documentary about the Chinese resistance (*The Four Hundred Million*). He emigrated to New York in 1939 and covered World War II (including the American invasion of Normandy) for *Life* magazine, among others. In 1947 he co-founded the Magnum Photos agency together with Cartier-Bresson, Chim, Rodger, and Vandivert. He produced a number of sensational books, including *A Russian Journal* (with Steinbeck, 1948) and *Report on Israel* (1950). Capa worked for numerous publications, including *Life, Holiday, Vu, Illustrated London, Collier's, Ce Soir*, and *Regards*. In 1955, *Life* instigated the annual Robert Capa Gold Medal Award. Capa is best known as a war photographer (five wars).

In addition to their news value, his photos capture the "decisive moment" in emotional, visual, and aesthetic terms, giving them a timeless and far-reaching power. Capa was a key figure in photojournalism. P.L.

Bibl.: Stuard, Capa, 1960 · Fárová, Capa, 1964 · Whenlan, Capa, 1985 · Bar-Am, Capa, 1988

Capitalist Realism → Richter, Gerhard

Cardenás, Santiago (Arroyo). *1937 Bogotá. Colombian artist, painter, and graphic designer living in Bogotá. He lived for several periods in the USA (1947–60, 1962–65), studying at the Rhode Island School of Design, Providence (1956–60), and Yale University (1962–64). Between 1960 and 1962 he lived in Germany, where he did national service for the US army. He has held several teaching posts, notably at the Escuela de Bellas Artes de la Univ. Nacional de Colombia in Bogotá (director 1972–74). After starting out in a → Pop vein, he moved on to → Magic Realism. His early pictures are dominated by the human form, but his later works incorporate tools and objects to form → assemblages, as well as vases and flowers. His picture series (*Los pizarrones*) combines such objects as clothes hangers, electric cables, roller blinds, and wall panels with the human body. Isolated and repeated photographically, these items are shrouded in an atmosphere of melancholy and silence. H.D.

Bibl.: Serrano, Cardenás, 1983

Caro, Anthony. *1924 New Malden. British sculptor living in Hampstead, London. He studied engineering at Cambridge University (1942–44), then sculpture at Regent Street Polytechnic in London (1946) and the Royal Academy Schools (1947–52). In 1949 he married the painter Sheila Girling. He was assistant to → Moore for two years (1951–53), then taught sculpture at St Martin's School of Art (1953–79). In 1981 he established the Triangle Workshop for Sculptors and Painters in Pine Plains, N.Y. Under the influence of David → Smith, Caro, who has won numerous awards, has become one of the leading abstract sculptors of recent times. From 1960 to 1966 he worked with monochrome geometric elements

Robert Capa , *Death of a Loyalist Soldier, 5.9.1936*, Gelatin bromide print, 24 x 34 cm, Magnum Photos

connected by H-, T-, and L-beams, and girders and rods (*Lock*, 1962). He also used industrial waste in his works (*Midday*, 1960). His *Table Pieces*, which he began in 1974, are small sculptures no bigger than a table top. From 1968–69 Caro adopted varnished or waxed steel elements with curved surfaces and edges and in the 1970s he used rusted steel or waste from steel rolling mills to create large floor pieces (*Veduggio* series, 1972–73). Since the 1980s he has created spiral-shaped sculptures with stepped or staggered arrangements and openings leading to interior spaces (*Octagon Tower/Tower of Discovery*, 1991). More recent works combine sculpture and architecture ("sculpitecture") to create interior spaces that can be entered (*Sea Music*, 1991). The evolution from his strictly geometrical Constructivist sculptures to the large, vertical works, → installations, and semi-abstract pieces of more recent years demonstrates Caro's unceasing determination to innovate. H.D.

Bibl.: Whelan, Caro, 1974 · Blume, Caro, 1980–89 · Waldman, Caro, 1982 · Schodek, Structure, 1993

Anthony Caro, *Veduggio-Sound*, 1972–73, Steel, rusted and laquered, 231 x 203.5 x 132 cm, Kunsthaus Zürich

Carr, Emily. *1871 Victoria, British Columbia, †1945Canadian artist, painter, and writer. She studied at the San Francisco School of Art (1889–95), the Westminster School of Art in England (1899–1904), and the Académie Colarossi, Paris (1910–11). On her return to Canada in 1912, she painted mainly landscapes showing her native British Columbia in highly expressive colors influenced by → Fauvism. Her subjects included Native-American villages and totem poles. In 1927, following many years of neglect, she discovered the work of the → Group of Seven in Toronto. Thereafter she devoted herself more fully to her work and toward the end of her life she became one of Canada's most important artists. Carr's works show nature as a spiritual creation and a supersensory force. She also wrote a number of autobiographical books (*The House of All Sorts*, 1944, *Growing Pains*, 1946). H.D.

Bibl.: Newlands, Carr, 1996

Carrà, Carlo. *1881 Quargennto, Alessandria, †1966 Milan. Italian artist, painter, designer, and art theorist. In 1899 Carrà worked on the decoration of the Italian pavilion for the Exposition Universelle in Paris. In 1900 he visited London, where he became enthusiastic about the anarchistic theories of Mikhail Bakunin, Max Stirner, and Marx. On his return to Milan in 1904 he studied at the Accademie di Brera and assimilated divisionism. After meeting → Boccioni and → Marinetti in 1908, he joined the → Futurists. He signed all the main Futurist manifestos and also wrote his own (*La pittura dei suoni, rumori, odori*, 1913). Carrà was strongly influenced by Cubism in his early paintings, which were initially monochrome but became increasingly colorful (*The Red Rider*, 1913). His simultaneous representation of movement is more strongly linked to the object than Boccioni's and does not dissolve into abstract "lines of force". Consequently his motifs remain recognizable even though the fragmentation is more complex (*Simultaneità*, 1913). He took part in all the major Futurist exhibitions, but increasingly dissociated himself from Marinetti's doctrinaire theories. In early 1914 Carrà turned to collage, linking Cubist elements with *parole in libertà*. Like the other Futurists, he greeted the war with rapture. In 1915 he published *Guerra pittura*, a collection of collages, drawings, and paintings. In 1917 he met de → Chirico and discovered → Pittura Metafisica (*The Metaphysical Muse*, 1917). Between 1919 and 1922 he collaborated on *Valori plastici* and became an art critic. His later work, which included murals, was marked by a return to a naturalistic style based on Renaissance painting. H.D.

Bibl.: Carrà, Milan, 1967–69 · Carrà, Rome, 1994–95

Carrington, Leonora. *1917 Clayton Green. British-born artist and writer (took Mexican nationality in 1942). She studied art at Ozenfant's academy in London. In 1937 she met → Ernst and settled in France with him. She had contacts with → Surrealists in Paris and joint exhibitions with them (Paris and Amsterdam, both 1938). In 1940, after Ernst's internment, she fled to Spain, before emigrating to New York in 1941 and then to Mexico following a marriage of convenience in 1942. In 1946, after divorcing, she married the photographer Imre Weisz. She moved to the US in 1985. Following early figurative paintings that were

Carlo Carrà, *Funeral of the Anarchist Galli*, 1911, Oil on canvas, 199 x 259 cm, The Museum of Modern Art, New York

Leonora Carrington, *Horses*, 1941, Oil on canvas,
66.5 x 81.5 cm, S.A.D.E. Foundation, Milan

full of metaphors relating to her childhood (*The Inn of the Dawn Horse*, 1936–37), Carrington developed a highly individual magical style drawing on her preoccupation with Celtic mythology, alchemist writings, and occult philosophy. Her narrative paintings with figures and animals are hermetic allegories that are technically and stylistically reminiscent of early Renaissance art (*The House Opposite*, 1945). Her literary work includes stories and novels, often autobiographical, such as *Down Below* (1944) and *The House of Fear* (1989). P.L.

Bibl.: Caws/Kuenzli/Raaberg, Surrealism, 1991 · Schlieker, Carrington, 1991 · Spengler, Carrington, 1995

Carroll, Lawrence. *1954 Melbourne, Australia. Australian painter and sculptor who lives and works in New York and Los Angeles. He studied at Moorpark College, California (1972–76), the Art Center College of Design, Pasadena, and the Otis Art Institute, Los Angeles (1976–80). In 1992 he took part in Dokumenta 9. Resembling boxlike sculptures, Carroll's creations are made of canvas, wood, and solid blocks of white paint that are rolled, folded, or layered. The multilayered surface is textured by means of "injuries", such as cuts, tears, and joins. Carroll uses paint and other materials in a restrained, sparing way, resulting in minimalist forms. His works are carefully positioned in relation to walls and floor, giving them a spatial dimension. Somewhere between easel painting and sculpture, they bring to mind → Minimal art and the creations of → Rauschenberg. P.L.

Bibl.: Carroll, Los Angeles, 1993 · Carroll, New York, 1994

Cartier-Bresson, Henri. *1908 Canteloup, France. French photographer living in Paris. Cartier-Bresson started out studying art in the 1920s, and after 1973 devoted himself to painting and drawing once again. During the four decades in between he created one of the most important photographic oeuvres of the 20th century. In 1934 he accompanied an ethnographic expedition to Mexico and the following year began working as a freelance photographer. He learnt about film-making from → Strand in New York and from 1936 to 1939 was assistant to film director Jean Renoir. In 1937 he made documentaries in Spain. From 1940 to 1943 he was a German POW. In 1947 he founded the Magnum Photos

agency with → Capa, → Seymour, and George Rodger. Between 1948 and 1965 he traveled to Burma, Pakistan, and China (1948–49, 1958–59), Canada, Mexico, and Cuba (1960), and Japan and India (1965). Although well traveled, he is not really a photojournalist. Taking his subjects from everyday life, Cartier-Bresson presents a timeless, humanist picture of people. His most famous cycle is *The Europeans* (1950–55), which inspired → Frank's *Americans* (1954–58) and René → Burri's *Germans*. His early work is characterized by a marked directness and spontaneity, while his later pictures are more clearly structured. Throughout his life Cartier-Bresson has endeavored to look into "the living heart of the person", showing them in their natural environment. He values inconspicuous moments as much as

grotesquely exaggerated situations and his pictures are imbued with a distinctively French blend of wit, charm, and irony. P.S.

Bibl.: Montier, Cartier-Bresson, 1997

Henri Cartier-Bresson, *Alicante, Spain*, 1933, Gelatin silver print, 18 x 24 cm, Magnum Photos

Casorati, Felice. *1883 Novara, †1963 Turin. Italian painter, printmaker, and sculptor. A talented musician, he exhibited at the 1907 Venice Biennale before attending art academies in Naples (1908–11) and Verona (1911–14). → Jugendstil was his formative influence, accentuated by his meeting → Klimt in 1910 (*Il sogno del melograno*, 1912–13). After illustrative, linear work, he shifted to → Pittura Metafisica (*L'Abbraccio*, 1919) and planar still lifes (*Uova sul cassettone*, c. 1920). More individual are the bizarre sleepers of *Meriggio* (1923) or *Silvana Cenni* (1922), a hieratic yet domestic female within a symmetrically awry interior with a Piero della Francesca-like cityscape beyond. Casorati was soon under the sway of → Valori plastici, which rejected → Futurism: the intense broken planes and mystery of *Conversazione platonica* (1925) – a man in a bowler hat regarding a prone nude female – shows how such "a return to the past" could be achieved without kitsch or pomposity. His high-contrast portraits remain close to → Novecento, above all to Ubaldo Oppi (1889–1942), as in *Cynthia* (1924). His later work is characterized by looser composition (*Daphne*, 1934) and hard contours (*Limone*, 1951). Casorati's interest in art for all took him toward design and he joined the Accademia Albertina, Turin. He also produced sets for La Scala. D.R.

Caulfield, Patrick. *1936 London. British painter and printmaker who lives and works in Chelsea, London. He studied at the Chelsea School of Art, London (1956–60), where he later taught (1963–71). He is widely regarded as a representative of the "third generation of British Pop art." In 1965 he was awarded the Prix de Jeunes Artistes in Paris. A retrospective of his work was held at the Tate Gallery, London, in 1981. His early work was influenced by a number of artists, including → Lichtenstein ("Young Contemporaries" exhibition, London, 1961), but he now experiments with combinations of abstract grid structures and figurative motifs (*Landscape with Birds*, 1963). In both his paintings on hardboard and his screenprints he depicts everyday subjects (*The Poems of Laforgue*, 1973), which he treats in strong, flat colors within clear, black outlines. P.L.

Bibl.: Livingstone, Caulfield, 1981 · Caulfield, 1995 · Caulfield, London, 1999

Cercle et Carré (French = circle and square). Group of abstract artists founded in Paris in 1929 by art critic Michel Seuphor and painter → Torres-García. Thanks to the journal of the same name, the initiators were able to attract countless new members throughout Europe in just a few months. In April 1930 the group organized an international exhibition of abstract art with Constructivist leanings by artists such as → Kandinsky, → Arp, → Taeuber-Arp, → Ozenfant, → Prampolini, Torres-García, → Pevsner, and → Vantongerloo. The group, which provided important support for abstract art in Paris, disbanded in 1931. The cause of abstraction was taken up by a new group, → Abstraction-Création, in the same year. H.D.

Bibl.: Seuphor, Cercle et Carré, 1971

César , *Thumb*, 1965, Gold plated bronze 185 x 95 x 38 cm, Musée Cantini, Marseille

César (César Baldaccini). *1921 Marseille, †1998 Paris. French sculptor. He studied at the École des Beaux-Arts, Marseille (1935–43), and at the École Nationale Supérieure des Beaux Arts, Paris (from 1943). In Paris he met A. → Giacometti, who later lived in the same building, → Picasso, and → Richier. He began making sculptures from plaster and iron in the late 1940s. In the 1950s he began to use pieces of scrap metal, which he welded and screwed together. In 1960 he joined the → Nouveaux Réalistes, coming into contact with → Arman, Yves → Klein, and → Tinguely. In the same year he began making his *Compressions* – square blocks of crushed car bodies. He subsequently extended this work to include materials such as cardboard, wood, jute, paper, and textiles. As a counterpart, in the mid-1960s he developed his *Expansions*, creating enlargements of body parts (*Thumb*, 1965; *Breast*, 1966; *Hand*, 1968), objects, and liquids by means of foam materials such as polyurethane (*Egg*, 1967, *Red Teapot*, 1968). With his experimental approach to materials and use of everyday, mass-produced objects, César represents a combination of → Nouveau Réalisme and → Pop art. R.S.

Bibl.: Restany, César, 1988 · César, 1993 · Durand-Ruel, César, 1994 · César, 1997

Cézanne, Paul. → precursors

Chadwick, Helen. *1953 Croydon, near London, †1996 London. British sculptor, photographer, and Performance artist. She studied at Brighton Polytechnic and the Chelsea School of Art (1973–77). She taught at the latter, as well as at the Royal College of Art (from 1987). In 1990 she received the Bill Brandt Award. Her first works were based on her interest in the city and the depersonalized individual in society (*Train of Thoughts*, 1978; *Model Institution*, 1981). Since the 1980s, her principal themes were the body and sexuality (*Ego Geometrica Sum*, 1984; *Piss Flowers*, 1993; *Cacao*, 1994) and the breaking down of polarities (male and female, spiritual and material, life and death). She also questioned stereotypical images in aesthetically perfect strategies of seduction and revulsion. Her most important medium was photography, but she chose unusual materials for her works, backing them up with a wealth of mystical and scientific sources. P.L.

Bibl.: Warner, Enfleshings, 1989 · Chadwick, Essen, 1994 · Warner, Chadwick, 1997

Chadwick, Lynn. *1914 London. British sculptor living in Lypiatt Park, near Stroud, Gloucestershire. He started out as an architectural draftsman and later worked as a designer, turning to sculpture in 1946. He has won numerous awards, including the International Sculpture Prize at the Venice Biennale in 1956. Together with → Armitage, Chadwick is one of the leading British metal sculptors. He works mainly with welded components. His early → mobiles and → stabiles were influenced by → Calder (*The Fisheater*, 1951). Since the 1950s he has combined static and moving elements (e.g. in his riblike sculptures), as well as abstract and figurative components, as in his fantastic hybrids of man and bird (*Winged Figures*, 1971). P.L.

Bibl.: Koster/Levine, Chadwick, 1988 · Farr, Chadwick, 1990

Chagall, Marc. *1887 Liosno near Vitebsk, †1985 Saint-Paul-de-Vence. Painter, illustrator, and designer of Russian Jewish origin. After attending several art schools in St. Petersburg, he won a scholarship to Paris in 1910. In 1917 he founded an art school in Vitebsk, remaining director until 1920. He then moved to Moscow, where he was stage designer for the newly founded Jewish Theater. He returned to Paris in 1923. Between 1941 and 1948 he lived in exile in New York. From 1950 he lived in Vence.

Chagall's work is an amalgam of eastern Jewish spirituality, Hasidism, Russian folk art, French modernity, → Orphism, the moonstruck magic of → Rousseau, and the heavy religious fervor of → Rouault, all of which combine to create a separate universe, a world with a wondrous passion for fairy tales and an inventory of recurring themes: cow and clown, violinist and lilacs, angel and lovers, cottage and Eiffel Tower. A master of the heavenly happy, lyrically melting, eccentric or darkly glowing miracles of color in all his diverse techniques, he was perhaps at his most virtuosic and subtle in his chromolithographs. During his time in Paris, he created transparently overlaid, glowing images indebted to Orphism (*I and the Village*, 1911; *Self-Portrait with Seven Fingers*, 1912). During his time in Russia, his

Marc Chagall, *The Fiddler*, 1911, Oil on canvas, 94.5 x 69.5 cm, Kunstsammlung Nordrhein-Westfalen, Düsseldorf

marriage to Bella inspired his love pictures with floating figures (*The Birthday*, 1915; *Double Portrait with Wineglasses*, 1917). While in Paris he was commissioned to illustrate Gogol's *Dead Souls* (1923), La Fontaine's *Fables* (1926), and the Bible (1931). In addition to cheerful pastorals, he also painted the occasional melancholic and threatening picture, both during his exile (*Yellow Crucifixion*, 1943) and above all after Bella's death in 1944. After his return to France, he produced a series of paintings of Parisian monuments. A second marriage in 1952 resulted in a veritable firework display of creativity: the gouaches and set for *Daphnis and Chloë*; stained-glass windows in Metz, Jerusalem, Zürich and at the UN Headquarters in New York; tapestries for the Knesset; murals for the Metropolitan Opera House in New York, mosaics, ceramics, and sets and costumes for the stage. L.Sch.

Bibl.: Schmalenbach, Chagall, 1979 · Haftmann, Chagall, 1985 · Kamensky, Chagall, 1989 · Compton, Chagall, 1990 · Güse, Chagall, 1994 · Chagall, Paris, 1995

Chaldej, Evgenij Annievic. *1917 Juzovka, †1997 Moscow. Russian photographer. From 1933 he worked in Stalino on the in-house magazine *Metallurg*, and later in a photographic laboratory. In 1936 he began working as a photographer for the Sojusfoto news agency and moved to Moscow. He produced numerous reportages on travel and Soviet life. Between 1941 and 1948 he was a war photographer (Balkans, Austria, Germany, Japan). From 1956 to 1971 he worked on *Pravda* and from 1960 to 1989 he lectured at the College of Journalism in Moscow. He won numerous awards for his work.

Chaldej captured many moving images of important stages in World War II. His best-known pictures include *On the Reichstag, May 4, 1945*, showing Red Army soldiers displaying the Russian flag on the Reichstag in Berlin, and his photographs of the Nuremberg trials (cross-examination of Göring) and of Jewish survivors in

Budapest. He also took a number of striking portraits. Chaldej's photos are always realistic, eschewing experimentation, false heroic posturing, and spectacular effects. H.D.

Bibl.: Chaldej, 1994

Chamberlain, John Angus. *1927 Rochester, Indiana. American sculptor, photographer, filmmaker, painter, and designer living in New York. He studied at the Art Institute of Chicago (1951–52) and Black Mountain College (1955). He lectured at the University of New Mexico, Santa Fe (1966).

Chamberlain's works range from small fragile objects along the lines of → Nouveau Réalisme to room-sized sculptures (*Coke Ennyday*, 1977). His major compositions are → assemblages made from crushed cars parts which are sometimes over-painted. In the 1990s he created a number of frieze-like reliefs in several parts. His more recent works are glossily painted creations of bent and twisted sheet metal. He also made experimental films in collaboration with → Warhol's Factory (*Amarillo Piece*, 1972). H.D.

Bibl.: Chamberlain, Amsterdam, 1996

Chambí, Martín (Jimenez). *1891 Coaza, Carabaya, †1973 Cuzco. Peruvian photographer. From 1900 he was assistant to a British photographer working for the Santo Domingo Mining Company. Between 1908 and 1917 he worked in the studio of Max Vargas, before becoming a freelance photographer. In 1920 he set up his own studio in Cuzco. Supporter of several photographic institutions (1958 first photographic competition in Southern Peru; 1971 photographic courses in Lima and Cuzco).

Chambi is regarded as one of Latin America's most important photographers. In addition to his studio work as a portrait photographer, he took powerful pictures of Inca buildings, Andean landscapes, and everyday life. He produced numerous group portraits showing families, athletes, festivals, processions, political gatherings, and hacienda owners. He also took more than 40 self-portraits in which he experimented with lighting and shadow. H.D.

Bibl.: Chambí, Washington, 1993

Marc Chagall, *The Betrothed*, 1938–39, Oil on canvas, 150 x 136.5 cm, Musée National d'art Moderne, Centre Georges Pompidou, Paris

Chapman, Dinos and Jake. *1962 (Dinos), 1966 (Jake). British sculptors. The Chapman brothers constitute one of the more challenging facets of New British Art (→ Young British Artists). Their figures of the obscene or the bathetic (astrophysicist Stephen Hawking in his wheelchair about to plummet over an outcrop; half-cartoon, half-mutant "children" burgeoning adult genitalia) are tailor-made to fulfil the pair's avowed aim of instilling "absolute moral panic" in the viewer. In *Six Feet Under* (1997), a brown glass-fiber catacomb is populated by mannequins with sub-Barbarella hairstyles and "Michael Jordan" black Nikes. In *Tragic Anatomies* (1996), 12 Siamese twin girls are equipped with sexual parts *de trop*; while in the Goya-derived yet unheroic *Disasters of War* (1996–97), penknife-modeled toy soldiers commit inventive atrocities. These creatures form part of "Chapmanworld" (as against Disneyworld) in a one-track but muscular critique of the sellable and showable that mixes and confounds the generations and genders. Their most intellectual piece was perhaps the five *Fuck Faces* (1995) that seem to take the Viennese School psychoanalysis of Wilhelm Fliess, concerning the connections between nose and genitals, to picturesquely ludicrous extremes. D.R.

Bibl.: Chapmanworld, 1996

Charchoune, Serge. *1888 Buguruslan, Ukraine, †1975 Villeneuve-Saint-Georges near Paris. Russian-born artist, painter, and writer. He studied in private studios in Moscow (1908–10) and then did military service (1910–12). He deserted and went to Paris, where he studied at the Russe Libre and La Palette academies (1912–14). He then moved to Barcelona (1914–17), where he joined the → Dada circle centered around the Josep Dalmau gallery and met → Picabia. He returned to Paris in 1917 and worked on Dadaist publications. Between 1914 and 1917, following a Cubist phase, he developed a personal style based on abstract symbols and figurative and geometric elements which he named "ornamental Cubism", but he also incorporated Dadaist ideas (influenced by Picabia). In the mid-1920s he came under the influence of anthroposophy, and by 1927 he had begun to move toward → Purism (*Fenêtre Printemps*, 1927). At the end of the 1920s he started producing semi-abstract landscapes and still lifes. In the mid-1940s water became a central theme and he began painting abstract works based on the rhythms of waves and modulations of white (*La Mer*, 1950). After 1956 Charchoune attempted to convert musical themes into painted motifs. His oeuvre also includes book design, illustration, and writings. H.D.

Bibl.: Charchoune, Paris, 1967

Chargesheimer, Karl Heinz (Hargesheimer). *1924 Cologne, †1972 Cologne. German photographer, sculptor, and designer. He studied photography and graphic design at the Werkkunstschule in Cologne (1942–44) and attended the Bayerische Staatslehranstalt für Lichtbildwesen in Munich. He won countless awards, including the Karl-Ernst-Osthaus award for photography (1970). From 1947 to 1949 he worked as a freelance stage photographer at theaters in Hamburg-Harburg,

Hanover, Cologne, and Essen. He also designed stage sets and created metal sculptures. In 1950 he took up experimental photography and in 1952 began making surrealist photomontages. He was a lecturer in advertising photography and graphics for film and photography in Düsseldorf (1950–56). From 1952 he worked as a freelance photographer for advertising companies and political parties. After a period as a photojournalist (from 1955), he worked as a stage set designer, theater photographer and director in Cologne (1960–66). From about 1968 he made kinetic sculptures ("meditation mills") and large-scale Chinese paintings. In 1968 the City of Cologne set up the Chargesheimer Award for Film, Photography, and Video.

During the 1950s and 1960s, Chargesheimer captured people and moods in postwar Germany with sensitivity and psychological insight. His "social landscape photography" consists of portraits of famous and "normal" people in their respective environments (book, *Unter Krahnenbäumen*, Cologne, 1958). His principal subject was the ruined city of Cologne as reconstruction was getting under way (*Köln 5 Uhr 30*, 1970). His photographs tend to be snapshots, frequently out of focus and unretouched, with tilted horizons. H.D.

Bibl.: Mißelbeck/Vollmer, Chargesheimer, 1996

Charlton, Alan. *1948 Sheffield, England. British artist living in London. He studied at the Sheffield School of Art (1965–66), the Camberwell School of Art (1966–69), and the Royal Academy Schools, London (1969–72).

Charlton paints strict monochrome pictures in different shades of gray with no hint of brushstrokes. In 1972 he started cutting small square holes into the canvas and later slashed it as well, cutting and delineating the painted area. At the end of the 1970s he created several series of small paintings that together made up one big one, as well as extremely narrow rectangles that look like positives of cutouts against large gray backgrounds. In 1983 he began his *Corner Paintings*, in which several narrow rectangular canvases are hung across the corners of the room. More recently Charlton has painted pictures for specific locations, thereby creating → environments. H.D.

Bibl.: Ritchie, Charlton, 1992

Chia, Sandro. *1946 Florence. Italian painter and sculptor living in New York, London, and Montaleino. He studied at the Istituto d'Arte Firenze (1962–67) and the Accademia di Belli Arti (1967–69). In 1969–70 he traveled in Europe, Turkey, and India. In 1980–81 he was funded by the city of Mönchengladbach. In 1985 his bronze sculpture *Passione per l'arte* was erected outside Bielefeld town hall.

In the early 1970s Chia experimented with → Conceptual art, but reverted to figurative painting in the mid-1970s. Together with → Clemente, → Cucchi, and → Paladino, he was one of the principal representatives of the → Transavantgarde. Usually large and strongly colored, his paintings depict fantasy worlds dominated by monumental heroic male figures

which show the influence of → Novecento. They deal with elementary emotions and aspects of behavior, providing an ironic reflection on the situation of the artist. Chia draws on artworks from Western art, ranging from antiquity to the old masters, which he revitalizes with humor and parody. He adopts a postmodern variety of styles and sometimes quotes directly. With their collage-like quality, sensual use of color, and Futurist-influenced dynamicism, his pictures are expressive and theatrical, but in terms of content they eschew passionate emotion. D.W.

Bibl.: Haenlein, Chia, 1984 · Weisner, Chia, 1986 · Honisch, Chia, 1992

Chicago, Judy . *1939 Chicago. American painter, sculptor, and Installation and Performance artist living in California. She studied at the University of California, Los Angeles (1960–64). Her work since the late 1960s has addressed issues of gender and female identity. In 1971 she co-founded with Miriam Schapiro the Feminist Art Program (California Institute of the Arts). In 1972 the two of them created *Womanhouse*, the first exhibition of feminist art, which challenged the role traditionally assigned to women in society (*Menstruation Bathroom*, an installation of everyday items). Her key work of feminist art, *The Dinner Party* (1979), on which many women collaborated, consists of a triangular table with 39 settings each assigned to a distinguished woman from Western civilization. On each of the plates lie sculpted labia, while the table itself stands on a floor of tiles inscribed with the names of 999 other distinguished women. K. S.-D.

Bibl.: Chicago, Flower, 1975 · Jones, Chicago, 1996

Chihuly, Dale. *1941 Tacoma, Washington. American glass sculptor. After initial study at Madison, by 1968 Chihuly was at Rhode Island School of Design, where he served as President of the Glass Department until 1980. He also trained as an architect. In 1968 he became the first American to study glassmaking at the Venini glassworks on Murano. In Chihuly's blown work, brightly colored, fluid floral shapes resembling interconnected orchids and shells predominate (*Glass Forests*; *Sea Forms*). Such exuberant studio-glass was well suited to the stage, as witnessed by his lighting sets for *Pelléas and Mélisande* for the Seattle Opera Company (1991). Associated in the hot-shop with Italo Scanga (1932–), in the mid-1990s he worked on a project for a 500-foot/150-meter glass-and-steel footbridge in Seattle. In 1999 Chihuly completed an installation in the atrium of the Victoria and Albert Museum, London. D.R.

Bibl.: Kisbit, Chihuly, 1997

Chillida, Eduardo. *1924 San Sebastián. Basque sculptor, artist, and graphic designer living in San Sebastián. He first studied architecture in Madrid (from 1943), before attending a private academy, the Circulo de Bellas Artes (1946). In 1948 he moved to Paris, returning to Spain in 1951. He received his first major commission in 1954 (four portals for the façade of the Basilica of Aranzazù, Onati). In 1957 he moved to Alto de Miracruz, San Sebastián. He traveled in the US

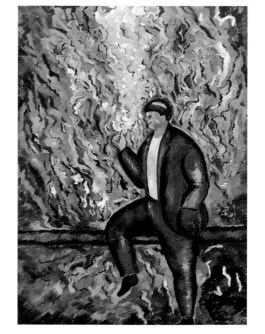

Sandro Chia, *Fire Raiser*, 1980, Oil on canvas, 208 x 144 cm, Private Collection

(1958) and Greece (1963). In 1971 he was visiting professor at the Carpenter Center for the Visual Arts at Harvard University, Cambridge, Mass., and in 1984 he set up the Chillida Foundation in Zabalaga. He has won numerous awards and prizes, including the German Orden pour le mérite für Wissenschaft und Künste.

Chillida's first phase was marked by Greek sculpture, which he had admired in the Louvre (*Torso*, 1948). He began making abstract sculpture in Hernani in the Basque country (1951–57), welding parts from agricultural machines. In 1955 he started cutting iron, resulting in more dynamic forms (*Hierro de temblor I*, 1955). He used traditional welding techniques to create large sculptures. In addition to iron and steel, he also used materials such as wood, granite, concrete, ceramics, and alabaster, often in contrasting combinations such as iron and wood (*Yunque de los sueños*, 1954–62). His trip to Greece (1963) opened his eyes to the effects of light. Using light-colored alabaster he was able to fuse light and form (*Elogio de la luz*, 1965). In the 1960s he started to make constructions from massive wooden beams and granite blocks for public areas and

Eduardo Chillida, *Gravitación*, 1995, Ink on paper, 22 x 22.5 cm

architectural sculptures which the viewer can enter. From 1971, using a unique molding method, he created monumental concrete sculptures with smooth surfaces and clear edges and lines (*Lugar de encuentros III*, Madrid, 1973). Chillida has also produced prints and book illustrations (including Heidegger's *Die Kunst und die Raum*, 1969; and woodcuts for the works of the Spanish poet Jorge Guillén, 1971). In 1989 his illustrations were shown at the Kestner-Gesellschaft in Hanover. Many of his works testify to a social commitment. His *Peines del viento* (*Wind Combs*), for example, of which he created a number of versions (1952–90), comment on Basque culture. He has been working on a gigantic project to excavate Mount Tindaya on Fuerteventura in order to create a space for all people (*Espacio para todo los hombres*) in harmony with nature. H.D.

Eduardo Chillida, *Wind Comb*, 1977, Steel, On the coast of San Sebastián

Bibl.: Chillida, Houston, 1966 · Estaban, Chillida, 1975 · Paz, Chillida, 1979 · Chillida, New York, 1979/80 · Koelen, Chillida, 1996

Chirico, Joseph Maria Alberto Giorgio de. *1888 Volos, Greece, †1978 Rome. Italian painter, sculptor, and designer. He studied at the polytechnic in Athens (1900–06) and the Akademie der Bildenden Künste, Munich (1906–08), where he was strongly influenced by German philosophy and Symbolist art. His early paintings were influenced by Arnold Böcklin (1908–09). In 1909 he moved to Italy, dividing his time between Milan and Florence, and in 1911 he joined his brother → Savinio in Paris. Repudiating the works of Nietzsche and Schopenhauer, the two brothers developed a nihilistic philosophy and a metaphysical theory of aesthetics, in which the world of things is seen not as a universe of shapes that appear but of meanings that reveal themselves (Baldacci). The artist's task is to enable the viewer to experience the riddles and nonsense concealed behind ordinary things. Objects become the signs of a visible vocabulary. Relieved of their conventional meaning and combined in illogical ways, they create moments of poetry and articulate intuitions that cannot be reproduced verbally. Thought is directly translated into a language of pictures.

De Chirico's first Metaphysical works (→ Pittura Metafisica) were painted in late 1909 (*Enigma of an Autumn Afternoon*). Following his arrival in Paris in 1911 he produced his series of Italian squares. With their dramatic lighting coming from a variety of sources, their arcades, tilting ground, chimneys, towers, railroads, shrubs, and fruit, they create an apparently dreamlike atmosphere. In 1914 he worked with Apollinaire and Savinio to develop "manichini" (tailors' dummies). During national service in Ferrara (1915–18) he painted a series of Metaphysical interiors, as well as such major works as *The Great Metaphysician* and *The Unquiet Muses*. About 1917, → Carrà, de → Pisis, and → Morandi fell under his influence. From 1918 he published theoretical texts on Metaphysical art in *Valori plastici* and other publications. In the autumn of 1919 he explained his change in style in an essay entitled *The Return to the Craft*. He attached more importance to technical refinement and reverted to a more traditional figurative style. His "classical"

phase in Rome and Florence (1920–21) was followed by a "romantic" period (1922–24). His works of this period (*Roman Villas*, numerous *Self-Portraits*) were executed in tempera. From 1925, in Paris, he painted a second series of *manichini* pictures, as well as horses and gladiators. He broke away from the Surrealists, who preferred his earlier works and his novel *Hebdomeros* (1929). From 1930 he divided his time between Florence,

Joseph Maria Alberto Giorgio de Chirico, *Mystery and Melancholy of a Street*, 1914, Oil on canvas, 87 x 71.5 cm, Private Collection

Milan, New York, and Paris. His new works were conventional and repeated motifs from his earlier work. One exception was the poetic series *Mysterious Baths* (1934–35). In 1944 he settled in Rome, where he was much in demand as a portraitist. Preferring a neo-baroque style, the *pictor optimus* wrote numerous texts attacking modern art. At the end of the 1960s, he produced a number of "neo-Metaphysical" paintings copying his earlier works. In addition to his painting, Casella, Pizzetti, Diaghilev, and Miloss called on his services as a set and costume designer and, starting in 1924, he worked on more than 20 opera or theater productions. De Chirico influenced → Surrealism, → Neue Sachlichkeit, → Magic Realism, → Pop art, → Conceptual art, and the → Transavantgarde, as well as aspects of → Postmodernism. G.R.

Bibl.: Soby, De Chirico, 1955 · Carrà, Metaphysical Art, 1971 · De Chirico, 1971 · Dell'Arco, Parigi 1924–1929, 1982 · Dell'Arco, L'opera, 1984 · De Chirico, Bristol, 1985 · Lista, De Chirico, 1991 · Baldacci, De Chirico, 1997 · Roos, De Chirico and Savinio, 1999

Christo (Christo Javacheff). *1935 Gabrovo, Bulgaria. Bulgarian-born sculptor and artist living in New York. He studied art, sculpture, and set design at the Academy in Sophia (1953–56), and at the Kunstakademie, Vienna (1956). In 1958 he moved to Paris and in 1964 settled in New York. He is married to Jeanne-Claude (née de Guillebon), who collaborates on all his projects. During his years in Paris he invented the practice of packaging (*empaquetage*) for which he is famous, wrapping small objects in fabric or

plastic sheeting. The idea was derived from → Man Ray and New York → Dada, but Christo gave it a completely new dimension. In 1961 he conceived a project for wrapping a public building, the first of a series of works that are amazing for their size, and the tenacity with which Christo implements them. His "wrappings" gradually assumed the character of huge, precisely planned → happenings (*42390 Cubic Feet Package*, Walker Art Center, Minneapolis, 1966; Kunsthalle, Berne, 1968). As well as objects and buildings, Christo has also wrapped landscapes. His principal exploits in this sphere are: *Wrapped Coast – One Million Square Feet* (Little Bay, Australia, 1969); the orange *Valley Curtain* (Rifle, Colorado, 1972); *Running Fence*, a fence that meanders through California for a distance of 39.5 kilometers (1976); *Surrounded Islands*, 11 islands off Miami surrounded by pink foil (1983); and *Umbrellas*, blue in Japan and yellow in the US (both 1991). The preparation – the studies of the site, the preliminary drawings, and above all the finding of sponsors – is an inherent part of the work. The wrapping of the Reichstag in Berlin, for example, from conception to realization, took from 1971 to 1995. This project attracted much media interest and a photographic record of the key stages was made by Wolfgang Volz. Christo's latest work is *Wrapped Trees* (1998–99) for the Museum Beyeler-Riehen, Basel-Riehen. All that remains of these ephemeral works are photos, large-scale drawings, collages, fabric samples, and map sections. H.D.

Bibl.: Christo, Catalogue, 1982 · Laporte, Christo, 1984 · Spies, Christo, 1984 · Christo, London, 1988 · Schellmann, Christo, 1988 · Taal-Teshuva, Christo, 1993 ·

Chryssa (Mavromichali Vardea). *1933 Athens. Greek-born sculptor living in the US and Greece. She studied at the Académie de la Grande Chaumière, Paris (1953–54), and the California School of Fine Arts, San Francisco (1954–55). In 1957 she settled in New York. Her first works were clay reliefs in a → Minimalist vein and plaster letters in display cases. Between 1956 and 1961 she worked with letters as symbols of communication in series such as *Deltoi*, *Tablets*, *Newspapers*, and *Projections*. In the early 1960s she began creating neon light → installations. Her rhythmic arrangements of right-angled, circular, and semicircular tubes create the impression of drawing with light (*The Gates to Times Square*, 1964–66). From 1980 she made baroque installations of aluminum, plastic, and neon tubes that lie somewhere between Minimalism, → Conceptual art, and → Pop art. H.D.

Bibl.: Restany, Chryssa, 1977 · Schultz, Chryssa, 1990

Citroën, Paul (Roloef Paul). *1896 Berlin, †1983 Wassenaar. Dutch painter, designer, and photographer. He studied art and sculpture in Berlin (1912–14). Between 1916 and 1918 he worked at the Der Sturm bookstore and had contacts with the → Dada movement in Berlin. In 1919 he began to create his own → photomontages and collages from photos, postcards, and printed texts. Between 1922 and 1924 he studied painting at the → Bauhaus, where he created a number of works that combined collage and drawing. His principal theme was the city (*Metropolis-Montagen*, 1921–27). Between 1924 and 1928 he worked as a portrait photographer in Berlin (he shared a studio with → Umbo) and art dealer. In 1928 he moved to Amsterdam, where he worked as a photographer, artist, and as an art dealer. In 1934 he founded the Nieuwe Kunstschool in Amsterdam, where Bauhaus teaching methods were used. In 1947–48 he worked as a stage designer for the Nederlandse Opera, and in 1948–49 he designed stamps. He also taught at the Academie voor Beeldenen Kunsten (1935–40, 1945–60).

Citroën's collages, which display a fascination with the metropolis, have none of the virulence normally associated with Dada collages. He was regarded as a leading exponent of the "new vision" in the Netherlands. H.D.

Bibl.: Rheeden et. al., Citroën, 1994

Čiurlionis, Mikalojus Konstantinas. *1875 Varena, Lithuania, †1911 Pustelnik Minski, Poland. Lithuanian painter. Čiurlionis initially studied music in Leipzig and Warsaw (some of his preludes, etc. are lyrical and harmonically daring) before turning to painting; his pastels of the early 1900s were → Symbolist and folkloric. Believing – with Alexander Scriabin, → Schoenberg, Lyonel → Feininger, and → Kandinsky – that painting and music were allied, he "composed" around 300 works (inc. *Fugues*), some of which explore Oriental and cosmogenic beliefs (*Creation of the World*, 1904–06). Informed with the serpentine forms of → Art Nouveau (close to → Thorn Prikker) and divided into planes of color, they are not truly Non Objective in the manner of Kandinsky's *Improvisations* (e. g. 1911–13). Abstractionist tendencies; natural imagery; and imagery close to → Kupka (*Sonata of the Sun*, 1907; *Stillness*, 1905–an island/head), → Redon (*The Belfry*, 1907), and Max Klinger (*Fairy Tale II*, 1907), combine in a highly personal oeuvre. Čiurlionis moved to St. Petersburg in 1908 and died insane. D.R.

Bibl.: Rannit, Čiurlionis, 1984

Clara Mosch. In the 1970s, a number of independent artists' groups, who opposed the bitter resistance of East Germany's cultural bureaucracy, broke away from the official association of artists in the DDR (VbK-DDR); Clara Mosch was one of the most important and influential of these. The founder members were → Claus (CLA), Thomas Ranft (RA), Michael Morgner (MO), Dagmar Ranft-Schinke (SCH), Gregor Torsten Schade (later Kozik), and photographer Rainer Wasse, who subsequently turned out to have been working with the state security organization (the state put a lot of effort into trying to destroy the group). On May 30, 1977, they set up the Clara Mosch "production gallery" in a former grocery in Chemnitz. In both his graphic works and paintings, Morgner favored large forms and a dense, almost monochrome pictorial language which was close to abstraction. Although Ranft shared Morgner's philosophical and moral stance, his drawings and prints were executed in a more intricate and nervous style. E.H.

Bibl.: SBZ/DDR, 1996

Camille Claudel, *The Waltz*, 1891–1905, Bronze, 25 cm high, Bayerische Staatsgemälde-sammlung, Neue Pinakothek, Munich.

of writer Paul Claudel. From 1885 to 1895 she was the assistant and mistress of → Rodin, who was 24 years her senior. After they separated, she refused all offers of help from him, despite increasing isolation and poverty. In 1913, suffering from paranoia, she entered a mental institution at Montdevergues, where she remained until her death. Her work was rediscovered in 1984 following a retrospective in Paris.

Such masterpieces as *The Waltz* (1895) and *Clotho* (1893) demonstrate Claudel's considerable talent and craftsmanship, as well as the influence of the formal tutoring she received from Rodin. Her many autobiographical works (*Maturity*, 1894–95; *The Beseecher*, 1900) testify to her impressive attempts to achieve artistic independence. Her small works (*The Gossips*, 1897; *The Wave*, 1900) are highly convincing, realistic compositions with a hint of → Art Nouveau. L.Sch.

Bibl.: Claudel, Paris, 1988 · Schmoll, Claudel, 1994 · Rivière, Claudel, 1996

Clark, Lygia. *1920 Belo Horizonte, †1988 Rio de Janeiro. Brazilian painter, performance artist, and sculptor. After studying with → Léger in Paris (1950–52) she abandoned figuration, producing *Untitleds* and *Compositions* made from the flat surfaces of → Constructivism and → Neo-Plasticism. Returning to Rio de Janeiro in 1954, she executed early → Concrete art works (*Modular Spaces*, late 1950s), including *Counter-reliefs*. In an initial move towards → Performance, there followed hinged pieces that could be adjusted by the viewer and were based on zoological imagery (*Pocket Animals*). Moving back to Europe in 1968, she had a retrospective at the Venice Biennale (to which she had already been invited in 1960 and 1962). Her growing interest in relational objects surfaced in *Grubs* (1965–), then *Biological Architecture* (1969–). An innovative therapist, she held a psychology course at the Sorbonne on gesture (1972–75). Her work (often in soft or non-rigid materials) included clothing sculptures with reversed zip hoods. She is among the most significant Brazilian artists, alongside → Oiticica. D.R.

Bibl.: Gullar/Pedrosa, Clark, 1980 · Fabrini, Clark, 1994

Claudel, Camille. *1864 Fère-en-Tardenois, Aisne, †1943 Montdevergues, near Villeneuve-les-Avignon, Vaucluse. French sculptor and artist, sister

Claus, Carlfriedrich. *1930 Annaberg, Erzgebirge. German painter living in the Erzgebirge in Germany. From an early age he was interested in philosophy and history. Strongly influenced by the theories of Karl Marx and Ernst Bloch, he became a Communist. His early work (late 1940s) was inspired by experimental poetry and → Abstract Expressionism. He developed a personal idiom in which handwritten texts were interwoven with landscapes. He preferred transparent supports, writing on both sides and thereby creating a synthesis of thesis (front) and antithesis (back).

Thomas Ranft and the other members of the → Clara Mosch group encouraged Claus in his printmaking endeavors (*Aurora*, 1977). He subsequently began to produce screenprints on plexiglass. In addition to *Aurora*, his most important works include *Geschichtsphilosophisches Kombinat*, *Aggregat K*, and *Karate Blätter*, which feature extreme shapes bearing no resemblance to letters. Claus, who was one of the DDR's leading independent thinkers and artists, exerted a considerable influence on the new generation of artists. E.H.

Bibl.: Lang, Malerei, 1980 · Zeitvergleich, 1983 · SBZ/DDR 1945–90, 1996

Clemente, Francesco. *1952 Naples. Italian painter and sculptor living in New York, Madras, and Rome. He initially studied architecture at the University of Rome (1970), and then philosophy. Following his first visit to India in 1973, he took up watercolor painting. In 1974 he traveled to Afghanistan and later met → Beuys in Naples. He visited India for a second time in 1977 and has since returned there for extended stays on a number of occasions. In 1979 he became an exponent of the → Transavantgarde with → Chia, → Cucchi, and → Paladino. In 1984 he collaborated with → Warhol and → Basquiat on 12 projects.

Clemente's work is essentially meditative and romantic in character. His erotic, Symbolist self-portraits and ideograms obey no established logic or conventional pictorial language, seeming to emerge directly from the imagination. Central to his work is the idea that human perception is fragmented – something he expresses

Carlfriedrich Claus, *Diaphanes Sprachblatt, Allegorischer Essay für Albert Wigand: Natural-isierung des Menschen, Human-isierung der Natur, ein kommu-nistisches Zukunftsproblem*, 1965, Double-sided screen on transparency, 70 x 85.5 cm

Francesco Clemente, *Maps of What is Effortless*, 1978, Gouache on paper, 152.4 x 144.8 cm, Private collection

in several different ways in groups of works. Within a given group, he shifts styles and uses a variety of techniques. Clemente's work is strongly influenced by East Asian spiritualism, which explains his interest in cyclical works. Since the 1980s he has produced extensive cycles of watercolors, as well as oils of exceptional chromatic quality. D.W.

Bibl.: Auping, Clemente, 1985 · Avedon, Clemente, 1987

Close, Chuck. *1940 Monroe, Washington. American artist and photographer living in New York. He studied at the University of Washington, Seattle (1958–62), and the Yale University School of Art and Architecture (1962–64), and was a Fulbright scholar at the Akademie der Bildenden Künste, Vienna (1964–65). He lectured at the University of Connecticut, Amherst (1965–67), the School of Visual Arts, New York (1967–71), and New York University (1970–73). He has been a member of the American Academy since 1992. He has won numerous awards, including an honorary doctorate from Skidmore College, Saratoga Springs, N.Y. (1993).

As a student Close worked in an → Abstract Expressionist style, and in the 1960s he explored → Pop art and → Minimal art. His *Big Nude* (1967–68) is an outsized monochrome nude based on a black-and-white photograph. After a 1958 *Self-Portrait*, Close decided to copy portrait photographs, painting the faces larger than life and reproducing every detail by means of an ingenious grid system. The central theme is not the person portrayed, however, but the actual process of turning the photograph into a painting in which every detail is reproduced in painstaking detail. He resumed color work in 1970, working on his photos with acrylic and airbrush, with each segment of the surface painted individually in glazed layers. In the 1980s he adopted the technique of finger painting, in which the paint is applied with the finger through a round template. At the same time he turned to photography, experimenting with a large-format polaroid camera. From 1981 he used masses of hand-cut paper poured through a grid

to make pictures in shades of gray. In 1980 he returned to oil painting, initially using his fingers and then, after 1986, brushes. These pictures were made up of abstract symbols so that the overall portrait can only be read from a distance. Unlike the → Photorealists, Close makes the techniques he uses, and the process of looking at pictures, the subjects of his paintings, rather than the motifs, and this identifies him more as a follower of → Neo-Impressionism. Since 1988 he has been confined to a wheelchair, but he continues to work with the aid of assistants. H.D.

Bibl.: Close, 1985 · Danto, Close, 1993 · Guare, Close, 1995 · Close, New York, 1998 · Storr, Close, 1998

Clough, Prunella. *1919 London, †1999 London. British painter and printmaker. Clough studied at the Chelsea School of Art, London, where she later joined the staff. Shortly after World War II she exhibited landscape images typical of the English → Neo-Romantic tradition, based on reminiscence rather than nostalgia, but was soon attracted by the non-representational, especially by French → Art Informel. In the early 1950s she produced abstract-influenced industrial scenes with figures of working people, though a painterly sensitivity to color and texture always held sway over descriptive notation. Together with figures such as Joan Eardley (1921–63) she was promoted by what is now the Browse & Darby Gallery in London; in 1960 she was the subject of a reputation-building retrospective at the Whitechapel. Printmaking – including original monoprints as well as editions – was an important component of her oeuvre. Clough's approach to media is complex, never forsaking an ambition to unite representational elements such as light and shade with formal devices such as overlapping or superimposed areas of color. The *Gate* series (early 1980s), for example, incorporates detailed overdrawing in chalk. D.R.

Bibl.: Clough, London, 1982 · Clough, Cambridge, 1999

Cobra. Group established in Paris in 1948 by Danish artist → Jorn, Belgian writer → Dotremont, and the Dutch painter → Appel in response to the desire for a new, undogmatic type of abstraction that was full of action, spontaneity, and naivety. The name is derived from the first letters of the capitals of the countries where the artists were born: COpenhagen, BRussels, and Amsterdam. Cobra reflected the mood of postwar Europe. It was characterized by wildly dramatic gestures; psychic expression that came, like a dream, from the subconscious; and the freedom of coarse artistic expression. The Cobra artists' works had affinities with → Action Painting in the USA, → Art Brut, → Art Informel in France, and → Neo-Expressionism in Germany. They incorporated elements from folk art and childrens' drawings, the magic of the primitive, Japanese landscapes, and romantic metaphors. Other protagonists included → Corneille, → Alechinsky, → Constant, the English artists Stephen Gilbert (1910–), William Gear (1915–1997), and → Atlan, as well as numerous poets and visual artists. Their meeting places were Brussels, Bregnerod near Copenhagen, and Paris. Jorn published the group's

Chuck Close, *John*, 1971–72, Acrylic on canvas, 254 x 228.6 cm, Pace Wildenstein Gallery, New York

journal, *Helhesten*, which contained manifestos, texts, and lithographies. Exhibitions of their major works were held in the Stedelijk Museum, Amsterdam (1949), and in Liège (1951). The group disbanded in 1951, but continued to exert an influence, for example on Frankfurt artist → Götz (Quadriga) and Munich groups → Spur, Wir, and Geflecht. L. Sch.

Bibl.: Cobra, Rotterdam, 1966 · Stokvis, Cobra, 1988

Cobra, Asger Jorn, *Dovre Gubben*, 1959, Oil on canvas, 129 x 80 cm, Musée National d'art Moderne, Centre Georges Pompidou, Paris

Coburn, Alvin Langdon. *1882 Boston, †1966 Rhos-on-Sea, Wales. American-born British photographer. From 1899 to 1901 he traveled in Europe, spending a lot of time in London. In 1901–02 he worked as a freelance photographer in New York, where he came into contact with → Stieglitz and his circle, and was a founder member of the Photo-Secession Group (1902). In 1906 he taught at the London County School of Photo-Engraving. In 1915 he co-founded the Pictorial Photographers of America and in 1931 was made an honorary member of the Royal Photographic Society in London. He settled in the United Kingdom in 1912 and took British nationality in 1932.

A pioneer of abstract photography, Coburn was influenced by Stieglitz, Japanese paintings, and Whistler. He took atmospheric portraits and urban and rural landscapes using soft focus and lenseless cameras. He used the gum printing process and worked in gravure (portfolios of London, 1909, and New York, 1910). In 1912 he took a series of pictures looking down from New York skyscrapers. In 1916–17 he began experimenting with a triangular tunnel of mirrors (vortoscope) in front of the camera lens, resulting in abstract pictures (vortographs). About 1918 he abandoned photography to pursue his interest in mysticism, Freemasonry, and Druidism. H.D.

Bibl.: Gernsheim, Coburn, 1966 · Koschatzky, Photographie, 1989

Cocteau, Jean. *1889 Maisons-Laffitte, Yvelines, †1963 Milly-la-Forêt, Essonne. French poet, novelist, playwright, actor, film director, draftsman, painter, and dandy. Cocteau was educated in Paris and soon became a fêted figure of Parisian avant-garde chic. A friend of → Picasso and → Modigliani, and writers Max Jacob and Guillaume Apollinaire, Cocteau was launched by Sergei Diaghilev who challenged him to *étonnez-moi* ("surprise me"), an exhibitionist command that became Cocteau's watchword. Designing ballets – *Parade* (1917; music by Erik Satie) and *Le Boeuf sur le toit* (1920; Darius Milhaud) – Cocteau also executed graphics around motifs such as the faun or angel, Harlequin, Oedipus, and the poet-sacrifice, Orpheus. He produced classicizing religious works for Notre-Dame de France, London (1960). He also decorated the Villa Santo Sospir in Saint-Jean-Cap-Ferrat (1950) and the chapel of Saint-Pierre at Villefranche-sur-Mer, and provided smoothly elegant frescoes for the Hôtel de Ville at Menton. His oeuvre also includes tapestry cartoons (*Birth of Pegasus*, 1953), ceramics, and erotica. D.R.

Bibl.: Emboden, Cocteau, 1989

Coldstream, (Sir) William (Menzies). *1908 Belford, Northumberland, †1987 London. British painter. Coldstream studied at the Slade School in London (1926–29) and exhibited with both the New English Art Club and the → London Group. His late 1920s/early 1930s works included interiors and a "zoo" series, alongside canvases in sober hues that show a characteristic "squareness" of human form in undramatic subjects (*The Studio*, 1932–33). He destroyed his attempts at "objective abstraction" and took a break from painting in 1934–37 to make films before setting up a drawing school with → Pasmore in 1937. As the → Euston Road School, this became a center of socially committed art in England (like → Jennings, Coldstream worked on the Mass Observation Project in 1938). *St Pancras Station* (1938) is a prime example of his restrained palette at this time. Coldstream also produced portraits of a more conservative stamp, while later figure pieces remain sober, with measured if increasingly broken application. From 1949 to 1975 Coldstream was Slade Professor at University College; he was also a Trustee at one time of both the National and Tate Galleries, London. D.R.

Bibl.: Gowing, Coldstream, 1990

Coleman, James. *1941 Ireland. Irish painter, installation, video, and performance artist living in Dublin and County Clare. Coleman's works are often montages of visual and aural stories, such as *Slide Piece*, 1972, which consists of picture slides of a square in Milan and a tape recording. Although the same shot is shown every time the slide changes, a storyteller recounts different impressions. Theatrical performances followed in the 1980s, often with actors (*Now and Then*, 1981). His works of the 1990s referred to popular culture (television, comics), as well as film, theater, and art, in order to perceive "reality" as a construction of different, even conflicting elements (*Background* 1991; *Lapsus Exposure*, 1992–94; *I.N.I.T.I.A.L.S.*, 1993–94). H.D.

Bibl.: Fisher, Coleman, 1983

Colescott, Robert. *1925 Oakland, California. The African-American painter Robert Colescott is strongly influenced by the monumental simplicity and narrative quality of → Léger's work, having studied under the French master in Paris in 1949. Back in California, Colescott engaged in experiments uniting figuration with expressive tendencies. After two years in Cairo, his evolution was influenced by the strong narrative Egyptian tradition, content gaining in significance with vividly colored large-scale works. Irony became crucial in an attempt to subvert stereotypical views, to question the meaning of history, to study the relationship between man and woman, and to underscore the very different canons of beauty in various cultures. With the emergence of multiculturalism in the late 1980s Colescott has received wider recognition with exhibitions in many American museums, and, in 1997, a pavilion at the Venice Biennale. S.G.

Bibl.: Colescott, 1997

collage, (French coller = to stick). (From the French *coller* = to stick.) A picture made up of different objects and materials, frequently combined with painting. Invented by the → Cubists, it became one of the main forms of expression in 20th-century art. The first collages were created during the phase of Analytical Cubism by → Braque and → Picasso. After painting patterns and imitation wood graining in their pictures, Braque was the first to incorporate real wallpaper (*Still Life with Fruit and Dish*, 1912). Subsequently he and Picasso made increasing use of decorative paper and newsprint in their pictures. The antecedents of collage can be found in 17th-century *trompe-l'œil* paintings, folk art, handicrafts, and cut-outs. Today the term encompasses a range of techniques, forms, and materials, such as → photomontage, découpage, rollage, → objets trouvés, → ready-mades, → montage, → assemblage, → accumulation, → combine painting, packaging, → environments, and → installations. The basic aim of collage is to create new pictorial connections and meanings that are not evident from the individual components. K.E.

Bibl.: Weschner, Collage, 1968 · Waldman, Collage, 1992 · Poggi, Collage, 1993

Color Field Painting. Variant of → Abstract Expressionism in which the paint is applied in large fields of color, in contrast to the gestural, multicolored approach of → Action Painting. The principal exponents were → Still, → Rothko, and B. → Newman, followed later by → Gottlieb, → Reinhardt, and, occasionally, → Motherwell. Color Field paintings consist of large expanses of strongly colored paint that cover the entire picture surface. In 1952 → Frankenthaler developed a staining process in which the raw, unprimed canvas is soaked in paint so that picture color and surface are identical (see also → Washington Color Painters). H.D.

Colquhoun, Robert. *1914 Kilmarnock, †1962 London. The Scottish figurative artist Colquhoun studied at the Glasgow School of Art (1933–37) where he met the painter Robert MacBryde (1913–1966), with whom his career is associated. After the war, the "Two Roberts" were introduced by art patron Peter Watson to the London → Neo-Romantics Minton and John Craxton (1922–). *Man and Horse, Siena Palio* (1950) shows the influence of → Picasso, while *Woman with a Leaping Cat* (1946) is a celebrated study in introspection and vitality. Vaguely → Expressionist coloring and theme (*Encounter*, 1942) were succeeded by more severe, almost Existentialist postwar work (*Figures in a Farmyard*, 1953). Colquhoun was an occasional set designer and a notable lithographer; he died in hardship and (in spite of a retrospective at Whitechapel in 1958) almost unrecognized. D.R.

Bibl.: Colquhoun, Edinburgh, 1981 · Paradise Lost, London, 1987

Colville, David Alexander. *1920 Toronto. Canadian painter, graphic artist, and draughtsman living in Wolfville, Nova Scotia. In 1938 he attended Mount Allison University, Sackville, New Brunswick. From 1942 he performed his military service in Corsica, the Netherlands, and in Germany. 1945 saw his return to Canada. In 1946–63 Colville taught at Mount Allison University, Sackville. Subsequently he devoted himself exclusively to painting. Colville is influenced by diverse figurative art forms, from ancient Egypt and early Renaissance art to → Seurat and → Moore, but also by American painters such as Thomas Eakins (1844–1916) and → Shahn. Colville is considered to be a typical representative of → Magic Realism. Despite their likeness to the depicted object and the precisely planned composition his pictures seem to emanate something mysterious. (*Couple on a Beach*, 1957). He painted a mural for Mount Allison University (*History of Mount Allison*, 1948). As a teacher his influence on Canadian artists was considerable. H.D.

Bibl.: Fry, Colville, 1994

Combas, Robert → graffiti

combine painting. Term coined by → Rauschenberg to denote a type of work in which a two-dimensional picture surface is combined with objects or photographic images. Combine paintings are related to → Dada, → collage, and → montage, but differ in that they incorporate large objects, as in Rauschenberg's *Black Market* (1961), a rope-tied combination of collage and a wooden case. Combine painting is also related to → environmentals, in which everyday objects are also sometimes used. H.D.

comic. A form of story-telling through pictures. The key features of the comic are the interplay between text and pictures (code), and the presentation of action with stationary figures in a sequence of pictures or panels. In a comic, the graphic and literary components are stylized to create their own language. There are different types of comic, from the newspaper comic strip to comic books. The precursors of the modern comic strip were Rodolphe Töpffer (1820) and Wilhelm Busch (1865), whose picture stories were popular throughout Europe, but the comic

strip as it is known today was born in 1896 in the US with the "Yellow Kid" by Richard Outcault and the "Katzenjammer Kids" by Rudolph Dirks. Their humorous approach was continued in 1910 in animal stories with anthropomorphic figures (Donald Duck by Barks). Foster's "Tarzan" was the first in a new generation of "straight" adventure comics with heroic figures, culminating in Dick Tracy, Buck Rogers, and Superman. Since the 1950s countless other types of comic have evolved, mainly in the US (underground comic, satire, horror, black humor). In recent years European comics have developed technologically and intellectually to match their American counterparts, and, although many are trivial, mass-produced products, some display a high level of artistry.

Many artists have taken an interest in comics, such as L. → Feininger with his "Kinder Kids" of 1906, and → Picasso, who chose this form of storytelling for his series of etchings "Franco's Dream and Lie 1937". → Schwitters also used comic cutouts in some of his works. However, it was not until the 1960s that the comic was used more widely in art. In works such as → Warhol's *Dick Tracy* (1960) and → Lichtenstein's *Hopeless* (1963), a single panel is blown up to wall size. → Rauschenberg used entire pages of comic strips for his → combine paintings, while → Fahlström used them as the basis for his own picture stories. More recent avant-garde art has been inspired by so-called hard or splatter comics, which use deliberately disgusting or shocking elements. P.L.

Bibl.: Comic Strips, Nuremberg, 1970 · Metken, Comics, 1970 · Reitberger, Comics, 1971 · Grünewald, Comics, 1982 · Varnedoe, High & Low, 1990

comic, Lyonel Feininger, *Illustration from "Le Témoin"*, 1906, Synthetic resin on canvas, vol. 1, issue 6, 1906

Computer art. Art's openness to novelty and innovation has found a new form of expression in the computer. Formal experimentation in art has often been triggered by technological inventions. Vannevar Bush, for example, first sketched a multimedia desktop computer as long ago as 1945, thereby laying an important foundation stone for artistic experimentation in the field of computing. Similarly, Ian Sutherland's "Sketchpad" program of 1962 for the Experiments in Art and Technology (→ EAT) foundation set up by → Rauschenberg and Billy Klüver led to the

comic, Andy Warhol, *Dick Tracy*, 1960, Synthetic resin on canvas, 201 x 114 cm, Coll. Mr. and Mrs. S.I. Newhouse Jr., S 144

recent artistic CD-ROMS by the London Audirom group and the *Artintact* series. After its rather modest infancy (computer graphics), computer art is today being used to develop an entirely new concept of art, namely that of simulation. The development of biomorphic shapes on the screen, from a repertoire of simple formulae, shows how computer technology can be used to create a new pictorial concept and enables the artist to create visual worlds that have never been seen before. Interactivity offers the possibility of new kinds of communication with the viewer or user. Net art is the latest development in computer art. The Internet-linked computer is regarded as a means of questioning the objectivity of art, or its fetishistic character. Many net art projects are based on political and emancipatory pathos. The E-zines that appear in the World Wide Web (*Telepolis* or *net-time.org*) form the link with the so-called hacker scene which regards itself as the new avantgarde. The computer is about to find acceptance as an artistic medium in the art world. As was the case with video, today's young artists regard the computer as just another tool of their artistic trade. G.B.

Bibl.: Lovejoy, Postmodern, 1989 · Popper, Electronic, 1993

Conceptual art. A type of art that emerged in the 1960s and consists of ideas and concepts rather than a finished work of art. In Conceptual art the physical realization of an artistic idea is dispensed with in favor of sketches, texts, and instructions intended to prompt the viewer to act or think. Marcel → Duchamp, whose → readymades brought about a new conceptual form of art, is widely regarded as the father of the movement. The term was actually given currency by → LeWitt, who used it in his article "Paragraphs on Conceptual Art" (*Artforum*, 1967): "In Conceptual art the idea or concept is the most important aspect of the work ... all planning and decisions are made beforehand and the execution is a

Conceptual art, Joseph Kosuth, *One and Three Chairs*, 1965, Installation with a wooden chair, 82 x 40 x 37 cm and photos, 112 x 79 and 50 x 75 cm, Musée National d'Art Moderne, Centre Georges Pompidou, Paris

perfunctory affair. The idea becomes the machine that makes the art." The principal exponents of Conceptual art were → Weiner and → Kosuth. The latter's *One and Three Chairs* (1965) is a good example of this type of art, consisting of a chair placed next to a photograph of the same chair, accompanied by a dictionary entry on the chair. Conceptual art also includes actions based on patterns of behavior and activity, such as those by Klaus Rinke (1939–), D. → Oppenheim, Bazon Brock, and Timm Ulrichs (1940–), who, in the 1970s, developed the idea of a "total art" as a restriction of "poetic, aesthetic, and dramatic phenomena." Neo-Conceptual, a new wave of Conceptual art first seen in the mid-1980s, crosses over into → Minimal art, → Body art, and → Performance art. H.D.

Bibl.: Szeemann, Attitudes, 1969 · Trini, Concept, 1971 · Lippard, Six Years, 1973 · Meyer, Conceptual Art, 1973 · Morgan, Conceptual Art, 1994

Concrete art. A term coined in the mid-20s for defining an art trend which dissociates itself from "Abstract Art". It describes an anti-figurative and non-representational mode of painting; instead of a subjective emotional, spiritually and irrationally charged, free and incidental form, concrete art is a totally rational, objectively-controlled, scientific and often mathematical method of generating pictures. Line, colour, geometric form and surface structure are not used as abstracting tools for the reproduction of impressions of nature but as concrete means for the production of carefully devised and constructed pictures. The pictures should therefore be understood as purely visual structures of a given logic and not as an expression of subjective feelings. The term does not apply to every kind of geometric abstraction.

The term Concrete art was first formulated by → Doesburg in 1924. He also played a leading role in 1930 when the manifesto was published and the group 'Art Concret' was founded which counts among its members followers of various art trends (→ Constructivism, De → Stijl, → Bauhaus and the → Cercle et Carré). In France its ideas were developed further in → Abstraction-Création and later reactivated in the → Salon des Réalités Nouvelles. It had followers in Italy (the Movimento Arte Concreta founded in 1948) and in Switzerland, where in Basle in 1944 → Bill organised the international exhibition Concrete art and founded the newspaper *abstrakt/konkret*. In 1960 a comprehensive retrospective Concrete art – 50 Years of Developmen' was held in Zürich. Concrete art had a decisive influence e.g. on American artists such as a.o. B. → Newman, → Ad Reinhardt (→ Hard-Edge Painting), F. → Stella and → Judd; in England on Ben

→ Nicholson; in Germany a.o. on → Lohse and → Geiger. It also had a great effect on → Op Art not last on literature in the form of "Concrete Poetry", where special emphasis was given to the structural form of the text. M.S.

Bibl.: Art Concret, 1930 · Abstraction-Création, 1931–36 · Konkrete Kunst, 1944 · Konkrete Kunst, 1960 · Doesburg, 1981

Congdon, William. *1912 Providence, Rhode Island, †1998 Milan. American painter. After an academic training, at the end of World War II, Congdon participated in the liberation of the concentration camp of Bergen-Belsen, a crucial experience that he conveyed in many drawings. Spending long periods in Italy, Paris, and New York, as well as traveling all around the world, he developed an interest in urban landscape which he painted in thick oil impasto on wood and on masonite, incising the surface in a manner reminiscent of → Klee's graffiti. In 1949, he started to exhibit at the prestigious Betty Parson Gallery, New York, where he became acquainted with → Action Painting. His painting then evolved towards the simplification of form with simple juxtaposed areas of color and towards an interest in nature and landscape, as well as religious subjects following his conversion to Catholicism in 1959. S.G.

Bibl.: Maritain, Congdon, 1962 · Congdon, 1992–93

Conner, Bruce → Funk art

Constant (Constant Anton Nieuwenhuys). *1920 Amsterdam. Dutch painter, sculptor, and printmaker living in Amsterdam. He studied at the Art Academy in Amsterdam (1939–41). In 1948 he cofounded → Cobra. From 1949 to 1953 he lived in Paris and London, before in 1958 subscribing to → Situationism for two years. He spent the 1960s working on his project *New Babylon*, a town of the future, after which he returned to painting.

From 1945 Constant began to paint highly expressive pictures based on children's drawings. Their central motif is the burnt earth – a metaphor for past catastrophes. His pictures of the 1940s show figures and animals living an uprooted existence. These works have a degree of abstraction which links them to De → Stijl, but the raw, informal treatment is also characteristic of Cobra. A member of the Situationists, Constant was preoccupied for many years with the problems of urban construction. In his later works he reverted to figurative paintings in which man's environment is presented as the mirror of his inner life. H.D.

Bibl.: Honnef, Constant, 1991 · Lambert, Constant, 1992 · Constant, Amsterdam, 1995

Concrete art, Max Bill, *Rhythm in 4 Squares*, 1943, Oil on canvas, 30 x 120 cm, Kunsthaus Zürich

Constructivism. A movement in abstract art that emerged about 1913 in Russia (→ Suprematism) and the Netherlands (De → Stijl), from where it spread to Poland, Hungary, Czechoslovakia, and Germany (→ Bauhaus). The movement was initially influenced by → Cubism, and in particular Picasso's Cubist → assemblages. The aim was to liberate art from emotional interpretations of reality and individual randomness in favor of abstract pattern (correlation of elements, inner structures, spatial tensions and energies). By detaching art from the "ballast of the representational world," it would be possible to arrive at an absolute value, "absolute and pure form" (→ Malevich). Art would thereby serve as a mirror of "universal harmony" (→ Mondrian). The Constructivist vocabulary consisted of geometric and stereometric primary forms, as well as architec-

Constructivism, *El Lissitzky*, Study for Proun G 7, 1922, Paper and cardboard, collage, 47.9 x 39 cm, Stedelijk Museum, Amsterdam

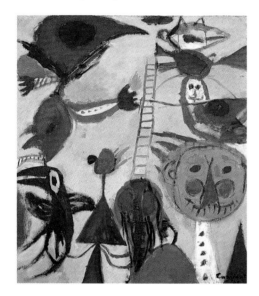

Constant, *The Little Ladder*, 1949, Oil on canvas, 90.2 x 74.9 cm, Coll. Haags Gemeentemuseum, The Hague

tonic elements. A reduced scale of colors was used. In Constructivism, the visionary artist was replaced by the rational designer, traditional concepts of style by economy of design, and bourgeois aesthetic by a functional, normative, collective art. By breaking down the barriers between genres, by integrating sound, film, and technology, Constructivists aimed to create a symbiosis of art, science, design, and architecture to serve a changing social context.

Different artists had different theoretical conceptions of Constructivism. In contrast to Malevich's Suprematism (*Black Square on a White Surface*, 1913), which had a strongly philosophical orientation, the Constructivism of → Tatlin, → Rodchenko, → Gabo, and → Pevsner was of a more utilitarian nature. Their ideas were spread to western Europe by → Lissitzky, where they had a formative influence on the De Stijl movement (→ Vordemberge-Gildewart), and the Bauhaus (→ Moholy-Nagy). Constructivist ideas also helped lay the foundations for → Concrete art, → Kinetic art, → Minimal art, and → Color Field Painting. W.S.

Bibl.: Roters, Constructivism, 1967 · Constructivism, Berlin, 1977 · Rotzler, Constructivism, 1977

Contemporary Group. The name of two groups of Australian artists set up to promote modern art in

their country. The first was founded in Sydney in 1925 by George Lambert (1873–1930), one of Australia's leading portrait painters, and his student Thea Proctor (1879–1966). Its members, who included Margaret Preston (1875–1963) and Grace Cossington Smith (1892–1984), were all influenced by → Post-Impressionism. The second group was founded in Melbourne in 1932 by George Bell (1878–1966). In 1938 it became the Contemporary Art Society (the Contemporary Art Society of Australia was established in 1961). H.D.

Continuità. Group of Italian artists that was formed in 1961 at the instigation of the art historian Giulio Carlo Argan (1909–1992). Several of its members had previously belonged to the → Forma group (founded in 1947), and the aims of the two groups were broadly similar. Continuità distanced itself from → social realism and from → Art Informel (which some of the members had belonged to), advocating a modern formalism and a return to the great tradition of Italian art. Its members, who included → Dorazio and Lucio → Fontana, experimented with geometric structures and optical effects in brilliant colors. Fontana solved the problem of creating a spatial effect on a two-dimensional surface with his celebrated gashes in the canvas. L.Sch.

Bibl.: Modesti, Pittura italiana, 1964 · Venturi, Italian Painting, 1967

Corinth, Lovis. *1858 Tapiau, East Prussia (now Gwardejsk, Russia), †1925 Zandvoort, Holland. German painter, printmaker, and writer. He studied at the Kunstakademie Königsberg (1876–80), the Kunstakademie, Munich (1880–82), and the Académie Julian, Paris (1884–86). Between 1891 and 1899 he lived in Munich. In 1900 he moved to Berlin, where he joined the → Secession, succeeding → Liebermann as president (1911). In the same year he suffered a stroke which left him paralyzed down one side. Between 1912 and 1914

he traveled to the Riviera, the southern Tyrol, and Italy, and in 1916 he traveled to Hamburg, the Baltic, and Tapiau. In 1918 he was appointed professor at the Berlin Akademie. In 1919 he built a house at Urfeld by the Walchensee, where he lived with his wife and children until his death. In 1919 he became a member of the Bayerischen Akademie der Schönen Künste in Munich.

Lovis Corinth, *The Jochberg and the Walchensee*, 1919, Oil on canvas, 65 x 88.5 cm, Museum Ostdeutsche Galerie, Regensburg

Between 1891 and 1899 Corinth painted portraits and generous figure compositions in a naturalistic style influenced by Courbet and Wilhelm Leibl. Despite joining the Munich Secession of 1892, he was unable to assert himself artistically because the art scene in Munich was dominated by Lenbach and Stuck. His disagreement with the Secession led to the establishment of the Freien Vereinigung, although this association was never able to exhibit. In 1900 he moved to Berlin, where his painting *Salome* (1899), which had been turned down in Munich, was shown at the third Secession exhibition to great acclaim. From 1903, after his marriage to Charlotte Berend, Corinth was in great demand as a portrait painter in Berlin. His style became increasingly Impressionistic, reinforced by voyages to Holland and Belgium (1907–11). However, the old masters such as Frans Hals and Rembrandt remained his models and he paraphrased them humorously in his historical paintings (*The Homeric Poet*, 1909). Following his move to Walchensee, he devoted himself to landscape painting. His Walchensee paintings, with their almost furious brushwork, are among his best and their influence can still be seen in present-day → Neo-Expressionist painting. H.D.

Bibl.: Berend-Corinth, Corinth, 1958 · Corinth, Bremen, 1986 · Corinth, Munich, 1986 · Corinth, Berlin/Munich, 1996 · Corinth, London, 1996 ·

Corneille (Cornelius Guillaume van Beverloo). *1922 Liège, Belgium. Belgian-born Dutch painter and ceramicist, living in Paris. He studied at the Rijksakademie, Amsterdam (1940–43), and later as an etcher under Hayter in Paris (from 1953). In 1954 he trained as a ceramicist at the Mazzotti works at Albisola. Self-taught as a painter, he started out painting naturalistic and Cubist works, but after co-founding → Cobra in 1948 he developed his own style, based in part on

children's drawings, with strongly contoured, rhythmic shapes and bright colors. After his time with Cobra, following major trips to Africa, South America, and Mexico in the 1950s, the sensitive poetry of his landscapes became more abstract. During this period he participated in the São Paulo and Venice → biennales, and in 1956 he was awarded the Guggenheim Prize for Holland. Since the late 1980s, his work has been dominated by large, majestic, strongly colored, ornamental shapes, evoking memories of Mexican or African art and featuring the recurring figure of a large bird. L.Sch.

Bibl.: Paquet, Corneille, 1988 · Cluny, Corneille, 1992

Cornell, Joseph. *1903 Nyack, New York, †1972 New York City. American sculptor. He studied at Phillips Academy, Andover, Mass. (1917–21), then worked as a salesman for the Whitman Textile Company (1921–30). He also worked as a textile designer for the Traphagan studio (1934–40). He was encouraged by → Ernst to create → assemblages, → collages, and picture boxes, which were exhibited for the first time in 1932 in the Levy Gallery in New York. Accepted by the Surrealists, he met Marcel → Duchamp. Throughout the 1930s he continued to develop his "shadow box" creations, which contained arrangements of photographs, illustrations, and small objects. As a result of his association with the Surrealists, he started to work with film and photography. A

major series of picture boxes created in the 1940s had birds as the central motif, which for Cornell symbolized the contemporary threat to freedom, thought, and imagination. In the mid-1950s he turned to collage and → frottage, using color prints from magazines and reproductions of pictures. He is widely regarded as a precursor of → Pop art. H.D.

Bibl.: Waldman, Cornell, 1977 · McShine, Cornell, 1981 · Cornell, 1992

Corrente. Group of Italian artists. Corrente took as its focus the → avant-garde publication *Corrente di vita giovanile* founded by Ernesto Treccani

Lovis Corinth, *The Large Martyrdom*, 1907, Oil on canvas, 251 x 190 cm, Museum Ostdeutsche Galerie, Regensburg

Corneille, *The Discovery of the Island*, 1965, Oil on canvas, 81 x 65 cm, Private Collection

Joseph Cornell, *A Dressing Room for Gilles*, 1939, Mixed media mounted in box construction, 38.7 x 24.1 x 7.6 cm, Richard L. Feigen & Co., Inc. New York

in Milan in 1938. The group had no particular unified approach to art, but was opposed to revivalist Italian art of the → Novecento, a return to classicism and the glorification of nationalism. Although the journal was banned in 1940, the group continued to exhibit and publish manifestoes. Members included Realists such as → Guttuso and Ennio Morlotti; Expressionists such as Renato Birolli and Bruno Cassinari, and abstract artists such as Lucio → Fontana and → Vedova, also in particular religious artists such as → Manzù. The group survived until 1943; many members were to have a retrospective influence on postwar Italian art.　L.Sch.

Bibl.: De Grada, Corrente, 1952 · Corrente, Milan, 1985

Cottingham, Robert. *1935 Brooklyn, New York. American painter, one of the foremost exponents of → Hyperrealism. Cottingham initially trained at the Pratt Institute, Brooklyn, and later moved to Newtown, CN. In 1964 he painted *Southland Hotel*, in which the central component was the showy sign. Since that time he has produced a great number of color woodcuts, large-scale prints (using all techniques), and paintings (*Busch's Jewelers,* 1974) along similar lines. Like → Estes and → Goings, his photo-based work recomposes the ephemeral world of American consumerism, but (like some → Demuth) concentrates on symbol, neon signs, trademarks, and slogans. These are treated in a highly representational yet sometimes textured manner, with some reflection effects and "telephoto" perspectives. In the late 1980s, a more abstract feel (*35 0,* 1986, etching) began to surface; in the 1990s the acrylic *Rolling Stock* series (some thickened with sand) approached a mechanistic aesthetic.　D.R.

Bibl.: Meisel, Photorealism, 1980 · Arthur, Realists, 1983 · Cottingham, Springfield, 1986

Covert, John. *1882 Pittsburgh, †1960 Pittsburgh. American artist. He studied at the Pittsburgh School of Design under M. Leiser (1901–07), the Kunstakademie, Munich, under C. von Marr (1910–12), and in Paris (1912–14). He returned to America in 1915 and joined the avant-garde circle (→ Dada) around Walter Arensberg in the following year. Influenced by → Picabia and Marcel → Duchamp, he created Cubist and geometric → collages and → assemblages that often incorporate word or number riddles. In 1916, together with Duchamp and Arensberg he established the → Society of Independent Artists in New York, where he exhibited. In 1923 he abandoned art to work as a businessman for a Pittsburgh steel company. Only a few of his works have survived (*Brass Band*, 1919).　L.Sch.

Bibl.: Klein, Covert, 1976 · Covert, Washington, 1979

Cragg, Tony. *1949 Liverpool. British sculptor living in Wuppertal, Germany. After working as a laboratory technician for the National Research Association (1966–68), he studied in Cheltenham (1969–70), Wimbledon (1970–73), and at the Royal College of Art, London (1973–77). His work was first exhibited in 1977. He took part in the 1982 and 1987 Documenta exhibitions, and the Venice Biennale in 1986 and 1993. In 1988 he

won the Turner Prize and was appointed professor at the Kunstakademie, Düsseldorf. He has been a member of the Royal Academy of Arts since 1994.

Cragg's first sculptures, which were transient works made out of simple materials, explored space and volume in the manner of → Land art. In the mid-1970s he began creating floor and wall works consisting of stacks or rows of small articles, frequently arranged to create a large object. At the beginning of the 1980s, he became known for his colored → assemblages of discarded plastic household items. He used these items of refuse to create icons that are imbued with an immanent criticism of civilization (*New Figuration*, 1985). He subsequently incorporated other materials and items to create surprising assemblages (*24 Hours Cycle*, 1985). His recent sculptures are covered with a sparkling skin of colored plastic chips or granules. This "disguise" led to his latest phase of biomorphic structures (*Generations*, 1988).　D.W.

Bibl.: Cragg, London, 1988

Craig-Martin, Michael. *1941 Dublin. Irish-born painter and conceptual artist. After early education in Washington D.C., Craig-Martin majored in painting at Yale; after 1966 he was mainly resident in London. One of Britain's foremost → Minimalists, his work in the 1960s concentrated on (less purist) variations of → Judd's cubes and shelves (*Assimilation,* 1971) and → Morris' glass orthogonals (*Four identical boxes with lids reversed,* 1969). Minimalist in form and → Conceptual in preoccupation, *Conviction* (1973) revolves around the conceit of a mirror reflecting the viewer. Artist statements often accompany such pieces. Later Conceptual works rely more on language and titling: *Oak Tree* (1973) was initially impounded by Australian customs as an illicit plant import – until it was realized that the title referred to a vessel of water on a glass shelf. In the 1980s, Craig-Martin produced large, linear, almost → Pop outlines of everyday objects on aluminum panel with colored steel rods.　D.R.

Bibl.: Craig-Martin, London, 1989

Cranbrook Academy of Art. Art school established in 1925 in Bloomfield Hills, Michigan, near Detroit, by newspaper baron George C. Booth and Finnish architect Eliel Saarinen (1873–1950), the major creative force behind the Cranbrook vision of art and pedagogy. It was the first art school in the US dedicated solely to graduate art studies and to emphasizing design as a field in its own right. It re-invigorated the ideas of the Arts &

Tony Cragg, *Als es wieder warm wurde*, 1985, Plastic-coated chipboard, wax crayon, cement pipe, plastic tube, 250 x 730 x 450 cm, Van der Heydt-Museum, Wuppertal

Crafts movement, specifically the integration of art with daily life. Its curriculum, which still emphasizes object-making, clarity of design, function, and art theory together with praxis, fostered technical and artistic innovation in all media. Its influence on postwar American architecture (Eero Saarinen), interior design (Charles Eames, Florence Knoll, Jack Lenor Larsen), sculpture (→ Milles, Harry Bertoia) and crafts (Maija Grotell, Harvey Littleton, Ed Rossbach, Toshiko Takaezu, Chunghi Choo) was extensive. In the 1980s, the design department became renowned for its experimental typographics (Katherine and Michael McCoy). J.C.M.

Bibl.: Cranbrook, New York, 1983

Cruz-Diez, Carlos. *1923 Caracas. Venezuelan artist. Lives in Paris and Caracas. He studied at the Escuela de Artes Plàsticas, Caracas (1940–45). In 1944 he became a graphic designer and between 1946 and 1951 he was director of an advertising agency. In 1947 he traveled to New York. Between 1953 and 1955 he lectured at the Escuela de Artes Plàsticas and worked as a magazine illustrator. In 1955 he moved to Barcelona. In 1957 he set up the Estudio de Artes Visualles. From 1958 to 1960 he was director of the Escuela de Artes Plàsticas in Caracas. In 1960 he moved to Paris.

Impressed by the work of → Soto, Cruz-Diez became interested in the optical effects of color. In 1959 he created his first Physichromies, which consist of strips of painted metal or plastic. As the viewer moves in front of them, the colors and images change and intensify. He has published a book on the theory of color, *Reflexion sobre el color* (Caracas, 1989). H.D.

Bibl.: Clay, Cruz-Diez, 1969

Cubism. Style of painting and sculpture, partially also of architecture, that began in Paris about 1907. Cubism was one of the most important avant-garde trends at the beginning of the 20th century. The term originated in Kahnweiler's gallery in 1908 during an exhibition of paintings by → Braque, when the art critic Louis Vauxcelles disparagingly described them as "small cubes." Influenced by → Cézanne, the principal exponents included → Picasso, Braque, → Léger, and → Derain. Their favored subjects were still lifes, landscapes and portraits; motifs were broken up into facets by means of stereometric forms and light and dark hues. The aim was to represent objects from a multiplicity of viewpoints.

There were two distinct phases of Cubism: Analytical Cubism (up to about 1912) and Synthetic Cubism (1912–14). In Analytical Cubism, objects were dissected into fragmented, facet-like components mainly in gray-blue hues (Picasso, *Seated Woman*, 1909). Synthetic Cubism did not take the object as the starting point for the picture, but rather constructed the object out of free forms and planes. In the course of 1912, Picasso and Braque added pieces of wallpaper, labels, and newspaper clippings to their work (→ collage) to reinforce the relationship with the object. From 1912 color was reintroduced. The splintered, hermetic forms were simplified, the multifaceted appearance of the object was enhanced, and realistic details were incorporated.

The Spanish painter → Gris, who had moved to Paris in 1906, combined these new methods in his paintings (*The Breakfast*, 1915). Late Cubism paved the way for → abstract art, with the picture being conceived as a largely autonomous arrangement (→ tableau-objet).

The influence of Cubism was not restricted to painting (→ Section d'Or, → Orphism), but also extended to sculpture and architecture in Europe. Picasso and Braque experimented with sculptural objects, relief collages, and wire sculptures. In 1911, → Archipenko started creating his "sculpto-paintings," in which forms project from a painted background. Following the works of Picasso and Braque, → Lipchitz, the most famous Cubist sculptor, made anthropomorphic sculptures with faceted surfaces and rhythmically contrasting curves and lines. In the space of less than ten years, Cubism had revolutionized European art. H.D.

Bibl.: Daix, Cubism, 1983 · Green, Cubism, 1987 · Golding, Cubism, 1988 · Rubin, Cubism, 1993 · Gleizes, Cubism, 1995

Cubo-Futurism. Term describing the particular blend of Cubist, Futurist, and primitive stylistic elements in Russian art, as exemplified in the work of → Malevich of 1912–13 who combined the futuristic representation of swift movement with a Cubist ordering of space (e. g. *Knife Grinder*, 1912). Malevich designed Cubo-Futuristic costumes and decorations for A. Krushenik's futuristic opera *Victory over the Sun* (1913). After 1915 this style was displaced by → Constructivist tendencies and eventually replaced by abstraction.

Cucchi, Enzo. *1949 Morro d'Alba (Marken). Self-taught Italian painter and sculptor. Lives in Ancona and Rome. In 1977 he had his first one-man exhibition in Milan and in 1979 took part in the fifteenth São Paulo Bienal. He took part in Documenta 7 (1982) and Documenta 8 (1987).

Enzo Cucchi became famous as a member of the → Transavantgarde and is today regarded as one of Italy's most outstanding painters. In his pictures and sculptures he conjures up ancient mythical worlds whose archaic force is set against the progressive destruction of culture. Constantly recurring motifs, such as elephants and fish, skulls and embryonic figures, houses, cliffs, the sea, ships, and carts, are used to transmit a wealth of often obscure associations. Cucchi's aim is to draw attention to the mythical primal force underlying his works. In order to strengthen the elemental force of his often large and irregularly shaped pictures, he incorporates

Cubism, Juan Gris, *Still Life (Violin and Inkwell)*, 1913, Oil on canvas, 89.5 x 60.5 cm, Kunstsammlung Nordrhein Westfalen, Düsseldorf

Enzo Cucchi, *Untitled*, 1984, Pencil on paper, 36 x 48 cm, Private Collection

ceramic, wood, and iron. He has an expressive style, with strong contrasts between light and dark, and between different colors. In addition to paintings and installations, Cucchi also draws small, simple pictures, often to accompany his own writings. Since 1982 he has also made sculptures, often in collaboration with other artists such as → Chia (*Lost Sculpture, Gray Sculpture*, 1982). His later installations were made of wood. Cucchi's work is essentially → Neo-Expressionist, but he has been strongly influenced by the work and charismatic personality of → Beuys. H.D.

Bibl.: Waldman, Cucchi, 1986 · Friedel, Cucchi, 1987 · Schulz-Hoffmann et. al., Cucchi, 1987

Enzo Cucchi, *In 1984 a thousand year journey through prehistory started*, 1984, Oil on canvas with lamp, 135 x 800 cm, Galerie Bruno Bischofberger, Zurich

Cuevas, José Luis. *1934 Mexico City. Self-taught Mexican artist living in New York, Paris, and Mexico City. Since 1947 he has worked primarily as an illustrator for Mexican magazines, but he has also produced illustrations for works by Kafka (*Kafka's World* and *Cuevas*, 1957). In 1960 he established the Nueva Presencia group of artists, who were opposed to the propagandist nature of → muralism and demanded greater artistic freedom. He has published illustrated books and series of graphics, and has also designed theater costumes and sets. He was awarded the Premio Nacional de Bellas Artes, Mexico, in 1981. H.D.

Bibl.: Cuevas, Cologne, 1978 · Tasende, Cuevas, 1991

Cunningham, Imogen. *1883 Portland, Oregon, †1976 San Francisco. American photographer. After university, a photography apprenticeship in Seattle, and a scholarship in Dresden, Cunningham set up her own studio in Seattle in 1910. In 1917, after causing a scandal with nude pictures of her husband, she fled to San Francisco. A founding member of the f/64 group (1932), Cunningham has been called the "innovator of West Coast photography." She took close-ups of plants and animals – zebras, snakeskins, magnolias, and callas flowers – that had never been seen before. She favored clean, sharply focused images and experimented with lighting. Her portraits reveal a fascinating interplay between people and their surroundings. She photographed for *Vanity Fair* and was hugely successful at the Stuttgart trade exhibition "Film and Photo" (1929). L. Sch.

Bibl.: Dater, 1979 · Lorenz, 1987

Curry, John Steuart. *1897 Dunavant, Kansas, †1946 Madison, Wisconsin. American painter and printmaker. Along with Grant → Wood from Iowa and T.H. → Benton of Missouri, John Steuart Curry was a central figure of the Midwestern school of → Regionalism that gained national prominence during the Depression era. Ironically, Curry's best known pictures of Middle America were painted from memory while he resided in the fashionable art colony of Westport, Connecticut. Curry trained at the Kansas Art Institute and the Art Institute of Chicago in the late teens prior to working as a magazine illustrator in New York during the early 1920s. He moved to Westport in 1924, and in 1926 enrolled in Basil Schoukhaiff's Russian Academy in Paris, where he also studied Old Master paintings at the Louvre. Curry would later combine Baroque compositions with Midwestern subjects to create his quintessential Regionalist paintings, such as the Claudian *Wisconsin Landscape* (1939). Returning to Westport in 1927, Curry embarked on a prolific period, creating theatrical scenes of Kansas ranging from the fervent fudamentalism of *Baptism in Kansas* (1928), to the awesome and sublime forces of nature in *Tornado* (1929) and *The Line Storm* (1934). While achieving national acclaim as the "Homer of Kansas" (New York Times), Curry was perceived as a harsh critic of the Midwest in his own state.

Curry returned to the Midwest in 1936, accepting the position of the first artist-in-residence of the University of Wisconsin, Madison. In 1937, he began work on his epic mural cycle for the Kansas Statehouse, Topeka. Curry's iconic, Michelangelesque figure of John Brown in *Tragic Prelude* alludes to the coming world war, and endures as one of the most compelling images of American art from the first half of the century. B.R.

Bibl.: Schmeckebier, Curry, 1943 · Kendall, Curry, 1986 · Junker, Curry, 1988

Dada. Meaningless name, first used in Zürich in 1916. Its main center of activity was the → Cabaret Voltaire set up by → Balla, → Tzara, et al. It became the *nom de guerre* of an international "anti-art" movement that, shocked by World

War I, questioned rationalism, traditional values, and the culture of the 19th century. The movement first manifested itself in 1914 in Zürich and New York, spreading rapidly after 1917 due to keen exchanges between its main centers: Zürich (1914–18), New York (1915–21), Barcelona (1916–20), Berlin (1917–22), Cologne (1919–22), and Paris (1917–22). Despite a shared rejection of accepted ideas, different strategies and results arose: in New York M. → Duchamp and → Man Ray worked on → ready-mades, → objects, and photography, and → Picabia with works that emphasized the mechanization of the art world and the crisis of the mimetic, whereas Zürich Dada centered on the rejection of aesthetic rules, the utilization of chance, (particularly manifested in concert soirées featuring the simultaneous sound association of spoken verse and noise) or in the mounted wood reliefs of → Arp. Tzara and Picabia encouraged Dada in Paris, which gave rise to the → Surrealist movement surrounding → Breton. In 1917 Hülsenbeck brought Dada to Berlin, and in 1918 Club Dada was formed, which soon became a more politicized movement, with → Hausmann, → Höch,

→ Baader, → Grosz, and → Heartfield. For a short time Dada activities also took place in Cologne (→ Ernst, → Baargeld), Dresden (→ Dix), Bucharest, Zagreb, the Netherlands (van → Doesburg), Belgium, and South America. In Hanover → Schwitters created his version of Dadaism through his → Merz constructions.

Dada's destruction of cultural conventions and anti-art rhetoric, achieved by means of provocation, shock, irony, and satire, also released immense creativity: ambiguous and playful experiments with unusual means and forms of expression, including trivia and calculated dilettantism. Following Cubism and Futurism, anything was suitable as subject matter. A passion for machines, simultaneity, and the pathos of everyday life were harnessed to create a new identity for art and life. The resulting nontraditional forms included free typography, → collage and → photomontage, objects and → assemblages. Magazines, manifestos, exhibitions, and provocative public appearances by the artists spread the movement's ideas. Dada provided the inspiration for many artists in the 1950s and 1960s (→ Neo-Dada, → Pop art). H.O.

Bibl.: Richter, Dada, 1961 · Schippers, Dada, 1974 · Reynolds Morse, Dada, 1975 · Bollinger/Magnaguagno/Meyer, Dada, 1985 · Naumann, Dada, 1994

Dalí, Salvador. *1904 Figueras, Catalonia, †1989 Figueras, Catalonia. Spanish painter, film maker, and writer. He studied at the Academy of Fine Arts, Madrid, from 1922 to 1926. Dalí's Surrealist adventures began in 1929 when he painted his first Surrealist picture (*The Lugubrious Game*). Becoming accepted by the Surrealist group around → Miró he held his first one-man exhibition in Paris in 1931, followed by New York in 1933. He fled to New York with his wife Gala in 1940 and stayed there until 1948. His first major retrospective was held in 1942. Dalí and his Gala returned to Spain in 1948, moving into a house in Port Lligat. A Dalí museum in Figueras opened in 1972.

Dalí's pictures are influenced by de → Chirico, → Ernst, Miró, and → Tanguy, but he also drew inspiration from Arcimboldo, Bracelli, and Gaudí. These influences are combined in a highly provocative pictorial language that links elements of dreams and the subconscious in deceptively realistically painted metaphors (*The Persistence of Memory*, 1931). He also collaborated with Luis Buñuel on experimental films, such as *Un Chien andalou* (1929) and *L'Âge d'or* (1931). A theoretical explanation of his "paranoiac-critical method" followed in 1935 in *La Femme invisible*. Dalí also turned to historical examples for inspiration, to Raphael and Piero di Cosimo as well as to Jean-François Millet's famous *Angelus*, which he incorporated in numerous quotations and variations (*Gala and the Angelus of Millet*, 1933). In early 1934 he became distanced from the Surrealist group because of his supposed fascistic tendencies. That same year, the bookstore Les Quatre Chemins displayed his 42 etchings and 30 drawings on the subject of "Les Chants de Maldoror" (after Lautréamont). In the 1940s, religious pictures revealed a break from the aggressive Surrealism of the 1930s and a commitment to the Catholic church (*The Madonna of Port Lligat*,

◄ Walter De Maria, *Lightning Field*, 1973–77, 400 stainless steel poles in the desert near Quemado, New Mexico, each diameter 5 cm, height 629 cm; arranged in a one mile by one kilometer grid, Dia Center for The Arts, New York (see p. 96)

Dada, George Grosz and John Heartfield at the Berlin Dada Exhibition with Tatlin Poster, 1920, Kunsthaus Zürich

Salvador Dalí, *The Enigma of Desire/My Mother, My Mother, My Mother*, 1929, Oil on canvas, 110 x 150 cm, Oskar Schlag Collection, Zürich

Salvador Dalí, *The Birth of the Liquid Desires*, 1932, Oil on canvas, 95 x 112 cm, Guggenheim Collection, Venice

1948). However, Dalí was also interested in recent scientific discoveries and wrote a *Mystical manifesto* on "nuclear mysticism" and "atomic art". In his pictures of this time, he combined theories on atomic physics with the Catholic mysticism of his home (*Assumpta antiprotonica*, 1956). From 1958, in a search for new effects and new ways of confusing the senses, Dalí turned increasingly to → Op art, → Art Informel and → Pop art creating huge, consistently remarkable pictures (*Gala in the Dream of Christopher Columbus*, 1958). The last years of his life were overshadowed by illness, depression, and accidents, and after Gala's death in 1982 he withdrew completely from the outside world. H.D.

Bibl.: Reynolds Morse, Dalí, 1974 · Descharnes, Dalí, 1985 · Descharnes, Dalí, 1993 · Ades, Dalí, 1995 · Radford, Dalí, 1997

Damisch, Gunter. *1958 Steyr, Upper Austria. Austrian painter and graphic artist living in Vienna. In 1978–83 he attended the Akademie der Bildenden Künste, Vienna. From 1998 he has been professor at the Vienna Kunstakademie. He has been awarded numerous prizes, including in 1995 the prize of the City of Vienna. Damisch normally works his paintings on the floor. Foreground and background are clearly defined, and the landscapes are criss-crossed with tracks like cut-out sheets of paper. Out of dense layers of paint amoeba-like, star-shaped formations crystallize as if out of a macro- or microcosm. Human contours become visible and, like the abstract forms, create independent elements. Damish's style is far removed from naturalistic realism but expresses his "innermost visions" (Novalis). In his most recent works the decorative sequences of dots and micro-organisms spread across the entire picture plane (*Red Field Cascades*, 1997–98). Besides drawings, lithographs, and etchings Damisch also creates bronze reliefs (*Blue Wall with Slits*, 1998). H.D.

Bibl.: Damisch, Essen, 1991

Darboven, Hanne. *1941 Munich. German Conceptual artist, living in Hamburg, who also studied at the Hochschule für Bildende Künste in Hamburg. She subsequently moved to New York (1966–68), where she was in close contact with → LeWitt. Her first retrospective was held in 1971 at the Westfälisches Kunstverein in Munster. She participated in major → Conceptual art exhibitions and at Documentas 5, 6, and 7. She represented Germany at the Biennale in Venice in 1982 and was awarded the Edwin Scharff Prize by the City of Hamburg in 1986.

Since the late 1960s, Darboven has worked mainly on the visualization of periods of time, to which end she has developed her own system of symbols. She uses number codes, texts, photos, and diagrams, usually worked on ordinary typewriter paper to record periods of time or historical events. The spatial expansion that is achieved by the way she hangs the sheets on the wall also allows the viewer to experience the temporal dimension of her work. Her intention is to allow the viewer to perceive the subconscious movement of time and the constant flow of information that surrounds us, while also reflecting the limits of human awareness in our perception of time and history. P.D.

Bibl.: Darboven, 1990 · Burgbacher-Krupka, 1994

Dau al Set. Dau al Set (the "seven-spotted" or "seven-sided die") was a Catalonian group of visual artists and writers active in Barcelona (1948–56), and set up by the poet Joan Brossa, the philosopher Arnaldo Puig, artists Modesto Cuixart (1925–), Joan Ponç (1927–84), → Tàpies and Joan Josep Tharrats (1918–). In their opposition to the academy and state art, the group demanded a new Catalan art that, in a similar way to → Surrealism, would be drawn from the subconscious, the imagination, and magic. The

Hanne Darboven, *Wende '80'*, 1980–81 (detail), Offset and 11 photo records, 416 pages, each 41 x 29.5 cm, Leo Castelli Gallery, New York

magazine of the same name appeared in Catalan, Spanish, and French, and contained articles on philosophy, anthropology, and ethnology, as well as art and literature. Also represented (in addition to the members) were Jorge Oteiza (1908–), → Saura, and others. L.Sch.

Bibl.: Cirlot, Dau al Set, 1986

Davie, Alan. *1920 Grangemouth, Scotland. Scottish-born artist who now divides his time between Cornwall (southwest England) and the Caribbean. Davie studied at Edinburgh College of Art from 1937 to 1940, then at the Royal Scottish Academy. His professions included that of master goldsmith, art lecturer, and jazz musician. Widely traveled he has drawn inspiration from sources as diverse as Zen Buddhism and Pre-Colombian art; paintings from → Pollock's totemistic stage have also been highly influential. Davie combines the mythical and the modern in a visual world of associative, hallucinatory, spontaneously written, or dripped signs (→ drip painting), in later works adding hieroglyphics and figures from ancient cultures. Thus he creates a magical pictorial world that conjures up the power of nature, religion, demoniacal possession, Eros and death, but at the same time the pleasures of music. Davie is regarded as one of the most influential British abstract artists of the 1950s. L.Sch.

Bibl.: Davie, Aberdeen, 1977 · Tucker, Davie, 1994

Davies, Arthur B(owen). *1862 Utica, New York, †1928 Florence. American painter. After training as an architectural draftsman, Davies attended the Arts Students League in New York. Early landscapes were followed by a dreamlike → Symbolist period (1895–1905) in the style of Albert P. Ryder (1847–1917); other influences included Giorgione, Pierre Puvis de Chavannes (1824–98), Ferdinand Holder (1853–1918), and Arnold Böcklin (1827–1901). His 20th-century works turned to a more classicizing, narrative tradition. Davies was an advocate, though not always a practitioner, of modernism (his work was included in 1908 by Robert → Henri in The → Eight's exhibition). His → Synchromist works (*Figures Synchromy*, 1913) fuse colours in the style of → Russell within Arcadian compositions; → "Cubo-Futurist" works followed after the → Armory Show (*Day of Good Fortune*, 1916). Davies later dabbled in theories of the *pneuma*, supposed to recapture the lost essence of Greek inspiration. Though early "Unicorn" paintings remained popular, his posthumous reputation suffered from his devotion to "beauty" and eclectic style. D.R.

Bibl.: Cortissoz, Davies, 1931 · Perlman, Davies, 1998

Davis, Stuart. *1894 Philadelphia, †1964 New York. American painter. His *Lucky Strike Pictures*, painted in the early 1920s, appear to be the surprising precursors of → Pop art. Davis was one of the first artists to make everyday objects – from bottles of Odol mouthwash to egg beaters – picturesque, although this was only one phase of a highly complex career. In 1913 he exhibited at the → Armory Show a number of his works in the realistic style of the → Ashcan School. Impressed

at the show by the works by → Braque, → Picasso, and → Léger, he began experimenting with Cubism. As well as pictures of everyday objects and city scenes (after a stay in Paris in 1928–29) he created rhythmic compositions in bright colors, punctuated with metropolitan signs such as advertising hoardings and neon illumintions. In the 1930s he spoke up in support of abstract art, which at the time was frowned upon by a group of leftist artists, to which he belonged. Davis' own move toward abstraction resulted in large-scale, elegant, and decoratively colored compositions, in the style of late Cubism. He became famous in Europe as the result of his solo exhibition at the 1952 Venice Biennale. L.Sch.

Bibl.: Wilkin, Davis, 1987 · Davis, New York, 1991

Davringhausen, Heinrich Maria. *1894 Aachen, †1970 Cagnes-sur-Mer. German artist working in the → Neue Sachlichkeit manner. He studied at the Kunstakademie in Düsseldorf (1913–14); and took part in a group exhibition at the Flechtheim gallery in 1914. That same year he met Carlo Mense in Ascona, and struck up a friendship with → Schrimpf. He moved to Berlin in 1915, meeting → Grosz, → Heartfield, and → Meidner. His first solo exhibition was held at the Galerie Goltz in Munich in 1919; at this time he met → Kanoldt. He participated in the 1925 Neue Sachlichkeit exhibition in Mannheim. Davringhausen moved to Majorca in 1933, and then to the South of France. During the Nazi regime 200 of his works were removed from German museums and branded "degenerate", and he was banned from painting and exhibiting. During the war he was interned in Cagnes-sur-Mer (1939–40) but escaped; he returned in 1945, and his work was rehabilitated in numerous exhibitions. His early portraits, expressing socio-critical accusations, were influenced by → Dix and Grosz. In the 1920s, Davringhausen's work turned towards → Magic Realism. G.P.

Bibl.: Eimert, 1995

De Andrea, John. *1941 Denver, Colorado. American sculptor living in Denver. He took his B.F.A. at the University of Colorado, Boulder, from 1961 to 1965, and was assistant at the University of New Mexico in Albuquerque from 1966 to 1968. Since 1970 he has participated in numerous exhibitions, becoming widely known in Europe after exhibiting at Documentas 5 (1972) and 7 (1982).

One of the main representatives of → Hyper-realism in sculpture, De Andrea's work presents the human body nude and in life size. He differs from → Hanson, who locates his figures in a social context by affording them clothing and accessories, in that his figures are totally nude. Working in polyvinyl (PVC), De Andrea casts individual body parts, joins them and paints them so that they look completely natural; the figure is then given hair. While the artificiality of his figures is evident in earlier works, he has continued to perfect his craft so as to create the most convincing illusion possible. Thus his work combines the classical ideals of antiquity with the realism of the present. D.S.

Bibl.: Yveline, De Andrea, 1982 · Bush, De Andrea, 1993

De Domenicis, Gino. *1947 Ancona, †1998 Rome. Italian painter and performance artist. Following the metaphysical tradition in Italian art De Domenicis's work focused on themes of immortality, invisibility, and constancy. He demonstrated these in his exhibitions of "invisible things" of the 1960s and 1970s in Rome, creating in particular an *Invisible Statue* consisting of shoes with a straw hat floating above. In his performance art people seemed to disappear, or he "materialized" signs of the zodiac into live bulls and lions. His 1972 installation at the Venice Biennale, using a Downs' syndrome boy caused controversy. He sought to keep his personal life a mystery to the extent of creating an advertizing poster announcing his own death. L.Sch.

Bibl.: Celant, 1980

De Maria, Walter. *1935 Albany, California. American sculptor and composer living in New York. He studied history and art at the University of California, Berkeley, (1953–59). Moving to New York in 1960, he came into contact with → Morris, the dancer Yvonne Rainer, and the composer La Monte Young. His early sculptures from the beginning of the 1960s were influenced by → Dada and other modern art movements; he then turned increasingly to simple geometric shapes and industrially manufactured materials, e.g. stainless steel and aluminum – materials which became characteristic of → Minimal art. In the mid-1960s he became involved in a wide range of artistic activities. He appeared at → happenings, composed two musicals (*Cricket Music*, 1964; *Ocean Music*, 1968), produced two films (*Three Circles and Two Lines in the Desert*; *Hard Core*, both 1969) and was, for a short time, drummer in the New York rock group The Velvet Underground. From 1968 he produced Minimalist sculptures and → Installations (such as the Munich *Erdraum* of 1968, or in 1987 the *5 Continents Sculpture* in the Staatsgalerie Stuttgart). He also realized → Land art projects in the deserts of the southwest US (from the mid-1960s), with the aim of creating situations where the landscape and nature, light and weather would become an intense, physical and psychic experience.

De Maria's best-known work, *Lightning Field* (1973–77), consists of 400 stainless steel posts (each approx. 6 m high) arranged in a carefully calculated grid over an area of 1.5 x 1 km. The optical effects change with the time and the weather, and it lights up briefly during thunder storms. The *Vertical Earth Kilometer* (Documenta 6, 1977), a 1-km-long brass rod buried in the square outside the Fridericianum in Kassel, attracted much attention. After De Maria, the notion of the work of art which blends invisibly into the environment is intended to make the viewer think about the earth and its relationship to the universe. De Maria is considered a pioneer in the development of Minimal art, → Conceptual art, and Land art. I.N.

Bibl.: Cooper, De Maria, 1985 · De Maria, New York, 1986 · De Maria, New York, 1992

Deacon, Richard. *1949 Bangor, Wales. British sculptor living in London. He studied at St Martin's School of Art (1969–72), the Royal College of Art (1974–77), and Chelsea School of Art (1977–78). In New York (1978–79) he came into close contact with → Minimal art and → Conceptual art, both of which were influential. Spirituality and sensual materiality meet in his work, which combines classical severity with great beauty and experimental openness. His sculptures, often in forms that recall shells, baskets, eggs, or horseshoes, are characterized by their meandering curved lines, bands, and beading. They frequently allude to the eye, heart, hand, or ear, and have subtle erotic implications. The metaphorical nature of his work is often revealed by the titles, e.g. *Tall Tree in the Ear*, *The Eye Has It* or *The Heart's in the Right Place*. Deacon uses a wide range of materials, from marble, wood, steel, stones, leather, and cloth to screws, linoleum, and plastic – even items found on waste-ground. The sensitive relationship between the inside and the outside that is fundamental to all his work is especially effective in *Blind, Deaf and Dumb*

Walter De Maria, *The Vertical Earth Kilometer*, 1977 (detail), Brass rod, buried, length 1 km, Documenta 6, Kassel

(Serpentine Gallery, London, 1985), where the outer steel and zinc form corresponds with the inner wooden shape. His sculptures in parks, between skyscrapers and outside museums in the UK, the USA, and Germany are largely in keeping with the landscape or place of installation. L.Sch.

Bibl.: Tazzi, Deacon, 1995 · Gillick, Deacon, 1999

Deakin, John. *1912 Babington, Cheshire, †1972 Brighton, Sussex. British photographer. He was involved in painting and sculpture before turning to photography in Paris in 1939. He was most prominent during the 1950s when he worked on British *Vogue*. His portraits during this period suggest an intimate closeness, e. g. of → Bacon, his friends and models (Bacon later painted portraits from these pictures) and media stars (e. g. Maria Callas and Yves Montand). In his photographic books, *Rome Alive* and *London Today*, he sought to reveal the truth behind the city rather than reflect its public face. L.Sch.

Bibl.: Deakin, 1996

decalcomania. → Ernst

décollage. An artistic technique and style, developed from and counter to → collage, that belongs to the wider field of → Nouveau Réalisme. In its specific sense the term refers to the pictures created from torn posters (*papiers déchirés*) by → Dufrêne, Raymond Hains (1926–), Jacques de la Villeglé (1926–), → Rotella, and → Vostell after 1957. Although aesthetically closely linked to → Abstract Expressionism, in terms of content these works are directly opposed to it, in that they directly refer to materials and reality. In a wider sense, the term is also used to refer to the principle of destructive change: tearing, burning, erasing, smearing, or painting over something, or pressing together the basic materials in an artwork, as practiced by → Rainer, Alberto → Burri, → César, → Rauschenberg, and many other artists. The action itself plays an important part, which, removed from the object that is being created, can also be a "décollage happening." R.S.

Bibl.: Weschner, Collage, 1968 · Waldman, Collage, 1992

Degas, Edgar. → precursors

Dekkers, Ad(naan). *1938 Nieuwpoort, †1974 Gorcum. Dutch sculptor. After studying in the Deptartment of Commercial Design in the Academie voor Beeldende Kunsten (1954–58), Rotterdam, he showed simple or geometric wooden wall reliefs similar to → Arp, initially in both monochrome and color. Abandoning color in the mid-1960s, his compositions became increasingly linear as he returned to the formative influence of → Mondrian. Exhibition-orientated, his work relies on lighting and texture (some later designs are incised into wooden panels). He is well known for his synthetic (mostly polyester) wall reliefs of the later 1960s which had affinities with → Minimalism. Not long before he died he provided designs for a large-scale relief for two walls of the Kröller-Müller Museum, Otterlo. In his final years Dekkers suffered increasingly from mental distress. D.R.

Bibl.: Blotkamp, Dekkers, 1981 · Dekkers, Amsterdam, 1998

Delaunay, Robert. *1885 Paris, †1941 Montpellier. French painter. He was apprenticed in theater design (1902–03), and participated in the → Blaue Reiter exhibitions (1912–13), and at the Erste Deutsche Herbstsalon (together with → Delaunay-Terk). He lived in Spain and Portugal (1914–1920). In 1921 he exhibited at the → Sturm Gallery in Berlin (with Sonia Delaunay), and the following year held a one-man exhibition at the Galerie Guillaume, Paris. He later decorated the Rail and Aviation Pavilion for the 1937 Exposition Universelle in Paris. Delaunay's early paintings were in the Impressionist and → Fauvist style. In 1909 he began a series of pictures of the Church of Saint-Séverin, an interpretation of the choir painted in expressively broken shapes to convey the active experience of sight. The Eiffel Tower is a recurring theme, featuring in much work between 1909 and 1911, and 1924 and 1930. In the first series the tower is split and divided into fields of color in the → Cubist style; in the second it rises up monumentally, an unmistakeable symbol of modern art. At the same time, Delaunay was developing his series of "city pictures," based on a postcard depicting the rooftops of Paris (*Les Villes*, 1909–11). In his series of "window pictures" (*Les Fenêtres*, 1912–13) and "circles" (*Formes circulaires*, from 1913), Delaunay moved on to "pure painting." These non-representational works, in which colors are arranged in geometric or circular patterns, greatly influenced the development of European art (→ Orphism). The juxtaposed colors appear to vibrate brightly in constant interaction – for Delaunay this was also a visual model of cosmic energy. In the 1920s he worked with his wife Sonia on projects for the Ballets Russes, for → Dada plays by → Tzara and on films by Marcel Herbier and René Le Somptier. He did not resume painting until 1930, when he began work on a series of abstract pictures (*Rhythm without End*, 1933), which were to inspire a number of successive directions in art (→ geometric abstraction, → Op art). H.D.

Bibl.: Delaunay, Paris, 1967–68 · Vriesen/Imdahl, Delaunay, 1969 · Cohen, Delaunay, 1978 · Buckberrough, Robert Delaunay, 1982 · Delaunay, Paris, 1987 · Delaunay, Paris, 1999

Robert Delaunay, *Fenêtres simultanées*, 1912, Oil on canvas and wood (painted frame), 46 x 40 cm, Kunsthalle, Hamburg

Delaunay-Terk, Sonia (Sofia Ilinitchna). *1885 Gradzinsk, Ukraine, †1979 Paris. Russian-born painter and graphic and textile designer. She studied at the Kunstakademie in Karlsruhe (1903–05), and moved to Paris in 1905. She married art dealer Wilhelm Uhde in 1908; and Robert → Delaunay in 1910; they spent the years 1914–20 in Spain and Portugal. In 1918 she produced stage and costume designs for Diaghilev's ballet *Cléopâtre*, and in 1926 opened her Boutique simultanée in Paris. In 1930 she joined the group → Abstraction-Création (with Robert Delaunay). In 1937 she created fittings and murals for the Rail and Aviation Pavilion at the Exposition Universelle in Paris. She was awarded the Légion d'honneur in 1975. She donated her graphic works to the Centre Pompidou, Paris, in 1976.

Sonia Terk worked in the → Fauvist style until she met Delaunay. The two artists had an unusually productive and mutually supportive relationship. Both were interested in color and light, which inspired Delaunay-Terk to produce large-scale, abstract pictures featuring simultaneous color contrasts (*Bal Bullier*, 1913). She discovered the "principle of simultaneity" before the war, employing it in designs for clothing, in appliqués for lamps and lightshades, bedspreads, and chests, as well as in book designs (*Le Prose du Transsibérien*, 1913). She resumed abstract work in 1930. Delaunay-Terk created a large number of abstract paintings and lithographs, as well as designs for tapestries, mosaics, costumes, textiles, scarves, tableware, tablecloths, and playing cards. She is regarded as an important abstract painter and precursor of → geometric abstraction. H.D.

Bibl.: Delaunay, Paris, 1967–68 · Delaunay, Paris, 1987 · Baron, Delaunay S., 1995

Delvaux, Paul. *1897 Antheit-les-Huy, †1994 Furnes. Belgian painter and printmaker. He studied architecture from 1917, and painting from 1920 to 1924 (under Constant Montalds) at the Académie des Beaux-Arts, Brussels, where he was also professor of painting during the 1950s. He was initially influenced by Belgian Expressionism (→ Permeke, Gustave de Smet [1877–1943], and → Ensor) (works destroyed). In 1932, impressed by the artistic and absurd world of the fairground and of the waxworks museum (Musée Spitzner), Delvaux began to develop a style close to → Surrealism, → Pittura Metafisica, de → Chirico and → Magritte. Although he was never officially a member of the Surrealists, he took part in their Paris exhibition in 1938, and the Surrealist exhibition held in Mexico in 1940. His personal pictorial language was in place by 1936: detailed, highly realistic draftsmanship and cool coloring undermine the visible reality with distortion, and bizarre compositions under a mysterious, dreamlike light. His few recurring themes include statue-like figures, usually nudes in conjunction with clothed women, moving though unreal, architectural scenes in deep perspectives; large, open areas; classical buildings, gloomy railway stations; barren, deserted landscapes, sometimes with skeletons. Mysterious and disturbingly enigmatic, and suggestive of a detached purity, Delvaux's women are objects of a melancholic, passive eroticism (*The Pink Ribbons*,

1937). The solipsistically lonely world of the men in his pictures of scholars (*The Astronomers*, 1961) is similarly without anchorage, and depressing in tone. Delvaux also created lithographs, etchings, and murals. K.S.-D.

Bibl.: Terrasse, Delvaux, 1972 · Butor/Clair/Houbart-Wilkin, Delvaux, 1975 · Jacob, Delvaux, 1976 · Scott, Delvaux, 1992 · Delvaux, Huy, 1997

Demuth, Charles. *1883 Lancaster, Pennsylvania, †1935 Lancaster, Pennsylvania. American painter. He studied at Pennsylvania Academy, Philadelphia, (1905–11). He visited Paris in 1912–14, meeting Ezra Pound and Gertrude Stein. In New York he associated with the → Stieglitz circle. In 1916–17 together with → Hartley, he worked in a → Cubist-influenced manner concentrating on architectural motifs. His expressionist and symbolistically oriented representations of everyday and literary motifs were replaced in 1921 by works in a → Precisionist style. His industrial pictures of Lancaster, constructed geometrically from light panels, hinted at a sacred aura. Demuth pioneered the notion of incorporating advertising texts into paintings. His "poster portraits" (e. g. *I Saw the Figure Five in Gold*, 1928) combined the name of the study with a favorite object, and were compositions of often urbane elegance. L.Sch.

Bibl.: Fahlman, Demuth, 1983 · Haskell, Demuth, 1987

Denis, Maurice. *1870 Granville, Manche, †1943 Saint-Germain-en-Laye. French painter, graphic designer, and art theorist. He studied at the Académie Julian, Paris, in 1888, and was cofounder of the → Nabis (with → Bernard, → Bonnard, Paul Ranson [1864–1901], → Roussel, → Sérusier, → Vuillard, and others). As the head of the Nabis, Denis organized the group's first exhibitions at the Château de Saint-Germain and also wrote numerous theoretical works (*Théories*, 1890–1910; *Nouvelles Théories*, 1922). His pictures manifest a decorative juxtaposition of area and color (*The Muses*, 1893). The flowing lines, delicate colors, and simplified forms look forward to

Paul Delvaux, *The Pink Ribbons*, 1937, Oil on canvas, 121.5 x 160 cm, Koninklijk Museum vor Schoone Kunsten, Antwerp

→ Art Nouveau. Denis studied the Italian Early Renaissance (especially Fra Angelico), which formed the inspiration for his religious paintings (*The Easter Mystery*, 1891). In 1899 Denis created his first religious decorations, for the chapel of the Collège Sainte-Croix, and a commission for the Church of Sainte-Marguerite followed in 1901–03. In 1919 he and George Desvallières set up the Ateliers d'Art Sacré, and he continued to teach there and at the Académie Ranson. In addition to his paintings, murals, and decorations, he illustrated books and produced graphics, stained-glass windows, and decorative art. H.D.

Bibl.: Cailler, Denis, 1968 · Denis, Zürich, 1972 · Bouillon, Denis, 1993 · Frèches-Thory/Perucchi-Petri, Nabis, 1993

Depero, Fortunato. *1892 Fondo, Trento, †1960 Rovereto, Trento. Italian painter, sculptor, and poet. He studied at the Kunstakademie, Vienna, producing his first works in 1907. His book *Spezzature-Impressioni-Signi e Ritmi* was published in 1913, and from 1914 he participated in Futurist exhibitions. He moved to Rovereto in 1919 and established the Casa d'Arte. From 1920 to 1928 he produced interior designs for museums, theaters, and large-scale events. He was in New York from 1928 to 1930, and signed the *Manifesto dell'Aeropittura* in 1929. Depero was the publisher of *Dinamismo Futurista* magazine in 1933. The Museo Depero opened in Rovereto in 1957.

In 1914, after producing early works that were marked by → Symbolism, Depero became the main exponent of second-generation → Futurism. Together with → Balla he designed *Complessi Plastici*, abstract sculptures made in a variety of materials, followed by mechanically operated sculptures. In his paintings, Depero represented dance with puppet-like forms and figures made up of various geometric elements (*Rotation of Ballerina with Parrots*, 1917–18). In his *Balli plastici* of 1918, Depero transposed a painted world of make-believe into the theater, with stylized marionettes dancing to the music of Casella or Bartók. Depero's preference for applied art can be seen in his numerous designs for interiors and clothes, and his commercial art, e.g. his 1930s drawings advertising Campari. H.D.

Bibl.: Passamani, Depero, 1981 · Scudiero/Liber, Depero, 1981

Derain, André. *1880 Chatou, near Paris, †1954 Near Garches. French painter and graphic designer. He took painting lessons with Camille Corot from 1895 to 1898 and subsequently attended the Académie Carrière in Paris (1898–1901). In 1904–05 he studied at the Académie Julian in Paris. He served in the army from 1914 to 1918. In 1919 he produced theater designs and costumes for Diaghilev's *La Boutique Fantastique*, followed by further commissions for ballet and opera designs. He settled in Chambourcy in 1935; a retrospective was held at the Kunsthalle Berne; also in the Petit Palais, Paris in 1937. After completing his military service in 1904, Derain devoted himself entirely to painting. His → Fauvist landscapes and urban paintings created in London and Collioure are vibrantly colored with a free, gestural brushwork. Shapes are highly simplified with black contours (*London Bridge*, 1906). As a result of his acquain-

André Derain, *The Bridge at Southwark*, 1905–06, Oil on canvas, 81 x 100 cm, Private Collection

tance with → Picasso and discovery of African sculptures, this highly colored painting style was replaced by a more formal composition using Cubist structures (*Château Cagnes*, 1910). Objects and figures became more simplified and condensed after 1912, resulting in paintings which are more idiosyncratic and delineated (his so-called "période gothique"; *The Last Supper*, 1913). Derain's art took on more and more → Neo-Classicist tendencies, although such pictorial contrasts were less marked in his later works. Numerous commissions for stage sets and costumes for operas and ballets brought Derain public acclaim as did his numerous illustrations, e.g. for Apollinaire, Ovid (1938), and Rabelais' *Pantagruel* (1942). H.D.

Bibl.: Cabanne, Derain, 1990 · Hoog, Derain, 1991 · Kellermann, Derain, 1992–96 · Pagé, Derain, 1994

Deschamps, Gérard. *1937 Lyon. French sculptor living in La Châtre, Indre. Since the 1950s he has preferred to work with textiles (chiffon, fabric), incorporating their substance, coloring, and structure into his "Collages et Plissages" to create a new repertoire of shapes from everyday found objects. Deschamps joined the → Nouveau Réalisme movement in 1962. K. S.-D.

Bibl.: Deschamps, Paris, 1991

Deutscher Werkbund. Association established in Munich in 1907 by architects, artists, and engineers with the aim of promoting the modernization of architecture, craft, and industrial design. The organization had its roots in the international reform movement of the 1880s which had set itself against eclecticism and historicism. The third craft exhibition staged in Dresden in 1906 promoted the idea of combining the arts and crafts, and Hermann Muthesius, Karl Schmidt, and Friedrich Naumann were the driving forces. Such designs that suited both the ultimate objective and the materials being used gave less importance to the individual object, but rather served high-quality mass production; the aim was that this would also result in an education of tastes at every social level, and German products would be made suitable for the world market. The Werkbund annual conferences discussed these issues, alongside ways of reforming the conflict between tradition and modernity, luxury and simplicity: the yearbooks published since 1912 (1926–1934

Die Form magazine) also carried the debate, and the results were shown at all major exhibitions. The first exhibition dedicated to the Werkbund was held in Cologne in 1914, and took as its theme the controversy over the trend to return to tradition, i. e. standardization or individual artistic creativity. From 1924 until it closed in 1933–34 the Werkbund incorporated the *Neues Bauen* movement (exhibition in Stuttgart 1927). The Werkbund was re-formed in 1950. H.O.

Bibl.: Conrads, Deutscher Werkbund, 1969 · Campbell, Deutscher Werkbund, 1981 · Junghanns, Deutscher Werkbund, 1982 · Werkbund, Deutscher Werkbund, 1982 · Werkbund, Cologne, 1984

Dezeuze, Daniel → Support-Surface

di Suvero, Mark. *1933 Shanghai, China. American sculptor living in New York. He spent his early childhood in Asia, moving to the US in 1941. He studied at the University of California, Santa Barbara, from 1954 to 1955, then at Berkeley. In 1957 he moved to New York, where he had contact with → Abstract Expressionist artists and sculptor David → Smith. He moved to Europe in 1971 staying there for four years in protest at US policies in Vietnam. His first major retrospective was held at the Whitney Museum of American Art, New York in 1975. His early sculptures were small Expressionistic figures in bronze and wood, but he dsoon began creating large-scale Constructivist works in steel. In the mid-1960s he started to work outdoors. His monumental sculptures feature materials used by the modern building industry – such as metal supports and girders, wood, and steel ropes – as well as objects found on waste ground. I.N.

Bibl.: Monte, di Suvero, 1975 · Osterwold, di Suvero, 1988 · Perlein, di Suvero, 1991

Díaz, Gonzalo. *1947 Santiago, Chile. Chilean painter, living in Santiago. He studied at the Escuela de Bellas Artes, Santiago, from 1959 to 1965, and taught there from 1960. He held further teaching posts in 1974 at the Universidad Católica and in 1977–86 at the Istituto de Arte Contemporáneo. In 1980 he was awarded a scholarship by the Italian government. In 1987 he received the John Simon Guggenheim Memorial Foundation Fellowship. Díaz began to create installations in the 1970s, then turned to painting. He was responsible for setting up the Avanzada group, a loose collection of politically active Chilean artists. In his paintings Díaz uses a variety of techniques to represent his country's national mythology and political history. J.A.F.

Bibl.: Kunst in Chile, Berlin, 1989 · Valdés, Díaz, 1991

Dibbets, Jan. *1941 Weert. Dutch photographer and Conceptual artist living in Amsterdam and San Casciano di Bagni. He studied at the Academy in Tilburg from 1959 to 1963, and at St Martin's School of Art in London (from 1967). In 1967 he set up the International Institute for the Re-education of Artists. He exhibited at the Venice → Biennale in 1972, and in 1984 was appointed professor at the Kunstakademie, Düsseldorf in 1984.

Influenced by → Mondrian, as well as by Vermeer and Saenredam, Dibbets initially produced monochrome, Minimalist paintings, but in 1967 turned to his preferred medium: photography. Following encounters with → Long and → Land art, he produced a number of photographs centered on a dialog between nature and geometric shape. In his *Perspective Corrections*, (1967–69), for example, he works on the phenomenon of perception (a trapezium appears to be square). In the 1970s he created picture sequences of material surfaces and structures (*Waterstudy of Structures*, 1975). More recently he has used film and video to foreground architectural details such as windows and interiors (*Octagon I*, 1982), while continuing to emphasize the isolated representation of individual elements and the structure of objects. P.L.

Bibl.: Dibbets, Minneapolis, 1987 · Dibbets, Paris, 1989 · Moure/Fuchs, Dibbets, 1991

Diebenkorn, Richard. *1922 Portland, Oregon, †1993 Berkeley, California. American painter, draftsman, and graphic designer. He studied at Stanford and Berkeley from 1940 to 1943, San Francisco (1946–47), and at the University of New Mexico, Albuquerque (1950–52). He traveled to Europe and Russia at the beginning of the 1960s. In 1966 he was appointed professor at the University of California, Los Angeles. His early abstract works were influenced by → Motherwell and de → Kooning, whereas his figurative paintings, interiors, and still lifes from 1955 were based on European → Expressionism. In 1967 he produced a series of more than 140 large-scale abstract paintings (*Ocean Park*) in light tones that reflect the sun-soaked Californian landscape. Diebenkorn moved to San Francisco in 1988. He stopped painting in 1989 (after a stroke) and turned to drawing and graphics. I.N.

Bibl.: Nordland, Diebenkorn, 1987 · Flam, Diebenkorn, 1992 · Livingstone, Diebenkorn, 1997

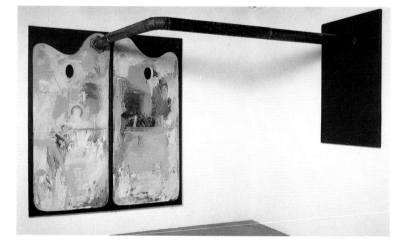

Dine, Jim. *1935 Cincinnati, Ohio. American painter, sculptor, graphic designer, stage set designer, performance artist, and writer living in New York. From 1953 to 1957 he studied at the University of Cincinnati, the Boston Museum School, and Ohio University. He moved to New York in 1958, and was appointed guest lecturer at Yale University, New Haven in 1965. Between

Jim Dine, *Two Palettes in Black with Stovepipe (Dream)*, 1963, Oil on canvas, stovepipe, 225 x 208 x 192 cm, Sonnabend Collection, New York

Otto Dix, *Portrait of Chairman and Senator for Danzig Prof. Dr. Ludwig Noé*, 1928, Tempera and resin with oil on canvas, mounted on plywood, 96 x 72 cm, Museum Ostdeutsche Galerie, Regensburg

1967 and 1971 he spent long periods of time in London and Paris, and then moved to Putney, Vermont. As well as his permanent studio in Putney, he also set up temporary studios in numerous other places around the world. He participated in → Documentas 4 (1968) and 7 (1977). In 1988 he was made a member of the American Academy and the Institute of Arts and Letters.

At the outset of his career Dine was involved with → happenings, and in the 1960s turned to painting and sculpture in an → Abstract Expressionist style. His paintings incorporate everyday objects and articles of clothing, ranging from ties to toothbrushes. His interest in items from daily life links him to → Pop art. His artistic creativity revolves around his approach to a wide variety of media and the different ways in which they can be used as forms of expression. I.N.

Bibl.: Glenn, 1985 · Feinberg, 1995 · Livingstone, Dine, 1997

Disler, Martin. *1949 Seewen, Solothurn, †1996 Geneva. Swiss painter and graphic designer. A self-taught artist, he painted his first pictures in 1969 while working as a carer in a psychiatric unit. In 1970 he worked as a stage manager and theater producer in Olten. He later studied in Bologna, Paris, and New York. From 1980 he collaborated with I. Grundel, whom he also married that year. He participated in Documenta 7 (1982). Disler is regarded as one of the pioneers of → Neue Wilde. His pictures, which he would create by means of a frenzied process, are quite startling and the result of ecstatic inspiration. His works speak of the conflicts involved in keeping body and soul together (*Mamma Grottino*, 1980; *Skinning and Dance*, 1990/91). He drew inspiration from archaic art forms, → Art Brut, and → Pollock, but deliberately refrained from following a particular style. P.L.

Bibl.: Disler, Basel, 1980 · Ammann, Disler, 1981 · Disler, Zürich, 1988 · Disler, Basel, 1997

divisionism. Synonym preferred by the → Neo-Impressionists for pointillism. The term was coined by art critic Félix Fénéon, who described as "divisionist" the method seen in Georges Seurat's paintings of dividing individual color values into elements of color located according to function and type (reflective hue, shadow, contrast). The Neo-Impressionists felt this term was more suitable for emphasising the difference between them and their predecessors, the Impres-

sionists, although it did not remain in everyday language for long. The Italian Neo-Impressionists (Gaetano Previati [1852–1920], Giovanni Segantini [1858–99] and Giuseppe Pellizza da Volpedo [1868–1907]) intended the term *Divisionismo* to emphasize the technical process of color division. Italian Divisionism was an important source of inspiration for → Futurism. H.D.

Bibl.: Belli, Divisionismo, 1990

Dix, Otto. *1891 Untermhausen near Gera, †1969 Singen (Hohentwiel). German painter and graphic designer. He attended the Kunstgewerbeschule, Dresden from 1909 to 1914 before joining up to fight in World War I. In 1919 he participated in the Dresden Secession with → Segall and → Felixmüller. He moved to Düsseldorf in 1922 where he studied at the Akademie, and joined the Junges Rheinland group (with → Ernst and O. Pankok). In 1923 the accusation levelled against him of producing "obscene representations" was lifted. In 1924 he produced his War series of 50 etchings, moving to Berlin the following year. His work appeared at the Neue Sachlichkeit exhibition in Mannheim. One-man exhibitions were held in Berlin and Munich in 1926. He returned to Dresden in 1927 to take up an appointment as professor at the Dresden Kunstakademie. He exhibited in New York, Essen, Paris, and Detroit in 1927–28. In 1931 he became a member of the Akademie der Künste, Berlin. He was removed from his teaching post in 1933 and the following year forbidden to exhibit. He withdrew to Hemmenhofen on Lake Constance in 1936. Held as a prisoner of war in 1945, he returned to Hemmenhofen in 1946. In 1955 he was made a member of the Akademie der Künste in West Berlin, and in 1957 honorary senator of the Hochschule der Bildenden Künste, Dresden. In 1964 he received the Carl von Ossietzky award. After → Expressionist and → Dadaist beginnings, Dix turned in 1922 to → Neue Sachlichkeit becoming, with → Grosz, one of its main exponents. He developed a form of extreme → Verism, but in his later works he returned to an Expressionist style.

The physical shock of war triggered Dix's bitingly critical pictures such as *The Trench* (1920–23), which represents war as an infernal horror. In 1937, this and other works by Dix were included in Nazis' "Degenerate Art" exhibition. In addition to his accusatory war pictures, Dix social satires (*The Match Seller I*, 1920), were also

Otto Dix, *The City* (triptych), 1927–28, Mixed media on wood, left and right panels 181 x 101 cm, center panel 181 x 200 cm, Galerie der Stadt, Stuttgart

highly controversial not just because of the subject, but also because of his perfect Old Master technique. His portraits from the 1920s and 1930s reveal a relentless realism and a deep understanding of human nature (*Portrait of his Parents I*, 1921). His large triptychs *The City* (1927–28) and *War* (1929–32) were created during his time in Dresden. After the Nazis banned him from exhibiting, Dix devoted himself to painting landscapes in the style of the Danube school. His later works, however, tended towards Expressionism (*Self-Portrait as a Prisoner of War*, 1947) and religious themes (*Large Crucifixion*, 1948). G.P.

Bibl.: Löffler, Dix, 1977 · Löffler, Dix, 1981 · Dix, Berlin, 1991 · Kinkel, Dix, 1991 · Pfäffle, Dix, 1991 · Dix, London, 1992

Dobell, (Sir) William. *1899 Newcastle, New South Wales, †1970 Wangi Wangi, New South Wales. Australian figurative painter. Study at the Slade, London, and travel in Belgium and France enabled Dobell to gain knowledge of the major figures in art. His work in England (1929–38) was socially aware – it is decorative and yet illustrative of London low life. The lurid colouring, close to → Scipione, of the bloated *Dead Landlord* (1946) is typical. On his return to Sydney in 1939 he treated themes related to the war effort (*Knocking-Off Time, Bankstown Aerodrome*, 1944). A Greco-esque, high-toned portrait of Joshua Smith (1943; destr.) controversially won the Archibald Prize. At the ensuing court case it was termed a "distortion" and the essentially traditionalist Dobell was lampooned in the press as a "bizarre" and purblind modernist. He was, however, Australia's most celebrated painter from 1950 onward (knighted in 1966). In the mid-1960s he experimented with abstract forms. Influences from Rembrandt, Mannerism, Post-Impressionism (*The Little Milliner*, 1936), → Soutine, and New Guinea imagery (from a 1950 visit) were often fused in Dobell's art to produce unsettling pieces (*The Thatchers*, 1953). D.R.

Bibl.: Gleeson, Dobell, 1981 · Adams, Dobell, 1983

Dobson, Frank (Owen). *1886 London, †1963 London. British sculptor. His early carving (1920s) was inspired by pieces by → Epstein and → Gaudier-Brzeska; Dobson was the only sculptor chosen by → Lewis for the → Vorticist "Group X" exhibition in 1920 (six works). Increasingly drawn to the female form naturalistically treated, Dobson's mature work is somewhat akin to → Modigliani and → Maillol. His calm and measured art remained close to → Gill and Gaudier almost throughout his career (*The Man Child*, 1921), its repose and simplicity of line making it popular with the gallery-going public. Other influences included → Moore and Indian sculpture. Late pieces approach the figure in a still more classical vein, though themes were often novel (*Woman with a Fish*, 1954). D.R.

Bibl.: Mortimer, Dobson, 1926 · Dobson, Cambridge, 1981

Documenta. Exhibition of international and predominantly contemporary art, held in Kassel, Germany, every four or five years. The exhibition runs for 100 days. The first Documenta was organized in 1955 by Arnold Bode, painter and professor at the Kunstakademie in Kassel, and art historian Werner Haftmann. A total of 670 works recorded the development of European art from 1905 to 1955. The aims of the exhibition were to rehabilitate modern art, denigrated by the Nazis as "degenerate", and also to set West German postwar art in an international context. Documenta 2 (d2), 1959, and d3, 1964, presented fine examples of gestural abstract art after 1945. The "language of abstraction" was considered an expression of the free West as opposed to the fettered art of → Socialist Realism. d4 in 1968 acknowledged New York's position as a major center for modern art by exhibiting numerous examples of American → Color Field Painting and → Pop art. The inclusion of many very recent

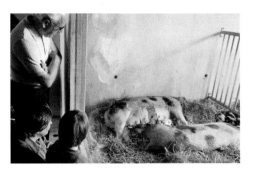

Documenta: Rosemarie Trockel and Carsten Höller, *House for Pigs and People*, 1997, Installation, Documenta 10, Kassel

works meant that Documenta became for the first time highly contemporary, and an important forum for art dealers. d5 in 1972 was the first to be the sole responsibility of one person (Harald Szeeman from Switzerland). It reflected the expanded boundaries of art in the 1960s, featuring → Action Painting and → Conceptual art, → environments, and archival documentation. Thereafter, a number of individuals were responsible for selecting works and designing the exhibitions: Manfred Schneckenburger from Cologne curated d6, 1977, and d8, 1987; Dutchman Rudi Fuchs d7, 1982; Belgian Jan Hoet d9, 1992, and Frenchwoman Catherine David d10 in 1997. In 1998 the selection board of the Documenta council appointed Nigerian Okwui Enwezor, who lives in New York, as the curator of Documenta 11 in 2002. F.K.

Bibl.: Schneckenburger, Documenta, 1983 · Kimpel, Documenta, 1997

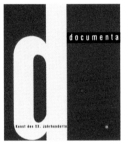

Documenta: *Cover of the 1st Documenta catalog*, 1955, Graphic design: A. Bode, H. Nickel and E. Schuh

Doesburg, Theo van (real name Christian Emil Marie Küpper). *1883 Utrecht, †1931 Davos. Dutch painter, architect, and theorist. After national service in 1914–16 he worked with architects J. J. P. Oud (1890–1963) and Jan Wils and produced his first abstract, geometric compositions. In 1917, together with → Mondrian, van der → Leck and Vilmos Huszár (1884–1960) and others, he founded the De → Stijl group. He wrote for its journal under a pseudonym (from 1920 J. K. Bonset and from 1921 Aldo Camini) and undertook numerous trips (including to Berlin and Weimar) to promote De Stijl ideas. In 1922 he supported the → Dada movement in Holland and edited the Dadaist *Mécano* magazine. He moved to Paris in 1923 and worked on Mies van der Rohe's magazine *G*. In 1924 he published the De Stijl architecture manifesto and held his first one-man exhibition in Weimar. From 1926 to 1928 he worked on

a large project to decorate and remodel the Café L'Aubette in Strasbourg (with → Arp and → Taeuber-Arp). In 1929 he published the first issue of *L'Art Concret* magazine. During 1929–30 he designed and built his own studio and house in Meudon. Van Doesburg was the co-founder in 1931 of the → Abstraction-Création group of artists.

In contrast to Mondrian, van Doesburg denied all esoteric associations and allowed relevance only to concrete artistic means (→ Concrete art). As a painter he was self-taught, and his development as an artist was largely determined by his architectural activities (e. g. with Oud, Villa Alle-

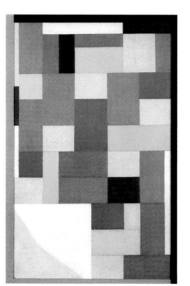

Theo van Doesburg, *Composition*, 1920, Oil on canvas, 130 x 80 cm, Musée National d'Art Moderne, Centre Georges Pompidou, Paris

gonda, Katwijk aan Zee, 1917; housing developments in Spangen, Rotterdam, 1919–21; with Gerrit Rietveld [1888–1964], interior for the de Eigt house in Katwijk aan Zee, 1919). In 1924 he turned away from horizontal-vertical picture construction and introduced diagonal frameworks, which added a dynamic new component (*Counter-Composition V*, 1924). Doesburg coined the term → Elementarism for this type of picture composition (manifesto, 1926). H.D.

Bibl.: Doesburg, Principles, 1969 · Baljeu, Doesburg, 1974 · Georgel, Doesburg, 1977 · Doig, Doesburg, 1986

Doisneau, Robert. *1912 Gentilly, †1994 Paris. French photographer. He became assistant to André Vigneau in 1931 after serving an apprenticeship in lithography. He began working as a photojournalist in 1932 (for *Excelsior* and elsewhere) and became a full-time freelance photographer in 1940. He was appointed industrial photographer for Renault in 1943, and became a member of the Agence Alliance Photo agency in 1945, and of the Rapho agency in 1946. In 1949 he joined *Vogue*. His book *La Banlieue de Paris* (with Blaise Cendrars) was published the same year. From 1955 he was involved in advertising photography. He also worked on short films (*Robert Doisneau's Paris*, 1973; *5 photographes*, 1983).

Doisneau specialized in photography for illustrated magazines. He is highly regarded for his fashion photography, photoreportage work, advertising photography, and ironic portrait and documentary pictures of a social nature (*Les*

Parisiens tels qu'ils sont, 1955; *Trois secondes d'éternité*, 1979). K.S.-D.

Bibl.: Ory, Doisneau, 1984 · Hamilton, Doisneau, 1995

Dokoupil, Jiri Georg. *1954 Krnov, Czech Republic. Czech-born painter, sculptor, graphic designer who has lived in Cologne since 1968. He studied art in Cologne, Frankfurt, and under → Haacke and → Kosuth in New York. He has acted as visiting teacher at art academies in Düsseldorf, Madrid, Amsterdam, and Kassel. Dokoupil's refusal to reveal anything, even own signature in his art earned him the nickname "the Sphinx." Even while still a member of the group Junge Wilde ("Mülheimer Freiheit"), he fell out with other Junge Wilden and developed his own strategies towards art. He soon went his own radically subjective way, producing pictures that were either baroque or surreal. Decorative pictures which mock everyday fetishism, almost illegible candle-soot pictures, ironically erotic images of children, the *Neue New York Series* with Christian and Jewish iconography. From around 1987, a cheerful informality came to dominate his works which have been described as emanating a "beautiful and surprising freedom of emptiness"; they include erotic works using materials such as soap bubbles, human milk, candle soot, and tyre tracks; despite being interpreted in a Freudian manner they manage to avoid irony. Sculptures or still lifes using fruit are combined with real fruit, photos smudged by candle soot, as well as drawings and graphics. L.Sch.

Bibl.: Dokoupil, Cologne, 1982 · Dokoupil, Drawings, 1989–91 · Dokoupil, Vienna, 1997

Donaldson, Jeff → AFRICOBRA

Dongen, Kees van (real name Cornelis Theodorus Maria van Dongen). *1877 Delfshaven near Rotterdam, †1968 Monaco. Dutch-born painter. He studied at the Academie van Beelenden Kunst in Rotterdam in 1894–95 and in 1896 worked as an illustrator for the Rotterdamsche Nieuwsblad. Moving to Paris in 1899, he joined the → Bateau-Lavoir group around → Picasso. There he took on

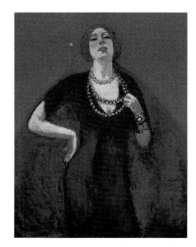

Kees van Dongen, *Portrait of Guus on a Red Background*, 1910, Oil on canvas, D.A. van Dongen Collection, Paris

Jiri Georg Dokoupil, *The Irreversible Metamorphosis of the Russian Race*, 1982, Mixed media and oil on canvas, 20 x 160 cm, Gerd de Vries Collection, Cologne

various jobs and became a caricaturist for satirical publications (e.g. *L'Assiette au beurre*, *Le rire*, *Froufrou*), and in 1903 for the *Revue Blanche*. He exhibited at the → Salon des Indépendants, 1904; the → Salon d'Automne, 1905 (→ Fauvism); and with Die → Brücke in Dresden, 1908. He traveled to Spain, Morocco and Italy (1910–11), and to Egypt (1913).

Through the good offices of Ambroise Vollard and Berthe Weill, van Dongen came into contact with → Matisse and the Fauves. He developed an individual style in which expressive Fauvist brushwork is combined with rapid strokes of bright color. He usually painted portraits of women or nudes, but also produced highly colored landscapes. Through → Pechstein, van Dongen also came into contact with the Brücke painters, and exhibited with them in Düsseldorf, Munich, and Berlin. His pictures became increasingly decorative after 1913 (*I and the Woman*, 1917), and the glowing colors are toned down, the light often theatrical. The carefully planned elegance of his portraits of women opened up a second career in the 1920s as a portrait painter to fashionable Paris (*Madame Jenny*, 1925). H.D.

Bibl.: Chaumeil, Dongen, 1967 · Melas-Kyriazi, Dongen, 1976 · Dongen, Nice, 1981 · Dongen, Paris, 1990

Donkey's Tail (Russian = *Oslini Khvost*). Avant-garde Russian art group comprising disenchanted members of the → Jack of Diamonds. The Donkey's Tail exhibition opened on March 11, 1912 and featured works by → Larionov, → Malevich, → Goncharova and → Tatlin, among others. The group's declared aim was the rejection of Western influences, its members espousing more traditional Russian forms such as içons and folk art. Larionov chose the name from an anecdote circulating in Paris, according to which a French artist had shown at the → Salon des Indépendants some pictures painted with a brush tied to a donkey's tail. H.D.

Bibl.: Gray, Avantgarde, 1963

Dorazio, Piero. *1927 Rome. Italian painter. He studied architecture in Rome from 1942 to 1945. After a phase of realist painting as a member of the Gruppo Arte Sociale (1945–46), Dorazio turned to → Futurism. Together with Pietro Consagra (1920–), Achille Perilli (1927–), → Turcato, and others, he published the *Manifesto de Formalismo* and founded the → Forma group. In 1949–50 he organized exhibitions for the group in the gallery L'Age d'Or. After experimenting with relief structures, in 1957–58 he painted pictures in the → Art Informel style with sensitively colored surfaces (*Basalto*, 1958). From here he developed his main subject of color, light, and structure (*Cercando la Magliana*, 1964) whereby Dorazio reduced his pictures increasingly to basic or complementary colors of a highly decorative nature. After a number of experiments with dissolution and solidification of the picture structure, in 1974 he achieved a harmonic orchestration of colors based on the regularity of → Neo-Impressionism. His tiny dot structures in changing colors create a living vibration of tone and light. H.D.

Bibl.: Dorazio, Todi, 1975 · Dorazio, Munich, 1981 · Dorazio, Milan, 1984 · Boehm, Dorazio, 1992

Dotremont, Christian. *1922 Tervuren near Brussels , †1979 Buizingen. Belgian painter, writer, and poet. He studied at Lewin Brzeski Art Academy (1939–40), and then moved to Paris in 1941–42, where he was influenced by the "manuscript drawings" of Paul Éluard and → Picasso, and collaborated on publications by the French Surrealist movement. In 1947 he co-founded the Franco-Belgian movement "Le Surréalisme Révolutionnaire" which turned against → Breton. With → Jorn he created his first *Word Pictures* in 1948 and founded the → Cobra group, becoming its main spokesperson. As chief editor of *Cobra* magazine, he published numerous articles about the group and the individual members. In 1955 he published his novel *La Pierre et L'Oreiller*. From 1962 he created "Logogrammes", picture poems in which lines of text are combined with graphic structures (*Logoglaces*, 1963; *Logoneiges*, 1973). He exhibited at the Venice Biennale in 1972. H.D.

Bibl.: Butor/Sicard, Dotremont, 1978 · Alechinsky/Calonne, Dotremont, 1991

Douglas, Aaron. *1898 Topeka, Kansas, †1979 Nashville, Tennessee. American painter and illustrator. With Palmer Hayden (1890–1964), Rex Goreleigh (1902–87), and Malvin Gray Johnson (1896–1934), the widely traveled "Father of Black American Art" was an important figure of the "New Negro" Harlem Renaissance centered around critic Alain Locke (1886–1954) in the 1920s. Douglas attended the University of Nebraska, Lincoln, subsequently teaching drawing in a high school in Kansas City before moving to Harlem, NYC, in 1925. There he provided illustrations to books (e.g. James Weldon Johnson's *God's Trombones*, 1927; and for Langston Hughes) and journals (e.g. *Crisis*) written by other African-Americans as well as producing poster-like murals (*Aspects of Negro Life*, 1934, inc. *Song of the Towers* and *The Negro in an African Setting*), often in collaboration with the → WPA. Influenced by

African and Ancient Egyptian art (*The Creation*, 1935), his oeuvre includes portraits, landscapes, and genre scenes. Most of his paintings, however, deal with African-American life in Harlem, dwelling on the graft and fortitude of the community (*Into Bondage*, 1936), rather than on squalor and oppression: "I refuse to compromise and see blacks as anything less than a proud and majestic people" (A. D.). His work is formally conservative, though perspectives and silhouetting are influenced by turn-of-the-century currents (*Window Cleaning*, 1935; the subject is viewed from the rear). D.R.

Dove, Arthur. *1880 Canandaigua, New York, †1946 Long Island, New York. American painter. He studied at Cornell University from 1898 to 1903, and then became a commercial illustrator. He visited Paris in 1908–09. Dove divided his time between his farm in Westport, New York, and his houseboat on Long Island. A friend of → Stieglitz and a member of the group around → Demuth, → Hartley, → Marin, and → O'Keeffe he was, like them, a tireless experimentalist. In 1910 he was one of the first Americans to paint abstract pictures: these were biomorphic stylizations of landscapes and musical compositions. After a period creating decorative assemblages and collages made from found objects, he withdrew into a more contemplative world of pantheistic nature abstractions. L.Sch.

Bibl.: Morgan, Dove, 1984 · Balken, Dove, 1997

drip painting. A method of painting in which liquid paint is dripped, sprayed, or scattered onto a canvas from a brush or other utensil. → Ernst invented the technique when he punched holes in a can and allowed paint to drip through it onto a canvas placed on the floor. → Pollock turned it into an individual style (→ Action Painting) by covering a canvas lying on the floor with paint of all types and consistencies, applied from all sides in spontaneous gestures to create a thick tapestry of color. H.D.

Felix Droese, *Untitled (On Human Flesh Tint, no. 4)*, 1983, Painting on a medical diagram, reverse side, 138 x 98 cm, Städtisches Kunstmuseum, Bonn

Droese, Felix. *1950 Singen, Hohentwiel. German sculptor and painter who lives near Mettmann-Diepensieben. He studied at the Kunstakademie, Düsseldorf from 1970 to 1976. His work centers around questions of religion, social problems, and utopias, for which he utilizes a specific sign language of original shapes: crucifixes, ships, trees, bird's nests, gallows, biers, shrouds. He often employs wood and glass, alongside black-and-white paper and cloth from which he cuts silhouettes; the "missing piece" is an inherent part of the work. A crucifixion of cuttings from tabloid newspapers (*From the Outset, Failure as Heroic Deed*, 1982), a 51-part cycle of medical diagrams painted with anguished metaphors for pain and suffering (*On Human Flesh Tint*, 1985), and his installation *Container with Lifeboat Stranded on an Alpine Summit* (1990) are associated with a major piece at the 1988 Venice Biennale in the pavilion of the "House of Weaponlessness." There, from monumental paper cut-outs, wood, glass, and metalwork he created a spiritual area that conjured up a cosmos enacting the mortal danger confronting culture and nature. His vast oeuvre of drawings is sensitive, meditative, and on occasion obscure. L.Sch.

Bibl.: Stemmler, Droese, 1988 · Droese, Düsseldorf, 1990

Drysdale, (Sir) Russell. *1912 Bognor Regis, England, †1981 Sydney. Australian painter and photographer. After studying under the relatively modernist George Bell (1878–1966) and at the Grande Chaumière (→ Académie), Drysdale fell under the influence of → Surrealism. Returning to Australia shortly before World War II, he exhibited paintings of rural New South Wales with youthful figures showing e. g. the effects of the serious 1944 drought. An → "Expressionist" vein (*Nudes*, 1938–39) became tempered through the 1940s. His 1950s works concentrated on "outback" subjects, including the plight of the Aboriginals (*Man with a Fish Spear*, 1958). Though more of a realist than → Nolan (both artists were promoted by the critic Kenneth Clark), "Tassy" also produced sparse and uncanny compositions with elongated figures (*Greenhide Jack at the Mailbox*, 1950). Intriguing are pen studies of Aboriginals and unromanticized color photographs of the outback (from the mid-1950s). D.R.

Bibl.: Dutton, Drysdale, 1981 · Boddington, Drysdale, 1987

Dubuffet, Jean. *1901 Le Havre, †1985 Paris. French painter, sculptor, and collage artist. He studied at the École des Beaux-Arts, Le Havre, while still at school. He was briefly a student at the Académie Julian, Paris, in 1918, then embarked on autodidactic activities, studying language, literature, philosophy, and music. He ceased his artistic acivities in 1924 and did not begin again seriously until 1942. He held his first exhibition at the Galerie René Drouin in Paris in 1944; his second followed in 1946. Between 1947 and 1949 he spent periods of time in the Algerian Sahara. In 1948 he set up the Compagnie de l'Art Brut with → Breton, and others (see → Art Brut) in 1948. He visited New York in 1951–52, and began to sculpt in 1954. In 1960–61 he experimented with music (with → Jorn among others). A major retrospective was held at the Guggenheim

Jean Dubuffet, *He has Taken off his Sandals*, 1947, Oil on canvas, 100 x 81 cm, Hamburger Kunsthalle

Museum in New York in 1973. In 1976 he bequeathed his collection of Art Brut to Lausanne (Château de Beaulieu). He published his life story, *Biographie au pas de course*, in 1985.

Dubuffet caused controversy among critics and the public when he exhibited at the Galerie Drouin in 1946. The immediate sensuality of his raw materials, a painterly impasto into which he incised coarsely archaic figures, stood in direct opposition to → geometric abstraction; the work seemed to confound every received aesthetic value. Dubuffet championed what he called Art Brut ("coarse art"), which included the art of the insane, political and socially aggressive graffiti, and children's drawings; under the auspices of the Compagnie de l'art brut he propagandized for an unmannered, genuine art that was not the product of an academic education, and which lay outside aesthetic standards. Dubuffet was inspired by artificial and natural materials (*Matériologies*, 1959, relief-like pictures made from crushed silver paper, papier mâché, artificial resins, sand, and glitter). His largest series of graphics is the (*Phénomènes*, 1958–62), numbering 400 lithographs, in which he reveals a purely phenomenononological view of the world. His "Hourloupe art language", created in 1962, is a figurative, abstract script that was transferred to three-dimensional designs from 1966, and later to free-standing sculptures, architecture, and stage plays (*Coucou Bazar*). In his later works (*Mires*, 1983; *Non-Lieux*, 1984) Dubuffet returned to techniques more akin to → Art Informel, combining them with the anarchic figuration of his early works. H.D.

Bibl.: Dubuffet, 1966–89 · Dubuffet/Damisch, 1967 · Dubuffet, Paris, 1973 · Thevoz, Dubuffet, 1986

Duchamp, Marcel. *1887 Blainville-Crevon, †1968 Neuilly-sur-Seine. French-born painter, sculptor and Conceptual artist. He moved to Paris in 1904, where he studied at the Académie Julian. Initially influenced by Cézanne, → Fauvism, → Cubism, and → Futurism, he exhibited at the → Salon d'Automne and at the → Salon des Indépendants

from 1908 (*Nude Descending a Staircase*, 1912; shown in 1913 at the → Armory Show in New York). He became friends with → Picabia and Guillaume Apollinaire. In 1913 he worked as a librarian at the Sainte-Geneviève library in Paris. During this time he produced notes, drawings, and studies for oils which were later used in his highly complex main work, *The Bride Stripped Bare by her Bachelors, Even (The Large Glass)* (1915–23). In 1913 he produced forerunners to his → readymades (*Bicycle Wheel*). Duchamp moved to New York in 1915, and started creating his readymades proper in 1916. He travelled to Buenos Aires and later to Paris in 1918–19, contacting the → Dada group there. He returned to New York in 1920 and set up the → Société Anonyme Inc. (with → Man Ray). He spent much of the period 1924–34 traveling and taking part in chess tournaments. In 1934 he published a portfolio with reproducible notes and sketches on *The Large Glass*, and the following year produced his *Rotoreliefs*. In 1941 he created his *Boîte-en-valise* (miniature reproductions of selected works). From 1946 to 1966 he worked on his last major work, *Étants donnés*. He married Alexina Sattler in 1954. The year 1967 saw the publication of a portfolio of notes in *The White Box*.

Alongside → Beuys, Duchamp is considered to be one of the major revitalizers of the art scene in the 20th century. With his mysterious, often incomplete works, his ready-mades, found objects (→ objets trouvés) elevated to the status of art works and his copious notes, Duchamp introduced a new concept of art, centered on the idea rather than the object. He is regarded as a pioneer of → Conceptual art. In his major work, *The Large Glass*, Duchamp combines some of the main themes of avant-garde art (movement, space/time, the fourth dimension) with a highly personal symbolism (which is sexual, but with hermetic and mystical overtones). His consistent refusal to use his talent for painting; his attitude of "aesthetic indifference," his interest in apparently banal, mass-produced utensils, his ready-mades – which he "selected" in an artistic act; and finally his notion of the unrecognized artist, working alone and in total seclusion, all combined to make Marcel Duchamp one of the greatest intellectual innovators of art in the 20th century. H.D.

Bibl.: Schwarz, Duchamp, 1969 · Mashek, Duchamp, 1975 · Daniels, Duchamp, 1992 · Duchamp, Ostfildern, 1995 · Stauffer, Duchamp, 1995 · Seigel, Duchamp, 1997

Marcel Duchamp, *Bicycle Wheel*, 1913, Bicycle wheel (64.8 cm diameter), mounted on a stool, 60.2 cm high. Original missing, Replica in the Arturo Schwarz Collection, Milan

Marcel Duchamp, *The Bride Stripped Bare by her Bachelors, Even (The Large Glass)*, 1915–23, Oil, varnish, lead foil, lead wire, dust on two glass panels (cracked) each mounted between two glass panels with glass strips, aluminum foil, and wood and steel frame, 272.5 x 175.8 cm, Philadelphia Museum of Art, Bequest of Katherine S. Dreier

Duchamp, Suzanne. *1889 Blainville near Rouen, †1963 Neuilly-sur-Seine. French painter. Sister of Marcel → Duchamp, → Villon and → Duchamp-Villon. She attended art school in Rouen and in 1919 married the Dada painter Jean Crotti (1878–1958). Her early works were naive Cubist compositions, and from 1919 to 1924 she was associated with the → Dadaist movement. Influenced by Marcel Duchamp's interest in mechanics, she created mechanical, abstract paintings (*Multiplication brisée et rétablie*, 1918–19). These included her *Ready-made Malheureux de Marcel Duchamp*, in which she records, in painstaking detail, a wedding gift from her brother, comprising written instructions for the realization of a *Ready-made Malheureux* with the aid of a geometry text book. Her later works became increasingly abstract. K. S.-D.

Bibl.: Crotti, Berne, 1983

Duchamp-Villon, Raymond. *1876 Damville, †1918 Cannes. French sculptor, brother of Marcel → Duchamp, Suzanne → Duchamp, and → Villon. Self-taught as an artist he started out as a medical student, and turned to sculpture in 1898, initially influenced by Rodin. Seeking increasingly simplified shapes, from 1904 he turned to → Cubism, transferring its principles to sculpture. He was a member of the Puteaux group of Cubist-affiliated artists (from 1911), and was the architect for their model *Maison cubiste*, exhibited at the → Salon d'Automne in 1912. His work includes numerous busts (e. g. *Charles Baudelaire*, 1911), and a number of versions of *The Horse* (1914), a sculpture which prefigures Italian → Futurism. K. S.-D.

Bibl.: Cabanne, Duchamp, 1997

Dufrêne, François. *1930 Paris, †1982 Paris. French painter and collage artist. He began as a poet, joining the → Lettrism movement of Isidore Isou in 1946. In 1953 he established what he called "Ultralettrism" with the aim of deconstructing language, and staged events that featured "Crirythmes" and accoustic improvizations called "Borborythmiques". He was co-founder in 1960 of → Nouveau Réalisme. In 1957 he invented the technique of → décollage using torn posters (*Questampages*, 1957): he removed posters from walls, carefully exposing the layers beneath until he had achieved an effect similar to that sought by practitioners of → Art Informel with their relief-like applications. Usually produced in series, his works have highly allusive titles (*Le Mot nu mental*, 1964). In the early 1970s he transferred the same principle to mattresses and mattress covers, creating what he called Bibliothèques prints. He also wrote concrete poetry and visual verse. K. S.-D.

Bibl.: Dufrêne, Paris, 1983 · Murmure, Rennes, 1994

Dufy, Raoul. *1877 Le Havre, †1953 Forcalquier. French painter and graphic artist. He studied under Léon Bonnat at the École des Beaux-Arts in Paris from 1899. He was initially drawn towards Impressionism and → Post-Impressionism (especially Gauguin and Van Gogh, see → precursors). In 1905, impressed by the works of → Matisse (e. g. *Luxe, calme et volupté*), he began to absorb

Raoul Dufy, *The Regattas*, 1907, Oil on canvas, 54 x 65 cm, Musée National d'Art Moderne de la Ville de Paris

→ Fauvist influences. His scenes of Normandy (sailing regattas, beaches, parades, flags, etc.), such as *The Beach at Sainte-Adresse* (1914), are marked by strong, bright colors with black contours. Following this phase he turned to → Cubism (1908–12) and developed an individual style, akin to the structured picture compositions of Cézanne, resisting bright colors in order to examine spatial and structural problems. Dufy created a number of woodcuts (for illustrations and fabric designs), which relieved the severity of strictly Cubist picture design. From 1920 he began to create the highly decorative pictures for which he is renowned (of racecourses, beach scenes, sailing regattas, casinos), using flowing, calligraphic outlines and generous areas of color. For Dufy, the distinction between drawing and pure color, between the description of the object and its colorfulness, is based on the process of seeing: the eye perceives color more quickly and more intensively than it perceives an outline. Watercolors became his chosen form of expression, the ideal way of holding spontaneous impressions. In 1937 he created his large-scale mural, *La Fée Electricité*, for the Exposition universelle in Paris. In his later works, each picture is dominated by a primary color; in 1944 he named this technique "peinture tonale." Dufy's extensive oeuvre includes book illustrations, designs for ballet, stage sets, fabrics (including for fashion designer Paul Poiret), and ceramics. K.S.-D.

Bibl.: Dufy, London, 1983 · Lafaille, Dufy, 1985 · Girad/Perez-Tibi, Dufy, 1993 · Forneris, Dufy, 1996

Duval-Carrié, Édouard. *1954 Port-au-Prince. Haitian painter. Although Duval-Carrié began painting in Montreal, in 1974, he is a thoroughly Haitian artist in the → Hyppolite lineage. Oils present imaginary and colorful episodes from the fraught history of his native island and its liberation hero Toussaint-L'Ouverture (shown crushing a snake's head, 1988) somewhat in the style of fellow Haitian Philomé Obin (1892–1977). Duval-Carrié has also produced enigmatic multiple-figure paintings alluding to voodoo and slave groups (perhaps modern versions of the macaroons who were Toussaint's problematic allies in the freedom struggle). He exhibits on Haiti, in France, and in Canada. D.R.

Earth art. → Land art

EAT (Experiments in Art and Technology). Organization founded in early 1967, by figures includ-

ing → Rauschenberg, to encourage the collaboration of artists and engineers; its formation followed a series of "nine evenings of theater and engineering" in New York. Initially financed by large corporations, EAT's aim was to place technology at the service of artists. Members included Gyorgy Kepes, → Cage, and R. Buckminster Fuller; its scope later extended to California and other parts of the US. The exhibition "Some More Beginnings" (Brooklyn Mus., 1969) included examples of → Kinetic Art, "Liquid Art," and → Environments. EAT was responsible for the Pepsi-Cola pavilion at Expo '70 in Osaka but declined during the decade. D.R.

Bibl.: EAT Pavilions, 1973

Eat Art Gallery. → Spoerri

École de Paris (French = School of Paris). A term that covers a number of styles without being precisely definable. It refers to French and non-French artists living in Paris during the first half of the 20th century, specifically painters (*peintres maudits*) who had settled in the artists' quarters of Montmartre and Montparnasse in the period from 1905 to 1925. These included → Chagall, → Foujita, → Kisling, → Modigliani, → Pascin, → Soutine and → Utrillo. Despite differing backgrounds and artistic approaches, they all painted in a style that could loosely be described as Expressionist, distancing themselves from → Cubism (1910–15). In the 1920s artists such as → Miró and → Ernst came to Paris, and → Fauvism became the dominant style there followed by → Surrealism in the 1930s. After the war, the term Nouvelle École de Paris gained currency, referring to artists such as → Bazaine, Maurice Estève (1904–), and → Manessier, who were moving in the direction of abstract art, as well as others who wanted to explore more traditional styles, e.g. → Cubism and → Fauvism. K.S.-D.

Bibl.: Nacenta, École de Paris, 1960 · Harambourg, École de Paris, 1993

écriture automatique (French = automatic writing). Technique devised by the Surrealists (→ Breton) as a means of "recording" texts, drawings, and pictures created subconsciously, for example in a (sometimes drug-induced) trance. For Breton, it was the spontaneous expression of internal

Max Ernst, *Long Live Love* or *Charming Countryside*, 1923, Oil on canvas, 131.5 x 98 cm, The Saint Louis Art Museum

processes of stimulation, with no attempt to control or correct them. (See → automatism.) H.D.

Bibl.: Bonnet, 1975

Eddy, Don. *1944 Long Beach, California. American artist working in the area of → photorealism. He studied at the University of Hawaii (1965–69) and the University of Santa Barbara, California (1969–70). In 1972 he started teaching at the University of New York. In 1970 he began painting automobile parts from photographs, with vivid, gleaming chrome that appears almost unreal (*Bumper* series) and distorted reflections of the real world (*Bumper Selection IX: Isla Vista*, 1970). His *Parking Garage* series, in a similar vein, was followed in 1971 by colorful paintings of showrooms (*VW Showroom Window*, 1972), in which the combination of mirrored images in the showroom window (street, light, etc.) and the two-dimensional window display creates a visual picture puzzle of true and reflected reality. K.S.-D.

Bibl.: Fotorealismus, Brunswick, 1973 · Hinson, Eddy, 1975

Edinburgh Group. Group of Scottish painters who exhibited together in 1912–13 and 1919–21 (from 1919 under the name of the Edinburgh Group). The portrait painter Eric Robertson (1887–1941), who studied under the Symbolist John Duncan, is generally regarded as having been the head of the group. Other members included Cecile Walton (1891–1956), Dorothy Johnstone (1892–1980), William O. Hutchinson (1889–1970), and John R. Barclay (1884–1963). David Alison (1882–1955), H. A. Cameron, and W. M. Glass (1885–1965) exhibited with the group in 1912–13. Stylistically, the group did not follow a particular school, producing work which ranged from traditional realism and symbolism to modern trends. F.P.

Bibl.: Hardie, Scottish Painting, 1990

Eight, The. Group of eight American painters: → Glackens, R. → Henri, George Luks (1867–1933) (see → Ashcan School), → Shinn, and → Sloan, who painted naturalistically; and → Davies, Ernest Lawson (1873–1939), and → Prendergast, who were oriented more toward Impressionism. The group was founded in 1907 in protest at the National Academy of Design, who had rejected works by Glackens, Luks, and Shinn. The group's only exhibition, which took place in 1908 at the Macbeth Gallery, provided impetus for American art, breaking the National Academy's monopoly and paving the way for future independent exhibitions of modern art in America, notably the → Armory Show. Four members of the group belonged to the Ashcan School. H.D.

Eisenstaedt, Alfred. *1898 Dierschau, Germany, †1995 Chilmark, Massachusetts. German photographer. He grew up in Berlin. Self-taught, he started working as a freelance photojournalist in 1926 (*Berliner Westspiegel*). He worked for Pacific and Atlantic Photos (from 1928), as a portrait photographer for the Nazi regime (from 1933), and as a war reporter in Ethiopia (1935). He became famous during this period for his portraits (*Thomas Mann as Nobel Prize Winner in*

Stockholm, 1935). In 1936 he emigrated to the US, where he became a photojournalist on the newly founded *Life* magazine (more than 80 covers). His work included numerous portraits of American high society. After 1945 he visited Italy and England (VIP portrait series, 1952). One of the most influential photojournalists of his time, Eisenstaedt received numerous awards and published a number of books (*Witness to Our Time*, 1966, reprinted 1987). His portraits are sober and for the most part unemotional. F.P.

Bibl.: Eisenstaedt, 1962 · Eisenstaedt, 1978

Elementarism. Term coined by van → Doesburg to describe a variant of → Neo-Plasticism. Whereas exponents of the latter were restricted to horizontals and verticals (right angles and rectangles), Elementarism incorporated diagonals with the intention of creating dynamic tension. A manifesto of Elementarism by van Doesburg appeared in the seventh issue of the journal *De Stijl* (1926): "In opposition to the homogenous, orthogonal form of representation in natural construction, elementarism presents a heterogeneous, contrasting, labile form by means of levels which are placed at angles in relation to the static, perpendicular axis of gravity." H.D.

Elsken, Ed van der. *1925 Amsterdam, †1990 Edam. Dutch photographer. He studied at the Akademie voor Kunst en Vormgeving, Amsterdam (1934–44), and the Nederlandse Fotovaschool, The Hague (1947). Between 1950 and 1955 he lived in Paris (published *Love on the Left Bank*, 1956), where he had contacts with → Steichen. From 1955 he had a number of one-man exhibitions (Chicago, Minneapolis, Hilversum). He traveled in Africa, Japan, Southeast Asia, Mexico, and the US (1957–60). In 1960 he turned to film-making, making experimental films which are close to *cinéma vérité*. Influenced by American photographers (see → Weegee, *Naked City*, 1945), van der Elsken's approach was more direct than most prewar photographers. He took fleeting images of everyday situations, including ugly and shocking subjects. His pictures "from the street" have the effect of turning the viewer into an eye witness. F.P.

Bibl.: Elsken, 1991

empaquetage (French = packaging). Term that describes the packaging of objects or buildings in paper, foil, and other materials to stimulate the viewer's perception and to open new ways of perceiving and thinking. Today this term formulated by → Man Ray applies among others to the works of → Christo. H.D.

James Ensor, *The Entry of Christ into Brussels*, 1887–88, Oil on canvas, 258 x 431 cm, Musée Royal des Beaux-Arts, Antwerp

Ensor, James. *1860 Ostend, †1949 Ostend. Belgian painter, etcher, and writer. He studied at the academies in Ostend and Brussels (1877–80). He was a co-founder in 1883 of the Neo-Impressionist group Les → Vingt in Brussels and in 1901 of the Libre Académie de Belgique. In 1926 he exhibited at the Venice Biennale and in 1939 had a retrospective in Paris. His early work was Realist and then Impressionist in style. In 1876 he began painting dark-toned landscapes and portraits, often with dramatic light effects. In 1880 he returned to Ostend, where he produced the majority of his works, which consisted of still lifes, portraits (*Willy Finch*, 1880), urban landscapes, interiors, and genre scenes. They are characterized by distorted forms, contrasts between light and dark, dissolved contours, and, on occasion, the application of paint in thick layers. His series of bourgeois interiors produced in 1881–82 (*Afternoon in Ostend*, 1881) are painted in a strong, deep-toned Impressionist style which Ensor abandoned in about 1883. Adopting a Symbolist idiom influenced by the work of Bosch, Goya, and Brueghel the Elder, he painted somber, fantastic, nightmarish scenes peopled by masked figures (*Death and the Masks*, 1888), skeletons, harlequins, and demons. These works conjure up a tragic, absurd world imbued with despair. From about 1886 he began using increasingly bright and expressive colors in garish contrasts, dominated by yellow and red.

Ed van der Elsken, *Durban, South Africa*, 1959–60, Gelatin silver (vintage) print, 23.9 x 30.2 cm, Museum Ludwig, Cologne

Ensor's work, including his etchings, deal with the problematic of human existence and the unresolved conflict between the individual and collectivity, a theme which he addressed in self-portraits (*Selbstbildnisse mit Blumenhut*, 1888) and in his famous *The Entry of Christ into Brussels* (1887–88; the middle cross is carved with "Ensor" instead of "Inri"). His major works were created between 1888 and 1892. After 1900 he lost some of his visionary power and started to repeat old themes. Ensor, who is today considered one of the pioneers of → Expressionism and → Surrealism, did not find public recognition until late in life. He was made a baron in 1929. K.S.-D.

Bibl.: Lesko, Ensor, 1985 · Tricot, Ensor, 1992 · Hostyn, Ensor, 1996

environment. An artwork consisting of a three-dimensional space which the viewer can enter. The concept of the environment – the inclusion of the viewer in the artwork, the merging of reality and art, inside and outside – first appeared in manifestos by → Kandinsky and the → Futurists. The earliest examples were → Schwitters' *Merzbau* (begun in the 1920s), the Proun rooms by → Lissitzky, and the Surrealist exhibitions of the

environment, George Segal, *The Restaurant*, 1964–66, Plaster, wood, chrome, laminated plastic, chipboard, and fluorescent light, 238 x 366.5 x 244 cm, Walker Art Center, Minneapolis

1930s. Marcel → Duchamp's → ready-mades paved the way for installations in public areas, culminating in his only major environment, the posthumously installed *Étant donnés: 1° La Chute d'eau, 2° Le Gaz d'éclairage* (1946–66). → Pop artists in the 1960s sought to connect everyday culture, art, design, and architecture, and the most important environments were created during this time, notably those by → Kienholz, whose bizarre contemporary tableaux combine role play, sexual taboos, and social criticism.

Paul Thek and Bruce Connor (see → Funk art) were two of the principal exponents of provocative environmental art, which led to the socially critical Hyperrealism of → Hanson, → De Andrea, and John Davies. → Oldenburg created huge "soft sculptures" and environments (*The Store*, 1965) that were biting satires on the American way of life. Unlike the corrosive → assemblages by Kienholz, George → Segal's environments, made from found objects and plaster figures, were poetic metaphors of specific everyday situations. The socially critical discourse of Environmental art has been further developed in the work of artists such as → Nauman and Jimmie Durham, while a more playful, technical variant has recently come to prominence in the contemporary art scene. H.D.

Bibl.: Henri, Environment, 1974 · Popper, Art, 1975 · Claus, Kunst, 1996

Epstein, Jacob. *1880 New York, †1959 London. American-born sculptor who grew up in New York. He studied at the → Art Students League of New York (1894–1902) and the Académie Julian, Paris. In 1905 he settled in London. Epstein received his first major commission in 1907, to make 18 statues for the façade of the British Medical Association building. Other public and private commissions followed, such as the Assyrian-inspired tombstone for Oscar Wilde's grave (Père-Lachaise Cemetery, Paris). His human figures were influenced by the classical formal language of the Renaissance and Rodin. Between 1913 and 1918, under → Brancusi's influence, he worked in a more abstract style. His best-known work of this period is *The Rock Drill* (1913), which synthesizes mechanist power and atavistic drives with a metaphor for the act of sculpting. He then reverted to more traditional representational forms. His large postwar commissions included the stone *Lazarus* (1947–48) at New College Chapel, Oxford, and *St. Michael and the Devil* (1956–58) at Coventry Cathedral. He created numerous busts of famous sitters, often in bronze (e.g., Joseph Conrad, Winston Churchill). In addition to his sculpture, he did many drawings and watercolors. He was knighted in 1954. I.N.

Bibl.: Silber, Epstein, 1986 · Friedman, Epstein, 1987 · Gardiner, Epstein, 1992

Erbslöh, Adolf. → Neue Künstlervereinigung München

Erfurth, Hugo. *1874 Halle, Saale, †1948 Gaienhofen near Constance. German photographer. He studied at the Kunstakademie, Dresden (1892–96), learning photography at the same time. In 1893 he became a theater photographer, setting up his own photographic studio in 1906. In 1919 he founded the Society of German Photographers. Erfurth, a key figure in German photography, specialized in high society portraits (including artists). In 1907 he moved from a conservative approach to a more individual style. F.P.

Bibl.: Erfurth, Cologne, 1992

Ernst, Max. *1891 Brühl near Cologne, †1976 Paris. German-born painter, printmaker, writer, and poet. He became an American citizen in 1948 and a French citizen in 1958. He studied philology, philosophy, and psychology in Bonn (1910–14). In 1911 he met → Macke, and exhibited with the Rhenish Expressionists in Bonn and at the Erster Deutscher Herbstsalon in the → Sturm Gallery. He met Guillaume Apollinaire, R. → Delaunay, and → Arp, and had contacts with

Max Ernst, *Angel of the Hearth*,
1937, Oil on canvas,
114 x 146 cm, Private Collection

→ Grosz and → Heartfield. His experiences during the war pushed his intellectual skepticism to anarchic, Dadaist confrontation. In 1919, together with → Baargeld he established the Cologne → Dada group and made himself unpopular with the church and the state as a result of his writings for *Der Ventilator* and *Schammade* (his 1919 and 1920 exhibitions were closed down). In 1920 he took part in the "Erste Internationale Dada-Messe." Between 1919 and 1926 his work was inspired by de → Chirico's → Pittura Metafisica. He had close contacts with → Breton and the poet Paul Éluard. In 1922 he moved to Paris and published the collage novels *Répétitions* and *Malheur des Immortels* in collaboration with Éluard. In 1925 he began experimenting with → collage and → frottage. In 1924 he supported Breton's *Manifeste du Surréalisme* and he remained an important member of the Surrealist movement until 1938. His collage novels *La Femme 100 Têtes* (1929) and *Une Semaine de bonté* (1934) became incunabula of Surrealism, and he worked on Buñuel's film *L'Age d'or* (1930). In 1934 he met → Giacometti in Switzerland and subsequently made his first sculptures. In 1937 his *Belle Jardinière* was shown at the exhibition of "Degenerate Art" in Munich. After his internment in France (1939), he fled to the US (1941), where he married Peggy Guggenheim and later Dorothea → Tanning, with whom he moved to Sedona, Arizona in 1946. In 1951 the first German retrospective of his work was held in Bühl. In 1953 he returned to Paris and the following year he won the painting prize at the Venice Biennale. In 1963 he and Tanning moved to the South of France.

Ernst's use of collage – one of the defining pictorial media of the 20th century, in which different levels of reality clash to create "poetic spark" – went far beyond Surrealism. Of all the techniques that he used – including decalcomania, frottage, grattage, and paint – it was collage that gave most powerful expression to Ernst's passion for coincidental metaphor. Collages for him were a vehicle for tracking subconscious, suppressed impulses that are submerged in the "surreal" empire of mythology, libido, sexual urges, and taboo, enabling them to take shape, like hallucinations, on the picture surface. His cryptic titles are an integral part of the insoluble conundrum of each picture's meaning (evident in his use of the name "Loplop," a birdlike creature that can change its shape). His search for inner imagery originated in the work of Romantic artists such as Caspar David Friedrich, whose paintings he admired and created Surrealist equivalents of. Ernst's importance in 20th-century art rests on his spirit of unceasing experimentation and his various achievements as the urbane strategist of the art of collage, to which he brought new and surprising effects, as the inventor of a number of "semi-automatic" techniques that stimulate the imagination, and as the creator of a poetically animated, dreamlike cosmos. W.S.

Bibl.: Spies, Ernst, 1986 · Spies, Ernst, 1991 · Spies, Ernst, Collages, 1991 · Spies, Ernst, 1999

Erró (real name Gudmundur Gudmundsson). *1932 Olafsvik, Iceland. Icelandic painter. Since 1985 he has lived in Paris, on Formentera, and in Bangkok. He studied at the academies in Reykjavik and Oslo (1949–53), and in Florence (fresco and restoration, 1955–57). Through Jean-Jacques Lebel, he came into contact with the → Surrealists, and with American and European → Pop artists. In 1958 he moved to Paris, where he joined the Nouvelle Figuration group (→ New Figuration) at the beginning of the 1960s. The group was dedicated to producing socially committed art that was intended to contribute to the process

of reform. Erró's themes revolve around cultural, political, and social conflict, and the confrontation between quotation and convention. Using techniques from Pop art and → Photorealism combined with art-historical quotes, he attempts to demythologize artistic clichés. F.P.

Bibl.: Erró, Catalogue, 1978/86

Escher, M(aurits) C(ornelis). *1898 Leeuwarden, †1972 Hilversum. Dutch engraver and etcher. After studying at the School voor Kunstniverheid (Applied Arts) in Haarlem (1919–22), Escher lived in Italy until the mid-1930s, honing his astonishing graphic skill. Tonal change in a pencil sketch, lithography, or wood-engraving can make a pond-bed and surface, fish and the reflections above coalesce (*Three Worlds*, 1955); dual-purpose outline groups of griffins turn from "real" to "casts" and thence to "flat" drawings by passing through the surface of a *Magic Mirror* (1946). Perspective puzzles were inspired by Baroque geometry and a mathematical system based on infinite regress and the Möbius strip (e. g., an indefinitely ascending courtyard staircase). Such images play with the conflict between intellectualized decoding of geometry and instinctive responses to visual cues. His work reproduces well and became popular in the 1970s, coinciding with a renewed interest in *trompe-l'oeil* and graphic imagery – a development not unconnected with the burgeoning importance of LP cover design. D.R.

Bibl.: Escher, 1976

Esprit Nouveau, L'. Periodical published in Paris by → Le Corbusier and → Ozenfant between October 1920 and January 1925 to disseminate the ideas of → Purism. However, it also contained a wide range of general contributions on contemporary art as a whole. Contributors included Roger Bissière (1886–1964), → Breton, → Cocteau, the poet Max Jacob, → Léger, → Lurçat, writer Blaise Cendrars, and composer Erik Satie. H.D.

Bibl.: Will-Levaillant, Esprit Nouveau, 1975

Estes, Richard. *1932 Kewanee, Illinois. American painter and printmaker living in New York and Maine. He studied at the Art Institute of Chicago (1952–56). In the late 1960s Estes began painting in a → Photorealist style. He works from photographs, although these are just an aid. Clever composition, great precision, subtle use of light and shade, and mirror effects give his highly skilled works a dense, highly aesthetic, and suggestive hyperreality. His preferred subjects are the façades, arcades, streets, store windows, stretch limousines, and telephone booths of New York, together with surprising panoramic views of Venice, Paris, Rome, London, and Barcelona. L.Sch.

Bibl.: Meisel, Estes, 1986 · Arthur, Estes, 1993

Euston Road School. British art movement. In late 1930s England, a number of painters – reacting to the lessons of → Sickert – were turning away from abstractionism and → Surrealism to a more relaxed style centered on urban themes. Many such artists were associated with the School of Drawing and Painting set up in London in 1937, including → Rogers, → Pasmore (whose style was to evolve), and, the chief exponent, → Coldstream. The critic Clive Bell first used the name in 1938, shortly after the School moved into premises on the Euston Road. Their art, in varying ways, espoused a tempered → social realism (Coldstream briefly worked on the Mass Observation Project in 1938), and employed a mellow, even dark, palette conveying naturalistic cityscapes, but not neglecting interior work. Other artists of the School, which closed after a final 1941 exhibition in the Ashmolean Museum, Oxford, included Lawrence Gowing (1918–), Graham → Bell, and William Townsend (1909–73). D.R.

Evans, Frederick H. *1853 London, †1943 London. British photographer. Originally a bookseller, he began to teach himself photography in 1883, initially taking pictures of landscapes and then buildings. Until World War I he was a leading photographer of English and French cathedrals. In 1905 he worked for *Country Life* magazine, producing a series of pictures of English vicarages and French châteaux (*Twenty-Five Great Houses of France*). His architectural photographs are highly artistic and poetically romantic. He also took portraits (*Aubrey Beardsley*, 1894) and wrote a number of essays on photography as an art form. In 1900 he became a member of The Linked Ring guild of photographers. F.P.

Bibl.: Hammond, Evans, 1992

Walker Evans, *Subway Portrait, New York*, 1938–40, Gelatin silver print, 11 x 13 cm

Evans, Walker. *1903 Saint Louis, Missouri, †1975 New Haven, Connecticut. American photographer. After studying literature in Paris (1926–27), he took up architectural photography in 1928 (he was self-taught), becoming freelance in 1935. From 1945 to 1965 he was an associate editor of *Fortune* magazine and between 1964 and 1974 he taught at Yale University. Evans captured both the mundane and the unusual in America's varied regional cultures. Between 1935 and 1945 he recorded social deprivation on the streets, in the subway, and in rural areas. He published several books of photographs, including *American Photographs* (1938) and *Let Us Now Praise Famous Men* (with James Agee, 1941). From 1940 he experimented with photo series and sequences, and in 1950 he started photographing industrial areas in North America. Walker's passionately realist work was an important contribution to the

tradition of "straight" photography and his pictures had an enduring influence on postwar photography. F.P.

Bibl.: Szarkowski, Evans, 1971

Evergood, Philip. *1901 New York City, †1973 Bridgewater, Connecticut. American painter. After attending the Slade, London (1921–23), and the → Académie Julian (1924–25), Evergood returned to New York in 1931. Incorporating a committed element of → social realism (*Through the Mill*, 1940), his canvases combine an inclination to the surreal (*Lily and Sparrows*, 1939) with an outward-focusing → Expressionism and an → Ensor-like treatment of the crowd. Though his work is similar to – if less-single minded than – that of → Grosz (a 1998 exhibition at Forum, New York, juxtaposed the two artists perhaps unfairly), less fraught contemporary American themes also surface (*Music*, 1933/38). In the 1950s this softer tendency resulted in less hotly colored canvases resembling → Buffet or even → Laurencin. Evergood enjoyed a major retrospective at the Whitney in 1960. D.R.

Bibl.: Taylor, Evergood, 1987

Export, Valie. *1940 Linz. Austrian multimedia artist. She studied design at the Textilfachschule in Vienna and then worked in film. In 1966 she designed the VALIE EXPORT logo. In 1970 at the *Body Sign Aktion Tattoo* she had a garter tattooed (as an attribute of her independent femininity), which she subsequently used as a trademark. In 1977 she took part in Documenta 6 and in 1980 she represented Austria at the Venice Biennale. Since 1995 she has been teaching multimedia and Performance art at the Hochschule für Medien in Cologne.

Export has influenced a number of artists of the younger generation, such as → Trockel and → Rist. She was a co-initiator of feminist performances, developing her own artistic approach in the context of → Vienna action art. In 1968 she started performing "feminist body actions" such as the tap-and-touch cinema, in which she wore around her upper body a large box with a curtain through which she allowed her breasts to be touched. Export is also famous for her Conceptual photography of the 1970s and more recently for her digital photographs (*Frau mit Hochhausarm*, 1989). In the 1980s she made feature-length films and videos about female writers, leading in recent years to large-scale multimedia installations. M.A.

Bibl.: Export, Reale, 1987 · Export, 1992 · Export, 1997

Expressionism. In its broadest sense, the term "expressionist" can be applied to any subjective artistic statement that deviates from academic or classical standards and expresses the inner experience of the artist at the moment of creation (see van Gogh in → precursors, → Pollock, and → Abstract Expressionism). More specifically, it refers to the movement that emerged in Germany at the beginning of the 20th century, championed by Herwarth Walden and the → Sturm Gallery, which provided a platform for Expressionist painters. The movement began with the founding of Die → Brücke in Dresden in 1905, peaked with activities of Der → Blaue Reiter and the Sturm group just before the outbreak of World War I, and declined in the 1920s, to be replaced by the neoclassical tendencies of the → Neue Sachlichkeit.

German Expressionism was more an expression of tension, contradiction, and conflict rather than a formally definable style and the movement extended beyond painting, spreading to film (Murnau), drama (Carl Sternheim, Georg Kaiser), and poetry (Jakob von Hoddis, Georg Heym). Its influence can also be seen in Bruno Taut's plans to cover the Alpine peaks with glass cities, in the general passion for jazz, vaudeville, free dance, and boxing, as well as the numerous esoteric circles bound up with healing and apocalyptic visions. The common denominator for these various facets of the movement lay in the rupturing effect of modern art at the beginning of the 20th century, which shattered the old order and blasted open the fossilized norms of art. The spiritual foundations of the movement were provided by the Dionysian vitality of Nietsche's writings and Bergson's philosophy of the *élan vital*, as well as Einstein's theory of relativity and quantum physics. The roots of the movement lay in the introspection of Romanticism, and its most extreme manifestations led to a glorification of war, from the ashes of which the "new man," it was hoped, would rise up like

Valie Export, *Tap-and-Touch Cinema*, 1968, Performance art in Vienna

Expressionism, Wassily
Kandinsky, jacket design for
the *Almanac of Der Blaue
Reiter*, 1911, Watercolor ,
Lenbachhaus, Munich

Expressionism, Ludwig
Kirchner, woodcut for the
Chronicle of Die Brücke, front
cover, 1913, Black woodcut
on red paper, 45.7 x 33.2 cm,
E. W. Kornfeld, Bern

a phoenix. It is possible to distinguish two distinct currents in the movement: that of the essentially Romantic and metaphysical work produced by the Munich-based artists, who revered art as the expression of the spiritual (Blaue Reiter, → Kandinsky), and the less mystical Expressionism of exponents in Dresden and Berlin (Die Brücke). The Expressionists deliberately disregarded academic technical standards, preferring to emphasize the inevitability of artistic expression. This led to a revival of the woodcut, the preference for "alla prima" painting, the application of brilliant, pure colors in complementary contrasts (→ Nolde), the widespread use of staccato brushwork to heighten physical tension (→ Kirchner), summary drawings that resembled caricatures (Die Brücke, → Kokoschka), and the Cubism-inspired spatial constriction and deformation of the composition (› Meidner). Themes ranged from social criticism to nudes in paradisical settings (pictures of the Moritzburg Lakes by Die Brücke), and from Upper Bavarian landscapes (Der Blaue Reiter) to crystalline animal pictures (→ Marc). Other elements which influenced the work of the Expressionists included their interest in folk and non-European art, and their fascination for the modern city, the realm of grandeur and decadence, ecstasy, and fear (→ Macke, Kirchner, → Heckel, and Meidner). W.S.

Bibl.: Selz, Expressionism, 1957 · Gordon, Expressionism, 1987 · Dube, Expressionists, 1988 · Weinstein, Expressionism, 1990

Exter, Alexandra Alexandrovna (née Grigorovich). *1882 Belestok near Kiev , †1949 Fontenay-aux-Roses near Paris. Russian painter and stage designer. She studied at the Kiev School of Art (graduated 1906) and then at the Académie de la Grande Chaumière, Paris (from 1908). Between 1909 and 1914 she made a number of trips to Paris, Italy, the Ukraine, and Russia. She had contacts with the Cubists (→ Picasso, → Braque, and the writer Apollinaire) and the Futurists (→ Marinetti and → Puni). The early part of her career (1917–22) was spent in Odessa, Kiev, and Moscow. In 1924 she emigrated to France, eventually settling in Fontenay-aux-Roses (from 1928). Exter was one of the most important abstract painters of the Russian avant-garde, participating in the Cubist, Futurist, → Constructivist, and Productivist movements. She was also the most radical stage designer of the immediate post-Revolutionary period. Her most original work in this sphere was done for the Kamerny Theater in Moscow, where she created complex sets with Constructivist blocks of color. She also produced graphic designs for books (e. g., on Picasso) and Futurist writings. Exter settled in France in 1924. K.S.-D.

Bibl.: Nakov, Exter, 1972

Fabre, Jan. *1958 Antwerp. Belgian Conceptual and performance artist, living in Antwerp. Studied in Antwerp at the Art Academy and the Institute of Arts and Crafts. His early works already demonstrated an overall artistic approach which

combined drawing, painting, object, and space. Towards the end of the 1970s Fabre developed the concept of *Blue Hour* which, since then, has been central to his work: fabrics, glasses, furniture, as well as complete installations, are infused throughout with a melancholy blue. In his plays, which he created from 1980 onwards, he is simultaneously author, actor, director, and stage and lighting designer. This inclination towards → Gesamtkunstwerk has culminated in poetic, mysterious operas such as *Sweet Temptations*, 1992 and *Glowing Icons*, 1998. J.J.

Bibl.: Fabre, 1990 · Romero, 1990 · Fabre, 1992

Fabro, Luciano. *1936 Turin. Italian → Conceptual artist, living in Milan since 1959. Self-taught, he took part in the Documenta exhibitions 5, 7, and 9 (1972, 1982, and 1992). His early work belongs to → Arte Povera. In the 1960s, influenced by Lucio → Fontana and → Manzoni, he created sculptures from everyday objects, with shapes based on elementary geometric forms (circles and squares). The *Tautologies* series (1968) can be regarded as a programmatic reflection on art. In the *Italie* series (1968–75) he reproduced an outline map of Italy in hide, glass, metal, and other materials. In the 1980s, using simple materials, he made → installations and → environments which often had a fairytale quality. J.J.

Bibl.: Fabro, Edinburgh, 1987 · De Sanna, Fabro, 1996 · Fabro, Paris, 1996

Fahlström, Öyvind. *1928 São Paulo, †1976 Stockholm. Swedish collage and object artist, representative of Narrative Figuration. Lived in Sweden from 1939 (moving to New York in 1961), and studied art history and archeology in Stockholm (1949–52). Fahlström developed a method of painting based on compositional clichés from comic strips. From 1962 he added moving parts and components (cut out of steel or painted plastic), attached magnetically or by hinges, thus turning his paintings into collages which could be added to or altered (*Sittings* series). Fahlström's work was closely related to his militant activism against e.g. war, imperialism, and the atomic industry (e.g. *Pentagon Puzzle*, 1970). He also worked in the fields of theater, poetry (*Manifeste pour une poésie concrète*, 1953), journalism, and film. K.S.-D.

Bibl.: Fahlström, Paris, 1980 · Fahlström, Valencia, 1992

Lucio Fontana, *Concetto spaziale, La Fine di dio*, 1964, Oil, tears, holes and sgraffito on canvas, 178 x 123 cm, Private Collection, Milan (see p. 123)

Fairweather, Ian. *1891 Bridge of Allan, †1974 Brisbane. Painter of Scottish origin. He studied in The Hague and London (1918–24) and lived in China, the Philippines, and India before settling on Bribie Island, northern Australia, in 1953. In his landscapes and pictures of figures, he was inspired equally by Chinese calligraphy and the art of the Aboriginals, successfully combining both influences to create a personal style. Aiming at ever greater freedom in coloring, his works were initially marked by → Post-Impressionism. Later he experimented with elements of → Cubism, and finally achieved an impressive concentration in a series of abstract gray meditative pictures (*Monastery*, 1961). L.Sch.

Bibl.: Bail, Fairweather, 1981 · Allen, Fairweather, 1997

Fantastic Realism. Artistic movement formed in Vienna in the years following World War II under the influence of the Saarbrücken painter Edgar Jené. Jené had lived for a long time in Paris and had been an advocate of → Breton's ideas in Vienna (in 1948 Paul Celan produced an excellent small monograph on Jené). One of its first meetings was held in the Austrian section of the International Art Club which was dominated by → Gütersloh and where, at that time, the young avant-garde from various stylistic genres congregated. Apart from the older member, Rudolf Hausner (1914–1995), the inner circle of this widespread and much debated movement of the 1950s and 1960s also included: Wolfgang Hulter (1928–), Erich Brauer (1929–), and Anton Lehmden (1929–), as well as Ernst Fuchs (1930–), all of whom were studying with Gütersloh at the Vienna Akademie der Bildenden Künste. They were, however, also pursuing their real interests by studying the Old Masters in the Akademie's gallery (Hieronymus Bosch), or at the Kunsthistorisches Museum where they were attracted particularly to the work of Pieter Breughel. At first known as the "Vienna Surrealists" they later became known as the "Vienna School of Fantastic Realism," a name suggested by the critic Johann Muschik. They differed from the Breton-inspired Surrealists in their more pronounced inclination towards the ideas of Sigmund Freud – especially his interpretation of dreams – and in their consciously imitation of an "Old Masterly" style of painting (which might be said to resemble the work of → Dalí). As far as a general link between the painters can be detected – they were very different in temperament and use of motif – it is clear that they all attempted to submit the "irrational" world of the human subconscious to a rationally ordered analysis, thereby controlling irrational phenomena. Their foregrounding of the stylistic methods of the Old Masters, as if addressing a contemporary issue, is convincing evidence of this general theme. From the beginning the Vienna School of Fantastic Realism was criticized for its "literary" tendencies, and later for its inclination towards unrestrained commercialization.

Fautrier, Jean. *1898 Paris, †1964 Châtenay-Malabry. French painter. From 1909 to 1917 he lived in London, studying at the Royal Academy and Slade School, and then moved to Paris. Between

Jean Fautrier, *Tête d'otage*, 1944, Oil on paper/canvas, 40.5 x 33 cm, Private Collection

sion. Though critics and public reviled the movement, it was basically the end result of Impressionism, and particularly → Neo-Impressionism (→ divisionism, Seurat). · The Fauvist style originated in Collioure on the Côte d'Azur, where Matisse, Derain, and for a time Vlaminck painted in unified, highly simplified shapes and sharply clashing color contrasts. Following the example of Van Gogh (see → precursors), these color contrasts were intended to fuse the impression of nature with the greatest possible expression of feeling. Gauguin (see → precursors) and the painting of the → Nabis also reinforced the belief of the young painters that intensity of expression could be obtained by intensifying color and simplifying form. Contacts with the German Expressionists (Die → Brücke, Der → Blaue Reiter) revealed less common ground, with differences in conception, particularly with regard to the abolition of symbolic content and social involvement. Fauvism was in its prime between 1904 and 1907. Thereafter the painters went their separate ways. The new model was provided by

Fauvism, Henri Matisse, *(Portrait of Mme Matisse,) The Green Line*, 1905, Oil on canvas, 40 x 32 cm, Statens Museum for Kunst, Copenhagen

1934 and 1939 he stopped painting, but took it up again on his return to Paris in 1940. In the 1920s he also started to produce sculptures, mostly figures and heads. Fautrier, who had already begun to paint in a gestural manner in the 1920s, is regarded as the precursor of → Art Informel, although he thought of himself as a realist rather than an abstract artist. At the beginning of the 1940s he began to apply impasto paint with palette knife and spatula to a ground of paper and plaster, to which he added colored powder. During the war he witnessed the shooting of hostages, an experience which inspired the series *Otages*, in which suffering is visualized in very abstracted heads. At the end of the 1940s he developed a new type of work – the *Originaux Multiples* – printing a basic drawing on a large number of canvases, which he completed by hand. In 1956 he painted the series *Têtes de partisans* in response to the invasion of Hungary by Soviet troops. During this period – as in the early work – depictions of objects and nudes continued to play an important role, as did series of structures and symmetrical compositions. He produced pictures with unified organic shapes alongside works with gestural, scriptural, and geometric elements, often in pastel colors. I.H

Bibl.: Fautrier, Paris, 1989 · Peyré, Fautrier, 1990

Fauvism. Movement in painting which emerged at the beginning of the 20th century and was centered on a group of French artists, notably → Matisse, → Marquet, → Manguin, → Camoin, Jean Puy (1876–1960), Louis Valtet (1865–1952), → Dufy, → Derain, → Friesz, and → Vlaminck. The name *fauves* (wild beasts) was applied to them during the → Salon d'Automne of 1905 by the critic Louis Vauxelles, who, on seeing a Renaissance-style sculpture in the middle of the gallery, exclaimed, "Donatello au milieu des fauves" ("Donatello among the wild beasts"). The members of the group were united in their shared artistic ideals: the use of pure color, simplification of line, and spontaneity of expres-

Fauvism, Albert Marquet, *Louvre Waterfront and the Pont-Neuf*, Paris, Oil on canvas, 60 x 71 cm, State Hermitage Museum, St Petersburg

Cézanne (see → precursors), whose commemorative exhibition in 1906 set new standards. → Braque, in particular, who had made a brief contribution to Fauvism (*L'Estaque*, 1906), once again shifted back to solid volumes in a quest for plasticity and deliberate design (→ Cubism). H.D.

Bibl.: Elderfield, Fauvism, 1976 · Oppler, Fauvism, 1976 · Freeman, Fauvism, 1989

Federal Art Project. The FAP was the first major US government project devised to give material assistance to visual artists, and ran from 1935 to 1943. Artists were remunerated when designs were accepted for public commissions or if they were felt deserving of relief (amounting to $23.50 a week). (With similar systems to aid the other arts, the arrangement was collectively known as the Federal Arts Projects.) Distinct from the Treasury Section of Painting and Sculpture – the Public Works of Art Project, and Treasury Relief Art Project – the FAP was part of the Works Progress (or Projects) Administration (WPA) and an aspect of F. D. Roosevelt's New Deal. More than a hundred community art centers and galleries were opened across the country. The project was not prescriptive in its funding allocation and employed more than five thousand artists at its height in 1936.

The FAP's influence on subsequent American movements was preponderant, though there was in truth no "FAP style" – primarily due to the independent spirit of its national director, the museum curator and American folk art scholar Holger Cahill (1887–1960). Around 2,500 murals and 18,000 sculptures, as well as more than 100,000 easel paintings, were produced under its auspices. D.R.

Bibl.: Meltzer, WPA, 1976

Feininger, Andreas. *1906 Paris, †1999 New York. American photojournalist and architect, son of Lyonel → Feininger. He studied architecture at the → Bauhaus in Weimar (1922–25) and the Staatlichen Bauschule in Zerbst (1925–28). He was subsequently employed by → Le Corbusier in Paris, before emigrating to Stockholm in 1933 where he worked as a freelance photographer. The following year Feininger set up his own photographic studio, specializing increasingly in architectural and industrial photography. In 1939 he moved to New York, where he became a staff photographer for *Life* magazine (1943–62), exerting a formative influence on its appearance. The basic principle underpinning his work is that of clarity of structure and message. In addition to views of architecture and machines, his subjects included elements from nature, such as shells, stones, or plants. C.W.

Bibl.: Feininger, Hamburg, 1981 · Feininger, Photographer, 1986 · Feininger, Warum, 1997

Andreas Feininger, *Hudson River Waterfront*, 1942, Gelatin silver print, 61 x 50.8 cm, Institut für Kulturaustausch, Tübingen

Feininger, Lyonel. *1871 New York, †1956 New York. American painter, graphic artist, and caricaturist. He studied at the Berlin Kunstakademie

Lyonel Feininger, *Marktkirche von Halle*, 1930, Oil on canvas, 100.7 x 85 cm, Staatsgalerie Moderner Kunst, Munich

(1888), was a pupil of Adolf Schlabitz, and also studied at the Colarossi Ecole d'Art in Paris (1892–93). From 1890 he worked as an illustrator for various periodicals. From 1893 to 1906 he lived in Berlin, thereafter moving to Paris, where he worked for two years as cartoonist for the *Chicago Sunday Tribune* and came into contact with the artistic circle of the Café Dôme. In 1908 he returned to Berlin and in 1913 took part in the Erster Deutscher Herbstsalon. His first one-man show took place in the → Sturm gallery (1917). From 1918 to 1926 he taught painting and graphics at the → Bauhaus in Weimar. Subsequently, he was editor of the Bauhaus books in Dessau, but had no teaching duties. He was co-founder of Die → Blaue Vier group of artists (with → Kandinsky, → Klee, and → Jawlensky). In 1932, after the closure of the Bauhaus, he moved to Berlin, then taught at Mills College in Oakland, California (1936). Following the "Degenerate Art" exhibition in 1937, he decided to move to the US permanently. He settled in New York, where at the 1939 World's Fair he created the decorations for the "Masterpieces of Art" pavilion.

Having started with lithographs and etchings, he finally turned to painting in 1906, motifs being Thuringian towns and villages, supplemented in 1907 by seascapes and sailing ships, inspired by a journey to Rügen. In Paris he met Robert → Delaunay, who, like the → Cubists, influenced his work. Through contact with the Berlin Sturm group he turned again with greater intensity to graphics, especially woodcuts, which from 1918 made up most of his graphic print work. At the Bauhaus Feininger was initially responsible for the school's printing workshop and the publication of the Bauhaus portfolios, before dedicating himself entirely to painting again after moving to Dessau. His sea pictures from this period used an oil varnishing technique which helped give them their floating transparency and crystalline clarity; Feininger declared them an attempt to connect with the fugal techniques of J. S. Bach. In 1936, after he had returned to the US, his style changed,

Lyonel Feininger, *The Ruins on the Cliff*, 1940, Oil on canvas, 48.5 x 72.5 cm, Museum Ostdeutsche Galerie, Regensburg

becoming more two-dimensional and more strongly marked by graphic elements (*Manhattan* series, 1940s). His late work moved closer to → Abstract Expressionism (*Sunset*, 1953), and he found particular inspiration in → Tobey. W.G.*

Bibl.: Prasse, Feininger, 1972 · Feininger, 1981 · Feininger, London, 1987 · Luckhardt, Feininger, 1997 · Feininger, 1998

Felixmüller, Conrad. *1897 Dresden, †1977 Berlin. German painter and graphic artist. He studied at the Kunstakademie, Dresden (1912–14), then worked freelance (1915). Between 1916 and 1928 he produced graphics for Franz Pfemfert's radical left-wing magazine *Die Aktion*. He was co-founder of the Expressionistische Arbeitsgemein-schaft (Expressionist Association, 1917) in Dresden, then of the Dresdener Sezession Gruppe (1919). In 1920, committed to social themes and contemporary issues, he went to the Ruhr area, having won the Saxon Rome Prize. Condemned from 1933 as "degenerate," from 1934 he lived in or around Berlin, moving to Tautenhain in 1944. He was Professor of Drawing at Martin-Luther-Universität Halle, from 1949 to 1961, before settling in Berlin (1962).

Throughout his career, Felixmüller was committed to the art of the figure, with an emphasis

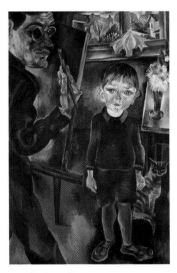

Conrad Felixmüller, *I paint my son Luca*, 1923, Oil on canvas, 115 x 75 cm, Museum Ostdeutsche Galerie, Regensburg

on portraiture. Until the mid-1920s, he worked in a politically orientated expressive realism which was derived from → Expressionism and, for a time, → Cubism. He then turned to a life-affirming art centered on a more private world, painted in a subtly coloristic manner (*Malerglück und Malerleben*, 1929). As well as producing portraits (of family, intellectuals, patrons), he painted a number of landscapes characterized by an "impressionistically refined naturalism." H.O.

Bibl.: Söhn, Felixmüller, 1977 · Söhn, Felixmüller, 1987 · Spielmann, Felixmüller, 1996

Fetting, Rainer. *1949 Wilhelmshaven. German painter living in Berlin and New York. He trained in Hanover as a carpenter and set designer, then studied at the Hochschule der bildenden Künste in Berlin (1972–77). In 1977, with Helmut Middendorf (1953–) (see → Neo-Expressionism), Salomé (1954–), and Bernd Zimmer (1948–), he co-founded the Galerie am Moritzplatz. A member of the → Neue Wilde, he has produced strongly colored, Neo-Expressionist portraits and pictures of figures (*Shower*, 1980–81), as well as townscapes featuring the Berlin Wall as the central motif. From 1984 he executed large-format paintings, creating montages on the canvas from pieces of driftwood. He also made expressive, figurative bronze sculptures, including that of Willy Brandt (1996; SPD headquarters, Berlin). J.J.

Bibl.: Fetting, Berlin, 1988 · Fetting, Copenhagen, 1996

Figuration. → New Figuration

Finlay, Ian Hamilton. *1925 Nassau, Bahamas. Scottish artist and poet. Finlay returned as a child to his family's native country, and worked for a time as a shepherd. He soon began writing and by the 1960s was one of Scotland's foremost concrete poets, also specializing in → kinetic bookwork and typographical verse. His "One-Word" poems are accompanied by a graphic illustration of a homophone. His magazine *Poor. Old. Tired. Horse* was founded in 1968. Through a plethora of media – engraved monumental stone, photographs, carved wood, poems and print work, architectural sculpture, and natural elements (trees with inscriptions) – Finlay is

Ian Hamilton Finlay, *Postcard with Robin*, 1975, Photograph, 10.6 x 15.2 cm

ROTKEHLCHEN

engaged in a solitary, almost forlorn task of discipline. His heartland combines the simplicity of toys, boats, and fish with German Romanticism, pre-Socratic philosophy, archaic orthography, and (fake) architectural history. In his work, history and outrage coalesce with prominent allusions to (though not so much imagery from) the Third Reich and the French Terror. The controversy surrounding his *Temple Garden* at Stonypath (Dunsyre, Lanarkshire) resulted in the "Little Spartan War" raged by Finlay's Free Arts Project against state funding and the Scottish Arts Council. More recent acts of pessimistic defiance include the *Inscribed Column* (1983, *in situ*, Strathclyde) on which a Saint-Just quotation reminds the deserted landscape: "The world has been empty since the Romans." D.R.

Bibl.: Abroix, Finlay, 1985 · Finlay, 1990

Fischl, Eric. *1948 New York. American painter and printmaker. He studied at the California Institute of Arts, Valencia (1970–72), and was professor at the Nova Scotia College of Art and Design, Halifax, Canada (1974–78). His first one-man exhibition was held in 1976 (Gallery B., Halifax), and he took part in Documenta 8 (1987). Fischl's realistic pictures can be seen as a provocative and voyeuristic reflection of the social neuroses of the American bourgeoisie. They are sustained by a sexual obsession tending toward hysteria. The light in which Fischl immerses his figures, who are usually preoccupied with themselves, gives them a strange intensity which transports them out of the everyday world on to a seemingly mythological plane. The conscious but sometimes contrived juxtaposition of African atavism and Western decadence invests his pictures with a fascination that oscillates between cultural pessimism and a delight in consumerism, between disgust and eroticism. W.S.

Bibl.: Whitney, Fischl, 1988 · Biletter, Fischl, 1990

Fischli & Weiss. Peter Fischli *1952 Zürich. David Weiss *1946 Zürich. Swiss photographers and installation and video artists, both living in Zürich. Fischli studied at the art academies in Urbino (1975–76) and Bologna (1976–77), while Weiss was a pupil at the Kunstgewerbeschulen in Zürich (1963–64) and Basle (1964–65). Since 1979 they have worked together, taking as their subjects things, materials, scenes, and situations central to everyday life. They bring these elements together in a way suggestive of → Dadaism, creating strange, short-lived → assemblages, → installations, and sculptures,

as well as films and videos (*Wurst-Serie*, 1979; varieties of meat and sausage presented as a mountainous landscape or a carpet store). Their small sculptures made of unfired clay, later of rubber, treat fairytale creatures and stories in an approximation of children's art. These were followed in the 1990s with videos and photographs, ("panoptic archives"), in which they recorded their travels, as well as banalities and surprises from everyday life (travel photographs of airports, 1990–91; 96-hour video installation on Swiss everyday life, 1995). Their central aim is to question commercial mass culture. The ironic, critical observation of daily life in their videos, photographs, and idiosyncratically designed sculptures and installations stimulates contemplation and amusement, fluctuating between play and seriousness, profundity and banality. I.N.

Bibl.: Frey, Fischli & Weiss, 1990 · Fischli and Weiss, Wolfsburg/Minneapolis, 1997

Fischli & Weiss, *Der Lauf der Dinge*, 1987, Installation with film props, 145 x 290 x 114 cm, Private Collection, Basle

Flack, Audrey. → Hyperrealism

Flanagan, Barry. *1941 Prestatyn, Flintshire. English sculptor and graphic artist. He lived in London until 1987 and subsequently in Ibiza. After varied studies in London, including literature, he settled on sculpture. Flanagan's early works were soft sculptures made of fabric and sand in biomorphic shapes. In the 1970s he produced small, ornate, zoomorphic stone sculptures, often full of humor (*A Nose in Repose*, 1979), as well as large metal compositions for town squares (Washington, Ghent, etc.). Since 1980 animals, particularly bronze hares with human features, have become a "trademark": they dance, sit up on their hind legs, box, and jump over bells or anvils. With a keen sense of ironic charm, this motif provides the artist with a range of bizarre formal opportunities. L.Sch.

Bibl.: Lampert, Flanagan, 1983 · Flanagan, London, 1990

Flavin, Dan. *1933 Jamaica, New York, †1996 Riverhead, New York. American conceptual and installation artist. He was a student at the New School for Social Research (1956) and studied history of art at Columbia University, New York (1957–59). He had his first one-man exhibition in New York (1961). Having started with abstract

Dan Flavin, *Untitled (for Otto Freundlich)*, 1990, Colored fluorescent tubes, each 120 x 60 cm, Museum Ostdeutsche Galerie, Regensburg

pictures, in 1961 Flavin introduced light into his work by installing lightbulbs in painted wooden boxes (*Icons*, 1961). The breakthrough into the strictly → Minimalist area came in 1963 with *Diagonal of May 25*, a revolutionary work dedicated to → Brancusi. It consisted of a 2.4 m-long fluorescent tube with a yellow light, which was fixed to the wall at an angle of 45 degrees. Just as Brancusi's *Endless Column* suggests infinity by repeating identical segments, here light shining into space emphasizes the materiality of the light fitting. From 1963 Flavin worked exclusively with standardized fluorescent tubes with variously colored lights, which he installed in different spatial situations. Despite his reduction of formal media to an absolute minimum, and his use of industrial articles and application of modular structures, Flavin did not exclude the transcendental and mythological interpretations traditionally associated with the emanation of light. From the mid-1960s he marked predetermined spatial situations, for instance the edges of floors or ceilings, with bands of light, or illuminated surfaces and corners with light. This changed the effect of the space and confused perception. In 1977 Flavin left the gallery context and began to create neon installations on buildings, as at the Guggenheim Museum, New York (1992) and for the façade of the Hamburger Bahnhof, Museum für Gegenwartskunst, Berlin (1996). H.D.

Bibl.: Flavin, Vancouver, 1969 · Flavin, Fort Worth, 1977 · Flavin, Frankfurt, 1993

Fluxus. A form of → Performance art which developed in parallel with → happenings. It is difficult to make an exact distinction with the happening – especially as some artists participated in both tendencies. With happenings, the course of events depends on the reactions of the viewers and the outcome is usually left open, whereas a Fluxus action often presented a carefully pre-arranged scenario into which the public would be integrated but had little opportunity to react. The root of the word "flux" refers to this transitory character, the constant change of ideas within – and members of – Fluxus organizations.

The beginnings of the Fluxus movement can be traced primarily to the courses on experimental composition held by → Cage in the late 1950s at the New School of Social Research in New York.

Early Fluxus artists, including → Brecht and Dick Higgins (1938–98), took part in these unconventional courses in which new music was supposed to emerge from sounds and noises. In the 1960s the movement spread to the US, Europe, and Japan (→ Vostell, → Beuys, → Kaprow, → Oldenburg). In George Maciunas (1931–) the New York Fluxus group gained an important fellow-campaigner and organizer (*An Anthology*, 1961; Fluxus Festival in Wiesbaden, 1962). Fluxus artists generally fought against theoretical formulations, however, and instead published a flood of manifestos, poems, and writings. Some of these were issued by Something Else Press, the publishing company founded by Dick Higgins in 1974, but for the most part they have disappeared as ephemeral testimony to a free form of art. Decades later the idea of Fluxus was still alive, carried on both by former participants and by younger artists, as the Fluxus revival at the beginning of the 1990s confirmed ("Fluxus Virus" exhibition, Cologne, 1992). H.D.

Bibl.: Fluxus, Wiesbaden, 1982/83 · Hendricks, Fluxus, 1988 · Kellein, Fluxus, 1995 · Friedman, Fluxus, 1998

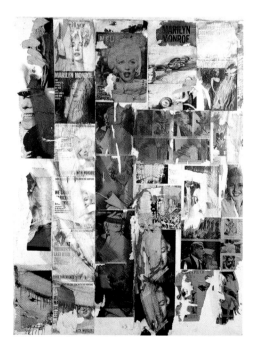

Fluxus, Wolf Vostell, *Marilyn, Idolo*, 1963, Collage and décollage, 157 x 122 cm, Museum moderner Kunst, Vienna

Lucio Fontana, *Concetto spaziale, La Fine di dio*, 1964, Oil, tears, holes and sgraffito on canvas, 178 x 123 cm, Private Collection, Milan

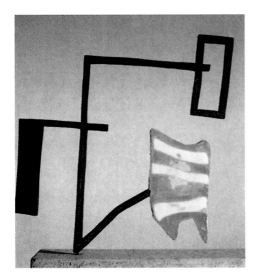

Lucio Fontana, *Scultura Astratta*, 1934, Painted iron and grafitti on painted plaster, Fondazione Lucio Fontana, Milan

Lucio Fontana, *Concetto spaziale*, 1962, ripped steel and grafitto, 97 x 197 cm, Fondazione Lucio Fontana, Milan (cf. jacket)

Fontana, Lucio. *1899 Rosario de Santa Fé, Argentina, †1968 Comabbio, near Varese. Italian painter and sculptor. In 1905 his family moved to Milan, where he subsequently studied at the Accademia di Brera. From 1922 to 1928 he lived in Argentina. From 1931 he produced figurative works, as well as abstract terracotta reliefs and painted plaster plaques. His first one-man exhibition of abstract sculptures was held in 1935. Fontana lived for a further period in Argentina (1939–46), where he issued his *Manifesto Blanco* (1946). In 1947 he returned to Milan, where he issued the first *Manifesto of Spatialism* and founded the group Movimento Spaziale. In 1949 he created his first *Ambiente spaziale* at the Galleria del Naviglio, Milan. · Avant-garde ideas and manifestos fell on fertile ground with Fontana. In 1949, with the aim of creating a synthesis of art forms (→ Gesamtkunstwerk), Fontana transformed his *Manifesto Blanco* into early → Environmental art (*Ambiente spaziale, Ambiente nero*), in which abstract shapes painted in luminous colors were illuminated by ultraviolet light in a dark space. In 1949 he began producing perforated canvases with the title *Concetto spaziale* ("Spatial Concept"). Perforated with a hole-punch and usually painted in monochrome, the pictures take → Surrealist experiments (→ frottage, → grattage) to radical extremes, and open up a new picture space. Parallel to the perforations, in the 1950s the *Pietre* ("Stones") series appeared, in which colored glass stones fill the surface of the picture in irregular patterns, thereby extending in a similar way the picture space. In 1958 Fontana began to make cuts in the monochrome surface of the canvas, developing a new, metaphysical picture space behind the gashes (*Attese su paesaggio*, from 1958; *Natura*, from 1959; *Quanta*, from 1959). At the beginning of the 1960s he combined paint with sand pastes, in which he would often make drawings or scratches. This led to the bronze objects of the 1960s (*Natura*). With their gaping cuts and hollow depressions, these represent an organic extension of his attempts to make space tangible. Fontana's artistic development came to an end with the series of works (*La Fine di dio* ["The Death of God"], from 1963) in which the oval picture supports are peppered with perforations of varying size and thickness.

Fontana's ideas and works had a strong influence on art in the 1960s (→ Arte Povera, → Zero).　H.D.

Bibl.: Crispolti, Fontana, 1974 · Fontana, Rimini, 1982 · Fontana, Lugano, 1987 · Joppolo, Fontana, 1992

Forces Nouvelles. An association of French painters which was founded in 1935 in Paris by Henri Héraut and lasted until 1939. Members included Robert Humbold (1907–62) and Jacques Despierre (1912–65); figures such as Alfred Pellan (1906–89) and Tal Coat (1905–85) also exhibited. Their aim was to revive French art through the traditions of craftsmanship and draftsmanship. Subjects from everyday life were conveyed through severe compositions and precise drawing. United in repudiating the avant-garde movements, the group's significance waned after World War II.　H.D.

Bibl.: Formes Nouvelles, Paris, 1980

Förg, Günther. *1952 Füssen. Swiss painter, sculptor, photographer, and graphic artist, living in Areuse, Switzerland. He studied at the Kunstakademie in Munich and had his first one-man exhibition there in 1980. He taught at the Hochschule für Gestaltung in Karlsruhe (1992–99), and then at the Munich Kunstakademie. His first works were gray pictures, in which he pursued → Conceptual abstract art following, for example, → Palermo and → Twombly. From 1976 he began to experiment with new supports (lead, aluminum, copper). He devised his own scale of colors and gave up Conceptual reduction in favor of a hedonistic interpretation of painting. From 1978 he produced murals, initially for private locations. His first photographic portraits date from 1982 and the following year he took photographs of the Casa Malaparte, Capri. He became involved in the Rationalist

Günther Förg, *Gardone*, 1986, Wooden case with 5 b/w photographs, 120 x 80 cm, Galerie Capitain, Cologne

architecture movement in Italy (large-format black and white architectural photographs from the early 1980s). In 1985 he produced his first sculptures (*Stele*) and in 1990 turned to oil painting on canvas. Since the 1990s his subject matter has once again included figures (→ Munch, → Baselitz). He has also produced → artists' books (e.g. on Ezra Pound, 1997). S.Go.

Bibl.: Förg, The Hague, 1988 · BDA, Förg, 1993 · Förg, Madrid, 1999

Forma. Group of Italian artists, including → Accardi, Pietro Consagra (1920–), → Dorazio, Antonio Sanfilippo (1923–80), and → Turcato. It was founded in Rome in 1947 and disbanded in 1951. As "formalists and Marxists," its members were opposed to the → Fronte Nuovo delle Arti, and the group provided an early forum for abstract art in Italy. Consagra and Turcato founded a monthly magazine, *Forma 1*, which in April 1947 published a manifesto on abstract painting. Some members of the group, including Consagra and Turcato, founded → Continuità in 1961. H.D.

Bibl.: Forma I, Venice, 1976

Foujita, Léonard-Tsuguharu. *1886 Tokyo, †1968 Zürich. Japanese – French painter. He studied at the Tokyo Academy (1906–10), and then in Korea and China. In 1913 he moved to London, before settling in Paris (→ École de Paris). He later became a French citizen (1953) and assumed the name Léonard out of admiration for Leonardo da Vinci (1959). Foujita is best known for his still-lifes and portraits, as well as his discreetly erotic female nudes. In the early 1930s he also produced numerous wall decorations and book illustrations. Foujita attempted a synthesis between Western and Eastern art, and his sensitivity to form and bright coloration create a pictorial mood reminiscent of → Rousseau. H.D.

Bibl.: Buisson, Foujita, 1987

Fox, Judy. *1957 Elizabeth, New Jersey. American sculptor and installation artist, living in New York. From 1978 he studied at Yale University, from 1979 at the École des Beaux-Arts in Paris, and from 1983 at the University of Fine Arts, New York. Her installations with life-size figures, e.g. seven figures of children in Sphinx Chapel, 1996, are reminiscent of the sculptures by → Hanson in their realism and of the photography of → Mann in their subtle eroticism. K.S.-D.

Bibl.: Johnson, 1990 · Taplin, 1994

Francis, Sam. *1923 San Mateo, California, †1994 Santa Monica, California. American painter and graphic artist. He studied botany, medicine, and psychology at the University of California, Berkeley (1941–43). He took up painting in 1944, studying at the California School of Fine Arts (1947), and then returned to the University of California to study art and history of art (1948–50). Between 1950 and 1957 he lived in Paris, where he studied briefly at the Académie (under → Léger). In 1952 he had his first one-man exhibition and took part in "Signifiants de l'informel." Between 1957 and 1958 he traveled abroad (including Mexico, Thailand, India, and Japan). From 1959 he divided his

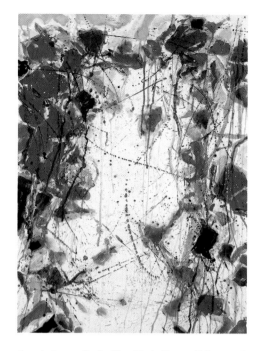

Sam Francis, *Untitled*, 1958, Distemper on paper, 75.5 x 56 cm, Merzbacher Coll., Switzerland

time between Paris, New York, Berne, Tokyo, and (from 1962) Santa Monica (which became his preferred place of residence from 1975). In 1969 he received an honorary doctorate from the University of California, Berkeley.

Francis was a representative of second-generation → Abstract Expressionism. In his large-format canvases and murals intense fields of color, touching and partially penetrating one another, are distributed across the painting surface in an → all-over manner. The drips and trickles of liquid paint are visible evidence of his gestural technique. A dark palette lightened to brilliant red, blue, and yellow tints after visits to Paris (where he was impressed by Monet's water-lily pictures [see → precursors]) and Aix-en-Provence. Color contrasts (including deep black) and the calligraphic rhythm of the brush lend the pictures lightness and transparency. The canvas is often left as an open field, energetically charged with gestural splashes and sweeps of the brush. This dynamic was consummately developed in the murals which appeared from 1959 (Chase Manhattan Bank, New York, 1959; Neue Nationalgalerie Berlin, 1969–71; Deutscher Bundestag, Bonn, 1992). In the grid pictures of the 1970s, multicolored splashes and drips cover dark grid structures. As well as paintings, Francis produced lithographs and monotypes. He realized his idea of free color form most impressively in a skyscape executed in 1966, in which five helicopters scattered streams of blue, red, magenta, yellow, and white colored pigments over Tokyo Bay. H.D.

Bibl.: Francis, Houston, 1967 · Francis, Buffalo, 1972 · Selz, Francis, 1982 · Francis, Berne, 1991

Frank, Robert. *1924 Zürich. Swiss-born photographer and film maker. Following his photographic training (1941) he produced photographic work for Gloriafilm in Zürich. From 1947 he worked in New York for *Harper's Bazaar* and between 1948 and 1953 he traveled in Europe and America. In 1950 he had contacts with → Steichen. His book of photographs entitled *Black,*

Sam Francis, *Taiaisha*, 1986, Acrylic on canvas, 397 x 681 cm, Private Collection

White and Things was published in 1952. In 1953 he gave up fashion photography, working as an independent picture journalist for *Life*, *Look*, *McCall's*, *Charm*, *Vogue*, and *Ladies' Home Journal*. During this period he became acquainted with Walker → Evans. In 1955–56 he traveled round the US on a Guggenheim grant. The resulting book, *Les Américains* (Paris, 1958; published in English as *The Americans*), remains one of the most influential books of photographs ever published. Equipped with a 35 mm camera, he captured in emotionally charged photographs the street life of America at the time of the Beat Generation (gas stations, cars, jukeboxes): these "icons of everyday life" have come to define our image of the US. With his spontaneous, intuitive method of working he creates a gestural, expressive pictorial language related to → Abstract Expressionism. In his coarse-grained black-and-white photographs whole sections remain out of focus, and thus Frank consciously foregrounds characteristics of the medium. · Between 1959 and 1972 he devoted himself primarily to film, mainly reflecting his immediate surroundings. He was a co-founder of the New American Cinema Group (1960). In the 1970s he created autobiographical collages and montages from Polaroids, photographs, and film extracts, into which were incorporated over-painting and writing. He subsequently turned to film again with *Life Dances On* (1980), *Home Improvements* (1985), and *Moving Pictures* (1994), improvised, strictly coded works which are in effect a mixture of documentary and feature film. His autobiographical book *The Lines of my Hand* was published in 1972. E.R.

Bibl.: Frank, Americans, 1978 · Frank, Lines, 1989 · Frank, Black, 1994 · Greenough, Frank, 1994 · Frank, Thank you, 1996

Frankenthaler, Helen. *1928 New York. American painter, printmaker, and sculptor, living in New York. She attended several art schools, studying under → Hofmann and → Tamayo. In the 1950s she met a number of the leading → Abstract Expressionists. She was married to → Motherwell for a while (1958–71). In one of her first abstract paintings (*Mountains and Sea*,1952) she discovered the technique of "staining," in which very thin paint is poured on to the unprimed canvas, creating a wash-like effect. This technique was taken up by Kenneth → Noland and → Louis and further developed in → Post-Painterly Abstraction. Frankenthaler remained faithful to this technique in her subsequent pictures. In the 1980s her works became calmer in mood and darker in color. She also produced etchings, lithographs, woodcuts, and ceramics. H.D.

Bibl.: Frankenthaler, Berlin, 1998

Freud, Lucian. *1922 Berlin. German-born British painter, grandson of Sigmund Freud. He emigrated to London in 1932 and became a British national in 1939. He studied at the Central School of Arts and Crafts, London (1938–42), and at Goldsmiths College (1942–43). He had the first one-man exhibition in the Lefèvre Gallery, London, in 1944, and in 1954 took part in the Venice Biennale. Freud's early works were painted in the style of → Magic Realism, with mimetic over-precision, earning him the nickname "The Ingres of

Lucian Freud, *Rose*, 1978–79, Oil on canvas, 91.5 x 78.5 cm, Sukejiro Irani, Tokyo

Lucian Freud, *Large Interior, W.IX*, 1973, Oil on canvas, 91.4 x 91.4 cm, Private Collection

Existentialism" (*Portrait of Francis Bacon*, 1952). At the end of the 1950s he developed his characteristic expressive brush style and somber, earthy colors. In contrast to → Bacon and Frank → Auerbach, Freud's tonal palette includes few bright color accents. He attaches great importance to a balanced composition which also incorporates small details harmoniously into the whole. Freud's pictures are predominantly portraits and nudes of people he knows well (mainly women), and each one is the product of months of work. The series featuring portraits of his mother from the late 1970s includes some of his finest and most psychologically sensitive works. The same precision and faithfulness to reality are found in Freud's pictures of old London houses and in his plant still lifes (*Two Plants*, 1977–80). A retrospective was held at the Hayward Gallery, London, in 1974. H.D.

Bibl.: Gowing, Freud, 1982 · Freud, Washington, 1987 · Freud, Rome, 1991–92 · Freud, New York, 1994

Freund, Gisèle. *1912 Berlin, †2000 Paris. German-born French photographer. She studied history of art and sociology in Freiburg and Frankfurt

(1931–33), and her teachers included Norbert Elias and Theodor W. Adorno. In 1933 she emigrated to Paris, where she studied at the Sorbonne, graduating in 1936. She then worked mainly for *Life* magazine as a journalist and photographic reporter. Her first color portrait studies of writers and artists appeared in 1938. From 1942 she made a series of trips to South America, mainly Argentina and Mexico, working as a freelance photographer and representative of a French aid committee. Between 1947 and 1954 she was part of the Magnum photographic agency. In 1978 she won the culture prize of the Deutsche Gesellschaft für Photographie (DGPh) and in 1980 the Grand Prix des Arts pour la Photographie. Freund is known primarily for her portraits of writers and artists, in which she reads a face like a book, with the invisible – what is written between the lines – as significant as the visible. In addition to her photographs, Freund also exerted great influence as a theorist. Her book *Photography and Society* (*Photographien und Erinnerungen*, Munich, 1976), for instance, is a standard work on the political history of photography. C.W.

Bibl.: Freund, New York, 1985 · Neyer, Freund, 1988 · Freund, Munich, 1998

Gisèle Freund, *André Gide under the Death Mask of Leopardi in his Appartment on Rue Vanneau*, Paris 1939, Dye-transfer print, 40 x 30 cm, Nina Beskow Agency, Paris

Freundlich, Otto. *1878 Stolp, Pomerania, †1943 Lublin-Majdanek concentration camp. German painter and sculptor. He studied in Munich, Florence, and Berlin. In 1908 he visited Paris for the first time, where he came into contact with the → Cubists. He returned to Germany in 1914 and joined the anti-war movement Die Aktion. After World War I, he became a member of the → Novembergruppe in Berlin and the Arbeiterrat für Kunst (Workers' Council for Art), producing numerous leaflets (art and social criticism). From 1924 to 1939 he lived in Paris, where he was a founder member of → Abstraction-Création (1931). In 1937 his work was condemned in Germany as "degenerate." His Paris studio was confiscated by the occupying Germans and in 1943 he was deported to Lublin-Majdanek because of his Jewish origins. His early work was → Expressionist in style, but became increasingly

Otto Freundlich, *Composition*, 1938/40, Gouache, 31.5 x 23.5 cm, Museum Ostdeutsche Galerie, Regensburg

geometric and abstract, dominated by mosaic-like or kaleidoscopic fields of strong color. In the realm of sculpture he initially produced heads similar to those of → Rodin, and later abstract architectural compositions ("*menhirs modernes*"). The Nazis chose his monumental head *The New Man*, of 1912, for the cover of the catalogue for the "Degenerate Art" exhibition (1937). The works *Ascension* (1929) and *Sculpture architecturale* (planned as a monumental work 20–30 m in height, 1934–35) are attempts to tackle general sculptural problems of shape and space. They also represent a search for a social role for works of art in the utopia of a new society. I.H.

Bibl.: Bohnen, Freundlich, 1982 · Freundlich, Pontoise, 1993 · Freundlich, Regensburg, 1994/95

Frey, Viola. *1933 Lodi, California. American Frey is one of the most important ceramic sculptors (along with → Arneson and David Gilhooly [born 1943]) to emerge from the → Bay Area Figuration and → Funk art movements. She received her B.F.A in 1956 from the California College of Arts and Crafts, Oakland, where she studied with → Diebenkorn, and her M.F.A. in 1958 from Tulane University, New Orleans, where she studied with → Rothko and Katherine Choy. Her table-top sculptures of the 1960s feature surrealistic juxtapositions of slip-cast, bric-à-brac figurines (such as dolls, roosters, skeletons) glazed in a → Pop art and expressionistic manner. In the early 1970s, taking a dynamic frieze-like approach, she transferred her cluttered, iconographic figurines onto large ceramic tondo plates that are reminiscent of → Art Brut ceramics. In 1976 she began creating male and female figures built from pieced-together, ceramic blocks. They are around nine feet tall, colossal golems with staid gestures and impersonal gazes, encrusted in thick layers of brightly colored glazes and decorative patterns. Throughout the 1980s and 1990s, Frey expanded her plate and figure series to create dynamic installations that comment on family psychology. J.C.M.

Bibl.: Frey, Philadelphia, 1984 · Frey, 1988

Friedlander, Lee. *1934 Aberdeen, Washington. American photographer, living in New York. He studied photography at the Art Center School in Los Angeles (1953–55), where his teachers included Edward Kaminski. He continued his studies in New York, where he came into contact with → Winogrand, → Frank, and → Arbus who, like him, were doing photographic reportages in the streets of New York. In 1967 he participated in a joint exhibition at the Museum of Modern Art entitled "New Documents;" the works comprised documentary photography of social criticism and so-called "straight photography." Friedlander described his work as a picture of the "American social landscape and its conditions." Typical of his style is the black and white photograph with great depth of field, incorporating reflected images. Frequently he photographs stretches of store window, which reflect typical American street scenes of the 1960s and 1970s. Reflections were also used as subjects in the *Self Portrait* series (published as a book in 1970). Friedlander's interest in jazz music inspired a series of portraits of American jazz musicians, including Ray Charles and Duke Ellington, in the 1950s and 1960s. C.W.

Bibl.: Friedlander, Nudes, 1996 · Friedlander, Musicians, 1998 · Friedlander/Szarkowski, Friedlander, 1998

Friesz, Othon. *1879 Le Havre, †1949 Paris. French painter. Studied at the École Municipale des Beaux-Arts in Le Havre from 1896 to 1899 (together with → Dufy and → Braque), and then at the Académie des Beaux-Arts, Paris (1899–1904). In 1905 he exhibited at the → Salon d'Automne and the following year stayed with Braque in La Ciotat. He visited Portugal in 1911 and from 1912 to 1914 had his own art school in Paris. From 1914 he taught at the Académie Moderne, from 1924 at the Académie Scandinave, and from 1944 at the Académie de la Grande Chaumière. In 1937 he started work on a large mural for the Palais de Chaillot with Dufy. As an early → Fauvist Friesz painted landscapes glowing with sunlight and pictures of figures in vividly contrasting colors. His most significant paintings were probably those he produced in 1906 in Antwerp (*Port of Antwerp*) and in 1907 in La Ciotat, L'Estaque, and Cassis (*Landscape near Ciotat*). After 1908 he turned to a simplified, sculptural formal language with more muted colors, and from 1911 came close to → Cubism. In his later years he painted in a traditional *chiaroscuro* style. H.D.

Bibl.: Friesz, Le Havre, 1979

Frink, Elizabeth. *1930 Thurlow, Suffolk, †1993 Blandford Forum, Dorset. British sculptor and printmaker. After studying at the Guildford (1947–49) and Chelsea (1949–53) Schools of Art, Frink taught at the latter, at St Martin's, and at the Royal College. Associated with the British school of sculpture that included Bernard Meadows (1915–), → Armitage, Lynn → Chadwick, and → Butler, she was receptive to → Giacometti and → Richier. Her naturalistic forms (birds, monumental heads, horses, and religious motifs including crucifixions) are comparatively traditional. Early work was energetic and almost distraught, but more sober, harmonious bronzes followed in the 1960s (*Falling Figures* series).

While living in France (late 1960s), she produced a disturbing series of heads with aviator goggles, as well as wingless, decapitated *Mirage Birds*. Back in England, Frink returned to emblematic figures of dogs, horses, and horsemen, and designed illustrations for artist's editions of Aesop (1968), *The Canterbury Tales* (1972), and *The Iliad* (1975). She was made a DBE in 1982. D.R.

Bibl.: Wilder, Frink, 1984

Fromanger, Gérard. *1939 Ponchartrain. French painter; studied in Paris at the Académie de la Grande Chaumière (1958–63). He was an exponent of → New Figuration. In painting built up with contrasting color surfaces, he deals primarily with the socio-political aspects of history and the present. He uses layout techniques from comics, collage, advertising, film, and mass media. He produced a series with cut-out wood surfaces (*Mon tableau fuit* and *Paysage découpé en dix*). Later series (*Boulevard des Italiens*, 1971; *The Painter and the Model*, 1972–73; *Desire is everywhere*, 1975) were based on photographic reports on urban life, the needs of modern man, and themes related to media and politics. Following the series *Tout est allumé* (1979), freer, more individual compositions of colors, forms, and symbols appeared. K.S.-D.

Bibl.: Prévert/Jouffroy, Fromanger, 1971 · Fromanger, Paris, 1979 · Fromanger, Paris, 1985

Fronte Nuovo delle Arti (Italian: New Front for the Arts). A group of Italian artists founded in 1946. The principal members of the group were → Guttuso, → Vedova, and → Viani, who painted abstract pictures in a prismatic style influenced by → Orphism and the late pictures of → Picasso. Some members of the group became involved with the Gruppo degli Otto Pittori Italiani in 1952, while Guttoso and Armando Pizzinato (1910–) turned to an expressive realism. H.D.

Bibl.: Sauvage, Fronte Nuovo, 1957

Frost, (Sir) Terry. *1915 Leamington Spa, Warwickshire. British painter. Interned in a German POW camp during World War II, Frost met Adrian Heath (1920–) who encouraged him to paint (1943). In 1946 he moved to → St Ives, Cornwall, and produced academic work at the School (*Chair*, 1947). He then moved to London and studied at Camberwell School of Art under → Coldstream, → Gowing, → Pasmore, etc., and was introduced to → Gris by the latter (first abstract, 1949). In 1950 he returned to St Ives, painting his characteristic superimposed "boat" shapes (*Movement: Green, Black, and White*, 1951), a "synthesis of movement and countermovement" from local harbor scenes. Collages and reliefs followed (he admitted uneasiness over the latter), some based on "stitching" canvas. · Frost's 1960s works illumined in bright colors the contrast between rectangle (including ground) and semicircle or arc. The concentric circle gained in importance in his work through the 1980s, construction predominating over facture. Frost's oeuvre essentially synthesizes decorative and compositional concerns. A South Bank National Touring Exhibition took place in 1999. D.R.

Bibl.: Frost, Newcastle, 1964 · Frost, London, 1976 · Frost, Reading, 1986

frottage. From the French *frotter* ("to rub"). A technique which involves placing a piece of paper on a rough surface and rubbing it with a pencil or crayon to obtain an impression. → Ernst was the first modern artist to use it (1925), combining wood grain, leaves, and plants into surreal patterns by a process of intuition, hallucination, and selective imagination. The principle of frottage was used in a slightly different way by → Pop artists (→ Rauschenberg, for example), who transferred pictures from magazines and advertisements by means of chemicals and rubbed them on to the support in reverse. W.S.

Bibl.: Spies, Frottage, 1986

Günter Fruhtrunk, *Presence II*, 1980, Acrylic on canvas, 178 x 301 cm, Städtische Galerie im Lenbachhaus, Munich

Fruhtrunk, Günter. *1923 Munich, †1982 Munich. Painter, graphic artist, and exponent of → Concrete art. He initially studied architecture (1940–41), and later attended the Akademie in Munich (1945–50). Subsequently he moved to Paris, where he worked in the studios of → Léger (1952) and → Arp (1955). From 1967 to 1982 he taught at the Kunstakademie in Munich. It was already clear in his early work that Fruhtrunk was trying to go beyond the → geometric abstraction being propagated in Paris at the time, and was developing a dynamic version of Concrete painting. Fruhtrunk's debate with → Suprematism illustrated a desire to destabilize the picture space and make it more dynamic. He also adopted Robert → Delaunay's *peinture pur* to create pictures of intense color and → Constructivist compositional structure (*Cadence jaune – rouge – violet*, 1961). Fruhtrunk subsequently found his subject: rhythm and light. Both were produced from a calculated arrangement of striped structures in vertical and, later, diagonal directions, and by a provocative constellation of contrasts. His late work, after years of asceticism in composition and painting technique, is characterized by greater painterly freedom and new "toxic" color contrasts (*Sinnenfundament*, 1982). H.D.

Bibl.: Fruhtrunk, Munich, 1993

fumage. The technique of fumage is a two-dimensional process by which a flame source (especially a candle) is applied to the support (often heavy-grade paper). Modification can be obtained either by directed soot-blackening or by actual fire holes. Fumage was introduced into Surrealism by → Paalen (*Fumage*; versions). In a 1937 version, nearly all of the oil-painted canvas is smoked in oval or circular rings that develop the composition. The technique was later employed by the American Gerome Kamrowski (1914–) and by Camille Bryen (1907–77). Johannes Schreiter

(1930–) used fumage intensively from 1958 in his *Brandcollagen* ("burning-collages"), as well as in abstract, geometrical compositions where often a single burnt hole and stain introduce a natural or semi-stochastic component. In some of his *Fazit* series, trails of smoked, brown-gold holes or ribbed tracks appear. The *pyrogravures* of Werner Schreib (1925–) constitute a variant of the technique. Yves → Klein produced some large-scale *peintures de feu* in the early 1960s. D.R.

functionalism. Principle according to which the form and structure of a building or object are derived from their utilitarian function. The term is primarily applied to architecture and design of the first half of the 20th century, sometimes as a polemic term or an expression of justification. Two, polemically opposed, trends crystallized from early 20th-century → Art Nouveau/ → Jugendstil and Neues Bauen: an organic functionalism based on an integral idea of shape in an organic spirit (van de → Velde); and a strenuous rationalism concerned solely with material, structural, and utilitarian values and which favored geometric shapes. Supporters of this latter trend separated architecture from art (Adolf Loos, Hannes Meyer) by dividing theory from practice. In the 1970s the → Postmodernists criticized this abandonment of emotional and other values. H.O.

Bibl.: De Zurko, Functionalism, 1957 · Posener, Functionalism, 1964 · Steadman, Design, 1979

Funk art. Movement that emerged in the 1960s in California (specifically the San Francisco region), which formulated its criticism of society in provocative → assemblages and → environments. The shock effect of these works derived from the use of macabre and unusual materials, such as the limbs of dolls, bones, skulls, pieces of flesh, stuffed animals, and waste products intended to depict the frailty of the human body (→ Kienholz, *State Hospital*, 1964–66). · Influenced equally by → Dada and → Pop art, Funk art was dedicated to undermining the formalism of the New York art scene with subversive works criticizing society; artists include Bruce Conner (1933–). C.W.-B.

Bibl.: Albright, Funk Art, 1985

frottage, Max Ernst, *The Forest*, 1927, Oil on canvas, 27 x 34.8 cm, Sprengel Museum, Sprengel Coll., Hanover

Futurism, Luigi Russolo, *Dinanismo di un'automobile*, 1912–13, Oil on canvas, Musée National d'art moderne, Centre Georges Pompidou, Paris

Futurism. Futurism was Italy's first contribution to the European modern age, and one of its most powerful sources of artistic impetus. The movement developed as a reaction to the naturalistic and historical trends of the 19th century, to which it opposed a radical philosophy intent on the future and progress. In February 1909, → Marinetti published in the Parisian newspaper *Le Figaro* the first manifesto of Futurism, in which he provocatively placed the beauty of movement and speed above the artistic ideals of the past. A tight-knit, strongly polemical band formed around Marinetti, which with campaigns and proclamations ("burn down the Louvre!") consciously sought confrontation with the educated classes. The manifestos and pamphlets typical of Futurism, which are among both the earliest examples of experimental typography and the first conceptual programs of art theory, aimed to replace the unprogressive philosophy of the 19th century with a dynamically modern one. Inspired by the discoveries of modern science (Einstein, Heisenberg) and Henri Bergson's philosophy of the "élan vital," → Severini sought a pictorial synthesis of time, place, shape, and color and, together with → Balla, → Boccioni, → Carrà, and → Russolo, wanted to bring together in one image the simultaneity ("*simultaneità*") of different sensual impressions. To this end, the static construction of a picture was to be overturned by transforming the space into dynamic, energy-laden streams of power which would reach the viewer directly and immediately, thus mobilizing his sensitivity. A recurrent motif of Futurism is modern life – machines, trains, and automobiles, whose motion is suggested by a rhythmic movement of fragments of objects. Italian Futurism had a great effect on German → Expressionism and the Russian avant-garde. Its aggressive thrust, the glorification of conflict and heroism, and its strong fascination with technology, brought Futurism dangerously close to Italian Fascism. W.S.

Bibl.: Gambillo, Futurism, 1958–62 · Appolonio, Futurism, 1975 · Futurism, Venice, 1986

Futurism, Filippo Tommaso Marinetti, *Zang Tumb Tumb*, 1912, Cover for Futurist book

Gabo, Naum. *1890 Birnast, †1977 Waterbury, Connecticut. Russian-born sculptor, brother of → Pevsner. He studied medicine and engineering in Munich (1910–14); visited Paris and Italy; and in 1915 sought refuge from the war in Oslo. In

1917 he moved to Moscow, where he wrote the *Realistic Manifesto* (1920) in collaboration with his brother. Between 1922 and 1932 he lived in Berlin, where he joined the → Novembergruppe (1922) and had contacts with the → Bauhaus and → De Stijl. During this period he produced numerous works in the public domain. After visits to Paris and England, he emigrated to the US in 1946, becoming an American citizen in 1952. In 1953–54 he taught at Harvard University.

Gabo was one of the principal exponents of → Constructivism. His first sculptures (torsos and heads) of 1915 were influenced by → Cubism and → Futurism (*Constructed Head No. 1*, 1915). He start-

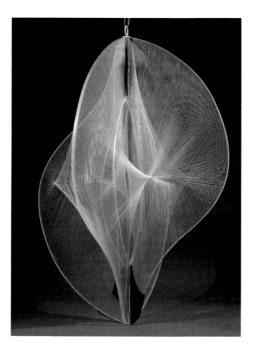

Naum Gabo, *Linear Construction in Space No. 2*, 1949/1972–73 , Perspex, height 43.5 cm, Private Collection, London

ed making → Kinetic sculpture in 1919 using oscillating wire (*Kinetic Construction*, 1919–20), in accordance with his *Realistic Manifesto*. After 1945 he created a new formal language in which light and movement dynamicize space (*Linear Construction in Space No. 2*). Subsequently he developed mechanical, magnetic, and electric devices to create movement and dynamic changes in his sculptures (→ Op art). P.L.

Bibl.: Read, Gabo, 1957 · Pevsner, Pevsner, 1964 · Nash/Merkert, Gabo, 1986 · Merkert, Gabo, 1989

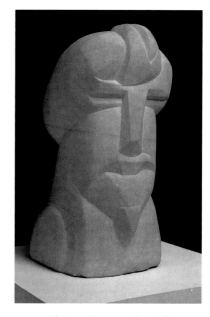

Henri Gaudier-Brzeska, *Hieratical Head of Ezra Pound*, 1914, Marble, 91.5 x 48.3 x 42 cm, Private Collection

Gaudier-Brzeska, Henri. *1891 Saint-Jean-de-Braye, †1915 Neuville-Saint-Vaast. French sculptor. After business training in England, he spent time in Germany and Paris, where he took up sculpture in 1910. The following year he settled in London. In 1913 he joined the revolutionary circle of the → Vorticists around Ezra Pound, of whom he produced the famous phallic *Hieratical Head* (1914). In 1914 he returned to France and was later killed in action. Gaudier-Brzeska carved directly into the material, working primarily in stone. His work was influenced both by → Cubism and by his admiration for the art of non-Western indigenous cultures. → Brancusi was also an inspiration to him. Despite their eclecticism, his sculptures are characterized by a unique and expressive vitality. In his repudiation of classical traditions and his mastery of his material, he became a pioneering figure in early-20th-century British sculpture. I.H.

Bibl.: Pound, Gaudier-Brzeska, 1916 · Cole, Gaudier-Brzeska, 1978 · Gaudier-Brzeska, Cambridge, 1983 · Silber, Gaudier-Brzeska, 1996 ·

Gauguin, Paul . → precursors

Gaul, Winfred. → Analytical painting

Geiger, Rupprecht. *1908 Munich. German painter and graphic artist, living in Munich. He studied architecture at the Kunstgewerbeschule in Munich (1926–29). After serving as a bricklayer's apprentice (1930–32), he studied at the Staatsbauschule, Munich (1933–35). Between 1936 and 1940 he worked in an architects' office, before serving in World War II (Ukraine, Greece). He was a founder member of the → ZEN 49 group. Between 1949 and 1962 he worked as an architect, and later taught at the Staatliche Kunstakademie Düsseldorf (1965–76). In 1970 he became a member of the Bayerische Akademie

Arshile Gorky, *Waterfall*, 1943 , Oil on canvas, 153.5 x 113 cm, The Tate Gallery London (see p. 138)

der Schönen Künste, Munich. His first land-
scapes, influenced by the light in Russia and
Greece, contained surreal effects. After the war,
he turned to abstraction. Following → Malevich,
his pictures were constructed from simple geo-
metric shapes and a small number of color con-
trasts. He sometimes used trapezium- or hook-
shaped formats (→ shaped canvas). After 1952
Geiger simplified his shapes into circles and
ovals, using luminous monochrome fields of
color, notably warm and cold hues of red. This
color is also central to Geiger's recent paintings,
as well as his → installations, → artists' books,
and prints. H.D.

Bibl.: Schuster, Geiger, 1988 · Friedl, Geiger, 1998

geometric abstraction. A form of → abstract art
characterized by the use of geometric forms and
intense colors. Its exponents took a rational
approach to pictorial composition with forms
that are devoid of representational associations
or metaphorical references. Geometric abstrac-
tion evolved out of → Neo-Plasticism and
→ Purism. The earliest examples were produced
at the beginning of the 20th century by
→ Kandinsky and → Mondrian, and the move-
ment took particular hold in Paris (→ Cercle et
Carré, 1929, → Abstraction-Création, 1931). After
1945, geometric abstraction was increasingly
superseded by an expressive, gestural approach
(→ Abstract Expressionism) and more recently by
→ Neo-Geo, which embraces a range of styles and
media. H.D.

Bibl.: Geometric Abstraction, Dallas, 1972 · Osborne, Abstraction,
1979

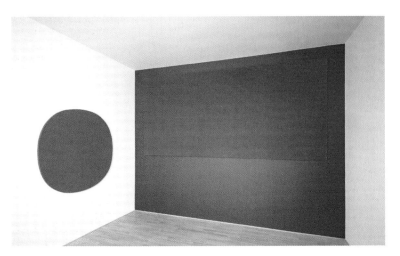

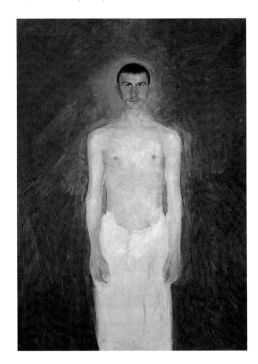

geometric abstraction, Piet Mondrian, *Victory Boogie-
Woogie*, 1942–43, Oil on canvas with colored adhesive strips
and paper, 126.1 x 126.1 cm, Gemeentemuseum, The Hague

Gerstl, Richard. *1883 Vienna, †1908 Vienna. Aus-
trian painter. He studied at the Akademie in
Vienna (1898). His enthusiasm for modern music
(particularly Mahler) brought him into contact
with the Viennese circle of musicians around
→ Schoenberg. Gerstl ran off with Schoenberg's
wife and later committed suicide. His work
remained largely unknown until an exhibition at
Kallir-Nierenstein in 1931.

 Along with → Klimt, → Kokoschka, and
→ Schiele, Gerstl was one of the most innovative
figures in turn-of-the-century Austrian art. In

Self-Portrait as Semi-Nude (about 1904), for exam-
ple, the artist, in an analogy with the figure of
Christ, is portrayed as an *artiste maudit*, an isolat-
ed, suffering human being. Gerstl used impasto
and favored open pictorial structures. He gradu-
ally eliminated narrative elements and his paint-
ings eventually verged on abstraction. His spon-
taneous style and his virtuosic use of color place
him in the front rank of Expressionist artists. He
painted impressive landscapes and portraits,
notably of eminent figures from Viennese musi-
cal life (Schoenberg, Zemlinsky). D.W.

Bibl.: Schröder, Gerstl, 1993

Gertler, Mark. *1891 Spitalfields, London, †1939
Highgate, London. British painter and printmak-
er. He passed his early years in his Polish family's
hometown of Przemysl. By 1906 Gertler was in
London and began attending art classes, entering
the Slade in 1908 and making contact with Dora
Carrington (1893–1932) and → Nevinson. His
paintings were daringly pared-down depictions
of hardship (*A Jewish Family*, 1913), though *The
Fruit Sorters* (1914) is a → Scuola Romana-like

Rupprecht Geiger, *New Red for
Gorbachov*, 1989, Installation,
Städtische Galerie im Lenbach-
haus, Munich

Richard Gerstl, *Self-Portrait
against a Blue Background*,
1905, Oil on canvas,
160 x 110 cm, Private Collection

idyll. After criticism for the "Hunnishness" of his *Creation of Eve* (1914), his most important pictures, *Merry-Go-Round* and *Gilbert Cannan at His Mill*, were both executed in 1916. The former is an indictment, in strident colors, of what Gertler saw as the irrelevance of pictorial concerns in the War years ("I don't understand all this abstract intellectual nonsense"); the latter is a lighter homage to a friend and his hounds. His later work includes nudes, → Derain-inspired still-lifes, and single figures, but he met with lackluster success and committed suicide after suffering long-term tuberculosis. D.R.

Bibl.: Woodson, Gertler, 1972

Franz Gertsch, *Gräser I*, 1995–96, Mineral pigment bound with resin and beeswax on unprimed cotton duck, 240 x 340 cm., Artist's Collection

Gertsch, Franz. *1930 Mörigen, Switzerland. Swiss painter and printmaker living in Rüschegg, Switzerland. Between 1947 and 1950 he produced his first woodcuts. In 1972 he took part in Documenta 5 and in 1978 exhibited at the Venice Biennale. Gertsch is an important exponent of European → Photorealism. Painting from greatly enlarged photographic slides, he concentrates on transparent light effects which make the objects, rendered in an almost pointillist style with extremely fine brushstrokes, appear as dematerialized color values (single spots of color). Through his choice of motif and detail, his use of snapshots and careful positioning, Gertsch succeeds in conveying characteristic (as well as sensual) elements of the object protrayed. His adherence to the reality of the slide and his romantic inclinations distinguish him from the American Photorealists. When he started developing his idiosyncratic method in 1969, he took photographs from magazines as his models, but he later used portraits of acquaintances. In 1986 he started to produce large-format, color-sensitive woodcuts (mineral paint on Japanese paper), in which the fine weave of the cuts creates a translucent, supernatural effect. Gertsch's pictures convey the inner nature of things, coming close to monochrome paintings. D.W.

Bibl.: Gertsch, Stuttgart, 1993

Gerz, Jochen. *1940 Berlin. German-born French Installation and Performance artist, and writer living in Paris and British Columbia. He studied German and linguistics in Cologne and Basle. In 1967 he moved to Paris. His first literary works date from about 1960. From 1984 he worked in collaboration with his wife, the sculptor Esther Shalev-Gerz. He has taught in Saarbrücken (from

Franz Gertsch, *Natascha IV*, 1987/88, Woodcut on Heizoburo Japanese paper 232.5 x 182 cm, Städtische Galerie im Lenbachhaus, Munich

Jochen Gerz, *Erase the Past*, 1991, 2 parts, each 18.5 x 13.7 cm; 2 parts each 28 x 20 cm, DG-Bank Collection, Frankfurt

1990) and Leipzig (1994). He has won numerous awards.

In 1967–68, following on from his earlier concrete poetry, Gerz began to combine words with photographs and symbols, exploring the disparity between them (*Statische Texte*, *Pieces*). In his video works and → performances (*Griechischen Stücke*, 1975–79), he exposed the fictitious world of the media and its pretence of objectivity, positioning his works in the gap between reality and reproduction. His public performances, → environments, and memorials (*Mahnmal gegen Faschismus*, 1986–93) demonstrate the importance he attaches to communication, inviting viewers to take part in active debate or participate through the Internet (*The Plural Sculpture*, 1995). These works are intended as → Process art, since they represent only an intermediate outcome in the flow of history. Gerz has also published numerous articles on art, notably "Die Zeit der Beschreibung" (books one to four, 1974–83). M.G.

Bibl.: Schwarz, Gerz, 1975 · Friese, Gerz, 1992 · Rattemeyer, Gerz, 1997

Gesamtkunstwerk. (German: "total work of art"). The uniting of all the arts (fine art, dramatic arts, dance, poetry, music) into one coherent work of art. The Gesamtkunstwerk represents an attempt to combine art and reality, because it incorporates "the tendency to break down the boundaries between aesthetic creation and reality" (O. Marquard). The concept can be traced back to Richard Wagner, who formulated the "work of art of the future" in his *Zürcher Schriften* (1850–51), using it as the basis for his musical dramas. Wagner recognized "that the actual processes of observation were not in accordance with the artistic specialization of individual genres and media" (B. Brock). Wagner's concept, as well as exploiting several organs of perception, implies the idea of art as a second nature. However, a theoretical definition of the Gesamtkunstwerk has never been made. The term has been applied, for example, to Gothic cathedrals, 14th- to 16th-century piazzas, Baroque castles and churches, and the design of idealized sites with sculptures (Filarete). The idea of the "multi-media" combination of all

Gesamtkunstwerk, Antoni Gaudí, *Sagrada Familia*, view of the east front, 1883–1926

the arts into a harmonious universality first emerged in the second half of the 18th century and among the Romantics. It acquired even greater importance in the 19th-century German philosophy of Idealism. The drive toward the Gesamtkunstwerk intensified toward the end of the 19th century with → Jugendstil, which attempted an entire aesthetic reshaping of the everyday. The idea of the Gesamtkunstwerk remained current in the 20th century, with manifold variations. The Catalan architect Gaudí, for example, subsumed the fine arts under the heading of architecture. In the theater, the Gesamtkunstwerk underwent the most varied expressions (A. Appia, M. Reinhardt, E. Piscator, P. Behrens). → Kandinsky attempted to unite the arts through his abstract painting and his text *Concerning the Spiritual in Art* (1912). → Mondrian recounted that "the new forms being realized in painting today are what we shall see around us in sculpture and architecture." The "Glass Chain" of Bruno Taut (about 1919–20) developed visionary architectural fantasies. Representatives of the → Bauhaus strove for a new art, where "there are no barriers between monumental and decorative art" (→ Gropius). The unity of art and life, the removal of the dividing line between the two was continued in → Dada (particularly in → Schwitters' *Merzbau*, 1920–36). This "history of the claim to totality of the creative individual" (H. Szeemann) culminates with → Beuys and his "social sculpture," which connects life to art, putting both on the same level. C.W.-B.

Bibl.: Gesamtkunstwerk, Zürich, 1983

Gette, Paul-Armand. *1927 Lyon. French Conceptual artist living in Paris. Initially he worked for fifteen years as a chemical engineer. His work explores the chasm between linguistic designation and visual perception, using scientific methodology and surrealist meticulousness. In 1956 he linked mineralogy and speech (linguistic "crystallizations") and in 1964 began making → assemblages from printed characters (1964). He then created sound poems out of botanical names and designations. More recent work includes photographic inventories of geological phenomena (*Horizon et paysage*, 1977) and photographs of young girls (*Le Pubis de la nymphe*, 1991–93) in a field of tension between distance and emotional proximity (*La vue et le toucher*, 1992). M.G.

Bibl.: Gette, Grenoble, 1989 · Gette, Grenoble, 1992 · Gette, Feu, 1993

Giacometti, Alberto. *1901 Borgonovo, near Stampa, †1966 Chur, Switzerland. Swiss sculptor, painter, draftsman, and illustrator. Son of the painter Giovanni Giacometti and cousin of the painter Augusto Giacometti. He studied at the École des Beaux-Arts in Geneva (1919). In 1922 he moved to Paris, where he studied at the Académie de la Grande Chaumière under → Bourdelle (1922–25). Between 1929 and 1934 he was part of the → Surrealist movement, but then worked from the model. He became friendly with → Masson, → Picasso, Sartre, and de Beauvoir. Between 1942 and 1945 he lived in Geneva, before returning to Paris after the war. In 1965 the Giacometti Foundation was founded in the Kunsthaus Zürich.

He made his first figurative sculptures in 1927–28 out of plaster or marble. Influenced by Cubism and non-European cultures, they consisted of thin volumes with flat surfaces (*Gazing Head*). These alternated with Surrealist, three-dimensional constructions (*Woman with Her Throat Cut*, 1932; *Palace at 4 a.m.*, 1933), which depict ideas from dreams and sensual illusions and already possess his characteristic elongation of form. In the 1930s he produced a number of portraits (primarily of his brother Diego) using a realistic approach. After 1945, painting (*Man Sitting*, 1949) became as important as sculpture (usually executed without the model). Giacometti

Alberto Giacometti, *Walking Man I*, 1960, Bronze, 183 x 26 x 95.5 cm, Foundation Maeght, Saint-Paul-de-Vence

Alberto Giacometti, *Head of a Man III (Diego)*, 1964, Oil on canvas, 65 x 45.5 cm, Kunsthaus Zürich, Alberto Giacometti Foundation

was not concerned with corporeality, but rather with the imaginary image of the figure in the energy field of space. His thin, fragile, almost dematerialized figures convey the sense of loss of human existence in the emptiness of space and reflect a personal struggle for the "impossible unity of world and ego." Whether small- or large-format, standing alone or in group formations, they manifest vital energy and experience of life. Raised on massive plinths, they stand in a relationship of tension to the surrounding space and ground (*Square, Three Figures, One Head*, 1950). His portraits from the 1960s rest like busts in a fleetingly alluded to spatial framework. Although enlivened by a pictorial concept, they nevertheless appear morbid and fragile (*Portrait of Annette*, 1960). The large figures of his late work convey a sense of the individual reality of man who immediately experiences and accepts his fate. P.L.

Bibl.: Giacometti, Zürich, 1990 · Schneider, Giacometti, 1994 · Sylvester, Giacometti, 1994 · Stooss, Giacometti, 1996 · Lord, Giacometti, 1997

Gilbert and George. *1943 San Martino, Italy (Gilbert) and *1942 Totnes, Devon (George). British Performance and photographic artists living in London. They met in 1967 while studying sculpture at St. Martin's School of Art, London, and have worked together since. Between 1969 and 1977 they appeared as "living sculptures" performing automaton-like movements in an artificial atmosphere (*Red Sculpture*, 1977) (see → Performance art). In parallel they produced other types of work, including *Charcoal on Paper Sculptures* (1970–74), showing the two artists in gigantic charcoal drawings assembled from single sheets, and "postal sculptures" (1969–75). Their "postcard sculptures" and "magazine sculptures" combine postcards together with photographs and cuttings from magazines into collages which verge on the abstract. Their first photographic works were produced in 1971 and took as their themes alcoholism and drunkenness. Individual photographs followed, combined in increasingly large, symmetrical col-

Gilbert and George, *Headed*, 1992 , Color photograph, C-Print, 169 x 142 cm, DG-Bank Collection, Frankfurt

lages. These explored the themes of city life, loneliness, social conflict, and being an outsider (*Dark Shadows*, 1974). From 1974 color began to pervade their work, usually virulent polychrome values contrasting with black and white. In their works of the 1980s, Gilbert and George as protagonists exchange places with other people or objects. These large-format assemblages of photographs have a painterly quality, thanks to new colors and the addition of writing and graffiti. They have a multilayered narrative structure which, in addition to their own homosexual biography, deals with taboo subjects (excretions, sperm, etc.). These stylized, over-sized picture objects are an expression of their theory that art springs from three essential sources of energy: the brain, the soul, and sexuality. In 1981 the film *The World of Gilbert and George* appeared. H.D.

Bibl.: Gilbert & George, Eindhoven, 1980 · Gilbert & George, Bordeaux, 1986 · Jahn, Gilbert & George, 1989

Gill, Eric. *1882 Brighton, Sussex, †1940 Uxbridge near London. British sculptor. He studied at Chichester Art School and, between 1900 and 1903, in London (including the Central School of Arts and Crafts). Gill, together with → Epstein and → Gaudier-Brzeska, was one of Britain's most important early-20th-century sculptors, exploring new subjects and developing new forms of expression. Inspired by medieval and Indian art, he was an exponent of direct carving, working without sketches of models. He created war memorials and numerous other works for public places, such as the *Stations of the Cross* (Westminster Cathedral, 1914–18), reliefs and sculptures for the headquarters of London Transport (St. James's Park, 1928–29), the façade of Broadcasting House in London (1929–33), and the League of Nations in Geneva (1935–38). He also produced many book illustrations. I.H.

Bibl.: Gill, Autobiography, 1940 · Collins, Gill, 1992 · Collins, Gill, 1998

Glackens, William (James). *1870 Philadelphia, Pennsylvania, †1938 Westport, Connecticut. American painter. After training at the Pennsylvania Academy of the Fine Arts, Glackens worked as an illustrator. He befriended Robert → Henri who encouraged him to begin oil painting, which he took up seriously at the turn of the century. He was a core member of the New York Realists and The → Eight (1907–08), both groups dedicated to → social realism and → Ashcan depictions of American life in the raw. Glackens' social interests, however, were tempered by a lively palette and a concentration on scenes of middle-class leisure rather than oppression or work. *Chez Mouquin* (1905) shows the Realists' favorite eatery in a bright and contrasting color scheme.

In 1912, Glackens was engaged in purchasing late-Impressionist canvases in Europe for Dr. Albert C. Barnes' collection at Merion. This enterprise had repercussions on a style that began increasingly to resemble Renoir's. A large-scale memorial show was held at the Whitney Museum of American Art in New York in the year of his death. D.R.

Bibl.: Gerdts, Glackens, 1996

glass art. With the emergence of → Art Nouveau (→ Jugendstil) and the lustred glass of Louis Comfort Tiffany (1848–1933), there was a blossoming of technical and creative innovation in glass art. Flashed glass, alabaster-like opal glass, artistic etching and cutting, and the combination of glass with other materials (e.g. shells) all demonstrate that glass designers of the period were primarily interested in glass as a material rather than in colored light. This was true for the production of craft objects (Émile Gallé, René Lalique), as well as stained glass for ecclesiastical and secular buildings, public and private. The design and the execution were usually carried out by different people. → Thorn Prikker was an important figure in German glass art in the 1920s, thanks both to his archaicizing stained-glass windows influenced by Jugendstil and his teaching. His pupil → Campendonk introduced elements from → Cubism and Der → Blaue Reiter into his glass designs. In 1922, at the Bauhaus in Weimar, J. → Albers designed abstract stained-glass windows (Haus Sommerfeld, Berlin) and created autonomous glass images from cullet. After 1925 he produced Constructivist glass compositions. The strictly functional glass designs of the Bauhaus also influenced the evolution of style. After World War II, the construction of new churches and the reconstruction of damaged ones, together with growing interest from major painters, led to a resurgence in stained-glass window design. Designs and technical developments, such as the use of concrete or synthetic frameworks instead of traditional lead frames, reinforced the close link between stained-glass windows and architecture. In France, → Rouault (church at Assy, 1947), → Léger (Sacré-Cœur, Audincourt, 1950–52), → Matisse (Chapelle du Rosaire, Vence, 1949–51), → Le Corbusier (Chapel of Notre-Dame-du-Haut, Ronchamp, 1950–55), and → Chagall (church at Assy, 1957) designed notable examples of glazing. In Germany, Georg Meistermann created numerous windows – secular (Westdeutscher Rundfunk, Cologne, 1952) and religious – characterized by an organic, abstract formal language. F.K.

Bibl.: Glasmalerei, Darmstadt, 1979

glass art, Marc Chagall, *The Expulsion of Adam and Eve from Paradise*, 1963–64, Stained glass window, 355 x 90 cm, Saint-Étienne Cathedral, Metz

Gleizes, Albert. *1881 Paris, †1953 Avignon. Seldtaught French painter. He founded the Abbaye de Créteil, a community of artists and writers (1906–08) and took part in the → Cubist Salon des Indépendants (1911). In 1912, together with → Metzinger, he wrote the book *Du cubisme* and also co-founded the group → Section d'Or. Between 1915 and 1917 he lived in New York. In 1927 he founded the Moly-Sabata religious community in Sablons. · Gleizes created important Cubist paintings, in which the breaking down of the object through the rhythmic distribution of color came close to → Futurism (Futurist ideas of movement and simultaneity are also discussed in *Du cubisme*). After the war he changed his religious orientation and attempted to treat Christian subjects in a Cubist style (*Mary in Glory*, 1931–32). Gleizes was inspired by Romantic artists, whose craft techniques he hoped to revive in the community of Moly-Sabata. Toward the end of his life, he also painted murals and wrote numerous theoretical treatises on art. H.D.

Bibl.: Gleizes, Paris, 1976

Domenico Gnoli, *Shirt Collar*, 1966, Oil and sand on canvas, 120 x 160 cm, Jan Krugier Gallery, New York

Gnoli, Domenico. *1933 Rome, †1970 New York. Italian painter, illustrator, and stage designer. He studied various art genres in Rome. In 1955 he encountered early success with his set design and costumes for *As You Like It* at the Old Vic in London. He subsequently confined himself to illustration and painting, living in New York, London, Paris, and Rome. His narrative illustrations and caricatures won many awards in the US. He was one of the first painters to turn away from the initially dominant trend of → Art Informel toward figuration. His paintings, devoid of people, present objects removed from the human world, in sharp focus and uncomfortable close-up: a monumentalized shirt collar, button, or woman's shoe, a length of tablecloth, an armchair or bed. He isolated everyday things so that they became puzzlingly and magically alienated from their context. He painted with virtuosity, creating smooth textures or admixtures sensually roughened with sand. His work harks back to → Pittura Metafisica and → Surrealism, but is at the same time related to contemporary → Pop art, extending its scope into the unreal. Gnoli's occasional sculptures are three-dimensional embodiments of his pictorial ideas. L.Sch.

Bibl.: Gnoli, Bremen. 1981 · Sgarbi, Gnoli, 1983

Gober, Robert. *1954 Wallingford, Connecticut. Lives in New York. American sculptor. He studied at the Tyler School of Art, Rome (1973–74), and at Middlebury College, Vermont (1975–76). In 1976 he moved to New York. Since about 1984 Gober has worked with everyday objects such as beds, doors, or playpens. He creates works in series, the first of which, *Sinks* (1984), refers overtly to Marcel → Duchamp's famous *Urinal*. However, instead of exhibiting unaltered an industrially manufactured utilitarian object as a → readymade, Gober copies his objects in minute detail, but with frequent small alterations. The influence of → Pop art and → Minimal art can also be seen in his work, together with echoes of → Surrealism. Gober's → installations from the late 1980s feature body parts modeled from life (*Untitled Leg*, 1989) and create a dreamlike, subliminally threatening atmosphere. C.W.

Bibl.: Gober, Rotterdam, 1990 · Gober, Los Angeles, 1997

Goeritz, Mathias. *1915 Danzig, †1990 Mexico. Painter, sculptor, and architect of German origin. From 1934 he studied art history in Berlin (graduating in 1940); from 1937 to 1939 he studied at the Kunstgewerbeschule Charlottenburg. During the war he lived in exile in Morocco and Spain, founding in 1948 the School of Altamira. His first sculptural works were executed in Mexico beginning in 1949. In 1953 he was involved in the foundation of the El Eco Museum and the "Manifesto of Emotional Architecture." From 1954 to 1959 he taught at the University of Mexico and was advisor for the Olympic Games. His work in Mexico and surrounding regions consisted of mural reliefs and large sculptures in concrete and steel, mostly in a stripped-down form. In 1980 his labyrinthine plans for the Saltiel Community Center in Jerusalem were realized. M.G.

Bibl.: Goeritz, 1992 · Werry, Goeritz, 1994

Gogh, Vincent van. → precursors

Goings, Ralph. *1926 Corning, California. American painter. After study at Sacramento State College, Goings began his career as an → Abstract Expressionist. He took up representational subject matter in 1962, concentrating on the lifestyle of modern America. In 1968 he adopted the pick-up truck as a Californian cultural icon (*Jeep*, 1969; *Dick's Union General*, 1971). By the later 1970s he had moved on from outdoor scenes to tackle interiors (*The Waitresses – Afternoon Break*, 1986) and even still lifes (*White Tower*, 1976: i.e. mug, sugar caster, etc.), and matt neatness began to replace surface reflectivity.

Close in spirit to → Estes and → Cottingham, Goings painstakingly airbrushes → Hyperrealist oils from photographic projections, taking around 45 days over each. He now works out of Charlotteville, New York. D.R.

Bibl.: Chase, Hyperrealism, 1973

Goldin, Nan. *1953 Washington, D.C.. American photographer and co-founder of the so-called Boston School. Goldin lives in New York. She studied at Tufts University, Medford (1977), and the School of the Museum of Fine Arts, Boston (1977–78). In 1978 she moved to New York. In 1996 a retrospective of her work was held at the Whitney Museum of American Art. · Her first pictures were snapshots, initially black and white and later in color, of family and friends. The suicide of her sister in 1965 prompted her to keep a pictorial record in memory of people she had loved. The result was a highly personal visual diary "which others can read." Her subjects are her friends and the everyday lives of people on the edge of society, often at intimate and personal moments. Her central theme is sexuality and the exercising of power. From the 1970s Goldin combined her pictures, which she sometimes sets to music or exhibits as multimedia shows, in three extensive series: *The Ballad of Sexual Dependency*, *I'll Be Your Mirror*, and *All by Myself*. C.W.

Bibl.: Goldin, Ballad, 1986 · Sussmann/Armstrong, Goldin, 1996 · Goldin, 1998

Nan Goldin, *Jimmy Paulette and Tabboo! In the Bathroom, NYC*, 1991, Cibachrome, 75 x 100 cm, Nan Goldin Studio, New York

Goldsmiths' College. → Young British Artists

Goldsworthy, Andy. *1956 Cheshire. British sculptor and → Land artist living in Dumfriesshire. He studied at Bradford Art College, Yorkshire (1974–75), and Preston Polytechnic (1975–78). In 1987 he visited Japan. Goldsworthy works in the open, without the use of tools, on found materials, such as stone (*Balanced Rocks*, 1978), earth, and vegetation (*Holes*, 1977). In 1989 he traveled to the North Pole, where he made walls of ice. Such operations are attempts to achieve an understanding of nature as a process. With the exception of his large projects in open country (*Leadgate Maze*, 1989), his works are preserved solely in photographs and preparatory sketches. This is also true of his sculptural actions (*Throws*). M.G.

Bibl.: Friedman, Goldsworthy, 1990 · Goldsworthy, Sheepfolds, 1996

Golub, Leon. *1922 Chicago. American painter, living in New York. He studied history of art from 1940 to 1942 and painting in Chicago from 1946 to 1950. In 1943–46 he served in the US army. In 1951 he married → Spero and from 1956–64 they lived in Florence and Paris, returning to New York in 1965. In 1966 Golub began teaching; since 1970 he has taught at Rutgers University, New Brunswick. He has received numerous awards (1996 Hiroshima Art Prize together with

Spero), and many honorary doctorates. The ethnic and mythological motifs (*The Prince Sphinx*, 1955) of his early work, as well as his pictures based on Greek sculpture (*Male Figure*, 1958), take as their theme general signs of crises in human existence. Golub adheres to figurative → Expressionism and rejects any form of abstraction for lack of content. From 1965 he focused on themes of war and the violent use of power, especially in the objectifation of the individual, as the mercenary, which finds expression in several of his groups of work (*Napalm*, 1969). Golub uses newspaper pictures which he either adapts or incorporates directly into → installations (*Violence Zone*, 1995). By including texts from the media Golub characterizes the works as "cynical reporting" which he turns against what he sees as the disappearance of real events in the mass of media pictures. M.G.

Bibl.: Kuspit, Golub, 1985 · Obrist, Golub, 1997 · Romain, Gegenwartskunst, 1997

Goncharova, Natalia. *1881 Ladychkino (Tula province), †1962 Paris. Russian painter and set designer. She studied sculpture at the Academy of Art in Moscow (1898–1902) and took up painting in 1904 after meeting → Larionov, whom she married in 1955. She was a founder member of the → Jack of Diamonds (1911) and wrote the manifesto of → Rayonism with Larionov (1913). In 1915 she and Larionov settled in Paris, where the same year she designed sets for Sergei Diaghilev (1872–1929) and produced book illustrations (1917). She became a French citizen in 1938 and in 1948 a retrospective of her work was held in Paris.

Goncharova was one of the founders of the Russian avant-garde. Her → Neo-Primitivist style initially had its origins in folk art. Influenced by → Futurism, her pictures contain radiant light effects and a → Cubist way of fragmenting objects. P.L.

Bibl.: Goncharova, 1990 · Yablonskaya, Goncharova, 1990

González, Julio. *1876 Barcelona, †1942 Paris. Spanish sculptor. Initially he worked in his father's goldsmith workshop, before taking a course in painting (1892–93). In 1900 he moved to Paris, where he became friendly with → Picasso. González exerted a strong influence on the development of metal sculpture in the second half of the 20th century. His iron sculptures of the 1920s and the 1930s combine figurative, Surrealist, and Constructivist elements. He knew how to exploit the properties of iron, its extreme hardness and malleability, to create linear, filigree sculptures. His method, which he described as "drawing in space," involved creating shapes not from bulk volume but by means of an open structure, thus involving the surrounding space. His forms, deployment of modern techniques such as welding and forging, and use of iron represented a renunciation of traditional sculptural methods. I.H.

Bibl.: González, Mannheim, 1977 · González, New York, 1983 · Merkert, González, 1987 · González, London, 1990 · González, Bern, 1997

Leon Golub, *White Squad I*, 1982, Acrylic on canvas, 304 × 518.2 cm, Whitney Museum of American Art, New York

Gonzalez-Torres, Felix. *1957 Guáimaro, Cuba, †1996 Miami, Florida. Cuban-born sculptor who worked in the US. Torres's body of work may be grouped into six series: stacks, floor works comprised of candy, billboards, light-strings, beaded curtains, and portraits. He rarely produced individual pieces himself but instead issued Certificates of Authenticity/Ownership containing guidelines for each work's assembly, shifting the responsibility of its presentation to its owner (collector). Torres did not believe that his art existed until it was owned. Refusing to maintain a studio space, Torres worked with readily available, endlessly replaceable materials in standard quantities and sizes: the centerpiece of his first exhibition at Andrea Rosen Gallery, New York (1990) was *Untitled*, two 29 × 23 × 26 in. stacks of paper, each printed with opposing text: NOWHERE BETTER THAN THIS PLACE; SOMEWHERE BETTER THAN THIS PLACE. Visitors were allowed to take home individual sheets, an act of participation – in which viewers could assist, if they chose to, in the disintegration/disappearance of the work – that was critical to Torres. This hands-on approach continues to be problematic for museums, where his pieces are situated alongside other works of art that are merely "on view." C.S.

Bibl.: Gonzalez-Torres, 1997

Gore, Spencer. *1878 Epsom, Surrey, †1914 Richmond, Surrey. British painter. He studied at the Slade School, London (1896–99), and became the first president of the → Camden Town Group (1911). Strongly influenced by Pissarro, Gauguin, and Cézanne (see → precursors), Gore was one of the most important English → Post-Impressionists. Bolder than most of his British contemporaries, he quickly moved away from lyrical, delicately colored theater, ballet, and garden scenes to paint powerfully structured, brightly colored landscapes, notably of London and Richmond. L.Sch.

Bibl.: Gore/Shone, Gore, 1983

Gorky, Arshile. *1904 Khorkom, Armenia, †1948 Sherman, Connecticut. Armenian-born American painter. After his family fled to the Caucasus in 1919, he emigrated to the US in 1920. He studied at the Providence Technical High School, Rhode Island (1920–22), the Rhode Island School of Design, and the New School of Design, Boston (1922–24). In 1925 he moved to New York, where he came into contact with John → Graham,

Arshile Gorky, *Waterfall*, 1943 , Oil on canvas, 153.5 x 113 cm, The Tate Gallery London

→ Davis, and de → Kooning. In 1932 he assumed the pseudonym Arshile Gorky. · Between 1935 and 1939 he worked for the → Federal Art Project (mural in Newark Airport, destroyed). In 1939 he painted a mural for the World's Fair in New York. His early work (*The Artist and His Mother*, 1926–29) was strongly influenced by Cézanne and the young → Picasso. In the 1930s his interest shifted to Cubist pictorial construction with geometric shapes (*Organic Construction*, 1932). From 1940, Picasso was superseded as a model by → Miró and Gorky developed a more improvisatory approach. Stimulated by the Surrealist artists who had emigrated to New York (→ Ernst, → Masson, and → Matta), he created images with Surrealist, luminously colorful, floating shapes (*The Liver is the Cock's Comb*, 1944). Gorky's associative, biomorphic pictorial language was developed in numerous oil paintings, drawings, and pastels which anticipated → Abstract Expressionism. The last pictures he painted before his tragic suicide have a strongly autobiographical character (*Agony*, 1947) and are characterized by inner conflict, dark coloration, and aggressive symbolism. H.D.

Bibl.: Rosenberg, Gorky, 1962 · Gorky, New York, 1981 · Jordan/Goldwater, Gorky, 1982 · Gorky, London, 1990

Arshile Gorky, *Scene in Khorkom*, c. 1936, Oil on canvas, 91.4 x 123.9 cm, Mr. and Mrs. David Lloyd Kreeger

Gormley, Antony. *1950 London. British sculptor and draftsman, active in south London. Educated at Cambridge University (1967–70) and in London at the Central (1973–74), Goldsmiths' College (1975–77), and the Slade (1977–79); an early thesis concerned → Spencer. Preoccupied by the relationship between space and the body, in 1981 (the year of a debut one-man show at the Whitechapel) he produced *Bed*, a "mattress" of sliced white bread eaten-out into the shape of a body. The theme was taken up in concrete in later works. His often seamed "body cases" are purposefully unemotional: he is keen to eschew "symbolic representation" (A.G., 1997) and "the melancholy of being trapped in the body [or] the body as womb, as tomb" (1994). To make his often improbably posed "everyman" casts, Gormley wraps himself completely in a "prison" of cling film, scrim, and plaster, from which a fiberglass mold is made; this is then cast in lead or iron and installed (e.g. in Cologne, 1997, *Total Strangers*). He says of these works: "There's a sense in which the object either displaces the space [...], or contains space [as in] the body cases" (e.g. *Critical Mass; Iron Man*, 1993). Versions of the atypical *Field* (1989–) – which lay behind a 1993 Turner Prize – treat of anomie through vast phalanxes of hand-sized anthropomorphic clay models, made by community co-workers, which fill the gallery

space. His controversial "cruciform" of weathering steel, *The Angel of the North* (1998; near Gateshead on the A1), is the tallest sculpture in Britain; *Quantum Cloud* (on the Thames in Greenwich, London, due for completion end 2000) will be still taller. D.R.

Gottlieb, Adolph. *1903 New York, †1974 New York. American painter. He studied at the → Art Students League (1919–21) and the Académie de la Grande Chaumiére, Paris (see → académie). In 1935 he co-founded the group The → Ten with → Rothko among others. In the early 1940s, influenced by → Surrealism and Indian sign language, he began to produce his *Pictographs*, which consist of fields strung together like writing and filled with letters, fragments of bodies, and suggestive symbols. At the end of the 1940s, he shifted toward totally abstract symbols (*Romanesque Façade*, 1949), before embarking on his *Imaginary Landscapes* (1951–56), compositions divided horizontally into "heaven" and "earth" zones (a duality which was also a feature of his late work). The closed circle stands for the cosmos and the amorphous shape for chaos (*Burst*, 1957). His decorative works included murals for the post office in Yerington, Nevada (1939), and tapestries for the synagogue in Milburn, New Jersey (1951). H.D.

Bibl.: McNaughton, Gottlieb, 1981

Götz, Karl Otto. *1914 Aachen. German painter and graphic artist, living in Niederbreitbach-Wolfenacker, Germany. He attended the Kunstgewerbeschule Aachen from 1932 to 1934. In 1936 he worked on abstract films, photographic art, and → photograms. In 1948–53 he was editor of the magazine *Meta*. In 1949 Götz came into contact with → Cobra, and in 1952 he co-founded the group of abstract painters, Quadriga. In 1959 he exhibited at → Documenta 2. From 1959 to 1979 he was Professor of Art at the Kunstakademie, Düsseldorf. Under the influence of → Wols and French → Tachisme, Götz developed his own technique of rapid, gestural abstraction from large color applications (usually black in interaction with a few brightly colors or, more recently also white on black), which are then turned into abstract traces of movement (*Danton's Death*, 1960). Calculation and emotion, rational and spontaneous elements are held in a delicate balance in Götz' paintings by the underlying artistic concept (movement, positive-negative, script character of the paint). H.D.

Bibl.: Zimmermann, Götz, 1994

Gowing, (Sir) Lawrence. *1918 Stamford Hill, London. British painter and art historian. In 1936, Gowing joined → Coldstream's class at Fitzroy St., producing oils in the subtle and tempered manner of the → Euston Road School master (*Mare St, Hackney*, 1937). In the 1940s and 1950s, pigment thickened in portraits (the powerful *Ilse Magdelen R*, 1953), still lifes and landscapes (the "Cézanne-green" *Tree Cavern*, 1947). Though acquainted with Ben → Nicholson since his Fitzroy days, abstractionism (derived from landscape) only surfaced meaningfully in the late 1950s and 1960s: *Wood: parabolic perspective* (1963)

seems near → Vasarely. A striking theme of the late 1970s/1980s is an elongated Vitruvian man treated in vibrant, physical style close to → Bacon. Gowing was knighted in 1982 and is best known as a scholar: publications include histories of art, editions of his critic friend Adrian Stokes, and studies of Vermeer, Constable, Turner, Cézanne, → Matisse, Coldstream, → Freud, and Bacon. D.R.

Bibl.: Gowing, London, 1983

Graeser, Camille. *1892 Carouge, Geneva, †1980 Zürich. Swiss painter and interior designer. He studied interior design at the Kunstgewerbeschule, Stuttgart (1913–15). He was a member of the → Deutscher Werkbund and had contacts with Der → Sturm. In 1977 he took part in Documenta 7. In the 1920s Graeser worked predominantly as an industrial and interior designer in Stuttgart, where he participated in the Weissenhof housing scheme under Mies van der Rohe. In 1933, after settling in Zurich, he devoted himself increasingly to painting, adopting a strict form of → geometric abstraction. He favored large formats and used few colors, which he combined in a wealth of variations (*Translokation*, 1968), thus anticipating → Minimal art. H.D.

Bibl.: Rotzler, Graeser, 1979

graffiti (From Italian *graffito* = scratched into). A general term for various kinds of inscription, script, symbol, sign, or picture usually scratched, painted, or sprayed on publicly visible surfaces. In the 20th century graffiti was often an illegal and anonymous activity, the expression of a youth subculture. A traditional thread runs from the political battle slogans painted on the walls of houses in the 1920s to the "alternative" slogans of the 1960s and 1970s ("Imagine there's a war and no one goes to it"). A contemporary version of written graffiti, which started in the US about 1968, can be seen in the "hits" or "tags" – ornamentally fashioned nicknames or code names, often abbreviated – made by young "writers" or "writer groups" to mark their presence in their own or someone else's area of town or in the subway. From such "tags" developed large-format pictures sprayed on walls as murals or on trains as "subway pieces" or "cars." Although the sprayers are anonymous, they have identifiable individual styles. By law such grafitti is usually categorized as vandalism and is removed by the authorities. At the end of the 1970s the art of grafitti was discovered by the art markets and museums. The Swiss Harald Naegeli, who at first acted anonymously and was given a prison sentence when discovered, became famous as the "Sprayer of Zurich." In the US and France, artists used the styles and strategies of grafitti, although they frequently painted on canvas or specially prepared advertising hoardings. Some of them, such as Robert Combas, → Scharf, and → Haring, became stars. F.K.

Bibl.: Cooper/Chalfant, Graffiti, 1984 · Cooper/Sciorra, Graffiti, 1994

Graham, Dan. *1942 Urbana, Illinois. American → Conceptual artist living in New York. Self-taught, he has worked in a variety of media. He produced his first large-scale works in 1966. In *Homes of America*, a series of photographic essays, Graham showed the development of urban architecture since the 1950s. In the 1970s he devoted himself to art and music criticism, → performances, films, and video. In his video installations (*Video Installation in Shop Windows*, Kassel, 1977) Graham incorporated viewers by filming them in a public or private space and screening the film at a different time on a monitor, thereby revealing certain recurring patterns of behavior. Since the 1980s he has concentrated on installations relating to architecture. On entering his glass pavilions the viewer is confronted with his or her own image and environment, the glass acting both as a reflective surface and a window onto the surrounding town or country. C.W.

Bibl.: Graham, Rock, 1993 · Moure, Graham, 1994 · Graham, Interviews, 1997

Dan Graham, *Triangular: Right Angles*, 1987, Glass and metal, 225 x 225 x 225 cm, Collection FRAC de Bourgogne, Dijon

Graham, John. *1881 Kiev, †1961 Paris. Russian-born American painter. In 1920 he emigrated to the US, settling in New York, where he studied at the → Art Students League of New York (1922). In 1931 he held a teaching post and took part in numerous exhibitions, some of which he organized himself. In 1937 he published *System and Dialectics of Art*, in which he set out his views on Cubism. He made extended visits to Europe, particularly Paris, which enabled him to act as a conduit for European avant-garde developments in the US, where he cultivated contacts with → Abstract Expressionists. His paintings, which included many portraits of women and still lifes, are in a Synthetic → Cubist style. M.G.

Bibl.: Graham, System, 1971 · Green, Graham, 1987/88

Graham, Robert. *1938 Mexico City. American sculptor. He studied at San José College (1961–63) and the San Francisco Art Institute (1963–64). Graham is concerned solely with the human figure and works directly from the model. In the 1960s he created small wax figures in plexiglass cases, usually in erotic, intimate situations. In the 1970s he began creating nude figures that were smaller than life size, placing them on tall plinths. He has also made large-scale works for public spaces. Unlike artists such as → De Andrea or → Hanson, who deceptively mimic reality, Gra-

ham uses traditional techniques of bronze casting, giving his figures an aura of artistic distance at odds with their lively contemporaneity. I.H.

Bibl.: Beal/Neubert, Graham, 1981 · Graham, Los Angeles, 1988 · Graham, Des Moines, 1990

Graham, Rodney. *1949 Vancouver. Canadian → Conceptual artist living in Vancouver. He studied history of art in Vancouver (1968–71). Graham's work explores various disciplines, such as literature, music, and film. Through the constant repeated reprinting of a literary text, such as *Büchner's Lenz* (1983) or the playing of a filmed costume drama, which he directs himself on continuous reel (*Vexation Island* 1997), Graham tests the validity of artworks, investing them with new levels of significance. Even visual and auditory perception are questioned, for example by the upside-down images of *Camera Obscura* (1979), or a new version of Wagner's *Parsifal* (*School of Velocity*, 1992). Graham thus presents an ironic critique of dogmatic attitudes in art and also an "over-writing" of prior art forms with new structures. M.G.

Bibl.: Yarlow, Graham, 1994

Grant, Duncan. *1885 Rothiemurchus, Scotland, †1978 Aldermaston. British painter and designer. He studied at Westminster School of Art, London (1902–05), and the Académie de la Palette, Paris (1906–07). In 1908 he became a member of the → Bloomsbury Group. In 1910–11 he exhibited with the → Camden Town Group and in 1915 with the → Vorticists. Between 1913 and 1919 he was the director of the Omega Workshops. From 1916 he lived with Vanessa → Bell at Charleston. Apart from a short abstract period, Grant painted in a → Post-Impressionist style (*Haystack in Front of Trees*, 1940). He was strongly influenced by avant-garde developments in Paris and his extensive travels (e.g. Byzantine mosaics in Turkey). In addition to his painting, he designed stage sets, textiles, costumes, and murals, often in collaboration with Bell. M.G.

Bibl.: Fry, Grant, 1923 · Shone, Grant, 1976 · Spalding, Grant, 1998

grattage. The term grattage (French *gratter* = to scratch, scrape) describes an artistic technique. Layers of paint already applied to the support are partially removed by scratching and scraping. This technique was popular mainly with the Surrealists (→ Surrealism) and the advocates of → Art Informel, but was perfected by → Ernst who transferred his expertise in → frottage to painting. He placed objects underneath the already painted canvas thereby visibly raising it like a relief. He then partially removed the layers of paint in these areas so that after removing the objects from underneath the canvas they would appear in the picture as "negative." H.D.

Graves, Morris. *1910 Fox Valley, Oregon. American painter living in Loleta, Oregon. Between 1928 and 1930 he worked as a seaman on mail boats in the Far East. He was largely self-taught, although he received some guidance from → Tobey in New York (1935). Influenced by → Surrealism and Chinese and Japanese art, Graves has developed a distinctive pictorial language, dominated by depictions of birds and small animals in broad, empty picture spaces (*Little-Known Bird of the Inner Eye*, 1941). Painted on canvas or Japanese paper, his images convey an impression of fragility and Far Eastern spirituality combined with a lyrical vision of earthly existence. Graves has also created abstract sculptures. H.D.

Bibl.: Graves, Eugene, 1966

Graves, Nancy. *1940 Pittsfield, Massachusetts. American sculptor and painter living in New York. She studied at Vasser College (1957–61) and the School of Art and Architecture, Yale University (1961–64). She first became known in 1966 for her Bactrian camel sculptures, reproduced life-size according to a painstaking process. Bone sculptures followed, which ranged from reproductions of whole skeletons to increasingly free arrangements. Her works based on Indian shamanism at the beginning of the 1970s contained echoes of cult religions and reflected her palaeontological and anthropological studies. More recently she has produced sculptures with floral effects and piles of everyday objects mixed with botanical elements, cast in bronze and painted (*Cheridwen*, *Black Ground* series, 1987). Her graphic works and paintings based on topographical or meteorological images, such as satellite pictures of the surface of the moon (*Lunar* series), explore visual structures. I.H.

Bibl.: Balken, Graves, 1986 · Carmean, Graves, 1987 · Graves, Aachen, 1992 · Yager, Graves, 1993

Gris, Juan. *1887 Madrid, †1927 Boulogne-sur-Seine. Spanish painter, set designer, illustrator, and sculptor. He attended the Escuela de Artes y Manufacturas, Madrid (1902–04), and was a

Nancy Graves, *Camels VII, VI and VIII*, 1968/69, Wood, steel, linen, polyurethane, animal hide, wax, oil paint, 244 x 274 x 121 cm, 228 x 366 x 112 cm, 228 x 305 x 122 cm, National Gallery of Canada, Ottawa

Juan Gris, *The Breakfast*, 1915, Oil and charcoal on canvas, 92 x 73 cm, Musée National d'Art Moderne, Centre Georges Pompidou, Paris

painting student of José Moreno Carbonero. In 1906 he moved to Paris (→ Bateau-Lavoir), where he initially worked as an illustrator for magazines (1906–10). In 1908 he met the art dealer Daniel-Levy Kahnweiler (under contract from 1912). He had his first one-man exhibition in 1919 in Léonce Rosenberg's Galerie de l'Effort Moderne. In 1922–23 he produced scenery and costume designs for Diaghilev's Ballets Russes. He was also active as an art theorist (lecture "Sur les possibilités de la peinture," Paris, 1924).

Gris combined the intuitive → Cubism of → Picasso and → Braque with a more systematic approach. His early works were monochrome pictures in shades of gray and brown in which the shapes of the objects are carved out in a sculptural way (*Portrait of Picasso*, 1912). He increasingly used color, giving his still lifes a rich orchestration made up of a few tones in a variety of shades (*Pear and Grapes on a Table*, 1913). He juxtaposed contrasting colors and shades, interspersing them with black and white. From 1914 he also used the Cubist → collage method of *papiers collés* to separate the three-dimensionality of the picture even more distinctly from the description of the object. This development led Gris to Synthetic Cubism (after 1915), in which color and shape were organized in such a way that "objects" arise from the artistic process itself (*Woman with a Mandolin*, 1915). In the works of the "architectural period" of 1916–19 (*Guitar and Fruit Bowl on a Table*, 1918), Gris achieved the "flat, colorful architecture" he was striving for, in which objectivity results from visual memory and a deductive method of form. Inspired by → Lipchitz, Gris also began to make sculptures at this time (*Harlequin*, 1917–18). In his later pictures, the poetic element is once again to the fore, the abstract form of the image acquiring an emotional, sensual aura by way of figurative borrowings (*Pierrot with Guitar*, 1922). H.D.

Bibl.: Kahnweiler, Gris, 1947 · Cooper/Potter, Gris, 1977 · Green, Gris, 1992

Gromaire, Marcel. *1892 Noyelles-sur-Sambre, †1971 Paris. French painter and graphic artist. He

received no formal training, instead frequenting artists' studios in Montparnasse. In 1918 he executed woodcuts for the book *Homme de Troupe* and in 1922 did his first etchings. In 1925 he produced illustrations for *Ruptures*. In 1937 he created murals for the Exposition Universelle in Paris. In 1952 he won the Carnegie Prize and in 1959 took part in Documenta 2. Gromaire's prewar work was influenced by Cézanne → precursors, but from 1920 he developed an expressive, monumental style (*War*, 1925). His main subject was massive, strongly contoured figures in close-up, reduced to essential forms and stripped of anecdotal detail. His monumental approach to composition and use of simplified forms led to cartoons for large tapestries and in 1939 he received a joint commission with → Lurçat to design pictorial carpets for Aubusson (*The Four Elements, The Four Seasons*). H.D.

Bibl.: Gromaire, Paris, 1980

Grooms, Red. *1937 Nashville, Tennessee. American painter, sculptor, and film-maker living in New York. He studied at Peabody College, Nashville, the Art Institute of Chicago, the New School of Social Research, New York, and at → Hofmann's summer school in Provincetown. In the late 1950s he was a pioneer of → happenings in New York (*The Burning Building*, 1959). In 1967 he developed his first three-dimensional panoramas – mixed-media constructions showing figures in everyday scenes as in comic strips. These often monumental environments were constructed by his collaborators (Ruckus Construction Co.). His work fuses elements from → Pop art with a personal symbolism, creating irreverent pastiches on the history of art (*Broadway Boogie-Woogie Revisited*, 1990). H.D.

Bibl.: Grooms, Philadelphia, 1985

Gropius, Walter. *1883 Berlin, †1969 Boston. German architect and designer. He studied at the Technische Hochschule, Munich (1903), the Technische Hochschule, Berlin (1905–07), and in Behrens' office in Berlin. Three years later he set up his own architectural practice, collaborating with Adolf Meyer until 1925. In 1911 he became a member of the → Deutscher Werkbund and in 1918 president of the Arbeitsrats für Kunst in Berlin. In 1919 he founded the → Bauhaus in Weimar, remaining director until 1928 (his motto for the school was "Art and technology, a new unity"). In 1928 he moved to Berlin and between 1934 and 1937 he lived in London, where he entered into partnership with Maxwell Fry. In 1937 he moved to the US, where he taught

Walter Gropius, *Bauhaus Books vol. 1, Gropius Bauhaus Buildings 12*, 1930, Book jacket, Albert Langen Verlag, Munich

architecture at the Graduate School of Design, Harvard University. In 1945 he founded The Architects' Collaborative (TAC).

One of the most influential architects and theorists of his time, Gropius was a pioneer of rationality in architecture and the mechanization of the building industry. His early design for the Fagus Works (1911–14) helped forge a new aesthetic for industrial buildings using glass and iron, developed further in his design for the Bauhaus building in Dessau (1925–26). His various housing schemes (Törten, Dessau, 1926–27; Dammerstock, Karlsruhe, 1927–28; Siemensstadt, Berlin, 1929–30) demonstrate his interest in modular construction and his quest to provide optimum living conditions. H.O.

Bibl.: Nerdinger, Gropius, 1985 · Probst/Schädlich, Gropius, 1985–87 · Nerdinger, Gropius, 1990–95

Grosvenor, Robert. *1937 New York. Self-taught American sculptor living in New York. He studied painting at the École des Arts Décoratifs in Paris (1957–59). From 1965 he began making large, elementary → Minimalist constructions out of plywood and metal, following these works with monumental outdoor sculptures. In the 1970s, his works showed a growing concern with the effects of time. His use of worn, damaged, and fragmented materials (wood and industrial materials such as concrete, plastic, steel, and iron) evokes the transience both of nature and works of art. They seem to suggest that time is remembrance, thereby assuming a significance that transcends pure objectivity. K.S.-D.

Bibl.: Grosvenor, Kerguéhennec, 1989

Grosz, George. *1893 Berlin, †1959 Berlin. German-born painter and graphic artist. He studied at the Königliche Sächsische Akademie der Künste (1909–12) and the Kunstgewerbeschule, Dresden (1912–14). In 1914 he enlisted in the army, but was discharged in 1917. In 1915–16 he met → Meidner and the Herzfelde brothers (→ Heartfield) and in 1917 became a key figure in the Berlin → Dada movement. In 1918 he joined the → Novembergruppe. In 1932 he was appointed to a teaching post at the → Art Students League of New York and the following year emigrated to the US. In 1937 seven of his works were exhibited by the Nazis in the "Degenerate Art" exhibition. He became an American citizen in 1938. In 1958 he became a member of the Academie der Künste in Berlin and the following year moved back to the city.

Grosz's career began with caricatures and book illustrations which contained echoes of Art Nouveau. In 1913 he discovered the work of → Pascin, with its fine brushstrokes, and he taught himself painting while continuing to draw for satirical publications. His vision, shaped by political and social circumstances, was a mixture of condemnation, horror, and the grotesque, and his technique incorporated children's scribbles, pornographic grafitti, and "the artistry of the mentally ill." His painting *Dedication to Oskar Panizza* (1917–18), a protest against humanity brutalized by war, was a digest of his themes and motifs. About 1920 he experimented with Dadaist forms of expression (includ-

George Grosz, *Pillars of Society*, 1926, Oil on canvas, 200 x 108 cm, Neue Nationalgalerie, Berlin

ing → collage) and together with → Hausmann, → Höch, and Heartfield put on nonsensical and intentionally provocative public performances. In the 1920s he became a leading exponent of → Neue Sachlichkeit. His pictures showing society and the loss of individuality incorporated elements from → Pittura Metafisica, with distorted city buildings and figures like puppets or dummies. He produced many drawings of war profiteers, politicians, pulpit preachers, and military men, which were widely distributed as reproductions. From 1924 he became increasingly interested in individuals and he produced a number of portraits. In America his drawings, cut off from their roots, became blander and his nudes acquired voyeuristic overtones. The late work of the 1950s is imbued with a romanticizing nostalgia. G.P.

Bibl.: Dückers, Grosz, 1979 · Hess, Grosz, 1985 · Kranzfelder, Grosz, 1993 · Schuster, Grosz, 1994

Group of Seven. Canadian art group. Named at an exhibition in the Art Gallery of Toronto during May 1920, the group comprised, among others, the Toronto artists Frank Carmichael (1890–1942), J. E. H. Macdonald (1873–1932), Lawren S. Harris (1885–1970), and Fred Varley (1881–1969); it also incorporated associates from other Canadian cities. The group focused on responses to landscape in an indigenous immediacy conveyed by heightened coloration and simplified form. After an initial rearguard action by European idioms, the group had become a dominant force by the late 1920s. It ceased to exhibit in late 1931 and disbanded in 1933, though its influence persisted until well in the 1950s and beyond the confines of Ontario. D.R.

Bibl.: Hunkin, Group of Seven, 1979

George Grosz, *The Street*, 1915, Oil on canvas, 45.5 x 35.5 cm, Staatsgalerie, Stuttgart

Groupe de Recherche d'Art Visuel (GRAV). Group of → Kinetic artists (formed in Paris in 1960) who explored the potential of visual art in a scientifically experimental way. The best-known members included → Morellet, Joel Stein (1926–), and Jean-Pierre Yvaral (1934–), together with the South American artists Horacio Garcia Rossi (1929–), → Le Parc, and Francisco Sobrino (1923–). Their works, a number of which were collective, included → environments, gridlike three-dimensional structures, and kinetic objects. Building on the ideas of → Groupe Espace, many of their works were designed to provoke the spectator into playful participation. The group disbanded in 1968. H.D.

Bibl.: GRAV, Dortmund, 1968

Groupe Espace. The Groupe Espace was founded in Paris in 1951 by André Bloc and artists working on *Art d'aujourd'hui* , a magazine that sought to apply the ideas of → Constructivism and → Neo-Plasticism to the urban social area. Members included Jean Dewasne, Étienne Béothy, Jean Gorin, Felix Del Marle, Edgar Pillet, → Vasarely and Kinetic artist Nicolas Schöffer. The group emphasized the unity of architecture, painting, and sculpture, and regarded art as a social phenomenon rather than an individual's subjective endeavor. H.D.

Grützke, Johannes. *1937 Berlin. German painter and set designer living in Berlin and Lüneburger Heide. He studied art in West Berlin (1957–63), and has lectured in Hamburg, Salzburg, and Nuremberg. His early pictures, produced in the late 1960s, are characterized by ironic baroque scenarios and picture-puzzle games. These led to theatrical scenes with groups of figures gazing provocatively out of the picture. His motifs range from the mythological, erotic, and literary to the everyday. With their monumental approach and growing psychological complexity, his pictures verge on caricature or the grotesque. The effect for which he is striving – following in the spirit of → Neue Sachlichkeit – could be described as both pre- and postmodern. His stage sets for Zadek (Mozart, Shakespeare, Wedekind, Fallada, etc.) caused a furore, as did his most important work to date, *The Procession of the Representatives of the People* (Paulskirche, Frankfurt, 1989–91). A panoramic mural with 200 figures, this work has been described as a "metaphor of world theater" (Beauchamp). L.Sch.

Bibl.: Grützke, Wolfsburg, 1992 · Bacher, Grützke, 1995

Guerrilla Girls. A group of feminist women artists founded in 1984 in New York to campaign against sexism and racism in the art world. As one of their aims is complete anonymity, they often wear gorilla masks in public. They also organize poster and leaflet campaigns. H.D.

Bibl.: Chadwick, Women, 1990 · Guerrilla Girls, 1995

Gursky, Andreas. *1955 Leipzig. German photographer living in Düsseldorf. He studied at the Folkwangschule, Essen (1981–87), and the Kunstakademie, Düsseldorf, with → Becher (1981–87). He photographs urban locations and industrial

Andreas Gursky, *Charles de Gaulle*, Paris, 1992, Color photograph, C-Print, 165 x 200 cm, DG-Bank Collection, Frankfurt

sites from a distant and elevated viewpoint, showing people, who appear as tiny figures in the large prints, in structured spaces and activities in which they no longer register as individuals. His pictures are characterized by dull colors, a lack of contrast or vivid detail, and the balancing of horizontal, vertical, and diagonal axes. Since 1992 Gursky has been processing his pictures using digital montage, which enables him to double motifs and intensify colors. C.W.-B.

Bibl.: Gursky, Düsseldorf, 1998 · Gursky, Wolfsburg, 1999

Guston, Philip. *1913 Montreal, †1980 Woodstock, New York. American painter and draftsman. He studied in Los Angeles at the Manual Arts High School (1927–29), where he made friends with → Pollock, and at the Otis Art Institute (1930–34). In 1934 he traveled to Mexico, before settling in New York. He taught at the State University of Iowa (1941–45), New York University (1951–58), and Boston University (1972–80). In 1960 he took part in the Venice Biennale. Between 1935 and 1942, influenced by the Mexican → muralists, Guston created murals with social and political themes for the → Federal Art Project. Initially he worked in a figurative vein, but then developed a style close to → Magic Realism, before producing works which were completely abstract but rejected Constructivism. At the beginning of the 1950s, his approach became more gestural (→ Abstract Impressionism) and his characteristic pictures of this period consist of pastel-colored grid structures (*Cythera*, 1957). At the beginning of the 1970s he returned to figurative painting, adopting an aggressively powerful style with expressionistic brushstrokes (*The Painter*, 1976). These late works anticipate → New Image Painting. D.W.

Bibl.: Storr, Guston, 1986

Gutai Group. Group of Japanese artists founded in 1954 in Osaka by Jiro Yoshihara (1905–1972). Its members included Kazuo Shiraga, Sadamasa Motonaga, Saburo Murakami, Shozo Shozo Shimamoto, Yasui Sumi, and Atsuko Tanaka. Besides → performances (Sky Festival, 1960) and experiments with materials (Murakami's piercing of paper panels, 1955), the group was known for painting actions similar to American → Action Painting. Work in other fields, such as → Op art and → Kinetic art, brought the group into contact with the European avant-garde (→ Zero, → Nul), as a result of which it participated in a number of exhibitions in Europe. The group disbanded in 1972 following Yoshihara's death. K.S.-D.

Bibl.: Gutai, Darmstadt, 1991

Gütersloh, Albert Paris von. *1887 Vienna, †1973 Baden near Vienna. Austrian painter and writer. A man of various talents, Gütersloh worked in the theater (as an actor under the name Albert Matthäus, as a set designer for Max Reinhardt among others, and as a producer), wrote several novels (*Die tanzende Törin,* 1911, and *Sonne und Mond,* 1962) and theoretical works on art theory, and was a self-taught painter (from 1912). He was part of the Neukunstgruppe around → Schiele. Between 1930 and 1938 he taught at the Kunstgewerbeschule in Vienna (including Gobelins tapestry). In 1940 his work was banned by the Nazis. From 1946 he was active in promoting modern art in postwar Vienna. From 1945 to 1962 he taught painting at the Akademie der Bildenden Künste in Vienna.

After early work in a → Jugendstil vein and a spell producing → Expressionist paintings, Gütersloh developed a cultivated representational style influenced by → Cubism and → Fauvism. Executed in painstaking lines, with a predilection for faceted forms, his pictures depict a dreamily mystical world which anticipates → Fantastic Realism. In addition to portraits, still lifes, and landscapes, he painted so-called *Miniaturen zur Schöpfung* (watercolor and gouache), showing ironic, fictitious human situations. H.O.

Bibl.: Hutter, Gütersloh, 1977 · Adler, Gütersloh, 1986 · Gütersloh, Vienna, 1987 · Laue, Gütersloh, 1996

Albert Paris von Gütersloh, *Still life with Violin,* c. 1920, Oil on canvas, 52 x 61.5 cm, Museum Moderner Kunst, Vienna

Gutfreund, Otto. *1889 Dvur Králové nad Lab, †1927 Prague. Czech sculptor. He studied at the School of Applied Arts, Prague (1906–09), and the Académie de la Grande Chaumière, Paris (1909–10). He fought in World War I and was interned between 1915 and 1918. In 1920 he returned to Prague, where he taught monumental sculpture at the School of Applied Arts (from 1926). In his early heads, figures, and reliefs he developed a style based on the expressive deformation of form through the use of light and shade. Influenced by → Cubism, he moved toward a geometric, dynamic abstraction. After the war, a short Constructivist phase was followed by a switch to naturalistic social criticism in the form of small-format genre scenes and images from the world of work. He also made portrait heads. I.H.

Bibl.: Gutfreund, Berlin, 1987 · Gutfreund, Prague, 1995

Renato Guttuso, *Crucifixion,* 1941, Oil on canvas, 200 x 200 cm, Galleria Nazionale d'Arte Moderna, Rome

Guttuso, Renato. *1911 Bagheria near Palermo, †1987 Rome. Italian painter, largely self-taught. He lived in Rome (1931–37), Milan (1937–39), and then Rome again. He had his first one-man exhibition in 1938. In 1940 he joined the Communist Party and in 1946 became a member of the group → Fronte Nuovo delle Arti. He was active politically, becoming a member of the World Council for Peace and winning peace prizes in 1950 (Warsaw), 1951, and 1972 (both in Moscow). In 1950 he took part in the Venice Biennale. In 1975 he became a city councillor in Palermo and was subsequently elected as senator.

Guttuso's works of the 1930s, painted in a blend of → Expressionism and → Cubism, were intended to draw attention to political corruption and injustice (*Crucifixion,* 1941). He always reacted directly to political and social events and consequently was forced to go into hiding in the 1940s. After the war he painted historical pictures in an Expressionist style, developing a form of → social realism. His work of the 1960s and 1970s showed → Surrealist tendencies. In spite of a more abstract approach and an increase in autobiographical subjects, his political engagement remained undiminished (*Report from Vietnam,* 1965). H.D.

Bibl.: Brandi, Guttuso, 1983 · Crispolti, Guttuso, 1983/85

Haacke, Hans. *1936 Cologne. German Conceptual artist, painter, and sculptor who has lived in New York since 1965. He studied at the Staatlichen Werkakademie in Kassel (1956–60). He has taught in Cologne, Philadelphia, and New

York. In 1993 he took part in the Venice Biennale. His work was initially influenced by the → Zero group, but in the 1960s it became increasingly concerned with social and political issues (*Real Time System* and *Condensation Boxes*). His sculptures *Grass Cube* (1967) and *Cooperative of Ants* (1969) explored biological and physical phenomena. Haacke's work was increasingly concerned with cultural politics, a consequence of his conviction that art programs are primarily organized for financial reasons and to cultivate the image of sponsors. In *Manet Project* (1974) and *Buhrlesque* (1985) he exposed the dealings of collectors and institutions, documenting them in photographs and → installations. His installation *Bottomless* [*Bodenlos*] for the German pavilion at the 1993 Venice Biennale was intended to be a metaphor for the state of Germany after reunification and the country's ongoing reconciliation with the past. P.L.

Bibl.: Bußmann/Matzner, Haacke, 1993 · Haacke, Stuttgart, 1993 · Haacke, Barcelona, 1995

Hans Haacke, *Buhrlesque*, 1985, Marble table, embroidered tablecloth, Bally shoes, candles, South African military magazine, 94 × 194 × 94 cm, Kunsthalle, Bern

Haas, Ernst. *1921 Vienna, †1986 New York. Austrian-born photojournalist and advertising photographer. He studied medicine and philosophy. After World War II Haas devoted himself to photography, working for the magazines *Der Film* and *Heute*. His breakthrough came with a series of pictures showing returning war prisoners in Vienna (1947). In 1949 he joined the Magnum Photos agency and in 1950 moved to New York, where he worked as a freelance photographer for *Life* magazine, *Paris-Match*, and *Esquire*, among

others. His series *Images of a Magic City*, published in 1952, was a pioneering work in color photography. His innovative approach to color and camera motion culminated in his book *The Creation* (1971). C.W.

Bibl.: Hess, Haas, 1992

Hacker, Dieter. *1942 Augsburg. German painter and sculptor living in Berlin. He studied at the Akademie der Bildenden Künste, Munich. In 1971 he opened the 7. Produzentengalerie in (West) Berlin and published an accompanying magazine. In 1976 he published the magazine *Volksfoto*. From 1977 he worked for German television and designed stage sets for Botho Strauss and Heiner Müller.

In the 1960s Hacker's work was centered on optical illusions and → Kinetic art. In his 7. Produzentengalerie, debate about the function of art was of greater importance than the pictorial results. After devoting himself to photography and film, in the 1970s Hacker returned to expressively painted figurative images dealing with cultural and social issues in theatrical and poetic picture puzzles. K.S.-D.

Bibl.: Hacker, London, 989

Halley, Peter. *1953 New York City. American painter. Halley was educated at Yale and the University of New Orleans. In the early 1980s he became associated with a new abstraction movement called Neo-Geometric Conceptualism (→ Neo-Geo) that parodied and reworked early abstract and semi-abstract styles, rejecting both (Neo-Neo-) Expressionism and the "sincerity" of "Bad Painting." Other putative figures included → Steinbach, (some) → Armleder, and Philip Taafe (1955–). Represented by the Gagosian Gallery, New York, and collected by Charles Saatchi, Halley's work has since moved on to nondescript figurative icons portraying images of confinement – perhaps a discreet allusion to the condition of the post-modern artist (Guy Debord is a reference). In 1995, his pamphlet *Images, Marks, and Models* analyzed visual simulation in relation to abstractionism. D.R.

Hambling, Maggi. *1945 Hadleigh, Suffolk. English painter. She trained initially (1962–64) at the East Anglian School of Art (with the noted colorist Cedric Morris [1889–1982]) before moving to London, where she studied at Camberwell School of Art (1964–67) and then the Slade (1967–69). After a brief "avant-garde" period, Hambling turned decisively to figuration. During a stint as the first artist in residence at the National Gallery, London (1980–81), Hambling produced a series of the British actor Max Wall, much appreciated in traditional circles for its unabashed coloring. In the mid-1980s she began to work seriously in landscape in a consciously "English" style (using monotypes from 1988). Perhaps in echo of the lessons of her teacher and Morris' companion Arthur Lett-Haines (1894–1978), symbolism dominated by the early 1990s in her imaginative compositions. Important motifs for this period include the Minotaur and solar myth. She has been producing ceramics since 1993. The

Rebecca Horn, *Turm der Namenlosen*, 1994, Installation with fruit ladders, violins, metal constructions, glass funnels, iron, water, hoses, pump, copper rods, Kestner Gesellschaft, Hannover

year 2000 sees the presentation of a cycle on the Crucifixion that she has been working on for many decades. D.R.

Bibl.: Hambling, London, 1987 · Hambling, Sunderland, 1993

Hamilton, Ann. *1956 Lima, Ohio. American Installation artist. Hamilton received her B.F.A. in Textile Design from the University of Kansas, and her M.F.A. in Sculpture from the Yale School of Art in 1985. She is known for her temporary, site-specific installations that take up the entire exhibition space. In her work she often juxtaposes cultural with natural artifacts – books, furniture, or money with flour, sheep, moths – giving her work an organic and at the same time a social dimension (*between taxonomy and communion*, 1992). Her installations appeal to all senses, often incorporating sound and touch. Language, in the form of quotations from literary sources, also plays a role in her work: *malediction* (1991) features a voice reading selections from two poems by Walt Whitman. She represented the US in the 21st São Paulo International Bienal in Brazil (1991) and in the 48th Venice Biennale (1999). J.F.

Bibl.: Hamilton, 1991 · Cooke, Hamilton, 1995

Hamilton, Richard. *1922 London. British painter, printmaker, and designer, a pioneer of → Pop art who lives at Northend Farm, Henley-on-Thames. After leaving school he worked in advertising and attended evening classes in painting. He then studied at the Royal Academy (1938–40 and 1946) and the Slade School of Art (1948–51). During his studies, he came into contact with Marcel → Duchamp. In 1952 he co-founded the → Independent Group. He taught at the Central School of Arts and Crafts (1952–53), King's College, University of Durham (1953–56), and the Royal College of Art (1957–61). Drawing on his experience of advertising work, Hamilton broke down the division between high art and applied, consumer-oriented art, thereby laying the foundations for Pop art. His pictures are concerned with the mass media, the consumer society, and popular culture, addressing contemporary issues of perception while borrowing from the history of art. His aim was to develop a new, free pictorial form combining pure and applied art, using Pop art to examine aspects of the advertising industry – the vision it puts forward and the processes of manipulation it uses. More recently, he has explored the possibilities of digital media (→ Computer art) and their effects on pictorial perception and art. I.N.

Bibl.: Hamilton, Works, 1982 · Field, Hamilton, 1983

Hammons, David. *1943 Springfield, Illinois. American Performance and Installation artist living in New York and Rome. In 1963 he moved to Los Angeles, where he studied advertising graphics. In 1988 he took part in Documenta 9.

Hammons finds inspiration and materials for his work in the streets of Harlem (empty bottles, bottle tops, left-over food, rusted metal parts, lumps of coal, hair, old tools). These everyday items unearthed in trash cans and scrapyards are for him objects from history to be processed into imaginative → installations (*Kick the Bucket*, 1989). Hammons' work reflects the experience of violence and discrimination in the African-American community. It would appear to occupy a niche between the work of Marcel → Duchamp and → Arte Povera, but is primarily motivated by a desire to counter cliché and prejudice with truthfulness. K.S.-D.

Bibl.: Hammons, San Diego, 1995

Duane Hanson, *Woman with Shopping Cart*, 1969, Painted fiberglass, polyester, articles of clothing, shopping cart with product packaging, figure 166 x 70 x 70 cm, Ludwig Forum für Internationale Kunst, Aachen

Richard Hamilton, *Just What is it that Makes Today's Homes so Different, so Appealing?*, 1956, Collage on paper, 26 x 25 cm, Kunsthalle Tübingen, Collection of Prof. Dr. Georg Zündel

Hanson, Duane. *1925 Alexandria, Minnesota, †1996 Boca Raton, Florida. American sculptor and Installation artist. He studied at the University of Minnesota and the Cranbook Academy of Art at Bloomfield Hills, Michigan (graduated 1951). From 1953 to 1960 he lived in Germany. He studied in Munich and worked as a sculptor in Bremerhaven, where he met George Gyro, who introduced him to polyester resin and fiberglass. In 1961 he returned to the US. In the 1960s he

began to develop what would become his principal form of expression: life-size figures generally arranged in groups. Made of fiberglass and synthetic resin, they were clad in real clothes and painted naturalistically. Endowed with an impressively "living" realism, they show normal Americans in their everyday surroundings, at work, eating, or practicing a sport. The mundaneness and → Hyperrealism of his figures convey the despair, helplessness, and frustration of the "American way of life" and prompt viewers to scrutinize themselves. I.N.

Bibl.: Varnedoe, Hanson, 1985 · Bush/Buchsteiner, Hanson, 1990 · Livingstone, Hanson, 1994 · Hanson, London, 1997

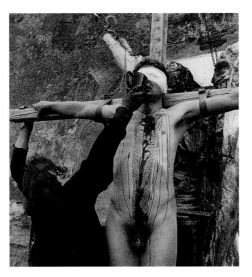

happening, Hermann Nitsch, *Scene from a Performance of the Orgien-Mysterien-Theater*, 1975, 50th Action, Prinzendorf, Schloß 1, Austria

happening. An artistic activity that consists of collective, public actions combining visual, theatrical, and auditory elements (→ Performance art). The term was coined by → Kaprow, who organized *18 Happenings in 6 Parts* in New York in 1959. The roots of the happening can be traced back to the simultaneous performances of the → Dadaists and → Futurists. In contrast to Dada spectacles, which were intended to be provocative, Kaprow and → Cage emphasized aesthetic sensibility. Happenings could be derived from → assemblage, → environments, → Art Informel, and, above all, the theater. The central aim was to involve the audience in the event. The critic Richard Kostelanetz distinguished four categories: pure happenings, staged happenings, staged performances, and kinetic environments. Representatives of pure happenings, such as Kaprow and → Vostell, were in favor of spontaneous actions by independent individuals transposed to unfamiliar places and strange situations. In → Nitsch's *Orgien-Mysterien-Theater*, the accent was placed on mutual experience in cult rituals. In the 1960s, forms of political protest such as sit-ins were also designated as happenings. Happenings took place not only in the US and Western Europe, but also in Japan (→ Gutai Group) and eastern Europe. In addition to happenings, members of → Fluxus developed "events," which were characterized by simpler preconditions and processes (*Toward Events* by George Brecht, 1959). D.S.

Bibl.: Becker, Happening, 1965 · Kirby, Happening, 1966 · Kostelanetz, Theatre, 1970 · Kulterman, Happening, 1971

Haraguchi, Noriyuki. *1946 Yokusaka. Japanese sculptor, Conceptual artist, and graphic artist. He studied at the Nihon University, Tokyo. Although he is not a → Minimal artist, Haraguchi takes elementary basic structures as his starting point. Since 1972 his work has consisted predominantly of monumental, sturdily built, iron sculptures and installations. He uses industrial materials such as concrete, steel, copper, and aluminum, in particular pipes, girders, slabs, and containers full of sump oil, which he finds in the industrial zone of Yokusaka. Haraguchi's aim is to depict the totality of perception in a particular space and site by means of simple shapes and their interrelationships. I.S.R.

Bibl.: Sello, Spiegelbilder, 1982

Hard-Edge Painting. A type of abstract painting characterized by geometric forms and "hard edges." The term was coined in 1958 by the American critic Jules Langner and from 1959 was applied by Lawrence Alloway to the work of painters such as Ellsworth → Kelly and Agnes → Martin, and the artists of the exhibition "Toward a New Abstraction" (Jewish Museum, New York, 1963), including Frank → Stella and Kenneth → Noland, to distinguish it from the gestural approach of → Lyrical Abstraction. Although there were points of contact with European → geometric abstraction and → Op art, exponents of Hard-Edge Painting rejected dogmatic geometrism and banished visible brushstrokes from their work. Josef → Albers (*Homage to the Square*) and → Matisse (→ collages and cut-outs) were precursors. H.D.

Hare, David. *1917 New York City, †1991 Jackson Hole, Wyoming. American sculptor and photographer. Hare's mother was an art collector and closely involved with the 1913 → Armory Show. With a degree in chemistry (1936), he began (1941) experimenting with abstract thermophotography (see → Ubac) in biomorphic or "crystallographic" forms. In contact with exiled figures from → Surrealism in New York, Hare edited the magazine *VVV* (1942–44), with → Ernst and M. → Duchamp among others. By 1944, he had turned from photography to sculpture, first in → Calder-like, plinth-less pieces in openwork metal or plaster (*Sunrise*, 1955). Concerned with Surrealist "connections" (D. H., 1946), his work is imbued with poetry and wit (*Catch*, 1947), incorporating stochastic tinted residues from the welding process (bronze, then iron), and is close to Herbert Ferber (1906–91) or Lynn → Chadwick. He was co-founder of the Subjects of the Artist School in 1948, and took up residence in France in 1953. In the early 1960s Hare began to shift to painting (*Cronus* series with collage, from 1968). By 1965 he had abandoned sculpture, only to return to it in the late 1970s, though dominant → Conceptual and → Minimalist trends were at odds with his aesthetic. D.R.

Haring, Keith. *1958 Reading, Pennsylvania, †1990 New York. American painter and graffiti artist. He studied at the School of Professional Art, Pittsburgh (1976–78), and the School of

Visual Arts, New York (1978). In 1982 he took part in Documenta 7. In 1986 he painted 107 meters of the Berlin Wall. Between 1986 and 1988 he opened his "Pop Shops" in New York and Tokyo. In 1987 he took part in campaigns against drug addiction and aids. With → Basquiat, Haring was one of the principal exponents of → graffiti art, which reached its zenith in New York in the 1980s. He created simple, recurring pictorial signs and formulae from the symbols of mass culture. The cartoon style of his pictures was derived from the graffiti of the illegal sprayer scene, although he was also strongly influenced by → Pop art. The "icons" of Pop, as Haring called his comic-like figures, pictograms, and marks, were intended for rapid dissemination and universal application, and he presented them on fluorescent displays, billboards, walls, and hoardings.

Keith Haring, *Untitled*, 1988,
Acrylic on canvas, 122 x 91 cm,
Private Collection

Keith Haring, *Untitled*, 1989, Installation, painted Cor-Ten steel, 366 x 264 x 310 cm, Kutztown, Pennsylvania

With their luminous colors and simplified forms, they were identifiable as trademarks. In addition to more cheerful motifs, he dealt with controversial topics using, among other things, elements of Christian iconography. His pictures functioned as contemporary "wall newspapers," which commented and reflected on current events. F.P.

Bibl.: Haring, Amsterdam, 1986 · Gruen, Haring, 1991 · Littmann, Haring, 1993 · Celant, Haring, 1997 · Haring, New York, 1997

Harlem Renaissance. Term describing the activities of African-American artists working in Harlem, New York, in the 1920s. It was largely a literary movement inspired by Alain Locke (1886–1954), who encouraged African-American artists and gave them a new self-assurance (*The Negro in Art*, 1941). Among the artists involved in the Harlem Renaissance were → Douglas, who was the first to use African motifs in his pictures, Palmer Hayden (1890–1964), and Malvin Gray Johnson (1896–1934). The movement petered out during the Great Depression of the 1930s. H.D.

Bibl.: Harlem Renaissance, 1997

Hartley, Marsden. *1877 Lewiston, Maine, †1943 Ellsworth, Maine. American painter and poet. He studied at the Cleveland School of Art (1898–99) and at the → Art Students League and National Academy of Design, New York (1900–04). From 1900 he lived on and off in Maine. He made a series of trips to Europe: in 1912 (Paris and Berlin, where he had contacts with Der → Blaue Reiter), between 1914 and 1916 (London, Paris, Berlin, and Munich), and in the 1920s. In 1932 he visited Mexico and in 1934 returned to Maine.

His early works, principally dark Maine landscapes (*Dark Mountain*, 1909), were in a Post-Impressionist style. About 1912–13, influenced by the Blaue Reiter, he turned increasingly to intuitive abstracts with cosmological overtones (*Synaesthetic Sensations*, 1913) and then symbolic abstraction (*Portrait of a German Officer*, 1914). In 1914 he also produced completely abstract series such as *Movement* and *Flag*, which had a formative influence on later American painters such as → Johns. On his return to the US in 1916 he started to produce Expressionist landscapes and still lifes (*Recollections of New Mexico*, 1923–24). On his last trip to Europe, during which he lived in the South of France, his paintings became more Cézannesque (*Trees and Rocks*, 1927). After 1937 he also painted a number of portraits. K.S.-D.

Bibl.: Haskell, Hartley, 1980 · Ludington, Hartley, 1998

Hartung, Hans. *1904 Leipzig, †1989 Antibes. German-born painter and printmaker. He studied philosophy, psychology, and history of art at Leipzig University and painting at the Leipzig Akademie der Schönen Künste. Between 1926 and 1931 he lived mainly in Paris. He fought for the French Foreign Legion in World War II and was badly wounded in 1944. In 1945 he returned to Paris, becoming a French citizen the following year. In 1960 he won the main painting prize at the Venice Biennale and in 1970 the Grand Prix des Beaux-Arts in Paris. In 1972 he moved to Antibes.

Hartung began developing his abstract pictorial language in the 1920s. In these works, color and line are manifestations of pure expressivity, originating not from spontaneous expression or state of mind (→ Art Informel), but from the discovery of shape in movement. The polarization of opposites was superseded in the 1930s by a calligraphic sign language with energetically executed groups of lines (*G 1936-10*, 1936). The paintings he produced after 1945 are characterized by greater control, with the lines becoming more voluminous and rhythmic. In his late period,

Marsden Hartley, *Paris Days ... Pre–War*, 1914, Oil on canvas, 105.5 x 86.5 cm, John and Barbara Landau Collection

Hartung experimented with → grattage and spray techniques. H.D.

Bibl.: Hartung, Berlin, 1975 · Hartung, Düsseldorf, 1981 · Daix, Hartung, 1991

Hartung, Karl. *1908 Hamburg, †1967 Berlin. German sculptor. He studied wood carving at the Kunstgewerbeschule, Hamburg (1925–29). Between 1929 and 1932 he lived in Paris, where he came under the influence of → Maillol, and in 1932–33 he stayed in Florence. In 1951 he taught at the Hochschule der Künste, Berlin. Starting out from classical figuration, and also from the work of → Arp and → Brancusi among others, in 1935 Hartung started to make abstract sculptures mostly based on the human body (*Reclining Figures*, 1938–51). His approach was based on the maxim "from inside to outside," which also applied to his search for prototypes (bird motif; *Urgeäst*, 1950). From the mid-1950s his structures and surfaces were broken up as if through damage, and he produced works with skeletal forms (*Thronoi*, 1959). H.O.

Bibl.: Krause, Hartung, 1998

Raoul Hausmann, *Dada-Cino*, 1921, Gouache on collage, 40 x 30 cm, Philippe-Guy E. Woog

Hans Hartung, *T. 1956–9*, 1956 , Oil on canvas, 180 x 137 cm, Anna-Eva Bergman, Antibes

Hausmann, Raoul. *1886 Vienna, †1971 Limoges. Austrian painter, photographer, → photomontage artist, and writer. He studied painting and sculpture in Berlin (1908–11) and from 1912 came into contact with avant-garde artists and writers there. Between 1915 and 1922 he was closely associated with → Höch (they lived together for a while). In 1918 he co-founded the Club Dada in Berlin and collaborated on the first → Dada manifesto with Richard Huelsenbeck. In 1919–20 he edited the periodical *Dada*, which he produced in collaboration with → Baader among others. In 1920, together with → Heartfield and → Grosz, he organized the "Erste Internationale Dada-Messe" and in 1920–21 organized Dada soirees in several European cities. In 1927 he invented his optophone, a device which converted kaleidoscopic forms into music, and in the same year he started to experiment with photographic techniques. Up until 1933, when he left

Germany, he wrote numerous articles on perception and art theory. After stays in Ibiza, Zurich, Prague, and Paris, in 1939 he lived clandestinely in the French provinces. In 1944 he settled in Limoges, where he devoted himself to art again (particularly painting, → collage, and photograms), also publishing articles on Dada ("Courier Dada," 1958, "In the Beginning was Dada," 1972). The work of the great experimental "Dadasopher" Hausmann embraced many activities: photomontage, collage, sound poems, → assemblage, dance, and photography. His aim, between invention and destruction, was creativity without boundaries, and he strove, with irony and improvisation, to devise "a new attitude in the field of optics." H.O.

Bibl.: Hausmann, Ostfildern, 1994 · Koch, Hausmann, 1994 · Züchner, Hausmann, 1998

Hayter, Stanley William. *1901 Hackney, †1988 Paris. British painter, printmaker, and draftsman. He settled in Paris in 1926. In 1927 he founded Atelier 17, a printing and graphic workshop (17, rue de Campagne-Première), where artists such as → Arp, → Miró, and → Tanguy worked. Between 1940 and 1950 he lived in New York, establishing Atelier 17 in the New School for Social Research. It was here that → Kline, de → Kooning, and → Pollock learnt about printmaking. In 1949 his standard manual *New Ways of Gravure* was published. In 1950 he returned to Paris, where he re-opened Atelier 17 in 1955 at the Académie Ranson. Hayter's own works are related to → Surrealism and emphasize color and texture. In his *Peintures jaunes* he explored the optical effects of waves, using intense colors. H.D.

Bibl.: Hacker, Hayter, 1988

Heartfield, John. *1891 Schmargendorf near Berlin, †1968 Berlin. German graphic artist and painter. He was the brother of the publicist and

writer Wieland Herzfelde (1896–1988). He studied at the Kunstgewerbeschule, Munich (1908–11), and the Kunst- und Handwerkerschule, Berlin-Charlottenburg (1912–14). In 1915 he met → Grosz. From 1916 he designed such Dada periodicals as *Neue Jugend*, *Jedermann sein eigener Fussball*, and *Die Pleite*. In 1917 he co-founded the Malik Press. Between 1917 and 1919 he designed film sets for the UFA. In 1918 he became a member of the KPD (German Communist Party), for which he produced articles and printed advertising material. In 1933 he emigrated to Prague, where he contributed to the *Arbeiter-Illustrierten – Zeitung*, and in 1938 to London, where he lived until his return to Germany in 1950. Drawing on typography and film cutting techniques, Heartfield developed an original approach to → photomontage, soon moving from the grotesque and the comic to biting satire and political agitation. These works combine words and images and are frequently constructed out of antitheses. Heartfield also created numerous book jackets, posters, and set designs. D.S.

Bibl.: Siepmann, Heartfield, 1977 · Pachnicke/Honnef, Heartfield, 1991

John Heartfield, *Berlin Calls for the Olympics*, 1936, Magazine AIZ 15, no. 26, of 6.24.1936, p. 416

Heckel, Erich. *1883 Döbel, Saxony, †1970 Radolfzell. German painter and printmaker. From 1901 he was friendly with → Schmidt-Rottluff. In 1904 he started studying architecture in Dresden and in 1905 he co-founded Die → Brücke. Between 1907 and 1910 he spent the summers in Dangast on the North Sea with Schmidt-Rottluff. In 1909 he traveled to Rome. In 1912 he met Thorn Prikker (1868–1932), → Marc, → Macke, and Lyonel → Feininger, in 1915 → Ensor and → Beckmann, and in 1919 → Klee. In 1918 he joined the Novembergruppe in Berlin. From 1919 to 1944 he spent summer months in Osterholz. In 1937 the Nazis declared his work "degenerate" and confiscated it. He was banned from exhibiting. In 1944 he moved to Hemmenhofen on Lake Constance. Between 1949 and 1955

Erich Heckel, *Fränzi with a Doll*, 1910, Oil on canvas, 65 x 70 cm, Private Collection

he taught at the Akademie der Bildenden Künste in Karlsruhe. In 1967 he donated works to the Brücke-Museum in Berlin.

Heckel was the driving force behind Die Brücke. Many of his works depict nature (the Moritzburg lakes, Dangast, the Baltic). In his paintings he used luminous yet diluted colors and his style was expansive, simple, and full of spiritual power. From 1913 he was influenced by → Cubism (*Gläserner Tag*). From 1914–15 his work reflected his experiences during World War I and his knowledge of human suffering. He began painting small, tormented figures in constricted spaces. In the 1920s he slowly moved away from → Expressionism and his pictures of figures and, more particularly, landscapes (cityscapes and harbors) took on classical, monumental proportions and gained in detail. In the 1930s he painted several portraits (artist friends). A prolific printmaker, he also executed wall decorations (1922–23, Angermuseum, Erfurt). G. P.

Bibl.: Dube, Heckel, 1964–74 · Vogt, Heckel, 1965 · Gabler, Heckel, 1983 · Sabarsky, Heckel, 1995

Heisig, Bernhard. *925 Breslau. German painter and printmaker living in Strodehne, Brandenburg. At the age of 17 he became a soldier and was taken prisoner by the Soviets. From 1948 he studied at the Kunstgewerbeschule, Leipzig. Between 1961 and 1990 he taught at the Hochschule für Grafik und Buchkunst, Leipzig. Heisig was one of three German artists (→ Mattheuer, → Tübke) who made a considerable contribution to → Socialist Realism, a field in which the search for an independent, convincing artistic approach often conflicts with narrow-minded socialist cultural politics. In his paintings, which were strongly influenced by → Corinth and → Beckmann, Heisig tackles major contemporary issues. His nightmare-like visions with their somber backdrops are filled with memories of war and Fascism. His expressive, gestural style has resulted in notable portraits (*Vaclav Neumann*, 1973). Heisig, who was one of the leading postwar German lithographers, produced prints which are densely structured and highly expressive (*The Fascist Nightmare*). E.H.

Bibl.: Kober, Heisig, 1973 · Merkert, Heisig, 1992

Bernhard Heisig, *Self-Portrait as Puppeteer*, 1982, Oil on canvas, 141 x 281 cm, Neue Nationalgalerie, Berlin

1936. After serving in World War II, he settled in West Berlin. In 1950 he won the Kunstpreis der Stadt Berlin. Berlin, which he increasingly saw as a place of temptation and threat, provided Heldt's principal subject matter. Using an undemonstrative, simplified style, he recorded masks and musical instruments, flowers, jugs, birds, houses, and streets in scenes that are bizarre, deserted, icy, and empty. His panic-stricken escape to Majorca did not allay his fears, and on his return to war-damaged Berlin he painted its ruins and burnt-out window frames (*View from a Window with a Dead Bird*, 1945). In the spirit of the Expressionist critique of towns and cities, he coined the term "Berlin on Sea" for this landscape of ruins to point up the victory of nature over the work of man. In his views from windows and his more abstract compositions the city is frozen in time as "still life." G.Pr.

Bibl.: Schmied, Heldt, 1974 · Schmied, Heldt, 1976

Werner Heldt, *Stormy Afternoon on the Spree*, 1951, Oil on canvas, 80 x 140 cm, Private Collection

Heizer, Michael. *1944 Berkeley, California. Land artist living in the Nevada desert and New York. He studied at the Art Institute of Chicago (1963–64). In 1967 he began creating earthworks (see → Land art) in the form of flat landscape structures, such as his *Dissipate and Isolated Masses* in the Nevada desert, which explores mankind's relationship to space. For *Double Negative* (Silver Springs, Nevada desert, 1967–70) and *Munich Depression* (Munich-Neuperlach, 1969), deep ditches were dug and the changes they underwent according to weather conditions were recorded on film, videotape, and in photographs. Other, more figurative earthworks can only be recognized from the air (*Effigy Tumuli*, 1985). In 1971 he began drawing on zinc plates and paper and in 1974 started producing abstract paintings. In 1988 he embarked on a series of large stone sculptures which owe much to prehistoric tools and weapons (*Charmstone No. 4*, 1990). H.D.

Bibl.: Whitney, Heizer, 1990

Held, Al. *1928 Brooklyn. American painter living in New York. He studied at the → Art Students League, New York (1948–49), and under → Zadkine at the Académie de la Grande Chaumière, Paris (1950–52). In 1953 he returned to New York. After producing work that was close to → Abstract Expressionism, in the 1960s Held began to produce large-format pictures characterized by free, → Hard-Edge, geometrical shapes and heavy impasto (*Taxi Cab III*, 1959). In the 1980s, stimulated by modern mathematics and Renaissance perspective, he painted strongly colored, three-dimensional shapes (cubes, parallelepipeds, tetrahedrons, etc.) on a gigantic scale. In these works he used techniques of perspective and anamorphosis, opening up the picture space to the observer (*Mantegna's Edge*). H.D.

Bibl.: Sandler, Held, 1984 · Held, New York, 1992

Heldt, Werner. *1904 Berlin, †1954 Sant' Angelo on Ischia. German painter and draftsman. He studied in Berlin at the Kunstgewerbeschule (1923–24) and the Akademie (1924–30). In 1930 he visited Paris. Between 1933 and 1935 he lived in Majorca, but was forced to return to Berlin in

Hélion, Jean. *1904 Couterne, †1987 Paris. French painter. In 1921 he started to study architecture in Paris, but took up painting in 1922 (he was self-taught). In 1929 he co-founded the group Art Concret (incorporated into → Abstraction-Création in 1931). He lived in the US from 1936 until 1940, when he joined the French army. He was taken prisoner but escaped to the US. In 1946 he returned to France. In 1929, influenced by → Torres-García and → Mondrian, Hélion turned to abstraction. These works featured sculpturally modeled shapes with mechanistic overtones arranged rhythmically on a ground suggestive of spatial depth. At the end of the 1930s he returned to a naturalistic idiom which, between 1948 and 1951, was close to → Surrealism. For his subject matter, Hélion drew on myths from everyday life and the magic of the material world. After years of neglect, his work was rediscovered in the 1960s by the artists of → New Figuration. K.S.-D.

Bibl.: Cousseau, Hélion, 1992 · Hélion, Journal, 1992

Henri, Florence. *1893 New York, †1982 Laboissière-en-Thelle. American painter and photographer. Initially she studied music and painting. After studying at the → Bauhaus under → Moholy-Nagy (1927), she devoted herself principally to photography. In 1929 she settled in Paris, where she established an advertising studio. Her early photographs (1928–30) demonstrate a concern with the rhythmic interplay between blocks and shapes, also evident in her geometric abstract paintings. In her complex abstract composition she frequently used mirrors and spheres, while her idiosyncratic

portraits, self-portraits, and photocollages include → Dada elements. She also took still lifes for advertising. E.R.

Bibl.: Henri, San Francisco, 1990

Henri, Robert. *1865 Cincinnati, Ohio, †1929 New York City. American painter. After a period under the influence of Thomas Eakins' realism, Henri studied in Paris at the → Académie Julian and at the École (1888–91) under the conservative Adolphe Bouguereau (1825–1905). Initially unimpressed by Impressionist landscape, Henri was keen instead to enlarge themes to include "low" subjects. A great enthusiast for Goya, Manet, and Velázquez ("every shape on a Velázquez head is a grand thing"), he imitated their dark hues in peasants, dancing girls, children, and even society ladies. Henri moved to New York in 1900 and taught at the School until 1906, when he founded his own institution. After rejection by the National Academy, the New York Realists around Henri staged an exhibition in 1908 at the Macbeth Gallery that established the grouping known as The → Eight. Henri is perhaps chiefly known as a teacher. His followers included → Glackens and → Sloan, who, with others, form the nucleus of the → Ashcan School. Henri himself was never quite as down-at-heel as this title implies, though works such as *West 57th Street* (1902) depict harsh urban life. His popular book, *The Art Spirit* (1923), details his artistic approach. D.R.

Bibl.: Henri, 1984

Hepworth, Barbara. *1903 Wakefield, Yorkshire, †1975 St Ives, Cornwall. British sculptor. She studied alongside → Moore at the Leeds School of Art (1919–21) and the Royal College of Art (1921–24). In 1924–25 she lived in Rome and in 1932–33 she visited Paris with Ben → Nicholson. In 1933 she joined → Abstraction-Création and in 1935 met → Gabo. She married Nicholson in 1934 and the couple settled in St Ives in 1939. She received numerous public commissions and in 1955 and 1959 took part in Documenta 1 and 2. In 1927 she abandoned her early seminaturalistic sculpture for abstraction. In 1930 she made the first openwork pieces for which she became internationally famous. After initally abstracting the human figure, in 1934 she abandoned figure pieces, although nature (specifically the landscape near St Ives) remained at the root of her work. The relationship between hollow and outline was a central feature of her work (*Sea Form Porthmeor*, 1958). Hepworth used marble, metal, and wood, and from 1938 she also incorporated string into her sculptures (*Wood and Strings*, 1944). K.S.-D.

Bibl.: Curtis/Wilkinson, Hepworth, 1994/95 · Festing, Hepworth, 1995

Herbin, Auguste. *1882 Quiévry, †1960 Paris. French painter. He studied at the École des Beaux-Arts, Lille (1899). In 1901 he moved to Paris, but made repeated visits to Bruges. He co-founded the group → Abstraction-Création with → Mondrian and → Vantongerloo in 1931 and was involved in the setting up of the → Salon des Réalités Nouvelles in 1946.

Initially influenced by the Impressionists and, about 1910, by → Cubism, in 1926 Herbin turned definitively to abstraction, using pure colors and elementary shapes (triangle, circle, rectangle, trapezium). About 1940 he developed a visual language based on correspondences between colors, shapes, forms, and letters of the alphabet (e.g. B, crimson, spherical shapes next to rectangular ones; G, dark orange, spherical shapes next to triangular ones; N, white, all shapes), making it possible to convert words or names into images (e.g. compositions on the words *gaieté* [gaiety] and *fin* [end], 1960). One of the principal exponents of → geometric abstraction, Herbin had an enormous influence on → Vasarely and → Op art. In addition to paintings and frescos, he also made sculptures. K.S.-D.

Bibl.: Herbin, L'art, 1949 · Claisse, Herbin, 1993 · Herbin, Céret, 1994

Herman, Josef. *1911 Warsaw, †2000 Polish–British painter. After study at the Warsaw Academy, Herman fled Poland in 1938 and traveled to Brussels, where he met → Permeke. He subsequently moved to Glasgow, where he became a close collaborator with → Adler. Just before the end of World War II, Herman moved to Ystradgynlais, a fishing village in Wales, where he continued the humanistic strain of "labor" subjects he had begun in Scotland. His first-rate collection of African miniature carvings exerted an influence on his art. His only public commission was the much-praised *Miners* frieze created in 1951 for the Festival of Britain. It is a somber paean to the glory of working people, a thematic that extended to easel paintings and drawings. An important retrospective was held at the Camden Arts Centre, London, in 1980. D.R.

Bibl.: Herman, 1996

Heron, Patrick. *1920 Leeds, †1999 Eagles Nest, Zennor, Cornwall. British painter. He studied at the Slade School of Art, London (1937–39). He was a conscientious objector during the war (1940–44). In 1944–45 he worked as assistant to the potter Bernard Leach in St Ives, where he met → Hepworth and Ben → Nicholson. He wrote art criticism for English magazines (1945–50) and was London correspondent for the New York magazine *Arts*. Heron's early paintings were influenced by → Braque and → Matisse, but toward the end of the 1950s, under the impact of → Abstract Expressionism, he turned to abstraction based primarily on → Color Field Painting

Auguste Herbin, *Friday I*, 1951, Oil on canvas, 96 x 129 cm, Musée National d'Art Moderne, Centre Georges Pompidou, Paris

and the work of → Rothko (*Yellow Painting*, 1958–59). Although his style evolved, Heron's work demonstrates a continual fascination with color. In 1955 his influential collection of essays *The Changing Forms of Art* was published. H.D.

Bibl.: Heron, London, 1985 · Gooding, Heron, 1994

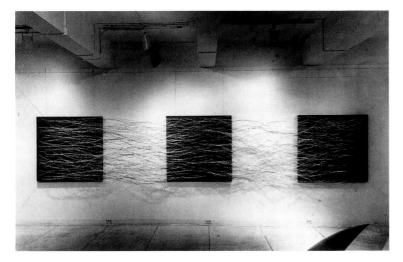

Eva Hesse, *Metronomic Irregularity II*, 1966 (reconstruction 1993), Painted wood, with wire wrapped in cotton, 3 panels, each 122 x 122 cm, total size 122 x 610 cm, Robert Miller Gallery, New York

Hesse, Eva. *1936 Hamburg, †1970 New York. German-born American sculptor and painter. Her family settled in New York in 1939 after fleeing the Nazis. She studied in New York at the Pratt Institute (1954) and the Cooper Union School (1954), and under J. → Albers at the Yale School of Art and Architecture (1957–59). In 1964–65 she visited Germany, where she came into contact with → Zero and → Fluxus. In 1968 she taught at the School of Visual Arts, New York, and in 1969 at the Boston Museum School. The first retrospective of her work took place at the Solomon R. Guggenheim Museum, New York in 1972. After early work in an → Abstract Expressionist vein, in about 1960 Hesse developed a versatile style of painting with autobiographical references. Her initially small-format paintings and drawings are characterized by linear construction and organic composition. The tension in her paintings derives from a balancing of the rational and the sensual, order and chaos, materiality and transparency. In 1964 she began to move away from → Art Informel to → Pop art "machine-part drawings," which she cut out and made into collages. In 1965, stimulated by remnants of material from a weaving mill, she made her first three-dimensional works (*Legs of Walking Ball*, 1965). During the last years of her life she devoted herself to sculpture, often using unusual materials such as latex and fiberglass, and incorporating elements bound with string. Many of her works were suspended or fixed to walls. Influences from → Minimal art are evident in her installations, but her work is distinguished by its more emotional treatment. P.L.

Bibl.: Lippard, Hesse, 1976 · Barette, Hesse, 1989 · Hesse, Ulm, 1994

Hill, Gary. *1951 Santa Monica, California. American Video artist living in Seattle. He studied at the → Art Students League of New York (1969). In 1973 he began experimenting with video. Between 1974 and 1976 he worked at Woodstock Community Video, New York, where he produced his first video works, which featured predominantly ecological imagery (*Air Raid*, 1974). From 1976, encouraged by the poets George Quasha and Charles Stein, he became interested in speech, resulting in video works addressing the relationships between picture, sound, writing, and speech (*Soundings*, 1979). In the 1980s, as part of an American-Japanese cultural project, he made videos in Japan inspired by texts by philosophers Maurice Blanchot (*Incidence of Catastrophe*, 1988) and Martin Heidegger (*Happenstance*, 1982–83), among others. In 1995 he won the sculpture prize at the Venice Biennale. In Hill's videos and installations, the immaterial character of film is contrasted with the traditional concept of the picture in art. They are primarily concerned with sound and time, and processes of perception. C.W.

Bibl.: Hill, Washington, 1994 · Hill, Liverpool, 1995 · Vischer, Hill, 1995

Gary Hill, *Primarily Speaking*, 1981–83, Video/sound installation, Donald Young Gallery, Seattle

Hine, Lewis Wickes. *1874 Oshkosh, Wisconsin, †1940 Hastings-on-Hudson, New York. American photographer, an exponent of social documentary photography. After training as a sociologist, in 1904 he started taking photographs while teaching at the Ethical Culture School in New York. He photographed immigrants on their arrival at Ellis Island, documenting their living and working conditions in the city. In 1907 he embarked on a series of pictures showing the working conditions of steelworkers in Pittsburgh. From then until 1917 he worked for the National Child Labor Committee (NCLC), photographing children at work with the aim of drawing attention to the problems of growing industrialization. Toward the end of World War I he traveled to Europe as a photographer on a Red Cross mission. In 1930 he was commissioned to photograph the construction of the Empire State Building. C.W.

Bibl.: Hine, Men at Work, 1977 · Hine, Empire State, 1998

Hirschfeld-Mack, Ludwig. *1893 Frankfurt am Main, †1965 Sydney, Australia. German-Australian painter. He studied with → Hölzel in Stuttgart (1919–20) and at the Weimar → Bauhaus (1920–25), where he performed *Farbenlichtspiele* ("color light plays"; from 1922 onward). Between 1925 and 1936 he taught at various art schools. In 1936 he went into exile in England. When war broke out he was interred and then sent to Australia (1940). From 1942 until his death he taught art at Geelong Grammar School, Victoria.

While at the Bauhaus, Hirschfeld-Mack produced paintings strongly influenced by → Itten, → Klee, and → Kandinsky, and set up a research seminar on color. His "color plays," created in collaboration with Kurt Schwerdtfeger, and his subsequent colored light projections to the accompaniment of piano music anticipated developments in → Kinetic art and → Light art. He also designed furniture and interior fittings (Musikheim, Frankfurt/Oder, 1929), musical instruments ("color chord," 1938), and educational toys (e. g. spinning tops, 1923). H.D.

Bibl.: Stasny, Hirschfeld-Mack, 1993

Hirst, Damien. *1965 Bristol. British sculptor and Installation artist living in London. He studied at Goldsmiths' College, London (1986–89). In 1993 he took part in the Venice Biennale and in 1995 won the Turner Prize. Fascinated from an early age by death, Hirst creates spectacular installations with preserved animal cadavers. His *The Physical Impossibility of Death in the Mind of Someone Living* (1991) shows a 4.5-meter-long tiger-shark in an aquarium full of formalin, while his *Mother and Child Divided* (1995), consisting of the severed halves of a cow and calf, seems to address existential fears and the inevitability of death. Hirst's spot and spin paintings, famously produced in seemingly endless series by Hirst's assistants plumb the repetitive possibilities of painting. Installations such as *The Medicine Cabinets* were featured in 1997 at the opening of a fashionable London restaurant called Pharmacy. M.G.

Bibl.: Hirst, London, 1991 · Hirst, New York, 1996

Hitchens, Ivon. *1893 London, †1979 Lavington Common, Sussex. English painter, primarily of landscape. After study at the Royal Academy Schools, London, in the 1910s, Hitchens exhibited with the Seven and Five Society from the 1920s (until 1935) and joined the → London Group. The son of a painter, he was initially associated with → Hepworth and → Moore, but did not embrace pure abstraction, keeping to figurative-lyrical landscapes (*South Coast*, 1969) in the English tradition (see → Heron). Starting out with a subdued, almost dark palette (under the sway of → Braque), these works gained in chromatic vibrancy and looseness of brush to near → Fauvism (*Algerian Woman*, 1939). His extensive oeuvre includes flower pieces and horizontal-format nudes as well as large-scale murals for e.g. Cecil Sharp House, London (1954), Nuffield College, Oxford (1959), and the University of Sussex (1963). His finest easel works combine vividness of recall and color with delicacy of light and shadow. D.R.

Bibl.: Hitchens, London, 1979

Hlito, Alfred. *1923 Buenos Aires. Argentinian painter living in Buenos Aires. He studied at the Academy of Art, Buenos Aires (1938–42). In 1946 he co-founded the Associación Arte Concreto Invención. In 1953 he traveled to Europe, where he met → Bill and → Kupka. In 1963 he moved to Mexico. From 1964 to 1973 he taught graphic design at the university in Mexico City. He then returned to Argentina. In the 1940s, under the influence of → Torres-García, he developed an abstract → Constructivist style. His work is based on an exploration of the relationship between color and form (Ritmos Cromàticos). M.G.

Höch, Hannah. *1889 Gotha, †1978 Berlin. German collage artist. She studied at the Kunstgewerbeschule, Berlin (1912–14). In 1915 she was appointed to a teaching post at the Kunstgewerbemuseum. Between 1916 and 1926 she worked as a graphic designer at Ullstein-Verlag. In 1920 she joined the → Novembergruppe.

In 1916 Höch began making collages and in 1918 started to experiment with photomontages (*Cut with the Kitchen Knife*, 1919), becoming, together with → Hausmann, one of the leading exponents of the technique. In 1922 she contributed two "grottoes" to the *Merzbau*. (→ Merz). In 1924 she had contacts with De → Stijl. Between 1926 and 1929 she lived with the Dutch writer Til Brugman in The Hague. She returned to Berlin in 1929, where she lived in seclusion while the Nazis were in power. In 1933 she was banned from exhibiting. In 1947 she began experimenting with color photographs. In addition to her collages and photomontages, she also produced paintings in a Critical Realist style. W.G.*

Bibl.: Adriani, Höch, 1980

David Hockney, *Mr. and Mrs. Clark and Percy*, 1970–71, Acrylic on canvas, 214 x 305 cm, Tate Gallery, London

Hockney, David. *1937 Bradford, Yorkshire. British painter, draftsman, photographer, printmaker, and set designer living in Los Angeles. He studied at the Bradford College of Art (1953–57) and the Royal College of Art, London (with → Kitaj and Allen → Jones; 1959–62). He made his first visit to Los Angeles in 1963 and settled there permanently in 1978. Some of Hockney's early paintings fell within the ambit of → Pop art (*Tea Paintings*, 1960–61), but in his works of the early 1960s he was more concerned with expressive figure illustration, sometimes drawing inspiration from poetry (*We Two Boys Together Clinging*, from a poem by Walt Whitman, 1961). During his first stays in Los Angeles his colors became lighter as he produced his famous pictures of swimming pools in acrylic (1966). In 1968, back in London, he turned toward a Photorealist style of painting (*Mr. and Mrs. Clark and Percy*, 1970–71). He also produced a number of subtle drawings (*Cecilia in a Black Dress with Red Stockings*, 1973) and opera sets (Stravinsky's *The Rake's Progress*, 1974–75). During the 1970s Hockney produced a number of paraphrases of modern art, in particular works by → Picasso. In the 1980s he became interested in photography, creating a number of large-format photocollages which consist of multiple views of a subject assembled in a Cubist

Ferdinand Hodler, *Spring*, 1901,
Oil on canvas, 99 x 129 cm,
Museum Folkwang, Essen

Hodler, Ferdinand. *1853 Berne, †1918 Geneva. Swiss painter. He trained as a painter of Swiss souvenir motifs in Thun (1867). In 1871 he moved to Geneva, where he studied at the Academy of Art. The naturalistic paintings of his early years were influenced by Corot, Courbet, and the Impressionists. In 1890 he adopted a monumental style (*The Night*) which owed much to Art Nouveau and Symbolism (reinforced by his trip to Paris in 1891, where he had contacts with the Rosicrucians). It is characterized by emphatic outlines, powerfully rendered figures, symmetrical composition, the parallel repetition of figures (what he termed "Parallelism"), and, in landscapes, vivid colors. In addition to landscapes and portraits he painted murals, some of which had historical subjects (*Return of the Swiss at Marignano*, 1896–1900). In his expressive late style Hodler made intensive use of "Parallelism" and his figures were strongly stylized (*The Dying Woman*, 1915). The spare, simplified landscapes painted toward the end of his life (*The Eiger, Mönch, and Jungfrau in the Moonlight*, 1908) anticipated later developments in abstract art. In his last years he also made a number of sculptures. K.S.-D.

Bibl.: Hodler, 1983 · Mühlenstein/Schmidt, Hodler, 1983 · Hodler, 1999

manner. More recently he has returned to classic genres with intensely colored interiors, still lifes, and portraits, as well as large landscapes consisting of up to 60 separate canvases (*A Bigger Canyon*, 1998). A.K.

Bibl.: Tuchman/Barron, Hockney, 1988 · Stangos, Hockney, 1993 · Mißelbeck, Hockney, 1996/97

Hodgkin, Howard (Sir). *1932 London. British painter and printmaker living in London. He studied at Camberwell School of Art (1949–50) and the Bath Academy of Art (1950–54), where he subsequently taught. In 1985 he won the Turner Prize and took part in the Venice Biennale. His semi-abstract paintings have autobiographical roots. He uses, for example, an object or an event as a starting point, interweaving his private experiences. His small-format pictures, painted in a gestural style with generally flat colors, are not created spontaneously, but result from a constant process of over-painting extending over many years. He has been influenced both by European modernists (primarily → Bonnard and → Matisse) and by contemporary Indian painting. He has also produced a number of prints (*Indian Leaves*, 1982). H.D.

Bibl.: Graham-Dixon, A., Hodgkin, 1994

Hödicke, Karl Horst. *1938 Nuremberg. German painter and graphic artist living in Berlin. He studied at the Hochschule der Bildenden Künste, Berlin (1959–60), and later taught there (from 1974). In 1980 he became a member of the Akademie. He visited New York in 1966–67 and won a Massimo scholarship to Rome in 1968. In 1998 he was awarded the Fred Thieler Prize. Rejecting Capitalist Realism and → Pop art, Hödicke initially painted everyday subjects and street scenes using a style based on Tachisme. His work of the 1960s was dominated by a concern with reflected light. Toward the end of the 1960s he made objects and experimental films. In the 1970s neon lighting became a frequent theme in his paintings of buildings in Berlin. Hödicke is regarded as a precursor of → Neue Wilde. D.S.

Bibl.: Hödicke, Berlin, 1993 · Hödicke, Cologne, 1997

Hofer, Karl (Carl). *1878 Karlsruhe, †1955 Berlin. German painter, draftsman, and printmaker. Study at the Akademie der Künste, Karlsruhe (1896–1901) was with Hans Thoma (1839–1924), though he was more taken with Arnold Böcklin (1827–1901). The frescoes by Hans von Marées (1873) in Naples and contact with → Klee were also formative. Hofer was interned in France during World War I, an experience which, combined with a journey to India (1909–11), made for a synthesis of the tortured and the lyrical, though he rejected → Expressionism as such. Imbued with shadowy chromaticism, his mid-period landscapes are idyllic if slightly eerie. His most celebrated canvases, however, show figure groups, especially of shy-looking girls (*The Letter*, 1944), without, for example, the sensuality of → Mueller or the energy of → Heckel. Symbolic works reacting to national turmoil followed in the 1930s, while some society pieces (*Grand Carnival*, 1928) have → Beckmann-like overtones. In 1934 Hofer was forbidden to teach or exhibit and was pilloried at the "Entartete Kunst" exhibition ("Degenerate Art"). In 1943 a bomb destroyed his studio with c. 150 paintings and 1,000 drawings. He also left only a score of woodcuts and c. 200 lithographs. *Black Moonlit Night* (1944) and *Cain and Abel* (1946) are stark paraphrases of his generation. A heated polemic concerning the merits of abstractionism (which Hofer flirted with only briefly in 1930–31) resulted in the resignations of → Nay, → Winter, and → Baumeister from the Deutscher Künstlerbund, thus isolating Hofer. Later nudes show the lessons of → Picasso (*Harpies*, 1954). D.R.

Bibl.: Rigby, Hofer 1976 · Furler, Hofer, 1978

Hoflehner, Rudolf. *1916 Linz. Austrian sculptor, painter, and graphic artist living in Vienna. After studies in mechanical engineering and

architecture, he studied stage design at the Akademie der Bildenden Künste in Vienna (1938–40). From 1945 to 1951 he taught at the Kunstgewerbeschule, Linz. In 1951 he moved to Vienna, where he switched from painting to sculpture, working until 1954 at → Wotruba's studio. From 1962 to 1981 he taught at the Akademie der Bildenden Künste, Stuttgart.

After early sculptures in wood, he began working with iron. His welded and cut figures abstracted the human form into expressive, towering shapes which evoke suffering, masculine aggression, and destruction (split figures, 1955–58; figures which are wounded or compacted into weapons, 1959–62). Some of these works were inspired by the work of Albert Camus (e.g. *Sisyphos*, 1957) and Samuel Beckett. With *Figure 81–Venus von Krieau* (1964) these forms were given a feminine counterpart. In 1966 he embarked on a series of falling figures (*Figure 99 K*). His last iron sculptures, made in 1968, coincided with his first paintings. In the latter, which were inspired by → Bacon, he seemed to be criticizing civilization (*Ecce Homo I*, 1970). During the 1970s drawing occupied an increasingly important place in his work. In addition to self-portraits (1976), he produced a series of meditations on death (1977–85). Subsequently he returned to monumental sculpture in fantastic forms. H.O.

Bibl.: Schmied, Hoflehner, 1988 · Hofmann, Hoflehner, 1993

Hans Hofmann, *Goliath*, 1960, Oil on canvas, 140 x 152 cm, University of California, Berkeley Art Museum

Hofmann, Hans. *1880 Weissenburg, †1966 New York. German-born painter and theorist. He studied in Munich at the Kunstschule Moritz Heymann (1898) and in Paris (1904–10) at the Académie de la Grande Chaumière and the Académie Colarossi. In 1908–09 he took part in the New Secession exhibition at Cassirer's gallery in Berlin. In 1915 he founded the Hofmann-Kunstschule in Munich (closed 1932). He went on to open several schools in the US after emigrating in 1932: the Hans Hofmann School of Fine Arts in New York (1933–58) and a summer school in Provincetown, Mass. (founded 1935), where he promoted European avant-garde art (→ Krasner was among his pupils). In 1941 he became an American citizen.

His work spanned geometric abstraction (*Pax Vobiscum*, 1964) and gestural work in the style of → Abstract Expressionism (*In the Wake of the Hurricane*, 1960). From 1958 he devoted himself entirely to his own painting, producing works which feature solid blocks of color against a more variegated background. In his final years he produced some of his finest paintings, which show his characteristic combination of emotion and rationality, gesture and geometric structure (*Renate's Nantucke*, 1965). I.N.

Bibl.: Friedel, Hofmann, 1997

holography. Technique developed in 1948 by the physicist D. Gabor for recording images. Image quality was greatly improved at the beginning of the 1960s by the development of laser technology. In contrast to representations with centralized perspective, in which the illusion of three-dimensional space is produced on a two-dimensional surface, holography enables the storing and reproduction of images with a three-dimensional structure. Holography was used as an artistic medium by the Center for Advanced Visual Studies to create → environments and has also been used as a form of → Hyperrealism. It was particularly popular in the 1970s. G.B.

Bibl.: Holografie, Munich, 1986 · Eichler, Holografie, 1993

Holt, Nancy. → Robert Smithson

Hölzel, Adolf. *1853 Olmütz, Moravia, †1934 Stuttgart. German painter. He studied at the Vienna Kunstakademie, 1872–76; Munich Kunstakademie, 1876–82; and Dachau (Dachauer Schule), 1887–1905. From 1905 to 1919 he taught at the Kunstakademie Stuttgart. His early Dachau works already demonstrated the importance of color to the artist. In 1905, through the use of elementary forms, he reached a level of abstraction (*Composition in Red*, 1905) that he brought to the so-called Hölzel group (→ Baumeister, → Schlemmer, → Itten, and Otto Meyer-Amden). From 1915 he focused on abstract, color-intensive oils and pastels (*Abstraction I*, 1915) and stained-glass windows (Bahlsen factory, 1915/16). In the late works

Rudolf Hoflehner, *Figure 21, Stoic Figure*, 1959, Iron, Height 245 cm, Staatsgalerie Stuttgart

Adolf Hölzel, *Saint Ursula*, 1914, Oil on canvas, 124 x 108 cm, Private Collection

of the 1920s, despite maximum color intensity, Hölzel's figurative origins are still formally recognizable (*Composition*, 1930). Hölzel's color theory was developed further at the → Bauhaus by Itten. H.D.

Bibl.: Venzmer, Hölzel, 1982

Holzer, Jenny. *1950 Gallipolis, Ohio. American Installation artist living in Hoosick Falls, N.Y. She studied at Duke University, Durham, North Carolina; the University of Chicago; Ohio University, Athens; and the Rhode Island School of Design. In 1977 she settled in New York, where she worked as a typesetter, wrote texts, and joined Colab (Collaboration Project). Her work has been shown in numerous exhibitions in galleries and museums around the world, including Documenta 7; a retrospective at the Des Moines Center, Iowa (1986); the Solomon R. Guggenheim Museum, New York (1989); and the Venice Biennale (1990).

As a student, Holzer created abstract pictures with stripes influenced by → Rothko and began experimenting with unsigned street decorations and posters. Fueled by her commitment to social and cultural critique, this led to the development of signs to be displayed in public places. The first series, *Truisms*, appeared in 1977. These were universal, impersonal statements which seemed to be simple generalizations, but on closer inspection revealed a deep and provocative content

Jenny Holzer, *Under a Rock*, 1986, Sign with LED display, 14 x 117 cm, Galerie Monika Sprüth, Cologne

(*Money creates taste*). She used advertising billboards, TV commercials, and electronic signs to bear her messages, achieving her biggest audience in 1982 with the advertising boards in Times Square. *Truisms* were followed by further collections of texts, such as *The Inflammatory Essays*, *The Living*, and *Survival Series*. Holzer's subsequent speech installations (*Sex Murder*, 1993–95) were more complex. In these works, monumental, timeless objects such as sarcophagi, benches, and marble slabs are juxtaposed with LED running scripts whose cool, indifferent language is in shocking contrast to portrayals of terrible events. P.L.

Bibl.: Waldman, Holzer, 1989 · Waldman, Jenny Holzer, 1989 · Holzer, Buffalo, 1990 · Auping, Holzer, 1992

Edward Hopper, *Hotel by a Railroad*, 1952, Oil on canvas, 79 x 102 cm, Hirshhorn Museum and Sculpture Garden, Washington DC

Edward Hopper, *Nighthawks*, 1942, Oil on canvas, 76.2 x 152.4 cm, The Art Institute of Chicago

Hopper, Edward. *1882 Nyack, New York, †1967 New York City. American painter. In 1899 he enrolled in a school for illustrators in New York, but a year later transferred to the New York School of Art (1900–06). While in his twenties he made several study trips to Paris (1906, 1909, 1910). In 1913 he took part in the Armory Show in New York. His first one-man exhibition was held at the Whitney Club in New York and the first major retrospective of his work took place at the Museum of Modern Art in 1933. Hopper initially worked as a commercial illustrator and was not able to devote himself to painting full-time until 1924.

His work consists exclusively of American motifs (sailing boats, coastal landscapes, isolated houses, deserted streets, people alone in rooms, halls, offices, or away from home in hotels and motels), although he was never part of → American Scene Painting. People and the loneliness, alienation, and disillusionment of modern life are at the heart of his work (*Nighthawks*, 1942). What is crucial in these themes of an America of unfulfilled dreams, however, is the treatment of light. Hopper's view of modern America may be disenchanted, or at least very sober, but his pictures are filled with light, conveyed in areas of strong contrast and luminous colors. In his later paintings, the compositions were simpler, the details summarily ommitted. The artist's attention was focused entirely on the play of light and

Jenny Holzer, *Under a Rock*, 1986, Sign with LED. display, 15.2 x 120 x 10 cm, 9 black granite benches, each 43.8 x 122 x 53.3 cm, Barbara Gladstone Gallery, New York

Rebecca Horn, *Mme Bovary – that's me – says G. Flaubert*,
1997, Installation with iron, glass, book, binoculars, Indian
ink, black feathers, 100 x 70 x 12 cm, Private Collection

shadow, giving the works an abstract structure.
Hopper's formal, distanced view of the motif, his
cold objectivity, and the film-like effect of his
compositions made him a cult figure in Ameri-
can painting in his own lifetime; he also
influenced American → photorealists and → Pop
artists of the 1960s. H.D.

Bibl.: Levin, Hopper, 1980 · Költzsch, Hopper, 1992 · Kranzfelder,
Hopper, 1992 · Levin, Hopper, 1992 · Schmied, Hopper, 1995

Horn, Rebecca. *1944 Michelstadt. German Instal-
lation and Performance artist who lives in Düs-
seldorf, Berlin, and New York. She studied at the
Kunstakademie, Hamburg (1964–70). She exhibit-
ed at Documentas 5, 6, 7, and 9 (1972, 1977, 1982,
1992) and the 1997 Venice → Biennale. She has
also taken part in sculpture projects in Münster.
In 1989 she started teaching at the Kunst-
hochschule in Berlin.

At the end of the 1960s she gave → Body art
performances with the aid of props such as tele-
scopic "artificial fingers" (1974) which enabled
her "to touch the walls with both hands at once"
(title). These metamorphoses of the body, pre-
served only in video documents, served as a per-
ceptual extension of her own awareness of body
and space. Her body objects were also kept as
reminders and shown in exhibitions. Subsequent
objects were powered by motors, cleverly con-
cealed to allow the sensual, magical, or
grotesque "personal life" of things to be con-
veyed. The materials used are luxurious (feathers
of exotic birds, butterfly wings, and musical
instruments) and exquisitely put together, and
vehicle synaesthetic experiences. They are also
symbolic metaphors for tenderness and aggres-
sion, evoking associations from the fields of
mythology, sacred ritual, and eroticism, as well
as historical events. The observer becomes an
accessory, a voyeur, even sometimes the object
itself. This provides a disconcerting experience
for the viewer, who is unable to assert control.
Her motifs and the abrupt changes in levels of
perception between the realistic, fantastic, and
grotesque suggest parallels with Romantic litera-
ture (e.g., E. T. A. Hoffmann). In Horn's films the
emotional charge of her objects is heightened by
their being promoted to the status of actors
determining the action. I.S.

Bibl.: Celant, Horn, 1993 · Celant, Horn, 1994 · Horn, Hanover, 1997

Hoyland, John. *1934 Sheffield, South Yorkshire.
British painter and printmaker. Initial training
was at Sheffield College of Art (1951–56) and the
Royal Academy Schools (1956–60); Hoyland now
works out of London. After tuition from → Pas-
more and → Turnbull, in 1960–61 he showed
fully abstract linear works at the → Situation
exhibitions, with bands of color being used to
investigate optical interactions and vibration
(from this time his titles were generally confined
to the date of completion). Hoyland's visits to
New York (the first dates from 1964) allowed him
to absorb lessons from → Motherwell, → Franken-
thaler, → Olitski, → Hofmann, and the unexhib-
ited canvases of → Louis whose veils of color are
not dissimilar to his own 1970s poured-paint
works. Influenced by → Color Field (*Painting*,
1960), Hoyland became interested in staining
techniques (*14.5.66*) before moving on to highly
textured acrylics with palette-knife application
(*Rabat, 30.8.72*). In the 1970s the influence of Hof-
mann (*10.8.75*) became predominant, with blocks
or chevron-shaped groupings interacting to
expand or gather in space (*North Sound,* 1979).
During the 1980s and 1990s he favoured swirling
twists of high-keyed color (*Genie,* 1988). Hoyland
is a prolific printmaker of screenprints, litho-
graphs, and later etchings and monotypes (espe-
cially in 1982–83). D.R.

Bibl.: Hoyland, London, 1967 · Hoyland, London, 1979 · *Gooding,
Hoyland, 1990*

Hrdlicka, Alfred. *1929 Vienna. Austrian sculptor,
draftsman, and printmaker living in Vienna. He
studied at the Kunstakademie, Vienna (1946–57)
with → Gütersloh and → Wotruba. He has taught
in Stuttgart (1971–73), Hamburg (1973–75),
Berlin (from 1986), and Vienna (from 1989). War,
murder, politics, religion, and the effects of
human inadequacy in the past and present are
the central themes of Hrdlicka's expressive work.
He rejects abstraction, seeing his art as political
commentary ("Agitation"). His numerous public
memorials (*Memorial for Karl Renner,* 1967, *Memor-
ial against War and Fascism,* 1991) continue to
cause a stir. His etchings and drawings depict
episodes from historical events (*French Revolution,*
1989) or provide a critique of art world heroes
(*Monsieur Rodin's Studios,* 1982). His extensive body
of work has been supplemented by a consider-
able number of articles (*Articles,* 1987). M.G.

Bibl.: Jenni, Hrdilicka, 1993 · Lenz, Hrdlicka, 1994 · Mennekes,
Hrdlicka, 1998

Alfred Hrdlicka, *Monsieur
Rodin's Studio: Meditation,*
1982, Bister, chalk, red ocher,
67 x 49 cm, Artist's Collection

Hubbuch, Karl. *1891 Karlsruhe, †1979 Karlsruhe.
German painter and graphic artist who studied
at the Akademie, Karlsruhe (1908–12) and the
Kunstgewerbemuseum, Berlin (with → Grosz,
1912–14). In 1928 he started teaching in Karl-
sruhe, but in 1933 he was dismissed and banned
from working by the Nazis (he was reinstated in
1947–48). In 1925 he took part in the → Neue
Sachlichkeit exhibition in Mannheim (one of his
best-known works in this vein is *The Schoolroom*).

Hubbuch was a sensitive but tough, forensi-
cally accurate chronicler of the 1920s, his precise
sense of line conveying the subtlest emotional
resonances. After 1945, although he was still pre-
occupied with issues of human dignity, his style

Stephan von Huene, *Wash-board Band*, 1967, Wood, leather, metal parts, technical equipment, 220 x 77 x 44 cm, Private Collection

shifted, becoming more aggressive and accusatory. He retained his militant intensity to the end. G.P.

Bibl.: Hartmann, Hubbuch, 1991 · Hubbuch, Karlsruhe, 1993/94

Huber, Stephan. *1952 Lindenberg, Allgäu. German Installation artist living in Munich. He studied at the Kunstakademie, Munich (1972–78). In 1987 he took part in Documenta 8 and in 1989 he was appointed to a teaching post at the Kunstakademie, Karlsruhe. After his early installations, which were theatrical and comically "baroque," in the 1980s Huber surprisingly began to produce wall objects of "classical" severity. In retrospect, this change of form can be seen to have given Huber's works a new metaphorical resonance. In his work objects and materials do not correspond to what they purport to be. The poetic and symbolic character of his installations, which cannot be grasped rationally, makes paradoxes manifest. I.S.

Bibl.: Huber, Munich, 1998

Huene, Stephan von. *1932 Los Angeles. American-born sculptor and sound artist living in Hamburg. He studied at Pasadena City College, the University of California, and Chouinard Art Institute, Los Angeles (1950–59). In 1980 he settled in Hamburg. He took part in Documenta 8 (1987). After early → Abstract Expressionist paintings and vaguely surreal → assemblages, in 1964 he made his first sound sculptures. His subsequent works have been concerned with synaesthetic concepts, exploring the interdisciplinary connections between visual, acoustic, and bodily perception. I.S.

Bibl.: v. Huene, Hanover, 1983

Hume, Gary. → Young British Artists

Friedensreich Hundertwasser, *Sun for Those who Cry in the Countryside*, 1959, Acrylic and mixed technique on cardboard, 97 x 146 cm, Essl Collection, Klosterneuburg, Vienna

Hundertwasser, Friedensreich. *1928 Vienna, †2000. Austrian painter and graphic artist. He studied at the Akademie der Künste, Vienna (1948). In 1949 he adopted the pseudonym Hundertwasser. In 1954 he developed the theory of "Transautomatism," a sort of antirationalism approximating to → automatism. In 1957 he published *Grammar of Seeing* and in 1959 created the

→ happening *The Endless Line* in collaboration with Bazon Brock. In 1961 he traveled to Japan, where he worked with Japanese wood carvers (woodcut portfolio *Nana Hyaku Mizu*, 1973). He exhibited at Documenta 3 (1964).

Hundertwasser's extensive travels over the years (Paris, Tuscany, Morocco, Tunis, Japan, India, Nepal, and New Zealand) had an effect on the direction his work took. He was also influenced by Viennese → Jugendstil, → Klee, and oriental miniatures. His œuvre includes colorful, large-scale abstract paintings ("kaleidoscopic landscapes") characterized by ornamental spiral forms (from 1953), labyrinthine motifs, and circles, meanders, and biomorphs. His graphics and poster designs became increasingly decorative. In the 1970s and 1980s he was active in the Green movement, producing idiosyncratic and controversial designs for façades, roof gardens, and buildings (Hundertwasser House, Vienna, 1983–86; Bad Soden; Tokyo). He died in 2000 while on a cruise. K.S.-D.

Bibl.: Schmied, Hundertwasser, 1964 · Hundertwasser, Cologne, 1980 · Rand, Hundertwasser, 1993 · Restany, Hundertwasser, 1998

Hyperrealism. A heightened form of → photorealism which emerged largely in the US in the second half of the 1960s following on from → Pop art. Major exponents included → Close, → Eddy, → Morley, Ben Schonzeit, John Baeder, and Audrey Flack. Their aim was to reproduce subjects in the most neutral way possible, free from any subjective interpretation by the artist. Objects are depicted with the greatest exactitude and as little painterly or brushstroke effect as possible. The term is also sometimes applied to sculptors (→ De Andrea, → Hanson). H.D.

Bibl.: Lucie-Smith, Superrealism, 1979

Hyppolite, Hector. *1894 Saint-Marc, †1948 Port-au-Prince. Haitian painter. Hyppolite was a voodoo *hougan* (priest) whose modest social standing and isolation kept him apart from the modern artistic community. In common with many self-taught painters, he discovered his calling late in life after many years in trade, producing upwards of 300 panels in his final few years. Drawing his figures directly onto paperboard, Hyppolite often applied his bright color with feathers or his fingers. To a greater extent than with the other early Haitian master Philomé Obin (1892–1977), for Hyppolite the spiritual home of Africa (Ginen) acquired considerable symbolic importance. His preferred themes included divinities and heroes, birds in foliage, still-lifes and portraits (often of an "official" cast reminiscent of → Rousseau). In the 1960s, his oeuvre amalgamating voodoo, secular, and Christian imagery attracted much commentary (some of it contradictory) from → Breton and Jean-Paul Sartre. He has since exerted a considerable influence on contemporary Haitian art, more on ethnic artists such as → Duval-Carrié and Préfète Duffante (1923–) than, say, on the → Surrealist Hervé Télémaque (born 1937). D.R.

Immendorff, Jörg. *1945 Bleckede near Lüneburg. German painter, draftsman, and sculptor, living in Düsseldorf, Hamburg and Frankfurt am Main. From 1963 he attended the Kunstakademie, Düsseldorf (initially as a scene painter, then studied

with → Beuys). From 1968 to 1970 created what he called his "Lidl" activities, manifestos, and performances (→ Action Art). From 1968 to 1980 he was an art instructor in Düsseldorf. In 1972 he participated in Documenta 5, in 1982 in Documenta 7. In 1976 he made contact with → Penck in Dresden with whom he entered into a German – German "Action Pact" and carried out a series of joint projects. He taught in Hamburg (Kunsthochschule 1982–83), Cologne (Werkkunstschule 1984–85). Since 1998 he has been professor at the Staatliche Hochschule für Bildende Künste in Frankfurt am Main.

Immendorff's socio-critical → happenings of the 1960s are characterized by scepticism concerning the social and political relevance of the art of the painter. At the beginning of the 1970s, this resulted in colorful, poster-like agitprop paintings. His "historical tableaux," created in the following years (in 1977 he started the series *Café Deutschland*), are garishly dim contemporary worlds full of political symbolism. Here he finds the pared-down style of representation and the wild, unleashed brush strokes which make him one of the most important artists of → New Figuration. A.R.

Bibl.: Immendorff, Basel, 1979 · Künstler-Räume, Hamburg, 1983 · Immendorff, Stuttgart, 1991 · Installation Art, San Diego, 1997

Jörg Immendorff, *Café Deutschland I*, 1977–78, Oil on canvas, 282 x 320 cm, Ludwig Museum, Cologne

Independent Group. Group founded in 1952–53 at the → Institute of Contemporary Arts (ICA) in London. Its members included R. → Hamilton, → Paolozzi, Lawrence Alloway, Reyner Banham and a few architects. In the early days this group contemplated incorporating popular culture

(advertising, media) into their work, a move which was critical for the development of English → Pop art. The group organized two exhibitions: "Parallel of Art and Life" in 1953 and "This is Tomorrow" at the Whitechapel Art Gallery, London, in 1956. Hamilton designed his most famous collage, *Just what is it that makes today's homes so different, so appealing?* for the catalog of the latter exhibition. H.D.

Bibl.: Robbins, Independent Group, 1990

Indiana, Robert. *1928 New Castle, Indiana. American painter and graphic artist who lives in New York. From 1945 to 1948 he attended art schools in Indianapolis and Utica; from 1949 to 1953 the Art Institute, Chicago; in 1953–54 he was at Edinburgh College of Art and the University of London. From 1954 Indiana worked in New York (making contact with Ellsworth → Kelly, → Martin, and → Rosenquist) and since 1978 in Vinalhaven, Maine.

Influenced by the new New York art movement (→ Rauschenberg) in the early 1960s, his first sculptures were assembled from discarded objects (shop signs, traffic signs, ships' masts) and commercial templates of the 19th century. He also produced bold "Sign Paintings" in bright

Robert Indiana, *Love*, 1966, Acrylic on canvas, 183 x 183 cm, Indianapolis Museum of Art

poster colors for which, inspired by → Hartley, → Demuth, Frank → Stella, Kelly, and → Johns, he uses templates (letters, concepts, numbers, geometric forms) in multiple variations (*Numbers-Series*). These everyday ciphers and symbols in their strict combination point to more complex, meaningful relationships (number mysticism). Indiana is well-known for his silk-screen prints, posters, and sculptures on the concept of "Love". He is among the main representatives of → Pop Art in the US, and influenced → Conceptual art of the 1980s and 1990s (→ Kosuth). S.H.

Bibl.: Weinhardt, Indiana, 1990 · Katz, Indiana, 1991 · Sheehan, Indiana, 1991

Informalism → Art Informel

Inkhuk (Institut Khudozhestvennoi Kulturi). The "Institute of Artistic Culture" was founded in May 1920 by members of the Institute of Fine Art of the → Narkompros in Moscow. The first active department, that of monumental art, also admitted independent members, among them → Kandinsky, → Popova, → Rodchenko, and → Stepanova. Kandinsky set up an analytical,

Asger Jorn, *Die Brücke*, 1958, Oil on canvas, 146 x 114 cm, Galerie van de Loo, Munich (see p. 168)

synthetic research, and educational program for the Institute which envisaged an investigation into individual art genres and the effect these had on the viewer. The idea was that in the synthetic part of the work, the means of expression in the various genres thereby "identified" were to be recombined into a synthesis – the new monumental art according to Kandinsky. In November 1920 a separate group led by Rodchenko was formed which, in contrast to Kandinsky, pursued a rational, scientific conception of art (→ Constructivism). In 1923–24 public funding was withdrawn and the Institute was closed. H.D.

Bibl.: Bowlt, Russian Art, 1976

Installation art. A term first coined in the 1960s within the sphere of → Minimal art and → Conceptual art to describe works that are not displayed as individual objects in an exhibition room, but whose physical presence emits a specific impression. Such works are often designed for a specific room and invariably require modification before they can be transferred to a different environment. For example, the quantity and size of steel base plates of → Andre's *Altstadt Rectangle*, which measured 5 x 20 m, had been designed so precisely for the exhibition room in Düsseldorf's Konrad Fischer gallery that the entire surface was covered, leaving just a narrow border around the work. → Kounellis's iron consoles and soot traces are also regarded as an installation, even though they cover only a single wall. Unlike an → environment, which targets a closed space and tends towards an illusionistic design, installations may address every single sense, but generally work with the existing space. D.S.

Bibl.: Wedewer, Räume, 1969 · Künstler-Räume, Hamburg, 1983 · Installation Art, San Diego, 1997

Institute of Contemporary Arts, London (ICA)). Organization established in 1947 by Roland Penrose, Herbert Read, P. Watson, and E.L.T. Mesens as an institute of modern art. Its first exhibition in February/March 1948 was entitled "40 Years of Modern Art" and exhibited → Matisse, → Picasso, and → Magritte, as well as the British artists → Bacon, → Paolozzi, and → Hepworth among others. A cinema in Oxford Street was chosen as its venue, to distinguish it from the established galleries. By the 1950s the Institute had made a name for itself as a place where painting and sculpture, architecture and music, theater and film could meet and profit from one another. The ICA has maintained this interdisciplinary character to the present day: situated in the center of London, near Trafalgar Square, it offers two cinemas, a theater, a bookshop specializing in contemporary art and three exhibition rooms in which "the best of new work by living artists" is shown. A.K.

Bibl.: Wederwer, Räume, 1969 · Sinker, 1997

International Style. This term (also International Modern [Style]) is essentially applied to architecture and design of the worldwide Modern movement. The architecture falling under this heading tends to be formalist, rectilinear, modular, undecorated, and monochrome, and spans → Le Corbusier and the → Bauhaus to Frank Lloyd Wright (1867–1959). In architecture, modernist pluralism overtook the hegemony of the International Style in the 1960s, with Brutalism in e.g. Britain; Neo-Liberty in Italy; and, especially in the 1970–80s, Post-Modern eclecticism and technological structuralism (e.g. Centre Pompidou, Paris) in both the US and Europe.

In the visual arts the expression is less widespread and covers productions of a similarly geometric nature derived mainly from De → Stijl and → Mondrian. More loosely, the term may be used to denote modernism in general, especially in its transcontinental manifestations or, even less helpfully, the globally "dominant" artistic credo or style of any contemporary period. D.R.

Intimisme (→ Nabis). This term defines a genre in painting in which intimate, domestic scenes are captured by a more or less Impressionist technique using often exaggerated colors to express a mood and atmosphere of cosy domesticity and family security. Among its main representatives since the 1890s (when the term was first formulated) are → Bonnard and especially → Vuillard. K.S.-D.

Ipoustéguy, Jean-(Robert). *1920 Dun-sur-Meuse. French self-taught sculptor and painter living in Choisy-le-Roi (since 1949 he has produced exclusively sculptural work). Since 1960 he has participated in exhibitions, including Documenta 3, and the Venice Biennale in 1964. Many of his sculptures appear in public places (e.g. *Alexander vor Ecbatane*, forecourt of the International Congress Center, Berlin, 1978). In line with the architectonic, abstract models of the 1950s the human figure is the dominant theme for Ipoustéguy's bronze and marble sculpture. With an analytical eye, the artist shows inner views of bodies in contrast with → Brancusi's closed form. Sickly, fragile figures alternate with sensuous smoothness or architectonic solidity, whilst thoughts of passion, eroticism, birth and death provide the thematic (*The Death of the Father*, 1968). I.S.

Bibl.: Gaudibert, Ipoustéguy, 1989

Irwin, Robert. *1928 Long Beach, California. American painter, sculptor, installation artist, and landscape designer living in San Diego. Irwin studied at the Otis Art Institute in Los Angeles between two terms of service in the US Army. He took further art training in Los Angeles at the Jepson Art Institute and Chouinard Art Institute. Irwin adopted the → Abstract Expressionist style of painting in the mid 1950s, beginning a lifelong journey of aesthetic inquiry and experimentation. He produced a series of paintings small enough to be "hand held." Large canvas paintings of lines, and then a series of dot paintings followed. The Disc series, installed suspended, was his final painted series before he abandoned painting for work he terms "site-conditioned" or "site-generated."

Interested in the effect of light and wanting the viewer to enter the work, Irwin creates pieces which incorporate the use of white, semi-

transparent fabric in installations such as *Scrim Veil – Black Rectangle – Natural Light* (1977). Environmental installations such as *Filigreed Line* (1979) contrast the man-made with the ever-changing environment. The year 1992 brought a commission from the Getty Center in Los Angeles to create a landscape in a three-acre valley below the Richard Meier designed museum. J.S.

Bibl.: Irwin, New York, 1977 · Weschler, Irwin, 1991

Itten, Johannes. *1888 Südern-Lindern (Bernese Oberland), †1967 Zürich. Swiss painter, art teacher, and writer. From 1902 until 1912 he studied at the École des Beaux-Arts, Geneva. In 1912 he qualified as a teacher. From 1913 to 1916 he studied with → Hölzel at the Kunstakademie Stuttgart. From 1916 he worked in Vienna. In 1919 he took up an appointment at the → Bauhaus in Weimar (1919–23 introductory

Johannes Itten, *The Encounter*, 1916, Oil on canvas, 105 x 80 cm, Kunsthaus Zürich

course, head of studio). From 1926 to 1934 he ran his own "Modern Art School" in Berlin. He was head of textile colleges in Krefeld (1932–38) and Zürich (1943–60). From 1938 to 1954 he was Director of the Kunstgewerbeschule and Kunstgewerbemuseum, Zürich. From 1952 to 1955 he was Director of the Rietberg Museum, Zürich. Influenced by Hölzel's color theory Itten produced his first abstract works in 1916 (e.g. *The Encounter*). The early works as well as his own studies of color and art theory which he was able to consolidate at the Bauhaus from 1919 and later through his teaching activities laid the foundation for his book *The Art of Color* published in 1961, which became a standard textbook in art education. In the course of producing numerous figurative as well as abstract works, Itten conducted his research into a rational analysis of color and form that produced his late work (*The Four Seasons*, 1963). In conjunction with his writings, his educational activities were considered pioneering for a long time. H.D.

Bibl.: Itten, Design and Form, 1964 · Itten, Berne, 1984 · Whitford, Bauhaus, 1984 · Itten, Ostfildern, 1994

Horst Janssen, *E. A. Poe, April 27*, 1988, Colored etching, 54.2 x 30 cm

Izquierdo, María. *1906 San Juan de los Lagos, Jalisco, †1955 Mexico City. Mexican painter. She studied at the Escuela Nacional de Bellas Artes

San Carlos. Until 1933 she lived and worked jointly with her partner → Tamayo. From 1931 she taught at the Escuela de Pintura y Escultura, Mexico City. Her early works show portraits, still lifes, and urban views using simple, strong forms, painted with earthy colors and in a naive style. In the 1930s circus themes dominated her work alongside allegorical compositions in a small format. This primitivism, rooted in Mexican folkart, was much admired by the French author Antonin Artaud who also supported her work. In the 1940s she devoted herself increasingly to dark landscapes. E.B.

Bibl.: Billeter, Izquierdo, 1987 · Izquierdo, Monterrey, 1995

Jack of Diamonds. An avant-garde art group (Rus.: *Bubnovy Valet*) established in Moscow in 1910 and active until 1917; also known as the "Knave of Diamonds" (the adopted French word for the card being *valet*). Founded by artists receptive to innovative Western art – → Larionov, → Goncharova, → Lentulov, and Robert Falk (1888–1958), among others – the group attracted major personalities such as → Exter, Vladimir → Burliuk, and David → Burliuk. Their meetings initially gravitated around Ilya Mashkov (1884–1944), who was expelled from the Academy for following French → Post-Impressionist trends. → Malevich, however, was attracted to the first exhibition (December 1910, Moscow) by the presence of Larionov and Goncharova. Foreign avant-garde artists (→ Kandinsky and → Jawlensky) were invited to take part in the show, but it was the crude popular print (*lubok*)-inspired work of Larionov and Goncharova that provoked a scandal. This pair soon left to set up the less Westernized – more "Scythian," the like-minded poet Khlebnikov would have said – → Donkey's Tail, while Malevich departed to re-exhibit with it independently only in 1916.

Other influences included → Fauvism and → Cubism. The second exhibition was if anything more dependent on foreigners than the first, not only Munich NKV and Die → Brücke members (Van → Dongen), but also French artists (→ Picasso and → Léger – *Sketch for Three Portraits*, 1911). David Burliuk's "manifesto"-review, named after the group, heralded the → Futurist revolution in Russian art, but Lentulov was the only remaining "Jack" member up to undertaking it at this stage, uniting in his → Cubo-Futurist work the influence of → Gleizes and mechanistic impulses. Only with the fifth exhibition (1916) did the group once more capture center-stage with Malevich, → Popova, → Rozanova, and → Kliun contributing, and Mashkov sidelined. The show witnessed the triumph of → Suprematism. The Jack of Diamonds folded in 1917 after a final show with notable entries from Exter. A Soviet retrospective in 1928 concentrated on the tame Cubism of Aleksandr Kuprin (1880–1960), Lentulov (at one stage), and Pyotr Konchalovsky (1876–1956), with Non-Objective art ignored. D.R.

Bibl.: Seven Moscow Artists, Cologne, 1984 · Pospelov, Moderne russische, 1985

Janssen, Horst. *1929 Hamburg, †1995 Hamburg. German painter and graphic artist, who studied at the Hochschule für Bildende Künste,

Hamburg. At the end of the 1950s, after having produced Expressionist colored woodcuts, Janssen switched to crayon and pen-and-ink drawing as well as etching, developing a very individual, detailed style, which combined the drawing technique of the Nazarenes with controversial ideas in the tradition of → Ensor and → Klee. Besides landscapes, influenced by Hokusai, 17th-century Dutch painting, and the German Romantics, Janssen painted portraits and self-portraits in which he expressed states of mind and psychic deformity by expressively resolved, but brilliantly mastered artistic methods (*Self-Portrait on the Art of Using a Pen. XLV*, 1971). He also wrote poetry, essays, treatises, and pamphlets on art. H. D.

Bibl.: Janssen, Hamburg, 1982 · Blessin, Janssen, 1992

Japonisme. The term Japonisme, introduced by Philippe Burty in 1872–73 (article in *La Renaissance littéraire et artistique*), describes initially a predilection for the artistic products of Japan, as well as their imitations; it related especially to the arts and crafts. Nowadays Japonisme refers generally to the adoption and development of Japanese artistic ideas. When in 1854, after more than two centuries of isolation, the barriers between Japan and the western world came down, Europe was confronted with a totally novel kind of aesthetics. Similar to the 18th-century fashion for all things Chinese, the 19th-century fashion for Japan was initially a form of exoticism, reflected in the early paintings of Manet, Monet, Stevens, Tissot, and Whistler (who at first only adopted Japanese motifs). Although Japonisme can be found in the works of Théodore Rousseau and Millet, it began on a large scale with the Impressionists, especially Degas and Whistler. These artists admired the light, transparent, and radiant colors of Japanese woodcuts as well as the unusual form of composition, e. g. overlaid margins and cutouts, asymmetries, and steep and foreshortened perspectives. A second wave of Japonisme inspired Post-Impressionists (→ Bernard, Gauguin, van Gogh, Toulouse-Lautrec [see → precursors]), the → Nabis, and the artists of → Jugendstil and → Art Nouveau, who recognized in Japanese colored woodcuts an art of naturalness and simplicity. U.P.-P.

Bibl.: Japonisme, New York, 1974 · Evett, Japonisme, 1982 · Japonisme, Paris, 1988 · Weisberg, Japonisme, 1990

Jawlensky, Alexei (von). *1864 Torzhok/Tver, Russia, †1941 Wiesbaden. Russian painter who spent 1882–96 pursuing a military career in Moscow and St. Petersburg where he also studied at the Academy of Art. From 1896 he studied at the Az.bè School in Munich, undertaking study trips to Provence and Brittany. In 1905 he participated in the Salon d'Automne, Paris. In 1909 he was co-founder (with → Kandinsky) of the → Neue Künstlervereinigung München. From 1981 he worked in Ascona. In 1924 he founded Die → Blaue Vier (with Kandinsky, → Klee and Lyonel → Feininger). The influence of Cézanne, Gauguin, and van Gogh (see → precursors) from 1907 led Jawlensky to a more expressive style whereby color, often contoured in black, played a dominant role (*The White Feather*, 1909). The friendship

with Kandinsky and the circle of the Der → Blaue Reiter intensified the simplification of form and Jawlensky's concentration on a suggestive palette (*Spanish Lady*, 1913). From 1917 he developed portraits into abstracted heads of saints and "mystic heads" (*Mystic Head*, 1917). A series of variations (on a theme of landscape) shows how much Jawlensky was approaching → abstract art and how he experienced color as a pure sound (*With Yellow Dot*, 1918). His later years were overshadowed by ill health, however they show a renewed intensification in visual expression.

By strictly geometrizing facial features, Jawlensky created an expressive symbol of the human face which, by contrasting bright and darkly subdued colors, invites the viewer to meditate upon the image. His last paintings up to 1938 (*Meditations*) are, in their simplicity and power of expression, a moving testimony to an almost totally paralyzed painter's will to live. H.D.

Bibl.: Schultze, Jawlensky, 1970 · Zweite, Jawlensky, 1983 · Belgin, Jawlensky, 1998

Alexei (von) Jawlensky, *Abstract Head*, 1929, Oil on laid paper on mounted cardboard, 36 x 25 cm, Merzbacher Collection, Switzerland

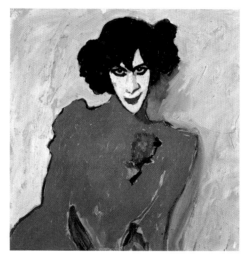

Alexei (von) Jawlensky, *Portrait of the Dancer Sacharoff*, 1909, Oil on cardboard, 69.5 x 66.5 cm, Städtische Galerie im Lenbachhaus, Munich

Jeanneret, Charles-Édouard. → Le Corbusier

Jenkins, Paul. *1923 Kansas City. American painter of → Abstract Expressionism who lives in New York. From 1948 to 1951 he studied at the → Art Students League of New York. From 1955 he was based in Paris, alternately staying in the US and in France. In his early works Jenkins already demonstrates a fascination with the "phenomenon of color" and develops a generous color technique similar to → Rothko and K. → Noland. He paints brilliant color bands spread over large surfaces, merging with one another and penetrating the untreated white canvas. In contrast to Noland's style of painting Jenkins gives his colors greater freedom to release specific energies and to experiment with the possibilities of mixing, thereby achieving a very lyrical effect (*Phenomena Wakiyaski*, 1961). H.D.

Bibl.: Bonafoux, Jenkins, 1991

Jennings, Humphrey (Frank Sinkler). *1907 Walberswick, Suffolk, †1950 Poros, Greece. British painter and photographer. Beginning as a set designer, Jennings worked throughout his life on

often politically aware film documentaries, starting with the GPO Film Unit (1934). In the mid-1930s he produced → Surrealist collages (one showed a swiss roll in a landscape) and was a member with → Breton and Roland Penrose (1900–84) of the Committee for the International Surrealist Exhibition in London (1936). He was an instigator of the 1937 Mass Observation of Coronation Day and other similar studies. Surrealistic photographs and paintings – which in plastic terms sought a "new solidity as firm as Cubism, but fluid" – have a → Magritte-like atmosphere (*Imaginary Portrait of Sir Isaac Newton*, 1940). A 1985 study, *Pandaemonium*, is a collection of linked quotations accounting for changes in image-perception from the mid-17th to the mid-19th centuries. With Penrose, E. L. T. Mesens, and the poet David Gascoigne, he was an important protagonist in British → Surrealism. An important retrospective of his films was shown at the National Film Theatre, London, in 2000. D.R.

Bibl.: Jennings (ed.), Jennings, 1982

Jetelová, Magdalena. *1946 Semily (now Czech Republic). Czech sculptor and installation artist. She studied from 1965 to 1971 at the Academy of Art, Prague; and in 1967 to 1968 at the Accademia de Brera, Milan. In 1987 she exhibited at Documenta 8. Since 1990 she has been Professor at the Kunstakademie in Düsseldorf. Jetelová's monumental, unbalanced wooden sculptures could be described as enactments of the Absurd. Whereas banal everyday objects, e.g. chairs, stairs, and doorways feature mainly in her early work, from the late 1980s onwards the context of place or situation becomes prominent only then to be changed by various technical alienation effects (light and laser projections) (*Iceland Project*, 1992). Her work combines elements of → Constructivism with tendencies to → Arte Povera and → Land art. I.S.

Bibl.: Wolbert, Jetelová, 1996 · Guthbrod, Jetelová, 1997

John, Augustus (Edwin). *1878 Tenby, Pembrokeshire, †1961 Fordingbridge, Hampshire. British painter. After initial study with Henry Tonks (1862–1937) at the Slade (1894–98), John emerged as a gifted draftsman. A bohemian life inspired much of his pre-World War I work based on idealized versions of the gypsies of north Wales (or women dressed like them), as in *Smiling Woman* (1909) – "fierce, disquieting, emphatic" (Roger Fry). Eventually he settled in Essex with his wife and frequented the New English Art Club as a more regular exhibitor than his sister Gwen → John. Although influenced by → Post-Impressionism, his style was conservative, perhaps an inescapable repercussion of commissioned portraiture (*W. B. Yeats*, 1907). His later *Madame Suggia* (1923) – playing the cello in a red robe – is a bravura subject that harks back to the Swagger Portrait. His success in this genre, he felt, was to the detriment of his compositional work. An early self-portrait (etched 1899–1900) establishes the myth of the hirsute rebellious artist, half-Beethoven, half-Lebrun *passion*. In his latter years, he was of the opinion that his sister's glory would outshine his own. D.R.

Bibl.: John, Chiaroscuro, 1952 · Easton/Holroyd, John, 1974

Jasper Johns, *Target with Plaster Casts*, 1955, Encaustic, collage on canvas with objects, 129.5 x 111.8 x 8.8 cm, David Geffen Collection, Los Angeles

John, Gwen(dolen) Mary. *1876 Haverfordwest, Pembrokeshire, †1939 Dieppe. British painter. Sister of Augustus. Gwen John studied briefly at Whistler's → Académie Carmen and settled in Paris in 1904, becoming a close friend of → Rodin and exhibiting with the New English Art Club until 1911. She lived in France, mostly at Meudon, until her death, an isolated figure contrasting with her flamboyant brother. Main subjects are three-quarter portraits (especially of nuns and other women; *The Student*, 1903), introspective self-portraits, and tranquil interiors (*Rue Terre Neuve*, 1928). Between 1910 and 1924 her main patron was the publicist of the Armory Show, John Quinn. With a highly refined and → Post-Impressionist concern for color in which impasto combines with grading, even the minute dimensions of her final studies show a reticent personality, although her confidence in handling induced some contemporary critics to declare her art superior to Whistler's. Such single-mindedness in a chosen field is not without parallels in → Morandi. D.R.

Bibl.: Taubman, John, 1985

Jasper Johns, *Flag*, 1954–55, Encaustic, oil, collage on fabric mounted on plywood, 3 parts, 107.3 x 154 cm, The Museum of Modern Art, New York

Johns, Jasper. *1930 Augusta, Georgia. American artist who lives in Stony Point, New York and Saint-Martin, South of France. In 1947–48 he attended the University of South Carolina. In 1967–68 he worked for the Merce Cunningham Dance Company and → Cage. In 1989 he was made an honorary member of the Royal Academy, London.

In the mid-1950s Johns produced the first *Flags*, *Targets*, and *Numbers* which, with their banal everyday motifs, paved the way for → Pop art and ushered in → Abstract Expressionism on the strength of their even → all-over painting technique. The flags series (*Flag on Orange Field*, 1957) became a symbol of a new concept of art which works with the ambiguity of signs. In the 1960s Johns experimented with → assemblages (*Field Painting*, 1964) where, like → Rauschenberg, he introduced a new realistic element into painting. The flat patterns of the 1970s, which on first glance have an abstract appearance, have again been borrowed from the repertoire of anonymous everyday motifs but allude quite strongly to private and art historical experiences. Increasing complexity leads Johns in the 1980s to incorporate in his pictures a host of art historical references from Grünewald to → Picasso and M. → Duchamp. Besides paintings, Johns' works also

comprise sculptures (*Painted Bronzes*, 1960) and technically perfect series of graphics (e. g. *Fool's House. Gemini G.E.L.*, 1972). H.D.

Bibl.: Bernstein, Johns, 1985 · Rosenthal/Fine, Johns, 1990 · Crichton, Johns, 1994 · Ortin, Johns, 1994

Johnson, Ray. *1927 Detroit, †1995. American painter, draftsman, and performance artist Johnson studied at the → Art Students League of New York(1944–45), and Black Mountain College with Josef Albers (1945–48), where he met → Cage and Merce Cunningham, among others. He worked in almost every medium and style. In the 1950s he made collages, which he called "moticos," from photographs from popular magazines (*Elvis Presley*, 1955). He is best-known, however, for having established Correspondence, or → Mail art: in the late 1960s he founded the New York Correspondence School, where he circulated his art (handmade postcards and stamps, collages, artists' books, etc.) through the US Postal System, thereby circumventing the conventional gallery circuit and the commercial exploitation of his art. He later used copying and fax machines to demonstrate the democratic potential of art. J.F.

Bibl.: Johnson, New York, 1984 · De Salvo/Gudis, Johnson, 2000

Jones, Allen. *1937 Southampton. British painter, sculptor, draftsman, and graphic artist living in London. From 1955 to 1959 he attended Hornsey College of Art; from 1959 to 1960, the Royal College of Art, and in 1961–63 he taught at the Croydon College of Art; in1964 he was at Chelsea School of Art in London. From 1968 to 1977 he was Visiting Professor at the Hochschule für Bildende Kunst, Hamburg, at the University of California, Los Angeles, and at the Hochschule für Bildende Künste, Berlin. In 1981 he became a member of the Royal Academy, London.

Jones ranks among the founders of British → Pop art. His paintings, sculptures, and → combine paintings are marked by an underlying eroticism and sexuality, provocatively presented in a bold formal language. His repertoire of motifs concentrates increasingly on the female body and fetishist characteristics associated with it, to striking effect. I.N.

Bibl.: Jones, Liverpool, 1979 · Livingstone, Jones, 1979

Jones, David. *1895 Brockley, Kent, †1974 Harrow. British painter, printmaker, poet (*In Parenthesis*, 1937; *Anathemata*, 1952), and illustrator in the spirit of William Blake and D. G. Rossetti. Jones saw his wartime experience on the Western Front as a personal and overwhelming eschatological event. Converting to Roman Catholicism in 1921, Jones joined → Gill's colony at Ditchling, Sussex, where he learned wood engraving (*The Book of Jonah*, 1926; *The Ancient Mariner*, 1929). After this illustrative, medievalizing period imbued with a serious religiosity and some grand watercolour landscapes, a mature style of complex lines building up into translucent figures emerged. He reacted to failing eyesight and two nervous breakdowns with works of mythical power (*The Four Queens*, 1941; *Vexilla Regis*, 1947). An important associate of → Neo-Romanticism, he followed Gill in hand-painting lettering in a "Celtic" vein. A retrospective was held at the Tate in 1981. D.R.

Bibl.: Blamires, Jones, 1971 · Gray, Jones, 1989

Jorn, Asger. *1914 Vejrum, Jutland, †1973 Aarhus. Danish painter, sculptor, and writer. From 1936 to 1939 he studied at the Académie Contemporaine with → Léger. Between 1948 and 1951 he was a leading member of → Cobra. From 1951 to 1953 he produced poems and essays on art. In 1953 he founded the 'Mouvement International pour un Bauhaus imaginiste'.

Inspired by → Klee and → Ernst, but also fascinated by Nordic tales and legends, Jorn devoted himself to painting fantasy figures, which led him to found Cobra. Confronting notions of → Art Informel Jorn translated symbolic figuration into a dynamic painting process in which he concealed the figurative representational motif under thick layers of paint and networks of lines (*Le monde perdu*, 1960). In the 1960s Jorn overpainted oil paintings and prints found at flea markets (*Modifications* and *Défigurations*), and produced ceramic works and collages. After a long break, during which he compiled a photographic collection, he began to paint again from 1966 onwards. In the last years of his life Jorn devoted himself more and more to sculpture (ceramic, bronze, and marble). He also founded the association of "International Situationists" (→ Situationism) and used it as a platform to criticise the functionalism of capitalist society and to campaign for a "uniform urbanism." H.D.

Bibl.: Atkins, Jorn, 1977/1980 · Jorn, New York, 1982 · Zweite, Jorn, 1987

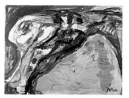

Asger Jorn, *Die Brücke*, 1958, Oil on canvas, 146 x 114 cm, Galerie van de Loo, Munich

Asger Jorn, *The Barbarian and the Berber Woman*, 1962, Oil on canvas, 130 x 89 cm, Private Collection

Judd, Donald. *1928 Excelsior Springs, Missouri, †1994 New York. Sculptor, advocate of → Minimal art. Between 1948 and 1952 he studied at Williamsburg, Virginia, and New York. From 1959 to 1965 he was art critic for *Arts Magazine*. His early works were in the style of → Abstract Expressionism. From 1961 to 1962 he produced sculptural objects which hover between the two-

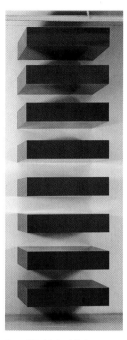

Donald Judd, *Untitled*,
1970–1983, 10 parts,
23 x 102 x 78.7 cm each, Paula
Cooper Gallery, New York

and three-dimensional (reliefs, and wood and metal constructions). An exhibition in 1963 at the Green Gallery in New York, together with → Flavin, → Morris, F. → Stella, E. → Kelly and → Poons already shows Judd to be a follower of Minimal art. From 1966 he used metals (sheet metal, brass, aluminum) and plexiglass which, shaped into regular, geometric bodies (mostly boxes), unpainted or varnished in bright primary colors, were exhibited either individually or in sequences. Judd arranged these elements on walls either vertically (*Stacks*) fixed to the wall like consoles or horizontally in pole form (*Progressions*) which, corresponding to mathematical sequences, are broken up (sculpture in ten parts *Untitled*, 1974). By these sequential repetitions and the use of mathematical methods Judd undermines the traditional hierarchy of composition and attempts to create an objective "democratic" art, meant to be experienced as a whole. His works from 1970 onwards were formed to suit the respective space and are, by their similarity to architectural forms and pieces of furniture, meant to question art's claim to absoluteness. In 1973 he acquired a building complex in Marfa, Texas, where he exhibited installations of his own work and that by other Minimal and → Conceptual artists. H.D.

Bibl.: Smith, Judd, 1975 · Haskell, Judd, 1988 · Poetter, Judd, 1989 · Noever, Judd, 1992

Jugendstil. The term for a florid, organic, and composite style c. 1900 in German-speaking lands, coined from the Munich newspaper *Die Jugend* (founded 1896). (→ Art Nouveau is the equivalent term for French-influenced areas.) Jugendstil adopted ideas from the fine arts (→ Symbolism, → Post-Impressionism, and → Japonisme), but manifested itself mainly in architecture, arts and crafts, and decorative and graphic art (book illustration, posters). New centers of the arts, such as Darmstadt (J. M. Olbrich [1867–1908]), sprang up, while practitioners formed "Secessionist" groups and set up private presses or art and craft studios (Vereinigte Werkstätte für Kunst und Handwerk, Munich, 1898; → Wiener Werkstätte, 1903). International exhibitions promoted the style on the world scene, and journals publicized the movement (*Deutsche Kunst und Dekoration*). Jugendstil maintained its momentum by means of a non-historicist reform of the arts in (particularly southern) Germany (August Endell [1871–1925], Studio Elvira, Munich, 1897–98; Otto Eckmann [1856–1902]) and Austro-Hungary (Hermann Obrist [1863–1927], *The Whiplash*, 1895; see also → Secession). Ideas such as the villa as a complete work of art (see → Hofmann) and the poster and book-wrapper as art (Josef Sattler [1867–1931], L. V. Zumbusch [1861–1927], Bernhard Pankok [1872–1943]) broke through the barriers separating "high = pure" and "low = applied" art, and strove for the aesthetic improvement of all domestic and art objects as well as toward a utopian reconciliation between art and technology.

The style's biomorphism and often asymmetric approach to line was intended to counter formal academicism, as in the graphics of Koloman Moser (1868–1918), Erwin Lang (1886–1962), B. Löffler, C. O. Czeschka (1878–1960), and Max Kurzweil (1867–1916). The best works synthesized line, ornament, construction, and purpose (the early underground station by Otto Wagner [1841–1918], Vienna, from 1894). It would seem that the rapid mutation of the style into "Werkstätte" (Josef Hoffmann [1870–1956]), in which straight lines and regular ornament compete with more luxuriant forms, limited the development of a "true," "organic" Jugendstil comparable to Art Nouveau in, say, Belgium. The style was also important in Lviv, Ukraine (Ivan Levynsky [1851–1915]); Riga, Latvia (Mikael Eisenstein [1867–1921]); Ljubljana, Slovenia (Joze Plecnik [1872–1957]); and Finland (Eliel Saarinen [1873–1950]). Jugendstil influenced painting and sculpture to a limited extent, but the statues of the Belgian Georg Minne (1866–1941), some → Klimt and → Kokoschka, the Viennese Emil Orlik (1870–1932), the Munich artists Hans Pellar (1868–1971) and Julius Dietz (1870–1957), and Hungarian painters such as János Vaszary and Aladór Körösföi, provide examples. Franz V. Bayros (1866–1924), from Vienna, and Thomas T. Heine (1867–1948), from Munich, were known as "Jugendstil Aubrey Beardsleys." Jugendstil and the criticism it catalyzed eventually paved the way for → Functionalism as well as for → Art Deco. H.O.

Bibl.: Madsen, Art Nouveau, 1976 · Kempton, Art Nouveau, 1977 · Russell, Jugendstil, 1981 · Wichmann, Jugendstil, 1984 · Sembach, Jugendstil, 1990

Jugendstil, Gustav Klimt,
Cover of the first issue of "Ver sacrum", 1898, Design: Alfred Roller, Gerlach and Schenk Publishers, Vienna

Junk art. A term formulated by Lawrence Alloway in 1961. It describes sculptural works made from discarded (junk) objects, and refers in particular to the works of → Rauschenberg (→ combine painting). Similar material was used in Californian → Funk art. American Junk art has parallels in the work of → Tàpies, A. → Burri and the artists of → Arte Povera, as well as of the artists of the → Gutai Group in Japan. H.D.

Kabakov, Ilya (Issifovich). *1933 Dniepropetrovsk, Ukraine. Ukrainian-born Conceptual artist and painter who has lived in New York since 1992. He studied at the Art College of the Leningrad Academy of Art in Samarkand, Uzbekistan. In 1945 he

moved to Moscow, where he studied graphic art (diploma in book illustration). From 1956 he worked as an illustrator, working on more than 100 books. During the 1960s he was a leading figure of the Moscow avant-garde and in 1965 became a member of the Artists' Association of the USSR. In 1985 his work was included in a traveling exhibition in Europe. In 1992 he participated in Documenta 9 and designed scenery and costumes for Alfred Schnittke's opera *Life with an Idiot*. In 1993 he taught at the Städelschule in Frankfurt. He has twice taken part in the Venice Biennale (1988, 1993).

Kabakov has worked in a range of media, producing several series of drawings (1970–78, album-bound), paintings, → environments, and objects. During the 1970s he developed the concept of "Expoart," incorporating elements from his own past with references to Russian culture. These environments are full of ironic subtexts. Many of Kabakov's works have combined texts and pictures, with the text commenting on,

Ilya Kabakov, *On the Roof*, 1996, Wood, planks, painting, construction, roof ridge, chimneys, 10 rooms, furniture, household utensils, slide projectors in each room in chronological sequence referring to biographical memories of the artist and Emma Kabakov, in variable dimensions, Installation, Palais des Beaux Arts, Brussels

questioning, or ignoring the picture. Between 1978 and 1982, he used this approach in his SHEK tables (SHEK = housing department), which are large, illustrated, tabular pictures based on → Socialist Realism. Here Kabakov fakes forms of bureaucratic regulatory plans, taking as his theme the control exercised over private lives hidden behind cold statistics (*Sunday Night*, 1980). The SHEK tables and albums became an integral part of the → installations produced since the early 1980s, which deal with life for ordinary people in Soviet Russia (*Red Pavilion*, 1993). K.S.-D.

◄ Wassily Kandinsky, *Improvisation 26 (Rowing)*, 1912, Oil on canvas, 97 x 107.5 cm, Städtische Galerie im Lenbachhaus, Munich (see p. 172)

Bibl.: Kabakov, London, 1989 · Kabakov, London, 1995 · Kabakov, Paris, 1995

Kadishman, Menashe. *1932 Tel Aviv. Israeli sculptor and painter. Studied in Tel Aviv (1947–50) and in Jerusalem and worked in London. His → Minimalist metal sculptures of the mid-1960s seemed weightless through an astute use of glass. In the 1970s transparency and environment became the key concepts. Natural themes such as plant and animal life were approached in an allusive manner. Echoing → Kounellis's famous *Cavalli* (1969), Kadishman exhibited 18 sheep in a straw-lined pen at the Venice Biennale in 1978. Neo-Expressionist paintings and sheet-steel or thick cor-ten cut-outs with zoomorphic motifs on grand themes followed: *Valley of Sadness* (1986), *The Sacrifice of Isaac* (1988), *The Flock* (1991, wire and metal rams' heads), and *Birth* (1992; cut-out with projecting newborn's head). D.R.

Bibl.: Kadishman, London, 1992

Kahlo, Frida. *1907 Coyoacan, Mexico, †1954 Coyoacan, Mexico. Mexican painter, daughter of the German-born photographer Guillermo Kahlo. Initially she studied medicine (1925). In 1924 she met → Rivera, whom she married in 1929 (they divorced in 1939 and remarried in 1940). In 1925 she was seriously injured in a bus accident, which left her a semi-invalid and childless (she had several miscarriages). From 1943 she taught at the Escuela de Pintura y Escultura, Mexico City. In 1953 she had a one-woman show in the Galeria Arte Contemporaneo, Mexico City.

Following her death, she was forgotten, but retrospectives in Berlin and London stimulated new interest in her work and she became something of a cult figure. As a result of her personal circumstances, Kahlo's paintings are unique and, in a deeper sense, can be seen as an embodiment of femininity. Her self-portraits are interwoven with stories and dramatic situations (e. g., abortion and physical pain, *Henry Ford Hospital*, 1923, *Broken Column*, 1944, *The Small Deer*, 1946). Owing much to traditional Mexican art, they dramatize her life story, bearing witness to her endurance. The famous double portrait *The Two Fridas* (1939) treats the duality of her personality (Mexican and European background). Kahlo described her own life symbolically, at the same time consigning it to the myth of history. E.B.

Bibl.: Herrera, Kahlo, 1983 · Herrera, Kahlo, 1991 · Tibol, Kahlo, 1993

Frida Kahlo, *Self-Portrait with Monkey*, 1940, Oil on chipboard, 60 x 40 cm, Harry Ransom Humanities Art Collection, University of Texas at Austin

Kandinsky, Wassily. *1866 Moscow, †1944 Neuilly-sur-Seine. Russian-born painter and art theorist. He studied law and economics in Moscow (1886–92). In 1896 he moved to Munich, studying at the Azbe Art College and the Academy of Art (1900). In 1901 he co-founded the exhibition society Phalanx (dissolved in 1904). Between 1904 and 1908 he traveled in Europe, spending a year in Paris with → Münter. In 1909 he was one of the founders of the Neue Künstlervereinigung München, which he resigned from in 1911 to found the → Blaue Reiter with → Marc (*Almanac* and exhibition, 1912). In 1912 he published *On the Spiritual in Art*. With the outbreak of war Kandinsky was forced to leave Munich, returning to Moscow, where he was active in both art and politics. In 1922 he accepted an invitation to teach at the → Bauhaus. In 1933, following the school's closure by the Nazis, he moved to Paris.

Kandinsky is one of the founding figures of abstract painting. Progressing rapidly from Impressionism, → Neo-Impressionism, and → Fauvism, by World War I he had already laid the foundations for non-representational art in his three important series *Impressions* (1909), *Improvisations* (1910), and *Compositions* (1911). In these works he put his theories into practice, breaking down the pictorial elements to create a cosmos of freely floating colors and forms (*Composition VII*, 1913). While teaching at the → Inkhuk in Moscow, he developed his ideas further (*Point and Line to Plane*, 1926), diverging from → Constructivism and → Suprematism. At the Bauhaus, where he directed the mural painting workshop, he developed a complex system of theories about color and form which he used in his teaching of the preliminary course. After an initially severe style (*Yellow-Red-Blue*, 1925), Kandinsky's painting at the Bauhaus became more relaxed and playful (*Moody*, 1930). His interest in a synaesthetic harmony of colors and forms found expression in 1928 in an abstract choreography for Mussorgsky's *Pictures at an Exhibition*. His move to Paris in 1933 heralded a new phase, characterized by biomorphic abstract forms (*Colored Ensemble*, 1938). Kandinsky's work, which lies somewhere between → Lyrical Abstraction and geometric rigidity, exerted an enormous influence.　W.G.

Bibl.: Kandinsky, 1982 · Roethel/Benjamin, Kandinsky, 1982/84 · Kandinsky, Berlin, 1984 · Hahlhoch, Kandinsky, 1993 · Whitford, Kandinsky, 1999

Wassily Kandinsky, *Impression III (Concert)*, 1911, Oil on canvas, 77.5 x 100 cm, Städtische Galerie im Lenbachhaus, Munich

Kanoldt, Alexander. *1881 Karlsruhe, †1939 Berlin. German painter. He studied at the Kunstgewerbeschule Karlsruhe (1899) and the Badische Akademie Karlsruhe (1901). Between 1908 and 1913 he was a member of the → Neue Künstlervereinigung München, coming into contact with → Kandinsky and → Jawlensky. From 1909 he lived in Munich, where he joined the → Secession (1913–20). He served in World War I (1914–18). He taught for a while at the Kunstakademie, Breslau (1925). In 1927 he joined the Baden Secession with → Hofer, → Schlichter, and Georg Scholz (1890–1945).

Kanoldt's early paintings were strongly influenced by pointillism and → Cubism. Rejecting abstraction, his style was based on that of his father, a prominent member of the German Roman School. Kanoldt's still lifes are characterized by their cool spareness, while his landscapes (*Subiaco Olevano*) and portraits, influenced by → Neue Sachlichkeit, are marked by a stillness and peace beyond time and everyday life.　G.P.

Bibl.: Kanoldt, Freiburg, 1987

Kanovitz, Howard. *1929 Fall River, Massachusetts. American painter living in New York. He studied at the Rhode Island School of Design (1949–51) and then worked in → Kline's studio in New York. From 1952 he worked as a freelance artist. Between 1956 and 1958 he traveled in Europe. He has taught at Southampton College (1977–78) and the School of Visual Arts, New York (1981–85).

Kanovitz is one of the most important exponents of → Photorealism. Going beyond the imitation of photography, he questions the essence of reality through *trompe-l'œil* effects, reflections, projections, and figures that appear to have been cut out. By creating pictures within pictures, he presents realism as a pure illusion. The process of perception rather than the object becomes the actual theme of the painting.　F.P.

Bibl.: Kanovitz, New York, 1987

Kantor, Tadeusz. *1915 Wielopole Skrzynskie near Kraców, †1990 Kraców. Polish artist and theater director. He studied at the Academy of Art, Kraców (1936–39). After directing an underground theater (1942–44), Kantor went on to become a leading figure in the revival of artistic life in Kraców following the war. In 1955 he founded the experimental theater Cricot 2 in Paris. He was a co-founder of the Kraców Group. In 1959 he took part in Documenta 2 and the Venice Biennale. He staged the first → happening in Poland in 1965 (*Cricotage*). In 1987 he participated in Documenta 8 with his performance, *The Death and Love Machine*.

Kantor, the most influential postwar artist in Poland, produced a varied body of work, including abstract paintings, → assemblages, → happenings, → Conceptual art, and performances. He devised new approaches to the theater, sometimes involving audience participation. His relieflike assemblages (umbrellas, paper bags) explore the themes of depersonalization and the loss of individual identity (*Multiparts*, 1970).　F.P.

Bibl.: Kantor, Journey, 1993

Wassily Kandinsky, *Improvisation 26 (Rowing)*, 1912 , Oil on canvas, 97 x 107.5 cm, Städtische Galerie im Lenbachhaus, Munich

Kapoor, Anish. *1954 Mumbai, India. British sculptor living in London. He studied at Hornsey School of Art and Chelsea School of Art in London. He is best known for his early sculptures, which consist of biomorphic elementary forms painted in primary colors (*1000 Names*, 1978–80). These works, completed following a trip to India, were inspired by Hindu mythology. Kapoor's work, centered on the themes of transcendence and purity of form and color, has something in common with that of Yves → Klein and the American → Minimalists. He makes creative use of the interplay between contrasts (concave/convex, positive/negative, colors, inside/outside, visible/invisible, material/immaterial), an aspect of his work also evident in his → installations (*Turning the World Inside Out*, 1995, *When I am Pregnant*, 1992). A.K.

Bibl.: Celant, Kapoor, 1996 · Kapoor, London, 1998

Kaprow, Allan. *1927 Atlantic City, New Jersey. American artist and theorist living in California. He studied at New York University (1945–49), the Hofmann School of Fine Arts (1947–48), New York University (1949–50), Columbia University (1950–52), and the New School for Social Research (1956–58). He has taught at the State University, N.Y., the California Institute of the Arts, and the University of California, San Diego, among other places. Kaprow was the principal creator of → happenings and → environments (*18 Happenings in 6 Parts*, 1959), incorporating gestural aspects of painting. From 1967 his "activities," as he called his happenings, became more restrained and intimate, involving simple, everyday rituals. Kaprow's artistic creativity has been supplemented by his extensive theoretical writings (*Assemblage, Environments and Happenings*, New York, 1966). C.W.-B.

Bibl.: Kirby, Happenings, 1966 · Kaprow, Dortmund, 1986

Allan Kaprow, *Sweet Wall*, 1970, Performance, West Berlin, René Block Gallery and DAAD, Berlin

Karavan, Dani. *1930 Tel Aviv. Israeli Conceptual artist living in Tel Aviv, Paris, and Florence. He studied painting in Tel Aviv, Jerusalem, and Florence (fresco). In 1984 he was visiting professor at the École Nationale Supérieure des Beaux-Arts in Paris. He took part in the 1976 Venice Biennale and Documentas 6 and 8 (1977, 1987), and has won numerous prizes (including the Kaiserring Goslar, 1996, and Praemium Imperiale, Japan, 1998). Karavan's work consists principally of wall reliefs and sculptures (*Negev-Monument*, Beer Sheba, 1963–68, bas-relief *Jerusalem City of Peace* for the Knesset, Jerusalem, 1965–66), as well as large-scale architectural → environments which incorporate the landscape (*Axe-majeur*, Cergy-Pontoise, 1980; Museumsplatz, Cologne; arcades *Hommage à Walter Benjamin*, Portbou, Spain, 1990–94). He uses various materials and media, both natural (light, wind, water, sand, stone) and man-made (laser, neon). His environments have influenced a number of architects, notably A. Schulte and W. Braunfels. K. S.-D.

Bibl.: Karavan, Amsterdam, 1993 · Karavan, Paris, 1993 · Laub, Karavan, 1995 · Restany, Karavan, 1997

Kassák, Lajos. *1887 Érsekújvár (Nové Zamky, Czech Republic), †1967 Budapest. Hungarian painter and theorist who played a central role as a promoter of the Hungarian avant-garde. In 1909 Kassák walked from Budapest to Paris, where he absorbed the lessons of → Cubism. He began a pacifist review, *A Tett* ("Action"), in 1915; this was followed by *MA* ("TODAY"), the main organ of → Activism during the Hungarian Republic. After the August 1919 reaction, *MA* retrenched to Vienna.

Kassák's artistic work includes collages, photomontages, and *Bildgedichte* (graphic poems), as well as strongly → Neo-Plasticist structures (1920s). Once back in Hungary, he edited journals such as *Dokumentum* (1926–27) and *Munka* ("Work," 1928–38), which by now treated the avant-garde as defunct, and composed his intellectual autobiography, *Egyember élete* ("Life of a Man," 7 vols., 1934). In the 1960s, a second geometrical phase had a pronounced effect on Hungarian → Hard-Edge painting. D.R.

Bibl.: Hungarian Avant Garde, Budapest, 1980

Katz, Alex. *1927 New York. American painter living in New York. He studied at the Cooper Union Art School (1946–49) and the Skowhegan School of Painting and Sculpture (1949–50). In the 1950s, after early work in an → Abstract Expressionist style, Katz developed a bold figurative idiom which made him a pioneer of → Pop art. His paintings of landscapes, buildings, and people resemble advertising posters, with simplified motifs and flat applications of color. He presents the external appearance of things, concealing the inner state behind the façade. F.P.

Bibl.: Katz, London, 1995

Kawara, On. *1933 Aichi-ken, Japan. Japanese Conceptual artist living in New York. He moved to Mexico (1955), where he studied architecture, and then settled in New York (1961). He took part in an exhibition of Conceptual art at the Art Museum in Basle, and Documentas 6 and 7 (1977, 1982). After figurative work, on moving to New York Kawara turned to → Conceptual art, producing a series of works which dealt with the definition of place and time: *Date Paintings* (begun in 1966), monochrome panels bearing the date of their completion, which he exhibited as series (*The Month of March 1970*, New York); *I Read* (from 1966), a collection of dated newspaper clippings of the days on which a date painting was completed; *I Went* (1968), based on notes about Kawara's movements on a particular day jotted down on a map; and *I Met* (1968), which consists of names of people he had met on a particular

day. In 1969 he compiled his 10-volume artwork *One Million Years*, which lists one million years of dates. Between 1968 and 1979 he sent postcards and telegrams to gallery owners, exhibition organizers, and friends, each inscribed with the words "I am still alive, OK." Kawara's works, at their most resonant and appealing when displayed in series, attempt to communicate temporal and spatial experiences in a seemingly objective, pseudo-scientific manner. H.D.

Bibl.: Schampers, On Kawara, 1991 · On Kawara, Frankfurt am Main, 1994 · Kittelmann, On Kawara, 1995 · Wäspe, On Kawara, 1997

On Kawara, *18 September, 1981; Friday, Today Series No. 31*, 1981, Liquitex on canvas, 45.7 x 61 cm

Kelley, Mike. *1954 Wayne near Detroit. American Performance and Installation artist living in Los Angeles. He studied at the University of Michigan, Ann Arbor (1976), and with → Baldessari at the California Institute of the Arts, Valencia (1978). Since 1981 he has had numerous one-man shows and in 1992 took part in Documenta 9. His early → performances owed much to the work of Gertrude Stein and the surrealistic writer Raymond Roussel. Based on repetition and the associative use of language, they explored linguistic structures and the various levels of meaning inherent in the concept of play. In parallel with his performances, he produced sculptures, drawings, texts, and photographs. Kelley's work is dominated by psychological, political, and ideological concerns (*Plato's Cave, Rothko's Chapel, Lincoln's Profile*, 1986). He draws on mass culture both for his themes and techniques (comics, cartoons, movies), thereby combining "low" and "high" culture. In the mid-1980s he began to make morbid sculptures, sometimes with sexual overtones, followed by installations

Mike Kelley, *Mixed Up*, 1982–83, Various materials and objects, c. 500 x 700 cm, City Museum Abteiberg, Mönchengladbach

featuring toys (*Eviscerated Corpse*, 1989). In 1992 he collaborated with Paul McCartney on a project based on the Heidi myth. Through distortion and perversion, they transformed the ideology of a "sane world" into a nightmarish → happening, exposing the repressed, shadowy, underside of civilization. K.S.-D.

Bibl.: Bartman/Barosh, Kelley, 1992 · Kellein, Kelley, 1992 · Sussman, Kelley, 1995

Kelly, Ellsworth. *1923 Newburgh, New York. American painter and printmaker living in Spencertown, N.Y. He studied at the Boston Museum School (1946–48) and the École des Beaux-Arts in Paris (1948), where he also taught at the American School (1950–51). In 1954 he returned to New York. During his stay in Paris, Kelly developed a form of geometric abstraction using primary colors (*Colors for a Large Wall*, 1951). On his return to America, he freed his pictures from their European models by linking his colored forms with the picture surface. His paintings consist mostly of geometric compositions made up of clearly delineated areas of bright color (→ Hard-Edge Painting). In the 1960s, he often used angular formats, combining monochrome panels to create wall-mounted → installations (→ shaped canvas). His initially gestural style gave way to greater clarity and a more architectural approach, resulting in wall-to-floor works that can be seen as sculptures as well as paintings (*Blue-Red*, 1966). During the 1970s he concentrated more on two-tone works of related surfaces (*Three Panels: Orange, Dark Gray, Green*, 1986). In addition to paintings, Kelly has produced prints, collages, and reliefs, together with sculptures made from wood and metal. The latter are based on both geometric and organic forms, alternating muted and strong colors (*Diagonal with Curve IX*, 1979). His commissions include the *Houston Triptych* (bronze, 1986) for the sculpture garden at the Museum of Fine Arts, Houston, where the curve motif dominates, as it does in his *Yellow Curve* (1990), which can be interpreted either as a painting or a sculpture. H.D.

Bibl.: Axsom, Kelly, 1987 · Bois, Kelly, 1992 · Waldman, Kelly, 1997

Kelly, Mary. *1941 Minneapolis, Minnesota. American installation artist, active in New York. Educated in Florence and at St Martin's School of Art, London (1968–70), Kelly has taught at Cambridge University and the Whitney Museum of American Art, New York (1989). A feminist art theorist, she is intimately acquainted with the work of Jacques Lacan and Juliet Mitchell. Kelly's first major work was the vast *Post-Partum Document* (1973–76/78), where the relation between

Ellsworth Kelly, *The Documenta-room: Blue Panel with Curve, White Panel with Curve, Green Panel with Curve, Red Panel with Curve*, 1991 (detail), Oil on canvas, 4 panels: 269 x 221 cm, 222 x 217 cm, 306 x 191 cm, 277 x 227 cm, Städtische Galerie im Lenbachhaus, Munich

Ellsworth Kelly, *Study for Antibes*, 1950, Oil on wood, 33 x 49.9 cm, Artist's Collection

maternal and infant fluids and her son's social-ization are presented in an almost → Minimalist fashion, the long gestation of the piece, its integration of childish inscriptions and "documentary" nature vehicling a (post-) feminist critique of maternity vs creativity vs exhibition. Incorporating steel pieces and photo-laminates, the multi-part *Interim* (1984–89: *Corpus*, on posture and dress; *Pecunia*, on woman as role and commodity; *Historia*; and *Potestas*) conveys an "identity" of post-maternal woman through enhanced "discursive" power. *Gloria Patri* (1992, mostly aluminum, some silk-screened) was a critique of virilism, while *Temporarily Possessed* (1995) is on allied themes. D.R.

Kent, Rockwell. *1882 Tarrytown, New York, †1971 Au Sable Forks, New York. American painter and graphic artist. After training in architecture, Kent studied art in New York under William Merritt Chase (1849–1916), Abbott Henderson Thayer (1849–1921), and Robert → Henri. His realistic and highly charged (often marine) landscapes in a vivid, dramatic style, show remote places such as Newfoundland, Alaska, Tierra del Fuego, and Greenland with strong contrasts and evident relish in nature (*Toilers of the Sea*, 1907). His oeuvre at this time was close in style to The → Eight and → Bellows. From 1920, his forms gained in solidity and became increasingly geometric. Kent worked as a lobster fisherman and wrote many books about his adventures (*Wilderness*, 1920; autobiography, *It's Me, O Lord*, 1955) as well as illustrating works such as the congenial *Moby Dick* (Chicago, 1930). He also produced wood engravings, bookplates, and prints that became widely popular. Kent was a left-winger and was investigated in the anti-Communist fervor of the 1940s and 1950s, though his art never suffered as a result of his involvement in politics. D.R.

Bibl.: Johnson, Kent, 1982

Kertész, André. *1894 Budapest, †1985 New York. Hungarian-born American photographer. Self-taught, he started to take photographs in 1912. He served in the Hungarian army during World War I. In 1917 he won his first prizes. In 1925 he settled in Paris, where he met → Outerbridge, → Man Ray, and the Surrealists around → Breton. He worked for various newspapers and magazines during this period, notably *Vu* (from 1928), and became friends with → Brassaï. In 1936 he

moved to New York, working for *Harper's Bazaar*, *Vogue*, *Look*, *House and Garden*, and *Coronet*. He became a US citizen in 1944. Between 1949 and 1962 he worked exclusively for Condé Nast.

Kertész produced a very poetic form of social documentary. His photographs of the Paris years, including his pictures of nudes distorted by means of a mirror, influenced Brassaï and → Cartier-Bresson. Pictures such as *The Fork*, *Swimmer Underwater*, *Park Bench*, and *Mondrian's Studio* are among the most famous photographs of the 20th century. A number of books of his photographs have been published, including *Paris vue par André Kertész* (1934) and *Day of Paris* (1945). R.M.

Bibl.: Ducrot, Kertész, 1972 · Kertész, 1997

Kesting, Edmund. *1892 Dresden-Löbtau, †1970 Birkenwerder. German painter and photographer. He studied in Dresden at the Kunstgewerbeschule (1911–14) and the Kunstakademie (1915–18), and came into contact with the Secessionist artists around → Felixmüller. In 1919 he founded the art school Der Weg. He became friends with Herwarth Walden and was in contact with Der → Sturm. In 1925 he began experimenting with collage and in 1928 took up photography, working as a commercial photographer (from 1932). In 1934 he was ostracized as "degenerate" and prohibited from painting and exhibiting. He subsequently devoted himself to portrait photography. After the war, he taught at the Staatlichen Hochschule für Werkkunst in Dresden (1946–48). His work finally achieved recognition in East Germany in 1980. R.M.

Bibl.: Kesting, Dresden, 1998

Anselm Kiefer, *Ways of Worldly Wisdom: The Battle of the Teutoburg Forest*, 1978–80, Woodcut, acrylic, shellac on paper, 344 x 413 cm, Städtische Galerie im Lenbachhaus, Munich

Kiefer, Anselm. *1945 Donaueschingen. German painter who lives in Hornbach-Walldürn (Odenwald region) and Barjac (Ardèche, France). He studied at the Kunstakademie in Freiburg, Karlsruhe, and Düsseldorf (1966–72). He took part in Documenta 8 (1987) and in 1990 a retrospective of his work was held at the Nationalgalerie, Berlin. Kiefer is a leading representative of → Neo-Expressionism. In his vivid, large-format pictures, he explores the myths and legends of German history, as well as events from the country's more recent past (*Germany's Spiritual Heroes*, 1973). His landscapes, saturated with material

André Kertész, *The Fork*, Paris, 1928, Vintage gelatin silver print, 19.4 x 24 cm, Ludwig Museum, Cologne

and frequently worked on with burner and ax, display an intentional ambiguity of idea and content, often complicated by inscriptions. His desolate, burnt scenes (*Painting=Burning*, 1974), however, are not intended to be a criticism of contemporary history, but more a dialogue with the myth of painting, an exploration of hubris and the expectation of salvation. Thus his pictures featuring winged palettes can be seen not only as parables of man's presumptuousness, but also as symbols of the artist's work. The tumbling (or rising) wing-palettes symbolize the possible failure of the artist, as well as his presumptuous yearning for salvation and transcendence (*Icarus=Märkischer Sand*, 1981). The heavily worked, multilayered works of recent years, whose titles are inscribed in the picture, are open to various interpretations (*Lilith*, 1990; *Saturn Time*, 1991). In addition to paintings and sculptures, Kiefer has also produced woodcuts, watercolors, and artist's books with reworked photographs. W.G.

Bibl.: Rosenthal, Kiefer, 1987 · Adriani, Kiefer, 1990 · Gilmour, Kiefer, 1990 · Kiefer, Dublin, 1990 · Lopez-Pedraza, Kiefer, 1996 · Saltzman, Kiefer, 1999

Kienholz, Edward. *1927 Fairfield, Washington, †1994 Sandpoint, Idaho. Self-taught American sculptor and Conceptual artist. In 1953 he moved to Los Angeles, where he founded the NOW gallery (1956), followed by the Ferus Gallery (1957). His environment *Roxy's* (1961) was shown at Documenta 4 (1968). From 1973 he divided his time between Berlin and Hope, Idaho, where he opened a gallery. In 1954 he began making painted wooden abstract reliefs (*Construction for Table*, 1957). He incorporated a found object into his work for the first time in 1958 (*The Little Rock Incident*), as well as writing. His works gradually evolved into life-size → assemblages and → installations with dolls and body casts (*Doe Family*, 1959–61). These treated such social themes as racial discrimination and the oppression of women (*Roxy's*, 1961), or the desensitizing effect of the mass media (*The Eleventh Hour Final*, 1968). He created "preliminary sketches" for these works in the form of small wall-mounted installations, which, from 1960, often carried additional instructions for the viewer. His "concept tableaux" provided a commentary on a particular work. His *Watercolors* (1969), small sales tags, took as their theme the exchange value of art. In 1972 he began working in collaboration with his wife, Nancy Reddin (1943–). In Berlin, they examined site-specific history by incorporating found objects (*Still Life* and *Volksempfänger* series, 1975–76). Their series *The Kienholz Men and Women* (1975–83) examined sexual discrimination. His later works explored various themes: the memories attached to objects (*Portrait of a Mother with Past Affixed Also*, 1981), social injustice and taboos (*The Caddy Court*, 1986–87), war (*The Big Double Cross*, 1987–89), and personal violence and abuse (*Jody, Jody, Jody*, 1993–94). M.G.

Bibl.: Weschler, Kienholz, 1977 · Kienholz, San Francisco, 1978 · Pincus, 1990 · Hopps, Kienholz, 1996

Edward Kienholz, The Caddy Court, *Interior View*, 1986/87, Mobiles Tableau, 213 x 702 x 254 cm, Nancy Reddin Kienholz Collection

Anselm Kiefer, *Poland is Not Yet Lost*, 1978, Oil on canvas, 211 x 272 cm, Museum Ostdeutsche Galerie, Regensburg

Edward Kienholz, *The Caddy Court*, 1986/87 (exterior view), Mobile tableau, 213 x 702 x 254 cm, Nancy Reddin Kienholz Collection

Kiesler, Frederick (John). *1890 Cernovcy, Ukraine, †1965 New York. Ukrainian-born American architect, designer, and sculptor. He studied architecture at the Kunstakademie, Vienna (1910–13). In 1923 he designed an "electro-mechanical" stage set in Berlin, where he came into contact with members of the De → Stijl group. In 1926 he settled in New York, where he worked on a succession of visionary architectural designs. He designed the Abstract Gallery in Peggy Guggenheim's Art of This Century Gallery (New York, 1942), the International Exhibition of Surrealism in Paris (1947), and the Shrine of the Book for the Dead Sea scrolls in Jerusalem (1957–65). Kiesler's theories were influenced by van → Doesburg and De Stijl. His approach was based on what he termed "correalism," according to which people and their environment are seen as a complex, integrated system of interrelations. Kiesler believed that the boundaries between different art forms should be removed, and that scientific findings as well as magic and myth had an equally important part to play in design (*Manifeste du Corréalisme*, Paris, 1947). His *Endless House* was a development of this idea, embodying an elastic concept of space that would do justice to the diverse interrelations of human life. Only a handful of his designs were actually realized. F.P.

Bibl.: Bogner, Kiesling, 1997

Kinetic art. Art which incorporates movement, real or illusory, mechanical or random. Like → Op art, the origins of Kinetic art lie in → Constructivism. The underlying principles are time, change, and randomness. The roots of Kinetic art can be traced back through the light and color scales of the 18th and 19th centuries to the automata of the ancient world. In the 20th century, early examples include M. → Duchamp's movable → ready-mades, → Tatlin's *Monument to the Third International* (1919–20), and works by → Man Ray, such as his metronome with the

photograph of an eye attached (1923). → Gabo conceived a "virtually kinetic space," in accordance with the theories set out in the *Realistic Manifesto* (1920) written in collaboration with → Pevsner. Their ideas were taken up by → Moholy-Nagy in his *Light-Space-Modulator* (1930), an electrical device for creating light and shadow effects. From 1932, Kinetic art became more widespread through → Calder's → mobiles.

Two basic currents can be distinguished in Kinetic art: one Constructivist and the other Dadaist. The former favored a systematization of sequences of movements and its exponents included → Schöffer and → Takis. A variant involved the use of light (→ Zero). Followers of the Dadaist tradition included → Tinguely, who built a self-destructive machine (*Homage to New York*, 1960), and → Bury. Kinetic art reached a peak in the 1960s, but a number of contemporary artists continue to use sequences of movement and randomly controlled processes in their work. Some, such as → Horn (*Peacock Machine*, 1982) and → Fischli & Weiss (*Der Lauf der Dinge*, 1987), have combined the principles of Kinetic art with video. W.S.

Bibl.: Malina, Kinetic Art, 1974 · Popper, Kinetic, 1975

Kinetic art, Jean Tinguely, *Stravinsky Fountain*, 1983, Centre Georges Pompidou, Paris

King, Phillip. *1934 Kheredine, near Tunis. British sculptor. Early, self-taught works after a visit to Paris were in a → Picasso – → Laurens synthesis, but after he became a student of → Caro at St Martin's School of Art, London, his works verged on → Surrealism (first exhibited in 1957). A onetime assistant to → Moore (1959–60), he became associated with the "New Generation" (exh., 1965) and pure abstraction, though the influence of → Matisse's improvizational cut-outs remained (*Slit*, 1966, arborite). Using industrial materials (steel mesh – *Brick Pieces*, 1974–and above all fiberglass: *Rosebud*, 1962), his brightly painted sculptures abandoned the plinth (the conical *And the Birds Began to Sing*, 1964), though they sometimes resemble dysfunctional supports (*Angle Poise*, 1973). He represented Britain at the Venice Biennale in 1968 (with → Riley). Irregular-shaped steel pieces followed with some ceramics, while monumental works such as *Sky* (1970) are powerful assertions of a fusion of industrial forms and natural imagery. Late sculptures are harmonious and reconciled, sometimes incorporating painting (*Where is Apollo Now?*, 1989–90). King was Professor of Sculpture at the Royal College of Art from 1980 to 1990. D.R.

Bibl.: King, London, 1968 · King, London, 1981

Kirchner, Ernst Ludwig. *1880 Aschaffenburg, †1938 Frauenkirch, Davos. German painter, printmaker, and sculptor, who studied architecture

Ernst Ludwig Kirchner, *Bridge over the Rhine in Cologne*, 1914, Oil on canvas, 120.5 x 91 cm, Neue Nationalgalerie, Berlin

in Dresden (1901–5). He became friends with Fritz Bleyl, → Heckel, and → Schmidt-Rottluff, and on June 7, 1905, co-founded Die → Brücke. In 1906 he met → Nolde. In 1909 he worked with → Pechstein, Heckel, and the model Fränzi Fehrmann at the Moritzburg lakes. In 1911 he moved to Berlin, where he painted a series of street scenes. In 1915 he was drafted into the German army but was discharged after a breakdown and admitted to a sanatorium in Königstein, Taunus, where he painted several murals. In 1917 he settled in Davos, Switzerland. Van de → Velde arranged for him to be admitted to a sanatorium in Kreuzlingen. In 1918 he met Nele van de Velde and moved to "In den Lärchen," a house in Frauenkirch, near Davos. At about this time, he began predating his works to ensure his place in art history as an innovator. In 1919 he began work on the "Davos Diary" and the following year collaborated with Nele.

In 1927 he received a commission to paint some murals in the Folkwang Museum in Essen. He became a member of the Akademie der Bildenden Künste in Berlin (1931) and an exhibition of his work was held at the Kunsthalle in Berne (1933). In 1936 he produced a relief for a school in Frauenkirch, but the following year 639 of his works were confiscated by the Nazis, some of which were included in the exhibition of → Degenerate Art. On June 15, 1938, he shot himself.

Kirchner was the leading figure in the Brücke group. His paintings consisted largely of figure compositions (nudes and portraits, often of intellectuals) and urban scenes (squares, bridges, streets) in a jagged, spiky, → Expressionist style. In addition to his paintings, he produced a large number of prints as well as wood sculptures. His voluminous correspondence and 180 sketchbooks give rare insight into his life and work. G.P.

Bibl.: Schiefler, Kirchner, 1926/31 · Dube/Dube, Kirchner, 1967 · Gordon, Kirchner, 1968 · Kornfeld, Kirchner, 1979 · Gabler, Kirchner, 1980 · Gabler, Kirchner, 1988 · Grisebach, Kirchner, 1995 · Presler, Kirchner, 1998

Ernst Ludwig Kirchner, *Male Nude (Adam)*, 1923, Wood, 169.6 x 40 x 31 cm, Staatsgalerie, Stuttgart

Per Kirkeby, *Untitled*, 1978, Oil on canvas,
208 x 135 cm, Michael Werner Gallery,
Cologne and New York

Per Kirkeby, *Untitled*, 1988,
Monotype, 213 x 106 cm,
Museum für Neue Kunst, ZKM,
Karlsruhe

Kirkeby, Per. *1938 Copenhagen. Danish painter, sculptor, film-maker, and writer who lives in Copenhagen, Laesö, Frankfurt am Main, and Arnasco. He studied geology and the natural sciences at the University of Copenhagen (1957–64). In 1958 and 1960 he made expeditions to Greenland and has since traveled to other regions of the world. In 1962 he joined the Eksperimenterende Kunst-skole in Copenhagen. He has made 24 films (1968–89). In 1982 he became a member of the Danish Academy of Literature. From 1988 he taught at the Städelschule in Frankfurt.

Influenced by → Fluxus, between 1963 and 1974 Kirkeby staged a number of → performances. During this period, he also made drawings on his geological expeditions, as well as collages, → ready-mades, and stenciled lacquer work. Under the influence of → Jorn and → Cobra, he sought a middle way between abstraction and representation (*Prototypes*, 1982). A number of his pictures refer to art historical models (his *Wood* series [1994], for example, alludes to Monet's *Waterlilies*). His technique is a form of → all-over painting and his pictures often have the appearance of geological strata. In addition to canvas, he has used Masonite and chalk boards as supports. His sculpture consists of installations in nature (*Lund*, 1968), minimalist works, and figurative pieces made from bricks (*Sphinx*, 1976), in addition to clay models and bronze sculptures in which the linking of history and nature is again prominent. Kirkeby has produced 70 publications to date, including written commentaries on his works and poetry. M.G.

Bibl.: Hunov, Kirkeby, 1979 · Gallwitz, Kirkeby, 1990 · Kirkeby, Handbuch, 1993 · Gachnang, Kirkeby, 1997 · Wilms, Kirkeby, 1998

Kisling, Moïse. *1891 Kraków, †1953 Sanary-sur-mer. Polish-born painter. In 1906 he attended Kraków Art Academy. From 1910 he was in Paris at the École des Beaux-Arts, where he made contact with the → Bateau-Lavoir and the → École de Paris. In 1940 he left for the US, returning to France in 1947. Initially influenced by → Cubism, Kisling painted strongly linear, brilliantly colored portraits, and nudes in the style of → Modigliani (e. g. *Woman with Polish Shawl*, c. 1928). Indifferent to avant-garde experiments Kisling remained true to expressively figurative painting (*Portrait de Madeleine Sologne*, 1936). S.H.

Bibl.: Kisling, Duisberg, 1965 · Kisling, Paris, 1984

Kitaj, Ronald B. (real name Ronald Brooks). *1932 Cleveland, Ohio. American painter and graphic artist living in Chelsea, London. He studied at the Cooper Union, New York (1950–51), the Kunstakademie, Vienna (1951–54), the Ruskin School, Oxford (1958–59), and the Royal College of Art, London (1959–61). Between 1961 and 1967 he taught in London, and was then a visiting professor in the US (1967 Berkeley, 1969–71 Los Angeles). Since 1972 he has been based in London. In 1976 he organized an exhibition of figurative paintings "The Human Clay" (→ London Group). In 1978–79 he stayed in the US. In 1988 he wrote the "First Diasporist Manifesto." A retrospective of his work was held at the Tate Gallery, London, in 1994.

Kitaj was a prominent figure on the London art scene during the 1960s and 1970s. His work is more figurative and full of literary and art historical references than that of his contemporaries (→ Hockney and A. → Jones). In the 1960s and early 1970s he produced a large number of silkscreen prints and in 1975, inspired by → Degas, he started to make pastel drawings. During the 1970s he became increasingly interested in his Jewish identity and the history of the Jews in Europe, resulting in more politically engaged work. H.D.

Bibl.: Livingstone, Kitaj, 1985 · Kinsman, Kitaj, 1994 · Morphet, Kitaj, 1994

Ronald B. Kitaj, *An Early Europe*, 1964, Oil on canvas, 152.4 x 213.4 cm, Private Collection

Kitchen Sink School. Group of English artists active in the 1950s. Leading members included John Bratby (1928–92), Derrick Greaves (1927–), Edward Middleditch (1923–87), and Jack → Smith. They produced a type of → social realism, specializing in unadorned representations of everyday middle-class life. The term was coined by the art critic David Sylvestor in 1954 in his article "English Realist Painting." Greaves and Smith were both born in Sheffield and the city featured in their work (Greaves, *Sheffield*, 1953). Although the artists staged joint exhibitions, they did not publish a program or manifesto, and by the late 1950s they had begun to develop in different directions. In 1956 they represented Great Britain at the Venice Biennale. A.K.

Bibl.: Sylvester, Kitchen Sink, 1954 · Fifties, Sheffield, 1984

kitsch. Term for products without style which lay claim to artistic value. The origin of the word is unclear, but it was probably first used in artists' circles in Munich in the late 19th century. Initially it was applied to paintings sloppily painted as "kitsch" (i. e. to be sold cheaply). Craft creation of kitsch went hand in hand with an industrial production, with the emphasis on anti-modern subjects such as roaring stags. Kitsch developed to take many forms, from cheap paperbacks, pop songs, and Hollywood movies to religious and political propaganda. Artists such as → Rockwell and Maxfield Parrish (1870–1966) have also been classified as kitsch. Kitsch creates a kind of harmony through romantic images, trivializing classical categories of art, supplanting beauty with symmetry, emotion with sentimentality, greatness with pathos, and tragedy with sensation. American art critic Clement Greenberg saw kitsch as being "destined for those who, insensible to the values of genuine culture, are hungry nevertheless for the diversion that only culture of some sort can provide. Kitsch, using for raw material the debased and academicized simulacra of genuine culture, welcomes and cultivates this insensibility." Following the assimilation of mass culture into Pop art in the 1960s and the emergence of → Postmodernism in the 1970s, kitsch established itself in the realm of high art, albeit it with an ironic slant, through the work of artists such as → Koons, Rhonda Zwillinger, and Pierre & Gilles. D.S.

Bibl.: Dorfles, Kitsch, 1969 · Hickey, Art Issues, 1995 · Kulka, Kitsch, 1996 · Greenberg, Kitsch, 1997

kitsch, Jeff Koons, *Yorkshire Terriers*, 1991, Polychrome wood, 44.5 x 52.1 x 43.2 cm

Klapheck, Konrad. *1935 Düsseldorf. German painter living in Düsseldorf. He studied at the Kunstakademie, Düsseldorf (1954–58), where he was later appointed professor (1979). In 1969 he visited New York. He has taken part in numerous international exhibitions, including Documenta 3 (1964). In the mid-1950s, taking → Magic Realism and → Surrealism as starting points, he began working on a "prosaic super representational presence" (→ Hyperrealism) in reaction to the vagueness of lyrical → Tachisme. His subjects are simple everyday objects, such as typewriters, sewing machines, telephones, and showers. He represents them in a straightforward yet monumental way, so that they resemble latter-day baroque emblems. Despite the apparent objectivity of his pictures, Klapheck makes small, absurd changes, which he refers to in the picture title.

Konrad Klapheck, *Typewriter*, 1955, Oil and collage on canvas 68 x 74 cm, Private Collection

During a trip to Paris (1956–57), he became acquainted with the work of M. → Duchamp and Raymond Roussel, and was associated with → Breton, who hailed him as a late exponent of Surrealism. In addition to his paintings, he has produced a number of prints. W. G.

Bibl.: Pierre, Klapheck, 1970 · Klapheck, Hamburg, 1985 · Klapheck, Paris, 1990

Jürgen Klauke, *Brainwave*, 1985, Mixed techniques on paper, 150 x 240 cm, Hermeyer Gallery, Munich

Klauke, Jürgen. *1943 Kliding near Cochem. German performance, video, and film artist living in Cologne. He studied graphic art in Cologne and taught there from 1970 to 1975. He staged performances at Documentas 6 and 8 (1977, 1987). Since 1992 he has been professor at the Kunsthochschule für Medien in Cologne. Klauke has worked in various media: drawing, photography, → Performance, and → Video. His works of the early 1970s, based on photographic sequences, were among the pioneering examples of staged photography. A leading exponent of → Body art, he used his own body to raise provocative questions about gender. His group of works *Formalization of Boredom* (1980–81), consisting of sequences of black and white photographs, tackles the themes of fear, isolation, and alienation. His "Prosecuritas" pictures of the late 1980s were made with the aid of X-ray machines. More recent series (*Sunday Neuroses*, *Consolation for Arse Holes*, since 1996) formulate existential situations, ironically reinterpreting rituals and roles in apparently absurd actions. F.K.

Bibl.: Klauke, Cologne, 1986

Klee, Paul. *1879 Münchenbuchsee near Berne, †1940 Muralto-Locarno. Swiss-German painter. He studied at the Kunstakademie, Munich, under Franz von Stuck (1900–01). He then lived in Berne for four years, before moving to Munich in 1906, where he came into contact with members of the → Blaue Reiter group. In 1912 he met R. → Delaunay in Paris. In 1913 he took part in an exhibition at the → Sturm gallery and the Erster Deutscher Herbstsalon in Berlin. In 1914 he co-founded the Neue → Secession in Munich, before traveling to Tunisia with → Macke and Louis Moilliet. Following military service (1916–18), he was invited to teach at the → Bauhaus in 1920. He took up his post in 1921 and remained for 10 years. He then taught at the Kunstakademie in Düsseldorf for two years (1931–33). He was dismissed by the Nazis and settled in Berne. His work was included in the "Degenerate Art" exhibition in 1937. In the last five years of his life he suffered from the debilitating disease slerodorma.

Paul Klee, *Rose Garden*, 1920, Oil on cardboard, 49 x 42.5 cm, Städtische Galerie im Lenbachhaus, Munich

Klee's early work consisted largely of etchings and drawings. From 1914, inspired by his trip to Tunisia, he devoted himself increasingly to painting, incorporating abstract elements influenced by Delaunay. During the years 1914 to 1920 he produced an enormously varied body of work, developing a rich repertoire of symbols and motifs both figurative and abstract. His teaching at the Bauhaus gave new impetus to his work and ideas (his *Pädagogisches Skizzenbuch* was published in 1925). He explored new techniques and themes, taking ideas from music (he was a proficient violinist), theater, literature, and philosophy. His interest in nature helped him to create a distinctive and comprehensive pictorial language of signs and forms. From 1933, his works became graver and more macabre in mood. He developed a stark, calligraphic style saturated with color, creating mysterious ciphers of human existence (*Stage Landscape*, 1937). W. G.

Bibl.: Jaffe, Klee, 1972 · Klee, Notebooks, 1973 · Geelhaar, Klee, 1982 · Klee, Munich, 1996 · Düchting, Klee, 1997 · Klee, Berne, 1998

Klein, Astrid. *1951 Cologne. German photographic artist living in Cologne and Leipzig. She studied at the Fachhochschule für Kunst und Design, Cologne (1973–77). From 1978 she began producing black and white photomontages combining motifs taken from newspapers, magazines, and television pictures with her own photographs. Some of them incorporate printed inscriptions. In 1993 she was appointed professor at the Hochschule für Graphik und Buchkunst in Leipzig.

Klein's juxtapositions of images create different layers of meaning and associations of ideas. Her early works were politically orientated and treated issues of resistance, censorship, and discrimination, while her recent pictures have explored themes of a more psychological nature. Her seven-part *Fremd* (1994) consists of mirror glass of which only narrow strips of the reflecting surface have been preserved. The viewer sees himself when he wants to view the picture as a complete entity. C.W.-B.

Bibl.: Güse, Klein, 1994

Klein, Yves. *1928 Nice, †1962 Paris. French painter and Conceptual artist. He studied in Nice (1944–46). In 1948 he made a trip to Italy. On his return to Nice, he became interested in the theories of Rosicrucianism. In 1952–53 he lived in Japan. In the mid-1950s he produced his first "monochromes" and in 1958 he carried out his first experiments with "living brushes" ("femmes-pinceaux"). In the same year, he caused a scandal with an exhibition of emptiness at the Galerie Iris Clert in Paris (*Le Vide*, 1958). In 1960 he organized the first public demonstration of his *Anthropométries*. He died of a heart attack.

Klein was one of the most influential artists in postwar Europe. His monochrome paintings, unlike similar works by later artists, were conceived not as a formal demonstration of color, but as an expression of deep spirituality. He developed his own deep hue of ultramarine blue and a special technique of applying it (*IKB 3*, 1960). He transferred this patented IKB (International Klein Blue) to various objects (sponges, stones, roots) as a way of demonstrating his interest in a purely spiritual energy, the "immaterial component of painting." In parallel with these monochromes, he organized early → performances (*Symphonie monotone*, *Le Saut dans le vide*) and → Conceptual works. His *Anthropométries*, impressions of naked, blue-dyed women on empty canvases (from 1960), were an expression of vital energy. Color was applied either positively (as a print) or negatively (as a contour) and the resulting compositions with their floating bodies were reminiscent of magic rituals and cave paintings (*ANT 96*, *Men Begin to Fly*, 1961). Klein repeatedly returned to pure color. During his last years, he used three original colors in monochrome pictures, sculptures, sponges, and sponge reliefs: blue, pink, and gold. This trio of colors was one of the central themes of his last major exhibition (Krefeld, 1961), together with a column and wall of fire. H.D.

Bibl.: Wember, Klein, 1969 · Restany, Klein, 1982 · Stich, Klein, 1994 · Klein, London, 1995 · Restany, Klein, 1997

Paul Klee, *Rapture*, 1939, Oil and watercolor on jute, 65 x 80 cm, Städtische Galerie im Lenbachhaus, Munich

Yves Klein, *RE 16, Do-Do-Do blue*, 1960, Sponges, sandstone, dry pigment and synthetic resin on wood, 200 x 165 x 18 cm, Private Collection

Klimt, Gustav. *1862 Baumgarten, †1918 Vienna. Austrian painter and graphic artist, who studied at the Kunstgewerbeschule, Vienna (1876–83). He started out as a successful decorative painter,

Gustav Klimt, *The Kiss*,
1907–08, Oil on canvas,
180 x 180 cm, Österreichische
Galerie Belvedere, Vienna

executing murals and ceiling paintings for public buildings (theater, Fiume, 1883; municipal theater, Karlsbad, 1886; Burgtheater, Vienna, 1887–88). However, influenced by → Jugendstil and the idea of the → Gesamtkunstwerk, he abandoned this type of work, developing from the late 1890s a stylized, decorative, symbolic pictorial language (*Beethoven-Fries*, pavilion at the Secession exhibition, 1902). He became a prominent figure in avant-garde circles. He was elected first president of the Vienna → Secession and produced illustrations for its journal *Ver Sacrum*. His painting displayed a growing preoccupation with ornamentation and contour at the expense of plasticity. Following a trip to Ravenna in 1903, where he saw early Christian mosaics, he changed course, and began developing his so-called "golden style." Klimt's mature work is characterized by stylized, naturalistic forms, sinuous lines, and ornamental surfaces in mosaic-like compositions. After 1905 he incorporated gold-colored areas. Many of his pictures feature female figures, but he also painted couples, portraits, and landscapes. His subjects often have an exaggerated, iconic appearance, detached from reality (*Portrait of Emilie Flöge*, 1902; *The Kiss*, 1907–08). Much of his work was erotic and his nudes, in particular his drawings of women in a state of sexual arousal, are highly sensual. Two of his central themes were Eros and the cycle of life (*The Three Ages of Women*, 1905; *Death and Life*, 1916). After 1910 his work became more restrained and less stylized, combining his characteristic flattened perspective with → Expressionist overtones. He exerted a strong influence on → Schiele and → Kokoschka. K. S.-D.

Bibl.: Nebehay, Klimt, 1990 · Neret, Klimt, 1992 · Whitford, Klimt, 1993

Franz Kline, *Siskind*, 1958, Oil on canvas, 203 x 282 cm, The Detroit Institute of Arts, Founders Society Purchase W. Hawkins Ferry Found

Kline, Franz. *1910 Wilkes-Barre, Pennsylvania, †1962 New York. American painter. He studied painting at Boston university (1931–35), continuing his study in London in 1937–38. In 1938 he returned to New York. From 1952 he taught at the Black Mountain College, North Carolina, and other places. In 1950 he had his first one-man show in New York. In 1956 and 1960 he exhibited at the Venice Biennale; and 1959 and 1964 at Documenta, Kassel. He had a retrospective at the Whitney Museum of American Art, New York, in 1968.

Kline's early works were Cubist portraits in small formats, landscapes, and murals. In the mid-1940s he became a member of The Club, where he met de → Kooning who, like → Pollock, had a major influence on him. At the end of the 1940s Kline produced his first works with bold, beam-like black shapes on an empty, white canvas (*Wotan*, 1950). Besides their calligraphic quality and the influence of de Kooning's sketches these paintings also showed the fascination Kline had for the city of New York, with its staccato rhythms and its rough, urban atmosphere. However, it was not only a free, dynamic style and a painterly application of color which were important to Kline: he also balanced light and dark effects which he tried out in many preliminary sketches. The titles of his works allude to personal preferences and memories, e.g. names of favorite places (*Delaware Gap*, 1958) and of locomotives (*Cardinal*, 1950). In the late 1950s Kline began to use more intense colors (*Zinc Yellow*, 1959) in order to test their structural characteristics. H.D.

Bibl.: Gaugh, Kline, 1979 · Gaugh, Kline, 1985 · Zevi, Kline, 1987

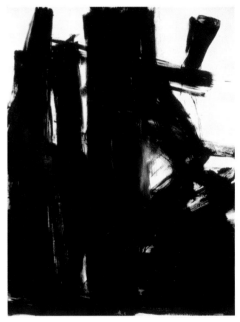

Franz Kline, *Black Iris*, 1961, Oil on canvas, 275 x 202 cm, The Museum of Contemporary Art, Los Angeles

Kliun, Ivan (Vasilyevich). *1873 Bolshiye Gorky, Vladimir province (Ukraine), †1943 Moscow. Russian painter and sculptor. After study in Kiev, Warsaw, and Moscow, Kliun (Klyun[kov]) initially painted in a Symbolist style. Intrigued by the modernist trends of the St. Petersburg "Union of Youth" (1913/14), he was creating painted relief and wire constructions in a → Cubo-Futurist aesthetic by 1913, taking part in the "Tramway V" (1915), "0.10" (1915), and → "Jack of Diamonds" (1917) shows. His fragmented pictures at this time incorporated words and rotary forms (*Ozonatov*, 1914). Aiming to "create forms from nothing," in 1917 he joined the Supremus circle, breaking with it in 1919 ("Art of Color" manifesto). His → Suprematism slowly departed from that of → Malevich, using techniques of transparency, "luminescence" à la → Rodchenko (c. 1918), and softer contours. He taught at SVOMAS

(1918–21) and joined → Inkhuk (1922). *Compositions* and *Wood Reliefs* (1920s) are essentially → Constructivist in appearance, though later geometricized still lifes show rather the influence of → Purism and → Ozenfant. D.R.

Bibl.: Nakov, Abstrait/Concret, 1981

Knave of Diamonds (Bubnovyi Valet). → Jack of Diamonds

Knoebel, Imi (Klaus Wolf Knöbel). *1940 Dessau. German painter and installation artist living in Düsseldorf. Knoebel studied under → Beuys at the Kunstakademie, Düsseldorf (1964–71). He was a friend of → Palermo and the two traveled to the US together in 1974. Inspired by → Malevich's *Black Square* (1915) and his text *The Non-Objective World* (1922), Knoebel developed a minimalist

Imi Knoebel, *Eva across Sylt – Red*, 1996, Acrylic, wood, aluminum, 237 x 304 x 16 cm, Artist's Collection

painting style which went beyond the confines of traditional easel painting. These works consist of arrangements of simple monochrome geometric shapes. He also made → assemblages out of wood and junk metal and experimented with photography, video, and light. In the mid-1970s, his forms became freer, producing assemblages with everyday objects and a range of colors. Knoebel is primarily interested in the interplay and autonomous effects of color, form, material, and space. M.S.

Bibl.: Knoebel, Maastricht, 1989 · Stüttgen, Knoebel, 1991 · Knoebel, Munich, 1996 · Schulz, Knoebel, 1998

Knowles, Alison. *1933 New York City. American artist living in New York and Barrytown. She studied at the Pratt Institute, Brooklyn (1954–59). In the early 1960s, Knowles was a member of the → Fluxus movement and took part in the first → happenings in New York, Wiesbaden, and Cologne. Strongly influenced by → Cage, her performances, which rely on viewer participation, combine voices and gestures with unconventional noises and instruments. Foodstuffs, particularly beans, also play an important role in her work. C.W.B.

Bibl.: Knowles, Cologne, 1992

Kogler, Peter. *1959 Innsbruck. Austrian artist living in Vienna. In 1985 he visited New York. After teaching at the Städelschule in Frankfurt am Main (1986), he received a scholarship to study in

Paris (1986–97). In 1989–90 he made a trip to Los Angeles. He took part in Documenta 9 (1992) and the 1995 Venice Biennale. In the early 1980s, Kogler's works drew on both → Pop art (reproduction of pictures, silkscreen prints) and → Minimal art (serializing of identical motifs). He made cardboard sculptures and works out of paper taking as motifs abstract human figures or body parts. In 1985 he began to produce computer-generated works. More recently, he has created large walls and rooms out of paper which he combines with monumental images (brain, ant, tube) arranged in decorative patterns. In 1995 he began to introduce architectonic elements into these environments. K. S.-D.

Bibl.: Kogler, Vienna, 1995

Kokoschka, Oskar. *1886 Pöchlarn near Vienna, †1980 Montreux. Austrian-born painter and graphic artist. He studied at the Kunstgewerbeschule, Vienna (1905–09), while working for the Wiener Werkstätte. In 1910 he came into contact with Herwarth Walden in Berlin and began contributing illustrations to Der → Sturm. In 1911 he returned to Vienna, where he met Alma Mahler. In 1913 he went to Italy. He served in the Austrian army (1914–16) and was badly wounded. In 1934 he moved to Prague and in 1938 to London (he took British nationality in 1947). From 1953 he lived in Villeneuve on Lake Geneva, while running a summer school in Salzburg (1953–63).

Kokoschka was catapulted into the limelight as a result of the 1908 Vienna → Secession exhibition, at which he exhibited a tapestry design, drawings, and potentially scandalous gouaches of nude girls. After dissociating himself from the Werkstätte, he turned to portrait painting, producing psychologically penetrating pictures characterized by overpainting and nervous brushwork (*Adolf Loos*, 1909). In 1911 he painted several large oil paintings with biblical themes (*Annunciation*, 1911). In these works, influenced by Cubism, he used more muted colors and a network of prism-like brushstrokes. His unhappy relationship with Alma Mahler led to obsessive themes (*Lovers with Cats*, 1917). His final artistic breakthrough was made in the 1920s, when he shifted from portraits to landscapes. In 1937, after his works were declared degenerate by the Nazis, he painted *Self-Portrait of the Degenerate Artist*. His late work in Villeneuve, which includes

Oskar Kokoschka, *Portrait of Herwarth Walden*, 1910, Oil on canvas, 100 x 69.3 cm, Staatsgalerie, Stuttgart

some particularly remarkable portraits (*President Theodor Heuss*, 1950), was marked by intense colors and an expressive style. He also produced illustrations (*The Trojan Women*, 1971) and stage sets (Salzburg Festival, Vienna Burgtheater, Florence Opera Festival). Kokoschka wrote several plays (*Mörder Hoffnung der Frauen*, 1908), as well as an autobiography. W.G.

Bibl.: Wingler, Kokoschka, 1956 · Kokoschka, Life, 1974 · Wingler/Welz, Kokoschka, 1975/81 · Schröder/Winkler, Kokoschka, 1991 · Weidinger, Kokoschka, 1998

Kolbe, Georg. *1877 Waldheim, †1947 Berlin. German sculptor. He studied painting at the Akademie der Bildenden Künste, Munich (1895–97), and at the Académie Julian in Paris (1897–98). In 1898 he visited Rome. He settled in Berlin in 1904, becoming a member of the Berlin → Secession the following year. In 1919 he joined the Prussian Akademie der Künste. Influenced by the fantastical Symbolist Max Klinger, Kolbe at first devoted himself to painting, but, inspired by → Rodin and → Maillol, he took up sculpture in 1899. He initially produced vigorous nudes (*Dancer*, 1912), but gradually developed a Cubist, Expressionist style. When the Nazis came to power, he changed direction again, adopting a more monumental, academic style featuring athletic figurative forms (*Large Pietà*; *Ring of Statues*, 1933–34, moved to Frankfurt am Main in 1954). H.O.

Bibl.: Berger, Kolbe, 1990 · Kolbe, Munich, 1997

Kollwitz, Käthe (née Schmidt). *1867 Königsberg, †1945 Moritzburg, Dresden. German graphic artist and sculptor. She studied at the Zeichenschule des Vereins Berliner Künstlerinnen (Association of Berlin Women Artists, 1885–88) and attended the drawing classes of L. Herterich in Munich (1888–89). In 1890 she married Karl Kollwitz, a doctor, and moved to a poor neighborhood in Berlin (Prenzlauer Berg). In 1904 she went to Paris and took sculpture classes at the Académie Julian. In 1907, after winning the Villa Romana Prize, she went to Florence. Kollwitz was the first woman to become a member of the Prussian Akademie der Künste (1919), but she was forced to resign in 1933 and went to live in the Klosterstrasse artists' community. In 1944 she moved Moritzburg.

Kollwitz grew up in a nondenominational, socialist home and her work is imbued with social compassion and a concern with the themes of deprivation, suffering, and death, protection and rebellion. She abandoned painting early on to concentrate on printmaking and drawing. Initially she worked on historical subjects, contradicting official historical records (*The Weavers' Revolt*, etchings, 1893–98). In 1910 she switched from etching to lithography, abandoning naturalism for a more expressive, sculptural style (*War*, 1922–24). Her best-known lithographs include the series *Death* (1934–35). About 1908 she also took up sculpture. Her anti-war works represent her finest achievement in this field, notably the group *Grieving Parents* (1924–32, Vladsloo, Belgium) and *The Tower of Mothers* (1937–38). H.O.

Bibl.: Nagel/Timm, Kollwitz, 1980 · Bohnke-Kollwitz, 1984 · Kollwitz, Berlin, 1995 · Prelinger, Kollwitz, 1996

Komar & Melamid (Komar, Vitaly and Melamid, Alexander). *1943 and 1945 Moscow. Russian painters and Conceptual artists based in New York since 1978. They studied at the Stroganov Institute of Art and Design, Moscow (1962–67), and began collaborating in 1965. In 1967 they initiated the Sots art movement. They had their first international exhibition in New York in 1976 and settled there in 1978. In 1988 they became American citizens. Their early paintings were in a → Socialist Realist style and were consciously eclectic (*Social Art Painting*). They contrast Western consumerism with "the soulful" in the form of parodies of political and erotic scenes with references to the

history of art and the commonplace (*Nostalgic Social Realism* series, 1981–84; *Diary* series on the theme of American modernism). Their œuvre also includes installations (*Biography of our Contemporary*). Their project "The Most Wanted paintings and the Least Wanted paintings" was an attempt to discover what a true "people's art" would look like, by means of a public poll (1993). M.G.

Bibl.: Ratcliff, Komar & Melamid, 1988 · Komar & Melamid, Österreich, 1998

Kooning, Willem de. *1904 Rotterdam, †1997 Long Island, New York. Dutch-born painter. He was apprenticed to a commercial art firm and took evening classes at the Academy of Art in Rotterdam (1916–24). In 1926 he traveled to the US as a stowaway. Between 1927 and 1935 he worked as a commercial artist and interior designer, then devoted himself totally to painting. He painted murals for the → Federal Art Project (1935–39) and received commissions for stage designs (1940). He lectured at → Black Mountain College (1948) and the School of Fine Arts, Yale (1950). He took part in Documentas 2, 3, and 6 (1959, 1964, 1976). In 1975 he set up the Rainbow Foundation for Sponsoring Young Artists.

Along with → Pollock, de Kooning was one of the most influential exponents of → Abstract Expressionism. In the 1940s, under the influence of → Gorky, he began painting abstract compositions similar to those of Pollock and → Kline. His series of *Women*, begun in 1950, caused a stir because of their wild vulgarity, vehement brushwork, and harsh colors. For de Kooning, the female body was less object of erotic fascination than a libidinous field on which the "adventure of painting" could be experienced (*Woman as Landscape*, 1955). His debt to the European painting tradition was evident in his abstract pictures with landscape associations (*Montauk Highway*, 1958). From 1970 he also produced small semifigurative bronze sculptures (*Large Torso*, 1974). Toward the end of his life, suffering from Alzheimer's disease, he made a surprising return to → Lyrical abstraction (*Untitled XI*, 1981). H.D.

Bibl.: Cummings, de Kooning, 1984 · Waldman, de Kooning, 1988 · Prather, de Kooning, 1994 · Storr, de Kooning, 1996

Koons, Jeff. *1955 York, Pennsylvania. American sculptor and Conceptual artist living in New York. He studied at the Maryland Institute of Art, Baltimore (1972–75), and the Art Institute of Chicago (1975–76). He was a prosperous Wall Street stockbroker before devoting himself to art. In 1991 he married the Italian porn star and politician Ilona Staller. A controversial figure, Koons is best known for his banal → kitsch artefacts (*Yorkshire Terriers*, 1991). Influenced by the Chicago Imagists, he popularized M. → Duchamp's concept of the → ready-made, using everyday objects such as vacuum cleaners (*The New*, 1980). These were often cast in bronze or stainless steel giving them a monumental feel (*Rabbit*, 1986). Ilona Staller has featured in much of his work, which can be seen as an exploration of issues surrounding high and low culture, and the commodification of art. M.G.

Bibl.: Koons, Handbook, 1992

Kosiče, Gyula. *1924 Kosiče, Eastern Czechoslovakia (Slovak Republic). Argentine geometricist sculptor, of Slovak birth. In Buenos Aires from 1928, he later studied at the Escuela Nacional de Bellas Artes Manuel Belgrano (1939–40) and was influenced by → Constructivism. In 1944 he collaborated with poet Edgar Bayley on *Arturo*, publicizing → geometric abstraction, and on *Invención 1* and *2* (Buenos Aires, 1945). He was involved in both Arte Concreto-Invención and Arte Concreto, favoring a "cold, dymanic, cerebral, dialectic" (G. K.) art against → Surrealism. He was the leading figure of "Gruppo Madí" together with Carmelo Arden Quin (1913–). His neon works, articulated mobiles (*Royi*, 1944), and – when in Paris in the later 1950s – hydraulic sculpture (*Hydrosculptures*, *Hidroceniticos*) are both modal and poetic; *Mobile Hyromural*, in plexiglass, water, and directed lighting (Buenos Aires, 1966), was more monumental in approach. He was an active polemicist and designed futuristic suspended habitats (early 1970s). D.R.

Bibl.: Squirru, Kosiče, 1990 · Art from Argentina, Oxford, 1994

Kossoff, Leon. *1926 London. British painter living in London. He studied at St Martin's School of Art (1949–53) and the Royal College of Art (1953–56), and also attended evening classes given by → Bomberg (1950–52). Like F. → Auerbach, Kossoff favors extremely heavy impasto in his paintings. His colors tend to be muted and he sometimes uses thick black outlines. His preparatory drawings are distinguished works in their own right. His main subjects are urban scenes in London (stations, swimming pools, street scenes, buildings), which are often reworked into series (*Booking Hall, Kilburn Underground Station No. 2*, 1980). Kossof has also produced portraits of close friends or members of his family (e.g., his parents, *Two Seated Figures No. 2, Spring*, 1980). A.K.

Bibl.: Kossoff, Venice, 1995 · Moorhouse, Kossoff, 1996

Willem de Kooning, *Woman*, 1953, Charcoal on paper, 91.4 x 59.7 cm, Private Collection

Willem de Kooning, *Woman in the Water*, 1967, Oil on paper mounted on canvas, 58.4 x 45.7 cm, Judy and Ken Robbins, USA

Kosuth, Joseph. *1945 Toledo, Ohio. American Conceptual artist living in New York and Ghent. He studied at the Toledo Museum School of Design (1955–62) and the Cleveland Art Institute (1963–64), and then in New York, at the School of Visual Arts (1965–67) and the New School for Social Research (1971–72). In 1975 he founded, with members of → Art & Language, the newspaper *The Fox*, and in 1969 he became editor of the journal *Art-Language*. He has taught in various places: the School of Visual Arts in New York (1967), the Hochschule der Bildenden Künste, Hamburg (1988–90), and the Kunstakademie, Stuttgart (1991).

Kosuth is one of the most important American exponents of → Conceptual art. In 1965 he began developing tautological works based on Wittgenstein's philosophy of language (*Four Square Glass Leaning*, 1965). His *Investigations* (1965–74) presented an object next to its photograph and the appropriate dictionary definition (*One and Three Chairs*, 1965). In his series *Text/Context* (texts on posters), he examined the social

Jannis Kounellis, *To be Invented there and then, Score from "La Pulcinella" by Igor Stravinsky*, 1972, Oil on canvas, 247 × 300 cm, Speck Collection, Cologne

Joseph Kosuth, *Electric Neon Light*, 1966, "English glass letters", neon lighting, Private Collection

context of art, while for the series *Ex Libris* (1989) he used literary extracts relating to particular cities (Buenos Aires, Antwerp). At Documenta 9 he put drapes over works of art, leaving only contours and signs stating the title, format, and technique visible (1992). The drapes themselves bore philosophical texts whose significance was undermined by repeated deletions. C.W.-B.

Bibl.: Kosuth, Meaning, 1981 · Kosuth, Art, 1991 · Kosuth, Play, 1992

Kounellis, Jannis. *1936 Piraeus. Greek artist who has lived in Rome since 1956. In 1969 he exhibited 12 live horses at the Galleria l'Attico in Rome. He took part in Documentas 5, 6, and 7 (1972, 1976, 1982). In 1978 Kounellis undertook work for the theater. He has taken part in numerous international exhibitions.

His early work consisted of canvases on which he painted letters, numbers, and arrows (1958–65). About 1967 he turned to → installations and → performances, which comprised poetic combinations of the natural and artificial. In the 1970s he became the leading protagonist of → Arte Povera, using organic and inorganic materials (coal, cotton wool, wool, hair, stones) and manufactured items (jute sacks, bedsteads, plaster casts). He introduced fire (gas flame) into his work as a symbol of change, energy, purification, and enlightenment, but also of destruction. In contrast to the progress-orientated works of → Futurism, → Fontana, and → Manzoni, who were searching for a visual expression of the dynamic, universal space of modern physics, Kounellis's allegories strike a pessimistic note. In his work, which sometimes has echoes of → Pittura Metafisica (presenting objects out of

context) and de → Chirico (motifs such as towers and trains), the antique assumes the role of a lost Arcadia. H.D.

Bibl.: Kounellis, Paris, 1980 · Kounellis, London, 1981 · Kounellis, Chicago, 1986 · Moure, Kounellis, 1990 · Kounellis, Frammenti, 1991

Kowalski, Piotr. *1927 L'viv, Ukraine, (formerly Poland). Polish-born French artist living in Paris. At the end of World War II he moved to France, then to Brazil and the US, studying science and architecture at MIT, Cambridge, Mass. (1947–52). Between 1952 and 1957 he worked as an architect in New York and Paris. He became a French citizen in 1971. His first sculptures, dating from the early 1960s, were made out of plastic and metal. He has since gone on to use a diverse range of materials and techniques, including electronics and holography. He has created a number of sculptures and environments incorporating → Kinetic elements and light (pyramid constructed in Bordeaux, 1973). A number of these sculptures and environments are to be found in the Paris suburbs. C. W.-B.

Bibl.: Bailly, Kowalski, 1988

Kozloff, Joyce (née Blumberg). *1942 Somerville, New Jersey. American painter, active in New York. Kozloff studied at Columbia University and the School of Visual Arts, New York (1973–74). In the late 1960s she moved from → Hard-Edge Painting to regular designs typical of Pattern & Decoration (P&D), incorporating "deliberately decorative" (J. K.) motifs from folk culture (Mexican textiles, Greek frets, basketry weave, Islamic arabesques, etc.). *An Interior Decorated* (1979) was a wall-installed piece melding unrelated media such as tapestry-patterned ceramics and serigraphy. There followed "non-ethnocentric" (J. K.) public art based on local cultures, especially in tiling; examples are at Boston (1979–85); California Airport, San Francisco (1982–83); Detroit (1985); Philadelphia (1985); and Washington DC National Airport (1997). *The Movies: Fantasies* (1991), for a metro station in Los Angeles, comprises glazed ceramic tiles of one-foot square featuring popular imagery (e.g. "Vampires"). The marble and glass *Underwater Landscape* (1989) is

highly evocative; in *Around the World on the 44th Parallel* (1995) each town on the latitude is "represented" by its own female ethnic craft. Somewhat unexpectedly, the 32 watercolors (each 22 inches square) of *Patterns of Desire* (publ. 1990) reacted to "→ Clemente or → Salle," (J. K.) with a "dialogue between pornography and ornament" and between the "'female domain'" [and] material that represents the 'male domain'" (J. K.). She is married to critic and photographer Max Kozloff, with whom she exhibits. D.R.

Krasner, Lee. *1908 New York, †1984 New York. American painter. Between 1926 and 1932, she studied in New York at the Cooper Union Art School and the National Academy of Design, and then attended the → Hofmann School (1937–40). She took part in the → Federal Art Project (1934–43). In 1940 she met Jackson Pollock, marrying him in 1945. Following early Cubist-inspired pictures, Krasner turned to abstraction under the influence of → Pollock (*Little Images*, 1943–45). Her first large-format works display a delicate calligraphic style (*Continuum*, 1949). In the 1960s she produced pictures with large areas of radiant color painted in a forceful style (*Solstice* series, 1980–81). She also made a number of collages. K.S.-D.

Bibl.: Krasner, New York, 1981 · Hobbs, Krasner, 1993

Kricke, Norbert. *1922 Düsseldorf, †1984 Düsseldorf. German sculptor. He studied at the Hochschule der Künste, Berlin (1946–47). He took part in Documentas 2 and 3 (1959, 1964) and the 1946 Venice Biennale. He taught at the Kunstakademie, Düsseldorf (1964–84). Kricke's abstract metal sculptures enter into a "dialogue" with the surrounding space, making it possible for the viewer to experience the abstract concepts of space and time. His early sculptures are dominated by a slow, fluid sense of movement, while more recent works are characterized by dynamic clusters of lines and staccato changes of direction. His "spatial sculptures" are at their most effective in public spaces. I.S.

Bibl.: Kricke, Stuttgart, 1996

Kruger, Barbara. *1945 Newark, New Jersey. American Conceptual artist living in New York and Los Angeles. She studied at Syracuse University (1964) and in New York at Parsons School of Design (under → Arbus) and the School of Visual Arts. In 1976 she started lecturing at UCLA in Berkeley. She worked initially as a graphic designer, but turned to art in the 1970s, using black-and-white photographs and → photomontages. She combines a fairly simple compositional technique with words or short meaningful sentences. She uses mostly newspaper pictures, which she crops and enlarges. Her work addresses various political and social questions, in particular the use and abuse of power, as well as feminist issues (*Buy me. I'll change your life*, 1984) and consumerism (*I shop therefore I am*, 1987). In her recourse to media techniques (direct address, poster-like visuals, signs), Kruger can be seen as a Postmodern artist. She has also written film reviews, designed book covers and posters, and

Barbara Kruger, Untitled (I shop therefore I am), 1987, Photograph silk-screen print, 304.8 x 304.8 cm, Thomas Ammann, Zürich

collaborated with architects and landscape designers. C.W.

Bibl.: King, Kruger, 1988 · Thomas, Kruger, 1988 · Linker, Miers, Kruger, 1990/1996

Krull, Germaine. *1897 Wilna, near Poznán, Poland, †1985 Wetzlar. Polish-German photographer. Having undertaken early study in photography (1916–18), Krull opened her own portrait studio in Berlin in 1920. In Paris in the 1920s, she met → Man Ray and → Kertész among others (*Self-Portrait*, 1925–with cigarette and camera). → Cocteau, Colette, André Gide, and André Malraux (a close friend) sat for her at various times. The album *Metal* uses themes from → Constructivism with a documentary interest in the industrial (cranes, bridges, engines, turbines), in repetitive schema (close to → Bourke-White), and in curious angles and framing. She traveled in Southeast Asia and Tibet in the 1930s, returning with prints of both the people and monuments, as well as to Brazil and Africa, where her approach in the 1940s was unsentimental but compassionate. She entered Europe with the US Sixth Army in 1944, taking photographs of the destruction wrought by both sides. An autobiography details her career. D.R.

Bibl.: Sichel, Krull, 1999

Kubin, Alfred. *1877 Litomerice, Bohemia, †1959 Zwickfeldt. Austrian graphic artist, painter, and writer. He trained as a photographer in Klagenfurt (1892–96). In 1898 he moved to Munich, where he studied at the Academy for a while. In 1906 he settled in Zwickfeldt, Upper Austria. In 1909 he became a member of the → Neue Künstlervereinigung (1909) and Der → Blaue Reiter (1911). His discovery of the work of Max Klinger, in particular his cycle of etchings *The Glove*, had a major impact on Kubin's nightmarish, fantastic early drawings. By 1904 Kubin had covered hundreds of sheets with obsessive images of sexual fear and coercion (torture, pain, impotence). Their publication (*Weber Portfolio*, 1903) sealed his notoriety. In 1905 he began experimenting with a paste and tempera technique. In 1908 he illustrated his own fantastical novel *The Other Side* with fluid pen and ink drawings. His other book illustrations and portfolios include *Sansara – A Cycle Without End* (1911); *On the Edge of Life* (1921);

Ali the White Stallion (1931); and *Fantasies in the Bohemian Woods* (1951). From 1922, stimulated by trips to the Bohemian woods, he increasingly depicted rural motifs. By 1937 he had achieved widespread recognition. A.H.

Bibl.: Raabe, Kubin, 1957 · Schmied, Kubin, 1967 · Kubin, Munich/Hamburg, 1990/1991 · Hoberg, Kubin, 1999

Kubota, Shigeko. *1937 Niigata. Japanese video and multimedia artist living in Düsseldorf. She attended teacher training college in Tokyo. Between 1965 and 1968 she lived in New York, where she taught at the School of Visual Arts. She

Frantisek Kupka, *Fugue in two Colors: Amphora*, 1912, Oil on canvas 211 x 200 cm, Nárdodní Gallery, Prague

Alfred Kubin, *Out of Bosnia*, c. 1919, Pen and watercolor, on handmade paper, 15.5 x 25.7 cm, Ostdeutsche Galerie Museum, Regensburg

took part in Documentas 6 and 7 (1976, 1982). In 1977 she married Nam June → Paik and the following year taught at the Kunstakademie in Düsseldorf. In 1979 she received a DAAD scholarship enabling her to stay in Berlin. She has used video in various ways: to keep a diary, for installations in combination with different materials (e. g., water in *Niagara Falls*, 1985), and to create ironic video sculptures based on the work of M. → Duchamp (*Nude Descending a Staircase [Duchampmania]*, 1975–76). The latter consists of plywood stairs which support video pictures of a nude descending them. I.S.R.

Bibl.: Felix, Kubota, 1981 · Jacob, Kubota, 1991

Kupka, František. *1871 Opocno, Eastern Bohemia, †1957 Puteaux near Paris. Czech painter. He studied at the Academies of Prague (1888–92) and Vienna (1892–93), and later in Paris, at the Académie Julian and the École des Beaux-Arts under → Laurens. He started out as a book illustrator and cartoonist (including for *L'Assiette au beurre*). He volunteered for military service during World War I (1914–18), then taught in Prague (1918–20). He was a founder member of the → Abstraction-Création group (1931–34). He took part in Documenta I (1955) and had a retrospective at the Solomon R. Guggenheim Museum in 1975. After initially being influenced by → Symbolism, in 1910 Kupka turned to abstraction, of which he was a pioneer with → Kandinsky and R. → Delaunay. The latter exerted an influence on his work, as did → Villon, → Gleizes, and → Léger. For Kupka, abstract painting was analagous to music and he sought to translate musical rhythms into colorful compositions (*Fugue in Two*

Colors. Amorpha, 1912). Unlike Delaunay, another representative of → Orphism, Kupka was interested less in rendering the energy of light through color than representing rhythms and movement in vertical sequences and circular or oval motifs (*Encounter*, 1913). His later work was in a more geometrical style (*Tangent*, 1933). H.D.

Bibl.: Vachtova, Kupka, 1968 · Kupka, New York, 1975 · Fauchereau, Kupka, 1989 · Kupka, Paris, 1989

Kusama, Yayoi. *1929 Matsumoto City, Japan. Japanese painter, sculptor, performer, and body artist, Kusama was initially strongly influenced by hallucinatory visions of stereotypic patterns, a recurrent theme in her accumulative paintings. Having moved to New York in 1957 she begun to paint monochromes which were exhibited with other artists (→ Manzoni, Yves → Klein) throughout the 1960s under the umbrella terms of New Tendency and New Style. In those years she also begun to create soft sculptures and explored new themes of sex and food, standing out as a pioneer in → Pop and → environments. Using electricity and mirrors, she moved towards → Kinetic art, exhibiting at the Venice Biennale in 1966, as well as in many international museums and galleries. → Happenings and performances using her and others' nude bodies reflects the artist's political involvement in the events of the 1960s. S.G.

Bibl.: Kusama, 1986 · Kusama, 1994 · Kusama, 1998–99

Kushner, Robert. *1949 Pasadena, California. American painter and Performance artist who studied at the University of California, San Diego from 1967 to 1971. In 1971–72 in Boston he created his first → collages and Performances (→ Action Painting) with selfmade costumes. From 1972 Kushner lived in New York, and in 1976 had his first one-man show there at the Holly Solomon Gallery. Inspired by the early modern (→ Picasso, → Léger, → Bonnard, and → Matisse) Kushner, from 1972, has designed costumes and stage sets for numerous plays and ballets; he also appears in performances in his own costumes and clothes. Besides the clothes designed to oriental patterns Kushner also draws on decorative elements from Chinese, Japanese, and European cultures for his cloth pictures, productions, and performances (→ Pattern art). K.S.-D.

Bibl.: Kardon, Kushner, 1987

La Fresnaye, Roger (Noël-François) de. *1885 Le Mans, †1925 Grasse. French painter. From 1903 studied at the Académie Julian, Paris; from 1908 at the École des Beaux-Arts and Académie Ranson (as a pupil of → Denis). Under the influence of

Cézanne (see → precursors) his early work led to → Cubism through a severe reduction of basic forms. This also led to contact with the group → Section d'Or. Some of his principal works are architecturally structured figurative scenes of intense color (*Seated Man – The Architect*, 1913; *The Conquest of the Air*, 1913), as well as scenes from military life (*The Artillery*, 1910) landscapes, still lifes, and portraits. In his later work, these classicist tendencies became more distinct; after suffering a war wound, he restricted himself to drawing and gouache, in the 1920s at times resembling de → Chirico's → Pittura Metafisica. K.S.-D.

Bibl.: Seligman, La Fresnaye, 1969

Lacey, Bruce. *1927 Catford, London. British sculptor, and robotics and Performance artist. After early training in explosives and mechanics, Lacey studied at Hornsey School of Art (1948–51) and the Royal College of Art (1951–54), abandoning painting in 1956. He subsequently worked with circus performance and cabaret (1970–), produced early collaborative → environments (*Osmosis*, 1965; *Ten Sitting Rooms*, 1970), and devised witty robotic constructions and → happenings (*British Landing on the Moon*, 1974). From the 1970s he executed ritualized performances on film (*Lacey Family Rituals*, e.g. 1973). Working partially out of Norfolk, he appeared at outside locations (e.g. the important prehistoric site of Avebury, Wiltshire) in order to focus their telluric and stellar forces. D.R.

Lachaise, Gaston. *1882 Paris, †1935 New York. French sculptor. He studied at the Paris Académie des Beaux-Arts, and worked in Paris from 1906 and in New York from 1912, where he rapidly became known not only for his portrait busts but especially for his voluptuous nudes. He worked in the tradition of → Maillol's classical concept of the figure, and voluminous, rounded forms are characteristic of his sculpture. In his large-scale bronze nudes (*Standing Woman*, 1932) in particular, which radiate muscular power and dynamic vitality, his manneristic tendency to exaggerate representations of the body is expressed. I.H.

Bibl.: Nordland, Lachaise, 1974 · Lachaise, 1979 · Kramer/Crane, Lachaise, 1987

Marie-Jo Lafontaine, *Les Larmes d'Acier,* 1987, 6-channel video and 2-channel audio installation, 27 monitors, 6 laser discs, 6 laser-disc players, wood, ZKM, Karlsruhe

Lafontaine, Marie-Jo. *1950 Antwerp. Belgian video and installation artist living in Brussels.

From 1975 to 1979 she studied in Brussels. Since 1976 she has taken part in many exhibitions, and received grants and awards, e.g. in 1986 she received the FIACRE grant from Ministère de la Culture de Paris; and in 1996 the European Photography Award. In 1992–98 she became Professor for media art at the State School of Design in Karlsruhe.

Lafontaine started in 1977 with monochrome black wall hangings woven with a linear structure. In her sculptural work in plaster, concrete, and lead she reproduces organic and geometric forms. Besides large-scale photographic work, pictorial objects form the main artistic focus in her work: monochrome painted wood reliefs, usually with a photographic motif, on which words in bronze characters are placed. In 1980 Lafontaine introduced video into her sculptures and → environments, creating video sculptures, some of which are of monumental proportions. Monitors and pedestals become elements of an extravagant architecture, taking on the character of monuments and memorials.

In Lafontaine's oeuvre, themes of Eros and Thanatos dominate – passion and reason – her works populated by vivid images of people and animals in extreme situations. Her work became widely recognized through *Les Larmes d'Acier* (Documenta 7, 1987). M.S.

Bibl.: Lafontaine, London, 1985 · Lafontaine, Edinburgh, 1989 · Lafontaine, Otegem, 1993 · Neumaier, Lafontaine, 1998

Marie-Jo Lafontaine, *Belle Jeunesse*, 1998, photograph, Photographic European Commission

Lam, Wifredo. *1902 Sagua la Grande, Cuba, †1982 Paris. Cuban painter and graphic artist who, from 1918 to 1923, studied in Havana, and in 1923 had his first exhibition at the Salón de Bellas Artes. In 1924 he received a study grant to travel to Europe; from 1938 he struck up a friendship with → Picasso, and joined the Surrealist movement (see → Surrealism); he also embarked on a study of African culture. In 1941 he left Europe, and took up residence in Havana. In 1959 and 1964 he took part in Documenta 2 and 3. Lam's Havana works combine Surrealistic fantasy visions with a composition oriented towards → Cubism. Lam's images (which unite human, animal, and plant forms) include elements of Caribbean myths and rituals. Some of the pictures, which are often based on ritualistic symbols, are of an autobiographical nature. D.W.

Bibl.: Laurin-Lam, 1996

Land art. This term came into existence in the US in the 1960s to designate art which, rather than depicting nature, instead tries to awaken ecological, cultural, or social consciousness of the environment through interventions or → performances in the natural world itself. Remote areas or deserted suburbs are typical scenes of actions that are elevated to the status of Land art by a variety of artistic concepts or operations. → Heizer, for instance, had 240,000 tonnes of rock excavated for his project *Double Negative* (Nevada, 1969–70), whereas → Long does not try to reshape nature, restricting himself to rearranging the objects he has found on walks to large-scale forms (line, circle, cross) in the landscape or in the gallery. Some of the most influential Land artists are: → De Maria (*Lightning Field*), → Smithson (*Spiral Jetty* in a salt lake in Utah), Dennis → Oppenheim, → Andre, and → Christo. The works, which are frequently ephemeral, exposed to the eroding effects of nature, are difficult to exploit commercially and are therefore documented by drawing, photo, film, and video. In the works of many American artists, impressive by their sheer size alone, Edmund Burke's 18th-century concept of the "sublime," where the individual is dwarfed and overwhelmed by the infinity of natural forms and spaces, is a useful point of reference, bridging both artistic and natural worlds. W.S.

Bibl.: Sonfist, Art in the Land, 1983 · Beardsley, Earthworks, 1989 · Kellein, Sputnik-Schock, 1989 · Malpas, Land art, 1997

Land art, Michael Heizer, *Nine Nevada Depressions: Black fill*, 1968, Excavation, 123,400 x 38,600 x 3,000 cm, Coyote Dry Lake Mojave Desert, California, now abandoned

Lange, Dorothea. *1895 Hoboken, New Jersey, †1965 Marin County, San Francisco. American photographer, who attended Clarence White School in New York. In 1919 she opened a studio of portrait photography in San Francisco. From 1932 she turned to social reporting focusing mainly on the living conditions of the unemployed and homeless migrant workers in California, and the impoverished black and white rural population in America's south and west during the depression (*Migrant Mother*, 1936). From 1935 to 1939 she participated in the project of the Resettlement Administration or the later Farm Security Administration (FSA). Lange's work is representative of a committed and lyrical documentation. After 1958 she worked on photoreportage in Asia, North Africa, and South America. U.P./S.U.

Bibl.: Heyman, Lange, 1979 · Lange, 1994

Lanyon, Peter. *1918 St Ives, Cornwall, †1964 Taunton, Somerset. British painter. After brief attendance at the → Euston Road School, Lanyon studied under Ben → Nicholson and → Gabo in his native town. His landscape painting underwent a series of radical transformations in this ambit, moving from lyrical evocation to full-blown abstraction with the adaptation of perspective as a main formal theme (*St Just*, 1953). The cliff edges and steep hills of the Cornish landscape that he rarely abandoned provided the naturalistic basis of these investigations. His later free-standing or boxed → assemblages were initially influenced by Gabo but their media became increasingly mixed (rope and driftwood). His canvases became broadly gestural through the 1950s and during occasional trips to the USA. He was successful in New York exhibitions in the 1950s and was a friend of → Rothko. Interest (from 1959) in flying was an important influence (*Glide Path*, 1964, relief painting). He perished in a gliding accident. D.R.

Bibl.: Lanyon, London, 1968 · Causey, Lanyon, 1971

Larionov, Mikhail. *1881 Tiraspol near Odessa, Ukraine, †1964 Fontenay-aux-Roses near Paris. Franco-Russian painter and graphic artist. He studied at the Academy of Painting, Sculpture, and Architecture in Moscow from 1898, where he met → Goncharova in 1900. In 1906 and 1914 he visited Paris, where he resided from 1917. He organized the exhibition → Jack of Diamonds in Moscow in 1910, and → Donkey's Tail in 1912. In 1912/13 he worked on illustrations for Futurist poems (e.g. Khlebnikov) and in 1913 on the manifesto of → Rayonism. From 1915 until the early 1940s his work mainly encompassed set designs (e.g. for the Ballets Russes). Initially under the influence of Impressionism, after 1906 he developed pictorial language of → Neo-Primitivism, particularly under the influence of → Fauvism and of Russian folklore (the world of soldiers and prostitutes; 1912 Venus Series) in which color and the application of paint become a subject matter in themselves. After 1915, Larionov executed less autonomous work, confining himself to still lifes and nudes in subdued colors, and after 1930 Rayonist watercolors. N.v.A.

Bibl.: Parton, Larionov, 1993 · Kovtun, Larionow, 1997

Lartigue, Jacques-Henri[-Charles-Auguste]. *1894 Courbevoie, †1986 Nice. French photographer Lartigue began his artistic career as a painter, producing his first photos from 1902. In 1914–15 he attended the Académie Julian in Paris. In 1963 his early work was rediscovered through an exhibition at MOMA in New York. In 1979 his entire photographic archive was presented to the French state. In 1984 he received the Culture Prize of the German Photographic Society.

His best-known photos were taken before 1918 and show studies in movement, typically horse races, cars, airplanes, sporting events, or beautiful women walking in the Bois de Boulogne in Paris (1911). He also took portraits of actresses and artists, who he captured with the attentive yet casual glance of the *flâneur*, combined with the direct spontaneity of the amateur. He continued to experiment with autochromes, the first practicable color process, as evidenced by impressionistic still lifes and landscapes.

Dorothea Lange, *Migrant Mother, Nipomo, California*, 1936, Gelatine silver print, 32.8 x 26.1 cm, Museum Ludwig, Cologne

Lartigue's cosmopolitan vitality, alongside his split-second evocation of contemporary events, predates the aesthetic of the New Vision, as well as photojournalism in the style of → Cartier-Bresson's "decisive moment." Until 1978 he was also a successful painter of flowers and sport subjects as well as of high-society portraits. U.P./S.U.

Bibl.: Lartigue, 1980 · Blume, Lartigue, 1997

Maria Lassnig, *Introvertierte Figuration*, 1958, Kreide, 60 x 44 cm, Sammlung Prelinger

Lassnig, Maria. *1919 Kappel, Carinthia. Austrian painter living in Vienna and Carinthia. In 1939–41 she trained as a primary school teacher; in 1941–43 she studied at the Kunstakademie in Vienna, making contact with → Rainer and the Wiener Gruppe. Thereafter she spent much time in Paris, New York, and Berlin. From 1980 she was Professor of Painting at the Hochschule für Angewandte Kunst in Vienna and took masterclasses in animated film. In 1980 she exhibited at the Venice Biennale, with → Export, and in 1982 at Documenta 7. In 1985 she had a retrospective at the Museum für Moderne Kunst in Vienna.

One of the influences on Lassnig's work up to 1950 was → Surrealism. From the 1960s, however, the pictorial representation of physical sensations becomes her central subject. She created pictures consisting of bizarre constructive elements linked with naturalistic components, expressing "introspective experience", which she describes as "body awareness." Physical sensations such as pain and pleasure are rendered in large, almost abstract portraits (*Quadratisches Körpergefühl*, 1960) or in small, delicate drawings. She also makes use of animated film. In the early 1980s, she created violently expressive pictures (*Blutstränen*, 1981), followed by more obvious realistic work with an almost humorous, ironic theme (*Heroischer Mistkübel*, 1992). P.L.

Bibl.: Lassnig, Vienna, 1985 · Weskott, Lassnig, 1995

Latham, John. *1921 Zambesi River, Northern Rhodesia (Zimbabwe). British experimental sculptor. During his studies at the Chelsea School of Art (1946–50), Latham exhibited with John Berger (1948). An initial interest in physics and psychology made him particularly sensitive to concerns of artistic perception, one of the outcomes being a theory of "micro-" or "least" events. He initially employed (often damaged) books (such as the *Encyclopedia Britannica*) in built reliefs which he called "skoobs" ("soft" versions appeared in 1960).

From 1964, these → assemblages were involved in Skoob Tower Celebration → happenings that often culminated in auto-da-fés (though he insisted that this was not as "a gesture of contempt for [...] literature"). A newsworthy event was the group mastication and subsequent distillation into sugar paste of a copy of Clement Greenberg's *Art and Culture* taken from the St Martin's School library. Latham was removed from his post on its return *in vitro*. His interests have since branched out into the social practice of art. D.R.

Bibl.: Latham, London, 1976

Laurencin, Marie. *1883 Paris, †1956 Paris. French painter, trained at the École des Beaux-Arts, Paris. She participated in the → Salon des Indépendants in 1905. In 1907, through her acquaintance with Apollinaire, she was accepted for membership of the → Bateau-Lavoir circle. She published her first poems under the pseudonym Louise Lalanne. In 1912 she exhibited with the → Section d'Or. In 1913 she participated in the → Armory Show. In Paris in 1924 she produced designs for décor and costumes for the Ballets Russes (for Nijinsky in particular) and set designs for *Les Biches* by Poulenc as well as for *À quoi rêvent les jeunes filles* at the Comédie Française in 1928. Although her early work was heavily influenced by → Picasso's pre-Cubist period, Laurencin developed an individual style independent of Cubism using subdued, delicate colors and two-dimensional, arabesque-like compositions. Portraits of her artist friends became one of her main subjects (*Apollinaire et ses amis*, 1909). She produced numerous illustrations for books. K.S.-D.

Bibl.: Pierre, Laurencin, 1988 · Groult, Laurencin, 1992 · Laurencin, Martigny, 1993

Marie Laurencin, *L'Italienne*, 1925, Private Collection, London

Laurens, Henri. *1885 Paris, †1954 Paris. French sculptor trained at the Paris school of crafts and in a scene painter's studio; as a sculptor he was self-taught. In 1911 he met → Braque and → Picasso, his first encounter with → Cubism. In 1915–19 he produced collages. In 1916 he had his first solo exhibition in Paris (Galerie de l'Effort). In 1917 he worked on papiers collés and book illustrations. In 1919 he made his first sculptures in the round focusing on basic stereometric forms. From 1925 he worked on designs for the Ballets Russes, and

in 1936–37 for the Paris Exposition Universelle, including → Le Corbusier's pavilion. In 1948 he participated in the Venice → Biennale. Alongside → Lipchitz, with whom he frequently worked, Laurens is one of the most important sculptors to create a sculptural version of Cubism.

Between 1915 and 1918 he executed constructions of stereometric forms in various materials (*The Clown*, 1915). Reliefs in stone and terracotta, as well as → collages were made according to the same principles and of the same subjects (heads, still lifes, figures), with overlapping, sharp-edged planes in several colors. From 1919 Laurens also produced sculpture in the round in stone and terracotta. From the middle of the 1920s, he broke away from the Cubist style, creating sculptures of figures using organic forms and distorted, biomorphic shapes (*The Mother*, 1935). In the 1930s and 1940s, Laurens created mythological figures with voluptuous female forms (*Siren*, 1944) influenced by → Maillol. He also produced book illustrations (e.g. for Theocritus' *Idylls* after 1945). K.S.-D.

Bibl.: Hofmann, Laurens, 1970 · Laurens, Paris, 1985 · Laurens, Lille, 1992

Lavier, Bertrand. *1949 Châtillon-sur-Seine. French painter and Conceptual artist, living in Aignay-le-Duc, Côte d'Or. Between 1968 and 1971 he studied horticulture at the École Nationale Supérieure d'horticulture, Versailles. In 1973 he had his first solo exhibition. In 1982 and 1987 he exhibited at → Documenta 7 and 8. Inspired by M. → Duchamp and → Nouveau Réalisme, Lavier has produced variations of the → ready-made since the 1980s, covering everyday objects with thick coats of acrylic paint, imitating the coloration of the object. Since 1984 he has concentrated on the sculptural aspect of objects by placing one object on top of another (e.g a fridge on an armchair). In his → object art, Lavier blurs the boundaries between sculpture and painting. K.S.-D.

Bibl.: Lavier, Paris, 1991

Law, Bob. *1934 Brentford, England. British painter and sculptor, living in Twickenham, Middlesex. His training as a technical draftsman took place in 1949, and thereafter he did military service from 1952 to 1954. From 1957 he worked as a freelance artist. Between 1964 and 1971 he attended Exeter School of Art, Devon. After watercolors and ceramics, Law's first metaphysical paintings and drawings with flat areas of color were produced in 1959, which in the manner of Western "mandalas", reflected his personal state of mind. In 1960 and 1969 he began his series of → Minimalist black-and-white pictures; these are built up of finely nuanced layers of acrylic paint. In *Number Roll* (1970) the active participation Law increasingly requires of the observer comes to the fore. After 1978–79, Law also became involved with sculpture (*Weighed Blue Series*, 1982). M.G.

Bibl.: Law, London, 1978 · Lucie-Smith, Seventies, 1985 · Compton, British Art, 1987

Lawler, Louise. *1947 Bronxville, New York. American photographer and central figure in → appropriation art, living in New York. She took her

B.F.A. Cornell in 1967. Lawler is one of the photo artists who examine art in the context of its commercial world. For her "settings" she photographs her artist colleagues (e.g. → Lichtenstein or → Johns) using museums as their surroundings. She thus documents and reveals the social status of art and at the same time challenges this system by presenting her pictures in exhibitions and in museums.

With these "pictorial appropriations" Lawler addresses several aspects of the contemporary art world at once: first, she refers to the market-value of works by taking photos at auctions or on the premises of famous collections, and secondly she shows the social value that is accorded to art. She thus ironically questions assumptions about modern art. Beside her photographic work, Lawler also produces → installation art and sculptures. C.W.

Bibl.: Crimp, Museum, 1993 · Elger, Lawler, 1994 · Schaffner/Winzen, Deep Storage, 1997

Le Brun, Christopher. *1951 Portsmouth. British painter and printmaker. Le Brun attended the Slade (1970–74) and Chelsea (1974–75) Schools of Art. After a brief flirtation with allusive landscape, he has become known for his large-scale, sometimes impasto, dreamily "Romantic" canvases initially redolent of late 19th-century → Symbolism. His central themes include the self-referential, effulgent figure of Pegasus, who activated the Hippocrene sources of inspiration, and Parnassus, realm of the Muses and artistic excellence. In the late 1980s, Le Brun produced a series of abstracted landscapes, and in 1994 showed at Marlborough (London) a series of large-scale works commissioned on Wagner opera. His latest exhibited work includes multi-state prints (1995–96) and small-scale sculpture (1998). D.R.

Bibl.: Le Brun, Edinburgh, 1985

Le Corbusier (Charles-Édouard Jeanneret). *1887 La Chaux-de-Fonds, Switzerland, †1965 Roquebrune-Cap Martin, Alpes-Maritimes. Major 20th-century architect, born in Switzerland. Le Corbusier attended art school in La Chaux-de-Fonds, then worked in architects' offices (1908 in Paris; 1910 in Berlin with Peter Behrens [1869–1940]). From 1917 he was in Paris, increasingly active as a painter. In 1918 he met → Ozenfant, and they jointly formulated the concept of → Purism (book title: *Après le cubisme*). He executed Purist paintings up to 1928, especially still lifes, and subsequently used the figure (the female nude). His

Henri Laurens, *The Clown*, 1915, Painted wood, 51.5 x 29.5 x 22.5 cm, Wilhelm Lehmbruck Museum, Duisburg

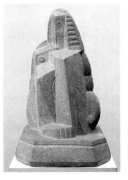

Henri Laurens, *Crouching Woman*, 1922 , Limestone, 53 x 33 x 19.5 cm, Neue Nationalgalerie, Berlin

Louise Lawler, *It could be Elvis*, 1994, Color photograph, C-print, 70.8 x 85 cm, DG-Bank Collection, Frankfurt

Le Corbusier, *Nature morte à la cruche blanche sur fond bleu*, 1919, Oil on canvas, 65.5 x 81 cm, Kunstmuseum, Basel

painting became increasingly abstract, influenced by → Léger, → Braque, and → Picasso. From the mid-1930s, he worked on designs for tapestries and murals. His first sculptures appeared in the 1940s, as he strove for a synthesis of expressive form, analagous to his architecture. After the end of the 1920s, he worked worldwide as an architect. Three main points emerge in his architectural work: mass production of residential buildings, urban development with centers consisting of similar tower blocks, and the development of a new type of housing project. Characteristic features are exposed pilotis (piers), walls and framework independent of each other, the freely designed ground plan and façade, and finally, the roof garden. In the 1940s, he gave up his typically planar, rational style using glass and metal and developed a more organic vocabulary. His most famous work in this style is the pilgrimage chapel in Notre-Dame-du-Haut in Ronchamp (1950–54). I.H.

Bibl.: Boesiger, Corbusier 1929–57 · Girsberger, Corbusier 1960 · Besset, Corbusier, 1968 · Hohl, Le Corbusier, 1971 · Brooks, Corbusier, 1987

Le Fauconnier, Henri Victor Gabriel. *1881 Hesdin, Pas-de-Calais, †1946 Paris. French painter who attended the Académie Julian, Paris from 1901. In 1912 he became a member of the → Section d'Or. Under → Derain's influence, Le Fauconnier painted portraits and landscapes in Brittany using simple, clear forms. He joined the Cubist circle (→ Cubism) in the Section d'Or, and also exhibited in important exhibitions in Moscow between 1908 and 1914 (→ Blue Rose). Work such as *Abundance* (1910) which fracture space to the point of abstraction attracted a great deal of attention, not only in Paris, especially among the Futurists, (→ Futurism), but also in Munich (→ Blaue Reiter). During World War I in the Netherlands, he developed an expressive and figurative style which contributed to the development of Dutch and Flemish → Expressionism. From 1925 in Paris, he went over to a style of painting more in tune with Realism. H.D.

Bibl.: Le Fauconnier, Amsterdam, 1959

Le Parc, Julio. *1928 Mendoza. Argentinian kinetic sculptor. After studying under → Fontana at the Escuela Superior de Bellas Artes, Buenos Aires (1943–46), Le Parc became interested in → Constructivism. He settled in Paris in 1958 and was involved in the foundation of the → Vasarely-inspired Groupe de Recherche d'Art Visuel (GRAV; 1960 to 1969), with Hugo Demarco (1932–) and Horacio García Rossi (1929–), and associated with Yvaral (Jean-Pierre Vasarely [1934–]) and → Morellet. The context of Le Parc's art is scientific and "programmed," incorporating the perceptual, somatic response of the spectator, though effects of the sublime are not alien to his pieces. He typically employs perspex columns, prisms of plexiglas, or metallic elements (*Light-Continuum*, 1962) in suspension mobiles that reflect or scatter the skimming light from a laterally placed, sometimes muted source (*Continual Mobile, Continual Light*, 1963). He encountered major success at the 1966 Kunst – Licht – Kunst exhibition (Van Abbemuseum, Eindhoven). In 1969 he returned to pictorial work, obtaining iterative patterning effects. D.R.

Bibl.: Clay et al., Le Parc, 1977

Lechner, Alf. *1925 Munich. German metal sculptor who lives in Geretsried near Munich. His artistic work began with a period (1940–43) of landscape painting. From 1948 to 1960 he trained as a metalworker and worked as an industrial designer. From 1957 he began to produce sculpture in steel, including some public commissions. The point of departure for the sculptures is the steel itself, tested to the limit while remaining true to the material: under enormous pressure, the steel is crushed, bent, and compressed, and through the use of special alloys induced to fracture. The central subject of his work series is the analysis and synthesis of elementary forms where form and material are mutually determinant. I.S.

Bibl.: Lechner, Stuttgart, 1998

Leck, Bart van der. *1876 Utrecht, †1958 Blaricum. Dutch painter. From 1891 to 1899 he was employed as a glass painter. He studied applied art in Amsterdam from 1900 to 1904. He worked in The Hague, Laren, and from 1919 in a house in Blaricum that he designed himself. In 1917 he was a founder member of De → Stijl (until 1918). He produced illustrated books, designed interiors and furniture and, from 1914, stained glass windows for Kröller-Müller; the museum of the same name at Otterlo houses the largest collection of his work. From 1916 he had close links with → Mondrian, and he made increasingly abstract compositions using primary colors. After 1918 he returned to figurative painting through geometrically composed forms, to textile design (1928) and to furniture. From 1935 he also produced ceramics. M.G.

Bibl.: Leck, Otterlo, 1994 · Leck, Wolfsburg, 1994

Lee, U Fan. *1936 South Kyongsang, South Korea. South Korean sculptor, painter, and essayist. Lee lives in Kamakura, Japan, and Paris. He studied fine art at the State University in Seoul. In 1956 he continued his studies in philosophy and Nihonga (Japanese modern-style painting) at Nihon University, Tokyo. In 1973 he was made Professor at Tama Academy of Art, Tokyo. With installations made from prefabricated materials and

stone for galleries, museums, and open spaces, Lee takes up a decidedly East-Asian position and thus differs greatly from other artists working in this field, such as → Serra, → Long, etc. As the co-founder of the avant-garde movement Mono-ha ("thing school"), he has had a great influence on contemporary Japanese art. Since 1968, he has been concerned with assembling heterogeneous materials such as glass, iron slabs, rubber, and cotton in combination with stone. He sees this as a representation of the relational state. His main works are floor-standing installations frequently consisting of iron slabs of various shapes, either laid out flat or formed into boxes and set up in series, or else as monumental "wall screens." He juxtaposes these slabs with loosely distributed rocks or cubes of stone. Lee sees his work as a connection ("relatum"), as a concrete encounter with another world existing "outside", extending far beyond the bounds of humanity into infinity. Lee sees the encounter with this "otherness" as the place of his own existence. In his painting, he continues this dialogue with the external, the other. His materials are usually similar to those in his sculpture: stone pigments mixed with oil applied with a broad brush. Whether he is painting a series of severe vertical lines or making short brush strokes that appear to hover, inter-weaving them or finally reducing them to "dots" made by rectangular brush strokes, the relation-ship between the form and the unoccupied support is the real subject. Space is highly active and is itself form, pointing into infinity as it tran-scends boundaries. I.S.-R.

Bibl.: Lee, Milan, 1994 · Lee, Leverkusen, 1995 · Lee, Frankfurt, 1998

Fernand Léger, *The Big Parade on a Red Background*, 1953, Oil on canvas, 114 x 155 cm, Musée National Léger, Biot

Léger, Fernand. *1881 Argentan, Normandy, †1955 Gif-sur-Yvette. French painter, graphic artist, and ceramist. From 1897 to 1899 he trained in architecture in Caen; until 1920 he worked as an architectural draftsman in Paris, where he studied at the École des arts décoratifs from 1903. From 1907 he associated with the Parisian avant-garde, and in 1911–12 was a mem-ber of → Section d'Or. In 1920 he founded the gallery L'ésprit nouveau. From 1940 to 1945 he took up residence in the US and lectured at Yale University and Mills College, California. From 1909, under the influence of Cézanne and → Cubism, Léger developed a characteristic style consisting of simple basic forms and subdued color (*Nudes in a Forest*, 1909–10). Impressed by R. → Delaunay, Léger began to introduce pure color

in intense contrasts (*Woman in Blue*, 1912). The most important principle was to make directly visible the intensity of formal and color con-trasts, the rhythm and dynamism of the modern world which Léger admired in technology and the machine.

In the "mechanistic" phase between 1917 and 1923 Léger linked geometrical forms, mechanical elements (propellers, cylinders, discs) with flag-like color (*The City*, 1919–20). The figure returned to a "mechanized classicism", retreating into hieratic severity and massive volume with con-crete anonymity of form (*Woman with Flowers in her Hand*, 1922). Under the influence of → Surre-alism, loose compositions were created in the 1930s and 1940s, heterogeneous objects being juxtaposed in complex compositions (*Mona Lisa with Keys*, 1930). The *Composition with Three Figures* of 1932 inaugurates a new interest in the human figure, which appears monumentalized and stat-ic in contrast to the objects and flat areas of color (*Big Julie*, 1945). "Pure color" returned in his late work in compositions consisting of many figures placed over flat areas of color that appear to float freely (*The Great Parade*, 1954). Léger also designed theater sets, and made films (*Le ballet mécanique*, 1924), murals, mosaics, stained-glass windows, tapestries, ceramics, and sculptures. H.D.

Bibl.: Green, Léger, 1976 · De Francia, Léger, 1983 · Bauquier/Mail-lard, Léger, 1990–95 · Schmalenbach, Léger, 1991 · Kosinski, Léger, 1994 · Lachner, Léger, 1998

Legros, Jean. *1917 Paris, †1981 Paris. French painter and sculptor. He studied philosophy and psychology at the University of Paris. He was self-taught as a painter. In the 1950s he produced Expressionist work. From 1956 to 1969 he designed stained-glass windows and worked on theoretical writings ("Peinture de bruit, peinture de silence," 1966). From 1970, he acquired a new interest in color after a number of bronzes in the tradition of → Arp. His *Toiles à bandes* (1973) shows intensely colored stripes; *Les Grues de Beaubourg* (1975–80) has bands of color inspired by the architecture of the Centre Pompidou in Paris, which maintain a playful balance. The last phase in his work was inspired by contemporary music (Berio, Stockhausen, Xenakis), which he translat-ed into circular pictures with dynamic eddies of color (*Ronds musicaux*, 1978–80). K.S.-D.

Bibl.: Legros, Mulhouse, 1988

Lehmbruck, Wilhelm. *1881 Duisburg, †1919 Berlin. German sculptor, graphic artist, drafts-man, and painter. From 1895 to 1901 he attended the Kunstgewerbeschule, and from 1901 to 1906 the Kunstakademie in Düsseldorf. In 1907 and 1910–14 he was in Paris, where he met → Archipenko, → Derain, and probably also → Brancusi. He was subsequently in Berlin (member of the Freie Sezession). In 1919 he joined the Prussian Akademie der Künste. Work-ing initially in the academic tradition, Lehm-bruck soon turned towards the work of → Rodin and Constantin Meunier (addressing social sub-jects from 1903; producing a design for *Monument "To Work"*, c. 1908–10). A new style of sculptural concentration appears after 1907. Meeting → Maillol and, almost at the same time, acquain-

Wilhelm Lehmbruck, *Head of a Thinker with Hand*, 1918, Artificial stone, 62 x 59 x 32 cm, Neue Nationalgalerie, Berlin

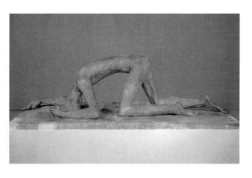

Wilhelm Lehmbruck, *The Vanquished*, 1915–16, Cast plaster, stained yellow, 78 x 240 x 82.5 cm, Wilhelm Lehmbruck Museum, Duisburg

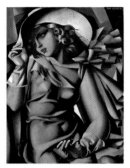

Tamara de Lempicka, *Young Girl in Green*, 1927, Oil on canvas, 53 x 39 cm, Musée National d'Art Moderne, Centre Georges Pompidou, Paris

tance with the work of Hans v. Marées led to a more relaxed statuary style (allegorical friezes of figures drawn or painted, 1909–10; *Large Standing Female Figure*, 1910), which was the starting point for systematic work in various materials, especially artificial stone, concentrating on the torso form. (*Woman Bathing*, 1913; *Striding Female Figure*). But the *Large Kneeling Woman* of 1911 breaks radically with this style, influenced by the art of antiquity, and is the beginning of a contribution to → Expressionist sculpture.

Subsequently, Lehmbruck's figures became severe, stylized, and elongated to the point of a deformed emaciation. The figure is located in space to be viewed from all sides (*Large Pensive Woman*, *Rising Youth*, both 1913–14); this tendency continued in 1918 as a self-portrait in *Head of a Thinker*. Lehmbruck reacted to the war and pacifist ideas in *The Vanquished* of 1915–16, and his seated figure of a man mourning (also known as *Seated Youth [Friend]*) of 1916–17. Beside his sculpture, drawings, engravings, and sketches (in pastel and oil) form a separate corpus of work, dealing in part with other subjects, religious and literary. H.O.

Bibl.: Lehmbruck, Edinburgh, 1977 · Händler, Lehmbruck, 1985 · Schubert, Lehmbruck, 1990 · Lahusen, Lehmbruck, 1997

Leibovitz, Annie. *1949 Warterbury, Connecticut. American photographer, living in New York. After studying painting (at San Francisco Art Institute), from 1970 she worked as a photographer for the pop music magazine *Rolling Stone*. In 1989, she received the Infinity Award for applied photography from the International Center of Photography, New York. She accompanied popular rock bands such as the Rolling Stones and Alice Cooper on tour, capturing the musicians in off-stage moments. The photojournalistic style of her pictures changed in the 1980s, after portraying celebrities from the American and European film world, as well as show business personalities. The use of lavish *mise en scènes* became increasingly important, as seen in portraits of musicians, actors, and artists such as David Byrne, Jeff Koons, and Clint Eastwood. Annie Leibovitz became famous for her photograph of Yoko Ono and John Lennon, taken shortly before the latter was murdered on December 8, 1980. U.P./S.U.

Bibl.: Leibovitz, 1999

Lempicka, Tamara de. *1898 Warsaw, †1980 Cuernavaca, Mexico. Polish-born painter. From 1918 she lived and worked in Paris, as a pupil at the Académie de la Grande Chaumière (under → Lhote and → Denis). From 1943 she was in New York. In 1973, a retrospective was held in Paris (Galerie du Luxembourg). Lempicka's pictures from the 1920s, experimentally open with regard to subject, format, and style, include in particular portraits of women, in which the de-individualized subject is interpreted as a series of Cubist facettes. Towards the end of the 1920s, her style became smoother and developed a cool, metallic sheen similar to → Verism and → Hyperrealism. In these compositions, occasionally inspired by works of art from earlier times, Lempicka shows androgynous figures presenting themselves in exhibitionist poses, thus creating a new image of woman. After the 1930s, elements from the fields of photography, film, and advertising had an influence on her dense, smooth, and sometimes striking painting style. After 1935, she turned increasingly to subjects such as poverty, age, refugees, and religion, where metallic hardness gives way to a melodramatic, sentimental naturalistic style. D.W.

Bibl.: Marmori, Lempicka, 1978

Lentulov, Aristarkh (Vasilievich). *1882 Nizhny Lomov, Penza, †1943 Moscow. Russian painter. After study in Kiev (1903–05), and at the St. Petersburg Academy (1906), he encountered → Larionov, Ilya Mashkov (1884–1944), and Robert Falk (1888–1958), participating in major exhibitions including "The Link" (1908), Souiz Molodezhi ("Union of Russian Artists," 1910), and → "World of Art" (1911). He was a founder member of → Jack of Diamonds, and his *Apostles* was a summit of Russian → Expressionism. In Paris (1911) at the Académie de la Palette he worked with → Le Fauconnier and encountered → Futurism (1912). A master of color, his dynamic *Moscow* and *Samovar* (both 1913) combine such influences with → Futurism, while *Battle of Victory* (1914) or *Country Church* (1918) fuse → Delaunay's chromatic schemes (close too to → Macke) with Russian "provincial" imagery. He worked at the Modern Lubok press.

In a period of → Cubo-Futurism (1911–15), Lentulov evolved (1912–14) to near abstraction (*Allegorical Depiction of the Patriotic War of 1812*), reverting to Expressionism and Synthetic Cubist constructs (*Girl Against a Fence*, 1918). After the Revolution Lentulov became a professor at SVO-MAS (Free Art Studios) (1918–) and joined → Inkhuk (1920) and → AKhRR (1926). D.R.

Bibl.: Lentulov, Cologne, 1984 · Murina, Lentulov, 1988

Leslie, Alfred. *1927 New York City. American painter working out of New York and Massachusetts. He studied at New York University (1956–57), meeting → Baziotes and Tony → Smith. Exhibiting at the Tibor Nagy Gallery, he began as an → Abstract Expressionist specializing in → Action Painting close to (early) de → Kooning. In the 1960s he transmuted into a quasi-Superrealist, more interested in the human form – or its interrelations with the material world – than consumer durables. Like those of → Pearlstein or Jack Beal (1931–), his figure pieces (*The Cocktail Party*, 1967–68) address alienation but eschew the caricature of e.g. → Katz. His studio was destroyed by fire in 1966, the year his friend the art critic Frank O'Hara was killed in

a car accident. *The Killing Cycle* (late 1960s–1970s) is a complex multi-part commentary on the latter event. Latter works have included evocative landscapes (*Morning Light*, 1980/89). D.R.

Lettrism, Lettrisme. Avant-garde artistic group based in Paris after World War II, linked to → Surrealism and later leading to → Situationism. The central figure was the Romanian Isidore Isou (1925–), who from 1946 propagated the idea that language, words, and figuration were dead and that they had to be replaced by letters. In a manifesto, Isou introduced 19 new characters and propounded ten laws on the treatment of the letter in creative writing. At a later point, he planned to unify all characters and disciplines through "hypergraphy." The Lettrists, joined by artists such as Maurice Lemaître (1926–), J. Spacagna and René Sabatier, founded the Centre de la Recherche Lettriste and the publishing house Lettrisme et Hypergraphie in 1963. Within the Lettrist movement that had started out with a post-Dadaist position, a left-wing opposition grouping developed that turned to cultural sabotage and split away in 1952 to form the Lettrist International. The chief activities – "roaming the streets" and "psychogeography" – were intended as practical models for what became a Situationist critique of town planning and everyday life, while Isou and his companions continued to concern themselves with art and aesthetics. D.S.

Bibl.: Broutin, Lettrism, 1972 · Foster, Lettrismus, 1983–4

Levine, Sherrie. *1947 Hazleton, Pennsylvania. American Conceptual artist, who has lived in New York since 1975. She took her B.A. in 1969, and her M.F.A. at the University of Wisconsin, Madison in 1973. In 1981 she caused a sensation with reproductions of famous photographs (*After Walker Evans*). Watercolors after reproductions of paintings (*After Kandinsky*, 1983) intensify the principle of → appropriation. A further variation consists of transforming icons of modernism into three-dimensional → installations (*La Fortune, after Man Ray*, 1991). With these artistic genres, Levine questions the originality of works of art, but also their inner structure and references. M.G.

Bibl.: Temkin, Levine, 1993

Levitt, Helen. *1913 Brooklyn. American photographer and film maker, living in New York. She attended Photo League in the 1930s. In 1935 she

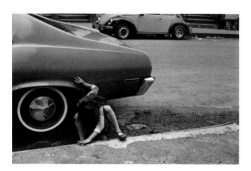
Helen Levitt, *New York*, 1940, Gelatin silver print, 27.9 x 35.6 cm, Laurence Miller Gallery, New York

met → Cartier-Bresson in New York. In 1936 Levitt began to take photographs on the street; one year later, children playing became her favorite subject. Unsentimentally, she registered childhood scenes on pavements and deserted lots. The spontaneity and freshness of these impressions is due to her ability to avoid intervening in what is going on; she frequently uses a mirror lens to shoot from an angle. In 1941 she worked as editing assistant to Luis Buñuel. In 1943 her first solo exhibition took place at MOMA. In 1944 Levitt, in collaboration with the author, James Agee, made the short film *In the Street*, showing children's activities in the streets. In 1946–47, she produced (with Agee and Janice Loeb) the film *The Quiet One* about a black child. After more than a decade working in films, she returned to photography in 1959, especially color. In 1959 to 1960 she took up a Guggenheim Fellowship. In the mid-1970s she could be found teaching at the Pratt Institute in Brooklyn. Her return to black-and-white photography took place in the 1980s. P.S.

Bibl.: Weiermair, Levitt, 1998

Lewis, [Percy] Wyndham. *1882 off Nova Scotia, †1957 London. British painter and author, born on his father's yacht off the Canadian coast. He attended the Slade School of Art, London, from 1898 to 1901. From 1902 to 1908 he travelled in Europe, living in Munich, Madrid, and Paris. He returned to London in 1909, where he painted and wrote short stories. In 1911 he co-founded the → Camden Town Group, and worked in the cabaret club The Cave of the Golden Calf. From 1910 his work increasingly synthesized the energy of → Expressionism, the plasticity of → Cubism and the mechanistic, speed-worship of → Futurism in an effort to create a new British art distinct from Edwardian values. Typical of this are his abstract, robot-like figures in urban settings (*The Crowd*, 1914–15) or machine-like concatenations of interlocking forms representing contained power (*Timon of Athens*, 1913). Cooperation in Roger Fry's Omega Workshops ended in a public dispute and led to the founding of the Rebel Art Centre in 1914, from which the Vorticists (→ Vorticism) were recruited. In 1914, together with the poet Ezra Pound and → Gaudier-Brzeska, Lewis published the first edition of the short-lived periodical *Blast* with the manifesto of the Vorticist group. After his return from World War I (*A Battery Shelled*, 1918), Lewis worked as an author of short stories, novels (*Tarr*, 1918), and articles for magazines and daily newspapers. Among his most important postwar pictures are portraits (e. g. *Edith Sitwell*, 1925–35), as well as work which harks back to the Vorticist period. A.K.

Bibl.: Lewis, Manchester, 1980 · Normand, Lewis, 1992

LeWitt, Sol. *1928 Hartford, Connecticut. American painter, sculptor, and Conceptual artist, living in New York. Between 1945 and 1949 he studied at Syracuse University, New York, and subsequently worked in New York. In 1953 he attended the Cartoonist and Illustrators School (later the School of Visual Arts). From 1960 to 1965 he worked as a designer at MOMA. He taught at the Museum Arts School (1964–67), Cooper Union

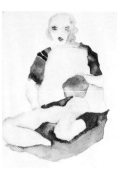
Sherrie Levine, *After Egon Schiele*, 1984, Watercolor on paper, 35.6 x 27.9 cm, John Sacchi Collection, courtesy of Baskerville & Watson, New York

[Percy] Wyndham Lewis, *The Dancers – Study for Kermesse?*, 1912, Pencil, black ink, watercolor and gouache on brown paper 30.1 x 29.2 cm, Manchester City Art Galleries

Sol LeWitt, *Untitled*, Four-color screen print, 81 × 81 cm

(1967–68), School of Visual Arts (1969–70) and the art department of New York University (1970–71). In 1976 he founded the bookshop and sales organization Printed Matter (→ artists' books). His first artistic works were three-dimensional floor and wall pieces in geometrical forms made in the early 1960s, and influenced by the → Bauhaus, → Constructivism, and De → Stijl. In 1964 the first *modular structures* were produced, initially black, later in white, wood or metal, repeated in mathematical progression (*47 Three-part Variations of Three Different Kinds of Cubes*, 1967). These cagelike constructions in the shape of pyramids, cubes, and angles are set up in space or mounted on the wall, producing new spatial effects through directional lighting. Grid and cube structures are combined to form complex gallery → installations.

The use of elemental primary forms, the concentration on problems of form and the rigorous logic of Lewitt's work are characteristic of → Minimal art. In 1968, in parallel to the sculptural work, a new phase began with mural drawings and paintings. Initially, LeWitt translated his three-dimensional grid constructions into networks of lines of varying density and direction. In the 1980s, these networks were painted in color, creating large-scale works with apparent spatial effects. LeWitt also produced books, drawings, and photographs using the same systematic approach. H.D.

Bibl.: Singer, LeWitt, 1984 · LeWitt, London, 1986 · LeWitt, 1992 · Lewitt, Munich, 1993 · LeWitt, Prints, 1993 · Reynolds, LeWitt, 1993

Lhote, André. *1885 Bordeaux, †1962 Paris. French painter and art theorist. He studied sculpture at the École des Beaux-Arts, Bordeaux. From 1906 he lived in Paris, joining → Section d'Or in 1912. In 1918 he set up his own school of painting in Paris. In 1950 he journeyed to Cairo, teaching at the art school there in 1951.

His work included publicly commissioned murals in 1937 (Exposition Universelle, Paris) and in 1955 (Faculty of Medicine, Bordeaux). Influenced by Cézanne, he joined the Cubist movement → Cubism, retaining the figurative forms and brilliant colours of R. → Delaunay. After the war, his work displayed links with synthetic Cubism (→ Gris), using brilliant areas of color and integrated figure scenes (*Rugby*, 1917). The tendency to → Neo-Classicism intensified in the 1950s, as Lhote integrated Cubist fragments with classical Realism (*Bathers*, 1935). As a teacher

and art theorist (*Traité du paysage et de la figure*, 1958), he had a great influence on the younger art generation. H.D.

Bibl.: Martin-Métry, Lhote, 1967 · Dorival, Lhote, 1981

Lichtenstein, Roy. *1923 New York, †1997 New York. American painter, sculptor, and graphic artist. From 1940 to 1949 he studied art at Ohio State University, interrupted from 1943 to 1945 by military service in Europe. From 1952 he was in Cleveland, where he worked as a technical draftsman and interior designer until 1957. From 1957 to 1960 he was Professor of Art at New State University in Oswego, New York. From 1960 he was at Highland Park, New Jersey, and from 1970 in Southampton, Long Island. 1966 saw his first solo exhibition at the Cleveland Museum of Art. In 1977 he showed at Documenta 6. In the early 1960s, Lichtenstein copied cartoons, sometimes just individual frames with his trademark painted raster, adding text balloons. Besides subjects from → comics and cartoons, Lichtenstein also treated representations of consumer goods from advertising. In 1965–66, he developed his *Brushstroke Pictures* (enlarged, abstract "gestural" brushstrokes) as a humorous reaction to → Action Painting. 1973 to 1979 was the period of the "École de Paris pictures"; parallel to this, he made reference to → Constructivism, → Futurism, → Surrealism, or German → Expressionism. In the early 1980s, he returned to the *Brushstrokes* series, into which he now incorporated spontaneously executed brushstrokes in the manner of → Abstract Expressionism. The *Perfect* and *Imperfect Paintings* (beginning 1986) were painted as purely abstract, geometric compositions. In 1994 there followed large-scale sculptures *Brushstrokes I* and *II* for Tokyo Plaza, New York.

Lichtenstein's artistic strategy is based on the adaptation of various models: their reworking or reversal in a bold style and artistic language developed along the lines of the vocabulary of forms of everyday consumer advertising and the mass media. He used unmixed primary colors and outlined the shapes in black. His art always remained closely wedded to easel painting and the classical act of painting. He also produced designs in ceramic, steel, or glass as well as bronze sculpture. With → Warhol, → Wesselmann, and → Rosenquist,

Roy Lichtenstein, *M – Maybe (A Girl's Picture)*, 1965, Magna on canvas, 152 × 152 cm, Museum Ludwig, Cologne

Lichtenstein is one of the main representatives of American → Pop art.　I.N.

Bibl.: Alloway, Lichtenstein, 1983 · Adelman/Tomkins, Lichtenstein, 1987 · Tomkins, Lichtenstein, 1988 · Busche, Lichtenstein, 1989 · Tuten, Lichtenstein, 1989 · Corlett, Lichtenstein, 1994

Licini, Osvaldo. *1894 Monte Vidon Corrado, Marches, †1958 Monte Vidon Corrado. Italian painter. Licini's mother was from France and he spent much of his life in that country. Showing a youthful interest in → Symbolist poetry, Licini initially (1908–13) attended the Accademia di Belli Arti, Bologna, with → Morandi. After → Futurist and → "Primitivist" beginnings, → Matisse-like pictures were dominated by French influences (he knew → Soutine, → Picasso, and → Modigliani). After participating in the → Novecento, he became associated with → Abstraction-Création, exhibiting in the early 1930s → Constructivist abstracts with trademark triangular forms (*Abstract Threads on a White Ground*, 1930). His individual style is neither allusive nor purely non-representational, but employs "signs that express force": *Addentare* (1936) presents tooth-like shapes that interlock with/into the planar, relatively uniform, surface. He emerged from World War II to produce symbolic, highly personal works using the same high-toned colors of the abstract phase (*Rebel Angel on a Yellow Background*, 1950–52).　D.R.

Bibl.: Argan, Licini, 1976 · Apa, Licini, 1985

Liebermann, Max. *1847 Berlin, †1935 Berlin. German painter and graphic artist. From 1868 to 1872 he was taught at the Kunstschule, Weimar. In 1872 and 1874–78 he visited Paris, after repeated visits to Holland also in 1872; from 1878 to 1883 he was in Munich, and subsequently in Berlin. In 1898 he was co-founder and president of the Berlin Secession, but resigned in 1911 after a conflict with the Expressionist opposition. In 1913 he left this association and joined the Freie Secession. In 1898 he joined the Prussian Akademie der Künste, where he was president

Max Liebermann, *Parrot Seller*, 1901–05, Oil on canvas, 86.5 x 70 cm, Private Collection

from 1920 to 1932. In the 1870s and 1880s, he produced monumental, weighty group scenes, partly inspired by Millet and Hals; Dutch orphanages and homes for the aged (from 1876); and agricultural themes as a utopian blueprint for a society consisting of communality and work (*Flaxworks Barn in Laren*, 1886–87), or with heroic individual figures (c. 1890–95). From the mid-1890s, his work made a transition to lively scenes of bourgeois leisure (beach scenes, riders, landscapes) and turned away from Naturalism combined with an assimilation of French Impressionism (especially Manet and Degas [see → precursors]). This led to the use of radiant color and looser handling in an endeavor to interpret the immediate experience of nature (*Papageienallee*, 1902).

In the postwar years, numerous portraits followed together with genre scenes from family life, many self-portraits, and especially a series from his garden in Wannsee, which clearly expresses the ideal of the Impressionist style (*Wannseegarten*, 1926). Liebermann was an important spokesman in the politics of art as well as a writer on painting (*Die Phantasie in der Malerei*, 1903).　H.O.

Bibl.: Eberle, Liebermann, 1979 · Busch, Liebermann, 1993 · Eberle, Liebermann, 1995 · Liebermann, Berlin, 1997

Light art, Maurizio Nannucci, *You can Imagine the Opposite*, 1991, Flourescent letters on the façade of the Städtische Galerie im Lenbachhaus, Munich

Light art. Artistic genre in which artificial or natural light is used as the primary means of artistic production. It aims to overcome the isolated work of art and is often used in → environments and → installations in a synaesthetic context. The colored-light keyboards of Aleksandr Skryabin (*Prometheus*, 1915) and V. Baranov-Rossiné (*Piano optophonétique*, 1917) are considered forerunners. Around 1919, the pioneer of light and space art, Thomas Wilfred, separated the projection of light from music by projecting color phenomena with the "Clavilux". While in photographic and film experiments light usually remained bound to a specific purpose, at the → Bauhaus, the *Reflektorische Lichtspiele* (1922) by → Hirschfeld-Mack developed further the 18th-century concept of the color organ, wherein rays of light were projected rhythmically to piano music. Without reference to music, → Moholy-Nagy developed a light – space modulator in 1930 with which he studied refraction and the creation of dynamic forms in space. While → Gabo's suggestion to put on a "light festival" in certain places in Berlin by means of special illuminations remained unrealized, the National Socialists used the medium for propaganda purposes with Albert Speer's "Cathedral of Light" in 1938. In the

1960s, experimentations with light reached a high point in → Kinetic art, e. g. in the work of → Schöffer (*Lumière et Mouvement*, 1967). The → Zero group and the Paris-based → Groupe de Recherche d'Art Visuel gave light art new momentum. The light spaces of → Turrell show a more meditative dimension concerned with the psychology of perception. Neon installations by → Flavin and → Chryssa also belong to the field of light art. D.S.

Bibl.: Light, Düsseldorf, 1966 · Light, Minneapolis, 1967 · Hess/Ashbery, Light, 1971 · Popper, Kinetic, 1975

Lin, [Ying] Maya. *1959 Athens, Ohio. American, sculptor, installation artist, and architect living in New York. Raised by artistic and intellectual parents who emigrated from China, Lin attended Yale University where she took courses in architecture. In 1981, her design, submitted as part of a class project, was selected as the winning entry for the Vietnam Veterans Memorial to be erected on the Mall in Washington, D.C. Critics attacked Lin's simple design of black granite walls now inscribed with some 58,000 names, but her once controversial design draws over a million people each year. The Civil Rights Memorial in Montgomery, Alabama, dedicated in 1989, was her last monument commission.

Since then she has worked on a wide range of projects which allow her to explore issues related to geography and topology. These range from sculpture, drawings, and paintings to interiors and furniture design, installation pieces and large-scale sculptural site designs such as *Wave Field* created for The University of Michigan in Ann Arbor. Currently, Lin runs a design studio in New York City. J.S.

Bibl.: Lin/Geldin, Lin, 1994 · Fleming, Lin, 1998

Lindner, Richard. *1901 Hamburg, †1978 New York. American painter and commercial artist of German origin. In 1905 his family moved to Nuremberg, where he studied at the Kunstgewerbeschule from 1922. From 1927 he was in Berlin and from 1929 in Munich, producing illustrations for newspapers, magazines, and books. He emigrated to Paris in 1933 (where he was interned in 1939). He moved to New York in 1941 (taking American citizenship in 1948). Working initially as a commercial artist and illustrator, Lindner turned to painting from 1950 (*The Child's Dream*, 1952). From 1953 he had a teaching post at Pratt Institute in Brooklyn and in 1960 became Professor of Art there.

In Lindner's painting, German culture and history are combined with American social phenomena (e.g. New York during and after World War II). In the 1950s his work was characterized by the cultural environment of Europe of the 1920s and 1930s and by an eroticism influenced by → Dix and → Grosz. In his later painting, he is increasingly concerned with American mass culture. His protagonists stem from the glamorous world of parties as well as from a shady underworld. Using bold forms and intense color, Lindner was less influenced by → Pop art, which was emerging in the US of the 1960s, than by the aesthetic of the machine age, represented by artists such as → Léger and → Schlemmer. Through a

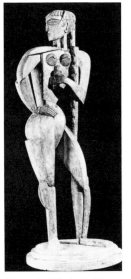

Jacques Lipchitz, *Jeune fille à la tresse*, 1914, Plaster, 83.7 x 31 x 32.5 cm, Jacques and Yulla Lipchitz

Richard Lindner, *Ludwig II*, 1962, Oil on canvas, 127 x 101.6 cm, The Cleveland Museum of Art

Richard Lindner, *The Couple*, 1971, Oil on canvas, 183 x 198 cm, Private Collection

type of montage technique, the figures in his paintings appear mechanistic and robbed of life. The provocative language of his pictures conceals a satirical commentary and critical judgment of the existential such as New York. I.N.

Bibl.: Ashton, Lindner, 1969 · Lindner, New York, 1978 · Spies, Lindner, 1980 · Spies/Loyall, Lindner, 1999

Lipchitz, Jacques (Chaim Jacob Lipchitz). *1891 Druskin-ki, Lithuania, †1973 Capri. Lithuanian-born sculptor. From 1901 to 1905 he attended commercial college in Bialystok. In 1905 he emigrated to Vilnius due to the anti-Semitic pogrom. In 1908 he moved to Paris, where he enrolled as a student at the École des Beaux-Arts, and subsequently at the Académie Julian. In Paris he met → Picasso, → Archipenko, and others and struck up a close friendship with → Gris. In 1922 he became a member of the group → Esprit Nouveau around → Le Corbusier. In 1924 he took French citizenship. In 1941 he fled to the US. After a fire in his New York studio, he moved to Hastings-upon-Hudson in 1952. Inspired by his contact with Cubists (→ Cubism) and his interest in the art of "primitive" peoples, Lipchitz produced rigorously constructed Cubist sculpture in stone and bronze between 1913–22, in which he is thematically close to Gris and Picasso treating subjects such as guitar players, musical instruments, and archaicizing heads. These are among the most important Cubist sculptural work. From the mid-1920s, however, Cubist elements recede, and the forms become more organic and sinuous. Instead of compact, dense blocks, an open, dynamic transparency emerges combined with a new emotionality, which can be interpreted as a reaction to contemporary events (*Les transparents*, figurative bronze sculptures). The bronzes of the third phase, which are accompanied by numerous drawings, show greater emphasis on volume and organic form and, in the 1960s, frequently have an uneven surface reminiscent of → Rodin. In portrayals of couples or mothers with children, Lipchitz emphasizes emotional, human values; in his large-scale mythological and biblical subjects, elements from → Surrealism can be detected. I.H.

Bibl.: Lipchitz, Los Angeles,1963 · Hammacher, Lipchitz, 1975 · Patai, Lipchitz, 1975 · Jenkins/Pullen, Lipchitz, 1986 · Wilkinson, Lipchitz, 1989

Lipton, Seymour. *1903 New York City, †1986 New York City. Internationally recognized as one of the major American sculptors, Lipton has exhibited in many major museums: after 1948 he was with the Betty Parsons Gallery and after 1965 with the Marlborough-Gerson Gallery. Lipton's early works dating from the Depression were concerned with elemental human feelings such as anguish, love, hope, and with the daily existence of the masses: wounded soldiers, subway beggars, etc. Influenced by → Cubism in breaking the closed solidity of human form, by the → Surrealist use of spontaneous free association, and by primitive art's interest in myth and the metaphors of brutality, Lipton's sculpture evolved toward an interest in bestial, possessed forms, in hybrids and mutants governed by an invisible drive to self-destruction. These ideas are conveyed by bronze and steel works in which forces oppose each other to create tension. S.G.

Bibl.: Elsen, Lipton, 1969

[Lasar] El Lissitzky, *Composition with Pliers*, 1920, Photogram, 29 x 23 cm, Galerie Gmurzynska, Cologne

Lissitzky, [Lasar] El. *1890 Potchinok, near Smolensk, †1941 Moscow. Russian painter, photographer, and designer. From 1909 to 1913 he studied engineering and architecture at the Polytechnische Hochschule in Darmstadt. In 1914 he returned to Moscow. From 1914 to 1918 he studied at the technological university in Riga. From 1919 to 1921 he was Professor at the art school founded by → Chagall in Vitebsk. In 1921 he became head of the faculty of architecture at the Vkhutemas art school, Moscow. From 1922 to 1925 he lived in Berlin. In 1923 he designed a Proun Room while in Dresden and Hanover, and made contact with the De → Stijl group. As an active member of the Unovis group led by → Malevich, Lissitzky developed his Proun pictures from 1919, as a kind of rationalized, spatial equivalent of → Suprematism in the pictorial plane. Influenced by → Constructivism, he gave up painting in 1922 to develop a new printing process (typography and layout) for advertising and concentrate on planning exhibitions, which transferred his principles of dynamic composition, intended to activate the eye of the observer, to the mass media. The Proun Room in Berlin (1923), one of the first gallery-based installations in the history of art, shows this transition from non-representational painting to composition in three-dimensional space.

In his revolutionary projects for designing dynamic exhibition spaces, some being equipped with motor-driven components, Lissitzky also broke new ground (e.g. *Room for Constructivist Art*, International Art Exhibition, Dresden 1926; *Abstract Cabinet* in the Provinzialmuseum, Hanover, 1926; Moscow Union Polygraphic Exhibition, 1927; Soviet Pavilion at the International Press Exhibition (PRESSA), Cologne, 1928). After initial experiments with photography and the photogram from the mid-1920s, the versatile Constructivist worked mainly for the propaganda magazine *USSR Under Construction*, for which he designed and planned several issues in the new climate of heroic, idealizing Stalinist aesthetics. H.G.

Bibl.: Lissitzky-Küppers, Lissitzky, 1968 · Lissitzky-Küppers, Lissitzky, 1980 · Lissitzky, Eindhoven, 1990 · Lubbers, Lissitzky, 1991

List, Herbert. *1903 Hamburg, †1974 Munich. German photographer. His first experiments in photography emerged in 1926–27 and in 1930, encouraged by A. → Feininger. In 1931 to 1935, List was influenced by → Surrealism (→ Man Ray, → Ernst, → Dalí, de → Chirico), producing still lifes and highly staged "visions." From 1936 he lived in Paris. In 1937 he undertook a journey to Greece, photographing ancient ruins, landscapes, secular architecture, and male nudes as "metaphysical visions", with the aim of bringing to life the myth of antiquity through mysterious images. His work achieved international fame in 1953 through an exhibition in Paris of his Greek photographs ("Hellas. A Pictorial Symphony"). In a similar manner, List documented the ruined landscape of Munich after the end of the war. He worked as a photojournalist in the subsequent period (e.g. for *Heute* magazine) and published work on the "primitive" arts of the South Seas and Africa. In 1948–49 he took portraits of artists in Paris including → Picasso, → Braque, → Chagall, → Miró, and → Arp. He joined the Paris office of the photographic collective Magnum. He published books of photographs, including *Rome* (1955), *Caribia* (1958), and *Napoli* (1962, in collaboration with the film director Vittorio de Sica). In 1965 he gave up photography and concentrated on collecting drawings. List's work occupies a unique position in German photography and is closely related to Surrealism and → Magic Realism. U.P./S.U.

Bibl.: Metken, List, 1980 · Scheler, List, 1999

Lohse, Richard-Paul. *1902 Zürich, †1988 Zürich. Swiss painter and graphic artist. From 1918 to 1922 he attended the Kunstgewerbeschule in Zürich. He took up residence in Paris in 1923. In 1937 he was co-founder of the group of artists called Allianz (→ Bill). Since 1942, Lohse has worked on strictly geometrical pictures with modular and serial arrangements of colors, subdivided vertically and horizontally (*15 Systematic Rows of Colors with Vertical Compression*, 1950–67). His work is based on harmonic theories of chromatics, such as mathematical progressions and divisions, which lend the precisely executed works the effect of fugues in color (*Rhythmic Progression*, 1952–59). Together with Bill, Lohse is a major Swiss → Concrete artist. H.D.

Bibl.: Albrecht, Lohse, 1974 · Lohse, Grenoble, 1988

Robert Longo, *Untitled*, 1982, Charcoal and graphite on paper, 152 x 198 cm, High Museum, Atlanta

London Group. Group of exhibitors founded in 1913 by → Epstein, → Lewis, and others, developing out of the → Camden Town Group. The association was composed of representatives of various artistic styles: Post-Impressionist, Cubist, and abstract work was exhibited. The London Group was conceived as a forum for progressive British artists reacting against the conservative Royal Academy. Working under the name of the London Group after 1913, their first exhibition in London was at the Goupil Gallery in 1914, at which the → Vorticists played a central role. From 1915, two exhibitions a year were put on regularly, even for artists who were not members of the group. When the art critic Roger Fry joined in 1919, together with V. → Bell and → Grant, the → Bloomsbury Group became the focus of the exhibitors' circle. In 1928 a retrospective of the association's first 15 years was held in the Burlington Gallery in London. From 1930, sculpture was increasingly represented (new members numbered → Moore and → Hepworth). After World War II, the group lost its progressive momentum (as formulated by Fry). In 1964 the London Group's 50th anniversary was marked at the Tate Gallery, London. A.K.

Bibl.: London Group, London, 1964 · Wilcox, London Group, 1995

Long, Richard. *1945 Bristol. British Installation and Land artist, photographer, and painter, living in Bristol. From 1962 to 1965 he studied at the West of England College of Art, Bristol, and from 1966 to 1968 at St Martin's School of Art, London. Even during his studentship, Long strove for a renewal of art through a turn towards nature and the landscape. In one of his earliest works, *A Line Made by Walking* of 1967, he photographed a straight line made in grass by walking repeatedly to and fro. Since then he has made walking, and thus his personal experience of nature, the basis of his art. Long's hikes across England, Ireland,

Richard Long, *A Circle in Alaska, Bering Strait. Driftwood on the Arctic Circle*, 1977, Installation in Alaska

the Himalayas, the deserts of West Africa and Australia take days or even weeks, and brought him international fame in the 1970s. He documents such treks photographically, in texts and also in sculptures and → installations which he makes from materials collected from the environment (depending on the kind of ground he has been hiking over, e. g. slate, flint, peat, driftwood, or pine needles). Two basic forms – circle and line – are laid out in ground sculptures, and since 1981, Long has painted pictures using the collected materials.

Long's art is not representational but the result of real activity and his personal experience of time and space. In contrast to the American → Land artists, e.g. → Heizer and → De Maria, Long does not interfere with nature, but tries to establish a reticent, personal dialogue with the environment by carrying his own experience of nature in the remotest areas of the earth into civilization, thus directly confronting the viewer, who is usually alienated from the landscape, with various forms from the natural world. I.N.

Bibl.: Long, Eindhoven, 1980 · Long, 1984 · Fuchs, Long, 1986 · Fulton/Seymour, Long, 1991 · Long, Hanover, 1999

Longo, Robert. *1953 New York. American painter, draftsman, sculptor, installation and media artist living in New York and, since 1990, in Paris. He studied art at State University College, Buffalo, New York, from 1973 to 1975. In 1982 he showed at → Documenta 7. In large-scale figurative drawings (*Men in the Cities,* 1980), Longo shows anonymous, isolated city dwellers (the subjects are his friends or taken from magazine illustrations) in the style of → photorealism; his central themes being fear, loneliness, and the interplay of illusion and reality. After these drawings came three-dimensional combines of metal and plastic. His monstrous bronze figures from 1986 show horrifying visions which seem to be influenced by → Boccioni's sculpture and science-fiction figures from Hollywood. In the heavy bronze flags created in 1990, which question the claims to power of Western civilization, Longo also quotes from sources in art history. His art reflects critically upon American and Western civilization, which is determined by power and commerce. Through multimedia work, he reacts to the permanent overstimulation of mass communication, confronting the viewer with the visual overabundance of new media. I.N.

Bibl.: Ratcliff, Longo, 1985 · Fox, Longo, 1989 · Gibson, Longo, 1991

Louis, Morris. *1912 Baltimore, Maryland, †1962 Washington, D.C. American painter. Born Morris Louis Bernstein, he changed his name by deed poll in 1938. After work on the WPA (→ Federal Art Project), Louis studied with → Siqueiros and painted social subjects in an → Expressionist style. Though living in Washington, D.C., from 1952 he came under the influence of the New York School of → Abstract Expressionism, pouring thinned, plastic-based pigment in ribbon-like bands over often unprimed and even unstretched canvas. The example of → Frankenthaler was preponderant in this development, though Louis went on to eliminate brush, texture, and painterly relief almost entirely. In his

Morris Louis, *Beta Zeta*, 1960–61, Acrylic on canvas, 255 x 439 cm, Neue Nationalgalerie, Berlin

huge *Veils* (1954) and *Veils II* (1958–59), Louis concentrated on bands – resembling translucent billowing fabrics – that overstain each other. Such → Color Field approaches were continued in *Unfurleds* (1959–61) in which bright rivulets slant down the sides of the acrylic surface (the center remains blank, as in the celebrated *Delta Beta*, 1960). Some of his striped canvases were even intended to be stretched diagonally. The more organized, almost → Op spaces of *Moving In* (1961) form part of the series of *Stripes* (1961–62) in which strict vertical bands of color slightly interpenetrate at the edges to give each strip an indistinct halo or "beat." Though often working in isolation, Louis was one of the foremost → Post-Painterly Abstractionists, without the energized quality of → Pollock or → Mitchell. His spatial treatment may be reminiscent of → Francis, but the approach to color source is all his own. D.R.

Bibl.: Elderfield, Louis, 1986

Lowry, L(aurence) S(tephen). *1887 Stretford, near Manchester, †1976 Glossop, Derbyshire. English painter. Belying the naive art simplicity of some canvases, Lowry intermittently attended Manchester Municipal Art School (1905–15) and Salford School of Art (1915–25). A long-time office employee (1910–52), he began to exhibit seriously when aged over 50; he was elected an RA in 1962. Lowry's work is noted for industrial landscapes with jerky "matchstick" figures against a backdrop of chimneys and viaducts that convey the anomie and repetitiveness – as against the squalor or violence – of urban life. He was initially close to the → Camden Town Group in poetic values and tightness of execution, though his handling quickly loosened (*Coming from the Mill*, 1930). Tones remained tempered, even drab, throughout his oeuvre (*Industrial Landscape*, 1950). The vernacular influence of Pieter Bruegel and Avercamp was crucial. His work initially appeared critical but now has a nostalgic air. Anecdotal works included *V-E Celebrations* (1945). No modernist, the reclusive Lowry – like → Prendergast, → Rockwell, or → Buffet – was more popular with the public than the critics, as was pointed up in late satirical pieces such as *Private View* (1958). There is a museum dedicated to his work in Salford. D.R.

Lucebert (Lubertus Jacobus Swaanswijk). *1924 Amsterdam. Dutch painter and poet living in Amsterdam. Lucebert is a member of the → Cobra group. From 1951, as a self-taught painter, he has worked with abstract, figurative scenes in a

simple style that emphasizes linearity (→ Magic Realism), and is reminiscent of → Klee in the humorously bizarre subject matter (*Apollinaire's Dream*, 1972). K.S.-D.

Bibl.: Lucebert, Amsterdam, 1969

Luks, George → Ashcan School, → Eight, The

Luminism. This term is used in various senses: 1. to designate an American movement of Pre-Impressionist landscape painting, i. e. the Luminist Movement of 1850–75; 2. as an alternative term for → Light art; 3. as a term for the Belgian Neo-Impressionist group (→ Neo-Impressionism) the Luminists, who derived the name from the magazine *Vie et Lumière* founded in 1904 with artists such as Anna Boch (1848–1936), Adrien Heymans (1839–1921), Émile Claus (1849–1924), and George Morren (1868–1941). H.D.

Lüpertz, Markus. *1941 Liberec (formerly Reichenberg in Bohemia). German painter and sculptor, living in Düsseldorf and Berlin. From 1948 he was based in Rheydt, in the Rhineland. In 1956 he attended the Werkkunstschule in Krefeld and Kunstakademie in Düsseldorf. From 1962 he was in Berlin, where the Galerie Großgörschen 35 was opened in 1964. In 1966 he produced his manifesto, "Kunst, die im Wege steht. Dithyrambisches Manifest". In 1970 he was at the Villa Romana, Florence. In 1976 he became Professor at the Staatliche Kunstakademie in Karlsruhe; from 1986 he was back at the Kunstakademie, Düsseldorf, and since 1988 as its rector. In contrast to informal influences predominant when he was a student, but equally to expressive figuration, Lüpertz described the new position of "Dithyrambic Painting" in the 1960s, which he formulated in his manifesto on the subject. Clearly defined, representationally derived forms are monumental presences in a painterly format; the ancient Greek song of praise to the cult of Dionysus is transformed into a formula for artistic pathos inspired by Nietzsche. Thus art becomes the "concretization of abstract forms."

A formal phase in which Lüpertz experimented with perspective and volume applied to everyday subjects contrasting with etiolated formats (*Spargelfeld – dithyrambisch*, 1966) is followed in 1970–74 by a phase of "painting subjects," in which negatively connoted subjects from German history are reexamined (*Arrangement für eine Mütze*, 1973). Lüpertz is, however, mainly

Markus Lüpertz, *Baumstamm – dithyrambisch*, 1966, Distemper on canvas, 113 x 146 cm, Museum Ostdeutsche Galerie, Regensburg

Markus Lüpertz, *Pierrot Lunaire*, 1984, Painted bronze, 140 x 100 x 100 cm, Private Collection

concerned with possible sources of friction for transposing emotionally charged subjects into "painterly painting," as is shown in the series of townscapes (*Babylon*, 1975) and style pictures (*Ship*, 1977), which oscillate between abstraction and figuration. In the early 1980s, Lüpertz took up with the principles of → Cubism and → Surrealism, which inform both more recent sculptural work (*Standbein – Spielbein*, 1982) and painting (*10 Bilder über das mykenische Lächeln*, 1985). In ever new transformations of form and subject, accompanied by references to the history of art (e.g. Poussin), Lüpertz has repeatedly confirmed the "will to paint" standing against the flood of image production in the media (series *Männer ohne Frauen*, 1993–97). H.D.

Bibl.: Haenlein, Lüpertz, 1983 · Lüpertz, 1991 · Caradente, Lüpertz, 1994 · Zweite, Lüpertz, 1996 · Fuchs, Lüpertz, 1997 · Gohr, Lüpertz, 1997

Lurçat, Jean. *1892 Bruyères, Vosges, †1966 Saint-Paul-de-Vence, Alpes-Maritimes. Self-taught French painter and tapestry designer. Briefly influenced by → Cubism and later by → Surrealism, in the 1930s Lurçat mainly produced Surrealist seascapes with abandoned, lonely figures (*Masts and Sails*, 1930), also numerous illustrations for contemporary creative writing. He is mainly renowned, however, for his revival of the art of tapestry, with which he was concerned from 1939, inspired by the "Apocalypse d'Angers." In 1940, Lurçat reorganized the tapestry works of Aubusson together with → Gromaire, for which he created his most important work (*The Song of the World*, 1957–63). K.S.-D.

Bibl.: Lurçat, Arras, 1968

Lüthi, Urs. *1947 Lucerne. Swiss painter, photographer, and sculptor, living in Munich and Kassel. He exhibited in 1977 at Documenta 6. Since 1994 he has been Professor at the Gesamthochschule, Kassel. An alternating use of various media and styles is characteristic of Lüthi's work. In the 1960s his work consisted of eccentric black-and-white self-portraits (→ Body art) and an increasing renunciation of painting. In the 1970s, large-scale photos in which Lüthi's main subject is banality, ugliness, and → kitsch, are presented almost narratively in grotesque episodes. In the 1980s his work became more conceptual and semiotic. Alongside landscapes and self-portraits, he has also produced → installations and series of objects. Cultural and historical quotations (concepts or symbols) are placed in a new context through multi-media ensembles. The end of the 1980s was marked by casts of his own head, juxtaposed with large-scale pictures. In the 1990s, bold word – picture combinations created a dialogue with objects and head-casts. D.W.

Bibl.: Lüthi, Klagenfurt, 1993

Lyrical Abstraction. The term *abstraction lyrique* was introduced in Paris by → Mathieu to characterize the tendencies in painting , "which, in light of the theories, represent the utmost in total and absolute freedom against all those who show traces of Cubism, Constructivism, and Surrealism" (Mathieu). Lyrical Abstraction considered itself to be a completely new beginning in painting, liberated from tradition and formalized systems of rules with the sole aim of being the incarnation of cosmic signs, only to be achieved by the fastest execution possible and in "a state of ecstasy" (Mathieu). The spontaneous act of painting is not intended to reveal unconscious structures in the Surrealist sense (→ écriture automatique, → automatism), but rather to exclude any formal concepts that might sully the purity of the epiphany. The painter's materials have the role of a pure catalyst or medium in this process. In the creative gestural process, the picture forms itself as "pure being" (M. Brion). In 1958, during the Nuit de la Poésie in the Théâtre Sarah Bernhardt in Paris, Mathieu painted a 4 x 12 meter canvas in just under 20 minutes.

Among the painters in the circle around lyrical abstraction were Mathieu, → Wols, H. → Hartung, and → Riopelle. It subsequently became a generally applied term for any non-geometrical, gestural, abstract painting. W.S.

Bibl.: Blok, Abstrakte Kunst, 1975

Lyrical Abstraction, Georges Mathieu, *Large White Algorithm*, 1951, Oil on canvas, 130 x 195 cm, Artist's Collection

Maar, Dora. *1907 Tours, †1997 Paris. French photographer and painter. Born of Yugoslav parentage, Maar spent some of her early years in Argentina. Moving to Paris, she studied both painting and photography, running (1931–34) a

photographic studio in Neuilly (*Lise Deharme at Home in Front of a Bird's Cage*, 1936, silver print). She became involved with the → Surrealist group in 1934 (*Portrait of Ubu*, 1936; *26 rue d'Astorg*, 1937, photomontage) and some of her prints are valuable documents of the movement. She soon became → Picasso's lover, and (with poet Paul Éluard's wife Nusch, her own favorite human subject) was a principal model (influential in *Weeping Woman*, 1937). She assisted the artist in work for *Guernica* and in photogravure (1937, in *Cahiers d'art*) before their separation in the mid-1940s.

Maar moved to painting (semi-)automatic landscapes in the later 1940s and 1950s. Alluring portraits by → Man Ray (1936) portray her as a Surrealist/artist femme fatale (→ Breton called her "L'Etoile rose") in the style of Meret → Oppenheim, Lee Miller, or Gisèle Prassinos. Other friends included writer Georges Bataille, → Tanguy, and → Dada polemicist Georges Huguet. In the last 30 years of her life Maar seemed to renounce her earlier artistic existence. D.R.

Bibl.: Maar, Fotografa, 1995 · Maar, Paris, 1998

McCollum, Allan. *1944 Los Angeles. American mixed-media artist. McCollum lives in New York and works in large-scale multiples. The *Surrogate Paintings* series (1978–84) comprises acrylics on wood and museum-board in a vast range of colors so as to cover the gallery walls like overpainted "empty" frames. Such sequences engage with timelessness and repetition; no two of the thousands of *Drawings* (1988) or *Individual Works* (1987) are congruent, but all derive from a single template set. Other series include *Actual Photos*, and the urns of *Perfect Vehicles* (1986–87). *Lost Objects* (1991) and *Natural Copies* (1995) are brightly colored enamel on polymer-reinforced Hydrocal casts of dinosaur bones and footprints, respectively. They pay homage to the phenomena of extinction and of collecting (alluding to their storage in the Carnegie Museum of Natural History), and are a wry comment on the 1990s mania for casting the human body. *Dogs from Pompeii* (1991) are of similar tenor, representation (studio molds of animals) working against narrative (the "original" ancient lava "casts"). D.R.

Bibl.: McCollum, 1996

Matta, The Birth of Man, 1982,
Oil on canvas, 182 x 210 cm,
Private Collection, Geneva
(see p. 217)

Macdonald, Jock (James Williamson Galloway). *1897 Thurso, Scotland, †1960 Toronto, Ontario. Canadian painter. Macdonald worked as an architectural draftsman and studied at the Edinburgh College of Art before emigrating to Vancouver in 1926. After early landscapes under the influence (early 1930s) of Fred Varley (1881–1969) and the → Group of Seven, he began painting the abstracts he later called "modalities" in the mid-1930s. In the 1940s he entered an almost → Surrealist phase (*Fish Family*, 1943). In the early 1950s thick transverse lines predominate in less "automatic" watercolors. Oils reappeared after Macdonald's stay in Europe in 1954 (where he met → Dubuffet and worked in Vence) and, later, after contact with Painters Eleven. His color areas turned more planar in the late 1950s, and in the 1960s large shimmering abstracts – more limpid than, say, → Schumacher's – emerged. He had a fruitful teaching career at the Ontario College of Art until his death. D.R.

Bibl.: Zemens, Macdonald, 1981

Macdonald-Wright, Stanton. *1890 Charlottesville, Virginia, †1973 Pacific Palisades, California. American painter. In 1904–05 he studied at the Art Students League, Los Angeles; in 1907–12 at the Sorbonne, the École des Beaux Arts, the Académie Colarossi, and the Académie Julian, Paris. In 1912 (with → Russell) he founded → Synchromism. In 1916 he returned to the US. From 1922 to 1930 he was director of the Art Students League, Los Angeles. In 1935–42 he cooperated on the → Federal Art Project. In 1942–52 he taught at the University of California.

Macdonald-Wright is regarded as the pioneer of abstract art in America. Synchromism, founded in Paris in 1912, is similar in the orientation of its color theory to R. → Delaunay's → Orphism. Macdonald-Wright's early pictures are frequently based on the human figure in contraposto. After about 1916 he began to paint in a more traditional style, but from the 1940s again took up stylistic elements from Synchromist painting. F.P.

Bibl.: Levin, Synchromism, 1978

Mach, David. *1956 Methil, Fife. Scottish sculptor based in London. While studying in Dundee (1974–79) Mach created combination sculptures in an abstract idiom of → Junk art. Associated with the → New British Sculpture of the 1980s, Mach's works eschew the "enriched materials" (D. M.) of → Cragg and → Woodrow, using e.g. large quantities of surplus pristine printed matter. In the early 1980s he constructed *in situ* massive yet elegant figurative → assemblages, alluding critically to both industry and "the rush to collect" (D. M.) through the use of over-produced materials: *Volkswagen* (1982; life-size, built from copies of German "Yellow Pages"); submarines from car tires; heads made of *Matches and Glue* (1994–95); and *Eckow* (1997, from coat-hangers). Combining → appropriation and → Serial art, Mach incorporates → kitsch mass products such as "Barbie" dolls (*Off the Beaten Track*, 1988) as elements in parodic series. Central formal themes include balance – as in *Animated Suspension* (1987), in which inflatable sea lions elevate cars on their snouts – and destruction: in *101 Dalmatians* (1988) a score of far-from-Disney resin hounds set about a nondescript bourgeois interior. D.R.

Bibl.: Mach, Oxford, 1985

Machine art. Name of a trend within Russian → Constructivism, founded by → Tatlin, which postulated a conscious contrast to the romantic, bourgeois conception of art by favoring a technical vocabulary and a radically rational concept of art (as engineering). Technical progress in the service of a social Utopia was made the basis of all artistic activity. Tatlin used technologically oriented images of Machine art as a symbolic way of making abstract concepts, such as dynamics, weightlessness, transparency, power, and construction, visible as symbols of progressive political developments. The most important testimonies to Machine art are Tatlin's 400-m tall tower, *Monument to the Third International*, (1919–20) and the flying machine *Letatlin*. W.S.

Bibl.: Die Große Utopie, 1992

Machine art, Vladimir Tatlin, *Model for the Monument to the Third International*, 1920, Wood, metal, height 420 cm

Maciunas, George. → Fluxus

Mack, Heinz. *1931 Lollar, Hesse. German Kinetic artist living in Mönchengladbach. In 1950–53 he studied painting at the Kunstakademie Düsseldorf; he spent 1953–56 studying philosophy at the University of Cologne. In 1964–66 he was in New York. From 1969 he was professor at the Hochschule der Künste, Berlin. With → Piene, Mack founded the → Zero movement under the influence of Y. → Klein (1958–1966). After early Tachiste works, after 1960 Mack developed light sculptures and cubes made of structured metal and glass, sometimes set in motion by motors (rotors), which produced an effect of spatially dynamic refraction (*Light Wall*, 1963). After 1963 he concentrated entirely on Kinetic light sculpture (→ Kinetic art). Cosmological allusions appeared in his work as the "visible part of the invisible," e.g. *Sahara Project* (1968) an artistic light garden on 11-m tall stelae in the desert. From 1968 he designed public squares, architecture, and interiors (*Pub*, 1991), in which he employed photocollages. In the 1980s Mack also worked with traditional sculptural material and completely revised his earlier designs. His work is completed by numerous theater designs, documentary films (TELE-MACK, 1968), lectures, and his own texts. M.G.

Bibl.: Honisch, Mack, 1986 · Ruhrberg, Mack, 1989 · Schmied, Mack, 1998

August Macke, *Zoological Gardens I*, 1912, Oil on canvas, 58.5 x 98 cm, Städtische Galerie im Lenbachhaus, Munich

Macke, August. *1887 Meschede, Sauerland, †1914 Perthe-les-Hurlus, Champagne. German painter. In 1904–06 he studied at the Kunstakademie and the Kunstgewerbeschule, Düsseldorf. In 1905 he traveled to Italy and in 1906 spent time in Belgium, Holland, and England. In 1907–08 he attended → Corinth's painting school in Berlin. After a period in Paris in 1908 he settled in Tegernsee. He was associated with the circle of the → Neue Künstlervereinigung München and forged a friendship with → Marc. In 1911 he collaborated on the almanac and exhibition (see Der → Blaue Reiter). In 1912 he was co-initiator of the

August Macke, *Turkish Café*, 1914, Oil on panel, 60 x 35 cm, Städtische Galerie im Lenbachhaus, Munich

→ Sonderbund exhibition, and traveled to Paris with Marc. In 1914 he traveled to Tunis (with → Klee and Louis Moillet [1880–1962]). Fascinated by French Impressionism, Macke's early work included landscapes, portraits, and café and street scenes in luminous colors and a very personal style. During his time at Tegernsee (1909–10) he strove to attain a clarified pictorial construction by means of extended areas of color and flowing contours (*Portrait with Apples*, 1909). Inspired by → Matisse, Macke continued to pursue a path towards the use of pure color without shadowing or modeling. His friendship with Marc brought not only contact with the Munich avant-garde, but also involved him in an intensive debate concerning laws of color and color composition. In 1913 in Paris he met R. → Delaunay, whose *Window Pictures* left a deep impression on him. Apart from a few attempts at abstract color composition (*Colored Shapes II*, 1913), Macke

Heinz Mack, *Time, Light and Space*, 1966, Plexiglas, Fresnel lenses, 228 x 42.5 x 10 cm, In the artist's garden

always remained attached to natural models, and by 1914 had created a series of extraordinarily colorful pictures of a cheerful, idyllic world in which Orphist and Cubist elements fuse in rhythmic compositions (*Zoological Garden I*, 1912). The 37 watercolors produced during his trip to Tunis, with their transparency and luminosity, are among Macke's best achievements. H.D.

Bibl.: Vriesen, Macke, 1957 · Güse, Macke, 1986 · Moeller, Macke, 1989 · Firmenich, Macke, 1992 · Heidrich, Macke, 1997

Mackintosh, Charles Rennie. *1868 Glasgow, †1928 London. Scottish architect and furniture designer, mainly active in Glasgow. He was a major figure of → Art Nouveau and one of the innovative "Glasgow Four" with Herbert MacNair (1868–1955) and Frances (1874–1921) and Margaret Macdonald (1864–1933), whom Mackintosh married in 1890. Celtic ornament, Gothic line and Symbolism, as well as Continental Art Nouveau (Jan → Toorop), were the foremost influences on a style which reined in floral ornament and exploited instead sober arrangement, elongation, strong chromatic contrasts, parallel lines and tight, rounded motifs (rose). His works include the new Glasgow School of Art building (1897/9–1907/9), the Cranston Tearooms (especially the furnishings in Argyle Street, 1897: damaged; and Willow Street, 1904–), and his own apartment (1900–). The style was publicized by his posters and *The Studio*, but became more influential abroad thanks to articles in *Mir Iskusstva* (see → World of Art), *Die Kunst, Dekorative Kunst*, the Secessionist *Ver Sacrum*, etc., the Germanic offshoot (crucial for Josef Hoffmann [1870–1956]) becoming known as *Mackintoshismus*. After World War I, he designed fabrics, though he practically abandoned architecture (a house in Northampton reflects Viennese influence), producing watercolors in the South of France during his clouded last years. D.R.

Bibl.: Kaplan, Mackintosh, 1996

McLean, Bruce. *1944 Glasgow. British painter and performance artist. In 1961–66 he studied in Glasgow and London (St Martin's School of Art). From 1965 he produced temporary sculptures, including *Ice on Grass Sculpture* (1967). In satirical performances he turned his art against the established art scene and its exponents. For example, in the action *Pose Work for Plinths I* (1971) he reconstructed → Moore's famous *Reclining Figures*. In 1971 he founded the group "Nice Style. The World's First Pose Band", with whom in 1977 he performed the play *Sorry! A Minimal Musical in Parts*, among other things. Since the mid-1970s his performances have become fewer; instead he is producing more painterly works in a debate with Expressionist styles. A.K.

Bibl.: Gooding, McLean, 1990

MacTaggart, (Sir) William. *1903 Loanhead, Midlothian, †1981 Edinburgh. Scottish painter. He was the grandson of William MacTaggart (1835–1910), one of the founders of later Scottish landscape painting. After studying at the Edinburgh College of Art, MacTaggart became a major and much respected painter in a traditional style

that owed much to the Scottish Colourists. His many landscapes and still-lifes, for instance, are imbued with a sense of activity and freedom derived from French models (he was a frequent visitor to that country), especially → Rouault (from 1952). Later work is influenced by Nordic Expressionist models. He was a long-time teacher at the Edinburgh College and a member of the Royal Scottish Academy. He was knighted in 1962. D.R.

Bibl.: Wood, MacTaggart, 1974

Maddox, Conroy. *1912 Ledbury, Hertfordshire. British painter, sculptor, and writer. In 1937 he worked with the Paris Surrealists, belonging to the London Surrealist group in 1938–40. He took part in the International Surrealist Exhibition, Paris 1947. In 1974 he published on → Dalí.

Maddox is a major exponent of British → Surrealism, which, as a movement, was not long-lived. He defended the movement uncompromisingly and tenaciously, attributing the disbanding of the London group to the lack of a cohesive political position. Maddox had intensive contacts with Parisian Surrealism. His stylistic stimuli came mainly from → Magritte, but the subjects of his work are generally anti-religious and ironic. F.P.

Bibl.: Ray, Surrealist Movement, 1941 · Harrison, English Art, 1981

Mafai, Mario. *1902 Rome, †1965 Rome. Italian painter. Mafai produced some early abstracts before becoming an important figure (with → Scipione) in the evocative and lyrical → Scuola Romana, spawned in 1928 from his Scuola di Via Cavour in opposition to → Novecento "Neo-classicism."

At the Accademia di Belle Arti, Rome (1922–25) he met his future wife, Lithuanian painter Antonietta Raphaël (1895–1975), who introduced him to both the → École de Paris and Judaic imagery. His carefully engineered aesthetic combined → Expressionism (close on occasion to → Soutine or → Kokoschka) with → Surrealism and the compositional mystery of → Pittura Metafisica (including de → Chirico's lay-figures), e.g. the series *Roman Suburbs*. Mafai was also possessed of calmer visions, such as his masterly still lifes (*Withered Flowers* series) and figure pieces of the 1930s, which concentrate on tonal values (*Women Undressing*, 1935). His work was less exuberant than that of Scipione: *Demolition of the Suburbs* (1939) reacted to the onset of Fascism by a silent, gray paean. His *Fantasies* and *Corteges* (1940s), however, are a gruesome indictment, not unlike → Guttuso. Mafai himself returned to the metaphysical in the late 1940s (*Streets*; *Markets*, series) and to abstraction in the 1950s. D.R.

Bibl.: Fagiolo/Rivosecchi, Mafai, 1986

Magic Realism. Term used from the mid-1920s (for the first time in 1925 by F. Roh) for an artistic style combining hard, sober realism with the emotional values of → Surrealism. Because of the stylistic resemblances to → Neue Sachlichkeit, a distinction between the two movements is not often made, though the artists categorized as

Magic Realists place more emphasis on pictorial values or moods rather than on the purely representational nature of their pictures. Today Magic Realism serves primarily as a collective term for painters of different movements who invest their Realism with supernatural tensions (→ Balthus, → Kisling, → Roy, → Albright, → Rousseau), and those who incline fairly strongly towards Neue Sachlichkeit, → Radziwill. Very little distinction is made between the terms Surrealism and Magic Realism in France and Belgium. The work of → Magritte possibly comes closest to this artistic style. A considerable group of these painters was active in the Netherlands (P. F. C. Koch, R. Hynckes, D. Ket, A. C. Willinck, and → Escher). G.P.

Bibl.: Schmied, Magischer Realismus, 1969 · Hülsewig-Johnen, Magischer Realismus, 1991

Magnelli, Alberto. *1888 Florence, †1971 Paris. Self-taught Italian painter, who started painting at the age of 16. In 1911 he first came into contact with the Italian artists of → Futurism and in 1914 → Cubism (in Paris). After a brief return to Florence from 1931 he was finally back in Paris and a member of → Abstraction-Création.

1914–18 saw his first abstract works, typically two- or three-dimensional shapes intersecting one another in an imaginary space. After a phase of stark representational painting and a two-year gap (1929–31), Magnelli began in Paris to develop his gouache-on-slate series, *Stones*, which brought him back to abstraction. He moved on to partly Constructivist, partly free, curved shapes in opaque colors, and also → collages. S.P.

Bibl.: Maisonnier, Magnelli, 1975/1980 · Magnelli, Avignon, 1988

René Magritte, *The Treachery of Pictures*, 1929, Oil on canvas, 60 x 81 cm, Los Angeles County Museum of Art

Magritte, René. *1898 Lessines, Hainaut, Belgium, †1967 Brussels. Belgian painter. He moved to Brussels in 1916, where until 1918 he attended the École des Beaux-Arts. In 1927 he moved to Paris. In 1928 he took part in the first group exhibition of the → Surrealists, and in 1936 in the International Surrealist Exhibition, London, and in Fantastic Art, Dada and Surrealism, New York. In 1954 his retrospective was held at the Palais des Beaux-Arts, Brussels. In 1956 he received the Guggenheim prize. In 1965 another retrospective was held at MOMA, New York.

Initially influenced by → Pittura Metafisica, Magritte found his own unmistakable personal style in the circle of the Paris Surrealists. Realistically delineated people and objects are removed from their habitual context and relocated in surprising optical and circumstantial combinations. Over a series of works he examined the relationship of art and imitation, of concept and depiction (*The Treachery of Pictures*, 1928–29), picture and image, exterior and interior, inner and outer view (*The Domain of Arnheim*, 1949). The titles of the pictures have the function of anticipating the viewer's expectations and often refer to poetic or philosophical sources. During the war Magritte began a series in the style of Renoir (*The Harvest*, 1943), but after a short, aggressive excursion in the direction of → Dubuffet (*période vache*), he returned to the formal technique of the Old Masters, which he also applied to mural painting (1951 Knokke-le-Zout; 1957 Palais des Beaux-Arts, Charleroi). He also illustrated the works of French poets (drawings for Éluard's poems in 1946; *Les Chants de Maldoror* by Lautréamont in 1948). H.D.

Bibl.: Hammacher, Magritte, 1970 · Magritte, Écrits, 1979 · Torczyner, Magritte, 1979 · Schneede, Magritte, 1982 · Gablik, Magritte, 1985 · Sylvester, Magritte, 1992–96

Mail art. The term first emerged in the 1960s and relates to the work of the American artist Ray → Johnson who mailed his collages, drawings, and letters. From this he developed a network of artistic communication. Johnson reworked the mail he received and sent it on to other artists with the request for further artistic reworking (known as "on-sending"). In 1972 the address list worldwide comprised 1400 Mail art artists. Those interested in this medium, which combines the international exchange of art work (permanent creation) by post with playful elements, are artists who are active in the areas of → Fluxus and → happenings, among them → Beuys, → Brecht, → Roth, → Vautier, and → Vostell. → Gilbert and George call postcards with photographs of their living sculptures "postal sculptures." Mail art enabled progressive artists of the Eastern bloc, e.g. Robert Rehfeldt in the GDR, to participate in the international exchange of art. Mail art may be likened to the tradition of classical art cards but updated to include conceptual elements. W.S.

Bibl.: Crane, Mail art, 1984 · Hedinger, Mail art, 1992

Maillol, Aristide. *1861 Banyuls-sur-Mer, †1944 Banyuls-sur-Mer. French sculptor, painter, and graphic artist. In 1882–86 he studied at the École des Beaux-Arts, Paris. 1892 saw his first contact with the → Nabis. From 1893 he began tapestry weaving in Banyuls-sur-Mer, and in 1895 produced

René Magritte, *Black Magic*, 1936–40, Oil on canvas, 73 x 54 cm, Galerie Brusberg, Berlin

Mail art, Robert Rehfeldt, *Art Letter*, 1982 , Original offset print, 30 x 21 cm

Aristide Maillol, *La Médi-terranée*, 1901, Bronze, height 103 cm , Oskar Reinhart Collection, Winterthur

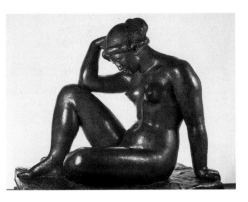

ful, though he was also a prolific religious artist (*Stations of the Cross*, Westminster Cathedral, London), converting to Roman Catholicism in 1949. He ran an art school with Martin → Bloch and exerted an early influence on → Bacon. D.R.

Bibl.: De Maistre, London, 1960

Malevich, Kasimir. *1878 Kiev, †1935 Leningrad. Russian painter. In 1905 he took private painting lessons in Moscow. In 1913 he worked on sets for the Futurist opera *Victory over the Sun* (with Kruchonych and Matiushin). In 1915 he turned to Suprematist compositions, publishing the *Suprematist Manifesto*. From 1918 he taught in Moscow, in 1919–20 in Vitebsk, and in 1922–26 in Petrograd/Leningrad. In 1924 he attended the Venice Biennale. In 1927 he traveled to Germany, and published *The Non-Objective World* (Bauhaus Books).

After Impressionist beginnings, his work in 1907–09 approached Russian Symbolism. Inspired by → Goncharova and → Larionov, in 1910–11 he moved towards a Russian-inspired Primitivism, involving motifs from nature and peasants depicted as saints as in icon painting (*Inbok*). His stylization of "primitive", non-illusionistic icons led via his knowledge of French → Cubism to what is known as → Cubo-Futurism. He combined this in an original way with the idea of "A-Logism", where the Cubo-Futurist method of taking apart human figures and things and re-assembling them was placed in new, non-logical, sensual contexts. In 1913–15 he developed *Black Square on White Ground* (1915) from stage and costume designs for the opera *Victory over the Sun* as a symbol of a Non-Objective reality, where forces of energy prevail and which can only be intuitively, not logically, comprehended and portrayed. From 1915 Malevich developed this into → Suprematism. Once he had taken his Non-Objective painting to the bounds of visibility with the *White Square on White Ground* (1919), he gave up painting and in revolutionary Russia turned to theory and teaching (UNOVIS – College of New Art, 1920). He returned to painting in 1927, and from 1929 created figurative work, mainly of peasants, to which he lent an exaggerated, iconic stature. H.G.

Bibl.: Malevich, 1969 · Simmons, Malevich, 1981 · Zhadova, Malevich, 1982 · Douglas, Malevich, 1994

his first sculptures. In 1902 he had his first one-man exhibition at the Galerie Vollard in Paris. 1905 brought friendship with → Matisse and Harry Graf Kessler. In 1908 he traveled to Greece and in 1936 to Italy.

Under the influence of Gauguin and the → Nabis, Maillol's early period produced portraits in strict profile and female figures in lyrical, colorful landscapes. Inspired by medieval tapestries he turned in 1892 to the art of weaving. From 1900 Maillol worked exclusively on sculpture. His chief motifs were female nudes enjoying the pleasures of life, self-absorbed in the natural world (*The Night*, 1902–09). They enabled an expression of humanistic ideals, while the tectonically self-contained, block-like structures with harmoniously proportioned, smooth surfaces revealed Maillol's study of ancient sculptures. From 1930 Maillol received countless commissions for memorials (including in 1919–33 war memorials); in 1906 *Action enchaînée* (memorial to the revolutionary Louis Auguste Blanqui), in 1912 *Cézanne Memorial* in the Tuileries in Paris, in 1930 *Claude Debussy*, and in 1937–43 *The River* (planned as a monument to Henri Barbusse). His graphic works (etchings, lithographs, woodcuts), for which he created his own paper (Papiers Mantoval), frequently illustrated classical literature (Virgil, Ovid). Maillol – the antithesis to → Rodin – with his demands for block-like sculpture (*en taille directe* and cast in one piece) gave 20th-century sculpture particularly in Germany (→ Kolbe, → Lehmbruck) a new direction. H.D.

Bibl.: Maillol, 1975 · Vierny, Maillol, 1986 · Lorquin, Maillol, 1995 · Berger/Zutter, Maillol, 1996

Kasimir Malevich, *Dynamic Suprematism no. 57*, 1916, Oil on canvas, 102.4 x 66.9 cm, Museum Ludwig, Cologne

Maistre, Roy (Levenson Laurent Joseph) de. *1894 Bowral, New South Wales, †1968 London. Australian – British painter. De Maistre studied at the Royal Art Society of NSW and Sydney Art School; his early paintings were local abstracts (1919). He then became active mainly in Europe (mid-1920s), living in London (early 1930s) before sharing his time between England and France (late 1930s). De Maistre was interested in the relationship between music and painting: his early rhythmical canvases are exercises in color theory with themes and titles (like those of → MacDonald-Wright, → Hartley, → Kupka, or → Itten) that allude to compositional practice. His later European works are of a less experimental nature, a tempered → Neo-Impressionism being followed by → Surrealism then, in the 1940s, by a Post-Cubist synthesis of Cézanne and → Matisse. His interiors and still lifes are perhaps most success-

Kasimir Malevich, *Black Square on White Ground*, c. 1929, Oil on canvas, 106 x 106 cm, State Russian Museum, St. Petersburg

Man Ray , *Noire et blanche*, 1926, Photograph

Man Ray (Emmanuel Radnitzky). *1890 Philadelphia, Pennsylvania, †1976 Paris. American painter, sculptor, film-maker, and photographer. In 1909–12 he took evening classes at the National Academy of Design, New York. In 1913 he met M. → Duchamp; he began his photographic portraits and photographic experiments in 1916. In 1920 he founded the → Société Anonyme, Inc. In 1921 he moved to Paris, producing his first "rayographs" in 1921–22. In 1923 he produced his first film, *Le Retour à la raison*. In 1926 he took part in the first Surrealist exhibition at the Galerie Pierre, Paris. He fled to the US in 1940, returning to Paris in 1961; the same year he was awarded the gold medal for photography at the Venice Biennale.

After a short Cubist phase, in 1917, with Duchamp and → Picabia, Man Ray was one of the founders of the New York Dada movement (→ Dada). His oeuvre as a painter was stylistically very rich, ranging from Surrealist to Tachiste pictures. His most important contribution was experimental photographs and films and his montages, which provided a link between Dadaism and → Surrealism and had great influence on younger object artists (including → Christo and → Kienholz). Around 1919–20 his photographic work resulted in the invention of the rayograph or rayogram, in which objects are placed at angles on photographic paper which is then exposed to light (*Champs délicieux*, 1919–21). From 1921 in Paris, Man Ray extended his activities to film (*Sea Star*, 1928) and created a world of alienated objects in his poetic and amusing montages (*The Gift*, 1921). With his sensitive portrait photographs, of → Ernst, → Breton, → Dalí, Duchamp, Gertrude Stein and Paul Éluard among others, he opened up new ways of seeing. Surrealist photographs such as *Le Violon d'Ingres* (1924) are among the masterpieces of autonomous, artistic photography. H.H.

Bibl.: Man Ray, Self Portrait, 1963 · Alexandrian, Man Ray, 1973 · Penrose, Man Ray, 1975 · Schwarz, Man Ray, 1977

Alfred Manessier, *Night of Gethsemane*, 1952, Oil on canvas, 198 x 148 cm, Kunstsammlung Nordrhein-Westfalen, Düsseldorf

Manessier, Alfred. *1911 Saint-Ouen, †1993 Paris. French painter. In 1926–33 he studied architecture in Amiens and Paris (École des Beaux-Arts), and fresco techniques in 1935 at the Académie Ranson under Roger Bissière (1886–1964), joining his circle in 1935. In 1955–64 his work was exhibited at Documenta 1–3 and in 1962 at the Venice Biennale.

His first works were powerfully colored paintings influenced by → Cubism and → Fauvism. At the end of the 1930s the influence of → Surrealism could be seen in works such as *The Last Horse*, (1938). Deeply impressed by a visit to the Trappist monastery of Soligny in 1943, after 1945 he began to favor a religiously inspired abstract painting using mosaic-like, strongly colored (often blue and red) designs, reminiscent of medieval stained-glass windows, (*Pilgrims in Emmaus*, 1944; *The Crown of Thorns*, 1950). After 1966 (and a visit to Spain) his work displayed increasingly cosmic, pantheistic moods in which, principally in landscapes, the harmonious connection between man, nature, and God is revealed (*Country Festival*, 1974; *Sand Landscapes*, 1977–83). He also produced important stained-glass windows, among others for churches in Basle (Allerheiligenkirche, 1952), Essen (crypt of the cathedral, 1959), Cologne (St Gereon, 1964), and Bremen (Marienkirche, 1969), as well as designs for tapestries with religious imagery. K. S.-D.

Bibl.: Hodin, Manessier, 1972 · Manessier, Paris, 1992

Man Ray , *Le Violon d'Ingres*, 1924, Gelatin silver print, 38 x 29 cm, J. Paul Getty Museum, Malibu

Robert Mangold, *Brown Wall*, 1964, Oil on plywood and metal (2 sections), 44 x 244 cm, Hallen für neue Kunst, Schaffhausen

Mangold, Robert. *1937 North Tonawanda, New York. American painter living in New York City and Washingtonville, New York. In 1956–63 he studied art at the Cleveland Institute of Art and Yale University. In 1972–82 he exhibited at Documenta 5–7. Mangold's geometric abstractions are based on a precisely calculated, dialectical excavation of the elements of color and surface, line and geometric shape, which constitute a picture (→ Minimal art). In the mid-1960s he produced his first large-format works, known as Wall and Area pictures, made of standardized sheets of plywood and masonite sprayed with muted colors. His V, W, and X series and the following multi-part works (masonite, canvas) use the gap between the panels as an integral component in the work. This is used as a graphic element together with the finely drawn pencil line which connects the linear framework indivisibly with the whole structure. After experiments with framed formations, after 1971 Mangold's characteristic work used a contour drawn in pencil to outline a geometric shape, e. g. a circle or ellipsis, which enters into a tense relationship with the distorted, polygonal shape of the painting (→ shaped canvas). From 1986 geometric figures also appeared on a fragmented background broken up by the use of a painter's knife or roller. A.G.

Bibl.: Battock, Mangold, 1968 · Mangold, New York, 1971 · Mangold, Amsterdam, 1982 · Mangold, Akron, 1985

Manguin, Henri [-Charles]. *1874 Paris, †1949 Saint-Tropez. French painter. From 1894 he was a pupil of the Symbolist Gustave Moreau in Paris, and at the same time enjoyed a friendship with → Marquet and → Matisse, with whom he became associated with → Fauvism. In 1902–04 they held joint exhibitions at the Galerie Weill in Paris. In 1907–10 he was in in Saint-Tropez, then alternately in Switzerland, Paris, and Provence and from 1949 in Saint-Tropez again. Manguin was also associated with → Signac.

After early contact with Impressionism and the → Nabis, Manguin developed a style of painting using strong colors with a wealth of contrasts (primarily in landscapes and nudes), in which the influence of Matisse can be seen early on (*Woman with Oranges*, 1904). This later gave way to a harmonious realization using more restrained colors (*July 14 in Saint-Tropez*, 1905). K. S.-D.

Bibl.: Sainsaulieu, Manguin, 1980– · Manguin, Sète, 1994

Mann, Sally. *1951 Lexington, Virginia. American photographer living in New York. In 1971–72 she studied photography and film. Her photographic subject-matter is primarily her own family (her three children, Emmett, Jessie, and Virginia). Since 1984 her project has been to show the children in everyday situations – frequently sleeping naked or playing – and only at a second glance is it obvious that these are posed scenes which Mann has created herself. Her work raises issues surrounding the mysteries of childhood, and addresses taboo subjects, such as the sexuality of children and the subtle eroticism of young women. In addition to these family portraits, Mann also works on landscapes and still lifes, often experimenting with a great variety of photographic techniques. C.W.

Bibl.: Mann, 1994 · Mann, 1997

Manship, Paul. *1885 St. Paul, Minnesota, †1966 New York City. American sculptor. After study in the US (→ Art Students League of New York) and in Rome (1909–12), in the early 1920s Manship was in New York, though he spent time in Paris from 1922 to 1926. In 1912, → Lachaise worked as his assistant. He worked mainly in bronze and stone in an elegant but sober style, combining archaic Greek with Indian (Hindu) and to a lesser extent Art Deco (*Diana*, 1925, bronze) influences. The gilded bronze fountain *Prometheus* is a New York landmark (1933, Rockefeller Center Plaza) typical of his monumentality and mythological concerns. The prettified academicism of such work meant that it dropped out of fashion during the 1940s. His portraits (especially in marble) endure better, perhaps, as rare survivors of the representational genre in sculpture (*John D. Rockefeller*, 1918). Other much-loved monuments include a florid gateway to the Bronx Zoo, New York (1934). D.R.

Bibl.: Rand, Manship, 1989

Piero Manzoni, *Achrome*, 1958, Kaolin on canvas, 60 x 80 cm, Civicio Museo d'Arte Contemporanea, Milan

Piero Manzoni, *Base of the World*, 1961, Iron, 82 x 100 x 100 cm, Herning Art Museum, Denmark

Manzoni, Piero. *1933 Soncino near Milan, †1963 Milan. Italian painter and Conceptual artist. He briefly attended the Accademia di Brera, Milan. In 1956 he produced the manifesto *Per la scoperta di una zona di immagini*, a plea for total artistic freedom. In 1957 he founded the Gruppo Nucleare (with → Fontana). In 1958 he beame a member of → Zero. After experiments with informalism, at the end of the 1950s Manzoni began his *Achromes*, which continued until 1962. These were colorless canvases covered with a base of plaster and comprising a collage of dyed white structures or materials (kaolin, felt, cotton, polystyrene, wool, rabbit skin, bread rolls) expressing "pure energy" by analogy with the "infinite

spaces" of Fontana. In 1959 conceptual works followed, e. g. *Linee di lunghezza variabile* , which used an ink pad often on very long rolls of white paper, rolled up and locked into containers. In 1959–61 he produced blow-up sculptures (*The Breath of the Artist*).

In 1957 Manzoni with other artists signed the manifesto *Contro lo Stile*, a radical denial of traditional aesthetics which favored content over the purity and autonomy of material structures. The conceptual unity of art and life is also invoked in 1961 in *Magic Bases*, as the person standing on them is elevated to a work of art. In the same year the *Living Sculptures* were nude models or artist colleagues which Manzoni signed and thus designated as works of art. Among his most provocative works are the ninety boxes *Merde d'Artista* (*Artist's Shit*), which are labelled and addressed to be sold at the market price for gold. In the tradition of → Futurism, Manzoni's work rejected all bourgeois standards and notions of art. His attitude gained great influence on the European art scene in the 1970s (→ Nouveau Réalisme, → Fluxus, Zero, → Arte Povera). H.D.

Bibl.: Celant, Manzoni, 1972 · Manzoni, 1974 · Celant, Manzoni, 1992

Manzù, Giacomo. *1908 Bergamo, †1991 Rome. Italian sculptor who, after an initial training as a wood engraver (1919–20) and apprenticeship as a plasterer and gilder (1921), worked from 1928 as a sculptor. In 1940–54 he was professor of sculpture at the Accademia di Brera in Milan, and in 1954–60 he taught sculpture at the International Summer Academy, Salzburg (→ Kokoschka).

His work, almost exclusively dedicated to the human figure, is characterized by lively realism. Apart from the motif of dancers, his work is dominated by formally compressed depictions of cardinals, variations on the theme of lovers. and portraits (Pope John XXIII). His church doors in Rome (St Peter's, 1948–64), Salzburg (cathedral, 1955–58) and Rotterdam (St Laurenz, 1965–69) reveal his links with the sculpture of the Renaissance. His late work comprises large numbers of narrative genre depictions. I.H.

Bibl.: Rewald, Manzù, 1967 · Cremer/Emmrich/Gloede, Manzù, 1979 · Manzù, Mexico City, 1991

Mapplethorpe, Robert. *1946 New York, †1989 New York. American photographer. In 1963–70 he studied art and advertising design at the Pratt Institute, Brooklyn. In 1965–70 he worked on underground films in New York. In 1970 Mapplethorpe began to take an interest in photography and art, and among his first works were → collages and → assemblages. From 1972 he worked as a freelance photographer. Among his themes were classical subjects, such as still lifes with flowers, portraits, and, in particular, nudes. In the 1970s Mapplethorpe achieved notoriety as a photographer by portraying his usually black lovers in provocative poses. In time the New York art scene discovered him and he became one of the most sought-after portrait photographers of the 1980s. In studio shots, using artificial light, sharp contrasts and a black-and-white technique, Mapplethorpe lent his models the character of classical sculptures. It is said that through his

Robert Mapplethorpe, *Milton Moore*, 1980, Gelatin silver print, 38.1 x 38.5 cm, Museum Ludwig, Cologne

friendship with the American singer Patti Smith, Mapplethorpe turned from blatantly homosexual themes to more subtle subjects such as flower arrangements. C.W.

Bibl.: Mapplethorpe, New York, 1988 · Mapplethorpe, Some Woman, 1989 · Mapplethorpe/Danto, Mapplethorpe, 1992

Marc, Franz. *1880 Munich, †1916 Verdun. German painter. Initially he studied theology and philosophy, and from 1900 attended the Kunstakademie, Munich. In 1903 and 1907 he visited Paris. Early one-man exhibitions were in Munich in 1910 and in 1911 (Galerie Thannhauser). He left the → Neue Künstlervereinigung München, co-founding the publishing and exhibition society of Der → Blaue Reiter. In 1913 he exhibited at the Erster Deutscher Herbstsalon. In 1916 a memorial exhibition was held at Der → Sturm gallery, Berlin.

Marc is one of the most important German painters of the 20th century. After early work in the style of the realist Munich School, he developed an expressive, abstract style which revealed a transcendental world view related to the Romantic philosophy of nature. His meeting with → Kandinsky in 1911 encouraged Marc's development towards a more powerful abstract art, and he moved from his previous realistic animal motifs to colorful symbols of purity and spirituality (*The Large Blue Horses*, 1911). In the circle of the Blaue Reiter, founded by Marc and Kandinsky, he encountered like-minded artists (→ Münter, → Macke, → Klee, → Jawlensky), who also wanted to go beyond observation of nature and reach a deeper understanding of the world. The most important medium of expression for this

Franz Marc, *In the Rain*, 1912, Oil on canvas, 81 x 105 cm, Städtische Galerie im Lenbachhaus, Munich

Franz Marc, *Blue Horse I*, 1911,
Oil on canvas, 112 x 84.5 cm,
Städtische Galerie im Lenbach-
haus, Munich

deeper investigation of the "essential" was the
symbolic power of color, as well as the Futurist
and Cubist analysis of motif, which in Marc was
re-interpreted as cristalline abstraction and pris-
matic interrelationships which led to metamor-
phosis into the spiritually pure (*Fate of the Ani-
mals*, 1913). How this individual pictorial lan-
guage (*Fighting Forms*, 1914) might have devel-
oped can be seen in Marc's *Sketchbooks from the
Field of Battle* (1914). Marc was killed at Verdun in
1916. H.D.

Bibl.: Levine, Marc, 1979 · Marc, Berkeley, 1979 · Moeller, Marc,
1989 · Franz, Marc, 1994 · Hünecke, Marc, 1994

Gerhard Marcks, *Venus of
Thuringia*, 1930, Bronze, height
177 cm, Gerhard-Marcks-
Stiftung, Bremen

Marcks, Gerhard. *1889 Berlin, †1981 Burgbrohl.
Self-taught German sculptor and graphic artist.
From 1911 he worked for porcelain manufactur-
ers at Schwarzburg and Meissen. In 1914 he was
in Paris. In 1919–25 he managed the Bauhaus
ceramics workshop in Dornburg. From 1921 he
took up wood engraving, inspired by L.
→ Feininger. In 1925 he was made professor of
sculpture at the Kunstgewerbeschule Burg
Giebichenstein, Halle. In 1933 he was dismissed
from his teaching post and in 1937, in Berlin,
banned from exhibiting. After the war in
1946–50 he became professor at the Landeskun-
stschule Hamburg. In 1946–48 he added six ter-
racotta figures to → Barlach's works at the
Katharinenkirche in Lübeck. From 1950 he lived
in Cologne.

Marcks' work began with animal sculpture
and experiments in the manner of → Jugendstil,
with different materials (particularly porcelain
and ceramics). From 1910 the human form dom-
inated, focusing attention on his rejection of the
academic style around 1900. At the Bauhaus he
produced late Expressionist abstract wood carv-
ings (*Woman Standing*, c. 1922) and geometric
ceramics. From the mid-1920s, under the
influence of Greek antiquity, his work changed,
producing sensual, powerful, and austerely mod-
eled figures (*Venus of Thuringia*, 1930). This change
also marked his later, more spiritual figures
(*Swimmer*, 1938). The later work aims at a syn-
thesis of natural forms and abstraction (memo-
rials, bronze church doors; *Prometheus Bound*,
1948). H.O.

Bibl.: Busch/Rudloff, Marcks, 1977 · Marcks, 1989 · Lammek, Mar-
cks, 1991 · Rudloff, Marcks, 1993

Marden, Brice. *1938 Bronxville, New York. Amer-
ican painter living in New York. In 1958–61 he
studied at Boston University's School of Fine and
Applied Arts, and in 1961–63 at Yale University
(with J. → Albers). In 1964 he had his first one-
man exhibition. In 1969–74 he took a teaching
post at the School of Visual Arts, New York. In
1972, 1977, and 1992 he exhibited at Documenta
5, 6, and 9.

Marden emerged In the 1960s with mono-
chrome works which, looking back to art-histori-
cal models, revived American → Color Field
Painting. Although he started from the flatness
of the abstract canvas, as the exponents of Radi-
cal Painting demanded, by the addition of
beeswax and other substances he endeavored to
achieve a particular materiality and chromatic
expression, without submitting to rigid precepts.
Multi-sectioned, austerely composed panels (e. g.

Brice Marden, *Humilatio (Subjugation)*, 1978, Oil and wax on
canvas, 213 x 244 cm, Museum Ludwig, Cologne

Interrogatio, 1978, from the series *Annunciation*)
alternated with monochrome paintings and
multi-colored stained-glass window designs. At
the beginning of the 1980s, under the influence
of Far Eastern calligraphy and poetry and → Pol-
lock's late work, Marden began a free, gestural
type of painting which opened up subjective,
emotional spaces amid a web of brushstrokes
(*Cold Mountain* series, 1988–91). H.D.

Bibl.: Marden, Amsterdam, 1981 · Marden, Berne, 1993 · Rose,
Marden, 1995

Marin, John. *1870 Rutherford, New Jersey, †1953
Cape Split, Maine. American painter who. from
1899 to 1901. studied painting at the Pennsylva-
nia Academy of Fine Arts, Philadelphia, and from
1901 to 1903 at the → Art Students League of New
York. In 1905–10 he visited Paris. From 1914 he
lived in Maine. His earliest landscape watercolors
date from 1888. His professional career began
with his move to Paris. From 1909 he was in
touch with → Stieglitz, to whom he owed his first
one-man exhibition. In oil paintings, water-
colors, drawings, and from 1905 in etchings
Marin captured city landscapes in Europe, the
streets of New York, the coast of Maine and, from
1930, circus scenes. His sketch-like style with a
tendency to the abstract is in keeping with the
atmosphere (*Street Scene, Abstraction*, 1917). M.G.

Bibl.: Fine, Marin, 1990

Marinetti, Filippo Tommaso. *1876 Alexandria, Egypt, †1944 Bellagio. Italian art theorist. Marinetti arrived in Paris in 1893 where, while "sharing digs with stokers," he made a successful literary debut in Symbolist free verse. On February 20, 1909, he published his celebrated "Futurist Manifesto" (in French) in *Le Figaro*. Provocatively worded, iconoclastic, and aphoristic, partially leaning on the writings of Papini and an idiosyncratic reading of Nietzsche and Bergson, it urged for the destruction of museums and extolled speed, the automobile, and all things mechanical, as well as trumpeting the purgative virtues of the only effective "hygiene": war. The "Political Manifesto" followed in 1909, with the *Manifesto dei pittori futuristi* being signed by → Balla, → Boccioni, → Severini, → Russolo, and → Carrà in 1910, while a "Technical Manifesto of Futurist Literature" appeared in 1912. Marinetti's influence also exerted itself in other countries he visited: Russia, as → Futurism and → Cubo-Futurism; and England, as → Vorticism and in the work of → Nevinson. With theories extending to dance and drama, Marinetti's literary ideal was *parole in libertà* or *Parolibere* ("Words in Freedom"), grounded in typographic audacity and concrete poetry. Originally his politics were anti-clerical and leftist, and after World War I, in the "Second Futurism," he endeavored with Balla and a new generation of artists to keep the flame alive against the rising tide of conventional Fascist art. By 1924, however, he seemed content to allow the movement to abscond from the social, leaving politics in the hands of "a President of the Council with a marvelous Futurist temperament": Mussolini (article, "Futurism and Fascism"). By 1942, the one-time *avant-gardiste* was unedifyingly extolling the Axis war machine as *poesia armata*. D.R.

Marini, Marino. *1901 Pistoia, †1980 Viareggio. Italian sculptor and painter. From 1917 to 1922 he attended the Accademia in Florence. From 1922 he studied sculpture in Monza under Arturo → Martini. In 1940 he became professor at the Accademia di Brera, Milan. In 1931–33 he undertook trips to France, England, and Belgium where he met → Tanguy, → Kandinsky, de → Chirico, and → González. From 1935 he produced series of works with figures of riders and the goddess Pomona. In 1942–46 he was in Switzerland, then in Milan. In 1928, 1948 (special show), and 1952 his work was shown at the Venice → Biennale. He also exhibited at → Documenta 1, 2, and 3. In 1973 the Marini Museum in Milan was opened; another was opened in 1986 in Florence.

Marini dedicated himself in equal measure to sculpture and painting: his sculptures were usually painted. His work, restricted to a few motifs (female nudes, portraits, horse and rider figures, artists, and traveling entertainers), is stylistically diverse and shows signs of being inspired by Etruscan art (using archaic goddess figures), → Maillol (Pomona series, the goddess of fertility), and after World War II by Cubist or abstract geometric styles. His materials were plaster, terracotta, wood, and bronze. The increasingly expressive treatment of the surface emerges in the same way in his painting (use of spatula, brush handle,

pointed objects). In the horse and rider figures Marini breaks away from the tradition of monuments to emperors and heroes which prevailed in the 19th century. For Marini the rearing or stumbling horse and the falling rider are symbols of the suffering individual. I.S.

Bibl.: Hammacher, Marini, 1970 · Waldberg, Marini, 1974 · Guastalla, Marini, 1991

Marquet, Albert. *1875 Bordeaux, †1947 Paris. French painter, graphic artist, and book illustrator. He studied at the École des Beaux-Arts in Paris under Gustave Moreau, and while there met → Matisse. He was an exponent of → Fauvism. He spent time in 1912 with Matisse in Morocco; in he 1940–45 was in Algiers.

His early works used tonal impasto. Around 1900 he created his first Fauvist pictures with strong color contrasts (*Nu, dit fauve*, 1898). From around 1910 a clarified pictorial structure with muted colors (with thinly applied, matt paints) characterized his work, which included atmospheric portraits and landscapes (frequently marinas, harbors, cityscapes, the banks of the Seine in Paris), in which Fauvism (in the method of painting) and Impressionism (in the motifs and compositional framing) are combined. From 1925 he favored watercolors. K.S.-D.

Bibl.: Marquet, Bordeaux/Paris, 1975 · Daulte, Marquet, 1995

Marsh, Reginald. *1898 Paris, †1954 Dorset, Vermont. American painter and printmaker. Marsh was born in France of American artist parents, Fred Dana Marsh (1872–1961) and Alice Marsh (née Randall), and returned to the US with them in 1900. He later studied at Yale University and in 1925 traveled to Europe, where he copied Old Masters. He moved to New York, attending the → Art Students League of New York (1927–28), drawing for *Vanity Fair* and *The New Yorker*, and becoming a "Fourteenth Street" painter. His early scenes of seedy New York street life (sometimes taken from photographs) – with subjects such as Times Square, Coney Island Beach, the elevated railway (*Why Not Take the "L"*, 1930), and the Bowery (*Tattoo and Haircut*, 1932) – were lively and colorful. His satirical but not overtly political work

Arturo Martini, *Hope*, 1930–31, Terracotta and wood, 160 x 70 cm, Private Collection

Marino Marini, *Rider*, 1947, Bronze, 163.8 x 154.9 x 67.3 cm, Tate Gallery, London

(*The Bowery – Strokey's Bar*, 1953) had themes such as prostitution, the circus, and the revue bar (*Down at Jimmy Kelly's*, 1936). His late pieces are similar in spirit if less colorful. D.R.

Bibl.: Cohen, Marsh, 1983

Martin, Agnes. *1912 Maklin, Saskatchewan, Canada. Canadian-born painter living in Galisteo, New Mexico. She lived in the US from 1932, attending Columbia University, New York, in 1941. From 1947 she took various teaching posts (including University of New Mexico). 1957–67 was her main productive phase in New York. A subsequent seven-year gap in work was connected with her move to New Mexico, but in 1974 she linked up almost seamlessly with her earlier work.

After figurative and biomorphic abstract pictures, in the 1960s geometric abstractions appeared which brought Martin recognition. In 1963 she reduced the surface of her graphic and painterly works to a network of fine points, strokes, and lines, which often extended to the edge of the square formats. These developed into pure grid structures, and, from the 1970s, to purely horizontal linear compositions. Martin's works have been linked to → Minimal art, because of their reductive pictorial language, but with her subtle structural nuances and her concept of art as a medium for developing consciousness, influenced by Far Eastern philosophies, Martin should really be seen as belonging to the spiritual environment of → Abstract Expressionism. A.G.

Bibl.: Martin, Munich, 1974 · Schwarz, Martin, 1992 · Martin, New York, 1993

Agnes Martin, *Mountain Flower*, 1985, Acrylic and graphite on canvas, 183 x 183 cm, The Pace Gallery, New York

Martin, Mary (née Balmford). *1907 Folkestone, Kent, †1969 London. British painter, and construction and relief artist; trained at Goldsmiths School of Art and the Royal School of Art, London. Often collaborating with her husband sculptor, Kenneth Martin (1905–1984; married 1930), she was a leading figure in British → Constructivism who leant towards → Op art. Leaving off landscape in 1950, she began with incised cuboids (*Columbarium*, 1951), then specialized in Perspex, formica, steel, and white- (and occasionally later black-) painted wood reliefs, alongside strictly mathematical yet visually perturbing variants on the (primarily) rectilinearly divided square or cube: *Expanding Permutation* (series of 10, 1969) centers on the half-square. Primary colors can appear as outlines on reliefs (*White-faced Relief*, 1957). Freestanding pieces appeared in the mid-1950s, though later she became best known for massive wall-mounts (large panels for the University of Sterling, 1969). For Martin, the artist "must have a capacity to enter into the architecture without dominating it or distracting from it [...] or becoming decorative." D.R.

Martini, Alberto. *1876 Oderzo, near Treviso, †1954 Milan. Italian painter and graphic artist. Martini's work created a world of imaginative, macabre, erotic, and grotesque scenes (etchings, drawings, lithographs, and more intensively from 1911 paintings). He was one of the most important representatives of Italian → Symbolism. Through his contacts with → Jugendstil artists (Max Klinger in Munich) and acquaintance with the works of Jan → Toorop, among others, Martini also moved towards › Surrealism. After 1911, (e.g. in portraits such as *Vittorio Pica*), he anticipated essentially Surrealist forms in his formal simplification and nightmarish reductions to erotic and fantastic elements. In spite of his Surrealist contacts, made during his 1920s' stay in Paris, Martini took no part in their exhibitions. K.S.-D.

Bibl.: Belloli, Martini, 1954 · Martini, 1978

Martini, Arturo. *1889 Treviso, †1947 Milan. Italian sculptor and painter. Initially he was apprenticed as a goldsmith and ceramicist, and later as a sculptor. In 1907 he studied at the Accademia in Venice, before embarking on study trips to Paris and Munich. In 1929 he was appointed to the Accademia in Monza. In the 1930s he received numerous commissions for public buildings. Despite his rather conventional formal language he is considered to be one of the most eminent Italian sculptors of the 20th century. His work, inspired by an ancient Roman and Etruscan style, remained largely realistic despite a tendency towards formal simplification, and took as its theme the representation of the human form. Most of his work is of the genre or narrative type and treats sacred or mythological motifs. Towards the end of the 1930s his creativity was in crisis. In search of a new, artistic language he started to create abstract works which, however, he destroyed. In his 1945 publication *Sculpture – a dead language* he analyzed the state of sculpture. Subsequently, but for a few public commissions (Milan town hall, University of Padua), he devoted himself exclusively to painting. I.H.

Bibl.: Peroco, Martini, 1962 · Martini, Milan, 1991 · Vianello, Martini, 1991

Masereel, Frans. *1889 Blankenberghe, †1972 Avignon. Belgian painter and graphic artist. In 1907–08 he attended the Hoger Institut voor Beeldende Kunsten, Ghent. From he 1909 traveled, visiting London and Paris, and producing his first etchings and woodcuts. His pacifist beliefs led to his work, in 1917–20, on a large number of Indian ink drawings for newspapers (*Demain*, *Les Tablettes*, and *La Feuille*). These were

produced in an expressive style which defined his further work (sharp-edged shapes divided into strong black-and-white areas). Inspired by literary illustrations, he produced picture stories, e.g. *My Book of Hours* (1919). Until 1922 he worked for the periodicals *La Lumière* and *Clarté*, and in 1928 for *Le Monde*. His socially committed, expressive woodcuts made him famous throughout Europe. From 1920 he dedicated himself with greater intensity to painting; his watercolor series appeared from 1925 to 1927, parallel to many woodcuts for Romain Rolland's *Jean Christophe*, and from now on formally oriented towards Indian ink painting (*La Sirène*, 1928). As well as this, he created interiors, and film and stage-set designs. In 1940 he fled from Paris and worked on anti-Fascist pamphlets, with war as his central subject (*La colère*, 1944–45). After 1948 he returned and further developed his prewar motifs, especially the city landscape. M. G.

Bibl.: Vorms, Masereel, 1967 · Masereel, Ghent, 1986 · Hofmann, Masereel, 1989 · Ritter, Masereel, 1992

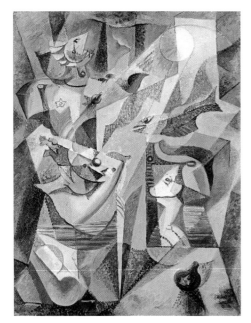

André Masson, *La Figue*, 1924, Oil on canvas, 65 x 50 cm, Private Collection, Paris

Masson, André. *1896 Balagny-sur-Thérain, †1987 Paris. French painter and graphic artist. From 1907 he studied art in Brussels, and from 1912 in Paris. In 1914, during his military service, he was severely and traumatically wounded. In 1922 he returned to Paris, making contact with the Surrealist circle around → Breton, to which he belonged until 1929, and then again from 1937. In 1939 he emigrated to New York, then Connecticut. After 1945 he returned to Paris and Aix-en-Provence. His work appeared in 1955–64 at → Documenta 1–3. In 1964 a retrospective was held in Berlin (Hochschule der Künste) and Amsterdam (Stedelijk Museum). In 1972 he exhibited at the Venice → Biennale.

Masso's early work is closely linked to analytical → Cubism. From the 1920s battle scenes and cosmic dramas with birds and fish as central motifs appeared, dealing with issues of wounding and death, and clearly conditioned by his traumatic war experiences. Through contact with the Surrealist group, Masson was inspired to produce abstract paintings with semi-automatic calligraphic drawings and sand collages (*Man and Woman*, 1926–27). Through the evocation of secret ciphers Masson sought an "allusion to elementary life" (Masson), which is in constant metamorphosis. During his period in New York, Masson's poetic pictorial language influenced the young painters of → Abstract Expressionism and pointed the way towards → Art Informel. Besides much graphic art, he also produced book illustrations and sculptural works. K.S.-D.

Bibl.: Lanchner, Masson, 1976 · Masson, Nîmes, 1985 · Masson, London, 1987 · Masson, 1994

Mataré, Ewald. *1887 Aachen, †1965 Büderich, near Düsseldorf. German sculptor, graphic artist, and painter. In 1907–12 he attended the Hochschule der Künste, Berlin. In 1918 he became a member of the → Novembergruppe. In 1932 he was made professor at the Kunstakademie Düsseldorf; he was dismissed in 1933 but returned in 1945–57. From beginnings as a painter, from 1920 Mataré moved into sculpture and woodcuts. In both these areas the representation of animals as a symbol of unity dominates. Distinct divisions between surface and body emerge more and more geometrically and graphically, the polished woods emphasizing the tactile and the material itself. He also produced idol-like torsos, portraits, and, from 1930, religious themes (doors for Cologne Cathedral). H.O.

Bibl.: Mataré, Cologne, 1987 · Schilling, Mataré, 1987

Material art. Art form which uses everyday found objects (→ objets trouvés) or industrially prefabricated (→ ready-made) objects and materials which are ostensibly alien to art, and makes them into artistic works by means of → collage, → assemblage, and → montage. → Braque and → Picasso first used such alien elements for montage in 1907 (e.g. cuttings from newspapers, wood shavings, business cards) in their collages and extended the symbolic realm of what is reproduceable in the traditional art work to include elements which already possess real meanings, such as practical objects and lettering. Russian → Constructivism, from which the term Material art is derived, stresses the technical, and the → Dada movement emphasizes the ironic aspects of the material and the ways it can be combined. In the course of the → Neo-Dada movement new versions emerged, which can also be regarded as belonging to Material art. → Rauschenberg's → combine paintings link elements of collage with expressive painting. The poeticizing of everyday objects, already attempted by → Schwitters, spread to the area of sculpture too (→ Chamberlain and → César's → accumulations). The assemblages of the New Realists (→ Nouveau Réalisme) of the 1960s emphasize even more strongly the "junk" aspect of the objects used (→ Kienholz, → Spoerri, → Tinguely). W.S.

Bibl.: Kultermann, Plastik, 1967

Mathieu, Georges. *1921 Boulogne-sur-Mer, Pas de Calais. Self-taught French painter and sculptor. He began to paint in 1942, and from 1947

Henri Matisse, *Blue Nude IV*, 1952, Gouache cut-out, 103 x 74 cm, Musée Henri Matisse, Nice

Matta, *The Birth of Man*, 1982, Oil on canvas, 182 x 210 cm, Private Collection, Geneva

Henri Matisse, *Still life with the "Dance"*, 1909, Oil on canvas, 89 x 116 cm, Hermitage, St Petersburg

turned to abstract art. He founded the group Non-figuration physique which was close to → Tachisme. In 1952 he traveled to the US and in 1959 exhibited at Documenta 2. From 1962 he worked on large sculptures, designs for furniture, tapestries, and murals. With his non-figurative, improvizational methods, Mathieu is regarded as a typical exponent of → Art Informel. Inspired by Far Eastern calligraphy, he introduced the fast, direct painting process (e. g. 1956 action painting for the Théâtre Sarah Bernhardt in Paris), transferring symbols in calligraphic form to picture surfaces previously under-painted in bright colors (*Dana*, 1958) often in large format. He was also an important art theorist (most recently: *Désormais seul en face de Dieu*, 1998). K.S.-D.

Bibl.: Mathieu, Tachisme, Paris, 1963 · Grainville/Xuriguera, Mathieu, 1993

Matisse, Henri. *1869 Le Cateau, Picardy, †1954 Nice. French painter, sculptor, and graphic artist. In 1891 he began his studies at the Académie Julian; then in 1893 at the École des Beaux-Arts (under Gustave Moreau); finally in 1898–99 at the Académie Carrière, Paris. In 1904 his first solo exhibition was held in Paris. He exhibited in 1905 at the → Salon d'Automne. In 1911–12 and 1913 he traveled to Morocco. From 1918 he lived in Nice. His work appeard in 1950 at the Venice Biennale.

The gradual development from 1905 via Impressionism and → Neo-Impressionism to → Fauvism led Matisse to search for perfection and harmony in color and composition (*Still life with Oranges*, 1913). Consequently he dedicated himself to inherent value in color, stressing in his theoretical writings color's powers of expression as the central factor in painting (*Notes d'un peintre*, 1908). Matisse derived from Fauvism a new understanding of chromatic harmony and expressed this during his Nice period (1916–29) nourished, among other things, by oriental impressions (Morocco), of interiors with lavish floral decor and odalisques (*Decorative Figure in front of an Ornamental Ground*, 1925). In drawing too Matisse achieved similar success by giving the linear contour a new autonomous unity (e. g. in numerous pencil-and-pen drawings). The decorative linking of color and line is clear in his paintings of the 1930s and 1940s, in large-scale stylized shapes and muted colors, embedded in floral arabesques. His aspiration towards harmony, purity, and equilibrium reached its climax in the decoration for the monastery chapel of Notre-Dame du Rosaire in Vence near Nice (1949–51),

for which he also created stained-glass window designs, and in his cut-out paper shapes painted in gouache (*gouaches découpées*), which he combined into abstract expressive rhythms (*Zulma*, 1950). Besides his painterly and graphic work (illustrations, for example, for Mallarmé's *Poésies*, 1932), Matisse also created stage sets (Stravinsky's *Le Chant du Rossignol*, 1919) and several important sculptures (*The Back IV*, c. 1930). H.D.

Bibl.: Schneider, Matisse, 1984 · Flam, Matisse, 1988 · Elderfield, Matisse, 1992 · Bois, Matisse, 1993 · Clement, Matisse, 1993 · Néret, Matisse, 1996

Matta, *Kruzifix him*, 1947, Oil on canvas, 149 x 195.6 cm, Collection of Mr. and Mrs. Harry Spiro, New York

Matta (Roberto Sebastian Antonio Matta Echaurren). *1911 Santiago, Chile. Chilean painter and draftsman living in Paris and Tarquinia, Italy. In 1926–32 he studied architecture and from 1934 worked in → Le Corbusier's architectural office. In 1937 he collaborated on the Spanish pavilion for the Exposition Universelle, Paris, and met → Breton. In 1938 he participated in the Surrealists' exhibition at the Galerie des Beaux-Arts. From 1940 to 1948 he was in New York. Expelled from the Surrealist group because of "intellectual disqualification and moral ignomiy", he subsequently spent 1949–54 in Rome. In 1957 his first large retrospective was held at MOMA, New York.

Matta's early Surrealist-influenced "psychological morphologies" of 1937 are visual correlations to various states of consciousness. In New York he became friendly with M. → Duchamp, → Gorky, and → Motherwell and became a propagandist for Surrealism. From his painterly beginnings he had been interested in only one theme: a vision of the unity of man and cosmos (series *The Earth is a Man*, 1941). The interplay of an indeterminate "cosmic" space and a world of symbols and bodies incorporated into it is his instrument for imagining a humanly inhabited cosmos. These anthropomorphic symbols originated in early years from hallucinatory submissions to his own psychic stimuli and dream experiences. Later, after the shock of the war, they took on a more human, but also more aggressive, form. Matta's visionary cosmic landscapes had a significant influence on → Pollock, → Rothko, and the → New York School. E.B.

Bibl.: Sabatier, Matta, 1975 · Matta, Paris, 1985 · Ferrari, Matta, 1986 · Ferrari, Matta, 1996

Matta-Clark, Gordon. *1943 New York, †1978 New York. American Conceptual artist, the son of → Matta. In 1962–69 he studied architecture at Cornell University, and, in 1963–64, French

literature in Paris. He never really practised as an architect in the true sense. During his student days he produced site-specific installations in the area around the Ithaca reservoir. In the following years the connection between nature and architecture dominated his projects and performances (*Tree-House*, 1971). In 1971 he embarked on his first venture into a type of architecture and artistic principle which from then on would determine his work. He used unoccupied rooms, and even whole buildings, houses, and warehouses destined for demolition as sculptural material by treating the structures as volumes to be altered by divisions, cut-out sections, and openings, thus creating new ways of perceiving space (*A W-Hole-House*, Milan, 1973; *Splitting*, Englewood, 1974). At the same time he revealed the hidden, tectonic construction of buildings and urban underground structures. Some of the cut-out segments were later exhibited in galleries, while the buildings themselves fulfilled their fate of demolition. Matta-Clark usually produced preparatory drawings and plans and then documented his projects photographically, habitually cutting up the photographs and making them into collages, in order to make the high degree of spatial complexity into a visual experience. Matta-Clark's works are to be seen as commentaries on social conditions and an aesthetically revolutionary social protest against conventions in art and architecture. Many of his ideas (e.g. suspended balloon structures or floating park complexes) remain visionary. I.H.

Bibl.: Brunelle, Matta-Clark, 1974 · Matta-Clark, Chicago, 1985 · Breitwieser, Matta-Clark, 1997

Gordon Matta-Clark, *Splitting*, 1977, Cibachrome, 76.2 x 101.6 cm, Private Collection

Mattheuer, Wolfgang . *1927 Reichenbach, Vogtland. German painter living in Leipzig. After training in lithography, military service, and an escape from the Soviets as a prisoner of war, Mattheuer attended the Kunstgewerbeschule in Leipzig. In 1947–51 he studied at the Leipzig Hochschule and in 1965–74 gained a professorship. In 1978 a retrospective was held at the Museum der bildenden Künste Leipzig. Mattheuer, with → Heisig and → Tübke, was among the founders and most important exponents of the so-called Leipzig School, an unusual feature of which was that it offered, within → Socialist Realism, a broad spectrum of media delivered by three completely different artistic personalities with differing artistic concepts. Mattheuer, who liked to relate this work to German Romanticism, Caspar David Friedrich in particular, is also close to → Magic Realism in his painting and his strongly expressive large-scale

Wolfgang Mattheuer, *Fright*, 1977, Oil on hardboard, 125 x 100 cm, Ludwig Galerie, Schloß Oberhausen

woodcuts. His pictures take a stance in political and social debates, but can be rather cryptic for the observer. His objective, yet smooth and firmly contoured method of painting appears to be easy to read, but in its hiatuses and symbolic codings it almost always indicates a deeper level of significance beyond the eye-catching surface. E.H.

Bibl.: Gaßner, Mattheuer, 1988 · Schönemann, Mattheuer, 1988 · Mattheuer-Neustädt, Bilder, 1997

Meidner, Ludwig. *1884 Bernstadt, Silesia, †1966 Darmstadt. German painter and graphic artist. In 1903–05 he attended the Königliche Kunstschule in Breslau. In 1906–07 he was in Paris. In 1912 he founded the group of painters Die Pathetiker with Richard Janthur (1883–1950) and Jakob Steinhardt (1887–1968). In 1913–16 he worked in Berlin; he undertook military service from 1916 to 1918. His first publications were *Im Nacken das Sternenmeer* and *Septemberschrei*. In 1919 until 1935 he was back in Berlin, but was soon persecuted as a "degenerate" artist. He moved temporarily to Cologne but in 1939 escaped to England, where he was interned. In 1952 he returned to Germany and in 1955 created a studio in Marxheim near Hofheim, Taunus. In 1963 he moved to Darmstadt. In 1964 he was awarded the Grand Cross of Merit. He was a member of the Berlin Akademie der Künste.

In 1912 Meidner began to work on Expressionist city landscapes, characterized by apocalyptic

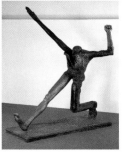

Wolfgang Mattheuer, *Step of the Century*, 1984–85, Painted bronze, 265 x 90 x 230 cm, Ludwig Galerie, Schloß Oberhausen

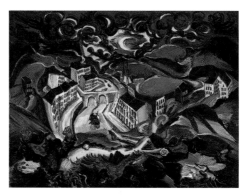

Ludwig Meidner, Crescent Moon Landscape, 1916, Oil on canvas, 80 x 100 cm, Museum Ostdeutsche Galerie, Regensburg

catastrophes (*The Burning City*, 1913). Images of devastation and despair conjured up the approaching world war (*Trenches*, 1912). He also produced self-portraits and portrait drawings in which he captured many personalities from the Berlin art scene. From 1919 to 1935 in Berlin he began to create graphic works, influenced by his Jewish background. Plagued by self-doubt, Meidner gave up painting completely, preferring to make his mark writing stories for a Berlin newspaper and, from 1935 in Cologne, teaching drawing (graphic cycles *Allegories*, 1935, and *Visions*, 1938). W.G.

Bibl.: Grochowiak, Meidner, 1966 · Hoffmann, Meidner, 1985 · Eliel, Meidner, 1990

Gerhard Merz, *Victory of the Sun 1987*, 1987, Installation, Kassel, Documenta 8

modeling the surroundings for his pictures himself by painting the walls of exhibition rooms with monochrome mineral paint. His points of reference were primarily derived from Italian Rationalism of the 1930s, from which he derived the term Archipittura. The first programmatic work using this concept was *ED IO ANCHE SON ARCHITETTO* in 1988. A further exploration is his contribution (window-less cube with a frieze of neon tubes) at the Venice Biennale of 1997. D.S.

Bibl.: Merz, Baden-Baden, 1987 · Riese, Merz, 1996

Merz, Mario. *1925 Milan. Italian sculptor, painter, and draftsman living in Turin. He studied medicine briefly, and was a member of an anti-Fascist resistance group. In 1946–49 he lived in Rome and Paris. His first one-man exhibition was in Turin (Galerie La Bussola) in 1954. In 1960–65 he produced spiral pictures influenced by → Art Informel. In 1968 he created his first igloos. 1972–82, and 1992 saw his work exhibited at Documenta 5–7 and 9; and in 1976 at the Venice Biennale. After 1966 Merz distanced himself from the worn-out gestures of Art Informel and searched for metaphors connecting nature and culture in objects themselves. Neon tubes and neon writing, isolated or in combination with everyday things, such as bottles and umbrellas, were used to convey a new understanding of art which sought to articulate elementary needs through simple materials (→ Arte Povera). Merz was interested in the "silent demonstration" of natural things (twigs, stones, slate, wax, wood) in archetypal methods of handling, collecting, laying or stacking, in order to transfer their inherent energy to the observer. From 1968 Merz

Merz, *Kurt Schwitters*, Merzbau, 1933, Sprengel-Museum, Hanover

Merz. Chief work of the Dada artist → Schwitters. A mixture of → montage, → assemblage, and → environment, the Merz-Bau (Merz building), the "Cathedral of Erotic Misery" (Schwitters), was conceived as a → Gesamtkunstwerk, which grew over time throughout all the floors of his house in Hanover. During his period in Oslo, Schwitters began a second Merz-Bau in 1937, and from 1940 a third in Little Langdale in Westmorland. All the Merz buildings were destroyed during the war. The artist derived the term Merz from a distorted form of the word Commerzbank seen in a collage. K.E.

Bibl.: Elger, Merzbau, 1986

Mario Merz, *Lizard*, 1978, Canvas and neon tubes, 280.7 x 233.7 x 10.2 cm, Anthony d'Offay Gallery, London

Merz, Gerhard. *1947 Mammendorf, Upper Bavaria. German painter, sculptor, and installation artist living in Berlin. From 1964 to 1967 his early work was expressive and painterly under the influence of → Bacon. In 1969–73 he attended the Kunstakademie Munich, and in 1977 exhibited at Documenta 6. His work in the period 1971–78 consisted of metal sculptures and line pictures drawn with thin pencil strokes, and a series of monochrome panels. He subsequently extended his inventory with the use of texts (*I love my time*, *Die Lage ist normal*). Around 1980 he began to integrate photographs into his screen-prints. From 1984 he created site-specific paintings,

Mario Merz, *Objekt Cache Toi*, 1968, Metal, wire netting, white fabric, pink and white sewing thread, neon tubes, 210 x 110 cm, Staatsgalerie Stuttgart

found in the igloo a metaphoric form for the connection between interior and exterior, for something which sheltered and protected, and also for the transitory and fleeting character of natural processes. Neon installations using the Fibonacci sequence (where each figure is equal to the sum of the two preceding figures), begun in 1969, make clear the processes of reproduction, illumination, and growth. Around 1977 Merz returned to gestural chromatically intense painting, but in combination with objects, the Fibonacci sequence, and other iconographic motifs. H.D.

Bibl.: Szeemann, Merz, 1985 · Celant, Merz, 1989 · Merz, Prato, 1990 · Eccher, Merz, 1995

Messager, Annette. *1943 Berck-sur-Mer. Sculptor living in Malakoff near Paris. She studied at the École des Arts décoratifs, Paris, in 1962–66. Her central theme since the 1960s has been the realm of the female, whereby she works autobiographical collections of objects (embroidery, stuffed animals, e.g. sparrows dressed in little sweaters; drawings and photographs) into → environments. Making numerous references to advertising, commercial cinema and the press, she plagiarizes and ironically depicts a world of women. In the 1980s (*Chimères*; *Effigies*; *Trophées*), she produced series based on anatomical photographic fragments, with monster-like creatures and threatening signs illustrating the theme of bodies and beautification. More recent works combine photographs, soft toys, and morality texts in apparently magical arrangements. K. S.-D.

Bibl.: Messager, Paris, 1995

Metzinger, Jean. *1883 Nantes, †1956 Paris. French self-taught painter. In 1911 he published *Du Cubisme*. In 1912 he became a member of → Section d'Or. After Neo-Impressionist and Fauvist beginnings Metzinger belonged to the inner circle of the Cubist painters (1911 Cubist group exhibition at the → Salon des Indépendants). As a theorist he took part in discussions about content, subject, and method in → Cubism. In his portraits, still lifes, and landscapes (*Cubist Landscape*, 1911) he remained, in spite of some geometric reduction, in the realm of the representational. After a phase of "Constructive Realism" (1920–24) he returned to Cubist facetting. H.D.

Bibl.: Metzinger/Gleizes, Cubisme, 1980 · Moser/Robbins, Metzinger, 1985 · Nikiel, Metzinger (in preparation)

Michals, Duane. *1932 McKeesport, Pennsylvania. American photographer living in New York. Until 1953 he studied art at the university in Denver. In 1958 he went to Russia and began his first photographic works. In 1977 he exhibited at Documenta. From 1960 he produced a series of portraits of artists (including → Warhol and → Matisse). He was intensively involved in → Surrealism and subsequently, from 1966, produced narrative picture sequences, with shades of the unreal and sometimes bizarre (*Sequential Stories*), to which from 1974 he often added explanatory texts. He often works with multiple exposures or simple black-and-white shots. His central themes are Eros (*A Young Girl's Dream*) and death (*Death comes to the Old Lady*), coincidence and dream, spirit and cosmos.

His conceptual method of producing pictures (in the studio) had a great influence on American photography in the 1970s. The interplay between reality and fiction, everyday and sophisticated culture made him one of the strategists of → Postmodernism in the 1980s. K.S.-D.

Bibl.: Bailey, Michals, 1975 · Livingstone, Michals, 1997

Henri Michaux, *Untitled*, 1984, Oil on cardboard, 41 x 27 cm, Private Collection

Michaux, Henri. *1899 Namur, †1984 Paris. Belgian painter and poet. After a reclusive and slightly sickly childhood, Michaux was inspired by the shock of reading of Lautréamont's *Chants de Maldoror* to begin writing. Having early in his life condemned art en bloc – "as if there wasn't enough reality already" – Michaux started drawing under the influence of → Klee, de → Chirico, and → Ernst in 1925. His travels (1927–38) in South America, Asia, and especially India (1930s) proved a revelation to him and he began drawing seriously in the late 1930s.

Michaux's early art seems to be derived from writing (with titles such as *Narration* and *Alphabet*) in which the marks become increasingly less like script and more disjointed as they continue towards the bottom of the page. Later works (still almost exclusively on paper) are more reminiscent of Chinese calligraphy, occasionally incorporating calculated spatterings or else elements from stone carvings (one group is called *Préhistoire*). The 1950–51 series *Mouvements*, for instance, comprised multiple, almost stereotyped pin-men (though with none of the boisterousness of → Penck's creations). After works with incised lines into which ink is washed, in the late 1940s Michaux begun a series of more expressive watercolors (and gouaches) where color provides a sort of underlining around central components of an essentially ovoid character (like that preferred by → Wols). From this stage of his career Michaux was to begin composing almost figurative pieces from whose dark ground wash haunting figures (some fleetingly equine) emerge in an atmosphere not unlike that of early → Kupka or → Kubin. Michaux also created *frottages* (→ Ernst). When his wife died in a horrific accident in 1948, he retreated to produce several hundred pen and watercolor drawings and a portfolio of lithographs (*Meidosems*). He wrote on the abstract painter Zao-Wou Ki (whose work is similar to his own), collaborated on occasion with → Matta,

and gave a magisterial account of his creative impulse in *Emergences, résurgences* (Geneva, 1972).

In 1956, Michaux began experimenting with the "uplift" and "selflessness" (as he described it) of hallucinogenic drugs and produced a body of intensely detailed *mescalinien* and *post-mescalinien* pen and ink drawings. The former comprise tightly agitated → all-over automatic scratchings of equal density (closer to → Tobey, if anyone, rather than to → Twombly, to whom Michaux is often compared); the latter are more fluid and occasionally seem to include landscape and vague facial elements, similar to his 1960s work in mixed media. Some later watercolors and acrylics (which he began to use around 1968) strangely recall late Guardi, including flickering human figures. D.R.

Bibl.: Michaux, New York, 1978 · Baatsch, Michaux, 1993 · Michaux, 1994 · Mason/Cheri, Michaux, 1995 · Michaux, Oeuvres, 1998–99

Middendorf, Helmut. → Neo-Expressionism

Milles, Carl (Wilhelm Emil). *1875 Lagga, near Uppsala, †1955 Lidingö, near Stockholm. Swedish sculptor. After training as a carpenter and studying at the Kungliga Tekniska Högskola in Stockholm (1895–97), Milles visited Paris (1897–1904), where he deepened his knowledge of the work of → Rodin, then traveled to Munich (1904–6). He also spent time in Sweden (Lidingö; from 1908 and after 1951) and the US (1931–45). His eclectic and humorous (*Folke Filbyter*, 1927) yet grandiose art was ideally suited to wide-ranging public commissions: *Franzén* (still under the sway of → Rodin); → Jugendstil bronze doors for the Church of Saltsjöbaden (1911–12); poised "Archaic Greek" *Dancers* (1913–14); the virtuoso Giambologna flight of *Sunglitter* (1918); the featheriness of *Europa and the Bull* (1926; Halmstad); the → Art Nouveau features of *Orpheus* (1936); industrial mannerism in *Nature and Man* (1940). The Carl Millesgården, Lidingö, near Stockholm, is now a museum of his work. D.R.

Bibl.: Rogers, Milles, 1940

Minimal art. American art movement of the 1960s, characterized by right-angled and cube-like forms which are arranged, usually in series. Minimal sculpture is often created by using industrial materials and methods of manufacture. Inspired by F. → Stella's *Black Paintings* (1958), various American artists worked with abstract geometric shapes. The first works of Minimal art were shown in 1963 by → Morris and → Judd. The painter John → Graham had already started a minimalist movement at the end of the 1920s, and in 1960 Judd had used the adjective "minimal" in his art criticism. The term Minimal art, however, first appeared in 1965 in the title of an essay by the philosopher Richard Wollheim. He said of M. → Duchamp's ready-mades, → Rauschenberg's *Combine Paintings* and → Reinhardt's *Black Paintings* "that their art content is minimal", which he saw as a lack of internal differentiation or a differentiation which the artists had failed to implement. The term only began to catch on with the touring exhibition Minimal Art, which took place in 1968 in The Hague, Düsseldorf, and Berlin. → Andre, → Flavin, Judd, → LeWitt and → Morris, who substantiated their works with theoretical concepts, are held to be the most important artists. The Minimal artists developed their elementary formal language in reaction to → Abstract Expressionism. Minimal art is regarded as the first genuinely American art movement which had no European counterpart. There were, however, developments with similar tendencies in music (including Philip Glass, La Monte Young, Steve Reich, Terry Riley) and in dance (in particular Trisha Brown, Lucinda Childs, Simone Forti, Yvonne Rainer). The term Minimalism covers the whole historical phenomenon. D.S.

Bibl.: Battcock, Minimal Art, 1968 · Minimal art, Bordeaux, 1985–86 · Baker, Minimalism, 1988 · Colpitt, Minimal Art, 1990

Minton, (Francis) John. *1917 Great Shelford, Cambridgeshire, †1957 London. British painter. Minton attended a number of London schools of art from 1935 to 1956 and taught at Camberwell and the Central. By the 1940s he was a celebrated → Neo-Romantic associated with Michael Ayrton (1921–76), → Colquhoun, Robert MacBryde (1913–66), and → Vaughan (with whom he lived, 1946–52). Minton's eclectic, emotional style combined elements from → Tchelitchew, William Blake (in his illustrations), and Samuel Palmer (*Landscape on a Rock*, 1939). His theme of predilection was the youthful male body in evocative settings (*Harvester Resting*, 1945, drawing), though he later also produced scenes of urban decay and exotic, less "Albion" topographies (*Rainstorm in Jamaica*). The medium of watercolor also suited his loose, languid brush, and much of his best work was as an illustrator, e.g. for an English edition of *Le Grand Meaulnes* (London, 1948), or the Corsica-inspired images for *Time Was Away* by Alan Ross (London, 1948). An urbane yet self-destructive spirit, Minton died of an overdose. D.R.

Bibl.: Spalding, Minton, 1991

Mir Iskusstva. → World of Art

Miró, Joan. *1893 Montroig, near Barcelona, †1983 Palma, Mallorca. Spanish painter, graphic artist, and sculptor. In 1907–15 he attended the art academy in Barcelona. In 1919 he went to Paris where he met → Picasso, and remained resident there from 1920. In 1924 he made contact with the artists of → Surrealism, and signed the Surrealist manifesto. In 1926 he made costume

Minimal art, Sol LeWitt, *Three Cubes with One Half-Off*, 1969, Painted steel, 160 x 305 x 305 cm, Louisiana Museum of Modern Art, Humlebaek

Joan Miró, *The Gold of the Azure*, 1967, Oil on canvas, 205 x 175 cm, Fundació Joan Miró, Barcelona

designs and stage sets for the Ballets Russes. In 1942 he returned to Barcelona. From 1956 he was resident in Palma, Mallorca. In 1977–83 he received commissions for monumental sculptures in Madrid and Chicago.

His early work from 1918 was marked by → Cubism and → Fauvism. His move to Paris (1921) brought important inspiration from the Surrealists. From Miró's detailed pictures a new system of symbols and colors developed (*Catalan Landscape*, 1923) which was highly regarded in Surrealist circles. In the *Paysages imaginaires*, which appeared from 1926, Miró suggested broad spatces with color modulations. In 1928 he was inspired by the Dutch masters on a trip to Holland (*Dutch Interiors*). At the beginning of the 1930s a series of large-format paintings with free-floating color forms was developed from → collages (*Peinture*, 1930). Shocked by the Spanish Civil War, Miró's "wild period" from 1936 produced pictures of figures with vivid colors and nightmarish scenarios, which culminated in the lost mural *The Reaper* (1937) for the Spanish pavilion at the Exposition Universelle in Paris. At the beginning of the war Miró settled in Varengville-sur-Mer in Normandy, where until 1941 he produced the *Constellations* series, which in its new-style openness (→ all-over painting) had a great influence on American art. In subsequent years he favored ceramic works (1956–58 wall ceramic for the UNESCO headquarters in Paris). In 1956 in his newly built studio in Palma de Mallorca Miró took up painting again with large-format abstract works. Besides his numerous ceramic and sculptural works, he also devoted himself to the old Catalan art of weaving (*sobreteixims*), possibly his most individual contribution to the art of modernism. H.D.

Bibl.: Erben, Miró, 1959 · Gimferrer, Miró, 1978 · Malet, Miró, 1988 · Cramer, Miró, 1989 · Prat, Miró, 1990 · Erben, Miró, 1993 · Lanchner, Miró, 1993

Mitchell, Joan. *1925 Chicago, †1992 Paris. American painter who, from 1944 to 1949, studied at the Art Institute, Chicago. She then lived in New York, having her first solo exhibition there in 1951. She traveled in Europe ("discovering" Cézanne and → Kandinsky). From 1959 she moved to France, after 1967 living in Vétheuil (near Giverny, Claude Monet's home). In touch with → Kline and de → Kooning, Mitchell became an important representative of → Abstract Expressionism. In France, through close observation of nature, she produced abstract, but poetically charged, gestural pictures with an intense palette inspired by Monet's late works, and often on large multi-sectioned canvases (*La Grande Vallée*, 1984). K.S.-D.

Bibl.: Mitchell, Paris, 1994

mixed media. Process developed in the 1960s, in which different media and materials, such as painting, sculpture, text, film, theater, and music are combined in an artistic process. The traditional genre boundaries are breached and the separation of artist and audience is suspended by this interaction. The artistic statement itself is located in the process (→ Action Painting, → happening, → Fluxus), which is recorded by means of film or video. The artistic objects and products arising from the action, on the other hand, are often only of a documentary nature. The deliberate use of technical media: projections, tape recordings, film, laser, video, interactive computer technology, is typical. Mixed media aims at an "integral" experience of art. It has its roots in Wagner's → Gesamtkunstwerk. Inspired by → Cage's musical experiments, in the 1960s → Paik, → Beuys, → Walther, and → Vostell, among others, attempted to mobilize the "senses of the onlooker" by means of mixed media actions to establish a direct link with social phenomena and processes. W.S.

Bibl.: Kultermann, Leben, 1970 · Morschel, Deutsche Kunst, 1972 · Klotz, Kunst der Gegenwart, 1997

mobile. The mobile was recognized as an independent art form through the work of → Calder. However, early attempts to incorporate the factor of movement, and thus the dimension of time, into sculpture can already be seen in → Tatlin's Counter Reliefs (1914), → Rodchenko's hanging constructions, and → Man Ray's lampshade (both 1920). In 1932 Calder presented sculptures made of wire and lead, which were

Joan Miró, *Person on Three Feet*, 1967, Painted bronze, 215 x 55 x 50 cm, Fundació Joan Miró, Barcelona

mobile, Alexander Rodchenko, *Hanging Construction no. 10*, 1920, Aluminum, 59 x 68 x 59 cm, Galerie Gmurzynska, Cologne

driven by electric motors or by a crank. It was during a visit to → Mondrian's studio that Calder had first hit on the idea of suspending a colored rectangle. M. → Duchamp suggested the name "mobile", which he had already applied to his own works as early as 1913. This describes not only the object, but also its most important characteristic. In 1934 mechanical mobiles were followed by mobiles which were moved only by air currents. A distinction was made between free-standing object mobiles, mounted on stands, and hanging mobiles. In contrast to Calder's motionless sculptures, known as → stabiles, the ability to change is the determining factor of mobiles, which belong to the beginnings of → Kinetic art. In the 1950s → Tinguely too started making sculptures driven by motors. W.S.

Bibl.: Popper, Kinetic, 1975 · Marter, Calder, 1991

Model, Lisette (Elise Felicie Amelie Stern [later Seybert]). *1901 Vienna, †1983 New York City. Austrian-American photographer. Born Elise Félic Amélie Seybert, Model began her artistic career as a composition pupil of → Schoenberg's in Vienna. She moved to Paris to continue music study in 1922, beginning photography in 1937. She moved to the United States in 1938, becoming a freelancer with *Harper's Bazaar* (1941–53). Most of her work comprises black-and-white portraits of often heavily built subjects, though architecture (especially monumental statues) also attracted her, as did multiple-exposure work (*Fifth Avenue*). She readily captured social interactions by intermixing the grand and the down-and-heel. Some of her most extraordinary prints are of incomplete dolls, taken in Venezuela. D.R.

Bibl.: Abbott, Model, 1979 · Model, New Orleans, 1981 · Model, Chicago, 1990

Paula Modersohn-Becker, *Kneeling Mother with Child at her Breast*, 1907, Oil tempera on canvas, 113 x 74 cm, Neue Nationalgalerie, Berlin

Modersohn-Becker, Paula. *1876 Dresden, †1907 Worpswede. German painter and graphic artist. From 1893 to 1895 she undertook teacher training in Bremen, and in 1896–98 attended the painting school of the Verein Berliner Künstlerinnen (Association of Berlin Women Artists). She visited Worpswede for the first time in 1897 and was based there permanently from 1898, becoming a member of the artist colony there. In 1901 she married Otto Modersohn, and from 1900 made long, significant visits to Paris (where she met, among others, → Rodin and → Maillol). Succinct, unadorned depictions of women and mother-and-child subjects already played an important role in her early work. Her landscapes, initially inspired by Naturalism and regional art, soon achieved a strictly composed form. Her still lifes testify to her early engagement with Cézanne. To express her idea of the indissoluble bond between the human being (woman) and nature she sought "great simplicity of form". Thus, starkly reduced compositions, which she called "runic script", characterized her creativity from about 1903, drawing inspiration from Gauguin among others (see → precursors). Her work displayed links to early → Cubism, especially in her portraits and self-portraits, and monumental nudes. H.O.

Bibl.: Busch, Modersohn-Becker, 1979 · Murken-Altrogge, Modersohn-Becker, 1991 · Friedel, Modersohn-Becker, 1997

Amedeo Modigliani, *Reclining Female Nude*, 1917, Oil on canvas, 60 x 92 cm, Staatsgalerie Stuttgart

Modigliani, Amedeo. *1884 Livorno, †1920 Paris. Italian painter, graphic artist, and sculptor. In 1906 he briefly studied art in Florence and Venice, then in Paris. In 1908 he exhibited at the → Salon des Indépendants. From 1909 he focused on sculptural works. In 1918 he had a one-man exhibition at Berthe Weill Gallery, Paris. Modigliani, both as a painter and sculptor, was principally a portaitist, although the female nude was another central theme of his work. Both portraits and nudes are characterized by their self-contained compositions and relatively indifferent expressions. The simple contours emphasize the over-elongation of the figures and heads. Modigliani derived his style as well as from → Fauvism and → Cubism, primarily from the study of African, Egyptian, and ancient Etruscan and Greek sculpture, using this in his drawings and watercolors. Direct inspiration came from → Brancusi and his method of working directly with stone. These influences were put into practice in their most original way in a cycle of heads from 1911–12 (*Standing Nude*, c. 1911). Around 1914–15 Modigliani gave up sculpture and devoted himself to painting, but maintained his sculptural style (*Lola de Valence*, c. 1915). Modigliani achieved lasting fame as a portraitist with his portraits of artists, produced after 1914 (Brancusi, → Gris, → Lipchitz, → Picasso, → Rivera, → Soutine). In spite of their mask-like stylization, his portraits retain a particular grace and spirituality. Compared with the early portraits, the arabesque-like line is more strongly emphasized, as it is also in his depictions of

nudes (*Reclining Nude*, 1917). In spite of the disastrous circumstances of his life, his last pictures convey an impression of peace and meditative withdrawal. The figures are removed from their surroundings, and, melancholy, isolated, and withdrawn into themselves, they hover in static poses which conjure up in the present a past ideal of beauty. K.S.-D.

Bibl.: Lanthemann, Modigliani, 1970 · Mann, Modigliani, 1980 · Schmalenbach, Modigliani, 1990 · Alexandre, Modigliani, 1993 · Kruszynski, Modigliani, 1996

Modotti, Tina. *1896 Udine, †1942 Mexico City. Mexican photographer. In 1913 she moved from Udine to San Francisco, finding employment there as a textile worker and actress. On her first visit to Mexico in 1922 she met → Rivera and his circle. Meeting → Weston, she lived with him from 1923 in Mexico City. In the following years, apart from working as a photographer and actress, Modotti was also very politically engaged, finally making this her primary activity in 1930. She had works commissioned by the IRH (International Red Help), active in Moscow, Mexico, Paris, and Madrid. Besides documentation of workers' demonstrations, her oeuvre includes pictures of Mexican Indian women, still lifes, and abstract compositions. C.W.

Bibl.: Constantine, Modotti, 1975 · Modotti, Philadelphia, 1995

László Moholy-Nagy, *Z VIII*, 1924, Oil on canvas, 114 x 132 cm, Neue Nationalgalerie, Berlin

Moholy-Nagy, László. *1895 Bácsborsod, Hungary, †1946 Chicago. Hungarian-born painter, draftsman, sculptor, photographer, and film maker. He was called up for military service in 1914–17. From 1918 he worked as a painter. In 1919–20 he was in Vienna, then in Berlin. In 1923 he was appointed to the → Bauhaus in Weimar, where he took over the metal workshop and some basic courses. In 1926 he published *Malerei, Photographie, Film*; in 1929 *Vom Material zur Architektur*. From 1928 he worked in Berlin as a set designer, exhibition organizer, and art theorist. In 1934–35 he emigrated to London. From 1937 he was in Chicago, as director of the New Bauhaus in Chicago (which lasted until the end of 1937). In 1938–46 he founded and directed the School of Design.

Influenced in his early days by → Expressionism and → Dada (*The Great Feeling Machine*, 1920–21), Moholy also experimented in the 1920s with montages and Constructivist works, inspired by the Russian avant-garde. Moholy's

→ Constructivist ideas at the Bauhaus (1923–28) had a decisive influence on the development of new products (Bauhaus Lamp, 1924), on photography, typography, and theater work. His artistic interest centered increasingly on the construction of light. As well as Constructivist oil paintings with fine varnish effects, Moholy used new synthetic materials, making sculptures with these too. From 1922 Moholy worked on a light – space modulator, a device first manufactured in 1930, driven by electricity for producing light and shadow effects, which Moholy also recorded in a film (*Play of Light of Black, White, and Gray*, 1930). In the same way as in his painted pictures, Moholy espoused a similar "moving vision" in photography and emphasized the value of

abstract forms. Resident in Berlin from 1928 to 1933, he designed stage-sets which demonstrated his light experiments to a wider audience. During his time teaching in America he also continued to work on Kinetic sculpture, photography, typography, and advertising graphics and became an important instigator of Constructivist and kinetic trends. H.D.

Bibl.: Moholy-Nagy, 1932 · Moholy-Nagy, 1969 · Passuth, Moholy-Nagy, 1984 · Moholy-Nagy, Marseille, 1991 · Moholy-Nagy, 1995

Mondrian, Piet (real name Pieter Cornelis Mondriaan). *1872 Amersfoort, near Utrecht, †1944 New York. Dutch painter. In 1892–97 he studied at the Rijksakademie, Amsterdam. His 1909 exhibition at the Stedelijk Museum Amsterdam included Fauvist pictures. In 1911–14 he lived in Paris, then returned to Holland. In 1917 with → Doesburg he founded the group → De Stijl. In 1919 he returned to Paris. In 1920 he published the article "Le Néo-Plasticisme" (→ Neo-Plasticism). In 1930 he became a member of the group → Cercle et Carré and in 1931 of → Abstraction-Création. From 1938 he lived in London and from 1940 in New York.

For Mondrian the "universal nature of color" is not expressed by autonomous tonal values, but in the relationships of the colors to one another,

Amedeo Modigliani, *Head*, 1911–12, Chalk sandstone, 50 x 19.6 x 19 cm, Private Collection

László Moholy-Nagy, *Self-portrait, Photogram*, 1926, Silver bromide print, 23.1 x 17.6 cm, Photographic Collection, Museum Folkwang, Essen

Piet Mondrian, *Composition with Red, Yellow, Blue, and Black*, 1921, Oil on canvas, 59.5 x 59.5 cm, Haags Gemeentemuseum, The Hague

three-dimensional elements could be transferred equally easily to sculpture. In 1913 → Larionov made a montage in the form of a smoker out of cardboard, cotton-wool, and wood; → Boccioni used the process for sculptures. In 1913 M. → Duchamp used the wheel of a bicycle and a stool to make a → ready-made, and it was in this period that → Picasso's metal and cardboard guitars appeared. The politically oriented wings of the → Dada movement, in particular the Berlin Dadaists, developed → photomontage to formulate satirical und political statements. → Heartfield called himself a "Dada montagist". The medium of film also adopted the process of montage in editing, and it thus became one of its most important formal techniques. → Tinguely took up the principle in one of his painting machines (1959) with ironic intent, while → Kienholz and Klaus Staeck (1938–) use montage to represent political themes. W.S.

Bibl.: Jürgens-Kirchhoff, Montage, 1978 · Honnef, Montage, 1991

which in his austerely composed pictures he constantly arranged in new variations. After Fauvist and Cubist beginnings, Mondrian developed out of landscape and architectural structures (e.g. *Composition No.10 – Pier and Sea*, 1915) a structural system of straight lines which intersect at right angles. In the paintings from his time in Paris (1919–38) the rectangular composition of black bars assists the changing relationship of the color. After 1921 Mondrian restricted himself to the derivative primary colors red, yellow, and blue, and the non-colors black, white, and gray, which are integrated into the system of lines in changing proportions, symmetries, and degrees of saturation (*Composition with Red, Yellow, Blue, and Black*, 1921). This strictly structured purism of color, seen by Mondrian as a symbol of the inner order of the world, was attacked by, among others, Doesburg as too rigid, with the result that in 1925 Mondrian left the De Stijl group. An impressive representation of his principle of art is the 1925 interior design for Ida Bienert's library in Plauen with its luminous areas of color and austere rectangularity. Inspired by the richness of life in New York after his emigration at the beginning of the 1940s, Mondrian began a new series, in which a rhythmic web of colored stripes mitigated the puritanical severity (*New York City I*, 1942). H.D.

Bibl.: Champa, Mondrian, 1985 · Mondrian, New Art, 1986 · Henkels, Mondrian, 1987 · Holtzman/James, Mondrian, 1987 · Jaffé, Mondrian, 1990 · Milner, Mondrian, 1992 · Blotkamp, Mondrian, 1994 · Joosten, Mondrian, 1998

Monet, Claude. → precursors

montage. The term montage, taken from the technical vocabulary of the 19th century, characterizes an artistic process in which pre-fabricated materials, usually alien to art, and often from a wide variety of areas (machine parts, remnants of material, junk) are composed into artefacts. This process differs slightly from → collage, which predates it chronologically and was used by the Cubists (→ Cubism) to incorporate elements alien to painting into the design of a painting. The principle of these relief-like pictures composed of

Henry Moore, Model for *Internal and External Forms*, 1951, Plaster with surface coloration, height 63.2 cm, The Henry Moore Foundation

Moore, Henry. *1898 Castleford, Yorkshire, †1986 Much Hadham, Hertfordshire. British sculptor and draftsman. Moore served in the army from 1917–19. In 1919–21 he attended Leeds School of Art, and in 1921–24 the Royal College of Art, London, also teaching there from 1924 to 1932. In 1932–39 he was a lecturer at Chelsea School of Art. In 1925 he traveled in France and Italy. In 1937 he joined the British group of Surrealists. From 1940 he was resident in Much Hadham. He was also the recipient of numerous awards. In 1953 he exhibited at the Venice → Biennale; in 1955–77 at → Documenta 1–3, and 6. In 1977 he founded the Much Hadham Foundation. Inspired by non-European art, by the 1920s Moore had already distanced himself from the traditional, academic formal canon. In his confrontation with the art of Africa, Central America, and Oceania he first produced coarsely fashioned, block-like figures, then elongated column-like figures, which corresponded with his desire to do justice to the material and are found similarly in Brancusi's work. Moore's *Mother and Child* (1924–25) in its stylization reflects these models particularly clearly. Apart from the constantly recurring mother-and-child motif, Moore became famous above all for his *Reclining Figures*, which ran as a theme through his work and allowed his development away from faithful imitation of the human form (*Reclining Woman*, 1927) to starkly abstracted, organic bodies (*Reclining Figure: Bone*, 1974). Particularly in the later figures Moore saw metaphors for landscape formations. He often

Henry Moore, *Reclining Figure*, 1929, Brown Hornton stone, 57.2 x 83.3 x 38 cm, City Art Gallery, Leeds

derived inspiration for his sculpture from found objects, such as driftwood or pieces of bone. As well as Meso-American art, Italian artists from the Trecento to the High Renaissance were of particular significance to Moore (e.g. *Madonna and Child*, 1943–44). In the 1930s his work became increasingly abstract as he developed an interest in the oeuvre of the Surrealists. In 1940 Moore became an → Official War Artist, and the moving *Shelter Drawings* appeared, in which he recorded the people who sought shelter from the Blitz in the tunnels of the London Underground. After the war Moore began working intensively in bronze (*King and Queen*, 1952–53). The large-format sculptures which raised Moore's late work to the monumental, are at their most impressive in conjunction with architecture or in open landscape (*Large Arch: Torso*, 1980, for Kensington Gardens, London). Among his main works are the large reclining figures for the UNESCO building in Paris (1957–58), for the Lincoln Art Center, New York (1963–65), and the Bundeskanzleramt in Bonn. He also produced extensive graphic cycles (*Elephant Skull Album*, 1969–70 and *Sheep Album*, 1972 and 1974). A.K.

Bibl.: Bowness/Read, Moore, 1965–88 · Cramer, Moore, 1973–86 · Red, Moore, 1979 · Moore, London, 1988 · Davis, Moore, 1992 · Mitchinson/Stallabrass, Moore, 1992

Giorgio Morandi, *Still life*, 1940, Oil on canvas, 42.5 x 53 cm, Civico Museum d'Arte Contemporanea, Milan

Morandi, Giorgio. *1890 Bologna, †1964 Bologna. Italian painter, graphic artist, and sculptor. In 1907–13 he was at the Accademia di Belle Arte in Bologna. In 1914 he met → Boccioni and → Carra and took part in the First Futurist Exhibition at the Galleria Sprovieri, Rome. In 1914–30 he taught drawing in Bologna. In 1919 he met de → Chirico. In 1928 and 1948 his work was shown at the Venice → Biennale. In 1930–56 he was professor of graphic art at the Accademia di Belle Arte in Bologna. In 1955–64 his work was exhibited at → Documenta 1–3. In 1909 Morandi became acquainted with the work of Cézanne and his classical concept of still life through reproductions, and this acted as his artistic benchmark throughout his life. After working in Futurist and Cubist styles Morandi turned briefly in 1918–20 to → Pittura Metafisica, and approached de Chirico in his choice of motifs. From 1930, living in secure circumstances thanks to a professorship, Morandi was given the space to develop a new pictorial concept. His main motif became still lifes consisting of few objects (often bottles and glasses), put together in a variety of different ways, depicted in a muted range

of colors and fine nuances (also in etchings). The plasticity of the simple objects was translated by the painterly treatment into a relationship of floating surfaces, which, owing to the pale tones, could be experienced as a subtle space of color and light. Increasing abstraction was evident in the 1930s in Morandi's depiction of objects, which he reduced to increasingly simple geometric shapes. At the same time the application of the paint and the brushstrokes became more visible. From 1940, series of pictures appeared which illustrated Morandi's spiritual approach in the relationship between objective portrayal and free painterly representation. H.D.

Bibl.: Vitali, Morandi, 1977 · Morandi, Bologna, 1989 · Morandi, Paris, 1996 · Wilkin, Morandi, 1996 · Güse/Morat, Morandi, 1999

Moreau, Jean-Jacques. *1899 Saint-Quentin, †1927 Cannes. Self-taught French painter. His studies in Florence brought him close to → Neo-Classicism. His few nudes, portraits, and landscapes, usually in small format, reveal the "return to order" of 1920s France in their classical composition and conservative coloration, at times also inspired by → La Fresnaye and → Derain. K.S.-D.

Bibl.: Moreau, Troyes, 1992

Morellet, François. *1926 Cholet. Partly self-taught French painter living in Paris. In 1950 he had his first one-man exhibition in Paris. In 1960 he co-founded the → Groupe de recherche d'art visuel (GRAV). In 1963–77 he exhibited at Documenta 3, 4, and 6; in 1970 and 1986 at the Venice → Biennale. In 1986 a retrospective was held at the Musée National d'Art Moderne, Paris. After a figurative and geometric early phase, Morellet's 1950s' pictures appeared with Minimalist (→ Minimal Art) systematic, geometric constructions, e.g. rectangular linear arrangements which covered the picture surface like a grid. As a member of GRAV Morellet worked from the beginning of the 1960s with both kinetic works, and moving neon tubes in the context of → Op art. In 1983–85 in the series *Géométries* he combined nature and art, with branches, twigs, and grasses gathered from the garden and the basic elements of the square and rectangular surfaces which pervaded his entire oeuvre (*Géométrie no.*

François Morellet, *Steel-Life*, no. 35, 1990, Acrylic on canvas on wood, aluminum strips, 296 x 296 cm, Artist's Collection

26, 1983). In the 1990s he returned to a stricter Minimal art with white canvases, which, off-set from the rectangular or tilted from an open steel frame, appear to overlap (*Steel-Life no. 36*, 1991). K.S.-D.

Bibl.: Lemoine, Morellet, 1986 · Morellet, Saarbrücken, 1991 · Anna, Morellet, 1994

Morley, Malcolm. *1931 London. British painter and sculptor who has lived in New York since 1958. In 1952–53 he attended Camberwell School of Arts and Crafts, then in 1954–57 the Royal College of Art, London. In 1972 he became professor at the State University of New York, Stonybrook. In 1984 he was awarded the Turner Prize.

Influenced by the → Abstract Expressionists Morley moved to New York and began his abstract paintings (often with black-and-white horizontal bands), in which the composition of the picture surface and the way the paint was applied were of particular significance. In 1964 he began a series of warships, which he depicted in a photorealistic manner, thus making his mark on the concept of Superrealism (e. g. *Cristofero Colombo*, 1965). Scenes based on documents from travel brochures also appeared in this style. In the 1970s he turned away increasingly from photorealism. His work gained a greater painterly quality, and at the same time he incorporated objects into his picture designs (e. g. a real bowl in *Room at Chelsea*, 1972). In the 1980s his pictures became more → Neo-Expressionist. A.K.

Bibl.: Morley, London, 1990 · Morley, Basel, 1991 · Morley, Paris, 1993

Malcolm Morley, *Train Wreck*, 1974, Oil on canvas, 152.5 x 244 cm, Museum moderner Kunst, Stiftung Ludwig, Vienna, on loan from Austrian Ludwig-Stiftung (since 1981)

Morris, Robert. *1931 Kansas City. American sculptor, installation and performance artist, painter, graphic artist, and draftsman living in New York. In 1948–50 he studied art in Kansas City; in 1950–51 in San Francisco; and in 1953–55 in Portland. From 1961 he lived in New York, and in 1963 studied art history at Hunter College, becoming professor there in 1967. In 1968, 1982, and 1989 his work was shown at Documenta 4, 6, and 8.

At the center of his many-faceted work is his ability to change the possibilites of representing the same material through different ways of positioning, placing, and form. After early gestural pictures, from the beginning of the 1960s he produced sculptures (1965–70 large sculptures), for which he frequently used industrially manufactured materials, such as plastics, metal, or felt (series of felt sculptures produced up until 1983) and neutral colors, in the spirit of → Minimal art. Besides this he also incorporated natural

Robert Morris, *Untitled*, 1982, Plaster relief in metal frame, 175 x 282 cm, Sonnabend Collection, New York

substances, such as earth, coal, and minerals. In dealing with these materials, he constantly returned to the subject of the fraught relationship between the composition of materials, their presentation and their reception. In the 1980s Morris returned to an expressive, figurative painting (series: *Psychomachia*, *Firestorm* and *Holocaust*), and at the same time his first etchings appeared. The caustic figurative pictures of the 1990s are once again critical commentaries on the age. I.N.

Bibl.: Compton/Sylvester, Morris, 1971 · Berger, Morris, 1989 · Morris, London, 1990 · Morris, New York, 1994

Moser, Wilfrid. *1914 Zürich. Self-taught Swiss painter living in Paris, Ronco, and Zürich since 1945. In his early work he was inspired by → Ensor and → Klee; his expressive abstract-figurative works belong to the → École de Paris. The favored motif of his pastels, painted woodcuts and reliefs, collages and oil paintings is the city (*Métro*, 1946). In 1961 he produced his first composite sculptures (*Sculpture grise*), from 1966 working exclusively on large-scale sculptures (*A Midsummer Night's Dream in Soho*, 1969–70). In 1975 he returned to figurative painting, including cliff motifs (his stone pictures). From 1990 he gave up sculpture and returned to themes from the 1950s in his painting (*Hommage à Tiepolo*). M.G.

Bibl.: Magnaguagno, Moser, 1993

Moses, Grandma (Anna Mary Moses, née Robertson). *1860 Greenwich, New York, †1961 Hoosick Falls, New York. "Grandma" Moses is one of the most celebrated → naive painters in America, with a reputation that can only be compared to → Rousseau, Csontvary in Hungary, or Generalić in Yugoslavia. Entirely self-taught, Moses began painting in earnest aged 70 (hence her nickname), being "discovered" in 1938. Although her material is often derived from pre-existing illustrations, her innocent country scenes (maple-sugar harvest at Halloween, walks in the woods) are picturesque and detailed with an alert sense of the changing seasons and of farm work. Moses's oeuvre was instrumental in a renaissance of interest in American naive art, culminating in the 1954 exhibition at the Smithsonian Institution. D.R.

Bibl.: Killir, Grandma Moses, 1973

Moses, Stefan. *1928 Liegnitz, Silesia. German photographer living in Munich. In 1945–47 he had a photographic apprenticeship in Breslau and Erfurt. From 1947 he worked as a stage photographer in Weimar. Since 1950 he has lived in Munich. He produced documentary photography and portraits for the publishers Kindler. In 1960–65 he worked as a photojournalist for *Stern* magazine, then as a freelance photographer. In his book *Germans* (sub-title: "Portraits of the Seventies", 1980) Moses photographed anonymous representatives of all social classes in front of a neutral backdrop. He made similar portraits of Germans from the GDR. In *Abschied und Anfang. Ostdeutsche Porträts 1989–90*, as a photographer of German postwar society, he also documents the end of an era. In his ongoing series of portraits *Alte im Wald* he confronts famous people with the organic, natural world. C.W.-B.

Bibl.: Moses, 1998

Moskowitz, Robert. → New Image Painting

Motherwell, Robert. *1915 Aberdeen, Washington, †1991 Provincetown, Massachusetts. American painter and graphic artist. He studied in 1932–37 at Stanford University; he studied painting at the California School of Fine Arts, San Francisco; and he spent 1937–38 at the Graduate School of Philosophy, Harvard University. In 1938–39 he spent time in France, and in 1940 moved to New York. There he studied history of art at Columbia University. In 1941 he visited Mexico. In this period he confronted → Surrealism with his own "automatic" drawings. From 1945 he published the series *Documents of Modern Art*. In 1948 he founded the art school "Subjects of the Artists". In 1950–59 he took a teaching post at Hunter College, New York. In 1959 he exhibited at Documenta 2. From 1970 he was in Greenwich, Connecticut.

Robert Motherwell, *Elegy for the Spanish Republic*, 1953–54, Oil on canvas, 209 x 315 cm, Museum Ludwig, Cologne

Robert Motherwell, *Je t'aime IV*, 1955–57, Oil on canvas, 177 x 255 cm, Staatsgalerie Moderner Kunst, Munich

Motherwell received numerous awards. His artistic subject matter was already clear in his early paintings (*Pancho Villa, Dead and Alive*, 1943): gestural, active shapes are combined with clear structures and these configurations correspond in content to Eros and Thanatos (life and death). This basic theme also characterized the picture series *Elegy to the Spanish Republic*, which from 1948 until his death he developed from small preparatory studies to large-scale paintings. Dramatically enlarged black bars and ovals form with the white background a "symbolic shape" which links the various levels of association to archetypical images (*Elegy to the Spanish Republic no. 133*, 1975/82). At the same time other series appeared (paintings and collages) with vivid handwriting and luminous colors, linked to his studies of French literature and art (*Viva*, 1947). In the 1960s Motherwell turned to the landscape of the Mediterranean, favoring powerful blue and green chromatic accents (*Summer in Italy*, 1960). The picture series *Open* developed from a window motif to a large-scale homage to color. Like the *Elegies*, the *Open* series also showed the broad palette of expressive possibilities using colors and lines which make Motherwell, along with → Pollock and → Kooning, an important exponent of → Abstract Expressionism and → Action Painting. H.D.

Bibl.: Arnason, Motherwell, 1977/1982 · Pleynet, Motherwell, 1989 · Motherwell, 1992 · Caws, Motherwell, 1996 · Rosand, Motherwell, 1996

Reinhard Mucha, *Wind und zu hohe Türme*, 1982, Installation, Saatchi Collection, London

Mucha, Reinhard. *1950 Düsseldorf. Sculptor and installation artist living in Düsseldorf. Mucha began his working life apprenticed to a blacksmith. In 1990 his work was exhibited at the Venice Biennale (installation: *Das Deutschlandgerät*); and in 1992 and 1997 at Documenta 10. At the end of the 1970s Mucha started to produce his "Schriftbilder" (written paintings), sometimes using gloss paint applied directly to the wall (*Krefeld-Oppum*, 1977). At the same time → installations with simple, usually found objects from the immediate environment of the artist appeared, which were to be understood as material witnesses to the past. Mucha's installation *Waiting-room* (1979–82/1997), in which he created a location which was both historical and fictitious including 242 place-name signs copied from German railway stations, is an example of his work using objects taken from a general and immediately comprehensible context. In this installation only one sign can be seen at a time, the others remain filed away on eleven metal shelves. Thus history is transformed into an image of the workings of

Reinhard Mucha, *Kroppach, Switzerland*, 1981–86, Mixed media, 80 x 160 x 35 cm, Private Collection

memory. Mucha was interested in the levels of connection between people and things in certain everyday situations, and the ways in which a "collective biography" develops between the individual and the object. F.P.

Bibl.: Mucha, Stuttgart, 1985 · Mucha, Paris, 1986 · Mucha, Basel, 1987

Georg Muche, *Oval Plastic Forms*, 1922, Oil on canvas on wood, 60.5 x 50 cm, Kunstsammlungen, Weimar

Muche, Georg. *1895 Querfurt, †1987 Lindau. German painter and craftsman. In 1913 he studied painting at the Ažbè-Schule, Munich. In 1914 he moved to Berlin, and, influenced by → Kandinsky, began to work in non-figurative styles. In 1916–19 he taught at the → Sturm art school, Berlin. From 1919 he took numerous teaching posts, principally in the specialist areas of graphics, weaving, textile art (including 1920–27 at the Bauhaus in Weimar and Dessau; 1927–31 at the Itten art school in Berlin; 1931–33 at the Kunstakademie, Breslau; 1933–38 at Hugo Häring's school Kunst und Werk, Berlin; and 1939–58 at the textile engineering school in Krefeld). From 1960 he lived in Lindau on Lake Constance. In 1979 he received the Lovis Corinth Prize, Regensburg.

Muche created a large, very diverse corpus, ranging from early abstract works (*Composition with Black and Green Form*, 1920) via the stylized figurative works of the 1920s to the naive Surrealistic paintings of the 1950s (*Picture with Dead Bird*, 1954). His graphic production, which made use of all the techniques available and moved between abstraction and figurative representation, constituted a sizeable proportion of his oeuvre. H.D.

Bibl.: Muche, Tübingen, 1995

Mueller, Otto. *1874 Liebau, Silesia, †1930 Breslau. German painter and graphic artist. In 1890–94 he trained in lithography in Görlitz and from 1894 to 1896 attended the Kunstakademie Dresden. In 1903–04 he met → Modersohn-Becker. In 1908–09 he moved to Berlin, and in 1910 joined the → Brücke group. From 1919 he was professor at the Akademie Breslau. In 1927 he created *Die Zigeunermappe*. In 1937 his work was condemned as "degenerate" (357 of his works were removed from museums). Initially influenced by Arnold Böcklin and Symbolism (these paintings were destroyed), he found his true subject matter in the open-air female nude. As a member of the artistic community Die Brücke, he developed a painting style of two-dimensional simplicity and muted earth tones with expressive outlines. Focuing on essentials, he concentrated his figure-world on clearly defined shapes. They are mostly slender female nudes with exotic, gypsy-like features posing in a silent, bare, and starkly simplified landscape (*Nude Standing under Trees*, 1915). Mueller took no part in the disputes, dissonances, and tensions which marked → Kirchner's pictorial world, for example. His tempera pictures and colored lithographs are similar to watercolors in their lightness and are characterized by Arcadian moods in tune with the rhythms of nature. Although his work did not encompass a wide variety of moods and styles, Mueller nevertheless created an oeuvre suggestive of timelessness. G.P.

Bibl.: Jähner, Mueller, 1974 · Karsch, Mueller, 1974 · Lüttichau, Mueller, 1993

Otto Mueller, *Large Nude Study*, c. 1920, Distemper on hessian, 170.5 x 60 cm, Museum Ostdeutsche Galerie, Regensburg

Mullican, Matt. *1951 Santa Monica, California. American Conceptual and installation artist, painter, graphic artist, photographer, and draftsman living in New York. In 1974 he studied at the California Institute of the Arts in Valencia. In 1973 he had his first exhibition in Boston, and in 1981 in Stuttgart. In 1995–96 he received a grant from the art program of the DAAD (German Academic Exchange Service) in Berlin. His artistic program, in the form of tabular systems, is based on conceptual reflections on the subject of symbols and language. In the 1980s he became famous for his so-called *Evolutionary Charts*: these were tables of universal, cultural, and artistic pictograms and symbols, which he produced on a large variety of supports (e.g. stone slabs, flags). Mullican reveals and questions their symbolic meaning by confronting them with abstract motifs and reducing familiar images to symbolic abstraction. I.N.

Bibl.: Mullican, Bath, 1981 · Mullican, Philadelphia, 1987

multiple. Manufactured object which always exists in several copies and is conceived especially for multiple reproduction. The multiple has been in existence as an artistic genre since the 1950s. Comparable to printmaking techniques, insofar as they are not actually used for reproduction, the "original" multiple is only produced through series manufacture. Ideologically the development of the multiple was closely linked to the desire for change in the relationship between art and society. On one side were artists such as → Vasarely, who saw in this a possibility for making art more available in society through the large numbers of works and low prices which should bring art to all social classes. Fluxus artists such as → Maciunas countered this democratization of the art market with a general disapproval of such commercial practices, and tried to undermine it through the production of deliberately unpretentious and "unsophisticated" objects. While → Beuys used multiples more idiosyncratically as a medium for conveying a message, Pop artists such as → Warhol concentrated on the superficiality of consumer items to indicate the fetishistic nature of the commodity. D.S.

Bibl.: Beuys, Multiples, 1980 · Buchholz/Magnani, Multiples, 1993 · Felix, Multiple, 1994

Munch, Edvard. *1863 Lote, Hedmark, Norway, †1944 Ekely, near Oslo. Norwegian painter and graphic artist. Initially he studied at Oslo technological university, then from 1881 at the Tegenskole, and in 1883 at F. Thaulow's Friluftsakademi (Modum). In 1885 he went to Paris. In 1889 he received his first one-man exhibition, and a state grant. In 1889–92 he lived in Paris, moving on to Berlin in 1892. He was in touch with the literary circle around Strindberg. In 1893 he began working on the *Frieze of Life*. In 1896–98 he had exhibitions at the → Salon des Indépendants, Oslo. In 1933 he was condemned as a "degenerate" artist. Among the most decisive impulses in his early work were a lightening of the palette which he learnt from Impressionism and a free brushstroke (*Self-portrait*, 1886). The paintings shown in Berlin in 1892 triggered the "Munch scandal" and led to the founding of the Berlin Secession.

In the years following, Munch painted a series of heavily expressive pictures (*Puberty*; *The Day After*; *Sick Girl*; all 1894). He now favored cityscapes, landscapes, and interiors in which human life is seen as drama and entanglement. Human situations were depicted principally in relation to Eros and death (*The Vampire*, 1893–94). From 1893 to 1894 Munch also dedicated more time to printmaking, repeating and transforming important themes from his paintings. In 1892–1908 he produced many of his most important works (*The Scream*, 1893), revealing in an expressive chromatics the abysses of the human soul which Munch himself had experienced since his youth through recurring spiritual crises.

It was not until the → Sonderbund exhibition in Cologne in 1912 that Munch's work was belatedly recognized as a precursor of Expressionist painting. This brought about a positive change in his attitude towards man and nature. His painting became more relaxed, both strong and light in color and large in scale, without losing its depth of expression. He began to paint more murals (University of Oslo, 1916; refectory of the Freia chocolate factory, Oslo; Oslo city hall, 1928), yet was still unable to complete his *Frieze of Life*, a self-contained series of paintings on the meaning of human existence. K.S.-D.

Bibl.: Moen, Munch, 1956–58 · Sarvig, Munch, 1980 · Heller, Munch, 1984 · Assem, Munch, 1992 · Hodin, Munch, 1995

Munkácsi, Martin. *1896 Kolozsvár, Hungary, †1963 New York. Hungarian-American photographer. From 1914 he worked as a sports reporter, and in 1921–22 produced his first sports photographs. From 1927 he was in Berlin, photographing for, among others, Ullstein; and in 1931–34, among others, for *The Studio*. From 1934 he was in New York, working for *Harpers Bazaar* (1933 saw his first fashion photographs for the magazine); in 1941–46, he also worked for *Life*. After 1943 he worked principally as a writer (poems, short stories, screenplays). His early photographs, taken in Europe, show scenes of everyday life: people in the street, in buses, in cafés, on the way to work, in conversation. Even in his fashion photographs he favored an unspectacular way of looking at things, dispensing with top models, formal poses, grandiose interiors, and dramatic lighting effects, and in this way he revolutionized fashion photography. C.W.-B.

Bibl.: Munkácsi, 1992

Münter, Gabriele. *1877 Berlin, †1962 Murnau. German painter who attended the Phalanx painting school, Munich in 1902. In 1904–08 she traveled with → Kandinsky to Italy, France, Switzerland, Holland, Tunisia, and several times to Russia. From 1909 she was based in Murnau and in contact with → Jawlensky and → Werefkin. She was a member of the → Neue Künstlervereinigung München. In 1911–12 she took part in exhibitions of the → Blaue Reiter group. In 1917 she moved to Copenhagen, returning to Murnau in 1920. In 1927 she took up painting again, and embarked on a trip to Paris. In 1957 she made a large donation of her own works and paintings by Kandinsky to the Städtische Galerie im Lenbachhaus, Munich.

A strong painterly talent, Münter had already developed in her early work an expressive, vividly chromatic type of painting which emphasized surfaces and renounced any idea of inner depiction. Her work shows inspiration derived equally from → Fauvism and Murnau glass painting (*Landscape with Hut in the Sunset*, 1908). Her landscapes, figure scenes, and portraits show a simplicity with a tendency towards humorous characterization (*Listening*, 1909). Thrown into a deep creative crisis by her split from Kandinsky (1916), she did not take up painting again until the 1930s. Works such as *Street in Murnau* (1931) are attempts to recall her mature Munich work in their stylization and coloration. H.D.

Bibl.: Windecker, Münter, 1991 · Friedel/Hoberg, Münter, 1992

Edvard Munch, *Death of Marat*, 1907, Oil on canvas, 150 x 200 cm, Munch Museet, Oslo

Edvard Munch, *Self-portrait in Weimar*, 1906, Oil on canvas, 110.5 x 120.5 cm, Munch Museet, Oslo

Gabriele Münter, *Jawlensky and Werefkin*, 1908–09, Oil on cardboard, 32.7 x 44.5 cm, Städtische Galerie im Lenbachhaus, Munich

muralism. Mexico's main contribution to the art of the 20th century consists of *muralismo*, socially and politically engaged wall painting which owes its origin (supported by the aim of integrating the arts into political and social renewal) to the Mexican revolution of 1910–17. Leading protagonists were → Rivera, → Orozco, and → Siqueiros. In 1921 the first murals appeared at the Escuela Nacional Preparatória (National Training School), from where the great themes of *muralismo* emerged: the history of Mexico, the Conquista with its devastating effects on the indigenous population, human tragedy in its historical context. The revolution also pointed to the Utopia of a new, better world and its Promethean people. It was this hope which

inspired Rivera in his frescos at the Secretaria de Educacion Publica (Ministry of Education). His chapel at Chapingo (1925–27) became the "Sistine Chapel of the 20th century". Orozco painted his most significant frescos in Guadelajara (Government Palace 1937; Hospicio Cabanas 1938–39). In the 1930s *muralismo* also took hold in the US. Rivera, Orozco, and Siqueiros painted important works outside Mexico (e.g. Detroit Institute of Arts; Chouinard School Los Angeles; Dartmouth College, Pennsylvania). The second generation of muralists is represented by Juan O'Gorman. Today the socially and politically motivated painting of the early 20th century has made way for a less aggressive pictorial world, searching for new aesthetic values. → Tamayo contrasts the historical and ideological content with an art focused on color and symbols.　E.B.

Bibl.: Charlot, Mexican Mural, 1963 · Rodriguez, Mexican Mural, 1969 ·· Rochfort, Mexican Muralists, 1993

Zoran Music, *We are not the last*, 1970–75, Etching, 47.4 x 34.9 cm

Murphy, Gerald. *1888 Boston, †1964 American painter, active in the 1920s. From a wealthy background, Murphy studied with → Goncharova in the early 1920s in Paris, meeting Sergei Diaghilev through her. The director of the Ballets Russes commissioned scenery from Murphy to add to designs by → Picasso and → Braque. His block-like application of color was much influenced by his friend → Léger. Between 1922 and 1929 Murphy produced around a dozen poster-like paintings of great simplicity, depicting modern objects in lines reminiscent of → Purism (*Cocktail*, 1927) but overlapping crisply as in → Cubism (*Razor*, 1924). Like the work of → Demuth, their bright "obviousness" heralds → Pop art (e.g. → Johns); *Villa America* (1922) combines the Stars and Stripes with lettering in a manner close to Stuart → Davis. Murphy abandoned painting when his sons became ill, and was able to recover his oeuvre only after World War II. In its precocious modernity, his work answered a national need for modernist forerunners in the 1950s–1960s.　D.R.

Murray, Elizabeth. *1940 Chicago. American painter, graphic artist, and printmaker living in New York. In 1958–62 she studied at the Art Institute of Chicago; and in 1962–64 at Mills College in Oakland, California. Her teaching posts have included Rosary Hill College, Buffalo, New York (1965–67), Yale University and the School of Visual Arts in New York (1977–80). In the 1970s she worked on figurative depictions, combined with abstract chromatic forms. She paints on both canvas and panel, avoiding a uniform, rectangular picture shape, and designing her works since 1976 as → shaped canvases. The fascination of her works comes from her inventive wealth of colors and shapes, and the combination of figurative and abstract approach.　I.N.

Bibl.: Murray, Dallas, 1987 · Murray, New York, 1997

Music, Zoran. *1909 Görz near Trieste. Italian painter, draftsman, and graphic artist, living in Venice and Paris. In 1930–34 he studied at the Academy of Art, Zagreb. In 1935 he visited Spain. In 1943 he was arrested by the Gestapo in Venice, and imprisoned in Dachau concentration camp, returning to Venice in 1945. In 1948 his work was exhibited at the Venice Biennale. From 1953 he worked in a studio in Paris. In 1955 his work appeared at Documenta 1. He has had major retrospectives in Brunswick (1962), Darmstadt (1977), Venice (1985), and Paris (1995). Music found influential models in → Schiele, → Grosz, and → Dix. He also learned from El Greco, Goya, and Byzantine art. His early landscape and nature paintings are descendants of the Viennese Secession and Impressionism. The drawings which he produced in the concentration camp at Dachau are both moving and vivid. After the war Music took up landscape painting again. His debate with Parisian → Art Informel, to which he never really gained access, led him into a creative crisis. In a recollection of the concentration camp themes in the cycle *We are not the last* (1970–75), he returned to figuration and painted the bare karst landscapes of Dalmatia, Venetian buildings, portraits, and cadavers. His late works include a confrontation with the self-portrait.　F.P.

Bibl.: Music, Klagenfurt, 1990 · Schmied, Music, 1995 · Schulze, Music, 1997

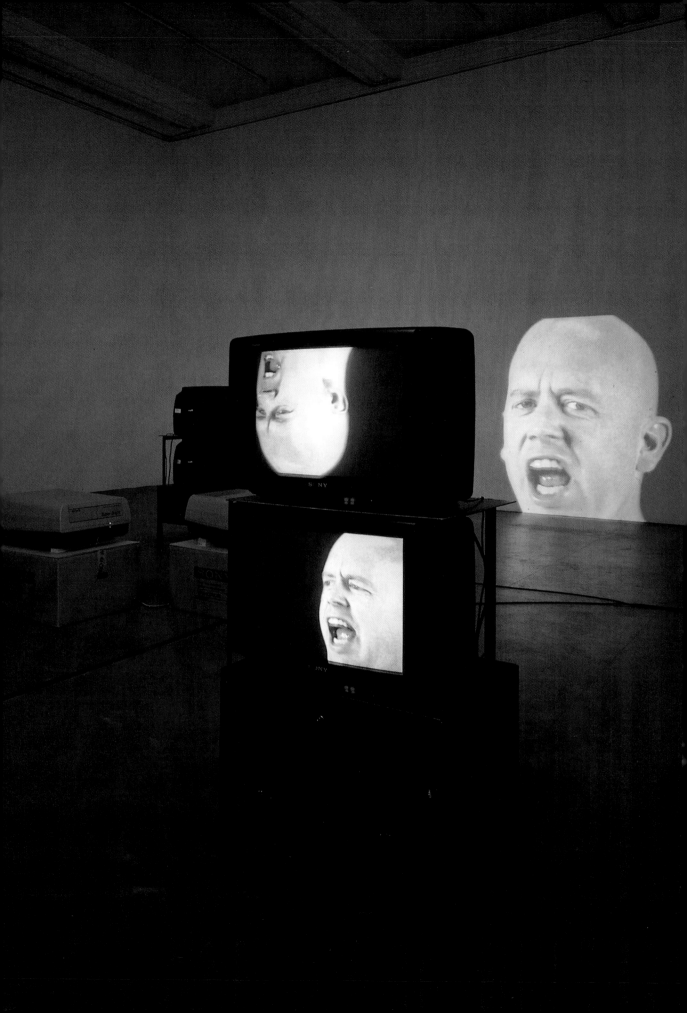

Nabis. Group of artists, mostly French, formed in Paris in 1889. It initially consisted mainly of students (→ Bonnard, → Denis, → Roussel, Paul Ranson) at the Académie Julian, where in October 1888 → Sérusier revealed to them the secrets of a

NO

new kind of painting practiced by Gauguin (→ precursors). The name Nabis is derived from the Hebrew *Nebiim*, meaning "prophet" or "enlightened one." Other members included → Vuillard from 1890, → Vallotton from 1892, and → Maillol from 1895. This loose grouping showed no uniformity of style. The common aim of these prophets of a new type of painting was the renewal of art in revolt against the academic, illusionistic, and naturalistic imitation of nature. The group's theorist, Denis, formulated this idea in 1890 in his maxim: "Remember that a picture, before being a warhorse, a naked woman or some kind of anecdote, is essentially a flat surface covered with colors in a particular arrangement." The subject of the picture should be subordinate to the media which the artist uses to formulate the essential features of things and the emotions they trigger. The role of line, shape, and color was no longer to describe the visible, but rather to serve as vehicles for the expression of the "invisible." The Nabis liberated themselves from con-

Nabis, Felix Vallotton, *Naked Woman Crouching in front of a Fireplace*, 1900, Oil on cardboard, 80 x 100 cm, Private Collection

ventional perspective, the illusionistic modeling of the body, and the traditional laws of proportion and movement. They favored interiors and street scenes, in which the vibrant rhythms of the rapidly changing city of Paris were captured in spontaneous recordings, like film clips. Their intimate interiors (the Nabis were also called → Intimistes) are filled with a mysterious atmosphere which, in the manner of → Symbolism, apprehends certain conditions of the soul. U.P.-P.

Bibl.: Perucchi-Petri, Nabis, 1976 · Mauner, Nabis, 1978 · Boyer, Nabis, 1988 · Frèches-Thory/Terrasse, Nabis, 1990

◁ Bruce Nauman, *Anthro/Sicio*, 1991, Video and projectors, monitors, players, Hamburger Kunsthalle (see p. 234)

Nadelman, Elie. *1882 Warsaw, †1946 Riverdale, New York. Polish-American sculptor. After brief study in Munich, Nadelman exhibited at the → Salon des Indépandants in Paris – where he lived from 1904 to 1914–and at the → Armory Show, New York (1913). Even at this juncture form was paramount in his work, the accumulation of curves in the figure being the central concern. Early work recalls a more representational → Brancusi or a fractured → Cubism. More celebrated are his playfully tubular nudes and dancers, echoed in many preparatory drawings. His *Man in the Open Air* (1914–15) shows a standing, unclothed figure sporting a derby, its juxtaposition of Praxiletes' *Apollo Sauroktonos* and Seurat (see → Neo-Impressionism) with a foretaste of → Art Deco dispensing debonair charm. Nadelman essayed work in galvano-plastique (metal over plaster); his 1940s plasters and papier-mâché statues are deliberately crude and more modeled. He had practically retired from the art world at this time, and his reputation receded until a New York MOMA retrospective in 1948. D.R.

Bibl.: Kirstein, Nadelman, 1973

naive art. The work of self-taught Sunday or amateur artists and their depictions of an idealized, timeless reality, often of a mystical or fantastic nature. This vision of a harmonious world is common to the various trends of naive art and has influenced a number of major modern artists (→ Chagall). Naive art, although already idealized in the art theory of Classicism, emerged as a distinct type of painting at variance with the prevailing trends of the time in the late 19th century. Its emergence was linked to the decline of European folk art traditions in the 19th century, to which it was the heir. Naive artists first achieved public prominence in France, thanks largely to the work of → Rousseau and the activities of the critic and collector Wilhelm Uhde. Leading exponents of naive art include André Bauchant (1873-1958), Camille Bombois (1883-1970), Dominique Peyronnet (1872-1943), René Rimbert (1896-), Séraphine (1864-1942), Louis Vivin (1861-1936) in France; Miguel Vivancos (1895-1972) in Spain; Léon Griffe (1881-1949) in Belgium; Ivan Generalic (1914-1992) in Croatia; Grandma → Moses and Morris Hirschfield (1872-1946) in America; and → Hyppolite in Haiti. Group exhibitions of works by naive artists increased their popularity (Les Peintres du Cœur Sacré, Paris, 1928). F.P.

Bibl.: Bihalji-Merin, Naive Art, 1964 · Carlino/Menozzi, Naive art, 1978 · Naive Art, Washington, 1992

Nannucci, Maurizio. *1939 Florence. Italian Conceptual artist living in Florence and Munich. In the 1960s he began producing experimental art using in particular photography and video. He successfully combined computer-generated music with visual processes, and concrete and phonetic poetry. Nannucci is a collector of words whose aim is to demonstrate the ambiguity of speech. Working principally in neon, and using sentences in his own handwriting (*You can imagine the opposite*) or words such as *Art, Light, Sign*, the letters of which are interlocked to form squares, he holds up speech for discussion, allowing it to become an object so that he can then trace it back to its original meaning. S.Pa.

Bibl.: Friedel, Nannucci, 1991

Narkompros (NKP). Founded after the October Revolution, the People's Commissariat for Cultural Enlightenment (NARKOMPROS) was set up to introduce new theoretical principles into education and culture. It was divided into five sections: organization, national education, social education, science, and art, one of the subdivisions of which was IZO (visual arts). IZO was founded at the beginning of 1918 and encompassed the fields of literature, applied and industrial art (design), theater, film, artistic construction, and architecture. Avant-garde artists such as → Kandinsky, → Malevich, → Rozanova, and → Tatlin served on the art committee. IZO organized exhibitions of art and ran the new art schools (Svomas/Vkhutemas) and research institutes (→ Inkhuk). From 1920–21 the committee was increasingly filled with artists who conformed to party ideology. H.D.

Bibl.: Avantgarde Russia, Los Angeles, 1980

Nash, David. *1945 Esher, Surrey. British sculptor and → Land artist living in Blaneau Ffestiniog, North Wales. He studied at the Kingston College of Art (1963–67). In 1964 he went to Paris, where he visited → Brancusi's studio. He became internationally successful following the exhibition British Art Now at the Solomon R. Guggenheim Museum in New York.

Nash strives to reconcile nature and art. He uses natural materials, chiefly wood, as the starting point for his archaic works, which usually consist of elementary forms. He reacts sensitively to the nature of the material and his works therefore integrate well into their natural situations. Nash has occasionally produced "cultural landscapes," in which he intervenes in his "planted sculptures" (e. g., young ash trees) to influence the direction of their growth. I.S.

Bibl.: Warner, Nash, 1996

Nash, Paul. *1889 London, †1946 Boscombe. English painter, designer, and art critic. He studied at the Slade School of Art, London (1910–11), but was otherwise self-taught. A leading member of → Unit One (founded in 1933), Nash was an → Official War Artist in both world wars, conveying the tragedy of armed conflict in gloomy, apocalyptic landscapes (Void, 1918). Influenced by the → Bloomsbury Group, Nash took a growing interest in the formal aspects of painting. He began to isolate individual objects, which might take on human or animal shape, and created dream landscapes which marked the beginning of his Surrealist pictures of the 1930s. Nash also produced art criticism, wood engravings, and designs for textiles and posters. A.K.

Bibl.: King, Nash, 1987 · Nash, London, 1994

National Socialist art. Can and should the art (from a badge to a monumental building) produced during the time of German Fascism be evaluated as "art," or should it be set aside as a special case in art history? Many critics believe that if it is bracketed off (using the argument of the humanist notion of political freedom as the basic precondition of art) this will mean a mere reversal of "degenerate art" as propagated by the National Socialists. They call for an informative presentation of National Socialist art in order to permit an examination of socio-cultural mechanisms.

National Socialist art for the Nazis was rooted in the work of the German Old Masters (Dürer, Altdorfer, Grünewald) and belonged to the tradition of 19th-century art (German Romanticism, realism). It had affinities with → Expressionism and adopted the ancient Greeks' ideals of beauty, which were perverted into hard, heroic, metallic images (Josef Thorak [1889–1952]). The aim was to glorify the "Aryan race," rejecting anything that deviated from the ideology. The type of art promoted by the Nazis was intended to counter modern art, which was declared sick, decadent, bourgeois, Jewish, bolshevik, and "degenerate" ("Degenerate Art" exhibition, Munich, 1937). A theoretical basis for National Socialist art was supplied by P. Schultze-Naumburg's Art and Race (1935), which revived in its central themes the genre painting of the 19th century (in particular landscape and the nude). The emphasis was on craftsmanship, but also a subliminal eroticism (evident in the work of Adolf Ziegler, "the master of German pubic hair"). National Socialist art was crudely propagandist: the woman, as "protectress of the species," symbolized health and fertility; the man stood for the "will for power" and the will to work, for a willingness to sacrifice oneself, and for a death-defiant aggression, illustrated by attributes such as swords, spears, and fists, as well as views pointing into the distance. Pseudo-Romantic idylls were intended to signify rootedness in the soil and show the family as the nucleus of the national community. For portraits, artists resorted to an ancient iconography of the leader. W.S.

Bibl.: Kunst im 3. Reich, Frankfurt, 1974 · Herding/Mittig, Nationalsozialistische Kunst, 1975 · Hinz, Art in the Third Reich, 1980 · Faschismus, Berlin, 1987 · Adam, Arts of the Third Reich, 1992

Nauman, Bruce. *1941 Fort Wayne, Indiana. American Conceptual and Video artist living in Galisteo, New Mexico. He studied mathematics, physics, and art at the University of Wisconsin, Madison (1960–64), and at the University of California, Davis (1964–66). Between 1966 and 1968 he taught at the San Francisco Art Institute. He took part in Documentas 4, 6, 7, and 9 (1968, 1976, 1982, 1992). In 1991 he won the Max-Beckmann-Preis, Frankfurt. Between 1993 and 1996 he had various retrospectives (including Centro de Arte Reina Sofia, Madrid, and Kunsthaus Zürich). In his varied, questioning œuvre, Nauman examines the structures and functions of

Bruce Nauman, *The True Artist Helps the World by Revealing Mystic Truths*, 1967, Neon tubes, 150 x 140 x 5 cm, Private Collection

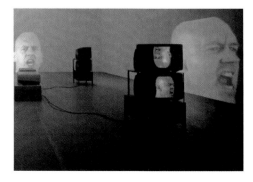

Bruce Nauman, *Anthro/Sicio*, 1991, Video and projectors, monitors, players, Hamburger Kunsthalle

perception, investigating "what art could be" (Nauman). Although he has used an abundance of media, some of his works belong to the → Minimalist tradition, notably the *Not-Forms*, which are made of fiberglass and cut-up rubber mats. In the 1960s he concentrated on works and actions linked to the body, including casts of body parts which were combined with other objects to disconcerting effect. The photographic work *Self-Portrait as a Fountain* (1966–67) was a parody of M. → Duchamp's iconic readymade *Fountain* (1917). His films from this period are about mundane events (*Thighing*, 1967, kneading the upper thigh with loud, sighing breathing). At the end of the 1960s he began using neon, showing rapidly changing, fragmented body parts or figures fatally penetrating one another, accompanied by satirical comments on sex and power. In his → installations, which include animal sculptures dragging along the ground (*Carousel*, 1988), Nauman confronts the observer with paradoxical situations which arouse fear. In his more recent video works he tests the viewer's patience and resilience by means of confusing images (*Clown Torture*, 1987, *Anthro/Sicio*, 1991). H.D.

Bibl.: Zutter, Nauman, 1990 · Benezra, Nauman, 1994 · Nauman, New York, 1995 · Labaume, Nauman, 1997 · Nauman, London, 1998

Navarro, Miquel. *1945 Mislata. Spanish sculptor and installation artist living in Madrid. In his early years he devoted himself to painting and sculpture, but at the beginning of the 1970s he turned increasingly to → installations and → montages, using ceramics in combination with other materials such as wood, glass, china, and iron. He created architectural forms using predominantly Cubist, spherical, and prismatic shapes which lend the works technological overtones. He has also made object sculptures. K.S.-D.

Bibl.: Miquel, Madrid, 1990

Ernst Wilhelm Nay, *Ocher, Yellow, and Dark Blue*, 1968, Oil on canvas, 162 x 150 cm, Neue Nationalgalerie, Berlin

Nay, Ernst Wilhelm. *1902 Berlin, †1968 Cologne. German painter. He studied at the Kunstakademie, Berlin (1925–28), and subsequently received a scholarship to study in Rome (1931). In 1936 he was banned from exhibiting and in 1937 his work was condemned as "degenerate." In the same year he visited the Lofoten Islands in the Arctic Circle. In 1940 he was called up for military service, serving in France as a cartographer. Between 1942 and 1945 he was able to continue with his painting. After the war he lived in Hofheim until 1951, when he settled in Cologne. He took part in Documentas 1, 2, and 3 (1955, 1959, 1964). In 1956 he became a member of the Akademie der Künste, Berlin. He represented West Germany at the 1964 Venice Biennale. His early work owed much to → Kirchner and → Matisse. During his stay in Rome he produced surrealist-abstract paintings and mythical, ornamental pictures of animals. His trip to the Lofoten Islands inspired a number of landscapes. By this time, the primacy of color was established in his work. After the war he embarked on his *Hekate* pictures, in which his vividly colored, expressive figurative style became increasingly abstract, with → Cubist fragmentation.

In the 1950s abstraction and pure color gained the upper hand in his work. In his theoretical

Ernst Wilhelm Nay, *Silver Star*, 1964, Oil on canvas, 200 x 160 cm, Private Collection

reflections of this period he spoke of the "formal value of color," a theme he explored in compositions with fugal rhythms and, from 1955, in "segment pictures," which contain subtle modulations of color and space. In his late works from 1965 he intensified the colors in ornamentally expansive compositions reminiscent of the cutouts of Matisse. With his emphasis on color as the formulative power, Nay was an important and influential figure in German abstract art. W.G.

Bibl.: Nay, Nuremberg, 1980 · Nay, Krefeld, 1985 · Nay, Cologne, 1990 · Gohr/Scheibler, Nay, 1991 · Haftmann, Nay, 1960–1991

Neel, Alice. *1900 Merion, Pennsylvania, †1984 New York City. American painter. After studying in Philadelphia and a fraught period in the early 1930s during which some of her work was destroyed, Neel moved to Spanish Harlem in 1938 before traveling in Europe. Later she became successful with the Graham Gallery, New York.

Always figurative, her work essentially comprised detailed portraits, some with slightly enlarged heads. Some of her sitters were celebrities in their own right (from scientist Linus Pauling to a wounded → Warhol, 1970), others are from the same social catchment area as → Pearlstein's. Her work, beginning in a naive style, evolved through an Objective phase (*Joe Gould*, 1931) to a somewhat playful frankness. Her oils became brighter in the 1960s through the influence of → Pop. Her avowed desire was to "capture the complete person" while keeping a steady eye on the (changing) Zeitgeist. A major retrospective was held at the Georgia Museum of Art in 1975. D.R.

Bibl.: Hills, Neel, 1983

Neoclassicism. Term applied to historicizing trends in art (particularly in the 1920s) which referred back to the ideals, forms, or themes of ancient Greek and Roman art. In the 20th century, the first signs of a return to the ideals of classical antiquity could be seen in Picasso's work of

about 1914 (massive figures, nude or in timeless draperies reminiscent of examples from antiquity). Mythological themes were common. Neoclassicism took hold particularly in the Mediterranean countries. Many artists had a Neoclassical phase in the 1920s, although most of them distanced themselves from it later. Important representatives included de → Chirico, → Léger, → Severini, and → Maillol. Experience of World War I may have been a triggering factor in the return to a tried and tested order and the timeless ideal forms of the ancients. Neoclassicism was in part a reaction to the radical experimentation that took place in art at the beginning of the century. It put forward an arcadian ideal, yielding forms which sought to combine timeless classical ideals of beauty with the functionalism of the industrial age (→ Purism). Neoclassicism was also appropriated by reactionary movements such as the → Novecento in Italy, where the Fascists used classical imagery in propaganda art. F.P.

Bibl.: On Classic Ground, London, 1990

Neo-Dada. A collective term for various trends in the 1950s and 1960s which renounced the abstraction of → Art Informel and → Tachisme in Europe and → Abstract Expressionism in the US, and returned to the methods of → Dada. The term was coined by art critics in 1958. Representatives of American → Pop art such as → Johns or → Rauschenberg were called Neo-Dadaists, as were members of → Nouveau Réalisme in France. New art forms like → combine painting, → Environmental Art, Material art, as well as → happenings and → Fluxus, were subsumed into it. In contrast to Dadaists, with their polemical, destructive attacks on art and society, Neo-Dadaists attempted new forms of expression which repudiated the abstract art prevalent at the time. Neo-Dadaist works bring art and life together, frequently incorporating everyday objects. Often humorous, they can be seen as an ironic commentary on technical perfection. S.Pa.

Bibl.: Müller, Neo-Dada, 1987 · Neo-Dada, New York, 1994

Neo-Expressionism. Movement largely confined to Germany which emerged at the beginning of the 1960s in reaction to abstract trends such as → Art Informel and → Zero, and also to → Neo-Dada. It was characterized by the expressive, subjective handling of objective motifs in colors charged with emotion. One of the first exponents of this movement was → Baselitz with his upside-down pictures begun at the end of the 1960s. He was followed by → Lüpertz and Bernd Koberling (1983–), who formed the group Vision (1960–64). Together with other artists such as → Hödicke, they were regarded as the forerunners of the → Neue Wilde painters, who brought international recognition to Neo-Expressionism at the beginning of the 1980s. Although Neo-Expressionism was closely associated with Germany, similar developments were taking place in other countries, notably the US (→ Guston, → Schnabel, → New Image Painting) and Italy (→ Transavantgarde). S.Pa.

Bibl.: Ruhrberg, Neo-Expressionismus, 1987

Neo-Geo. Short for Neo-Geometric Conceptualism. Neo-Geo reflected a move away from the figurative Neo-Expressionism of the 1980s to a calmer, more impersonal, geometric pictorial language, containing overt references to the history of abstract art. The term covers a large number of artists working and thinking along different lines. They include → Armleder, → Förg, Peter Halley (1953–), → Knoebel, → Lavier, and G. → Merz. It sometimes overlaps with terms such as "Second Modernists" and "New Abstraction," introduced by H. Klotz in 1994. M.S.

Bibl.: Brüderlin, Neo-Geo, 1986 · Neo-Geo, Munich, 1986 · Neo-Geo, Munich, 1995

Neo-Impressionism. A development of Impressionism originating with the pointillist paintings of Georges Seurat (*La Grande Jatte*, 1884–86). Using scientific theories of optics, Seurat developed a new painting technique in which he juxtaposed regular dots (*point* in French, hence pointillism) of pure color, so that when seen from a distance they acquire a heightened luminosity. Since the technique was based on the analysis of color according to the laws of complementary and simultaneous contrasts, it was also known as → divisionism. The term Neo-Impressionism was coined in 1886 by the critic Félix Fénéon (1861–1944) in the periodical *L'Art moderne*, and was spread by, among others, → Signac in his article "De Eugène Delacroix au Néo-Impressionisme" (1899). Other exponents of Neo-Impressionism included Vittore Grubicy de Dragon (1851–1920), Giovanni Segantini (1858–1899), Henri-Edmond Cross (1856–1910), Maximilien Luce (1858–1941), Théo van Rysselberghe (1862–1926), Jan → Toorop, George Morren (1868–1941), van de → Velde, → Angrand, and Alfred William Finch (1854–1930). Neo-Impressionism had a profound influence on the development of painting at the beginning of the 20th century, notably in the work of → Matisse and R. → Delaunay in France, → Mondrian in Holland, and → Kandinsky in Germany. H.D.

Bibl.: Post-Impressionism, London, 1979–80 · Impressionism to Symbolism, London, 1994 · Franz, Farben des Lichts, 1996/97

Neo-Plasticism. Term coined by → Mondrian in his pamphlet *Le Néo-Plasticisme* (1920) to describe his style of abstract painting, characterized by horizontal-vertical structuring and the use of primary colors together with black, white, and gray. For Mondrian, these elements formed a "universal structuring medium" permitting the expression of harmonious cosmic laws. His theory was rooted in theosophical and philosophical sources, notably M. Schoenmaekers' book *Het Nieuwe Wereldbeeld* (1915). Mondrian sometimes used the term *nieuwe beelding* ("new structure") as a synonym for Neo-Plasticism (De → Stijl). H.D.

Bibl.: Mondrian, Néo-Plasticisme, 1920 · Mondrian, New Art, 1986

Neo-Primitivism. A Russian movement whose name, *Neo-primitivizm*, was coined from a book by Aleksandr Shevchenko (1882–1948). Burgeoning as early as 1906, as a coherent force it grew out of discontent with the Western-orientated (French, → Cubist) art, voguish in the country around

1912–13. The work of the most important exponents, → Goncharova and → Larionov, had even during their adhesion to the avant-garde → Jack of Diamonds collective become increasingly inspired by the simplistic compositions of *lubok* (the traditional tragi-comic Russian print), Siberian painted artefacts, and traditional signboards, as well as by neo-pagan themes in poetry and by the hieratic manner of the icons. Nonetheless, the members of the → Donkey's Tail (1912) group (including → Malevich) and their followers (Pavel Filonov [1883–1941], David → Burliuk, and visual poets Khlebnikov and Kruchenykh) continued to be influenced by advanced Western models. Their deliberately archaic and crude → Expressionism fused the Russian "Oriental" themes typical of Neo-Primitivism with Cubistic spatial concerns. D.R.

Bibl.: Bowlt, Russian Art, 1976 · Parton, Larionov, 1993

Neo-Realism. Term used at different times in the 20th century to describe realist trends. It was initially used in 1913 by British painters Charles Ginner (1878–1952) and Harold Gilman (1876–1919) to assert their belief that good art was based on close contact with nature. The term was later applied to a movement of the 1950s, largely confined to Western European countries, which was loosely related to parallel trends in literature and film. It represented a move toward realism and away from abstraction. Many artists associated with Neo-Realism were involved in the social struggles of the postwar period. In Italy, the leading exponent was → Guttuso, who, following in the footsteps of → Picasso, wanted to reform the contemporary image of history. Similar developments took place in France under the banner of Néo-Réalisme (confusingly, Neo-Realism has also been used as a synonym for → Nouveau Réalisme). In a wider sense, Mexican → muralism of the 1920s and 1930s, and the British → Kitchen Sink painters of the 1950s were facets of the same trend. Neo-Realism was eclipsed by new developments in art during the 1960s. H.D.

Bibl.: Sager, Realismus, 1973

Neo-Romanticism. Neo-Romanticism (Neo-Romantic Painting) was an important force in British art from the mid-1930s to the early 1950s. The term covered figurative, conservative art concerned with spiritual identity and the Arcadian nature of "Albion": paintings were often emotionally charged and theatrical, deriving imagery from William Blake, Samuel Palmer, and → Surrealism (especially the swirling forms of → Masson). Associated with the movement at one time or another were → Piper, → Moore, Paul → Nash, David → Jones, → Vaughan, and → Sutherland, as well as Robert MacBryde (1913–66), → Minton, John Craxton (1922), Michael Ayrton (1921–75), Cecil Collins (1908–89), and → Hitchens. Other figures involved included art historian Kenneth Clark, critic Herbert Read, patron Peter Watson, poet Geoffrey Grigson, and → Lewis. The Neo-Romantics' popularity naturally waned in the → Abstract Expressionist and British → Pop phases, but in the wake of the 1980s "return to the figurative," their reputation has risen. D.R.

Bibl.: Paradise Lost, London, 1987 · Yorke, Neo-Romanticism, 1988

Neue Künstlervereinigung München. An association of artists founded in Munich in 1909 to organize exhibitions. Its origins lay in the Munich salon of → Werefkin and → Jawlensky. The individual styles of members varied, but were close to → Expressionism and → Fauvism. Members included → Kandinsky, Jawlensky, → Münter, → Marc, Kanoldt, and → Kubin. The NKVM organized three exhibitions, the first in 1909, the second in 1910, and the third in 1911–12. Following their resignation from the NKVM, Kandinsky and Marc promptly organized the First Exhibition of the Editors of the → Blaue Reiter. The reason for their resignation was the rejection of an abstract picture by Kandinsky, principally by the conservative wing under → Kanoldt. This refusal to accept the path chosen by Kandinsky led to the dissolution of the NKVM in 1912. H.D.

Bibl.: Friedel/Hoberg, Neue Künstlervereinigung München, 1999

Neue Sachlichkeit. Term for a trend in painting of the 1920s, mainly centered on Germany, which in contrast to the concept of → Expressionism, focuses on the detached representation of a cool, factual reality by way of a smooth, stylized form. The term was coined in 1923 by G. H. Hartlaub, director of the Kunsthalle in Mannheim, who wanted to assemble realistic painting of that era and combine it in one exhibition which was realized in 1925 as a traveling exhibition (1927 Berlin; 1929 Amsterdam). It is also referred to as → Magic Realism.

Whereas in Munich a Neoclassical trend emerged out of the movement through painters such as → Kanoldt, → Schrimpf, W. Heise and C. Mense, in Berlin a socio-critical, left-orientated movement developed which is also described as → Verism, because of its stark representation of cityscapes (→ Dix, → Grosz, → Davringhausen, → Schlichter). Neue Sachlichkeit in architecture and design refers to a stylistic form which turns its back on historicism in favour of functionalism (see → Novecento, → Functionalism, → Constructivism). G.P.

Bibl.: Roh, Nach-Expressionismus, 1925 · Schmied, Neue Sachlichkeit, 1969 · Hulten, Realismus, 1981 · Presler, Glanz und Elend, 1992 · Buderer/Fath, Neue Sachlichkeit, 1994

Neue Wilde. Term describing a stylistic trend which developed in Germany from 1977, parallel with the Italian → Arte Cifra and which, in contrast to → Minimalist and → Conceptual art, was expressed through a spontaneously passionate, intensely colored and figurative manner of painting. The phrase derived from a 1979 exhibition, Les Nouveaux Fauves/The New Savages held at the Ludwig-Forum Moderner Kunst in Aachen where attempts were made to find connections between → Fauvism, → Expressionism, and a new style of painting. Its main instigators were the Berlin painters → Hödicke, Bernd Koberling (1938–) and → Lüpertz. Among the advocates of "Heftige Malerei" [violent painting] in Berlin were → Fetting, → Middendorf, Salomé and B. → Zimmer; in Cologne Walter Dahn (1954–) and → Dokoupil formed a group called Mülheimer Freiheit. In Hamburg Martin Kippenberger (1953–), Werner Büttner (1954–) and the brothers Albert (1954–) and Markus Oehlen (1956–) were

Neue Künstlervereinigung München, Wassily Kandinsky, *Poster for the first exhibition of the Neue Künstlervereinigung München*, 1909, Colored lithograph, 94 x 64 cm, Städtische Galerie im Lenbachhaus, Munich

among the first representatives of this wildly figurative style of painting which made social interventions using an ironic, sarcastic manner. In the mid-1980s many painters rejected this label to pursue their own individual styles. H.D.

Bibl.: Faust/Vries, Neue Wilde, 1982 · Klotz, Neue Wilde, 1984

Nevelson, Louise (née Berliawsky). *1899 Kiev, †1988 New York. Russian-born American sculptor who emigrated to the US with her family in 1905. She studied sculpture at the → Art Students League (1929–30) and made several trips to Europe (1931, 1948). In 1932 she worked as assistant to → Rivera. She took part in the Venice Biennale (1962, 1976) and Documentas 3 and 4 (1964, 1968).

Nevelson made numerous freestanding sculptures and interior designs (US Courthouse, Philadelphia, 1976). Her early work consisted of totemic wooden → assemblages. In 1958 she began making wooden sculptured walls composed of boxes and compartments containing abstract shapes and objects (sections of balustrade, tools, etc.). These monumental works have the ironic quality of Dada objects (→ Arp, → Schwitters). She used monochrome colors suggesting a sacred environment. In 1976 she designed the Erol Baker Chapel in New York along similar lines. I.S.

Bibl.: Celant, Nevelson, 1995

Nevinson, C(hristopher) R.W. *1889 London, †1946 London. British painter. Nevinson initially studied at the Académie Julian. He was briefly a member of the Rebel Art Centre (early 1914); he did not join the → Vorticists, but from 1914 to 1919 produced → Futurist work, punctuated one of → Marinetti's London "lectures" with drumbeats. His work moved away from Impressionism thanks to → Severini, whom he met in 1912; through him he subsequently met → Boccioni, → Soffici, and the poet Guillaume Apollinaire. In a British context, his Futurism is generally simpler than → Bomberg and less violent than → Lewis. If *The Arrival* (1913–14) betrays the preponderance of Severini, works as a war artist (*Mitrailleuse,* chalk drawing) remind one of the illustrations of infantry blind aggression by → Gromaire. Neutral if energetic trench lines appear in works close to Boccioni, while *Bursting Shell* (1915) seems to present a mythical yet near-abstract view of war matériel. His *aeropittura* works (*Pursuing a Taube,* 1915–16) are in a more sober style than those of → Prampolini or → Depero. Postwar painting included the two well-dressed *bourgeoises* simpering in the streetlights of *War Profiteers* (1917), saying farewell to the glorification of war perhaps more effectively than his cool (compared, say, to → Dix) portrayals of the conflict. His fine later work includes poetico – mythical works and *Strand by Night* (c. 1927). The Archive of Modern British Art (Tate) contains a wealth of publications by him. D.R.

Bibl.: Nevinson, London, 1999

New British Sculpture. A loose grouping of British sculptors who emerged at the beginning of the 1980s. The expression was used in reviews of the show "Objects and Sculpture," held at the ICA, London (1981). Though abstraction predominated at the exhibition, the artists concerned also made use of the new discovery of (or trend for) the bodily (see → Gormley). Mixed media, → appropriation and industrial "recycling" (e. g. → Woodrow, → Cragg) on the whole typified what remained an object-orientated attitude to materials. Major figures included → Kapoor, → Deacon, and → Mach alongside Cragg and the slightly older Woodrow, followed by Shirazeh Honshiary (1955–), Julian Opie (1958–), Alison Wilding (1948–), and Richard Wentworth (1947–). D.R.

New Figuration. The term New Figuration (Nouvelle Figuration in French) was introduced by the critic Michel Ragon in 1961 with reference to figurative trends in painting at a time when abstraction was dominant. For a time it was regarded as a European equivalent of American → Pop art, but in fact the term encompassed a heterogeneous range of artists (→ Adami, → Arroyo, and → Erró, among others). However, they shared a common technique (large-scale painting in acrylic), as well as a recourse to photography and film, and a socially critical stance. The exhibition Mythologies Quotidiennes in 1964 represented the movement's peak in France. At the end of the 1960s, the term was extended to similar trends in Europe, but became increasingly redundant in the light of the varied individual styles of the artists in question. H.D.

Bibl.: New Figuration, 1964 · New Figuration, 1977

New Image Painting. Term applied in the late 1970s to American figurative painting in the wake of → Neo-Expressionism. It was given currency by the exhibition New Image Painting at the Whitney Museum of American Art, New York (1978). A precursor of the New Imagists was → Guston, who abandoned his → Abstract Expressionist idiom in the 1970s in favor of a comic-like figurative style. Other artists who have been described as New Image painters include → Borofsky and → Rothenberg. H.D.

Bibl.: Godfrey, New Image Painting, 1986

New York School. Term applied to the artists involved in the various avant-garde trends which emerged in New York in the 1940s, notably → Abstract Expressionism (including the Surrealist-influenced work of → Gorky and → Baziotes) and → Color Field Painting. The term was extended to encompass various painters and sculptors living in New York, including → Hofmann, → Lindner, → Nevelson, T. → Smith, and → Warhol. In 1965 works by the major New York-based artists of this period were presented at an exhibition at the Los Angeles County Museum in 1965, New York School: The First Generation, Paintings of the 1940s and 1950s. H.D.

Bibl.: Ashton, New York School, 1980

Newman, Barnett. *1905 New York, †1970 New York. American painter, printmaker, and sculptor. He studied at the → Art Students League (1922) and the City College of New York

Barnett Newman, *In Couples*, 1949, Oil on canvas, 168 x 40.5 cm, Private Collection

(1923–27). In 1948 he founded the Subjects of the Artist School (with → Baziotes, → Motherwell, and → Rothko). He took part in Documentas 1 and 4 (1959, 1968). Between 1962 and 1964 he lectured at the University of Philadelphia.

The different facets of Newman's œuvre were already apparent in his first one-man shows (1950, 1951). His paintings characteristically consist of monochrome fields free from any trace of brushstrokes, divided by one or more stripes, or "zips" (*Vir Heroicus Sublimis*, 1950–51). These basic elements are constantly varied, with the size and format of the canvas, the arrangement and composition of the zips, and the colors changing from one painting to the next. Rejecting the European tradition of abstract painting, Newman adopted a philosophical approach at the heart of which was the sense of "the sublime" which he wished the viewer to experience. Newman intended his huge, luminous colored surfaces to lead to a liberated and heightened awareness. The vertical (and in an early phase horizontal) zips, which cannot be seen in their entirety close up, appear as breaches between different spheres of experience, contrasting with and amplifying the colored fields. Because of his austere style, Newman was an isolated figure in the New York of the 1950s, out of step with the gestural painting of → Abstract Expressionism popular at the time. His most important work, the 14 *Stations of the Cross* (1958–66), was produced following a heart attack. This series sums up his belief in the power of abstract painting to convey spiritual messages. In his last years he produced large steel sculptures (*Broken Obelisk*, 1963–67), as well as lithographs and the important series of pictures *Who's Afraid of Red, Yellow, and Blue* (1966–70). H.D.

Bibl.: Hess, Newman, 1971 · Richardson, Newman, 1979 · O'Neill, Newman, 1990 · Rosenberg, Newman, 1978/1994 · Strick, Newman, 1994

Barnett Newman, *Who's afraid of Red, Yellow and Blue III*, 1967–68, Oil on canvas, 245 x 543 cm, Stedelijk Museum, Amsterdam

Nicholson, Ben. *1894 Denham, Buckinghamshire, †1982 London. British painter and sculptor. He studied at the Slade School of Art, London (1910–11). He was a member of → Unit One (1932) and → Abstraction-Création (1933–37). From 1940 he lived in St Ives, Cornwall, with → Hepworth (the second of his three wives). In 1958 he settled in Switzerland. He took part in Documentas 1, 2, and 3 (1955, 1959, 1964).

Nicholson was one of the foremost exponents of → Concrete art. His early still lifes and landscapes were painted in a simplified geometrical style inspired by → Cubism. In 1933 he painted his first abstract works, in which geometric shapes are linked with continuous wavy lines scratched into the picture surface. From 1945, inspired by → Mondrian, he used circles and squares in severe abstract compositions (*Silver-line*, 1959). In the 1960s he also produced reliefs (*Tuscan Relief*, 1967), as well as drawings with architectural and still-life motifs. H.D.

Bibl.: Russel, Nicholson, 1969 · Lewison, Nicholson, 1991 · Lewison, Nicholson, 1993

Nicholson, (Sir) William (Newzam Prior). *1872 Newark on Trent, Nottinghamshire, †1949 Blewbury, Berkshire. British painter. William Nicholson briefly studied at the → Académie Julian, Paris. As "Beggarstaff" with his brother-in-law James Pryde, he designed posters in a → Post-Impressionist (Toulouse-Lautrec or → Bonnard) style. Nicholson was commissioned by publisher William Heinemann to produce a series of woodcuts (*An Alphabet* and *An Almanac of Twelve Sports*, 1897/98). These squibs have an amicable British wit, as does the *Square Book of Animals* (1899). From the turn of the century Nicholson worked predominantly in oils, producing stunning portraits (*Max Beerbohm*, 1905) in a looser version of those by John Singer Sargent (1856–1925). He was gifted as a painter of still lifes and interiors (society in straightened circumstances beneath a high ceiling in *Ballroom in a Air Raid,* 1918; or the grandiose *City Dinner*, 1932). His "landskips" had nostalgic charm (*Whitestone Pond, Hampstead*), and included Post-Impressionist versions of Paris (from 1914) and low-lying studies of e.g. Rottingdean (*Winter*, 1910). D.R.

Bibl.: Nicholson, William Nicholson, 1996

Nicholson, Winifred. *1893 Oxford, †1981British painter. Born Rosa Winifred Roberts, Winifred joined the 7&5 Society (disbanded 1935) and married Ben → Nicholson, divorcing in 1938. She became a close friend of → Mondrian and (perhaps more relevantly to her work) → Arp. She lived in Switzerland, Paris, and Cumberland. Her flower paintings of the 1920s are primarily concerned with color over form, the arrangements showing up an interest in contrast and abbreviated space, also apparent in the work of fellow woman artist Frances Hodgkins (1870–1947). A few paintings of 1934–37 might be taken for her husband's creations with their repetition of the circle (compressed into an ellipse or confined in a block), but the structure of white-on-white surfaces is less paramount. After the end of the War, Winifred returned to flower painting with large, less detailed areas of background color (*Honeysuckle and Sweet Peas*, 1945–46) working in the Scottish islands, Greece, and Morocco. Her work was given a full retrospective at the Tate Gallery, London, in 1989. D.R.

Bibl.: Collins, Winifred Nicholson, 1987

Nitsch, Hermann. *1938 Vienna. Austrian Performance artist, painter, and draftsman living in Prinzendorf, near Vienna. He studied at the Graphische Lehr- und Versuchsanstalt, Vienna (1953–58). In 1969 he published works on the theories behind his "Orgien-Mysterien-Theater." Between 1971 and 1989 he taught at the Städelschule in Frankfurt. He took part in Documentas 5 and 7 (1972, 1982).

At the end of the 1950s Nitsch began writing plays which, adopting the idea of the

Hermann Nitsch, *Large Picture with Painter's Smock*, 1988,
Acrylic, blood on canvas, 200 x 300 cm, Sammlung Essl,
Klosterneuburg, Vienna

→ Gesamtkunstwerk, envisaged an orgiastic festival embracing all the senses: the "Orgien-Mysterien-Theater." These orgiastic performances were followed by a series of painting performances (1960–62) involving the audience. The central concept was a parallel with Christ's Passion and its comparison with the ancient myth of Dionysus. The tearing apart of a dead lamb, for example, was intended to be a cathartic act which would permit the "revelation of physical urges." Ecstasy was seen as a celebration of human existence. In 1972 Nitsch was able to present and document parts of this gigantic, confusing spectacle in the grounds of his castle in Prinzendorf. Nitsch has expressed his ideas in drawings, graphic works, and a flood of publications, including poems in the style of Georg Trakl, Stefan George, and Nietzsche. With his "poured pictures," Nitsch developed a new type of action painting. The resulting pictures were exhibited in 1969, along with relics from his performances such as biers, monstrances, chalices, clerical garments, and painters' smocks. H.D.

Bibl.: Nitsch, Orgien, 1979 · Rychlik, Nitsch, 1986 · Ronte/Zweite, Nitsch, 1988 · Nitsch, Theorie, 1995 · Hegyi, Nitsch, 1996

Noguchi, Isamu. *1904 Los Angeles, †1988 New York. American sculptor. He was brought up in Japan. On his return to the US he studied medicine first in Indiana and then in New York, where he simultaneously took sculpture classes. In 1927 he won a Guggenheim Fellowship enabling him to spend two years in Paris, where he worked as → Brancusi's assistant and met → Calder. In 1931–32 he traveled in China. He studied Chinese calligraphy and Japanese gardens. He took part in Documentas 2 and 3 (1959, 1964). During the early years of his career, Noguchi made portrait busts and embarked on a successful career as a stage designer (working for Martha Graham, Balanchine, and Merce Cunningham). After World War II he began to gain international recognition as a sculptor and from the 1960s he received numerous major commissions for public spaces, a number of which were for sculpture gardens (including the Garden of the Delegates and the Japanese Garden for the UNESCO building in Paris). Substantiating his claim to be a universal artist, Noguchi's work encompassed many cultures and impacted on various movements – → Constructivism, → Surrealism, and → Minimal art – defying categorization. I.S.

Bibl.: Ashton, Noguchi, 1992

Nolan, (Sir) Sidney (Robert). *1917 Melbourne, †1992 London. Nolan is Australia's most celebrated artist. Initially influenced by modernism through reproductions of → Klee, → Picasso, and → Matisse as well as → Dada and → Surrealism (*Head of Rimbaud*, 1938–39), Nolan worked in quick-drying Ripolin, painting falsely "clumsy" Australian landscapes, the figures laid in with a finger or sponge. Allusions to everyday events that might surprise the European add to the charm (*Hare in a Trap*, 1946). He extended his Australian concerns into myth with an extensive cycle (over 30 paintings) on the outlaw Ned Kelly, whose rectangular body armor stands out enigmatically against the cinnabar-pink scrubland. Nolan then produced outback landscapes, including some of mines accompanied by outsized animals (*Pretty Polly Mine*, *Little Dog Mine*, both 1948). After decamping to London after encouragement from the art historian Kenneth Clark, he traveled to Greece (1955–56) and the US, producing a second Kelly series (*The Glenrowan Siege*, 1955) before moving onto "mythological" works based on animals (herons, Leda's swan). Employing a scraper over white-primed hardboard in later studies, he ranged widely in inspiration: Chinese landscape, African game, mangrove swamps, surrealist "portraits," Antarctic explorers. A major late project was a floral mural (*Paradise Garden*, 1968–70). Nolan was also a prolific graphic artist and set designer. D.R.

Bibl.: Clark, Nolan, 1961

Noland, Cady. *1956 Washington. American Installation artist living in New York. She took part in the Venice Biennale (1990) and Documenta 9 (1992). Noland's working methods are not unlike those of an ethnologist. Her → assemblages and → installations, as well as her fictional encyclopedia, are studded with consumer items, everyday objects, and newspaper photographs. Her works conjure up events or entire histories, plumbing the depths of the modern American lifestyle. Noland is concerned with a public search for identity, exploring images, clichés, marketing mechanisms, and violence. She favors unusual places for her exhibitions, on one occasion choosing a multistory parking lot (Kassel, 1992). I.S.

Bibl.: Noland, Stuttgart, 1992

Noland, Kenneth. *1924 Asheville, North Carolina. American painter. He studied at → Black Mountain College (1946–48) and in Paris under → Zadkine (1948–49). He taught at the Institute of Contemporary Art, Washington, D.C. (1949–51), and the Washington Workshop Center of Arts (1951–60). In 1977 he became a member of the American Academy and Institute of Art and Letters, and in 1985 he was appointed Milton Avery Professor at Bard College, Annandale-on-Hudson. He took part in Documenta 9 (1992). With → Louis he developed the technique of staining, soaking the unprimed canvas with thinned acrylic paint. Drawing on an elementary repertoire of motifs – circle, right-angle, parallel lines – Noland experimented with paint, exploring its application, texture, transparency, and intensity (*Bloom*, 1960). Closely linked to the problem of pigment was the

Kenneth Noland, *Ember*, 1960,
Acrylic on canvas, 179 x 178 cm,
Private Collection

choice of support, the shape of which had an impact on the optical effect of the picture (→ shaped canvas). Following his *Chevrons* of the 1960s and 1970s, for which he used thinned paint applied without texture, Noland returned to classical painting techniques with priming and spatula. At this time he also began making sculptures of painted canvas and Plexiglas (*Doors: Step by Step*, 1987) and produced architecture-related work (Weisner Building, Massachusetts Institute of Technology, Boston). In the mid-1980s he discovered → Computer art. H.D.

Bibl.: Moffet, Noland, 1977 · Waldman, Noland, 1977 · Wilkin, Noland, 1990 · Agee, Noland, 1993

Emil Nolde, *Whitsun*, 1909, Oil on canvas, 87 x 107 cm, Neue Nationalgalerie, Berlin

Nolde, Emil. *1867 Nolde, near Tondern, †1956 Seebüll, near Neukirchen. German painter and printmaker, born Emil Hansen. After training as a cabinetmaker and wood carver (1884–88), he taught at the Kunstgewerbeschule, Karlsruhe (1889), and in St. Gallen (1892–97). In 1899 he studied painting under → Hölzel and at the Académie Julian in Paris. He took part in the 1906 exhibition of the Berlin → Secession and in the same year became a member of Die → Brücke. However, he was expelled from the Secession in 1910 following a personal attack on → Liebermann. In 1913–14 he accompanied an ethnographic expedition to the South Sea islands. He subsequently settled in Seebüll (1926) and became a member of the Preussische Akademie der Schönen Künste (1931). In 1937 he was condemned as a "degenerate artist" and 1,052 of his works were confiscated. In 1946 he took up teaching and in 1956 founded the Ada and Emil Nolde Seebüll Foundation, which has a large collection of his work.

Nolde, one of the most important exponents of → Expressionism, was a solitary figure isolated from the major artistic movements of his time. His early paintings were in a late Impressionist style with pale hues. Influenced by the work of van Gogh, Gauguin (→ precursors), and → Munch, his colors became more intense, his brushstrokes heavier, and the sense of space more constricted. Nolde's principal themes included coastal landscapes and religious scenes (*Whitsun*, 1909), but his imagination was particularly fired by flowers (*Garden in Seebüll*, 1928). He experimented with → Tachiste techniques and incorporated the element of chance into his painting (*Fantasy Cycle*, 1905). Although he painted a number of scenes recording nightlife in Berlin (*Im Café*, 1911), Nolde was particularly fascinated by → primitivism, producing a number of still lifes with exotic figures and masks. The study material he brought back from New Guinea was processed in drawings, watercolors, and paintings (1915). He was banned from painting by the Nazis (although he had supported the Nazi Party), but he secretly painted hundreds of small watercolors (*Ungemalte Bilder*, "Unpainted Pictures"), which he reworked after 1945 as oil paintings. The watercolors of flowers and landscapes near his home in Seebüll produced in the last years of his life did much to increase the popularity of his work. W.G.

Bibl.: Haftmann, Nolde, 1965 · Urban, Nolde, 1987–90 · Brugger/Reuther, Nolde, 1994 · Ackley, Nolde, 1995 · Nolde, London, 1995 · Schiefler/Mosel, Nolde, 1995

Nouveau Réalisme (French = New Realism). Movement launched in Paris in 1960 by the French critic Pierre Restany. The leading exponents were Y. → Klein, → Tinguely, → Arman, → Dufrène, → Spoerri, → César, → Rotella, de → Saint Phalle, and → Deschamps. These artists incorporated everyday objects and junk into their → assemblages, → accumulations (Arman), and → readymades, resulting in a new repertoire of forms, sometimes fed by → Dada ideas (the movement was also called → Neo-Dada). Spoerri invented a new kind of → object art with his *tableau-piège* and → Christo introduced the new medium of wrapping (→ empaquetage). H.D.

Bibl.: Nouveaux Réalistes, 1986

Nouvelle Tendance (French = New Tendency). An international, heterogeneous movement of the 1960s aimed at a purist abstract type of art in the Constructivist tradition. Common elements were the investigation of optical phenomena (→ Op art), sometimes in the form of monochrome paintings, and the use of new creative media such as movement, light, and sound (→ Kinetic art). Within the loose framework of the movement, small groups of artists formed in different countries, including → Zero in Germany and → Nul in the Netherlands. Artists of the French → Groupe de Recherche d'Art Visuel (GRAV) experimented with light and Kinetic art. H.D.

Bibl.: Nouvelle Tendance, Paris, 1964

Novecento. The Italian word for the 20th century was also the name of a group founded in 1922. It comprised representatives of → Futurism, → Pittura Metafisica, and → Neo-Impressionism who rejected avant-garde painting in favor of a return to classical Italian traditions. Early protagonists included Achille Funi (1890–1972), Ubaldo Oppi (1889–1946), and → Sironi. Later the movement was joined by → Soffici, → Marini, → Casorati, → Prampolini, de → Pisis, Ottone Rosai (1895–1957), Felice Carena (1879–1966), and Ferruccio Ferrazzi (1891–1978). Its nationalist leanings brought the group recognition from the Fascists, although not all of the artists complied with the heroic approach required at the time. S.Pa.

Bibl.: Ballo, Novecento, 1958

Novembergruppe. Association of artists founded in Berlin in December 1918. It was named after the revolution that had taken place in Germany

the month before, leading to the fall of the imperial regime. The Novembergruppe was initiated by → Pechstein, among others, and became a melting pot for progressive artists, including architects, painters, sculptors, writers, film-makers, and composers. Artistically, it embraced all the various modern movements. Until 1921 the group had contacts with the Arbeitsrat für Kunst. In spite of several attempts to form local groups, it remained confined to Berlin. Initially driven by Utopian ideas (the bringing together of art and the people, the unity of the arts), by 1920 it had become an exhibition organization for modern art active in a variety of fields. H.O.

Bibl.: Kliemann, Novembergruppe, 1960 · Novembergruppe, Berlin, 1993

Nul. Dutch group of artists founded in 1961 by, among others, → Armando and Jan Schoonhoven (1914-). The Nul Groep, which can be seen as a reaction to → Art Informel and → Abstract Expressionism, was an offshoot of the international → Nouvelle Tendance movement. Some of the work produced by the group, such as Schoonhoven's series of white reliefs in which he explored the visual and tactile qualitites of different materials, were similar to those produced by the → Zero group. The group published a periodical *Nul=0* (1961–63). H.D.

Bibl.: Nul, Amsterdam, 1962/1965

Nussbaum, Felix. *1904 Osnabrück, †1944 Auschwitz. German painter. He studied at the Kunstgewerbeschule, Hamburg (1922–23), and the Staatsschule für freie und angewandte Kunst, Berlin (1924–29). He received a grant to work at the Villa Massimo in Rome (1932–33). In 1934 he went into exile in Belgium and between 1935 and 1938 lived in various places. In 1940 he was interned but he escaped. In 1944 he was arrested and deported. His early works (family portraits, self-portraits, city views, and landscapes), which show the influence of van Gogh and → Rousseau, portray the world as a benign place full of poetry. In 1926 he painted portraits of his parents in a style marked by → Neue Sachlichkeit. In 1928 his work began to gain recognition in Berlin. Subsequently he developed a fantastical figurative pictorial language which owed something to de → Chirico, → Carrà, and, in its coloration, → Hofer (*The Wild Square*, 1931). Marked by the persecution of Jews throughout Europe and his own internment and escape, Nussbaum went on to produce impressive, symbolic works which document human suffering and horror (*Triumph of Death*, 1944). His own plight was captured in self-portraits, showing him naked and unprotected, tormented by fear, surrounded by walls as an outcast with a Jewish passport, or led by an organ grinder, with skeletons dancing around him, along his final path into the fire. Most of his works are housed in the Felix-Nussbaum-Museum in Osnabrück. G.P.

Bibl.: Kaster, Nussbaum, 1989 · Berger, Nussbaum, 1995

Nutt, Jim. *1938 Pittsfield, Massachusetts. American painter, living in Chicago. He participated in the late 1960s "Hairy Who" installation/happen-

ings and was invited to the 36th Venice Biennale (1972). His early works, in bold acrylics or colored pencil on paper (sometimes brown), were in crude "poor taste" (*ZZZit* [series], 1970) and featured haunting comic-strip zoomorphic humanoids indulging in unedifying activities. Since the 1970s, his central theme has been the confrontation between men and women, depicted in unconsciously stereotypical scenes of long-limbed, elongated-headed creatures with dialogic titles: *You're giving me trouble* (1974); *I'm not one to quibble (but you're wrong)* (1977). A series of acrylic "portraits" (1987–93) parade a similar (female) face with slight but crucial changes, each with a distantly allusive title: *Pool*; *Tomb*; *Pug*; *Gulf*; *Plume*; *Proof*, etc. In 1995 Nutt had a US mid-career traveling retrospective (Henry Art Gallery, University of Washington, Seattle, etc.). D.R.

Bibl.: Bowman, Nutt, 1994

O'Keeffe, Georgia. *1887 Near Sun Prairie, Wisconsin, †1986 Santa Fe, New Mexico. American painter. She studied at the Art Insitute of Chicago (1905–06) and the → Art Students League of New York (1907–8). She then worked as a commercial artist for two years, before teaching in schools in South Carolina, Texas, and Virginia. She had her first one-woman show in 1917. In 1918 she settled in New York, supported by → Stieglitz (whom she married in 1924). In 1949 she settled in Abiquiu, New Mexico.

O'Keeffe traveled widely and won numerous awards. Her early abstract drawings, known as *Specials* (1915), were influenced by → Kandinsky, Far Eastern principles of structure, and the expansive style of → Art Nouveau. The ornamental, geometric shapes in these works were based on flowers and other organic forms. She followed these with strongly colored watercolors in a loosely abstract style. In her subsequent pictures of flowers, still lifes, and industrial landscapes, she went on to develop her intuitive, semi-abstract language based on elementary natural shapes. Inspired by the photographs of → Strand, she enlarged her motifs (principally flowers such as Calla lilies) so that they appeared in close up, thereby heightening the impression of abstraction. Between 1925 and 1930 she painted atmospheric, visionary landscapes of New York in a similar vein.

Like Kandinsky, O'Keeffe took music as a model for her sometimes expressively exaggerated transpositions of "inner sounds" (*Symphony*). From the 1920s, the landscapes of New Mexico opened up new repertoires of motifs, including fantastic, surreal desert mountain ranges and sun-bleached animal bones, their cavities revealing a view of the sky. She increasingly sought to minimalize her forms and colors, coming close to → Color Field Painting and → Abstract Expressionism. K.S-D.

Bibl.: Cowart, O'Keeffe, 1989 · Benke, O'Keeffe, 1996 · Winter, O'Keeffe, 1998

objects. The incorporation of objects into works of art dates back to the second decade of the 20th century. Between 1912 and 1916, → Picasso, in parallel with his development of the Cubist

Georgia O'Keeffe, *Arazee No. 6*, 1930, Oil on canvas, 101.6 x 76.2 cm, Alfred Stieglitz Collection, Washington

Georgia O'Keeffe, *Shelton Hotel, New York No. 1*, 1926, Oil on canvas, 81.3 x 43.2 cm, The Regis Collection Minneapolis, Minnesota

→ collage, created reliefs and three-dimensional works using materials hitherto foreign to art. In 1914 he placed a real metal sugar strainer on top of his *Absinthe Glass* with a replica sugar cube. → Duchamp created his first → ready-mades in 1913 with his *Bicycle Wheel* mounted on a kitchen stool, followed a year later by the *Bottle Rack*. Such objects were chosen deliberately, but artists such as → Schwitters created their → assemblages with the aid of the chance find, the → objet trouvé. The use of objects could be motivated by narrative concerns, in order to convey a certain content three-dimensionally, but it was also done for aesthetic reasons, to exploit the formal qualities of the object beyond its intended function. In → Dada, objects were used as a means of provocation, while in → Surrealism they were combined to develop a wide variety of associations of a dreamlike nature. Objects took on an increasingly central role in the reaction to abstraction and → Art Informel, particularly in the 1960s through the work of the Pop artists and the Nouveaux Réalistes. → Rauschenberg's → combine paintings, → Spoerri's "trap pictures," → Christo's wrappings, and the socially critical → environments of → Kienholz were all equally influential. These classical uses of the object developed into kinetic constructions, → multiples, performances, and objects designed for use, as well as → Conceptual works, in which the emphasis was placed on the symbolic nature of the object rather than its materiality. D.S.

Bibl.: Waldman, Collage, 1992 · Erickson, Objects, 1995

objet trouvé. A man-made or natural object found by the artist and incorporated, in its entirety or in part, into an artwork. The object in question could be modified further through fragmentation or coloring. Incorporated into a picture or → collage, or combined with other found items into an → assemblage, the objet trouvé is removed from its original function and acquires an aesthetic quality which, in the context of the work of art, can result in surprising characteristics and associations. As its origin usually remains identifiable, the object creates a link between the work of art and often mundane connections outside art. The objet trouvé emphasizes the coincidental and the playful element inherent in creativity. It was an important aspect of → Dada and → Surrealism. In his → Merz collages, → Schwitters incorporated, among other things, pieces of metal and wood, scraps of newspaper, and entrance tickets. For the Surrealists, the objet trouvé was a resonant manifestation of the unconscious and therefore had the quality of a fetish. After World War II, artists with widely differing approaches and themes used the refuse of consumer society or bogus historical evidence in sculptures and → environments (→ Nouveau Réalisme, → Fluxus, → Pop art). F.K.

Bibl.: Kellerer, Objet trouvé, 1982 · Waldman, Collage, 1992

Oelze, Richard. *1900 Magdeburg, †1980 Posteholz. German painter. He studied under → Itten at the Weimar → Bauhaus (1921–26). Oelze led a wandering existence, living in Dresden (1926–29), where he became involved in the Dresden → Secession, Ancona (1930–31), Berlin

Richard Oelze, *Oracle*, 1955, Oil on canvas, 100 x 125 cm, Private Collection

(1931–33), Paris (1933–36), where he had contacts with → Breton and the Surrealists, Switzerland (1936–38), Worpswede (1939–62), and Posteholz (1962 until his death). Between 1940 and 1945 he served in the army and was taken prisoner. He took part in Documentas 2 and 3 (1959 and 1964), and the Venice Biennale (1968). His early pictures feature fantastic scenes with ghostly figures, fusing organic forms and demonic connotations. His work began to gain recognition in 1945, but it was not until 1959 (Documenta, Surrealism retrospectives in Paris, 1959, and New York, 1960) that his reputation was established. Influenced by → Dix, his meticulously varnished oil paintings (*Expectation*, 1935–36) consist of figurative pictures and landscapes of a more abstract and surreal nature. In the 1950s, his paintings became increasingly abstract, presenting a hermetic world featuring anthropomorphic, vegetable, and geological shapes (*Growing Silence*, 1961). W.G.

Bibl.: Schmied, Oelze, 1987 · Damsch-Wiehager, Oelze, 1989

Official War Art. Official War Art was sponsored by the British and other governments during World War I, and to a lesser extent World War II, to record the effects of conflict for both propaganda and information-gathering. (The Axis powers also had similar schemes, but the term is generally confined to Allied projects.) Organized under the auspices of the Ministry of Information in World War I, the program began in 1916 with Muirhead Bone (1876–1953; his lithographs comprised *The Western Front*, 1917), followed by Paul → Nash, → Nevinson, → Spencer, Eric Kennington (1888–1960), William Orpen (1878–1931), and others. The art produced varied in quality and propaganda value, some of it depicting the horrors of war (e.g. by John Singer Sargent [1856–1925]), though without the vitriol of → Dix's very unofficial etchings in Germany. By World War II (when both → Sutherland and → Piper were appointed), photography had usurped the propaganda value of visual art to an extent, although → Moore's drawings of the London Underground being used as an air-raid shelter remain powerful. (Other very different war-inspired art includes → Futurism and → Socialist Realism.) D.R.

Oiticica, Hélio. *1937 Rio de Janeiro, †1980 Rio de Janeiro. Brazilian painter. He studied at the Escola do Museu e Arte Moderna, Rio de Janeiro (1954). In 1959 he became a member of Grupo

Neoconcreto (→ Concrete art). He has taken part in the São Paulo Bienal on two occasions (1957, 1959) and in 1969 he had a one-man exhibition at the Whitechapel Art Gallery, London. His early works were in the tradition of Concrete art (*Metaesquemas*, 1957–58). From 1959 he started to produce three-dimensional works, notably the *Bólides* (mid-1960s) which consist of glass containers and boxes filled with colored pigment and earth. In the 1960s he organized → happenings and created → environments which reflected cultural and social conditions in Brazil, examining in particular the conflict between tradition and technology. K.S.-D.

Bibl.: Oiticica, Rotterdam, 1992

Oldenburg, Claes. *1929 Stockholm. Swedish-born sculptor and painter. His family settled in Chicago in 1936. Since 1959 he has lived in New York. He studied art and literature at Yale University (1946–50) and then studied at the Art Institute of Chicago (1953–54). He had his first one-man exhibition at the Judson Gallery, New York, in 1959. He took part in the Venice Biennale in 1964 and 1968, and in Documentas 4, 6, and 7 (1968, 1977, 1982). On settling in New York he came into contact with → Kaprow (→ happening) and began making his first three-dimensional → assemblages using papier mâché and refuse, achieving striking effects with color casts. These had developed by the early 1960s into → environments (*The Street*, 1960), with figures, buildings, and cars made from refuse materials. In 1961 he opened "The Store" in his studio on the Lower East Side in New York, where he sold food items and consumer goods roughly replicated in plaster or papier mâché and brightly painted like advertisements. In a third cycle, *The Home* (1962–63), he focused on everyday objects, exposing the fetishistic nature of consumer behavior through over-emphasis, making them in outsized dimensions and painting them in garish, luminous colors. Washstands, kitchen appliances, fans, and telephones were produced in three versions: a "hard" version in garishly painted corrugated cardboard; a "supernaturally colorless" version made of linen filled with Java cotton; and a "soft" version made of vinyl (*Soft*

Callbox, 1963). The manipulation of consumer objects culminated in the *Soft Sculptures* (exhibited in 1962 in the Green Gallery) (see → Soft sculpture). From 1965 he began producing designs for urban monuments (*Lipstick Ascending on Caterpillar*, 1969). Since 1976 he has collaborated with his wife Coosje van Bruggen. In the 1980s and 1990s he undertook various projects, including *Mouse-Museum/Ray Gun Wing* (Museum Ludwig, Cologne, 1979), *The Course of the Knife* (Campo d'Arsenale, Venice, 1984–85), and his giant *Shuttlecocks* in the grounds of the Nelson-Atkins Museum of Art, Kansas City (1994). H.D.

Bibl.: Bruggen, Oldenburg, 1991 · Solway/Lawson, Oldenburg, 1991 · Celant, Oldenburg, 1995 · Celant, Oldenburg, 1996

Claes Oldenburg, *Trowel I*, 1971, Steel colored with spray paint, 1170 x 365 cm, Rijksmuseum Kröller-Müller, Otterlo

Olitski, Jules. *1922 Snowsk, Russia. Russian-born American painter and sculptor, a prominent exponent of → Post-Painterly Abstraction. He was brought to the US by his grandmother and mother in 1924. He studied at the National Academy of Design and the Beaux Arts Institute in New York (1939–42). He became an American citizen in 1942 and did military service between 1942 and 1945. From 1949 to 1951 he lived in Paris, where he studied sculpture under → Zadkine and attended the Académie de la Grande Chaumière. On his return to the US, he studied to be an art teacher at New York University (1952–55), leading to teaching posts in New York and at Bennington College, Vermont (1956–66). He took part in the Venice Biennale (1966) and Documenta 4 (1968). His early works were inspired by → Dubuffet, → Fautrier, and de → Staël. In the 1960s, influenced by → Frankenthaler and K. → Noland, he started experimenting with stain techniques, using pale, thinly applied colors and biomorphic shapes. He began using a spray gun in 1964 to create large-format → Color Field pictures (*Green and Pink*, 1965). He has also made painted steel sculptures. K.S.-D.

Bibl.: Geldzahler, Olitski, 1991

Ono, Yoko. *1933 Tokyo. Japanese-born → Conceptual and → Performance artist living in Tokyo, London, and New York. She studied music, literature, and philosophy at Gakushin University, Tokyo, and continued her studies at the Sarah Lawrence College, New York (1953). At the beginning of the 1960s she took part in → Fluxus events. Inspired by → Dada, M. → Duchamp, and → Cage, she went on to produce works incorporating everyday → objects and experimented with music and film. At the beginning of her marriage (1969–80) to John Lennon, they produced a series of joint projects (*Bed-In*, 1969, *War is Over*, 1969). In 1988, revisiting the political and feminist terrain of her early work, she produced bronze casts of her works of the 1960s (*Bronze Age*), providing a critique of the materialistic image of art and society in the 1980s. A.R.

Bibl.: Ono, Munich, 1998

Onslow Ford, Gordon. *1912 Wendover, England. British-born painter who lives in Inverness, California. Between 1936 and 1939 he lived in Paris, where he met → Matta, the two artists exerting a reciprocal influence on each other. In 1939 he

Claes Oldenburg, *Soft Washstand*, 1965, Vinyl, filled 143 x 80 x 50 cm, Private Collection

joined the → Surrealists. In 1940 he emigrated to the US and then traveled in Mexico (1941–47), where he was involved in the Dynaton movement with → Paalen, collaborating on the latter's *DYN* periodical. In 1951 he helped Paalen organize a Dynaton exhibition in San Francisco. In the 1950s he retired to the Point Reyes peninsula north of San Francisco. After his early interest in Surrealism and → Futurism, Onslow Ford became involved with Zen Buddhism, resulting in meditative pictures close to → Color Field Painting. In these works he developed a system of symbols (lines, circles, blobs, and stars) influenced by calligraphy. S.Pa.

Bibl.: Onslow Ford, Washington, 1975 · Onslow Ford, Santiago de Compostela, 1998

Op art. (abbreviation of Optical art.) Movement in abstract art, largely restricted to painting and printmaking, which began in the 1950s. The term was given currency by the Responsive Eye exhibition at the Museum of Modern Art, New York, in 1965. Op art is concerned with the laws and characteristics of visual perception, and in particular phenomena of optical illusion. Exploiting the vagaries of human perception, Op artists employ a range of devices to create effects of movement or vibration: color or black-and-white contrasts, geometric patterns, minute disruptions in formal sequences, and deliberate ambiguities in the relationship between fore- and background. Op art developed in parallel with → Kinetic art and the two movements have many affinities, with shared ideas based on academic theory, the body, space, time, and movement. The roots of Op art lie in → Futurism, → Orphism, the color experiments undertaken at the → Bauhaus, and → Constructivism. The influence of the latter is particular evident in Op artists' use of geometric pattern and serial structures, the Utopian social ideas of some of its practitioners, and the concept of an art which is based on the basic principles of human perception and can therefore be comprehended by everyone. The basic principles of Op art were formulated in the theories and paintings of J. → Albers. Leading exponents include → Riley, → Anuskiewicz, and, sometimes with three-dimensional works, → Soto, → Agam, and → Tomasello. There is often an overlap between Kinetic and Op art (→ Zero). F.K.

Bibl.: Seitz, Responsive Eye, 1965 · Barrett, Op Art, 1970 · Türr, Optical Art, 1986

Opalka, Roman. *1931 Hocquincourt, Abbéville. Painter of Polish origin living in Bazérac, southern France. In 1935 his family moved to Poland. In 1940 he was deported to Germany, returning to Poland in 1946. He studied at the Lódz College of Art (1949–50) and the Warsaw Academy of Art (1951–56). In 1962 he took part in the Venice Biennale and in 1966 had his first one-man exhibition in Warsaw. In 1976 he received a grant to visit Berlin and the following year participated in Documenta 6. He moved to France and became a French citizen in 1984. In 1993 a retrospective of his work was held at the Musée d'Art Moderne, Paris.

His early works were monochrome paintings with a horizontal structuring. In 1965 he embarked on the essentially → Conceptual project which has dominated his work ever since. This consists in writing numbers continuously from one to infinity on identical monochrome gray canvases. From 1972 the gray tone was lightened each time by one percent, so that the line of figures and the background became imperceptibly more alike and would one day merge. In addition, every day Opalka recorded his voice saying each number onto a tape and took a photograph of his face. Opalka's work, which can be seen as a reflection on his own existence, is intended to make time comprehensible in an artistic, immaterial way. K.S.-D.

Bibl.: Lemarche-Vadel, Opalka, 1986 · Opalka, Berlin, 1994 · Noel, Opalka, 1996

Roman Opalka, *1965/1 – infinite, Travel Sheets, detail 1707151–1710048*, 1965, Drawing, black Indian ink on paper, 33.3 x 24 cm, Artist's Collection

Oppenheim, Dennis. *1938 Mason City, Washington. American Conceptual and Performance artist living in New York. He studied at the California College of Arts and Crafts, Oakland (1959–64), and Stanford University (1964–65). After completing his studies, he initially produced → Land art, creating large-scale outdoor projects which were recorded in photographs. At the beginning of the 1970s he was active as a Performance artist, then turning to mechanical → installations (*Factories*) reminiscent of the works of → Tinguely. In the 1980s he worked on the *Fireworks* series, which incorporated electric motors and fireworks. He also produced traditional → assemblages made out of fragments of metal and other materials. In the 1990s these developed into large-scale installations with figures and objects, together with sculptures which, through their often outsized dimensions and unusual compositions, seem to question the everyday reality we accept as normal. I.N.

Bibl.: Oppenheim, Basel, 1979 · McEvelley/Heiss, Oppenheim, 1991 · Oppenheim, Milan, 1997

Oppenheim, Meret. *1913 Berlin, †1985 Basel. German-Swiss painter and sculptor. She studied at the Kunstgewerbeschule in Basel, then moved to Paris (1932), where she attended the Académie de la Grande Chaumière. In 1936 she had her first one-woman exhibition at the Galerie Schulthess in Basel. In 1937 she returned to Basel, teaching at the Hochschule für Kunst und Gewerbe (1937–39). In 1942 she took part in the "First Papers of Surrealism" in New York. Inspired by the ideas and works of the → Surrealists, Oppenheim created poems, drawings, collages, and objects which often incorporated → objets trouvés. Many of her works are ironic, poetic codes for personal feelings, often with sexual content. They constantly reflect the struggle of a woman artist seeking freedom in a male society (*Objet: Breakfast in Fur*, 1936). Nude photographs taken of her by → Man Ray made her famous as a "femme surréaliste." After a long creative crisis, she joined the circle of artists in Berne, where she lived with her husband. In 1956 she designed costumes for → Spoerri's production of → Picasso's play *Le désir attrapé par la queue*. In 1959 she organized the *Cannibal Feast* in Berne, featuring a naked woman lying on a table and covered with food. This work was repeated in Paris and was her last contact with the Paris Surrealists. F.K.

Bibl.: Curiger, Oppenheim, 1990 · Helfenstein, Oppenheim, 1993 · Burckhardt, Oppenheim, 1996 · Meyer-Thoss, Oppenheim, 1996

Meret Oppenheim, *Object: Breakfast in Fur*, 1936, Cup, saucer and spoon, covered with fur, cup diam. 10.9 cm, saucer diam. 23.7 cm, spoon length 20.2 cm, height 7.3 cm, Museum of Modern Art, New York

Oppenheimer, Max. *1885 Vienna, †1954 New York. Austrian painter, printmaker, and writer. He studied at the Akademie der Bildenden Künste, Vienna (1900–03), and the Academy of Art, Prague (1903–06). From 1912 to 1915 he was a member of → Schiele's circle in Vienna. During World War I he sought refuge in Switzerland (1915–25), then moved to Berlin (1925–31). In 1932 he returned to Vienna, before emigrating to New York in 1938. After being influenced early on by → Expressionism, Oppenheimer drew inspiration from → Futurism and → Neue Sachlichkeit for his portraits (*Schoenberg, Busoni*), religious themes, and topics from contemporary life and music (monumental picture *The Symphony*, 1921–23). He also produced series of etchings based on the work of Heine and Flaubert. He often signed himself Mopp. H.O.

Bibl.: Puttkamer, Oppenheimer, 1998

Orozco, José Clemente. *1883 Zapotlan el Grande (Ciudad Guzman), Jalisco, Mexico, †1949 Mexico City. Mexican painter. In 1890 his family moved to Mexico City. He studied agronomy (1897–1900) and then attended the Escuela Nacional Preparatoria (1900–03). He subsequently studied painting at the Academy San Carlos (1906–14). Orozco began working as a political cartoonist. He had his first one-man exhibition in 1916, but left Mexico for the US in 1917, staying for three years. In 1922 he started work on the murals at the Escuela Nacional Preparatoria, immediately establishing himself as one of the founding members of → muralism. Between 1927 and 1934 he made regular trips to the US, where he painted murals recounting the history of America for Dartmouth College in Hanover, New Hampshire (1932–34). In 1934 he was commissioned to paint a mural at the Palacio de Bellas Artes in Mexico City, alongside → Rivera, → Siqueiros, and → Tamayo. Orozco's most important work was painted in the main hall of the university at Guadalajara in 1936 and takes as its themes man the creator and the purpose of science. His mural

in the stairwell of the Palace of Government, painted a year later, shows the independence hero Hidalgo. In 1938–39 he painted a cycle on the Spanish Conquista at the Hospicio Cabanas in Guadalajara. The naive narrative style of the early period had by this time given way to a powerful monumental style characterized by a three-dimensional solidity and strong coloring which owed much to early Mexican art.

The easel pictures of his last years show the beginnings of an abstract, painterly technique which has suggestions of → Art Informel. Orozco, together with Rivera and Siqueiros, was one of the leading exponents of Mexican Muralism. His dramatic, expressive style, combined with his passionate sympathy for the fate of the human race, made him internationally famous. E.B.

Bibl.: Orozco, 1981

Orphism. Term coined in 1913 by the writer Guillaume Apollinaire for a type of abstract painting which developed out of → Cubism. It was originally applied to the painting of Robert and Sonia → Delaunay, who in about 1912 had created the first abstract pictures using pure prismatic colors (*Les Fenêtres*). Apollinaire, who at the time was updating the myth of Orpheus in his poetry collection *The Bestiary or the Pursuit of Orpheus* (1919), defined Orphism as "the art of painting new structures out of elements which have not been borrowed from the visual sphere, but have been created entirely by the artist himself, and been endowed by him with fullness of reality. The

Meret Oppenheim, *Octavia*, 1969, Oil on wood, materials, saw, 187 x 47 cm, Galerie Eugenia Cucalón, New York

José Clemente Orozco, *Christ Destroys his Cross*, 1943, Oil on canvas, 93 x 130 cm, Museo de Arte Alvar y Carmen T. de Carillo Gil, Mexico City

José Clemente Orozco, *Man in Flames*, 1938–39, Cupola fresco at the Hospicio (orphanage) Cabanas, Guadalajara, Mexico

works of the Orphic artist must simultaneously give a pure aesthetic pleasure, a structure which is self-evident, and a sublime meaning, that is, the subject. This is pure art." Although Apollinaire intended the term to apply chiefly to the work of R. Delaunay, he did associate other painters with this trend, notably → Kupka, → Picabia, → Léger, and even M. → Duchamp and → Picasso ("The Painters of Cubism," 1913). The painters themselves remained skeptical toward labeling of this kind. H.D.

Bibl.: Spate, Orphism, 1979

Oursler, Tony. *1957 New York. American Video artist living in Boston. He studied at Rockland Community College, Suffern, N.Y., and the California Institute of Arts, Valencia. Since then he has taught at the Massachusetts College of Art, Boston. He had his first one-man exhibition in 1981 with the video *Viewpoints* (Museum of Modern Art, New York). He took part in Documentas 9 and 10 (1992, 1997). Oursler's work examines the influence of the mass media on the popular psyche. Since the 1980s he has created video sculptures (*Dummies and Dolls*, 1989); wall-mounted objects (*Poisoned Candies*) featuring greatly enlarged packets of chewing gum; candy, and drinks; and watercolors of packaging. H.D.

Bibl.: Oursler, Hanover, 1998

Outerbridge, Paul. *1896 New York, †1958 New York. American photographer. He studied art at the → Art Students League and photography at the Clarence H. White School of Photography. He met → Stieglitz in 1923 and studied under → Archipenko. In 1932 he began teaching at White's photography school. He started out as an advertising and news photographer for *Harper's Bazaar* and *Vogue*. In 1924 he moved to Paris, where he experimented with color photography. In 1928 he returned to the US, opening a portrait studio in Hollywood. In addition to his advertising photography, Outerbridge is principally known for his nude studies and still lifes, which owe much to → Neue Sachlichkeit. K. S.-D.

Bibl.: Howe, Outerbridge, 1980

Outsider art. Outsider art covers any made by individuals untrained in art and unattached to any creative authority within the area of Western cultural production. Hence it should exclude primitive artefacts as such, and refers in essence to three bodies of work. Firstly, untrained individuals who discover (often late in life) that they are creative: examples include the "interlocked forms" of Gaston Chaissac (1910–64); the interlaced drawings of Scottie [Wilson] (1888–1972); the mannerist shell masks of Pascal-Désiré Maisonneuve (1863–1934); and the disturbing scenes of Hans Krüsi (1920–1995). Some of this output may be known as → naive art, but this term should be reserved for non-professional artists who endeavor to produce conventional or folk-inspired art. Secondly, it refers to mediumistic graphic artists, often women – Laure Pigeon (1882–1965); Séraphine (Louis) (1864–1942); Madge Gill (1882–1961; "guided by an invisible force") – who compose automatically constructed drawings based on representational (often portrait) themes. Finally, it refers to artists who are either disturbed or institutionally insane. Following an early study by "Marcel Réja" (Dr Paul Meunier) in 1907, the most authentic body of such work ever gathered is the celebrated Prinzhorn Collection in Heidelberg, investigated under the auspices of Dr Heinrich Prinzhorn whose *Bildernei der Geisteskranken* of 1922 was duly noted by → Ernst. The Collection was visited by → Kubin, Ernst Kris, and the psychoanalyst Binswanger in the 1920s, but was ransacked by a new director, Dr Wagner, for the Nazi "Entartete Kunst" exhibition ("Degenerate Art") in an effort to show up modernism as similarly "mad."

The art of the insane (mostly classed as schizophrenic) is indeed the most difficult of all to formalize. It embraces the huge and superbly symmetrical compositions of the miner Augustin Lesage (1876–1954); the elaborate circular inscriptions and animal/human figures of Adolf Wölfli (1864–1930); eerie agglomerations (*The Fly Man and the Snake*, 1925–27) by Heinrich Anton Müller (1865–1930); the buckwheat-germ designs of Franz Karl Bühler (1864–1940); the disturbing "Discourse on Castrati" by Oskar Herzberg (fl. 1912–41); the "Last Judgments" of Heinrich Mebes; the Arcimboldesque landscapes of August Natterer; the "cerebellograms" (1906) of Louis Umgelter, and so forth. A major promoter of outsider art was → Dubuffet, whose efforts brought together the collection of the Compagnie de l'art brut in 1948: more than 15,000 works (since 1976 at Lausanne) overseen at present by Michel Thévoz, who also edits *textes bruts* (→ Art Brut.) D.R.

Bibl.: Cardinal, Outsider Art, 1972 · Peiry, L'art brut, 1997

Ozenfant, Amédée. *1886 Saint-Quentin, †1966 Cannes. French painter and writer on art. In 1906 he moved to Paris. He took part in the Salons d'Automne of 1910–11 and 1914. In 1918 he founded → Purism with → Le Corbusier and together they published the periodical *L'Esprit nouveau* (1920–25). He had his first one-man exhibition in 1927 at the Galerie Barbazanges in Paris. Between 1935 and 1938 he lived in London, then moving to New York, where he founded the Ozenfant School of Fine Arts. In 1955 he returned to France. In the manifesto *Après le Cubisme*, which appeared in 1918, Ozenfant and Le Corbusier defined Purism. Criticizing "decorative" synthetic → Cubism, they demanded a return to "pure," rational principles. Ozenfant's own pictures show objects, and later figures, in strictly constructed, precisely drawn compositions with flat, muted colors. As a theorist and teacher, Ozenfant exerted a considerable influence (*Art*, 1927, published in English as *Foundations of Modern Art*, 1931). K.S.-D.

Bibl.: Ball, Ozenfant, 1978 · Golding, Ozenfant, 1985

Paalen, Wolfgang. *1905 Vienna , †1959 Taxco, Mexico. Self-taught Austrian-born painter and writer. Paalen lived in Berlin in the 1920s, then in Paris, where he met Paul Éluard, → Ernst, and → Breton. He joined the group → Abstraction-

Création in 1934, and the Surrealists (→ Surrealism) in 1935. His work showed at major exhibitions: in 1934–35 Thèse, Antithèse, Synthèse in Lucerne (with → Klee, → Kandinsky and others), in 1936 Dada, Fantastic Art, and Surrealism at the Museum of Modern Art, New York. He moved to Mexico City at the outbreak of World War II, and became a Mexican national in 1947. In 1940 he and Breton organized the first international exhibition of Surrealists in Mexico (Galería de Arte Mexicano, Mexico City). He broke with the Surrealists in 1941. In the 1930s he invented the technique known as → fumage ("smoke painting"), in which a lighted candle was used to create smoke and soot on canvas – a technique that was not without its risks. He also experimented with → objets trouvés. In 1942 he established *DYN*, the art magazine, from the theoretical discussions of which Paalen in 1946 derived the theory of *dynaton* (from the Greek = "that which is possible"), in which the space-time relationship was conveyed artistically. At the same time, his work was discovered as a forerunner and pioneer of → Abstract Expressionism. A.R.

Bibl.: Pierre, Paalen, 1980 · Morales, Paalen, 1984

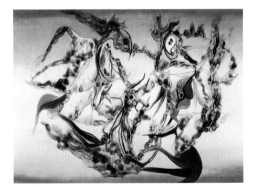

Wolfgang Paalen, *Ciel de Pieuvre*, 1938, Fumage and oil on canvas, 97 x 130 cm, Private Collection, Munich

Page, Robin. *1932 London. British sculptor and painter who moved to Germany in 1959. He studied at Vancouver School of Art from 1952 to 1954, then lectured at Leeds College of Art (1960–65), and the Akademie der Bildenden Künste, Munich (1981–98). Associated with the → Fluxus group since the first → happenings of the 1960s, Page participated in Fluxus Fluxorum, at the Venice Biennale (1989) and the Fluxbritannica exhibition at the Tate Gallery, London (1994), among others. Page's poster-like paintings and

sculptures are characterized by the humor and bright colors of → comics, the inclusion of fragments of works by other artists (→ Picasso, → Brancusi, M. → Duchamp), and by the figure of the artist himself, who is often at the center of his works (*Robin Page/Bluebeard Eats Little Artists for Breakfast*, 1989). A.R.

Bibl.: Lynn, Page, 1973 · Robinson, Page, 1996

Paik, Nam June. *1932 Seoul. Korean video, Conceptual, and Performance artist, and composer living in New York and Düsseldorf. He moved to Hong Kong in 1950, then to Japan, studying music, history of art, and philosophy at the University of Tokyo until 1956; music in Munich in 1956–57; composition in Freiburg im Breisgau in 1957–58. At this point he met → Cage. He studied electronic music in Cologne from 1958 to 1963, participating in the → Fluxus Festival in Wiesbaden in 1962. Paik was back in Japan in 1963–64 then moved to New York in 1964. He took part in the 1975 São Paulo Bienal, and 1977 and 1987 Documentas 6 and 8. He held a professorship at the Kunstakademie Düsseldorf from 1979 to 1996. His touring exhibition Video Time – Video Space of 1991–92 traveled to Düsseldorf, Basel, Zürich, and Vienna.

Paik was one of the main protagonists of the Fluxus movement in the 1960s, together with → Beuys and → Maciunas. From an early stage he devoted himself to new media and the associated interdisciplinary opportunities. His first works with adapted TV sets appeared in the Parnaß gallery in Wuppertal in 1963. From 1964 he worked with Charlotte Moormann on pieces of music and video installations that were staged in unconventional concerts and performances (in US and Germany). New technology – synthesizers, computers, and digital processing – facilitated a more advanced implementation of ideas, e.g. electromagnetic manipulation of color TV sets. Paik linked his electronically processed video tapes (*Electronic Opera No. 1*, 1969) to abstract films of the 1920s (see H. → Richter). In his "closed-circuit" video installations, he confronted culture with technology (*TV Buddha*, 1974). In his multi-TV installations, the arrangement of the monitors is as important as an area of experience as the multiplication of impressions in the sychronized tape show. His more recent works are increasingly large-scale, and incorporate the latest technology, e. g. *Beuys-Voice* (Documenta 8, 1987). In his performances of the 1980s, Paik also

Nam June Paik, *TV-Buddha*, 1974, Wooden Buddha, camera, monitor, 160 x 215 cm, Stedelijk Museum, Amsterdam

◁ A. R. Penck, *Standart*, 1971, Acrylic on canvas, 290 x 290 cm, Private Collection

made use of satellite technology for the simultaneous transmission of electronic pictures worldwide. H.D.

Bibl.: Hanhardt, Paik, 1982 · Fargier, Paik, 1989 · Decker, Paik, 1992 · Bußmann/Matzner, Paik, 1993 · Esser, Paik, 1997

Mimmo Paladino, *Baal*, 1986, Various materials on canvas, wooden frame, diameter 260.4 cm, Sperone West Water Gallery, New York

Paladino, Mimmo. *1948 Paduli, near Benevent. Italian painter and sculptor living in Paduli and in Milan. Paladino studied at the Liceo artistico at Benevento in 1964–68. His first one-man exhibition was held at the Galleria Lucio Amelio, Naples, in 1977. His work appeared in 1982 at Documenta 7. In 1982–85 he lived in Brazil. Paladino, → Clemente, → Chia, and → Cucchi were all members of the Italian → Transavantgarde, a group that, in the 1970s, produced new, sensual paintings from a number of sources to counter → Arte Povera, which prevailed at the time. Paladino's pictures process elements from material and → Conceptual art in an artistic event, combining archaic figures and abbreviated shapes in compositions that are deeply meaningful and extremely melancholic (*Stabat Mater*, 1986). Mask-like, stylized figures, skull-like faces, abstract symbols, but also relief-like objects, are bound together in an ornamental surface pattern that is defined by a restrained, cultivated colorfulness. His more recent works are free-standing, figurative sculptures. K.S.-D.

Bibl.: Dorflès, Paladino, 1984 · Paladino, London, 1991 · Braun/Rosenthal, Paladino, 1992

Palermo, Blinky. *1943 Leipzig, †1977 Maldives. German painter, born Peter Schwarze and adopted by a married couple named Heisterkamp. He moved to Münster in 1952 and attended the Werkkunstschule Münster in 1961; from 1962 to 1967 he studied at the Kunstakademie, Düsseldorf under → Beuys and Bruno Goller (1901–98). He adopted the pseudonym Blinky Palermo in 1964. He moved to New York in 1973.

His early orientation towards Constructivist elements and → Color Field Painting remained a decisive feature in all his works, although they changed quickly and frequently in formal and painterly strategies. Works that, from 1964, were on the borderline between painting and sculpture, led to wall installations and → environments. From 1968 this development continued in

his wall drawings and paintings (*Wandzeichnungen*, 1968–69). Although this development was followed by printed graphics, in 1966 his easel pictures changed to fabric (*Stoffbild kobaltblaugrauviolett*, 1970) and acrylic pictures on steel and aluminum that were shown in sequences as wall installations. H.D.

Bibl.: Jahn, Palermo, 1983 · Palermo, 1984 · Schwenk, Palermo, 1991 · Moeller, Palermo, 1995

Paley, Albert Raymond. *1944 Philadelphia. American sculptor Paley earned his M.F.A. in 1969 from Tyler School of Art, Temple University, in Philadelphia, where he studied goldsmithing under Stanley Lechtzin. In the 1970s and 1980s he played a major role in the revival of sculptural ironwork techniques in America, producing jewelry, monumental sculpture, decorative furniture, and architectural metalwork which reflected the ideas of the → American Craft movement. He drew on a variety of sources of inspiration, notably the characteristic forms of baroque, → Art Nouveau, and → abstract art, and his work contradicted the Minimalist school of modern sculpture (exemplified by the work of David → Smith and → Judd). Paley's work also blurred the boundary between jewelry as fashion and jewelry as bodily ornament and questioned the importance of scale. His exuberant, organic forms are forged in metal (which make it seem soft and malleable) and reveal his superb craftsmanship as an ironsmith. In the 1980s and 1990s he began to create large-scale public art works with the assistance of his workshop, Paley Studios, in Rochester, New York. J.C.M.

Bibl.: Paley, 1991 · Lucie-Smith, Paley, 1996

Panamarenko (Henry van Herwegen). *1940 Antwerp. Dutch sculptor living in Antwerp. He studied at the Koninklijk Akademie voor Schon Kunst in Antwerp from 1955 to 1960, and pursued his own studies in the natural sciences. He attended the Nationaal Hoger Instituut, Antwerp, in 1962–64. In 1964–65 he was co-

Nam June Paik, *Passage*, 1986, Two-channel video sculpture, 13 monitors, 2 laser discs, 2 laser disc players, TV cabinet, cupboard, shelving, picture tubes, light bulbs, 348 x 431 x 61 cm, ZKM, Karlsruhe

Blinky Palermo, *Untitled*, 1972, Object in two parts, caseine on cotton on wood, 248 x 146 x 4 cm, Staatsgalerie Moderner Kunst, Munich

Panamarenko, *Unbilly II*,
1976–77, Metal, plastic,
styrofoam, Japanese vellum,
wood, wire, leather,
269 x 365 x 270 cm, Air Force
Officer Training School,
Fürstenfeldbruck

publisher of the magazine *Happening News*, and
produced his first → happenings and actions. He
was co-founder in 1966 of the Wide White Space
Gallery and created his first "poetic objects." He
built his first aircraft in 1967, his first airship in
1969, and made his first attempt at flying in 1971.
In 1975 he published a book on *The Mechanism of
Gravity*. His *Research into the Unsolved Problems of
Locomotion* led to the construction of numerous
man-powered automobiles, airships, and flying
machines. Although not intended for use, their
technical perfection means that they are fully
working machines. Situated somewhere between
engineering art and personal mythology, Pana-
marenko's sculptures, which are all hand-made,
pose questions about manufacturing conditions
and the role of art in today's society in a political,
economic, socio-cultural, and technological con-
text. S.Pa.

Bibl.: Baudson, Panamarenko, 1996

Pane, Gina. *1939 Biarritz, †1990 Paris. French
exponent of → Body art. She studied at the École
des Beaux-Arts Paris and in the Atelier d'Art
Sacré, Arnoldi, from 1961 to 1963. Pane opened
the Atelier du Performance at the Centre Georges
Pompidou in 1978; and from 1980 was Professor
of Art at the École des Beaux-Arts in Le Mans. Her
Body art (→ Performance art) continued through-
out the 1970s, moving into evetns where she
deliberately injured her own body, such as in *Psy-
ché* (1974), in which she made tiny razor cuts in
her eyelids so that the blood looked like eyeshad-
ow. In her 1980s sculptures, Pane showed the
human body in relation to its social context
(*François d'Assise trois fois aux blessures stigmatisé
[version I]*, 1985–87). S.Pa.

Bibl.: Benson/Vescoso, Pane, 1990

Giulio Paolini, *Proteus I, II, III*,
1971, Plaster and plexiglas,
base, 10 x 30 x 30 cm;
20 x 30 x 30 cm; 10 x 25 x 30 cm,
Paul Maenz Collection,
Cologne

Paolini, Giulio. *1940 Genoa. Italian Conceptual
artist living in Turin and Paris. He worked as a
theater set designer until 1960. His first solo exhi-
bition was in 1964 in the Galleria La Salita, Rome.
He participated in the Arte Povera exhibition at
the Galleria La Bertesca, Genoa, in 1967. From
1967 his work began to incorporate art historical

quotations. He participated in the Arte Povera
exhibition at the Kunstverein Munich in 1971.
His work appeared at Documenta 5, 6, 8, and 9
between 1972 and 1992. In 1981 he received a
DAAD scholarship for Berlin. In 1984 his work
appeared at the Venice Biennale. 1986 saw his ret-
rospective at the Staatsgalerie Stuttgart.

Among → Arte Povera artists, Paolini repre-
sents a more Conceptual form of art. As a reaction
to → Art Informel and → Neo-Expressionism, he
addresses intrinsically aesthetic questions, e.g.
the problems of the relationship between original
and copy, which he constantly expresses anew in
his works. In doing so, he ignores verbal means
(texts), as in → Art & Language, choosing instead
to address problematic visual experiences
through photographs and plaster models, as in
his 1975 series *Mimesis*, in which two copies of the
same statue are positioned opposite each other
(e.g. *Praxiteles Hermes*). Their silent dialogue causes
the viewer to consider both the history of art, and
the function of original and copy. Since the 1980s
he has created highly complex → installations
that incorporate new media (video). K.S.-D.

Bibl.: Szeemann, Paolini, 1980 · Kunz, Paolini, 1981 · Inboden,
Paolini, 1986 · Poli, Paolini, 1990

Paolozzi, Eduardo. *1924 Leith near Edinburgh.
British sculptor, graphic designer, film maker,
and writer living in London. His artistic educa-
tion began in 1943 at Edinburgh College of Art;
1944–47 at Slade School of Fine Art, Oxford and
London. He held lectureships from 1949 to 1955
at Central School of Arts and Crafts, London (tex-
tile designs); in 1955–58 at St Martin's School of
Art, London (sculpture); in 1981–90 at the
Akademie der Bildenden Künste, Munich. He had
one-man exhibitions 1964 at the Museum of Mod-
ern Art, New York, and in 1971 at the Tate
Gallery, London.

Paolozzi's artistic development was marked
by a two-year stay in Paris (1947–49), where he
had contact with → Giacometti, → Tzara,
→ Braque, and → Léger, among others, and the

Eduardo Paolozzi, *Wittgenstein at Casino*, 1963–64, Painted
aluminum, 183 x 138.8 x 49.5 cm, City Art Galleries, Leeds

examination of → Surrealism and → Dubuffet's → Art Brut (*Paris Bird*, 1948–49). His collages made from magazines and brochures, which he has reproduced by silk-screen printing from the 1950s, made him one of the founder members of British → Pop art. His sculpture, which incorporates scrap and found objects as well as high-quality materials, reveals a preoccupation with the human form (heads etc.) and a questionable fascination for modern machine aesthetics (*His Majesty the Wheel*, 1958–59). A.R.

Bibl.: Paolozzi, 1962 · Miles, Paolozzi, 1977 ·· Paolozzi, Edinburgh, 1985 ·· Paolozzi, London, 1987 ·

paper art. Collective term covering all art forms in which paper and paper substitutes (e. g. papier maché and card) are used as an autonomous artistic means of expression. At the time when these "cheap" materials were first becoming established, → Braque and → Picasso created their *papiers collés* from colored paper, newspaper cuttings, and scraps of wallpaper. Other experiments were carried out at the → Bauhaus (J. → Albers' experiments with endless paper, 1928), and later within the → Zero group. In addition to techniques such as cutting, folding, embossing, constructing (→ Fontana works with a hole punch and knife), natural processes such as seeping, yellowing and decomposing (→ Beuys) are also incorporated. → Rauschenberg discovered "pulp," colored paper fiber, which was subsequently used by artists such as K. → Noland and → Hockney. The international Biennale for paper, called Paper Art, takes place in the Leopold-Hoesch Museum in Düren. A.R.

Bibl.: Eimert, Paper Art, 1994 · Electric Paper, Bochum, 1998

Parmiggiani, Claudio. *1943 Luzzara, Reggio Emilia. Italian Conceptual artist and sculptor living in Turin. He studied in 1959–61 at the Instituto Statale di Belle Arti, Modena, and in 1971–73 became a lecturer at the Accademia di Belle Arti, Macerata. His work appeared in 1972 at the Venice Biennale. In his early works Parmiggiani referred to the works of M. → Duchamp and → Manzoni; at the forefront is the ironic or metaphoric distortion of objects (*Globo*, 1968). Like his contemporaries → Pistoletto and → Paolini, he is bound by a passion for conceptual works, → installations, and photographic works. The source of his art is the cultural heritage of the West: from creation myths and dream pictures, Parmiggiani develops poetically ironic → assemblages (*Cercle de plumes, Cercle de feu*, 1969) and (generally outdoor) sculpture installations (*Casa sotto la Luna*, 1991). A.R.

Bibl.: Parmiggiani, Bologna, 1985 · Parmiggiani, Milan, 1988

Pascali, Pino. *1935 Bari, †1968 Rome. Italian sculptor, and Installation, and Performance artist, Pascali had his first show at Galleria La Tartaruga in Rome (1965), then in the significant → Arte Povera exhibition organized by Germano Celant in 1967, and he was allocated a room at the Venice → Biennale in 1968. Initially influenced by → Pop art and → Neo-Dada, his work involves a futuristic taste for irony, paradox, the undermining of the sacred, the recovery

of childlike creativity, political commitment against war (*Cannone "Bella ciao"*, 1965, in metal and wood; a fake cannon, like an outgrown toy, named after a famous partisan song), the resourcing of agrarian culture, and an awareness of culture's contamination by mass-media myths (installations with haystacks, huts, rope-bridges, and creepers, reminiscent of *Tarzan* movies). S.G.

Bibl.: D'Elia, Pascali, 1983

Paschke, Ed. *1939 Chicago. American painter living in Chicago. He studied at the Art Institute of Chicago (1957–61). From 1970 he was Professor at the Academy of Art in St. Louis, later at the Art Institute of Chicago. An exponent of → Pop art, Paschke, inspired by → Lindner, among others, developed an interest for social outcasts (prostitutes, transvestites), whom he portrays in a grotesque, anti-aesthetic style (*Pink Lady*, 1970). His later works usually portray "normal" citizens, although the faces are distorted by neon lights to look like masks, an indication of the change in perception caused by the influence of the mass media. S.Pa.

Bibl.: Benezra, Paschke, 1990

Pascin, Jules. *1885 Vidin, Bulgaria, †1930 Paris. Bulgarian – American painter. Initially self-taught, Pascin (born Julius Pincas) moved to Munich in 1903 and began to contribute to the satirical journal *Simplicissimus*. Meeting up with → Grosz in Paris in 1905, he indulged in a famously Bohemian lifestyle, portraying in a graphic style the colorful characters he encountered: sailors, whores, models, café regulars, and bum-rush brawlers, some compositions entering an almost Surrealistic realm (*Fantasia*, 1921). Pascin was in America during World War I, traveling extensively in the South. He became a US citizen in 1920, but soon returned to Paris. In the late 1910s he embarked on a brief → Cubist-influenced phase with broken surfaces (*Hermine David*, 1918), before producing a number of large-scale Biblical scenes (*Lazarus and the Rich Man*, 1923–25). The 1920s also saw him return to studies of half-clothed, prone young girls who provided scope for foreshortening. Their shimmering fluidity of line is mitigated by a diluted, almost blurred, tone. Pascin was a heavy drinker and, depressed prior to a show, committed suicide in his studio. D.R.

Bibl.: Werner, Pascin, 1962

Pasmore, (Edwin John) Victor. *1908 Chelsham, Surrey, †1998 Gudga, Malta. British painter and relief and construction artist. After exposure to art in the capital's galleries, Pasmore enrolled at the Central School of Art before joining the London Group in 1934. He began with high-keyed → Fauvist still lifes, but also exhibited at an "Objective Abstraction" exhibition (works destroyed). With → Coldstream and → Rogers he set up the → Euston Road School in 1937, though social concerns were never paramount. He began nude and landscape work (e.g. of the Thames bankside) in tempered tones, but around late 1947 adopted abstraction, becoming increasingly

geometric in the 1950s. Under the influence of Ben → Nicholson he produced black and white constructions, often incorporating wood and clear Perspex in a rarefied reworking of → Constructivism. Such severity made way for an organic and occasionally romantic element in the late 1950s and early 1960s. After visits to Malta (1960s), chromatic values gained in significance.

Pasmore was associated with Richard → Hamilton, → Frost, → Richards, and Adrian Heath (1920–92). He taught at Camberwell School of Art (1943–49) and Central (1949–53; where he introduced Bauhaus-like pedagogy to English art study), was master of painting at King's College (University) Newcastle (1954–61), and design consultant for Peterlee New Town (1955–77). He was awarded the CBE in 1959; and elected an RA in 1983. D.R.

Pattern art. Direction briefly taken by American painting in the 1970s (also known as Pattern & Decoration or the "New Decorativeness"). Artists such as → Kushner created large-scale pictures and → installations with strongly colored, decorative patterns in "rejection" of → Minimal art. Inspired by → Matisse and → Dufy, as well as by international, especially Asian textile art (kimonos, Indian batik), Pattern art exhibitions (Holly Solomon Gallery, New York, from 1975) consisted not only of picture compositions with floral, ornamental and figurative patterns, but also of sculpture installations and original designs of fabrics and cloths, some of which were presented in performances. H.D.

Bibl.: Pattern Painting, Brussels, 1979 · Pattern Painting, Nice, 1980

Pearlstein, Philip. *1924 Pittsburg, Pennsylvania. American painter. Pearlstein attended Carnegie Institute of Technology before studying art history in New York. The early 1950s saw lyrical abstract work followed by a → Pop phase. On a 1958 Fulbright Grant to Italy he continued the landscape work he had begun on trips round the US, with a marked predilection for mountains. From 1959 he has painted almost exclusively nudes (especially female), initially with a creamy, broken surface, but since the mid-1960s with a heightened precision of tone. His often strangely cropped models are placed with props in uncomfortable but not impossible poses, bereft of all expression and engagement with the viewer (unlike → Freud's). Concerned with "seeing the body for itself," Pearlstein wants to rescue the body "from its tormented, agonized condition given it by the expressionistic artists" (1975). Recent work retains these themes, treated with a crisp line that eschews the smoothness of Photorealism. A mid-career retrospective was held in 1983 at the Milwaukee Art Museum, etc. D.R.

Bibl.: Bowman, Pearlstein, 1983

Pechstein, Max. *1881 Eckersbach near Zwickau, †1955 Berlin. German painter and graphic designer. He studied interior decoration from 1896 to 1900; and from 1900 to 1902 was at the Kunstgewerbeschule, Dresden; 1902–06 at the Akademie der Bildenden Künste, Dresden. In

A. R. Penck, *Standart*, 1971, Acrylic on canvas, 290 x 290 cm, Private Collection

Max Pechstein, *Blue Day*, 1911, Oil on canvas, 80 x 100 cm, Private Collection

1906–12 he was a member of the → Brücke group. He moved to Berlin in 1908 and became a member of the Berlin → Secession. In 1911, together with → Kirchner, he set up the MUIM – Institut (Moderner Unterricht in Malerei = modern painting education). He saw active military service in 1915–16. In 1918 he was a co-founder of the Arbeitsrat für Kunst, the working council for art. In 1922 he joined the Prussian Akademie der Künste. Banned from painting and exhibiting in 1933 Pechstein was denounced as "degenerate" in 1937. From 1945 he was Professor at the Hochschule für Bildende Künste in Berlin.

Pechstein was always influenced by van Gogh, although he adopted the strong colors of his decoratively composed paintings from the Brücke painters. Trained academically, he set great store by drawing and composition, never entirely detaching painterliness from the object. It was his contact with nature, as in his paintings of the Moritzburger lakes and in Nidden, that made his brushwork looser and added contrast to the coloring (*Three Nudes in a Landscape*, 1911). On a trip to Palau in the Pacific (1914) he discovered indigenous "primitive art," and worked to simplify his style accordingly (*Palau Triptych*, 1917). In the 1920s the strong expression of his landscapes was toned down in favor of a calmer, more narrative style of painting with layers of color. G.P.

Bibl.: Krüger, Pechstein, 1988 · Dieterich, Pechstein, 1995 · Möller, Pechstein, 1996 · Möller, Pechstein, 1997

Penck, A. R. (Ralf Winkler). *1935 Dresden. German painter and sculptor living in New York and Berlin. In 1956 he became apprentice to a copywriter; as a painter he was self-taught. He made a living as a postman, stoker, and night-watchman. His first "stick-men pictures" appeared in 1960–61. In 1965 he occupied himself with mathematics, cybernetics, and information theory, which resulted in his "System and World pictures." His first "Standart" pictures were created in 1966, and from 1968 his "Standart" models appeared made of sticking plasters. He assumed the pseudonym of A. R. Penck after the geologist and ice-age researcher Albrecht Penck (1858–1945). He founded the Lücke group of artists in 1970. His work appeared in 1972–92 at Documentas 5, 7, and 9. His first wooden sculptures were created in 1977; in 1982 he worked with bronze for the first time. He left the German Democratic Republic in 1980. In 1982 he published *Krater und Wolke* magazine. In 1988 he became a lecturer at the Kunstakademie, Düsseldorf.

A. R. Penck, *The Crossing*, 1963, Oil on canvas, 94 x 120 cm, Neue Galerie der Stadt Aachen, Sammlung Ludwig

Having lived and worked underground for many years, the exhibition of Penck's World and Standart pictures at Documenta 5 (1972) finally brought him recognition as an artist. His highly figurative pictorial language consists of a system of archaic symbols or technoid formulations that were complemented in the 1970s by free forms and stronger coloring. As well as greater freedom of movement, the 1980s brought a move towards the monumental, combined with freer, more gestural painting, although his former language of symbols frequently reappeared in large, figurative combinations. W.G.*

Bibl.: Koepplin, Penck, 1978 · Gohr, Penck, 1981 · Penck, Saint-Étienne, 1985 · Grisebach, Penck, 1988 · Yau, Penck, 1993

Penn, Irving. *1917 Plainfield, New Jersey. American portrait, fashion, and still life photographer living in New York. From 1934–38 he studied design at the Philadelphia Museum School of Industrial Art, followed by a career as a freelance designer. From 1943 Penn worked on *Vogue* magazine, initially as a designer, and subsequently as a photographer. He produced more than 100 covers, and numerous fashion photographs. From 1952 he also produced a number of private commissions.

Never concerned solely with fashion, but primarily with the people wearing the creations, Penn prefers a neutral background and strong black-and-white contrasts, always placing the model's personality at the center of his pictures. The neutral background also serves as a backdrop for a number of portraits of artists, actors, writers, and composers: he took portraits of M. → Duchamp, → Grosz and → O'Keeffe, among others, positioned in a triangle of gray-draped walls. In addition to fashion and portrait photographs, he photographed nudes (*Nudes*, 1949–50), as well as people in their work surroundings and members of ethnic minotiries. Penn is regarded as one of the fathers of fashion photography. C.W.

Bibl.: Penn, Chicago, 1997 · Penn, Hamburg, 1999

Pereira, I[rene] Rice. *1902 Chelsea, Massachusetts, †1971 Marbella, Spain. American painter, born Irene M. Rice. She attended the → Art Students League of New York (1927–31) and taught (1936–39) at the → Bauhaus-inspired Design Laboratory (originally part of the → WPA and FAP). After Cubistic canvases related to → Sheeler and abstract work (*White Rectangle No. 1*, 1938), early

pieces incorporated corrugated multi-layered pressed-glass panels that endowed a shallow space with non-perspectival depth (eerie in *Shadows with Painting*, 1940; decorative in *Shooting Stars*, 1952). Pursuing interests in the Faust legend, → Symbolist art, Taoism, alchemy, ancient and medieval light theory, Jung, and the occult, her work (e.g. *Oblique Progression*, 1948) stands outside the objectivist stance of art derived from → Cubism and → Constructivism, the theories of → Moholy-Nagy being formative in this connection. Her → artists' books include *The Lapis* (1957), based on a "cameo" of a draped figure on an abstract ground. Her latter years were embittered by disputes over plagiarism (by e.g. → Agam). D.R.

Perejaume (Boreil Guinart, Pere Jaume). *1957 Sant Pol de Mar, Barcelona. Spanish sculptor and writer living in Sant Pol de Mar. He studied the history of art at the Universidad Central, Barcelona. Influenced by → Miró and → Tàpies, Perejaume joined the "second Catalan avantgarde" at the end of the 1970s. In a negation of traditional genres and material standards, he works in a wide range of media (painting, photography, sculpture, installation, and theater), testing the interplay between them (→ Postmodernism). His work revolves around his experience of nature and culture, and the verbal perception of this. He has studied local sources, such as 19th-century Catalan landscape painting and the myths surrounding "mad" King Ludwig of Bavaria. A.R.

Bibl.: Escala, Munich, 1990 · Perejaume, Barcelona, 1999

Performance art. Oppositional movement, emerging in the 1960s, to stem the tide towards → Art Informel and → Abstract Expressionism both of which were felt to have become sclerotic in approach. The work of art, as an isolated museum piece, was to be substituted by creative action to establish a new, live relationship between artist and audience. The means of representation are taken from choreography, the experimental theater, and music performances. This overlap of methods and media was meant to bridge the division between art and the viewer – and beyond the duration of the performance, between art and life.

One of the most frequently used terms to describe Performance art was formulated by → Kaprow who, with his *18 Happenings in 6 parts* performed in New York in 1958, introduced the term → happening . He thus placed the emphasis on its procedural, temporal nature. At the same time, the → Fluxus movement began to develop

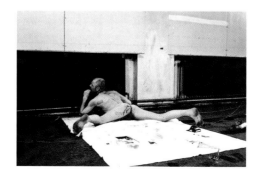

Performance art, Günter Brus, *Zerreißprobe*, 1970, Aktionsraum, Munich

(c. 1960) which, in its connections with music, theater, and elements of fine art, aimed to push back the boundaries of art, or even abolish them altogether. A particular role in Performance art is occupied by → Vienna action art. Its best-known artists, Otto Muehl (1925–) and → Nitsch, broke social taboos in their representation of orgiastic tableaux. Equally, the performances of → Beuys occupy a particular place in the framework of what became a much broadened concept, although Beuys also participated in many Fluxus events. In the 1970s Performance replaced the earlier happenings whose critical role had been superseded by artistic as well as political developments. H.D.

Bibl.: Seitz, Abstract, 1983 · Goldberg, Performance, 1988 ·· Sayre, Performance, 1989 ·

Permeke, Constant. *1886 Antwerp, †1952 Ostend. Belgian painter and sculptor. Permeke attended the Ghent Academy in 1904, meeting van der → Berghe. After contact with Gustave de Smet (1877–1943), he moved to the artists' colony of Laethem-Saint-Martin (Sint-Martens-Latem; 1909–12). His early → Jugendstil portrait *Marietje in a Shawl* (1907) daringly shows the three-quarter figure from the rear. An → Expressionist phase included brighter flower pieces and dark-hued winter landscapes, while *Street in Ostend* (1923) is close to → Sironi. His figures developed in power and → primitivism throughout the 1920s (*Coffee drinker*, 1928), while the seascapes of this time have something of the menace of → Nolde. He employed the palette-knife increasingly throughout the 1930s and, mid-decade, even began to sculpt bronzes. In 1929 he moved to the village of Jabbeke and took a house he called "De Vier Winden" (now the Provinciaal Museum Permeke). His later work is lighter in tone and texture, concentrating on the nude in what (for the time) are almost classic figures. D.R.

Bibl.: Chiappini, Permeke, 1996

Pevsner, Antoine. *1884 Orel, †1962 Paris. Russian-born painter and sculptor, elder brother of → Gabo. In 1902–10 he was at Kiev Art School and the Academy of St. Petersburg. In Paris from 1911 to 1913 he associated with → Archipenko and → Modigliani. His paintings from this period (*Abstract Shapes* 1913, *Absinth* 1914, *Clown's Head*, 1915) form a unique synthesis of elements from traditional icon painting (geometric, sharply delineated color areas, inverse perspective, flat, relief-like picture area, emphasized surface materiality) and the facette structure of Cubist painting. From 1915–17 in Oslo he and Gabo experimented with sculpture, setting the foundations for → Constructivist cavity sculpture, the concept of which is laid down in the *Realistic Manifesto* published by the brothers in Moscow in 1920. This new sculpture was not formed by the mass, as in traditional sculpture, but by the lines and surfaces of unbounded space. Of equal significance as the perception of space was that of time, in dynamically flowing, penetrating spaces, and the contrast or transition between light areas and dark cavities. After the Moscow years (1917–23) and his move to Paris (1923), Pevsner worked almost solely as a sculptor, creating constructions

of sheet steel and transparent plastic that transcended the "compact mass" (*Torso*, 1924–26, *Portrait of Marcel Duchamp*, 1926). After the 1930s, the undulating surfaces of the volume of the cavities were formed predominantly from closely linked bronze wires that caused the seemingly dematerialized, flowing sculptures to vibrate. H.G.

Bibl.: Massat, Pevsner, 1956 · Pevsner, Paris, 1957 · Pevsner, Pevsner, 1964

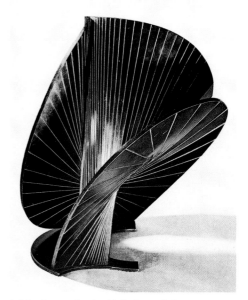

Antoine Pevsner, *Developable Surface*, 1938, Copper, 64 x 51 cm, Private Collection, Basel

Pfeuffer, Helmut. *1933 Schweinfurt am Main. German painter living in Mittbach, Isen. He studied from 1956 to 1958 at the Akademie der Bildenden Künste, Nuremberg; 1958–60 at the Akademie Stuttgart; and in 1960 started work as a painter in Munich, moving to Mittbach, Isen, in 1975. In 1980 he was awarded the Prize for New Painting of the City of Munich.

As an independently minded artist, Pfeuffer has developed his work away from commercial trends with a gestural, vital style. He pursues his anatomizing of man and landscape with an emotional energy and penetrating powers of perception. He returns the energies which had been released in → Art Informel to figurative and landscape painting, in order to give them a new vitality. His sensual body-landscapes also link him to the eroticism of the Viennese Expressionists (e. g. → Klimt, → Schiele, and → Kokoschka). H.D.

Bibl.: Knapp, Pfeuffer, 1985 · Schneidler, Pfeuffer, 1995

Phillips, Peter. *1939 Birmingham. British painter living on Majorca. From 1955 to 1959 he attended Birmingham College of Art; and 1959–62 the Royal College of Art, London. He was lecturer at Coventry College of Art and Birmingham College of Art in 1962–83. From 1964 to 1966 he lived in New York; in 1967–88 in Zürich. Phillips is a leading British exponent of → Pop art, who combines quotations from pin-up and comic books in a post-Cubist, collage-like style (→ Young Contemporaries). He uses spray technology to give his pictures a glossy, machined appearance (*Custom Paintings*, 1964–67). In the mid-1960s he created

the plastic, wood, and plexiglass sculptures that are related to → Minimal art. H.D.

Bibl.: Livingstone, Phillips, 1982

Phillips, Tom. *1937 London. British painter, graphic designer, musician, and writer living in London. He studied literature at St Catherine's College, Oxford, from 1957 to 1960; and art from 1961 to 1963 at Camberwell School of Art. In 1973 he composed an opera, *Irma* (première in 1980). Often inspired by colorful postcards, Phillips transformed the motif into subtle pictorial metaphors in a flawless painting process. After 1966 he used texts from a Victorian novella (*A Human Document*, by W. H. Mallock, 1892) as the basis for prints and other picture works which he compiled under the title of *A Humument*. He has also created illustrations for Dante's *Inferno* (1979–83). H.D.

Bibl.: Phillips, Music, 1996

photogram. A photographic image produced without a camera. Photograms are made by arranging two- or three-dimensional objects on light-sensitive material and exposing the arrangement to light. The objects appear as white silhouettes on a dark ground. The earliest examples date from 1840 in the form of cliché verre prints. From 1918 C. → Schad, among others, used this technique to produce what he called schadographs, composing and exposing objects (including paper templates) on photographic paper. In 1922 → Man Ray created his first → rayogram based on the photogram. His rayograms had a considerable influence, particularly on the → photomontages by → Grosz, → Heartfield, → Hausmann, → Lissitzky, → Rodchenko and → Moholy-Nagy, who valued this technique as "productive photography" (subjective photography) in contrast to reproductive photography. Another type appeared after 1945 with the photograms of figures by Floris M. Neusüss, in which people were exposed in original size onto light-sensitive fabric or paper. The technique is still widely used in the field of photographic design. K.S.-D.

Bibl.: Haus, Fotogramm, 1978 · Dada, Hanover, 1979 · Neusüss, Fotogramm, 1990

photomontage. The technique of combining parts of different photographs to create an image. A photomontage can be produced by one of two different processes. The positive montage consists of details of motifs from existing or specially produced photographs which are arranged on a base to form a new image, which is then reproduced. The negative or light montage is made up of motifs or details of motifs which are altered by technical reproduction or chemical processes and copied on top of, or next to, one another. Photomontage has its origins in the collage technique of → Cubism (*papiers collés*). In the 1920s, the Berlin Dadaists (→ Heartfield, → Grosz, and → Hausmann) discovered photomontage as an independent style for social critique. → Höch and → Lissitzky also created effective photomontages, as did the Bauhaus artists → Moholy-Nagy and → Bayer, who made innovative use of techniques from commercial art in photographs, posters, advertisements, and book design. The influence of photomontage can also be detected in the paintings and graphics of → Baumeister and → Schlemmer among others. The technique of photomontage has been revived by → Pop artists, exponents of → Nouveau Réalisme and contemporary artists such as → Baldessari and → Staeck. K.S.-D.

Bibl.: Haenlein, Photomontage, 1979 · Leclanche-Boulé, Photomontage, 1984 · Ades, Photomontage, 1986 · Evans/Gohl, Photomontage, 1986

photorealism. A style of painting which emerged at the end of the 1960s in reaction to → Pop art and → Conceptual art. It is characterized by the recording of seemingly unimportant details in a hyperrealist way using a reproductive, photographic precision. Photorealism has its roots primarily in America, where painters such as → Close and → Estes and sculptors such as G. → Segal and → Kienholz propagated a new realism, based on the naturalistic reproduction of photographs. In Europe photorealism appeared in particular following Documenta 5 (1972), which explored ways of dealing with reality in art. Photorealist subjects are frequently banal everyday scenes such as street views, landscapes or store windows. The intention is to examine the illusionistic depiction of reality and its relationship to the perception of the viewer. Other exponents of photorealism in painting are → Gertsch, G. → Richter, and → Artschwager (→ Hyperrealism). C.W.

Bibl.: Meisel, Photorealism, 1980 · Sager, Photorealism, 1982 · Meisel, Photorealism, 1993

photomontage, John Heartfield, *Adolf, der Übermensch schluckt Gold und redet Blech*, 1932, Arbeiter-Illustrierten-Zeitung, 4/32, no. 29, of 7.17.1932, p. 675

photorealism, Richard Estes, *Telephone Booths*, 1968, Thyssen-Bornemisza Collection

Picabia, Francis. *1879 Paris, †1953 Paris. French painter. He studied at the École des Arts Décoratifs, Paris, until 1895. In 1911 he joined → Section d'Or. Between 1912 and 1917 he made several trips to New York. From 1917 to 1924 he was co-publisher of *391*, the Dadaist magazine, and until 1918 a member of the Zürich Dada group (→ Dada). He moved to Paris in 1919; and in 1920 was co-founder of the Paris Dada group (with M. → Duchamp, → Breton, → Tzara). He left the Dada movement in 1921–22 and turned to painting, creating transparencies from 1927, and abstract painting with symbolic and amorphic elements from 1945. His dot pictures appeared in 1949. In a few years Picabia passed through the decisive stages of modern art, from Impressionism through → Fauvism and → Cubism, moving on to → Orphism and Abstraction (→ Abstract art). He also figured largely in Dadaism and → Surrealism.

Francis Picabia, *La nuit espagnole*, 1922, Enamel paint on canvas, 162.5 x 131 cm, Museum Ludwig, Sammlung Ludwig, Cologne

Francis Picabia, *Lunaris*, 1928, Oil on plywood, 119 x 95 cm, Henry and Cheryl Welt, New York

Within the circle of the Section d'Or, this intellectual outsider studied theories on the "fourth dimension" and non-Euclidean geometry which resulted in wholly abstract pictures (*Edtaonisl*, 1913), prematurely categorized by Apollinaire as Orphism. Shortly afterwards he created mechanomorphic pictures that put man and machine in relationship to each other – and Picabia at the front of the New York Dada movement (*L'Enfant carburateur*, c. 1919). However, Picabia broke away from this somewhat dogmatic movement, trying his hand at choreography (*Relâche*) and screenplays (*Entr'acte* by René Clair). He returned to painting in 1927, when he adopted a style that superimposed several motifs to surprising effects (transparencies; e.g. *Dispar*, c. 1929). In the 1940s he took pictures of bullfighters, nudes etc., moving towards the boundaries of → kitsch (*Women and Bulldog*, 1941–42). He returned to abstract art in 1945, ending his disparate but extraordinarily creative career with dot pictures that were just ahead of → Polke (*Carte à jouer*, 1949). Through his wealth of often just touched-on themes, styles, and techniques, Picabia is today regarded as an important precursor of → Postmodernism. H.D.

Bibl.: Sanouillet, Picabia, 1960–66 · Camfield, Picabia, 1979 · Borràs, Picabia, 1985 · Fauchereau, Picabia, 1996

Picasso, Pablo. *1881 Málaga, †1973 Mougins near Cannes. Spanish painter, sculptor, graphic designer, and ceramist. In 1895 he studied at La Lonja art school, Barcelona. His first visit to Paris was in 1900, and he began using his mother's maiden name, Picasso, in 1901. He moved to Paris in 1904, establishing his studio at the → Bateau-Lavoir. In 1917 he designed stage sets and costumes for the Ballets Russes. In 1939 he created the *Suite Vollard* series of etchings. He joined the Communist Party in 1944. After 1946 he spent much time on the Côte d'Azur, and in Vauvenargues from 1958. He donated many works to the museum in Barcelona in 1970. Influenced by → Symbolism and Toulouse-Lautrec, Picasso developed his own independent style in Paris during his Blue Period: motifs from everyday life in Paris that were marked by poverty, age, and loneliness, painted predominantly in blue. 1905–07 was his Rose Period, with lyrical pictures of jugglers, harlequins, acrobats, and high-wire artists. In 1906, influenced by African sculpture and masks (→ primitivism), and breaking away from Cézanne, Picasso began his geometrical nudes and landscapes that, following on from his key work, *Les Demoiselles d'Avignon* (1907), led to → Cubism. After 1912 his increasingly abstract pictures revealed large-scale shapes and strong chromatic values (synthetic Cubism), and led to

Pablo Picasso, *Night Fishing at Antibes*, 1939, Oil on canvas, 205.7 x 345.4 cm, Museum of Modern Art, New York

his works in → collage (*papiers collés*, → Braque), in which he once more inclined towards a stronger, more objective legibility. These were followed by three-dimensional sculptures made from paper, card, sheet metal, and wire. From 1915 Picasso interpreted his formal Cubist repertoire playfully yet elegantly in figurative picture compositions, whilst at the same time developing a Neoclassical style between 1920 and 1924 (*Two Women Running*, 1922). Around 1925 he began to move

Pablo Picasso, *Les Demoiselles d'Avignon*, 1907, Oil on canvas, 243.9 x 233.7 cm, Museum of Modern Art, New York

towards → Surrealism, extending his Cubist deformations by literary association and an increased force of expression (*Bathers with a Toy Boat*, 1937). In the 1930s he created sculptures, assemblages, and wire objects that had a great influence on 20th-century sculpture. The individual symbolism of these years peaked in 1937 in his etchings on *The Dream and Lie of Franco* and his major work *Guernica* (Spanish pavilion at the Exposition universelle in Paris) which expressed his horror at the bombing of this town during the Spanish Civil War. After World War II he carried out more technical experiments and created ceramics and graphic cycles. His later works consist of variations on a number of themes and motifs, and worked through historic examples (Delacroix, Velàzquez, Manet) in artistic cycles. His great adaptability, his brilliant and vital handling of the extremes of pictorial reality, his own stylistic pluralism and apparently inexhaustible creative forces made Picasso arguably the most admired artist of the 20th century. H.D.

Bibl.: Zervos, Picasso, 1932–78 · Besnard-Bernadac, Picasso, 1971 · Spies, Picasso, 1972 · Daix/Rosselet, Picasso, 1979 · Picasso, Paris, 1979 · Rubin, Picasso, 1993 · Chipp, Picasso, 1995–98 · McCully, Picasso, 1999

Piene, Otto. *1928 Laasphe, Westphalia. German born painter, graphic designer, and sculptor, living in Cambridge, Mass. From 1948 to 1950 he studied at the Akademie der Bildenden Künste, Munich; 1950–53 he was at the Kunstakademie, Düsseldorf; from 1953 to 1957 he studied philosophy at Cologne University. In 1957 he was cofounder (with → Mack) of → Zero. In 1964 he was guest professor at the University of Pennsylvania; and his work → appeared in Documenta 3. In 1968

he became lecturer at the Massachusetts Institute of Technology, Cambridge, and has been director of the Center of Advanced Visual Studies there since 1974. Following his early grid pictures, Piene created his first smoke and fire pictures in 1960 (*Smoke Picture*, 1962), which were followed by kinetic objects and → environments with so-called light ballets. At the end of the 1960s, he was involved with air projects ("sky art") creating floating, gas-filled colored sculptures (*Black Stacks Helium Sculpture*, 1976). K.S.-D.

Bibl.: Wiese, Piene, 1996

Piper, John. *1903 Epsom, Surrey, †1992 London. British painter, graphic designer, artist, designer, and writer. In 1926–28 he studied art at Richmond School of Art and at the Royal College of Art, London. In 1928–33 he worked as art critic for *The Listener* and *The Nation*. In 1933 he joined the → London Group; and in 1934 the Seven & Five Society. Initially an exponent of abstract art, in the 1930s Piper turned to landscapes and architectural motifs in the tradition of the English Romantics. During World War II he painted watercolors of bomb-damaged buildings and architectural scenes of Windsor Castle and Renishaw Hall in Derbyshire in a Romantic style. As well as landscapes and architectural work, Piper's varied creativity included book illustrations, stage sets (for operas by Benjamin Britten and the Royal Ballet), ceramics, stained-glass windows (Coventry Cathedral), textiles, and art criticism (*British Romantic Artists*, 1942). H.D.

Bibl.: West, Piper, 1979 · Piper, London, 1983

Pisis, Filippo de. *1896 Ferrara, †1956 Milan. Italian painter and art critic. From 1914 he studied literature in Bologna. In 1916 he met de → Chirico, → Carrà and others. From 1920 he was in Rome, and after 1925 in Paris. In 1940 he settled in Milan, moving to Venice in 1943. He was briefly influenced by → Pittura Metafisica, then turned to a Manet-orientated, Impressionistic lyricism, followed by the Parisian Cubists around → Picasso and the independent style of → Ensor. His work consists of still lifes, animals, landscapes, figures, and veduta (e. g. *Ponte sulla Senna*, 1937) in delicate, usually fragmented colors. S.Pa.

Bibl.: Briganti, De Pisis, 1991 · Buzzoni, De Pisis, 1996

Pistoletto, Michelangelo. *1933 Biella. Self-taught Italian painter and installation artist living in Turin. He worked as an art restorer from 1947 to 1958. His first paintings appeared in 1956. In 1960 his first one-man exhibition took place in the Galleria Galatea, Turin. In 1967 he won the Grand Prix of the São Paulo Bienal. From 1968 to 1970 he worked on actions and → happenings in Milan, Rome, and Turin. From 1979 to 1981 he was in the US, and in 1982, 1992, and 1997 he exhibited at Documentas 7, 9, and 10.

From the early 1960s Pistoletto represented a form of Conceptual art that utilized every shape, material, idea, and means. The central theme was the confrontation with imitation and with the relationship between picture and reality, which he represented in his *Mirror* pictures (from 1962) by seamlessly applying photographs to the mirror surface. In his sculptures which began in 1964, e. g. *Venus in Rags*, Pistoletto questions the traditional values of art by confronting classical beauty with tatty rags, accepted norms with chance, permanence with transience. After a phase of intense action, he produced from 1980 a series of sculptures of out-sized heads and torsos, made of foam or marble, whose roughly modelled surfaces are reminiscent of → Giacometti. In the 1990s he turned to "Progetto Arte," which to him represented a link between a variety of fields of human activity: architecture, fashion, design, but also trade and economics were seen as forming a productively interconnected system that would lead to the overcoming of existential emptiness and the sensory crisis of the modern age. S.Pa.

Bibl.: Celant, Pistoletto, 1984 · Pistoletto, Amsterdam, 1986 · Celant, Pistoletto, 1990 · Corà, Pistoletto, 1995

Pittura Metafisica, Giorgio de Chirico, *The Disquieting Muses*, c. 1916, Tempera on cardboard, 94 x 62 cm, Staatsgalerie Moderner Kunst, Munich

Pittura Metafisica. A term coined by de → Chirico and → Carrà in 1917 for "metaphysical painting," the objective of which was "to construct a new metaphysical psychology of things" (de Chirico). The artist's task is to reveal the mystery of the universe concealed behind the veil of what is visible. A non-logical combination of the objects into a visual vocabulary is used to evoke poetic experiences. In 1909–10, de Chirico created his first "metaphysical paintings" (*Enigma of an Autumn Afternoon*, 1910); from the same period comes → Savinio's isolated drawing (*Oracle*, 1909) and joint compositions of the "deepest music" (première Munich, 1911). The isolation of the objects, their sculptural but severely simplified shapes, and their hard shadows evoke a mysterious atmosphere. From 1917 de → Pisis attempted to develop the metaphysical ideology further, into a stronger artistic understanding (*Western Still Life*, 1919). In 1917 Carrà adopted some of de Chirico's typical stylistic features and iconographic elements (*Metaphysical Muse*, 1917), but avoided his radical, Nietzsche-based nihilism. From 1918 → Morandi reworked creative stylistic

Michelangelo Pistoletto, *Vietnam*, 1965, Graphite pencil, oil and tracing paper on polished stainless steel, 220 x 120 x 2.2 cm, The Menil Collection, Houston

features of de Chirico's Ferrarese pictures (including the tailor's dummy as a motif). The historical phase of Pittura Metafisica found an independent reformulation in Savinio's painting (from 1925). G.R.

Bibl.: Pittura Metafisica, Bologna/Ferrara, 1980–81 · Fossati, La Pittura metafisica, 1988 · Porzio, Savinio, 1988 · Poli, La Metafisica, 1989 · Baldacci, De Chirico, 1997

Plessi, Fabrizio. *1940 Reggio Emilia. Italian Installation, Video and Performance artist living in Venice. He studied at the Accademia di Belli Arti in Venice and lectured there from 1964. He participated in the Venice Biennale from 1970. In 1982 a complete showing of his video œuvre took place in the Centre Pompidou, Paris. He was awarded the L'immagine elettronica prize in 1987, and the same year exhibited at Documenta 7. In 1990 he became professor at the Hochschule für Medien in Cologne, and from 1994 lecturer in electronic scenography. From 1968 Plessi became interested in water as a subject, using it for films, → installations, videos, and performances (→ Action art). He worked together with choreographer Frédéric Flamand on a number of stage sets, one of which was for the 1989 performance of the opera *The Fall of Icarus* (music by Michael Nyman). A.R.

Bibl.: Plessi, Mainz, 1998

Poirier, Anne and Patrick. *1942 Marseille (Anne), *1942 Nantes (Patrick). French sculptors and Installation artists living in Ivry near Paris, and in Rome. From 1963 to 1966 they studied at the École Nationale des Arts Décoratifs in Paris. In 1967 they received scholarships to the Villa Medici in Rome, after which they worked together as a couple. They have had numerous exhibitions, including at Documenta 5 in 1972. The Poiriers' work revolves around the subjects of archaeology and mythology which they use as a source of artistic inspiration and metapor for forgetting and remembering. Trips to Rome and travels to excavation sites resulted in 1974 and 1977 in subjectively reconstructed models of the antique ruins of Ostia Antica and Domus Aurea, made from tiny clay tiles and charcoal. The Poiriers use and imitate archaeological methods, acting as forensic scientists who (re-)construct archetypes and forgotten myths. Papier mâché "casts" (*Moulages*) of antique sculptures are displayed in showcases with plants, found objects, photographs and notes, and extended by fictional reports. Since the 1980s they have also created large-scale, suggestively designed sculptural installations, inspired by mythological stories such as the Battle of the Titans, often in reaction

to the *genius loci* of an exhibition site (*Ephialtes*, garden of the Villa Celle at Pistoia), and numerous works in public spaces (including broken colossal columns, on the autoroute du Sud at Sucheres). F.K.

Bibl.: Morgan, Poirier, 1986

Poliakoff, Serge. *1906 Moscow, †1969 Paris. Russian-born painter who fled from Russia to Paris in 1918, where he studied music and worked as a guitarist. He studied in 1929–30 at the Académie de la Grande Chaumière, Paris (among others places); in 1935–37 at the Slade School of Art, London. On his return to Paris he became friends with → Kandinsky, → Freundlich and R. and S. → Delaunay. He received the Kandinsky prize in 1947, and the Lissone prize in 1959. In 1959 and 1964 he showed at Documentas 2 and 3. Poliakoff became a French national in 1962 and was awarded the Tokyo Biennale Prize in 1965. Stimulated equally by the colorfulness of → Orphism and the structures of → Cubism, after a Fauvistic beginning (→ Fauvism) in the 1930s Poliakoff turned to abstraction (→ abstract art). At the end of the 1940s he produced various monumental compositions, and a number of diptyches and triptyches in the 1950s. At the beginning of the 1950s he developed a form of abstract art that consisted of puzzle-like shapes and blocks of color in a restrained, generally dark palette. The actual color surfaces are lively in construction, and seem almost to be illuminated from within (*Red and Blue Composition*, 1965). After 1962 the colors were usually developed from a given chromatic scale but of varying saturation. H.D.

Bibl.: Durozoi, Poliakoff, 1984 · Brütsch, Poliakoff, 1993

Serge Poliakoff, *Composition*, 1959, Oil on canvas, 130 x 96.5 cm, Museum Moderner Kunst, Sammlung Ludwig, Vienna

Polke, Sigmar. *1941 Oels, Lower Saxony . German painter living in Cologne and Hamburg. Polke lived in West Berlin from 1953, and later in Düsseldorf. He studied glass painting in 1959–60. From 1961 to 1967 he was at the Kunstakademie in Düsseldorf. In 1963 he founded Capitalist Realism (with G. → Richter and others). From 1977 he was a lecturer and from 1989 to 1991 Professor at the Hochschule für Bildende Künste in Hamburg.

Anne and Patrick Poirier, 1. *Fragility, Wounds*, 2. *Fragility, Sex*, 1996–97 , Color photography, Infochrome, 12-part series, each 60 x 40 cm, DG-Bank Collection, Frankfurt

Sigmar Polke, *Hollywood*, 1971, Various materials on ticking, 2 pieces, 180 x 180 cm, 110 x 130 cm, Städtische Galerie im Lenbachhaus, Munich

Sigmar Polke, *Flowers*, 1967, Dispersion on canvas, 160 x 125 cm, Museum Ostdeutsche Galerie, Regensburg

In 1972–82 he exhibited at Documentas 5–7. He lived in Cologne from 1978, receiving numerous awards (including in 1986 the Grand Prix in painting, Venice Biennale; 1988 Baden-Württemberg award).

From the beginning, Polke's imagination was inspired by banal, everyday situations rather than metaphysical speculation in the abstract realm. His Capitalist Realist works (*The Sausage Eater*, 1963) display this ordinariness as do the filter images from the same period, in which Polke underpinned the "bad-taste" images, drawn from popular culture, with a coarsening, levelling filter. Interior design and decoration, designs for coffee tables and the world of kitsch are deliberately kept amateurish, reminiscent of → Picabia's "transparent" pictures (*Modern Art*, 1968). This ironic stance was also achieved using historical examples from the history of art which, detached from their context, were confronted with the techniques of Art Informel (*Untitled – Referring to Max Ernst*, 1981). Coincidence plays an increasingly decisive role in Polke's pictures. Using materials from the early days of painting, Polke has, since the 1980s, turned his pictures into chemical laboratories that are able to change their appearance even when in their final position in the museum or gallery (*New Pictures*, 1992). In all of this, he does not seek superficial innovation, but rather to preserve a concept of the painting which would appear to have become obsolete through the rise of the new media, but in which Polke constantly traces new changes in style. H.D.

Bibl.: Heubach/Buchloh, Polke, 1976 · Polke, Liverpool, 1995 · Schimmel, Polke, 1995 · Belting, Polke, 1997

Pollock, Jackson. *1912 Cody, Wyoming, †1956 East Hampton, New York. American painter. He studied at the Manual Arts School, Los Angeles from 1925 to 1929; from 1929/30 at the → Art Students League of New York (under T. H. → Benton). In 1936–43 he created murals for the → WPA program, becoming friends with → Motherwell in 1942. He created the first → drip paintings in 1946–47. Pollock was treated for alcoholism in 1951, and underwent psychoanalysis from 1955.

From 1946 to 1947, after Expressionist, figurative beginnings, Pollock, one of the greatest exponents of 20th-century art and founder of American → Abstract Expressionism, developed his new paint technique of "dripping," in which the paint was poured or flicked onto an unstretched canvas until he had created a dense network of color traces and smears, resulting in a gestural, expressive picture with an elementary rhythm.

The gestures of the paint smears hint at music and dance, as well as having figurative associations which Pollock, because of his studies under Benton (→ American Scene Painting) was never able (or willing) to obscure completely. The picture area is not just an "arena" (C. Greenberg) in which Pollock enacts his techniques, fed as they are by a variety of impulses including Indian sand painting, the automatic techniques of → Surrealism and jazz music, but it is also a field of experimentation for the free development of autonomous painting (*Number 5*, 1948).

Portrait formats alternate with landscape formats welcoming to the dance-like movements of the brush. The circular gestures of the brush are concentrated and particularly forceful in the tondo form (*Tondo*, 1948). Pollock also experimented with new painting techniques (industrial paints, use of texturing materials, of trowels, knives, and sticks) and consistencies (e.g. staining) to extend the conventional meaning of painting. His later works revealed a new depth, although his efforts were cut short by his untimely death (*The Deep*, 1953), often harking back to his early mythological, figurative pictures (*Easter and the Totem*, 1953). Pollock's art is identified on both sides of the Atlantic with the breakthrough to an independent American art free of European influences. H.D.

Bibl.: O'Connor, Pollock, 1978 · Pollock, New York, 1980 · Rose, Pollock, 1980 · Frascina, Pollock, 1985 · Landau, Pollock, 1989 · Pollock, London, 1999

Pomodoro, Arnaldo. *1926 Morciano di Romagna. Italian sculptor Pomodoro started his career in the Milan artistic milieu of the 1950s, where research, (for example, by his friend → Fontana), centered on problems of space. Pomodoro works mostly with metal (bronze, iron, steel), creating forms reminiscent of archaic symbols, such as columns, pyramids, and spheres which are split in order to reveal the interior, or incorporating machine parts, or else whose surfaces are engraved like ancient steles. His works have been exhibited at the Venice Biennale (1964; Prize), at the Marlborough Galleries in Rome and New York, and are installed in the courtyard of the Vatican Museums as well as in front of the ONU building. S.G.

Bibl.: Pomodoro, 1984

Poons, Larry. *1937 Tokyo. Japanese-born American painter living in New York. He studied at the New England Conservatory of Music, London, from 1955 to 1957; in 1958 at the Museum School of Fine Arts, Boston. He returned to New York in 1958–59. His first one-man exhibition was at the

Jackson Pollock, *Mural*, 1943, Oil on canvas, 247 x 605 cm, The University of Iowa Museum of Art, Iowa City

Jackson Pollock, *Untitled*, c. 1949, Fabric collage, paper, card, enamel, aluminum on Pavatex, 78.5 x 57.5 cm, Fondation Beyeler, Riehen

Green Gallery in 1963; he exhibited in 1967 at the Leo Castelli Gallery, New York, and in 1968 at Documenta 4. From the 1960s Poons was influenced by the → Abstract Expressionism of (→ Pollock and → Rothko) and created chromatic experiments ("dot pictures") with ornamental structures, whirling discs and ovals of color on strongly colored backgrounds (*Knoxville*, 1966). In the 1970s and 1980s these compositions became increasingly dense as different materials were added, resulting in compact, sensuous reliefs. K.S.-D.

Bibl.: Moffet, Poons, 1981

Pop art, Richard Hamilton, *Epiphany*, 1964, Cellulose on wood, diam. 112 cm, Artist's Collection

Pop art. Art movement that began primarily in Great Britain and the US in 1956 in reaction to the values and transmission of mass media culture. It was preceded by a rediscovery of Dadaist techniques and ideas as practiced at the → Institute of Contemporary Arts in London since 1952 by the → Independent Group. In his 1947 collage *I was a Rich Man's Plaything* → Paolozzi used the word "Pop!" graphically to represent a shot from a gun. In 1957 Hamilton recorded, "Pop Art is popular (designed for a mass audience), transient (short-term solution), expendable (easily forgotten), low-cost, mass produced, young (aimed at youth), witty, sexy, gimmicky, glamorous, big business." As a term, "Pop Art" is based on a 1958 text by the art critic, Lawrence Alloway, who retrospectively described the period to 1960 as the first phase in which Pop art was applied to the totality of pop-cultural products (primarily visual mass communication). From 1961 to 1964 the term was restricted to art works with figurative representations that were derived from the commercial mass media, such as → comic strips and advertising posters. During this "iconographic phase of Pop art" a distinction was made between individual motifs and methods of design in the traditional media of painting and sculpture, and attention was directed towards the American artists → Warhol, → Rauschenberg, → Lichtenstein, → Johns, → Oldenburg, → Rosenquist, → Ramos, → Indiana, and → Dine. These artists' works radicalized the British approach by varying, serially and mechanically, the images of the stars transmitted in the media and banal everyday objects or standardized consumer goods, turning them into images of Pop art. Pop art is regarded as having become established internationally in 1965. French → Nouveau Réalisme and, for a short time, the ideas of Germany's Capitalist Realism are generally regarded as the continental European equivalent. D.S.

Bibl.: Lippard, Pop art, 1968 · Compton, Pop art, 1970 · Alloway, Pop art, 1974 · Mahsun, Pop art, 1989 · Osterwold, Pop art, 1989 · Livingstone, Pop art, 1991

Popova, Lyubov. *1889 near Moscow , †1924 near Moscow. Russian painter, typographer, stage designer, and textile designer. She studied art in Moscow, sharing a studio with → Tatlin ("The Tower") in Moscow in 1912. She was in Paris in 1912–13 in → Le Fauconnier and → Metzinger's studio. She returned to Moscow in 1913. Popova's personal interpretation of French → Cubism appeared in nudes composed of fragmented geometric shapes. She interspered the fragmented figures with "atmospheric levels" in the shape of

triangles, parallelograms, etc. From 1916, inspired by the → Suprematism of → Malevich, she developed her *Painterly Architectonics* in which she transposed right- or acute-angled color areas, leaving them opaque or transparent. *Space Force Construction* in 1920–21, heralded the arrival of → Constructivism, and Popova is generally regarded as a co-founder. Popova treated the apparatus of stage sets (for the revolutionary mass pageant "Struggle and Victory" in 1921; "Earth in Turmoil" 1923) in the same way as the linear reduction of the color areas, moving from painting to representation in real space. Designs for work-suits for the actors led to Constructivist textiles, and to designs for modern everyday clothing (1924 for the First State Textile Factory in Moscow); in the last two decades of her life the slogans she created for the stage led her to an expressive typography that helped to establish the Constructivist style of the prints. She died prematurely of scarlet fever. H.G.

Bibl.: Adaskina/Sarabjanov, Popova, 1990 ·· Popova, 1991

Lyubov Popova, *Composition*, 1917, Gouache on paper, 33.3 x 24.4 cm, Private Collection

Porter, Eliot. *1901 Winnetka, Illinois, †1990 Santa Fe, New Mexico. Self-taught American photographer. He studied chemistry at Harvard University, Cambridge, from 1920 to 1924, then at Harvard Medical School. From 1929 to 1939 he worked as a researcher and lecturer in bacteriology and biochemistry. He became a professional photographer in 1939. Moving to Santa Fe in 1946 he became regular contributor to *Audubon Magazine*. Porter specialized in landscapes and animals, which he took in their natural environments using innovative methods (stroboscope flashes, filters, using scaffolding and tall ladders). He undertook numerous expeditions, including to Baja on the California – Mexico border, the Galapagos islands, Greece, Turkey, the Antarctic, and Maine, and recorded the results of these trips in volumes of color photographs. C.W.-B.

Bibl.: Porter, 1992

Porter, Fairfield. *1907 Winnetka, Illinois, †1975 Southampton, New York. American painter and printmaker. From an artistic family, Porter studied art at Harvard (1924–28) and was a student of

T. H. → Benton at the → Art Students League of New York (1928–30). Of Socialist leanings, he began to write political art criticism and contributed to *The Nation* and *ARTNews*. After a → social realism phase (*Subway*, 1929), his figurative work was influenced by Intimism; he later favored small-scale domestic scenes (*Interior with Rocking Chairs*, 1950) and (more occasionally) landscapes. The late 1940s saw broader handling and larger formats (*Katie and Anne*, 1955). Though associated with → Rivers (portrait, 1951), his work is more muted and illustrative. His palette brightened in the 1960s and 1970s (*View from Upstairs*, 1966) and relationships between masses became increasingly formal (*The Beginning of the Fields*, 1973). His works of scholarship include a monograph on *Thomas Eakins* (New York, 1959). D.R.

Bibl.: Ludman, Porter, 1981 · Spike, Porter, 1992

Portinari, Cándido. *1903 São Paulo, †1962 Rio de Janeiro. Brazilian painter. He attended art school in Rio de Janeiro from 1918, traveling to Europe in 1928 (including Paris). From 1936 to 1939 he was professor at the University of Rio de Janeiro. After Cubist and Surrealist beginnings, he adopted a realist style. Inspired by Mexico's → muralism, he began to paint murals in 1933, and from 1936–45 his work addressed monumental sociocritical themes for the Ministry of Education in São Paulo. He designed a number of murals (including some with the architect O. Niemeyer) for public buildings (including the Church of St. Francis in Pampulha [Belo Horizonte], 1943–45; the Library of Congress in Washington, 1942; UNO Building, New York, 1953–57: *War and Peace*). He adopted Expressionist compositions (complex installations, clear colors, highly expressive shapes and forms). His later works were of motifs from Brazilian history, religious and regional themes, and portraits. K.S.-D.

Bibl.: Kent, Portinari, 1940 · Portinari, São Paulo, 1979

Post-Impressionism. Initially Roger Fry's exhibition title (1910–11 Grafton Galleries, London: Manet and the Post-Impressionists) covering artists (mostly French) who transformed or adapted Impressionsim between 1880 and 1905. Central figures were Cézanne, Gauguin, van Gogh (see → precursors) and, to a limited extent, Seurat (see → Neo-Impressionism), who broke away from precise observation and designed a number of different artistic strategies aimed at autonomy of the means and the painting. H.D.

Bibl.: House/Stevens, Post-Impressionism, 1979

Post-Minimalism. Collective term for a number of American artists, each of whom has, since 1966, created their own version of → Minimal art, although they all differ greatly in their playful approach and use of geometry, and in their emphasis of the character of the material. There were three categories: first, artists such as → Serra, → Sonnier, → Samaras, → Nauman and → Hesse, who accentuated characteristic materials such as lead, neon, felt, and latex, or who drew attention to the process of manufacture and distortion; second, artists who based their work on mathematical, information or color theories,

such as B. D. Rockburne; third, conceptual and body-emphasizing approaches that were used by → Burden and → Acconci in direct reaction to the radical abstraction of Minimal art. D.S.

Bibl.: Pincus-Witten, Post-Minimalism, 1977 · Pincus-Witten, Post-Minimalism, 1987

Post-Painterly Abstraction. Vague term that covered the tendencies of American art in the late-1950s/early 1960s to differentiate itself from gestural → Abstract Expressionism and strive towards pure color painting (title of the 1964 exhibition in Los Angeles County Museum). It included artists as diverse as → Frankenthaler, → Held, → Francis, Ellsworth → Kelly, → Louis, K. → Noland, → Olitski and F. → Stella. The emphasis of the flatness of a picture was considered the decisive sign of modernistic painting. This ideological, very American idea was also used to describe an absolute boundary of painting, which was on occasion formally reduced to such an extent that it was almost impossible to maintain the difference between an ontologically pure picture and the status of a simple object. The term was not in common use for long. New Abstraction was for a while an alternative term. M.S.

Bibl.: Greenberg, Post-Painterly Abstraction, 1964

Postmodernism. Term relating to different genres and describing a fundamental, pluralist view which distances itself from modernism which had come to be perceived as monotonous and dogmatic. The term was defined clearly in 1969 in North American literary criticism as the link between élite and mass culture (→ Pop art). Applied to architecture in 1975, the term refers to "double coding" as the decisive characteristic of postmodern buildings: a combination of historicizing and modern forms and regional and international references which aim to address different consumer groups. J.-F. Lyotard who treated this theme philosophically in 1979 described the postmodern as the spiritual state of the present after the collapse of great utopian ideas. The ideology of uniformity (which is characteristic of modernism and the new age) should therefore be replaced by a "Paralogy" focusing on difference, discontinuity, ambiguity, and paradox. While the classical avant-garde movements reject any traditional references, paying homage to a concept of linear progress and declaring their particular style as definitive, Postmodernism calls for a productive consideration of history and an equal dual existence of possibilities. Evidence of postmodern artistic composition may be found in the work of → Polke who adopts stylistic change as his strategy. Postmodernism should be seen less as anti-modern than as a revision of a modernism that is restricted purely to functionalism and rationalism. The term also referred to artistic trends of the 1980s, e.g. the Italian → Transavantgarde. D.S.

Bibl.: Feyerabend, Postmodernism, 1980 · Klotz, Postmodernism, 1984 · Welsch, Postmodernism, 1987 · Welsch, Postmodernism, 1988

Pousette-Dart, Richard. *1916 St.Paul, Minnesota, †1992 New York. Self-taught American painter. He had his first one-man exhibition in 1941 in the

Artists' Gallery, New York. He taught from 1959 to 1961 at the New School for Social Research, from 1968 to 1969 at Columbia University, and from 1970 to 1974 at Sarah Lawrence College, all in New York. In 1959 he exhibited at Documenta 2. From 1940 he created totemistic, ritual forms, circles, ellipses and star-shaped designs in dense pictorial layers (*Symphony No. 1*, *The Transcendental*, 1942). After 1959 these forms were replaced by subtly modulated tones that dissolved everything objective in a fabric of colors. He also experimented with → collage, photography, and wire sculpture. K.S.-D.

Bibl.: Pousette-Dart, 1997–98

Pozzi, Lucio. *1935 Milan. Italian painter who has lived in New York since 1962. He studied sculpture in Milan from 1952 to 1956, and architecture in Rome in 1957–58. Since 1962 he has held exhibitions of analytical paintings and drawings. In 1977 his work appeared at Documenta 6. He has taught widely: 1969–75 (history of art and architecture) at Cooper Union, New York; 1975 at Princeton University; since 1979 at the School for Visual Arts, New York. In the 1970s he researched → Performances and → Installations, and created film, photo, audio, and video works. While dealing with a number of different media, Pozzi continuously considers the elements of painting, and has since the early 1980s adopted a gestural, figurative style of painting. A.R.

Bibl.: Ball, Pozzi, 1981 ·

Prager, Heinz-Günter. *1944 Herne. German sculptor living in Cologne and Brunswick. From 1964 to 1968 he attended the Werkkunstschule, Münster. In 1973–74 he was in Florence (receiving the Villa Romana award), and had several periods working in the Villa Massimo, Rome. From 1983 he was Professor of sculpture at the Hochschule für Bildende Künste in Brunswick. He has produced numerous works for public places, including *Großes Kreuzstück* (1987) in the park of Schloß Philippsruhe, Hanau. Industrially manufactured iron and steel sheets serve as a raw material for non-objective sculptures in elementary shapes, whose central point of reference to the human body only becomes obvious when viewed from all sides. Prager's point of departure is the relationship of one's own body to the volumes of the sculpture, and to the intervening empty space. Prager's *in situ* designs divide and accentuate the public area and form a link between architecture and nature. I.S.

Bibl.: Uelsberg, Dortmund, 1996–97

Prampolini, Enrico. *1894 Modena, †1956 Rome. Italian painter, sculptor, stage set designer, costume designer, architect, and art critic. He studied briefly at the Accademia in Rome. In 1912 he published his manifesto "Bombardiamo le Accademie e industrializziamo l'arte" ("Let's Bomb the Academies and Industrialize Art") and joined the Futurists. In 1919 he joined the → Novembergruppe. He was in Paris from 1925 to 1937, and in 1931 joined → Abstraction-Création. He was a co-signatory of the → Aeropittura manifesto by Marinetti. After his first Futurist paintings, he created abstract compositions, Futurist waistcoats, and material collages (*arte polimaterica*) in 1914 that made his name as one of the main exponents of abstract art in Italy. S.Pa.

Bibl.: Prampolini, 1992

Precisionism. American movement in painting originating c. 1915 but most widespread in the 1920s and 1930s. Industrial plant and urban installations were presented in a simplified, clean-cut, formally reduced, → Cubist idiom without figures in realist perspective, though viewpoints may be close-up or canted. Also known as the "Immaculates" or "Sterilists," the Precisionists included → Demuth and → Sheeler, as well as → O'Keeffe (though her themes are natural), George Ault (1891–1948; semi-Surrealist nocturnals), the American – Canadian Ralston Crawford (1906–78; formal analyses of industrial architecture, 1930s), and Niles Spencer (1893–1952; increasingly planar machines, 1930s–40s). Influenced by photography, the movement encouraged the acceptance of an ostensibly "non-aesthetic" thematic and abstraction of form. Printmaking was an important component of its popularization. The flattening of contour and treatment of shadow (though not facture and theme) bear superficial resemblance to → Purism, while rendering overlaps with figurative → Surrealism. Similar experiments occurred in → Neue Sachlichkeit (e.g. Carl Grossberg [1894–1940]). The American fascination with accuracy in portrayal of such material persists in 1960s–70s Superrealism and → Hyperrealism. D.R.

Bibl.: Friedman, Precisionism, 1960 · Precisionism, Colombus, 1994

precursors, Paul Cézanne, *The Large Bathers*, 1895–1904, Oil on canvas, 127 x 196 cm, The National Gallery, London

precursors. Towards the end of the 19th century a handful of artists emerged from the Impressionist movement to confront the spontaneity and virtuosity of the back-to-basics way of painting with a new desire for orderliness. A central figure of this → Post-Impressionism is Paul Cézanne who transposed his motifs – portraits, landscapes, and figurative pictures – into a color system of extreme clarity. The motifs appear in undramatic simplicity woven into a dense fabric of color relationships, but also transfigured on a seemingly crystalline ground, untouched by the changeability of life. Claude Monet's late paintings of waterlilies appear totally opposite to this (or perhaps complementary) when, in a protean change of colors, they attempt to represent a different concept of nature. Monet's experiments with color techniques already point to the later developments of → Art Informel and → Tachisme.

Paul Gauguin too started off from Impressionism and, in the sparse landscape of Brittany, developed a new style which he called → Synthesism. By combining various sources of inspiration, which included the technique of religious stained glass as well as Japanese woodcuts, Gauguin devised an innovative way of painting in strong colors and simplified forms. Unlike Monet, Gauguin did not start from the direct observation of nature but, through a correspondence of color and form, he sought to "evoke" intuitions, dreams, and visions.

In a short time span between 1886 and 1890, driven by a self-destructive desire for creativity, Vincent van Gogh produced paintings using brilliant colors and an expressive power of form. Like Gauguin, with whom he intended to set up an artists' association in Arles, he saw colors not merely as simple, graphic means but as a suggestive language capable of having a direct effect on the soul. Van Gogh does not demonstrate an overarching Impressionist view but an intense, etched-in vision of nature as a cosmic whole, influenced by the power of fate.

George Seurat had also recognized the expressive power inherent in color. However, the passionate exuberance of van Gogh was as alien to him as was the mystic stance of Gauguin and the → Nabis. By employing various scientific theories he developed a color system consisting of minute elements (pointillism) which, by "optical mixing" were meant to achieve a stronger brilliance and intensity than the traditional Impressionist technique (see → Neo-Impressionism). Despite a positivistic faith in science he eventually paved the way for a new concept of art which creates an autonomous, coherent work of art out of basic pictorial elements. Starting from different viewpoints Monet, Cézanne, Gauguin, van Gogh, and Seurat each played a decisive role in bringing about the change from the imitation of nature to focusing on a reality of the image itself which was so crucial for modernism. H.D.

Bibl.: Loevgren, Modernism, 1971 · Hofmann, Moderne Kunst, 1978 · Rewald, Nachimpressionismus, 1986 · Franz, Farben des Lichts, 1996/97

Prem, Heimrad. → Spur

Prendergast, Maurice (Brazil). *1858 St. John's, Newfoundland, †1924 New York City. American painter and printmaker, of Canadian birth. In the US from 1868, he traveled to Paris in 1891 and attended the Atelier Colarossi and the Académie Julian, encountering the → Nabis' aesthetic. At first mainly a landscapist and seascape watercolorist, he also composed monotypes – especially of lone society ladies (many now in the Terra Museum at Chicago) – and wash watercolors of e.g. city women at work or at the sea (*On the Beach*, c. 1907). In Italy, he produced series on Venice (1898, 1911–). He became a member of The → Eight (1908), and exhibited small oil landscapes near → Fauvism in New York (1908) before relocating there in 1911. His *Landscape with Figures* (1910–13), exhibited in the → Armory Show which he helped organize, shows precocious awareness of the European avant-garde. (Some oils are close to → Vuillard.) Postwar, he returned to female figures on

the seashore or in parks viewed from an elevation. (His brother, the sculptor Charles [1863–1948], designed frames for his canvases.) D.R.

Bibl.: Clark/Matthews/Owens, Prendergast, 1990

precursors, Claude Monet, *Waterlilies*, 1916–20, Oil on canvas, 200 x 425 cm, Musée d'Orangerie, Paris

primitivism. Primitivism, a return to the original archaic and magical cult and art forms of "primitive" tribes, is one of modern art's main sources of inspiration. It was originally a countermovement to the normative claims of classical academic art. It fulfills a romantic yearning for what is original and pure, for the mythical and the magical in art. Gauguin (see → precursors) was the first to lay claim to the superiority of primitive art forms. In 1912, D. → Burliuk declared in the → Blaue Reiter almanac that "barbaric art" was the means by which "the chains of academicism would be broken in order to set art free." This, however, did not mean cultural regression, but rather that the arts had been released from the restraints of western patterns of thought and art. With differing ideas and objectives, → Fauvism, → Cubism, German → Expressionism and → Surrealism all drew inspiration from African tribal art and Oceanic masks and sculptures. The Russian avant-garde was inspired by icons and folk art. → Land art aims to reveal the magical precision of archaic constructions and landmarks (→ Long); while → Performance artists (→ Beuys, → Nitsch) take on the role of medicine men and shamen in order to conceive personal mythologies. W.S.

Bibl.: Goldwater, Primitivism, 1938 · Rubin, Primitivism, 1988 · Rhodes, Primitivism, 1994

Prince, Richard. *1949 Panama Canal Zone. Self-taught American painter, artist, and photographer living in New York. His first one-man exhibition was held in the Angus Whyte Gallery, Boston, in 1973. Retrospectives have been held in the Whitney Museum of American Art, New York, in 1992; at the Kunstverein and Kunsthalle, Düsseldorf, in 1993; and in 1994 at the Kestner-Gesellschaft, Hanover, and elsewhere. Prince re-photographs photos from the consumer world: living rooms, wristwatches, girl bikers, etc. Above all, he reproduces moments of pure force, of male excitement,

Richard Prince, *Untitled (Cowboy)*, 1980–84, Color photograph, 127 x 177.8 cm, Artist's Collection

sexuality and violence, often using details, and occasionally out of focus. From the mid-1980s he produced his "jokes", a repertoire of about 20 well-known jokes that he silk-screens onto large-scale canvases. His *Protest Paintings* followed in the 1990s, the forms of which are reminiscent of placards carried on demonstrations, but whose texts recount jokes instead. Despite references to → Pollock and → Rauschenberg, his pictures avoid classification. Their neutrality and objectivity are neither criticism of the media, nor of consumer behavior. Thus the artist, who continues to see himself as a painter and makes no claim to be creating something new, becomes a modern mediator without a defined public role. S.Pa.

Bibl.: Grundberg, Prince, 1990 · Phillips, Prince, 1992 · Prince, New York, 1992 · Prince, Zürich, 1995

Ivan Puni, *Suprematist Composition*, 1915, Oil on canvas, 94 x 65 cm, Stedelijk Museum, Amsterdam

Print Renaissance. The term refers to the renewed impetus given American printmaking (especially lithography, then serigraphy) in the late 1950s and 1960s, especially on the West Coast. In 1957, following the pioneering work of → Hayter and against commercial litho, work by Universal Limited Art Editions workshops (ULAE) included → Rivers, Fritz Glarner (1899–1972), → Johns, and → Rauschenberg. In Hollywood in 1959–60, the Tamarind Lithography Workshop endowed by the Ford Foundation was set up by June Wayne, moving to Albuquerque in the 1970s and working with e.g. → Guston, de → Kooning, → Motherwell, and → Francis. Kenneth Tyler (1931–) became Technical Director (1964), in 1965 establishing Gemini Ltd (later Gemini GEL or Graphic Editions Ltd), working with Josef → Albers and → Shahn; other clients including Frank → Stella, → Frankenthaler, → Oldenburg, → Motherwell, and → Hockney. "Great prints are made by great artists" (K. T.). Other groundbreaking workshops included Cirrus Editions Ltd, Simca Prints, and Tyler Graphics, major exponents including → Dine, → Bontecou, Alexander Liberman (1912–), Barnett → Newman, and Allen → Jones. The term also denotes the fresh interest shown in printwork in the 1920s–40s by → Sloan, with e.g. Adolf Dehn (1895–1960), Howard Cook (1901–80), and Gifford Beal (1876–1956). D.R.

Process art. A typical phenomenon of the 1960s and 1970s that aimed to expand the term art, and differed from the spontaneity and coincidence of → happenings and → Fluxus in its detailed planning and precise objectivity of the artistic action. The artist has a limited arsenal of objects (often objects that are in daily use) and (elementary) patterns of behavior at his disposal, within which he demonstrates causal links and connections. The declared objective is the sensitization of perception, and an increase in the awareness of consumer-orientated patterns of behavior in modern society. Process art's main protagonists are → Walther and Klaus Rinke (1939–) (→ Nauman and → Sonnier to a lesser degree) (→ Auto-destructive art). W.S.

Bibl.: Lippard, Six Years, 1973 · Process art, Los Angeles, 1998

Puni, Ivan. *1894 Kuokkala, Finland, †1956 Paris. Finnish-born painter, the son of a cellist of Italian origin. From 1910 to 1912 he studied in Paris (Académie Julian), returning to St. Petersburg in 1912. In 1914, under the influence of Russian → Cubo-Futurism (D. → Burliuk, → Malevich), he turned to → Cubism, and in 1915 to → Suprematism. Puni combined painted, geometric picture elements with flowing shapes to create reliefs (*Suprematistic Relief Sculpture*, 1915), adding individual items to them (*Hammer Relief*, 1915–21; *Plate Relief* 1919). He was co-publisher of the *Suprematist Manifesto* in 1915. After the 1918 Revolution he became a professor at the art school in Vitebsk, which was run by → Chagall. He emigrated to Berlin in the fall of 1920, became a critic of Suprematism, and propagated a "constructive naturalism" in the Cubist style (he published *Contemporary Art* in 1923). He moved to Paris in 1924, and pursued figurative painting inspired by the → Nabis. H. G.

Bibl.: Puni, Paris, 1966 · Berninger/Cartier, Pougny, 1972–92 · Puni, Paris, 1993

Purism. Art movement that arose from → Cubism and was developed by → Ozenfant and → Le Corbusier between 1918 and 1925. The term was used by Ozenfant in an article written in 1916 for *L'Élan* magazine, and taken up in *Apres le cubisme* (1918) and *Esprit Nouveau* magazines, which appeared between 1920 and 1925, as the programmatic slogan for a direction of art which, on the one hand, followed on from the achievements of Cubism, and on the other rejected its abstract, decorative tendencies and demanded clarification of or closer links to the depicted object. Preferred motifs were simple, everyday objects (musical instruments, vases, decanters, glasses, bottles) that were reproduced in severely shaped, clearly constructed, cool compositions. A.G.

Bibl.: Golding/Green, Purism, 1971 ·· Ball, Purism, 1978

Puryear, Martin. *1941 Washington, D. C.. American sculptor and Installation artist living in Accord, NY. He studied biology from 1959 to 1963 at the University of Washington, D. C. making the acquaintance there of K. → Noland. Thereafter he traveled to Africa. In 1966–68 he was at the Academy in Stockholm. In 1992 his works were shown at Documenta 9. The varied repertoire of forms used for his sculptures and objects is somewhere between stereometric constructions and organic or biomorphic shapes, as he allows the material employed to guide him (usually natural materials, such as wood). He also creates socio-critical works: in repeated installations of a (Nomadic) tent he draws attention to the problems of the intimidation and expulsion of ethnic minorities – a subject that has preoccupied him since his time in Africa. I.S.

Bibl.: Benezra/Storr, Puryear, 1992

Quinn, Marc. → Young British Artists

Rabinovitch, David. *1943 Toronto. Canadian sculptor who lives in New York. He is the twin brother of Royden → Rabinovitch. From 1963 to 1968 he studied at the University of Western Ontario (physics and English literature). In 1963

he made his first floor works from thin sheet steel. Inspired by Roman architecture, he created the series *Metric (Roman) Constructions* (1971), examining the relationship between part shapes and overall shape, and the ways in which they are perceived. Since then he has created multi-part sculptures, some of which have complex outlines. By drilling through steel sheets he places the horizontal mass in opposition to the vertical construction, which results in an optical system of reference. To experience this system of coordinates, the observer has to walk around the asymmetrical sculpture – with each change of position the viewer is able to see a completely different impression of the sculpture. He is now considered one of the main exponents of floor sculpture. I.H.

Bibl.: Rabinovitch, Chemnitz, 1995 · Davis, Rabinovitch, 1996 ·

Rabinovitch, Royden (Leslie). *1943 Toronto. Canadian sculptor who lives in New York, Cambridge (England) and Dublin. Twin brother of David → Rabinovitch. After studying music, the self-taught artist gained wide recognition at "The Heart of London" exhibition (1968) in Ottawa, Canada. He moved to New York in 1975. He has taught at the University of Cambridge since 1984; and has been a life member of Clare Hall since 1986. His earliest sculptures include the abstract steel group *Three Homages to Jazz Drummers/Three Judgements on Origins of Abstract Thinking* (1962), which is an attempt at a synthesis between natural science, philosophy, and music. His work is linked to Minimalism, an example of which can be seen in the severe, geometric experiments of the *Handed Manifolds* series of works, which was begun in 1972. A.R.

Bibl.: Rabinovitch, Ghent, 1984 · Rabinovitch, Mönchengladbach, 1985 · Rabinovitch, Berne, 1990 · Rabinovitch, The Hague, 1992

Radermacher, Norbert. *1953 Aachen. German sculptor and graphic artist living in Berlin. From 1973 to 1979 he studied at the Kunstakademie, Düsseldorf. In 1991 he became guest professor at the Akademie der Bildenden Künste, Munich, and in 1992 professor at the Gesamthochschule, Kassel. Since 1980 Radermacher has painted "Stücke für Städte" (a title coined after the exhibition in Berlin, Künstlerhaus Bethanien, 1985). These are situational, usually small, anonymous sculptures or interventions in urban thoroughfares. His assimilation of the existing system of symbols of the public arena demands the attention of a non-museal audience (*The Vases*, Kassel, 1987 Documenta 8) and makes traces of history visible again: as in *Santiago*, casts of pilgrim scallops (French: coquilles de St. Jacques, in allusion to St. James the Greater = Sant'Iago) at twelve stations of the former pilgrimage route between the Tour St. Jacques and Place St. Jacques in Paris (1981). A.R.

Bibl.: Radermacher, Munich, 1991 · Radermacher, Wiesbaden, 1994 · KünstlerprofessorInnen, Kassel, 1996

Räderscheidt, Anton. *1892 Cologne, †1970 Cologne. German painter. He studied in 1910–14 at the Kunstgewerbeschule in Cologne and Kunstakademie in Düsseldorf. In 1919 he met → Freundlich, → Ernst and → Arp, and his work was influenced by de → Chirico and → Carrà. In 1920–30 he became associated with → Magic Realism. In 1925 he exhibited at the Neue Sachlichkeit exhibition. He emigrated to France in 1934. He was interned in Toulon and Les Milles in 1940, and fled to Switzerland in 1942, returning to Cologne in 1949.

His early works are marked by elements of realism, and also his combination of Neue Sachlichkeit with Magic Realism to produce paintings of sober, monotonous anonymity and lack of movement and shadows in the empty spaces. At the end of the 1920s he returned to his Expressionist beginnings. From 1949 he began to work more figuratively in a deliberate opposition to abstract art. Ignored in his later period, he anticipated the realist movements of the 1960s in conscious isolation. From 1958 he adopted a gestural style of painting of great individuality and free, abstract forms. G.P.

Bibl.: Richter, Räderscheidt, 1972 · Herzog, Räderscheidt, 1991

Anton Räderscheidt, *Young Man with Yellow Gloves*, 1921, Oil on wood, 27 x 18.5 cm, Private Collection

Mark Rothko, *Untitled (Yellow, Red, Orange on Orange)*, 1954, Oil on canvas, 292 x 231 cm, Kate Rothko Prizel Collection

Radziwill, Franz. *1895 Strohausen, Weser-marsch, †1983 Wilhelmshaven. German painter who started his career as a builder's apprentice (1909–15), while also studying architecture. From 1915 to 1919 he served as a soldier, after which he returned to Bremen. He was in contact with artists of Die → Brücke, and worked in Berlin from 1920 with the artists associated with → Neue Sachlichkeit. He traveled to and through Holland between 1925 and 1933, during which time he also studied in Dresden (1927). There he struck up a friendship with → Dix. Radziwill was made a Professor in Düsseldorf in 1933, but was dismissed from the post in 1935. In 1937 his work was removed from German museums and brand-ed "degenerate." He was banned from exhibiting in 1938; the following year he was called up for military service (1939–42). In 1963 Radziwill received the Prix de Rome. He gave up painting in 1972 after experiencing sight problems.

His association with the Brücke artists → Schmidt-Rottluff, → Heckel, → Mueller, and → Pechstein gave the artist's early work an inde-pendence. After the experiences of World War I, the disasters of reality could only be expressed in a pictorial language which was half Neue Sach-lichkeit, half → Magic Realism. Idyllic, yet at the same time "flowing with apocalyptic horrors, and painted with extraordinary ability, truly that of an Old Master." In this manner in 1972 Radzi-will recorded his knowledge and his visions of the "unstable, hallucinatory underpinning" (Haftmann) of the world. G.Pr.

Bibl.: Presler, Radziwill, 1993 · Firmenich, Radziwill, 1995 · Seeba, Radziwill, 1995

Franz Radziwill, *Entrance to a Village, End of a Working Day*, 1928, Oil on particleboard, 95 x 115.5 cm, Museum Ost-deutsche Galerie, Regensburg

Rainer, Arnulf. *1929 Baden near Vienna . Austri-an painter living in Vienna and Enzenkirchen, Upper Austria. From 1947 to 1949 he was at the Staatsgewerbeschule in Villach; and from 1950 briefly at the Hochschule für angewandte Kunst and at the Akademie der bildende Künste in Vien-na. From then on he was self-taught. In 1972–82 his work appeared in Documentas 5–7. Under the influence of the gestural methods of → Pollock, → Riopelle and → Wols, whom he met in Paris in 1951, Rainer moved towards abstract "micro-structures" (*Atomisation*, 1951). In 1953 he devel-oped the principle of "overpainting," which he still pursues today and which was initially simi-lar to → Art Informel, a gestural process of paint-ing in which the individual painted layers

Arnulf Rainer, *Kreuzherz*, 1959/1973, Oil on wood, 208 x 81 cm, Städtische Galerie im Lenbachhaus, Munich

beneath remain visible. The simple cross-shape of the support sustains his entire oeuvre.

After some intense experiences with drugs and studies at psychiatric clinics, in 1969 Rainer began to overpaint photographs of his own face and body as well as photographs of pictures by Old Masters and contemporary artists. Examinations of body language and the question of his own identity manifest themselves in his series of *Face Farces* and *Body Poses* (*Drohungen*, 1973), which reveal points of contact with → Vienna action art. Rainer consis-tently breaks social taboos, not only those of eroti-cism (he overpaints pornographic pictures) but also, since 1977, of mortality in a series of death masks and drawings. After a brief phase of foot and finger paintings, Rainer moved to religious themes in the 1980s (crucifixes, martyrdom, cata-strophes, and angels), followed by overpaintings of botanical and zoological illustrations from books published in the 18th and 19th centuries. H.D.

Bibl.: Breicha, Rainer, 1980 · Catoir, Rainer, 1989 · Fuchs, Rainer, 1989 · Ullrich, Rainer, 1994 · Aigner, Rainer, 1997

Arnulf Rainer, Cross, *Black on Yellow*, 1957, Oil on particle-board, 167 x 150 cm, Private Collection, Vienna

Ramos, Mel. *1935 Sacramento, California. American painter. Ramos studied at his local State College of Art, but found himself ill at ease with predominant Bay Area painting, his early allusive abstracts giving no indication of the path to come. His first versions of Superman and other comic-book heroes (1961) were painterly, but he rapidly developed a style that mimicked the unified tones of printing (though he does not show the raster à la → Lichtenstein). Subjects from 1964 centered on scantily clad models from girlie magazines (with series titles such as *Peek-a-boo* or *Kiss me*) juxtaposed with outsized items of Americana – *Lucky Strike* soft packs, phallic ketchup bottles, etc. (*Miss Firestone*, 1965). Work in the 1970s included animals with → Pop consumer odalisques in suggestive but not obscene poses. Since the late 1980s he has branched out into more traditional figure work. D.R.

Bibl.: Claridge, Ramos, 1975

Rauschenberg, Robert. *1925 Port Arthur, Texas. American painter and sculptor who lives in New York. He studied at the Académie Julian, Paris (1947); at → Black Mountain College, North Carolina, under J. → Albers (1948–49); and with the → Art Students League of New York (1949–50). His first one-man exhibitions were at the Betty Parsons' Gallery, New York (1951). In 1952–53 he traveled to Spain, North Africa, and Italy. In 1959 and 1977 his work appeared at Documentas 2–4, and 6. In 1966 established Experiments in Art and Technology (→ EAT) (with Billy Kluver). From 1984 he was manager of the Rauschenberg Overseas Cultural Interchange (ROCI) project.

From 1953, Rauschenberg combined the gestural painting methods of → Action Painting with objects and → objets trouvés, resulting in so-called → combine paintings (*Monogram*, 1955–59). A collision of banal, everyday objects and spontaneous coloring revealed a planned opposition to rational discourse that could not be explained by art historical models or unambiguous subject matter. Originally known as → Neo-Dada, the term soon proved to be too constricting. A co-operation with → Cage and Cunningham's Dance Company led to a lifelong interest in designing stage sets. Rauschenberg discovered another area of interest

Robert Rauschenberg, *Retroactive II*, 1964, Oil, silk-screen on canvas, 213 x 152 cm, Stefan T. Edlis Collection

Robert Rauschenberg, *Canyon*, 1959, Combine painting, different techniques and materials on canvas, 208 x 178 x 61 cm, Sonnabend Collection, New York

in 1965, in the EAT group, which experimented with the possible uses for modern technology in art. In the 1960s, impressed by → Warhol's works, Rauschenberg began to work with silk-screen, photo frottage, and photographic reproduction (*Retroactive I*, 1964). His series *Stoned Moon*, (1969) was inspired by the Apollo 11 program, and shows a fascinated involvement with the possibilities offered by modern technology; this continues in his → installations of the 1980s and 1990s. Rauschenberg's innovative techniques, critical position, and inexhaustible artistic imagination have had a considerable influence on the latest generation of American artists. H.D.

Bibl.: Tomkins, Rauschenberg, 1980 · Cowart, Rauschenberg, 1991 · Craft, Rauschenberg, 1997 · Hopps, Rauschenberg, 1997

rayogram/rayograph. → Man Ray

Rayonism. Direction of Russian Futurism (also known as Rayism and Luchism) developed after 1912 by → Larionov and → Goncharova. It was first seen at the 6th → World of Art exhibition in Moscow in November/December 1912. *Rayonists and People of the Future – a Manifesto* and *Rayonistic Painting* were published in 1913. Taking on board the ideas and thought processes of Italian → Futurism, → Cubism, and → Orphism, and including scientific findings on the materiality of light, Larionov's work dissolved initially recognizable objects into rays and beams of expanding and overlapping colors and lights that open out like fans (rayons). N.v.A.

Bibl.: Bowlt, Rayonism, 1988 · Kowtun, Larionov, 1988

Raysse, Martial. *1936 Golfe-Juan, Alpes-Maritimes. French self-taught painter. An early → Nouveau Réalisme phase close to → Spoerri included untransformed *étalages*, e.g the display racks of *Hygiène de la Vision* (1961). *Souviens-toi de Tahiti* (1963) and *Paysage champêtre en quinze tons* (1963), however, heralded the exploration of a cool, leisurely world (in mixed media and/or acrylic), now eschewing the social irony of → Pop art. *Formes* (1968–) showed half-figure silhouettes in smooth, stereotyped settings, their anomie reminiscent of → Katz. His 1962 environment *Raysse Beach* combined the picturesque of the seaside (his birthplace is a resort) with warm neons (also in *America, America*, 1964) and trademark appliqué parasols. Fluorescent color compositions now also incorporated pastel and tempera, while his imagery (including detached anatomical features and collage) remained studiedly anodyne: *Calm Images* (1972) and other works display a nostalgic *Méditerranéanisme*. A precocious mythological and art historically allusive style (1970s) persists, e. g. the female figure of *La Source* (1989), *L'Enfance de Bacchus* (1991), and *Georges et le Dragon* (1990; combat between two "humans"). Raysse is also a filmmaker and theater designer. D.R.

Bibl.: Raysse, Paris, 1992

ready-made. An industrially manufactured object that is removed from the context of its function and declared a work of art by the artist. The finished product may remain unchanged or

be subjected to only minor alterations. The first ready-mades (*Bicycle Wheel*, *Bottle Rack*, *Fountain*) and the term itself originate with the Dadaist Marcel → Duchamp. The renunciation of the traditional art work that is manifested in the ready-made is intended as a deliberate provocation by the artist: it points emphatically at the priority of the idea over artisanal execution. K.E.

Bibl.: Daniels, Duchamp, 1992

realism. Realism as an art-theoretical term refers to no specific movement or phenomena that are easily defined by common structures or content. The variety and diversity of the sub-groups alone (e.g. utopian, critical, metaphysical, → Socialist, → social, figurative, or → Fantastic realism) confirm that the term is also used in contradictory contexts and for extremely heterogenous manifestations. On the one hand realism designates a traditional movement in art which sees an apparently extremely close relationship between art and the real world (the realism of antiquity, Dutch realism of the 17th century), in opposition to idealism, but it can also go far beyond the mere reflection of visual reality (on which Naturalism concentrates). Realism is also an art-theoretical "battle cry", evoked in Gustave Courbet's demand for truth, modernity, and the artist's response to the social situation and problems of his time as a moral imperative of art. Thus realism is less a style than a method of approaching reality with aesthetic means that requires a critical, sceptical, ironic, questioning and/or committed relationship to what exists. It does not postulate an unattainable ideal that ignores contradictions (as idealism does), but tries instead to reveal contradictions with the (long-term) objective of changing reality. W.S.

Bibl.: Nochlin, Realism, 1966 · Nochlin, Realism, 1974 · Needham, Realism, 1988 · Kiterding, Realism, 1991

Redon, Odilon (Bertrand-Jean). *1840 Bordeaux, †1916 Paris. French painter, printmaker, and draftsman whose literary and visionary work in lithography and charcoal (the *Noirs*) belongs essentially to 19th-century → Symbolism. Favorite themes included the severed head (Orpheus, St. John the Baptist) and the single, all-seeing, floating, or flying eye. Until 1890, his exhibited work was monochrome, with painting (brightly colored flowers and spiritual or sacrificial subjects) subsequently gaining in importance (*Yeux Clos*, 1889–90, oil). His illustrations for Poe, Shakespeare, and Mallarmé were a great influence on Post-Symbolist aesthetic, while his palette was admired by the → Nabis (with whom he was exhibited in 1899) and the → Fauves (including → Matisse). D.R.

Bibl.: Harrison, Redon, 1986 · Wildenstein, Redon, 1992

Regionalism. An American school of representational painting, associated with Midwestern artists of the 1930s, and principally the works of Grant → Wood, T.H. → Benton, and → Curry. This "triumvirate" of Regionalism achieved national acclaim during the isolationist Depression era for their "purely American" figurative and landscape paintings and prints. Yet surprisingly, all

Odilon (Bertrand-Jean) Redon, *The Cyclops*, c. 1898, Oil on panel, 64 x 51 cm, Rijksmuseum Kröller-Müller, Otterlo

three Regionalists had their formative experiences in Europe during the 1920s. After painting hundreds of Impressionist-inspired *plein-air* landscapes in France and his native Iowa, Grant Wood developed his signature style of meticulous realism following a 1928 trip to Munich, where he saw → Neue Sachlichkeit paintings and the Old Master works that inspired them. The most avant-garde of the Regionalists, Thomas Hart Benton practiced a → Synchromist-inspired color Cubism while rooming with Stanton McDonald Wright in Paris during the 1920s. Of the three Regionalists, John Steuart Curry was the most conservative, painting recollections of his native Kansas from Westport, Connecticut. For his masterpiece, the Kansas Statehouse murals of 1937–42, Curry portrayed the Kansan abolitionist John Brown on the eve of the Civil War.

With the rise of Abstract Expressionism, Regionalism fell out of favor until serious scholarship revived its reputation, beginning in 1975. This was furthered by major exhibitions in the 1980s and 1990s. B.R.

Bibl.: Dennis, Regionalists, 1988 · Roberts, Wood, 1996

Rego, Paula. *1935 Lisbon. Portuguese painter. After attending the Slade School of Art 1952–56 and shifting between Portugal and England, Rego now lives and works in London. In the 1970s she turned from collage and collage-derived drawings and canvases (*Popular Proverb*, 1961) to an independent style. Her initial approach, in acrylic, was highly colored and graphic. Treated with a contextual rather than perspectival regard to relative size, themes include interactions between animals and people, influenced by children's literature (*Girl and Dog* series draws on a hallmark allusion to "Charity"); the revenge of women on men; and family tensions (*The Family*, 1988). By 1985–86, more naturalistic figures and compositions emerged, close to → Balthus but less voyeuristic (*Looking Back*, 1987). Recent projects include rewrites of Disney's *Fantasia* with the ostriches as ungainly females (1995–96) and a cycle of illustrations for a classical novel by Eça de Queirós (1998). In 1988, Rego enjoyed a mid-career retrospective at the Serpentine Gallery,

Ad Reinhardt, *Abstract Painting*, 1959, Oil on canvas, 274.5 x 101.5 cm, Marlborough International Fine Art

London, and the Fundação Calouste Gulbenkian, Lisbon. D.R.

Bibl.: Rego, Liverpool, 1997

Reinhardt, Ad. *1913 Buffalo, †1967 New York. American painter. He spent 1931 to 1937 at Columbia University, New York (studying history of art); and 1936–37 at the National Academy of Design (studying painting). From 1937 to 1947 he was a member of the → American Abstract Artists; from 1947 a lecturer at Brooklyn College and elsewhere. He received a Guggenheim scholarship in 1967. His work appeared at the 1968 Documenta 4. In the 1930s he created Constructivistic, geometric pictures that were influenced by the works of → Mondrian (*Number 30*, 1938). From the mid-1940s severe division of the surface relaxed into an expressive technique in which the picture area is veiled over in light shades with calligraphic rhythm. His caricatures, drawn during the war, were precursors of his later attacks on the narrow-mindedness of the contemporary art world. In the 1950s, Reinhardt developed a rigorous new approach to art. The picture elements were simplified to such an extent that they worked together in an unobtrusive ensemble. The field structures, initially colored in reds and blues, peak in an almost homogenous black, and only after a period of observation is the viewer able to discern smaller shapes and vibrant areas of color with a minimal depth of movement. Reinhardt's objective, however, is not to play the different techniques like a virtuoso, but absolute, autonomous painting. Numerous writings testify to his desire for "art-as-art." The autonomous picture must not be contaminated by content and ideas removed from painting; the simple picture composition must not detract from the idea of pure art. His ascetic perception defined art as an independent area of human self-recognition away from everyday life, and made him one of the early exponents of → Minimal and → Conceptual art. H.D.

Bibl.: Rowell, Reinhardt, 1980 · Lippard, Reinhardt, 1981 · Bois, Reinhardt, 1991 · Reinhardt, Art, 1991

Germaine Richier, *The Praying Mantis*, 1946, Bronze, 158 x 56 x 78 cm, Museum am Ostwall, Dortmund

Richards, Ceri. *1903 Dunvant, near Swansea, †1971 London. British painter of Welsh-speaking origins. He studied in Swansea (1921–24) and at the Royal College of Art, London (1924–27). Based in London, Richards exhibited at the International Surrealist Exhibition there in 1936. Influenced by → Picasso and → Arp, he joined the → London Group (1937) and began (semi-) figurative relief-constructions. During World War II Richards was appointed to Cardiff School of Art, where his style was derived from Romanticized versions of natural themes. Richards's postwar work often refers to music: the *Cathédrale engloutie* series (1959–62) of paintings and constructions being inspired by "the tremendous depth" (C. R.) of Claude Debussy's evocative 1910 *Prélude* (Richards was an accomplished pianist). The *Cycle of Nature* paintings (from 1944) were powerful Celtic metaphors employing tracery applied with a paint-soaked "whip" of string, while *"Do not go gentle into that good night"* (1956) is based on Dylan Thomas' poem. A notable scenographer, Richards designed sets for Benjamin Britten's *Noyes Fludde*

(1958). He was active as a printmaker, and produced wall-paintings for the Shakespeare Festival (Stratford, 1965) and designs for the interior of the Blessed Sacrament Chapel in Liverpool Cathedral (1965). His wife Frances Richards (1903–85), née Clayton, whom he married in 1929, was also an artist. D.R.

Bibl.: Sanesi, Richards, 1973 · Richards, London, 1981

Richier, Germaine. *1902 Grans near Arles, †1959 Montpellier. French sculptor and graphic artist. In 1921–26 she studied at the École des Beaux-Arts, Montpellier; from 1926 to 1929 she worked in the studio run by → Bourdelle. Richier's work was shown at the 1937 Exposition Universelle in Paris (at which she was awarded a medal of honor for her bronze sculpture *Méditérranée*); during the war years, 1939–46, she based her studio in Zürich.

Her early pieces show similarities to that of Bourdelle and → Rodin. Inspired by → Giacometti, from 1940 she developed her characteristic early style: mythically charged hermaphrodites (in which extreme distortions emphasize the links between humans, animals, plants, and minerals), such as grasshopper women. These were greatly inspired by processes of transformation and changing shapes in nature. Richier used materials taken from nature, such as roots and branches, including them directly in her work without following any one particular style (similar to the ideals espoused by Surrealism and Expressionism). The intentionally severely reduced bodies, with rough and cracked surfaces, express links to decay, destruction, suffering, and apocalypse. In 1950 she created a figure of *The Crucified Christ* for the church in Assy. From 1951 she produced lead sculptures together with K. → Hartung and → Vieira da Silva. She also worked on graphics, including book illustrations for Rimbaud and her husband, René de Soulier. In 1952 Richier exhibited at the Venice Biennale; in 1959 and 1964 she exhibited at Documentas 2 and 3; and in 1965 her work was featured in a Paris retrospective (Musée National d'Art Moderne). I.S.

Bibl.: Richier, Antibes, 1985

Richter, Gerhard. *1932 Dresden. German painter living in Cologne. From 1949 to 1952 he worked as a stage set designer and producing advertising graphics in Zittau. In 1952–56 he was at the Hochschule für Bildende Künste, Dresden. From 1960 he was in Düsseldorf, where he remained until 1963 at the Kunstakademie. 1963 saw his "Demonstration für den Kapitalistischen Realismus". In 1968/69 he taught art in Düsseldorf, and became professor at the Kunstakademie from 1971. In 1972 his work appeared at the Venice Biennale; and in 1972–97 at Documentas 1–10. In 1981 he received the Arnold Bode prize; and in 1985 the Kokoschka prize.

Distrusting the "universal language of abstraction" in the 1960s Richter drew instead on the trivia of the visual mass media. In his blurred and unfocused paintings, which are based on newspaper pictures and amateur photos, he plays the two genres one against the other. In a large series of 48 portraits of personalities from the worlds of culture and science (Venice Biennale, 1972) Richter initially refuses this

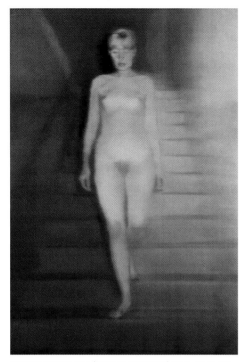

Gerhard Richter, *Ema (Nude on a Staircase)*, 1966, Oil on canvas, 200 x 130 cm, Museum Ludwig, Cologne

confrontation, turning instead to the material of painting itself. In 1976 he began to produce strongly colored compositions, at first on small canvases, in which he incorporated and brilliantly developed various methods, including → Informal. Under the heading of "Abstract Pictures," the works, which became increasingly large-scale, represented the biggest group of works to date on the subject of "painting as painting," yet were constantly interrupted by "realistic" pictures (Red Army Fraction series, mother-and-child series, candle motifs). Abstraction is, for him, first and foremost a social model, a comparison of social conditions in which the "most diverse and most contradictory things are brought together, living and viable, in the greatest possible freedom" (Richter). H.D.

Bibl.: Richter, London, 1991 · König, Richter, 1993 · Obrist, Richter, 1995 · Obrist, Richter, 1996

Richter, Hans. *1888 Berlin, †1976 Locarno. German painter and film maker. In 1906–08 he worked as an apprentice in his father's carpentry workshop, then attended the Kunstakademie in Berlin. He was at the Kunstakademie, Weimar until 1910. In 1912–13 he was in contact with the → Sturm group in Berlin. In 1916 he became a member of the → Dada movement, Zürich. In 1921 he worked on the publication *De Stijl*; in 1923–26 he was publisher of *G* magazine. He fled to Switzerland in 1931, moving to the USA in 1941. In 1944–47 he worked on the movie *Dreams that Money Can't Buy*. 1952 saw his one-man exhibition in the Stedelijk Museum, Amsterdam. After early Expressionist pictures, Richter collaborated with Viking Eggeling (1880–1925) on pictorial experiments with musical analogies that led to abstract "scroll" drawings (*Fugue in Red and Green*, 1923). Since it is only possible to represent time as a shape in art, Richter soon turned to

innovative experiments with movies. His first abstract film was produced in 1921–22 (*Rhythm 21*). He found new impulses in → Constructivism, passed onto him by van → Doesburg and → Lissitzky. In the reel of images, *Orchestration of Color* (1923), Richter transferred his film experiences to painting, producing the first vertical format to employ the principle of counterpoint and complementary colors. In addition to his abstract painting, to which he kept returning, in film Richter turned to spiritual organization and began his first Surrealist film productions, which he continued after emigrating to the US. He settled in Ancona in 1958, after which he concentrated solely on painting and writing (*Dada, Art and Anti-art*, 1964, new edn. 1997). H.D.

Bibl.: Richter, Dada, 1961 · Sanesi, Richter, 1975 · Fifield, Richter, 1993

Rickey, George. *1907 South Bend, Indiana. American sculptor and Kinetic artist living in East Chatham, New York. He moved in 1913 to Glasgow, Scotland. From 1926 to 1929 he was in Oxford at Balliol College, and from 1928 to 1929 at the Ruskin School of Drawing. In 1929–30 he was in Paris at the Académie Lhote and Académie Moderne (with → Léger and → Ozenfant). In 1934 until 1942 he was back in New York. He performed his military service from 1942 to 1945. He held several professorships between 1949 and 1966 (including Tulane University, New Orleans). His first sculpture exhibition in New York was in 1955 and the following year he published his book *Art and Artist* (on Kinetic art). His work appeared at the 1964 Documenta 3. In 1967 he published his standard work *Constructivism: Origins and Evolution*. Committed to → Kinetic art and → Constructivism, he gained international fame in the 1960s. He expanded → Calder's imaginative world in mobiles and geometric designs. Contrary to their plain, geometric, usually straight-lined, even surfaces, his sculptures, when exposed to the forces of nature (e. g. wind, gravity), develop complex and spontaneous movements. The sections and shapes of the space they occupy, their speed and duration, the relationship between the different items, and the interplay between light and shadow on the moving steel surfaces represent Rickey's central artistic interest. I.N.

Bibl.: Rickey, Washington, 1966 · Rosenthal, Rickey, 1977 · Rickey, Montreal, 1981 · Tomii, Rickey, 1988 · Rickey, Paris, 1990

Rietveld, Gerrit. → Stijl, De

George Rickey, *Six Lines Horizontal*, 1964, Stainless steel, height 61 cm, Kimiko und John Rowers Collection, Colorado

Gerhard Richter, *Zero Rocket*, 1966, Oil on canvas, 93 x 73 cm, Museum Ostdeutsche Galerie, Regensburg

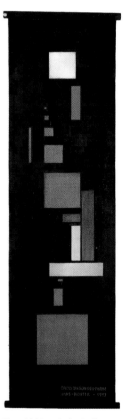

Hans Richter, *Orchestration of Color*, 1923, Oil on canvas, 153 x 41.7 cm, Staatsgalerie Stuttgart

Riley, Bridget. *1931 London. British painter living in London. She studied in London first at Goldsmiths' College (1949–52), then at the Royal College of Art (1952–55). From 1959 to 1961 she taught at Hornsey College of Art, and from 1962 at the art school in Croyden, and elsewhere. In 1968 she received the Grand Prix for painting at the Venice Biennale. In 1968 and 1977 she showed at Documentas 4 and 6. Through her involvement with the theory and practice of

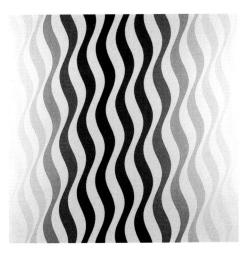

Bridget Riley, *Arrest IV*, 1965, Emulsion on canvas, 179.1 x 179.1 cm, Luciana Moores

→ Neo-Impressionism, Riley began in the 1960s to paint severe, black-and-white paintings with optically disquieting effects, which made her one of the best known exponents of → Op art (*Breath*, 1966). In 1966 she began to use color contrasts in strong values, which, arranged in bands, created subtle light effects to the eye of the observer (*Cherry Autumn*, 1983). In the 1980s she replaced the stripes with diagonally placed strips of color to achieve a clear emphasis of the colored area in the style of Cézanne (*High Sky 2*, 1992). Her interest in color and music in movement resulted in stage set designs for the ballet *Colour Moves* (Edinburgh Festival, 1983). H.D.

Bibl.: Riley, London, 1973 · Riley, 1995 · Stecker, Riley, 2000

Ringgold, Faith. *1930 New York. American painter and sculptor Ringgold grew up in Harlem and earned her M.F.A. in 1959 from the City College of New York, where she studied with Robert Gwathmey (1903–) and Yasuo Kuniyoshi (1893–1953). A multi-media artist, she is best known for her story-telling quilts of colorful painted and pieced fabric; the quilts often take family members, other African-Americans or women as their subject matter. Ringgold's work (as well as her life) is characterized by her concern for civil rights issues. The first work to gain her national attention was *American People* (1963–67), a canvas series with political themes.

An activist leader for African-Americans and women artists, she helped to organize the Ad Hoc Women's Art Group (1970), which challenged the discrimination against women in museum exhibitions, and Where We Are (1971), a support group of black women artists exhibiting in New York. Ringgold's work changed in the 1970s, when she began making paintings on cloth and soft sculpture, bringing together African quilting techniques, traditional women's work (sewing),

and story-telling texts; similar to Haitian art of the 1960s, her imagery and techniques mix European academic and African folk art traditions. Her *French Collection* series of quilted paintings (1990–94), considered one of her best series, is a feminist narrative of epic dimensions. J.C.M.

Bibl.: Ringgold, 1985 · Ringgold, 1998

Riopelle, Jean-Paul. *1923 Montreal. Canadian-born painter and sculptor living in Paris. He briefly studied mathematics (1940–42), then went to the Academy of Art in Montreal to study painting. He was inspired by → Breton (*Le surrealisme et la peinture*) in 1945 to try abstract art and experiment with → automatism. In 1947 in Paris he was in contact with the → École de Paris; also with → Pollock, → Rothko and → Mathieu. In the 1962 Venice Biennale he was awarded the Unesco prize. He also created sculptures, e.g. fountains for the Olympic Stadium in Montreal, 1976. Stylistically, his postwar works lie somewhere between American and French art. His first works were → drip paintings, followed by more rhythmically expressive structures using colored mosaics and fine grid structures, and with the paint applied more thickly, almost like relief. At the end of the 1960s he moved towards figurative work. I.S.

Bibl.: Riopelle, New York, 1989

Rist, Pipilotti. *1962 Rheintal, Switzerland. Swiss Video and computer artist living in Basel, Zürich, and Leipzig. In 1981–85 she attended the Hochschule für Angewandte Kunst in Vienna (studying commercial art and photography), and in 1986 she studied audio-visual design at the Schule für Gestaltung in Basel. She also worked as a computer graphic designer for the pharmaceutical industry. In 1997 her work was shown at the Venice Biennale, receiving the Premio 2000. In 1988–94 she was a member of the music and performance group *Les Reines prochaines*. In her installations, she manipulates and overloads the video machines in order to distort the pictures that are transmitted into a specially created environment. In *Digesting Impressions* (1992), Rist presented a screening showing a stomach endoscopy placed inside a yellow swimsuit. S.Pa.

Bibl.: Rist, St. Gallen, 1994

Rivera, Diego. *1886 Guanajuato, Mexico, †1957 Mexico City. Mexican artist and painter, and a leading muralist (→ muralism). From 1896 to 1902 he studied at the Academia de San Carlos, Mexico City; then at the Academia de San Fernando, Madrid. In 1907 he received a scholarship for Spain, and traveled in Europe (including Paris, Madrid, and Italy), where he was impressed by Cézanne; his work was influenced by pointillism and → Cubism. He returned to Mexico in 1920–21, where he was a member of the Communist party until 1921; he was also co-founder of the union of revolutionary artists, sculptors, and graphic designers. In 1923–28 he produced frescoes in the Ministry of Education (life of the Mexican populace and political Utopia). He married → Kahlo in 1928. In 1929–30 he worked on frescoes in the Palacio de Cortez in Cuernavaca. This cycle took him into historical motifs: the early

Diego Rivera, *Jacques Lipchitz (Portrait of a Young Man)*, 1914, Oil on canvas, 65.1 x 54.9 cm, Museum of Modern Art, New York

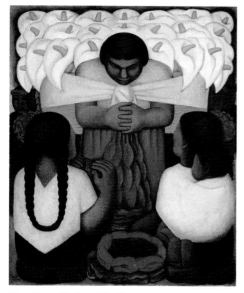

Diego Rivera, *The Day of the Flowers*, 1925, Encaustic on canvas, 147.4 x 120.6 cm, Los Angeles County Museum of Art

cultures of Mexico, the Conquistadores, independence, and the Revolution. In 1930–34 he worked in the USA, where he created murals in California; 1932 saw him in Detroit (*Detroit Industry*, Institute of Arts), and 1933 in New York (mural at Rockefeller Center; destroyed because of the picture of Lenin). In Mexico in the Palacio de Bellas Artes, he completed the mural intended for the Rockefeller Center. In 193–40 he took up easel painting (including landscapes and portraits). In 1940–57 he worked on numerous murals, including *Dream of a Sunday Afternoon in the Alameda Park* (1947–48) for the Hotel Prado (now the Museum in Alameda Park). In 1949 a retrospective was held in the Palacio de Bellas Artes. In 1955 Diego Rivera bequeathed the Blue House in Coyoacan, where Kahlo had lived, to the Mexican people.

Rivera is Mexico's best-known artist. Although he made his name internationally with his murals, his easel paintings hold the prime position in his overall œuvre. In subject matter and artistic conception, these works complement his murals. Apart from the portraits, which were usually commissions, and his self-portraits, here too Mexico and its indigenous population are the central theme. E.B.

Bibl.: Rivera, Detroit, 1986 · Rodriguez, Rivera, 1989 · Rochfort, Mexican Muralists, 1993

Rivers, Larry (Yitzroch Loiza Grossberg). *1923 New York. American painter, graphic designer, and sculptor living in New York. He studied composition at the Juilliard School of Music in New York in 1944–45, becoming a jazz saxophonist. In 1947–48 he studied art under → Hofmann; in 1948–51 at New York University. In 1950 he traveled to Europe. His work appeared in 1964, 1969, and 1977 at Documentas 3, 4, and 6. In 1966 he produced stage designs for Stravinsky's *Oedipus Rex*. In 1970 a retrospective was held at the Art Institute of Chicago.

In the 1960s, Rivers developed a realistic form of figurative representation that combined → assemblages made of everyday objects (cigarette packets etc.) with artistic elements by de

→ Kooning (*Kings*, 1960). He also included → Pop art, that was based on → Abstract Expressionism. Together with → Tinguely, he created the Kinetic work *Turning Friendship of America and France* in 1962. In 1963 there followed → collages and oil paintings that paraphrased Rembrandt's *Staalmeesters* (1662) after pictures on Dutch cigar boxes. From 1962–64, Rivers worked on drawings, paintings, and sculptures onto which he stencilled, in several languages, the names of parts of the female body, a process that contradicts the sensual character of the works. Rivers still uses the techniques he adopted in the 1960s in collages, graphics, assemblages, and paintings, a new thematic addition being research into his Jewish identity. K.S.-D.

Bibl.: Brightman, Rivers, 1979 · Harrison, Rivers, 1984 · Hunter, Rivers, 1989

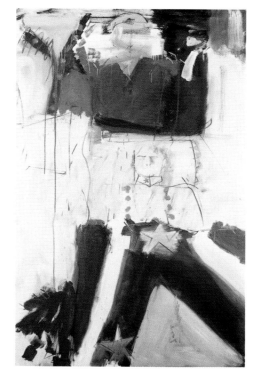

Larry Rivers, *Final Veteran: The Last Civil War Veteran in the Coffin*, 1961, Oil on canvas, 203.2 x 129.5 cm, Waddington Galleries, London

Roberts, William. *1895 London, †1980 London. British painter. He began in 1909 as a poster and commercial artist, taking evening classes at St Martin's School of Art, London. In 1910–13 he attended the Slade School of Art, London. He was an → Official War Artist during World War I. In 1925–60 he taught at the Central School of Art, London. He was co-signatory of the *Vorticist Manifesto* (→ Vorticism) that appeared in 1914 in the first issue of *BLAST*. He encountered → Post-Impressionism and → Cubism on his travels through France and Italy in 1913, and his work emulated → Léger in the 1920s: figure paintings based on geometric shapes in everyday scenes, that attempt to reveal the mechanistic structure of modern city life (*The Vorticists at the Restaurant de la Tour Eiffel: Spring 1915*, 1961–62). A.R.

Bibl.: Roberts, Vortex, 1958 · Roberts, London, 1984 · Roberts, London, 1989

Rockwell, Norman (Percevel). *1894 New York City, †1978 Stockbridge, Massachusetts. American

illustrator and painter, best known for his *Saturday Evening Post* covers. Rockwell studied at the → Art Students League of New York. Engaged by Condé Nast at age 17, he sold his first illustration to the *Post* (a huge seller at the time) in 1916, working for it for the next 47 years. Trips abroad gave him access to the European avant-garde, though his main influences were the American Realists. He would produce oil paintings, which were then printed up as color illustrations. He used photographs from around 1937. His most memorable image was of a working woman in wartime, *Rosie the Riveter,* for a 1943 *Post* number. During World War II his propaganda posters, such as *Four Freedoms*, were distributed by the Office of War Information.

In the 1960s his mood turned slightly more somber (a series on racism, for example), though this may have been a reaction to the pervasive political liberalism. Rockwell was a meticulous craftsman, his central themes being the family and the small-town or industrial life of conservative "best-possible-world" (N. R.) America (*Is He Coming?*, 1920, shows idyllic children awaiting Santa). The producer of a large number of society portraits, Rockwell has mass appeal but was often reviled by the critics. A sizeable museum devoted to his work opened in Stockbridge in 1993. D.R.

Rodchenko, Aleksander St. Petersburg, †1956 Moscow. Russian painter, designer, and photographer who spent 1911–14 at art school in Kasan, then studied graphics at the Stroganov School in Moscow in 1915. He met → Tatlin in 1916, and joined the Moscow art avant-garde after the October Revolution of 1917. He was active in the reformation of Russian art life as well as a leading member of the Moscow → Inkhuk, co-founder of → Constructivism and professor at the Moscow VkhUTEMAS (Higher Artistic-Technical Workshops). He was married to → Stepanova. His social activities matched his revolutionary artistic practice: *White Sculpture* (1918) consisting of geometric areas that fitted together like a puzzle; architectural utopias in 1919; *Black on Black*, a series of paintings (in reference to Malevich's *White on White* pictures); linear constructions and manifesto *The Line* in 1920; suspended constructions (the first sculptures that did not stand on the floor), first monochrome paintings in pure red, yellow, and blue collectively known as *The Last Painting* in 1921. Rodchenko founded Constructivism in Moscow and proclaimed the slogan "Art into Life". He gave up painting to design furniture (including designs for polyfunctional complex furniture) and visual work (typography, photography). In 1923 he developed Constructivist typography and worked as a typographer for several magazine and book publishers (working closely with the poet W. Mayakovsky). From 1924 he developed a new photographic aesthetic with strong dynamic motifs shot from above and below and canted. In addition to his work as a Constructivist photographer, photojournalist and layout artist, he also designed functionalist furniture and costumes for revolutionary plays and films. His "formalist" photography was strongly criticized between 1932 and 1935, but he continued to work as a photographer and layout artist for the Stalinist propaganda machine.

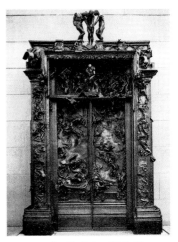

He resumed painting at the same time, and created a series of circus pictures and abstract → drip paintings. H.G.

Bibl.: Karginov, Rodchenko, 1975 · · Rodchenko, Oxford, 1979 · Khan-Magomedov, Rodtschenko, 1987 · Rodchenko, New York, 1989 · Noever, Rodchenko, 1991

Rodin, Auguste. *1840 Paris, †1917 Meudon. French sculptor who studied at the École des Arts Décoratifs, Paris (1854–57). In 1864–71 he produced his first sculptures, relocating to Belgium in 1872–74, where he worked on the Stock Exchange. He traveled regularly, e. g. visiting Florence and Rome in 1876, where his introduction to the works of Michelangelo released him from the constraints of the academic style in which he had been trained. In 1877 Rodin became interest-

Auguste Rodin, *The Gates of Hell*, 1880–1917, Bronze, height 550 cm, Musée Rodin, Paris

ed in Gothic cathedrals (leading to his 1914 illustrations of the book *Les Cathédrales de France*). He came into contact with the Symbolist circle in the 1880s (Mallarmé), by whom he was influenced for the rest of his life. He received major public commissions from 1880 onwards (e. g. *The Gates of Hell*, 1880–1917, incomplete, now at the Musée Rodin, Paris). In 1883 he began a relationship with Camille → Claudel (ended in 1898). In the 1890s he worked on a project for a *Tower of Work* and monuments to Victor Hugo (model 1897), amongst other projects. He lived in Meudon from 1894 (Villa des Brillants, now a museum), and came into contact with the poet Rainer Maria Rilke, among others. In 1900 he was given his own pavilion for the Paris Exposition Universelle. In 1907 he relocated to the Hôtel Biron, Paris, and worked at a studio in the city (in 1916 it became the Rodin Museum).

Rodin turned away from → Neo-Classicism at an early stage, and took up a more baroque form of expression (*The Man with the Broken Nose*, 1864), partly because of his trip to Italy and the work of Jean-Baptiste Carpeaux (1827–75). His statue *The Age of Bronze* (1876) caused a scandal as it was considered too lifelike (it was widely believed that he had used a cast from life). His work was pioneering with its new, uneven surface treatment, fragmentation, and lack of plinth, e. g. in the group of figures *The Burghers of Calais* (1884–86). Several figures in his main work *The Gates of Hell* were

Aleksander Rodchenko, *Non-objective Composition*, 1918, Oil on canvas, 53 x 21 cm, State Museum, St. Petersburg

created as free-standing single figures (including *The Thinker*, 1880–1900; *Ugolino*, 1882; and *Crouching Woman*, 1882). Rodin's strongly erotic motivation is apparent in his drawings, which he often washed over with bright colors, and in many sculptures (inspired by Claudel) (*Danaïdes*, 1885; *The Kiss*, 1886). Using the torso as an autonomous shape, and drawing the impressionistic surface design out of the block, Rodin revolutionized sculpture (see → Bourdelle and → Maillol) and at the same time reacted to the fragmentation of modern perception with a new aesthetic that became of overwhelming importance in modern sculpture. K.S.-D.

Bibl.: Elsen, Rodin, 1980 · Grunfeld, Rodin, 1987 · Goldscheider, Rodin, 1989 · Crone/Salzmann, Rodin, 1991 · Jarrasé, Rodin, 1995

Rogers, Claude. *1907 London, †1979 London. Brought up partly in Argentina, Rogers was a British painter, mainly of landscapes, cityscapes, portraits, and interiors. After study at the Slade School of Art, London (1925–29), Rogers' early mature style was a firm realism, both in subject and treatment (*Mrs. Richard Chilver*, 1937). Renting a studio at 12 Fitzroy Street in 1937, he was joined by → Pasmore and then → Coldstream in founding an influential drawing school which became known (after moving to the Euston Road) as the → Euston Road School, with an overt policy of "training the observation" (*The Blow Lamp*, 1953). With posts at Camberwell School of Art, the Slade, and Reading University (where he was professor), he was more significant as a teacher perhaps than as a practitioner. His later style showed → Cubist and abstractionist influences and a looser manner. D.R.

Bibl.: Pery, Rogers, 1995

Rohlfs, Christian. *1849 Niendorf, †1938 Hagen. German painter and graphic designer, who received a severe knee injury in 1864, as a result of which his leg later had to be amputated. In 1874–84 he studied painting at the Kunstakademie, Weimar. He moved to Berlin in 1895 and became a member of the Berlin Secession in 1900. In 1905 and 1906 he undertook summer trips to Soest. He also began a friendship with → Nolde. In 1911 he was made a member of the New Secession; and in 1914 of the Free Secession. In 1924 Rohlfs was awarded membership of the Prussian Akademie der Künste, Berlin. From 1927–38 he lived in Ascona. In 1937 he was excluded from the Berlin Academy and his works were confiscated.

As a historical and genre painter, Rohlfs found early recognition in Weimar. His independent stylistic development, parallel to the school of Barbizon and French Impressionism (townscapes, flower, and figure pieces), which he experienced through the intervention of van de → Velde, was apparent from 1888. After 1906 he adopted a floating, transparent style. Rohlfs also analyzed the later works of Monet and van Gogh (→ precursors), and pioneered Expressionism. In his expressive later style, Rohlfs preferred tempera on canvas and paper. He also produced watercolors and print graphics. H.D.

Bibl.: Vogt, Rohlfs, 1958 · Vogt/Köcke, Rohlfs, 1978 · Bußmann, Rohlfs, 1989 · Happel, Rohlfs, 1992

Roman School. → Scuola Romana

Rosenquist, James. *1933 Grand Forks, North Dakota. American painter, graphic designer, and sculptor. In 1948 he won a scholarship to the Minneapolis School of Art, studying thereafter in 1952–55 at the University of Minnesota; and in 1957–59 at the → Art Students League of New York. After 1957 he also became a poster and commercial artist. In the 1960s he began to use large-scale formats taking enlarged pictures, which he cut out and used in his own artistic works. His motifs were drawn from posters and advertising industry media, whose neutral, anonymous pictorial language he adopted. He is also active politically. Together with → Warhol, → Rauschenberg, and → Lichtenstein Rosenquist is regarded as one of the protagonists of American → Pop art. I.N.

Bibl.: Rosenquist, New York, 1972 · Rosenquist, London, 1982 · Goldman, Rosenquist, 1992 · Glenn, Rosenquist, 1993

Rosler, Martha. *1943 Brooklyn, New York. American video and performance artist and photographer, also a sophisticated theorist who has been widely published, Rosler received her B.A. from Brooklyn College, CUNY, in 1965; and her M.F.A. from the University of California, San Diego, in 1974, where she studied under → Kaprow and others. She juxtaposes linguistic and visual descriptive systems to comment on how historical and political frameworks condition images in photography, video, television, and language. Dominant themes in the 1970s were the social and economic constraints that inhibit women (*The Semiotics of the Kitchen*, 1975). She collaborated with Group Material in the 1980s, participating in town meetings that examined the effects of urban planning and homelessness on society (*If You Lived Here...*, 1987–89). In 1982 she participated in Documenta 7 with the performance *Watchword of the Eighties*. In the 1990s her work has become increasingly global, focusing on communication systems. J.F.

Bibl.: de Zegher, Rosler, 1998

Christian Rohlfs, *Acrobats*, 1916, Tempera on canvas, 110 x 75.5 cm, Museum Folkwang, Essen

Rosso, Medardo. *1858 Turin, †1928 Milan. Italian sculptor chiefly known for his powerful works in wax over plaster. After attendance at the Accademia di Belle Arti di Brera, Milan (1882–83; expelled), he made contact with the left-wing Scapigliati group (e.g. Giuseppe Grandi [1843–94]). *Impressioni d'un omnibus* (1884, destr.) combines naturalism with free handling. He turned from → Luminist painting and works in-the-round to relief sculpture in *Carne d'altrui* (1883) and the wax *Portinaria* (1883; later purchased by Emile Zola). As with Eugène Carrière (1849–1906), his reliefs make up in their friction between external and internal for what they lose in "solidity" (e.g. *L'età d'oro* [1886]). There are parallels with Impressionist dissolution of contour (*Bacio sotto il lampione*, 1882) and photographic blurring (*Aetas aurea*). In Paris (1884/86) he worked with Jean Dalou (1838–1902). Befriending → Rodin in 1894, they became estranged in 1898 after the latter refused to admit the Italian's influence on his handling in *Balzac*. Although the image is "projected" from a single standpoint (*La Rieuse*, 1890), the convoluted modeling of a large, almost hollow shell and the absorption of the plinth renders circular viewing irresistible. By *Madame X* (1896, wax) formal reduction is proto-abstract. His creativity ebbed in the early 1900s; a final *Ecce Puer* (1906, bronze) is conventional. Rosso was later championed by → Soffici, → Boccioni, and Mussolini's mistress Margherita Sarfatti (see → Novecento). D.R.

Bibl.: Rosso, Milan, 1979 · Sanna, Rosso, Milan

Roszak, Theodore. *1907 Poznań, †1981 New York City. Polish – American sculptor and painter. Roszak's family arrived in the US in 1909. He studied in Chicago and at the National Academy of Design, New York (1925–26) where he was intrigued by the Realists. Traveling to Europe in 1929, he worked in Prague and came under the influence of the dreamscapes of de → Chirico, before being attracted to → Constructivism during his travels. On his return to the US, he was inspired by → Bauhaus models to concentrate on metal sculpture; he also experimented with photogram methods. His oeuvre during the 1930s became increasingly Constructivist, furthered by his connection with → Moholy-Nagy at the Design Laboratory (1938–1940). By the mid-1940s, however, a more organic, less geometrical sense infused his work, in parallel with the new departures of → Abstract Expressionism in painting (tower and spire for the MIT chapel, 1953–56). His celebrated *Whaler at Nantucket* (1952, steel) combines abstract and social concerns in a typical late manner. He was an active printmaker and his late, large-scale drawings deal with cosmogonic themes. D.R.

Rotella, Mimmo. *1918 Cantanzaro. Italian painter living in Milan. He completed his studies at the Accademia di Belle Arti in Naples, then moved to Rome in 1945, where he worked as a designer at the Ministry for Post and Telecommunications. In 1951–52 he was awarded a Fulbright scholarship to Kansas City. He joined → Nouveau Réalisme in 1960. He was in Paris from 1964, returning to Italy in the mid-1980s.

After painting geometric and pictures in the → Informal style, Rotella retired from painting in 1953, saying that there was nothing left to do in art. A year later, however, he began making → décollages from torn advertising and movie posters, which he stuck to large-scale canvases (*Casablanca*, 1963–83), thus linking his work to the → Pop art movement. S.Pa.

Bibl.: Hunter, Rotella, 1982 ·· Barilli, Rotella, 1996

Mimmo Rotella, *Elvis Presley*, 1972, Décollage, 194 x 139 cm, Museum Ludwig, Cologne

Roth, Dieter. *1930 Hanover, †1998 Basel. Self-taught painter and → Performance artist, who was born in Germany but moved to Switzerland in 1943. He studied graphic art from 1947 to 1951. In 1953, inspired by → Spoerri, Roth created sculptures made from dough. He traveled to New York at the end of the 1950s, where he created Kinetic sculptures, works using letterpress, and photograms, and participated in → happenings. He lived in Reykjavik from 1957–64, after which he lectured in the USA, London, and Düsseldorf. In 1968 and 1977 his works were exhibited at Documenta. In the 1970s he collaborated with various artists (including → Rainer and R.→ Hamilton). His varied works: graphics, collages, pictures, objects, and → artists' books lie outside the traditional categories of art. His poetic kinetics, the pictorial humor of disparate materials "unworthy" of art, and the visualization of the decaying process of foodstuffs confirm a closeness to → Fluxus and → Process art. K.S.-D.

Bibl.: Roth, Passau, 1992 · Roth, Cologne, 1998

Rothenberg, Susan. *1945 Buffalo. American painter living in Galisteo, New Mexico. She was educated at Cornell University, and Corcoran Museum School, Washington (1962–67). In 1989 she married → Nauman. She travelled to Greece (from 1965), to Mexico (1979) and China (1988). In 1980 her work appeared at the Venice Biennale, and in 1992 at Documenta 9. Her early art consisted of → Minimalist works and collages, and in 1973 she turned to figuration. Inspired by life in New Mexico, Rothenberg committed herself to a single subject – the horse – as a personal figure of identity or a totemistic Indian symbol of life and

movement. Initially shown as a geometric stylization, since 1981 she has also painted her horses and other subjects in oils, creating sensual, expressive compositions of mobile forms. K.S.-D.

Bibl.: Auping, Rothenberg, 1992

Rothko, Mark (Marcus Rothkowitz). *1903 Dvinsk, Lithuania, †1970 New York. Lithuanian-born painter who emigrated to Oregon, USA, in 1910. In 1921–23 he attended Yale University, New Haven; in 1924–29 the → Art Students League of New York. In 1935 he was founder of The → Ten group of Expressionists (including → Gottlieb). In 1949 he set up the Subjects of the Artist art school, lecturing there and at its successor, Studio 53, until 1955; in 1951–54 he lectured at Hunter College, New York; in 1957 at Tulane University, New Orleans. In 1959 his work was exhibited at Documenta 2. In 1961 the Museum of Modern Art, New York, held a first retrospective. Rothko was also commissioned to paint murals for the Seagram Building, New York (1958), Harvard University, Cambridge (1961) and, the highlight of his career, in the chapel used for the marriage of the de Menils in Houston, Texas (Rothko Chapel, 1964; consecrated in 1971). Despite his success, Rothko suffered from serious depression, which is also evident in his later acrylics, dark in color and with stark, light-colored edging. He committed suicide in 1970.

After a figurative Expressionistic phase, Rothko incorporated Surreal and mythological elements into his "mythical paintings" of the 1940s. As a result, these "tragic and timeless themes" (Rothko) were reduced to calligraphic symbols that, increasingly, disappeared behind hazy color fields. After 1949–50 these "multiforms" developed into Rothko's classic pictorial language: vague, rectangular color fields applied to a colored background using a special technique, which created an illusion of floating. According to Rothko, the uncertainty of the artistic infrastructure "dissolves the mind and frees the memory". The calming tension of these huge pictures is achieved by gently toned color contrasts. Because of his Jewish background, a mystical interpretation is as likely as any conscious recourse to Burke's sublime in European landscape painting. After his first exhibition (in the Guggenheim's Art of the Century Gallery) Rothko soon became famous as an important exponent of → Color Field Painting in the → New York School. H.D.

Bibl.: Rothko, London, 1987 · Chave, Rothko, 1991 · Glimcher, Rothko, 1991 · Breslin, Rothko, 1995 · Weis, Rothko, 1998

Georges Rouault, *Head of a Tragic Clown*, 1904, Watercolor, gouache, and pastel on paper, 37 x 26.5 cm, Kunsthaus Zürich

Rouault, Georges. *1871 Paris, †1958 Paris. French painter and graphic designer, who received an apprenticeship in glass staining from 1885 to 1890 at the École des Beaux-Arts, Paris under Gustave Moreau. Rouault became Curator at the Musée Moreau from 1898 and, in 1904 co-founded the Salon d'Automne. From 1905 he came into contact with → Matisse and → Fauvism. The Museum of Modern Art, New York, staged an exhibition of his work in 1945. Immersed in the artistic environment of Moreau, Rouault experienced the symbolistic desire for another world, the mysterious and the mystical, that continued to characterize his work even after he turned to Fauvism after 1905. Inspired by writers such as J. K. Huysmans (*À Rebours*) and Léon Bloy (*La Femme pauvre*), Rouault turned, with a strong moral commitment, to Christian scenes and figurative representations of clowns. prostitutes, farmers, and workers (*Prostitute at her Mirror*, 1906). From 1910, inspired by his experience of glass painting, his pictures acquired a thick, opaque surface; the glowing colors are surrounded by dark, strong contours (*The Three Judges*, 1913). 1917–27 saw the creation of a major graphic oeuvre (among others, for Baudelaire's *Les Fleurs du Mal* and *Miserere*, 1927; appeared in 1948). Rouault also created stage settings for the Ballets Russes and stained-glass windows for churches (Assy, 1948). K.S.-D.

Bibl.: Dorival, Rouault, 1988 · Hergott, Rouault, 1991 · Rouault, London, 1993 · Marcoulesco, Rouault, 1996

Rousseau, Henri (Le Douanier Rousseau). *1844 Laval, Mayenne, †1910 Paris. Self-taught French painter. In 1863–67 he worked for the Government Chancellory until his dismissal in 1868. He moved to Paris, where he worked as a bailiff, and became a customs official in 1871. At the Louvre, he worked on painting and copying from 1884. From 1886 he was a regular at the → Salon des Indépendants (apart from 1899 and 1900). An amateur painter, he introduced himself to the Paris art scene with *An Evening at the Carneval*

Mark Rothko, *Untitled (Yellow, Red, Orange on Orange)*, 1954, Oil on canvas, 292 x 231 cm, Kate Rothko Prizel Collection

(1886) in the Salon des Indépendants. To Parisian artists of the avant-garde, Rousseau was no "naive Sunday painter", but a serious artist, a new "primitive" who, like Cézanne, was passionate about posterity and monumentality in painting. This is apparent in his 26 jungle pictures (1891; 1904–10), which, inspired by Delacroix and Salon paintings, world exhibitions, the palm houses and conservatories of the time, and often by lexicological works, reveal a surprising sophistication in the geometric compositions of leaf shapes around hunting scenes or attacks by animals on humans. His highly varied pictures, portraits, landscapes, sporting pictures, genre themes, and still lifes were deservedly acclaimed by both → Surrealism and → Magic Realism. H.D.

Bibl.: Vallier, Rousseau, 1979 · Le Pichon, Rousseau, 1981 · Certigny, Rousseau, 1984–89 · Shattuck, Rousseau, 1985

Henri Rousseau, *Exotic Landscape*, 1910, Oil on canvas, 130 x 162 cm, The Norton Simon Foundation, Pasadena, California

Roussel, Ker-Xavier. *1867 Lory-lès-Metz, Moselle, †1944 Étang-la-Ville, Yvelines. French painter. After early use of a tempered, Corot-like palette, Roussel attended the Académie Julian (with → Bonnard and → Vallotton), there encountering the art of Gauguin through → Sérusier. In 1888 he co-founded the → Nabis with Bonnard, → Vuillard, → Denis, and Sérusier. After a period of engaging in decorative arts as well as easel painting in a broad → Synthesism or the cool, occasionally *cloisonné* manner of Denis (*Projet*, c. 1892), his 20th-century work reverted to reined-in → Neo-Impressionism and personalized mythological themes. With themes and even figure arrangements similar to those of Arnold Böcklin (1827–1901), Roussel's bucolic paradise excludes tragedy: sunny landscapes dwarf dancing or amorous couples (*Le Jardin des Hespérides,* 1924; *Printemps à Etang-la-Ville*, 1926). A graphic artist of charm, Roussel's larger commissions include the curtain for the Comédie on the Champs-Elysées (1912); the entrance of the Kunstmuseum, Winterthur (the almost garish *Printemps*, 1918); and the Théâtre de Chaillot (*La danse*, 1937). D.R.

Bibl.: Salomon, Roussel, 1967

Roy, Pierre. *1880 Nantes, †1950 Milan. French painter who studied at the Paris Académie Julian and the École des Arts Décoratifs in Paris. Initially inspired by → Fauvism, Roy discovered the works of de → Chirico in 1919 and based his own work on the style of → Magic Realism. Usually set against a backdrop of door or window frames, the observer's view opens onto compressed, box-like rooms with scenes from private reminiscences and obsessions (*La Rue du Port* or *Doux Souvenir*, 1943). Briefly associated with Surrealism, Roy followed his own path as an independent artist after 1928. He was also a stage designer, and produced graphics and illustrated books. K.S.-D.

Bibl.: Roy, Nantes, 1966

Rozanova, Olga (Vladimirovna). *1886 Malenki, Vladimir province, †1918 Moscow. Russian painter and sculptor. After training at the Stroganov School of Applied Art in Moscow (1904–10) and with Samuil M. Dudin, Rozanova moved to St. Petersburg in 1911 and joined the "Union of Youth," publishing a manifesto, *The Bases of the New Art* [...] (1913). In the same year she participated in Matyushin's → Futurist opera *Victory over the Sun*. Successively "a Realist, an Impressionist, and a Futurist" (→ Kliun, writing in 1918), she developed the Futurist book, "illustrating" the *Zaum* (transrational) poetry of her husband-to-be Aleksei Kruchenykh (1910s). Exhibiting with "Tramway V" and "0.10" (1915), she joined → Malevich's Supremus group (1916). She worked under → Tatlin (composing "painterly constructions") and directed an industrial art course with → Rodchenko before being engaged to teach textiles at SVOMAS (1918). If *The Four Aces* (1915–16) links *lubok* (popular print) and geometric themes, *Green Stripe* (1917) is pure → Suprematist abstraction. Rozanova died prematurely of diphtheria. D.R.

Bibl.: Amazons, London, 1999

Ruff, Thomas. *1958 Zell am Harmersbach. German photographer living in Düsseldorf. He studied at the Kunstakademie, Düsseldorf from 1977 to 1985 under → Becher, and was strongly influenced by the latter's factual documentary photography. His work appeared in 1992 at Documenta 9; and in 1995 at the Venice Biennale. Ruff began to photograph interiors at the end of the 1970s: photographic explorations of the domestic environment of his childhood. In the mid-1980s he broke away from the purely documentary approach. The portrait, house, and star series, newspaper photographs, *Night* series and *Other Portraits* are fundamentally images from his own imagination. They follow strict rules of composition: monochrome backgrounds, frontal view, and isolation from the surroundings. The technical apparatus is a fundamental part of Ruff's process of creation. He also uses computer manipulation to show that any and every (viewing) apparatus produces reality, which he replicates. Ruff's works are "pictures of pictures," reflections of perceptual processes, photography's claim to authenticity, and the political dimension of its application. His poster series (from 1996) are typical examples: large-scale computer montages in the style of → Heartfield that

treat the attitudes of well-known politicians with irony. A.W.

Bibl.: Ruff, Bonn, 1991 · Brauchitsch, Ruff, 1992

Ruscha, Ed(ward). *1937 Omaha, Nebraska. American painter and photographer living in Los Angeles. He studied at the Art Institute of Los Angeles from 1956 to 1960, followed by a brief spell as a commercial artist. In 1969–70 he was guest professor at the University of California. In 1970 he made his first film, *Premium*. In the early 1960s he produced a picture series consisting of a single word against a neutral background, also screen prints, composed of flowers, food, and lubricants. The clarity and precision of his panels is impressive. They contain figurative and verbal

Ed(ward) Ruscha, *Flash, L. A. Times*, 1963, Oil on canvas, 182.9 x 170.2 cm, With kind permission of the Mead Corporation

symbols, e.g. blood, egg-yolk, and gunpowder. Ruscha transfers linguistic symbols into a pictorial idiom and places the results on supports so as to suggest a cosmic world. His work also includes photography. His first book of photography (*Twenty-six Gasoline Stations*) was published in 1963. His photos appear only in books designed by him, with titles such as *Some Los Angeles Apartments*, *Real Estate Opportunities*, *Record*, or *Coloured People*. Ruscha's first public commission, a mural for the Miami Dade Public Library (1985), bears the legend *Words Without Thoughts Never To Heaven Go*. His works in the 1990s are on curved stretcher canvases. C.W.-B.

Bibl.: Ruscha, Rotterdam, 1989–91 · Ruscha, New York, 1992

Russell, Morgan. *1886 New York, †1953 Broomall, Pennsylvania. American painter. After a brief period at the → Art Students League of New York, Russell went to Paris in 1906, where he was influenced by → Orphism. Together with → Macdonald-Wright he invented → Synchromism, an abstract style of painting that was based on the work of R. → Delaunay and consisted of strong colors and geometric circles (*Synchromy*, c. 1913–14). After separating from Macdonald-Wright, Russell moved to Aigremont in 1920 and continued to paint in a loose, Synchromist style. In his later works (in the USA after 1946) Russell returned to traditional religious painting. H.D.

Bibl.: Russell, Los Angeles, 1977

Russolo, Luigi. *1885 Portogruaro, Veneto, †1947 Cerro di Laveno, Lake Maggiore. Italian painter. Moving to Milan in 1901 with his musical family, Russolo was self-taught as a painter and initially worked as a picture restorer. Under the influence of Gaetano Previati (1852–1920), from 1909 he produced work in the vein of → Divisionism (*Perfume*, 1909) or → Symbolism: *The Sleeping City* (1910, etching); an original portrait of the melomaniac *Nietzsche* (c. 1909). Meeting → Boccioni, → Carrà, and → Marinetti, he was drawn into their orbit, signing the *Manifesto dei pittori futuristi* and *La pittura futurista – manifesto tecnico* (both 1910). His work was rarely muscularly → Futuristic like Boccioni's, seeking instead to translate (quasi-) musical themes (including echoes) into visual equivalents (*La Musica*, 1911), or to capture light effects (*Lamps*, 1910; *Street Light – Study of Light*, 1909). *The Revolt* (1911) shows the crowd penetrating a city by way of symbolic arrows in a dynamic typical of the time (M. → Duchamp, *Nude Descending a Staircase*, 1911; → Bragaglia, *Fotodinamismi*; → Balla, *Girl Running along a Balcony*, 1912, etc.). In 1913 Russolo left off painting, publishing a manifesto (*L'arte dei rumori*, Milan, 1913) in which he laid the foundations of an art of noise. With technician Ugo Piatti, he constructed "Intonarumori" (noise emitters), giving concerts (photographs and recordings survive), and became interested in tuning airplane engines musically. Rejecting Fascism, he moved to Paris in 1927. He classified his later work as "classico moderne." D.R.

Bibl.: Zanovello Russolo, Russolo, 1958 · Collovini, Russolo, 1997

Ryder, Albert Pinkham. *1847 New Bedford, Massachusetts, †1917 Elmhurst, New York. American painter. A solitary figure, he was highly regarded for mystically tinged allegories and pantheist sea pieces. Resident in New York City from 1870, he nonetheless remained true to a virtually self-taught style. Early landscapes are infused with the yellowish or greenish-gray light and ochre hues of Corot, although they are closer in execution to Théodore Rousseau. Desolate seascapes such as *Moonlit Cove* (c. 1880–85) or the celebrated *Toilers of the Sea* (1884, nominally after Victor Hugo) show an attachment to his birthplace and a Turner-like sensibility to the omnipotence of the ocean. After one of many trips to Europe in 1882, Ryder became influenced by the aesthetic and pessimism of → Symbolism, though he eschewed decadence or even sensuality (*Temple of the Mind*, 1885; or the brooding *Under a Cloud*, 1882). The highly literary *Forest of Arden, Lorelei, Jonah* (1890), *Siegfried and the Rhine Maidens* (1891), *Titania*, etc. are saved from cliché by their muted tonality. He made great use of the palette knife, employing unconventional media and, latterly, rich glazing and heavy overpainting, to the detriment of conservation. He also produced decorations on mirrors and screens. After 1900, he worked solely on reworkings. He died a recluse. D.R.

Bibl.: Homer/Goodrich, Ryder, 1989

Ryman, Robert. *1930 New York. American painter living in New York. He attended Tennessee Polytechnic Institute, Cookville, in 1948–49; George Peabody College, Nashville (studying music) in 1940–50. From 1952 he worked as a saxophonist in New York, and painted his first pictures in 1953. In 1972, 1977, and 1982 his works appeared at Documentas 5–7. His early works reveal an interest in the fundamentals of artistic practice, of paint, material, and execution. In the early 1970s he reduced all color to white to create a neutral tone value that was nevertheless full of nuance. In systematic series, white is investigated for its consistency, transparency, and toning on various different supports (canvas, cotton, cardboard, copper, steel, wood, plexiglas, fiberglass, vinyl). In order to avoid questions of composition, Ryman's works are usually square (*Winsor*, 1965), which, as a directionless surface, concentrates the structure of the picture totally on the act of painting and material structure (oil, casein, gouache, acrylic, enamel, and varnishes). Since 1976 he has integrated black, white, or transparent picture fasteners as compositional elements. He combines different sizes and types of fastening clips (*Receiver*, 1987) that may be extended to wide aluminum tracks (*Transport*, 1985) or reduced to screws or nails, which in his *Versions* of 1992 cast fine lines of shadow onto the white field. However, his systematic, conceptual approach is not intended to circumvent the personal experience of light and color. H.D.

Bibl.: Ryman, London, 1977 · Bois, Ryman, 1981 · Frémont, Ryman, 1991 · Storr, Ryman, 1993

Robert Ryman, *Exeter*, 1968, Oil on linen with adhesive tape frame, 250 x 250 cm, Private Collection

Sacharow-Ross, Igor. *1947 Chabarovsk, Eastern Siberia. Russian-born painter, graphic artist, Performance and Installation artist, living in Munich. In 1964–70 he studied at the art school in Chabarovsk, teaching there until May 1971. At

◄ Katharina Sieverding, *196/I–VII/1972, Die Sonne um Mitternacht schauen*, 1972, Photograph, 420 x 220 cm (detail, see p. 299)

first illegally, then from 1972 with official permission, he moved to Leningrad (now St. Petersburg), where he took part in the underground art scene and in → happenings and performances, as well as producing paintings in an expressive, narrative style. His works reached the West via private connections and were exhibited in 1977 at the → Institute of Contemporary Arts, London, the Arts Club of Washington, and the Venice Biennale. His increasing public presence brought Sacharow-Ross to the attention of the KGB, with the result that his studio was trashed on numerous occasions and he was banned from teaching. In 1978 he fled to the West and has lived in Munich since 1979 where his work has developed as a cross-over between the areas of painting, installation, and performance. His multimedia work draws on a variety of themes – Christian symbolism, cabalistic themes, mathematical formulae, and organic structures – and from their interaction the artist creates a new, spiritual image of the world. H.D.

Bibl.: Weiss, Sacharow-Ross, 1993

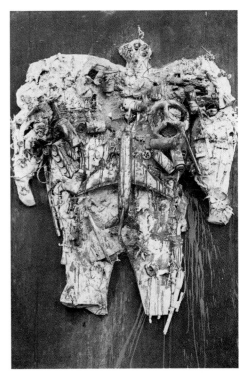

Niki de Saint Phalle, *Big Man – Red (Munich Shooting Picture)*, 1962, Assemblage, 230 x 110 cm, Private Collection

(1983) in Paris which included painted sculptures and kinetic objects by Tinguely. Her main architectural project since 1969 is her *Tarot-Garden* in Tuscany (since 1979 featuring walk-around and live-in sculptures). Saint-Phalle is also engaged in directing and film work, and designs for furniture, jewelry, costumes, and scenery. I.H.

Bibl.: Niki de Saint Phalle, 1980 · Saint Phalle, Paris, 1993 · Mazzanti, Saint Phalle, 1998

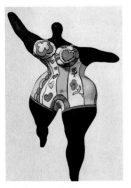

Niki de Saint Phalle, *Dancing Black Nana*, 1965–66, Polyester, height 200 cm, Private Collection

Saint Phalle, Niki de. *1930 Neuilly-sur-Seine. French, self-taught sculptor and painter who lives in Soisy and Tuscany. In 1933 she and her family moved to the US, returning to France in 1953, where in 1955 she met → Tinguely, with whom she has lived and worked since 1960. Her first works were colorful, naive, fairytale-like pictures. In 1961 she carried out her first shooting actions during which she fired a gun at relief-like pictures, which caused paint bags, hidden behind the plaster surface, to splatter their contents. In 1961 she became a member of → Nouveau Réalisme. Since 1963 through her → assemblages she has engaged with the various roles of women. She created women giving birth, devouring mothers, brides, witches, and prostitutes. In 1964 she produced her first *Nanas*, voluptuous, colorful figures of women, initially made from wool, yarn, papier maché, and wire scaffolding, later from polyester. The artist wants these *Nanas* to be understood as symbols of a happy, liberated woman and as messengers of a new matriarchal age. In the 1980s she altered the formal conception into *skinnies*, transparent structures, shaped from thin rolls, with themes taken from mythology and fantasy. In 1966 she created a monumental (28 m), walk-around Nana (Hon) with Tinguely and → Ultvedt. There were further collaborations such as the Stravinsky Fountain

Salgado, Sebastião. *1944 Aimores, Brazil. Brazilian photographer living in Paris. Salgado studied law at Vitória (1963) and economics at São Paulo (1967–68). Initially employed by an international coffee company in London, he subsequently turned to photography. His first photo reportage in 1973 was on the Nigerian famine. He completed further documentaries on disaster zones, human rights violations, and poverty-striken lives. In 1986 he was named photojournalist of the year by the International Center of Photography in New York. In the same year Salgado began a documentary project on physical labor throughout the world, which he finished in 1992. For this "archeology of the industrial age" he selected 40 occupations, and produced a series of documentaries on each. Particularly impressive is his description of the life of mine workers in the Brazilian gold mine of Sera Pelada (1987), in which his images of the crowds of people echo the laws of wealth and power making the people appear like ants. In his often ghastly visions of human destiny Salgado nevertheless lends his subjects a dignity they have retained in spite of adverse life circumstances. C.W.

Salle, David. *1952 Norman, Oklahoma. American painter, draftsman, and graphic artist living

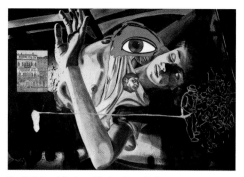

David Salle, *Colonia*, 1986, Acrylic and oil on canvas,
239 x 245 cm, Leon Hecht and Robert Pincus-Witten
Collection, New York

in New York. In 1970–75 he studied at the California Institute of the Arts in Valencia under → Baldessari. In the 1970s, influenced by → Conceptual art, his work included → performances and → installations as well as video and photography. In 1979 he turned to painting and drawing, featuring mainly superimpositions of a number of pictures of different style and content. He quoted images and subjects from artists belonging to a range of epochs and juxtaposed them with cartoons or advertising pictures from the 1930s, 1940s, and 1950s. Images of men and women are taken from films and magazines of the time, so that classical, high art and popular sub-culture co-exist with kitsch. Eroticism and sexuality, quoting pornographic pictures taken from mass media, determine the imagery. Salle's tense superimposition of subject matter points beyond the obvious eroticism of the images being juxtaposed with the secret desires of lower middle-class life in 1950s America. By means of these formal and textual superimpositions Salle questions generally recognized "truths", which determine contemporary social, cultural, and political life. I.N.

Salomon, Erich. *1886 Berlin, †1944 Auschwitz. German photographer and photojournalist. After a law degree he worked for the Ullstein publishing house in Berlin. In 1927 he began taking his first photos, and worked from 1928 as a photojournalist (for *Graphic* and *Fortune* magazines among others). He traveled at this time to England and the US. In 1931 his photographic volume

Erich Salomon, *Night Session of the German and French
Ministers at the War Debts Conference in The Hague*, January
1930, Gelatin silver print c.1955, 27.8 x 36 cm, Museum Ludwig, Cologne

Famous Contemporaries in Unguarded Moments was published. He worked in England, France, and Switzerland after 1935, but lived in the Netherlands. In 1943 he was deported to Auschwitz.

Salomon began his career as a photojournalist using an Ermanox plate camera, but switched in 1932 to the more portable Leica. His gift of staying discreetly yet persistently in the background at crucial moments earned him his reputation as the "roi des indiscrets". At numerous conferences, balls, and receptions he managed to photograph politicians and celebrities at the very moments they felt unobserved. Yet his pictures are never spitefully revealing, displaying rather great sensitivity to the situation and empathy for those portrayed. C.W.

Salon d'Automne. Art exhibition mounted every October or November. The first was held in 1903 at the Grand Palais, Paris, with the aim of showing all trends of → Post-Impressionist modern painting. The Salon d'Automne became particularly famous at its 1905 appearance at which → Matisse and friends exhibited, and where the term → Fauvism was coined. In 1907 the Salon mounted a Cézanne retrospective and a Gauguin retrospective exhibition (see → precursors). In 1911 Apollinaire presented R. → Delaunay, → Gleizes, → Metzinger, and → Léger among others. The Salon remained an important exhibition for avant-garde art well into the 1950s when it was overtaken in radicality by the Paris Biennale or the Salon de la Jeune Peinture. H.D.

Salon des Indépendants. Founded in 1884 as the first non-juried salon of young artists and the avant-garde, the Salon des Indépendants became a model for future → Secessions. The 1884 Salon (held in barracks in the Tuileries) as well as subsequent salons (held in the Cours de la Reine) were directed mainly towards → Neo-Impressionism. Thus the Salon, towards the turn of the century, increasingly became the venue of the avant-garde. In 1905 → Matisse exhibited his painting *Luxe, calme et volupté* there, and in 1906 *La joie de vivre*. Up until 1914 the Salon exhibited important trends in modern painting: → Cubism (first in 1911), → Orphism, and → Futurism. In 1914 it was overtaken in significance by the → Salon d'Automne. H.D.

Salon des Réalités Nouvelles. Paris salon, founded in 1946 to present mainly geometrical abstract art (→ Concrete art), → Constructivism, and → geometric abstraction. The title originates from a 1939 exhibition held in the Galerie Charpentier in Paris. Each exhibition was accompanied by a publication, participants being selected by a committee of artists (→ Herbin, → Pevsner, → Kupka), critics and museum staff. By 1955 it had also opened its doors to → Art Informel and → Tachisme. H.D.

Samaras, Lucas. *1936 Kastoria, Greece. Greekborn sculptor and photographer living in New York, Samaras moved to the US in 1948. In 1955–59 he studied art history at Rutgers University and at

the Colombia University, New York. 1955 saw his first solo exhibitions at Rutgers, and 1968, 1972, and 1977 his exhibition at → Documenta 4, 5, and 6. In 1969 he taught at Yale University, and in 1970–71 at Brooklyn College, New York. In 1980 he showed at the Venice → Biennale.

In the 1960s Samaras participated in early → happenings in the circle around → Kaprow and the → Fluxus movement. Subsequently he created bizarre, fetish-like objects stuck with nails, and also experimented with light and mirrors (*Mirrored Room*, 1966). Since the 1970s he has been working as a photographer on "AutoPolaroids" (1970), and obsessive nude photography of himself, which in later series were retrospectively painted and manipulated (*Photo-transformations*, *Phantasmata*). The *Séances de pose* of the 1980s show nude photographs of members of the New York art scene. H.D.

August Sander, *Baker*, 1928, Gelatin silver print, 29.9 x 21 cm, Stadtmuseum, Munich

Sander, August. *1876 Herdorf an der Heller, Siegerland, †1964 Cologne. German photographer who began his career in 1897–99 as a photographic assistant in Trier. In 1903–04 he received his first photographic awards. In 1910 he took up residence in Cologne. In 1929 his photo book *Face of the Times* was published (the plates were destroyed by the Nazis in 1936). Sander is known mainly through his extensive portrait collection *Citizens of the Twentieth Century* (begun in 1911), which presents people from all kinds of occupations and social backgrounds. The objective of the portrait collection was the representation of man (e.g. farmers of the Westerwald region, artists, politicians, missionaries, etc.) as archetype, thus creating a mirror for the age (this was the period of the Weimar Republic in Germany). Sander produced further anthologies of landscapes, townscapes, and nature studies. His landscape photographs, characterized like his portraits by a functional objectivity, focus above all on the areas around the Rhine, the Siebengebirge and the Westerwald. In 1952 Sander completed

August Sander, *Young Farmers in their Sunday Best, Westerwald*, 1913, Gelatin silver print c. 1950, 30.4 x 20.5 cm, Museum Ludwig, Cologne

one of his last great projects, 16 series called *Cologne As It Used to Be*, in which he presented the town before and after its destruction during the war. C.W.

Sandle, Michael. *1936 Weymouth, Dorset. British-German sculptor and draftsman. Sandle attended the Slade School of Art (1956–59) but has been active in Germany for much of his career (Pforzheim, 1973; and latterly the Akademie der Bildener Kunst, Karlsruhe, from 1980), a move which has encouraged meditation on World War II. By the mid-1960s he was rebelling against what he saw as a lack of gravity in contemporary art (*Succubus*, 1965–66). The imagery of violence in *Orange and Lemons* (1966) persisted in his abstract glass-fiber *Monumentum pro Gesualdo* (1966–69) – referring to the 16th-century composer who killed his wife and her lover – where figurative, abstract, and installation properties fuse in an unfashionable manner. His celebrated *Twentieth Century Memorial* (1971–78) is in bronze, which he states is "less contradictory [... i.e.] portable for memorials." The comfortably cushioned, cartoon Mouse figure armed with a machine-gun is an anti-Vietnam War statement as well as a reflection, like all Sandle's subsequent art (*Transformer* and *Submarine Monuments*), on eschatology. D.R.

Bibl.: Sandle, Liverpool, 1995

Saul, Peter. *1934 San Francisco, California. American painter, sometimes referred to as the "insider's outsider," Saul is a propagator of "wrong" taste who ups the psychological ante on politically loaded subjects ranging from the Vietnam War to the execution of serial killer John Wayne Gacy, by rendering them splatter-film style: acrid colors and hard edges accentuate genitalia and gaping orifices amid acts of greed, sex, and violence. After graduating from Washington University in St. Louis (1956), Saul spent nine years in Europe before returning to the Bay Area. While abroad, he was discovered by Surrealist painter → Matta who referred him to the influential American dealer Allan Frumkin. Through more than 20 exhibitions at Frumkin's New York and Chicago galleries, from 1962–87, Saul gained a following for his → Pop-like paintings. Even so, institutions – including that of art – have not been spared Saul's treatment, as demonstrated in his 1972 series of portraits which irreverently parody influential critics, artists, and political figures of the period. An amalgam of Mad Comics, B-movies, and pulp fiction, Saul's work shares similarities with the San Francisco → Funk school and Chicago's Hairy Who and has served as a starting point for younger artists such as → Scharf. Saul currently lives and works in Austin, Texas. C.S.

Bibl.: Carlozzi, Saul, 1989

Saura, Antonio. *1930 Huesca, Spain. Self-taught Spanish painter, graphic artist, and writer, resident in Cuenca since 1978. He is the brother of film director Carlos Saura. His first works appeared in 1947. From 1952 to 1955 he was resident in Paris, where he belonged to a group of

Surrealist artists and writers. He was a founding member and leader of the artists' group El Paso in Madrid (1957–60). In 1964, 1977, and 1982 he exhibited at Documenta. Since the 1950s Saura has been influenced by gestural → Art Informel. His work is determined by series of images, e.g. crucifixions and the so-called *Fantastic Portraits* (*Brigitte Bardot Series*, 1958–59). Saura's central focus is the human face, wherein he moves between the opportunities of non-representational, immediate expression and the portrayal of basic human situations. A.R.

Saville, Jenny → Young British Artists

Savinio, Alberto (Andrea Alberto de Chirico). *1891 Athens, †1952 Rome. The Italian painter, writer, set designer, critic, and composer Alberto de Chirico adopted the pseudonym Savinio in 1914 to avoid having his work confused with that of his brother, Giorgio. After music study with Max Reger (from 1906), Alberto traveled to Paris in 1910, meeting → Picasso and → Breton. In Italy he was to associate with the author Massimo Bontempelli, de → Pisis, and → Carrà, and to contribute to the formalist → Valori plastici. Collage-inspired works close to those of de Pisis have been dated 1917, while his brother refers to Savinio's debut in 1909 (the small *Oracle* close to Arnold Böcklin [1827–1901]). Large-scale Metaphysical (→ Pittura Metafisica) works appear around 1925–26. Alberto favored the "intellect" over the "dream," and his work is less studiedly atmospheric than de → Chirico's: pinhead nudes looking like clairvoyant parodies of Fascist art flex their muscles (*I costruttori del Paradiso*, 1929) or duck-billed dowagers sit demurely in bourgeois interiors (*La fidèle épouse,* 1930–31). Travel (with ships replacing trains) and a contorted Greek mythology surface in large oils with none of the portentousness of his elder brother's late manner. Ironic distance is the predominant tone: Savinio was less taken up with self-portraiture than de Chirico. Since the 1960s his art and brilliant writing have regained their status. D.R.

Bibl.: Savinio, Milan, 1976 · Savinio, Rome, 1978

Schad, Christian. *1894 Miesbach, †1982 Stuttgart. German painter and photographic experimentalist. In 1913 he attended the Akademie der Bildenden Künste in Munich. From 1915 to 1920 he was resident in Zürich and Geneva. In 1919 he organized the Dada World Congress in Geneva, and participated in → Dada actions. In 1918 he created his first → Photograms (so-called "Schadographs"). From 1920 to 1925 he resided in Italy (mainly Naples). From 1925 to 1927 he lived in Vienna, from 1928 in Berlin, from 1942 in Aschaffenburg (where he made a copy of the Stuppach Madonna) and from 1962 in Keilberg. 1936 saw an exhibition of his work at MOMA, New York. In 1980 he received an honorary professorship. In 1999 Miesbach set up the Christian Schad Zentrum.

His career debuted with Dada actions in Zürich and Geneva (jointly with the writer Wilhelm Serner), and with paintings and graphic work, wood reliefs, and relief assemblages, as well as Photograms influenced by Cubism. Following his stay in Italy portraiture became a central theme. In Berlin at the beginning of the 1930s Schad developed pen-and-ink drawings and oil paintings in the manner of → Neue Sachlichkeit, in particular subdued portraits showing the erotic areas of conflict around those portrayed (*Count St. Genois d'Anneaucourt*, 1927) and highlighting their isolation. After 1945 he worked on portraits, life studies, and mythological scenes (as well as more etchings, drawings, and Photograms) in the Expressionist tradition. G.P.

Schamberg, Morton. *1882 Philadelphia, †1918 Philadelphia. American painter and photographer. Studied architecture at the University of Philadelphia, 1899–1903, and painting at the Academy of Fine Arts in Philadelphia at Chase until 1906, where he became friends with → Sheeler. In 1906–12 he undertook several European journeys that encouraged his Cubo-Realist paintings and made him a pioneer of → abstract painting in the US. He also took part in the → Dada movement. From 1913 he worked as a photographer to earn money and at the same time undertook paintings in which he translated realistic elements such as machinery into abstract compositions. S.Pa.

Alberto Savinio, *The Lost Ship*, 1926, Oil on canvas, 82 x 66 cm, Private Collection, Turin

Schapiro, Miriam. *1923 Toronto. American painter and collagist Schapiro is a pioneer in feminist art, theory, and education. She spent most of her childhood in New York, and received her B.A., M.A., and M.F.A. from the University of Iowa (1945, 1946, 1949). Her early paintings are → Abstract Expressionist in style; her works became more structured and geometric with feminist themes in the early 1960s. Together with → Chicago she founded the Feminist Art Program at the California Institute of the Arts (1971–73). In 1972 she codirected Womanhouse, an old Hollywood mansion in which women artists were invited to create a uniquely female environment. Melissa Meyer and Schapiro coined the term "femmage" to refer to collages composed of artifacts traditionally associated with women (buttons, embroidery, etc.) in 1975 (*Again Sixteen Windows*, 1973). In the 1980s she created predominantly figurative works (*I'm Dancing as Fast as I Can*, 1984) which are divided into large,

Christian Schad, *Operation*, 1929, Oil on canvas, 125 x 95 cm, Städtische Galerie im Lenbachhaus, Munich

flat shapes in bright acrylic, and covered with patterned fabric. J.F.

Bibl.: Schapiro, St. Louis, 1985 · Schapiro, New York, 1986

Scharf, Kenny. *1958 Los Angeles. American painter currently living in New York. Appropriation and recombination are central to Scharf's paintings, which brim with images lifted from fast food logos, Hanna-Barbera cartoons, television commercials, Sci-fi design, and past art styles. During the 1980s, under the alias of Van Chrome, Scharf "detailed" a variety of household objects with Day-Glo paint and knickknacks. Likewise, he spruced up the public street – in the manner of "street writers" Futura 2000 and Haze – by "tagging" the route from his Long Island City studio to his Manhattan apartment. Simultaneously, Scharf produced paintings in which altered cartoon characters act out scenarios from historical paintings and classical mythology. In *St. Elroy Slaying the Dragon* (1982), a Jetson-cum-centaur assumes the dragon-killing role of Uccello's St. George. More recently, Scharf has recycled his own imagery – biomorphic creatures, space towers, illusionistically rendered blobs – into billboard-sized paintings. Flaunting "bad" taste and crowded with information, Scharf's paintings reflect and imitate the consumer graffiti that constitutes everyday life in the fast-paced, sound-bite culture of the twenty-first century. C.S.

Bibl.: Scharf, 1998

Egon Schiele, *Self-Portrait, Grimacing*, 1910, Gouache on paper, 45.3 x 30.7 cm, Rudolf Leopold Collection, Vienna

Schiele, Egon. *1890 Tulln, †1918 Vienna. Austrian painter and draftsman who from 1906 to 1909 attended the Akademie der Bildenden Künste in Vienna, where, in 1907, he met → Klimt. In 1909 Schiele founded the "Neukunstgruppe", collaborating with the → Wiener Werkstätte. From 1911 he was resident in Krumau (now Cesky Krumlov, Czech Republic) where his co-habitation with Wally Neuzil and young female models caused a scandal. After 1912 he lived in Neulengbach where he was arrested and imprisoned on charges of sexual intercourse with a minor and possession of pornographic drawings. He later moved to Vienna. In 1913 he became a member of the art association the Bund Österreichischer Künstler. In 1915 he married Edith Harms and was called up for military service. After a successful exhibition as part of the Vienna → Secession in 1918, Schiele became recognized as the leading modern Austrian artist.

His early work (up to 1910) features decorative forms in the manner of the Vienna Secession and Klimt's ornamentation. His main work, dated 1910–15, stresses aggressive, destructive self-portraits as well as nude self-portraits, frequently emphasizing his theatrical self-stylization as a sick and suffering artist through shrill colors, distortion of the body, and unusual perspectives. By the same token Schiele presents the female body as a conscious provocation both by choice of image (the naked, non-idealized, sexualized body) and the facial expressions of the models themselves. The obscene exhibition of genitalia offended against contemporary ideas of modesty. The sexualizing of the body, which is Schiele's point of departure in his search for identity, proves his contemporaneity with Freud and Otto

Egon Schiele, *Dead Mother I*, 1910, Oil and pencil on panel, 32 x 25.7 cm, Rudolf Leopold Collection, Vienna

Weininger. Schiele's graphic work is considered particularly innovative in its expressive use of form, whilst Schiele himself valued his larger-scale easel paintings. His allegorical oil paintings on the whole are redeemed by their symbolic or religious subject matter. As in his images of figures, in his landscapes Schiele removes the subject matter from its spatio-temporal location. His late work (from 1916) emphasizes realism and harmony. Schiele finally abandoned self-portraiture and in the last two years of his life focused mainly on the portrait. E.R.

Schjerfbeck, Helene. *1862 Helsinki, †1946 Saltsjöbaden, Stockholm. Finnish painter. After study in Helsinki, she went to Paris (1880) and practised under academic artists, painting historical subjects. On moving to the colonies of Pont-Aven (*Fête juive*, 1883) and → St Ives, she produced more intimate pieces (some watercolor) and small, unmuddy landscapes (*Première verdure*, 1889). She also visited (1890s) St. Petersburg, Vienna, and Florence. In 1884 she began a long sequence of startling self-portraits (mainly oils; to 1945) that are close in power to → Munch, → Spilliaert, → Beckmann, or → Schoenberg. They mirror both her ill health (she retreated to a solitary existence at Hyvinkää from 1902) and the historical situation. Beginning confidently in e.g. 1895, suffering is visible in 1912 and the face ghostly by 1945. She also made portraits of (unnamed) girls and female subjects (*The Seamstress*, 1905) and quiet still lifes. D.R.

Bibl.: Boulton-Smith, Finnish Painting, 1970

Schlemmer, Oskar. *1888 Stuttgart, †1943 Baden-Baden. German painter, sculptor, and set designer. In 1905–09 he attended the Kunstgewerbeschule and Akademie der Bildenden Künste in Stuttgart. From 1921 to 1929 he was at the → Bauhaus Weimar (the workshop for mural painting, wood, and stone sculpture) and Dessau (1923 stage workshop). In 1928–30 he created murals for the Folkwang Museum in Essen. From

Oskar Schlemmer, *Pale Group with Blue Blonde*, 1937, Oil on paper mounted on cardboard, 65.5 x 50.7 cm, Museum Ostdeutsche Galerie, Regensburg

1929 to 1932 he held a professorship at the Kunstakademie in Breslau (now Wrocław, Poland), thereafter until 1933 he worked at the Staatsschule für Kunst und Kunstgewerbe in Berlin. From 1933 to 1937 he lived in Switzerland, and from 1940 he was employed at the Institut für Malstoffe in Wuppertal.

Even during his time as → Hölzel's apprentice Schlemmer studied theories of synaesthesia and color which led him, from 1921 at the Bauhaus, following extensive production (stone sculpture, mural painting, metal workshop, life drawing) to work in the stage workshop. His *Triadic Ballet* (stylized figures with costumes made from stereometric elementary shapes), on which he had been working since the beginning of the 1920s, was performed several times, to the accompaniment of Hindemith's music among others, and shows a fascinating synthesis of symbolic abstract choreography and the Expressionist figurework, which he also had been pursuing in his spatio-figurative paintings (*Five Figures in a Room*, 1925). Cruelly persecuted by the Nazi regime (who destroyed the Bauhaus murals in Weimar, and removed the murals at the Folkwang museum), after 1939 Schlemmer tried to get by through work on camouflage paintings. Hope returned when he was employed to carry out experiments with varnishes for the Wuppertal varnish factory-owner Herberts, experiments which anticipated trends in → Art Informel. Apart from this he created one more significant series of paintings (*Window Pictures*, 1942). With an extensive portfolio of paintings, drawings, graphic art, sculpture, mural paintings, dramatic work, and teaching methods Schlemmer has to be counted as one of the most versatile and stimulating artists of the 20th century. H.D.

Schlichter, Rudolf. *1890 Calw, Württemburg, †1955 Munich. German painter. He began to work in 1904 as an apprentice enamel painter. From 1907 to 1910 he attended the Kunstgewerbeschule in Stuttgart. From 1910 he studied at the Kunstakademie in Karlsruhe. In 1916 he began his military service (he was discharged early following a hunger strike). In 1919 he co-

founded the "Rih" group in Karlsruhe and moved to Berlin where he met → Grosz and → Heartfield and became a member of the → Novembergruppe. In 1920 he participated in the Erste Internationale Dada-Messe. He also worked as an illustrator for several publishers.

In 1931 he wrote his autobiography *Das widerspenstige Fleisch* and in 1933 *Tönerne Füße*. In 1932–33 he moved to Rottenburg, Neckar. In 1939 his work was confiscated as "degenerate" and in the same year he moved to Munich. Following the end of his Dada phase Schlichter came to represent the Verism wing of → Neue Sachlichkeit. For him art became a weapon in the struggle against the bourgeoisie and militarism, an attitude which landed him in court. Nevertheless his style did not lack in clarity or old-master accuracy. His artistic and human interests lay with the down-trodden in society, in particular in the metropolis (streetlife, subculture of the intellectual bohemian), and in parallel he worked on portraits and representations of sexual obsessions. His increasing popularity is attested to by portraits of Berlin celebrities (*Bert Brecht*, 1926; *Egon Erwin Kisch*, 1928; *Oskar Maria Graf*, 1923). Towards the end of the 1920s Schlichter turned his attention to conservative circles (*Portrait Ernst Jünger*) and devoted himself to images which criticized the regime (*Blinde Macht*, 1934), and led to the confiscation of his work. His post-war work is Surrealistic in tenor. G.P.

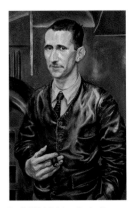

Rudolf Schlichter, *Portrait of Bert Brecht*, 1926, Oil on canvas, 75.5 x 46 cm, Städtische Galerie im Lenbachhaus, Munich

Schmidt-Rottluff, Karl (Karl Schmidt). *1884 Rottluff near Chemnitz, †1976 Berlin. German painter and graphic artist. From 1905 he studied architecture at the Technische Hochschule, Dresden. He was co-founder of the artists' group Die → Brücke. In 1907–12 he took up summer residence in Dangast and in 1912 moved to Berlin, participating in the → Sonderbund exhibition in Cologne. In 1913 Die Brücke disbanded. From 1915 to 1918 he did his military service in Lithuania and Russia. In 1918–21 he was a member of the Arbeitsrat für Kunst and a staff member of the magazine *Aktion*. In 1918–43 he lived in Berlin, and from 1931 to 1933 was a member of the Prussian Akademie der Künste. 1933 saw his work in German museums confiscated. In 1943 he moved to Rottluff; in 1946 he returned to Berlin, and there from 1947 to 1954 was professor at the Hochschule für Bildende Künste.

At first Schmitt-Rottluff worked on impetuous, expressive landscapes during his stays in

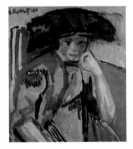

Karl Schmidt-Rottluff, *Portrait of Rosa Schapire*, 1911, Oil on canvas, 84 x 76 cm, Brücke-Museum, Berlin

Karl Schmidt-Rottluff, *Landscape with Lighthouse (Nidden)*, 1913, Oil on canvas, 88 x 101 cm, Museum Ostdeutsche Galerie, Regensburg

Dangast between 1907 and 1912 (*Landscape with Fields*, 1911). Not until 1911 does the portrait, which up to this point made just an occasional appearance, gain in significance (*Portrait of Rose Schapire*, 1911). By contrast with his artist friends, whose pictures on the whole were still bound by tonal values, Schmidt-Rotluff went further in his combination of brilliant primary colors. He incorporated ideas inspired by → Cubism in his nude studies and house views from 1912, as well as in his portraits and figure paintings which kept emerging from 1914 (*June Evening*, 1919). His graphic work of the time is also characterized by hard and angular shapes (graphic series on the New Testament, 1918). After the war and following a brief interlude at the Arbeitsrat für Kunst, Schmidt-Rotluff continued seamlessly with motifs continued from the Brücke years, above all with landscapes, multi-figured bathing scenes, portraits and still lifes in graduated, and thus less brilliant colors. H.D.

Schmit, Thomas. → Conceptual art S.Pa.

Schnabel, Julian. *1951 New York. American painter, graphic artist, and sculptor living in New York. In 1965 he moved to Brownsville, Texas, studying at the University of Houston from 1969 to 1973. In 1973–74 he participated in the Independent Study Program of the Whitney Museum of American Art, New York. In 1976 he had his first solo exhibition at the Museum of Contemporary Art, Houston. In the same year he moved to New York. In 1976 and 1977 he traveled through Europe, exhibiting in 1980 at the Venice → Biennale. In 1978 Schnabel caused controversy by using non-painterly materials in his paintings such as stags' antlers, nails, and tree-branches. His supports were wood, velvet, or tarpaulins. In 1979 he exhibited his plate pictures for the first time in New York, using broken pieces of crockery painted in oils with representational or figurative motifs. 1983 saw the emergence of his first bronze sculptures. From the beginning, parallel to paintings and sculptures, Schnabel also produced works on paper that integrate a rich diversity of materials, e.g. fabric, photographs, and adhesive tape. From 1987 to 1988 he released his series *Recognitions*, letter-images whereby the names of saints, as well as religious and ecclesiastical symbols are projected onto tent canvas. In 1996 he directed a film of the life of the painter → Basquiat who died in 1988. I.N.

Schneemann, Carolee. American painter, filmmaker and performance artist who received her M.F.A. from the University of Illinois, Urbana, her M.A. from Bard College, and attended the Columbia University School of Painting and Sculpture. She grew up in the tradition of → happenings, which she termed "kinetic theater". She has broadened the discourse in art regarding gender, sexuality, and the body. Her theories regarding women's emancipation were influenced by the writings of Simone de Beauvoir and Wilhelm Reich's theories of the connection between sexuality and freedom. *Eye Body* (1963) is a series of photographs in which she emphasized her sexuality and used her body both as sculptural material and a surface on which to paint. *Fuses* (1965–68), a video of sexual interactions with her husband, can be read as not only a demystification of beauty and the body, but also as a piece in which a women is both object and active in the creation of an image. In more recent works, such as *Mortal Coils* (1993–94), she has examined the taboos of death and loss. J.F.

Bibl.: Schneemann, Works and Writings, 1997 · Schneemann, Schneemann, 2000

Schober, Helmut. *1947 Innsbruck. Austrian painter, graphic artist, sculptor, and Performance artist living in Milan. In 1968–72 he studied art at the Hochschule für Angewandte Kunst, Vienna. His collaborative works with the Italian photographer Mario Giacomelli took place from 1969 to 1971. He moved to Milan in 1972. In 1973–74 he worked on → Performance art using videotape and film. In 1979–80 he lived in New York and from 1982–86 in Rapallo. The Museum des 20. Jahrhunderts in Vienna held his retrospective in 1983–84. In 1986 he exhibited at the

Julian Schnabel, *Circumnavigating the Sea of Shit*, 1979, Plates, oil and wax on wood, 244 x 244 cm, Gallery Bruno Bischofberger, Zürich

Venice Biennale, and in 1977 and 1987 at Documenta 6 and 8.

After early sculptural and photographic work, Schober's later videos and films were distinct from → Vienna action art in that he explored the inclusion of "real" movement in the sense of → Minimal art and → Conceptual art into the subject matter. After 1979 he turned to large-scale paintings and drawings in graphite and acrylics, pursuing an experimental representation of space, time, and light. His richly differentiated planes emerge from the interaction of colored and black-and-white cloud-shapes, misty fields, and spirals, which appear to float above a nucleus of luminous colored matter. Schober thematizes metaphysical and cosmic ideas through the use of a quaint but appealingly uncommercial approach. H.D.

Bibl.: Ronte, Schober, 1993

Schoenberg, Arnold (Franz Walter). *1874 Vienna, †1951 Los Angeles. Austrian painter and composer.

Taught painting by → Gerstl (c. 1906), Schoenberg produced nearly all his 60 or so canvases in a brief period following the suicide of his mentor in 1908. This event coincided with the composer's "break with tonality," inducing him to try his hand at a perhaps more malleable art. Well received by the → Expressionists and the musical → Kandinsky (who stated that his work "focuses directly on the essential"), he sold three paintings to Gustav Mahler. Schoenberg was of the opinion that "art stems from the unconscious;" his vibrant *Visions* and *Gazes* (e. g. *Red Gaze*) present spectral faces with staring, iridescent eyes (*Tears*). Other works include an evocative full-length portrait of Alban Berg presented to his composer friend, the pathetic *Burial of Gustav Mahler*, stage designs for *Die glückliche Hand* (1910–13) and *Erwartung* (1909), and a disturbing late self-portrait (1920[?]). Schoenberg practically abandoned painting once his compositional quandary had been resolved by the invention of dodecaphony.　D.R.

Bibl.: Hahl-Koch, Arnold Schoenberg, Wassily Kandinsky, 1984

Schöffer, Nicolas. *1912 Kalocsa, Hungary, †1992 Paris. Hungarian-born sculptor and representative of → Kinetic art. He was educated at the Budapest Academy. From 1936 he lived in Paris, where he attended the École des Beaux-Arts. His "spatiodynamic" constructions originated in 1948, followed in 1967 by "luminodynamic" and in 1960 by "chronodynamic" constructions, that is, sculptures created from movable painted elements, displaying a multitude of color and light effects. He also created electronically controlled robot sculptures which reacted to light and sound. He was increasingly concerned with a synthesis of monumental sculpture, light and color effects, movement, music, architecture, and urban development, e. g. in the cybernetic towers at Liège (1961) and Paris (La Défense, 1972). He also worked in the domain of contemporary theater.　I.H.

Schönebeck, Eugen. *1936 Heidenau near Dresden. German painter living in Berlin. In 1954 he was apprenticed at the Meisterschule für Angewandte Kunst in East Berlin. In 1955–61 he attended the Hochschule der Künste in West Berlin. In 1957 he met → Baselitz with whom he was to collaborate until 1962. Towards the end of the 1960s he abandoned painting. In 1992 he was awarded the Berlinische Galerie's Fred Thieler Prize for Painting.

In his two *Pandämonische Manifeste* of 1961 and 1962 Schönebeck – together with Baselitz – called for a new representational style of painting. His monumental portraits of communist leaders appear as an adaptation of → Léger and Aleksandr Deineka (1899–1969) in the style of "humane Realism".　S.Pa.

School of London. Term coined by → Kitaj in 1976, and disseminated throughout Europe as the title of a touring exhibition organized by the British Council in 1987 (*A School of London: Six Figurative Painters*). Among the painters of the School of London were → Andrews, F. → Auerbach,

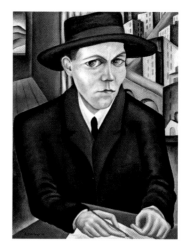

→ Bacon, → Freud, → Kossoff, and Kitaj. Alistair Hicks, in his 1989 book *The School of London: the Resurgence of Contemporary Painting*, was to extend the term to cover abstract artists such as → Ayres and → Hodgkin.　H.D.

Schrimpf, Georg. *1889 Munich, †1938 Berlin. German painter. In 1902 he worked as a baker's apprentice. In 1913 he visited Ascona. In 1915 he began his military service, gaining an early discharge. He returned to Berlin until 1918, when he moved to Munich and in 1921 gained recognition as a member of the "New Secession". In 1922 he was back in Italy, where he made contact with → Valori plastici including → Carrà who wrote a monograph on him. In 1925 he participated in the Mannheim exhibition "Neue Sachlichkeit." From 1927 he held a professorship at the Meisterschule für Dekorationskunst in Munich. In 1929 he took part in an exhibition "Neue Sachlichkeit" in Amsterdam. In 1933–37 he was Professor at the Hochschule für Kunsterziehung in Berlin.

Despite adverse circumstances Schrimpf succeeded in his struggle to become an independent artist. He was fascinated by the spiritual image world of → Marc and the decorative primitivism of Douanier → Rousseau. In Berlin he became acquainted with → Expressionism. Artistic currents as different as Expressionism and Neo-Classicism were combined in Schrimpf's landscapes where he achieved clear formal compositions. His figure paintings, in their depiction of ordinary people, angelic girls, and mothers, distill a timeless existence full of dignity and calm.　G.P.

Schröder-Sonnenstern, Friedrich. *1892 Tilsit, †1982 Berlin. German graphic artist. he 1906 he gained admission to an approved school; from 1908 he worked as an apprentice gardener, stable boy, and circus clown. In 1915 he began active service in the military, being transferred to the reserves in 1917; the same year he was admitted to an asylum and sectioned. In 1918 he founded the "Office for Astrology and Magnetopathic Healing"; in 1930 he was readmitted to an asylum. From 1949 he began to produce colored drawings. With no formal training he created distinctive drawings using human figures and animals, sexually symbolic patterns, and idiosyncratic

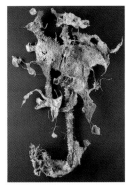

Bernard Schultze, Long Red Migof, 1971, Wood, Oil, Wire, Textiles, Plastic mass, 183 x 114 x 59 cm, Museum Ostdeutsche Galerie, Regensburg

fabulous beasts. His color drawings break taboos and transcend norms, delving into secrets with a biting irony and bitter mockery. In 1959 his creative powers vanished as unprompted as they had appeared. G.P.

Schultze, Bernard. *1915 Schneidemühl, Prussia (now Pila, Poland). German painter and sculptor living in Cologne. From 1934 to 1939 he attended both the Hochschule für Kunsterziehung, Berlin, and the Kunstakademie, Düsseldorf . In 1939–45 he was on military service in Russia and Africa. In 1945 he produced his first Surrealist work following the loss of his early work. In 1947–68 he lived in Frankfurt am Main. In 1952 he became a founding member of the Quadriga group. In 1959, 1964, and 1977 he exhibited at Documenta 2, 3, and 6. Since 1968 he has been resident in Cologne. In 1986 he received the Lovis Corinth Prize.

As a representative of gestural expressive painting Schultze had in the 1950s developed his own style in the areas of → Tachisme, → lyrical abstraction, and → Action painting, inspired, above all, by the painting of → Riopelle. His pictures, luxuriant landscapes with relief-like superimpositions of the paint layers, appear to hold a wealth of narrative opportunities. But in the course of the 1950s and 1960s form and color became more important than spatial representation, resulting in independent sculptures and large installations (from 1961, rich three-dimensional collage sculptures, e. g. *Migof Constructions*). In the 1980s his paintings expanded into a sizable landscape format. Colors that were previously finely tuned now burst into loud clamors, and abstract Surrealist forms imploded into bright, seemingly baroque spaces. H.D.

Schumacher, Emil. *1912 Hagen, Westphalia. German painter living in Hagen. In 1932–35 he studies at the Kunstgewerbeschule in Dortmund. In 1939–45 his war service entailed work in an arms factory as an engineering draftsman. In 1947 he was co-founder of the group "Junger Westen." In 1951 he traveled to Paris. From 1958 to 1960 he was Professor at the Hochschule für Bildende Künste, Hamburg. In 1959, 1964, and 1977 his work appeared at Documenta 2, 3, and 6. From 1966 to 1977 he had a professorship at the Kunstakademie, Karlsruhe. In 1967–68 he worked at the Minneapolis School of Art. Since 1971 he has had a home on Ibiza. He has been awarded numerous prizes.

Emil Schumacher, *Palau*, 1985, Oil on panel, 170 x 250 cm, Neue Nationalgalerie, Berlin

Following beginnings in → Cubism, Schumacher, after his period in Paris, arrived at an imagery close to → Art Informel, his particular interest being "material painting." At the same time he constructed tactile objects (1956–59), relief-like structures made of wire-mesh, plaster, or papier maché. His encounter with French Art Informel has, since 1957, led to work which emphasizing the material, wherein pigment-saturated surfaces are contrasted with black lines violently crossing the surface. In order to achieve unusual material effects Schumacher is not averse to destroying the support. In his *Hammerbildern* (from 1966), Schumacher takes his hammer to door panels, or joiners' benches in order to produce a conscious awareness of the insides of the material. Materials such as paper, sisal-cord, or lead are often integrated into his pictures. Apart from canvas he uses wood, crumpled-up paper, and lead as supports (*Paracelsus*, 1967). It was not until his late work that his restrained earthy coloration came to be supplemented by stronger hues (*Palau*, 1985), above all a brilliant ultramarine blue, but also a fiery red and a lurid yellow. In addition to *matière* Schumacher values references to landscapes, inspired by his travels (*Djerba Series*, from 1969). Schumacher relates the idea of an all-encompassing but damaged earth to his artistic topos where the artist is inscribed within the fractured *matière* of the painting. H.D.

Thomas Schütte, *Walzer*, 1985, Wood, painted figures, height 36.5 cm, Kaiser-Wilhelm-Museum Collection, Krefeld

Schütte, Thomas. *1954 Oldenburg. German painter and sculptor who lives in Düsseldorf. From 1973 to 1981 he studied at the Kunstakademie in Dusseldorf. Schütte's → installations and objects always refer to concrete spaces, usually in some way allied to the art world (*Everything okay*, interior of a Cologne shop selling art postcards, 1981). Schütte uses space as the stage-set on which he plays using small wooden figures, dummy pillars, painted sculptures, etc. Apart from their reference to the observer these installations discuss the interrelation of sculpture and visual perception. Schütte also paints numerous watercolors as preparatory studies for his installations. C.W.

Schwarzkogler, Rudolf. *1940 Vienna, †1969 Vienna. Austrian performance artist. Schwarzkogler studied at the Graphische Lehr- und Versuchanstalt in Vienna, where he encountered → Nitsch, who later introduced him to → Brus and Otto Muehl (1925–). Influenced by → Kokoschka and → Schiele, as well as by Antonin Artaud and Existentialism, his aesthetic is less ritualistic and "performative" than that of other members of → Vienna action art. All his actions – beginning with the parodic *Hochzeit* (1965, a wedding in which the bridegroom "plays" an accordion) – were carefully scripted, employing passive figures who undergo relatively calm, staged ordeals; violence is uppermost only in *II* (1965), in the juxtaposition of gutted herring, razor blades, and Heinz Cibulka's penis. Props for the six *Aktionen* included medical instruments, flowers, a sponge (in the mouth of the bride in *Hochzeit*), pigment, electrical apparatus, and his hallmark muslin gags/bandages. Though drawings survive, the last five private actions were designed to be photographed, and focused on detachment and castration rather than pain (Brus) or religiosity (Nitsch): "...a white circle/ether/chloroform/a fine wire..." (poem, 1965). Extreme fasting and isolation may have lain behind his suicide. D.R.

Bibl.: Schwarzkogeler, Klagenfurt, 1989

Schwitters, Kurt. *1887 Hanover, †1948 Ambleside, Westmorland, England. German painter, sculptor, collagist, and poet. Schwitters attended the Akademie der Künste in Dresden (1909–14) before beginning his military service in 1917. In 1918–19 he studied architecture at the Technische Hochschule, Hanover. In 1918 he also had his first exhibition in the Der → Sturm gallery. In 1922 he participated in the Weimar Dada Congress. From 1923 to 1932 he edited *Merz* magazine. In 1924 he began creating his first → Merz-Bau in his home in Hanover. 1924 saw the first performance of his *Ur-Sonata*, a non-semantic sound collage, at the Dessau → Bauhaus. In 1932 he became a member of → Abstraction-Création. In 1933 he emigrated to Norway and created his second Merz-Bau. In 1940 he moved to England resulting in his third Merz-Bau.

Schwitters's first → collages and → assemblages from scrap and objects (Merz-Bilder) originated in 1919. His poetry collection *Anna Blume* brought him recognition among the → Dada avant-garde in Berlin. More importantly, however, his contact with → Doesburg and the De → Stijl movement, as well as with → Gropius and the Bauhaus inspired him to a more → Constructivist style of work. Owing to financial difficulties in the 1920s Schwitters worked as a commercial designer and typographer for several companies. In 1927, together with Lesar Domela (1900–92), → Moholy-Nagy, and → Vordemberge-Gildewart he founded the "circle of new commercial designers." In the same year he held the founding meeting of "abstract Hanover" in his house in Hanover, which by now had been taken over by his first Merz-Bau, a wildly exuberant room sculpture. In 1929 he received a commission from Gropius to work on his construction of the Dammerstock estate in Karlsruhe as a commercial artist. Financially eased by his father's

inheritance in the 1930s Schwitters returned to painting, mainly abstracts. Apart from his paintings and sculptural work, which aim at a "synthetic art", Schwitters published numerous articles, poems, and visual texts following in the tradition of Apollinaire and Mallarmé. H.D.

Scipione [Gino Bonichi]. *1904 Macerata, †1933 Arco. Italian graphic artist and painter. Largely self-taught, Scipione (who took his pseudonym from the munificent Scipio Africanus in 1927) briefly studied at the Academy in Rome. Initially influenced by → Mafai, he was introduced to the color of → Soutine by Antonietta Raphaël (1895–1975) (as in the de → Pisis-like *Octopus*). Around 1928–29 he abandoned the clarity of his → "Novecento" style to produce dark-hued cityscapes close to those of Turin's Carlo Levi (1902–). In the apocalyptic *Piazza Navona* (1930), Bernini's statues slowly emerge from liquefaction under a blood-red sky. After a period as a quasi-Surrealist (*Via Ottaviano*, 1930, shows mannequins in a handcart), Scipione entered the Fascist orbit, contributing to *L'Italia litteraria* (1930 onwards), though he also provided covers for the poet Eugenio Montale. He was venerated as a founder of the → Scuola Romana movement (1927) and after his premature death (of tuberculosis contracted at an early age) became a legend of Fascist art. Scipione's witty drawings (of clerics, artistic gatherings, etc.) outnumber a small corpus of paintings. D.R.

Bibl.: Scipione, Macerata, 1985

Scott, Tim. *1937 London. British sculptor, living in London. From 1954 to 1959 he studied architecture, and in 1959–61 sculpture at St Martin's School of Art under → Caro; since 1961 Scott has worked as a lecturer at St Martin's. In 1990–91 he was visiting lecturer in Chile. From 1993 he was Professor at the Kunstakademie, Nuremberg. His early work suggested a primarily architectonic amd Constructivist conception, as he assembles in a montage basic geometrical forms from various materials (steel rods, wooden or acrylic plates) to create more complex, partly colored spatial constructions. From the 1970s on he has produce increasingly organic shapes, preferring the technique of welding which stresses the structural properties of steel (its malleability, mass, and density). I.S.

Scott, William. *1913 Greenock, Strathclyde, Scotland, †1989 near Bath, England. British painter, who worked in France, England, and Scotland. From 1928 to 1931 he attended Belfast College of Art and in 1931–35 the Royal Academy Schools in London. He taught, among other places, at the Bath Academy of Art from 1941 to 1956. Scott's early work is modelled on the French painters, mainly Cézanne, → Derain, and → Picasso (*Girl and Blue Table*, 1938). After 1945 he created still lifes of simplified composition and color, moving from 1952–54 into more abstract forms. In 1953 he traveled to the US where he met → Pollock, → Rothko, and → Kline, as a result of which he developed his own individual position between figuration and abstraction (*Brown Earth Scheme*, 1973). A.R.

Kurt Schwitters, *Merzbild 31*, 1920, Assemblage, 97.8 x 65.8 cm, Kurt Schwitters Collection of the Nord LB in the Niedersächsische Sparkassenstiftung

Sean Scully, *This-That*, 1986, Oil on canvas, 290 x 244 cm, Städtische Galerie im Lenbachhaus, Munich

Scully, Sean. *1945 Dublin. Irish-born painter, naturalized American in 1983. From 1949 Scully lived in London. In 1965–73 he studied at Croydon College of Art, London, thereafter at Newcastle University and Harvard University. In 1975 he moved to the US, teaching from 1977 to 1983 at Princeton University. Scully's early work was characterized by a grid-system of colored bands, which generate a multitude of colorful interactions (→ Op Art, → Riley). In the course of his artistic development during the 1980s he arrived at a style of painting which consisted of parallel, slightly mismatched horizontal or vertical stripes of different lengths, thus emphasizing the brushstroke. His use of color alternates between a warm orange, red, and brown and cold shades of gray and black. The colored stripes connect to rhythmically structured bands of geometrical composition, often on several canvases and changing formats. For Scully abstract, geometric imagery offers the opportunity to reformulate the spiritual forms of expression of classical modernism (→ Kandinsky). H.D.

Scuola Romana. The "Roman School" was an association of artists active in the capital in two phases (1927–33 and 1933–40). → Mafai (whose studio provided Roberto Longh's epithet, "La Scuola di Via Cavour," in 1929), his Lithuanian-born wife Antonietta Raphaël (1895–1975), → Scipione, and Marino Mazzacurati (1907–69) were the central figures. Their art was lyrical, intimist (Mafai) and sometimes fantastical (Scipione), with loose, quasi-Expressionist brushwork, opposing both the "Neo-classicism" of the Fascist-inspired → Novecento (→ Sironi) and – in general – → Pittura Metafisica.

A second grouping arose around Mafai in the mid-1930s, including Emanuele Cavalli (1904–81), Giuseppe Capogrossi (1900–72), and Roberto Melli (1885–1958). Other artists (not of the group) of an expressive, figurative, and free-spirited stamp in the 1930s included Carlo Levi (1902–75), Fausto Pirandello (1899–1975), Alifgi Sassu (1912–), and Renato Birolli (1906–59). The flame was inherited by the Milanese *Corrente* group from 1938. D.R.

Bibl.: Fagiolo dell'Arco, Scuola Romana, 1986

Secession (Sezession). Term used, especially in German-speaking contexts, to describe the separation of an artistic group from an existing artistic association, with the objectives of both documenting an altered conception of art through exhibitions of their own and of creating an alternative commercial position. The foundation of the first Secessions (1892 in Munich and Berlin) led to similar endeavors in e.g. Vienna, Prague, Hanover, Stuttgart, and Darmstadt. As a rule Secessionist associations turned against academic art and presented themselves as innovators under the banner of modernity. While the earlier Secessions were pluralistic associations of convenience that tried to reconcile naturalistic, Impressionist and → Art Nouveau trends, later formations, however, were set up alongside a differentiated concept of style, such as the Dresden Secession (1919–23), for example, which was purely Expressionist. Some groups created their

Secession, Joseph Maria Olbrich, *Sezession Building*, Vienna, 1898–99

own means of publication and organized a building for their exhibitions, such as in Vienna in 1899 through the offices of the Secession member Joseph Maria Olbrich (1867–1908). Internal divisions flared up in many places, producing in Munich in 1901 the "Phalanx", in 1909 the → Neue Künstlervereinigung München, and in 1913 the "Neue Sezession". As late as after 1945 there were further new groupings such as the "Neue Rheinische Sezession" whose members included → Mataré and → Nay. D.S.

Section d'Or. Group of Cubist painters (→ Cubism) who met in 1912 in → Villon's studio in Puteaux to debate aesthetic and art theoretical questions. The name refers to the theory of the Golden Section, which expresses a precise scale and proportion within the format of a painting. Members of the exhibition Section d'Or, mounted in October 1912, were, apart from Villon, M. → Duchamp, → Gris, → Picabia, → Lhote, → Metzinger, → Gleizes, de → La Fresnaye, → Léger, and R. → Delaunay who introduced the group's engagement with color theory and practice (→ Orphism). They also discussed the question raised by → Futurism regarding the possibility of representing movement within a picture. The

Arthur Segal, *Nude on the Beach*, 1920, Oil on canvas, 76 x 95 cm, Museum Ostdeutsche Galerie, Regensburg

name of the group soon lost its significance owing to the different stylistic development of the members. H.D.

Segal, Arthur. *1875 Jassy, Romania, †1944 London. Romanian-born painter and graphic artist, working mainly in Germany and Switzerland. From 1892 he was at the Akademie in Berlin, and from 1896 pursued studies in Munich. In 1910 he founded in Berlin, jointly with e.g. → Pechstein the Neue → Secession. Up to 1920 he was greatly influenced by Impressionism and → Divisionism, but in the following years his contact with the → Blaue Reiter group encouraged his work to develop in an Expressionist manner (in 1911–13 he published wood- and lino-cuts in the magazine *Der Sturm*). From 1914 he was resident in Switzerland, where he participated in Dada exhibitions and the Zürich-based Cabaret Voltaire (and where his Prismatic Compositions originate). As a member of the → Novembergruppe (1921) and director of a school of painting (which he pursued in exile in London from 1936) he increasingly acquired a neo-naturalistic style. A.R.

George Segal, *Still Life with Shoe and Rooster (Braque)*, 1986, Plaster and wood, painted, 132 x 93 x 70 cm, Sidney Janis Gallery, New York

Segal, George. *1924 New York City, †2000 South Brunswick, New Jersey. American sculptor, installation artist, and draftsman. In 1941–42 he attended the Cooper Union in New York; 1942–46 and 1961–63, Rutgers University; 1947–48, Pratt Institute of Design in Brooklyn; and 1948–49, New York University. From 1958 he produced sculptures, at first roughly worked human figures made from wire-mesh, jute, and plaster. In 1961 for the first time he created figures after life models (using plaster molds) usually shown in everyday activities (at the movie box-office, petrol station, in the bus or bath-tub). He thus produced not just portrait-sculptures but also installations with figures which highlight the

habits, banality, and monotony of everyday life. The figures' neutral white color simultaneously suggests alienation and distance as well as physical presence and closeness: their original portrait character thus takes on a universal quality where private experience and social reality are equally relevant. His engagement with everyday issues locate his work close to → Pop art from which he was, however, distinguished by his socio-critical political involvement. From the mid-1970s he used plaster molds taken from life models as cavities which he filled with liquid plaster in order to work on their exterior in greater detail. The figures were then painted in color or cast in bronze. In the 1980s he supplemented his work on life-size figures with other motifs from everyday life. He has also produced still lifes in a similar manner, reminiscent of compositions by Cézanne or → Morandi. I.N.

Segall, Lasar. *1891 Vilnius, Lithuania, †1957 São Paulo. Lithuanian-born painter, graphic artist, and sculptor. From 1906 he was resident in Berlin where he attended the Hochschule der Künste from 1907 to 1909. From 1910 he attended the Kunstakademie in Dresden. In 1912 he traveled to Brazil. In 1914–17 he was interned in Meissen and Zittau. In 1919 he was co-founder of the Dresden → Secession. From 1923 he lived in São Paulo, where the Lasar Segall Museum was founded. His early work (including his graphic work: lithographies and woodcuts) displays tendencies towards late Expressionist imagery, using social and often Jewish themes. In his landscapes and figural scenes, which he worked on in Brazil from 1923, he increasingly connected expressiveness with constructive composition. In the 1930s he created sculptural work and in the 1940s expressive pictures on the persecution of the Jews. In the course of his further artistic development a move towards → geometric abstraction may be perceived. K.S.-D.

Seguí, Antonio. *1934 Córdoba, Argentina. Argentinian painter and draftsman who has been resident in Paris since 1963. From 1950 he studied painting and law in Argentina, and from 1952 painting and sculpture in France and Spain. He traveled extensively through the US, and Central and South America. His proximity to Narrative Figuration may be explained both by his painting in the style of the European tradition, and by his subversive and revolutionary themes which he realizes in a shocking manner, such as the resolutely brown-tones *Requiem for a Soldier* (1963), which features grimacing, distorted faces and a reference to the crucified Christ. S.Pa.

Seligmann, Kurt. *1900 Basel, †1962 Sugar Loaf, New York. Swiss-American painter and printmaker. Influenced early on by the Swiss Renaissance tradition of engraving (Urs Graf, N. M. Deutsch, etc.), Seligmann befriended → Giacometti in 1919. Living in Paris (1929–38), he became a member of both → Abstraction-Création and the → Surrealists (*Ultra-furniture* [destr.], exhibited 1938, is a stool supported on four women's legs). Throughout his career he created etchings and

Richard Serra, *One Ton Prop (House of Cards)*, 1969–81, 4 lead plates, each 165 x 165 cm, Galerie m, Bochum

paintings with echoes of → Masson and → Ernst, presenting "giant" biomorphic creatures that interpenetrate energetically, sometimes against an indefinite landscape. The interest he shared with → Breton in myth and sorcery (*The Mirror of Magic*, 1948, is a serious account of the subject) synthesized the "heraldic symbolism of his art" (Breton). He emigrated to the US in 1939 where, impressed (like Ernst and → Tanguy) with the geology of the continent, he responded in a lightened palette with what he termed "cyclonic landscapes" (*Souvenir of America*, 1943) and a renewed interest in representational forms (*The Balcony*, 1958). D.R.

Serial art, Andy Warhol, *Lavender Disaster*, 1963, Acrylic and silkscreen print on canvas, 269 x 208 cm, The Menil Collection, Houston

Serial art. A broad phenomenon in the visual arts, closely connected conceptually with similar methods in literature, music, and also mathematics. Recognized as an artistic procedure as early as the late 19th century, e.g. in pictures where the serial principle had cognitive claims. Monet's work (cathedral, haystack, poplar and waterlily pictures) presents a serial representation of the image, which is shown at different times of day and in different seasons. Alfred Sisley's and Cézanne's (→ precursors) approaches are similar. The underlying idea is to show the picture's motif undergoing change. → Mondrian, too, follows this train of thought. Indeed, he raises the method to the ultimate abstraction of all visible structures.

J. → Albers' series *Homage to the Square* (from 1949) radicalizes the serial method by lending static, formal composition different effects solely through colors and their respective interactions (see → Reinhardt and Frank → Stella). Serialism is also a principle of → Minimal art. Each variation forms a non-hierarchical part of an overall idea, which in itself contains an infinite numbers of variations. There are similar approaches to be found in the works of the German artists → Palermo and → Knoebel.

Most → Pop Art is serial in structure, especially → Warhol where serialism functions as a (frequently) ambivalent critique of the perception of modern everyday culture, characterized by images from mass-communication, and reproduced in an arbitrary frequency. The series as a concept is a typical procedure of contemporary art and culture. M.S.

Serra, Richard. *1939 San Francisco. American sculptor living in New York. His studies included 1957–61 in Berkeley and Santa Barbara; and 1961–64 at Yale University (with e. g. J. → Albers). In 1965–66 he resided in Italy, where he began his experiments in the direction of → Arte Povera. From 1968 he produced characteristic works in steel, where the material always determined the form. In 1967 he composed the "Verb List": 85 concepts referring to the treatment of materials. These terms are "visualized" in a number of different works with materials such as rubber, solid and liquid lead (*Splash* series), and steel. In the series *Prop Pieces*, for example, he explores the principle of supporting and leaning through numerous variations. Geometrical shapes in lead or steel are placed in such a way that they support one another, the corners or walls thereby becoming involved. He works without the help of welding, rivets or screws, simply stacking steelplates on top of one another, as in the *Skullcracker* series (1968), where the laws of gravity alone determine load and position. Balance becomes the work's central topic. Apart from a conceptually determined formal simplification it is the dialectical reference of the work to its environment that is of fundamental significance. Just as space determines the sculptures so they in turn define space. This is true also for works in the open landscape (*Open Field Vertical Horizontal Elevations*, 1979–80) as well as in urban space. The spectator can experience the works realized in this context (*Terminal*, 1977; *Tilted Arc*, 1981; *Berlin Junction*, 1986–87; *Intersection*, 1992), which are architectonic and not simply visual in character involving the whole physical body. They are articulations of spatial experiences, which evoke sensations of insecurity. Balance and one's sense of orientation are disturbed and undermined through the monumental, seemingly unstable forms and through an inability to seize these foreshortened views in their entirety. The sculptural system of coordinates contradicts that of the spectator. Apart from his sculptures, since 1971 Serra has produced mainly black, large-scale drawings, which he calls two-dimensional sculptures. I.H.

Richard Serra, *Gate*, 1987, Wrought iron, 2 pillars, each 364 x 31.5 x 32 cm; 2 bars, each 446/522 x 32 x 32 cm, Städtische Galerie im Lenbachhaus, Munich

Serrano, Andres. *1950 New York City. American color photographer. Of Hispanic origin, Serrano studied at the Brooklyn Museum Art School (1967–69). Photos in the 1980s concerned the individual and its stereotype, spirituality and its loss, and mortality and its recording. The infamous *Piss Christ* (1987) has widely been criticized as blasphemous since the pretty red glow, and the work's title, emanate from a plastic crucifix suspended in urine. A *Pietà* shows an "Andrea del Sarto" virgin cradling a fish while *Heaven and Hell* depict a bloodied woman and a smiling Cardinal. Following series on Budapest (e.g. *Prostitute and Client*), on nomad members of the homeless community (*Nomads*, 1990), and on Klansmen, and a seemingly reverent piece on *The Church* (1991), Serrano's *Morgue* (1992) showed quiescent, almost waxen, details of the dead (from rat poison, knife, AIDS, etc.). *A History of Sex* (1996) entailed individuals displaying emblems of sexual identity for the Cibachrome: bondage, zoophilia, masturbation, urolognia, etc. are treated with a cold aestheticism similar to → Mapplethorpe's gay imagery. Both artists have been the target of political critiques. D.R.

Bibl.: Wallis, Serrano, 1995

Sérusier, Paul (Henri). *1864 Paris, †1927 Morlaix, Finistère. French painter and set designer. During study at the → Académie Julian (1885–90) he befriended → Denis, and knew → Bonnard and → Roussel in Paris. Through → Bernard he met Gauguin (see → precursors) at Pont-Aven (1888). His followers included Armand Séguin (1869–1930), F. Mogens Ballin (1871–1914), Charles Filiger (1863–1928), and Jan Verkade (1868–1946). Sérusier's bright, unprimed panel, *Bois d'Amour at Pont-Aven* (1888), with its mutation of substance into reflection and solid into aqueous, presented a striking contrast to the artist's anecdotal *Breton Weaver* of earlier that year. The work became known as *Le Talisman* for its significance in → Nabis circles (from 1890) – in fact it is more advanced than their work and lacks the Gauguinesque contours of e.g. the large *Pont-Aven Triptych* (1892–). He made sets for puppet theaters and for Alfred Jarry's scandalous *Ubu Roi* (1896). Beginning with *Tobias and the Angel* (c. 1894), Sérusier turned to medievalizing compositions in his house at Chateauneuf-de-Faou (1904–06 and 1912–14). *The Spinners* (c. 1918) and other works are based on complex chromatic theories (the → Klimt-like *Champ de blé d'or,* c. 1912; *Ogival Landscape*, 1920). D.R.

Servranckx, Victor. *1897 Diegem, near Brussels, †1965 Vilvoorde. Belgian painter and sculptor. In 1913–17 he studied at the Académie des Beaux-Arts, Brussels. In 1917 he produced his first abstract works. In 1932–35 he taught at the École des Arts Industriels et Décoratifs d'Ixelles in Brussels. He showed at the Venice → Biennale in 1948 and 1954. The powerful abstract works he produced from 1917 based on the machine aesthetic of → Futurism began to approach → Purism and → Neo-Plasticism. From 1925 he also worked as an interior designer (showing at the Exposition internationale des arts décoratifs in Paris). In the 1930s a → Surrealist phase ensued as well as decorative

art works. In 1937 he created a monumental fresco for the Salon de la Radio in Brussels. From 1947 he returned to abstract works. K.S.-D.

Seurat, Georges. → Neo-Impressionism

Severini, Gino. *1883 Cortona, †1966 Paris. Italian painter. From 1899 he was resident in Rome. There he worked as an accountant and began to study drawing. In 1910 he met → Boccioni and → Balla, who disseminated the principles of French Impressionism and Italian → divisionism. From 1906 he lived in Paris. In 1910 Balla, Boccioni, → Carrà, → Russolo, and Severini published the "Manifesto della pittura Futurista". In 1913 Severini had his first solo exhibition in the Marlborough Gallery in London. *Du cubisme au classicisme* was published in Paris in 1921.

In 1935 he temporarily returned to Italy. In 1946 he published his autobiography *Tutta la vita di un pittore*. At this time he produced his first divisionist work, above all *Dancers*, which would soon be succeeded by Parisian paintings in which Severini attempted to reconcile → Futurism with → Cubism (*War*, 1914). He also turned towards purely geometrical representation.

In around 1920 Severini broke with the Cubo-Futurists and turned towards a representational, classical style in the tradition of → Valori plastici (with commissions to decorate churches, castles, etc.). After 1945 he returned to abstract painting. S.Pa.

Gino Severini, *The Blue Dancer*, 1912, Oil on canvas, 61 x 46 cm, Mattioli Collection, Milan

Seymour, David. *1911 Warsaw, †1956 Egypt. Polish-born photographer. He studied at the Akademie für Graphische Künste in Leipzig and subsequently at the Sorbonne in Paris. There he taught himself photography, becoming friendly with photographers → Cartier-Bresson and → Capa. His first published photographs appeared in the French magazine *Regards* in 1934. Commissioned by *Regards*, Seymour went to Spain in 1936 to document the Civil War. In 1939 he moved to the US, where apart from his work as a photojournalist he enlisted in the US army. In 1947 Seymour, together with Capa, Cartier-Bresson and George Rodger founded the photo agency, Magnum Photos Inc. As well as numerous war photos Seymour's work includes

Children of Europe, portraits, and unposed genre scenes. C.W.

Shahn, Ben. *1898 Kovno, Lithuania, †1969 New York. Lithuanian-born painter, graphic artist, photographer, designer, and writer who emigrated to the US in 1906. In 1913–17 he trained as an apprentice lithographer. In 1919–21 he studied biology, and in 1921–22 worked as a painter in New York. In 1933, as an assistant to → Rivera, he worked on *Man at the Crossroads* for the Rockefeller Center. In 1935–38 he worked as a photographer for the Farm Security Administration (documenting poverty in farm communities). During World War II he produced posters for the Office of War Information. From 1956 he was Professor at Harvard University. In 1959 and 1964 he exhibited at → Documenta 2 and 3. He also worked on a socially motivated, realistic painting series illustrating Sacco and Vanzetti (1931–32). Influenced by → Dufy, → Rouault, and Rivera, Shahn's work combines painting with photographic effects (*Liberation*, 1945). S.Pa.

shaped canvas. Unconventionally shaped canvas preferred since c. 1960 by artists such as F. → Stella, K. → Noland, → Davis, and E. → Kelly, in connection with → Post-Painterly Abstraction and → Hard-Edge Painting, where the irregular outline of the canvas is either identical with the structure of the painted area, or where its purpose is to intensify the dynamic tension directed out into the surrounding space (→ installation). H.D.

Joel Shapiro, *Untitled*, 1986, Painted wood, 94 x 147 x 122 cm

Shapiro, Joel. *1941 New York. American sculptor living in New York. He attended New York University from 1961 to 1969. From 1970 he had one-man exhibitions (e. g. 1995 at Walker Arts Center, Minneapolis sculpture garden). In 1977 and 1982 he exhibited at Documenta 6 and 7. His work began with sculptural elementary shapes in a Minimalist vein (→ Judd and → Morris), thereafter proceeding to evoke richly metaphorical objects: the house as the central focus of human existence, bridges, boats, or coffins in simplified elementary shapes. The location of his sculptures within a space is of crucial relevance to Shapiro, and so his sculptures are often built for their given exhibition context. In the 1980s sculptures emerge which may be seen as both abstract constructions of inclined planes and beams set diagonally against one another, or as figures reduced to their geometrical, Cubist components. Every-

Charles Sheeler, *Upper Deck*, 1929, Oil on canvas, 74 x 56.5 cm, Fogg Art Museum, Harvard University Art Museums, Cambridge, Mass., Louise E. Bettens Fund

thing appears to be in motion. Indeed, Shapiro emphasizes the instability and frailty of his abstract constructions, or of their component parts. He thus questions the memorial, monumental, and heroic preoccupations of sculpture. I.S.

Jeffrey Shaw, *Himmelstor*, 1987, Single-channel video installation, laserdisc, laserdisc Player, projector, flat mirror, walk-in mirror, 420 x 400 x 320 cm, ZKM, Karlsruhe

Shaw, Jeffrey. *1944 Melbourne, Australia. Australian-born installation and multimedia artist living in Karlsruhe. Shaw studied architecture and history of art at Melbourne University (1962–64) as well as sculpture at the Accademia di Belli Arti di Brera, Milan (1965), and St Martin's School of Art, London (1966). From 1967 he was resident in Amsterdam, where he founded the Eventstructure Research Group (active until 1982). From 1991 he worked at the ZKM (Center for Art and Media Technology) in Karlsruhe, and from 1995 was Professor at the Hochschule für Gestaltung in Karlsruhe.

Shaw's artistic beginnings were in "Expanded Cinema" (*MovieMovie*, 1966), which relies upon the mobility of technical devices, audience participation and the use of new materials. "Outdoor-Invironments" follow, such as his so-called Inflatables, blow-up sculptures such as *Waterwalk Tube* (1970), a pneumatic tetrahedron-shaped tunnel, 250 meters in length, inside which visitors could walk across Lake Masch in Hanover. Work with slides and video projections in the 1970s led to interactive video sculptures and installations (*The Narrative Landscape*, 1985–95). Shaw is regarded as a pioneer of interactive art. A.R.

Sheeler, Charles. *1883 Philadelphia, †1965 Dobbs Ferry, New York. American painter and photographer. In 1900–06 he attended the Philadelphia School of Industrial Art and Pennsylvania Academy of the Fine Arts. At this time he traveled to Holland, England, and Spain. After 1910 he

worked as a photographer. Sheeler's early work consists mainly of architectural photographs and paintings of contemporary sculptures and paintings. In 1917 he produced a photo-series of the so-called Doylestown House, revealing Sheeler's interest in abstraction. In the 1920s he worked as an advertising photographer, for Condé Nast and Ford in Detroit (prints of the model "A" for which Sheeler had spent six weeks photographing in the Ford plant in Detroit) among others. His photographic oeuvre can be described as an example of so-called straight photography – photographs of great clarity and detail that allow the spectator to feel Sheeler's enthusiasm for industrial buildings and life in the city. His painted work moved from Cubist beginnings to a cubistic approach to representation which treated the industrial or mechanistic themes as a series of brightly colored planes. Sheeler's painting is characterized by this clarity and love of form, colorful canvases being considered (with → Demuth) the very epitome of → Precisionism. C.W.

Sherman, Cindy. *1954 Glen Ridge, New Jersey. American photographer and artist living in New York. She studied painting and photography at the State University College, Buffalo (B.A. 1976). Since 1977 she has been based in New York. In her first major photo-series (*Untitled Film Stills*, 1977) Sherman simulated scenes which recalled Hollywood-style soap operas. In her productions, which are inspired by the history of film and photo-book love-stories, Sherman always plays the main actress. With props, masks, and ingenious lighting she imitates scenes which, since they incorporate film clichés, appear immediately familiar. *Film Stills* were followed by fashion photos, Sherman also works for designers (e.g. Issey Miyake). She experiments with the use of make-up, wigs, and prostheses, which are also an important component of her subsequent series, *History Portraits* (1988–90). This series of portraits, originally planned as three individual sequences, was published in 1991 as a book of the same title. These ostensibly historical women's portraits, for which Sherman was yet again the model, refer to Old Master paintings, whose actual identification is undermined by their appeal to only hazy recollections. After her *History Portraits* she created photo-series in which organic matter was the basic theme. The *Disasters* series, for instance, shows gateaux and other sweets as "a sugary overkill": normally appealing foods are arranged in such a manner that they appear repulsive and disgusting. In her *Sex Pictures* (since 1992) Sherman examines the hidden and the grotesque, by combining body parts for medical research with erotic accoutrements such as lingerie or silk fabrics. Sherman's work offers a postmodern, feminist, and psychoanalytical interpretation of her subject matter. C.W.

Shinn, Everett. *1876 Woodstown, New Jersey, †1953 New York City. American painter, designer, and illustrator. He attended the Pennsylvania Academy of Fine Arts, Philadelphia (1893–96) and subsequently joined Robert → Henri, → Sloan, and → Glackens in New York, eventually as part of The → Eight. His → social realism was less concerned with the urban poor (*The Laundress*, 1903, pastel) than that of most of the group. Under the influence of Manet (*Outdoor Stage*, 1902, pastel), Degas (*Orchestra Pit*, 1906–07, oil), Forain (*The Magician*, 1906, red chalk), and perhaps → Sickert, around 1900 he concentrated on theatrical scenes which paradoxically showed the manner in which city-dwellers might "escape" just the squalor that the → Ashcan School was depicting (*Winter's Night on Broadway*, 1908). Illustration (for bookwork, as well as for the Philadelphia Press, then *Harper's Bazaar*, *New York Herald*, etc.) still predominated. Shinn was a master pastellist, as in the Daumieresque *Seine Embankment* (1903). Murals for Trenton City Hall, N.J. are an early example of a public commission showing unidealized labor (1911). Painting less and less – *East River Bridge* (1940) is of his 1900's style – he turned playwright, movie director, and designer. D.R.

Bibl.: De Shazo, Shinn, 1974

Sickert, Walter Richard. *1860 Munich, †1942 Bathampton, Somerset. British painter and printmaker. Leaving the Slade in 1881 after a few months, Sickert joined as an assistant in the studio of James Whistler (1834–1903), from whom he derives his low-keyed palette. He visited Degas (→ precursors) and gained awareness of the potential of less purely Impressionistic work and of the structural limitations of wet-on-wet and *alla prima*. Influenced by German prints, he turned to the music hall for inspiration (the early *Circus*, 1887) and joined the New English Art Club in 1888. Innovations included a use of mirrors that is yet more radical than that of Degas, alongside plunging perspectives, canted views, and askew, sometimes rear-view, figures. He later moved on to more open townscapes, e.g. of Venice and of Dieppe, where he lived from 1898 to 1905 (*Dieppe Sands*, 1919). Interiors are claustrophobic rather than intimiste (*L'Ennui*, c. 1913; *Le lit de cuivre*, c. 1906), especially so in his intentionally

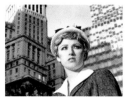

Cindy Sherman, *Untitled Film Still, No. 21*, 1978, Gelatin silver print, 20.3 x 25.4 cm, Metro Pictures, New York

Cindy Sherman/Richard Prince, *Untitled # 69*, 1980, C-print, 50 x 60 cm, DG-Bank Collection, Frankfurt

drab → Camden Town period (around 1905–14; group dating from 1911). While most of the portraits are naturally less turbulent (the painter *Jacques-Émile Blanche*, c. 1910), some 1920s handling approaches → Bonnard. Sharing Degas' interest in photography, Sickert used the process directly as a source for portraiture, especially from the mid-1920s, resulting in increased immediacy rather than mimesis.

A masterly printmaker who commanded techniques from soft-ground to drypoint, Sickert provided a link between elements of the Continental avant-garde and England. He was an influential artist and teacher who, in British terms, changed both theme and technique within the figurative tradition. D.R.

Bibl.: Baron, Sickert, 1973

Katharina Sieverding,
196/I–VII/1972, Die Sonne um Mitternacht schauen, 1972,
Photograph, 420 x 220 cm

Sieverding, Katharina. *1944 Prague. Czech-born photographer and artist living in Dusseldorf. From 1967–74 she studied at the Staatliche Kunstakademie in Düsseldorf with → Beuys. In 1972–82 she exhibited at Documenta 5–7. In 1976–77 she traveled to the US, in 1978 to China. Sieverding's first photographs consist of large self-portraits which may be interpreted in several ways and which are programmatic for her entire work. She continued with this series of portraits while also addressing Beuys' theme of making the artist a public part of the artistic event. Through her specific kind of presentation she made the photographic medium itself her topic: her tableaux, developed in the darkroom, are exposed to colored spotlights, thus illustrating the process of "exposure" on several levels. Sieverding belongs to a generation of artists whose work formulates clear political statements. In her series *The Reality has been very different* (1977) she refers to US strategies of economic and military imperialism. In a further series, *Norad* (1980), she addresses the nuclear threat. The *Steigbilder*, which Sieverding exhibited at the Venice Biennale refers to several political contexts, and demonstrate Sieverding's use of the digital process. C.W.

Signac, Paul. *1863 Paris, †1935 Paris. French painter. Initially an Impressionist (q.v. studies of the *quais*), noted by Armand Guillaumin (1841–1927), in 1884 he and Georges Seurat devised the chromatic principles of → divisionism. From 1891 he would move to Saint-Tropez each summer to paint. After Seurat's death in 1891 Signac became the focus of pointillism for H.-E. Cross (1856–1910), van de → Velde, → Angrand, et al. In part through his book *D'Eugène Delacroix au néo-impressionnisme* (1899), his influence c. 1900–10 was immense: → Matisse, Robert → Delaunay, → Braque, → Metzinger, → Derain, → Heckel, → Rohlfs, → Mondrian, Jan → Toorop, → Amiet, → Severini, and → Klimt all passed through divisionist phases, as did figures such as G. Pelizza da Volpedo (1868–1907), Curt Herrmann (1854–1929), Paul Baum (1859–1932), Jan Sluyters (1881–1957), and Jószef Rippl-Rónai (1861–1927).

An admirer of Claude Lorrain and a keen sailor (q.v. Théo van Rysselberghe's *Signac sur son bateau*), he depicted many ports. A famous por-

David Alfaro Siqueiros, *Head*, 1930, Oil on panel, 53.5 x 43 cm, Museum of Art, Rhode Island School of Design, Latin American Art Collection, Nancy Sayles Day

trait depicts the anarchistic critic Félix Fénéon before swirls of color (1890). If in *Port of Saint-Tropez* (1893) points are as small as those of Seurat or Maximillian Luce (1858–1941), Signac's pointillism was generally broader. He used round marks (like Willy Finch [1854–1930]) in *Saint-Tropez, The Lighthouse* (1895); oblong dashes (like Louis Hayet [1864–1940] and Emile Schuffenecker [1851–1934]) that are the width of a flat or bright brush (*Concarneau. Adagio Opus 121. Calm*, 1891); or even squares (*Pont des Arts*, 1928). His manner is freer in many watercolors. Drawings (with ink and black chalk) were unusually important for an artist of his ilk, and some shimmering lithographs (*Les Bateaux*, 1897–98) are superb. D.R.

Simonds, Charles. *1945 New York. American sculptor living in New York. In 1963–69 he studied at the University of California, Berkley, and Rutgers University. In 1969–71 he worked as a teacher. In 1970–74 he began his film projects and → performances. In 1976 he published "Three Peoples". In 1977 his work was showed at Documenta 6. In the 1970s Simonds became well-known through his miniature sculptures of old architecture in New York walls and corners (→ Land art). In 1971 he created → Body art with *Landscape Body Dwelling*. The artist's naked body, covered with mud turned into a landscape with ruins. In time this turned into a series of transportable models of ruins which in time grow into his *Pompeii-Complex*. Simonds' work deals with the historicity of culture, which he tracks down like a forensic detective through its ruins and traces. K.S.-D.

Siqueiros, David Alfaro. *1896 Chihuahua (Santa Rosalía de Camargo), Mexico, †1974 Mexico City. Mexican painter and graphic artist. In 1912–13 he attended the Academia de San Carlos, Mexico City. From 1919 to 1922 he was in Paris and Barcelona. The artist, a foremost exponent of Mexican → Muralism, was a close friend of → Rivera. In 1924 he produced his first mural *Myths* in the Escuela Nacional Preparatoria. From 1925 to 1930 he was an active member of the Communist Party; he abandoned painting during these years. Commissions for murals included the Plaza Art Center, Los Angeles. In 1936 in New York, he founded the "Siqueiros Experimental Workshop, a Laboratory of Modern Techniques", and was also a teacher of → Pollock. In 1937–39 he fought as a Republican soldier in the Spanish Civil War. Numerous murals were created in the following years. In 1960–64 he was imprisoned for criticizing Mexican politics (during which time he created more than 200 paintings, drawings, and sketches for prints). Siqueiros attempted to make modern synthetic materials and industrial techniques accessible for painters, being the first ever artist to work with a spray gun. In 1944 he painted the 100 square-meter mural *The New Democracy* (worked using the principle of dynamic multi-view perspectives) for the Palacio de Bellas Artes in Mexico City. His frescoes also expressed his social and political views on social insurance (1952–54). His monumental fresco *The March of Humanity*

(1964–69) demands social security for every Mexican worker. Siqueiro's significance in the development of a new contemporary art and his influence on abstract art (Pollock) have not been explored until very recently. E.B.

Mario Sironi, *Composition with Propeller*, 1915, Tempera and collage on cardboard, 74.5 x 61.5 cm, Mattioli Collection, Milan

Sironi, Mario. *1885 Sassari, Sardinia, †1961 Milan. Italian painter. Sironi's early, quietly "industrial" paintings of Turin (*Yellow Truck*, 1918) are far removed from the power and speed of → Futurism; the semi-deserted cityscapes breathe in the simplified atmosphere of → Pittura Metafisica (*The White Horse and the Jetty*, 1924). Later → Novecento works such as *The Architect* (1922), *The Pupil* (1924), and *Solitude* (1926) show dark interiors with brooding three-quarter figures. Sironi's State work in the early 1930s included large → social realism-cum-Pompeiian mosaics in a Fascist and heroic style close to → Campigli (Milan, Palazzo dell'Informazione), and stained-glass windows for Marcello Piacentini's Ministry in Rome (1931–32). His later painting returned to → Intimisme. D.R.

Bibl.: Sironi, 1980 · Ferrari, Sironi, 1985

Situationism, Internationale situationniste. One of the most original post-war movements of revolutionary and artistic theory and practice. Founded in 1957 in Italy it continued until 1972 (flourishing between 1959 and 1969; 1962 saw the resignation of the creative artists). Guy Debord, associated with Parisian → Lettrism until 1952, provided the theoretical declaration of principle ("Report on the Construction of Situations"), whereby artistic activity was to be expanded in a socially relevant manner to aid the revolutionary overturn of both capitalist and socialist power structures (art going beyond the work of art) through constructing situations, psycho-geographical analyses of urban space, driving forward experiments on behavior such as e. g. roaming around town (*dérive*), the radicalization of play, or the deliberate alienation of pre-fabricated aesthetic objects. The movement attacked the European art scene of the time in its own magazine (*Internationale situationniste* published until 1969) and quickly disseminated to Brussels (Maurice Wyckaert, [1923–]), Munich (→ Spur),

Copenhagen (Jürgen Nash, [1920–]) and Amsterdam (C. and J. Jong). Until 1967 the main theoretical works were *Hand Book on the Art of Living for the Young Generation* and *The Society of the Spectacle*. The movement was greatly involved in the radicalization of confrontation, (e. g. the 1968 general strike in France). One of its early texts *Manual for Misuse*, 1956, reads like the secret blueprint for many artistic practices of the 1980s and 1990s. R.O.

Slevogt, Max. *1868 Landshut, Bavaria, †1932 Neukastel, Rhineland. German painter and graphic artist. 1885–89 he studied at the Kunstakademie, Munich; 1889 he attended the Académie Julian, Paris. In 1890–97 he was in Munich, where from 1892 to 1893 he was a member of the Munich → Secession, and thereafter a member of the Freie Vereinigung. In 1901 he moved to Berlin, becoming a member of the Berlin Secession until 1913, then joined the Freie Sezession. In 1914 he traveled to Egypt. After 1918 he was resident in Neukastel, Rhineland. In 1924 he painted murals in the concert hall in Neukastel. In 1929 he traveled to Venice. In 1931 he created the Golgatha fresco in the Friedenskirche, Ludwigshafen.

Slevogt is the most significant colorist among German Impressionists, his brushstroke schooled by Monet (→ precursors) and Renoir, and his palette uses highly differentiated color – as shown by his theatrical portraits (from 1902), superbly painted representations of dancers and opera singers (*Champagne Song*, 1902). His late still lifes and Rhenish landscapes (*Neukastel Vine Bower*, 1917) bear witness to Slevogt's refined use of color and strong composition. Graphic art was an important focus of his artistic activity, and by incorporating all the accepted techniques he created not only illustrations of literary themes but also independent pieces (*Alexander*, series, 1932). H.D.

Max Slevogt, *Neukastel Garden*, 1931, Oil on canvas, 68.5 x 86.5 cm, Private Collection

Sloan, John. *1871 Lock Haven, Pennsylvania, †1951 Hanover, New Hampshire. American painter and printmaker. After study at the Pennsylvania Academy of Fine Arts (1892–94), Sloan became a magazine illustrator. He joined Robert → Henri in New York in 1904, becoming increasingly attracted to urban subjects, though portraiture remained central. His compositions (*Easter Eve*, 1907) are less gloomy than the → Ashcan images by others in the group (e. g. → Glackens) around Henri. Although Sloan was left-wing in his politics and a member of The → Eight, his art presents a Romanticized element, voicing his

contention that "human life is a joy." Even the squalid *Backyards, Greenwich Village* (1914) is enlivened by cats and boys at play. His later work added landscapes of the Southwest, though nude studies continued to form an important area of his oeuvre. In the late 1920s he began to extend the etching technique of hatching to tempera, a process he never abandoned. He was an important publicist for American painting and his ideas are published as *Gist of Art* (New York, 1939). A retrospective was held at the Whitney in 1980. D.R.

Bibl.: Elzea, Sloan, 1991

David Smith, *Untitled (Zik VI)*, 1964, Steel girders, painter ocher yellow, 200 x 112.5 x 73.5 cm, Collection of Candida and Rebecca Smith

Smith, David. *1906 Decatur, Indiana, †1965 Albany, New York. American sculptor. He studied in 1926–31 at the → Art Students League of New York. In 1941 he moved to Bolton Landing, to his own studio, "Terminal Iron Works". From 1950 to 1951 he had a Guggenheim scholarship. In 1951 he exhibited at the Saõ Paulo → Biennale, and in 1954 at the Venice Biennale. His work was shown in 1959, 1964, 1968, and 1977 at → Documenta 2–4, and 6. From 1930 Smith experimented with wood, stone, and metal in unusual, colored constructions. J. → Graham and → González introduced him to African ethnic art which, together with that of → Picasso, → Giacometti, and → Laurens, inspired his first iron sculptures. During the 1940s he expressed his private mythology in complex biomorphous → assemblages (*House of the Blacksmith*, 1945). After the war, works made of pieces of machinery and found objects emerged from his workshop (*Agricola*, from 1951; *Tank-Totems*, from 1952) which, on account of the unusual use and combination of the objects, achieved a Surrealist, magical atmosphere. Smith's working method was characterized by a playful handling of form and material. The sculptures reach out into space like signs which lend his open air installations, as well as those in the sculpture park of Bolton Landing, an emphatic, silhouette-like aura. In his works of the 1960s, *Circle*, *Zig*, and *Cubi*, Smith aligned himself more strongly to basic geometric forms. Surface effects are emphasized by the use of color and polished stainless steel. As in the 1950s this development was complemented by abstract drawings. H.D.

Smith, Jack. *1928 Sheffield. British painter. After studying locally and at St Martin's School of Art, Smith entered the Royal College in 1950. According to the critic David Sylvester, he soon became a leading exponent of the Kitchen Sink School (with John Berger's protégé John Bratby [1928–92], and Smith's fellow students at the RCA, Derrick Greaves [1927–] and Edward Middleditch [1923–87]), though in truth even at this time social concerns were subordinate to formal experiment. Interiors and metaphorical still lifes concentrating on oblique light effects predominated in the 1950s. After an increasing use of impasto and branching out into landscape, Smith's work gradually turned abstract, with geometrical shapes being located on simple, plain color grounds in almost → Hard-Edge compositions. Later, looser work makes much of connections between musical and painterly compositional language. D.R.

Bibl.: Jack Smith, London, 1969

Kiki Smith, *Train*, 1993, wax and glass beads, height 134.6 cm, Private collection

Smith, Kiki. *1954 Nuremberg. American sculptor, painter, and Installation artist Kiki Smith initially worked with Collab., New York. She has showed at Pace Wildenstein, New York; Anthony d'Offay, London; and Kestner, Hanover. Throughout the 1980s and early 1990s, Smith almost exclusively addressed the intimacy of the body (individuals of both genders suspended or standing in wax, glass, or clay; *Cadaver Table I* and *II*, bronze, 1996, marked with a hollowed-out thorax). An original departure used paper (*Untitled*, 1991, is a flaccid "Tuscan Renaissance" bust). This counter-academic body is not attacked, but neither is it hallowed as the vessel of some secret integrity. In the 1990s Smith also began to produce delicate glass animals, plexiglas stars, bronze mice and spoor, and drawings of beasts of the forest and birds (*The Fourth Day of the Destruction of Birds*, 1997) that demonstrate a concern with environmental issues. D.R.

Bibl.: Kiki Smith, Montreal, 1996 · Kiki Smith, 1998

Smith, (Sir) Matthew (Arnold Bracy). *1897 Halifax, Yorkshire, †1959 London. British painter. Smith enrolled at the Slade in 1905, traveling to northern France in 1909–10 and subsequently showing with the → Salon des Indépendants somewhat → Fauvist works (1911/12/13). Wounded in World War I, he exhibited with the London Group throughout the 1920s. Roger Fry indicated his "predilection for the shock of positive and intense primaries," and indeed, although contact was by accounts slight, Smith's work (the late *Large Decoration II*, c. 1951–53) resembles that of → Matisse and → Manguin, his portraits of women being particularly successful. → Expressionist landscapes (e. g. of Cornwall, early 1920s) are saturated in tone, whereas his Pays d'Aix works of the mid-1930s display a clarified palette (*Aix-en-Provence*, c. 1937) that still exploits the functional use of color. Knighted in 1954, his work was praised by → Bacon for its rich hues. D.R.

Bibl.: Matthew Smith, London, 1983

Smith, Richard. *1931 Letchworth, Hertfordshire. British painter living in New York. Smith attended Luton School of Art, 1948–50, and St Albans School of Art, 1952–54; then the Royal College of Art, London, 1954–57. He taught at Hammersmith College of Art, London, 1957–58; also St Martin's School of Art, London, 1961–63. From 1959 to 1961 he was in New York. In 1975 a retrospective was held at the Tate Gallery, London. In 1978 he moved to New York.

Influenced by F. → Stella, → Poons, and R. → Morris in the 1960s Smith turned from a figurative style of painting, close to → Pop art which made use of notions of packaging, to a simplified, more formalistic imagery using → shaped canvas formats. The unstretched canvases, mounted on metal rods and painted in monochrome subsequently developed into → installations constructed in the shape of kites (*Five Finger Exercise*, 1976). From 1993 he returned to acrylic painting using band-like, criss-crossing color structures. H.D.

Smith, Tony. *1912 South Orange, New Jersey, †1980 New York. American sculptor, painter, and architect. In 1934–36 he studied at the → Art Students League of New York; in 1937–38 at the New Bauhaus, Chicago. In 1938–39 he worked as assistant to Frank Lloyd Wright. His teaching included a period at New York University (School of Education) (1946–50); Cooper Union School (1950–52); the Pratt Institute, New York (1951–52); Hunter College, New York (1962–74). From 1953 to 1955 he was in Germany. In 1969 his work appeared in Documenta 4.

Earning his living as an architect in the 1940s and 1950s, Smith also began in the 1940s to create paintings in the style of → Abstract Expressionism. From 1960 he devoted himself exclusively to sculpture, which incorporated his experiences as an architect. Smith combined stereometric shapes, mainly cubes, tetrahedrons, and octohedrons, into large metal sculptures according to a modular system, and assembles them into complicated multiple-view constructions, frequently monumental outdoor sculptures (*Gracehoper*, 1972, Detroit Institute of Arts). H.D.

Lippard, Tony Smith, 1973

Smithson, Robert. *1938 Passaic, New Jersey, †1973 Amarillo, Texas. American Land artist. From 1953 to 1956 he attended the → Art Students League of New York and Brooklyn Museum School. In 1963 he married Nancy Holt. He began writing on art-theoretical issues in the 1960s. His early paintings were in the style of American Expressionism, such as collages created from gathered plants. In 1964–67 he made a series of sculptures using iron, glass, and plastic in clear, geometrical shapes and uniform color. In these pieces related to → Minimal art, he investigated questions of proportion and perspective. From 1968 he made excursions into post-industrial regions, which led to his Earth and → Land art projects. His 1967 series *Monuments of Passaic* (24 photos), showing the monuments of an industrial town, clarified the memorial and abstract status of Smithson's approach in what is an extension of the → objet trouvé. After 1968 he developed the dialectical principle of *Sites* (outdoor space) and *Non-sites* (situations created in the gallery or museum, where geometrical containers are filled with unworked natural materials; supplemented by maps). Smithson thus aesthetisizes geology and expands sculpture following geographical documents. In *Mirror Displacements* of 1969, a piece of landscape art, he used mirrors to enlarge space. In 1970–73 he produced his monumental landscape works, often helical earth deposits. *Spiral Jetty* (1970), the helical accumulation of rocks and boulders on the bank of the Great Salt Lake in Utah, has become an icon of Land art – its spiral symbolizing rebirth, growth, and infinity. In *Partially Buried Woodshed* (1970) a wooden cottage, filled with earth, is left to the ravages of the luxuriant surrounding vegetation. Smithson regarded the effects of civilization on landscape as an organic part of nature, and the devastation caused by natural disasters as basic aesthetic occurrences. The idea of entropy – the idea of irreversible change in a closed system which ends in collapse – is crucial. Numerous of Smithson's projects concern elementary processes in nature, such as decomposition. I.H.

Holt, Smithson, 1979 · Hobbs, Smithson, 1982–83 · Tsai, Smithson, 1991 · Smithson, Brussels, 1994

social realism. A term referring to art concerned with (mainly urban) working classes portrayed in a socio-critical light. Though overlapping in part with → Socialist Realism, it is devoid of triumphalism and represents a democratic critique of conditions rather than a call to revolution. Emerging from 19th-century Realism (Daumier, Courbet) and associated with projects such as Mass Observation in the UK, the tendency was most important in the US during the early 20th century, where the → Ashcan paintings of → Sloan, → Glackens, and → Shinn had revealed the squalor of city life (e. g. *Breaker Boy* by George Luks [1867–1933], 1921). The school influenced art in the Depression while the main outlet for the socially committed was the 1930s WPA (Works Progress [Projects] Administration). Later exponents of this approach include Walker → Evans, George Biddle (1885–1973), Jack Levine (1915–), and → Shahn. One of the crucial influences on committed art were Mexican muralists such as → Rivera, → Orozco (*Catharsis*, 1933), and → Siqueiros. Large-scale propagandist art was also taken up in other Latin American countries (in Ecuador with Oswaldo Guayasamín [1919–99]; in Brazil with → Portinari, etc.). In Europe, the most popular figure is → Kollwitz (though the expressly social dimension of her work is disputable), while → Grosz and → Dix lampooned the cruelty of inter-war Germany. Like the → Neue Sachlichkeit artists (→ Nussbaum),

Robert Smithson, *Spiral Jetty*, 1970, Great Salt Lake, Rozei Point, Utah, total length 480 m, width 4.8 m

→ Guttuso in Italy combined modernist techniques with social criticism. D.R.

Bibl.: Shapiro, Social Realism, 1973 · Lincoln, German Realism, 1980

Socialist Realism. First attested in 1932, this term covers the "dictatorship of the proletariat" in the arts as expounded by Stalin, who saw the avant-garde as perniciously "intuitive" or "formalistic." After the Formalizm and → Futurism of the 1920s, Russian art was subordinated to the Party, and themes such as industry (Boris V. Shcherbakov [1916–], *The Foundry*, 1947) and agricultural collectivization – together with mammoth portraits – predominated from the 1930s. Through committees and *Pravda,* party strongman Andrei Zhdanov (1896–1948) exerted "iron control" over the "class-aware" artist and "the truthful, historically concrete portrayal of reality in its revolutionary development [...] in the spirit of Socialism." This rigidly figurative, pseudo-historical, idealized, ideological, and often triumphalist aesthetic is reflected in the "heroic" statues of Sergei Merkurov (1881–1952) and Vera Mukhina (1889–1953; the huge *Worker and the Farm Girl,* 1937), while painters in the peasant or bureaucratic style included Aleksandr M. Gerasimov (1881–1963; *We have a Metro!*, 1947), Vasilii P. Efanov (1900–78), Vladimir A. Serov (1910–68), Fyodor P. Reshetnikov (1906–89), Isaak I. Brodski (1883–1939; a fine *Lenin in Smolny*, 1930), and the humanist strain of Aleksandr A. Deineka (1899–1969; *The Defence of Sebastopol*, 1952). After 1956, artists such as Nikolay I. Andronov (1929–) and Viktor E. Popkov (1932–74) mainly executed works (*Builders of the Bratsk Hydroelectric Power Station,* 1961) in the "Severe Style" (Russian = *Surovyy stil'*), near → Neue Sachlichkeit. During the later Cold War years painters such as Vyacheslav M. Mariuspolski (1906–86), Aleksandr I. Laktionov (1910–72; *Into the New Flat*, 1952), Evgeni K. Lesin (1917–), and Boris M. Lavrenko (1920–) indulged in an academicized "kitsch." This aesthetic – wholly foreign to Marx and Engels – lay simultaneously behind some exceedingly brutal Soviet architecture as well as Shostakovich's ambiguously "heroic" Fifth Symphony (1937). "*Sots Art*" was an ironical 1980s version of Socialist Realism, exemplified by Erik V. Bulatov (1933–) and → Komar & Melamid. D.R.

Bibl.: Vaughan, Socialist Realism, 1973 · Cullerne Bown, Art under Stalin, 1990

Société Anonyme Inc.. Association founded by the art collector and writer Katherine S. Dreier (1877–1952) in 1920, jointly with M. → Duchamp and → Man Ray for the promotion of modern art in America. From 1920–40 the Société organized 84 exhibitions showing works of art by modern artists (e.g. → Klee, → Malevich, → Miró, and → Schwitters) in rented rooms on New York's 47th Street. These exhibitions were accompanied, following the model of Herwarth Walden's → Sturm gallery, by readings and publications. The largest event took place in 1926 in the Brooklyn Museum, following the legendary → Armory Show of 1913. A substantial portion of Dreier's works of art and library was donated to Yale University in 1941. H.D.

Society of Independent Artists. Association founded in 1916 in New York to succeed the Association of American Painters and Sculptors, which had been disbanded following the establishment of the → Armory Show. The objective of the Society of Independent Artists was to support progressive artists with exhibitions which, like the French → Salon des Indépendants, were organized without a jury and were open to every artist upon payment of a small fee. The first and also the biggest exhibition was opened in April 1917 in New York with 2,500 works by approximately 1,200 artists, among them works by → Brancusi and → Picasso. Called the Big Show it was the biggest exhibition of modern art in America to date. It became famous through its rejection of M. → Duchamp's urinal (*Fountain*, 1917), one of his first → ready-mades. Annual exhibitions continued until 1944. H.D.

Soffici, Ardengo. *1879 Rignano sull'Arno, Tuscany, †1964 Forte dei Marmi, Lucca. Italian painter, printmaker, and critic. He met Giovanni Fattori (1825–1908) at the Accademia, Florence, and became acquainted early with → Symbolism and Giovanni Segantini (1858–99) (see *Europa*, 1905). As an illustrator in Paris (1900–) he met → Picasso, → Braque, → Gris, and the poets Guillaume Apollinaire and Jean Moréas (→ Nabis-like covers, 1902). A champion in *La Voce* of → Rosso (1909–10), he attacked → Futurism (late 1911). A brawl (recalled by → Carrà) ensued in Florence with → Boccioni and the Milanese; reconciled, the Florentines with Soffici joined the Futurist camp. Abandoning Symbolism, he wrote for *Lacerba* (1913–) and produced (1912–13) urban Futurist work where – in Russian → Cubo-Futurist mode – *simultaneità* predominated over speed (*Decomposition of the Planes of a Lamp*, 1912; *Synthesis of the City of Prato*, 1912; *Composition with Purgative Almanac*, 1914). He composed → Cubist still lifes (with the bottle as theme), books (*BIF§ZF+18 simultaneità e chimismi lirici*, Florence, 1915) in *parole in libertà* (see → Marinetti), and oils with typography (*Ink-well*, 1914). Impatient with Futurist posturing, by 1920 he had joined the *rappel à l'ordre* with *Rete mediterranea* and other Fascist-leaning journals (1930s). His best mature works (to late 1940s) are tranquil country landscapes indebted to Cézanne: *Tuscan Hill* (1925), *Casa Colonica* (1944). D.R.

Bibl.: Cavallo/Raimondi/Russoli, Soffici, 1967 · Parronchi, Soffici, 1976 · Soffici, Macerata, 1988

Soft sculpture. Term (also Soft art) used for sculptural works in soft, unstructured materials. It refers mainly to → Oldenburg's works (*Soft Typewriter*, 1963). Other figures involved in Soft art include → Chamberlain and participants in → Nouveau Réalisme and → Arte Povera. In recent decades the combination of "soft" and "hard" materials has become predominant in most sculpture. H.D.

Solano, Susana. *1946 Barcelona. Spanish sculptor living in Sant Just Desvern near Barcelona. She attended the Barcelona Real Academia where she later taught. After early small bronzes the

end of the 1980s saw her large sculptures made from bent and welded iron plates. Since 1987 she has produced work which is at once architectural and furniture-like in character, assembled from iron frameworks, pipes, grids, and sheet steel. In these sculptures, which resemble booths or cages, Solano is concerned with both physical and mental spatial effects. The transparency of the bars and struts creates a fluent transition between materiality and immateriality, restriction and openness. I.H.

K. R. H. Sonderborg, *Faster than the Sound*, 1953, Gouache on paper, 49 x 69 cm, Otto van de Loo, Munich

Sonderborg, K. R. H. (real name Kurt Rudolf Hoffmann). *1923 Sonderborg, Denmark. Danish painter resident in Stuttgart, Paris, Berlin, and Chicago. From 1938 to 1940 he took a commercial apprenticeship, and from 1947 to 1949 attended the Landeskunstschule in Hamburg. In 1951 he changed his name to K. R. H. Sonderborg. In 1953 he became a member of the group → ZEN 49. In 1958 he moved to Paris. From 1965 he was professor at the Staatliche Akademie der Bildenden Künste in Stuttgart. Emerging from → Tachisme and → Action Painting, Sonderborg focuses on aspects of movement and speed. Expressive gestures cross the picture plane diagonally, driving out color which is restricted to black and some red. Wiped traces, streaks, and scratches create the painting's rhythm, and lead, through the large empty spaces that are left, to associations of "infinity, emptiness, primal force, and flow" – principles of Zen Buddhism with which Sonderborg feels in sympathy. H.D.

Sonderbund. Association of artists, collectors, and museum workers founded in Düsseldorf in 1909 which strove, under the chairmanship of K. E. Osthaus (founder of the Folkwang Museum in Hagen, 1902) to promote collaboration between artists and audience. It was the 4th Sonderbund exhibition of 1912, in the Cologne Kunsthalle, which became famous, showing important representatives of the artistic avant-garde (with the exception of the Futurists) in particular works by Cézanne, van Gogh, Gauguin, (→ precursors), → Signac, → Picasso, → Mondrian, and → Munch, as well as representatives of → Cubism, → Nabis, → Fauvism, and the artists of Die → Brücke and Der → Blaue Reiter. It became a model for the → Armory Show of 1913 in New York. H.D.

Sonfist, Alan. *1946 New York City. American environmental artist. Interested in animal life

from an early age (Hemlock Forest, NY, and the Bronx Zoo), as a boy Sonfist made a drawing of his body enfolded in a tree. After study at Ohio State, he taught at MIT (1967–76). His work is a non-invasive version of → Land art, concentrating on the plant world and trees, extracting items from nature to be photographed or installed, rather than disrupting the terrain (*Elements Selection*). In the 1970s, Sonfist repositioned sticks, earth, etc. lifted up from a piece of untouched ground onto a bolt of unrolled canvas (*Direct Museum*). His "tree-tracings" are made by rubbing a roll of paper wrapped round a tree with a block of natural resin (1979). Later pieces have taken on a mythical dimension: *The Maze of the Great Oak of Denmark with Stone Ship* [...] (1994), dialogues with Norse nature religion. D.R.

Sonnier, Keith. *1941 Mamou, Louisiana. American Installation and Conceptual artist, and sculptor, living in New York. His studies include: 1959–63 at the University of Southwestern Louisiana, Lafayette; and 1965–66 at Douglas College, Rutgers University, interrupted by travels to England, France, and Italy. Inspired by → Morris, Sonnier turned in the 1960s towards new artistic means of expression inspired by → Minimal art. In the late 1960s he created wall reliefs and floor sculptures made from Indian cotton, foam, and other soft materials. Influenced by → Nauman's work he began in 1968 to work with light using different colored neon and fluorescent strips which he combined with mirrors, lead foil, glass, or aluminum. By means of this modern technical medium Sonnier produced a new use of color, creating an independent structural form in his work. Letters or abstract signs shaped from neon strips appear, some in the form of wall sculptures. A further, extensive area in his work is his engagement with video and radio transmission. I.N.

Keith Sonnier, *Wrapped Neon-Object*, 1969, Neonstrips, Cable and Transformer, 248 x 187 x 151 cm, Museum Ludwig, Ludwig Foundation, Cologne

Soto, Jesús Rafael. *1923 Cuidad Bolívar. Venezuelan painter and sculptor, living in Paris and Caracas. In 1942–47 he studied at the Escuela de Artes Plasticas, Caracas. From 1947 to 1950 he was director of the Escuela de las Bellas Artes, Maracaibo. From 1950 he lived in Paris, where he earned his living as a guitarist and constructed his first → kinetic sculptures. Starting in 1956 he worked with the gallery Denise René and artists such as → Vasarely, → Tinguely, and → Takis. In

Jesús Rafael Soto, *Blue Center*, 1968, Colored stripes on wood, 133 x 131 cm, Private Collection

1973 he founded a museum for modern art in Ciudad Bolívar. → Mondrian's idea to make space dynamic and Soto's desire to put Mondrian's art in motion lead, together with inspirations from twelve-tone music, to kinetic pieces in which Soto generated vibrations through squares and lines. Without mechanical or engine-driven help he managed to show motion in a purely artistic way, thus becoming a forerunner of → Op art. In 1969 he created his first *Penetrables*: countless thin nylon strings suspended from the ceiling which begin to vibrate in the slightest breeze. The nylon strings are subsequently replaced by thin metal rods which form an inverted dome, such as in his *Virtual Volume* of 1987. In his paintings Soto combines squares and lines in constantly new permutations, thus creating a variety of "vibrations". S.Pa.

Soulages, Pierre. *1919 Rodez, Aveyron. French painter living in Sète and Paris. In 1938 he passed a brief spell at the École des Beaux-Arts in Paris, then returned home. In 1943 he discovered abstract art. In 1947 he moved to Paris, where he came in contact with → Picabia, H. → Hartung, and → Léger. He took part in the Salon des Surindépendants. In 1949 he had his first one-man exhibition in Paris. In 1949–51 he created stage sets and costume designs. In 1953 he exhibited at the São Paulo Bienale. In 1955, 1959, and 1964 his work was shown at Documenta 1–3. Impressed by the Romanesque architecture and the Celtic monuments of his native region Soulages' work in the 1940s was a heavy, archaicizing painting composed of broad black gestures on a light ground. In later pictures the choice of tools dictated the aesthetic effect of his massive hatchings, which often were achieved by using a wide rubber spatula or roller brushes instead of a paintbrush. The dominant black is supplemented with just one more color, either blue, brown, or red. (*Painting 28.12.1959*). The gestures' heaviness makes the pictorial composition appear frozen, despite the use of dynamic force. In 1987 he created the design for a monumental tapestry for the French Finance Ministry, and in 1995 glass windows for the Abbaye de Conques. H.D.

Pierre Soulages, *June 29, 53*, 1953, Oil on canvas, 195 x 130 cm, Pierre Soulages Collection, Paris

Sound Installation/Sound Art. A critical factor in the development of 20th-century art is the tendency to break down the boundaries between genres and, by synthesis, create new forms of expression. Sound installations and sound sculpture have established themselves as new art genres in the area between music and fine art. Space thereby becomes a determining element in the creative process: sound sources, positioned in unusual places open new aural perspectives, sounds set in motion or interactive sound installations whereby the audience, through its movement, activates sound or causes it to change. The spatialization of sound invalidates the traditional concert condition. Instead, the audience is actively requested to approach the sounds or sound objects and thereby open up the aural space. The boundary between sound installation and sound sculpture is in flux and is determined by the role which the visual design plays in each work. Historically, sound installations and

Chaim Soutine, *Self-portrait*, c.1918, Oil on canvas, 54.6 x 45.7 cm, The Henry and Rose Pearlman Foundation

Sound Installation/Sound Art, Ivan Faktor, Kees de Groot, Nurr (Hofstetter, Steuer, Wild), Shuk/Kurpershoek, *Brand Project: Monitor procession, Home*, 1995, Installation, Dresden

sculpture can be traced back esp. to the Italian Futurist → Russolo ('Manifesto on the Art of Sound', 1913), who constructed mechanical sound objects fitted with sound trumpets (*Intonarumori*), which were crucial for sound art. In 1938, inspired by Russolo the composer Edgard Varèse created one of the first sound installation (World Fair in Brussels). On the recommendation of → Le Corbusier, Varèse designed a version of his 'Poème electronique' for Le Corbusier's Philips Pavilion which was played over 500 loudspeakers inside the pavilion. In parallel with Varèse a number of artists began to redefine the conventional boundaries between music and fine art. The development of electronic music in particular opened new possibilities for generating and reproducing sound (→ Cage). At present many artists are actively involved in the area of sound installations and sound sculpture e. g. → Kubisch and Rolf Julius. U.M.

Bibl.: Bräm, Klangkunst, 1986 · De la Motte, Klanginstallation, 1990 · Klangkunst, 1996

Soutine, Chaim. *1893 Smilovichi near Minsk (now Belarus), †1943 Paris. Russian-born painter. From 1910 to 1913 he attended Vilnius Art Academy. From 1913 he lived in Paris. In 1915 he met → Modigliani, with whom in 1918 he traveled to Vence and Cagnes-sur-Mer. From 1919 to 1922 he lived in Céret (French Pyrenees), painting. Back in Paris, he destroyed the majority of the pictures he painted there. From 1923 he received support from the American collector Albert C. Barnes. In 1925 he traveled to Amsterdam. From 1926 he changed residences frequently in Paris. In 1927 he had his first one-man exhibition and success. In 1928–29 he was back in Vence, where he created the series, the *Big Tree*. From 1930 to 1935 he spent the summers in the house of his patrons the Castaing family. Caught by the outbreak of war in 1939 in Civry-sur-Serein he was thereafter obliged to change his address frequently.

Following his first barren landscapes and still lifes in earthy colors, both influenced by Cézanne's (→ precursors) conception of space, in 1917 Soutine arrived at the gestural style of painting which would characterize his work. His landscapes and portraits, painted in the so-called

Céret-style, are of prime importance, the motif becoming secondary to the impetuous brush-stroke. These pictures are on the border of gestural abstraction. Apart from numerous frontal portraits, distorted into caricature (*Portrait de Madeleine Castaing*, c. 1928), 1923 saw the emergence of paintings in the style of the Old Masters (Chardin, Rembrandt), particularly with the theme of animal carcasses. Soutine's versions of Rembrandt's *Flayed Ox* are superb examples of the act of painting itself, an act in which color becomes independent in both brilliance and material properties. From 1930 the increasing influence of Corot and Courbet can be seen. Working outside contemporary trends Soutine's uncompromising, subjectively expressive manner of painting, as well as his use of *matière* as a dense compact mass, may be read as an anticipation of the 1950s' gestural → Abstract Expressionism. A.G.

Chaim Soutine, *Beef*, c. 1925, Oil on canvas, 166.1 x 114.9 cm, Stedelijk Museum, Amsterdam

Sow, Ousmane. *1935 Dakar. Senegalese sculptor living in Dakar. In the 1950s he studied at the École des Beaux-Arts in Paris, while earning his living as a therapeutic masseur. He became well-known through his life-size figures of members of the Southern Sudanese ethnic group the Noubas (shown in 1992 at → Documenta). His massive, powerful figures are of expressive vividness without being naturalistic. They represent "exotic" figures who are not to be seen as showpieces, but who stand before the European spectator with self-assured vitality and distance. His latest works comprise large-scale scenes from the life of the Nouba and Masai, as well as representations of the battle against Native Americans at Little Big Horn. They were exhibited on the Pont des Arts, Paris in spring 1999. I.H.

Soyer, Moses and Raphael. *1899 Borisoglebsk, Russia, †1974 New York/1987 New York. Russian-born American painters. The Soyer twins emigrated with their family to the US in 1913, and were best known for their "Fourteenth Street School" paintings (→ social realism) which followed the earlier → Ashcan tendency, though the Soyers are less satirical than, for example, → Shahn. The Manhattan street scenes of the Depression especially by Raphael were highly successful (*Office Girls*, 1936). He also produced a poignant record of his Jewish parent's middle-class existence (to which he also alluded in several volumes of autobiography) in intimate interiors. Moses specialized in honestly depicted social scenes of the city with a slightly sharper edge and, like Raphael, participated in the → Federal Art Project, painting a pair of murals for a post office in Philadelphia, PA (1939). The artist and model in the studio was a favorite theme of Moses, while his essays extolled social realism and criticized the limits of → Regionalism. His self-portrait with Raphael and Isaac, *Three Brothers* (1963–64) is a fine rendition which goes beyond realism to psychological commentary. The younger brother shown, Isaac (1907–81), was a painter specializing in vargrants and other misfits. D.R.

Spatialism. Italian anti-Constructivist and anti-rational art trend founded by → Fontana as expressed in the *Manifesto Blanco* (1946) and other writings published between 1947 and 1953 (e.g. manifestos of Spatialism; 1952 by A. → Burri among others). Fontana subjects received ideas of space in painting to a fundamental critique by extending the concept of space to include the new demands of the technical age, thus defining space as the interrelation of color, light, and movement. He thus attempts to abolish received boundaries between the genres of painting and sculpture. H.D.

Spencer, [Sir] Stanley. *1891 Cookham, Berkshire, †1959 Taplow, Buckinghamshire. British painter. Though he studied at the Slade School (1908–12), Spencer lived for much of life in his native village. He participated in Roger Fry's Second Post-Impressionist Exhibition and showed at the New English Art Club. The most famous of many images of resurrection (*The Resurrection: Cookham*, 1924–26) takes up the challenge of involving the modern commoner in an eschatology at once more humanist and less tragic than in, say, → Ensor's *Christ's Entry in Brussels*. Work as a war artist in Macedonia inspired the large oil murals at Sandham War Memorial Chapel, Burghclere, Hants (1927–32; including another *Resurrection*), an elaborate, dream-like work which shows the soldiers struggling free of death in much the same way as they had heaved themselves out of the trenches. Such imaginative imagery with large, swelling, closely drawn figures, obsessively observed in an invigorating post-Pre-Raphaelite style became his trademark (*St Francis and the Birds*, 1935). His *Nursery* (1936) is a critique of contemporary parenthood, while innovative treatments of shipbuilding also seem to have a social subtext. Completely unaffected by the concerns of modernism, Spencer is best approached as a quasi-religious artist whose work harks back to Blake and to Renaissance Italy, rephrasing their work as personal catharsis. More erotically charged works (*Leg of Mutton Nude*, 1936–37) build into a private universe of half celebratory, half frustrated, sensual innocence, tainted on occa-

sion by disillusionment. He was knighted in 1959. There is a memorial gallery to his life and work in Cookham. D.R.

Bibl.: Collis, Spencer, 1962 · Rothenstein, Spencer, 1979

Spero, Nancy. *1926 Cleveland, Ohio. American painter and installation artist living in New York. In 1949 she attended the Art Institute of Chicago. She was → Lhote's student in Paris and in 1949–50 attended the École des Beaux-Arts. In 1951 she married → Golub. From 1964 she has lived in New York and in 1969 became a member of the group Women Artists in Revolution. In 1971 she co-founded the New York Artists in Residence Gallery. In 1997 her work appeared at → Documenta 10. Spero created *The War Series* (1966–70) as a response to the Vietnam War. Subsequently she has worked on political actions and analyses of war, perpetrator and victim, power and violence. A pioneer of feminist art since the 1970s, she has made women's loss of social language an issue. Referring also to their primeval strengths, she quotes female images from the most diverse cultures, from mythical figures to contemporary media ideals, at times combining them with texts. Male domination is represented by the absence of the male image. She works with printing stamps, collage, and text fragments on panel-like lengths (mostly paper), and recently with large, mainly temporary wall designs (1990 house wall in Derry, Northern Ireland; 1993 wall of the Jewish Museum in New York). The dominant topic of her latest pieces of work is the body of the self-assured, active woman, her independence and self-confident sexuality. K.S.-D.

Spilliaert, Léon. *1881 Ostend, †1946 Brussels. Belgian painter whose art is an amalgam of an unconventional → Symbolism and a tempered → Expressionism. Other than in a few works, such as *Eve and the Serpent* (1913), he employed the flowing lines of → Art Nouveau less to embroider patterns (as in the work of → Thorn Prikker) and J.→ Toorop than to elicit dynamism or calm, with themes such as the beach (the quasi-abstract *Marine and Dunes*, c. 1945), swimming (*Girl Bathing*, 1910), and wind effects (*Gust of Wind*, 1904) being typical. Introduced to French Symbolists by the poet Émile Verhaeren in 1904, he was a frequent visitor to Paris; some ink work (*Woman repairing a fishing-net*, 1910) is close to → Bonnard. Like Xavier Mellery (1845–1921) and Fernand Khnopff (1858–1921), he used atmos-

pheric gradations of tone to blend figure into space (*Young woman holding a goblet*, 1910). Though linked to Belgian → Post-Impressionism and possessed of the wit of a → Vallotton (as in the bemused figures of *Two women visiting an exhibition*, 1912), Spilliaert's subtle watercolors and gouaches are primarily dream-like (*Vertigo*, 1908), if occasionally as horrifying as → Ensor (*Les pendus*, c. 1912). His obsessive self-portraits (12 between 1907 and 1908 alone) are particularly spectral. D.R.

Bibl.: Tricot, Spilliaert, 1996

Spoerri, Daniel. *1930 Galati, Romania. Romanian-born sculptor, living near Berne. He studied ballet from 1950 to 1954, working as a dancer at the Staatstheater, Berne. From 1957 to 1959 he worked as assistant director at the Landestheater, Darmstadt. From 1959 he was in Paris, where he was a co-founder of → Nouveau Réalisme. In 1963 he participated in the Festum Fluxorum Fluxus at the Kunstakademie, Düsseldorf. In 1968 he coined the term Eat Art for his artistic work with foodstuffs and founded the Spoerri restaurant in Düsseldorf; in 1970 he established the Eat Art Gallery. In 1979–80 he worked on films and stage sets. He held professorships from 1977 to 1982 at the Kunsthochschule, Cologne, and from 1983 to 1993 at the Kunstakademie, Munich. Since the 1950s he has also been active as an editor and writer.

Spoerri's art and performances are characterized by his scurrilous sense of humor, as he plays with deception, disturbance, the perversion of materials (→ kitsch), and the reversal of situations as artistic principles in themselves. In 1960 he exhibited his trap or snare pictures: these are everyday items, e. g. the leftovers of a meal, which are fixed in their chance arrangement on their respective surfaces. Spoerri declared the result a picture to be suspended vertically from a wall. In his word-traps of 1963–64 he depicted words or

Daniel Spoerri, *This World's Happiness*, 1960–71, Mixed media, 170 x 100 x 19 cm, Karl Gerstner Collection

sayings. Apart from → assemblages and object pictures, he repeatedly organized Eat Art events. Since 1985 he has produced sculptures, where objects charged with a religious or ritual content from different cultures are assembled. I.H.

Spur. Artistic group, founded in Munich in 1957, whose members included painters Heimrad Prem (1934–78), H. P. Zimmer (1936–) and Helmut Sturm (1932–), as well as the sculptor Lothar Fischer (1933–). Influenced by → Jorn and → Cobra, the group attempted a reconciliation of free artistic means (→ Art Informel) with figuration and content as their stylistic principle. As associates of → Situationism they organized political actions and distributed manifestos, which were rejected by the conservative mood of the time. Following their amalgamation with the similarly directed Wir group (Helmut Rieger, Florian Köhler, Heino Naujoks, Hans Matthäus Bachmayer, Reinhold Keller) to form the Geflecht group (1965–67) many collaborative pieces of work were created. H.D.

St Ives School. St Ives in Cornwall, on the rugged southwest coast of England, was a favorite haunt of painters during the 19th century. Whistler (1883–84), → Sickert, and → Schjerfbeck all worked in St Ives, while the notable potter Bernard Leach (1887–1979) established a workshop there. As a modern grouping however, the St Ives School dates from the arrival of → Hepworth and Ben → Nicholson in 1939. Their friend the influential critic Adrian Stokes also lived nearby, while Nicholson remained there until the late 1950s. The pair attracted other artists, such as → Gabo and especially British names such as occasional residents → Frost, John Wells (1907–), → Heron, Alexander Mackenzie (1923–), and → Wynter; other visitors included → Pasmore and Adrian Heath (1920–92), two links with metropolitan → Constructivism. → Lanyon was born at St Ives and did much of his work there. Though Sunday painters abound today, and the Tate has opened an annexe in the town, the modernist school as such had become defunct by the mid-1960s. There is some connection between the residents and their associates in their concern with near-abstract, lyrical, landscape-derived color syntheses. D.R.

Bibl.: Whybrow, St Ives, 1994

stabile. Since 1931 → Calder had been creating abstract sculptures which had been named stabiles by → Arp on the occasion of a 1932 exhibition. As counterparts, → mobiles, named by M. → Duchamp, were created at the same time. A combination of both principles is termed a mobile-stabile. While mobiles are moveable constructions of wire, rods, and organically shaped metal discs, set in motion by air currents, and sometimes by motors, stabiles formed a static opposing pole. Despite their massive appearance and rootedness they appeared delicate and elegant. In their formal, transparent construction with characteristic leg- or wing-like elements they are reminiscent of fantastic out-sized insects. Calder realized several stabiles in monumental dimensions for urban public spaces. I.H.

Staël, Nicolas de. *1914 St Petersburg, †1955 Antibes. Russian-born painter. In 1919 his family fled first to Poland, then into exile to Belgium. From 1933 to 1936 he studied at the Académie des Beaux-Arts, Brussels. From 1938 he was in Paris. In 1939–40 he joined the Foreign Legion. In 1944 his exhibition "Peintures abstraites" was held at L'Esquisse, Paris. In 1956 a retrospective was held at the Musée d'Art Moderne, Paris.

He began to compose his first abstract pictures in 1942, inspired by the second → École de Paris, and developed them after 1944 into mosaic-like structures in his series of *Compositions*. In 1952 de Staël's work took a decisive turn. The areas of color, intensely and broadly applied with a painter's knife, became figurative, or consciously evoked figurative associations (*Footballers in the Parc des Princes*, 1952). His coloration, inspired by → Matisse (*gouaches découpées*) intensified in the mid-1950s in numerous fluidly painted landscapes following travels to Sicily (*Syracuse*, 1954) and the Midi. De Staël appears to have moved consciously between the poles of abstraction and figuration without having resolved the antinomy in his prematurely interrupted oeuvre. K.S.-D.

Nicolas de Staël, *Le Fort d'Antibes*, 1955, Oil on canvas, 130 x 89 cm, Mme. Jacques Dubourg, Paris

Stamos, Theodorus. *1922 New York City, †1997 New York City. American lyrical abstract painter, of Greek extraction. He trained in sculpture at the American Artists' School when he was aged only 14, then turned to painting. Influenced by → Avery and → Gorky, early works were semi-Surrealist abstractions of beach debris and shells, treated for their formal characteristics rather than their powers of evocation. Personally acquainted with → Gottlieb and → Newman, he traveled to Europe (1948; especially Greece) and exhibited with → Baziotes and → Tobey, his approach becoming more abstract, though aquatic, zoomorphic, or mythically-inspired imagery often provided a starting-point (as for Baziotes and another friend, → Rothko). As the forms gained in structure, poetic allusion ebbed and sparsely geographic layouts supplemented textured geologies. By the 1950s, he could be counted as an → Abstract Expressionist (appearing in 1951 as one of the "Irascibles" in *Life* magazine). Extensive sequences from the 1960s/early 1970s, such as *Sun-Box* (*Delphic Sun-Box*; *Spartan Sun-Box*, 1971; etc.), were determined by geometry, while mid-1970s series returned to spatial preoccupations (*Infinity Field*). Stamos taught at → Black Mountain College and the → Art Students League of New York. He also executed tapestry designs. D.R.

Bibl.: Pomeroy, Stamos, 1970

Steer, Philip Wilson. *1860 Birkenhead, Cheshire, †1942 London. British figurative painter. Steer's training was under the conservatives William Bouguereau and Alexandre Cabanel in Paris, and he had an opening exhibition at the New English Art Club. By the late 1880s (exhibiting with "Les XX," 1887), Steer had become attracted to the Impressionists, especially Monet. Freely brushed, dappled beach scenes remain popular (*Boulogne Sands – Children Shrimping*, 1891). They combine Eugène Boudin's interest in the linear effect of the horizon on figure arrangement with a sense

of the delight in the foreshore as felt by young girls *en fleurs* (*Two Girls on the Pierhead*, 1887–88). A masterful if light-hued colorist, Steer is a foremost English Impressionist. He was a friend of → Sickert, whose wit he shared, but he had more limited influence due to his preference for decorative composition in quiet related tones. His interest in flat, calm seascapes and light effects is similar to that of Belgian → Post-Impressionists, though later landscapes are heavier and high-toned (*Deserted Quarry [Ironbridge]*, 1910). His semi-nudes are prettily suggestive (*Sleep*, 1898) and his watercolors and wash-drawings (1900–20s) are tasteful but often lack the calculated evocative quality of his beach work. D.R.

Bibl.: MacColl, Steer, 1945 · Laughton, Steer, 1971

Steichen, Edward. *1879 Luxembourg, †1973 West Redding, Connecticut. American self-taught photographer, born in Luxembourg. He arrived in 1881 in Michigan, US, and in 1894–98 was an apprentice lithographer, as well as an art student at the Milwaukee Art Students League. From 1900 to 1903 he studied in Paris. Returning to New York, he was a founding member of the Photo Secession. In 1923–38 he was chief photographer at Condé Nast publishing and responsible for the fashion magazines *Vanity Fair* and *Vogue*. In 1947–62 he was director of the photographic department at MOMA, New York.

Characteristic of Steichen's early work are self-portraits, landscapes, nudes, and portraits, inspired by Impressionism and Symbolism, which, retouched by hand, blur the boundaries between painting and photography. In the 1920s this so-called pictorial photography shifted to objective representation. Fashion photography aside (of which he is an important representative), in the 1930s Steichen produced authentic "documentary" portraits of writers, painters, and actors, achieving both calm composition and a personal relationship with the model in order to reach beyond the self-confidence that sitters commonly display in front of the camera. As a museum director he is well-known for the exhibition Family of Man (1955), which provided an overview of living conditions around the middle of the 20th century. C. W.-B.

Steinbach, Haïm. *1944 Rechovot, Israel. Israeli-born sculptor and installation artist, living in Brooklyn. His education included: 1962–68 Pratt Institute, Brooklyn, 1965–66 Université d'Aix, Marseille, 1971–73 Yale University. In 1993 he exhibited at the Venice Biennale and Docu-

Haïm Steinbach, *Untitled*, 1987, Wall-mounted object, mixed media, gold and silver, 159.5 x 228 x 67.5 cm, FER Collection

menta 9. Steinbach's work illustrates the role of the artist in his "complicity in the production of desires, and the production of beautiful, seductive objects" (Steinbach). The observer is confronted with everyday items, e.g. food cans, bottles, souvenirs etc. which are exhibited on specially manufactured pedestals, consoles, and shelves. By means of this quasi-sacred presentation, the aesthetics (or rather the commercialized pathos) of the objects are ironically disrupted, and the relationship of the aesthetically duped observer to the packaged object is placed in question. I.S.

Steinberg, Saul. *1914 Ramnicul Sārat near Bucharest, †1999 New York. Romanian-born American draftsman, caricaturist, and painter. Steinberg studied psychology and sociology in Bucharest. From 1932 he was in Milan, where he studied architecture, and began to make his first humorous drawings. In 1942 he emigrated to the US, where he worked primarily as a caricaturist for the magazine *The New Yorker*. His concise, sketch-like line and stylization influenced the art of caricature greatly in the years after 1945. His ironic illustrations of American everyday life brought him worldwide acclaim. He published numerous anthologies of drawings (e.g. *All in a Line*, 1949; *Labyrinth* 1959). He also created a series of large, collage-like murals for the US Pavilion at EXPO '58 in Brussels (*Americans*, 1958). K.S.-D.

Edward Steichen, *Charlie Chaplin*, 1931, Vintage silver bromide print, 25 x 19.8 cm, Museum Ludwig, Cologne

Steir, Pat. *1940 Newark, New Jersey. American painter. Born Iris Patricia Sukoneck, Steir studied (1956–58) with → Lindner and encountered → Minimalism in the early 1970s. Her initial style was that of illustrative → Conceptual art, complete with grids, numbers, and graphics (*The Way to New Jersey*, 1971), while the 1980s saw more experiments with the painterly and with color (especially in the conceptual flower paintings, *The Bruegel Series*, 1982–84). Associated with "new image painting," she is most famous for wave paintings derived from treating e.g. Courbet's marine canvases in an alien style (Turner, → Ensor, etc.). In the late 1980s, informal tendencies emerged in *Waterfall* paintings made through drip-and-run processes, but which allow for the use of multidirectional line and brush, thereby conflating abstractionism (the gesture) and representation (the waterfall). D.R.

Bibl.: McEvilley, Pat Steir, 1995

Stella, Frank. *1936 Malden, Massachusetts. American painter living in New York. Stella attended Phillips Academy, Andover; and in 1954–58 studied history and art history at Princeton University. In 1968 and 1977 he exhibited at Documenta 4 and 6. In 1983 he was visiting professor at Harvard University. In 1992 he produced his first architectural designs.

Stella's *Black Paintings*, large canvases with a symmetrical pattern of broad black stripes, were to oppose → Abstract Expressionism as early as 1959. Stella subsequently began to determine the paint surface's apparent form through the underlying structure of the patterns and thus developed his *Aluminium* and *Copper* series using → shaped canvas. Stella rigorously developed symmetrical picture structures into clearly defined, geometrically severe and compartmentalized areas of color, in which each color received maximum autonomy. His compositions became increasingly complex and integrated the influence of Islamic and Irish-Celtic patterns (*Protractor* series, from 1968). His large-format collage series *Polish Villages*, begun in 1971, concluded the transition from painting to relief. In the 1970s Stella produced large relief sculptures, which consist of exuberantly colored geometrical shapes. After 1980 these are supplemented with major graphics cycles (*Circuits, Shards, Cones, and Pillars*). The increasing wealth of spatial illusion, e.g. in *Hooloomooloo* (1994), takes on references to baroque sky-painting which the theoretically reflective Stella has incorporated into the abstract imagery of his more recent work by means of computer graphics. H.D.

Frank Stella, *Harewa*, 1978, Mixed media on aluminum, 227 x 340 x 71 cm, Gabriele Henkel Collection, Courtesy of Hans Strelow, Düsseldorf

Stella, Joseph. *1877 Muro Lucano, near Naples, †1946 New York. Italian-born painter, who in 1896 emigrated to the US. In 1897–1901 he attended the → Art Students League of New York and worked as an illustrator for the periodical *The Survey Graphic*. From 1909 to 1912 he lived in Europe, where he was influenced by → Futurism and → Cubism, whose imagery he used in his turbulent, chromatically intense pictures of American scenes (*Battle of Lights*, 1913–14). He achieved a typically Futuristic effect in the kaleidoscope-like merging of different viewpoints in his major paintings *Brooklyn Bridge* (1917–18) and *The Voice of the City of New York Interpreted*, (1920–22). In the 1920s he exhibited with M. → Duchamp and → Man Ray in the → Society of Independent Artists and the → Société Anonyme. In 1930–34 he lived in Paris. His work returned to a conservative style from the middle of the 1920s onwards. K.S.-D.

Stepanova, Varvara (Fyodorovna). *1894 Kovno (Kaunas, Lithuania), †1958 Moscow. Russian painter and designer. Stepanova studied at the Kazan School of Fine Art (c. 1910–13) – where she met her future husband → Rodchenko – then in Moscow (c. 1912) under Ilya Mashkov (1884–1944), linchpin of the → Jack of Diamonds. She was involved with → Futurism, painting, and composing *Zaum* nonsense/sound poetry and compiling collage books in mock-crude *lobok* (Russian print) style, including *Gaust Chaba* (1918), and illustrations for Aleksei Kruchenykh. She worked from 1918 in IZO at → Narkompros and was an early member of → Inkhuk, exhibiting → Constructivist (inc. collage) works at the "5x5=25" exhibition (1921) as well as figurative/geometric woodcuts for e.g. Alexei Gan's journal, *Kino-Fot*. She later associated with dramatic artists Esfir Shub, Dziga Vertov, and Vladimir Mayakovsky (posters, 1925). Like → Popova (and Sonia → Delaunay and → Taeuber-Arp), fabric design was an important area of her work, with contributions at once to abstraction and to Soviet standardization (*sportodezhda*, universal "sports outfit," 1923). For Meyerhold's production of *Smert Tarelkina* ("The Death of Tarelkin") she designed (1922) advanced collapsible sets and geometric costumes (including the female doctor's famous "trapezoid" overalls). She is to be valued for her simplicity, color sense, and mechanical yet sensitive approach to the figure (*Five Figures on a White Background*, 1920), close to → Schlemmer or some → Malevich. D.R.

Bibl.: Lavrentiev, Stepanova, 1988 · Bowlt/Drutt, New York, 1999

Stieglitz, Alfred. *1864 Hoboken, New Jersey, †1946 New York. American photographer and important innovator in 20th-century photography. From 1881 he lived in Berlin, where he studied mechanical engineering and later, photography. In Europe he was influenced by the "soft-focus" painterly style of Pictoralism (→ Tonalism). In 1890 he returned to New York where he experimented with techniques of photography and photogravure. From 1892 he was editor of the periodical *The American Amateur Photographer* and from 1897 to 1902 of *Camera Notes* which mainly espoused Pictoralism. Focusing increasingly on his own work, in 1903 Stieglitz founded the periodical *Camera Work* which in the coming years was to be a photographic and artistic avantgarde forum, and which also provided the exhibition catalogue for Gallery 219, a space run by Stieglitz from 1905 to 1917. Apart from French modernist pictures, the gallery exhibited works by seminal photographers of the day (e.g. → Steichen). In 1917 he gave up magazine and gallery work.

Steichen identified a new trend in photography in the work of his younger colleague → Strand: from now on Pictoralism seemed no longer relevant, and was replaced by ideas of photographic construction and immediate presentation. Stieglitz himself took up this premise in a series of New York photographs, which are formally structured compositions of unspectacular motifs. The climax of his photographic work were his so-called *Equivalents* of the late 1920s and early 1930s. In numerous sky pictures Stieglitz examined cloud formations which became metaphors for his own philosophy of life.

Frank Stella, *Luis Miguel Dominguin (1st version)*, 1960, Aluminum paint on canvas, 237.5 x 181.5 cm, Private Collection

Joseph Stella, *American Landscape*, 1929, Oil on canvas, 200.5 x 100 cm, Walker Art Center Collection, Minneapolis

With his photographs, but mostly through his work as a curator and editor, Stieglitz's contribution was second to none in making photography the equal of painting and sculpture as an artistic, expressive medium. He married the artist → O'Keeffe in 1924. C.W.

Stijl, De. Influential movement founded in 1917 in Leiden by van → Doesburg, → Mondrian, and others. The movement's objective was the innovation of painting, sculpture, and architecture by means of fundamentally simplified geometrical shapes. It included painters such as → Vantongerloo, van der → Leck and → Vordemberge-Gildewart, as well as designers (Gerrit Rietveld [1888–1964]) and architects (J. J. P. Oud [1890–1963]). Its mouthpiece was the periodical *De Stijl*, where the De Stijl manifesto had been published. Its nucleus was a universal, anti-individualistic, and to begin with, also a mystical and philosophical need for expression through geometrically abstract means: emphasis was on horizontal and vertical lines and a requirement for color purism on the basis of the primary colors red-blue-yellow (as already employed by Mondrian). Like Russian → Constructivism De Stijl's imagery, which had been derived from → Cubism, was seen as a model for the New Design (→ Neo-Plasticism) of the total environment. It was for this reason that frequent collaborations between architects and designers took place. The De Stijl program had sustained effects on architecture, which was able to articulate clearly the strict functionality demanded, the rectangularity of space, and the use of pure color to indicate spatial relationships (e.g. Huis ter Heide by R. van't Hoff, Utrecht, 1916; Rietveld's Schröder House, Utrecht, 1924). Rietveld's Red-Blue-Chair (1918–23) reconciles all the formal and functional ideas of De Stijl in its purist austerity and in its spatial relationships accentuated by primary colors. While in painting its dogmatic strictness was soon to be modified by other formal possibilities (→ Elementarism, → Concrete art), De Stijl's effect on European architecture was significant, and many of its Constructivist principles were brought to fulfilment in the work of the → Bauhaus (Mies van der Rohe). H.D.

Still, Clyfford. *1904 Grandin, North Dakota, †1980 New York. American painter. In 1926–27 and 1931–33 he studied at Spokane University, Washington. His teaching work included 1933–41 at Washington State College, Pullman, and 1946–50 at the California School of Fine Arts, San Francisco. In 1943 he had his first one-man exhibition at the San Francisco Museum of Art. From 1945 he lived in New York, exhibiting in 1959 at → Documenta 2. 1979 saw his retrospective at MOMA, New York.

Still's early figurative pictures were influenced by American → Regionalism and T. H. → Benton, but also by the work of Cézanne and van Gogh (→ precursors). In the 1940s, under the influence of → Surrealism, he produced semi-abstract representations with a mythical and symbolic content. In New York Still joined the painters of → Abstract Expressionism and took part in the setting up of the Subjects of the Artist art school. In these years Still achieved his mature style:

Clyfford Still, *1963-A*, 1963, Oil on canvas, 290 x 192 cm, Albright Knox Art Gallery, Buffalo

Clyfford Still, *July 1945 R (PH-193)*, 1945, Oil on canvas, 175 x 81 cm, Albright Knox Art Gallery, Buffalo

Alfred Stieglitz, *The 'tween Deck*, 1907, Vintage silver chloride print, 11 x 9.2 cm, Alfred Stieglitz Collection, Washington

rugged shapes appear to hover in broad areas of color or merge into dense fiery structures. Despite their seemingly aggressive shapes his pictures radiate some kind of meditation or spirituality which connects him to his friend → Rothko. His late work was characterized by a strong emphasis on the vertical and large empty areas of canvas on which colors drift like islands. In his last years he also produced numerous pastels. H.D.

Strand, Paul. *1890 New York City, †1976 Orgeval, France. American photographer and film producer. From 1907 to 1909 he studied at the Ethical Culture School, New York; at the same time he studied photography under → Hine. From 1911 he worked as a freelance photographer. He traveled greatly, e.g. to Europe, New Mexico, Canada, and Mexico, before moving to France in 1950.

Strand is one of the significant innovators of photography in the first half of the 20th century. Although his early work was to a large extent characterized by Pictoralism (→ Tonalism), in about 1914, Strand moved away from compositional design in photography. His acquaintance with → Stieglitz (1907) and his conception of his art as a medium in its own right, independent of painting, led to his work becoming increasingly abstract. The photos of this new period, also

Paul Strand, *The Family, Luzzara, Italy*, 1953, Gelatin silver print, 24 x 30 cm, Paul Strand Archive, Aperture Foundation

known as "pure photography" can be organized into three main types of motif: first, shots of New York, where Strand attempts to capture the movement of the city; second, still lifes in which the motif is cropped in such a way that it appears as a mere abstract composition; third, portraits as in-depth social studies. He also made documentary films (*Manhattan*, 1920) and composed numerous photographic books. C.W.

Struth, Thomas. *1954 Geldern, Lower Rhineland. German photographer living in Düsseldorf. In 1973–80 he studied painting with G. → Richter and photography with → Becher at the Kunstakademie, Düsseldorf. From 1983 he was professor at the Staatliche Hochschule für Gestaltung.

Struth is mainly concerned with the three classic genres of photography: cityscapes, portraits, and the interior. From the mid-1970s onwards he created a collection of cityscapes (*Unconscious Places*), which show urban life with the maximum of objectivity. His work constructs a schematized concept for taking photographs: slightly elevated camera position, uncontrasted illumination, while maintaining maximum depth of field, large format, and neutral background. Even a series of portraits begun in 1984 follows these principles of neutral technique. In his posed portraits, individual or group pictures, the sitters can decide on how they want to be photographed. Since 1989 he has been working on his so-called museum pictures, where he photographs museum visitors in order to make them more aware, on subsequent visits, of their surroundings. C.W.

Strzemiński, Władysław. *1893 Minsk, †1952 Łódz. Russian-born Polish painter. In 1919 he became a member of → Malevich's UNOWIS Group. In 1920 he taught at an art school in Smolensk, during this period producing Suprematist compositions and collages, using tools and industrial products (*Counter Relief*, 1919–20). In 1922 he moved to Poland where he was co-founder of the → Constructivist group → Blok (1924–26). Because of its rejection of utilitarian tendencies in 1926 Strzemiński changed over to the architectural group Praesens (1926–29), where he advocated an analytic Constructivism. The pamphlet "Unism in Painting" (1928) formed the basis of the program of overcoming the dualism in painting of color and line. Anticipating the → Color Field Painting of the 1950s and 1960s he developed an absolutely flat form of painting by avoiding any contrasts and by pursuing a homogeneous picture construction that was not orientated towards the center but towards the edges of the picture (*Unistic Compositions/Architectural Compositions*, 1924–34). He continued to be influential as a theoretician and teacher until 1949. H.G.

Sturm, Der. The artistic and cultural periodical *Der Sturm* (The Storm) was published between 1910 and 1932 in Berlin by the art-critic, musician, and writer Herwart Walden (1878–1941). In his gallery of the same name Walden mounted, from 1912, exhibitions of → Expressionism, → Cubism, and → Futurism, as well as the Erster

Deutscher Herbstsalon of 1913. In 1916 a school under the directorship of → Muche and in 1918 the Sturm theater, directed by Lothar Schreyer joined the associated Sturm publishing house as well as bookshop. It was Walden's concern to propagate the "new image of creative man". In its initial period he promoted the literature of early Expressionism. From 1912 the fine arts were his primary focus of interest, but he was unsuccessful in bringing on board avant-garde artists of the post-war period (with the exception of → Schwitters). His increasing political orientation towards Russia caused Walden to cease gallery work in 1928. When he moved to Moscow in 1932 the magazine was discontinued. D.S.

Štyrský, Jindřich. *1899 Cermna, †1942 Prague. Czech painter, photographer, book illustrator (of → Breton, Jaroslav Seifert, Klaus Mann, etc.), poet, writer (inc. erotica), translator (Rimbaud, de Sade), and collage artist. He studied at the Akademie výtvarných umění, Prague (1920–23), and was influenced by indigenous → Cubism (*The Singer*, 1923) and → Constructivism. A member of Devětsil (1923), he traveled with Josef Síma (1891–1971) and his lifelong companion → Toyen to Paris (1925–28). He founded Artificialismus (and its journal, *Red*), a combination of abstractionism and associationism (*Hoarfrost*, 1927). Following the 1932 exhibition, Poezie, Štyrský – with → Teige and joined by Jindřich Heisler (1914–53) – founded the Czech → Surrealist group in 1934 under Toyen's impetus (her *Fright*, 1932, is a formal answer to his *Transformation*, 1932). Štyrský's often wickedly witty *papiers collés* (*Paysage échiquier*, 1925), photographic or engraving collages, and *cadavres exquis* are based on mutation or a combination of strange views on everyday objects. D.R.

Bibl.: Moussu, Štyrský, 1982 · Štyrský, Paris, 1982 · Štyrský, Hamburg, 1990 · Štyrský, Paris, 1997

Sudek, Josef. *1896 Kolín on the Elbe, Bohemia, †1976 Prague. Czech photographer. By contrast to popular photojournalism of the 20th century Sudek represents that rare type, the photographic artist. Sudek was supreme in being what one might call a sculptor of light, who in his conscious limitation to a few objects – a glass of water, an egg, a stone – created a universe of light gradations which approached the metaphysical. Apart from numerous landscapes in the vicinity of Prague (from c. 1957 taken with a panoramic camera) Sudek achieved his greatest mastery in his still lifes. Following his attendance at a trade school in Kutná Hora and an apprenticeship as a book-binder he studied from 1922 to 1924 at the school for graphic arts in Prague. In 1922 he was a founding member of the Prague Photographic Club. Following his expulsion in 1924 he became a founding member of the Czech Photographic Society. From 1927 he had a studio in the center of Prague and founded the Sudek Gallery for the Fine Arts. Among his most important series are pictures on the Home for the Disabled (1922–27), the Prague St Vitus Cathedral (1924–28), advertising photography (1930), *The Studio Window* (1940–54), *The Magic Garden*, *Vanished Statues* (1952), and *Labyrinths* (1963–72). In his early work

Der Sturm, Oskar Kokoschka, *Poster Design for the Periodical* Der Sturm, 1911, Oil on canvas, 102 x 70 cm, Szépművészeti Múzeum, Budapest

in particular he was committed to Pictoralism (→ Tonalism) and always remained close to this trend both in mood and softness of focus, but at the same time Sudek is also a representative of a very sober functionalist style. P.S.

Sugaï, Kumi. *1919 Kobe, †1995 Kobe. Japanese painter. From 1937 to 1942 he studied at the Osaka Art Academy, and at the Teii Nakamura Art School (Japanese painting), subsequently working in Kobe as a commercial designer. From 1952 he was in Paris, where in 1955 he had his first one man exhibition (Gallery Craven). In 1959 and 1964 his work was shown at Documenta 2 and 3 and in 1962 at the Venice Biennale. In his early work (from 1952) he made figurative elements abstract (e.g. by association with Japanese written characters), or gave Japanese characters a figurative shape (e.g. Samurai, Oni [devil], and Olsa [hill] as characters in the landscape). His work approaches → lyrical abstraction, using increasingly abstract imagery whilst retaining recognizable Far Eastern lettering in his painting. K.S.-D.

Sultan, Donald. *1951 Asheville, North Carolina. American painter Donald Sultan's large-scale paintings show a dual interest in the great tradition of art and in modernity. He represents traditional subjects such as still lifes, landscapes, cityscapes, forest fires, battleships, and horse-riders, which he reworks in an up-to-date style with modern materials. Artistically maturing during the dominance of → geometric abstraction, Sultan reduces complex objects from the real world (such as lemons or smokestacks) to simple shapes, which thereby take on more than one meaning, and which are a vehicle for erotic undercurrents. Images are painted on the kind of large vinyl tiles used to cover factory floors, on which Sultan applies a thick layer of butyl rubber, a matt-black material which exerts a strong physical presence, conveying an amalgam of forces contrasting with the bright colors of his figures. S.G.

Bibl.: Sultan, Chicago, 1987

Support-Surface. Artists' group, formed in the 1970s in Nice around → Cane and Claude Viallat (1936–) following the first Support-Surface exhibition of 1970. In 1971 they radicalized and politicized their objectives, causing the withdrawal of several members. Fundamental for Support-Surface is the group's repudiation of the classical idea of the work of art and its interest in the elementary structures constituting the work (canvas, frame, etc.). Analysing the material fundamentals of painting and sculpture the artists used simple crafts techniques – such as plaiting, meshing, and the knotting of ropes and ribbons – as well as dyeing, bleaching, and folding canvases, presenting the results in unconventional places, such as outdoors. Apart from its artistic practice Support-Surface formulated a complicated theory of dialectical materialism, psychoanalysis, and structural linguistics which was published in its periodical *Peinture. Cahiers Théoriques*, founded in 1971. Internationally little known, the group nevertheless influenced the younger generation of French artists. A.G.

Suprematism. Term, coined around 1913 by → Malevich to indicate an art purified from all representation, expressing itself through geometrical shapes and colors. Malevich propagated this idea of art in numerous writings, such as in his pamphlet *From Cubism and Futurism to Suprematism* accompanying the exhibition 0.10. The Final Exhibition of Futurist Painting in Petrograd (St Petersburg) in 1915; his 1922 work *Suprematis – Abstraction or the Liberated Nothing* and his pamphlet *The Abstract World* (Munich 1927; English translation London 1969) were issued as Bauhaus publications. In these theoretical works Malevich postulates the necessary abstraction of the work of art, independent of all content and material objectives, and considered previous expressions of art to be directional. The new art was not to be a continued development of old art forms, but an expression of a pure sensation of energy – for Malevich the primeval state behind the material world. Malevich's composition *Black Square on a White Ground* (shown in 1915 at the 0.10 exhibition) was the first artistic manifestation of Suprematism.

The new direction of non-objective painting influenced numerous other Russian artists, such as → Puni, → Rozanova, → Popova, Nadezhda Udalsova (1886–1961) and → Rodchenko. In the beginning of the 1920s Malevich and → Lissitzky founded the association UNOVIS, which propagated Suprematism as the new canon for art. UNOVIS members were working in various art institutions (e.g. 1923–26 in SINKHUK) and disseminated Suprematism through these conduits. In the 1920s Suprematism exerted a strong influence upon architecture, textile design, and graphic art. Fundamentally, Malevich designed a new world through Suprematism, which was to reconcile the most modern scientific findings with a visionary search for the secret structure of the world. In abstract painting he created an idealistic, spiritual superstructure which exerted great influence upon its further development. H.D.

Surrealism. Modern art movement which from 1921 had initially developed as the Parisian branch of → Dada. Its objective was to make accessible to art the realms of the oneiric, the unconscious, irrational, and imaginary. Two fundamental principles underlay Surrealist aesthetics. The premise "beautiful as the chance encounter of a sewing machine and an umbrella on a dissecting table" which Lautréamont (I. Ducasse) had provided as early as 1868 in *Les Chants de Maldoror* explained the principle of combining alien

elements to cause a poetic spark. The principle of automatism on the other hand was formulated by the group's spokesperson, the writer and poet → Breton in his *First Surrealist Manifesto* of 1924: "SURREALISM, n., – pure psychic automatism, through which we express in words, writing, or in any other activity, the actual functioning of thought; thoughts dictated apart from any control by reason, and any aesthetical or ethical consideration." Breton had, jointly with Philippe Soupault, already attempted this procedure in his 1921 text *Les Champs magnétiques*. Within the area of painting → Masson's drawings follow this procedure, whilst → Ernst's collages are examples of combinatory imagery. → Delvaux, → Tanguy, → Magritte, and → Dalí also worked on ways of precisely calculating dream-like pictures by means of illusionary objectivity, whilst → Arp and → Miró emphasized the playful, abstract moment in a work's process of creation. The Surrealists considered themselves representatives of a new frame of mind, heavily influenced by psychoanalysis. Their mouthpiece, the journal "La Révolution Surréaliste" (1924–29) imitated the appearance of scientific publications. Despite several splits international Surrealist circles continued to exist into the 1960s in Mexico, Czechoslovakia, Scandinavia, and the US, as well as in France. D.S.

Survage [Sturzwage], Léopold. *1879 Moscow, †1968 Paris. Russian-born French painter and illustrator, and set, textile, and tapestry designer. Starting as a piano tuner, he entered the Moscow School (1899) and was soon associated with the magazine *Zolotoye runo* ("Golden Fleece"), the → Jack of Diamonds group (1910), → Archipenko, David and Vladimir → Burliuk, → Larionov, and → Goncharova. He moved to France in 1909. An artist-musician like → Čiurlionis or → Schoenberg, from 1912 he produced abstract compositions entitled *Colored Rhythm* (close to Robert → Delaunay) which he planned to animate cinematographically in flowing "symphonies in color," heralding a new "autonomous art" (L. S.). His kaleidoscopic canvases – with a central color/light focus or a fringe-like interference – resemble photisms or phosphenes, but he never succeeded in creating abstract film (as Viking Eggeling [1880–1925] and Hans → Richter were to do in the early 1920s). His collage-like postwar work, employing interlocking planes (*Portrait of the Baroness d'Oettingen*, 1917), is closer to → Cubism than to Neo-classicism. He was commissioned by Diaghilev for sets and costumes for Stravinsky's *Mavra*, (e.g. *La Voisine*, 1922) and made sets for *Le Coeur à gaz* by → Tzara (1923). *La Fille aux cheveux longs* (c. 1920) is similar to → Picabia. He was a friend of → Masson, and a → Surrealist phase followed in the 1930s. D.R.

Bibl.: Russett/Starr, Animation, 1976 · Warnod, Survage, 1983 · Survage, 1992

Sutherland, Graham (Vivian). *1903 London, †1980 London. British painter and printmaker. Having begun his artistic career as a successful printmaker following a period of study at Goldsmiths' College of Art (1921–26), Sutherland took up painting in the very early 1930s. Trips to Pembrokeshire, Wales, resulted in his first creative canvases (from

1934). Working up open-air sketches in oils, Sutherland gradually became taken with smaller elements from the "exultant strangeness of the place," and developed a style with foreshortening and condensing closer to Paul → Nash (*Green Tree Form*, 1939). His drawings fostered an interest in natural forms, his line redolent of a favorite etcher, Samuel Palmer (1805–81). After a period as an → Official War Artist, mostly in Britain, Sutherland produced highly textured studies of thorn trees and religious paintings. His compositions during the later 1940s gradually became more restricted (still lifes, plants); by the 1950s, his Standing, Poised, or Armoured Forms were independent interpretations of a natural world "reassembled" in often strong, dark colors, with etiolated crosses or interlocked shapes (*La Petite Afrique*, 1953). In addition to landscapes of the French Riviera (he purchased a house in Menton in the mid-1950s) and a succession of intriguing if not universally acclaimed portraits (Lady Churchill famously had that of Sir Winston destroyed), from 1955 to 1961 Sutherland again took up a religious theme in designs for the Coventry Cathedral tapestry. In 1967, he returned to Wales and his beloved studies of trees, including a late series of aquatints. D.R.

Bibl.: Cooper, Sutherland, 1961

Suvero, Mark di. *1933 Shanghai, China. American sculptor of Italo-French descent, living in New York. He has been based in the US since 1941. In 1953–54 he attended San Francisco City College; 1954–55, University of California, Santa Barbara; and 1956, University of California, Berkeley. In 1957 he moved to New York, where in 1963 he was co-founder of the Park Place Gallery. In 1968 he participated in → Documenta 4. 1975 saw a retrospective at the Whitney Museum of American Art, New York.

Di Suvero's early work consists of small, expressive bronze sculptures (*Hand Pierced*, 1959) and constructions in wood, often including → objets trouvés (*Tom*, 1959). At the beginning of the 1960s he discovered metal as a material and became a pioneer of → Junk art. He constructs huge sculptures from steel girders, rusty chains, and scrap metal which appear like monumental signs in public spaces (1966 *Tower Peace*, Los Angeles, a protest against the Vietnam War). Di Suvero's extended → Constructivism is based upon fundamental experiences of the infinity of space. Yet he simultaneously deploys constructive forms by combining the pure physical force of the material with a functional aesthetics. A.R.

Svanberg, Max Walter. *1912 Malmö, †1994. Swedish painter and draftsman. Though → Breton had enthused about the bizarre imagery of his work in "Surrealism and Painting" (essay orig. pub. 1954), Svanberg only met the Surrealists on a belated trip to Paris in 1964. He was the founder (with Carl Otto Hulten [1916–]) of the Malmö Imaginistgruppen. Svanberg's planar compositions are close to some of → Brauner's and to → Ernst's late → Dada linework. Gouaches and pen-and-ink drawings are dominated by animals, females, and their morphs indulging in interpenetrations or balancing acts: two-headed in *Poetical*

Graham Sutherland, *Thorn Trees*, 1945/46, Oil on cardboard, 105 x 99 cm, Albright Knox Gallery, Buffalo

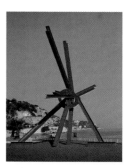

Mark di Suvero, *Tendresse*, 1989–90 , Steel, 900 x 650 x 940 cm , Gagosian Gallery, New York

Projection, I; accompanied by a lion-basilisk in *Strange Pregnancy* (both 1950). As in → Schröder-Sonnenstern or Paul Wünderlich (1927–), and in some of the insane art (see → Outsider art) in the Prinzhorn Collection (e.g. Oskar Deitmayer), sexuality is patent, whereas meaning is hermetic. Woman is a mythical creature without a history: an impossible sexual apparatus, half Horus-Apollo, half embroidery-wrapped call-girl. D.R.

Bibl.: Svanberg, Malmö, 1979

Symbolism. Artistic style emerging towards the end of the 19th century in literature and the fine arts, and directed against Realism, Naturalism and Impressionism as part of a broad anti-materialist and anti-rationalist current. Its nucleus was a small circle of writers associated with the French poet Stéphane Mallarmé (including André Gide, Paul Verlaine, Paul Valéry, and Émile Verhaeren). Their idea of "poésie pure" was intended as an art free from social or cultural references, referring to mystical and religious correspondences, as formulated in the *Symbolist Manifesto* (1886) by Jean Moréas, which gave the movement its name. These ideas were disseminated in a series of Symbolist periodicals and were well received by painters, indicting Impressionism's lack of ideal and spiritual content. → Gauguin and his circle in Pont-Aven was among the artists' influences, as well as the later → Nabis. It is, however, impossible to speak of a unified Symbolist style, since isolated figures such as → Redon, → Kupka, → Munch, and → Hodler were all briefly associated with the style, and Symbolist ideas tended to remain vague and undefined. Fundamental, however, was Baudelaire's theory of *correspondances* according to which all of life is linked by mysterious connections. Correspondences between color and music, for example, promoted the development of abstract painting at the beginning of the 20th century, just as many Symbolist paintings already displayed abstracting tendencies despite widely diverse themes. Symbolism, apart from giving impetus to → Expressionism and → Pittura Metafisica was also instrumental in paving the way for → Surrealism. K.S.-D.

Synchromism. Artistic style founded in 1912–13 by American painters → Russell and → Macdonald-Wright in the wake of → Orphism. Abstract color pictures illustrate the relationship between primary colors in elementary geometrical shapes, based upon the color theories of Michel-Eugène Chevreul, Percyval Tudor-Hart, and Hermann von Helmholtz. In spite of a manifesto of their own (1913) the Synchromists' proximity to R. → Delaunay's abstract pictures remains noticeable, which may explain the short duration of this movement.

Synchromism briefly influenced other American painters in its colorful abstraction, amongst them T. H. → Benton and Andrew Dasburg (1887–1979) in New York as well as Patrick Henry Bruce (1881–1936) in Paris. It was, however, abandoned by its founders after the end of World War I in favor of figurative styles. H.D.

Synthesism. Symbolist style of painting (→ Symbolism), coined by Gauguin, → Bernard and other artists of the School of Pont-Aven after 1888 as a reaction to → divisionism. Pictures were to be painted from memory to form a synthesis between perceptual and conceptual worlds. The characteristics are decorative surfaces with simplified forms and brilliant areas of color, which remove the paintings from mere objective representation, making form, and above all color, independent within the structure of the painting. Synthesism became publicly known through the exhibition of the Group of Impressionists and Synthesists at the Café Volpini, Paris, organized by Gauguin on the occasion of the Exposition Universelle in 1889. A.G.

Systemic painting. Title of an exhibition which took place in 1966 at the Solomon R. Guggenheim Museum in New York. Paintings by → Held, → Newman, K. → Noland, → Poons, → Reinhardt, and F. → Stella contributed to a discourse on American modernist painting which can be traced back to the art critic Clement Greenberg. Greenberg favored a style of painting freed from all external characteristics of the medium, focusing essentially on the flatness of the canvas, to be executed according to given, systematically structured plans (e.g. in *Modernist Painting*, 1961, and *Post-Painterly Abstraction*, 1964). The internal, formal and logical structure of the abstract work became the essential criterion of this type of painting. Stella's → shaped canvases, which showed a reciprocal unity of form and inner structure, played a particular role. The painting thus appears as an object which integrates space as a surface, thus questioning recognized boundaries between painting and sculpture. Despite its consciously basic materials and cognitive premises this type of painting is far from being cool, impersonal, and overly intellectual. It is precisely in its logical reduction, formal clarity, and particular use of color that one finds systemic painting's sensual and subjective epiphany, which is often the result of much intuitive and personally inspired preliminary work. M.S.

Szabó, Lászlo. *1917 Debrecen, Hungary, †1985 Budapest. Hungarian sculptor. Initially Szabó studied law, then attended art school in Geneva. From 1947 he lived on a scholarship in Paris, where in the 1950s he worked among the artistic avant-garde. In 1954 he founded the group Quinze Sculpteurs. His use of form, influenced by → Arp and → Laurens is characterized by an organically full modeling of hollows and bulges. The sculptures frequently recall geological structures, resembling landscapes, eroded or hollowed out by water, or architectural fragments. Alongside abstract fertility symbols, he also created fantastically shaped animals; another preferred topic is mother and child groups. His original departure was the creation of habitable sculptures, achieved through hybridizing sculpture and architecture, which to a certain extent he realized in his own studio. I.H.

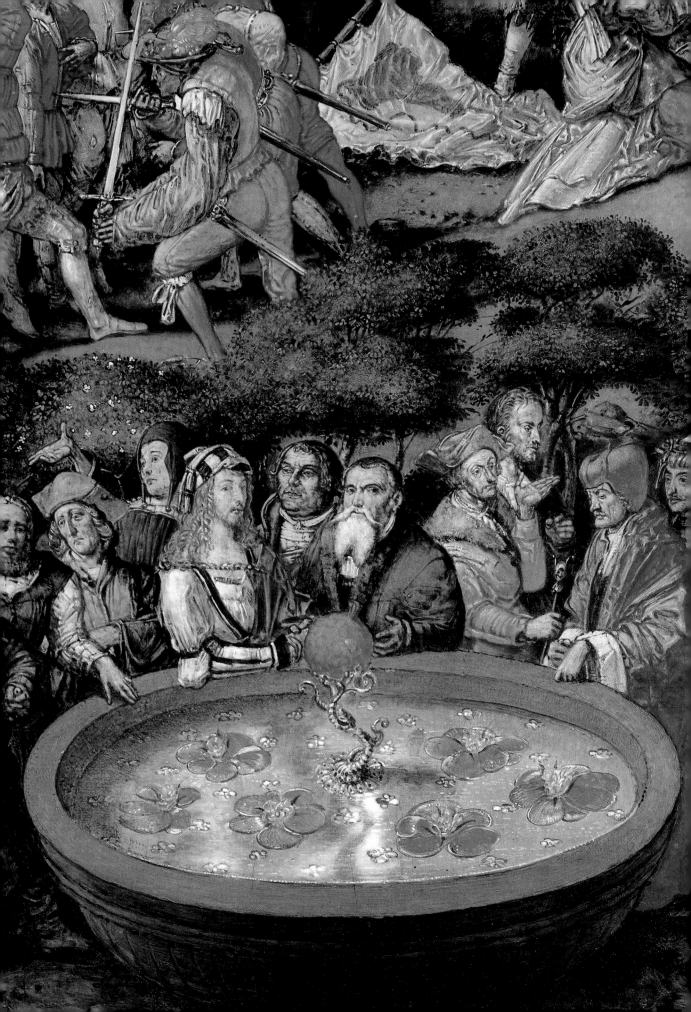

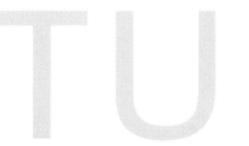

Taaffe, Philip. *1955 Elizabeth, New Jersey. American painter living in New York. He received his B.F.A. at Cooper Union in New York in 1977. He lived in Naples in 1989–91. After his work of the mid-1980s, which was based on appropriating pictures and pictorial elements from works of American abstraction and → Op art (→ Newman, E. → Kelly, → Riley), Taaffe's paintings of the late 1980s, besides ornamental ribbons, cords, and spirals, drew increasingly on an architectural wealth of items such as lathe-turned fragments of balcony balustrades and other, often symmetrical motifs from the decorative arts. Taaffe's interest in ornament and also its postmodern access to already existing abstract forms may be understood, on the one hand, as a critical dialogue with the achievements of abstraction and, on the other, as the utopian attempt to reformulate it in the age of → Postmodernism. A.G.

Bibl.: Taaffe, 1993 · Taaffe, 1996

Tabard, Maurice. *1897 Lyon, †1984 Nice. French photographer. After an early period as a portrait photographer in the US, Tabard returned to Paris in 1928, meeting → Man Ray, → Magritte, and the Surrealist author Philippe Soupault who introduced him to local fashion editors. In 1930 he produced his first "simultaneous impressions" (prints) based on multiple exposure, which were followed by *photograms* (see → Lissitzky, → Moholy-Nagy). In 1932, initiated by Man Ray into solarization, he went on to analyze the technique thoroughly, his surfaces being less fractured than → Ubac's. Working on the female nude and the still life, Tabard was employed as a freelance photographer, reproduced in publications as diverse as *Foto-Auge*, *Bifur*, and *Jardin des Modes*, producing fashion images of elegant poise. Latterly he worked as a staff photographer on *Harper's Bazaar*. D.R.

Bibl.: Gassmann, Tabard, 1987

tableau-objet (French = painting-object). Term used by → Picasso and → Braque to emphasize the autonomy of the picture and its independence from external sources (representational subjects and motifs). H.D.

Tachisme. Tachisme (Fr: *la tache* = smudge or stain) is a specifically French version of → Abstract Expressionism, which emerged in the 1950s. While not completely excluding mimetic, legible elements in analogy to nature, it does reject geometrical constructions and includes calligraphic methods and procedures, emphasizing the importance of the *matière* itself as an expressive medium as well as the spontaneous character of the act of painting. It is hard to draw a line between Tachisme on the one hand and → Art Informel, → Lyrical Abstraction, or → Art Brut on the other. C. Estienne tried to unite a group of Tachistes (including Jean Degottex [1918–88] and Simon Hantai [1922–]) under a common program at the Paris Salon d'Octobre (1950–55) from 1950 onwards, just as the periodical *Cimaise* promoted the painters of Lyrical Abstraction. After 1955, the term disappeared and the artists were absorbed by internationalization of Art Informel. W.S.

Bibl.: Ragon, Expression, 1951 · Mathieu, Tachisme, 1963

Tadeusz, Norbert. *1940 Dortmund. German painter living in Brunswick, Düsseldorf, and at Casa Testaferrata in Empoli. He began an apprenticeship as an interior designer, in 1960–61 at the Werkkunstschule, Dortmund; he then attended Düsseldorf Kunstakademie until 1966, initially working with Gerhard Hoehme (1920–89), then as a pupil of → Beuys. In 1973–81 he lectured at the Kunstakademie, Düsseldorf, in Münster. He was awarded the Villa Romana Prize in 1983. Until 1988 he was professor at the Kunstakademie in Münster, and until 1991 at the Hochschule der Künste, Berlin. Subsequently he was at the Hochschule für Bildende Künste, Brunswick.

Tadeusz produces figurative, highly expressive paintings with frequently alienating perspectives, in particular treating nudes, landscapes, interiors, horses, and slaughtered animals. S.Pa.

Bibl.: Nobis, Tadeusz, 1997

Taeuber-Arp, Sophie. *1889 Davos, †1943 Zürich. Swiss painter, sculptor, and textile artist. In 1908 she attended the Gewerbeschule in St. Gallen. In 1911–13 she trained at W. v. Debschitz's workshop in Munich. In 1916–28 she took up a teaching post at the Zürich Kunstgewerbeschule. In 1921 she married → Arp. From 1928 she lived in Meudon, near Paris. In 1930 she joined → Cercle et Carré, then → Abstraction-Création. In 1941–43 she lived in Grasse, near Nice with Arp, → Magnelli, and → Delaunay-Terk. In 1943 she returned to Zürich.

After training in the crafts, Taeuber-Arp participated with Arp in → Dada actions in Zürich and created → collages, embroidery, and drawings with mosaic structures; these were later superseded by symbolic and figurative depictions. Subsequently she tended increasingly towards → geometric abstraction including her design work for the interior of the cinema, restaurant, and dance hall Aubette in Strasbourg (1927–28; painted over in 1938). Her reliefs, sculptures and paintings, were an inspiration to Arp as well as constituting an independent contribution to abstract art. H.D.

Bibl.: Staber, Taeuber-Arp, 1970 · Taeuber-Arp, Strasbourg, 1977 · Lanchner, Taeuber-Arp, 1981 · Pagé, Taeuber-Arp, 1989

Takis (Panagiotti Vassilakis Takis). *1925 Athens. Self-taught, Greek-born sculptor living in Paris. He embarked on his first sculptural works in 1946. In 1953–54 he lived in London, and from 1955 in Paris. In 1968 and 1977 his work was exhibited at Documenta 4 and 6.

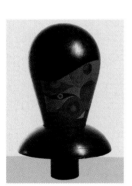

Sophie Taeuber-Arp, *Dada Head*, 1918–19, Painted wood, 34 x 20 x 20 cm, Musée National d'Art Moderne, Centre Georges Pompidou, Paris

◁ Werner Tübke, *Fountain of Life*, detail from *Early Bourgeois Revolution in Germany*, 1976–87, Oil on canvas, overall dimensions 14 x 123 m, Bad Frankenhausen (see p. 324)

Takis's early work comprised figurative sculptures influenced by the art of antiquity. After moving to Paris, he began an approach to → Kinetic art. His main concern in his art, which is mainly based on magnetism, is the visualization of invisible forces (e. g. thin rods with terminal electromagnets so as to create oscillations through magnetic fields). In his *Light Signals*, he studies the effects of light as a form of electromagnetic energy. From 1965, he developed *Musical Sculptures*, in which pins moved by magnetic forces produce sounds. Since the 1970s, this has been extended to create *Musical Spaces* → environments. I.H.

Bibl.: Pacquement, Takis, 1993

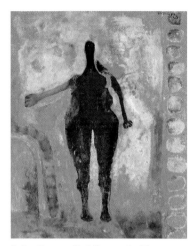

Rufino Tamayo, *Black Venus*, 1965, Oil on canvas, 100 x 81.2 cm, MacElheney Collection, Austin, Texas

Tamayo, Rufino. *1899 Oaxaca, †1992 Mexico City. Mexican painter. In 1911 he moved to Mexico City, studying from 1917 to 1921 at the Escuela de Artes Plásticas, where he also worked as a lecturer in 1928–29. In 1921–25 he became head of the ethnographic department at the Museo Nacional de Arqueologia, where he encountered Pre-Columbian art that would inform his own work. He lived in New York during two periods, 1926–28 and 1936–46. In 1938–47 he held a teaching post at Dalton School, and painted several murals. In 1946 he taught at Brooklyn Museum. 1949 found him in Paris, and in 1953 his work appeared in the Bienal in São Paulo, where he also painted a mural for the Unesco building. In 1960 he was awarded the Guggenheim Foundation Prize, New York. In 1964 he received the National Prize of Mexico.

Tamayo considered his art to be universal, although his roots lie firmly in Mexican culture. His painting is a rejection of → muralism, which is mainly concerned with political and social subjects. Tamayo dedicated himself more to a pictorial language, which he derived from European modernism. Nevertheless, the human form is central to his work, to which, in spite of its formal abstraction, he gives the greatest possible lyrical expression. E.B.

Bibl.: Paz, Tamayo, 1959 · Genaver, Tamayo, 1974 · Paz/Lassaigne, Tamayo, 1982

Tanguy, Yves. *1900 Paris, †1955 Woodbury, Connecticut. French painter. Following a stint as a merchant seaman, Tanguy was inspired to become an artist after glimpsing (reportedly from a bus platform) canvases by de → Chirico through the window of Paul Guillaume's gallery in 1923. Fired by → Surrealist tracts, Tanguy joined the group in 1925, remaining a faithful signatory and stalwart for many years (his disheveled head stands out in group photos of the "heroic" period). In 1939, he met the American painter Kay Sage; they married, eventually settling on a farm in Woodbury, Connecticut. Tanguy became a US citizen in 1946. In less straitened circumstances than before, he was able to travel and join up with, among others, → Miró, → Ernst, and M. → Duchamp. After a *naïf* phase (*At the Fair*, 1926, resembles → Rousseau), Tanguy emerged from the uncomposed automatism of *Il faisait ce qu'il voulait* (1927) into the unmistakable mature oils. Flat, half-marine backgrounds of melding, soft-hued stratus clouds are studded with telluric formations, petrified seashore animals or pebbles, floating on or scurrying over the indeterminate surface. These hypnagogic components may have been absorbed during sojourns in Brittany as a child and journeys to Africa (repeated in 1930). Shape is created by automatism (they "precipitate" out of the ground) but the thematic derives from an aesthetic of the vague. As Rudolf Arnheim has observed, Tanguy's "eerie landscapes" adhere to the "convention of naturalistically depicted space, light, and materiality": indeed, the objects even cast shadows. After an initial liquid stage, during the 1930s menhirs and "cliffs" (erected on stilts; *Indefinite Divisibility*, 1942) acquire a lapidary relief. Whereas earlier work generally laid out the features in bands at the base of the canvas, by later in the decade the upper picture space is invaded by increasingly modeled objects, often pierced by glass (or perhaps steel) blades, horizontal and vertical. By the 1940s the landscapes become less dreamlike, with interlocking forms resembling zinc, aluminum, or bone piling up along the edges above a distant "Martian" plain (*Anguish, II*, 1949). 1950s work depicted Giants' Causeway-like platforms. An important retrospective was held in 1955 at MOMA, New York. D.R.

Bibl.: Tanguy, Paris, 1982 · Tanguy, 1995

Tanner, Henry Ossawa. *1859 Pittsburgh, Pennsylvania, †1937 Paris, France. American painter. Initially self-taught, Tanner overcame racial prejudice to enroll at the Pennsylvania Academy of Fine Arts in 1880 and studied with the great American painter, Thomas Eakins (1844–1916). Inspired by the success of Edmonia Lewis (c. 1840–1909), Tanner dreamed of going to Rome. Following a brief stint as art instructor at Clark College in Atlanta, he traveled to Europe. In Paris, he studied at the Académie Julien under Jean-Paul Laurens. Finding the city to be free from racial prejudice and segregation, Tanner developed his own personal style, exchanging landscapes and portraits for expressions of freedom, peace, and religion. Like Rembrandt, Tanner used light to draw the viewer's attention to a specific, and often a very dramatic point with the use of shading. Examples include *Banjo Lesson* (1893) *Daniel in the Lions' Den* (1896). With the acquisition of a landscape in 1996, Tanner

Yves Tanguy, *Paysage surréaliste*, 1927, Oil on canvas, 100 x 81 cm, Staatliche Kunsthalle, Karlsruhe

became the first African-American artist represented in the permanent collection of the White House in Washington, D.C. J.S.

Bibl.: Matthews, Tanner, 1969 · Mosby, Tanner, 1995

Dorothea Tanning, *Mohn-Hotel, Room 202*, 1970, Environment, Musée National d'Art Moderne, Centre Georges Pompidou, Paris

Tanning, Dorothea. *1910 Galesburg, Illinois. American painter. Tanning returned to New York in 1939 after a visit to Paris during which she had become intrigued by → Surrealism. In 1942, she met → Ernst; they married and moved to Arizona (interesting film footage survives of their house in the desert). Tanning returned to Paris in the 1950s; she now lives in the US. The pretty teenagers in her luridly colored, academically painted early canvases are misguided but not – as in → Bellmer or Leonor Fini (1908–96) – obscene. In a disturbingly "Gothick" atmosphere of pointed arches (close to Leonora → Carrington), benighted adolescent girls are ensnared in expansive drapery: Mannerist in *Palaestra* (1947); aggressive in *Anges gardiens* (1946); tattered in *La Chambre des Amis* (1950–52). *Birthday* (1942; also the title of a 1988 autobiography) shows a coral-encrusted woman next to an *enfilade* of half-open doors (a classic "screen image"). *Eine Kleine Nachtmusik* (1946) presents schoolgirls pursued by (perhaps) a sunflower "Triffid." Sometimes an infant-cum-King Charles spaniel, "Katchina" (redolent of babyhood photographs of the artist), observes the proceedings. The theme is femininity, its solitude and constraints (*Maternity*). Works of the 1950s–60s are painted more loosely, in a → Matta-like firefly radiance (*Deux Mots*, 1963; more abstract in *Cataclysme*, 1961). In the 1960s Tanning made ballet designs and fantastical textile sculpture. D.R.

Bibl.: Bousquet, Tanning, 1966

Tansey, Mark. *1949 San Jose, California. American painter, living in New York City. After a time as a studio assistant to → Frankenthaler and a stint at the Whitney Museum, Tansey developed into a foremost exponent of "post-modern" painting (mid-career retrospective, Museum of Fine Arts, Boston, 1994). His first important "statement" was a *Short History of Modernist Painting* (1979–80), a multi-layered frieze based on popular imagery bearing no obvious relation to aesthetics. His later works (often in a single tone) are "illustrations" of cultural history: *The Innocent Eye Test* (1981), shows Paul Potter's Baroque *The Young Bull* (1647) being presented to a real cow; *Derrida Queries De Man* (1990) has two figures: Sherlock Holmes with Moriarty on the Reichenbach Falls and philosopher Jacques Derrida "wrestling" with critic Paul De Man; *Mont Sainte-Victoire* conflates Cézanne's *Bathers* with his favorite mountain. "I think of the painted picture as an

embodiment of the very problem we face with the notion of 'reality'" (M. T.). D.R.

Bibl.: Freeman, Tansey, 1993

Tàpies, Antoni. *1923 Barcelona. Spanish painter, graphic artist, and sculptor living in Barcelona. In 1943–46 he studied law in Barcelona, and in 1948 was co-founder of the → Dau al Set group. In 1956 he traveled to Italy, and in 1959, 1964, and 1977 his works were exhibited at Documenta 2, 3, and 6. In 1981 he was awarded the Gold Medal of the Spanish State, and received an honorary doctorate from the Royal College of Art, London. 1987 saw the opening of Fundació Antoni Tàpies.

In the Barcelona art scene, Tàpies encountered → Surrealism, and was also heavily influenced by Catalan culture, which in his early work he translated into Surrealist landscapes. With a study grant to work in Paris, Tàpies discovered → Art Autre, then in fashion, and → Dubuffet's and → Fautrier's sculptural works that induced him to create similar structures. Using oil paint mixed with sand and other materials, he scratched ambiguous, mysterious signs reminiscent of graffiti on Paris walls which referred to his studies of occult and esoteric writings (*Painting with Red Cross*, 1954). → Mixed media and found objects were also introduced into the works, rejecting any tendency towards a decorative appeal. This radical anti-aesthetic continued into the sculptural objects of the 1970s. His works are intended to function like an intellectual map on which the fragments and signs of a mental reality that have been submerged in a technocratic culture are to be found. In his writings, Tàpies severely criticizes the one-sided rationality of capitalist society as well as any kind of cultural dirigism. His anti-aesthetic heavily influenced the development of contemporary art (e. g. → Beuys and → Twombly). H.D.

Bibl.: Cirici, Tàpies, 1972 · Penrose, Tàpies, 1978 · Franzke, Tàpies, 1992 · Wye, Tàpies, 1992 ·· Giménez/Ashton, Tàpies, 1995 · Agustí, Tàpies, 1988–1997

Antoni Tàpies, *Metal Door with Violin*, 1956, Paint and violin on metal door, 200 x 150 x 13 cm, Fundació Antoni Tàpies, Barcelona

Antoni Tàpies, *Painting with Red Cross*, 1954, Oil on canvas, 195 x 130.5 cm, Kunstmuseum, St. Gallen

Tatlin, Vladimir. *1885 Moscow, †1953 Moscow. Russian painter, sculptor, and designer. He studied painting in Moscow (at the School of Painting, Sculpture and Architecture). In 1904–09 he attended art school in Penza (studying Russian icon painting), and as a sailor traveled to Egypt and Syria. After the 1917 Revolution, he worked actively in areas of cultural reorganization, e.g. his 1919–20 work on the tower for the alternative Monument to the Third International (a utopian synthesis of Tatlin's material art and futuristic kinetic popular architecture). In 1921–25 he became head of the department of material culture at the State Institute of Artistic Culture (→ Inkhuk). In 1925–27 he taught at the Kiev Art Institute, and in 1927–33 was a teacher of product design at the Vkhutein (Higher State Art Technical Studio, subsequently the Institute of Silicates). He opened his first studio in Moscow. Meetings with the Cubo-Futurists took place in St Petersburg and Moscow via → Larionov and D. → Burliuk.

In 1910–11 Tatlin produced drawings and paintings on the lives of fishermen and boatmen (*Sailor (Self-Portrait)*, 1911) in a Neo-Primitivist synthesis of French avant-garde and Russian icon painting. In 1912–13 he worked on female nudes using the same decorative curved style. He transferred this style of painting to theatrical set designs (e.g. for the operas *A Life for the Tsar*, 1914, and *The Flying Dutchman*, 1915). In 1914 he was in Berlin and Paris, where he was particularly influenced by → Picasso's Cubist work. Back in Moscow, his first painterly reliefs were produced out of wood, metal, glass, and cardboard (synthesostatic compositions). These tactile, material compositions had a great influence on the Russian avant-garde competing with → Malevich's philosophy of art as a symbol of a non-objective world. This rivalry culminated in the Last Futurist Exhibition 0.10, where Malevich unveiled his abstract → Suprematism and Tatlin showed 15 counter reliefs, and free-hanging corner counter-reliefs. Tatlin will be remembered as the founder of Russian → Constructivism in its most ergonomic form, enabling the transition from painting and reliefs to product design. In 1923 he brought his material culture to bear on experimental stage sets for Velemir Khlebnikov's (1855–1922) acoustic theater, Zangezi. In 1929–32 he worked on a manpowered glider called Letatlin (an organic alternative to powered flight). Under the influence of Formalism, Tatlin returned to painting after 1933 (portraits, landscapes, still lifes) and also created theatrical set designs. H.G.

Bibl.: Larissa, Tatlin, 1984 · Harten, Tatlin, 1993 · Tatlin, Cologne, 1993

Tchelitchew (Tchelitchev, Tchelitcheff, Chelichev),
Pavel. *1898 Kaluga, †1957 Grottaferrata, Lazio, Italy. Russian-American painter and stage designer. After attending art classes at the University of Moscow (1916–18) and at the Kiev Academy (1918–20), Tchelitchew produced early work in a somewhat muted → Cubo-Futurist style influenced by → Exter. In Paris by 1923, his style mutated: new work incorporated cosmic emblems such as eggs, centered on a versatile treatment of the figure that soon attracted other artists (the "Néo-Humanistes"). Classically drawn, if strange,

Vladimir Tatlin, *Letatlin*, 1929–32, Different materials, 110 x 1070 x 190 cm, State Museum for Air and Space Travel, Monino

Parisian themes became more "visionary," with highly charged portraits (*Madame Bonjean*, 1931; portrait with tiny acrobats). Once in the US (1934), he created a cycle that symbolized the passage of the soul after death and the harmony of universe through an idiosyncratic reading of Pythagoras, theology, and Florentine humanism (the verdant *Phenomena*, 1936–38; *Cache-cache*, 1940–42). Tchelitchew was also a first-rate stage designer (e.g. *Ondine*, 1939). D.R.

Bibl.: Kirsten, Tchelitchew, 1994

Teige, Karel. *1900 Prague, †1951 Prague. Czech painter and book illustrator. A leading theoretician of the Czech avant-garde between the two world wars, Teige was also active in the fields of architecture, photography, typography, film, and theater. In 1920 he was co-founder and theoretician of the group Devětsil publication *ReD*) which linked authors, architects, and artists and which, after its initial, socially engaged activities, turned its attention mainly to → Constructivism and → Magic Realism. In 1924 Teige launched Poetism, formulating its program in the "Manifesto of Poetism." In 1934 he was co-founder of the Prague Surrealists (until 1947); he also maintained close contact with the Paris section. A special artistic genre of Poetism influenced by Dadaism (→ Dada), the picture poem, was developed by Teige, with the text and image complementing and enhancing each other. From 1927 to 1929 he worked on book covers and cover pages for among others, *ReD* where he combined photocollages with modern typography. From 1934 he made Surrealist → collages, producing his most important works between 1939 and 1942. Teige is regarded as a pioneer of this genre. E.R.

Bibl.: Teige, Houston, 1990 · Teige, Prague, 1994 · Teige, Frankfurt, 1998

Karel Teige, *Collage no. 353*, 1948

Ten, The. Group of American painters from Boston and New York, who exhibited together in 1898–1919 after splitting from the Society of American Artists, whom they considered too conservative. Most of them had studied in Paris and were influenced by Impressionism. They includ-

ed Frank W. Benson (1862–1951), William M. Chase (1849–1916), and Childe Hassam (1859–1935). This informal grouping was the predecessor of The → Eight and the → Armory Show.

The Ten was also the name of a group of American painters who exhibited in New York between 1935 and 1939, of whom the most famous were → Gottlieb and → Rothko. Artists of both abstract and figurative schools belonged to this very heterogeneous group. H.D.

Thiebaud, Wayne. *1920 Mesa, Arizona. American painter living in California. He began his artistic life in 1938–49 as a cartoonist and commercial artist for Hollywood film studios. In 1949–51 he studied art at State College in Sacramento, California. Up until 1959, he was a lecturer at the Art Department of Sacramento City College, then professor at the University of California in Davis. This representative of hard-core painting within → Pop art started his famous series of still lifes in 1961, featuring cakes, pies, and ice-cream cones, as they are sold in American drugstores. Because of his true-to-life representations of figures and landscapes (*Urban Freeways,* 1979–80) he is considered to be a predecessor of → photorealism. S.Pa.

Bibl.: Tsujimoto, Thiebaud, 1985

Thorn Prikker, Jan. *1868 The Hague, †1932 Cologne. Dutch painter and designer. In 1881–87 he studied at the academy in The Hague, later becoming artistic director of an Arts and Craft shop there. Between 1904 and 1910 he taught at the Kunstgewerbeschule in Krefeld, then at the Folkwang School in Hagen and Essen. In 1919–23 he was at the Akademie in Munich, then for three years at the Düsseldorf Kunstakademie, and 1926–32 at the Kunstschule, Cologne.

The work of this symbolist painter was strongly influenced by Japanese woodcuts and the religious ideas of the → Nabis. After early Pointillist experiments he turned to the linear style of

→ Jugendstil. He was also active in various areas of the arts and crafts and created numerous stained-glass windows, e. g. the cycle of St. George in Cologne (1930). S.Pa.

Bibl.: Wex, Thorn Prikker, 1984

Tinguely, Jean. *1925 Fribourg, †1991 Berne. Swiss sculptor who trained at the Kunstgewerbeschule in Basel. From 1953 he was in Paris, where in 1955 he met → Saint Phalle, with whom he lived and worked since the 1960s. In 1960 he was co-founder of the Nouveaux Réalistes (→ Nouveau Réalisme). He is the most important exponent of → Kinetic art. The leitmotif of his art is movement that can be experienced acoustically or visually. The raw materials of his sound-producing, motor-driven machine sculptures are often metal parts retrieved from the scrapyard. The viewer is often involved in artistic happenings as an active participant. The *Métamatics*, which he has been making since 1959, painting machines, with which the user can create art. These humorous works, that were often created within → happenings in the framework of → Performance art, reflect an enthusiasm for technology, and in their absurdity and pointlessness make an ironic comment on the modern industrial world as well as the commercial side of art. They can be understood analogously to his auto-destructive machines (since 1960). Between 1964 and 1979, his works took on increasingly monumental, sculptural proportions, the movements having been simplified and unified by being painted black. He built a large, walk-in *Nana* (*Hon*) with Saint Phalle and → Ultvedt in Stockholm in 1966. From 1969 he worked on his construction of *Cyclops*, a giant, grotesque sculpture in the woods near Fontainebleau. Besides Saint Phalle, he has worked with Bernard Luginbühl (1929–), Jean-Pierre Raynaud (1939–) and others. Tinguely has made several fountains for public spaces (Basel 1977, Paris 1983, with Saint Phalle) which feature playful elements. He also created auto-sculptures from rusting car bodies. In the early 1980s, a creative phase of baroque, almost unfettered abundance began. With light bulbs and animal skeletons, new materials appeared, and altar-like compositions awakened religious associations (*Mengele-High Altar*, 1986). The amusing, humorous tone increasingly makes way for a demonic, chaotic language, reflecting an engagement with the theme of death. A substantial proportion of his work has been on show at the Tinguely Museum in Basel since 1996. I.H.

Bibl.: Hultén, Tinguely, 1975 · Bischofberger, Tinguely, 1982 · Hultén, Tinguely, 1987 · Violand-Hobi, Tinguely, 1995 · Tinguely, Basel, 1996

Tobey, Mark. *1890 Centerville, Wisconsin, †1976 Basel. American painter. From 1906 to 1908 he studied at the Art Institute of Chicago. Early work included graphic art for fashion studios. In 1917 he had his first one-man exhibition at the Knoedler Gallery, New York. In 1922–25 he studied calligraphy and composition at the University of Seattle, also holding a teaching post at the Cornish School there. In 1931–38, he taught at Dartington Hall School, Devon. In 1935 he spent time in a Zen monastery in Japan to study calligraphy.

Mark Tobey, *White Journey*, 1956, Body color in paste binder on paper mounted on Pavatex, 113 x 89.5 cm, Fondation Beyeler, Riehen

1938 saw the production of musical compositions. In 1958 his work was shown at the Venice Biennale where it won the painting prize. In 1959 and 1964 he appeared at Documenta 2 and 3. Since 1960 he has lived in Basel. The painter J. Thompson introduced Tobey to the Bahá'í religion, a universal synthesis of eastern religions influenced by Islam. Tobey has been interested all his life in spiritual doctrine, which has also had an effect on his pictorial style. Initially figuratively orientated, from 1935 he developed a style of written characters influenced by eastern calligraphy, consisting of a network of white lines on a dark background, in which figurative motifs and symbols were at first integrated. (*Red Man – White Man – Black Man*, 1945). This style was subsequently refined, with delicately interwoven lines (→ all-over painting) rhythmically covering the whole picture area (*Wild Field*, 1959).

Tobey conceived of his work in paint and in print as a unity of form and movement in the universe, as a varied expression of oneness inherent all things. In spite of the meditative aura of his pictures, his work had a great influence on the gestural style of → Abstract Expressionism as well as European → Art Informel. H.D.

Bibl.: Tobey, Washington, 1974 · Dahl, Tobey, 1984 · Rathbone, Tobey, 1984 · Bärmann, Tobey, 1997

Toledo, Francisco. *1940 Juchitán, Mexico. Mexican painter and graphic artist, working also with ceramics and bronzes; lives in Oaxaca state. He studied art in Mexico City, and spent time in Paris (1960–65 and 1984). He has also spent time in New York. Since 1987 he has lived in Mexico, receiving the Mexican national prize in 1998.

Toledo occupies an important place in Mexican contemporary art. His work weaves together particular myths from the cultural past with his own personal memories. His Zapotec heritage is a vital element in his works: man and the animals enter into a mystical relationship, and this unity of being constitutes an inexorable certainty for Toledo. E.B.

Bibl.: Cardozo, Toledo, 1967 · Billeter, Toledo, 1995

Tomasello, Luis. *1915 La Plata, Argentina. Argentinian-born light artist living in Paris since 1957. In 1932–40 he attended the Escuela Nacional de Bellas Artes, La Plata; in 1940–44 the Escuela Nacional de Bellas Artes, Buenos Aires. Since 1951 he has lived in Europe, joining the group of Argentinian artists in Paris in 1957. In the late 1950s, he produced his first relief-like objects in white wood, or polyester prisms on white geometrical planes. Their effect is based on the multiple refraction of light. The principle of this work, referred to by Tomasello as "Atmosphère Chromoplastique", was transferred to large-scale murals. He has received numerous public commissions (e. g. Palais des Congrès, Paris). S.Pa.

Bibl.: Tomasello, 1976 · Tomasello, 1991

Tomlin, Bradley Walker. *1899 Syracuse, New York, †1953 New York City. American mainly abstract painter. After training at Syracuse University (1917–21) he worked as a commercial illustrator, traveling to Europe in the 1920s. Like many Americans, significant paintings of the late 1930s used Surrealist imagery (*Outward Preoccupations*, c. 1939); also semi-abstract still lifes (*The Goblet*, 1940). A friend of → Guston at Woodstock, he formed an association with → Gottlieb and others. From 1948, now influenced by → Miró, Tomlin formed part of → Abstract Expressionism: on → all-over canvases neutrally entitled with number and year there swarm understatedly chromatic dashes, "T"s, hatches, swirls, and right angles, calligraphics that are inscribed, positioned or swept rather than scribbled or thrown. This poetical, controlled style is closer to Gottlieb, → Mitchell (*Number 5 – 1952*), → Frankenthaler, and late 1940s → Kline (*Number 9 – 1950*) than to e. g. → Pollock. D.R.

Tonalism. An important stage in the evolution of American landscape painting around the turn of the 20th century. Retrospectively christened, the tendency was enshrined by a 1972 exhibition in San Francisco, "The Color of Mood: American Tonalism 1880–1910." It covers "poetical," evenly brushed nightscapes and mist pieces, subdued in color and closely allied in mood to experiments in "soft-focus" pictorial photography. Leaving off the contrastive treatment of The → Eight and of French Impressionism and Belgian → Post-Impressionism (evident even in evening pieces), the painters of "Quietism" as it was also known combined elements from Turner, Claude, Whistler, and the more intimate American → Luminism in subtle, graded treatment of light and shade. George Innes Snr. (1825–94), Dwight Tryon (1849–1925), and Thomas Dewing (1851–1938) were central figures. D.R.

Toorop, Charley. *1891 Katwijk, †1955 Bergen. Dutch painter. After taking up music, Charley Toorop became a painter in 1914, with initial training under her father, Jan → Toorop. First fruits bore the stamp of Toorop the elder's early → Art Nouveau style, but soon Van Gogh became the preponderant influence, though Jan's subtly → Expressionist late style may have also have had a hand in her development. In the 1930s she

painted rather → Neue Sachlichkeit landscapes (some with a → social realist cast), while the 1940s brought a concern with Neo-Cubist space. D.R.

Toorop, Jan. *1858 Poerworedjo, Java, †1928 The Hague. Dutch painter. Born in Indonesia, Toorop did not leave for Europe until age 13. Study in various Dutch art schools (1876–88) followed. He was a member of Les XX and exhibited at the Vienna Secession. Toorop's middle period is dominated by → Post-Impressionist → Intimisme (*Trio fleuri*, 1885–86), printmaking (especially 1892–95), and large → Symbolist works in a "*cloisonné*" style (*O Grave, where is thy Victory*, 1892) associated with Jan Thorn Prikker (1868–1926). The isolation of the figure elements and the solemnity of the events has parallels with literature and stained-glass window design. His *pointillé* → divisionism became freer in the 1900s, the points being squared (like → Signac's), but assembled in a manner (*The Middelburg Canal at Flessingue*, 1907) closer to Theo van Rysselberghe (1862–1926). Applied art (tiles, clayware) increased in importance for him throughout the 1900s. From c. 1912, a hint of → Expressionism surfaces in his energetic portrait studies (graphic and painted). D.R.

Bibl.: Grinten, Toorop, 1983

Torres-García, Joaquín. *1874 Montevideo, †1949 Montevideo. Uruguayan painter, who moved to Catalonia in 1881. In 1892–95 he attended the Real Academia de Catalunya and Cercle Artistic de Sant Lluc in Barcelona. Between 1903 and 1908 he received numerous public commissions for frescoes (since destroyed). In 1904 (with Gaudí) he worked on stained-glass windows for the cathedral in Palma, Mallorca, and the Sagrada Familia in Barcelona. From 1920 to 1922 he was in New York, then in 1924 in Villefranche-sur-Mer, France. In 1926 he had his first exhibition in Paris, and settled there. Contacts with the artistic avant-garde included → Vantongerloo, van → Doesburg and → Mondrian. In 1930 he co-founded → Cercle et Carré. In 1928, influenced by Pre-Columbian art, he developed the style and philosophy for his universal from of → Constructivism. In 1934 he returned to Uruguay, where he engaged in writing and teaching; in 1944 he founded the Taller Torres-García (a forum for teaching and collective work). After producing pictures and frescoes influenced by the Symbolist Neo-Classicism of Catalan Noucentisme, Torres-García experimented with a schematic graphic style developed since his trip to New York. His first stay in Paris led to the final formulation of his painterly style and its theoretical basis, under the influence of → Neo-Plasticism and the discovery of ancient American art. His compositions, with earth-colored and impasto paint, is determined by a right-angled grid constructed following the rules of the golden section, into which he placed symbols, geometrical signs, pictograms, and written characters. Torres-García's achievement was to link a modern European, Constructivist style to a highly significant South American pictorial and written culture. His teaching and writing led to the founding of the Southern School, and has influenced art in Uruguay, Brazil, and Chile up to the present day. A.G.

Bibl.: Torres-García, London, 1985 · Torres-García, Madrid, 1991 · Ramirez, Torres-García, 1992

Toyen, *À la table verte*, 1945, Oil on canvas, 110 x 160 cm, Private Collection, Paris

Toyen (Marie Čerminová). *1902 Prague, †1980 Paris. Czech-born painter. She spent 1925–28 in Paris with her partner, the painter, → Štyrský. In 1934 she was co-founder of the Prague Surrealists (first exhibition in 1935), and in touch with → Breton and the poet Paul Éluard. After the German occupation in 1939, further exhibitions were prohibited. She helped to hide the poet Jindrich Heisler from the Nazis. She translated the French writers Arthur Rimbaud, Lautréamont, Alfred Jarry, and Guillaume Apollinaire into Czech. She lived in Paris with Heisler from 1947.

Her early paintings in the 1920s were influenced by popular Cubist styles, but later superseded by distinctly simple landscapes. She began her first Surrealist pictures with J. Stýrsky in 1929. From 1935, she was encouraged by Breton and → Ernst – who recognized her talent – to exhibit at all international exhibitions of Surrealism (except 1939–45). One of the main subjects of her pictures is fear. In *The Dangerous Hour*, an eagle with red eyes fills the entire canvas. From its wings, human hands are growing and grasping at a wall studded with glass splinters. S.Pa.

Bibl.: Ivsic, Toyen, 1974 · Bischof, Toyen, 1987

Transavantgarde (Italian: *transavanguardia*). Term coined by the art critic Achille Bonito Oliva for a group of Italian painters including → Chia, → Clemente, → Cucchi, Nicola de Maria (1954–) and → Paladino. As a reaction against → Minimal art and → Conceptual art, these artists brought together a return to classical easel painting with an interest in myths and legends, a recourse to sources in art history with a conscious mixing of styles (→ Postmodernism). H.D.

Bibl.: Oliva, Transavantgarde, 1982

Joaquín Torres-García, *Figure in Red*, 1931, Oil on wood, 44.5 x 15.2 cm, Bernard Chappard Collection, New York

Joaquín Torres-García, *Street Scene*, 1930, Oil on card, 55 x 77.5 cm, Eduardo F. Constantini and María Teresa de Constantini Collection, Buenos Aires

Tremlett, David. *1945 St Austell, Cornwall. British Conceptual artist living in Bovington, Hertfordshire. In 1962–63 he attended Falmouth School; in 1963–66, Birmingham Art School; in 1966–69, the Royal College of Art, London. Initially working with photography and sound recording, he later turned to drawing and pastels.

Starting from sketchy notes, Tremlett composes large-scale figurative abstract forms in subtle color, using cryptic signs (also written characters), to refer to personal impressions and feelings he has experienced on his travels through landscapes, everyday habits, and encounters. K.S.-D.

Bibl.: Tremlett, Paris, 1985

Trockel, Rosemarie. *1952 Schwerte. German sculptor, Installation artist, and media artist living in Cologne. In 1974–78 she studied painting at the Werkkunstschule, Cologne. 1991 saw her retrospective in the US, among other places at the Institute of Contemporary Art, Boston. Since 1997 she has been professor at the Düsseldorf Kunstakademie, and in the same year her work was shown at Documenta 10. In 1999 she exhibited at the Venice Biennale.

Trockel's work is about patterns of thought and behavior in western society, the marketing mechanisms which influence and determine it, and about the commercial aspects of art. Using the aesthetic of professional advertising, she provokes associations and destroys received ideas, e.g. "typically female" art, by seemingly making use of cliché itself. But on closer inspection her provocative attitude is revealed. Her "woolmark" seal of quality has become famous through her knitted works. Recently she has made increasing use of film and video (e.g. at the Venice Biennale, 1999). I.S.

Bibl.: Trockel, London, 1998

Truitt, Anne. *1921 Baltimore, Maryland. American sculptor. Although seldom grouped with Minimalist peers such as → Judd, → Morris, or Tony → Smith, Anne Truitt was producing proto-minimalist, monochrome, primary forms as early as 1961. Like others in the → Minimalist camp, Truitt was concerned with ideal forms and viewer context; however, as the 1960s progressed, she also became interested in the coloration of her free-standing aluminum or wooden columns and boxes. By applying both pale and bright colors to her constructions – in bands or broad fields – Truitt achieved an optical flattening of their volumes. During this time she was also in close contact with → Color Field painters K. → Noland and → Louis. The resulting back-and-forth movement between the objecthood and pictorialism of her sculptures, what she has called "the counterpointing of shape and color," makes them resistant to categorization. Truitt studied at the Institute of Contemporary Art in Washington, D.C. (1948–49), and the Dallas Museum of Fine Arts (1950). In 1973 she had a retrospective of her work at the Whitney Museum of American Art. C.S.

Bibl.: Truitt, Daybook, 1982

Tübke, Werner. *1929 Schönbeck, Elbe. German painter, who trained as a painter in Magdeburg after 1945. In 1950–54 Tübke studied art education and psychology in Leipzig. In 1956 he became senior assistant at the Leipziger Hochschule für Grafik und Buchkunst. In 1971 he traveled to Italy, having exhibitions in Milan, Florence, and Rome. In 1970 he taught at the Leipzig Hochschule. In 1978 he met de → Chirico in Rome, and in 1987 he completed a monumental painting in Bad Frankenhausen. Together with → Heisig and → Mattheuer, Tübke has had a particularly formative influence on the so-called Leipziger Schule.

In the 1960s, he was already influenced by historical models, and studied early Dutch and German painting. When he showed the third version of the picture *Memoirs of Dr. jur. Schulze* at the 7th regional art exhibition in Leipzig in 1965, he set off a violent debate as to whether dealing with historical styles in such a virtuoso manner did not violate the demands of → Socialist Realism. Tübke masters the entire gamut of world art; in a meticulous, naturalistic style, he presents his intellectual, polyvalent pictorial inventions which culminated in the monumental *Early Bourgeois Revolution in Germany* in Frankenhausen, on which he worked from 1976–87. E.H.

Bibl.: Meißner, Tübke, 1974 · Beaucamp, Tübke, 1988 · Tübke, Bad Frankenhausen, 1999

Tucker, Albert. *1914 Melbourne, Australia, †1999 Self-taught Australian painter, graphic artist, and photographer. He was called up for military service between 1939 and 1945, traveling to Japan in 1947. He also lived in London (1947–48), France (1948–50), Germany (1951), Italy (1952–56), London (1956–58), and New York (1958–60). He also produced theoretical work ("Antipodean Manifesto" in favor of figurative art, 1959). In 1960 he returned to Melbourne.

Tucker's painting and photography is socially engaged, showing particular concern for the Aboriginals, about whose issues he has written several times. His portraits and landscape scenes took up subjects from daily life in Australia (e.g. bush clearance) and were influenced by the dense painterly texture of A. → Burri and → Tàpies (e.g. series *Images of Modern Evil* 1943–46). K.S.-D.

Bibl.: Tucker, Melbourne, 1998

Tucker, William. *1935 Cairo. Egyptian-born sculptor living in London and the US. In 1955–58 he studied history in Oxford, and in 1959–60 sculpture at St Martin's School of Art, London. In 1963 he had his first one-man exhibition. In the 1960s and 1970s he was a critic, theoretician, and head of the English Minimalists. In 1972 he showed at the Venice Biennale. From 1978 he was in New York, where he taught at Columbia University from 1978–82. In 1986 he took US citizenship. Tucker saw himself as a follower of M. → Duchamp and → Brancusi. His early work comprises object-like sculpture in steel and wood (also plastic and fiberglass), which he uses in abstract, largely geometrical forms (circles, arches, ellipses, and triangles); from 1985 he worked on open, structured surfaces (→ Rodin). Seemingly figurative series (heads) and abstract associa-

Werner Tübke, *Fountain of Life*, detail from *Early Bourgeois Revolution in Germany*, 1976–87, Oil on canvas, overall dimensions 14 x 123 m, Bad Frankenhausen

James Turrell, *Side Look*, 1992, Installation with fluorescent light, tungsten fanlight and daylight, Städtische Galerie im Lenbachhaus, München

tions with nature show his interest in the phenomenon of weight and gravity and their opposites. K.S.-D.

Bibl.: Tucker, Washington, 1984 · Ashton, Tucker, 1987

Turcato, Giulio. *1912 Mantua. Italian painter and sculptor. He attended several Venetian art schools (1920–26); in 1934 he performed military service in Sicily; in 1939 he relocated to Milan. In 1943 he moved to Rome where he was active in the Resistance and became co-founder of numerous artistic groups, including: 1945, Art Club; 1946, → Fronte Nuovo delle Arti; and 1947, → Forma 1. He lived in Paris in 1950. In 1958 he showed at the Venice Biennale; in 1959 at Documenta 2; and in 1973 at the São Paulo Bienal. In 1984 he created scenery for Petrassi's "VIII Concerto" at the Rome Opera, as well as for his own opera "Turcato/Moduli in viola/Ommaggio a Kandinsky" at the Venice Biennale. At first wavering between abstraction and figuration, by the beginning of the 1950s Turcato was developing a calligraphic style of painting along the lines of Surrealist → automatism. The resulting series link the sensitization of the painting's surface (by means of → collage and different materials) with a colorful use of lettering (→ Nay) (for example *Ricordo di New York*, 1963). In later works the "fare pittura" espoused the most diverse means (determined by gesture, structure of spots, ideograms, materials, and color field). This freedom of techniques which Turcato brought into the realms of → Transavantgarde, also influenced his polychrome objects and sculptures (*La Libertà*, 1973–83). H.D.

Bibl.: Stabenow, Turcato, 1985

Turnbull, William. *1922 Dundee, Scotland. British painter living in London. In 1939–41 he worked as an illustrator for the magazine and comic publisher D. C. Thompson in Dundee. From 1946 to 1948 he studied at the Slade School of Fine Art, London. 1948–50 he spent in Paris. Since 1950 he has lived in London. 1952–61 and 1964–72 were period of teaching at the Central School of Arts and Crafts, London. In 1957 he traveled to the US; in 1962 to Japan, Cambodia, and Malaysia. Encouraged by → Brancusi and → Giacometti, whom he met in Paris, he produced sculptures which, under the influence of → Surrealism and → primitivism, he later developed into archaicizing sculptures resembling idols (*Idol 5*, 1957). In the 1960s, he moved on to geometrical steel constructions in a Minimalist style, corresponding to his → Color Field Paintings. H.D.

Bibl.: Turnbull, 1996

Turrell, James. *1943 Los Angeles. American Light artist living in Flagstaff, Arizona and Inishkeame in the West of Ireland. In 1961–65 he studied experimental psychology and mathematics at Pomona College, Claremont, California. From 1966 Turrell dedicated himself exclusively to art, his early interest being in the exploration of light and space → Light art. In the early *Shallow Space Constructions*, beams of light from hidden projectors divide the darkened room into seemingly intangible surfaces of light (*Wedgewood III*, 1969). In the *Mendota Stoppages* (1969–74), Turrell develops experiential spaces filled with light, that can be entered and which disrupt the viewers' perception, for example, so-called *Ganzfeld Pieces* (*Danae*, 1983). These light spaces are complemented by *Dark Pieces*: rooms in which the viewer is made aware of his own perceptions through low-level light stimuli (*Pleiades*, 1983). In the landscape piece, *Roden Crater Project* (from 1981), a nature observatory planned in an extinct volcanic crater near Flagstaff, Arizona, rooms, tunnels, chambers, and zones enable light phenomena through the use of natural illumination, thus linking human perception with cosmic events. H.D.

Bibl.: Adock, Turrell, 1990 · Helfenstein/Schenker, Turrell, 1991 · Svestka, Turrell, 1991 · Turrell, London, 1993

Tuttle, Richard. *1941 Rahway, New Jersey. American sculptor, painter, and draftsman living in Santa Fe, New Mexico. In 1962 he studied at the Pratt School of Design, Brooklyn, and in 1963 at Trinity College, Hanford, Connecticut; in 1963–64 he attended the Cooper Union School of Art and Architecture, New York. Since 1965 he has been represented by the Betty Parsons Gallery, New York. In 1968 he traveled to Japan, where he studied Far Eastern culture and philosophy. In 1972 he had a one-man exhibition at MOMA, New York. He exhibited his work at Documenta 5, 6, and 7; and at the 1976 Venice Biennale. Tuttle's work transcends the boundaries of

Richard Tuttle, *Pink Oval Landscape*, 1964, Painted canvas on 4 wooden supports, 43.5 × 9 × 16 cm, Private Collection

various art forms, merging the standpoints of → Hard-Edge Painting, → Minimal art, and → Pop art. His assemblages of mundane found objects (e.g. styrofoam packaging, scraps of cable, nails, note pads) seem unpretentious and random; minimal interventions in the material elevate them from everyday objects to art. His work seems fragile and ephemeral. In the course of the production process, the tendency towards dematerialization becomes apparent, e.g. in the *wire pieces* consisting of a combination of pencil marks on the wall, wires that emphasise space, and their shadows. When setting up an exhibition, Tuttle attributes great significance to the relationship between the work and its given surroundings. I.S.

Bibl.: Tuttle, Amsterdam, 1992

Twombly, Cy. *1929 Lexington, Virginia. American painter living in Rome. In 1948–49 he studied at Boston School of Fine Art; in 1950–52 at the → Art Students League of New York, and → Black Mountain College, Beria, North Carolina. He traveled to Spain, North Africa and Italy with → Rauschenberg, returning to the US in 1953. In 1955–56 he held a teaching post at the Art Department, Southern Seminary Junior College, Buena Vista, Virginia. In 1957 he moved to Rome. In 1977 and 1982 his works appeared at → Documenta 6 and 7. In his dialogue with → Abstract Expressionism, but also under the influence of → Klee, Twombly's works developed a delicate network of signs, words, numbers, and concrete fragments. With his move to Italy, he forged a link beween the psychogram and mythological and literary references (*Leda and the Swan*, 1961). Painterly elements increasingly joined linear components, dabs of bright color accentuating both lines and ground. In the 1960s, he produced "blackboard" pictures on a gray-green ground, on which the act of writing is transformed into a physical gesture. In the mid-1970s, Twombly's work became more varied. With collaged elements and various painting materials, he created expressive structures (*Hero and Leander*, 1981–84). In each successive painting, graphic elements dissolve in increasingly violent whirls of color, culminating in the Fauvistic flower pictures of the 1990s. From the 1950s on, sculptural work from found objects and simple materials, which he

Cy Twombly, *Vengeance of Achilles*, 1962, Oil, crayon, and pencil on canvas, 300 x 175 cm, Kunsthaus Zürich

paints white, has complemented his two-dimensional oeuvre. H.D.

Bibl.: Lambert, Twombly, 1979 · Szeemann, Twombly, 1987 · Bastian, Twombly, 1992–95 · Twombly, New York, 1994

Tworkow, Jack. *1900 Biala, Poland, †1982 Provincetown, Massachisetts. Polish – American painter. Emigrating to the US in 1913, Tworkow studied at the National Academy of Design, New York (1923–25). He was active at the → Art Students League and in the Works Progress (Projects) Administration (see → WPA). He abandoned his early still-life thematic, first for the figure treated expressively, and then in the mid-1940s for an → Abstract Expressionist mode under the influence of Willem de → Kooning, whom he had met in 1934. The 1950s (during which he taught at → Black Mountain College) saw intense research into texture (*House of the Sun*, 1952–53); in the 1960s his art turned more geometric, with grid structures and unmixed color predominating. The canvases of the 1970s are worked as geometric areas from which rhythmical, serried forms emerge. D.R.

Bibl.: Tworkow, New York, 1964 · Tworkow, Philadelphia, 1987

Tzara, Tristan. *1896 Moinesti, †1963 Paris. Romanian-born French writer. Tzara founded → Dada (calling it "without cause and without theory," *Manifeste*, 1918) at the Cabaret Voltaire, Zurich, in 1916, with Hugo → Ball and others. His ironic wit proved a considerable asset (*M. Antipyrine*, poem). With → Picabia in Paris in 1919, he was fêted by the *Littérature* group (Philippe Soupault, → Breton, Louis Aragon), and remained at the forefront of Paris Dada until its folding in 1923. Editor of the typographically

Cy Twombly, *Leda and the Swan*, 1961, Oil, pencil, and colored crayon on canvas, 190 x 200 cm, Artist's Collection

Günter Uecker, *Nagelobjekt*,
1963, Tempera, nails, canvas on
wood, 110 x 110 cm, Neuerburg
Collection, Cologne

daring *Dada* (1917–22), he also (like Breton) became an early collector of primitive art. Tzara was at loggerheads with → Surrealism's leader over the Barrès "trial;" nonetheless his poetry progressed through a mellower, *automatiste* phase (*L'Homme approximatif,* 1931). Writing on → Ernst, → Schwitters, → Man Ray, etc., his own pieces were illustrated by → Masson, → Picasso, → Miró, and others. While his concern for painting was limited, Tzara showed a heightened awareness of the performance aspects of any "anti-philosophy of acrobatics" (Dada), where masks, costumes, readings, and sound would combine anti-academic → Futurism with Laban-schule dance to "break down the rigid edifice of art." His lucid and acerbic critiques continued to amuse and bemuse the Paris scene; in the growing context of abstractionism, Tzara's ideas appeared to lose status after World War II. D.R.

Bibl.: Tzara, Œuvres Complètes, 1975–82

Ubac, Raoul. *1910 Malmédy, Belgium, †1985 Paris. French photographer and sculptor. In the 1930s Ubac worked with → Ernst among the Cologne Progressive Künstler. Returning to Paris in 1935, he furthered his contacts with → Breton and poet Roger Gilbert Lecomte, and specialized in photography with techniques including *brûlage* and silvery iridization (the crowd in Combat, 1937, and the Gradiva-like couple in *Solarisation* [1937] appear to be constructed of iron filings). After World War II, Ubac distanced himself from → Surrealism, producing double-sided slate reliefs (*ardoises*) in the form of organic steles or textured landscapes. Later work showed greater concern with the human (especially the head), the slate being worked more extensively in high relief like a deep thumbprint or ploughed field. His painting in the 1950s focused on large-scale oils of curvilinear abstraction. Ubac's work in resin relief, woodcut, and gravure is extensive (he studied with → Hayter), and he was also productive in tapestry, mosaic, and stained glass. D.R.

Bibl.: Frénand, Ubac, 1985

Uecker, Günter. *1930 Wendorf, Mecklenburg. German sculptor and kinetic artist living in Düsseldorf. In 1949–53 he studied in Wismar and at the Berlin-Weißensee Kunstakademie, moving in 1953 to the Kunstakademie, Düsseldorf where he stayed until 1957. From 1957 to 1966 he was a member of → Zero. In 1962 participated in the exhibition nul in the Stedelijk Museum in Amsterdam, and in the Zero Festival in Düsseldorf. In 1964, 1968, and 1977 he exhibited at Documentas 3, 4, and 7; and in 1970 at the Venice Biennale. In 1972 he worked on the film "Schwarzraum-Weißraum." In 1976 he became professor at the Kunstakademie, Düsseldorf. He produced stage designs for Beethoven's *Fidelio* in Bremen (1974) as well as other operas including Henze's *Die Basseriden*, for the Stuttgart Staatsoper (1989). As a reaction to Chernobyl in 1986 he created expressive pictures using ashes. In 1999 he designed the chapel at the German Bundestag in Berlin. At the beginning of the 1950s in response to the works of Yves → Klein and → Fontana, Uecker produced clearly-structured, white monochrome, relief-like pictures. From 1957 he developed his themes of dynamics in light and monochromy by sticking nails over the picture plane and frame. By setting the white-sprayed nails in rhythmic rows, creating spiral-shaped movements and concentrations he produces subtle interactions of light and shadow. From 1960 onwards he worked on creating → environments using light-dynamic objects (*Salon de Lumière*, 1962) and pieces of furniture stuck with nails. In collaboration with → Piene and → Mack (Zero) Uecker turned increasingly towards kinetic light art but also continued with his large nail objects (*Large Iron Cube*, 1971). Inspired by the art of primitive people and Zen Buddhism, he has from the 1980s onwards also included natural materials in his more recent kinetic → installations (*Aufwischen*, 1988). I.S.

Bibl.: Honisch, Uecker, 1986 · Honisch, Uecker, 1993

Uhlig, Max. *1937 Dresden. German painter and graphic artist living in Dresden and the South of France. Initially he studied lettering and sign

Max Uhlig, *Large Seated Figure (half length)*, 1986, Oil on canvas, 200 x 114 cm, Grundkredit-bank, Berlin

painting, and from 1955 studied at the Hochschule für bildende Kunst, Dresden. Until 1979 he earned his living as a lithographer and copper-plate engraver. In 1989 he began teaching at the Kunstakademie, Nuremberg. In 1991 he was made Visiting Professor at the Internationale Akademie Pentiment in Hamburg.

In the 1960s Uhlig's work aroused interest through vivid portraits of artist colleagues which he created using a dense linear structure. In the following years he developed a marked personal style of painting and graphic art (mainly in his portraits and landscapes) which was sustained by the close combination of net-like, linear structures and → Tachiste, painterly elements. Unaffected by the constraints of → Socialist Realism but also detached from the fashionable western trends of the 1970s, he produced a rich pictorial and graphic work which in the 1980s gained a further psychological impact in its total rejection of any narrative elements. E.H.

Bibl.: Lang, Malerei, 1980 · Brusberg/Eckhardt, Zeitvergleich '88, 1988 · Uhlig, Dresden, 1994

Ultvedt, Per Olof. *1927 Kemi, Finland. Finnish painter and sculptor. After initial figurative pictures featuring animal motifs Ultveldt made contact with → Nouveau Réalisme through → Tinguely. He made large objects constructed from welded scrap metal set in motion by an electric motor, such as the monumental sculpture made from parts of a dismantled printing presses, *The Face of a Newspaper* (1964). He collaborated with → Saint Phalle in her monumental sculpture *Hon* (1966). He also creates furniture-like structures, filled with found objects and domestic appliances which, set in motion, perform weird acrobatics. K.S.-D.

Bibl.: Schwedische Kunst, Nuremberg, 1970

Umbo (Otto Umbehr). *1902 Düsseldorf, †1980 Hanover. German photographer. In 1921–23 he studied at the Bauhaus, from 1925 working in the film industry in Berlin. In 1927 his portraits of the actress Ruth Landshoff and other pictures were published in Berlin magazines (*Der Querschnitt, Uhu, Welt-Magazin*). In 1928 he co-founded the photographic agency Dephot and until 1930 lectured at the Kunstschule founded in Berlin by → Itten. From 1934 to 1940 he worked as a freelance press photographer for *Der Sturm* and *Signal* among others, then became a press photographer for the navy. In 1943 his apartment and studio, and along with it Umbo's entire archives, were destroyed by bombing. After 1945 he worked as a photojournalist and photography teacher in Hanover. Strongly influenced by Itten's formal theory Umbo maintained an artistic approach to photography. In addition his creative work is strongly influenced by cinema aesthetics ("Painters, move into films!"). Tilted horizons, drastic cropping of the subject, the use of multiple exposures, and a preference for harsh contrasts are typical of Umbo's photographs. C.W.-B.

Bibl.: Umbo, Düsseldorf, 1995

Unit One. A group of avant-garde British artists who banded together briefly in 1933. A letter from Paul → Nash in *The Times* on June 12 publicly announced Unit One's inception. The initial members were painters: near-Surrealist John Armstrong (1893–1973), abstractionist John Bigge (1892–1973), Frances Hodgkins (1870–1947; who promptly resigned, being replaced by Tristam Hillier [1905–83]), → Burra, Ben → Nicholson, Nash, → Wadsworth, the sculptors → Hepworth and → Moore, and the architects Wells Coates and Colin Lucas. In 1934, the group published *Unit One: The Modern Movement in English Architecture, Painting, and Sculpture*, edited by the avant-garde if Surrealistically inclined critic Herbert Read. It stressed the unity of the arts in time-honored → Bauhaus style, though without systematic program or manifesto and simultaneously defending individuality. Indeed, the artists differed enormously in style: their only joint exhibition was held in 1934 in the new, modernist Mayor Gallery in London, before traveling countrywide. The group was important in providing a platform for genuinely contemporary (→ Surrealist and abstract) tendencies in England. D.R.

Bibl.: Unit One, London, 1984

Utrillo, Maurice (Maurice Valadon). *1883 Paris, †1955 Dax, Landes. French painter, the illegitimate son of → Valadon. His painting began in 1902, after encouragement from his mother. His early years were also clouded by a severe alcohol dependency. From 1914 he undertook trips to Brittany and Corsica and in 1924 he moved to his mother's château in Saint-Bertin, Ain. In 1926 he worked on stage scenery for the Ballets Russes. In 1928 he was made Chevalier de la Légion d'honneur. In 1934 he married Lucie Pauwels. At Montmartre in Paris Utrillo painted his preferred motif in an Impressionist style. Around 1908 he began the so-called White Period (since he sometimes mixed plaster into the paint) featuring picturesque motifs of Parisian houses depicted using seemingly naive perspectival foreshortenings (*La Place du Tertre*, 1912). Despite frequent

spells in detoxification clinics Utrillo continued to paint uninterruptedly and produced a remarkable body of work which found wide acclaim from 1926 onwards. His phase of strong colors was inspired by postcard motifs in particular. However, finally cured of his alcoholism at an advanced age, his work became repetitive, relying on well-established motifs which have contributed greatly to the popular image of the Parisian locale. H.D.

Bibl.: Pétridès, Utrillo, 1959–1974 · Fabris, Utrillo, 1982 · Warnod, Utrillo, 1983/84

Maurice Utrillo, *The Hermitage in Solothurn*, c. 1923, Oil on canvas, 54.5 x 64.5 cm, Solothurn Museum of Art , Josef Müller Foundation

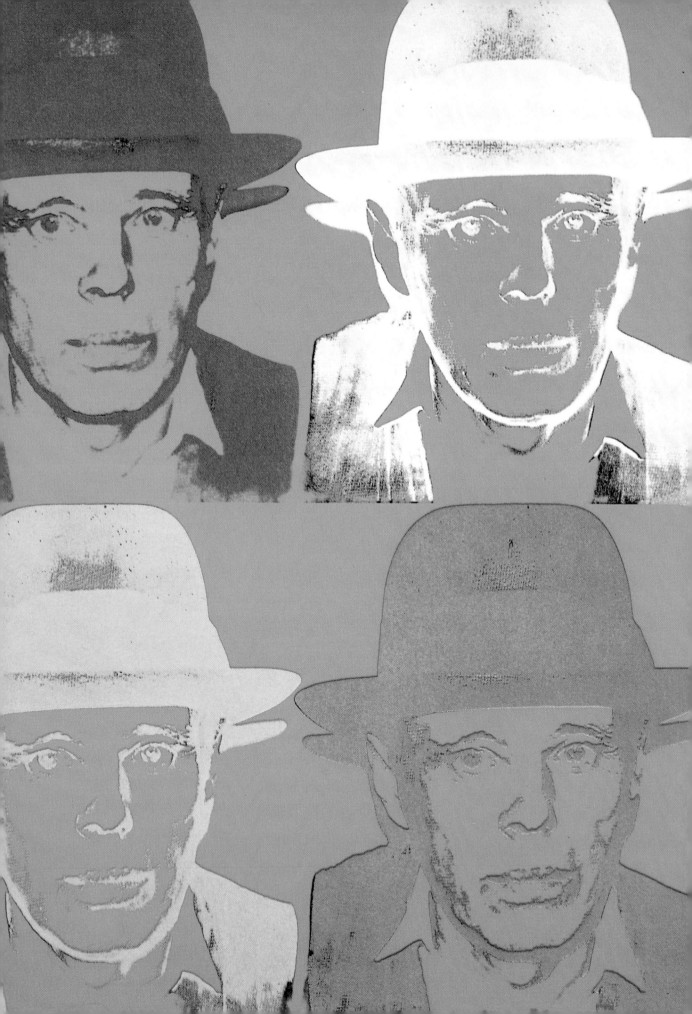

Valadon, Suzanne. *1865 Bessines-sur-Gartempe, Haute Vienne, †1938 Paris. Self-taught French painter. Initially Valadon worked as a circus acrobat in Paris, then as a seamstress and model for Puvis de Chavannes, Renoir, and Toulouse-Lautrec, among others, all of whom recognized her talent and, together with Degas, supported her. Her first known painting dates from 1883, the year her son, → Utrillo, was born. Her early works are detailed studies and portraits in the style of Degas. From 1896, and securely established by her marriage, Valadon was able to devote herself entirely to painting. Influenced by Gauguin (see → precursors) she produced numerous landscapes, self-portraits, portraits (e.g. *Erik Satie*), female figures, still lifes, and especially nudes with strong, harsh contours and with compact, clear colors and forms. The figures are set off against one another by dark outlines and the body shapes are emphasized by white highlighting. H.D.

Bibl.: Warnod, Valadon, 1981

Vallotton, Félix. *1865 Lausanne, †1925 Paris. French painter and graphic artist. In 1882 he began studies at the Académie Julian, Paris, participating in the Salon des artistes français in 1885, and later, on a regularly basis, in the → Salon des Indépendants. From 1894 he worked as a graphic artist for *La Revue Blanche* and *Le Rire*. In 1902–25 he was co-founder and a regular participant in the → Salon d'Automne. From 1908 he lectured at the Académie Ranson, Paris. In 1921–24 he took up landscape painting in the South of France. As a member of the → Nabis Vallotton devoted himself in particular to printmaking and portrait studies, and from 1891 to woodcuts. After his separation from the Nabis in 1901 he turned more and more to painting, striving for a spatial, sculptural style. The strong colors of the 1890s were replaced by a delicately colored → Intimisme resulting from his collaboration with → Vuillard. Around 1905 he changed his style for the last time to a less ornamental approach in which atmosphere gives way to intense color contrasts; his plain, yet quietly erotic nudes in particular caused controversy (*Nude with Book*, 1924). His "composed landscapes." too, do not deviate from this alienated rigidity and artificiality (*Sandbanks along the Loire*, 1923). K.S.-D.

Bibl.: Guisan/Jakubec, Vallotton, 1973–75 · Ducrey, Vallotton, 1989 · Busch/Dorival/Grainville, P., Vallotton, 1992 ·

Valori plastici. Art magazine published in Rome between 1918 and 1921 (in Italian and French editions) by the art critic and rather conservative painter M. Broglio (1891–1948). The first edition, discussed ideas put forward in → Pittura Metafisica, and also carried articles by → Carrà, de → Chirico, and → Savinio. Although the magazine also reported on the European avant-garde (→ Cubism and De → Stijl) its main emphasis was on the return to Classical values in art. H.D.

Bibl.: Fossati, Valori Plastici, 1981

Vantongerloo, Georges. *1886 Antwerp, †1965 Paris. Belgian painter, sculptor, and architect. Between 1905 and 1910 he attended art academies in Antwerp and Brussels. In 1914–17 he performed his military service. On this return he spent some time in Holland. In 1918 he was co-founder of De → Stijl, working until 1920 for the journal *De Stijl*. He spent 1919–27 in Menton and in 1923 participated in the De Stijl exhibition at the Galerie de l'Effort Moderne, Paris. In 1924 he published *L'Art et son avenir*. In 1927 he moved to Paris. In 1931–37 he was co-founder and Vice-President of → Abstraction-Création. After a Fauvist phase Vantongerloo met → Mondrian, van → Doesburg, and van der → Leck in the context of the De Stijl movement. His first abstract paintings and sculptures, however, began to show signs of deviating from the purist aesthetics of → Neo-Plasticism in that he applied Ostwald color norms. With his vertically and horizontally aligned sculptures he aimed to transfer the essential structural elements of De Stijl to sculpture (*Construction dans la sphère, ocno 2*, 1917) applying mathematical formulae and volumetric calculations to his work. In the 1930s and 1940, as a member of Abstraction-Création, he produced paintings influenced by → Malevich and plexiglass sculptures. He also made project designs for bridges and airports. H.D.

Bibl.: Vantongerloo, Brussels, 1981 · Ceuleers, Vantongerloo, 1996 · Vantongerloo, London, 1996

Vasarely, Victor. *1908 Pécs, Hungary, †1997 Paris. Hungarian-born painter. In 1925–27 he studied medicine in Budapest, moving to the Podolni-

Georges Vantongerloo, *Métal: y = ax – bx · cx*, 1935, New silver, height 38.5 cm, Basel Foundation, Museum of Art, Basel

◁ Andy Warhol, *Joseph Beuys, State III*, 1980–83, Silk-screen print, 101.6 x 81.3 cm, Schellmann Publishers, Munich – New York

Félix Vallotton, *Female Nude with Arm Raised*, 1911, Oil on canvas, 99.5 x 81 cm, Emanuel Hoffmann Private Collection

Victor Vasarely, *Rugó*, 1978, Acrylic on canvas, 283 x 138 cm, J. Salomon, Circle Gallery

Volkmann Academy of Art in 1928. In 1929–30 he worked in → Bortnyik's studio (Budapest Bauhaus). He moved to Paris in 1930, working until 1944 as a graphic artist. In 1955–68 he exhibitied at Documentas 1–4. In 1961 he moved to Anne-sur-Marne. 1970 saw the founding of Fondation Vasarely in Gordes, Vaucluse (closed down 1996). In 1982 he founded the Vasarely Center in Oslo. From 1947, inspired by → Constructivism, he developed his own method of geometric abstraction based on mathematical calculations. After intensive work on scientific theories he perceived his chromatic, geometrical pictures as direct, emotionally perceptible responses to energy, space, body, matter, movement, and time in a world shaped by technological progress and based on increasingly abstract scientific premises. Vasarely's → Op art phase began in 1951 with his first kinetic picture series *Noir et Blanc*, consisting of plexiglass plates mounted one on the other, and with painted compositions. In 1954 he created monumental ceramic murals, his first *Intégrations architectoniques*. From 1959 his patented system of *Unités plastiques* was created, a kind of pictorial alphabet made from basic forms and chromatic scales. The works, graphics, and posters were often batch-produced by his staff, thus realizing Vasarely's social utopian idea of works of art affordable to all. F.K.

Bibl.: Vasarely, 1965–80 · Ferrier, Vasarely, 1969 · Diehl, Vasarely, 1972 · Motte, Vasarely, 1986

Vaughan, Keith. *1912 Selsey, Sussex, †1977 London. British painter. After World War I, Vaughan met → Sutherland (a major influence) and the → Neo-Romantics → Colquhoun and → Minton, adopting a style similar to (if more controlled than) the latter, centered on architectural compositions. His increasingly evocative imagery of paradisical landscapes and color environments inhabited by male nudes à la Cézanne soon leant towards the abstract. Post-Cubist canvases of the

1950s involved block-like areas of color (influenced it seems by de → Staël). Late works number powerful abstract "illustrations" of Rimbaud and Baudelaire. Vaughan's confessional *Journals 1939 – 77* (new ed. A. Ross, 1989) give a vivid if depressing account of his drinking and his primarily closet homosexuality. Suffering from cancer, Vaughan took his own life. D.R.

Vautier, Ben. *1935 Naples. Italian Conceptual, Fluxus, and action artist living in Nice. In 1939 he went to live in Turkey, traveling in 1945–49 via Egypt to Naples, Lausanne, and Nice. In 1955 he met → Arman and Yves → Klein. From 1958 a second-hand record shop in Nice, became the center of his artistic activities and his gallery. In 1962 (on the recommendation of → Maciunas) he joined the → Fluxus movement, and later also groups associated with → Neo-Dada within → Nouveau Réalisme and the anti-art movement. In 1972 his work was shown at Documenta 5. In 1975 he gave control of his shop to the Centre Pompidou in Paris. The attempt to develop new, provocative works along the lines of Marcel → Duchamp led Vautier to → happenings, language pictures, and his own exhibition (in 1962 at Gallery One, London, during the Misfits Fair), but also to theoretical treatises. His *Lettres à Daniel Spoerri* of 1962 comprise two files and were later publicized as *Tout BEN*. In the 1980s Vautier distanced himself more and more from art and has latterly been concentrating on his long-standing interest in ethnic groups. S.Pa.

Bibl.: Vautier, 1987 · Vautier, Paris, 1991

Ben Vautier, *Ben is more important than nobody*, 1972, Acrylic on canvas, 97 x 130 cm, Ludwig Museum at the Deutschherrenhaus, Coblenz

Vedova, Emilio. *1919 Venice, †1995 Self-taught Italian painter. Vedova was a representative of Italian → Art Informel. In 1942 he became a member of the Corrente group opposed to the Fascist conception of art. In 1944–45 he was a member of the North Italian partisan movement. After the war he co-founded the → Fronte Nuovo delle Arti and was a signatory of the manifesto "Oltre Guernica" (1946) which supported → Picasso's moral and aesthetic stance. In 1952 he became a member of the Gruppo degli Otto. In 1955, 1959, and 1964 he exhibited at Documentas 1, 2, and 3. From 1965 to 1970 he was director of the summer school in Salzburg, and in 1975 became Professor at the Accademia di Belle Arti in Venice.

Vedova's early, artistic career is marked by his opposition to Fascist aesthetic policies, and his path towards abstraction can be seen as a protest against the form and content of its regulations. At first, after having studied the works of the Old

Emilio Vedova, *Absurd Berlin Diary '64 – Plurimo No. 5,* 1964, Oil, tempera, charcoal, collage, decollage on wooden panels, metal hinge, cords, 284 x 260 x 80 cm, Artist's Collection

architect and designer in → Art Nouveau his house Bloemenwerf in Uccle, expresses the idea of the → Gesamtkunstwerk in its planning, polygonal ground-plan, and interior design. With the founding of the Studios of Applied Art (1898) in Ixelles near Brussels (also a branch in Berlin), van de Velde set standards for new design and created various interiors. His principal works are the Folkwang Museum in Hagen (1900–02), the Weimar Kunstgewerbemuseum (1904–06) and the Werkbund Theater in Cologne (1914, demolished 1920). His work exerted considerable influence on applied art and interior design in Europe. G.P.

Bibl.: Pecher, van de Velde, 1981 · Curjel, van de Velde, 1986 · Sembach, H. van de Velde, 1989

Emilio Vedova, *Disco "Non dove'87 – II" (op. 4),* 1987, Oil on wood, diam. 279 cm

Masters (paintings by Tintoretto and Piranesi's *Prisons*, inter alia), he produced dramatic, dark paintings (*Crocefissione da dietro*, 1937) and spectacular architectural drawings (*San Moisë*, 1937–38). By the beginning of the 1940s, he had developed an informal style of expression which approached → Lyrical Abstraction, whereas the postwar series *Géométries noires* (1946–50) consciously stems this free-flowing style. In 1953 Vedova arrived at the automatic and abstract gestural style of painting for which he became known, and developed an → Abstract Expressionism which incorporates spontaneity, rhythm of movement, and the use of lighting techniques. Painted → assemblages from wood and → objets trouvés followed. Since the early 1960s he has worked on large-scale cycles: 1961 saw the start of the series *Plurimi*, movable collages where, not dissimilar from Dadaist assemblages, the two dimensional canvas is replaced by spatial installations, among them the series *Absurd Berlin Diary* (1964). The → multiple *Spazio/plurimo/luce* (1967) for the Italian pavilion at the Montreal Expo is the culmination of his experiments with light. In the 1980s he produced *Dischi*, round and oval paintings on wooden disks which hang, lie, or tilt freely in space. A.R.

Bibl.: Vedova, Munich, 1986 · Vedova, Milan, 1991 · Vedova, Milan, 1993 · Vedova, Trento, 1996

Velde, Henry van de. *1863 Antwerp, †1957 Zürich. Belgin architect, designer, and writer on art. He studied painting in Antwerp, Paris, and Brussels from 1881–85, and in 1890 architecture and the applied arts. In 1895 he built and designed his own house, Bloemenwerf, in Uccle. From 1907 to 1915 he was founder and head of the Kunstgewerbeschule, Weimar. In 1907 he cofounded the Deutscher Werkbund. In 1917 he moved to Switzerland and in 1921 to Holland. He planned the Kröller-Müller Museum in Otterlo, and in 1925–36 was professor of architecture in Ghent; in 1926–35 he was head of the Institut supérieur des Arts décoratifs, Brussels. From 1925 he pursued building and lecturing activities in Belgium, Germany, France, and the Netherlands. In 1947 he moved to Oberägeri, Switzerland. His painting was initially pointillist in style, influenced by Gauguin's (see → precursors) landscapes in planar composition. An influential

Veličkovič, Vladimir. *1935 Belgrade. Serbian painter and graphic artist living in Paris. After studying architecture he began to paint, drawing on the work of Grünewald and the early Italian masters. Later, in imitation of → Bacon, he created works with Surrealist, imaginative traits in which he conjures up a world of horror (*Chute III*, 1964). From 1972, inspired by the photographs of Eadweard Muybridge, he designed illusionary picture spaces where the movements of figures or individual body parts (often dismembered) are shown in repetitive arrangements (*Cible, fig. II*, 1974). In an ironic take on scientific procedures, he adds tables and scales to the pictures, which appear to "measure" the sequences of movement and convulsions. H.D.

Bibl.: Le Bot, Veličkovič, 1979 · Veličkovič, Besançon, 1981

Verism. Verism (from Latin *verus* = true) was a reaction to the emotional world of → Expressionism, a rational, precise way of looking at the horrors of World War I and, by way of condemnation, attempting to portray its background and circumstances with surgical accuracy and emotionally detached analysis. "The Verist holds up a mirror to the grotesque faces of his contemporaries" (Grosz, 1925). → Dix, → Grosz, and → Schlichter count among its protagonists. Verism was politically left-wing in orientatation, its radical, anti-social and aggressive stance rooted in the → Dada movement. Typical stylistic features are graphic precision, emphasis on contours, a rational style of painting that emphasizes the subject in a colorful manner, and a

predilection for socio-political themes including expression of the artist's viewpoint (indictments, irony, sarcasm). W.S.

Bibl.: Schneede, Verism, 1979 · Angermeyer-Deubner, Verism, 1988

Viani, Alberto. *1906 Quistello, Mantua, †1989 Mestre. Italian sculptor. He studied at the Accademia di Belle Arti, Venice. From 1944 he worked as assistant to → Martini and, after his death, was his successor as professor of sculpture in Venice. In 1946 he was co-founder of → Fronte Nuovo delle Arti. Initially strongly influenced by Martini, he later turned to the more abstract form language of → Arp and → Brancusi. His works in plaster, stone, and bronze show soft fluid lines, intimating the human body without actually portraying it. S.Pa.

Bibl.: Santini, Viani, 1990

Video art. The popularization of television in the 1960s bestowed upon the electronic monitor the previously unknown role of visual mediator. The artistic processing of a non-reflected input of images, which itself uses the medium for the purpose of their transfer, coincides approximately with the beginnings of → Pop art in the early 1960s. The first works in the field of video art can be seen predominantly as a critique of the new medium. Among the early and influential artists are → Vostell (e.g. *TV Collage. No.1*, 1958; *TV Funeral*, 1963) and → Paik (*Zen TV*, 1963). Paik reduces the televisual image to a vertical line and makes the speed of the image, as the main television feature, subject to a subversive strategy. Whereas in the 1960s video works were of a more socio-critical nature and often related to → Performances, in the 1970s an epistemological strategy emerged. The works of → Weibel (*Observations of the Observation*; *Uncertainty*, 1973) rank highly among what are called closed-circuit installations, where, for example, three cameras and monitors are arranged in a circle, while the viewer is never able to see himself even if he enters this circle. While Weibel's works assume the character of an experimental media assemblage, other protagonists think in terms of their roles as sculptors or traditional painters. → Viola (*The Theater of Memory*, 1985) or → Nauman (*Rat Maze with Rock & Roll Drummer*, 1988) work with installations where the video itself forms a central element. More recently the monitor has become just one medium among many, the term "video artist" becoming almost obsolete. Only since its combination with sculptural elements has video art more or less established itself as an art form. Early experimental tapes are still today given relatively little status. In the 1980s the borderline between video art and popular commercial video productions (e.g. music video clips with occasionally artistic pretensions) became blurred. The artist duo M+M analyzed the medium of video as a means to portray the world and the world of media (*Hintz-Kleiderkammer*, 1994). At present a tendency is emerging whereby video and computer art are merging (e.g. internet works by the Jodi.org group1998 video prize at ZKM). G.B.

Bibl.: Herzogenrath/Decker, Video-Skulptur, 1989 · Hell, Video, 1990 · Popper, Electronic, 1993 ·

Video art: Franziska Megert, *Play with Fire*, 1989, 6 channel video, 2 channel audio installation, 6 monitors, 6 videotapes, 6 videoplayers, 2 plinths, 250 x 180 x 100 cm, ZKM, Karlsruhe

Vieira da Silva, Maria Elena. *1908 Lisbon, †1992 Paris. Portugese-born painter. In 1928–29 she was taught by → Bourdelle and Charles Despiau (1874–1946); subsequently she went to paint and work with → Friesz and → Léger. Her first employment was as an industrial designer and illustrator. In 1932 at the Académie Ranson in Paris, she studied with Roger Bissière (1886–1964). From 1934 to 1940 she returned to Portugal, moving in 1941 to Rio de Janeiro, Brazil, where she stayed till 1947; she then returned to Paris. In 1950 and 1954 her work appeared at the Venice Biennale; in 1955, 1959, and 1964 at Documentas 1–3. In the 1930s she was associated with the → École de Paris where the works of Bissière and → Torres-García in particular had a formative influence. After some experimentation she developed her own basic graphic vocabulary which, inspired by → Surrealism, comprised imaginative, visionary elements. Through an emphasized graphic line structure in her pictures of the 1940s, imaginary, geometrical spaces are compressed into small and miniscule units as symbol of the great metropolis, and at the same time an expression

Maria Elena Vieira da Silva, *A Breton Feast*, 1952, Oil on hessian, 92 x 72.5 cm, Private Collection

of the angst of modern man in a new Babylon. In her later works the claustrophobic elements wane and forms taken from the architectural environment are transformed into poetic, chromatically rich structures. H.D.

Bibl.: Esteban, Vieira da Silva, 1969 · Lassaigne/Weelen, Vieira da Silva, 1992 · Weelen/Jaeger, Vieira da Silva, 1994

Vienna action art (Wiener Aktionismus). A specifically Austrian art form, directed against political, religious and cultural power structures. It originated in the 1960s and ranks somewhere between → happening and → Action Painting. The Vienna action artists' aim is to increase awareness by breaking taboos (in the tradition of → Kokoschka and → Schiele), to expose repressed bourgeois morals and sexuality (inspired by Freud). They use provocative religious rituals (sermons, processions, sacrifices, self-flagellation, and the iconography of martyrs) as part of an alienation process. In Vienna action art, the artistic act becomes a cult action, ecstasy a stimulant for artistic action, and self-mutilation an artistic strategy (injuries, wounds, self-amputations, even staged suicides). Its followers include Otto Muehl, → Brus, → Nitsch, → Rainer, and → Schwarzkogler. W.S.

Bibl.: Schwarz, Aktionismus, 1960 · Jappe, Aktionskunst, 1993 · Schimmel/Noever, Out of Actions, 1998

Villon, Jacques (Gaston Duchamp). *1875 Damville, †1963 Puteaux. French painter. In 1894 he moved to Paris, training in the studio of F. Cormon, and becoming an illustrator for *Le Courrier français*, *L'Assiette au beurre*, and *Chat noir*. In 1911–12 he was a founder member of → Section d'Or. In 1914–18 he undertook military service. In 1935 he traveled to the US. In 1939 he participated in the first Salon des Réalités Nouvelles, and in 1955, 1959, and 1964 his work appeared at Documentas 1, 2, and 3. He won a prestigious prize at the Venice Biennale. From 1895, under the pseudonym "Jacques Villon," the middle → Duchamp brother produced lithographs which demonstrate the influence of Toulouse-Lautrec. In 1911 Villon turned to → Cubism and alongside geometric composition he developed a very colorful palette (*Seated Woman*, 1914): the simplification of form and color modulation led to abstraction. He also produced numerous graphic works. H.D.

Bibl.: Villon, Paris, 1980 · Villon, Neuchâtel, 1982

Bill Viola, *The Greeting*, 1995, Video picture sequence, Kestner Gesellschaft, Hanover

Vingt, Les. Baudelaire's revulsion (1864–66) at the cultural life of "poor Belgians" was later shared by Edmond Picard (1836–1924) and Octave Maus (1856–1919), editor of the journal *La Moderne*, who in 1883 described it as being controlled by a "coterie of octopuses." That year the two founded an artistic group avowedly "jeune, moderne et sociale" and open to both "Impressionists and impossibilists," numbering 20 members (painters and sculptors). It held annual exhibitions between 1884 and 1893. Members included → Ensor, Neo-Impressionists Willy Finch (1854–1930), van de → Velde, and Theo van Rysselberghe (1862–1926); Symbolists Xavier Mellery (1845–1921), and Fernand Khnopff (1858–1951), who designed the XX logo; and the "pornographer" Félicien Rops (1833–1941). Each show also included 20 prominent foreign invitees, such as J. → Toorop, → Steer, → Rodin, → Liebermann, Monet, and Cézanne; James Abbott McNeill Whistler (1834–1903) and John Singer Sargent (1826–1925), who was hung next to Ensor in 1994; the then little-known Pissarro, → Redon and van Gogh; and the Neo-Impressionists Henri-Edmond Cross (1856–1910), Maximilien Luce (1858–1941), and → Seurat (whose *Grande Jatte* created a scandal in 1887).

Lectures (e.g. by the Parisian lion Catulle Mendès) and concerts (organized by Ysaÿe) also defended the "bringers of the new." By 1893 poet Émile Verhaeren could write that Les Vingt's "goal seems attained." Les Vingt were superseded that year by La Libre Esthétique, which also embraced the applied arts. D.R.

Bibl.: Les Vingt, Brussels, 1962 · Block, Vingt, 1984 · Belgian Avant-Garde, London, 1994

Viola, Bill. *1951 New York. American video artist living in Long Beach, California. In 1969–73 he attended the College of Visual and Performing Arts, Syracuse University, New York; in 1973–80 he was employed by D. Tudor (music group "Rainforest"). In 1983 he received a teaching contract at the California Institute of the Arts, Valencia, California. In his early works Viola experimented with the theory of perception and technology. After extensive traveling (which brought him into contact with religious mysticism, Zen Buddhism, and other cosmological considerations) he concentrated on questions of meaning. His preferred working methods are closed-circuit processes (closed video cycles), differing video running speeds, slow motion, time lapse and change in

Bill Viola, *The City of Man*, 1989, 3-channel video, 4-channel sound installation, 3 laser discs, 3 laser-disc players, 3 projectors, 3 projection screens, 214 x 428 cm, ZKM, Karlsruhe

proportions, wherein sound, as a "sculptural material" plays a special role. In his recent video installations Viola examines the bases of human existence, and the relationship of thought to action, inner to outer reality. C.W.-B.

Bibl.: Viola, New York, 1987 · Violette, Viola, 1995 · Viola, New York, 1997

Visser, Carel. *1928 Papendrecht. Dutch sculptor living in Rijswijk. In 1948–49 he attended Delft Technische Hogeschool studying architecture, and in 1949–51 the Academie van Beelenden Kunst in the Hague, studying sculpture. In 1952 he moved to Amsterdam. In 1962 he took up a teaching contract at Washington University, St. Louis. In 1958 and 1968 his work appeared at the Venice Biennale; and in 1968 at Documenta 4. Public commissions include sculpture for Schiphol airport in Amsterdam in 1967. His early work comprises abstract, Cubist sculptures in the tradition of Dutch Constructivism as well as representational works drawn from nature. Besides traditional sculptural material he also uses everyday or industrially made objects. Despite an overall heterogeneity, clear arrangements and structuring prevail (producing assemblages of individual parts by alignment or stacking, or by dismantling a closed form and reduction to a skeleton structure). I.S.

Bibl.: Elger/Fuchs, Visser, 1990

Maurice de Vlaminck, *The Bridge at Chatou*, 1906, Oil on canvas, 50 x 73 cm, Musée National d'Art Moderne, Centre Georges Pompidou, Paris

Vlaminck, Maurice de. *1876 Paris, †1958 Rueil-la-Gadelière, Eure-et-Loir. Self-taught French painter. He started working life as a racing cyclist and as a violinist in a provincial orchestra. In 1900 he met → Derain and turned to painting. Contact with → Matisse gave him crucial encouragement and in 1905 he exhibited in the famous Fauves exhibition at the Salon d'Automne (→ Fauvism). Inspired by van Gogh (→ precursors) he painted landscapes and still lifes in particular with an unfettered brush stroke and in constrasting colors (*The Bridge at Chatou*, 1906). Around 1908 after experiencing with the works of Cézanne he produced more harmonious compositions in subdued colors. A consolidation of forms brought him into contact with → Cubism which path – unlike Derain – he did not follow. Soon his palette darkened and blazing, restless compositions emerged, typical of Flemish Expressionism, which persisted in his late work (*Auvers*, 1927). From 1925, living a secluded existence in La Tourillière, Vlaminck painted a host of still

lifes, landscapes, and portraits which, in their sparse, pointed expression, are executed to perfection. After his book *Portraits avant décès* was published in 1943 the free French accused him of collaboration (in 1944 he was acquitted by a French special court). In 1955 he exhibitited at Documenta 1. H.D.

Bibl.: Sauvage, Vlaminck, 1956 · Crespelle, Vlaminck, 1958 · Werner, Vlaminck, 1975

Vogeler, Heinrich. *1872 Bremen, †1942 Kazakhstan. German painter, graphic artist, and architect. In 1890–93 he attended the Kunstakademie, Düsseldorf, and from 1894 the → Worpswede School. In 1914 he undertook voluntary military service, ending up in 1918 in a clinic for nervous diseases. In 1919 he founded the workers' commune Barkenhoff. His first trip to the Soviet Union occurred in 1923 and in 1931 he moved to Moscow. He died in 1942 in Khazakstan under mysterious circumstances.

After leaving the academy Vogeler sought inspiration through direct contact with nature. In Worpswede he found a group of painters who were pursuing the same aim, trying to cope with urbanization and the mechanization of all aspects of life by returning to their native landscape. Although close to nature (*The Lark*, 1902, shows a man staring up at the sky) Vogeler's work also reveals the romantic, idealistic concept of a sane world. Influenced by → Jugendstil he turned to book illustration and craft design. Vogeler's design of the guild hall in the old Bremen town hall is among the most famous of Jugendstil works. After World War I he founded a Communist school for workers in Worpswede and traveled several times to the Soviet Union where, in 1931, he eventually settled, and where he created monumental, polemical murals containing elements of a futuristic style. G.P.

Bibl.: Petzet, Vogler, 1972 · Vogeler, 1982

Vordemberge-Gildewart, Friedrich. *1899 Osnabrück, †1962 Ulm. German painter. In 1919–23 he attended the Technische Hochschule and Kunstgewerbeschule in Hanover (studying architecture and sculpture). At this time he forged friendships with → Schwitters, → Arp, van → Doesburg, and → Lissitzky. In 1925 he became a member of De → Stijl, and in 1927 co-founder of "die abstrakten hannover"; and in 1931 he was co-founder of → Abstraction-Création in Paris. During 1936–37 he was in Berlin, then in Switzerland until his emigration to Amsterdam in 1938. In 1954 he was appointed head of the department of visual

Friedrich Vordemberge-Gildewart, *Composition No. 189*, 1952, Oil on canvas, 50 x 70 cm, Pfälzerische Landesgewerbeanstalt, Pfalzgalerie, Kaiserslautern

communication at the Hochschule für Gestaltung, Ulm. Vordemberge-Gildewart was an early German representative of Constructivist, abstract art, but also a pioneer in the field of typography. His first → collages were soon succeeded by strict, geometric pictures. S.Pa.

Bibl.: Helms, Vordemberge-Gildewart, 1990 · Vordemberge-Gildewart, Wiesbaden, 1997

Vorticism. Avant-garde English art movement, which emerged c. 1914, having links to → Futurism (especially → Marinetti), but also comprising elements of → Cubism and → Expressionism. Among the practitioners of Vorticism were artists (e.g. → Epstein, and → Wadsworth) and the writers (Ezra Pound, T.S. Eliot, and T.E. Hume). Its authoritative initiator, → Lewis, protested against continental Futurism and in 1914 the wide-ranging journal *Blast* was published, of which only two issues appeared. It contained Lewis' manifesto of the Vorticists which was directed against Marinetti's Futurism. The term "vortex", as formulated by Pound, put forward the idea that the Vorticist is in the center of a whirling mass where it is most concentrated. Vorticism is marked by sharp, abstract forms among which the human figure, if present, is obscured as a robotic figure (e.g. Lewis, *The Crowd*, 1914–15). Such glorification of the Machine Age resulted in a strong, virile, and aggressive form of art. After the beginning of World War I the group was disbanded. A.K.

Bibl.: Cork, Vorticism, 1976 · Vorticism, Berlin, 1996/97

Vostell, Wolf. *1932 Leverkusen, †1998 Berlin. German painter, graphic artist, sculptor, Fluxus and happening artist. In 1950–53 he completed an apprenticeship in lithography, studying art at the Werkkunstschule, Wuppertal and at the École des Beaux-Arts, Paris in 1954–55; in 1957–58 he studied at the Kunstakademie, Düsseldorf. In 1962–69 he worked as co-editor of the journal *Décollage*. In 1962 he was a co-founder of → Fluxus and associate organizer of numerous Fluxus events. In 1965 he produced the demonstration *Happening, Fluxus, Pop Art, New Realism*. In 1968 and 1990 his work appeared at the Venice Biennale. From 1971 he was in Berlin. In 1976 he founded the Museo Vostell Malpartida de Cáceres in Spain. In 1977 he exhibited at Documenta 6. In 1997 he received the Hannah Höch prize for his lifetime work. In his method of → décollage Vostell aimed to put an end to the manipulations of the information culture and to raise people's critical awareness of consumerism and advertising. The destructive treatment of acid-etched pictures and layered pictures also provided a source of inspiration. From 1958 he developed → happening into one of the most socio-critical means of expression. As a co-founder of the Fluxus movement he staged numerous performances and action events; traveling in a Fluxus train he spread his ideas of a mobile art academy to over 15 German towns. In his late works he gave serious thought to the automobile as a fetish, producing, for example, the highly disputed concrete Cadillac at the 750th anniversary festival in Berlin (on the Kurfürstendamm) in 1987. H.D.

Bibl.: Schilling, Vostell, 1980 · Gottberg, Vostell, 1981 · Vostell, Strasbourg, 1988 · Schmied, Vostell, 1992 · Dominguez, Vostell, 1994

Wolf Vostell, *Endogenous Depression*, 1984, Television sculpture, television set, concrete base, 73 x 46 x 64 cm; plinth: 91 x 80 x 50.5 cm, ZKM, Karlsruhe

Vuillard, Édouard. *1868 Cuiseaux, Saône-et-Loire, †1940 La Baule. French painter. In 1886 he attended the Académie Julian in Paris, then in 1887 the École des Beaux-Arts in Paris. In 1888–89 he worked on self-portraits and still lifes in the style of Chardin and the Dutch school of the 17th century. In 1890 he joined the → Nabis. From 1893 he was staff member of the *Revue blanche* and of the *Théâtre de l'œuvre*. In 1892, 1894, 1895, and 1896 he received several commissions for complex interior design projects. In 1936 he created a design for the League of Nations Palace in Geneva. True Nabis' approach, Vuillard developed a markedly planar style; he did not, however, dismiss the concept of picture space in principle but worked out a new graphic method of arranging two- and three-dimensionality on to the plane instead of the academically traditional, illusionistic method of representation. His themes revolved around family members, his closest friends, and the seamstresses in his mother's dressmaking studio in the family home (see → Intimisme). These everyday scenes were frequently transformed into almost sacred ceremonies, defined by an "inner life" which also formed Maurice Maeterlinck's theme in his plays. Around 1900 a turning point occurred in Vuillard's work: his *cloisonné* compositions made way for a renewed emphasis on the picture space and a new notion of light and color. U.P.

Bibl.: Preston, Vuillard, 1985 · Thomson, Vuillard, 1988 · Easton, Vuillard, 1989/90 · Groom, Vuillard, 1993

Edward Wadsworth, *North Sea*, 1928, Tempera on canvas 86.4 x 60.9 cm, Private Collection

Wadsworth, Edward. *1889 Cleckheaton, Yorkshire, †1949 London. British painter. He studied engineering in Munich in 1906–07 and in 1908 art at the Bradford School of Art; also 1909–12 at the Slade School of Fine Art in London. In the 1920s he mde several trips to France and Italy. From 1932 he was a member of → Abstraction-Création, and in 1933 a founder member of → Unit One. In 1951 a retrospective of Wadsworth's work was held at the Tate Gallery in London. As a fervent admirer of → Post-Impressionism and → Cubism Wadsworth was one of the signatories of the *Vorticist Manifesto* (→ Vorticism) in 1914, and

provided a translation of → Kandinsky's *Concerning the Spiritual in Art* for the first edition of the journal *Blast*. His paintings and woodcuts of this period (many of them destroyed or lost) show the industrialized environment of his childhood in strong, contrastingly vibrant compositions. In the 1920s he immersed himself in the paintings of the early Renaissance, especially Fra Angelico. This is followed by a more objective style in which, similar to de → Chirico, he developed a predilection for tempera. Besides abstract experiments with amorphous forms, marine themes, seascapes, and beach still lifes with shells (*Coquillages*,1926), sometimes incorporating Surrealist elements, provide the main features of his work. A.R.

Bibl.: Wadsworth, London, 1974 · Wadsworth, Bradford, 1989

Walker, John. *1939 Birmingham. English painter and printmaker (lithography) working mainly in New York City. Attended Birmingham College of Art (1955–60) and the Académie de la Grande Chaumière (1961–63). After the → shaped canvases of the mid-1960s, he became increasingly influenced by the drama of high → Abstract Expressionism and → Post-Painterly Abstraction, and his near abstracts gained in scale. The mid-1970s saw textured gelled chalk with collage paintings in a post-Cubist idiom (some of them three meters tall), often *Untitled*. Other sequences included the *Blackboard Suite* (1973–) and *Newhaven Etchings* (1977–). In keeping with the prevailing aesthetic, reinterpreting earlier art (Manet, Goya, and Velázquez with *Red Strand Infanta II* [1981]) became a preoccupation in the late 1970s, though Walker never embraced ironic → Postmodernism. Elements from Oceanic art, including skull racks and vegetation, appeared in the 1980s, as did Japanese imagery (Kabuki theater and word-painting), all in a → Neo-Expressionist vein that rejected Eurocentricism and harked back to ritual (see → New Image Painting). Late 1990s painterly abstracts concerned World War I and collective and paternal memories (*Generations*). D.R.

Bibl.: Walker, London, 1985

Wall, Jeff. *1946 Vancouver, Canada. Canadian photographer living in Vancouver. He studied history of art at the University of British Columbia in 1964–70, then took a doctorate at the Courtauld

Jeff Wall, *Movie Audience*, 1979, 7 slides mounted on 3 projectors, each 102 x 102 cm, Städtische Galerie im Lenbachhaus, Munich

Institute in London. Since 1974 he has lectured at the Simon Fraser University in Vancouver and the University of British Columbia as well as having visiting professorships in Munich, Düsseldorf, and London. In the 1960s and 1970s, Wall began as a painter but then addressed the possibilities of → Conceptual art. Since 1977 he has been working on large-scale transparencies which he mounts on light boxes in order to let light as a material structure penetrate the work. Following the definition of Baudelaire, Wall sees himself as a "Painter of Modern Life" who creates an image of his age using the latest technological equipment. His work, however, frequently contains compositional elements and motifs taken from paintings of past centuries, in particular by Manet and Delacroix (e. g. *Picture for Women*, 1979; *The Storyteller*, 1986). Like a film maker, i. e. with precise planning and the use of videos, still photos, and computer manipulation, Wall often prepares his pictures for months beforehand only to present them as alleged snapshots. The viewer often only recognizes the staged event at a second glance. In the 1980s Wall's themes focused on urban scenes as found in the suburbs and industrial estates of Vancouver. These landscapes, symbols of a sick, social system, are the backdrop for troubled interpersonal relationships (e. g. *Eviction Struggle*, 1988). Since the 1990s grotesque scenes (e. g. *Vampires' Picnic*, 1991; *Dead Troops Talk*, 1992) appear in Wall's staged photographic work along with the representation of landscapes. He produced a series of black-and-white photographs for Documenta 10 using traditional photographic forms, such as documentary photography by Walker → Evans or → Lange. C.W.

Bibl.: Wall, London, 1995 · De Duve/Pelenc/Groys, Wall 1996 · Wall, Munich, 1996

Walther, Franz Erhard. *1939 Fulda. German Performance artist living in Halstenbeck. In 1957–59 he attended the Werkkunstschule in Offenbach; in 1959–61 the Hochschule für Bildende Künste in Frankfurt; and in 1962–64 the Kunstakademie in Düsseldorf. In 1963–69 he produced *1. Werksatz* with action-related, textile objects. In 1967–71 he was in New York. 1969–72 saw the production of *2. Werksatz* consisting of useable metal objects. In 1969 he had a one-man exhibition in the Lange House Museum, Krefeld and the Kunsthalle, Düsseldorf. In 1971 he returned to Germany and

Jeff Wall, *The Thinker*, 1986, Color photograph, 236 x 254 cm, Private Collection

became Professor of Sculpture at the Hochschule für bildende Künste, Hamburg. In 1972 and 1977 his work appeared in Documentas 5 and 6. The objects designed by Walther since 1963, mostly from fabric, serve as a tool-set for testing sensual perception and physical awareness in the true sense of → Process art (*Werkhandlungen*, *Werkvorführungen*). Such material art projects are accompanied by original design drawings. K.S.-D.

Bibl.: Damsch-Wiehager, Walther, 1993 · Walther, Hamburg, 1998

Andy Warhol, *Joseph Beuys, State III*, 1980–83, Silk-screen print, 101.6 x 81.3 cm, Schellmann Publishers, Munich – New York

Andy Warhol, *Lenin*, 1986, Acrylic and silk-screen on canvas, 213 x 178 cm, Städtische Galerie im Lenbachhaus, Munich

Warhol, Andy (born Andrew Warhola). *1928 Pittsburgh, Pennsylvania, †1987 New York. American painter, graphic artist, and film maker of Czechoslovakian parentage. He studied in 1945–49 at the Carnegie Institute of Technology in Pittsburgh, then moved to New York where he worked as an illustrator and commercial artist. From 1960 he produced pictures using material from → comics. In 1962 he founded the Factory (film, photographic, and music studio). In 1968 his first European exhibition took place in Stockholm; his work also appeared in Documenta 4. His early paintings (see → Pop art) were initially intended as backdrops for store window displays. From 1962 his first picture series emerged (*Campbell's Soup Cans*; *Coca-Cola Bottles*), then silk-screen prints of dollar bills. Warhol established Pop art with subsequent picture series on the themes of death and catastrophe (*Electric Chair*, 1966). During the 1960s he devoted himself increasingly to film work (*Chelsea Girls*, 1966) and organised events, for example with the influential rock band The Velvet Underground. In the 1970s he became a portrait painter to New York society, producing silk-screen prints from photographs of famous people and reworking them (*Marilyn Monroe*, 1967). The series *Myths*, produced in 1981, comprises American cult figures (e. g. Superman).

Warhol also loved to be on stage himself; in 1985 he exhibited himself as a live work of art behind glass in a New York nightclub. After working for years together with his assistants at the Factory he devoted himself from 1984 onwards to joint projects with → Basquiat and → Clemente. The historical significance of Warhol lies less in his status as a cult style figure, than in his abolition of the principle of artistic originality. H.D.

Bibl.: Warhol, New York, 1988 · Bockris, Warhol, 1989 · O'Pray, Warhol, 1989 · Warhol, Diaries, 1989 · Warhol, Pittsburgh, 1989 · Coplans/Baudrillard, Warhol, 1990 · Warhol, 1998

Washington Color Painters. Group of painters from Washington D.C., in the 1950s and 1960s, leading protagonists of → Color Field Painting.

The most important artists were → Louis and K. → Noland. Other members were Gene Davis (1920–85), Thomas Downing (1928–), Howard Mehring (1931–), and Paul Reed (1919–). The group took its name from an exhibition entitled The Washington Color Painters which was held in the Washington Gallery of Modern Art. H.D.

Webb, Boyd. *1947 Christchurch, New Zealand. New Zealand photographer living in London. He studied sculpture at the Ilam School of Art in Christchurch in 1968–71 and, in 1972–75, at the Royal College of Art in London. Webb's early works frequently show arrangements containing one inconspicuous but, at second glance, disturbing detail such as the photograph of a garden idyll where frozen eels serve as a fence (*Eels*, 1979). Since 1982 Webb works with large-scale Cibachromes which show absurdly Surrealist scenes: cosmos-like compositions of an unreal world with lavish studio scenery where man, animals, and objects from his environment are shown in unusual contexts. The significance of such staged tableaux often reveals itself only from the poetically absurd picture titles (*Glorious Morning*, 1986; *Enzyme*, 1986). C.W.

Bibl.: Webb, 1987

Weber, Max. *1881 Bialystok, Poland, †1961 New York. Polish painter and sculptor. He arrived in 1891 in the US, attending the Pratt Institute in Brooklyn in 1898–1901. In 1902 taught at summer school, University of Virginia. He attended the Académie Julian in Paris in 1905–08, making contact with → Matisse, → Picasso, and → Rousseau among others. In 1909 he returned to the US. From 1917 he was Director of the → Society of Independent Artists, and in 1925 became lecturer at the → Art Students League in New York (where he taught → Rothko). His work appeared in 1950 at the Venice Biennale. In Paris in 1905–08 he encountered the influence of various avant-garde styles. His initial Expressionist, figurative style of painting tended towards → abstract art under the influence of Cézanne and → Cubism. In 1915 he created *Spiral Rhythm*, one of the first abstract sculptures in America. In 1919, after studying Jewish themes, he returned to figurative art. Weber represents the link between the American avant-garde movement and European art. I.S.

Bibl.: North, Weber, 1983

Weegee (Arthur Felling). *1899 Zloczew (formerly Austria, now Poland), †1968 New York. American photographer. In 1910 Weegee settled in New York where at first he made a living from odd jobs. In the 1920s he worked for the photographic agency Acme Newspicture, and from 1935 as a freelance press photographer. He quickly made a name for himself as a papparazzo photographer. Through contacts with the New York police and by installing police radio equipment in his car he frequently managed to be first at the scene of an accident or crime to record the gruesome underbelly of glamorous New York nightlife. His photographs of nightly traffic accidents, fires, and crimes of violence, all taken with a strong flash,

Weegee, *Lovers at the Movies*, c. 1940, Infrared photograph, vintage gelatin silver print, 27 x 34.5 cm, Dietmar Siegert Collection, Munich

are lent an extra ruthless reality through their dramatic play of light and shadow. In 1945 Weegee published his first book *Naked City* which, with his collaboration, was made into a Hollywood film in 1947. C.W.

Bibl.: Weegee, 1997

Wegman, William. *1943 Holoyoke, Massachusetts. American painter, draughtsman, photographer, and video artist living in New York. In 1963–67 he studied painting at the Massachusetts College of Art in Boston; and in 1965–67 at the University of Illinois in Urbana. After university he began his early video work and painting, often in connection with → Minimal and → Conceptual Art, always turning its seriousness wittily on its head. In the early 1970s Wegman began working with his Weimaraner dog Man Ray (and since 1987 with Fay Ray). In countless photographs he dresses Man Ray in fancy clothes and has him perform human tasks (*Man Ray as an Elephant,* 1981; *Man Ray Dressed up for the Ball,* 1988). Alongside the famous dog pictures, Wegman also turned to painting in 1985, and his pictures express more socio-critical concerns by contrast with his humorous photography. C.W.

Bibl.: Wegman, 1991

Weibel, Peter. *1944 Odessa. German Performance and video artist, art theorist, media artist, exhibition organizer living in Karlsruhe. Weibel studied literature, medicine, logic, and philosophy in Paris and Vienna, writing a dissertation on mathematical logic. He has organized many performance art events together with → Export within the context of → Vienna action art. In the 1970s he began to experiment with conceptually and technologically orientated art, thereby initiating ideas of virtual reality and cyberspace. He was co-organizer of Ars Electronica in Linz. In 1984–89 he became Professor at the State University of New York at Buffalo; in 1989–95 Director of the New Media Institute at the Städelschule in Frankfurt; and in 1984–98 Professor at the Hochschule für angewandte Kunst in Vienna. Since the end of 1998 he has been Director of the Center for Art and Media Technology (ZKM) in Karlsruhe. He has published numerous publications and exhibitions on issues in art and media theory. M.S.

Bibl.: Schuler, Weibel, 1996

Weight, Carel. *1908 London, †1997 London. British figurative painter. He trained in London at Hammersmith School of Art (1928–30) and Goldsmiths' College (1930–33), and worked as an as an → Official War Artist in occupied territories from 1945. Influenced by the mainstream of British art rather than by international trends, his landscapes and cityscapes (often of south London and its "forlorn gentility" [Frances Spalding]) are in a loose-handled → Euston Road School style (*Clapham Junction,* 1978). Weight is best known for intriguing scenes of human drama localized in domestic, if often hardly homely, settings (*The Friends,* 1968). A somewhat conservative figure and Royal Academy Trustee, he taught at the Royal College of Art from 1947 and – in the face of the → Abstract Expressionist storm – was Professor of Painting 1957–73. D.R.

Bibl.: Weight, Weight, 1994

Weiner, Lawrence. *1942 New York. American self-taught Conceptual artist living both in New York and Amsterdam. In 1969 he participated in the exhibition When Attitudes Become Form; and in 1972, 1977, and 1982 at Documentas 5, 6, and 7. After studying philosophy and literature at Hunter College, New York, Weiner experimented with forms of expression through painting and sculpture: craters formed by explosions (*Cratering Piece,* 1960), paintings with television test-cards in the form of propellers, sections through rectangles. In the mid-1960s he began to analyze the basic preconditions for artistic production through the medium of language, the idea and concept of a work of art being of prime concern to him, the material-dependent execution remaining secondary. The role of the painter as sole creator of the work of art is eliminated, and the work as such becomes reality through its linguistic formulation. With such considerations Weiner became a co-founder of → Conceptual art and inspired artists such as → Kosuth, → Barry, and → Kawara. Weiner, however, does not present his work as an author of texts but as a genuine visual artist working in a wide variety of genres, from → artists' books to large-scale murals on interior or exterior walls. He also produces videos, films, records, and tape recordings. H.D.

Bibl.: Fuchs, Weiner, 1976 · Weiner, Amsterdam, 1988 · Mari, Weiner, 1992 · Weiner, Villeurbanne, 1993

Lawrence Weiner, *Just About Enough/Just Over There, Air de Paris,* Nice, 1990, Text: various dimensions

Weiss, David. → Fischli & Weiss

Werefkin, Marianne von. *1860 Tula, †1938 Ascona. Russian painter. From 1883 she studied at the Moscow School of Art, and in 1886–96 took

Marianne von Werefkin, *Self-portrait I*, c. 1910, Tempera on cardboard, 51 x 34 cm, Städtische Galerie im Lenbachhaus, Munich

private tuition from Realist Ilja Repin in St. Petersburg. In 1891 she forged a friendship with → Jawlensky with whom she settled in Munich in 1897. She stopped painting and devoted herself to organizational work, hosting a Salon which became a meeting place for the Munich avant-garde. In 1901/02 she was temporarily in Paris and in 1905 she took up painting again. In 1909 she was co-founder of the → Neue Künstlervereinigung München. In 1912 she participated in the → Blaue Reiter exhibition, organized by → Sturm in Berlin. In 1913 she took part in the → Sonderbund in Cologne and the Erster Deutscher Herbstsalon in Berlin. In 1914 she moved to Switzerland together with Jawlensky, first to St. Prex, then in 1917 to Zürich and finally in 1918 to Ascona. In 1920 after separating from Jawlensky she settled in Ascona. While in Munich, her early Symbolist work was succeeded by increasingly Expressionist stylistic means. Her *Self Portrait I* (c. 1910) shows the strong influence of van Gogh (→ precursors). In contrast to the other members of the Blaue Reiter Werefkin never painted abstract pictures herself, yet she counts nevertheless as one of the pioneers of German modernism on the strength of her powers of criticism and judgement. S.Pa.

Bibl.: Russ, Werefkin, 1980 · Brögmann, Werefkin, 1996

Wesselmann, Tom. *1931 Cincinnati, Ohio. American painter, sculptor, graphic artist, and draughtsman, living in New York since 1963. In 1951–52 and 1954–56 he studied psychology at the University of Cincinnati in Ohio, interrupted by military service in Korea (1952–54). While studying he also took courses at the Cincinnati Art Academy. In 1956–59 he moved to New York to study at the Cooper Union School of Arts and Architecture. In 1959–60 he produced his first independent works, small-scale collages from dis-

Tom Wesselmann, *Great American Nude, No. 98*, 1967, 5 canvases placed in 3 rows one behind the other, oil on canvas 250 x 380 x 130 cm, Ludwig Museum, Ludwig Foundation, Cologne

carded paper and other found material (*Little Great American Nudes*, 1961–62) which are developed further into large-scale still lifes with everyday utensils and elements from the world of advertising. This was followed by his large-format series *Great American Nudes* and *Bathtubs*. In the late 1960s his motifs were increasingly dominated by a superficial eroticism. The choice of trivial motifs, their reduction to stereotypes, the sexual symbolism, as well as the impersonal poster-like design, the use of bright colors and the monumentalization contribute to making him one of the cof-ounders of American → Pop art in the 1960s. Wesselmann frees himself from the traditional, rectangular picture format and places undefined outlines around the picture motif. He integrates real objects into the picture such as towels or gives his curved plexiglass figures a

relief-like character as in the *Great American Nude 72* or *82*. In 1983 he started developing metal works, fleeting sketches of landscapes, still lifes or nudes which are electronically transferred onto metal plates and cut out by lasers. I.N.

Bibl.: Wesselmann, Long Beach, 1974 · Wesselmann, Tokyo, 1991 · Hunter, Wesselmann, 1994 · Wesselmann, New York, 1998

West, Franz. *1947 Vienna. Austrian sculptor and Performance artist living in Vienna. He studied at the Akademie der Bildenden Künste, Vienna, and became Visiting Professor at the Frankfurter Städelschule. In 1987 and 1997 his "Sculpture

Franz West, *Rest*, 1994, Installation: mixed media, various dimensions, Dia Center for the Arts, New York

Projects" appeared in Münster. In 1990 his work was presented at the Venice Biennale; and in 1992 at Documenta 9. Active bodily experience is the central theme of the artists of → Vienna action art, and true to this, West's works can be "perceived" only by the undertaking of haptic tasks. This is made possible e.g. by "Paßstücke," portable sculptures which, in the form of artificial limbs, restrict the body's mobility. His iron-welded seating objects can be used and sat on by the viewer: in this vein, 28 sofas placed in the sculpture plaza of the Museum of Contemporary Art in Los Angeles serve to promote communication. On the basis of the usability of objects, West tries to test and extend the frontiers between art and everyday life. The ambivalence of his works as sculptures and, at the same time, functional objects becomes obvious in an exhibition environment. I.S.

Bibl.: West, Venice, 1990 · West, Vienna, 1996

Weston, Edward. *1886 Highland Park, Illinois, †1958 Carmel, California. American photographer who in 1907 studied at the Illinois College of Photography in Chicago. Until 1911 he undertook darkroom work for professional photographers. In 1923 he moved to Mexico with → Modotti where he opened his own photographic studio. In 1929–58 he ran a studio in Carmel together with his son Brett, also owning from 1935 to 1937 a studio in Santa Monica. In 1932 he was co-founder of the group f/64 (Ansel → Adams).

Weston's early work was marked by soft shade studies in the style of artistic pictorialism. At the beginning of the 1920s his photographic perception changed and he became more adventurous in his experiments and more accurate in detail. Weston's main themes were nature and nude photography. His purist studies of bodies and landscapes, but also of everyday objects like fruit

and vegetables, give rise to a clean-lined, unmanipulated photograph, with a tendency towards abstraction. C.W.-B.

Bibl.: Gilles, Weston, 1995

Edward Weston, *Cabbage Leaf*, 1931, Gelatin silver print, 18 x 23 cm, Lane Collection

Whiteley, Brett. *1939 Sydney, †1992 Thirrou, near Wollongong, New South Wales. Australian painter, sculptor, and printmaker. Whiteley studied at the Julian Ashton art school at Sydney before showing (*Red Painting*) in the 1961 "Recent Australian Painting" exhibition at the Whitechapel Gallery, London. Though influenced by → Dobell, his figurative painting was a sensuous and "distorted" – if tempered – "Expressionist" meld of European and Australian modes in the style of → Bacon (a portrait of Bacon dates from 1972). On returning to Sydney, he began depicting a peculiarly Antipodean view of daily life in almost → Pop collages and sculptures (*Platypus*, 1965), some of them mixed-media. From the early 1960s, he produced prints and screen-printed posters, though his most notorious paintings of the time (1964–65) drew partial inspiration from the British murderer John Christie (*Cheetah in Rillington Place*, 1964). Work in the 1970s used a contrasting "swirl" motif (*Baudelaire's Dance*, 1975). Greatly interested in non-European cultures and prey to addictions of various kinds, Whiteley died following an overdose: "I am determined to crush a colored picture from that area within me that is game and wild and intoxicated … can I do it?" (1989). D.R.

Bibl.: McGrath, Whiteley, 1979

Whiteread, Rachel. *1963 London. British sculptor living in London. She attended Brighton Polytechnic in 1982–85, and in 1985–87 the Slade School of Fine Art. In 1992–93 she was awarded a DAAD Scholarship to Berlin. In 1993 she received the Turner Prize; and in 1996 the prize for the Jewish memorial in Vienna. Her work appeared in 1997 at the Venice Biennale and Documenta 10. In 1998 she received a public commission for the City of New York: the installation of the plastic sculpture *without title (Water Tank)* on the roof of a high-rise building. Whiteread's sculptural principle corresponds to the reversal of inside and outside, or positive and negative form. After having made plaster casts or impressions of parts of her body she applied this procedure to everyday objects (e. g. a cupboard, bathtub). The best-known work to date, *house*, was made in 1993 in the East End of London where she filled an entire empty space, i.e. the rooms of a Victorian house, with plaster as if making a cast. The outer surfaces of the sculpture were thus formed by the inner walls

of the house. Although initially biographically orientated her work is gaining increasing importance as a way of fixing archaeological or ethnological evidence, as well as through its tendency to thematize social and historic concerns. I.S.

Bibl.: Whiteread, Liverpool, 1996

Wiener Werkstätte. Community of artists' and artisans' studios in Vienna (1903–32), founded in the wake of the Vienna → Secession by the architect Josef Hoffmann (1870–1956) and the painter Koloman Moser (1868–1918). It gained an international reputation by acquiring a workforce of more than 100 people in a very short time. It included studios for gold, silver, metal, and leather working, as well carpentry, varnishing and lacquer work: in 1914 a fashion section was incorporated. Inspired by the idea of imbuing all aspects of everyday life with art, concepts of design and functionally determined architecture were gradually introduced (1903–05 Purkersdorf Sanatorium, first modern logically functional building in Austria). Until Moser's departure the application of geometric principles remained the predominant design feature (the so-called Constructive → Jugendstil). With the advent of in 1908 of Eduard Josef Wimmer (1882–1961) and in 1915 of Dagobert Peche (1887–1923) the functionally determined concept was succeeded by the production of imaginatively decorated luxury goods (as voiced in Adolf Loos' critique, 1927). A.R.

Bibl.: Kallir, Wiener Werkstätte, 1984 · Schweiger, Wiener Werkstätte, 1984 · Wiener Werkstätte, Brussels, 1987

Williams, Fred(erick). *1927 Melbourne, †1982 Melbourne. Australian painter and printmaker. He studied at the National Gallery Art School, Melbourne (1944–49); then at the Chelsea School of Art and the Central School of Arts and Crafts, London (1951–56). Early works on board ranged from quiet, → Braque-like still lifes to → Synthesism, from geometric semi-abstracts and planar nudes to near → Expressionist portraits (*My Godson*, c. 1960/61–). In London, he produced picturesque studies of the music hall and intriguing dancers (1952) and acrobats (1967). His elected

Rachel Whiteread, *Untitled (House)*, 1993, Building material, plaster, height c. 1000 cm, Dismantled (formerly Grove Road, London)

theme was, however, landscape. Vaguely → Tachiste on occasion (*Aboriginal Graves*, 1967), his vibrant and involved markings in a variety of forms (including etching in multi-states, tondi, gouache sketch) concentrate on the Australian structure as geology or hydrology, aerial sweep or horizon (*Yarra River*, 1971, etc.), through the heat haze or in the scorched gum-tree forest: *You Yangs* series (early 1960s), *Upwey* (mid-1960s), *Wild Dog Creek* (1977), etc. D.R.

Bibl.: Williams, Canberra, 1987 · Mollison, Williams, 1988

Wilson, Robert. *1941 Waco, Texas. American stage designer and theater director living in New York. In 1959–62 he attended the University of Texas at Austin, then the Pratt Institute, New York; in 1964 he studied painting at the American Center in Paris; and the following year architecture at the Pratt Institute, New York. In 1963 he initiated his films and video performances, and from 1965 took on theatrial work. Since 1967 he has produced one-man shows at the Museum of Fine Arts in Boston among other places. Wilson belongs to the innovators of 20th-century theater. His productions are characterized by lavish lighting and scenery turning them into *tableaux vivants* which address issues of visual perception. Besides his purely theatrical work Wilson has also turned museums into imaginary stages (Villa Stuck Museum, Munich 1998) and has himself written plays (*The Life and Times of Sigmund Freud*). C.W.

Bibl.: Brecht, Wilson, 1984 · Birnie Danzker, Wilson, 1998 · Quadri, Wilson, 1998

Garry Winogrand, *Untitled*, 1950s, Gelatine silver print, 26.2 x 33.7 cm, Center for Creative Photography, The University of Arizona, Tuscon

Winogrand, Garry. *1928 New York, †1984 Mexico. American photographer. In 1947–48 he studied painting at the City College in New York, then at Columbia University in New York. From 1952 he took on regular photographic work for magazines (including *Harper's Bazaar*). In the mid-1960s his work displayed more active involvement in sociological themes such as political meetings, demonstrations, street scenes. In 1964 he took a series on the New York Zoo and Coney Island Aquarium (*The Animal*). His teaching assignments include the New York School for Social Research, New York, and the School of the Art Institute of Chicago and University of Texas, Austin. Together with → Frank, → Friedlander, and → Arbus he belongs to a group of photographers who present life in a plain unadorned manner. His pictures (often shot from an angle) can present absurd groupings, moments of encounter by people whose eyes meet or who stare into a void. C.W.-B.

Bibl.: Winogrand, 1988

Winter, Fritz. *1905 Altenbögge near Unna, †1976 Herrsching, Ammersee. German painter. In 1919–27 he trained as an electrician, working as an electrical fitter and miner. In 1924 he found himself unemployed, and produced his first drawings. In 1927–30 he studied at the → Bauhaus in Dessau, moving to Berlin in 1930. In 1931–32 he taught at the Pädagogische Akademie Halle, Saale. In 1933 he moved to Allach near Munich; and in 1935 to Dießen, Ammersee. In 1937 he was banned from painting. From 1939 to 1945 he performed military service on the eastern front and in 1946–49 was a prisoner of war. In 1949 he was a founder member of → ZEN 49, and his work appeared in 1950 at the Venice Biennale. In 1955–70 he became Professor at the Kassel Hochschule für Bildende Künste.

In 1929 Winter created his first abstract work in the Bauhaus tradition (→ Klee). In 1944 when

Fritz Winter, *A Sign*, 1950, Oil on panel, 50 x 70 cm, Fritz-Winter-Haus, Ahlen

convalescing in Dießen he produced his series of what was subsequently called the *Triebkräfte der Erde*, where Winter expressed his clear artistic direction: abstract forms rotating in the picture plane with gesturally animated lines in subdued, yet suggestive colors, demonstrate a pantheistic concept. After his return from Siberia in 1949, he incorporated informal methods such as → drip painting, sgraffito, and stencil work to extend the pictorial repertoire by spatial elements, rhythm of form, color contrast, and shades of brightness. The concentrated act of painting in Winter's work also serves to open up a spiritual dimension. H.D.

Bibl.: Lohberg, Winter, 1986 · Winter, Stuttgart, 1990 · Winter, Kassel, 1993

Witkiewicz, Stanislaw Ignacy (also known as Witkacy). *1885 Warsaw, †1939 Jeziory. Polish painter and photographer. An inventive novelist (*Insatiability*, 1932), Witkiewicz (known also as Witacy) was an artistic polymath. An amateur musician who had had contacts with Karol Szymanowski in 1904, he was initially influenced by Giovanni Segantini (1858–1899), Arnold Böcklin (1827–1901), and Gauguin (→ precursors). A reader of logical positivism, he also traveled to New Guinea at the invitation of the anthropologist Malinowski in 1914. Like August Strindberg (whose literary postures he shared), he produced many photographic portraits (*Multiple Self-Portrait*, 1915–17; in uniform). After witnessing the October Revolution, he returned to Poland to

write plays (*Metaphysics for a Two-headed Calf* is a representative title) and sardonic tracts ("New Forms in Painting," 1919). In 1928 he set up the ironically mercantile one-man "Portrait Company," which turned out visionary, post-Symbolist pastel commissions according to pre-set criteria: "ironic," "realistic," "experimental," "expressionist," "saturated with interpretation," etc. From 1930, under the influence of mescaline (like → Michaux) and other substances, he drew eroticized fantasies close to those of fellow writers Bruno Schulz, Fritz von Herzmanovsky-Orlando, or → Kubin. Concluding that "artists will be interned" in this "most horrible of epochs," Witkacy opened his veins on September 18, 1939. His work is held at Słupsk and Poznań. D.R.

Bibl.: Micińska, Witkiewicz, 1990

Wodiczko, Krzysztof. *1943 Warsaw. Polish-born installation artist active in Canada and the US. He was trained in fine art at the Akademia Sztuk Pieknych, Warsaw (1962–68), and later became director of the Center for Advanced Study at MIT (1994–). He produced (1970s) functionless "machines" and "vehicles" without destination, not with the joyfulness of e. g. → Tinguely, but as industrial critique. The large-scale *Public Projections* (1981–) realized on many public buildings in European cities were mordant allusions to political and historical turpitude: US and Soviet missiles in Brooklyn; a swastika on the site of the South African Embassy, London. His most famous work to date is the *Homeless Vehicle* (1987–88). Half recycling bank, half MRI-scanner in form, it was the *engagé,* non-aesthetic outcome of an experiment, adjusted to the demands of New York street people during its "manufacture" and "testing." It was perhaps more significant in terms of empowerment than as a technical solution, but it did highlight the problems of sleeping rough. (Vehicle/refuge projects by Atelier [Joop] van Lieshout [1963–], Lucy Orta [1966–], Fabrice Hybert [1961–], and "Art Seine Tri D" also followed this line.) The 1990s saw multimedia sculptures (*Alien Staff, Mouthpiece*). D.R.

Wölfli, Adolf. → Art Brut

Wols (Alfred Otto Wolfgang Schulze). *1913 Berlin, †1951 Paris. German painter and photographer. In 1919 he settled in Dresden with his family, working in 1931 in the photographic studio of G. Jonas, Dresden. He spent some time at the Bauhaus in Berlin (→ Moholy-Nagy). In 1932 he moved to Paris; thereafter in 1933–35 to Barcelona and the on to Ibiza. In 1936–39 he was back in Paris, working mainly as a photographer. In 1937 he adopted the pseudonym Wols. He was interned in 1939–40. 1947 saw his successful second show at the Drouin Gallery in Paris. In 1955, 1959, and 1964 his work was exhibited posthumously at Documentas 1, 2, and 3.

Apart from press photography in Paris Wols worked on individually interpreted portraits, cityscapes, and still lifes where the factuality of the new vision emerging at the time combined with the fascination for the transitory. Interned at the beginning of war, Wols turned to visual

Wols, *The Blue Phantom*, 1951, Oil on canvas, 73 x 60 cm, Museum Ludwig, Cologne

representation. Figures, architecture, objects and landscapes, reminiscent of → Kubin and → Klee overlap in small watercolors and tiny drawings. The contact he made with the Surrealist circle before the war, now consolidated itself in a kind of psychic → automatism which, especially from 1940 onwards, increasingly obscured the representational element of his work. After the war Wols met the writer Jean-Paul Sartre in Paris who supported him financially. At the initiative of Drouin, owner of the gallery where his first one-man show of watercolors and pen-and-ink drawings in 1945 took place, Wols began to paint in oils. The resulting works in 1947 were exhibited at Drouin and caused considerable enthusiasm among the Paris avant-garde. The signs, lines, and color blobs spontaneously applied to a ground prepared in different ways, form impenetrable networks of shapes, partially associated with the biomorphous, but also revealing the psychic condition of the sick artist (*L'aile de papillon*, 1947). Based on these "psychogrammes" → Mathieu formulated the term → Art Informel. In the last years of his life Wols illustrated the works of Jean Paulhan, Sartre, Franz Kafka, René de Solier, and Antonin Artaud. H.D.

Bibl.: Glozer, Wols, 1978 · Wols, Zurich, 1989 · Wols, Edinburgh, 1990 · Osterwold/Knubben, Wols, 1997

Wood, Beatrice. *1894 San Francisco. American ceramist. After a cross-continental childhood, Wood studied art briefly at the Académie Julian in Paris, and then at the Comédie Française. In 1916 she moved to New York to pursue a theatrical career, at which time she met and became intimate friends with Marcel → Duchamp, Henri-Pierre Roché, → Picabia, → Man Ray and others who formed the New York Dada circle. She helped to organize the Society of Independent Artists and exhibited works in their first annual exhibition at the Grand Central Palace in New York in 1917, as well as published her cartoonish, Dada-inspired drawings, prints, and paintings in Duchamp's avant-garde magazines, *Rogue* and *The Blind Man*. She moved to California in 1933, and, in the 1940s, began to take a serious interest in ceramics, studying with some of the most influential potters of the day (Glen Lukens at the University of California and the Austrian potters Otto and Gertrud Natzler). By the 1970s, Wood was famous for her copper and gold lusterware plates and

vessels that functioned more as expressive sculptures than as objects for use, making her an important figure in the history of the → American Craft Movement. She is also known for her whimsical figurative ceramic sculptures, called "sophisticated primitives," that are made in a consciously naive style and depict varying themes, from political issues to social commentary on the interplay between the sexes. J.C.M.

Bibl.: Naumann, New York Dada, 1994 · Wood, New York, 1997

Wood, Grant. *1891 Anamosa, Iowa, †1942 Iowa City. American painter. In 1910–11 he took summer courses at the School of Design and Handicraft, Minneapolis, and in 1913–16 evening classes at the Art Institute of Chicago. In 1923–24 he studied at the Académie Julian, Paris, and in 1928 in Munich. In 1932 he opened the Stone City Colony and Art School, Iowa City. From 1934 to 1941 he lectured at the University of Iowa, Ames. Initially Impressionist orientated but influenced by the art of the German Renaissance and → Neue Sachlichkeit, Wood's work conveys a coolly detached, at times ironically fragmented realism. The farmers and middle-class people of the mid-West, represented with detailed accuracy and technical precision, have made Wood one of the most significant protagonists of American realism and → Regionalism (*American Gothic*, 1930). A.G.

Bibl.: Wood, Davenport, 1995

Woodrow, Bill. *1948 Henley, Oxfordshire. British sculptor, living in London. In 1967–68 he attended Winchester School of Art; 1968–71 St Martin's, and Chelsea Schools of Art, London. He is associated with → Cragg and → Deacon. He exhibited at the Venice Biennale in 1982, and in 1987 at Documenta 8. From early on Woodrow was concerned with metal sculpture; parallel to this through film and photography he was critically engaged with English → Land art. Since the end of the 1970s his work has often transformed everyday and consumer goods (e.g. auto parts, cutlery) into inventive, disturbing forms. Despite the work of the metal cutters and drill, and the addition of chromatic decoration the original object can always be recognized for what it is (or was); thus the viewer becomes witness to the metamorphosis. Since the 1980s Woodrow has extended his symbolic compositions into → environments, or installations with occasionally ominous associations. His recent bronze sculpture for the fourth plinth in Trafalgar Square, London, *Regardless of History* (2000), demonstrates this mixture of the organic and the doom-laden. I.S.

Bibl.: Roberts, 1996

World of Art (Russian = *Mir Iskusstva*). Group of Russian artists and writers (1898–1906), originally based in St. Petersburg, which imported elegantly decorative → Symbolist and aesthetic currents into Russia. Its guiding lights were → Benois (the most abreast of Western trends), → Bakst, and Sergei Diaghilev (who organized exhibitions in 1899/1900), together with Valentin Serov (1865–1911), Konstantin Somov (1869–1939), and Mikhail Vrubel (1856–1910; 24

works in 1902). Inspirations inc. → Čiurlionis, Parisian → Post-Impressionism, and the musical color experiments of Aleksandr Skryabin (1872–1915). After 1902 Moscow artists came to predominate over foreign invitees, though their journal *Mir Iskusstva* (1898–1905) published Cézanne in 1904–05. → Larionov and → Jawlensky showed at the last exhibition. Revived by Benois (curator at the Hermitage from 1918), a second cycle of shows under *Mir* auspices lasted from 1910 to 1924 and included work by → Chagall, → Kandinsky, El → Lissitzky, → Tatlin, and Natan I. Altman (1889–1970). D.R.

Bibl.: Bowlt, World of Art, 1979

Worpswede School. German artists' colony founded in Worpswede near Bremen in 1889 with Fritz Mackensen and Otto Modersohn which, by rejecting academic norms, relied on nature for inspiration and arrived at a new concept of the landscape. In 1894 Fritz Overbeck and → Vogeler joined, in 1899 Hans am Ende. In 1895 they established themselves as the Künstlervereinigung Worpswede, and participate in the Annual Exhibition of the Works of Art of all Nations at the Munich Glaspalast, achieving the artistic breakthrough which also attracted the first female art students, among them Paula Becker (→ Modersohn-Becker). Overbeck's departure in 1905, Modersohn-Becker's premature death in 1907, Otto Modersohn's move to Fischerhude in 1908, and Mackensen's appointment to Weimar in 1908, spelt the end of the "return to nature." The motifs of the School's paintings, drawings, and graphic work are arranged in severe compositions, enthralled by the monumentality of the simple, and bathed in an unmistakeable atmosphere. Accurate in detail and never losing sight of the subject matter the works go beyond Impressionism. Modersohn-Becker's genius was well ahead of her time, and to a large extent her career developed independently from that of the Worpswede artists. G.P.

Bibl.: Riedel, Worpswede, 1976 · Mück, Worpswede, 1998

Wotruba, Fritz. *1907 Vienna, †1975 Vienna. Austrian sculptor, painter, and draughtsman. In 1921–24 he served an apprenticeship as a die-engraver. In 1926–29 he studied sculpture at the Kunstgewerbeschule, Vienna. He spent 1938–45 in Switzerland; then until 1950 he was Professor at the Akademie der Bildenden Künste, Vienna.

At this time he abandoned anatomical design and concentrated on structural, tectonic principles. The sculptures, reduced to their core volume, in both stone and bronze, initially consisted of coarse, angular blocks until, in 1953–54, a phase of rounded, column-like figures followed. At the end of the 1950s he returned to a cubic formal language. His sculptures, always modeled on the human figure, are characterized by compact volume and statuesque peacefulness. He dismantled the form into components to reconstruct it in free rhythms, creating resting, elevated figures. He also worked for the theater (1948–87) and as an architect (Dreifaltigkeitskirche, Vienna 1974–76). I.H.

Bibl.: Wotruba, Hanover, 1967 · Breicha, Wotruba, 1977 · Heer, Wotruba, 1977

WPA/FAP (Works Progress Administration). Job creation scheme of the American government for artists during the economic depression of 1935–43. Approximately 5000 artists received honoraria from the funds of the WPA for various works, such as murals, easel paintings, and sculptures for public buildings, primarily through the → Federal Art Project. The works also included painted and graphic illustrations of American decorative art for *The Index of American Design*. Almost all influential artists of the time participated in the project, representational as well as abstract ones (apart from B. → Newman, e.g. all artists of → Abstract Expressionism). The muralists → Rivera and → Orozco exerted the greatest influence on mural art. H.D.

Wyeth, Andrew. *1917 Chadds Ford, Pennsylvania. American painter living in Chadds Ford and in Cushing, Maine. His first tuition came from his father, the illustrator of children's books N.C. Wyeth. From 1939 he worked in tempera and watercolors, mainly on landscape motifs of Pennsylvania and Maine. In 1971–85 he produced the series *Helga Pictures* (200 portraits). There was a retrospective of his work at the Metropolitan Museum of Art, New York, in 1976.

Wyeth preferred motifs from his immediate surroundings which he reproduces true to nature and with a meticulous technique (*Christina's World*, 1948). Thanks to his exceptional observational powers and realistic representation Wyeth numbers among the most popular painters in the US. His studies show an element of → Abstract Expressionism. H.D.

Bibl.: Wyeth, New York, 1998

Wynter, Bryan. *1915 London, †1975 London. English painter. Wynter attended the Slade School in London (1938–40) before settling in Cornwall (→ St Ives). He gradually moved from free landscapes of the mid-1940s (*Derelict Tin Mine*) to → Abstract Expressionist works in the mid-1950s which were still vaguely redolent of landscape (*Seedtime*, 1958–59) with powerful suggestions of space. He later devised extremely complex "grid" systems to analyze the relationships between contrasting forms and colors. His style gradually gained in intensity through the 1960s, though he later took a radical turn towards → kinetic sculpture: pairs of mechanical, light constructions revolving in front of mirrors known as "IMOOS" ("Images Moving Out Onto Space"), such as *IMOOS VI*, 1965. D.R.

Yeats, Jack Butler. *1871 London, †1957 Dublin. Younger brother of the poet W. B. Yeats, and the best-known Irish painter of the century. His colorful scenes of Irish daily life (tinkers and ostlers, the circus, music-hall) and Celtic myth derived inspiration from the nationalist spirit of an independent Eire. Educated at Sligo, in whose landscape and light he delighted (memoir, *Sligo*, 1930), his early artwork was mainly illustrative. Studying under Fred[erick] Brown (1851–1941) in London, he first used watercolor, but in about 1915 he began to paint semi-Impressionist works in oil. Initially conservative, around the mid-1920s

Yeats' painterly style became freer with high-keyed colors (→ Kokoschka became a great friend). His work in the later period can be "mushy" and almost unrecognizable under a rich, frenetic impasto (*Boy Jumping into the Water*, 1947). Perhaps somewhat overproductive (more than a thousand paintings and many thousands of drawings), Yeats' reputation has declined abroad though it remains high in Ireland following a centenary reappraisal. D.R.

Bibl.: Pyle, Yeats, 1970 · Yeats, Dublin, 1971

Yoshihara, Jiro → Gutai Group

Young British Artists. The YBAs, as they came to be called, are a varied group of voguish, highly motivated, and much fêted artists who came to prominence in London in the late 1980s with the three Freeze exhibitions (1988). Promoted primarily by advertising mogul Charles Saatchi, the YBAs are known for their "scandalous" behavior, daring use of materials, obsessions with sex and death themes, and social mobility. Alumni of Goldsmiths' College and other institutions, the artists *qua* group came to public attention at the aptly if hubristical entitled Sensation exhibition (organized by → Hirst at the Royal Academy, 1997) of selections from the Saatchi stable, after which the scarcely conservative → Sandle resigned from the RA in protest. Among the stars of the media were Tracy Emin (1963–) and her now (in)famous tent, *Everybody I Have Ever Slept With 1963–95*; a giant portrait of the murderer Myra Hindley (*Myra*, 1995) by Marcus Harvey (1963–), made up of childlike handprints; and the elephant-dung *Mary, Holy Virgin* by Chris Ofili (1968–). Apart from the → Chapman brothers and → Whiteread, other associated art includes the figurative paintings of Gary Hume (1962–), the melting sexual monsters of Paul Finnegan (1968–), the "vulgar" mixed-media work of Sarah Lucas (1962–), superrealist *Dead Dad* (1986–97) by Australian-born Ron Mueck (1958–), a self-portrait by Marc Quinn (1964–) made from his own frozen blood (*Self*, 1991), hugely overweight females by Jenny Saville (1970–), serious → Pop by Richard Patterson (1963–) (*Blue Minotaur*, 1996), and color prints by Sam Taylor-Wood (1967–) (*Wrecked*, 1996, is a parody of the Last Supper). In 1999 the Brooklyn Museum, New York, courted scandal by showing examples of the YBAs' work which so shocked the burghers that the city mayor threatened cuts in museum funding. D.R.

Bibl.: Kent/Cork, Young British Art, 1997 · Sensation, London, 1997 · Stallabrass, High Art Lite, 2000

Young Contemporaries. An approximately annual exhibition of British art held in London from 1949 which, in 1974, changed its name to "New Contemporaries" (since some of the artists could no longer be thought of as strictly up-and-coming, perhaps). The first show took place at the galleries of the Royal Society of British Artists and others have followed in, among other venues, the → Institute of Contemporary Arts (ICA) – also founded (initially on Dover Street) in the flush of post-war British enthusiasm in 1947. The exhibition in 1961 (showing → Hockney, Allen → Jones, and → Kitaj) remains famous for providing a

platform for early British → Pop art. (The association of "British" and "contemporary" in this context should not evoke the "Contemporary Style" championed for example by Herbert Read in *Contemporary British Art*, 1951, which advocated abstract, geometrical forms for applied art.) D.R.

Youngerman, Jack. *1926 Louisville, Kentucky. American painter. On completion of his studies (University of Missouri, 1947), Youngerman traveled to Europe and settled for a time in Paris studying at the École des Beaux-Arts (1947–48) before transferring to New York. His early abstract canvases initially evinced a → Matisse-like easefulness of long, even forms in flowing lines, but he was soon producing works close to the predominant → Hard-Edge style: large, brightly colored, broad layers of paint form irregular, concentric shapes – rather reminiscent of organic forms but unrepentantly flat – where the systematic "interchangeable" shapes are differentiated only by color (*Nexus*, 1987). Composed in chevron, overlapping, or shifting forms, the quasi-symmetrical extrapolation on an often white ground of a central motif sets the keynote. Other works include lithographs, screenprints, and abstract sculpture. D.R.

Bibl.: Systematic Painting, New York, 1966

Zadkine, Ossip. *1890 Vitebsk, †1967 Paris. Russian-born sculptor and painter. In 1905–06 he studied at Sunderland Art School, and in 1908–09 at the Central School of Arts and Crafts, London. In 1909 he moved to Paris, participating in the → Salon des Indépendants and the → Salon d'Automne in 1911. There he met with avant-garde artists (including → Picasso, → Matisse, de → Chirico, and → Rousseau). In 1931 he traveled to Greece. In 1941–44 he was exiled in New York. In 1945 he became Professor at the Académie de la Grande Chaumière, Paris. His work appeared in the 1950 Venice Biennale, and in Documenta 2 (1959). 1982 saw the opening of the Zadkine Museum in his former house and studio in Paris.

In his early works Zadkine showed a preference for analytical → Cubism and later transposed its formal language to sculpture, together with → Laurens, → Lipchitz, and → Archipenko. Figuration as a means of expressing emotion became his main theme. The analysis of Cubist form gradually shifted to a futuristic biomorphous or Surreal approach as a result of his increasingly expressive style. The most intense and dramatic figure in his œuvre, *Ruined Town*, installed in Rotterdam in 1953, became a symbol of suffering creation. Its intensity stems from the ambivalent expression between powerlessness and enraged revolt which is formally represented in the contradictory motif of movement. The importance of Zadkine does not only lie in his multi-layered style with its emphasis on material, but also in his contribution to new figurative themes in postwar sculpture. I.S.

Bibl.: Lecombre, Zadkine, 1989 · Marchal, Zadkine, 1992

Zebra. Group of artists associated with (→ Neo-Realism) founded in Hamburg in 1965 by the painters → Asmus, Peter Nagel (1941–), Nikolaus

Störtenbecker (1940–) and Dietmar Ullrich (1940–) as a reaction to the predominant → Art Informel. After Störtenbecker's departure the sculptors C. Biederbick-Tewes, K. Biederbick and Harro Jacob (1939–) joined in 1977. In search of objective, present-day imagery directly related to real life their work, based on photographic material, shows everyday scenes partially in a representational and partially in an exemplum-based or metaphorical style. Pictures by Zebra artists, with their alienating effect created by the choice and arrangement of motifs, show sculpturally modelled bodies on a mainly flat ground. They are distinguished by smooth facture, graphic detail, and remote coolness as well as an ability to capture fleeting movement. Distribution by way of printed media (serigraphs, mezzotints, aquatints) was of prime concern. A.G.

Bibl.: Zebra, Hamburg, 1980

ZEN 49. Association of German abstract artists founded in Munich in 1949 by the painters → Baumeister, Rolf Cavael (1898–1979), Gerhard Fietz (1910–), → Geiger, Willi Hempel (1905–85), → Winter and the sculptor, Brigitte Meier-Denninghoff (1923–) (later Matschinsky-Denninghoff). The British consul and art historian J. A. Thwaites was its initiator. During the six years of its existence, the group organized exhibitions (the first one took place at the Central Art Collecting Point in Munich in 1950) to which guests were invited who partially joined the group, inter alia → Bissier, K. → Hartung, → Nay, → Schumacher, → Thieler, → Trier, and → Sonderborg. Their common creed was the commitment to abstraction without defining a particular style. The name derives from Japanese Zen painting. S.Pa.

Bibl.: Poetter, ZEN 49, 1986 · Lüttichau, ZEN 49, 1988 · ZEN 49, Troyes, 1989

Zero. Zero (originally the name of an art magazine published in 1958), describes a group of artists (1958–66) centered around → Mack, → Piene, and → Uecker, who rejected any association with traditional easel painting (from Illusionism to → Informal), in order to proclaim a new beginning for painting, starting at nought. Zero's creative materials are chiefly light and movement in space; other elements employed are fire, water, and air, as well as technical materials that overlap genres; the principle that art does not just exist but happens; "new technical means as well as the powers of nature" are employed (Piene 1964). Zero was the first postwar group of artists to have a positive relationship with techno-industrial civilization and made efforts to lessen the alienation beween art and the public. Zero forged numerous lateral links with like-minded European artists, joint exhibitions with → Fontana (*Concetti spaziali*), Yves → Klein (monochrome as well as Neo-Dadaist elements), and → Tinguely (kinetic objects) among others. Mack tried "to make light vibrate" with the help of technoid reliefs and metal rasters, Piene staged *Light Ballets* using smoke and fire, Uecker created white *Meditation Objects* with structure-forming nail beds that produce displays of light and shadow. Zero forms part of the

tradition of → Kinetic art started by → Moholy-Nagy, → Gabo, and → Pevsner. W.S.

Bibl.: Zero, 1973 · Zero, Essen, 1992 · Damsch-Wiehager, Zero Italien, 1995/96

Zille, Heinrich. *1858 Radeburg, †1929 Berlin. German lithographer, photographer, and draftsman. In his youth he took private drawing lessons. In 1872 he was apprenticed as a lithographer; and took evening classes in drawing and other studies with von Werner. In 1877 he began his work with the "Fotografische Gesellschaft", producing his first graphic works and socio-critical drawings; in 1882 he made his first photographic self-portraits, and in 1887 early portraits of his family. In the 1890s his photographic creativity was at its peak. With an incomparably fresh eye he captured the wine cellars of old Berlin, its backyards and alleyways, fairgrounds, and markets, although photography was never at this time a source of income. Among his most significant photographic series are the pictures of the Krögel, an old quarter of the historic Berlin (from 1895), a series of children in the swimming pool (1897–1901), a fairground at the Lietzensee in Charlottenburg (1897–1900), women collecting firewood (1897–98) or a rubbish dump (1898–99). Although, prior to the photographs of the women collecting firewood, he had already produced drawings and watercolors on the same theme in 1895, he created his first etchings and aquatints in 1898–99, using motifs from his photographs. In 1901 he participated for the first time in the black-and-white photography exhibition of the Berlin → Secession. From 1902, as he became more and more successful in drawing and as a genre painter, his photographic activities decreased. In 1903 he became a member of the Berlin Secession, and his first drawings were published in *Simplicissimus*, and later in *Lustige Blätter* and *Jugend*. In 1905–06 he created the last of his photographic series. In 1907 he left the "Fotografische Gesellschaft." Working freelance since then, he became a celebrated illustrator of the ordinary people of Berlin. He produced numerous illustrated books: e.g. *Street Children* (1908), *My Milieu*, (1913), and *Whores' Gossip* (1921). In 1924 Zille abandoned photography, becoming a member of the Preußische Akademie der Künste; his photographic work was rediscovered only decades later. P.S.

Bibl.: Kaufhold, Zille, 1995 · Flügge/Neyer, Zille, 1997

Zimmer, H. P. (Hans Peter). *1936 Berlin, †1992. German painter. In 1956–57 he studied at the Hochschule für Bildende Künste in Hamburg; in 1957–60 at the Akademie der Bildenden Künste in Munich. In 1958 he was co-founder of → Spur; and from 1966 a member of the Geflecht group. In 1959–62 he was a member of the Internationale Situationniste (→ Situationism). In 1963 he worked on designs for fantasy architecture. In 1964 he traveled to Italy. In 1982 he became Professor at the Hochschule der Bildenden Künste in Brunswick.

Heinrich Zille, *Nine Boys Practicing Handstands*, before 1900, Gelatin silver print, 20.7 x 26.2 cm, Berlinische Galerie, Berlin

Inspired by → Cobra and in reaction against → Nolde and → Beckmann Zimmer's work at the start of the 1960s displayed a figurative Expressionism, the figures being produced from an ecstatic, Informel-derived process. His tree pictures (*Narrenbäume*) appeared in 1984 using similarly Expressionistic vocabulary, whose precursors can be seen in van Gogh and → Munch. His last works concerned themselves with everyday life. K.S.-D.

Bibl.: Zimmer, Wolfsburg, 1986

Zorio, Gilberto. *1944 Andorno Micca. Italian sculptor living in Turin. In 1963–70 he studied painting and sculpture at the Accademia di Belle Arti in Turin. From 1986 he taught at the Liceo Artistica in Cuneo, and from 1971 in Turin. His work appeared in 1972 and 1992 at Documentas 5 and 9; and in 1986 at the Venice Biennale. By the use of chemical substances, Zorio's work began in 1966 to show a gradual change in materials. As a member of → Arte Povera Zorio uses different materials such as leather, lead, terracotta, and glass for his objects and → installations but also incorporates standardized items such as athletic javelins, compressors, and neon light strips. S.Pa.

Bibl.: Zorio, Amsterdam, 1987

Zucker, Joe. → New Image Painting

Zush (Alberto Porta). *1946 Barcelona. Self-taught Spanish painter living in Barcelona and New York. In 1968 he changed his name to Zush and developed what he calls an "Evrugo Mental State". He lived for a short while on Ibiza, and from 1975 to 1977 worked in New York. His stylized, non-classifiable pictures are diagrams of his own ideas representing psychic states and inner landscapes. S.Pa.

Bibl.: Stals, Zush, 1997

Appendices

Abadie/Hulten, Calder, 1993
Abadie, D./P. Hulten (eds.), *Alexander Calder. Die großen Skulpturen. Der andere Calder* (exh. cat.) Kunst- und Ausstellungshalle der Bundesrepublik Deutschland Bonn, Stuttgart, 1993

Abakanowicz, Düsseldorf , 1993
Magdalena Abakanowicz Skulpturen (exh.cat.), Düsseldorf, 1993

Abakanowicz, New York, 1982
Abakanowicz (exh. cat.), Museum of Contemporary Art, New York, 1982

Abbott, Atget, 1965
Abbott, B., *The World of Atget*, New York, 1965

Abbott, Model, 1979
Abbott, B., *Lisette Model*, Millerton NY, 1979

Abbott/McCausland, New York, 1939
Abbott, Berenice, and E. McCausland, *Changing New York*, New York, 1939

Abramovic, Amsterdam, 1989
Abramović (exh. cat.), Stedelijk Museum, Amsterdam, 1989

Abramovic, Eindhoven, 1985
Abramović (exh. cat.), Stedelijk van Abbe-Museum, Eindhoven, 1985

Abramovic, Paris, 1990
Abramović (exh. cat.), Musée National d'Art Moderne Centre Georges Pompidou, Paris, 1990

Abroix, Finlay, 1985
Abroix, Y., *Ian Hamilton Finlay: A Visual Primer*, Edinburgh, 1985

Abstraction-Création, 1931–36
J. Hélion und A. Herbin (Hrsg.), Abstraction-Création. Art non figuratif, 5 Bde., Paris 1931–1936

Abstraction-Création, Paris, 1978
Abstraction-Création (exh. cat.), Musée National d'Art Moderne, Paris, 1978

Accardi, Madrid, 1985
Carla Accardi (exh. cat.), Istituto Italiano di Cultura, Madrid, 1985

Accardi, Milan, 1983
Carla Accardi (exh. cat.), Padiglione d'Arte Contemporanea, Milan, 1983

Ackley, Nolde, 1995
Ackley, C. S. (et al.), *Nolde: the Painter's Prints*, Boston, 1995

Ackling, Warwick, 1997
Black Sun. Roger Ackling (exh. cat.), Mead Gallery, Warwick Arts Centre, 1997

Activism, London, 1980
The Hungarian Avant Garde: The Eight and The Activists (exh. cat.), Hayward Gallery, London, 1980

Adam, Amsterdam, 1955
Henri-Georges Adam (exh. cat.), Stedelijk Museum Amsterdam, 1955

Adam, Arts of the Third Reich, 1992
Adam, P., *The Arts of the Third Reich*, London, 1992

Adami, 1988
Adami, Valeri, *Les Règles du montage*, Paris, 1988

Adami, 1996
Adami, V., *Adami: narrazioni mitologhici [...], capricci*, Milan,1996

Adams, 1997
Adams, A., *The American Wilderness*, Berkeley, 1997

Adams, Dobell, 1983
Adams, B., *Portrait of an Artist: A Biography of William Dobell*, Melbourne, 1983

Adams, Northampton, 1971
Robert Adams, *Retrospective* (exh. cat.), Northampton Art Gallery, Northampton, 1971

Adaskina/Sarabjanov, Popova, 1990
Adaskina N. and D., Sarabjanov, *Liubov Popova*, London, 1990

Adelman/Tomkins, Lichtenstein, 1987
Adelman, B., and C. Tomkins, *The Art of Roy Lichtenstein: Mural with Blue Brushstroke*, London, 1987

Ades, Dalí, 1995
Ades, D., *Dalí*, London/New York, 1995

Ades, Photomontage, 1986
Ades, D., *Photomontage*, New York/London 1986

Adler, Düsseldorf, 1985
Jankel Adler (1895–1949) (exh. cat.), Städtische Kunsthalle Düsseldorf, 1985

Adler, Gütersloh, 1986
Adler, J. (ed.), *Allegorie und Eros. Texte von und mit Albert Paris Gütersloh*, Munich, 1986

Adock, Turrell, 1990
Adock, C., *James Turrell: The Art of Light and Space*, Berkley/Los Angeles/Oxford, 1990

Adrian, Chicago Imagism, 1994
Adrian, Dennis, *Chicago Imagism: A Twenty-Five Year Survey*, with an introduction by Brady Roberts (exh. cat.), Iowa, 1994

Adrian, Sight, 1985
Adrian, Dennis, *Sight Out of Mind: Essays and Criticism on Art*, Ann Arbor, 1985

Adriani, Cézanne, 1982
Adriani, G., *Paul Cézanne. Aquarelle*, Cologne, 1982

Adriani, Cézanne, 1992
Adriani, G., *Paul Cézanne. Gemälde*, Cologne, 1992

Adriani, Höch, 1980
Adriani, G. (ed.), *Hannah Höch – Fotomontagen, Gemälde, Aquarelle*, Cologne, 1980

Adriani, Kiefer, 1990
Adriani, G. (ed.), *The Books of Anselm Kiefer–1969–1990*, London, 1991

Adriani/Konnertz/Thomas, Beuys, 1979
Adriani G., Konnertz, W., and T. Thomas, *Joseph Beuys, Life and Works*, New York, 1979

Aeropittura, Milan, 1977
Aeropittura (exh. cat.), Galeria d'arte moderna, Milan, 1977

Afro, Opere, 1989
Afro – l'itinerario astratto, opere 1948–1975, Milan, 1989

Agam, Amsterdam, 1973
Yaacov Agam (exh. cat.), Stedelijk Museum, Amsterdam, 1973

Agee, Noland, 1993
Agee, W. C. (ed.), *Kenneth Noland. The Circle Paintings 1956–1963* (exh. cat.), Museum of Fine Arts, Houston, 1993

Agustí, Tàpies, 1988–1997
Agustí, A. et al. (eds.), *Antoni Tàpies. The Complete Works*, 4 vols., New York, 1988–97

Aigner, Rainer, 1997
Aigner, C. et al. (eds.), *Arnulf Rainer, Abgrundtiefe, Perspektive*, Krems, 1997

Aiken et al., Burra, 1992
Aiken J., et al., *Edward Burra, A Painter*, London, 1992

Aillaud, 1991
Aillaud, G., *Dessins, brouillons, projets, envies*, Paris, 1991

Alberola, Nîmes, 1990
Jean-Michel Alberola, *Astronomie populaire* (exh. cat.), Musée d'art contemporain, Nîmes, 1990

Alberola, Paris, 1985
Jean-Michel Alberola (exh. cat.), Centre Georges Pompidou, Paris, 1985

Albers, 1977
Albers, J., *Despite Straight Lines*, Cambridge, Mass., 1977

Albers, London, 1989
Josef Albers (exh. cat.), Mayor Gallery, London, 1989

Albrecht, Lohse, 1974
Albrecht, H. J., *Farbe als Sprache. Robert Delaunay – Josef Albers – Richard Paul Lohse*, Cologne, 1974

Albright, Funk Art, 1985
Albright, T., *Art in the San Francisco Bay Area 1945–1980*, Berkeley, Los Angeles, 1985

Albright, San Francisco Bay Area, 1985
Albright, T., *Art in the San Francisco Bay Area 1945–1980*, Berkeley/London, 1985

Alcopley, Amsterdam, 1962
Alcopley (exh. cat.), Stedlijk Museum, Amsterdam, 1962

Alechinsky, 1973
Alechinsky, P., *Les estampes de 1946 à 1972*, Paris, 1973

Alechinsky, New York, 1987
Pierre Alechinsky: Margin and Center (exh. cat.), Guggenheim Museum, New York, 1987

Alechinsky/Calonne, Dotremont, 1991
Alechinsky, P. and J. Calonne, *Facéties et compagnie de Christian Dotremont*, Brussels, 1991

Alexandre, Modigliani, 1993
Alexandre, N., *The Unknown Modigliani: Drawings from the Collection of Paul Alexandre*, London, 1993

Alexandrian, Bellmer, 1972
Alexandrian, S., *Hans Bellmer*, Paris, 1983

Alexandrian, Man Ray, 1973
Alexandrian, S., *Man Ray*, Paris, 1973

Allen, Fairweather, 1997
Allen, C., "Ian Fairweather," in *Art in Australia*, 1997

Alloway, Lichtenstein, 1983
Alloway, L., *Roy Lichtenstein*, New York, 1983

Alloway, Pop art, 1974
Alloway, L., *American Pop Art*, New York, 1974

Altenbourg, Arbeiten, 1988
Gerhard Altenbourg, Arbeiten 1947–1987, Bremen, Tübingen, Hanover, Berlin, 1988

Amado, 1997
Jean Amado: Trente ans de sculpture, Nîmes, 1997

Amanshaus/Ronte, Brus, 1986
Amanshaus, H. and D. Ronte, *Günter Brus: Der Überblick*, Salzburg/Vienna, 1986

Amaral, Tarsila, 1971
Amaral, Aracy, *Desenhos de Tarsila*, São Paulo,1971

Amazons, London, 1999
Amazons of the Avant-Garde (exh. cat.), Royal Academy, London, 1999

American Abstract Artists, 1957
American Abstract Artists, The World of Abstract Art, New York, 1957

Amiet, Kunst, 1948
Amiet, Cuno, *Über Kunst und Künstler*, Berne, 1948

Amiet, Philadelphia, 1991
Cuno Amiet, Giovanni Giacometti, Augusto Giacometti: Three Swiss Painters (exh. cat.), University Park Pennsylvania State University, 1974

Ammann, Disler, 1981
Ammann, J.-C., "Martin Disler: Bilder vom Maler" in *Kunst-Bulletin* 4, 1981

Andre, Hague/Eindhorn, 1987
Carl Andre (exh. cat.), Haags Gemeentemuseum/The Hague, Van Abbe-Museum/Eindhoven, 1987

Andre/Frampton, 1981
Carl Andre and Hollis Frampton, 12 Dialogues 1962–1963, Halifax/N.S., 1981

Andrews, London, 1978
Michael Andrews, Paintings 1977–78 (exh. cat.), Anthony d'Offay Gallery, London, 1978

Andrews, London, 1980
Michael Andrews (exh. cat.), Arts Council of Great Britain, London, 1980

Andrews, London, 1986
Rock of Ages Cleft for Me: Recent Paintings by Michael Andrews (exh. cat.), Anthony d'Offay Gallery, London, 1986

Angermeyer-Deubner, Verism, 1988
Angermeyer-Deubner, M., *Neue Sachlichkeit und Verismus in Karlsruhe*, Karlsruhe, 1988

Anna, Morellet, 1994
Anna, S. (ed.), *François Morellet. Installations/Catalogue raisonné seiner Installationen*, Chemnitz, 1994

Anselmo, 1972
Anselmo, Giovanni, *Leggere*, Turin, 1972

Anselmo, Lyon, 1989
Giovanni Anselmo (exh. cat.), Musée d'Art Contemporain, Lyon, 1989

Anselmo, Modena, 1989
Anselmo (exh. cat.), Palazzo dei Giardini Pubblici, Modena, 1989

Antes, Hanover, 1983
Horst Antes, Kunstmuseum Hannover with the Sprengel Collection, Catalogue of the Hermann Collection, Bremen, Hanover, 1983

Anzinger, 1985
Anzinger, Siegfried, *Laokoon übt, Zeichnungen 1985*, Galerie Krinzinger, Klagenfurt, 1986

Anzinger, New York, 1984
Siegfried Anzinger, Hubert Schmalix (exh. cat.), Holly Solomon Gallery, New York, 1984

Apa, Licini, 1985
Apa, M., *Licini: Opere dal 1913 al 1957*, Milan, 1985

Appel, 1991
Karel Appel: The Complete Sculptures, New York, 1991

Appolonio, Futurism, 1975
Appolonio, U. (ed.), *Futurist Manifestos*, London, 1975

Arakawa, Berlin, 1990
Arakawa, daadgalerie Berlin, 1990

Arakawa , Munich, 1981
Arakawa, Städtische Galerie im Lenbachhaus, Munich, 1981

Arbus, Arbus, 1973
Arbus, Doon (ed.), *Diane Arbus*, New York, 1973

Arbus/Como, Untitled, 1995
Arbus, D., and Y. Como, *Untitled*, London, 1995

Archipenko, Fifty Years, 1960
Archipenko, Alexander and Fifty Art Historians, *Archipenko: Fifty Creative Years 1908–1958*, New York, 1960

Archipenko, Los Angeles, 1986
Alexander Archipenko: A Retrospective Memorial Exhibition (exh. cat.), University of California, Los Angeles, 1986

Ardon, 1995
Mordecai Ardon (1896–1992): In Memoriam (exh. cat.), Marlborough Fine Arts, London, 1995

Ardon, Berlin, 1978
Mordecai Ardon, Bilder aus den Jahren 1953–1978 (exh. cat.), Berliner Kunstverein, Berlin, 1978

Argan, Licini, 1976
Argan, G. C., *Licini*, Sasso Marconi, 1976

Arikha , London, 1988
Avigdor Arikha (exh. cat.), Marlborough Fine Art, London, 1998

Armando, The Hague, 1989
Armando: Die Berliner Jahre (exh. cat.), The Hague, 1989

Armitage, London, 1959
Kenneth Armitage (exh. cat.), Whitechapel Gallery, London, 1959

Armitage, London, 1972–73
Kenneth Armitage (exh. cat.), Arts Council, London 1972

Armleder, Sculpture, 1990
John M. Armleder, *Furniture Sculpture 1980–1990* (exh. cat.), Musée Rath, Geneva, 1990

Armleder, Vienna, 1993
John M. Armleder (exh. cat.), Vienna Secession, Vienna, 1993

Armstrong, Artschwager, 1988
Armstrong, R., *Richard Artschwager* (exh. cat.), Whitney Museum of American Art, New York, 1988

Arnason, Calder, 1971
Arnason, H. H., *Calder*, New York/Paris, 1971

Arnason, Motherwell, 1977/1982
Arnason, H., *Robert Motherwell*, New York, 1977/1982

Arp, 1967
Arp, J., *Collected French Writings*, London, 1967

Arroyo, Paris, 1982
Arroyo (exh. cat.), Musée National d'Art Moderne Centre Georges Pompidou, Paris, 1982

Art at the Edge, 1983
Art at the Edge (exh. cat.), MOMA, Oxford, 1983

Art Concret, 1930
Art Concret, Paris, 1930

Art from Argentina, Oxford, 1994
Art from Argentina, 1920–1994 (exh. cat.), MOMA, Oxford, 1994

Art & Language, London, 1986
Art & Language, Confessions: Incidents in a Museum (exh. cat.), Lisson Gallery, London, 1986

Art & Language, Oxford, 1975
Art & Language 1966–1975 (exh. cat.), MOMA., Oxford, 1975

Arte Italiana, London, 1982–83
Arte Italiana 1960–82 (exh. cat.), London, 1982–83

Arthur, Estes, 1993
Arthur, J., *Richard Estes: Paintings and Prints*, San Francisco, 1993

Arthur, Realists, 1983
Arthur, J., *Realists at Work*, New York, 1983

Artschwager, Basel, 1985
Richard Artschwager (exh. cat.), Kunsthalle Basel, 1985

Artschwager, Buffalo, 1979
Richard Artschwager's Theme(s) (exh. cat.), Albright Knox Art Gallery, Buffalo/NY, 1979

Artschwager, Paris, 1989
Richard Artschwager (exh. cat.), Musée National d'Art Moderne, Centre Georges Pompidou, Paris, 1989

Ashton, Lindner, 1969
Ashton, D., *Richard Lindner*, New York, 1969

Ashton, New York School, 1980
Ashton, D., *The New York School: A Cultural Reckoning*, New York, 1980

Ashton, Noguchi, 1992
Ashton, D., *Noguchi East and West*, New York, 1992

Ashton, Tucker, 1987
Ashton, D., *William Tucker, Gods: Five Recent Sculptures* (exh. cat.), Tate Gallery, London, 1987

Assem, Munch, 1992
Assem, A. et al., *The Frieze of Life, Edvard Munch*, National Gallery, London, 1992

Atkins, Jorn, 1977/1980
Atkins, G., *Asger Jorn*, 3 vols., London, 1977/1980

Attersee, Vienna, 1990
Attersee – Die gemalte Reise, Verein zur Aufarbeitung der Werke Österreichischer Künstler, Vienna, 1990

Auberjonois, Lausanne, 1994
René Auberjonois (exh. cat.), Musée des Beaux-Arts, Lausanne, 1994

Auberjonois, Paris, 1977
Auberjonois (exh. cat.), Musée d'art moderne de la Ville de Paris, 1977

Auerbach, London, 1978
Frank Auerbach (exh. cat.), Arts Council, London, 1978

Auerbach, London, 1987
Frank Auerbach: Recent Paintings (exh. cat.), Marlborough Galleries (London), 1987

Auerbach, Venice, 1986
Frank Auerbach: Paintings and Drawings 1977–85 (exh. cat.), British Pavilion, XLII Venice Biennale, British Council, London, 1986

Auping, Abstract, 1987
Auping, M. (ed.), *Abstract Expressionism: The Crucial Developments*, New York, 1987

Auping, Clemente, 1985
Auping, M., *Francesco Clemente*, (exh. cat..), The John and Mable Ringling Museum of Art, Sarasota, 1985

Auping, Holzer, 1992
Auping, M., *Jenny Holzer*, New York, 1992

Auping, Rothenberg, 1992
Auping, M., *Susan Rothenberg. Paintings and Drawings* (exh. cat.), Albright Knox Art Gallery, Buffalo, New York, 1992

Avantgarde Russia, Los Angeles, 1980
The Avantgarde in Russia 1900–1930–New Perspectives (exh. cat.), Los Angeles County Museum of Art, 1980

Avantgarde & Ukraine, 1993
Avantgarde & Ukraine (exh. cat.), Villa Stuck, Munich, 1993

Avedon, Clemente, 1987
Avedon, E. (ed.), *Clemente: An Interview with Francesco Clemente by Rainer Crone and Georgia Marsh*, New York, 1987

Avramidis, Nuremberg, 1980
Joannis Avramidis, Skulpturen, Entwürfe, Zeichnungen (exh. cat.), Kunsthalle Nurenberg, 1980

Avramidis, Stuttgart, 1986
Joannis Avramidis, Zeichnungen (exh. cat.), Staatsgalerie Stuttgart, 1986

Axsom, Kelly, 1987
Axsom, K., *Ellsworth Kelly, the Graphic Work*, New York, 1987

Aycock, London, 1985
Alice Aycock (exh. cat.), Serpentine Gallery, London, 1985

Ayres, London, 1983
Gillian Ayres (exh. cat.), Arts Council, London, 1983

Ayres, Oxford, 1981
Gillian Ayres, Paintings (exh. cat.), MOMA, Oxford, 1981

Azaceta, New York, 1993
Luis Cruz Azaceta: Selected Works 1978–1993, Alternative Museum, New York, 1993

Baal-Teshuva, Calder, 1998
Baal-Teshuva, J., *Alexander Calder*, Cologne, 1998

Baatsch, Michaux, 1993
Baatsch, H.-A. (ed.), *Henri Michaux. Peinture et poésie*, Paris, 1993

Bach, Brancusi, 1995
Bach, F.T. (ed.) *Constantin Brancusi 1876–1957* (exh. cat.) Philadelphia Museum of Art, Philadelphia, 1995

Bacher, Grützke, 1995
Bacher, J., *Johannes Grützke Selbstverständlich*, Aachen/Leipzig/Paris, 1995

Badt, Cézanne, 1956
Badt, K., *Die Kunst Cézannes*, Munich, 1956

Bärmann, Tobey, 1997
Bärmann, M. et al. (eds.), *Mark Tobey* (exh. cat.), Museo Nacional Centro de Arte Reina Sofia, Madrid, 1997

Baigell, American Scene, 1974
Baigell, M., *American Scene: American Painting of the 1930s*, New York, 1974

Bail, Fairweather, 1981
Bail, M., *Ian Fairweather*, Sydney, 1981

Bailey, Michals, 1975
Bailey, D., *Duane Michals. The Photographic Illusion*, New York, 1975

Bailly, Kowalski, 1988
Bailly, J.-C., *Piotr Kowalsky*, Paris, 1988

Baker, Minimalism, 1988
Baker, K., *Minimalism*, New York, 1988

Baldacci, De Chirico, 1997
Baldacci, P., *De Chirico, The Metaphysical Period 1888–1919*, Boston/New York/Toronto/London, 1997

Baljeu, Doesburg, 1974
Baljeu, J., *Theo van Doesburg*, New York/London, 1974

Balken, Dove, 1997
Balken, D. et al. (eds.), *Arthur Dove. A Retrospective* (exh. cat.), Cambridge, Mass., 1997

Balken, Graves, 1986
Balken, D. B., *Nancy Graves. Painting, Sculpture, Drawing* (exh. cat.), Vassar College Art Gallery, Poughkeepsie/New York, 1986

Ball, Munich, 1986
Hugo Ball, 1886/1986 Leben und Werk (exh. cat.), Städtische Galerie im Lenbachhaus, Munich, 1986

Ball, Ozenfant, 1978
Ball, S. L., *Ozenfant and Purism. The Evolution of a Style 1915–1930*, Ann Arbor, 1978

Ball, Pozzi, 1981
Ball, T. (ed.), *Lucio Pozzi: Abstract Paintings*, New York, 1981

Ball, Purism, 1978
Ball, S. L., *Ozenfant and Purism, The Evolution of a Style 1915–1930*, Yale University, New Haven (diss.), 1978

Balla, Con Balla, 1984–86
Balla, E., *Con Balla, I – III*, Milan, 1984–86

Ballo, Novecento, 1958
Ballo, G., *Modern Italian painting: from Futurism to the Present-day*, London, 1958

Balthus, Lausanne, 1993
Balthus (exh. cat.), Musée cantonal des Beaux-Arts, Lausanne/Ghent, 1993

Balthus, Paris, 1983
Balthus (exh. cat.), Musée National d'Art Moderne, Centre Georges Pompidou, Paris, 1983

Bar-Am, Capa, 1988
Bar-Am, M. (ed.), *Robert Capa: Photographs from Israel 1948–50* (exh. cat.), Tel Aviv, 1988

Barette, Hesse, 1989
Barette, B., *Eva Hesse: Sculpture*, New York, 1989

Barilli, Rotella, 1996
Barilli, R. and T. Sicoli, *Rotella* (exh. cat.), Museo Civico Palazzo Zagarese, Rende/Cosenza, 1996

Barnett, Blue Four, 1997
Barnett, V., *The Blue Four: Feininger, Jawlensky, Kandinsky, and Klee in the New World*, New Haven, 1997

Barney, Hamburg, 1996
Matthew Barney, Tony Oursler, Jeff Wall, Hamburg, 1996

Barnicoat, Posters, 1986
Barnicoat, J., *Posters*, London, 1986

Baron, Delaunay S., 1995
Baron, S., and J. Damase, *Sonia Delaunay: the Life of the Artist*, London, 1995

Baron, Sickert, 1973
Baron, W. *Sickert*, Oxford, 1973

Barrett, Op Art, 1970
Barrett, C., *Op Art*, London, 1970

Bartlett, Milwaukee, 1988
Jennifer Bartlett, Recent Work (exh. cat.), Milwaukee Art Museum, 1988

Bartman/Barosh, Kelley, 1992
Bartman, W. S. and M. Barosh (eds.), *Mike Kelley. Art Resources Transfer*, New York, 1992

Baselitz, London, 1983
Baselitz (exh. cat.), Whitechapel Gallery, London, 1983

Basquiat, New York, 1990
Jean-Michel Basquiat Drawings (exh. cat.), Robert Miller Gallery, New York, 1990

Bastian, Twombly, 1992–95
Bastian, H., *Cy Twombly: Catalogue Raisonné of the Paintings*, Munich, 1992–95

Battcock, Minimal Art, 1968
Battcock, G. (ed.), *Minimal Art. A Critical Anthology*, New York, 1968

Battock, Mangold, 1968
Battock, G. (ed.), *Minimal Art, a Critical Anthology*, New York, 1968

Baudrillant, Baj, 1980
Baudrillant, J., *Enrico Baj*, Paris 1980

Baudson, Panamarenko, 1996
Baudson, M., *Panamarenko*, Paris, 1996

Baumeister, 1960
Baumeister, W., *Das Unbekannte in der Kunst*, Stuttgart, 1947 (Cologne, 1960)

Baumgarten, Mönchengladbach, 1983
Lothar Baumgarten, (exh. cat.) Städt. Museum Abteiberg Mönchengladbach, 1983

Bauquier/Maillard, Léger, 1990–95
Bauquier, G. and N. Maillard (eds.), *Fernand Léger. Catalogue raisonné de l'œuvre peint 1903-1931* 4 vols., Paris 1990–95

Bayer, Berlin, 1982
Herbert Bayer. Das künstlerische Werk 1918-1933 (exh. cat.), Bauhaus-Archiv Berlin, 1982

Baziotes, New York, 1965
William Baziotes (exh. cat.), The Solomon R. Guggenheim Museum, New York, 1965

BDA, Förg, 1993
BDA (ed.), *Günther Förg: Fotografien 1982–1992*, Stuttgart, 1993

Beal/Neubert, Graham, 1981
Beal, G. W. J., and G. W. Neubert, *Statues, Robert Graham*, Minneapolis, 1981

Beardsley, Earthworks, 1989
Beardsley, J., *Earthworks and Beyond*, New York, 1989

Beaton, 1986
Cecil Beaton (exh. cat.), Barbican Art Gallery, London, 1986

Beaucamp, Tübke, 1988
Beaucamp, E., "Reise ins Innere der Geschichte. Werner Tübkes Bauernkriegs-Panorama im thüringischen Bad Frankenhausen" in Brusberg, D. und U. Eckhardt (eds.), *Zeitvergleich '88 dreizehn Maler aus der DDR*, Berlin, 1988

Becher, Stuttgart, 1977
Becher, B. and H., *Typologie industrieller Bauten 1963-75* (exh. cat.), Biennale São Paulo, Stuttgart, 1977

Becker, Happening, 1965
Becker, J. and W. Vostell (eds.), *Happening, Fluxus, Pop Art, Nouveau Réalisme – Eine Dokumentation*, Reinbek, 1965

Beckett, Arikha, 1995
Beckett, Samuel, et al., *Arikha*, Paris, 1985

Beckmann, Munich, 1984
Max Beckmann. Retrospektive (exh. cat.), Haus der Kunst Munich, 1984

Beckmann, Self-portrait, 1997
Beckmann, M., *Self-portrait in Words: Collected Writings and Statements, 1903-1950*, Chicago Ill., 1997

Belgian Avant-Garde, London, 1994
Impressionism to Symbolism: The Belgian Avant-Garde, 1880-1900 (exh. cat.), Royal Academy of Arts, London, 1994

Belgin, Jawlensky, 1998
Belgin, T., *Alexej v. Jawlensky. Reisen, Freunde, Wandlungen*, Heidelberg, 1998

Bell, Lyon, 1989
Larry Bell (exh. cat.), Musée d'Art Contemporain, Lyon, 1989

Belli, Divisionismo, 1990
Belli, G., *L'Ete del Divisionismo*, Milan, 1990

Bellmer, Paris, 1983
Hans Bellmer, photographe (exh. cat.), Musée National d'Art Moderne Centre Georges-Pompidou, Paris, 1983

Belloli, Martini, 1954
Belloli, C., *Il surrealismo di Alberto Martini*, Brescia, 1954

Bellows, Los Angeles, 1992
The Paintings of George Bellows (exh. cat.), Los Angeles, County Mus. of Art, 1992

Belting, Polke, 1997
Belting, H. et al. (eds.), *Sigmar Polke. Die drei Lügen der Malerei* (exh. cat.), Kunst- und Ausstellungshalle der Bundesrepublik Deutschland, Bonn, Stuttgart, 1997

Benezra, Nauman, 1994
Benezra, N. et al. (ed.), *Bruce Nauman* (exh. cat.), Walker Art Center, Minneapolis, Minneapolis, 1994

Benezra, Paschke, 1990
Benezra, N., *Ed Paschke* (exh. cat.), The Art Institute of Chicago, 1990

Benezra/Storr, Puryear, 1992
Benezra, N., and R. Storr, *Martin Puryear* (exh. cat.), The Art Institute of Chicago, London/New York 1992

Benke, O'Keeffe, 1996
Benke, B., *Georgia O'Keeffe. 1887–1986. Blüten in der Wüste*, Cologne, 1996

Benson/Vescoso, Pane, 1990
Benson, M., and M. Vescoso, *Gina Pane*, Paris, 1990

Berend-Corinth, Corinth, 1958
Berend-Corinth, C., *Die Gemälde von Lovis Corinth* (catalogue raisonné, Munich, 1958

Berger, Kolbe, 1990
Berger, U., *Georg Kolbe. Leben und Werk*, Berlin, 1990

Berger, Morris, 1989
Berger, M., *Labyrinths: Robert Morris, Minimalism, and the 1960s*, New York, 1989

Berger, Nussbaum, 1995
Berger, E., *Felix Nussbaum. Verfemte Kunst – Exilkunst – Widerstandskunst*, Bramsche, 1995

Berger/Zutter, Maillol, 1996
Berger, U. and J. Zutter (eds.), *Aristide Maillol* (exh. cat.), Georg-Kolbe-Museum Berlin, 1996

Berguis, Baader, 1977
Bergius, H., N. Miller, and K. Riha, *Johannes Baader Oberdada, Schriften, Manifeste, Flugblätter, Billets, Werke und Taten*, Giessen, 1977

Bernhard, Karlsruhe, 1990
Franz Bernhard (exh. cat.), Badischer Kunstverein, Karlsruhe, 1990

Berninger/Cartier, Pougny, 1972–92
Berninger, H., and J. A. Cartier, *Jean Pougny, Catalogue de l'œuvre*, Tübingen 1972–92

Bernstein, Johns, 1985
Bernstein, R., *Jasper Johns' Paintings and Sculptures 1954-74*, Ann Arbor, Michigan, 1985

Bertrand, 1992
Jean-Pierre Bertrand (exh. cat.), Musée des Beaux-Arts, Nantes, 1992

Besnard-Bernadac, Picasso, 1971
Besnard-Bernadac, M.L., *The Musée Picasso, Paris, Volume I, Catalogue of the Collection: Paintings, Papiers Collés, Picture Reliefs, Sculpture, Ceramics*, London, 1971

Besset, Corbusier, 1968
Besset, M., *Who was Le Corbusier?*, Geneva, 1968

Beuys, Multiples, 1980
Beuys, J., *Multiples, catalogue raisonné* (J. Schellmann and B. Klüser, eds.), New York, 1980

Biennale, Venice, 1996
La Biennale di Venezia. Le Esposizioni Internazionali d'Arte 1895-1995, Venice, 1996

Bihalji-Merin, Naive Art, 1964
Bihalji-Merin, O. (ed.), *World Encyclopedia of Naive Art*, London, 1964

Biletter, Fischl, 1990
Biletter, E., *Eric Fischl. Gemälde und Zeichnungen*, Berne, 1990

Bill, 1987
Max Bill. Retrospektive. Skulpturen, Gemälde, Grafik 1928-87 (exh. cat.), Schirn Kunsthalle, Frankfurt a. M., 1987

Bill, Buffalo, 1974
Max Bill (exh. cat.), Albright Knox Art Gallery, Buffalo NY, 1974

Billeter, Izquierdo, 1987
Billeter, E., *Imagen de Mexico*, Berne, 1987

Billeter, Toledo, 1995
Billeter, E., "Francisco Toledo – ein zapotekischer Traum" in *Visionen, Mexikanische Kunst zwischen Avantgarde und Aktualität* (exh. cat.), Museum Würth, Künzelsau, Berne, 1995

Bing, New Orleans, 1985
Ilse Bing. Three Decades of Photography (exh. cat.), New Orleans Museum of Art, New Orleans, 1985

Birnie Danzker, Wilson, 1998
Birnie Danzker, J.-A., *Richard Wilson: Steel Velvet*, Michigan, 1998

Bischof, Bischof, 1990
Bischof, M. (ed.), *Werner Bischof: 1916-1954. Leben und Werk*, Berne, 1990

Bischof, Toyen, 1987
Bischof, R. (ed.), *Toyen. Das malerische Werk*, Frankfurt am Main, 1987

Bischof/Schifferli, Bischof, 1961
Bischof, R. and P. Schifferli, *Werner Bischof. Querschnitt*, Zürich, 1961

Bischofberger, Tinguely, 1982
Bischofberger, C., *Jean Tinguely, catalogue raisonné: Sculptures and Reliefs, 1954-1968*, New York, 1982

Bissier, Mendrisio, 1989
Julius Bissier, opere 1930-1965 (exh. cat.), Museo d'Arte, Mendrisio, 1989

Blake, London, 1983
Peter Blake. Retrospective (exh. cat.), Tate Gallery, London, 1983

Blamires, Jones, 1971
Blamires, D., *David Jones: Artist and Writer*, Manchester, 1971

Bleckner, New York, 1995
Ross Bleckner (exh. cat.), Solomon R. Guggenheim Museum, New York, 1995

Blessin, Janssen, 1992
Blessin, S., *Horst Janssen*, Göttingen, 1992

Block, Vingt, 1984
Block, J., *Les Vingt and Belgian Avantgardism, 1868–1894*, Ann Arbor, Michigan, 1984

Blok, 1973
Constructivism in Poland 1923-36 (exh. cat.), Museum Folkwang Essen et al., Essen, 1973

Blok, Abstrakte Kunst, 1975
Blok, C., *Geschichte der abstrakten Kunst 1900-1960*, Cologne, 1975

Bloom, Berlin, 1988
Ghost Writer (exh. cat.), DAAD Galerie, Berlin, 1988

Bloom, Columbus, 1998
The Collections of Barbara Bloom (exh. cat.), Wexner Center for the Arts, Columbus, 1998

Blotkamp, Dekkers, 1981
Blotkamp, C., *Ad Dekkers*, The Hague, 1981

Blotkamp, Mondrian, 1994
Blotkamp, C., *Mondrian – The Art of Destruction*, Zwolle, 1994

Blum, Essen, 1983
Heiner Blum: Zeitzeichen (exh. cat.), Fotonetz, Essen, 1983

Blume, Caro, 1980–89
Blume, D., *Anthony Caro. Catalogue raisonné* (10 vols.), Hamburg, 1980-89

Blume, Lartigue, 1997
Blume, M., *Lartigue's Riviera*, New York, 1997

Boccioni, Milan, 1982
Boccioni a Milano (exh. cat.), Palazzo Reale, Milan, 1982

Bochner, Lucerne, 1985
Mel Bochner. Bilder und Zeichnungen 1973-1985 (exh. cat.), Kunstmuseum Luzern, Lucerne, 1985

Bockris, Warhol, 1989
Bockris, V., *Warhol*, London, 1989

Boddington, Drysdale, 1987
Boddington, J., *Russell Drysdale Photographer*, Melbourne, 1987

Bodmer, Basel, 1978
Walter Bodmer (exh. cat.), Kunstmuseum Basel, Basel, 1978

Boehm, Dorazio, 1992
Boehm, G., et al., *Piero Dorazio. Arbeiten auf Papier*, Saulgau, 1992

Boesiger, Corbusier 1929–57
Boesiger (ed.), *Le Corbusier, Œuvre complète*, vols. 1–8, Zürich, 1929–57

Bogner, Kiesling, 1997
Bogner, D., *Frederick Kiesler 1890-1965. Inside the Endless House* (exh. cat.), Vienna, 1997

Bohnen, Freundlich, 1982
Bohnen, U. (ed.), *Otto Freundlich: Schriften. Ein Wegbereiter der gegenstandslosen Kunst*, Cologne, 1982

Bohnke-Kollwitz, 1984
Bohnke-Kollwitz, J. (ed.), *Käthe Kollwitz, Die Tagebücher*, Berlin, 1984

Bois, Kelly, 1992
Bois Y.-A. et al., *Ellsworth Kelly, the Years in France, 1948-1954*, Munich, 1992

Bois, Matisse, 1993
Bois, Y.-A. and D. Fourcade (eds.), *Henri Matisse 1904-1917* (exh. cat.), Centre Georges Pompidou, Paris, 1993

Bois, Reinhardt, 1991
Bois, Y.-A. (ed.), *Ad Reinhardt* (exh. cat.), Los Angeles Museum of Contemporary Art, 1991

Bois, Ryman, 1981
Bois, Y.-A. and C. Sauer (eds.), *Robert Ryman* (exh. cat.) Musée National d'Art Moderne, Paris, 1981

Bollinger/Magnaguagno/Meyer, Dada, 1985
Bollinger, H., Magnaguagno, G. and R. Meyer, *Dada in Zürich*, Zürich, 1985

Boltanski, Paris, 1978
Christian Boltanski. Reconstitution (exh. cat.), Paris, 1978

Boltanski, Paris, 1984
Christian Boltanski. Retrospektive (exh. cat.), Musée National d'art moderne, Centre Georges Pompidou, Paris, 1984

Bonafoux, Jenkins, 1991
Bonafoux, P., *Paul Jenkins – conjonctions et annexes*, Paris, 1991

Bonnard, London, 1997
Pierre Bonnard (exh. cat.), Tate Gallery, London, 1997

Bonnet, 1975
Bonnet, M., *André Breton et la naissance de l'aventure surréaliste*, Paris, 1975

Borduas, 1976
Paul-Émile Borduas, National Gallery of Canada, Ottawa (Canadian Artists series no. 3), 1976

Borès, Paris, 1982
Francisco Borès (exh. cat.), Artcurial, Paris, 1982

Borofsky, Basel, 1981
Jonathan Borofsky. Zeichnungen (exh. cat.), Kunstmuseum Basel, Basel, 1981

Borofsky, Frankfurt am Main, 1991
Jonathan Borofsky. Countings 1287718–3311003 (exh. cat.), Portikus, Frankfurt am Main, 1991

Borràs, Picabia, 1985
Borràs, M.-L., *Picabia*, London, 1985

Bortnyik, Budapest, 1978
Bortnyik Sándor: Emlékkiállítása (exh. cat. [commemorative]), Magyar Nemzeti Galéria, Budapest, 1978

Bortolan, Campigli, 1992
Bortolan, L., *Campigli e il suo segreto*, Milan, 1992

Bott, Baumeister, 1990
Bott, G., *Figuration und Bildformat. Zur Auflösung des Bildbegriffs in der Malerei Willi Baumeisters*, (diss.), Bochum, 1990

Boubat, Paris, 1990
Édouard Boubat (exh. cat.), Musée Carnavalet, Paris, 1990

Bouillon, Denis, 1993
Bouillon, J.-P., *Maurice Denis*, Geneva, 1993

Boulton-Smith, Finnish Painting, 1970
Boulton-Smith, J., *Modern Finnish Painting and Graphic Art*, London, 1970

Bourdon, Andre, 1978
Bourdon, D., *Carl Andre: Sculpture 1959–1977*, New York, 1978

Bourgeois, Destruction, 1998
Bourgeois, L., *Destruction of the Rather, Reconstruction of the Father, Writings and Interviews* (eds. M.-L. Bernadec and H.-U. Obrist), London, 1998

Bourgeois, New York, 1982
Louise Bourgeois (exh. cat.), Museum of Modern Art, New York, 1982

Bousquet, Tanning, 1966
Bousquet, A., *La Peinture de Dorothea Tanning*, Paris, 1966

Bouvet, Bonnard, 1981
Bouvet, F., *Bonnard. The Complete Graphic Work*, London, 1981

Bowlt, Rayonism, 1988
Bowlt, J. E. (ed.), *Russian Art of the Avant Garde: Theory and Criticism 1902–1934*, London, 1988

Bowlt, Russian Art, 1976
Bowlt, J. E. (ed.), *Russian Art of the Avant Garde: Theory and Criticism 1902–1934*, London, 1988

Bowlt, Silver Age, 1979
Bowlt, J. E., *The Silver Age: Russian Art of the Early Twentieth Century and the "World of Art" Group*, Newtonville, Mass., 1979

Bowlt, World of Art, 1979
Bowlt, J.E., *The Silver Age: Russian Art of the Early Twentieth Century and the "World of Art" Group*, Newtonville, Mass., 1979

Bowlt/Drutt, New York, 1999
Bowlt, John E. and Matthew Drutt (eds.), *Amazons of the Avant Garde*, New York, 1999

Bowlt/Misler, 1993
Bowlt, J. and N. Misler, *Twentieth Century Russian and East European Painting. The Thyssen-Bornemisza Collection*, London, 1993

Bowman, Nutt, 1994
Bowman, R., *Jim Nutt*, Cincinnati, 1994

Bowman, Pearlstein, 1983
Bowman R., *Philip Pearlstein, The Complete Paintings*, New York, 1983

Bowness/Read, Moore, 1965–88
Bowness, A. and H. Read (eds.), *Henry Moore. Complete Sculpture 1921–1986*, 6 vols., London, 1965–88

Boyer, Nabis, 1988
Boyer P. (ed.), *The Nabis and the Parisian Avantgarde*, New Brunswick, 1988

Boyle, Auckland,1990
Mark Boyle (exh. cat.), City Art Gallery, Auckland, 1990

Bräm, Sound, 1986
Bräm, T., *Musik und Raum*, Basel, 1986

Braider, Ashcan, 1971
Braider, D., *George Bellows and the Ashcan School of Painting*, New York, 1971

Brancusi, Paris, 1995
Constantin Brancusi. 1876–1957 (exh. cat.), Musée National d'Art Moderne, Centre Georges Pompidou, Paris/Philadelphia Museum of Art, Paris, 1995

Brandi, Guttuso, 1983
Brandi, C., *Guttuso*, Milan, 1983

Brandt, London, 1993
Bill Brandt (exh. cat.), Barbican Art Gallery, London, 1993

Brangwyn, Walthamstow, 1974
Catalogue of the Works of Sir Frank Brangwyn, R.A., 1967–1956, William Morris Gallery, Walthamstow, 1974

Braque, Bordeaux, 1982
Georges Braque en Europe: Centenaire de la naissance (exh. cat.), Galerie des Beaux-Arts, Bordeaux/Musée de l'Art moderne, Strasbourg, 1982

Braque, Saint-Paul de Vence, 1994
Georges Braque. Retrospektive (exh. cat.), Fondation Maeght, Saint-Paul de Vence, 1994

Brassaï, Artists, 1982
Brassaï, *The Artists of my Life*, New York, 1982

Brassai, Paris, 1988
Brassaï: Paris le jour, Paris la nuit (exh. cat.), Musée Carnavalet, Paris, 1988

Brauchitsch, Ruff, 1992
Brauchitsch, B. v., *Thomas Ruff*, Frankfurt am Main, 1992

Braun/Rosenthal, Paladino, 1992
Braun, E., and N. Rosenthal, *Mimmo Paladino*, Milan, 1993

Brauner, Paris, 1972
Brauner (exh. cat.), MNAM, Paris, 1972

Brecht, Wilson, 1984
Brecht, S., *The Theatre of Visions: Robert Wilson*, Frankfurt am Main, 1984

Breicha/Klocker, Gemeinschaftsarbeit, 1992
Breicha, O. and H. Klocker (eds.), *Miteinander Zueinander Gegeneinander: Gemeinschaftarbeit Österreichischer Künstler und ihrer Freunde nach 1950 bis in die 80er Jahre*, Klagenfurt, 1992

Breicha, Rainer, 1980
Breicha, O. (ed.), *Arnulf Rainer. Hirndrang. Selbstkommentar und andere Texte zu Werk und Person*, Salzburg, 1980

Breicha, Wotruba, 1977
Breicha, O. (ed.), *Wotruba. Figur als Widerstand: Bilder und Schriften zu Leben und Werk*, Salzburg, 1977

Breitwieser, Matta-Clark, 1997
Breitwieser, S. (ed.), *Gordon Matta-Clark. Reorganizing Structure by Drawing Through It* (catalogue raisonné), Generali Foundation, Vienna, 1997

Brendel, Cologne, 1989
Walter Brendel (exh. cat.), Galerie Tengelmann, Cologne, 1989

Brenken, Balkenhol, 1989
Brenken, A., "Stephan Balkenhol," in *Art* 1989, no. 1, pp. 42–50

Breslin, Rothko, 1995
Breslin, J. E. B., *Mark Rothko*, New York, 1995

Breton, Surrealism, 1969
Breton, A., *The Manifestos of Surrealism*, Ann Arbor Mich., 1969

Briganti, De Pisis, 1991
Briganti, G., *De Pisis, Catalogo generale*, 2 vols., Milan, 1991

Brightman, Rivers, 1979
Brightman, C. (ed.), *Drawings and Digressions by Larry Rivers*, New York, 1979

Brisley, Glasgow, 1986
Stuart Brisley: Georgiana Collection, Third Eye Centre, Glasgow, 1986

Brögmann, Werefkin, 1996
Brögmann, N., *Marianne von Werefkin, Œuvres peintes 1907–1936* (exh. cat.), Fondation Neumann, Gingis, 1996

Broodthaers, Cologne, 1982
Marcel Broodthaers catalogue des Livres (exh. cat.), Galerie Michael Werner, Cologne, 1982

Broodthaers, London, 1980
Marcel Broodthaers (exh. cat.), Tate Gallery, London, 1980

Brooks, Corbusier, 1987
Brooks, A.H., *Le Corbusier*, Princeton, 1987

Broutin, Lettrism, 1972
Broutin, J.-P. (et al.), *Lettrisme et hypergraphie*, Paris, 1972

Brüderlin, Neo-Geo, 1986
Brüderlin, M., "Postmoderne Seele und Geometrie. Perspektiven eines neuen Kunstphänomens," in *Kunstforum* 86, 1986, pp. 298 ff.

Brütsch, Poliakoff, 1993
Brütsch, F., *Serge Poliakoff 1900–1969*, Neuchâtel, 1993

Bruggen, Oldenburg, 1991
Bruggen, C. v., *Claes Oldenburg. Just another Room/Nur ein anderer Raum* (exh. cat.), Portikus Frankfurt am Main, 1991

Brugger/Reuther, Nolde, 1994
Brugger, I., and M. Reuther (eds.), *Emil Nolde* (exh. cat.), Kunstforum Bank Austria, Vienna, 1994

Brunelle, Matta-Clark, 1974
Brunelle, A., "The Great Divide, Anarchitecture by Gordon Matta-Clark" in *Art in America*, Sept. – Oct., 1974

Brusberg, Antes, 1983
Brusberg, D., *Horst Antes – Bilder und Blätter 1960–1987*, Berlin, 1988

Brusberg/Eckhardt, Zeitvergleich '88, 1988
Brusberg, D. and U. Eckhardt (eds.), *Zeitvergleich '88. 13 Maler aus der DDR*, Berlin, 1988

Buchheister/Kemp, Buchheister, 1984
Buchheister, E. and W. Kemp, *Carl Buchheister – Werkverzeichnis der abstrakten Arbeiten*, Nuremberg, 1984

Buchheister/Kemp, Buchheister, 1986
Buchheister, E. and W. Kemp, *Carl Buchheister – Werkverzeichnis der gegenständlichen Arbeiten*, Nuremberg, 1986

Buchholz/Magnani, Multiples, 1993
Buchholz, D., and G. Magnani (eds.), *International Index of Multiples from Duchamp to the Present*, Cologne, 1993

Buchloh, Broodthaers, 1995
Buchloh, B. et al., *Marcel Broodthaers. Conférences* (exh. cat.), Musée National d'Art Moderne, Centre Georges Pompidou, Paris, 1995

Buchloh, Buren, 1981
Buchloh, B. (ed.), *Daniel Buren. Les couleurs: sculpture. Les formes: peinture*, Halifax, 1981

Buckberrough, Robert Delaunay, 1982
Buckberrough, S. A., *Robert Delaunay, the Discovery of Simultaneity*, Ann Arbor, 1982

Buderer/Fath, Neue Sachlichkeit, 1994
Buderer, H. J., and M. Fath, *Neue Sachlichkeit. Bilder auf der Suche nach der Wirklichkeit*, Munich, 1994

Bürger, Theory of the Avantgarde, 1974
Bürger, P., *Theory of the Avantgarde*, Manchester, 1976

Buisson, Foujita, 1987
Buisson, S. and D. Buisson, *La vie et l'œuvre de Léonard-Tsuguharu Foujita*, Paris, 1987

Burckhardt, Oppenheim, 1996
Burckhardt J., et al., *Meret Oppenheim: Beyond the Teacup*, New York, 1996

Buren, Œuvres, 1991
Buren, D., *Œuvres complètes*, Bordeaux, 1991

Burgbacher-Krupka, 1994
Burgbacher-Krupka, I., *Hanne Darboven, Konstruiert, Literarisch, Musikalisch – The Sculpting of Time*, Stuttgart, 1994

Burgin, 1973
Burgin, *Work and Commentary (1969–1973)*, London, 1973

Burgin, 1986
Burgin, V., *Between*, Oxford, 1986

Burgin, Eindhoven, 1977
Victor Burgin (exh. cat.), Stedelijk Van Abbemuseum, Eindhoven, 1977

Burkhart, Budd, 1979
Burkhart, D., "David Budd," in *Artweek*, 1979, no. 10, p. 5

Burljuk, Cologne, 1966
Burljuk. Bilder von 1907 bis 1966 (exh. cat.), Galerie Gmurzynska, Cologne, 1966

Burra, 1994
Edward Burra: The Formative Years, London, 1994

Burroghs, Benton, 1981
Burroghs, P., *Thomas Hart Benton. A Portrait*, New York, 1981

Busch, Liebermann, 1993
Busch, G. (ed.), *Max Liebermann. Vision der Wirklichkeit. Ausgewählte Schriften und Reden*, Frankfurt am Main, 1993

Busch, Modersohn-Becker, 1979
Busch, G. and L. v. Reinken, *Paula Modersohn-Becker in Briefen und Tagebüchern*, Frankfurt am Main, 1979

Busch/Dorival/Grainville, P., Vallotton, 1992
Busch, G., B. Dorival, and P. Grainville, *Félix Vallotton*, Paris, 1992

Busch/Rudloff, Marcks, 1977
Busch, G. and M. Rudloff, *Gerhard Marcks. Das plastische Werk*, Berlin, 1977 (catalogue raisonné)

Busche, Lichtenstein, 1989
Busche, Ernst A., *Roy Lichtenstein. Pop Paintings 1961–1969*, Munich, 1989

Bush, De Andrea, 1993
Bush, M. H., *John De Andrea* (exh. cat.), ACA Galleries, New York, 1993

Bush, Edinburgh, 1980
Jack Bush: Paintings and Drawings 1955–1976 (exh. cat.), Talbot Rice Art Centre, Edinburgh, 1980

Bush, Toronto, 1976
Jack Bush: A Retrospective (exh. cat.), Art Gallery of Ontario, Toronto, 1976

Bush/Buchsteiner, Hanson, 1990
Bush, M.H. and T. Buchsteiner (eds.), *Duane Hanson. Skulpturen* (exh. cat.), Kunsthalle and Kunstverein Tübingen et al., Stuttgart, 1990

Bußmann, Rohlfs, 1989
Bußmann, K. et al. (eds.), *Christian Rohlfs* (exh. cat.), Westfälisches Landesmuseum Münster, Stuttgart, 1989

Bußmann/Matzner, Haacke, 1993
Bußmann, K. and F. Matzner (eds.), *Hans Haacke, Deutscher Pavillon*, Venice Biennale, 1993

Bußmann/Matzner, Paik, 1993
Bußmann, K. and F. Matzner (ed.), *Nam June Paik. Eine Database*, Stuttgart, 1993

Butler, London, 1983
Reg Butler (exh. cat.), Tate Gallery, London, 1983

Butor/Clair/Houbart-Wilkin, Delvaux, 1975
Butor, M., J. Clair and S. Houbart-Wilkin (eds.), *Paul Delvaux. Catalogue raisonné de l'œuvre peint*, Brussels, 1975

Butor/Sicard, Dotremont, 1978
Butor, M. and M. Sicard, *Dotremont et ses écrivures*, Paris, 1978

Buzzoni, De Pisis, 1996
Buzzoni, A. (ed.), *De Pisis* (exh. cat.), Museo d'Arte Moderna e Contemporanea, Ferrara, 1996

Byars, Paris, 1995
James Lee Byars: the monument to language, the diamond floor (exh. cat.), Fondation Cartier, Paris, 1995

Cabanne, Bazaine, 1990
Cabanne, P., *Jean Bazaine*, Paris, 1990

Cabanne, Derain, 1990
Cabanne, P., *André Derain*, Paris, 1990

Cabanne, Duchamp, 1997
Cabanne, P., *Duchamp & Cie.*, Paris, 1997

Cahun, Munich, 1997
Claude Cahun, (exh. cat.), Kunstverein München, Munich, 1997

Cahun, Paris, 1995
Claude Cahun, (exh. cat.), Musée d'art moderne de la Ville de Paris, 1995

Cailler, Denis, 1968
Cailler, P., *Catalogue raisonné de l'oeuvre gravé et lithographique de Maurice Denis*, Geneva, 1968

Calas, Art, 1968
Calas, N., *Art in the Age of Risk and Other Essays*, New York, 1968

Calder, New York, 1976/77
Calder's Universe, (exh. cat.), The Whitney Museum of American Art, New York, 1976/77

Calder, Paris, 1996
Alexander Calder 1898–1976 (exh. cat.), Musée Nat. d'Art moderne, Centre Georges Pompidou, Paris, 1996

Callahan, Adams, 1993
Callahan, H. (ed.), *Ansel Adams in Color*, Boston, 1993

Calvesi, Boccioni, 1983
Calvesi, M. and E. Coen, *Boccioni. L'Opera completa*, Milan, 1983

Calvesi, Burri, 1971
Calvesi, M., *Alberto Burri*, Milan, 1971

Camden Town Group, London, 1951
The Camden Town Group, (exh. cat.), Arts Council of Great Britain, London, 1951

Camfield, Picabia, 1979
Camfield, W. A., *Francis Picabia: His Art, Life and Times*, Princeton, 1979

Camoin, St-Tropez, 1991
Camoin et St-Tropez (exh. cat.), Musée de l'Annonciade, St-Tropez, 1991

Campbell, Deutscher Werkbund, 1981
Campbell, J., *Der Deutsche Werkbund*, Stuttgart, 1981

Campus, Mönchengladbach, 1990
Peter Campus, (exh. cat.), Städt. Museum Abteiberg, Mönchengladbach, 1990

Cane, Saint-Paul-de-Vence, 1983
Louis Cane, (exh. cat.), Fondation Maeght, Saint-Paul-de-Vence, 1983

Caradente, Lüpertz, 1994
Caradente, C., *Markus Lüpertz*, Milan, 1994

Cardinal, Outsider Art, 1972
Cardinal, R., *Outsider Art*, London, 1972

Cardozo, Toledo, 1967
Cardoza y Aragón, L., *Toledo*, Mexico City, 1967

Carlino/Menozzi, Naive art, 1978
Carlino, W., and D. Menozzi, *Catalogo nazionale di grafica naive*, Reggio Emilia, 1978

Carlozzi, Saul, 1989
Carlozzi, Annette Dimeo, *Peter Saul*, Aspen, 1989

Carmean, Graves, 1987
Carmean, E. A. Jr. et al., *The Sculpture of Nancy Graves: A Catalogue Raisonné* (exh. cat.), Fort Worth Art Museum, New York, 1987

Carrà, Metaphysical Art, 1971
Carrà, *Metaphysical Art*, London, 1971

Carrà, Milan, 1967–69
Carrà, M., *Carlo Carrà. Tutta l'opera pittorica*, 3 vols., Milan, 1967–69

Carrà, Rome, 1994–95
Carlo Carrà (exh.cat.), Galleria Nazionale d'Arte Moderna, Rome, 1994–95

Carroll, Los Angeles, 1993
Lawrence Carroll, (exh. cat.), Los Angeles Ace Cont. Exhibitions, 1993

Carroll, New York, 1994
Lawrence Carroll, (exh. cat.), Stix Gallery, New York, 1988

Catoir, Rainer, 1989
Catoir, B. *Arnulf Rainer. Übermalte Bücher*, Munich, 1989

Caulfield, 1995
Caulfield, P., *The Poems of Jules Laforgue*, Manchester, 1995

Caulfield, London, 1999
Patrick Caulfield (exh. cat.), Hayward Gallery, London, 1999

Causey, Lanyon, 1971
Causey, A., *Peter Lanyon*, Henley-on-Thames, 1971

Cavallo/Raimondi/Russoli, Soffici, 1967
Cavallo, L., G. Raimondi, and F. Russoli, *Ardengo Soffici e il cubo-futurismo*, Florence, 1967

Caws, Motherwell, 1996
Caws, M. A., *Robert Motherwell. What Art Holds*, New York, 1996

Caws/Kuenzli/Raaberg, Surrealism, 1991
Caws, M. A., R. Kuenzli and G. Raaberg (eds.), *Surrealism and Women*, London, 1991

Celant, 1980
Celant, G., "Art to the Power N", in *Artforum*, December 1980, pp. 100 ff.

Celant, Arte Povera, 1969
Celant, G., *Arte Povera*, London, 1969

Celant, Haring, 1997
Celant, G.(ed.), *Keith Haring*, New York, 1997

Celant, Horn, 1993
Celant, G. (ed.), *Rebecca Horn* (exh. cat.), Solomon R. Guggenheim Museum, New York, 1993

Celant, Horn, 1994
Celant, G. (ed.), *Rebecca Horn* (exh. cat.), Kunsthalle Wien, Vienna, 1994

Celant, Kapoor, 1996
Celant, G., *Anish Kapoor*, London, 1996

Celant, Manzoni, 1972
Celant, G., *Piero Manzoni*, New York, 1972

Celant, Manzoni, 1992
Celant, G. (ed.), *Piero Manzoni* (exh. cat.), Castello di Rivoli, Milan, 1992

Celant, Merz, 1989
Celant, G. (ed.), *Mario Merz* (exh. cat.), Solomon R. Guggenheim Museum, New York, 1989

Celant, Nevelson, 1995
Celant, G., *Louise Nevelson, Silent Music* (exh. cat.), Galerie Gmurzynska, Cologne, 1995

Celant, Oldenburg, 1995
Celant, G. (ed.), *Claes Oldenburg and Coosje van Bruggen. Large Scale Projects*, London, 1995

Celant, Oldenburg, 1996
Celant, G. et al., *Claes Oldenburg: an Anthology* (exh. cat.), National Gallery of Art, Washington, D.C., 1996

Celant, Pistoletto, 1984
Celant, G., *Pistoletto*, Florence, 1984

Celant, Pistoletto, 1990
Celant, G., *Michelangelo Pistoletto*, New York, 1989

Certigny, Rousseau, 1984–89
Certigny, H., *Le Douanier Rousseau en son temps. Biographie et catalogue raisonnée* 2 vols., Tokyo 1984–89

César, 1993
César. Œuvres de 1947 à 1993, (exh. cat.), Centre de la Vieille Charité, Marseille, 1993

César, 1997
César, Rétrospective, (exh. cat.), Musée du Jeu de Paume, Paris, 1997

Ceuleers, Vantongerloo, 1996
Ceuleers, J. v. (ed.), *Georges Vantongerloo* (exh. cat.), Kunstmuseum Antwerpen et al., Antwerp, 1996

Cézanne, Washington, 1988–89
Cézanne the Early Years (exh. cat.), National Gall. of Art, Washington D. C., 1988–89

Chadwick, Essen, 1994
Helen Chadwick "effluvia", (exh. cat.), Museum Folkwang, Essen, 1994

Chadwick, Woman, 1990
Chadwick, W., *Woman, Art and Society*, London, 1990

Chadwick, Women, 1990
Chadwick, W., *Women, Art and Society*, London, 1990

Chagall, Paris, 1995
Marc Chagall: les années russes, (exh. cat.), Musée d'art moderne de la Ville de Paris, 1995

Chaldej, 1994
Von Moskau nach Berlin. Bilder des russischen Fotografen Jewgeni Chaldej, Berlin, 1994

Chamberlain, Amsterdam, 1996
John Chamberlain. Current Works and Fond Memories , (exh. cat.), Stedelijkmuseum Amsterdam, 1996

Chambí, Washington, 1993
Martín Chambí. Photographs 1920–1950, (exh. cat.), Washington/London, 1993

Champa, Mondrian, 1985
Champa, K. S., *Mondrian Studies*, Chicago, London, 1985

Chapmanworld, 1996
Chapmanworld, London, 1996

Charchoune, Paris, 1967
Serge Charchoune, (exh. cat.) Musée Nationale d'Art moderne, Paris, 1967

Charlot, Mexican Mural, 1963
Charlot, J., *The Mexican Mural Renaissance 1920–1925*, New Haven, 1963

Chase, Hyperrealism, 1973
Chase, L., *Hyperrealism*, London, 1973

Chaumeil, Dongen, 1967
Chaumeil, L., *Van Dongen. L'Homme et l'artiste, la vie et l'œuvre*, Geneva, 1967

Chave, Rothko, 1991
Chave, A. C., *Mark Rothko. Subjects in Abstraction*, New Haven/London, 1991

Chiappini, Permeke, 1996
Chiappini R. (ed.), *Constant Permeke* (exh. cat.), Museo d'arte moderna, Milan, 1996

Chicago, Flower, 1975
Chicago, J., *Through the Flower: My Struggle as a Woman Artist*, New York, 1975

Chillida, Houston, 1966
EC, (exh. cat.), Museum of Fine Arts, Houston, 1966

Chillida, New York, 1979/80
Chillida. A Retrospective, (exh. cat.), The Guggenheim Museum New York, New York, 1979/80

Chipp, Picasso, 1995–98
Chipp, H. B. (ed.), *Pablo Picasso. Catalogue Raisonné of his works*, vols.1–6, San Francisco, 1995–98

Christo, Catalogue, 1982
Christo: Catalogue Raisonné, New York, 198

Christo, London, 1988
Christo and Jeanne-Claude, *Christo: the umbrellas: joint project for Japan and USA: drawings and collages [...] photographs by Wolfgang Volz* (exh. cat.), Annely Juda Fine Art, London, 1988

Cirici, Tàpies, 1972
Cirici, A., *Tàpies: Witness of Silence*, Barcelona, 1972

Cirlot, Dau al Set, 1986
Cirlot, L., *Es grupo Dau al Set*, Madrid, 1986

Claisse, Herbin, 1993
Claisse, G., *Herbin, catalogue raisonné de l'œuvre peint*, Lausanne, 1993

Claridge, Ramos, 1975
Claridge, E., *Mel Ramos*, London, 1975

Clark, Nolan, 1961
Clark, K., *Sidney Nolan*, London, 1961

Clark/Matthews/Owens, Prendergast, 1990
Clark, C., N. Matthews, and G. Owens, *Maurice Brazil Prendergast, Charles Prendergast: A Catalogue Raisonné*, Munich, 1990

Claudel, Paris, 1988
Paris, R.-M., *Camille Claudel: The Life of Camille Claudel, Rodin's Muse and Mistress*, New York, 1988

Claus, Appel, 1963
Claus, H., *Karel Appel, Painter*, Amsterdam, 1963

Claus, Kunst, 1996
Claus, J., *Kunst heute*, Cologne, 1986

Clay, Cruz-Diez, 1969
Clay, J., *Cruz-Diez et les trois étapes de la couleur moderne*, (exh. cat.), Galerie Denise René, Paris, 1969

Clay et al., Le Parc, 1977
Clay, J. et al., *Le Parc*, Madrid, 1977

Clement, Matisse, 1993
Clement, R. T., *Henri Matisse. A Bio-Bibliography*, Westport, 1993

Close, 1985
Chuck Close. Works on paper, (exh. cat.), Contemporary Arts Museum, Houston/Texas, 1985

Close, New York, 1998
Chuck Close, (exh. cat.), Museum of Modern Art, New York, 1998

Clough, Cambridge, 1999
Prunella Clough (exh. cat.), Cambridge, Kettle's Yard, 1999

Clough, London, 1982
Prunella Clough: New Paintings 1979–82 (exh. cat.), London, Warwick Arts Trust, 1982

Cluny, Corneille, 1992
Cluny, C. M., *Corneille*, Paris, 1992

Cobra, Rotterdam, 1966
Cobra 1948–51, (exh. cat.), Museum Boymans-van Beuningen, Rotterdam, 1966

Coen, Boccioni, 1988
Coen, E. (ed.) *Boccioni* (exh. cat.), Metropolitan Museum of Art, New York, 1988

Cogniat, Bonnard, 1991
Cogniat, R., *Bonnard*, Munich, 1991

Cohen, Bayer, 1984
Cohen, A., *Herbert Bayer. The Complete Work*, Cambridge, Mass., 1984

Cohen, Delaunay, 1978
Cohen, A. A. (ed.), *The Writings of Robert and Sonia Delaunay*, New York, 1978

Cohen, Marsh, 1983
Cohen, M., *Reginald Marsh's New York: Paintings, Drawings, Prints, and Photographs*, New York, 1983

Cole, Gaudier-Brzeska, 1978
Cole, R., *Burning to Speak. The Life and Art of Henri Gaudier-Brzeska*, Oxford, 1978

Colescott, 1997
Robert Colescott. Recent Paintings (exh. cat.), Venice, 1997

Collins, Gill, 1992
Collins, J., *Eric Gill. Sculpture*, (exh. cat.), Barbican Art Gallery, London, 1992

Collins, Gill, 1998
Collins, J., *Eric Gill. The Sculpture. A Catalogue Raisonné*, London, 1998

Collins, Winifred Nicholson, 1987
Collins, J., *Winifred Nicholson*, London, 1987

Collis, Spencer, 1962
Collis, M. S., *Stanley Spencer. A Biography*, London, 1962

Collovini, Russolo, 1997
Collovini, D., *Luigi Russolo – un'appendice al futurismo*, Venice, 1997

Colpitt, Minimal Art, 1990
Colpitt, F., *Minimal Art. The Critical Perspective*, Ann Arbor, 1990

Colquhoun, Edinburgh, 1981
Robert Colquhoun (exh. cat.), City of Edinburgh Museums and Art Galleries, 1981

Comic Strips, Nuremberg, 1970
Comic Strips, Geschichte, Struktur, Wirkung und Verbreitung der Bildergeschichte, (exh. cat.), Kunsthalle, Nuremberg, 1970

Compton, British Art, 1987
Compton, S. (ed.), *British Art in the 20th Century*, Munich, 1987

Compton, Chagall, 1990
Compton, S., *Marc Chagall – My Life, My Dream. Berlin and Paris 1922–1940*, Munich, 1990

Compton, Pop art, 1970
Compton, S., *British Art in the 20th century: the Modern Movement*, London, 1987

Compton/Sylvester, Morris, 1971
Compton, M. and D. Sylvester (eds.), *Robert Morris* (exh. cat.), Tate Gallery, London, 1971

Congdon, 1992–93
William Congdon, Quattro continenti in cinquant'anni di pittura (exh. cat.), Milan, 1992–93

Conrads, Deutscher Werkbund, 1969
Conrads, U. (ed.) *"Die Form" Stimme des Deutschen Werkbunds 1925–1934*, Gütersloh, 1969

Constant, Amsterdam, 1995
Constant, *Schilderijen 1948–95*, (exh. cat.), Amsterdam, 1995

Constantine, Modotti, 1975
Constantine, M., *Tina Modotti, a Fragile Life*, New York, 1975

Constructivism, Berlin, 1977
Tendenzen der Zwanziger Jahre (exh. cat.), Berlin, 1977

Conwill et al., Bearden, 1991
Conwill, K. H., M. S. Campbell and S. F. Patton, *Memory and Metaphor: The Art of Romare Bearden 1940–87*, New York, 1991

Cooke, Hamilton, 1995
Cooke, Lynn, *Ann Hamilton: Tropos*, New York, 1995

Cooper, De Maria, 1985
Cooper J. C. (ed.), *Walter De Maria: Two Very Large Presentations* (exh. cat.), Moderne Museet, Stockholm, 1985

Cooper, Sutherland, 1961
Cooper, D., *The Work of Graham Sutherland*, London, 1961

Cooper/Chalfant, Graffiti, 1984
Cooper M., and H. Chalfant, *Subway Art*, New York, 1984

Cooper/Potter, Gris, 1977
Cooper, D. and M. Potter (eds.), *Juan Gris. Catalogue raisonné de l'œuvre peint*, 2 vols., Paris, 1977

Cooper/Sciorra, Graffiti, 1994
Cooper, M., and J. Sciorra, *R.I.P.: New York Spraycan Memorials*, London, 1994

Coplans/Baudrillard, Warhol, 1990
Coplans, J. and J. Baudrillard, *Andy Warhol. Silkscreens from the Sixties*, Munich, 1990

Corà, Pistoletto, 1995
Corà, B., *Michelangelo Pistoletto*, Milan, 1995

Corinth, Berlin/Munich, 1996
Schuster, P.-K./Vitali, C. and B. Butts, *Lovis Corinth*, (exh. cat.), Haus der Kunst, München/Nationalgalerie, Berlin, Munich, 1996

Corinth, Bremen, 1986
Lovis Corinth. Die Bilder vom Walchensee, (exh. cat.), Kunsthalle, Bremen, 1986

Corinth, London, 1996
Lovis Corinth, (exh. cat.), Tate Gallery, London/Saint Louis Art Museum, 1996

Corinth, Munich, 1986
Lovis Corinth, (exh. cat.), Folkwang Museum Essen/Hypo-Kunsthalle, Munich, 1986

Cork, Vorticism, 1976
Cork, R., *Vorticism and Abstract Art in the First Machine Age*, 2 vols., London, 1976

Corlett, Lichtenstein, 1994
Corlett, M. L., *The Prints of Roy Lichtenstein*, Washington, 1994

Cornell, 1992
Joseph Cornell 1903–1972, (exh. cat.), Galerie Karsten Greve, Cologne, 1992

Corrente, Milan, 1985
Corrente: Il movimento di arte e cultura di opposizione (exh. cat.), Palazzo Realo Milano, Milan, 1985

Cortissoz, Davies, 1931
Cortissoz, R., *Arthur B. Davies*, New York, 1931

Cottingham, Springfield, 1986
Cottingham Print Multiples, Springfield Art Museum, Missouri, 1986

Cousseau, Hélion, 1992
Cousseau H.-C., *Jean Hélion*, Paris, 1992

Covert, Washington, 1979
John Covert, (exh. cat.), Hirshhorn Museum, Washington D.C., 1979

Cowart, O'Keeffe, 1989
Cowart, J. et al., *Georgia O'Keeffe. Ihr Leben und Werk*, Berne, 1989

Cowart, Rauschenberg, 1991
Cowart, J. et al. (eds.), *ROCI – Rauschenberg Overseas Culture Interchange* (exh. cat.), National Gallery of Art, Washington, 1991

Craft, Rauschenberg, 1997
Craft, C., *Robert Rauschenberg*, Haywire, New York, 1997

Cragg, London, 1988
Tony Cragg, (exh. cat.), The British Council, London, 1988

Craig-Martin, London, 1989
Michael Craig-Martin: A Retrospective 1968–89 (exh. cat.), Whitechapel Art Gallery, London, 1989

Cramer, Miró, 1989
Cramer, P., *Joan Miró: catalogue raisonné des livres illustrés*, Geneva, 1989

Cramer, Moore, 1973–86
Cramer, G. et al. (eds.), *Henry Moore. The Graphic Work 1931–1984*, 4 vols., Geneva, 1973–86

Cranbrook, New York, 1983
Design in America: The Cranbrook Vision 1925–50 (exh. cat.), Detroit Institute of Arts/Metropolitan Museum of Art, New York, 1983

Crane, Mail art, 1984
M. Crane (ed.), *Correspondance Art Source Book for the Network of International Post Art Activity*, San Francisco, 1984

Cremer/Emmrich/Gloede, Manzù, 1979
Cremer, F., I. Emmrich, and G. Gloede, *Giacomo Manzù*, East Berlin, 1979

Crespelle, Vlaminck, 1958
Crespelle, J.-P., *Vlaminck. Fauve de la peinture*, Paris, 1958

Crichton, Johns, 1994
Crichton, M., *Jasper Johns*, New York/London, 1994

Crimp, Museum, 1993
Crimp, D., *On the Museum's Ruins*, Cambridge, Mass., 1993

Crispolti, Afro, 1987
Crispolti, E., *Dino, Mirko, Afro Basaldella*, Rome, 1987

Crispolti, Fontana, 1974
Crispolti, E. and J. van der Marck, *Lucio Fontana: Catalogue raisonné des peintures, sculptures et environments spatiaux*, 2 vols, Brussels, 1974

Crispolti, Guttuso, 1983/85
Crispolti, E., *Renato Guttuso: Catalogo generale dei dipinti*, 3 vols., Milan, 1983/85

Crone/Salzmann, Rodin, 1991
Crone, R., and S. Salzmann (eds.), *Rodin: Eros and Creativity*, Munich, 1991

Crotti, Berne, 1983
Jean Crotti, Tabu Dada, Jean Crotti e Suzanne Duchamp 1915–22 (exh. cat.), Kunsthalle, Berne, 1983

Croydon, Albright, 1978
Croydon, M., *Ivan Albright*, New York, 1978

Cuevas, Cologne, 1978
José Luis Cuevas. Zeichnungen und Grafik, (exh. cat.), Museum Ludwig Köln, Cologne, 1978

Cullerne Bown, Art under Stalin, 1990
Cullerne Bown, M., *Art under Stalin*, Oxford, 1990

Cummings, de Kooning, 1984
Cummings, P. (ed.), *Willem de Kooning. Zeichnungen, Gemälde, Skulpturen* (exh. cat.), Akademie der Künste, Berlin, Munich, 1984

Cuno, Borofsky, 1992
Cuno, J. (ed.), *Subject(s), Prints and Multiples by Jonathan Borofsky 1982–1991* (exh. cat.), Hood Museum of Art, Dartmouth College et al., Hanover 1992

Curiger, Oppenheim, 1990
Curiger, B. *Meret Oppenheim: Defiance in the face of Freedom*, Zürich, 1990

Curjel, van de Velde, 1986
Curjel, H. (ed.), *Henry van de Velde, Geschichte meines Lebens*, Munich, 1986

Curtis/Wilkinson, Hepworth, 1994/95
Curtis, P. and A. G.Wilkinson, *Barbara Hepworth. A Retrospective* (exh. cat.), Tate Gallery London 1994; Seattle, 1995

D'Elia, Pascali, 1983
D'Elia, Anna (ed.), *Pino Pascali*, Bari, 1983

Dada, Hanover, 1979
Dada, Photographie und Photocollage (exh. cat.), Kestner-Gesellschaft, Hanover, 1979

Daffron, Bourke-White, 1988
Daffron, C., *Margaret Bourke-White Photographer*, New York, 1988

Dahl, Tobey, 1984
Dahl, A. L. (ed.), *Mark Tobey. Art and Belief. A Collection of Essays and Other Pieces*, Oxford, 1984

Daix, Cubism, 1983
Daix, P., *Cubism and Cubists*, London, 1983

Daix, Hartung, 1991
Daix, P., *Hans Hartung*, Paris, 1991

Daix/Rosselet, Picasso, 1979
Daix, P. and J. Rosselet (eds.), *Le Cubisme de Picasso. Catalogue raisonné de l'œuvre peint 1907–1916*, Neuchâtel, 1979

Damisch, Essen, 1991
Gunter Damisch Malerei, Skulptur (exh. cat.), Museum Folkwang, Essen, 1991

Damsch-Wiehager, Oelze, 1989
Damsch-Wiehager, R., *Richard Oelze. Ein alter Meister der Moderne*, Munich/Lucerne, 1989

Damsch-Wiehager, Walther, 1993
Damsch-Wiehager, R. (ed.), *Franz Erhard Walther. Antwort der Körper* (exh. cat.), Galerie Villa Merkel Esslingen, Stuttgart, 1993

Damsch-Wiehager, Zero Italien, 1995/96
Damsch-Wiehager, R. (ed.), *Zero Italien. Azimut 1959/60 in Mailand und heute* (exh. cat.), Villa Merkel, Esslingen, 1995–96

Daniels, Duchamp, 1992
Daniels, D., *Duchamp und die anderen. Der Modellfall einer künstlerischen Wirkungsgeschichte in der Moderne*, Cologne, 1992

Danto, Close, 1993
Danto, A.C., *Chuck Close: Recent Paintings*, (exh. cat.), The Pace Gallery, New York, 1993

Darboven, 1990
Hanne Darboven, Quartett "88" (exh. cat.), Portikus, Frankfurt am Main/Cologne, 1990

Dater, 1979
Dater, J., *Imogen Cunningham, A Portrait*, Boston, 1979

Daulte, Marquet, 1995
Daulte, F., *Albert Marquet*, Paris, 1995

Davie, Aberdeen, 1977
Alan Davie (exh. cat.), City of Aberdeen
Art Gallery and Museum, Aberdeen,
1977

Davies, Bacon, 1986
Davies, H. and St. Yard, *Francis Bacon*,
New York, 1986

Davis, Moore, 1992
Davis, A. (ed.), *Henry Moore. Bibliography.
Henry Moore Foundation*, 5 vols., London,
1992

Davis, New York, 1991
Stuart Davis. American Painter (exh. cat.),
The Metropolitan Museum of Art, New
York, 1991

Davis, Rabinovitch, 1996
Davis, W., *Pacing the World, Construction
in the Sculpture of David Rabinowitch*,
Cambridge, Mass., 1996

De Chirico, 1971
De Chirico, G., *The Memoirs of Giorgio de
Chirico*, London, 1971

De Chirico, Bristol, 1985
Late De Chirico (exh. cat.), Arnolfini
Gallery, Bristol, 1985

De Duve/Pelenc/Groys, Wall 1996
De Duve, T., Pelenc, A. and B. Groys, *Jeff
Wall*, London, 1996

De Francia, Léger, 1983
Francia, P. de, *Fernand Léger*, New
Haven, 1983

De Grada, Corrente, 1952
De Grada, R., *Il movimento di Corrente*,
Milan, 1952

De la Motte, Klanginstallation, 1990
De la Motte-Haber, H., *Musik und
Bildende Kunst: Von der Tonmalerei zur
Klangskulptur*, Laaber, 1990

De Maistre, London, 1960
Roy De Maistre, Whitechapel Art Gallery,
London, 1960

De Maria, New York, 1986
Walter De Maria: Large Rod Series (exh.
cat.), Xavier Foucade Gallery, New York,
1986

De Maria, New York, 1992
Walter De Maria: the 5 7 9 series (exh. cat.),
Gogosian Gallery, New York, 1992

De Salvo/Gudis, Johnson, 2000
De Salvo, Donna and Catherine Gudis
Ray Johnson: Correspondences (exh. cat),
New York, 2000

De Sanna, Fabro, 1996
De Sanna, J., *Luciano Fabro, Biografia
Eidografica*, Udine, 1996

De Shazo, Shinn, 1974
De Shazo, E., *Everett Shinn, 1876–1953: A
Figure in his Time*, New York, 1974

de Zegher, Rosler, 1998
de Zegher, Catherine (ed.), *Martha Rosler:
Positions in the Life World*, Cambridge,
Mass, 1998

De Zurko, Functionalism, 1957
De Zurko, E. R., *Origins of Functionalist
Theory*, New York, 1957

Deakin, 1996
John Deakin: Photographien (exh. cat.),
Munich, 1996

Dearstyne, Bauhaus, 1986
Dearstyne, H. (ed. D. Spaeth), *Inside the
Bauhaus*, New York, 1986

Decker, Paik, 1992
Decker, E. (ed.), *Nam June Paik.
Niederschriften eines Kulturnomaden*,
Cologne, 1992

Deinert, Künstlerbücher, 1995
Deinert, K., *Künstlerbücher*, Hamburg,
1995

Dekkers, Amsterdam, 1998
*Waves Breaking on the Shore: Ad Dekkers in
his Time*, Stedelijk Museum,
Amsterdam, 1998

Delaunay, Paris, 1967–68
Sonia Delaunay. Retrospective (exh. cat.),
Musée National d'Art Moderne, Paris,
1967–68

Delaunay, Paris, 1987
Robert et Sonia Delaunay (exh. cat.), Musée
d'art moderne de la Ville de Paris, 1987

Delaunay, Paris, 1999
Robert Delaunay Retrospective (exh. cat.),
Musée Nationale d'Art Moderne, Centre
Georges Pompidou, Paris, 1999

Dell'Arco, L'opera, 1984
Fagiolo dell'Arco, M., *L'opera completa di
de Chirico 1908–1924*, Milan, 1984

Dell'Arco, Parigi 1924–1929, 1982
Fagiolo dell'Arco, M. and P. Baldacci,
*Giorgio de Chirico. Parigi 1924–1929 – dalla
nascita del Surrealismo al crollo di Wall
Street*, Milan, 1982

Delvaux, Huy, 1997
Scott, D. and C. van Deun, *Le Pays Mosan
de Paul Delvaux* (exh. cat.), Musée
Communal Huy, Liège, 1997

Denis, Zürich, 1972
*Maurice Denis: Gemälde, Handzeichnungen,
Druckgrafik. Meisterwerke aus der
Sammlung Maurice Denis* (exh. cat.),
Kunsthaus, Zürich, 1972

Dennis, Regionalists, 1988
Dennis, James M., *Renegade Regionalists*,
Madison, 1998

Derrida, Adami, 1978
Derrida, J., "+R (par dessus le marché),"
in *La Vérité en peinture*, Paris, 1978

Deschamps, Paris, 1991
*Gérard Deschamps, Surprimés et Plissages
1956–1965* (exh. cat.), Galerie Peyroulet,
Paris, 1991

Descharnes, Dalí, 1985
Descharnes, R., *Dalí*, London, 1985

Descharnes, Dali, 1993
Descharnes, R. and G. Neret, *Salvador
Dalí, I – II*, Cologne, 1993

Di Martino, Biennale 1982
Di Martino, E., *Storia della Biennale
1895–1982*, Milan, 1982

Dialog, 1981
Dialog z Marcel Duchamp, Lublin, 1981

Dibbets, Minneapolis, 1987
Jan Dibbets (exh. cat.), Walker Art
Center, Minneapolis, 1987

Dibbets, Paris, 1989
Jan Dibbets (exh. cat.), Galerie Lelong,
Paris, 1989

Die Große Utopie, 1992
Die Große Utopie (exh. cat.), Frankfurt am
Main, 1992, pp. 95 ff.

Diehl, Vasarely, 1972
Diehl, G., *Vasarely*, Lugano, 1972

Dieterich, Pechstein, 1995
Dieterich, G. et al. (ed.), *Max Pechstein.
Das ferne Paradies* (exh. cat.), Städtisches
Kunstmuseum Spendhaus, Reutlingen,
1995

Disler, Basel, 1980
*Martin Disler, Invasion durch eine falsche
Sprache* (exh. cat.), Kunsthalle Basel,
1980

Disler, Basel, 1997
Die letzten Aquarelle von Martin Disler (exh.
cat.), Kunstmuseum, Basel, 1997

Disler, Zürich, 1988
Martin Disler, Bilder und Plastiken 1987
(exh. cat.), Kunsthaus, Zürich, 1988

Dix, Berlin, 1991
Otto Dix. Zum 100. Geburtstag 1891–1991,
Galerie der Stadt Stuttgart/Neue
Nationalgalerie, Berlin 1991

Dix, London, 1992
Otto Dix, 1891–1969, Tate Gallery,
London, 1992

Dobson, Cambridge, 1981
*Time and Pure Sculpture: Frank Dobson
1886–1963* (exh. cat.), Cambridge, 1981

Doesburg, Principles, 1969
Doesburg, T. van, *Principles of NeoPlastic
Art*, New York, 1969

Doig, Doesburg, 1986
Doig, A., *Theo van Doesburg. Painting into
Architecture, Theory into Practice*,
Cambridge, 1986

Dokoupil, Cologne, 1982
Jiri Georg Dokoupil – Neue Kölner Schule
(exh. cat.), Paul Maenz Galerie, Cologne,
1982

Dokoupil, Drawings, 1989–91
Dokoupil – Drawings, vols. 1-8, Brescia et
al., 1989–91

Dokoupil, Vienna, 1997
*Jiri Georg Dokoupil – Something strange
and fantastic* (exh. cat.), Museum
Moderne Kunst Stiftung Ludwig,
Vienna, 1997

Dominguez, Vostell, 1994
Dominguez, A. F. (ed.), *Museo Vostell
Malpartída de Cáceres*, 1994

Dongen, Nice, 1981
Kees van Dongen 1877–1968 (exh. cat.),
Musée des Beaux-Arts Jules Chéret,
Nice, 1981

Dongen, Paris, 1990
Kees Van Dongen (exh. cat.), Musée d'art
moderne de la Ville de Paris, 1990

Dorazio, Milan, 1984
Piero Dorazio (exh. cat.), Galleria
Nazionale d'Arte Moderna Rom, Milan,
1984

Dorazio, Munich, 1981
Dorazio (exh. cat.), Bayer.
Staatsgemäldesammlungen, Munich,
1981

Dorazio, Todi, 1975
Piero Dorazio. Mostra retrospettiva 1946–75
(exh. cat.), Palazzo del Popolo, Todi,
1975

Dorfles, Kitsch, 1969
Dorfles, G., *Kitsch – an Anthology of Bad
Taste*, New York, 1969

Dorflès, Paladino, 1984
Dorflès, G., *Mimmo Paladino*, Milan, 1984

Dorival, Atlan, 1962
Dorival, B., *Atlan*, Paris, 1962

Dorival, Lhote, 1981
Dorival, B. (ed.), *André Lhote. Rétrospective
1907–1962. Peintures, aquarelles, dessins*
(exh. cat.) Artcurial, Paris, 1981

Dorival, Rouault, 1988
Dorival, B. (ed.), *Georges Rouault: L'oeuvre
peinte*, Paris, 1988

Douglas, Malevich, 1994
Douglas, C., *Malevich*, London, 1994

Dreier, Burljuk, 1944
Dreier, K., *Burljuk*, New York, 1944

Droese, Düsseldorf, 1990
Felix Droese – Die Welt hinter der Welt (exh.
cat.), Kunstmuseum Düsseldorf, 1990

Droste, Bauhaus, 1990
Droste, M., *Bauhaus*, Cologne, 1990

Dube, Expressionists, 1988
Dube, W.D., *The Expressionists*,
London/New York, 1988

Dube, Heckel, 1964–74
Dube, A. and W.-D., *Erich Heckel. Das
graphische Werk*, 3 vols., New York,
1964–74

Dube/Dube, Kirchner, 1967
Dube, A. and W.-D., *E. L. Kirchner. Das
graphische Werk*, Munich, 1967

Dubuffet, 1966–89
Catalogue des travaux de Jean Dubuffet,
vols.1–28, compiled by Max Loreau,
vols. 29–37, compiled by J. Dubuffet and
the Fondation Jean Dubuffet Paris,
Lausanne/Paris, 1966–89

Dubuffet, Paris, 1973
Dubuffet (exh. cat.), Grand Palais, Paris,
1973

Dubuffet/Damisch, 1967
Dubuffet, J. and H. Damisch, *Prospectus
et tous écrits suivants* (2 vols.), Paris, 1967

Duchamp, Ostfildern, 1995
Marcel Duchamp Respirateur (exh. cat.),
Staatliches Museum Schwerin,
Ostfildern, 1995

Ducrey, Vallotton, 1989
Ducrey, M., *Félix Vallotton. His Life, His
Technique, His Painting*, Lausanne, 1989

Ducrot, Kertész, 1972
Ducrot, N., *André Kertész. Soixante ans de
photographie 1912–1972*, Paris, 1972

Düchting, Cézanne, 1989/1999
Düchting, H., *Paul Cézanne. Natur wird
Kunst*, Cologne, 1989 (1999 new edition)

Düchting, Klee, 1997
Düchting, H., *Paul Klee, Painting Music*,
Munich, 1997

Dückers, Grosz, 1979
Dückers, A., *George Grosz. Das
druckgraphische Werk*, Frankfurt a. M.,
1979

Dufet/Jianou, Bourdelle, 1984
Dufet, M., and I. Jianou, *Bourdelle*, Paris,
1984 [1965]

Dufrène, Paris, 1983
Pour François Dufrène (exh. cat.), Musée
National d'Art Moderne, Centre George
Pompidou, Paris, 1983

Dufy, London, 1983
Raoul Dufy 1877–1953 (exh. cat.), Arts
Council, London, 1983

Durand-Ruel, Arman, 1991
Durand-Ruel, D., *Arman: catalogue
raisonné*, Paris, 1991

Durand-Ruel, César, 1994
Durand-Ruel, D., *César, Catalogue
raisonnée I, 1947–64*, Paris, 1994

Durozoi, Poliakoff, 1984
Durozoi, G., *Poliakoff*, Paris, 1984

Dutton, Drysdale, 1981
Dutton, G., *Russell Drysdale*, London,
1981 [1964]

Easton, Vuillard, 1989/90
Easton, E. W., *The Intimate Interiors of
Edouard Vuillard* (exh. cat.), The Museum
of Fine Arts, Houston, 1989–90

Easton/Holroyd, John, 1974
Easton, M., and M. Holroyd, *The Art of
Augustus John*, London, 1974

EAT Pavilions, 1973
EAT Pavilions, New York, 1973

Eberle, Liebermann, 1979
Eberle, M. (ed.), *Max Liebermann in seiner
Zeit* (exh. cat.), Nationalgalerie Berlin,
1979

Eberle, Liebermann, 1995
Eberle, M., *Max Liebermann.
Werkverzeichnis der Gemälde, I – II*,
Munich, 1995

Eccher, Merz, 1995
Eccher, D. (ed.), *Mario Merz* (exh. cat.), Galleria Civica d'Arte Contemporanea Trient, Turin, 1995

Ehmer, Visuelle Kommunikation, 1971
Hartwig, H., "Anonyme Skulpturen von Hilla und Bernhard Becher," in Ehmer, H.K. (ed.), *Visuelle Kommunikation*, Cologne, 1971

Eichler, Holografie, 1993
Eichler, J. and G. Ackermann, *Holografie*, Berlin, 1993

Eimert, 1995
Eimert, Dorothea, *Heinrich Maria Davringhausen 1894–1970*, Cologne, 1995

Eimert, Paper Art, 1994
Eimert, D., *Paper Art. Geschichte der Papierkunst. History of Paper Art*, Cologne, 1994

Eisenstaedt, 1962
Alfred Eisenstaedt. Zeuge seiner Zeit, (exh. cat.), Bonn, 1962

Eisenstaedt, 1978
Eisenstaedt's Guide to Photography, New York, 1978

Elderfield, Fauvism, 1976
Elderfield, J. (ed.), *Fauvism: The "Wild Beasts" and its Affinities* (exh. cat.), Museum of Modern Art, New York, 1976

Elderfield, Louis, 1986
Elderfield, J., *Morris Louis*, New York, 1986

Elderfield, Matisse, 1992
Elderfield, J. (ed.), *Henri Matisse. A Retrospective* (exh. cat.), Museum of Modern Art, New York, 1992

Electric Paper, Bochum, 1998
Electric Paper. Paper Art 7 (exh. cat.), Leopold-Hoesch-Museum Düren, Bochum, 1998

Elger, Lawler, 1994
Elger, D. (ed.), *Louise Lawler*, Stuttgart, 1994

Elger, Merzbau, 1986
Elger, D., *Der Merzbau. Eine Werkbiographie*, Cologne, 1984

Elger/Fuchs, Visser, 1990
Elger, D. and R. Fuchs, *Carel Visser* (exh. cat.), Sprengel Museum, Hanover, 1990

Eliel, Meidner, 1990
Eliel, C. S. (ed.), *Ludwig Meidner, Apokalyptische Landschaften*, Munich, 1990

Elliott, Byars, 1990
Elliott, J. (ed.), *The Perfect Thought. Works by James Lee Byars* (exh. cat.), Univ. Art Museum, Berkeley, 1990

Elsen, Lipton, 1969
Elsen, Albert, *Seymour Lipton*, New York, 1969

Elsen, Rodin, 1980
Elsen, A., *In Rodin's Studio*, London, 1980

Elsken, 1991
Once Upon a Time. Ed van der Elsken. Fragment, Amsterdam, 1991

Elzea, Sloan, 1991
Elzea, R., *John Sloan's Oil Paintings: A Catalogue Raisonnée* (2 vols.), Dover, Delaware, 1991

Emboden, Cocteau, 1989
Emboden, W., *The Visual Art of Jean Cocteau*, New York, 1989

Engels/Söhn, Campendonk, 1996
Engels, M. T. and G. Söhn, *Campendonk. Das graphische Werk*, Düsseldorf, 1996

Erben, Miró, 1959
Erben, W., *Joan Miró. 1893–1983*, New York, 1959

Erben, Miró, 1993
Erben, W., *Joan Miró*, Cologne, 1993

Erfurth, Cologne, 1992
Hugo Erfurth. Fotograf zwischen Tradition und Moderne (exh. cat.), Cologne, 1992

Erickson, Objects, 1995
Erickson, J., *The Fate of the Object. From Modern Object to Postmodern Sign in Performance, Art and Poetry*, Ann Arbor, Michigan, 1995

Erró, Catalogue, 1978/86
Erró. Catalogue général, Paris, 1978/86

Escala, Munich, 1990
Escala (exh. cat.), Städtische Galerie im Lenbachhaus, Munich, 1990

Escher, 1976
Escher, B., *The Magic Mirror: The Work of M. C. Escher*, New York, 1976

Eskildsen, Auerbach, 1998
Eskildsen, U., et al., *Ellen Auerbach*, London/New York, 1998

Esser, Paik, 1997
Esser, E. (ed.), *Nam June Paik + Charlotte Moormann. MedienkunstVisionen. CD-Rom*, Cologne, 1997

Essers, Bissier, 1993
Essers, V., *Julius Bissier zum 100. Geburtstag* (exh. cat.), Stuttgart, 1993

Estaban, Chillida, 1975
Estaban, C., *Chillida*, Paris, 1975

Esteban, Vieira da Silva, 1969
Esteban, C. (ed.) *Vieira da Silva. Peintures 1935–1969* (exh. cat.), Musée national d'art moderne, Paris, 1969

Evans/Gohl, Photomontage, 1986
Evans, D. and S. Gohl, *Photomontage: A Political Weapon*, London, 1986

Everitt, Abstract Expressionism, 1975
Everitt, A., *Abstract Expressionism*, London, 1975

Evett, Japonisme, 1982
Evett, E., *The Critical Response of Japanese Art in Late 19th-Century Europe*, Ann Arbor, 1982

Export, 1992
Valie Export, (exh. cat.), Oberösterreichische Landesgalerie, Linz, 1992

Export, 1997
Reality, Valie Export, (exh. cat.), Museum moderner Kunst Stiftung Ludwig Wien, Vienna/New York, 1997

Export, Reale, 1987
Valie Export, *Das Reale und sein Double: Der Körper – Ein Essay*, Bern, 1987

Fabre, 1990
Jan Fabre, *Fabre's Book of Insects*, Ghent, 1990

Fabre, 1992
Jan Fabre, *Zeichnung, Skulptur, Zeichnung* (exh.cat.), Kunstverein Hanover, 1992

Fabrini, Clark, 1994
Fabrini, R. N., *O espaço de Lygia Clark*, São Paulo, 1994

Fabris, Utrillo, 1982
Fabris, J., *Utrillo. Sa Vie, son œuvre*, Paris, 1982

Fabro, Edinburgh, 1987
Luciano Fabro: Works, 1963–1986 (exh. cat.), Fruit Market Gallery, Edinburgh, 1987

Fabro, Paris, 1996
Luciano Fabro (exh. cat.), Musée Nat. d'art moderne Centre Georges Pompidou, Paris, 1996

Fagiolo dell'Arco, Scuola Romana, 1986
Fagiolo dell'Arco, M., *Scuola Romana: Pittura e scultura a Roma, 1914–1943*, Rome, 1986

Fagiolo/Rivosecchi, Mafai, 1986
Fagiolo, M., and V. Rivosecchi, *Mario Mafai*, Rome, 1986

Fahlman, Demuth, 1983
Fahlman, B., *Pennsylvania Modern: Charles Demuth of Lancaster* (exh. cat.), Philadelphia Museum of Art, 1983

Fahlström, Paris, 1980
Öyvind Fahlström (exh. cat.), Musée Nat. d'art moderne, Centre Georges Pompidou, Paris, 1980

Fahlström, Valencia, 1992
Öyvind Fahlström (exh. cat.), IVAM Centre Julio González, Valencia, 1992

Fanelli/Godoli, Futurismo, 1988
Fanelli, G. and E. Godoli, *Il Futurismo e la grafica*, Milan, 1988

Fargier, Paik, 1989
Fargier, J.P., *Nam June Paik*, Paris, 1989

Fárová, Capa, 1964
Fárová, Anna (ed.), *Robert Capa—Images of War*, New York, 1964

Farr, Chadwick, 1990
Farr, D. and E. Chadwick, *Lynn Chadwick, Sculptor, with a Complete Illustrated Catalogue 1947–1988*, Oxford, 1990

Faschismus, Berlin, 1987
Inszenierung der Macht. Ästhetische Faszination im Faschismus (exh. cat.), Berlin, 1987

Faucherau, Arp, 1988
Faucherau, S., *Arp*, Paris, 1988

Fauchereau, Kupka, 1989
Fauchereau, S., *Kupka*, New York, 1989

Fauchereau, Picabia, 1996
Fauchereau, S., *Picabia*, Paris, 1996

Faust, Bijl, 1991
Faust, W. M., "Neue Energien für den Raum", in *Art*, 1991, no.7, pp. 38–41

Faust/Vries, Neue Wilde, 1982
Faust, W. M. and G. de Vries, *Hunger nach Bildern*, Cologne, 1982

Fautrier, Paris, 1989
Fautrier 1898–1964 (exh. cat.), Musée d'art moderne de la Ville de Paris, Paris, 1989

Feinberg, 1995
Feinberg, J. E., *Jim Dine*, New York, 1995

Feininger, 1981
Lyonel Feininger: Karikaturen, Comic Strips, Illustrationen, 1888–1915 (exh. cat.), Museum für Kunst und Gewerbe, Hamburg/Wilhelm-Busch-Museum, Hanover, 1981

Feininger, 1998
Lyonel Feininger (exh. cat.), Haus der Kunst, Munich, 1998

Feininger, Hamburg, 1981
Andreas Feininger (exh. cat.), Museum für Kunst und Gewerbe, Hamburg, 1981

Feininger, London, 1987
Lyonel Feininger: The Early Years, 1889–1919 (exh. cat.), Marlborough Fine Art, London, 1987

Feininger, Photographer, 1986
Andreas Feininger, Photographer, New York, 1986

Feininger, Warum, 1997
Andreas Feininger, Warum ich fotografiere, Schaffhausen, 1997

Felix, Kubota, 1981
Felix, Z. (ed.), *Shigeko Kubota. Video Sculptures* (exh. cat.), Museum Folkwang, Essen, 1981

Felix, Multiple, 1994
Felix, Z., (ed.), *Das Jahrhundert des Multiple. Von Duchamp bis zur Gegenwart* (exh. cat.), Deichtorhallen Hamburg, Ostfildern, 1994

Ferrari, Matta, 1986
Ferrari, G. (ed.), *Matta. Entretiens morphologiques. Notebook No.1 1936–1944*, London, Paris, Tübingen, 1986

Ferrari, Matta, 1996
Ferrari, G. (ed.), *Matta etcetera*, Geneva, 1996

Ferrari, Sironi, 1985
Ferrari, C. G., *Sironi (1885–1961)*, Milan, 1985

Ferrier, Vasarely, 1969
Ferrier, J.-L., *Entretiens avec Vasarely*, Paris, 1969

Festing, Hepworth, 1995
Festing, S., *Barbara Hepworth. A Life of Forms*, London, 1995

Fetting, Berlin, 1988
Rainer Fetting, Gemälde und Skulpturen (exh. cat.), Raab-Galerie, Berlin, 1988

Fetting, Copenhagen, 1996
Rainer Fetting in Copenhagen (exh. cat.), Christian Dam Gallery, Copenhagen, 1996

Feyerabend, Postmodernism, 1980
Feyerabend, P., *Erkenntnis für freie Menschen*, Frankfurt am Main, 1980

Field, Hamilton, 1983
Field, R., *Richard Hamilton: Image and Process*, London, 1983

Fifield, Richter, 1993
Fifield, C., *True Artist and True Friend. A Biography of Hans Richter*, New York, 1993

Fifties, Sheffield, 1984
The Forgotten Fifties (exh. cat.), Graves Art Gallery, Sheffield, 1984

Fine, Marin, 1990
Fine, R. E., *John Marin* (exh. cat.), National Gallery of Art, Washington, 1990

Finlay, 1990
Graeme Murray Gallery (ed.), *Ian Hamilton Finlay: Catalogue Raisonné 1958–1990*, Edinburgh, 1990

Firmenich, Campendonk, 1989
Firmenich, A., *Heinrich Campendonk. Leben und Expression. Werk. Mit einem Werkkatalog des malerischen Œuvres*, Recklinghausen, 1989

Firmenich, Macke, 1992
Firmenich, A. (ed.), *August Macke. 'Gesang der Schönheit der Dinge'. Aquarelle und Zeichnungen* (exh. cat.), Kunsthalle Emden et al., Cologne, 1992

Firmenich, Radziwill, 1995
Firmenich, A. and R. Schulze (eds.), *Franz Radziwill. Werkverzeichnis der Gemälde*, Cologne, 1995

Fischer, Beckmann, 1972
Fischer, Friedhelm W., *Max Beckmann – Symbol und Weltbild*, Munich, 1972

Fischli and Weiss, Wolfsburg/Minneapolis, 1997
Fischli P. and David Weiss, *Arbeiten im Dunkeln* (exh. cat.), Kunstmuseum Wolfsburg/Walker Art Center Minneapolis, 1997

Fisher, Coleman, 1983
Fisher, J., *Enigma of the Hero in the Work of James Coleman*, Derry, 1983

Flam, Diebenkorn, 1992
Flam, J., *Richard Diebenkorn. Ocean Park*, New York, 1992

Flam, Matisse, 1988
Flam, J., *Matisse, a Retrospective*, New York, 1988

Flanagan, London, 1990
Barry Flanagan (exh. cat.), Waddington Galleries, London, 1990

Flavin, Fort Worth, 1977
Dan Flavin: Drawings, Diagrams and Prints 1972–1975. Installations in Fluorescent Light 1972–1975 (exh. cat.), Fort Worth Art Museum, 1977

Flavin, Frankfurt, 1993
Dan Flavin. Installationen in fluoreszierendem Licht 1989–1993 (exh. cat.), Städt. Galerie im Städel, Frankfurt am Main/Ostfildern, 1993

Flavin, Vancouver, 1969
Fluorescent Light, Etc. from Dan Flavin (exh. cat.), National Gallery, Ottawa/Art Gallery, Vancouver, 1969

Fleming, Lin, 1998
Fleming, J., et al, *Maya Lin: Topologies* (exh. cat.). Southeastern Center for Contemporary Arts, Winston Salem, 1998

Flügge/Neyer, Zille, 1997
Flügge, M. and H.-J. Neyer, *Heinrich Zille – Zeichner der Großstadt*, Amsterdam, 1997

Fluxus, Wiesbaden, 1982/83
Fluxus 1962–1982 (exh. cat.), Kunstverein Wiesbaden et. al., Wiesbaden, 1982/83

Förg, Madrid, 1999
Günther Förg (exh. cat.), Museo Nacional Centro de Arte Reina Sofia, Madrid, 1999

Förg, The Hague, 1988
Günther Förg (exh. cat.), Haags Gemeentemuseum, The Hague, 1988

Fontana, Lugano, 1987
Fontana e lo spazialismo (exh. cat.), Villa Malpensata, Lugano, 1987

Fontana, Rimini, 1982
Lucio Fontana (exh. cat.), Sala comunale d'arte contemporanea, Rimini, 1982

Forma I, Venice, 1976
Forma I (exh. cat.), Venice, 1976

Formes Nouvelles, Paris, 1980
Formes nouvelles (exh. cat.), Animation-Recherche-Confrontation, Paris, 1980

Forneris, Dufy, 1996
Forneris, J. (ed.), *Raoul Dufy* (exh. cat.), Kunsthaus, Vienna, 1996

Fossati, La Pittura metafisica, 1988
Fossati, P., *La "Pittura metafisica"*, Turin, 1988

Fossati, Valori Plastici, 1981
Fossati, P., *Valori Plastici 1918–1922*, Turin, 1981

Foster, Lettrismus, 1983–4
Foster, S.C. (ed.), *Lettrisme. Into the Present* (exh. cat.), Univ. of Iowa Museum of Art, Iowa, 1983–84

Fotorealismus, Brunswick, 1973
Amerikanischer Fotorealismus (exh. cat.), Kunstverein Braunschweig, Brunswick, 1973

Fox, Longo, 1989
Fox, H. N. (ed.), *Robert Longo*, Los Angeles County Museum, 1989

Francblin, Buren, 1987
Francblin, C., *Daniel Buren*, Paris, 1987

Francis, Berne, 1991
Sam Francis: Eine Retrospektive. 40 Years of Friendship. Werke 1945–1990 (exh. cat.), Kunsthalle, Berne, 1991

Francis, Buffalo, 1972
Sam Francis: Painting 1947–1972(exh. cat.), Albright-Knox Art Gallery, Buffalo, 1972

Francis, Houston, 1967
Sam Francis (exh. cat.), Museum of Fine Arts, Houston, 1967

Frank, Americans, 1978
Frank, Robert, *The Americans*, Millerton, N.Y., 1978

Frank, Black, 1994
Frank, Robert, *Black White and Things*, Zürich, 1994

Frank, Lines, 1989
Frank, Robert, *The Lines of my Hand*, Zürich, 1989

Frank, Thank you, 1996
Frank, Robert, *Thank you*, Zürich, 1996

Frankenthaler, Berlin, 1998
Helen Frankenthaler: Mountains and Sea. Gemälde 1952–1998 (exh. cat.), Deutsche Guggenheim Berlin, Ostfildern, 1998

Frantz, Art Deco, 1986
Frantz, P., *Art Déco Graphics*, London, 1986

Franz, Farben des Lichts, 1996/97
Franz, E. (ed.), *Farben des Lichts. Paul Signac und der Beginn der Moderne von Matisse bis Mondrian* (exh. cat.), Westfälisches Landesmuseum für Kunst und Kulturgeschichte Münster, Ostfildern, 1996/97

Franz, Marc, 1994
Franz, E. (ed.), *Franz Marc. Kräfte der Natur. Werke 1912–1915* (exh. cat.), Westfälisches Landesmuseum Münster et al., Stuttgart, 1994

Franzke, Baselitz, 1988
Franzke, A., *Georg Baselitz*, Munich, 1988

Franzke, Tàpies, 1992
Franzke, A., *Tàpies*, Munich, 1992

Frascina, Pollock, 1985
Frascina, F., *Pollock and After: The Critical Debate*, New York, 1985

Frèches-Thory/Perucchi-Petri, Nabis, 1993
Frèches-Thory, C. and U. Perucchi-Petri (eds.), *Die Nabis. Propheten der Moderne* (exh. cat.) Kunsthaus Zürich, Munich, 1993

Frèches-Thory/Terrasse, Nabis, 1990
Frèches-Thory, C., and A. Terrasse, *Les Nabis*, Paris, 1990

Freeman, Fauvism, 1989
Freeman, J., *The Fauve Landscape*, New York, 1989

Freeman, Tansey, 1993
Freeman, J. (ed.), *Mark Tansey*, Los Angeles County Museum of Art, 1993

Frei, Bill, 1991
Frei, H., *Konkrete Architektur: Über Max Bill als Architekt*, Baden, 1991

Frémont, Ryman, 1991
Frémont, J., *Robert Ryman: le paradoxe absolu*, Caen, 1991

Frénand, Ubac, 1985
Frénand, A., *Ubac et les fondements de son art*, Paris, 1985

Freud, New York, 1994
Lucian Freud: Retrospective (exh. cat.), The Museum of Modern Art, New York, 1994

Freud, Rome, 1991–92
Lucian Freud: Paintings and Works on Paper 1940–1991 (exh. cat.), Palazzo Ruspoli, Rome, 1991–92

Freud, Washington, 1987
Lucian Freud, Paintings (exh. cat.), Hirshhorn Museum and Sculpture Garden, Smithsonian Institution, Washington, 1987

Freund, Munich, 1998
Freund, Gisèle, *Photographien und Erinnerungen*, Munich, 1998

Freund, New York, 1985
Gisèle Freund: Photographer, New York, 1985

Freundlich, Pontoise, 1993
Otto Freundlich et ses amis (exh. cat.), Musée de Pontoise, 1993

Freundlich, Regensburg, 1994/95
Otto Freundlich: Ein Wegbereiter der abstrakten Kunst (exh. cat.), Museum Ostdeutsche Galerie Regensburg/Kulturgeschichtliches Museum Osnabrück, 1994/1995

Frey, 1988
Viola Frey: Monumental Figures 1978–1987, Los Angeles, 1988

Frey, Fischli & Weiss, 1990
Frey, P. (ed.), *Das Geheimnis der Arbeit. Texte zum Werk von Peter Fischli & David Weiss*, Munich/Düsseldorf, 1990

Frey, Philadelphia, 1984
It's All Part of Clay: Viola Frey, (exh. cat.), Philadelphia, 1984

Friedel, Cucchi, 1987
Friedel, H. (ed.), *Enzo Cucchi*, 3 vols. (exh. cat.), Städt. Galerie im Lenbachhaus, Munich, 1987

Friedel, Hofmann, 1997
Friedel, H. (ed.), *Hans Hofmann. Wunder des Rhythmus und Schönheit des Raumes* (exh. cat.), Städt. Galerie im Lenbachhaus Munich et al., Ostfildern, 1997

Friedel, Modersohn-Becker, 1997
Friedel, H. (ed.), *Paula Modersohn-Becker* (exh. cat.), Städtische Galerie im Lenbachhaus, Munich, 1997

Friedel, Nannucci, 1991
Friedel, H. (ed.), *Maurizio Nannucci. You can imagine the opposite* (exh. cat.), Munich, 1991

Friedel/Hoberg, Blauer Reiter, 1999
Friedel, H. and A. Hoberg (eds.), *Der Blaue Reiter und das Neue Bild*, Munich, 1999

Friedel/Hoberg, Münter, 1992
Friedel, H. and A. Hoberg (eds.), *Gabriele Münter 1877–1962. Retrospektive* (exh. cat.), Städtische Galerie im Lenbachhaus, Munich, 1992

Friedel/Hoberg, Neue Künstlervereinigung München, 1999
Friedel, H., and A. Hoberg (eds.), *Der Blaue Reiter und das Neue Bild* (exh. cat.), Städtische Galerie im Lenbachhaus München, Munich, 1999

Friedl, Geiger, 1998
Friedl, H. (ed.), Rupprecht Geiger (exh. cat.), *Städt. Galerie im Lenbachhaus*, Munich, 1998

Friedlander, Musicians, 1998
Friedlander, Lee, *American Musicians*, New York, 1998

Friedlander, Nudes, 1996
Friedlander, Lee, *Nudes*, New York, 1996

Friedlander/Szarkowski, Friedlander, 1998
Friedlander, Lee, and John Szarkowski, *Lee Friedlander: Self Portraits*, New York, 1998

Friedman, Epstein, 1987
Friedman, T. and E. Silber (eds.), *Jacob Epstein. Sculpture and Drawings* (exh. cat.), Leeds City Galleries, Leeds, 1987

Friedman, Fluxus, 1998
Friedman, K., *The Fluxus Reader*, London, 1998

Friedman, Goldsworthy, 1990
Friedman, T. et. al. (ed.), *Hand to Earth. Andy Goldsworthy Sculpture 1976–1990* (exh. cat.), City Art Gallery, Leeds, 1990

Friedman, Precisionism, 1960
Friedman, M., *The Precisionist View in American Art*, Walker Art Center, Minneapolis, 1960

Friese, Gerz, 1992
Friese, P. (ed.), *Jochen Gerz. Life After Humanism. Photo, Text 1988–1992* (exh. cat.), Neues Museum Weserburg et. al., Stuttgart, 1992

Friesz, Le Havre, 1979
Othon Friesz. Retrospective (exh. cat.), Musée des Beaux-Arts André Malraux, Le Havre, 1979

Fromanger, Paris, 1979
Gérard Fromanger 1978–1979 (exh. cat.), Musée National d'Art Moderne Centre Georges Pompidou, Paris, 1979

Fromanger, Paris, 1985
Fromanger. Chimères (exh. cat.), Galerie Brachot, Paris, 1985

Frost, London, 1976
Terry Frost: Paintings, Drawings, Collages (exh. cat.), Arts Council of Great Britain, London, 1976

Frost, Newcastle, 1964
Terry Frost: A Retrospective (exh. cat.), Newcastle upon Tyne, 1964

Frost, Reading, 1986
Terry Frost: Painting in the 1980s (exh. cat.), University of Reading, 1986

Fruhtrunk, Munich, 1993
Schuster, P.-K. (ed.), *Günter Fruhtrunk. Retrospektive* (exh. cat.), Neue Nationalgalerie Berlin etc., Munich, 1993

Fry, Colville, 1994
Fry, P., *Alex Colville. Paintings, Prints and Processes 1983–1994*, (exh. cat.), Museum of Fine Arts, Montreal, 1994

Fry, Grant, 1923
Fry, R., *Duncan Grant*, London, 1923

Fuchs, Long, 1986
Fuchs, R. (ed.), *Richard Long* (exh. cat.), The Solomon R. Guggenheim Museum, New York, 1986

Fuchs, Lüpertz, 1997
Fuchs, R. (ed.), *Markus Lüpertz* (exh. cat.), Stedelijk Museum, Amsterdam, 1997

Fuchs, Rainer, 1989
Fuchs, R. (ed.), *Arnulf Rainer* (exh. cat.), Solomon R. Guggenheim Museum New York, Munich, 1989

Fuchs, Weiner, 1976
Fuchs, R. (ed.), *Lawrence Weiner* (exh. cat.), Stedelijk Van Abbemuseum, Eindhoven, 1976

Fulton/Seymour, Long, 1991
Fulton H., and Seymour A., *Richard Long: Walking in Circles*, London, 1991

Furler, Hofer, 1978
Furler, E., *Karl Hofer: Leben und Werk in Daten und Bildern*, Frankfurt, 1978

Futurism, Venice, 1986
Hulten, P. (ed.), *Futurismo & Futurismi* (exh. cat.), Palazzo Grassi, Venice, 1986

Gabler, Heckel, 1983
Gabler, K., *Erich Heckel und sein Kreis. Dokumente, Fotos, Briefe, Schriften*, Stuttgart/Zürich, 1983

Gabler, Kirchner, 1980
Gabler, K., *E. L. Kirchner. Band I: Dokumente, Fotos, Schriften, Briefe. Band II: Zeichnungen, Pastelle, Aquarelle*, Aschaffenburg, 1980

Gabler, Kirchner, 1988
Gabler, Wolfram, *Ernst Ludwig Kirchner als Illustrator*, Berlin, 1988

Gablik, Magritte, 1985
Gablik, S., *Magritte*, London, 1985

Gachnang, Kirkeby, 1997
Gachnang, J. et al. (eds.), *Per Kirkeby. Backsteinskulptur und Architektur. Werkverzeichnis*, Cologne, 1997

Gallwitz, Kirkeby, 1990
Gallwitz, K. (ed.), *Per Kirkeby. Gemälde, Arbeiten auf Papier, Skulpturen 1977–1990* (exh. cat.), Städtische Galerie im Städelschen Kunstinstitut, Frankfurt am Main, 1990

Gambillo, Futurism, 1958–62
Gambillo, M. Drudi, and T. Fiori, *Archivi del futurismo*, Rome, 1958–62

Gardiner, Epstein, 1992
Gardiner, S., *Epstein. Artist Against Establishment*, London, 1992

Gassmann, Tabard, 1987
Gassmann, P., *Maurice Tabard*, Paris, 1987

Gaßner, Mattheuer, 1988
Gaßner, H., "Die mythische Dimension in der Malerei. Am Beispiel von Wolfgang Mattheuer und Walter Libuda" in Brusberg, Dieter and Ulrich Eckhardt (eds.), *Zeitvergleich '88 – dreizehn Maler aus der DDR*, Berlin, 1988

Gaudibert, Ipoustéguy, 1989
Gaudibert, R., *Ipoustéguy*, Paris, 1989

Gaudier-Brzeska, Cambridge, 1983
Henri Gaudier-Brzeska. Sculptor 1891–1915 (exh. cat.), Kettle's Yard Gallery, Cambridge, 1983

Gaugh, Kline, 1979
Gaugh, H. F., *Franz Kline. The Color Abstraction* (exh. cat.), The Phillips Collection, Washington D.C., 1979

Gaugh, Kline, 1985
Gaugh, H. F., *The Vital Gesture: Franz Kline*, New York, 1985

Geelhaar, Klee, 1982
Geelhaar, C., *Paul Klee: Life and Work*, Woodbury NY, 1982

Geist, Brancusi, 1969
Geist, S. (ed.), *Brancusi. A Retrospective* (exh. cat.), The Salomon R. Guggenheim Museum, New York, 1969

Geist, Brancusi, 1987
Geist, S., *Brancusi. The Sculpture und Drawing*, New York ,1975

Geldzahler, Olitski, 1991
Geldzahler, H. et al. (eds.), *Jules Olitski* (exh. cat.), Salander-O'Reilly Galleries, New York, 1990

Genaver, Tamayo, 1974
Genaver, E., *Rufino Tamayo*, New York, 1974

Geometric Abstraction, Dallas, 1972
Geometric abstraction 1926–42 (exh. cat.), Museum of Fine Arts, Dallas, 1972

Geometric Abstraction, New York, 1962
Geometric Abstraction in America (exh. cat.), Whitney Museum of American Art, New York, 1962

Georgel, Doesburg, 1977
Georgel, P., *Theo van Doesburg: Projets pour l'Aubette*, Paris, 1977

Gerdts, Glackens, 1996
Gerdts, W., *William Glackens*, New York, 1996

Gerlinger, Brücke, 1995
Gerlinger, H. et al., *Die Maler der Brücke*, Stuttgart, 1995

Gernsheim, Coburn, 1966
Gernsheim, H. and A. (ed.), *Alvin Langdon Coburn. An Autobiography*, London, 1966

Gertsch, Stuttgart, 1993
Franz Gertsch. Landschaften, (exh. cat.), Stuttgart, 1993

Gesamtkunstwerk, Zürich, 1983
Der Hang zum Gesamtkunstwerk. Europäische Utopien seit 1800, (exh. cat.), Kunsthaus Zürich et. al., 1983

Gette, Feu, 1993
Gette, P.-A., *Feu*, Paris, 1993

Gette, Grenoble, 1989
Nymphe, Nymphaea & Voisinages, (exh. cat.), Centre National d'Art Contemporain de Grenoble, 1989

Gette, Grenoble, 1992
Paul-Armand Gette. De part et d'autre du fleuve. La perennité du volcanisme rhénan, (exh. cat.), Les Musées de la ville de Strasbourg, 1992

Giacometti, Zürich, 1990
Die Sammlung der Alberto Giacometti-Stiftung, Zürich, 1990

Gibson, Longo, 1991
Gibson, W., *Robert Longo*, Kyoto, 1991

Gilbert & George, Bordeaux, 1986
Gilbert & George. The Complete Pictures 1971–1985 (exh. cat.), CAPC Musée d'art contemporain de Bordeaux, 1986

Gilbert & George, Eindhoven, 1980
Gilbert & George 1968 to 1980 (exh. cat.), Stedelijk Van Abbemuseum, Eindhoven, 1980

Gill, Autobiography, 1940
Gill, E., *Autobiography*, London, 1940

Gilles, Weston, 1995
Gilles, M. (ed.), *Edward Weston, Forms of Passion*, Paris, 1995

Gillick, Deacon, 1999
Gillick, Liam, et al., *Richard Deacon* (exh. cat.), Tate Gallery, Liverpool, 1999

Gilmour, Kiefer, 1990
Gilmour, J. C., *Fire on the Earth: Anselm Kiefer and the Post-Modern World*, Philadelphia, 1990

Giménez/Ashton, Tàpies, 1995
Giménez, C. and D. Ashton (eds.), *Antoni Tàpies* (exh. cat.), Solomon R. Guggenheim Museum, Paris/New York, 1995

Gimferrer, Miró, 1978
Gimferrer, P., *Miró and the Catalan Spirit*, Barcelona, 1975

Girad/Perez-Tibi, Dufy, 1993
Girad, X. and D. Perez-Tibi, *Dufy. Le Peintre décorateur*, Paris, 1993

Girsberger, Corbusier 1960
Editions Girsberger (ed.), *Le Corbusier 1910–1960*, Zürich, 1960

Glasmalerei, Darmstadt, 1979
Das Bild in Glas, (exh. cat.), Hessisches Landesmuseum Darmstadt, 1979

Gleeson, Dobell, 1981
Gleeson, J., *William Dobell: A Biographical and Critical Study*, Sydney, 1981 [1964]

Gleizes, Cubism, 1995
Gleizes, A., *The Epic [1913]*, Ampuis, 1995

Gleizes, Paris, 1976
Albert Gleizes (exh. cat.), Musée Nat. d'Art moderne, Centre Georges Pompidou, Paris, 1976

Glenn, 1985
Glenn, C. W., *Jim Dine: Drawings*, New York, 1985

Glenn, Rosenquist, 1993
Glenn, C. W., *Time Dust. James Rosenquist. Complete Graphics 1962–1992*, New York, 1993

Glimcher, Rothko, 1991
Glimcher, M. (ed.), *The Art of Mark Rothko. Into an Unknown World*, New York, 1991

Glozer, Wols, 1978
Glozer, L., *Wols Photograph*, Munich, 1978

Gnoli, Bremen, 1981
Domenico Gnoli 1933–1970. Gemälde, Skulpturen, Zeichnungen, Druckgraphik, (exh. cat.), Kunsthalle Bremen, 1981

Gober, Los Angeles, 1997
Robert Gober, (exh. cat.), Museum of Contemporary Art, Los Angeles, 1997

Gober, Rotterdam, 1990
Robert Gober, (exh. cat.), Museum Boymans-van Beuningen, Rotterdam, 1990

Godfrey, New Image Painting, 1986
Godfrey, T., *The New Image Painting in the 1980s*, New York, 1986

Göpel, Beckmann, 1976
Göpel, E. and B., *Max Beckmann. Katalog der Gemälde*, 2 vols., Berne, 1976

Goeritz, 1992
Mathias Goeritz. El Eco (exh. cat.), Akademie der Künste, Berlin, 1992

Gohr, Lüpertz, 1997
Gohr, S. (ed.), *Markus Lüpertz* (exh. cat.), Kunsthalle der Hypo-Kulturstiftung München, Munich, 1997

Gohr, Penck, 1981
Gohr, S. (ed.), *A. R. Penck. Gemälde, Handzeichnungen* (exh. cat.) Josef-Haubrich-Kunsthalle, Cologne, 1981

Gohr/Scheibler, Nay, 1991
Gohr, S., and A. Scheibler (eds.), *Ernst Wilhelm Nay. Werkverzeichnis der Ölgemälde 1922–1968*, 2 vols., Cologne, 1991

Goldberg, Performance, 1988
Goldberg, R., *Performance Art from Futurism to the Present-day*, London, 1988

Goldin, 1998
Emotions + Relations. Nan Goldin, David Armstrong, Mark Morrisroe, Jack Pierson (exh. cat.), Hamburger Kunsthalle, Hamburg, 1998

Goldin, Ballad, 1986
Goldin, N., *The Ballad of Sexual Dependency*, New York, 1986

Golding, Cubism, 1988
Golding, J., *Cubism, a History and an Analysis*, London, 1988

Golding, Ozenfant, 1985
Golding, J., *Ozenfant*, New York, 1985

Golding/Green, Purism, 1971
Golding, J., and C. Green, *Léger and Purist Paris*, London, 1971

Goldman, Rosenquist, 1992
Goldman, J., *James Rosenquist. Early Pictures 1961–64*, New York, 1992

Goldscheider, Rodin, 1989
Goldscheider, C., *Auguste Rodin. Vie et œuvre. Catalogue raisoné de l'œuvre sculpté, vol.1: 1860–1886*, Lausanne/Paris, 1989

Goldsworthy, Sheepfolds, 1996
Goldsworthy, A., *Sheepfolds*, London, 1996

Goldwater, Broodthaers, 1989
Goldwater, R., *Marcel Broodthaers*, New York, 1989

Goldwater, Primitivism, 1938
Goldwater, R., *Primitivism in Modern Painting*, New York, 1938

Goncharova, 1990
Künstlerinnen des 20. Jahrhunderts (exh. cat.), Museum Wiesbaden, 1990

González, Bern, 1997
Julio González – Zeichnen im Raum (exh. cat.), Kunstmuseum Bern, 1997

González, London, 1990
Julio González – Sculptures and Drawings (exh. cat.), Whitechapel Art Gallery, London, 1990

González, Mannheim, 1977
Julio González 1876–1942 (exh. cat.), Städtische Kunsthalle Mannheim, 1977

González, New York, 1983
Julio González 1876–1942. Plastiken, Zeichnungen, Kunstgewerbe (exh. cat.), The Solomon R. Guggenheim Museum, New York, 1983

Gonzalez-Torres, 1997
Felix Gonzalez-Torres: I. Text and II. Catalogue Raisonné. Ostfildern, 1997

Gooding, Heron, 1994
Gooding, Mel, *Patrick Heron*, London, 1994

Gooding, Hoyland, 1990
Gooding, M., *John Hoyland*, London, 1990

Gooding, McLean, 1990
Gooding, M., *Bruce McLean*, New York, 1990

Gordon, Expressionism, 1987
Gordon, D.E., *Expressionism – Art and Idea*, New Haven, 1987

Gordon, Kirchner, 1968
Gordon, D.E., *Ernst Ludwig Kirchner*, Cambridge, Mass., 1968

Gore/Shone, Gore, 1983
Gore, F. and R. Shone, *Spencer Frederick Gore (1878–1914)*, London, 1983

Gorky, London, 1990
Arshile Gorky 1904–1948 (exh. cat.), Whitechapel Art Gallery, London, 1990

Gorky, New York, 1981
Waldman, D. (ed.), *Arshile Gorky 1904–1948. A Retrospective* (exh. cat.), The Solomon R. Guggenheim Museum, New York, 1981

Gottberg, Vostell, 1981
Gottberg, D. (ed.), *Vostell. Fluxus-Zug. Das mobile Museum*, Berlin, 1981

Gowing, Coldstream, 1990
Gowing, L., *The Paintings of William Coldstream*, London, 1990

Gowing, Freud, 1982
Gowing, L., *Lucian Freud*, London/New York, 1982

Gowing, London, 1983
Lawrence Gowing (exh. cat.), Hayward Gallery, London, 1983

Graham, Des Moines, 1990
Robert Graham (exh. cat.), Des Moines Art Center, Iowa, 1981

Graham, Interviews, 1997
Graham, D., *Interviews*, Ostfildern, 1997

Graham, Los Angeles, 1988
Robert Graham (exh. cat.), Los Angeles County Museum of Art, 1988

Graham, Rock, 1993
Graham, D., *Rock my Religion, Writings and Art Projects, 1965–1990*, Cambridge Mass., 1993

Graham, System, 1971
Graham, John, *System and Dialectics of Art*, Baltimore, 1971

Graham-Dixon, A., Hodgkin, 1994
Graham-Dixon, A., *Howard Hodgkin*, London, 1994

Grainville/Xuriguera, Mathieu, 1993
Grainville, P. and G. Xuriguera, *Georges Mathieu*, Paris, 1993

GRAV, Dortmund, 1968
GRAV (exh. cat.), Museum am Ostwall, Dortmund, 1968

Graves, Aachen, 1992
Nancy Graves, ihre Kamele in Aachen und deren Restaurierung, ed. by Ludwig Forum für internationale Kunst, Aachen, 1992

Graves, Eugene, 1966
Graves – a Retrospective (exh. cat.), Museum of Art, Eugene, Oregon, 1966

Gray, Avantgarde, 1963
Gray, C., *Die russische Avantgarde der modernen Kunst, 1863–1922*, Cologne, 1963

Gray, Experiment, 1962
Gray, C., *The Great Experiment: Russian Art, 1863–1922*, London, 1962

Gray, Jones, 1989
Gray, N., *The Paintings of David Jones*, London, 1989

Green, Cubism, 1987
Green, C., *Cubism and its Enemies, Modern Movements in French Art 1916–1928*, New Haven, 1987

Green, Graham, 1987/88
Green, E., *John Graham. Artist and Avatar* (exh. cat.), The Phillips Collection, Washington, 1987/88

Green, Gris, 1992
Green, C. et al., (eds.), *Juan Gris* (exh. cat.), Whitechapel Art Gallery, London, 1992

Green, Léger, 1976
Green, C., *Léger and the Avant-Garde*, New Haven/London, 1976

Greenberg, Kitsch, 1997
Greenberg, C., "Avantgarde und Kitsch" (1939), in *Die Essenz der Moderne. Ausgewählte Essays und Kritiken*, Dresden, 1997

Greenberg, Post-Painterly Abstraction, 1964
Greenberg, C. (ed.), *Post-Painterly Abstraction* (exh. cat.), Los Angeles County Museum of Art, Los Angeles, 1964

Greenough, Frank, 1994
Greenough, S., and P. Brookman, *Robert Frank*, Washington, 1994

Grenier, Brassaï, 1990
Grenier, R., *Brassaï*, London, 1990

Griesbach, Aufbruch, 1991
Griesbach, L., *Aufbruch der Moderne in Dresden und Berlin*, Munich/Zürich, 1991

Grinten, Toorop, 1983
Grinten van der, H. (ed.), *Jan Toorop und der niederländische Symbolismus*, Neuss, 1985

Grisebach, Kirchner, 1995
Grisebach, L., *Ernst Ludwig Kirchner*, Cologne, 1995

Grisebach, Penck, 1988
Grisebach, L. et al. (eds.), *A. R. Penck* (exh. cat.), Nationalgalerie Berlin, Munich, 1988

Grochowiak, Meidner, 1966
Grochowiak, T., *Ludwig Meidner*, Recklinghausen, 1966

Grohmann, Baumeister, 1963
Grohmann, W., *Willi Baumeister. Leben und Werk*, Cologne, 1963

Gromaire, Paris, 1980
Marcel Gromaire. Retrospective (exh. cat.), Musée de l'Art Moderne de la Ville de Paris, Paris, 1980

Groom, Vuillard, 1993
Groom, G., *Edouard Vuillard, Painter-Decorator*, New Haven/London, 1993

Grooms, Philadelphia, 1985
Red Grooms – A Retrospective, 1956–1984 (exh. cat.), Pennsylvania Academy of Fine Arts, Philadelphia, 1985

Grosvenor, Kerguéhennec, 1989
Robert Grosvenor (exh. cat.), Centre d'art Kerguéhennec, 1989

Groult, Laurencin, 1992
Groult, F., *Marie Laurencin. Ein Leben für die Kunst*, Munich, 1992

Gruen, Basquiat, 1991
Gruen, J. and K. Haring, *Jean-Michel Basquiat. The Authorized Biography*, New York, 1991

Gruen, Haring, 1991
Gruen, J., *Keith Haring, The Authorized Biography*, London, 1991

Grünewald, Comics, 1982
Grünewald, D., *Comics – Kitsch oder Kunst? Die Bildergeschichte in Analyse und Unterricht. Ein Handbuch zur Comic-Didaktik*, Basel/Weilheim, 1982

Grützke, Wolfsburg, 1992
Johannes Grützke – Kunstpreis der Stadt Wolfsburg (exh. cat.), Städtische Galerie und Kunstverein Wolfsburg, 1992

Grundberg, Prince, 1990
Grundberg, A., "Richard Prince, Photographer", in *Crisis of the Real: Writings on Photography 1974–1989*, New York 1990, pp. 133–36

Grunfeld, Rodin, 1987
Grunfeld, F. V., *Rodin: a Biography*, New York, 1987

Guare, Close, 1995
Guare, J., *Chuck Close: life and work, 1988–1995*, London, 1995

Guastalla, Marini, 1991
Guastalla, G. and G. (eds.), *Marino Marini. Werkverzeichnis der Graphik*, Langenhagen, 1991

Guerrilla Girls, 1995
Confessions of the Guerrilla Girls (Whoever They Really Are), New York, 1995

Güse, Chagall, 1994
Güse, E.-F. (ed.), *Marc Chagall. Druckgraphik*, Saarland Museum Saarbrücken, Stuttgart,1994

Güse, Klein, 1994
Güse. E. G., and E. Uthemann (eds.), *Astrid Klein* (exh. cat.), Saarland Museum, Saarbrücken, 1994

Güse, Macke, 1986
Güse, E.-G. (ed.), *August Macke. Gemälde, Aquarelle, Zeichnungen* (exh. cat.), Westfälisches Landesmuseum für Kunst- und Kulturgeschichte Münster et al., Munich, 1986

Güse/Morat, Morandi, 1999
Güse, E.G., and A. Morat, *Morandi: Paintings – Watercolours – Drawings – Etchings*, Munich, 1999

Gütersloh, Vienna, 1987
Albert Paris Gütersloh, (exh. cat.) Sezession, Vienna, 1987

Guisan/Jakubec, Vallotton, 1973–75
Guisan, G. and D. Jakubec (eds.), *Félix Vallotton. Documents pour une biographie et pour l'histoire d'une œuvre*, 3 vols., Paris, 1973–75

Gullar/Pedrosa, Clark, 1980
Gullar, F., and M. Pedrosa, *Lygia Clark*, Rio de Janeiro, 1980

Gumpert, Boltanski, 1994
Gumpert, L., *Christian Boltanski*, London, 1994

Gursky, Düsseldorf, 1998
Andreas Gursky (exh. cat.), Kunsthalle Düsseldorf, Munich, 1998

Gursky, Wolfsburg, 1999
Andreas Gursky Fotografie (exh. cat.), Kunstmuseum Wolfsburg, 1999

Gutai, Darmstadt, 1991
Gutai (exh. cat.), Mathildenhöhe, Darmstadt, 1991

Gutfreund, Berlin, 1987
Otto Gutfreund 1889–1927, Plastiken und Zeichnungen (exh. cat.), Staatliche Museen zu Berlin, Nationalgalerie, Berlin, 1987

Gutfreund, Prague, 1995
Otto Gutfreund (exh. cat.), Narodní Galerie, Prague, 1995

Guthbrod, Jetelová, 1997
Guthbrod, H. (ed.), *Magdalena Jetelová. Multi Purposes. Zwischen den Stühlen* (exh. cat.), Badisches Landesmuseum Karlsruhe, Karlsruhe, 1997

Haacke, Barcelona, 1995
Obra Social, Hans Haacke (exh. cat.), Fundación Antoní Tàpies, Barcelona, 1995

Haacke, Stuttgart, 1993
Hans Haacke, *Bodenlos* (exh. cat.), Stuttgart, 1993

Hacker, Hayter, 1988
Hacker, P. M. S., *The Renaissance of Gravure – The Art of S. W. Hayter*, Oxford, 1988

Hacker, London, 989
Dieter Hacker (exh. cat.), Marlborough Gallery, London, 1989

Händler, Lehmbruck, 1985
Händler, G., *Wilhelm Lehmbruck – Die Zeichnungen der Reifezeit*, Stuttgart, 1985

Haenlein, Chia, 1984
Haenlein, C. (ed.), *Sandro Chia. Bilder 1976–1983*, (exh. cat.), Kestner-Gesellschaft Hannover, Berlin, 1984

Haenlein, Lüpertz, 1983
Haenlein, C. (ed.), *Markus Lüpertz: Bilder 1970–1983* (exh. cat.), Kestner-Gesellschaft, Hanover, 1983

Haenlein, Photomontage, 1979
Haenlein, C.-A., *Dada Photomontagen*, Hanover 1979

Haftmann, Baumeister, 1976
Haftmann, W., *Willi Baumeister. Gilgamesch*, Cologne, 1976

Haftmann, Chagall, 1985
Haftmann, W., *Marc Chagall*, London, 1985

Haftmann, Nay, 1960–1991
Haftmann, W., *Ernst Wilhelm Nay*, Cologne, 1960/1991

Haftmann, Nolde, 1965
Haftmann, W., *Emil Nolde: the Forbidden Pictures*, New York, 1965

Hahl-Koch, Arnold Schoenberg, Wassily Kandinsky, 1984
Hahl-Koch, J., *Arnold Schoenberg, Wassily Kandinsky: Letters, Documents, Pictures*, London, 1984

Hahlhoch, Kandinsky, 1993
Hahlhoch, J., *Kandinsky*, London and New York, 1993

Halperin, Aesthete and Anarchist, 1988
Halperin, J. U., *Félix Fénéon: Aesthete and Anarchist in Fin-de-Siècle Paris*, New Haven, 1988

Hambling, London, 1987
Maggi Hambling: Paintings, Drawings and Watercolours (exh. cat.), Serpentine Gallery, London, 1987

Hambling, Sunderland, 1993
Maggi Hambling: Towards Laughter (exh. cat.), Northern Centre for the Arts, Sunderland, 1993

Hamilton, 1991
Ann Hamilton (exh. cat.), San Diego Museum of Contemporary Art, 1991

Hamilton, Doisneau, 1995
Hamilton, P., *Robert Doisneau: a Photographer's Life*, New York, 1995

Hamilton, Works, 1982
Hamilton, R., *Collected Works*, London, 1982

Hammacher, Lipchitz, 1975
Hammacher, A.M., *Jacques Lipchitz*, New York, 1975

Hammacher, Magritte, 1970
Hammacher, A. M., *René Magritte*, London, 1970

Hammacher, Marini, 1970
Hammacher, A. M., *Marino Marini: Sculpture, Painting, Drawing*, London, 1970

Hammond, Evans, 1992
Hammond, A. (ed.), *Frederick H. Evans. Selected Texts and Bibliography*, Boston, Mass., 1992

Hammons, San Diego, 1995
David Hammons, Raising the Rubble (exh. cat.), San Diego Museum of Art, 1995

Hanhardt, Paik, 1982
Hanhardt, J. G. (ed.), *Nam June Paik*, New York, 1982

Hanson, London, 1997
Duane Hanson (exh. cat.), Saatchi Gallery, London, 1997

Happel, Rohlfs, 1992
Happel, R. (ed.), *Christian Rohlfs* (exh. cat.), Kunstverein Braunschweig, Brunswick, 1992

Harambourg, École de Paris, 1993
Harambourg, L., *L'École de Paris 1945–1965. Dictionnaire des Peintres*, Neuchâtel, 1993

Hardie, Scottish Painting, 1990
Hardie, W., *Scottish Painting 1837 to the Present*, London, 1990

Haring, Amsterdam, 1986
Keith Haring (exh. cat.), Stedelijk Museum Amsterdam, 1986

Haring, New York, 1997
Keith Haring (exh. cat.), Whitney Museum of American Art, New York, 1997

Harlem Renaissance, 1997
Rhapsodies in Black: Art of the Harlem Renaissance (exh. cat.), Hayward Gallery, London, 1997

Harris, Black Mountain College, 1988
Harris, M. E., *The Arts at Black Mountain College*, Cambridge, Mass., 1988

Harrison, English Art, 1981
Harrison, C., *English Art and Modernism: 1900–1939*, London, 1981

Harrison, Redon, 1986
Harrison, S. R., *Catalog of the Etchings of Odilon Redon*, New York, 1986

Harrison, Rivers, 1984
Harrison, H. A., *Larry Rivers*, New York, 1984

Harrison/Orton, Art & Language, 1982
Harrison, C., and F. Orton, *A Provisional History of Art & Language*, Paris, 1982

Harten, Byars, 1986
Harten, J. (ed.), *James Lee Byars: Palast der Philosophie. The Philosophical Palace* (exh. cat.), Städt. Kunsthalle, Düsseldorf, 1986

Harten, Tatlin, 1993
Harten, J. (ed.), *Vladimir Tatlin. Leben, Werk, Wirkung. Ein internationales Symposium*, Cologne, 1993

Hartmann, Hubbuch, 1991
Hartmann, W., *Karl Hubbuch. Der Zeichner*, Stuttgart, 1991

Hartung, Berlin, 1975
Hans Hartung. Retrospektive 1921–1973. Gemälde, Tuschen, Zeichnungen (exh. cat.), Nationalgalerie Berlin, 1975

Hartung, Düsseldorf, 1981
Hans Hartung. Malerei, Zeichnung, Fotografie (exh. cat.), Kunsthalle Düsseldorf et al., 1981

Haskell, Demuth, 1987
Haskell, B., *Charles Demuth* (exh. cat.), Whitney Museum of American Art, New York, 1987

Haskell, Hartley, 1980
Haskell, B., *Marsden Hartley* (exh. cat.), Whitney Museum of American Art, New York, 1980

Haskell, Judd, 1988
Haskell, B. (ed.), *Donald Judd* (exh. cat.), Whitney Museum of American Art, New York, 1988

Haus, Fotogramm, 1978
Haus, A., *Moholy-Nagy. Fotos und Fotogramme*, Munich, 1978

Hausmann, Ostfildern, 1994
Der deutsche Spiesser ärgert sich. Raoul Hausmann 1886–1971, (exh. cat.), Berlinische Galerie Berlin, Ostfildern, 1994

Hayter, Adler, 1948
Hayter, S. W., *Jankel Adler*, London, 1948

Hedinger, Mail art, 1992
Hedinger, B., *Die Künstlerpostkarte: Von den Anfängen bis zur Gegenwart*, Munich, 1992

Heer, Wotruba, 1977
Heer, F., *Fritz Wotruba*, Sankt Gallen, 1977

Hegyi, Nitsch, 1996
Hegyi, L. et al. (eds.), *Hermann Nitsch. Das Orgien Mysterien Theater* (exh. cat.), Museum Moderner Kunst Stiftung Ludwig, Vienna, 1996

Heidrich, Macke, 1997
Heidrich, U. (ed.), *August Macke. Aquarelle. Werkverzeichnis*, Stuttgart, 1997

Held, New York, 1992
Al Held. New Paintings (exh. cat.), A. Emmerich Gallery, New York, 1992

Helfenstein, Oppenheim, 1993
Helfenstein, J., *Meret Oppenheim und der Surrealismus*, Stuttgart,1993

Helfenstein/Schenker, Turrell, 1991
Helfenstein, J. and C. Schenker (eds.), *James Turrell. First Light* (exh. cat.), Kunstmuseum, Berne, 1991

Hélion, Journal, 1992
Hélion, J., *Journal d'un peintre*, Paris, 1992

Hell, Video, 1990
Hell, D., *Illuminating Video. An Essential Guide to Video Art*, New York, 1990

Heller, Munch, 1984
Heller, R., *Munch, his Life and Work*, London, 1984

Heller/Williams, Regionalists, 1976
Heller, N., and J. Williams, *The Regionalists: Painters of the American Scene*, New York, 1976

Helms, Vordemberge-Gildewart, 1990
Helms, D. (ed.), *Vordemberge-Gildewart. The Complete Works*, Munich, 1990

Hendricks, Fluxus, 1988
Hendricks, J., *Fluxus Codex*, New York, 1988

Henkels, Mondrian, 1987
Henkels, H. (ed.), *Mondrian – From Figuration to Abstraction* (exh. cat.), The Seibu Museum of Art Tokyo/Haags Gemeentemuseum, The Hague, 1987

Henri, 1984
Henri, R., *The Art Spirit*, New York, 1984

Henri, Environment, 1974
Henri, A., *Environments and Happenings*, London, 1974

Henri, San Francisco, 1990
Florence Henri: Artists-Photographer of the Avant-Garde (exh. cat.), San Francisco Museum for Modern Art, San Francisco, 1990

Herbin, Céret, 1994
Herbin (exh. cat.), Musée d'Art Moderne, Céret, 1994

Herbin, L'art, 1949
Herbin, A., *L'art non-figuratif, non-objectif*, Paris, 1949

Herding/Mittig, Nationalsozialistische Kunst, 1975
Herding, K., and H.-E. Mittig, *Kunst und Alltag im NS-System*, Gießen, 1975

Hergott, Rouault, 1991
Hergott, F., *Rouault*, Paris, 1991

Herman, 1996
Herman, N. Josef, *Herman: A Working Life*, London, 1996

Heron, London, 1985
Patrick Heron (exh. cat.), Barbican Art Gallery, London, 1985

Herrera, Kahlo, 1983
Herrera, H., *Frida: A biography of Frida Kahlo*, New York, 1983

Herrera, Kahlo, 1991
Herrera, H., *Frida Kahlo, the Paintings*, London, 1991

Herzog, Räderscheidt, 1991
Herzog, G., *Anton Räderscheidt*, Cologne, 1991

Herzogenrath/Decker, Video-Skulptur, 1989
Herzogenrath, W. and E. Decker (eds.), *Video-Skulptur, retrospektiv und aktuell 1963–1989*, Cologne, 1989

Hess, Grosz, 1985
Hess, H., *George Grosz*, New Haven, 1985

Hess, Haas, 1992
Hess, H.-E. and F. Langer (eds.), *Ernst Haas*, Hamburg, 1992

Hess, Newman, 1971
Hess, T.B., *Barnett Newman*, New York, 1971

Hess/Ashbery, Light, 1971
Hess, T. B. and J. Ashbery (eds.), *Light in Art*, New York, 1971

Hesse, Ulm, 1994
Eva Hesse, Drawing in Space – Bilder und Reliefs (exh. cat.), Ulmer Museum, Ulm, 1994

Heubach/Buchloh, Polke, 1976
Heubach, F. W., and B. H. D. Buchloh (eds.), *Sigmar Polke. Bilder, Tücher, Objekte. Werkauswahl 1962–1971* (exh. cat.), Kunsthalle Tübingen et al., Tübingen, 1976

Heyman, Lange, 1979
Heyman, T.T., *Celebrating A Collection. The Work of Dorothea Lange* (exh. cat.), The Oakland Museum, 1979

Hickey, Art Issues, 1995
Hickey, *Art Issues*, New York, 1995

Hill, Liverpool, 1995
Gary Hill in the Light of the Other (exh. cat.), Tate Gallery, Liverpool, 1995

Hill, Washington, 1994
Gary Hill (exh. cat.), Hirshhorn Museum, Washington, 1994

Hills, Neel, 1983
Hills, P., *Alice Neel*, New York, 1983

Hine, Empire State, 1998
Lewis W. Hine. The Empire State Building, New York, 1998

Hine, Men at Work, 1977
Hine, L. W., *Men at Work. Photographic Studies of Modern Men and Machines*, New York, 1977 (first published, 1932)

Hinson, Eddy, 1975
Hinson, T. E., Eddy. "New shoes for H." in *The Bulletin of the Cleveland Museum of Art*, 1975 (vol. 62), pp. 291–99

Hinz, Art in the Third Reich, 1980
Hinz, B., *Art in the Third Reich*, London, 1980

Hirst, London, 1991
Damien Hirst (exh. cat.), Inst. of Contemporary Arts, London, 1991

Hirst, New York, 1996
Damien Hirst. No Sense of Absolute Corruption (exh. cat.), Gargosian Gallery, New York, 1996

Hitchens, London, 1979
Ivon Hitchens: A Retrospective Exhibition (exh. cat.), London, Royal Academy of Arts, 1979

Hobbs, Krasner, 1993
Hobbs, R. C., *Lee Krasner*, New York, 1993

Hoberg, Bloch, 1997
Hoberg, A., *Albert Bloch – Ein amerikanischer Blauer Reiter* (exh. cat.), Städt. Galerie im Lenbachhaus, Munich, 1997

Hoberg, Kubin, 1999
Hoberg, A., *Alfred Kubin. Das lithographische Werk*, Munich, 1999

Hochreiter, Atzwanger, 1981
Hochreiter, Otto, and Peter Weiermair (eds.), *Peter Paul Atzwanger, 1888–1974, Photographien*, Innsbruck, 1981

Hodin, Manessier, 1972
Hodin, J.P., *Manessier*, Neuchâtel, 1972

Hodin, Munch, 1972
Hodin, J. P., *Edvard Munch*, London, 1972

Hodler, 1983
Ferdinand Hodler (exh. cat.), Nationalgalerie Berlin, Zürich, 1983

Hodler, 1999
Hodler (exh. cat.), Hypo-Kunsthalle, Munich, 1999

Hödicke, Berlin, 1993
K. H. Hödicke, Berliner Ring. Bilder und Skulpturen 1975–1992 (exh. cat.), Neuer Berliner Kunstverein, Berlin 1993

Hödicke, Cologne, 1997
K. H. Hödicke, havapaintmilkaday. Bilder von der Westküste Irlands 1981–1996 (exh. cat.), Kunsthalle Emden, Cologne, 1997

Hoffmann, Meidner, 1985
Hoffmann, K. (ed.), *Ludwig Meidner*, Wolfsburg, 1985

Hofmaier, Beckmann, 1990
Hofmaier, J., *Max Beckmann: Catalogue Raisonné of the Prints*, 2 vols., Berne, 1990

Hofmann, Braque, 1962
Hofmann, W., *Georges Braque – His Graphic Work*, London, 1962

Hofmann, Hoflehner, 1993
Hofmann, W., *Rudolf Hoflehner*, Stuttgart, 1993

Hofmann, Laurens, 1970
Hofmann, W., *Henri Laurens. Das plastische Werk*, Stuttgart, 1970

Hofmann, Masereel, 1989
Hofmann, K.-L. et al. (eds.), *Frans Masereel*, Saarbrücken, 1989

Hofmann, Moderne Kunst, 1978
Hofmann, W., *Grundlagen der Modernen Kunst*, Stuttgart, 1978

Hohl, Le Corbusier, 1971
Hohl, R., *Le Corbusier: the Painter*, New York, 1971

Holografie, Munich, 1986
Holografie: Neues Medium für Kunst und Technik (exh. cat.), Deutsches Museum, Munich, 1986

Holtzman/James, Mondrian, 1987
Holtzman, H. and M. S. James (eds.), *The New Art – The New Life. The Collected Writings of Piet Mondrian*, London, 1987

Holzer, Buffalo, 1990
Jenny Holzer: The Venice Installation: United States Pavilion, 44th Venice Biennale [...], Buffalo, NY, 1990

Homer/Goodrich, Ryder, 1989
Homer, W., and L. Goodrich, *Albert Pinkham Ryder: Painter of Dreams*, New York, 1989

Honeff/Millet, Analytische Malerei, 1975
Honeff, Klaus, and Catherine Millet, *Analytische Malerei*, Genoa, 1975

Honisch, Chia, 1992
Honisch, D. (ed.) *Sandro Chia* (exh. cat.), Nationalgalerie, Berlin, 1992

Honisch, Mack, 1986
Honisch, D., *Mack – Skulpturen 1953–1986. Werkverzeichnis*, Düsseldorf, Vienna, 1986

Honisch, Uecker, 1986
Honisch, D. (ed.), *Uecker. Mit einem Werkverzeichnis von M. Haedecke (1955–1980)*, Stuttgart, 1982/New York, 1986

Honisch, Uecker, 1993
Honisch, D. (ed.), *Günther Uecker. Eine Retrospektive* (exh. cat.), Kunsthalle der Hypo-Kulturstiftung, Munich, 1993

Honnef, Anna and Bernhard Blume, 1992–95
Honnef, K. (ed.), *Anna und Bernhard Blume*, 3 vols., Cologne, 1992–95

Honnef, Constant, 1991
Honnef, K., "Constant – Wirken in der Sphäre des Abenteuers" in *Künstler. Kritisches Lexikon der Gegenwartskunst* edition 20, Munich, 1991

Honnef, Montage, 1991
Honnef, K., *Symbolische Form als anschauliches Erkenntnisprinzip: Ein Versuch zur Montage, in: John Heartfield* (exh. cat.), Akademie der Künste, Berlin, Cologne, 1991

Honnef, Transzendentaler Konstruktivismus, 1995
Honnef, K. (ed.), *Transzendentaler Konstruktivismus* (exh. cat.), Kunsthalle Bremen, Bremen, 1995

Hoog, Derain, 1991
Hoog, M. (ed.), *Un certain Derain* (exh. cat.), Musée de l'Orangerie, Paris, 1991

Hopps, Kienholz, 1996
Hopps, W., *Kienholz. A Retrospective. Edward and Nancy Reddin Kienholz*, Whitney Museum of American Art, New York, 1996

Hopps, Rauschenberg, 1997
Hopps, W. (ed.), *Robert Rauschenberg, A Retrospective* (exh. cat.), Solomon R. Guggenheim Museum, New York, 1997

Horn, Hanover, 1997
Rebecca Horn. The Glance of Infinity (exh. cat.), Kestner Gesellschaft Hannover, 1997

Hostyn, Ensor, 1996
Hostyn, N., *James Ensor. Vie et œuvre*, Bruges, 1996

House/Stevens, Post-Impressionism, 1979
House, J., and M. Stevens, *Post-Impressionism. Cross-Currents in European Painting*, London, 1979

Howe, Outerbridge, 1980
Howe, G., *Paul Outerbridge, Jr.*, New York, 1980

Hoyland, London, 1967
John Hoyland: Paintings, 1960–67 (exh. cat.), Whitechapel Art Gallery, London, 1967

Hoyland, London, 1979
John Hoyland: Paintings, 1967–1979 (exh. cat.), Serpentine Gallery, London, 1979

Hubbuch, Karlsruhe, 1993/94
Karl Hubbuch, Retrospektive, Städtische Galerie im Prinz Max Palais, Karlsruhe, 1993/94

Huber, Munich, 1998
Stephan Huber. In situ Projekte. Kunst im Dialog mit ihrem Ort, Munich, 1998

Hülsewig-Johnen, Magischer Realismus, 1991
Hülsewig-Johnen, J. (ed.), *Neue Sachlichkeit. Magischer Realismus*, Bielefeld, 1991

Hünecke, Marc, 1994
Hünecke, A., *Franz Marc. Tierschicksale. Kunst als Heilsgeschichte*, Frankfurt am Main, 1994

Hüneke, Blauer Reiter, 1989
Hüneke, A. (ed.), *Der Blaue Reiter. Dokumente einer geistigen Bewegung*, Leipzig, 1989

Hulten, Realismus, 1981
Hulten, P. (ed.), *Realismus 1919–1939*, Munich, 1981

Hultén, Tinguely, 1975
Hultén, P., *Jean Tinguely-Méta*, London, 1975

Hultén, Tinguely, 1987
Hultén, P., *Jean Tinguely – A Magic Stronger than Death* (exh. cat.), Palazzo Grassi Venice, London, 1987

Hundertwasser, Cologne, 1980
Friedensreich Hundertwasser. Regentag (exh. cat.), Museum Ludwig, Cologne, 1980

Hungarian Avant Garde, Budapest, 1980
Kassák Lajos: The Hungarian Avant Garde (exh. cat.), Magyar Nemzéti Múseum, Budapest, 1987

Hunkin, Group of Seven, 1979
Hunkin, H., *The Group of Seven: Canada's Great Landscape Painters*, Edinburgh, 1979

Hunov, Kirkeby, 1979
Hunov, J. (ed.), *Per Kirkeby, oeuvrekatalog 1958–1977 over raderinger, linoleumssnit, traesnit*, Copenhagen, 1979

Hunter, Rivers, 1989
Hunter, S., *Larry Rivers*, New York, 1989

Hunter, Rotella, 1982
Hunter, S., *Mimmo Rotella: des collages 1954–1964*, Milan, 1982

Hunter, Wesselmann, 1994
Hunter, S., *Tom Wesselmann*, London, 1994

Hutter, Gütersloh, 1977
Hutter, H., *Albert Paris Gütersloh*, Vienna/Munich, 1977

Immendorff, Basel, 1979
Jörg Immendorff. Café Deutschland (exh. cat.), Kunstmuseum Basel, 1979

Immendorff, Stuttgart, 1991
Immendorff. Malerei 1983–1990 (exh. cat.), Galerie der Stadt Esslingen, Villa Merkel, Museum moderner Kunst Wien, Stuttgart, 1991

Impressionism to Symbolism, London, 1994
Impressionism to Symbolism: the Belgian Avant-Garde 1880–1900 (exh. cat.), Royal Academy of Arts, London, 1994

Inboden, Paolini, 1986
Inboden, G. (ed.), *Giulio Paolini*, 4 vols. (exh. cat.), Staatsgalerie Stuttgart, 1986

Installation Art, San Diego, 1997
Blurring the Boundaries. Installation Art 1969–1996 (exh. cat.), Museum of Contemporary Art, San Diego, 1997

Ionesco/Balthazar, Bury, 1976
Ionesco, E. and A. Balthazar, *Pol Bury*, Brussels, 1976

Irwin, New York, 1977
Robert Irwin (exh. cat.), New York, Whitney Museum of Art, 1977

Itten, Berne, 1984
Johannes Itten. Künstler und Lehrer (exh. cat.), Kunstmuseum Berne, 1984

Itten, Design and Form, 1964
Itten, J., *Design and Form. The Basic Course at the Bauhaus*, New York, 1964

Itten, Ostfildern, 1994
Das frühe Bauhaus und Johannes Itten (exh. cat.), Kunstsammlungen zu Weimar, Ostfildern, 1994

Ivsic, Toyen, 1974
Ivsic, R., *Toyen*, Paris, 1974

Izquierdo, Monterrey, 1995
Maria Izquierdo (exh. cat.), Museo de Monterrey, Monterrey, 1995

Jack Smith, London, 1969
Jack Smith (exh. cat.), Whitechapel Art Gallery, London, 1969

Jackson-Groves, Barlach, 1972
Jackson-Groves N. (ed.), *Ernst Barlach: Life in Work*, Königstein im Taunus, 1972

Jacob, Delvaux, 1976
Jacob, M., *Paul Delvaux. L'œuvre graphique*, Monte Carlo, 1976

Jacob, Kubota, 1991
Jacob, M. J. (ed.), *Shigeko Kubota* (exh. cat.), Seattle, 1991

Jähner, Brücke, 1986
Jähner, H., *Künstlergruppe Brücke. Geschichte einer Gemeinschaft und das Lebenswerk ihrer Repräsentanten*, Stuttgart/Berlin, 1986

Jähner, Mueller, 1974
Jähner, H., *Otto Mueller*, Dresden, 1974

Jaffe, Baskin, 1980
Jaffe, I. B., *The Sculpture of Leonard Baskin*, New York, 1980

Jaffe, Klee, 1972
Jaffe, H.-J., *Klee*, London, 1972

Jaffé, Mondrian, 1990
Jaffé, H. L. C., *Piet Mondrian*, Cologne, 1990

Jahn, Gilbert & George, 1989
Jahn, W., *Die Kunst von Gilbert & George oder eine Ästhetik der Existenz*, Munich, 1989

Jahn, Palermo, 1983
Jahn, F. (ed.), *Palermo – Gesamte Grafik und Auflagenobjekte 1966–1975*, Munich, 1983

James, Bell, 1985
James, S., "Vanessa Bell," in *Woman's Art Journal*, 1985, vol. 6, pp. 51–59

Janssen, Hamburg, 1982
Horst Janssen – Retrospektive auf Verdacht (exh. cat.), Museum für Kunst und Gewerbe, Hamburg, 1982

Japonisme, New York, 1974
The Great Wave: The Influence of Japanese Woodcuts on French Painting (exh. cat.), Metropolitan Museum of Art, New York, 1974

Japonisme, Paris, 1988
Le Japonisme (exh. cat.), Grand Palais, Paris/National Museum of Western Art, Tokyo, 1988

Jappe, Aktionskunst, 1993
Jappe, E., *Performance – Ritual – Prozeß: Handbuch der Aktionskunst in Europa*, Munich, 1993

Jappe, Performance, 1993
Jappe, E., *Performance – Ritual – Prozeß. Handbuch der Aktionskunst in Europa*, Munich, 1993

Jarrasé, Rodin, 1995
Jarrasé, D., *Rodin. A Passion for Movement*, New York, 1995

Jenkins/Pullen, Lipchitz, 1986
Jenkins, D. F. and D. Pullen (eds.), *The Lipchitz Gift. Models for the Sculpture* (exh. cat.), Tate Gallery, London, 1986

Jenni, Hrdlicka, 1993
Jenni, U. (ed.), *Alfred Hrdlicka. Mahnmal gegen Krieg und Faschismus in Wien*, 2 vols., Graz 1993

Jennings (ed.), Jennings, 1982
Jennings, M. L. (ed.), *Humphrey Jennings: Film-maker, Painter, Poet*, London, 1982

John, Chiaroscuro, 1952
John, A., *Chiaroscuro*, Oxford, 1952

Johnson, 1990
Johnson, K., "Judy Fox at Carlo Lamanga," in *Art in America*, 1990, no. 5

Johnson, Kent, 1982
Johnson, F., *Rockwell Kent: An Anthology of his Work*, New York, 1982

Johnson, New York, 1984
Correspondence: An Exhibition of the Letters of Ray Johnson (exh. cat.), Roslyn, New York, 1984

Jones, Chicago, 1996
Jones, A. (ed.), *Sexual politics. Judy Chicago's Dinner Party in Feminist Art History*, Berkeley, 1996

Jones, Liverpool, 1979
Allen Jones. Retrospective of Paintings 1957–1978 (exh. cat.), Walker Art Gallery, Liverpool, 1979

Joosten, Mondrian, 1998
Joosten, J. M. and R. P. Welsh (eds.), *Piet Mondrian. Catalogue raisonné*, 2 vols., Munich, 1998

Joppolo, Fontana, 1992
Joppolo, G., *Une vie d'artiste: Lucio Fontana*, Marseille, 1992

Jordan/Goldwater, Gorky, 1982
Jordan, J. M. and R. Goldwater, *The Paintings of Arshile Gorky. A Critical Catalogue*, New York, 1982

Jorn, New York, 1982
Asger Jorn (exh. cat.), The Solomon R. Guggenheim Museum, New York ,1982

Jouffroy, Brauner, 1996
Jouffroy, A., *Victor Brauner le tropisme totemique*, Paris, 1996

Jürgens-Kirchhoff, Montage, 1978
Jürgens-Kirchhoff, A., *Technik und Tendenz der Montage in der bildenden Kunst des 20. Jahrhunderts*, Lahn-Giessen, 1978

Junghanns, Deutscher Werkbund, 1982
Junghanns, K., *Der Deutsche Werkbund. Sein erstes Jahrzehnt*, Berlin, 1982

Junker, Curry, 1988
Junker, Patricia et al., *John Steuart Curry: Inventing the Middle West*, New York, 1998

Kabakov, London, 1989
Ilya Kabakov, Ten Characters (exh. cat.), ICA, London, 1989

Kabakov, London, 1995
Ilya Kabakov: the Man who Flew into his Pictures (exh. cat.), ICA, London, 1995

Kabakov, Paris, 1995
Ilya Kabakov. Installations 1983–1985 (exh. cat.), Musée National d'Art Moderne, Centre Georges Pompidou, Paris, 1995

Kadishman, London, 1992
Menashe Kadishman: Sculpture and Drawings (exh. cat.), Annely Juda Fine Art, London, 1992

Kahnweiler, Gris, 1947
Kahnweiler, D., *Juan Gris. His Life and Work*, London, 1947

Kai, AFRICOBRA, 1990
Kai, Nubia, *AFRICOBRA: The First Twenty Years*, Atlanta, 1990

Kallir, Wiener Werkstätte, 1984
Kallir, J., *Viennese Design and the Wiener Werkstätte*, New York, 1986

Kamensky, Chagall, 1989
Kamensky, A., *Chagall: The Russian Years 1907–1922*, London/New York, 1989

Kandinsky, 1982
Kandinsky, W., *The Complete Writings on Art* (eds. K. C. Lindsay and P. Vergo), London, 1982

Kandinsky, Berlin, 1984
Kandinsky: Russische Zeit und Bauhaus-Jahre (exh. cat.), Kunsthaus Zürich/Bauhaus-Archiv, Berlin, 1984

Kandinsky/Marc, Almanach, 1912 (1979)
Kandinsky, W. and F. Marc, *Der Blaue Reiter (Dokumentarische Neuausgabe des Almanachs von 1912)*, ed. by K. Lankheit, Munich/Zürich, 1979

Kanoldt, Freiburg, 1987
Alexander Kanoldt 1881–1939. Gemälde, Zeichnungen, Lithographien (exh. cat.), Museum für Neue Kunst, Freiburg, 1987

Kanovitz, New York, 1987
Kanovitz: the Work of the 1980s (exh. cat.), Marlborough Gallery, New York, 1987

Kantor, Journey, 1993
Kantor, T., *A Journey through other Spaces: Essays and Manifestos, 1944–1990*, Berkeley, 1993

Kaplan, Mackintosh, 1996
Kaplan, W. (ed.), *Charles Rennie Mackintosh*. New York, 1996

Kapoor, London, 1998
Anish Kapoor (exh. cat.), Hayward Gallery, London, 1998

Kaprow, Dortmund, 1986
Allan Kaprow. Collagen, Environments, Videos, Broschüren, Geschichten, Happening- und Activity-Dokumente 1956–1986 (exh.cat.). Museum am Ostwall, Dortmund, Solingen, 1986

Karavan, Amsterdam, 1993
Passage: Dani Karavan (exh. cat.), Stedelijk Museum, Amsterdam, 1993

Karavan, Paris, 1993
Dani Karavan: Questions d'urbanité (exh. cat.), Galerie Jeanne Bucher, Paris, 1993

Kardon, Anderson, 1983
Kardon, J., *Laurie Anderson: Works from 1969 to 1983*, Philadelphia, 1983

Kardon, Kushner, 1987
Kardon, J. (ed.), *Robert Kushner* (exh. cat.), Institute of Contemporary Art, University of Pennsylvania, Philadelphia, 1987

Karginov, Rodchenko, 1975
Karginov, G., *Rodchenko*, London, 1975

Karsch, Mueller, 1974
Karsch, F., *Otto Mueller. Das graphische Gesamtwerk*, Berlin, 1974

Kaster, Nussbaum, 1989
Kaster, K. G., *Felix Nussbaum. Eine biographische und ikonographische Deutung seines Werks*, Cologne, 1989

Katz, Indiana, 1991
Katz, W. (ed.), *Robert Indiana. Early Sculpture 1960–1962* (exh. cat.), Salma-Caro Gallery, London, 1991

Katz, London, 1995
Alex Katz (exh. cat.), Saatchi Gallery, London, 1998

Kaufhold, Zille, 1995
Kaufhold, E., *Heinrich Zille. Photograph der Moderne*, Munich, 1995

Kellein, Fluxus, 1995
Kellein, T., *Fluxus*, London, 1995

Kellein, Kelley, 1992
Kellein, T. (ed.), *Mike Kelley* (exh. cat.), Kunsthalle Basel, 1992

Kellein, Sputnik-Schock, 1989
Kellein, T., *Sputnik-Schock und Mondlandung. Künstler, Großprojekte von Y. Klein zu Christo*, Stuttgart, 1989

Kellerer, Objet trouvé, 1982
Kellerer, C., *Der Sprung ins Leere. Objet trouvé, Surrealismus, Zen*, Cologne, 1982

Kellermann, Derain, 1992–96
Kellermann, M. (ed.), *André Derain. Catalogue de l'œuvre peint. 1895–1934* (2 vols.), Paris, 1992–96

Kempton, Art Nouveau, 1977
Kempton, R., *Art Nouveau. An Annotated Bibliography*, Los Angeles, 1977

Kendall, Curry, 1986
Kendall, M. Sue, *Rethinking Regionalism: John Steuart Curry and the Kansas Mural Controversy*, Washington D.C., 1986

Kent, Portinari, 1940
Kent, R., *Portinari. His Life and Art*, Chicago, 1940

Kent/Cork, Young British Art, 1997
Kent, S., and R. Cork, *Young British Art: The Saatchi Decade*, London, 1997

Kertész, 1997
André Kertész. His Life and Work, New York, 1997

Kesting, Dresden, 1998
Edmund Kesting (exh. cat.), Staatliche Kunstsammlungen, Dresden, 1998

Khan-Magomedov, Rodtschenko, 1987
Khan-Magomedov, S. O. H., *Rodchenko: The Complete Work*, Cambridge, Mass., 1987

Kiefer, Dublin, 1990
Anselm Kiefer: Jason, Douglas Hyde Gallery, Dublin, 1990

Kienholz, San Francisco, 1978
Edward Kienholz (exh. cat.), Museum of Modern Art, San Francisco, 1978

Kiki Smith, 1998
Kiki Smith: All Creatures Great and Small, Kestner Gesellschaft, Hanover, 1998

Kiki Smith, Montreal, 1996
Kiki Smith (exh. cat.), Montreal Museum of Fine Arts, 1996

Killir, Grandma Moses, 1973
Killir, O., *Grandma Moses*, New York, 1973

Kimpel, Documenta, 1997
Kimpel, H., *Documenta: Mythos und Wirklichkeit*, Cologne, 1997

King, Kruger, 1988
King, S., *Barbara Kruger. "My Pretty Pony,"* New York, 1988

King, London, 1968
Phillip King: Sculpture 1960–1968 (exh. cat.), Whitechapel Art Gallery, London, 1968

King, London, 1981
Phillip King (exh. cat.), Arts Council of Great Britain, London, 1981

King, Nash, 1987
King, J., *Interior Landscapes. A Life of Paul Nash*, London, 1987

Kinkel, Dix, 1991
Kinkel, H., *Otto Dix. Die Toten und die Nackten*, Berlin, 1991

Kinsman, Kitaj, 1994
Kinsman, J. (ed), *The Prints of R. B. Kitaj*, Brookfield, 1994

Kirby, Happening, 1966
Kirby, M., *Happenings – An Illustrated Anthology*, New York, 1966

Kirby, Happenings, 1966
Kirby, M., *Happenings – an Illustrated Anthology*, New York, 1966

Kirkeby, Handbuch, 1993
Per Kirkeby, *Handbuch. Texte zur Architektur und Kunst*, Berlin/Berne, 1993

Kirstein, Nadelman, 1973
Kirstein, L., *Elie Nadelman*, New York, 1973

Kirsten, Tchelitchew, 1994
Kirsten, L. *Tchelitchew*, Santa Fe, 1994

Kisbit, Chihuly, 1997
Kisbit, D. B., *Dale Chihuly*, Seattle, 1997

Kisling, Duisberg, 1965
Moïse Kisling 1891–1953. Pariser Begegnungen 1904–1914 (exh. cat.), Wilhelm Lehmbruck-Museum, Duisburg, 1965

Kisling, Paris, 1984
Moïse Kisling. Rétrospective (exh. cat.), Grand Palais, Paris, 1984

Kiterding, Realism, 1991
Kiterding, R., *Realism: To Venture Independence*, New York, 1991

Kitschen, Cézanne, 1995
Kitschen, F., *Cézanne. Stilleben*, Stuttgart, 1995

Kittelmann, Borofsky, 1993
Kittelmann, U., *Jonathan Borofsky. Dem Publikum gewidmet*, Stuttgart, 1993

Kittelmann, On Kawara, 1995
Kittelmann, U. (ed.), *On Kawara. Erscheinen-Verschwinden* (exh. cat.), Kölnischer Kunstverein, Cologne, 1995

Klangkunst, 1996
Klangkunst (exh. cat.), Akademie der Künste Berlin, Munich, 1996

Klapheck, Hamburg, 1985
Konrad Klapheck. Retrospektive 1955–1985 (exh. cat.), Kunsthalle Hamburg, Munich, 1985

Klapheck, Paris, 1990
Konrad Klapheck. Peintres et dessins (exh. cat.), Galerie Lelong, Paris, 1990

Klauke, Cologne, 1986
Jürgen Klauke. Eine Ewigkeit ein Lächeln, Arbeiten 1970–1986 (exh. cat.), Badischer Kunstverein Karlsruhe, Cologne, 1986

Klee, Berne, 1998
Paul Klee. Catalogue raisonée vol.1: Works, 1883–1912, ed. by the Paul-Klee-Stiftung, Kunstmuseum Berne, 1998

Klee, Munich, 1996
Paul Klee – Die Zeit der Reife (exh. cat.), Kunsthalle Mannheim, Munich, 1996

Klee, Notebooks, 1973
Klee, P., *Notebooks* (ed. J. Spiller), 2 vols., New York, 1973

Klein, Covert, 1976
Klein, M., *John Covert 1882–1960*, Washington D.C., 1976

Klein, 1995
Yves Klein Now, Sixteen Views – Leap into the Void (exh. cat.), Hayward Gallery, London, 1995

Kliemann, Novembergruppe, 1960
Kliemann, H., *Die Novembergruppe*, Berlin, 1960

Klotz, Kunst der Gegenwart, 1997
Klotz, H. (ed.), *Kunst der Gegenwart* (exh. cat.), Museum für Neue Kunst. Zentrum für Kunst- und Medientechnologie Karlsruhe, Munich, 1997

Klotz, Neue Wilde, 1984
Klotz, H., *Die Neuen Wilden in Berlin*, Stuttgart, 1984

Klotz, Postmodernism, 1984
Klotz, H. (ed.), *Die Revision der Moderne. Postmoderne Architektur 1960–80* (exh. cat.), Deutsches Architekturmuseum, Frankfurt am Main, Munich, 1984

Knapp, Pfeuffer, 1985
Knapp, G., *Helmut Pfeuffer. Trama und Drama. Retrospektive 1960–1985* (exh. cat.), Museum Villa Stuck, Munich, 1985

Knoebel, Maastricht, 1989
Imi Knoebel 1968–1988 (exh. cat.), Bonnefantenmuseum, Maastricht, 1989

Knoebel, Munich, 1996
Imi Knoebel. Retrospektive 1968–1996 (exh. cat.), Haus der Kunst, Munich, 1996

Knowles, Cologne, 1992
Alison Knowles. Um-Laut (exh. cat.), Galerie Schüppenhauer, Cologne, 1992

Kober, Heisig, 1973
Kober, Max, "Bernhard Heisig – Leben und Werk" in *Bernhard Heisig, Gemälde, Zeichnungen, Lithografien*, Dresden/Leipzig, 1973

Koch, Hausmann, 1994
Koch, A., *Ich bin immerhin der grösste Experimentator Österreichs. Raoul Hausmann, Dada und Neodada*, Innsbruck, l994

Koelen, Chillida, 1996
Koelen van der, M., *Eduardo Chillida. Werkverzeichnis der Druckgrafik 1986–1996*, Mainz/Munich, 1996

Költzsch, Hopper, 1992
Költzsch G.-W. (ed.), *Die Wahrheit des Sichtbaren – Edward Hopper und die Fotografie* (exh. cat.), Museum Folkwang Essen, 1992

Kolbe, Munich, 1997
Georg Kolbe (exh. cat.), Georg-Kolbe-Museum Berlin, Munich, 1997

Kollwitz, Berlin, 1995
Käthe Kollwitz (exh. cat.), Käthe Kollwitz-Museum, Berlin, 1995

Komar & Melamid, Österreich, 1998
Komar & Melamid, *"Schön-Häßlich". Das beliebteste und das unbeliebteste Bild Österreichs*, Vienna, 1998

Konkrete Kunst, 1944
Bill, M. (ed.), *Konkrete Kunst* (exh. cat.), Basel, 1944

Konkrete Kunst, 1960
Bill, M. (ed.), *Konkrete Kunst – 50 Jahre Entwicklung* (exh. cat.), Munich, 1960

Koons, Handbook, 1992
The Jeff Koons Handbook, London, 1992

Kornfeld, Kirchner, 1979
Kornfeld, Eberhard W., *Ernst Ludwig Kirchner. Nachzeichnungen seines Lebens*, Berne, 1979

Koschatzky, Photographie, 1989
Koschatzky, W., *Die Kunst der Photographie*, Herrsching, 1989

Kosinski, Léger, 1994
Kosinski, D. (ed.), *Fernand Léger 1911–1924: The Rhythm of Modern Life*, Munich, 1994

Kossoff, Venice, 1995
Leon Kossoff, Recent Paintings (exh. cat.), British Pavilion, XLVI Venice Biennale/Stedelijk Museum, Amsterdam, 1995

Kostelanetz, Cage, 1994
Kostelanetz, R., *Writings about John Cage*, Ann Arbor, 1994

Kostelanetz, Theatre, 1970
Kostelanetz, R., *The Theatre of Mixed Means. An Introduction to Happenings, Kinetic Environments and other Mixed Performance*, London, 1970

Koster/Levine, Chadwick, 1988
Koster, N. and P. Levine, *Lynn Chadwick. The Sculptor and His World*, Leiden, 1988

Kosuth, Art, 1991
Kosuth, J., *Art after Philosophy and after: Collected Writings, 1966–1990* (ed. by G. Guercio), Cambridge, Mass., 1991

Kosuth, Meaning, 1981
Kosuth, J., *The Making of Meaning: Selected Writings and Documentation of Investigations on Art since 1965*, Stuttgart, 1981

Kosuth, Play, 1992
The Play of the Unmentionable, an installation by Joseph Kosuth at the Brooklyn Museum (essay by D. Freedberg), New York, 1992

Kounellis, Chicago, 1986
Jacob, M. J. and R. McEvilley (eds.), *Jannis Kounellis. A Retrospective* (exh. cat.), Museum of Contemporary Art, Chicago, 1986

Kounellis, Frammenti, 1991
Kounellis, J., *Frammenti di memoria […]* (C. Haenlein, ed.), Winterthur, 1991

Kounellis, London, 1981
Jannis Kounellis (exh. cat.), Whitechapel Art Gallery, London, 1981

Kounellis, Paris, 1980
Kounellis (exh. cat.), ARC Musée d'art moderne de la Ville de Paris, 1980

Kovtun, Larionow, 1997
Kovtun, E., *Mikhail Larionov*, London, 1997

Kowtun, Larionov, 1988
Kowtun, J., *Mikhail Larionov 1881–1964*, Bournemouth, 1998

Kramer, Avery, 1962
Kramer, H., *Milton Avery: Paintings 1930–60*, New York, 1962

Kramer/Crane, Lachaise, 1987
Kramer, H., H. Crane et al., *The Sculpture of Gaston Lachaise*, New York, 1987

Kranzfelder, Grosz, 1993
Kranzfelder, I., *George Grosz 1893–1957*, Cologne, 1993

Kranzfelder, Hopper, 1992
Kranzfelder, I., *Edward Hopper*, Cologne, 1995

Krasner, New York, 1981
Lee Krasner, Recent Works (exh. cat.), Pace Gallery, New York, 1981

Krause, Hartung, 1998
Krause, M., *Karl Hartung, 1908-1967. Metamorphosen von Mensch und Natur. Monographie und Werkverzeichnis*, Munich, 1998

Krauss, Brassaï, 1985
Krauss, R., *L'Amour fou* (exh. cat.), National Gallery of Art, Washington D.C., 1985

König, Richter, 1993
König, K. (ed.), *Gerhard Richter* 3 vols. (exh. cat.), Kunst- und Ausstellungshalle der Bundesrepublik Deutschland Bonn, Stuttgart, 1993

Koepplin, Penck, 1978
Koepplin, D. (ed.), *A. R. Penck. Zeichnungen bis 1975* (exh. cat.), Kunstmuseum, Basel, 1978

Kogler, Vienna, 1995
Peter Kogler (exh. cat.), Wiener Sezession, Vienna, 1995

Kokoschka, Life, 1974
Kokoschka, O., *My Life*, London, 1974

Kricke, Stuttgart, 1996
Norbert Kricke, 1922–1984, Zeichnungen und Raumplastiken (exh. cat.), Institut für Auslandsbeziehungen, Stuttgart, 1996

Krüger, Pechstein, 1988
Krüger, G. (ed.) *Das druckgraphische Werk Max Pechsteins*, Tökendorf, 1988

Kruszynski, Modigliani, 1996
Kruszynski, A., *Amadeo Modigliani: Portraits and Nudes*, Munich, 1996

Kubin, Munich/Hamburg, 1990/1991
Alfred Kubin (exh. cat.), Lenbachhaus Munich/Kunsthalle Hamburg, 1990/1991

Künstler-Räume, Hamburg, 1983
Künstler-Räume (exh. cat.), Kunstverein Hamburg, 1983

KünstlerprofessorInnen, Kassel, 1996
KünstlerprofessorInnen (exh. cat.), Kunstverein Kassel, 1996

Kulka, Kitsch, 1996
Kulka, T., *Kitsch and Art*, New York, 1996

Kulterman, Happening, 1971
Kulterman, U., *Art-Events and Happenings*, New York, 1971

Kultermann, Leben, 1970
Kultermann, U., *Leben and Kunst. Zur Funktion von Intermedia*, Tübingen, 1970

Kultermann, Plastik, 1967
Kultermann, U., *Neue Dimensionen der Plastik*, Tübingen, 1967

Kunst im 3. Reich, Frankfurt, 1974
Kunst im 3. Reich: Dokumente der Unterwerfung (exh. cat.), Frankfurt am Main, 1974

Kunst in Chile, Berlin, 1989
Cirugia plástica. Konzepte zeitgen. Kunst in Chile 1980–1989 (exh. cat.), Staatlche Kunsthalle Berlin, 1989

Kunz, Paolini, 1981
Kunz, M. (ed.), *Giulio Paolini. Werke und Schriften 1960–1980*, 2 vols. (exh. cat.), Kunstmuseum Lucerne, 1981

Kupka, New York, 1975
Frank Kupka. A Retrospective (exh. cat.), Solomon R. Guggenheim Museum, New York, 1975

Kupka, Paris, 1989
Frantisek Kupka ou l'invention d'une abstraction (exh. cat.), Musée d'art moderne de la Ville de Paris, 1989

Kusama, 1986
Yayoi Kusama, Infinity-Explosion (exh. cat.), Fuji Television Gallery, Tokyo, 1986

Kusama, 1994
Yayoi Kusama, My Solitary Way to Death (exh. cat.), Fuji Television Gallery, Tokyo, 1994

Kusama, 1998–99
Yayoi Kusama, 1958–1968 (exh. cat.), Los Angeles County Museum of Art/The Japan Foundation/MOMA New York, 1998–99

Kuspit, Appel, 1994
Kuspit, D., *Karel Appel Sculpture: A Catalogue Raisonnée*, New York, 1994

Kuspit, Golub, 1985
Kuspit, D., *Leon Golub. Existential/Activist Painter*, New Brunswick, 1985

Labaume, Nauman, 1997
Labaume, V. et al. (ed.) *Bruce Nauman. Image/Text 1966–1996* (exh. cat.), Kunstmuseum Wolfsburg, Stuttgart, 1997

Labyrinth, Massachusetts, 1975
Labyrinth, Symbol and Meaning in Contemporary Art, Norton, Mass., 1975

Lachaise, 1979
Gaston Lachaise (exh. cat.), Memorial Art Gallery, Rochester, 1979

Lachner, Léger, 1998
Lachner, C. (ed.) *Léger* (exh. cat.), The Museum of Modern Art, New York, 1998

Lafaille, Dufy, 1985
Lafaille, M. and F. Guillon-Lafaille, *Raoul Dufy. Catalogue raisonné: Aquarelles, gouaches et pastels, Paris 1981; L'Œuvre peint*, Paris, 1985

Lafontaine, Edinburgh, 1989
Marie-Jo Lafontaine (exh. cat.), Fruitmarket Gallery, Edinburgh, 1989

Lafontaine, London, 1985
Performance Art and Video Installation (exh. cat.), Tate Gallery, London, 1985

Lafontaine, Otegem, 1993
Marie-Jo Lafontaine. Himmel und Hölle (exh. cat.), Dewer Art Gallery, Otegem, 1993

Lahusen, Lehmbruck, 1997
Lahusen, M. C., *Wilhelm Lehmbruck. Gemälde und großformatige Bilder*, Munich, 1997

Lambert, Constant, 1992
Lambert, J.-C., *Constant*, Paris, 1992

Lambert, Twombly, 1992
Lambert, Y., *Catalogue raisonné des œuvres sur papier de Cy Twombly*, Milan, 1979

Lammek, Marcks, 1991
Lammek, K., *Gerhard Marcks. Das druckgraphische Werk*, Stuttgart, 1991 (catalogue raisonné)

Lampert, Flanagan, 1983
Lampert, C. (ed.), *Barry Flanagan: Sculptures* (exh. cat.), Musée Nat. d'art moderne, Centre Georges Pompidou, Paris, 1983

Lanchner, Masson, 1976
Lanchner, C. and W. Rubin (eds.), *André Masson*, The Museum of Modern Art, New York, 1976

Lanchner, Miró, 1993
Lanchner, C. (ed.) *Joan Miró* (exh. cat.), MOMA, New York, 1993

Lanchner, Taeuber-Arp, 1981
Lanchner, C. (ed.) *Sophie Taeuber-Arp* (exh. cat.), MOMA, New York, 1981

Landau, Pollock, 1989
Landau, E., *Jackson Pollock*, London, 1989

Lang, Malerei, 1980
Lang, L., *Malerei und Grafik in der DDR*, Leipzig 1980

Lange, 1994
Dorothea Lange. American Photographs, San Francisco, 1994

Langenfeld, Ackermann, 1972
Langenfeld, L., *Max Ackermann: Aspekte seines Gesamtwerkes*, Stuttgart/Berlin/Cologne/Mainz,1972

Langui, van der Berghe, 1966
Langui, E., *Frits van den Berghe 1883–1939 (Cat. raisonnée de son œuvre peint)*, Brussels, 1966

Lanthemann, Modigliani, 1970
Lanthemann, J., *Modigliani 1884–1920. Catalogue raisonné. sa vie, son œuvre, son art*, Barcelona, 1970

Lanyon, London, 1968
Peter Lanyon (exh. cat.), Arts Council of Great Britain, London, 1968

Laporte, Christo, 1984
Laporte, D.G., *Christo*, Paris/New York, 1985

Larissa, Tatlin, 1984
Larissa, A. S. (ed.) *Tatlin*, Budapest, 1984

Lartigue, 1980
The Autochromes of J.-H., Lartigue 1912–1927, Paris, 1980

Lassaigne/Weelen, Vieira da Silva, 1992
Lassaigne, J. and G. Weelen, *Vieira da Silva*, Paris, 1992

Lassnig, Vienna, 1985
Maria Lassnig, Retrospektive (exh. cat.), Museum für Moderne Kunst, Vienna, 1985

Latham, London, 1976
John Latham (exh. cat.), Tate Gallery, London, 1976

Laub, Karavan, 1995
Laub, P., *Karavan: Strasse der Menschenrechte = Way of Human Rights*, Bonn, 1995

Laue, Gütersloh, 1996
Laue, E., *Pictorialism in the Fictional Miniatures of Albert Paris Gütersloh*, New York/Berlin, 1996

Laughton, Euston Road School, 1986
Laughton, B., *The Euston Road School. A Study in Objective Painting*, Aldershot, 1986

Laughton, Steer, 1971
Laughton, B., *Philip Wilson Steer*, Oxford, 1971

Laurencin, Martigny, 1993
Marie Laurencin (exh. cat.), Musée Martigny, 1993

Laurens, Lille, 1992
Henri Laurens, Rétrospective (exh. cat.), Musée d'Art Moderne de la Commune Urbaine de Lille, 1992

Laurens, Paris, 1985
Henri Laurens. Le cubisme, constructions et collages (exh. cat.), MNAM, Paris, 1985

Laurin-Lam, 1996
Laurin-Lam, L., *Wifredo Lam. Catalogue Raisonné of the Painted Work, vol. I 1923–1960*, Lausanne, 1996

Lavier, Paris, 1991
Bertrand Lavier (exh. cat.), Musée National d'Art Moderne, Centre Georges-Pompidou, Paris, 1991

Lavrentiev, Stepanova, 1988
Lavrentiev, A., *Varvara Stepanova: The Complete Work*, London, 1988

Law, London, 1978
Bob Law. Paintings and Drawings 1959–1978 (exh. cat.), Whitechapel Art Gallery, London, 1978

Lawrence, Brown, 1987
Lawrence, Sidney, *Roger Brown*, (exh. cat.), New York, 1987

Lazar, Cage, 1993
Lazar, J. et. al. (ed.) *John Cage. Rolywholyover*, New York, 1993

Le Bot, Veličkovič, 1979
Le Bot, M., *Vladimir Veličkovič, essai sur le symbolisme artistique*, Paris, 1979

Le Brun, Edinburgh, 1985
Christopher Le Brun Paintings 1984–85 (exh. cat.), Edinburgh, 1985

Le Fauconnier, Amsterdam, 1959
Le Fauconnier (exh. cat.), Stedelijk Museum, Amsterdam, 1959

Le Pichon, Buffet, 1989
Le Pichon, Y., *Bernard Buffet I – II*, Paris, 1989

Le Pichon, Rousseau, 1981
Le Pichon, Y., *Le monde du Douanier Rousseau*, Paris, 1981

Lechner, Stuttgart, 1998
Alf Lechner. Zeichnungen und Skulptur (exh. cat.), Inst. für Auslandsbeziehungen, Stuttgart, 1998

Leck, Otterlo, 1994
Bart van der Leck (exh. cat.), Kröller-Müller Museum, Otterlo, 1994

Leck, Wolfsburg, 1994
Bart van der Leck. Maler der Moderne (exh. cat.), Kunstmuseum Wolfsburg, 1994

Leclanche-Boulé, Photomontage, 1984
Leclanche-Boulé, C., *Typographies et photomontages constructivistes en URSS*, Paris, 1984

Lecombre, Zadkine, 1989
Lecombre, S., *Musée Zadkine, Catalogue des Sculptures* (exh. cat.), Paris, 1989

Lee, Frankfurt, 1998
U Fan Lee, Bilder und Skulpturen (exh. cat.), Städelsches Kunstinstitut und Städtische Galerie, Frankfurt am Main, 1998

Lee, Leverkusen, 1995
U Fan Lee, (exh. cat.), Städtisches Museum Schloß Moirsbroich, Leverkusen, 1995

Lee, Milan, 1994
U Fan Lee (exh. cat.), Fondazione Mudima, Milan, 1994

Legros, Mulhouse, 1988
Jean Legros (exh. cat.), Musée des Beaux-Arts, Mulhouse, 1988

Lehmbruck, Edinburgh, 1977
Wilhelm Lehmbruck (exh. cat.), Scottish National Gallery of Modern Art, Edinburgh, 1977

Leibovitz, 1999
Women: Photographs by Annie Leibovitz London, 1999

Lemagny, Atget, 2000
Lemagny, J-C., et al, *Atget the Pioneer*, New York, 2000

Lemarche-Vadel, Opalka, 1986
Lemarche-Vadel, B et al., *Opalka 1965/1–4*, Paris-Tours, 1986

Lemoine, Morellet, 1986
Lemoine, S., *François Morellet*, Zürich, 1986

Lentulov, Cologne, 1984
Sieben Moskauer Künstler/Seven Moscow Artists 1910–1930 (exh. cat.), Galerie Gmurzynska, Cologne, 1984

Lenz, Hrdlicka, 1994
Lenz, C. (ed.) *Alfred Hrdlicka. Zeichnungen* (exh. cat.), Olaf Gulbransson Museum Tegernsee, Munich, 1994

Leperlier, Cahun, 1992
Leperlier, F., *Claude Cahun. L'Écart et la métamorphose*, Paris 1992

Leroy, Atget, 1976
Leroy, J., *Atget. Magicien du vieux Paris en son époque*, Paris, 1976

Les Vingt, Brussels, 1962
La Groupe des XX et son temps (exh. cat.), Musée d'art moderne Brussels, Otterlo, 1962

Lesko, Ensor, 1985
Lesko, D., *James Ensor: The Creative Years*, Princeton, 1985

Lespinasse, Angrand, 1982
Lespinasse, F., *Charles Angrand 1854–1926)*, Rouen, 1982

Levin, Hopper, 1980
Levin G. (ed.) *Edward Hopper: The Art and the Artists* (exh. cat.), Whitney Museum of American Art, New York, 1980

Levin, Hopper, 1992
Levin, G., *Edward Hopper*, New York, 1992

Levin, Synchromism, 1978
Levin, G., *Synchromism and American Colour Abstraction, 1910–1925* (exh. cat.), New York, 1978

Levine, Marc, 1979
Levine, F. S., *The Apocalyptic Vision. The Art of Franz Marc as German Expressionism*, New York, 1979

Levinson, Bakst, 1924
Levinson, A., *Histoire de Léon Bakst*, Paris, 1924.

Lewis, Manchester, 1980
Wyndham Lewis (exh. cat.), City Art Gallery, Manchester, 1980

Lewison, Nicholson, 1991
Lewison, J., *Ben Nicholson*, London/New York, 1991

Lewison, Nicholson, 1993
Lewison, J. (ed.), *Ben Nicholson* (exh. cat.) Tate Gallery, London, 1993

LeWitt, 1992
Sol LeWitt. Catalogue Raisonné of the Wall Drawings 1984–1992, Berne 1992

LeWitt, London, 1986
Sol LeWitt. Prints 1970–1986 (exh. cat.), Tate Gallery, London, 1986

Lewitt, Munich, 1993
Sol LeWitt. Structures (exh. cat.), Museum Villa Stuck, Munich, 1993

LeWitt, Prints, 1993
Sol LeWitt. Prints (exh. cat.), MOMA, New York, 1993

Leymarie, Balthus, 1982
Leymarie, J., *Balthus*, Ghent, 1982

Liebermann, Berlin, 1997
Max Liebermann. Jahrhundertwende, (exh. cat.) Nationalgalerie, Berlin. 1997

Light, Düsseldorf, 1966
Licht und Bewegung. Kinetische Kunst (exh. cat.), Kunstverein für die Rheinlande und Westfalen, Düsseldorf, 1966

Light, Minneapolis, 1967
Light, Motion, Space (exh. cat.), Walker Art Center, Minneapolis, 1967

Lin/Geldin, Lin, 1994
Lin, M. and Sherrie Geldin et al., *Maya Lin; Private/Public* (exh.cat.), Wexner Center for the Arts, The Ohio State University 1994

Lincoln, German Realism, 1980
Lincoln, L. (ed.), *German Realism of the Twenties: The Artist as Social Critic*, Minneapolis, 1980

Lindner, New York, 1978
Richard Lindner (1901–1978) (exh. cat.), MOMA, New York, 1978

Linker, Acconci, 1994
Linker, K., *Vito Acconci*, New York, 1994

Linker, Miers, Kruger, 1990/1996
Linker, K., and C. Miers (eds.), *Love for Sale. The Words and Pictures by Barbara Kruger*, New York, 1990/1996

Lipchitz, Los Angeles,1963
Jacques Lipchitz. A Retrospective Selected by the Artists (exh. cat.), The Art Galleries, Univ. of California, Los Angles, 1963

Lippard, Hesse, 1976
Lippard, L.R., *Eva Hesse*, New York, 1976

Lippard, Pop art, 1968
Lippard, L. R. (ed.), *Pop Art*, London, 1970

Lippard, Reinhardt, 1981
Lippard, L., *Ad Reinhardt*, New York, 1981

Lippard, Six Years, 1973
Lippard, L., *Six Years: the Dematerialization of the Art Object*, New York, 1973

Lissitzky, Eindhoven, 1990
El Lissitzky, Architect, Painter, Photographer, Typographer (exh. cat.), Stedelijk van Abbemuseum, Eindhoven, 1990

Lissitzky-Küppers, Lissitzky, 1968
Lissitzky-Küppers, S., *El Lissitzky. Life, Letters, Texts*, London, 1968

Lissitzky-Küppers, Lissitzky, 1980
Lissitzky-Küppers, S., *El Lissitzky*, London, 1980

Lista, Balla, 1982
Lista, G., *Giacomo Balla*, Modena, 1982

Lista, De Chirico, 1991
Lista, G., *De Chirico*, Paris, 1991

Littmann, Haring, 1993
Littmann, K., *Keith Haring. Editions on Paper 1982–90*, Stuttgart, 1993

Livingstone, Buckley, 1985
Livingstone, M. (ed.), *Stephen Buckley. Retrospective* (exh. cat.), Museum of Modern Art, Oxford, 1985

Livingstone, Caulfield, 1981
Livingstone, M., (ed.), *Patrick Caulfield, Paintings 1963–81*, (exh. cat.), The Tate Gallery, London, 1981

Livingstone, Diebenkorn, 1997
Livingstone, J. (ed.), *The Art of Richard Diebenkorn* (exh. cat.), Whitney Museum of American Art, New York, 1997

Livingstone, Dine, 1997
Livingstone, M., *Jim Dine. The Alchemy of Images*, New York, 1997

Livingstone, Hanson, 1994
Livingstone, M. (ed.), *Duane Hanson* (exh. cat.), Montreal Museum of Fine Arts et al., Montreal, 1994

Livingstone, Jones, 1979
Livingstone, M., *Allen Jones, Sheer Magic*, London, 1979

Livingstone, Kitaj, 1985
Livingstone, M., *R. B. Kitaj*, Oxford/New York, 1985

Livingstone, Michals, 1997
Livingstone, M., *Duane Michals. Eine Werkübersicht*, Munich, 1997

Livingstone, Phillips, 1982
Livingstone, M. (ed.), *Peter Phillips Retrovision. Paintings 1960–82* (exh. cat.), Walker Art Gallery Liverpool, 1982

Livingstone, Pop art, 1991
Livingstone, M. (ed.), *Pop Art*, London, 1991

Locher, Boyle, 1978
Locher, J. L., *Mark Boyle's Journey to the Surface of the Earth*, Stuttgart/London, 1978

Löffler, Dix, 1977
Löffler, F., *Otto Dix. Leben und Werk*, Dresden, 1977

Löffler, Dix, 1981
Löffler, F., *O. Dix. Werkverzeichnis der Gemälde*, Recklinghausen, 1981

Loetscher, Photographie, 1991
Loetscher, H. (ed.), *Photographie in der Schweiz 1840 bis heute*, Wabern, 1991

Loevgren, Modernism, 1971
Loevgren, S., *The Genesis of Modernism. Seurat, Gauguin, van Gogh & French Symbolism in the 1880s*, London, 1971

Lohberg, Winter, 1986
Lohberg, G. (ed.), *Fritz Winter, Leben und Werk. Werkverzeichnis der Gemälde*, Munich, 1986

Lohse, Grenoble, 1988
Richard Paul Lohse (exh. cat.), Musée de Grenoble, Grenoble, 1988

London Group, London, 1964
London Group: 1914–64 Jubilee Exhibition: Fifty years of British Art at the Tate Gallery (exh. cat.), London, 1964

Long, 1984
Postcards 1968–1982/Richard Long (exh. cat.), CAPC, Bordeaux, 1984

Long, Eindhoven, 1980
Richard Long (exh. cat.), Stedelijk Van Abbemuseum, Eindhoven, 1980

Long, Hanover, 1999
Richard Long (exh. cat.), Kunstverein Hannover, Hanover, 1999

Longo, Annigoni, 1968
Longo, Udo, *Pietà e amore nell'arte di Pietro Annigoni*, Milan, 1968

Lopez-Pedraza, Kiefer, 1996
Lopez-Pedraza, R., *Anselm Kiefer. The Psychology of "After the Catastrophe"*, New York, 1996

Lord, Giacometti, 1997
Lord, J., *Alberto Giacometti, Ein Portrait*, Berlin 1997

Lorenz, 1987
Lorenz, R., *Imogen Cunningham: Frontiers, Photographs 1906–1976*, Washington D.C., 1987

Lorquin, Maillol, 1995
Lorquin, B., *Aristide Maillol*, London/New York, 1995

Lovejoy, Postmodern, 1989
Lovejoy, M., *Postmodern Currents: Art in a Technological Age*, London, 1989

Lubbers, Lissitzky, 1991
Lubbers, F., *El Lissitzky 1890–1941*, London, 1991

Lucebert, Amsterdam, 1969
Lucebert – schilderijen, gouaches, tekeningen en grafief (exh. cat.), Stedelijk Museum, Amsterdam, 1969

Lucie-Smith, Art Deco, 1990
Lucie-Smith, E., *Art Déco Painting*, Oxford, 1990

Lucie-Smith, Benton, 1990
Lucie-Smith, E., *Fletcher Benton*, New York, 1990

Lucie-Smith, Paley, 1996
Lucie-Smith, E., *The Art of Albert Paley*, New York, 1996

Lucie-Smith, Seventies, 1985
Lucie-Smith, E., *Art in the Seventies*, London, 1985

Lucie-Smith, Superrealism, 1979
Lucie-Smith, E., *Superrealism*, Oxford, 1979

Luckhardt, Feininger, 1997
Luckhardt, U., *Lyonel Feininger*, Munich, 1997

Ludington, Hartley, 1998
Ludington, T., *Seeking the Spiritual. The Paintings of Marsden Hartley* (exh. cat.), Ackland Art Museum Chapel Hill, Chesterfield, 1998

Ludman, Porter, 1981
Ludman, J. *Fairfield Porter: A Catalogue Raisonné of his Prints*, Westbury, 1981

Lüpertz, 1991
Markus Lüpertz. Druckgraphik – Werkverzeichnis 1960–1990, Stuttgart, 1991

Lüthi, Klagenfurt, 1993
Urs Lüthi (exh. cat.), Bonner Kunstverein, Klagenfurt, 1993

Lüttichau, Mueller, 1993
Lüttichau, M.-A. v., *Otto Mueller*, Cologne, 1993

Lüttichau, ZEN 49, 1988
Lüttichau, M.-A. v., "Zen 49" in *Stationen der Moderne* (exh. cat.), Berlinische Galerie, Berlin, 1988

Lumsden, Bloomsbury, 1976
Lumsden, I., *The Bloomsbury Painters and their Circle*, Fredericton, N. B., 1976

Luna Arroyo et al., Anguiano, 1990
Luna Arroyo et al., *Raúl Anguiano, Grupo Arte Contemporáneo*, Mexico City, 1990

Lunde, Anuszkiewicz, 1977
Lunde, K., *Anuszkiewicz*, New York, 1977

Lunde, Bishop, 1975
Lunde, K., *Isabel Bishop*, New York, 1975

Lurçat, Arras, 1968
Hommage à Jean Lurçat (exh. cat.), Musée Municipal, Arras, 1968

Lust, Bellmer, 1990
Lust, H., *Hans Bellmer*, New York, 1990

Lynn, Page, 1973
Lynn, E., "A Note on Robin Page," in *Art International*, May 1973, pp. 28–30

Lyotard, Apple, 1994
Lyotard, Jean-Francois, *Karel Appel Peintre, Geste et Commentaire*, Paris, 1994

Maar, Fotografa, 1995
Maar, D., *Fotografa*, Valencia, 1995

Maar, Paris, 1998
Les Livres de Dora Maar (sales cat.), Hôtel Drouot, Paris, 1998

MacColl, Steer, 1945
MacColl, D. S., *Life, Work, and Setting of Philip Wilson Steer*, Oxford, 1945

Mach, Oxford, 1985
David Mach: Towards a Landscape (exh. cat.), MOMA, Oxford, 1985

Maciejunes, Burchfield, 1997
Maciejunes, N. V., *The Paintings of Charles Burchfield: North by Midwest*, New York, 1997

Madsen, Art Nouveau, 1976
Madsen, S. T., *Sources of Art Nouveau*, New York 1976

Magnaguagno, Moser, 1993
Magnaguagno, G. (ed.), *Wilfrid Moser. Ein Schweizer Beitrag zur europäischen Nachkriegskunst* (exh. cat.), Kunsthaus Zürich, 1993

Magnelli, Avignon, 1988
Magnelli: Exposition du Centenaire (exh. cat.), Palais des Papes, Avignon, 1988

Magritte, Écrits, 1979
Magritte, R., *Écrits complets*, Paris, 1979

Mahsun, Pop art, 1989
Mahsun, C. A. (ed.), *Pop Art. The Critical Dialogue*, Ann Arbor/Michigan, 1989

Maillol, 1975
Aristide Maillol 1861–1944 (exh. cat.), The Solomon R. Guggenheim Museum, New York, 1975

Maisonnier, Magnelli, 1975/1980
Maisonnier, A., *Catalogues raisonnés I: L'œuvre peint, II: L'œuvre gravé*, Paris 1975/1980

Malet, Miró, 1988
Malet, R. M. (ed.), *Obra de Joan Miró. Fundacio Joan Miró*, Barcelona, 1988

Malevich, 1969
Malevich, K.S., *Essays in Art*, 2 vols, London, 1969

Malina, Kinetic Art, 1974
Malina, F. J. (ed.), *Kinetic Art, Theory and Practice*, New York, 1974

Malpas, Land art, 1997
Malpas, W., *Land Art, Earthworks, Installations, Environments, Sculpture: from 1960 to the Present Day*, Kidderminster, 1997

Man Ray, Self Portrait, 1963
Man Ray, *Self Portrait*, London, 1963

Manessier, Paris, 1992
Alfred Manessier (exh. cat.), Grand Palais, Paris, 1992

Mangold, Akron, 1985
Robert Mangold (exh. cat.), Akron Art Museum, Akron Ohio, 1985

Mangold, Amsterdam, 1982
Robert Mangold, Schilderijen/Paintings 1964–1982 (exh. cat.), Stedelijk Museum, Amsterdam, 1982

Mangold, New York, 1971
Robert Mangold (exh. cat.), Solomon R. Guggenheim Museum, New York, 1971

Manguin, Sète, 1994
Henri Manguin 1874–1949. Lumière du Midi (exh. cat.), Musée Paul-Valéry, Sète, 1994

Mann, 1994
Still Time, Sally Mann. Photographs 1971–1991, Aperture Foundation, New York, 1994

Mann, 1997
Sally Mann, Unmittelbare Familie, Munich, 1997

Mann, Modigliani, 1980
Mann, C., *Modigliani*, London, 1980

Manzoni, 1974
Piero Manzoni (exh. cat.), Tate Gallery, London, 1974

Manzù, Mexico City, 1991
Giacomo Manzù – Temas y variaciones (exh. cat.), Museo de Arte Moderno Mexico City, Milan, 1991

Mapplethorpe, New York, 1988
Robert Mapplethorpe (exh. cat.), Whitney Museum of American Art, New York, 1988

Mapplethorpe, Some Woman, 1989
Robert Mapplethorpe, Some Women, Munich, 1989

Mapplethorpe/Danto, Mapplethorpe, 1992
Mapplethorpe, R. and A. C. Danto, *Mapplethorpe*, London, 1992

Marc, Berkeley, 1979
Franz Marc 1880–1916 (exh. cat.), University of California Art Museum at Berkeley, 1979

Marchal, Zadkine, 1992
Marchal, G.-L., *Ossip Zadkine: la sculpture*, Rodez, 1992

Marcks, 1989
Gerhard Marcks (exh. cat.), Nationalgalerie Berlin, Munich, 1989

Marcondes, Tarsila, 1986
Marcondes, Marcos A., *Tarsila*, São Paulo, 1986

Marcoulesco, Rouault, 1996
Marcoulesco, I., *Georges Rouault. The Inner Light*, Houston, 1996

Marden, Amsterdam, 1981
Brice Marden (exh. cat.), Stedelijk Museum, Amsterdam, 1981

Marden, Berne, 1993
Bois, Y.-A. and U. Loock (eds.), *Brice Marden* (exh. cat.), Kunsthalle Berne et al., Berne, 1993

Mari, Weiner, 1992
Mari, B. (ed.), *Show (&) Tell. The Films and Videos of Lawrence Weiner*, Ghent, 1992

Maritain, Congdon, 1962
Maritain, J. (et al.), *In my Disk of Gold: the Itinerary to Christ of William Congdon*, New York, 1962

Marmori, Lempicka, 1978
Marmori, G., *Tamara de Lempicka*, London, 1978

Marquet, Bordeaux/Paris, 1975
Albert Marquet (exh. cat.), Galerie des BeauxArts/Orangerie des Tuileries, Bordeaux/Paris, 1975

Marshall, Basquiat, 1992
Marshall, R., *Jean-Michel Basquiat* (exh. cat.), Whitney Museum of American Art, New York, 1992

Marter, Calder, 1991
Marter, J. M., *Alexander Calder*, Cambridge, Mass., 1991

Martin, Brecht, 1978
Martin, H., *An Introduction to George Brecht's Book of the Tumbler on Fire*, Milan, 1978

Martin, Futurist Art, 1968
Martin, M. W., *Futurist Art and Theory 1909–15*, Oxford, 1968

Martin, Munich, 1974
Agnes Martin (exh. cat.), Kunstraum Munich, 1974

Martin, New York, 1993
Agnes Martin (exh.cat.), Whitney Museum of American Art, New York, 1993

Martin-Métry, Lhote, 1967
Martin-Méry, G. (ed.), *Hommage à André Lhote* (exh. cat.), Musée des Beaux-Arts, Bordeaux,1967

Martin/Restany, Arman, 1974
Martin, H., and P. Restany, *Arman*, New York, 1974

Martini, 1978
Alberto Martini simbolista, (exh. cat.), Galleria del Levante, Milan, 1978

Martini, Milan, 1991
Arturo Martini 1889–1947. L'œuvre sculpté (exh. cat.), Hôtel de Ville Paris, Milan, 1991

Masereel, Ghent, 1986
Frans Masereel (exh. cat.), Museum voor Schone Kunsten, Ghent, 1986

Mashek, Duchamp, 1975
Masheck, J. (ed.), *Marcel Duchamp in Perspective*, New Jersey, 1975

Mason/Cheri, Michaux, 1995
Mason, R. M., and C. Cheri, *Henri Michaux. Les estampes 1948–1984*, Paris, 1995

Massat, Pevsner, 1956
Massat, R., *Antoine Pevsner et le constructivisme*, Paris, 1956

Masson, 1994
Masson, A., *Le rebelle du Surréalisme: écrits* (F. Levaillant, ed.), Paris, 1994

Masson, London, 1987
André Masson: Line unleashed [...] (exh. cat.), Hayward Gallery, London, 1987

Masson, Nîmes, 1985
André Masson (exh. cat.), Musée des Beaux-Arts, Nîmes, 1985

Mataré, Cologne, 1987
Ewald Mataré. Retrospektive (exh. cat.), Kunstverein, Cologne, 1987

Mathieu, Tachisme, 1963
Mathieu, G., *Au-delà du Tachisme*, Paris, 1963

Matta, Paris, 1985
Matta (exh. cat.), Centre Georges Pompidou, Paris, 1985

Matta-Clark, Chicago, 1985
Gordon Matta-Clark – A Retrospective (exh. cat.), Museum of Contemporary Art, Chicago, 1985

Mattenklott, Blossfeldt, 1981
Mattenklott, G., *Karl Blossfeldt. Das fotografische Werk*, Munich, 1981

Mattenklott, Blossfeldt, 1998
Mattenklott, G., *Karl Blossfeldt. Natural Art Forms*, London, 1998

Mattheuer-Neustädt, Bilder, 1997
Mattheuer-Neustädt, U., *Bilder als Botschaft – Die Botschaft der Bilder*, Leipzig, 1997

Matthew Smith, London, 1983
Matthew Smith (exh. cat.), Barbican Art Gallery, London, 1983

Matthews, Tanner, 1969
Matthews, Marcia M., *Henry Ossawa Tanner, American Artist*, Chicago, 1969

Mauner, Nabis, 1978
Mauner, G. L., *The Nabis: their History and their Art, 1888–1896*, New York, 1978

Mazzanti, Saint Phalle, 1998
Mazzanti, A., *Niki de Saint Phalle: Tarot Garden*, Milan, 1998

McCollum, 1996
Allan McCollum: Interview by Thomas Lawson, Los Angeles/New York, 1996

McCully, Picasso, 1999
McCully, M., *Ceramics of Picasso*, 2 vols., Paris, 1999

McEvelley/Heiss, Oppenheim, 1991
McEvelley, T., and A. Heiss (eds.), *Dennis Oppenheim. Selected Works 1967–1990*, New York, 1991

McEvilley, Pat Steir, 1995
McEvilley, T., *Pat Steir*, New York, 1995

McGrath, Whiteley, 1979
McGrath, S., *Brett Whiteley*, Sydney, 1979

McNaughton, Gottlieb, 1981
McNaughton, M.D. and L. Alloway, *Adolph Gottlieb 1903–1974–A Retrospective* (exh. cat.), Washington, 1981

McShine, Cornell, 1981
McShine, K. (ed.), *Joseph Cornell*, (exh. cat.), The Museum of Modern Art, New York, 1981 (reprinted Munich, 1990)

Meisel, Estes, 1986
Meisel, L., *Richard Estes: The Complete Paintings 1966–1985*, New York, 1986

Meisel, Photorealism, 1980
Meisel, L. K. (ed.), *Photorealism*, New York, 1980

Meisel, Photorealism, 1993
Meisel, L. K., *Photorealism since 1980*, New York, 1993

Meißner, Tübke, 1974
Meißner, G., *Werner Tübke*, Leipzig, 1974

Melas-Kyriazi, Dongen, 1976
Melas-Kyriazi, J., *Van Dongen après le Fauvisme*, Lausanne, 1976

Meltzer, WPA, 1976
Meltzer, M., *The WPA Arts Projects*, New York, 1976

Mennekes, Hrdlicka, 1998
Mennekes, F. et al. (eds.), *Alfred Hrdlicka. Glaubenskriege* (exh. cat.), Bank Austria, Vienna, 1998

Merkert, Gabo, 1989
Merkert, J. (ed.), *Naum Gabo. Ein russischer Konstruktivist in Berlin 1922–1932*, Berlin, 1989

Merkert, González, 1987
Merkert, J., *Julio González. Catalogue raisonné des sculptures*, Milan, 1987

Merkert, Heisig, 1992
Merkert, Jörn (ed.), *Bernhard Heisig*, Munich, 1992

Merz, Baden-Baden, 1987
Gerhard Merz (exh. cat.), Staatliche Kunsthalle Baden-Baden, 1987

Merz, Prato, 1990
Mario Merz. La spazio è curvo e diretto (exh. cat.), Museo d'Arte Contemporaneo, Prato, 1990

Messager, Paris, 1995
Annette Messager. Rétrospective (exh. cat.), Musée d'art Moderne de la Ville de Paris, 1995

Metken, Comics, 1970
Metken, G., *Comics*, Frankfurt a. M./Hamburg, 1970

Metken, List, 1980
Metken, G., *Herbert List. Fotografia metafisica*, Munich, 1980

Metzger, Documents, 1992
Metzger, G., *Documents 1959–92*, Amsterdam, 1992

Metzinger/Gleizes, Cubisme, 1980
Metzinger, J. and A. Gleizes, *Du Cubisme*, Paris, 1912

Meyer, Conceptual Art, 1973
Meyer, U., *Conceptual Art*, New York, 1973

Meyer-Thoss, Oppenheim, 1996
Meyer-Thoss, C., *Meret Oppenheim. Buch der Ideen*, Zürich, 1996

Michaelsen, Archipenko
Michaelsen, K. J., et al. (eds.) *Alexander Archipenko: A Centennial Tribute* (exh. cat.), National Gallery of Art, Washington D.C., 1986

Michaux, 1994
Michaux, H., *Darkness Moves* (tr. D. Bell), Berkeley, 1994

Michaux, New York, 1978
Michaux (exh. cat.), Solomon R. Guggenheim Museum, New York, 1978

Michaux, Oeuvres, 1998–99
Michaux, Henri, *Oeuvres complètes* (ed. R. Bellour), Paris, 1998–99

Micińska, Witkiewicz, 1990
Micińska, A., *Witkiewicz: Life and Work*, Warsaw, 1990

Miles, Paolozzi, 1977
Miles, R., *The Complete Prints of Eduardo Paolozzi*, London, 1977

Miller, American Realists, 1969
Miller, D. C., and A. H. Barr (eds), *American Realists and Magic Realists*, New York, 1969

Milner, Mondrian, 1992
Milner, J., *Mondrian*, London, 1992

Minimal art, Bordeaux, 1985–86
Art Minimal (exh. cat.), 2 vols., CAPC, Bordeaux, 1985–86

Miquel, Madrid, 1990
Miquel Navarro. Minerva Paranoica (exh. cat.), Centro de Arte Reina Sofia, Madrid, 1990

Mißelbeck, Hockney, 1996/97
Mißelbeck, R. (ed.), *David Hockney. Retrospective Photoworks* (ed.), Museum Ludwig Köln, Cologne, 1996/97

Mißelbeck/Vollmer, Chargesheimer, 1996
Mißelbeck, R. and W. Vollmer (eds.), *Chargesheimer, Köln 1970/1995. 25 Jahre Stadt-Architektur*, Cologne, 1996

Mitchell, Paris, 1994
Joan Mitchell (exh. cat.), Galerie nationale du Jeu de Paume, Paris, 1994

Mitchinson/Stallabrass, Moore, 1992
Mitchinson, D. and J. Stallabrass, *Henry Moore*, Paris, 1992

Model, Chicago, 1990
Lisette Model (exh. cat.) Musée des Beaux-Arts du Canada, Ottawa, Chicago, 1990

Model, New Orleans, 1981
Lisette Model: A Retrospective (exh. cat.) Museum of Art, New Orleans, 1981

Modesti, Pittura italiana, 1964
Modesti, R., *Pittura italiana contemporanea*, Milan, 1964

Modotti, Philadelphia, 1995
Tina Modotti Photographs (exh. cat.), Philadelphia Museum of Art, 1995

Moeller, Macke, 1989
Moeller, M. M. (ed.), *August Macke. Die Tunisreise*, Munich, 1989

Moeller, Marc, 1989
Moeller, M. M., *Franz Marc. Aquarelle und Zeichnungen* (exh. cat.), Brücke-Museum Berlin et al., Stuttgart, 1989

Moeller, Palermo, 1995
Moeller, T. (ed.), *Palermo. Bilder und Objekte, Zeichnungen*, 2 vols., Stuttgart, 1995

Möller, Pechstein, 1996
Möller, M. M. (ed.), *Max Pechstein* (exh. cat.), Brücke-Museum Berlin et al., Munich, 1996

Möller, Pechstein, 1997
Möller, M. M. (ed.), *Max Pechstein. Sein malerisches Werk* (exh. cat.), Kunsthalle Tübingen et al., Tübingen, 1997

Moen, Munch, 1956–58
Moen, A., *Edvard Munch: Graphic Art and Paintings*, 3 vols., Oslo, 1956–58

Moffet, Noland, 1977
Moffet, K., *Kenneth Noland*, New York, 1977

Moffet, Poons, 1981
Moffet, K. and T. Fenton (eds.), *Larry Poons. Paintings 1971–1981* (exh. cat.), Museum of Fine Arts, Boston, 1981

Moholy-Nagy, 1932
Moholy-Nagy, L., *The New Vision: from Material to Architecture*, 1932

Moholy-Nagy, 1969
Moholy-Nagy, L., *Painting, Photography, Film*, London, 1969

Moholy-Nagy, 1995
Moholy-Nagy, L., *Autobiographical Writings* (L. Kaplan, ed.), Durham, 1995

Moholy-Nagy, Marseille, 1991
László Moholy-Nagy (exh. cat.), Musée Cantini, Marseille, 1991

Moldehn, Künstlerbücher, 1996
Moldehn, D., *Buchwerke: Künstlerbücher und Buchobjekte von 1960 bis 1995*, Nuremberg, 1996

Mollison, Williams, 1988
Mollison, J., *Fred Williams*, Sydney, 1988

Mondrian, Néo-Plasticisme, 1920
Mondrian, P., *Le Néo-Plasticisme: principe général de l'équivalence plastique*, Paris, 1920

Mondrian, New Art, 1986
Mondrian, P., *The New Art, the New Life: the Collected Writings of Piet Mondrian* (H. Holtzman and M. S. James, eds.), London, 1986

Monte, Bengston, 1968
Monte, J., *Billy Al Bengston* (exh. cat.), Los Angeles County Museum of Art, Los Angeles, 1968

Monte, di Suvero, 1975
Monte, J. K., *Mark di Suvero. Retrospective* (exh. cat.), Whitney Museum of American Art, New York, 1975

Montier, Cartier-Bresson, 1997
Jean-Pierre Montier, *Henri Cartier-Bresson. Son art. Sa vie*, Paris/London, 1997

Moore, London, 1988
Henry Moore (exh. cat.), Royal Academy of Arts, London, 1988

Moorhouse, Kossoff, 1996
Moorhouse, P., *Leon Kossoff* (exh. cat.), Tate Gallery, London, 1996

Morales, Paalen, 1984
Morales, L., *Wolfgang Paalen: Introductor de la pintura surrealista en México*, Mexico City, 1984

Morandi, Bologna, 1989
Morandi nelle raccolte private bolognese (exh. cat.), San Giorgio in Poggiale, Bologna, 1989

Morandi, Paris, 1996
Giorgio Morandi (exh. cat.), Fondation Dian Vierny, Musée Maillol, Paris, 1996

Moreau, Troyes, 1992
Jean-Jacques Moreau (exh. cat.), Musée d'Art moderne, Troyes, 1992

Morellet, Saarbrücken, 1991
François Morellet: Grands Formats (exh. cat.), Saarland Museum, Saarbrücken, 1991

Morgan, Barry, 1986
Morgan, R. C., *Robert Barry*, Bielefeld, 1986

Morgan, Conceptual Art, 1994
Morgan, R.C., *Conceptual Art, An American Perspective*, London, 1994

Morgan, Dove, 1984
Morgan, A. L., *Arthur Dove: Life and Work, with a Catalogue Raisonné*, Newark, 1984

Morgan, Poirier, 1986
Morgan, S., *Anne and Patrick Poirier: Lost Archetypes*, Bath, 1986

Morley, Basel, 1991
Malcolm Morley (exh. cat.), Kunsthalle Basel, 1991

Morley, London, 1990
Malcolm Morley (exh. cat.), Anthony d'Offay Gallery, London, 1990

Morley, Paris, 1993
Malcolm Morley. Retrospective 1954–1993 (exh. cat.), Centre Georges Pompidou, Paris, 1993

Morphet, Kitaj, 1994
Morphet, R. (ed.), *R.B. Kitaj Retrospective* (exh. cat.), Tate Gallery, London, 1994

Morris, London, 1990
Robert Morris (exh. cat.), Tate Gallery, London, 1990

Morris, New York, 1994
Robert Morris. Retrospective (exh. cat.), Solomon R. Guggenheim Museum, New York, 1994

Morschel, Deutsche Kunst, 1972
Morschel, J., *Deutsche Kunst der 60er Jahre, Teil II: Plastik, Objekte, Aktionen*, Munich, 1972

Mortimer, Dobson, 1926
Mortimer, R., *Frank Dobson*, London, 1926

Mosby, Tanner, 1995
Mosby, Dewey F., *Across Continents and Cultures: The Art and Life of Henry Ossawa Tanner* (exh. cat.), Kansas City, 1995

Moser/Robbins, Metzinger, 1985
Moser, J. and D. Robbins (eds.), *Jean Metzinger in Retrospect* (exh. cat.), The University of Iowa Museum of Art, Iowa City, 1985

Moses, 1998
Stefan Moses. Jeder Mensch ist eine kleine Gesellschaft, Munich, 1998

Motherwell, 1992
Motherwell, R. *The Collected Writings* (S. Terenzio, ed.), New York, 1992

Motte, Vasarely, 1986
Motte, M. de la and A. Tolnay, *Vasarely. Werke aus sechs Jahrzehnten* (exh. cat.), Villa Merkel Esslingen, Stuttgart, 1986

Moure, Graham, 1994
Moure, G., (ed.), *Dan Graham*, Barcelona, 1998

Moure, Kounellis, 1990
Moure, G. (ed.), *Kounellis*, New York, 1990

Moure/Fuchs, Dibbets, 1991
Moure, G. and R. Fuchs, *Interior Light. Works on Architecture 1969–90*, New York, 1991

Moussu, Štyrský, 1982
Moussu, A. (ed.), *Jindřich Štyrský: Fotografické dílo*, Prague, 1982

Mucha, Basel, 1987
Reinhard Mucha. Nordausgang; Kasse beim Fahrer (exh. cat.), Kunsthalle Bern, Kunsthalle Basel, 1987

Mucha, Paris, 1986
Reinhard Mucha (exh. cat.), Musée national d'art moderne Centre Georges-Pompidou, Paris, 1986

Mucha, Stuttgart, 1985
Reinhard Mucha. Das Figur-Grund Problem in der Architektur des Barock (für dich allein bleibt nur das Grab) (exh. cat.), Württembergischer Kunstverein, Stuttgart, 1985

Muche, Tübingen, 1995
Georg Muche, Sturm Bauhaus Spätwerk (exh. cat.), Bad Homburg v. d. Höhe, Tübingen, 1995

Mück, Worpswede, 1998
Mück, H.-D. (ed.), *Insel des Schönen. Künstler-Kolonie Worpswede 1889–1908*, 2 vols., Stuttgart/Frankfurt am Main, 1998

Mühlenstein/Schmidt, Hodler, 1983
Mühlenstein, H. and G. Schmidt, *Ferdinand Hodler. Sein Leben und sein Werk*, Zürich, 1983

Müller, Neo-Dada, 1987
Müller, M., *Aspekte der Dada-Rezeption 1950–66*, Essen, 1987

Mullican, Bath, 1981
Mullican (exh. cat.), Artsite Gallery, Bath, 1981

Mullican, Philadelphia, 1987
Matt Mullican (exh. cat.), Goldie Paley Gallery, Moore Collection of Art, Philadelphia, 1987

Munkácsi, 1992
Martin Munkácsi. An Aperture Monograph, New York, 1992

Munro, Originals, 1979
Munro, E. C., *Originals: American Women Artists*, New York, 1979

Murina, Lentulov, 1988
Murina, E., *Aristarkh Lentulov*, Milan, 1988

Murken-Altrogge, Modersohn-Becker, 1991
Murken-Altrogge, Ch., *Paula Modersohn-Becker*, Cologne, 1991

Murray, Dallas, 1987
Elizabeth Murray. Paintings and Drawings (exh. cat.), Dallas Museum of Art and the MIT Committee on the Visual Arts, New York, 1987

Murray, New York, 1997
Elizabeth Murray. Recent Paintings (exh. cat.), Pace Wildenstein Gallery, New York, 1997

Music, Klagenfurt, 1990
Zoran Music. Zeichnungen, Aquarelle, Gouachen 1945–1990 (exh. cat.), Klagenfurt, 1990

Mussini, Baj, 1990
Mussini, M. (ed.), *I libri di Baj*, Milan, 1990

Nacenta, École de Paris, 1960
Nacenta, R., *École de Paris*, Paris, 1960

Nagel/Timm, Kollwitz, 1980
Nagel, O. and W. Timm, *Käthe Kollwitz. Die Handzeichnungen*, Stuttgart 1980

Naive Art, Washington, 1992
American Naive Painting (exh. cat.), National Gallery of Art, Washington D.C., 1992

Nakov, Abstrait/Concret, 1981
Nakov, A., *Abstrait/Concret: Art non-objectif russe et polonais*, Paris, 1981

Nakov, Exter, 1972
Nakov, A., *Alexandra Exter*, (exh. cat.), Galerie Jean Chauvelin, Paris, 1972

Nash, London, 1994
A Bitter Truth: Avant-Garde Art and the Great War (exh. cat.), Barbican Art Gallery, London, 1994

Nash/Merkert, Gabo, 1986
Nash, S. and J. Merkert (eds.), *Naum Gabo – Sechzig Jahre Konstruktivismus*, Munich, 1986

Nauman, London, 1998
Bruce Nauman (exh. cat.), Hayward Gallery, London, 1998

Nauman, New York, 1995
Bruce Nauman (exh. cat.), The Museum of Modern Art New York, New York, 1995

Naumann, Dada, 1994
Naumann, F., *New York Dada*, New York, 1994

Naumann, New York Dada, 1994
Naumann Francis M., *New York Dada 1915–1923*, New York, 1994

Navratil, Bilder, 1993
Navratil, Leo, *Bilder nach Bildern*, Salzburg, Vienna, 1993

Nay, Cologne, 1990
Gohr, S. (ed.), *Ernst Wilhelm Nay. Retrospektive* (exh. cat.), Museum Ludwig, Cologne, 1990

Nay, Krefeld, 1985
Ernst Wilhelm Nay. Bilder kommen aus Bildern (exh. cat.), Museum Haus Lange Krefeld, Krefeld, 1985

Nay, Nuremberg, 1980
Ernst Wilhelm Nay. 1902–1968. Bilder und Dokumente (exh. cat.), Germanisches Nationalmuseum Nürnberg, Munich, 1980

Nebehay, Klimt, 1990
Nebehay, C. M., *Gustav Klimt. Von der Zeichnung zum Bild*, Wiesbaden, 1990

Needham, Realism, 1988
Needham, G., *Nineteenth-Century Realism*, New York, 1988

Neo-Dada, New York, 1994
Hapgood, S., *Neo-Dada. Redefining Art* (exh. cat.), New York, 1994

Neo-Geo, Munich, 1986
Geometria nova (exh. cat.), Kunstverein München, 1986

Neo-Geo, Munich, 1995
Monochromie, Geometrie (exh. cat.), Sammlung Goetz, Munich, 1995

Nerdinger, Belling, 1981
Nerdinger, W., *Rudolf Belling und die Kunstströmungen in Berlin 1918–1923*, Berlin, 1981

Nerdinger, Gropius, 1985
Nerdinger, W., *Walter Gropius*, (exh. cat.), Bauhaus-Archiv Berlin, Berlin, 1985

Nerdinger, Gropius, 1990–95
Nerdinger, W. (ed.), *The Walter Gropius Archive. An Illustrated Catalogue, I – IV*, New York, 1990–95

Neret, Klimt, 1992
Neret, G., *Gustav Klimt*, Cologne, 1992

Néret, Matisse, 1996
Néret, G., *Henri Matisse*, Cologne, 1996

Neumaier, Lafontaine, 1998
Neumaier, O. et al. (eds.), *Marie-Jo Lafontaine*, Ostfildern, 1998

Neusüss, Fotogramm, 1990
Neusüss, F., *Das Fotogramm in der Kunst des 20. Jhs. Die andere Seite der Bilder. Fotografie ohne Kamera*, Cologne, 1990

Nevinson, London, 1999
C. R. W. Nevinson: The Twentieth Century (exh. cat.), Imperial War Museum, London, 1999

New Figuration, 1964
Mythologies quotidiennes (exh. cat.), Musée de l'art moderne de la Ville de Paris, Paris, 1964

New Figuration, 1977
Mythologies quotidiennes II (exh. cat.), ARC 2, Paris, 1977

Newlands, Carr, 1996
Newlands, A., *Emily Carr. An Introduction to her Life and Art*, Willowdale, 1996

Neyer, Freund, 1988
Neyer, H. J., *Gisèle Freund*, Berlin, 1988

Nicholson, William Nicholson, 1996
Nicholson, N., *Sir William Nicholson, Painter [. . .]*, London, 1996

Niki de Saint Phalle, 1980
Niki de Saint Phalle (exh. cat.), Musée nationale d'art moderne, Centre Georges Pompidou, Paris, 1980

Nikiel, Metzinger (in preparation)
Nikiel, B. (ed.), *Jean Metzinger. Catalogue raisonné* (in preparation)

Nitsch, Orgien, 1979
Nitsch, H., *Das Orgien Mysterien Theater. Die Partituren aller ausgeführten Aktionen 1960–1978*, Naples/Munich/Vienna, 1979

Nitsch, Theorie, 1995
Nitsch, H., *Zur Theorie des Orgien Mysterien Theaters. Zweiter Versuch*, Salzburg, 1995

Nobis, Tadeusz, 1997
Nobis, B., *Norbert Tadeusz*, Hanover, 1997

Nochlin, Realism, 1966
Nochlin, L. (ed.), *Realism and Tradition in Art*, Englewood Cliffs, 1966

Nochlin, Realism, 1974
Nochlin, L., *Realism*, New York, 1974

Noel, Opalka, 1996
Noel, B. et al. (eds.), *Roman Opalka*, Paris, 1996

Noever, Burden, 1996
Noever, P., *Chris Burden: Jenseits der Grenzen* (exh. cat.), Museum für Angewandte Kunst, Vienna, 1996

Noever, Judd, 1992
Noever, P. (ed.), *Donald Judd. Architektur*, Stuttgart, 1992

Noever, Rodchenko, 1991
Noever, P. *Aleksandr M. Rodchenko and Varava F. Stepanova*, Munich, 1991

Noland, Stuttgart, 1992
Cady Noland, Towards a Metalanguage of Evil (exh. cat.), Documenta 9, Kassel, Stuttgart, 1992

Nolde, London, 1995
Vergo, P., and F. Lunn (eds.), *Emil Nolde* (exh. cat.), Whitechapel Art Gallery, London, 1995

Nordland, Burri, 1977
Nordland, G. (ed.), *Alberto Burri. A Retrospective View 1948–1978* (exh. cat.), Frederick S. Wight Art Gallery, University of California, Los Angeles, 1977

Nordland, Diebenkorn, 1987
Nordland, G., *Richard Diebenkorn*, New York, 1987

Nordland, Lachaise, 1974
Nordland, G., *Gaston Lachaise*, New York, 1974

Normand, Lewis, 1992
Normand, T., *Wyndham Lewis the Artist*, London, 1992

North, Weber, 1983
North, P., *Max Weber, American Modern* (exh. cat.), The Jewish Museum, New York, 1983

Nouveaux Réalistes, 1986
Les Nouveaux Réalistes (exh. cat.), Musée d'Art Moderne de la Ville de Paris, Paris, 1986

Nouvelle Tendance, Paris, 1964
Nouvelle Tendance (exh. cat.), Musée des Arts Décoratifs, Paris, 1964

Novembergruppe, Berlin, 1993
Novembergruppe (exh. cat.), Galerie Bodo Niemann, Berlin, 1993

Novotny, Cézanne, 1970
Novotny, F., *Cézanne und das Ende der wissenschaftlichen Perspektive*, Vienna, 1970

Nul, Amsterdam, 1962/1965
Nul (exh. cat.), Stedelijk Museum Amsterdam, 1962/1965

O'Connor, Pollock, 1978
O'Connor, F. V. et al. (eds.), *Jackson Pollock. Catalogue raisonné of Paintings, Drawings and Other Works*, 4 vols., New Haven/London, 1978

O'Neill, Newman, 1990
O'Neill, J. P. (ed.), *Barnett Newman. Selected Writings and Interviews*, New York, 1990

O'Pray, Warhol, 1989
O'Pray, M. (ed.), *Andy Warhol. Film Factory*, London, 1989

Obrist, Golub, 1997
Obrist, H.-U. (ed.), *Leon Golub. Do paintings bite?*, Stuttgart, 1997

Obrist, Richter, 1995
Obrist, H.-U. (ed.), *The Daily Practice of Painting: Writings, Interviews, 1962–1993, Gerard Richter*, London, 1995

Obrist, Richter, 1996
Obrist, H.-U. (ed.), *Gerhard Richter – 100 Bilder* (exh. cat.) Carré d'Art, Musée d'Art Contemporain, Nîmes, 1996

Oiticica, Rotterdam, 1992
Hélio Oiticica (exh. cat.), Witte de With Center for Contemporary Art, Rotterdam, 1992

Oliva, Transavantgarde, 1982
Oliva, A. B., *Transavantgarde international*, Milan, 1982

On Classic Ground, London, 1990
On Classic Ground: Picasso, Léger, de Chirico and the New Classicism, 1910–1930 (exh. cat.), Tate Gallery, London, 1990

On Kawara, Frankfurt am Main, 1994
On Kawara (exh. cat.), Museum für Moderne Kunst, Frankfurt am Main, 1994

Ono, Munich, 1998
Yoko Ono. Have You Seen the Horizon Lately? (exh. cat.), Museum Villa Stuck, Munich, 1998

Onslow Ford, Santiago de Compostela, 1998
Gordon Onslow Ford, Mirando en lo profundo (exh. cat.), Fundación Eugenio Granell, Santiago de Compostela, 1998

Onslow Ford, Washington, 1975
Onslow Ford (exh. cat.), Pyramid Gallery, Washington, 1975

Opalka, Berlin, 1994
Roman Opalka (exh. cat.), Neue Nationalgalerie, Berlin, 1994

Oppenheim, Basel, 1979
Dennis Oppenheim (exh. cat.), Kunsthalle Basel, Basel, 1979

Oppenheim, Milan, 1997
Dennis Oppenheim (exh. cat.), Venezia Contemporaneo (text by Germano Celant), Milan, 1997

Oppler, Fauvism, 1976
Oppler, E. C., *Fauvism Reexamined*, New York ,1976

Orozco, 1981
José Clemente Orozco, (exh. cat.), Orangerie Schloss Charlottenburg Berlin, Berlin, 1981

Ortin, Johns, 1994
Ortin, F., *Figuring Jasper Johns*, London, 1994

Ory, Doisneau, 1984
Ory, P., *Doisneau: Photographies 1940–1944*, Paris, 1984

Osborne, Abstraction, 1979
Osborne, H., *Abstraction and Artifice in Twentieth-Century Art*, London, 1979

Osterwold, di Suvero, 1988
Osterwold, T. (ed.), *Mark di Suvero* (exh. cat.), Württembergischer Kunstverein, Stuttgart,1988

Osterwold, Pop art, 1989
Osterwold, T., *Pop Art*, Cologne, 1989

Osterwold/Knubben, Wols, 1997
Osterwold, T. and T. Knubben (eds.), *Wols. Aquarelle 1937–1951*, Städtische Galerie Altes Theater Ravensburg, Stuttgart, 1997

Oursler, Hanover, 1998
Tony Oursler (exh. cat.), Kunstverein Hannover, 1998

Oxlade, Bomberg 1977
Oxlade, R., *David Bomberg*, London, 1977

Pachnicke/Honnef, Heartfield, 1991
Pachnicke, P. and K. Honnef, *John Heartfield* (exh. cat.), Akademie der Künste Berlin, Altes Museum, Cologne, 1991

Pacquement, Takis, 1993
Pacquement, A. (ed.), *Takis* (exh. cat.), Galerie Nationale du Jeu de Paume, Paris, 1993

Pagé, Derain, 1994
Pagé, S. (ed.), *André Derain – Retrospective* (exh. cat.), Musée d'Art Moderne de la Ville de Paris, 1994

Pagé, Taeuber-Arp, 1989
Pagé, S. et al. (eds.), *Sophie Taeuber-Arp* (exh. cat.), Musée d'Art Moderne de la Ville de Paris, 1989

Pahlke, Bury, 1988
Pahlke, R. E., *Pol Bury*, Hamburg, 1988

Paladino, London, 1991
Mimmo Paladino : il respiro della bellezza (exh. cat.), Waddington Galleries, London, 1991

Palermo, 1984
Palermo – Werke 1963–1977 (exh. cat.) Kunstmuseum Winterthur et al., Munich, 1984

Paley, 1991
Albert Paley (exh. cat.), Philadelphia, 1991

Paolozzi, 1962
Eduardo Paolozzi, *Metafisical Translations*, London, 1962

Paolozzi, Edinburgh, 1985
Eduardo Paolozzi (exh. cat.), Royal Scottish Academy, Edinburgh, 1985

Paolozzi, London, 1987
Eduardo Paolozzi (exh. cat.), Serpentine Gallery, London, 1987

Paquet, Corneille, 1988
Paquet, M., *Corneille – La Sensibilité du sensible*, Paris, 1988

Paradise Lost, London, 1987
A Paradise Lost: The Neo-Romantic Imagination in Britain 1935–55 (exh. cat.), Barbican Art Gallery, London, 1987

Parmiggiani, Bologna, 1985
Parmiggiani, C., *Il sangue del colore*, Milan, 1988

Parmiggiani, Milan, 1988
Claudio Parmiggiani (exh. cat.), Sala Rossa/Sala delle Specchi, Bologna, 1985

Parronchi, Soffici, 1976
Parronchi, A., *Soffici*, Rome, 1976

Parton, Larionov, 1993
Parton, A., *Mikhail Larionov and the Russian Avant-Garde*, London, 1993

Passamani, Depero, 1981
Passamani, B. (ed.), *Fortunato Depero* (exh. cat.), Musei Civici, Galleria Museo Depero, Rovereto, 1981

Passoni, Aeropittura futurista, 1970
Passoni, F., *Aeropittura futurista*, Milan, 1970

Passuth, Burlyuk, 1979
Passuth, K., "David Burlyuk, paintings 1907–1966," in *Cahiers du Musée National d'Art Moderne*, 2 (1979), pp. 282

Passuth, Moholy-Nagy, 1984
Passuth, K., *Moholy-Nagy*, London, 1984

Patai, Lipchitz, 1975
Patai, I., *Encounter: the Life of Jacques Lipchitz*, New York, 1975

Pattern Painting, Brussels, 1979
Pattern Painting (exh. cat.), Palais des Beaux-Arts, Brussels, 1979

Pattern Painting, Nice, 1980
Pattern Painting (exh. cat.), Musée de Nice, Nice, 1980

Paz, Chillida, 1979
Paz, O., *Chillida*, Paris, 1979

Paz, Tamayo, 1959
Paz, O., *Tamayo en la pintura mexicana*, Mexico City, 1959

Paz/Lassaigne, Tamayo, 1982
Paz, O. and J. Lassaigne, *Rufino Tamayo*, Barcelona, 1982

Pearce, Boyd, 1993
Pearce, B., *Arthur Boyd: Retrospective* (exh. cat.), Art Gallery of New South Wales, Sydney, 1993

Pecher, van de Velde, 1981
Pecher, W. D. (ed.), *Henry van de Velde. Das Gesamtwerk*, vol. 1, *Gestaltung*, Munich, 1981

Peiry, L'art brut, 1997
Peiry, L., *L'art brut*, Paris, 1997

Penck, Saint-Étienne, 1985
A.R. Penck (exh. cat.), Musée de Saint-Étienne, 1985

Penn, Chicago, 1997
Irving Penn. A Career in Photography (exh. cat.), The Art Institute of Chicago, 1997

Penn, Hamburg, 1999
Irving Penn. Retrospektive (exh. cat.), Museum für Kunst und Gewerbe, Hamburg, 1999

Penrose, Man Ray, 1975
Penrose, R., *Man Ray*, London, 1975

Penrose, Tàpies, 1978
Penrose, R., *Tàpies*, London, 1978

Perejaume, Barcelona, 1999
Perejaume. Retrospectiva (exh. cat.), Museu d'Art Contemporani, Barcelona, 1999

Perlein, di Suvero, 1991
Perlein, G. (ed.), *Mark di Suvero. Retrospective 1959–1991* (exh. cat.), Musée d'Art Moderne et d'Art Contemporain, Nice, 1991

Perlman, Davies, 1998
Perlman, B. B., *The Lives, Loves, and Art of Arthur B. Davies*, New York, 1998

Peroco, Martini, 1962
Perocco, G., *Arturo Martini*, Rome, 1962

Perucchi-Petri, Nabis, 1976
Perucchi-Petri, U., *Die Nabis und Japan. Das Frühwerk von Bonnard, Vuillard und Denis*, Munich, 1976

Pery, Rogers, 1995
Pery, J., *An Affectionate Eye: The Life of Claude Rogers*, Bristol, 1995

Pétridès, Utrillo, 1959–1974
Pétridès, P. (ed.), *L'œuvre complet de Utrillo*, 5 vols., Paris, 1959–74

Petzet, Vogler, 1972
Petzet, H. W., *Von Worpswede nach Moskau. Heinrich Vogeler. Ein Künstler zwischen den Zeiten*, Cologne, 1972

Pevsner, Paris, 1957
Antoine Pevsner (exh. cat.), Musée National d'Art moderne, Paris, 1957

Pevsner, Pevsner, 1964
Pevsner, A., *A Biographical Sketch of My Brothers Naum Gabo and Antoine Pevsner*, Amsterdam, 1964

Peyré, Fautrier, 1990
Peyré, Y., *Fautrier ou les outrages de l'impossible*, Paris, 1990

Pfäffle, Dix, 1991
Pfäffle, S., *Otto Dix. Werkverzeichnis der Aquarelle und Gouachen*, Stuttgart,1991

Phillips, Music, 1996
Phillips, T., *Music in Art*, Munich, 1996

Phillips, Prince, 1992
Phillips, L. (ed.), *Richard Prince*, New York, 1992

Phillips, Reviews, 1993
Phillips, P.C., "Reviews – Ida Applebroog," in *Artforum*, 32, 2, 1993

Picasso, Paris, 1979
Picasso: Oeuvres reçues en paiement des droits de succession (exh. cat.)., Galleries du Grand Palais, Paris, 1979

Pierre, Klapheck, 1970
Pierre, J. (ed.) *Konrad Klapheck. Werkverzeichnis der Gemälde*, Cologne, 1970

Pierre, Laurencin, 1988
Pierre, J., *Marie Laurencin*, Paris 1988

Pierre, Paalen, 1980
Pierre, J., *Paalen*, Paris, 1980

Pincus, 1990
Pincus, R. L. (ed.), *On a Scale that Competes with the World. The Art of Edward and Nancy Reddin Kienholz*, Berkeley, 1990

Pincus-Witten, Post-Minimalism, 1977
Pincus-Witten, R., *Postminimalism. American Art of the Decade*, New York, 1977

Pincus-Witten, Post-Minimalism, 1987
Pincus-Witten, R., *Postminimalism into Maximalism. American Art, 1966–1986*, Ann Arbor, Michigan, 1987

Piper, London, 1983
John Piper (exh. cat.), Tate Gallery, London, 1983

Pirovano, Burri, 1985
Pirovano, C. (ed.), *Burri* (exh. cat.), Pinacoteca di Brera, Milan, 1985

Pistoletto, Amsterdam, 1986
Pistoletto: prima parte (exh. cat.), Stedelijk Van Abbemuseum Amsterdam, 1986

Pittura Metafisica, Bologna/Ferrara, 1980–81
Pittura Metafisica: Museo documentario & Gli anni venti (exh. cat.), 3 vols, Galleria d'Arte Moderna/Galleria Civica d'Arte Moderna/, Bologna/Ferrara, 1980–81

Plessi, Mainz, 1998
Fabrizio Plessi, Opus Video Sculpture. Werkverzeichnis der Video-Skulpturen und -Installationen 1976–1998, Mainz et al., 1998

Pleynet, Motherwell, 1989
Pleynet, M., *Robert Motherwell*, Paris, 1989

Poetter, Judd, 1989
Poetter, J. (ed.), *Donald Judd* (exh. cat.), Staatl. Kunsthalle Baden-Baden, 1989

Poetter, ZEN 49, 1986
Poetter, J. (ed.), *ZEN 49* (exh. cat.), Kunsthalle, Baden-Baden, 1986

Poggi, Collage, 1993
Poggi, C., *In Defiance of Painting: Cubism, Futurism, and the Invention of Collage*, New Haven, 1993

Poggioli, Avant-Garde, 1968
Poggioli, R., *The Theory of the Avant-Garde*, Cambridge/Mass., 1968

Pohlen, Alighiero & Boetti, 1992
Pohlen, A., *Alighiero & Boetti. Synchronizität als ein Prinzip akausaler Zusammenhänge* (exh. cat.), Kunstverein Bonn et al., Basel, 1992

Poli, La Metafisica, 1989
Poli, F., *La Metafisica*, Rome/Bari, 1989

Poli, Paolini, 1990
Poli, F., *Guilio Paolini*, Turin, 1990

Polieri, Atlan, 1989
Polieri, Jacques, et al. (eds), *Atlan. Premières Periodes 1940/1954*, Paris, 1989

Polke, Liverpool, 1995
Sigmund Polke (exh. cat.), Tate Gallery, Liverpool, 1995

Pollock, London, 1999
Jackson Pollock (exh. cat.), Tate Gallery, London, 1999

Pollock, New York, 1980
Jackson Pollock, Drawings into Paintings (exh. cat.), MOMA, New York, 1980

Pologne contemporaine, Paris, 1983
Pologne contemporaine (exh. cat.), Paris, 1983

Pomeroy, Stamos, 1970
Pomeroy, R., *Stamos*, New York, 1970

Pomodoro, 1984
Arnaldo Pomodoro. Luoghi fondamentali (exh. cat.), Florence, 1984

Popova, 1991
Liubov Popova (exh. cat.), MOMA, New York, 1991

Popper, Agam, 1990
Popper, F., *Agam*, New York, 1990

Popper, Art, 1975
Popper, F., *Art, Action and Participation*, London, 1975

Popper, Electronic, 1993
Popper, F., *Art of the Electronic Age*, London, 1993

Popper, Kinetic, 1975
Popper, F., *Origins and Development of Kinetic Art*, London, 1975

Porter, 1992
Eliot Porter, The Grand Canyon, New York, 1992

Portinari, São Paulo, 1979
Cândido Portinari (exh. cat.), Museu de Arte Contemporanea de São Paulo, 1979

Porzio, Savinio, 1988
Porzio, M., *Savinio musicista. Il suono metafisico*, Venice, 1988

Posener, Functionalism, 1964
Posener, J., *Anfänge des Funktionalismus*, Berlin, 1964

Pospelov, Moderne russische, 1985
Pospelov, *Moderne russische Malerei, Die Künstlergruppe Karo-Bube*, Dresden, 1985

Post-Impressionism, London, 1979–80
Post-Impressionism (exh. cat.), Royal Academy of Arts, London, 1979–80

Poulsen, Danish Painting, 1976
Poulsen, V., *Danish Painting and Sculpture*, Copenhagen, 1976

Pound, Gaudier-Brzeska, 1916
Pound, Ezra, *Gaudier-Brzeska. A Memoir*, London, 1916

Pousette-Dart, 1997–98
Richard Pousette-Dart 1916–1992 (exh. cat.), Metropolitan Museum of Art, New York, 1997–98

Prampolini, 1992
Prampolini. Dal Futurismo all'Informale (exh. cat.), Palazzo delle Esposizione, Rome, 1992

Prasse, Feininger, 1972
Prasse, L. E., *Lyonel Feininger: A Definitive Catalogue of his Graphic Work* (exh. cat.), Cleveland Museum of Art, 1972, Berlin, 1972

Prat, Miró, 1990
Prat, J.-L. (ed.), *Joan Miró. Retrospéctive de l'œuvre peint* (exh. cat.), Fondation Maeght, Saint-Paul de Vence, 1990

Prather, de Kooning, 1994
Prather, M. (ed.), *Willem de Kooning. Paintings* (exh. cat.), National Gallery of Art, Washington, D. C., 1994

Precisionism, Columbus, 1994
Precisionism in America 1915–1941: Reordering Reality (exh. cat.), Columbus Museum of Art, 1994

Prelinger, Kollwitz, 1996
Prelinger, E. (ed.) *Käthe Kollwitz* (exh. cat.), National Gallery of Art Washington, 1992

Presler, Glanz und Elend, 1992
Presler, G., *Glanz und Elend der 20er Jahre. Die Malerei der Neuen Sachlichkeit*, Cologne, 1992

Presler, Kirchner, 1998
Presler, Gerd, *Ernst Ludwig Kirchner. Seine Frauen, seine Modelle, seine Bilder*, Munich, 1998

Presler, Radziwill, 1993
Presler, G., *Franz Radziwill. Werkverzeichnis der Druckgraphik*, Karlsruhe, 1993

Preston, Vuillard, 1985
Preston, S., *Vuillard*, London, 1985

Prévert/Jouffroy, Fromanger, 1971
Prévert, J., and A. Jouffroy, *Fromanger*, Paris, 1971

Prince, New York, 1992
Richard Prince (exh. cat.), Whitney Museum of American Art, New York, 1992

Prince, Zürich, 1995
Richard Prince: Adult Comedy Drama, Zürich, 1995

Pritchett, Cage, 1993
Pritchett, J.W., *The Music of John Cage*, New York, 1993

Probst/Schädlich, Gropius, 1985–87
Probst, W. and C. Schädlich, *Walter Gropius, I – III*, Berlin 1985–87

Process art, Los Angeles, 1998
Out of Actions (exh. cat.), Museum of Contemporary Art Los Angeles, 1998

Pruzhan, Bakst, 1987
Pruzhan, I., *Léon Bakst*, London, 1987

Puni, Paris, 1966
Donation Puni (exh. cat.), Orangerie des Tuileries, Paris, 1966

Puni, Paris, 1993
Jean Pougny (exh. cat.), Musée d'art moderne de la Ville de Paris, 1993

Puttkamer, Oppenheimer, 1998
Von Puttkamer, M.-A., *Max Oppenheimer – Mopp*, Vienna, 1998

Pyle, Yeats, 1970
Pyle, H., *Jack B. Yeats: A Biography*, London, 1970

Quadri, Wilson, 1998
Quadri, F. (et al.), *Robert Wilson*, New York, 1998

Raabe, Kubin, 1957
Raabe, P., *Alfred Kubin. Leben – Werk – Wirkung*, Hamburg, 1957

Rabinovitch, Berne, 1990
Royden Rabinowitch, Skulpturen/Sculptures 1990 (exh. cat.), Kunstmuseum Berne, 1990

Rabinovitch, Chemnitz, 1995
David Rabinovitch – The Major Sequenced Conic Sculptures (exh. cat.), Städtische Kunstsammlungen, Chemnitz, 1995

Rabinovitch, Ghent, 1984
Royden Rabinowitch, Sculptures and Drawings in the Collection, Museum van hedendaagse Kunst, Ghent, 1984

Rabinovitch, Mönchengladbach, 1985
Royden Rabinowitch. Skulpturen, Eine Auswahl 1963–1985 (exh. cat.), Städt. Museum Abteiberg, Mönchengladbach, 1985

Rabinovitch, The Hague, 1992
Royden Rabinowitch, Sculpture 1962/1992 (exh. cat.), Haags Gemeentemuseum, The Hague, Eindhoven, 1992

Radermacher, Munich, 1991
Norbert Radermacher (exh. cat.), Staatsgalerie Moderner Kunst, Munich, 1991

Radermacher, Wiesbaden, 1994
Norbert Radermacher (exh. cat.), Museum Wiesbaden, 1993

Radford, Dalí, 1997
Radford, R., *Salvador Dalí*, London 1997

Ragon, Atlan, 1989
Ragon, M., *Atlan, mon ami*, Paris, 1989

Ragon, Expression, 1951
Ragon, M., *Expression et non-figuration*, Paris, 1951

Ramirez, Torres-García, 1992
Ramirez, M.-C., *El Taller Torres-García, the School of the South and its Legacy*, Austin, Texas, 1992

Rand, Hundertwasser, 1993
Rand, H., *Friedensreich Hundertwasser*, Cologne, 1993

Rand, Manship, 1989
Rand, H., *Paul Manship*, London, 1989

Rannit, Ciurlionis, 1984
Rannit, A., *Mikalojus Konstantinas Ciurlionis: Lithuanian Visionary Painter*, Chicago, 1984

Ratcliff, Komar & Melamid, 1988
Ratcliff, C., *Komar & Melamid*, New York, 1988

Ratcliff, Longo, 1985
Ratcliff, C., *Robert Longo*, New York ,1985

Rathbone, Tobey, 1984
Rathbone, E. E. (ed.), *Mark Tobey. City Paintings* (exh. cat.), National Gallery of Art, Washington, 1984

Rattemeyer, Gerz, 1997
Rattemeyer, Volker (ed.), *Jochen Gerz. Get out of my lies. 18 Installationen der siebziger Jahre*, (exh. cat.), Museum Wiesbaden, 1997

Ray, Surrealist Movement, 1941
Ray, P., *The Surrealist Movement in England*, London, 1941

Raysse, Paris, 1992
Martial Raysse (exh. cat.), Musée du Jeu
de Paume/Carré d'art-musée,
Paris/Nîmes, 1992

Read, Arp, 1968
Read, H., *Jean Arp*, London, 1968

Read, Gabo, 1957
Read, H. and L. Martin, *Naum Gabo*,
London, 1957

Red, Moore, 1979
Read, H., *Henry Moore: Portrait of an
Artist*, London, New York, 1979

Rego, Liverpool, 1997
Paula Rego (exh. cat.), Tate Gallery,
Liverpool, 1997

Reinhardt, Art, 1991
Reinhardt, A., *Art-as-art: the Selected
Writings of Ad Reinhardt* (B. Rose, ed.),
Berkeley, 1991

Reitberger, Comics, 1971
Reitberger, R. and W. Fuchs, *Comics.
Anatomie eines Massenmediums*, Munich,
1971

Restany, César, 1988
Restany, P., *César*, Paris/Milan, 1988

Restany, Chryssa, 1977
Restany, P., *Chryssa*, New York, 1977

Restany, Hundertwasser, 1998
Restany, P., *Hundertwasser*, Cologne,
1998

Restany, Karavan, 1997
Restany, P., *Dani Karavan*, Munich, 1997

Restany, Klein, 1982
Restany, P., *Yves Klein*, Paris, 1982

Restany, Klein, 1997
Restany, P. et al. (eds.), *Yves Klein*, Oslo,
1997

Revill, Cage, 1992
Revill, D., *The Roaring Silence: John Cage, a
life*, London, 1992

Rewald, Balthus, 1984
Rewald, S., *Balthus*, New York, 1984

Rewald, Cézanne, 1986
Rewald, J., *Paul Cézanne*, Cologne, 1986

Rewald, Manzù, 1967
Rewald, J., *Giacomo Manzù*, London, 1967

Rewald, Nachimpressionismus, 1986
Rewald, J., *Von van Gogh bis Gauguin. Die
Geschichte des Nachimpressionismus*,
Cologne, 1986

Rewald/Feilchenfeldt, Cézanne, 1997
Rewald, J. and W. Feilchenfeldt (eds.),
*The Paintings of Paul Cézanne. A Catalogue
Raisonné*, 2 vols., New York, 1997

Reynolds, LeWitt, 1993
Reynolds, J. (ed.), *Sol LeWitt. Twenty-Five
Years of Wall Drawings 1968–1993* (exh.
cat.), Addison Gallery of American Art,
Andover, Mass., 1993

Reynolds Morse, Dada, 1975
Reynold Morse, A., *Dada, Monograph of a
Movement*, London, 1975

Reynolds Morse, Dalí, 1974
Reynolds Morse, A., *Dalí, A Guide to his
Works in Public Museums*, Cleveland, 1974

Rheeden et. al., Citroën, 1994
van Rheeden, H./Feenstra, M. and B.
Rijkschroeff, *Paul Citroen Kunstenaar,
docent, verzamelaar*, Zwolle, 1994

Rhodes, Primitivism, 1994
Rhodes, C., *Primitivism and Modern Art*,
London and New York, 1994

Richards, London, 1981
Ceri Richards (exh. cat.), Tate Gallery,
London, 1981

Richardson, Newman, 1979
Richardson, B., *Barnett Newman The
Complete Drawings 1944–1969*, Baltimore,
1979

Richier, Antibes, 1985
Germaine Richier (exh. cat.), Musée
Picasso, Antibes, 1985

Richter, Dada, 1961
Richter, H., *Dada, Profile*, Zürich, 1961

Richter, London, 1991
Gerhard Richter (exh. cat.), Tate Gallery,
London, 1991

Richter, Räderscheidt, 1972
Richter, H., *Anton Räderscheidt*,
Recklinghausen, 1972

Rickey, Montreal, 1981
George Rickey (exh. cat.), Musée de l'art
contemporain, Montreal, 1981

Rickey, Paris, 1990
George Rickey (exh. cat.), Artcurial, Paris,
1990

Rickey, Washington, 1966
*George Rickey: Sixteen Years of Kinetic
Sculpture* (exh. cat.), Corcoran Gallery,
Washington D.C., 1966

Riedel, Worpswede, 1976
Riedel, K. V., "Worpswede im
Teufelsmoor bei Bremen" in *Deutsche
Künstlerkolonien und Künstlerorte* (ed.
Gerhard Wietek), Munich, 1976, pp.
100 ff.

Riese, Merz, 1996
Riese, U., *Gerhard Merz*, Zürich, 1996

Rigby, Hofer 1976
Rigby, I. K., *Karl Hofer*, New York, 1976

Riley, 1995
Bridget Riley. Dialogues on Art, London,
1995

Riley, London, 1973
*Bridget Riley. Paintings and Drawings
1961–1973* (exh. cat.), Arts Council of
Great Britain, London 1973

Ringgold, 1985
*Faith Ringgold: Painting, Sculpture,
Performance* (exh. cat.), Wooster, Ohio,
1985

Ringgold, 1998
*Dancing at the Louvre: Faith Ringgold's
French Collection and Other Story Quilts*
(exh. cat.), Berkeley, 1998

Riopelle, New York, 1989
Riopelle, Paintings from the Fifties (exh.
cat.), Pierre Matisse Gallery, New York,
1989

Rist, St. Gallen, 1994
*Pipilotti Rist. I'm not a Girl who Misses
Much* (exh. cat.), Kunstmuseum St.
Gallen, 1994

Ritchie, Charlton, 1992
Ritchie, C., *Charlton. Interventions*, (exh.
cat.), Art Gallery of Ontario, Toronto,
1992

Ritter, Masereel, 1992
Ritter, P. (ed.), *Frans Masereel. Eine
anotierte Bibliographie*, Munich, 1992

Rivera, Detroit, 1986
Diego Rivera, Retrospective (exh. cat.),
Detroit Art Institute, 1986

Rivière, Claudel, 1996
Rivière, A., Gaudichon, B. and D.
Ghanassia, *Camille Claudel: Catalogue
raisonné*, Paris, 1996

Robbins, Independent Group, 1990
Robbins, D (ed.), *The Independent Group:
Post-War Britain and the Aesthetics of
Plenty*, London, 1990

Roberts, 1996
Roberts, J., *Bill Woodrow*, (exh. cat.), Tate
Gallery, London, 1996

Roberts, London, 1984
William Roberts. An Artist and his Family
(exh. cat.), National Portrait Gallery,
London, 1984

Roberts, London, 1989
*William Roberts R. A. Paintings, Drawings
and Watercolours 1910–1978* (exh. cat.),
Albemarle Gallery, London, 1989

Roberts, Vortex, 1958
Roberts, W., *The Vortex Pamphlets,
1956–1958*, London, 1958

Roberts, Wood, 1996
Roberts, B., James Dennis, et al., *Grant
Wood: An American Master Revealed* (exh.
cat.), San Francisco, 1995

Robinson, Page, 1996
Robinson, M., "Page, Robin Bluebeard,"
in *Contemporary Artists*, Detroit, 1996,
pp. 880–82

Rochfort, Mexican Muralists, 1993
Rochfort, D., *Mexican Muralists: Orozco,
Rivera, Siqueiros*, London, 1993

Rodchenko, New York, 1989
Aleksandr Rodchenko (exh. cat.), The
Museum of Modern Art, New York, 1998

Rodchenko, Oxford, 1979
Rodchenko (exh. cat.), MOMA, Oxford,
1979

Rodriguez, Mexican Mural, 1969
Rodriguez, A., *A History of Mexican Mural
Painting*, London, 1969

Rodriguez, Rivera, 1989
Rodriguez, A., *Diego Rivera, Mural
Painting*, Mexico City, 1989

Roethel/Benjamin, Kandinsky, 1982/84
Roethel, H. K. and J. K. Benjamin,
*Kandinsky. Catalogue raisonné of the oil
paintings*, vol. 1, 1900–1921, vol. 2,
1922–1944, Munich, 1982/84

Rogers, Milles, 1940
Rogers, M. R., *Carl Milles: An
Interpretation of his Work*, New
Haven/London, 1940

Roh, Nach-Expressionismus, 1925
Roh, F., *Nach-Expressionismus. Magischer
Realismus. Probleme der neuesten
Europäischen Malerei*, Leipzig, 1925

Romain, Baschang, 1991
Romain, L., *Hans Baschang*, Krit.
Lexikon der Gegenwartskunst, Nr. 14,
München 1991

Romain, Gegenwartskunst, 1997
Romain, L. (ed.), *Künstler. Kritisches
Lexikon der Gegenwartskunst* 38th edition,
issue 18, Munich, 1997

Romero, 1990
Romero, M., *The Dance Sections*, Ghent,
1990

Ronte, Schober, 1993
Ronte, D. (ed.), *Helmut Schober.
Performance-Zeichnung-Malerei-Plastische
Projekte* (exh. cat.), Sprengel Museum
Hannover, Munich, 1993

Ronte/Zweite, Nitsch, 1988
Ronte, D., and A. Zweite (eds.), *Nitsch.
Das bildnerische Werk* (exh. cat.),
Städtische Galerie im Lenbachhaus
München, Munich/Salzburg/Vienna,
1988

Roos, De Chirico and Savinio, 1999
Roos, G., *Giorgio de Chirico and Alberto
Savinio, Verso un'arte nuova 1906–1911*,
Bologna, 1999

Rosand, Motherwell, 1996
Rosand, D. (eds.), *Robert Motherwell on
Paper. Drawings, Prints, Collages* (exh. cat.),
Museum of Modern Art, New York, 1996

Rose, Marden, 1995
Rose, B., *Brice Marden. Drawings*, New
York, 1995

Rose, Pollock, 1980
Rose, B. (ed.), *Jackson Pollock. Drawings
into Paintings* (exh. cat.), MOMA, New
York, 1980

Rosenberg, Gorky, 1962
Rosenberg, H., *Arshile Gorky. The Man, The
Time, The Idea*, New York, 1962

Rosenberg, Newman, 1978/1994
Rosenberg, H., *Barnett Newman*, New
York, 1978/1994

Rosenblum, Photography, 1984
Rosenblum, N., *A World History of
Photography*, New York, 1984

Rosenquist, London, 1982
Rosenquist: Paintings from the '60s (exh.
cat.), Mayor Gallery, London, 1982

Rosenquist, New York, 1972
James Rosenquist (exh. cat.), Whitney
Museum of American Art, New York,
1972

Rosenthal, Kiefer, 1987
Rosenthal, M., *Anselm Kiefer*, Chicago,
1987

Rosenthal, Rickey, 1977
Rosenthal, N., *George Rickey*, New York,
1977

Rosenthal/Fine, Johns, 1990
Rosenthal, N. and Fine, R.E., *Drawings of
Jasper Johns*, London, 1990

Rosenthal/Marshall, Borofsky, 1984
Rosenthal, M./Marshall, R. (eds.),
Jonathan Borofsky (exh. cat.),
Philadelphia Museum of Art, 1984

Ross, Abstract, 1990
Ross, C., *Abstract Expressionism: Creators
and Critics, An Anthology*, New York, 1990

Rosso, Milan, 1979
Mostra di Medardo Rosso (1858–1928) (exh.
cat.), Palazzo Permanente, Milan, 1979

Roters, Constructivism, 1967
Roters, E., *Avantgarde in Osteuropa
1910–1930* (exh. cat.), Akademie der
Künste, Berlin, 1967

Roth, Cologne, 1998
*Dieter Roth, Zeichnungen, Skulpturen und
Multiples*, Cologne, 1988

Roth, Passau, 1992
Dieter Roth (exh. cat.), Museum
Moderner Kunst, Passau, 1992

Rothenstein, Bacon, 1964
Rothenstein, J., *Francis Bacon* (catalogue
raisonné, documentation by R. Alley),
London, 1964

Rothenstein, Spencer, 1979
Rothenstein, J. (ed.), *Stanley Spencer*,
London, 1979

Rothko, London, 1987
Mark Rothko, 1903–1970 (exh. cat.), Tate
Gallery, London, 1987

Rotzler, Constructivism, 1977
Rotzler, W., *Konstruktive Konzepte. Eine
Geschichte der konstruktiven Kunst vom
Kubismus bis heute*, Zürich, 1977

Rotzler, Graeser, 1979
Rotzler, W., *Camille Graeser. Lebenswerk
und Lebensweg eines konstruktiven Malers*,
Zürich, 1979

Rotzler, Objektkunst, 1981
Rotzler, W., *Objektkunst. Von Duchamp bis
zur Gegenwart*, Cologne, 1981

Rouault, London, 1993
Rouault: The Early Years, 1903–1920 (exh.
cat.), Royal Academy of Arts, London,
1993

Rowell, Reinhardt, 1980
Rowell, M. (ed.), *Reinhardt and Color* (exh.
cat.), Solomon R. Guggenheim Museum,
New York, 1980

Roy, Nantes, 1966
Souvenir de Pierre Roy (exh. cat.), Musée
des Beaux-Arts, Nantes, 1966

Rubin, Cézanne, 1977
Rubin, W. (ed.), *Cézanne. The Late Work* (exh. cat..), Museum of Modern Art, New York, 1977

Rubin, Cubism, 1993
Rubin, W., *Picasso and Braque, Pioneering Cubism*, 2nd ed., New York, 1993

Rubin, Picasso, 1993
Rubin, W., *Picasso and Braque, Pioneering Cubism*, 2nd ed., New York, 1993

Rubin, Primitivism, 1988
Rubin, W. (ed.) *"Primitivism" in 20th-century Art, Affinity of the Tribal and the Modern*, 2 vols., New York, 1988

Rudloff, Marcks, 1993
Rudloff, M., *Gerhard Marcks und die Antike*, Bremen/Heidelberg, 1993

Ruff, Bonn, 1991
Thomas Ruff (exh. cat.), Bonner Kunstverein, Bonn, 1991

Ruhrberg, Mack, 1989
Ruhrberg, K. (ed.), *Sehverwandtschaften im Werk von Heinz Mack*, Stuttgart, 1989

Ruhrberg, Neo-Expressionismus, 1987
Ruhrberg, K., *Die Malerei unseres Jahrhunderts*, Düsseldorf, 1987

Ruscha, New York, 1992
Edward Ruscha. Stains 1971 to 1975 (exh. cat.), New York, 1992

Ruscha, Rotterdam, 1989–91
Edward Ruscha. Paintings (exh. cat.), Museum Boymans-van Beuningen, Rotterdam 1989–91

Russ, Werefkin, 1980
Russ, S. et al. (eds.), *Marianne von Werefkin. Gemälde und Skizzen* (exh. cat.), Landesmuseum, Wiesbaden, 1980

Russel, Nicholson, 1969
Russel, J. (ed.), *Ben Nicholson. Drawings, Paintings and Reliefs 1911–1968*, Berne, 1969

Russell, Jugendstil, 1981
Russell, F. (ed.), *Architektur des Jugendstils*, Stuttgart, 1981

Russell, Los Angeles, 1977
Morgan Russell (exh. cat.), Los Angeles County Museum of Art, 1977

Russett/Starr, Animation, 1976
Russett R., and C. Starr, *Experimental Animation*, New York, 1976

Rutter, 1927
Rutter, F., *Since I was Twenty-five*, London, 1927

Rychlik, Nitsch, 1986
Rychlik, O. (ed.), *Hermann Nitsch – Das früheste Werk*, Vienna, 1986

Ryman, London, 1977
Robert Ryman (exh. cat.), Whitechapel Art Gallery, London, 1977

Sabarsky, Heckel, 1995
Sabarsky, S., *Erich Heckel, Die frühen Jahre*, Salzweg bei Passau, 1995

Sabatier, Matta, 1975
Sabatier, S., *Matta. Catalogue raisonné de l'œuvre gravé (1934–1974)*, Paris, 1975

Sager, Photorealism, 1982
Sager, P., *Neue Formen des Realismus*, Cologne, 1982

Sager, Realismus, 1973
Sager, P., *Neue Formen des Realismus. Kunst zwischen Illusion und Wirklichkeit*, Cologne, 1973

Sainsaulieu, Manguin, 1980–
Sainsaulieu, M.-C., *Henri Manguin: catalogue raisonné de l'oeuvre peinte*, Neuchâtel, 1980–

Saint Phalle, Paris, 1993
Nikki de Saint Phalle (exh. cat.), Musée d'art moderne de la Ville de Paris, 1993

Salomon, Roussel, 1967
Salomon, J. K. X., *Roussel*, Paris, 1967

Saltzman, Kiefer, 1999
Saltzman, L., *Anselm Kiefer and art after Auschwitz*, Cambridge, 1999

Sandle, Liverpool, 1995
Michael Sandle: Memorials for the Twentieth Century (exh. cat.), Tate Gallery, Liverpool, 1995

Sandler, Abstract Expressionism, 1970
Sandler, I., *Abstract Expressionism: The Triumph of American Painting*, London, 1970

Sandler, Held, 1984
Sandler, I., *Al Held*, New York, 1984

Sandoz-Keller, Amiet, 1988
Sandoz-Keller, Geneviève, *Cuno Amiet, les Années Symbolistes 1897–1903*, Neuchâtel, 1988

Sanesi, Richards, 1973
Sanesi, R., *The Graphic Work of Ceri Richards*, Milan, 1973

Sanesi, Richter, 1975
Sanesi, R., *The Pictorial Language of Hans Richter*, Milan, 1975

Sanna, Rosso, Milan
de Sanna, J., *Medardoa Rosso o la creazione dello spazio moderno*, Milan, 1985

Sanouillet, Picabia, 1960–66
Sanouillet, M. (ed.), *Francis Picabia et '391'* 2 vols., Paris, 1960–66

Santini, Viani, 1990
Santini, P. C., *Alberto Viani*, Milan, 1990

Sarvig, Munch, 1980
Sarvig, O., *The Graphic Works of Edvard Munch*, Copenhagen, 1980

Sauvage, Fronte Nuovo, 1957
Sauvage T., *Pittura italiana del dopoguera*, Milan, 1957

Sauvage, Vlaminck, 1956
Sauvage, M., *Vlaminck. Sa vie et son message*, Geneva, 1956

Savinio, Milan, 1976
Alberto Savinio (exh. cat.), Palazzo Reale, Milan, 1976

Savinio, Rome, 1978
Alberto Savinio (exh. cat.), Palazzo delle Esposizioni, Rome, 1978

Sayre, Performance, 1989
Sayre, H., *The Object of Performance*, Chicago, 1989

SBZ/DDR 1945–90, 1996
Günter Feist, Eckhart Gillen and Beatrice Vierneisel (eds.), *Kunstdokumentation SBZ/DDR 1945–1990*, Cologne, 1996, pp. 728 ff.

Schaffner/Winzen, Deep Storage, 1997
Schaffner, J. and M. Winzen (eds.), *Deep Storage: Collecting, Storing, and Archiving in Art*, Munich, 1997

Schampers, On Kawara, 1991
Schampers, K. (ed.), *On Kawara. Date Paintings in 89 Cities* (exh. cat.), Museum Boymans-van Beuningen, Rotterdam, 1991

Schapiro, New York, 1986
Miriam Schapiro (exh. cat.), Bernice Steinbaum Gallery, New York, 1986

Schapiro, St. Louis, 1985
Miriam Schapiro: Femmages, 1971–1985 (exh. cat.), Brentwood Gallery, St. Louis, 1985

Scharf, 1998
Kenny Scharf (exh. cat.) University Galleries, Illinois State University, 1998

Scheler, List, 1999
Scheler, Max (ed.), *Herbert List*, Munich, 1999.

Schell, Albers, 1989
Schell, Maximilian, *Anni und Josef Albers. Eine Retrospektive*, Villa Stuck, Munich, 1989

Schellmann, Christo, 1988
Schellmann, J. (ed.), *Christo. Prints and Objects 1963–87*, Munich, 1988

Schiefler, Kirchner, 1926/31
Schiefler, G., *Die Graphik E. L. Kirchners*, Berlin, 1926/31

Schiefler/Mosel, Nolde, 1995
Schiefler, G., and C. Mosel (eds.), *Emil Nolde. Das graphische Werk* 2 vols. (Berlin 1927), Cologne, 1966/67, 1995

Schilling, Mataré, 1987
Schilling, S. M., *Ewald Mataré. Das plastische Werk. Werkverzeichnis*, Cologe, 1987

Schilling, Vostell, 1980
Schilling, J. (ed.), *Wolf Vostell. Decollagen, Verwischungen, Schichtenbilder, Bleibilder, Objektbilder 1955–1979* (exh. cat.), Kunstverein, Brunswick, 1980

Schimmel, Polke, 1995
Schimmel, P., *Sigmar Polke – Photoworks, When Pictures Vanish* (exh. cat.), Los Angeles Museum of Contemporary Art, 1995

Schimmel/Noever, Out of Actions, 1998
Schimmel, P. and P. Noever, *Out of Actions. Zwischen Performance und Objekt 1949–1979* (exh. cat.), Museum of Contemporary Art, Los Angeles, 1998

Schippers, Dada, 1974
Schippers, K., *Holland Dada*, Amsterdam, 1974

Schlieker, Carrington, 1991
Schlieker, A. (ed.), *Leonora Carrington, Paintings, drawings and sculptures 1940–1990* (exh. cat.), London, 1991.

Schmalenbach, Bissier, 1987
Schmalenbach, W., *Julius Bissier, Tuschen und Aquarelle*, Berlin, 1987

Schmalenbach, Bissier, 1993
Schmalenbach, W. (ed.), *Julius Bissier* (exh. cat.), Kunstsammlung Nordrhein-Westfalen, Düsseldorf, 1993

Schmalenbach, Chagall, 1979
Schmalenbach, W. and C. Sorlier, *Marc Chagall*, Frankfurt/Berlin/Vienna, 1979

Schmalenbach, Léger, 1991
Schmalenbach, W., *Fernand Léger*, Cologne, 1991

Schmalenbach, Modigliani, 1990
Schmalenbach, W., *Amadeo Modigliani: Paintings, Sculptures, Drawings*, Munich, 1990

Schmeckebier, Curry, 1943
Schmeckebier, Laurence E., *John Steuart Curry's Pageant of America*, New York, 1943

Schmidt, Ausgebürgert,1990
W. Schmidt (ed.), *Ausgebürgert, Künstler aus der DDR 1949–1989* (exh. cat.), Albertinum, Dresden, 1990

Schmied, Bacon, 1996
Schmied, W., *Francis Bacon, Commitment and Conflict*, Munich, 1996

Schmied, Deutsche Kunst, 1975
Schmied, W., *Deutsche Kunst seit 1945*, Munich, 1975

Schmied, Heldt, 1974
Schmied, W., *Malerei nach 1945. In Deutschland, Österreich und der Schweiz*, Frankfurt a. M. et al., 1974

Schmied, Heldt, 1976
Schmied, W., *Werner Heldt*. (With catalogue raisonné by Eberhard Seel), Cologne, 1976

Schmied, Hoflehner, 1988
Schmied, W., *Rudolf Hoflehner. Wandel und Kontinuität*, Stuttgart, 1988

Schmied, Hopper, 1995
Schmied, W., *Edward Hopper – Bilder aus Amerika*, Munich 1995

Schmied, Hundertwasser, 1964
Schmied, W. (ed.), *Hundertwasser. Œuvre-Katalog*, Hanover 1964

Schmied, Kubin, 1967
Schmied, W., *Der Zeichner Alfred Kubin*, Salzburg, 1967

Schmied, Mack, 1998
Schmied, W. (ed.), *Utopie und Wirklichkeit im Werk von Heinz Mack*, Cologne, 1998

Schmied, Magischer Realismus, 1969
Schmied, W., *Neue Sachlichkeit und Magischer Realismus in Deutschland 1918–1933*, Hanover, 1969

Schmied, Music, 1995
Schmied, W. (ed.), *Zoran Music. Die späten Jahre* (exh. cat.), Bayer. Akademie der Schönen Künste, Munich, 1995

Schmied, Neue Sachlichkeit, 1969
Schmied, W., *Neue Sachlichkeit und Magischer Realismus in Deutschland 1918–1933*, Hanover, 1969

Schmied, Oelze, 1987
Schmied, W. (ed.), *Richard Oelze 1900–1980. Gemälde und Zeichnungen*, Berlin, 1987

Schmied, Vostell, 1992
Schmied, W., *Die fünf Hämmer des Wolf Vostell*, Berlin, 1992

Schmoll, Claudel, 1994
Schmoll, J. A., *Rodin und Camille Claudel*, Munich, 1994

Schmoll-Eisenwerth, Belling, 1985
Schmoll-Eisenwerth, J. A., *Rudolf Belling (Studien zur Kunstgeschichte)*, Munich, 1985

Schneckenburger, Documenta, 1983
Schneckenburger, M., *documenta. Idee und Institution*, Munich, 1983

Schneede, Boccioni, 1994
Schneede, U., *Umberto Boccioni*, Stuttgart, 1994

Schneede, Magritte, 1982
Schneede, U. M., *René Magritte, Life and Work*, Woodbury NY, 1982

Schneede, Verism, 1979
Schneede, U. M., *Die zwanziger Jahre, Manifeste und Dokumente deutscher Künstler*, Cologne, 1979

Schneemann, Schneemann, 2000
Schneemann, Carolee, Dan Cameron, and Christine Stiles, *Carolee Schneemann: Up to and Including Her Limits*, 2000

Schneemann, Works and Writings, 1997
Schneemann, Carolee, and Bruce McPherson (eds.), *More than Meat Joy: Performance Works and Selected Writings*, New York, 1997

Schneider, Giacometti, 1994
Schneider, A. (ed.), *Alberto Giacometti: Skulpturen, Gemälde, Zeichnungen*, München, 1994

Schneider, Matisse, 1984
Schneider, P., *Henri Matisse*, London, 1984

Schneidler, Pfeuffer, 1995
Schneidler, H. (ed.), *Helmut Pfeuffer. Die Gestalt der Natur – die Natur der Gestalt; verkörperlichte Bildräume; Arbeiten auf Papier 1984–94* (exh. cat.) Städtische Galerie Regensburg, 1995

Schodek, Structure, 1993
Schodek, D. L., *Structure in Sculpture*, Cambridge, 1993

Schönemann, Mattheuer, 1988
Schönemann, H., *Wolfgang Mattheuer*, Leipzig, 1988

Schor, Medusa Redux, 1990
Schor, M., "Medusa Redux, Ida Applebroog, and the Spaces of Post-Modernity," in *Artforum*, 28, 7, 1990

Schreiber/Asmus, 1972
Schreiber, A. B., and B. Asmus, *Werkverzeichnis Dieter Asmus 1965–72*, Hamburg, 1972

Schröder, Gerstl, 1993
Schröder, K. A., *Richard Gerstl 1883–1908* (exh. cat.), Kunstforum der Bank Austria Wien, Vienna, 1995

Schröder/Winkler, Kokoschka, 1991
Schröder, K.-A., and J. Winkler (eds.), *Oskar Kokoschka*, Munich, 1991

Schubert, Lehmbruck, 1990
Schubert, D., *Die Kunst Wilhelm Lehmbrucks*, Worms/Dresden, 1990

Schuchter, Bloch, 1991
Schuchter, M, *Albert Bloch*, (diss.), Innsbruck, 1991

Schuler, Weibel, 1996
Schuler, R. (ed.), *Peter Weibel. Bildwelten 1982–1996*, Vienna, 1996

Schult, Barlach, 1958–71
Schult, F., *Ernst Barlach Werkverzeichnis I – II*, Hamburg 1958–71

Schultz, Chryssa, 1990
Schultz, D.G., *Chryssa Cityscapes*, London/New York, 1990

Schultze, Jawlensky, 1970
Schultze, A., *Alexej Jawlensky*, Cologne, 1970

Schulz, Knoebel, 1998
Schulz, M., *Imi Knoebel. Die Tradition des gegenstandslosen Bildes*, Munich, 1998

Schulz-Hoffmann, Bevan, 1993
Schulz-Hoffmann, C., *Tony Bevan*, Munich, 1989

Schulz-Hoffmann et. al., Cucchi, 1987
Schulz-Hoffmann, C. and U. Weisner (eds.), *Enzo Cucchi. Guida al disegno* (exh. cat.), Kunsthalle Bielefeld/Staatsgalerie moderner Kunst München, Munich, 1987

Schulze, Music, 1997
Schulze, S., *Zoran Music* (exh. cat.), Schirn Kunsthalle Frankfurt, Ostfildern, 1997

Schuster, Geiger, 1988
Schuster, P.-K. (ed.), *Rupprecht Geiger* (exh. cat.), Staatsgalerie Moderner Kunst im Haus der Kunst, Munich, 1988

Schuster, Grosz, 1994
Schuster, P.-K. (ed.), *George Grosz. Berlin-New York* (exh. cat.), Neue Nationalgalerie, Berlin, 1994

Schwarz, Aktionismus, 1960
Schwarz, D., *Von der Aktionsmalerei zum Aktionismus*, Vienna, 1960

Schwarz, Duchamp, 1969
Schwarz, A., *The Complete Works of Marcel Duchamp*, London/New York, 1969

Schwarz, Gerz, 1975
Schwarz, M. (ed.), *Jochen Gerz. Foto, Texte, The French Wall & Stücke*, (exh. cat.), Badischer Kunstverein, Karlsruhe, 1975

Schwarz, Man Ray, 1977
Schwarz, A., *Man Ray: the Rigour of Imagination*, London, 1977

Schwarz, Martin, 1992
Schwarz, D. (ed.), *Agnes Martin, Writings/Schriften*, Winterthur, 1992

Schwarzkogeler, Klagenfurt, 1989
Der Zertrümmerte Spiegel: Wiener Aktionismus (exh. cat.) Museum Ludwig, Klagenfurt, 1989

Schwedische Kunst, Nuremberg, 1970
Licht, Objekt, Bewegung, Raum. Schwedische Kunst (exh. cat.), Kunsthalle, Nuremberg, 1970

Schweiger, Wiener Werkstätte, 1984
Schweiger, W. J., *Wiener Werkstätte: Design in Vienna*, London, 1984

Schwenk, Palermo, 1991
Schwenk, B., *Studien zur Person und zum Werk des Malers Blinky Palermo*, Bonn, 1991

Scipione, Macerata, 1985
Scipione 1904–33 (exh. cat.), Palazzo Ricci, Macerata, 1985

Scott, Delvaux, 1992
Scott, D., *Paul Delvaux. Surrealizing the Nude*, London, 1992

Scudiero/Liber, Depero, 1981
Scudiero, M. and D. Liber (eds.), *Depero Futurista + New York* (exh. cat.), Musei Civici, Galleria Museo Depero, Rovereto, 1981

Sculpture, New York, 1986
Sculpture for Public Spaces. Maquettes, Models, and Proposals (exh. cat.), New York, 1986

Seeba, Radziwill, 1995
Seeba, W., *Franz Radziwill. Magie der Städte*, Bremen, 1995

Seigel, Duchamp, 1997
Seigel, J., *The Private World of Marcel Duchamp*, Berkeley, 1997

Seitz, Abstract, 1983
Seitz, W., *Abstract Expressionism in America*, Cambridge Mass., 1983

Seitz, Responsive Eye, 1965
Seitz, W. C. (ed.), *The Responsive Eye* (exh. cat.), MOMA, New York, 1965

Seligman, La Fresnaye, 1969
Seligman, G. (ed.), *Roger de La Fresnaye. Avec le catalogue raisonné de l'œuvre*, Neuchâtel, 1969

Sello, Spiegelbilder, 1982
Sello, K., *Spiegelbilder*, Hanover 1982

Selz, Expressionism, 1957
Selz, P., *German Expressionist Painting*, Berkeley, 1957

Selz, Francis, 1982
Selz, P., *Sam Francis* (2nd ed.), New York, 1982

Sembach, H. van de Velde, 1989
Sembach, K.J., *Henry van de Velde*, London, 1989

Sembach, Jugendstil, 1990
Sembach, K.-J., *Jugendstil*, Cologne, 1990

Semin, Boltanski, 1988
Semin, D., *Boltanski*, Paris, 1988

Semin, Boltanski, London 1997
Semin, D. u.a., *Christian Boltanski*, London 1997

Sensation, London, 1997
Sensation: Young British Art from the Saatchi Collection (exh. cat.), Royal Academy of Arts, London, 1997

Serota, Andre, 1978
Serota, N. (ed.), *Carl Andre: Sculpture 1950–1978* (exh. cat.), Whitechapel Art Gallery, London, 1978

Serrano, Cardenás, 1983
Serrano, E., *The Art of Santiago Cardenás* (exh.cat.), Francis Wolfson Art Gallery, Miami, 1983

Seuphor, Cercle et Carré, 1971
Seuphor, M. (ed.), *Cercle et Carré*, Paris, 1971

Seven Moscow Artists, Cologne, 1984
Seven Moscow Artists 1910–30 (exh. cat.), Gmurzynska Galerie, Cologne, 1984

Sgarbi, Botero, 1991
Sgarbi V., *Fernando Botero – Dipinti, Sculture, Disegni*, Milan, 1991

Sgarbi, Gnoli, 1983
Sgarbi, V., *Gnoli*, Milan, 1983

Shanahan, Evidence, 1994
Shanahan, Mary (ed.) *Evidence 1944–1994, Richard Avedon*, Munich, 1994

Shapiro, Social Realism, 1973
Shapiro, D., *Social Realism: Art as a Weapon*, New York, 1973

Shattuck, Rousseau, 1985
Shattuck, R. et al. (ed.), *Henri Rousseau* (exh. cat.), MOMA, New York, 1985

Sheehan, Indiana, 1991
Sheehan, S., *Robert Indiana prints: a catalogue raisonné 1951–1991*, New York, 1991

Shone, Bloomsbury, 1996
Shone, R., *Bloomsbury Portraits*, London, 1976 (rpt. 1996)

Shone, Grant, 1976
Shone, R., *Duncan Grant*, London, 1976

Sichel, Krull, 1999
Sichel, K., *Germaine Krull: The Art of the Photographer*, Ann Arbor, 1999

Siepmann, Heartfield, 1977
Siepmann, E., *Montage: John Heartfield. Vom Club Dada zur Arbeiter-Illustrierten-Zeitung*, Berlin, 1977

Silber, Epstein, 1986
Silber, E., *The Sculpture of Jacob Epstein*, Oxford, 1986

Silber, Gaudier-Brzeska, 1996
Silber, E., *Gaudier-Brzeska: Life and Art*, London/New York, 1996

Simmons, Malevich, 1981
Simmons, W. S. *Kasimir Malevich's Black Square and the Genesis of Suprematism, 1907–1915*, New York, 1981

Singer, LeWitt, 1984
Singer, S. (ed.), *Sol LeWitt. Wall Drawings 1968–1984* (exh. cat.), Stedelijk Museum, Amsterdam, 1984

Sinker, 1997
Sinker, Mark, *Fifty Years of the Future. A Chronicle of the Institute of Contemporary Arts 1947–1997*, London, 1997

Sironi, 1980
Sironi, M., *Scritti editi e inediti* (ed. E. Camesasca), Milan, 1980

Smith, Art as Politic, 1978
Smith., A. C., *Art as Politic: The Abstract Expressionist Avantgarde*, Ann Arbor, 1978

Smith, Craft, 1986
Smith, Paul S., *Craft Today: Poetry of the Physical*, New York, 1986

Smith, Judd, 1975
Smith, B., *Donald Judd. Catalogue raisonné of Paintings, Objects and Wood-Blocks 1960–1974* (exh. cat.), National Gallery of Canada, Ottawa, 1975

Sobelmann, Cane, 1990
Sobelmann, I., *ibid., vol.II: 1986–90*, Paris, 1990

Soby, De Chirico, 1955
Soby, J. T., *Giorgio de Chirico*, The Museum of Modern Art, New York, 1955

Söhn, Felixmüller, 1977
Söhn, G., *Conrad Felixmüller. Von ihm, über ihn*, Düsseldorf, 1977

Söhn, Felixmüller, 1987
Söhn, G., *Conrad Felixmüller. Das graphische Werk*, Düsseldorf, 1987

Soffici, Macerata, 1988
Ardengo Soffici, 1879–1964 (exh. cat.), Pinacoteca Comunale, Macerata, 1988

Sollers, Cane, 1986
Sollers, P., *Cat. raisonné des sculptures de Louis Cane*, vol. I: 1978–85, Paris, 1986

Solway/Lawson, Oldenburg, 1991
Solway, A., and T. Lawson (eds.), *Claes Oldenburg. Multiples in Retrospect 1964–1990*, New York, 1991

Sonfist, Art in the Land, 1983
Sonfist, A. (ed.), *Art in the Land. A Critical Anthology of Environmental Art*, New York, 1983

Spalding, Barker, 1982
Spalding, F., "Clive Barker," in *Arts Review* 34, 1982 (2), p. 22

Spalding, Grant, 1998
Spalding, F., *Duncan Grant, A Biography*, London, 1998

Spalding, Minton, 1991
Spalding, F., *Dance till the Stars Come Down: A Biography of John Minton*, London, 1991

Spate, Orphism, 1979
Spate, V., *Orphism. The Evolution of Non-Figurative Painting in Paris 1910–1914*, Oxford, 1979

Spengler, Carrington, 1995
Spengler, T. (ed.), *Leonora Carrington, Apropos*, Frankfurt a. M., 1995

Spielmann, Felixmüller, 1996
Spielmann, H., *Conrad Felixmüller* [paintings catalogue], Cologne, 1996

Spies, Botero, 1986
Spies, W. (ed.), *Fernando Botero*, Munich, 1986

Spies, Christo, 1984
Spies, W., *Surrounded Islands*, Cologne, 1984

Spies, Ernst, 1986
Spies, W., *Max Ernst frottages*, London, 1986

Spies, Ernst, 1991
Spies, W. (ed.), *Max Ernst*, (exh. cat.), Tate Gallery London, 1991

Spies, Ernst, 1999
Spies, W., (ed.), *Max Ernst – Die Retrospektive*, (exh. cat.), Neue Nationalgalerie Berlin/Haus der Kunst München, Cologne, 1999

Spies, Ernst, Collages, 1991
Spies, W., *Max Ernst, Collages, the Invention of the Surrealist Universe*, London, 1991

Spies, Frottage, 1986
Spies, W., *Max Ernst: Frottages*, London, 1986

Spies, Lindner, 1980
Spies, W., *Lindner*, Paris, 1980

Spies, Picasso, 1972
Spies, W., *Les Sculptures de Picasso*, Lausanne/Paris, 1972

Spies/Loyall, Lindner, 1999
Spies, W. and C. Loyall (eds) *Richard Lindner. Catalogue raisonné of Paintings, Watercolors and Drawings*, Munich, 1999

Spike, Porter, 1992
Spike, J. T., *Fairfield Porter: An American Classic*, New York, 1992

Squirru, Kosče, 1990
Squirru, R., et al., *Kosče*, Buenos Aires, 1990

Štyrský, Hamburg, 1990
Tschechische Avantgarde 1922–1940 (exh. cat.), Kunstveriein in Hamburg, 1990

Štyrský, Paris, 1982
Štyrský, Toyen, Heisler (exh. cat.), Musée National d'Art Moderne, Centre Georges Pompidou, Paris, 1982

Štyrský, Paris, 1997
Les Années trente en Europe. Le temps menaçant (exh. cat.), Musée d'art moderne de la ville de Paris, 1997

Stabenow, Turcato, 1985
Stabenow, C. (ed.) *Giulio Turcato* (exh. cat.), Staatsgalerie Moderner Kunst, Munich, 1985

Staber, Taeuber-Arp, 1970
Staber, M., *Sophie Taeuber-Arp*, Lausanne, 1970

Stallabrass, High Art Lite, 2000
Stallabrass, Julian, *High Art Lite*, London, 2000

Stals, Zush, 1997
Stals, J. L., *Zush*, Barcelona, 1997

Stangos, Hockney, 1993
Stangos, N. (ed.), *David Hockney. That's the Way I See It*, London, 1993

Stasny, Hirschfeld-Mack, 1993
Stasny, P., *Ludwig Hirschfeld-Mack (1893–1965). Bauhausgeselle in Weimar. Ein Beitrag zur Bauhausforschung*, (diss.) Vienna, 1993

Stauffer, Duchamp, 1995
Stauffer, S., *Marcel Duchamp. Die Schriften*, Zürich, 1981

Steadman, Design, 1979
Steadman, P., *The Evolution of Designs: Biological Analogy in Architecture and the Applied Arts*, Cambridge, 1979

Stecker, Riley, 2000
Stecker, R., et al., *Bridget Riley: Selected Paintings 1961–99*, Ostfildern, 2000

Steingräber, Burri, 1980
Steingräber, E. (ed.), *Alberto Burri. Il Viaggio* (exh. cat.), Staatsgalerie Moderner Kunst, Munich, 1980

Stemmler, Droese, 1988
Stemmler, D. (ed.), *Felix Droese – Haus der Waffenlosigkeit/Bundesrepublik Deutschland*, Düsseldorf, 1988

Stich, Klein, 1994
Stich, S. (ed.) *Yves Klein*, London, 1994

Stokvis, Cobra, 1988
Stokvis, W., *Cobra: an International Movement in Art after the Second World War*, New York, 1988

Stooss, Giacometti, 1996
Stooss, T., Elliott, P. and C. Doswald (eds.), *Alberto Giacometti 1901–1966*, (exh. cat.), Kunsthalle Wien, Ostfildern,1996

Storr, Close, 1998
Storr, R., *Chuck Close*, New York, 1998

Storr, de Kooning, 1996
Storr, R., and G. Garells (eds.), *Willem de Kooning. The Late Paintings* (exh. cat.), San Francisco Museum of Modern Art, San Francisco, 1995

Storr, Guston, 1986
Storr, R., *Philip Guston*, New York, 1986

Storr, Ryman, 1993
Storr, R. (ed.), *Robert Ryman* (exh. cat.), Tate Gallery, London, 1993

Strick, Newman, 1994
Strick, J. (ed.), *The Sublime is Now. The Early Work of Barnett Newman. Paintings and Drawings 1944–1949* (exh. cat.), Pace Wildenstein Gallery, New York, 1994

Strigaljow, Agitprop, 1996
Strigaljow, A., "Agitprop: Die Kunst extremer politischer Situationen," in Anatonowa, I., and J. Merkert (eds), *Berlin Moskau 1900–1950*, (exh. cat.), Martin-Gropius-Bau Berlin, 1996

Stuard, Capa, 1960
Stuard, J. and J. Steinbeck, *Robert Capa: War Photographs*, Washington D.C., 1960

Stüttgen, Knoebel, 1991
Stüttgen, J., *Der Keilrahmen des Imi Knoebel 1968/89*, Cologne, 1991

Sultan, Chicago, 1987
Donald Sultan (exh. cat.), Museum of Contemporary Art, Chicago, 1987

Survage, 1992
Survage, L., *Ecrits sur la peinture*, Paris, 1992

Sussman, Kelley, 1995
Sussman, E. (ed.), *Mike Kelley. Catholic Tastes* (exh. cat.), Whitney Museum of American Art, New York, 1993

Sussmann/Armstrong, Goldin, 1996
Sussmann, E. and D. Armstrong (eds.), *Nan Goldin, I'll be your mirror* (exh. cat.), Whitney Museum of American Art, New York, 1996

Svanberg, Malmö, 1979
Max Walter Svanberg (exh. cat.), Konsthall, Malmö, 1979

Svestka, Turrell, 1991
Svestka, J. (ed.), *James Turrell. Perceptual Cells* (exh. cat.), Kunstverein für die Rheinlande und Westfalen, Düsseldorf, 1991

Sylvester, Bacon, 1982
Sylvester, David, *Conversations with Francis Bacon*, London, 1975

Sylvester, Bomberg, 1973
Sylvester, D., *Bomberg – Paintings, Drawings, Watercolours, Lithographs* (exh. cat.), Fischer Fine Art, London, 1973

Sylvester, Giacometti, 1994
Sylvester, D., *Looking at Giacometti*, London, 1994

Sylvester, Kitchen Sink, 1954
Sylvester, D., "The Kitchen Sink," in *Encounter III/15*, 1954, pp. 61–64

Sylvester, Magritte, 1992–96
Sylvester, D. and S. Whitfield, *René Magritte. Catalogue raisonné*, 6 vols., Antwerp and London, 1992–96

Systematic Painting, New York, 1966
Systematic Painting (exh. cat.), Solomon R. Guggenheim Museum, New York, 1966

Szarkowski (ed.), Callahan, 1976
Szarkowski, J (ed.), *Callahan*, New York, 1976

Szarkowski, Evans, 1971
Szarkowski, J. (intro.), *Walker Evans*, New York, 1971

Szeemann, Attitudes, 1969
Szeemann, H. (ed.), *When Attitudes Become Form*, (exh, cat,), Kunsthalle, Berne, 1969

Szeemann, Beuys, 1993
Szeemann, H., *Beuys* (exh. cat.), Kunsthaus Zürich, Zürich, 1993

Szeemann, Merz, 1985
Szeemann, H. et al. (eds.), *Mario Merz*, 2 vols. (exh. cat.), Kunsthaus Zürich 1985

Szeemann, Paolini, 1980
Szeemann, H. et al. (eds.), *Giulio Paolini* (exh. cat.), Stedelijk Museum Amsterdam et al., Amsterdam, 1980

Szeemann, Twombly, 1987
Szeemann, H., *Cy Twombly* (exh. cat.), Kunsthalle Zürich, Munich, 1987

Taaffe, 1993
Philip Taaffe, New York (exh. cat.), Center of the Fine Arts, Miami, 1993

Taaffe, 1996
Philip Taaffe's Imaginary City (exh. cat.), Wiener Secession, Vienna, 1996

Taal-Teshuva, Christo, 1993
Taal-Teshuva, J., *Christo: The Reichstag and Urban Projects*, Munich, 1993

Taeuber-Arp, Strasbourg, 1977
Sophie Taeuber-Arp (exh. cat.), Musée des Beaux-Arts, Strasbourg, 1977

Taillandier, Beaudin, 1965
Taillandier, Y., "André Beaudin," in *Connaissance des arts*, 1965, no. 161, pp. 38–43

Tanchis, Munari, 1987
Tanchis, A., *Bruno Munari, Design as Art*, Cambridge Mass., 1987

Tanguy, 1995
Yves Tanguy, druide surréaliste, Paris, 1995

Tanguy, Paris, 1982
Yves Tanguy (exh. cat.), Musée d'art moderne de la Ville de Paris, Centre Pompidou, 1982

Taplin, 1994
Taplin, R., "Judy Fox at PPOW," in *Art in America* 1994, no. 5

Tarsila, 1982
Tarsila – obras 1920/1930, São Paulo, IBM do Brasil, 1982

Tasende, Cuevas, 1991
Tasende, J. M. (ed.), *Twenty Years with José Luis Cuevas* ,(exh. cat.), Tasende Gallery, La Jolla, 1991

Tatlin, Cologne, 1993
Vladimir Tatlin. Retrospektive (exh. cat.), Städtische Kunsthalle Düsseldorf, Cologne, 1993

Taubman, John, 1985
Taubman, M., *Gwen John: The Artist and her Work*, New York, 1985

Taylor, Evergood, 1987
Taylor, K., *Philip Evergood: Never Separate from the Heart*, Ludwigsburg, 1987

Tazzi, Deacon, 1995
Tazzi, Pier Luigi, et al., *Richard Deacon*, London, 1995

Teige, Frankfurt, 1998
Karel Teige. Liquidierung der 'Kunst'. Analysen, Manifeste, Frankfurt am Main, 1998

Teige, Houston, 1990
Czech Modernism: 1900 –1945 (exh. cat.), The Museum of Fine Arts, Houston, 1990

Teige, Prague, 1994
Karel Teige. Surrealist Collages 1935–1951. From the Collections of the Museum of National Literature in Prague, Prague, 1994

Temkin, Levine, 1993
Temkin, A. (ed.), *Sherrie Levine. Newborn* (exh. cat.), Philadelphia Museum of Art, 1993

Terrasse, Bonnard, 1989
Terrasse, A., *Pierre Bonnard*, Cologne, 1989

Terrasse, Delvaux, 1972
Terrasse, A., *Paul Delvaux*, Berlin, 1972

Theewen, Boltanski, 1996
Theewen, C. (ed.), *Confusion – Selection: Gespräche und Texte über Bibliotheken, Archive, Depots von und mit Christian Boltanski*, Cologne, 1996

Thevoz, Dubuffet, 1986
Thevoz, M., *Jean Dubuffet*, Geneva, 1986

Thiel, 1994
Frank Thiel. Fotografie (exh. cat.), Institut für Auslandsbeziehungen, Stuttgart, 1994

Thomas, Bill, 1993
Thomas, A., *Max Bill*, Biel, 1993

Thomas, Kruger, 1988
Thomas, G. (ed.) *Barbara Kruger* (exh. cat.), National Art Gallery, Wellington, 1988

Thomson, Vuillard, 1988
Thomson, B., *Vuillard*, Oxford, 1988

Tibol, Kahlo, 1993
Tibol, R., *Frida Kahlo: an Open Life*, Alberquerque, 1993

Tinguely, Basel, 1996
Museum Jean Tinguely Basel, 2 vols., Berne, 1996

Tisdall, Beuys, 1976
Tisdall, C., *Joseph Beuys, coyote*, Munich, 1976

Tobey, Washington, 1974
Tribute to Mark Tobey (exh. cat.), Smithsonian Institution, Washington D.C., 1974

Tomasello, 1976
Luis Tomasello (exh. cat.), Musée d'Art Moderne de la Ville de Paris, Paris, 1976

Tomasello, 1991
Luis Tomasello (exh. cat.), Centre Noroît, Arras, 1991

Tomii, Rickey, 1988
Tomii, R., *Between Two Continents: George Rickey. Kinetic Art and Constructivism 1949–1968*, Ann Arbor, 1988

Tomkins, Lichtenstein, 1988
Tomkins, C., *Roy Lichtenstein: Mural with Blue Brushstroke*, New York, 1988

Tomkins, Rauschenberg, 1980
Tomkins, C., *Off the Wall, Robert Rauschenberg and the Art World of our Time*, Garden City NY, 1980

Torczyner, Magritte, 1979
Torczyner, H., *Magritte: the True Art of Painting*, London, 1979

Torres-García, London, 1985
Torres-García, Grid-Pattern-Sign (exh. cat.), Hayward Gallery, London, 1985

Torres-García, Madrid, 1991
Torres-García (exh. cat.), Museo Nacional Centro de Arte Reina Sofia, Madrid, 1991

Torruella Leval et al., Azaceta, 1991
Torruella Leval, S., P. Yenawine, and I. Sheppard, *Luis Cruz Azaceta: The AIDS Epidemic Series* (exh. cat.), The Queens Museum of Art, Queens, 1991

Trapp, Blume, New York, 1987
Trapp, F., *Peter Blume*, New York, 1987

Tremlett, Paris, 1985
David Tremlett. Rough Ride (exh. cat.), Musée national d'Art moderne, Centre Georges Pompidou, Paris, 1985

Tricot, Ensor, 1992
Tricot, X. (ed.), *James Ensor. Catalogue raisonné des peintures, I – II*, Antwerp, 1992

Tricot, Spilliaert, 1996
Tricot, X., *Léon Spilliaert*, Ghent, 1996

Trini, Concept, 1971
Trini, T. (ed.), *Concept and Concept. An Anthology on Conceptual Art*, Milan, 1971

Trockel, London, 1998
Rosemarie Trockel, Werkgruppen 1986–1998 (exh. cat.), Whitechapel Art Gallery, London, 1998

Truitt, Daybook, 1982
Truitt, Anne, *Daybook: The Journal of an Artist*, New York, 1982

Tsujimoto,Thiebaud, 1985
Tsujimoto, K., *Wayne Thiebaud* (exh. cat.), San Francisco, Museum of Modern Art, Seattle/London, 1985

Tuchman/Barron, Hockney, 1988
Tuchman, M. and S. Barron (ed.), *David Hockney. Eine Retrospektive* (exh.cat.), County Museum of Art, Los Angeles et al., Cologne, 1988

Tucker, Davie, 1994
Tucker, M. (ed.), *Alan Davie: the Quest for the Miraculous*, London, 1994

Tucker, Melbourne, 1998
Albert Tucker. 50 Years of Photographs (exh. cat.), Lauraine Diggins Fine Art, Melbourne, 1998

Tucker, Washington, 1984
William Tucker: Sculptures 1974–84 (exh. cat.), Hirshhorn Museum, Washington D. C., 1984

Tübke, Bad Frankenhausen, 1999
Werner Tübke. Das malerische Werk 1976–1999 (exh. cat.), Panorama Museum Bad Frankenhausen, Dresden/Amsterdam, 1999

Türr, Optical Art, 1986
Türr, K., *Optical Art. Ornament oder Experiment?*, Berlin, 1986

Turnbull, 1996
William Turnbull. Sculpture and Paintings (exh. cat.), Serpentine Gallery, London, 1996

Turrell, London, 1993
James Turrell, Air Mass (exh. cat.), Hayward Gallery, London, 1993

Tuten, Lichtenstein, 1989
Tuten, F., *Roy Lichtenstein. The Bronze Sculpture 1976–1989*, New York, 1989

Tuttle, Amsterdam, 1992
Richard Tuttle: the Poetry of Form. Drawings from the Vogel collection (exh. cat.), Institute of Contemporary Art, Amsterdam, 1992

Twombly, New York, 1994
Cy Twombly, a Retrospective (exh. cat.), MOMA, New York, 1994

Tworkow, New York, 1964
Jack Tworkow (exh. cat.), Whitney Museum of American Art, New York, 1964

Tworkow, Philadelphia, 1987
Jack Tworkow Paintings, 1928–82 (exh. cat.), Academy of Fine Art, Philadelphia, 1987

Tzara, Œuvres Complètes, 1975–82
Œuvres Complètes, 6 vols., Paris, 1975–82

Uelsberg, Dortmund, 1996–97
Uelsberg, G., *Heinz-Günther Prager, Skulpturen 1980–1995* (exh. cat.), Museum für Konkrete Kunst Ingolstadt, Dortmund, 1996–97

Uhlig, Dresden, 1994
Max Uhlig. Gemälde, Aquarelle, Zeichnung, Grafik, Skizzenbücher (exh. cat.), Kupferstichkabinett, Dresden, 1994

Ullrich, Rainer, 1994
Ullrich, F. (ed.), *Arnulf Rainer* (exh. cat.), Städt. Kunsthalle Recklinghausen, 1994

Umbo, Düsseldorf, 1995
Umbo. Vom Bauhaus zum Bildjournalismus (exh. cat.), Kunstverein für die Rheinlande und Westfalen, Düsseldorf, 1995

Unit One, London, 1984
Unit One: Spirit of the '30s (exh. cat.), Mayor Gallery, London, 1984

Urban, Nolde, 1987–90
Urban, M. (ed.), *Emil Nolde: Catalogue Raisonné of the Paintings*, New York, 1987–90

v. Huene, Hanover, 1983
Stephan von Huene. Klangskulpturen (exh. cat.), Kestner-Gesellschaft Hannover, 1983

Vachtova, Kupka, 1968
Vachtova, L., *Frantisek Kupka. Pioneer of Abstract Art*, New York and Toronto, 1968

Valdés, Díaz, 1991
Valdés, A., "Gonzalo Díaz" in *Contemporary Art from Chile* (exh. cat.), American Society, New York, 1991

Vallier, Rousseau, 1979
Vallier, D., *Henri Rousseau*, Paris, 1979

Van Bruggen, Baldessari, 1990
Van Bruggen, C., *John Baldessari*, New York, 1990

Vantongerloo, Brussels, 1981
Georges Vantongerloo (exh. cat.), Musées Royaux des Beaux Arts de Belgique, Brussels, 1981

Vantongerloo, London, 1996
Max Bill and Georges Vantongerloo: a working friendship[...] (exh. cat.), Annely Juda Fine Art, London, 1996

Varnedoe, Hanson, 1985
Varnedoe, K., *Duane Hanson*, New York, 1985

Varnedoe, High & Low, 1990
Varnedoe, K. and A. Gopnik, *High & Low. Moderne Kunst und Trivialkultur*, Munich, 1990

Vasarely, 1965–80
Vasarely, V., *La grande Monographie*, 4 vols., Neuchâtel, 1965–80

Vaughan, Socialist Realism, 1973
Vaughan James, C., *Soviet Socialist Realism: Origins and Theory*, London, 1973

Vautier, 1987
Ben, *La Vérité de A – Z*, Paris, 1987

Vautier, Paris, 1991
Ben Vautier, *Les Citations* (exh. cat.), Musée national d'art moderne, Centre Georges Pompidou, Paris, 1991

Vedova, Milan, 1991
*Vedova, … continuum … * (exh. cat.), Padiglione d'Arte Contemporanea di Milano, Milan, 1991

Vedova, Milan, 1993
Emilio Vedova (exh. cat.), Museo d'Arte Moderna, Lugano, Milan, 1993

Vedova, Munich, 1986
Emilio Vedova (exh. cat.), Staatsgalerie moderner Kunst, Munich, 1986

Vedova, Trento, 1996
Emilio Vedova (exh. cat.), Galleria Civica di Arte Contemporanea, Trento, 1996

Veličković, Besançon, 1981
Vladimir Veličković (exh. cat.), Centre Culturel Pierre Bayle, Besançon, 1981

Venturi, Italian Painting, 1967
Venturi, L., *Post-war Italian Painting*, New York, 1967

Venzmer, Hölzel, 1982
Venzmer, W., *Adolf Hölzel. Leben und Werk*, Stuttgart, 1982

Vestal, Abbott, 1970
Vestal. E., *Berenice Abbott, Photographs*, New York, 1970

Vianello, Martini, 1991
Vianello, G. (ed.), *Arturo Martini*, (exh. cat.), Philippe Daverio Gallery, New York and Milan, 1991

Vierny, Maillol, 1986
Vierny, D. et al. (ed.), *Maillol. La Méditerranée* (exh. cat.), Musée d'Orsay, Paris, 1986

Villon, Neuchâtel, 1982
Jacques Villon 1875–1963 (exh. cat.), Musée d'Art et d'Histoire, Neuchâtel, 1982

Villon, Paris, 1980
Jacques Villon. 30 peintures, 1919–1960 (exh. cat.), Galerie Louis Carré et Cie, Paris, 1980

Viola, New York, 1987
Bill Viola. Installations and Videotapes (exh. cat.), The Museum of Modern Art, New York, 1987

Viola, New York, 1997
Bill Viola (exh. cat.), Whitney Museum of American Art, New York, 1997

Violand-Hobi, Tinguely, 1995
Violand-Hobi, H. E., *Jean Tinguely. Biographie und Werk*, Munich, 1995

Violette, Viola, 1995
Violette, R. (ed.), *Reasons for Knocking at an Empty House, Writings 1973–1994, Bill Viola*, London, 1995

Vischer, Hill, 1995
Theodora Vischer (ed.), *Gary Hill. Arbeit am Video* (exh. cat.), Museum für Gegenwartskunst Basel, Ostfildern, 1995

Vitali, Morandi, 1977
Vitali, L., *Morandi. Catalogo Generale vol. 1: 1910–1947, vol. 2: 1948–1964*, Milan, 1977

Vitt, Zentrodada, 1985
Vitt, W. (ed.), *Neues über den Zentrodada aus Köln*, Starnberg, 1985

Vogeler, 1982
Heinrich Vogeler. Vom Romantiker zum Revolutionär. Ölbilder, Zeichnungen, Grafik, Dokumente von 1885–1924 (exh. cat.), Kunstverein, Bonn, 1982

Vogt, Blue Rider, 1980
Vogt, P., *The Blue Rider*, London, 1980

Vogt, Heckel, 1965
Vogt, P., *Erich Heckel*, Recklinghausen, 1965

Vogt, Rohlfs, 1958
Vogt, P. (ed.), *Christian Rohlfs. Aquarelle, Wassertempera, Zeichnungen*, Recklinghausen, 1958

Vogt/Köcke, Rohlfs, 1978
Vogt, P. and U. Köcke (eds.), *Christian Rohlfs. Œuvrekatalog der Gemälde*, Recklinghausen, 1978

vom Bruch, Düsseldorf, 1994
Klaus vom Bruch. Im Fluge – rasend – Jago (exh. cat.), Kunsthalle, Düsseldorf,1994

Vordemberge-Gildewart, Wiesbaden, 1997
Retrospektive Friedrich Vordemberge-Gildewart (exh. cat.), Museum Wiesbaden, 1997

Vorms, Masereel, 1967
Vorms, P., *Gespräche mit Frans Masereel*, Dresden, 1967

Vorticism, Berlin, 1996/97
Blast: Vortizismus – die erste Avantgarde in England 1914–18 (exh. cat.), Sprengel Museum Hanover, et al., Berlin, 1996

Vostell, Strasbourg, 1988
Wolf Vostell (exh. cat.), Musée de Strasbourg, 1988

Vriesen, Macke, 1957
Vriesen, G., *August Macke*, Stuttgart, 1957

Vriesen/Imdahl, Delaunay, 1969
Vriesen, G., and M. Imdahl, *Light and Color*, New York, 1969

Wadsworth, Bradford, 1989
A Genius of Industrial England. Edward Wadsworth 1889–1949 (exh. cat.), Cartwright Hall, Bradford, 1989

Wadsworth, London, 1974
Edward Wadsworth 1889–1949. Paintings, Drawings, Prints (exh. cat.), London, 1974

Wäspe, On Kawara, 1997
Wäspe, R. (ed.), *On Kawara 1964-Paris-New York* (exh. cat.), Kunstmuseum St. Gallen, 1997

Waldberg, Marini, 1974
Waldberg, P., and G. di San Lorenzo, *Complete Works of Marino Marini*, 2nd ed., New York, 1974

Waldemar, Baselitz, 1995
Waldemar, D., *Georg Baselitz* (exh. cat.), Solomon R. Guggenheim Museum, New York, 1995

Waldman, Albers, 1988
Waldman, D., J. Poetter, and P. Hahn (eds.), *Josef Albers: A Retrospective* (exh. cat.), Solomon R. Guggenheim Museum, New York, 1988

Waldman, Assemblage, 1992
Waldman, D., *Collage, Assemblage and the Found Object*, London, 1992

Waldman, Caro, 1982
Waldman, D., *Anthony Caro*, New York, 1982

Waldman, Collage, 1992
Waldman, D., *Collage, Assemblage, and the Found Object*, London, 1992

Waldman, Cornell, 1977
Waldman, D., *Joseph Cornell*, New York, 1977

Waldman, Cucchi, 1986
Waldman, D. (ed.), *Enzo Cucchi* (exh. cat), The Solomon R. Guggenheim Museum New York, New York, 1986

Waldman, de Kooning, 1988
Waldman, D., *Willem de Kooning*, London, 1988

Waldman, Holzer, 1989
Waldman, D. (ed.), *Jenny Holzer* (exh. cat.), Solomon R. Guggenheim Museum, New York, 1989

Waldman, Jenny Holzer, 1989
Waldman, D., *Jenny Holzer*, New York, 1989

Waldman, Kelly, 1997
Waldman, D. (ed.), *Ellsworth Kelly – Retrospektive* (exh. cat.), Solomon R. Guggenheim Museum, New York, 1997

Waldman, Noland, 1977
Waldman, D. (ed.), *Kenneth Noland. A Retrospective* (exh. cat.), Solomon R. Guggenheim Museum, New York, 1977

Walker, London, 1985
John Walker: Paintings from the Alba and Oceania Series, 1979–84 (exh. cat.), Hayward Gallery, London, 1985

Wall, London, 1995
Jeff Wall, Whitechapel Art Gallery, London, 1995

Wall, Munich, 1996
Jeff Wall. Space and Vision (exh. cat.), Städtische Galerie im Lenbachhaus, Munich, 1996

Wallis, Serrano, 1995
Wallis, B. (ed.), *Andres Serrano – Body & Soul*, New York, 1995

Walther, Hamburg, 1998
Franz Erhard Walther. Gelenke im Raum (exh. cat.), Deichtorhallen, Hamburg, 1998

Warhol, 1998
Andy Warhol: A Factory, Ostfildern, 1998

Warhol, Diaries, 1989
Warhol, A., *The Andy Warhol Diaries* (ed. P. Hackett), London, 1989

Warhol, New York, 1988
The Andy Warhol Collection (sales cat.), 6 vols., Sotheby's, New York, 1988

Warhol, Pittsburgh, 1989
"Success is a Job in New York", *The Early Art and Business of Andy Warhol* (exh. cat.), Grey Art Gallery, Pittsburgh, 1989

Warner, Chadwick, 1997
Warner, M., *Stilled lives: Helen Chadwick*, Edinburgh, 1997

Warner, Enfleshings, 1989
Warner, M., *H. Chadwick, Enfleshings*, London/New York, 1989

Warner, Nash, 1996
Warner, M., *David Nash: Form into Time*, London, 1996

Warnod, Bateau-Lavoir, 1976
Warnod, J., *Bateau-Lavoir. Wiege des Kubismus 1892–1914*, Geneva, 1976

Warnod, Survage, 1983
Warnod, J., *Survage*, Brussels, 1983

Warnod, Utrillo, 1983/84
Warnod, J., *Utrillo*, Paris, 1983

Warnod, Valadon, 1981
Warnod, J., *Suzanne Valadon*, New York, 1981

Webb, 1987
Boyd Webb. Photographien 1981–1987 (exh. cat.), Kestner Gesellschaft, Hanover, 1987

Webb/Short, Bellmer, 1985
Webb, P. and R. Short, *Hans Bellmer*, London, 1985

Weber, Albers, 1984
Weber, N. F., *The Drawings of Josef Albers*, New Haven, 1984

Wedewer, Räume, 1969
Wedewer, R. (ed.), *Räume und Environments* (exh. cat.), Städt. Museum Leverkusen, Schloß Morsbroich, Cologne-Opladen, 1969

Weegee, 1997
Weegee's World, Boston, 1997

Weelen/Jaeger, Vieira da Silva, 1994
Weelen, G. and J.-F. Jaeger, *Vieira da Silva. Catalogue raisonné*, Geneva, 1994

Wegman, 1991
William Wegman, L'Oeuvre photographique, Limoges, 1991

Weidinger, Kokoschka, 1998
Weidinger, A. (ed.), *Die Thermopylen. Oskar Kokoschka – Ein großer Europäer* (exh. cat.), Albertina, Vienna, 1998

Weiermair, Levitt, 1998
Weiermair, P. (ed.), *Helen Levitt*, New York, 1998

Weight, Weight, 1994
Weight, R. W., *Carel Weight: A Haunted Imagination*, Newton Abbot, 1994

Weiner, Amsterdam, 1988
Lawrence Weiner. Works from the Beginning of the Sixties towards the End of the Eighties (exh. cat.), Stedelijk Museum, Amsterdam, 1988

Weiner, Villeurbanne, 1993
Lawrence Weiner. Specific & General Works (exh. cat.), Le Nouveau Musée, Institute d'Art Contemporain, Villeurbanne, 1993

Weinhardt, Indiana, 1990
Weinhardt, C., *Robert Indiana*, New York, 1990

Weinstein, Expressionism, 1990
Weinstein, J., *The End of Expressionism*, Chicago, 1990

Weis, Rothko, 1998
Weis, J. (ed.), *Mark Rothko* (exh. cat.), National Gallery of Art, Washington, D.C., 1998

Weisberg, Japonisme, 1990
Weisberg, Gabriel, P. and Y., *Japonisme. An Annotated Bibliography*, New York/London 1990

Weisner, Chia, 1986
Weisner, U. (ed.), *Sandro Chia. Passione per l'arte. Leidenschaft für die Kunst* , (exh. cat.), Kunsthalle Bielefeld, Bielefeld, 1986

Weiss, Sacharow-Ross, 1993
Weiss, E. (ed.) *Igor Sacharow-Ross* (exh. cat.) Neue Trejakow-Galerie, Moscow, Munich, 1993

Welsch, Postmodernism, 1987
Welsch, W., *Unsere postmoderne Moderne*, Weinheim, 1987

Welsch, Postmodernism, 1988
Welsch, W. (ed.), *Wege aus der Moderne. Schlüsseltexte der Postmoderne-Diskussion*, Weinheim 1988

Wember, Klein, 1969
Wember, P., *Yves Klein, catalogue raisonné*, Cologne, 1969

Werkbund, Cologne, 1984
Die Deutscher Werkbund-Ausstellung Köln 1914 (exh. cat.), Kölnischer Kunstverein, Cologne, 1984

Werkbund, Deutscher Werkbund, 1982
Werkbund-Archiv (ed.), *Die Zwanziger Jahres des Deutschen Werkbunds*, Giessen, 1982

Werner, Barlach, 1966
Werner, A., *Ernst Barlach*, New York, 1966

Werner, Pascin, 1962
Werner A., *Pascin*, London, 1962

Werner, Vlaminck, 1975
Werner, A., *Maurice Vlaminck*, New York, 1975

Werry, Goeritz, 1994
Werry, E., *Mathias Goeritz. 1915–1990*, Munich, 1994

Wescher, Collage, 1968
Wescher, Herta, *Die Collage*, Cologne, 1968

Weschler, Irwin, 1991
Weschler, Lawrence, *Seeing Is Forgetting the Name of the Thing One Sees: A Life of Contemporary Artist Robert Irwin*, University of California Press, 1991

Weschler, Kienholz, 1977
Weschler, L. (ed.), *Edward Kienholz*, 2 vols., Los Angeles, 1977

Weschner, Collage, 1968
Weschner, H., *Collage*, New York, 1968

Weskott, Lassnig, 1995
Weskott, H., (ed.), *Maria Lassnig. Zeichnungen und Aquarelle 1946–1995*, Munich, 1995

Wesselmann, Long Beach, 1974
Tom Wesselmann. The Early Years. Collages 1959–1962 (exh. cat.), Art Galleries, California State University, Long Beach, 1974

Wesselmann, New York, 1998
Tom Wesselmann. New Abstract Paintings (exh. cat.), Sidney Janis Gallery, New York, 1998

Wesselmann, Tokyo, 1991
Tom Wesselmann. Recent Still Lifes and Landscapes (exh. cat.), Galerie Tokoro, Tokyo, 1991

West, Piper, 1979
West, A., *John Piper*, London, 1979

West, Venice, 1990
Franz West, Austria, Biennale di Venezia(exh. cat.), Venice, 1990

West, Vienna, 1996
Franz West, Proforma (exh. cat.), Museum moderner Kunst Stiftung Ludwig, Vienna, 1996

Wex, Thorn Prikker, 1984
Wex, J. L., *Jan Thorn Prikker. Abstraktion und Konkretion in freier und angewandter Kunst* (diss.), Bochum, 1984

Whelan, Caro, 1974
Whelan, R., *Anthony Caro*, Harmondsworth, 1974

Whenlan, Capa, 1985
Whenlan, R., *Robert Capa: A Biography*, New York, 1985

Whiteread, Liverpool, 1996
Rachel Whiteread, Shedding Life (exh. cat.), Tate Gallery, Liverpool, 1996

Whitford, Bauhaus, 1984
Whitford, F. *Bauhaus*, New York, 1984

Whitford, Kandinsky, 1999
Whitford F., *Kandinsky: Watercolours and Other Works on Paper* (exh. cat.), Royal Academy of Arts, London, 1999

Whitford, Klimt, 1993
Whitford, F., *Gustav Klimt*, London, 1993

Whitney, Fischl, 1988
Whitney, D. (ed.), *Eric Fischl*, New York, 1988

Whitney, Heizer, 1990
Whitney, D., *Michael Heizer* (exh. cat.), Waddington Galleries, London, 1990

Whybrow, St Ives, 1994
Whybrow, M., *St Ives, Portrait of an Art Colony*, Woodbridge, Suffolk, 1994

Wichmann, Jugendstil, 1984
Wichmann, S., *Jugendstil floral funktional: in Deutschland, Österreich und den Einflußgebieten*, Herrsching, 1984

Wieland, Anna & Bernhard Blume, 1992
Wieland, A. (ed.), *Anna & Bernhard Blume. Großfotoserien 1985–1990* (exh. cat.), Rheinisches Landesmuseum Bonn, Cologne, 1992

Wiener Werkstätte, Brussels, 1987
Wiener Werkstätte. Atelier Viennois 1903–1932 (exh. cat.), Galerie CGER, Brussels, 1987

Wiese, Piene, 1996
Wiese, S. v. and S. Rennert (eds.), *Otto Piene. Retrospektive 1952–1996* (exh. cat.), Kunstmuseum and Kunstpalast Düsseldorf, Cologne, 1996

Wilcox, London Group, 1995
Wilcox, D.J., *The London Group 1913–1939. The Artists and their Works*, Aldershot, 1995

Wildenstein, Redon, 1992
Wildenstein, A., *Catalogue raisonné des peintures d'Odilon Redon*, Paris, 1992 (3 vols).

Wilder, Frink, 1984
Wilder, J., *Elizabeth Frink: Catalogue Raisonnée*, Salisbury, 1984

Wilkin, Davis, 1987
Wilkin, K., *Stuart Davis*, New York, 1987

Wilkin, Morandi, 1996
Wilkin, K., *Giorgio Morandi*, New York, 1996

Wilkin, Noland, 1990
Wilkin, K., *Kenneth Noland*, New York, 1990

Wilkinson, Lipchitz, 1989
Wilkinson, A. G. (ed.) *Jacques Lipchitz. A Life in Sculpture* (exh. cat.), Art Gallery of Ontario, Toronto, 1989

Will-Levaillant, Esprit Nouveau, 1975
Will-Levaillant, F., *Norme et Forme à travers l'Esprit nouveau dans le retour à l'ordre*, Saint-Étienne, 1975

Williams, Canberra, 1987
Mollison, J., *Fred Williams*, Australian National Gallery, Canberra, 1987

Wilms, Kirkeby, 1998
Wilmes, U. (ed.), *Per Kirkeby. Die Bronzen*, Munich/Cologne, 1998

Windecker, Münter, 1991
Windecker, S., *Gabriele Münter. Eine Künstlerin aus dem Kreis des Blauen Reiter*, Berlin, 1991

Wingler, Bauhaus, 1962
Wingler, H. M., *Das Bauhaus 1919–33*, Berlin, 1962

Wingler, Kokoschka, 1956
Wingler, H. M., *Oskar Kokoschka. Das Werk des Malers*, Salzburg, 1956

Wingler/Welz, Kokoschka, 1975/81
Wingler, H. M., and F. Welz, *Oskar Kokoschka. Das druckgraphische Werk*, 2 vols., Salzburg, 1975/1981

Winogrand, 1988
Winogrand. Figments from the Real World (exh. cat.), MOMA, New York, 1988

Winter, Kassel, 1993
Fritz Winter 1905–1976 (exh. cat.), Neue Galerie, Kassel, 1993

Winter, O'Keeffe, 1998
Winter, J., *My name is Georgia*, San Diego, 1998

Winter, Stuttgart, 1990
Fritz Winter (exh. cat.), Galerie der Stadt Stuttgart, 1990

Wolbert, Jetelová, 1996
Wolbert, K. (ed.), *Magdalena Jetelová. Orte und Räume* (exh. cat.), Institut Mathildenhöhe, Darmstadt, 1996

Wollen, Meeting, 1993
Wollen, P., *Meeting*, London, 1993

Wols, Edinburgh, 1990
Wols – Paintings, National Galleries of Scotland, Edinburgh, 1990

Wols, Zurich, 1989
Wols. Bilder, Aquarelle, Zeichnungen, Fotos, Druckgraphik (exh. cat.), Kunsthaus Zürich, 1989

Wood, Davenport, 1995
Grant Wood. An American Master Revealed (exh. cat.), Davenport (Iowa) Museum of Art, 1995

Wood, MacTaggart, 1974
Wood, H. H., *MacTaggart*, Edinburgh, 1974

Wood, New York, 1997
Beatrice Wood: A Centennial Tribute (exh. cat), New York, 1997

Woodson, Gertler, 1972
Woodson, J., *Mark Gertler*, London, 1972

Wotruba, Hanover, 1967
Wotruba (exh. cat.), Kestner-Gesellschaft, Hanover, 1967

Wye, Tàpies, 1992
Wye, D., *Antoni Tàpies in Print*, London, 1992

Wyeth, New York, 1998
Andrew Wyeth, Landscapes (exh. cat.), The Whitney Museum of American Art, New York, 1998

Yablonskaya, Goncharova, 1990
Yablonskaya, M. N., *Woman Artists of Russia's New Age, 1900–1935*, London, 1990

Yager, Graves, 1993
Yager, D. et al., *Nancy Graves: Recent Works* (exh. cat.), Fine Arts Gallery, University of Maryland, 1993

Yarlow, Graham, 1994
Yarlow, L. et al. (eds.), *Rodney Graham. Works from 1976 to 1994* (exh. cat.), Art Gallery of York University, Toronto, 1994

Yau, Penck, 1993
Yau, J., *A. R. Penck*, New York, 1993

Yeats, Dublin, 1971
Jack B. Yeats, 1871–1957 (exh. cat.), National Gallery Dublin, 1971

Yglesias, Bishop, 1988
Yglesias, H., *Isabel Bishop*, New York, 1988

Yorke, Neo-Romanticism, 1988
Yorke, M., *The Spirit of Place: Nine Neo-Romantic Artists*, London, 1988

Yveline, De Andrea, 1982
Yveline, P., *John De Andrea: Sculptures 1978–81* (exh. cat.), The Aspen Center for the Visual Arts, Aspen, Colorado, 1982

Zanovello Russolo, Russolo, 1958
Zanovello Russolo M., *Russolo, L'uomo, l'artista*, Milan, 1958

Zebra, Hamburg, 1980
Gruppe Zebra (exh. cat.), Kunsthalle Bremen, Hamburg, 1980

Zeitvergleich, 1983
Vogel, Carl, "Carl Friedrich Claus" in *Zeitvergleich, Malerei und Grafik aus der DDR*, Cologne, 1983, pp. 55 ff.

Zemens, Macdonald, 1981
Zemens, J. (ed.), *Jock Macdonald: The Inner Landscape […]* (exh. cat.), Art Gallery of Ontario, Toronto, 1981

ZEN 49, Troyes, 1989
Zen 49, 1949–1955 (exh. cat.), Centre d'art contemporain, Saint-Priest, Troyes, 1989

Zero, 1973
Piene, O. and H. Mack (eds.), *Zero. Texte und Dokumente*, Cologne, 1973

Zero, Essen, 1992
Zero. Eine europ. Avantgarde, (exh. cat.), Folkwang-Museum, Essen, 1992

Zervos, Picasso, 1932–78
Zervos, C., *Pablo Picasso, catalogue général des peintures, dessins, aquarelles et gouaches*, 33 vols., Paris, 1932–76

Zevi, Kline, 1987
Zevi, A., *Franz Kline*, Milan, 1987

Zhadova, Malevich, 1982
Zhadova, L. A., *Malevich, Suprematism and Revolution in Russian Art*, London, 1982

Zimmer, Wolfsburg, 1986
HP Zimmer. Bilder – Objekte – Räume (exh. cat.), Kunstverein Wolfsburg, 1986

Zimmermann, Götz, 1994
Zimmermann, H. (ed.), *K. O. Götz – Malerei 1935–1993* (exh. cat.), Staatl. Kunstsammlung Dresden Albertinum, Gemäldegalerie Neuer Meister, Dresden, 1994

Zorio, Amsterdam, 1987
Gilberto Zorio (exh. cat.), Stedelijk van Abbemuseum Eindhoven, 1987

Züchner, Hausmann, 1998
Züchner, E. (ed.), *Scharfrichter der bürgerlichen Seele. Raoul Hausmann in Berlin*, Ostfildern, 1998

Zutter, Nauman, 1990
Zutter, J. (ed.), *Bruce Nauman. Skulpturen und Installationen 1985–1990* (exh. cat.), Museum für Gegenwartskunst, Basel, 1990

Zweite, Blauer Reiter, 1991
Zweite, A. (ed.) and A. Hoberg, *Der Blaue Reiter im Lenbachhaus München*, Munich, 1991

Zweite, Jawlensky, 1983
Zweite, A. (ed.), *Alexej Jawlensky 1864–1941* (exh. cat.), Städt. Galerie im Lenbachhaus, Munich, 1983

Zweite, Jorn, 1987
Zweite, A. (ed.), *Asger Jorn 1914–1973. Gemälde, Zeichnungen, Aquarelle, Gouachen, Skulpturen* (exh. cat.), Städt. Galerie im Lenbachhaus, Munich, 1987

Zweite, Lüpertz, 1996
Zweite, A. (ed.), *Markus Lüpertz. Gemälde-Skulpturen* (exh. cat.), Kunstsammlung Nordrhein-Westfalen Düsseldorf, Ostfildern, 1996

Picture Credits

© 2000 Contemporary Collection of The Cleveland Museum of Art, 1965, 199 b

© 2000 The Museum of Modern Art, New York, 36, 43 t, 73 b, 167 c r, 246 l, 257 r, 257 b, 273 b r

© 2000, The Art Institute of Chicago, 13 r, 159 c r

ADAGP C. Brancusi Mnamcci, Centre Pompidou Legs Brancusi 1957, 58

Allan Finkelman, New York; Steven Maklansky, New Orleans, 57 r

Artothek Peissenberg, 20 t, 119 t r, 228 b l, 258 c

Attilio Maranzano, Montalcino, 146, 160 t l

Bernhard Schmitt, Karlsruhe, 297 t

Bildarchiv Preußischer Kulturbesitz, Staatliche Museen, Berlin, 143 t r, 152 b r, 177 t, 192 c, 194 b r, 202 t, 223 l, 224 l, 235 l, 241, 291 b

Courtesy of Jenny Holzer, 159 c l, 159 b

David Allison, New York, 188

Dia Center for the Arts, New York, 341 r

Dia Center for the Arts, New York, John Cliett, 92, 96

Doris Quarella, Zürich, 53

Galerie der Stadt Stuttgart, 40 l, 101 b

Galerie van de Loo, Munich, 168 t r,

Hamburger Kunsthalle, Elke Walford, Hamburg, 97, 106 t l, 234 b

Hermann Kiessling, Berlin, 39

Indianapolis Museum of Art, 163 r

Institut für Kulturaustausch, Tübingen, 119 b l

John Riddy, London, 125 c r

Kira Perov, Long Beach, California, 337, b., 338 t.

Kunsthalle Bern, 147

Kunsthaus Zürich, 73 t, 93, 326 t r

Kunsthaus Zürich, Alberto Giacometti-Stiftung, 135 t l

Kunsthaus Zürich, Estate of Max Bill, 48 t

Kunstmuseum Basel, 23

Leo Castelli Gallery, 234 r

Los Angeles County Museum of Art, Los Angeles County Fund, 274 t

Los Angeles County Museum of Art, Mr. and Mrs. William Preston Harrison Collection, 208 l

Lothar Schnepf, Cologne, courtesy Galerie Michael Werner, Cologne and New York, 178 t l and t r

Ludwig Forum für internationale Kunst, Sammlung Ludwig, 148 r

Magnum Photos, 72, 74 r

Münchner Stadtmuseum, 285 l.

Musée National d'Art Moderne, Centre Georges Pompidou, Paris, 22 t, 35 t, 60 t, 76 b, 83, 85 b, 103 l, 129 t, 142 t, 154 b, 195 l, 317, 319 t, 336 l

Museum Ludwig, Cologne, 257 t l, 341 b

Museum Ostdeutsche Galerie, Regensburg, 6, 15 l, 46 b r, 88 t r, 88 t l, 101 t l, 119 t, 120 t, 120 b, 122 t, 176 t r, 183 t l, 183 t r, 187 l, 202 b, 218 b, 229 t l, 260 t r, 268 l, 272 t l, 291 t, 293 b

Museum Ostdeutsche Galerie, Regensburg; photoarchive C. Raman Schlemmer, I-28824 Oggebbio, 288 t l

Nic Tenwiggenhorn, 182 l

Peggy Guggenheim Collection, Venice, 14 t r, 59 l, 94 c l

Peter Bellamy, New York, 32, 57 l

Philadelphia Museum of Art: Bequest of Katherine S. Dreier, 106 b

Quentin Bertoux, Grenoble, back jacket, 64

Rheinisches Bildarchiv, Cologne, 20 b, 25 t r, 27 b, 48 b, 49 b, 110 b, 163 l, 175 b l, 183 b, 190 b r, 197 b, 209 c l, 209 b, 212 b, 213 c r, 228 c l, 272 t l, 277, 284 b, 285 l, 304 c r, 309 r, 344

Rolf Lenz, 298 b

Sammlung Essl, Klosterneuburg, Vienna, 19 l., 28, 63, 240 t

Sander Photographie GmbH, Cologne, 123 b r

Staatsgalerie moderner Kunst, Munich, 38 t r, 250 b

Staatsgalerie Stuttgart, 143 b l, 158 t r, 177 b l, 182 b, 223 r, 253 l, 256, 272 c r

Städtische Galerie im Lenbachhaus, Munich, 34, 47, 128 l, 166 c, 170, 172 b, 174 t, 174 t r, 175 r, 180 t r, 198 r, 206 t, 206 c, 213 t l, 212 b r, 230 b, 260 t r, 286 b, 290, 293 t l, 295 b r, 326 t r, 338 t r, 339 b, 345 t l

Städtische Galerie im Lenbachhaus, Munich, Gabriele Münter and Johannes Eichner Foundation and Städtische Galerie, 180 t l

Tate Gallery, London 2000, 33b, 38 t l, 130, 139 t l, 214 b

The Museum of Contemporary Art, Los Angeles, The Panza Collection, 181 r

The Saint Louis Art Museum, 108

Thomas Goldschmidt, Karlsruhe, 337 l

Whitney Museum of American Art, New York, 138

Editorial Committee

Professor Dr. Wieland Schmied
President of the Bavarian Akademie
der Schönen Künste, Munich

Dr. Frank Whitford
Wolfson College, University of
Cambridge, formerly of the Royal
College of Art, London

Professor Frank Zöllner
Professor of Art History,
University of Leipzig

Authors

Marion Ackermann M.A.
Nicola v. Albrecht N.v.A.
Elaine Barella E.Ba.
Erika Billeter E.B.
Gerhard Blechinger G.B.
Monica Bohm-Duchen M.B.-D.
Ursula Dann U.D.
Patricia Drück P.D.
Hajo Düchting H.D.
Klaus Eid K.E.
Simonetta Fraquelli S.F.
John Alan Farmer J.A.F.
Julia Fuchshuber J.F.
Hubertus Gaßner H.G.
Annegret Gerleit A.G.
Silvia Guastalla S.G.
Siegfried Gohr S.Go.
Walter Grasskamp W.G.
Milena Greif M.G.
Inge Herold I.H.
Helmut Heß H.H.
Annegret Hoberg A.H.
Eckhard Hollmann E.H.
Sabine Höng S.H.
Joachim Jäger J.J.
Alexandra Kapp A.K.
Friederike Kitschen F.K.
Petra Larass P.L.
Jane C. Milosch J.C.M.
Reinhold Mißelbeck R.M.
Ulrich Müller U.M.
Irene Netta I.N.
Roberto Ohrt R.O.
Harald Olbrich H.O.
Susanna Partsch S.Pa.
Stefanie Penck S.P.
Ursula Perucchi-Petri U.P.-P.
Ulrich Pohlmann/Stefanie Unruh U.P./S.U.
Gerd Presler G.P.
Frank Purrmann F.P.
David Radzinowicz D.R.
Brady Roberts B.R.
Gerd Roos G.R.
Anna Sarah Rühl A.R.
Esther Ruelfs E.R.
Karin Sagner-Düchting K.S.-D.
Irmtraud Schaarschmidt-Richter I.S.-R.
Lillian Schacherl L.Sch.
Dieter Scholz D.S.
Martin Schulz M.S.
Josephine Shea J.S.
Isabell Siben I.S.
Courtenay Smith C.S.
Reinhard Spieler R.S.
Walter Springer W.S.
Peter Stepan P.S.
Ines Turian I.T.
Cordula Walter-Bolhöfer C.W.-B.
Christine Walter C.W.
Dirk Welich D.W.
Astrid Wege A.W.
Joseph R. Wolin J.R.W.

Texts marked W.G.* are reworked entries
taken from Walter Grasskamp's extensive
biographies previously published in *Deutsche Kunst
im 20. Jahrhundert*, Munich, 1986, pp. 474ff.

Jacket image: Detail from Lucio Fontana,
Concetto Spaziale, 1962 (see p. 123)
Back jacket, top to bottom: Frida Kahlo,
Self-portrait with monkey, 1940 (see p. 171)
Umberto Boccioni, *Continuous Forms in
Space*, 1913, bronze, 126.4 x 89 x 40.6 cm,
Contemporary Art Museum, São Paolo
Helen Levitt, *New York*, 1940 (see p. 196)
Pierre Alechinsky, *Central Park*, 1965 (see p. 14)
Andy Warhol, *Lenin*, 1986 (see p. 339)
Daniel Buren, *Work in situ, Autour du retour d'un
retour*, 1988 (see p. 64)
Franz Marc, *Blue Horse I*, 1911 (see p. 213)
Joseph Beuys, *Zeige Deine Wunde*, 1974–75
(see p. 47)

Prestel Verlag
Mandlstrasse 26 · D-80802 Munich · Germany
Tel.: (089) 38 17 09-0 · Fax: (089) 38 17 09-35

4 Bloomsbury Place · London WC1A 2QA
Tel.: (020) 7323 5004 · Fax: (020) 7636 8004

175 Fifth Avenue, Suite 402 · New York NY 10010
Tel.: (212) 995 2720 · Fax: (212) 995 2733

www.prestel.com
www.prestel.de

Library of Congress Card Number: 99-069-78

Prestel books are available worldwide. Please
contact your nearest bookseller or any of the
above addresses for information concerning
your local distributor.

For the English edition

Editorial direction: Philippa Hurd

Editing: Christine Davis, Lucinda Hawksley
David Radzinowicz Howell, Bernard Wooding

Translations: Rosemarie Baines, Mo Croasdale,
David Erban, Christian Goodden, Bettina Jung,
Suzanne Walters
Picture research: Melanie Pfaff

Design and typesetting in Swift and TheSans:
Matthias Hauer
Jacket design: WIGEL, Munich

Database design and management:
Wilhelm Vornehm, Munich
Origination: Repro Brüll, Saalfelden
Printing: Appl, Wemding
Bound in "Chromo" by Bamberger Kaliko
by MIB Conzella, Pfarrkirchen

Printed in Germany on acid free paper

ISBN 3-7913-2325-3